ART IN AMERICA
1945–1970

ART IN AMERICA
1945–1970

WRITINGS FROM THE AGE OF
ABSTRACT EXPRESSIONISM, POP ART,
AND MINIMALISM

Jed Perl, *editor*

THE LIBRARY OF AMERICA

Some of the material in this volume is reprinted
by permission of the holders of copyright and publication rights.
If an owner has been unintentionally omitted,
acknowledgment will gladly be made in future printings.
See the Sources and Acknowledgments on page 833 for further information.

This paper meets the requirements of
ANSI/NISO Z39.48-1992 (Permanence of Paper).

Distributed to the trade in the United States
by Penguin Random House Inc.
and in Canada by Penguin Random House Canada Ltd.

Library of Congress Control Number: 2013957900
ISBN 978–1–59853–310–1

First Printing
The Library of America — 259

Contents

John Ashbery

Color Illustrations
(following page 196)

1. Morris Graves, *Time of Change*
2. John Graham, *Two Sisters (Les Mamelles d'outre-mer)*
3. Jackson Pollock, *Cathedral*
4. Mark Rothko, *No. 1 (No. 18, 1948)*
5. Robert Motherwell, *At Five in the Afternoon*
6. Anni Albers, *Black-White-Gold I*
7. Charles Burchfield, *Gateway to September*
8. Barnett Newman, *Vir Heroicus Sublimis*
9. Clyfford Still, *1951-T No. 3*
10. Willem de Kooning, *Woman, I*
11. Grace Hartigan, *The Persian Jacket*
12. Larry Rivers, *O'Hara Nude with Boots*
13. Jack Tworkov, *Pink Mississippi*
14. Joseph Cornell, *Untitled (Hôtel de l'Etoile)*
15. Robert Rauschenberg, *Bed*
16. Jasper Johns, *Target with Four Faces*
17. Helen Frankenthaler, *Giralda*
18. Alfred Leslie, *Quartet #1*
19. Hans Hofmann, *Equinox*
20. Roy Lichtenstein, *The Engagement Ring*
21. James Rosenquist, *Silver Skies*
22. Andy Warhol, *Marilyn Diptych*
23. Joan Brown, *Girl in Chair*
24. Donald Judd, *Untitled*
25. Robert Morris, *Untitled (Ring of Light)*
26. Joan Mitchell, *Girolata Triptych*
27. Philip Guston, *The Light*
28. Jane Freilicher, *Peonies*
29. Jess, *The Enamord Mage: Translation #6*
30. Philip Pearlstein, *Models in the Studio*
31. Romare Bearden, *Black Manhattan*
32. Fairfield Porter, *Self-Portrait*

Introduction

Art writing is always a literary mongrel. But there has never been a period when the visual arts have been written about with more mongrel energy—with more unexpected mixtures of reportage, rhapsody, analysis, advocacy, editorializing, and philosophy— than in America in the quarter century after World War II. The international reputations achieved by Jackson Pollock, Willem de Kooning, Mark Rothko, David Smith, and various other painters and sculptors were a display of freewheeling artistic prowess that signaled a dramatic realignment in the relationship between the Old World and the New. And America's equally freewheeling literary fraternity was eager to spread the news.

As to how the news would be interpreted, that was a whole other story. Honestly, it was an entire storybook full of stories, as will become apparent from the range of impressions, interpretations, and theories encompassed in these pages. The sense of confidence and authority that American artists, curators, collectors, critics, gallerygoers, and museumgoers were experiencing in the 1950s and 1960s was certainly unprecedented. What was not so easy to explain was the nature of this new assertiveness. In a 1953 essay, "Parable of American Painting," Harold Rosenberg argued that the finest American artists were pragmatists and improvisationalists, to some degree not unlike the eighteenth-century Americans, the Coonskinners as he called them, who had defeated the more traditionally minded British. But if the American artist's oppositional nature helped to explain how American art came of age in the middle of the twentieth century, the historical thrust of Rosenberg's argument served as a reminder that the swaggering authority of the new American art was not entirely new. Certainly there were American artists who had already been interested in embracing the role of the dissident or the renegade in the first quarter of the twentieth century, when they watched as the *Nude Descending a Staircase*—the work of a Frenchman, Marcel Duchamp— created a sensation at the 1913 Armory Show. Meanwhile, Alfred Stieglitz was quietly building an audience for avant-garde art through his pioneering exhibitions of work by Picasso, Matisse, John Marin, Arthur Dove, and Georgia O'Keeffe, as well as in

the pages of his magazine *Camera Work*. By the 1950s, New York and indeed much of the rest of the country were home to several overlapping generations of artists who regarded themselves as avant-gardists and modernists of one sort or another. And all these creators—the younger and the older painters and sculptors, with their differing styles, values, attitudes, and objectives—were promoted, critiqued, celebrated, and explicated in the art writing of the period, which when taken together comprises an achievement as substantial as any produced in a comparable period of time in one of the great European centers.

While the rise of landscape painting in America in the nineteenth century had inspired the nation's first substantial body of writing about art and aesthetics, it was probably the battles for art-for-art's-sake that the American expatriate James McNeill Whistler waged through his eloquent texts at the end of the century that laid the groundwork for America's cosmopolitan sophistication when it came to the visual arts. Around the same time, Henry James was exploring the American imagination's confrontation with Europe's visual arts traditions, beginning with *Roderick Hudson*, his early novel about a promising young American sculptor who comes to a tragic end, and concluding with his biographical study of an old friend, the American expatriate sculptor William Wetmore Story, a book that stands as a marginal but nonetheless magnificent achievement in the James canon. There were certainly other original voices speaking out about the visual arts around 1900; among them were John La Farge, Elihu Vedder, and Sadakichi Hartmann, who each argued for an American aesthetic with its own forms of mystery and magic. The great questions that would challenge so many mid-twentieth-century writers—How do we define the Americanness of American art? What is the American artist's relationship with cosmopolitan values?—have been debated for a very long time.

Paul Rosenfeld's *Port of New York*, published in 1924, is arguably the first book that devotes significant space to the visual arts in twentieth-century America and has endured, a small classic of adventuresome thought that celebrates the artists in the Stieglitz circle with passages of strikingly impressionistic lyric prose. Any account of American art criticism in the first half of the twentieth century ought to give pride of place to Rosenfeld,

and also include generous selections of work by Marsden Hart-
ley, William Carlos Williams, Walter Pach, Henry McBride,
Lewis Mumford, and Lincoln Kirstein, as well as some more
conservative voices, especially Royal Cortissoz. If any general-
ization can be made about such a wide range of writing, it is
that the struggle to define modernity and the struggle to under-
stand the nature of America were seen as proceeding hand in
hand. The fruit of these explorations—which were also pursued
through the exhibition programs of pioneering institutions such
as the Museum of Modern Art, the Whitney Museum of Ameri-
can Art, and the Gallery of Living Art at New York University—
was a new level of cultural self-confidence. Clement Greenberg's
take-no-prisoners view of modern art might not have been pos-
sible without Stieglitz's ardent embrace of art-for-art's-sake a
generation earlier, which of course did not prevent Greenberg
from complaining in 1942 that "there is about [Stieglitz] and
his disciples too much art with a capital A, and too many of the
swans in his park are only geese."

In the 1940s or 1950s, although there were certainly art critics
with regular posts, among them Henry McBride at *The New
York Sun* and Robert M. Coates at *The New Yorker*, it was pretty
much impossible to imagine that writing about art could be
an intellectual and literary discipline capable of sustaining a
person for a lifetime. I think it is safe to say that Greenberg and
Rosenberg started out with the idea of dedicating their lives to
literary, philosophic, and sociological investigations, and only
came to see the contemporary visual arts as a challenge worthy
of their gifts once de Kooning and Pollock had become figures
to be reckoned with. And just as the painters were emboldened
by the work that Europeans had done and were continuing to
do, so the American critics looked to examples from the other
side of the Atlantic, especially Baudelaire in nineteenth-century
France and Clive Bell, Herbert Read, and Roger Fry (who had
been a curator at the Metropolitan Museum of Art) in the En-
gland of more recent times. The presence in the United States
during World War II of André Breton, whose writings on art
demonstrate a freedom of thought and feeling that his Surreal-
ist polemics often lack, offered a more immediate example of
a poet attuned to the dynamics and nuances of the visual arts,

although Breton, who did not speak English, had relatively little direct contact with the Americans. Whatever influence Continental art criticism had, there was also a sense among the younger Americans that they were approaching the art of writing about art on their own terms, with a sensitivity to broad social and political issues fueled by the leftist but anti-Soviet interests of *Partisan Review,* a magazine that nearly everybody in the downtown art world followed to one degree or another and with which many authors included in this volume were associated—not only Greenberg and Rosenberg, but also Meyer Schapiro, Dwight Macdonald, and Mary McCarthy.

The appetite for criticism grew right along with the appetite for art. So it was hardly surprising that as time went on more and more artists and writers found themselves publishing their thoughts about the visual arts, whether occasionally or in some cases eventually full-time. The publication program of the Museum of Modern Art provided foundational texts by curators with acute critical minds, including the museum's founding director, Alfred H. Barr, Jr., and James Thrall Soby, James Johnson Sweeney, and Peter Selz. Robert Motherwell edited, for the art book dealer and publisher George Wittenborn, a pioneering series of critical texts spanning the twentieth century entitled Documents of Modern Art; Motherwell's 1951 anthology, *The Dada Painters and Poets,* is widely recognized as key to the revival of interest in the movement. During the same period, *Art News, Art in America,* and *Arts Magazine*— all presences on the scene from much earlier in the century— grew in size and scope; for a time these magazines covered in at least capsule form nearly every exhibition in New York, with brief reviews by writers of considerable distinction, including the poet James Schuyler. There was also, all through the period, a rich growth of smaller, often frankly experimental magazines that had a partial or near-total focus on the visual arts: *The Tiger's Eye, Possibilities, trans/formation, It Is, Black Mountain Review, Art and Literature,* and *Evergreen Review,* though this last reached far too wide an audience to be counted a "little magazine." In the 1960s a new generation of journals came to the fore, especially *Artforum* and *Art International,* loaded with advertisements that reflected the astonishing success of an expanding art market.

Can any dominant tendencies be discerned amid these competing voices? While it may be too much to speak of a pattern, it is not amiss to suggest that two strong and in many respects divergent approaches did emerge. One group of writers, chief among them poet-critics and painter-critics including Frank O'Hara, Fairfield Porter, and John Ashbery, tended to embrace criticism as an instinctive and impressionistic activity, with the author embodying the role of the Baudelairean flaneur, rejecting broad generalizations and steel-trap conclusions in favor of the bold thrust and the telling glance. The second group of writers, beginning with Greenberg even before the war and continuing with Michael Fried in the late 1960s, aimed to locate immediate experience within the larger movements of art history, and were attuned to the contemporary implications of the aesthetics of Kant and Hegel and other canonical philosophers. In the 1950s and 1960s these divergent approaches tended to find strong support in different magazines, with *Art News* under the editorship of Thomas Hess developing a lyrical and impressionistic approach to the visual arts, while by the end of the 1960s *Artforum* was for at least a time very much associated with a more analytical and theoretical approach.

But however far apart the two approaches might appear—and by the 1970s the practitioners were hardly acknowledging one another's existence—the great majority of writers agreed that the rise of Abstract Expressionism was the defining development in American art. It was just that the interpretations could turn out to be radically different, depending on who was looking at the work of Pollock, de Kooning, or Barnett Newman. Which is not to say that the lines were always so clearly drawn. The best writers have a way of surprising us with the freedom of their thought. Even Greenberg, by turns reviled and revered for his theoretical purity, had in his reviews of the 1940s registered immediate experience with diamond-like precision. As for Hess, his glittering, poetic, at-an-angle impressions of people and places and works of art were wedded to a gift for searchingly incisive interpretations of the artist's rapidly shifting social situation. Different writers responded in radically different ways to the revival of interest in Monet's *Water Lilies* in the early 1950s and to the upsurge of interest in collage a few years later, and it is only when we study their views in tandem that

we really begin to grasp the intellectual richness of the period. Magazines could certainly present divergent vantage points, and many of them changed their editorial orientation as the years went by. Although *Art and Literature,* published in Europe but with an American orientation significantly shaped by Ashbery, was very much associated with the work of the poet-critics, the magazine also found space for Greenberg's seminal essay "Modernist Painting" (though this was not its first appearance). At *The Nation,* where much of Greenberg's criticism had originally appeared, Fairfield Porter, who had in fact locked horns with Greenberg, was later the regular critic. *Artforum* in its early years, under the editorship of Philip Leider, was a much more intellectually rigorous magazine than many would regard it as being a decade later.

Criticism itself became a subject of study in the 1960s, with art writers invited to anatomize their craft at gatherings in museums, colleges, and universities. At Princeton in the mid-1950s, William Seitz produced a pioneering PhD thesis devoted to contemporary American art, a study of the Abstract Expressionists done with the support of Barr. Twenty years later, Fried and Rosalind Krauss, who while still in school were much influenced by Greenberg's criticism, were building extraordinarily successful careers that to some extent merged art history and art criticism, previously regarded as utterly distinct disciplines. The publication from 1986 to 1993 of Greenberg's *Collected Essays and Criticism* in four volumes may be regarded as American art writing's coming of age, the mongrel now pedigreed. Those writers fortunate enough to have their work or a significant part of their work brought together in one or more volumes—they include Porter, Ashbery, and Donald Judd—now very much have the advantage over a writer such as Hess, whose first-rate essays and reviews have never been collected, or even Rosenberg, who although there are many out-of-print collections of his work, has not yet been granted the selected or collected criticism that would make his achievement graspable as a totality. What is clear is that the story of art in the decades after World War II becomes ever more complex as one delves into the back issues of magazines that have not yet been digitized and are not always easy to access even in our great research libraries. Then there are the writings contained in extraordinarily

ephemeral exhibition catalogues, as well as what is turning out to be a not inconsiderable body of letters and journals—some beginning to find their way into print, some no doubt still waiting to be discovered. If one is willing to take the time to look at this treasure trove of writing about postwar painting and sculpture, a fraction of which is brought together in this book, what emerges is a magnificent, cacophonous sort of oratorio, with soloists and choir members agreeing about little except that the time has come for American art to take its place on the world stage.

Jed Perl

JACKSON POLLOCK

Jackson Pollock (1912–1956) died on an August night on Long Island, a drunk driver on the way to a party who lost control of his car. He was already the defining figure in postwar American art, the man who "broke the ice," as his friend Willem de Kooning put it when friends gathered to remember him. Pollock was born in Cody, Wyoming, struggled in New York in the 1930s, and came into his own in the mid-1940s, giving the improvisational techniques and mythic obsessions of the European Surrealists a bold, lyric attack that struck many as immediately American. He was moody, difficult, frequently abrasive, heavily dependent on the ministrations of his wife, the painter Lee Krasner, and a circle of supporters that included the critic Clement Greenberg and the collector and dealer Peggy Guggenheim, whose monthly stipend gave Pollock a measure of freedom in the 1940s. By 1949, when *Life* magazine profiled Pollock, he was the prototype of the new American artist, a tough-talking, hard-drinking creative spirit; it has been said that the character of Stanley Kowalski in Tennessee Williams's *A Streetcar Named Desire* owed something to Pollock, whom Williams knew from summers in Provincetown. Although Krasner remembered her conversations about art with her husband as exhilarating, Pollock committed almost nothing to paper. The statement included here—published in the single issue of a little magazine, *Possibilities*—evokes the direct, unmediated painterly process that Pollock was developing as he dripped and flung paint onto canvas placed flat on the floor. His blunt, plainspoken prose—and his allusion to the Native American sand painting that he may have known in his youth—announce a desire to speak the language of the New World, without recourse to European theories or philosophies.

My Painting

MY painting does not come from the easel. I hardly ever stretch my canvas before painting. I prefer to tack the unstretched canvas to the hard wall or the floor. I need the resistance of a hard surface. On the floor I am more at ease. I feel nearer, more a part of the painting, since this way I can walk around it, work from the four sides and literally be *in* the painting. This is akin to the method of the Indian sand painters of the West.

I continue to get further away from the usual painter's tools

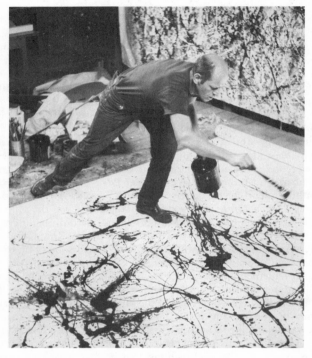

Hans Namuth: *Jackson Pollock*, 1950.

such as easel, palette, brushes, etc. I prefer sticks, trowels, knives and dripping fluid paint or a heavy impasto with sand, broken glass and other foreign matter added.

When I am *in* my painting, I'm not aware of what I'm doing. It is only after a sort of "get acquainted" period that I see what I have been about. I have no fears about making changes, destroying the image, etc., because the painting has a life of its own. I try to let it come through. It is only when I lose contact with the painting that the result is a mess. Otherwise there is a pure harmony, an easy give and take, and the painting comes out well.

1947

MARK ROTHKO

Mark Rothko (1903–1970) was ten when his Jewish family emigrated from Russia to the United States in 1913. He grew up in Portland, Oregon, attended Yale for two years, and by the 1930s was bringing a lyric gift to paintings of New Yorkers at the beach or on the subway. His most famous statement is a redefinition of romanticism, originally published in *Possibilities* in 1947. By then Rothko had been painting abstractly for a decade and had rejected what he regarded as obviously exotic subjects in favor of enigmatic totemic presences, by turns aerial or aquatic in spirit, invoked with thin washes of color and light, calligraphic strokes. Although Rothko had labored on a treatise on painting in 1941—it was only published posthumously, as *The Painter's Reality*—he ultimately believed his work was best experienced by the unfettered eye, without recourse to theory. The canvases composed of shimmering, soft-edged rectangles that he began to produce in the late 1940s and that are surely his greatest achievement invite a contemplative response. In the last two decades of his life, Rothko struggled to reconcile the mystical quietism of his art, a spirit that culminated in his work for the Rothko Chapel in Houston in the 1960s, with an art world eager to embrace him as a celebrity producing iconic images. By then the palette in his paintings had darkened considerably, as he struggled with heart problems and a failing marriage; he committed suicide in his studio.

John Stephan: Cover of *The Tiger's Eye* 6, December 1948.

The Romantics Were Prompted

THE romantics were prompted to seek exotic subjects and to travel to far off places. They failed to realize that, though the transcendental must involve the strange and unfamiliar, not everything strange and unfamiliar is transcendental.

The unfriendliness of society to his activity is difficult for the artist to accept. Yet this very hostility can act as a lever for the true liberation. Freed from a false sense of security and community, the artist can abandon his plastic bankbook, just as he has abandoned other forms of security. Both the sense of community and of security depend on the familiar. Free of them, transcendental experiences become possible.

I think of my pictures as dramas; the shapes in the pictures are the performers. They have been created from the need for

a group of actors who are able to move dramaticall[y]
embarrassment and execute gestures without sham[e]

Neither the action nor the actors can be anticip[ated or de]-
scribed in advance. They begin as an unknown [...in]
an unknown space. It is at the moment of com[...]
a flash of recognition, they are seen to have th[e...]
function which was intended. Ideas and plans th[at...]
mind at the start were simply the doorway th[rough which they]
left the world in which they occur.

The great cubist pictures thus transcend [the...im]-
plications of the cubist program. The mos[t...]
artist fashions through constant practice [...and which serve]
to produce miracles when they are nee[ded...the]
miraculous: the instant one is complete[d...]
the creation and the creator is ended[...Such a]
picture must be for him, as for anyo[ne experiencing it later, a]
revelation, an unexpected and unpre[cedented resolution of an]
eternally familiar need.

On shapes:
They are unique elements in a [...]
They are organisms with v[olition and a passion for self-]
assertion.
They move with internal fr[eedom, and without need to con-]
form with or to violate what [...]
They have no direct asso[ciation with any particular visible]
experience, but in them one recogn[izes the principle and pas-]
sion of organisms.

The presentation of this drama in the familia[r world was]
never possible, unless everyday acts belonged to a ritua[l ac-]
cepted as referring to a transcendent realm.

Even the archaic artist, who had an uncanny virtuosity found it
necessary to create a group of intermediaries, monsters, hybrids,
gods and demi-gods. The difference is that, since the archaic
artist was living in a more practical society than ours, the ur-
gency for transcendent experience was understood, and given
official status. As a consequence, the human figure and other
elements from the familiar world could be combined with, or
participate as a whole in the enactment of the excess which
characterize this improbable hierarchy. With us the disguise

6

give (among others) memory, history or geometry, which are
swamps of generalization from [which] one might pull out
parodies of ideas (which are ghosts) but never an idea in itself.
To achieve this clarity is, inevitably, to be understood.

THE progression of a painter's work, as i[t travels in time from]
point to point, will be toward clarity; toward th[e elimination]
of all obstacles between the painter and the idea, and be[tween]
the idea and the observer. As examples of such obstacles, [I]

MARK ROTHKO

Mark Rothko (1903–1970) was ten when his Jewish family emigrated from Russia to the United States in 1913. He grew up in Portland, Oregon, attended Yale for two years, and by the 1930s was bringing a lyric gift to paintings of New Yorkers at the beach or on the subway. His most famous statement is a redefinition of romanticism, originally published in *Possibilities* in 1947. By then Rothko had been painting abstractly for a decade and had rejected what he regarded as obviously exotic subjects in favor of enigmatic totemic presences, by turns aerial or aquatic in spirit, invoked with thin washes of color and light, calligraphic strokes. Although Rothko had labored on a treatise on painting in 1941—it was only published posthumously, as *The Painter's Reality*—he ultimately believed his work was best experienced by the unfettered eye, without recourse to theory. The canvases composed of shimmering, soft-edged rectangles that he began to produce in the late 1940s and that are surely his greatest achievement invite a contemplative response. In the last two decades of his life, Rothko struggled to reconcile the mystical quietism of his art, a spirit that culminated in his work for the Rothko Chapel in Houston in the 1960s, with an art world eager to embrace him as a celebrity producing iconic images. By then the palette in his paintings had darkened considerably, as he struggled with heart problems and a failing marriage; he committed suicide in his studio.

The Romantics Were Prompted

THE romantics were prompted to seek exotic subjects and to travel to far off places. They failed to realize that, though the transcendental must involve the strange and unfamiliar, not everything strange and unfamiliar is transcendental.

The unfriendliness of society to his activity is difficult for the artist to accept. Yet this very hostility can act as a lever for the true liberation. Freed from a false sense of security and community, the artist can abandon his plastic bankbook, just as he has abandoned other forms of security. Both the sense of community and of security depend on the familiar. Free of them, transcendental experiences become possible.

I think of my pictures as dramas; the shapes in the pictures are the performers. They have been created from the need for

3

a group of actors who are able to move dramatically without embarrassment and execute gestures without shame.

Neither the action nor the actors can be anticipated, or described in advance. They begin as an unknown adventure in an unknown space. It is at the moment of completion that in a flash of recognition, they are seen to have the quantity and function which was intended. Ideas and plans that existed in the mind at the start were simply the doorway through which one left the world in which they occur.

The great cubist pictures thus transcend and belie the implications of the cubist program. The most important tool the artist fashions through constant practice is faith in his ability to produce miracles when they are needed. Pictures must be miraculous: the instant one is completed, the intimacy between the creation and the creator is ended. He is an outsider. The picture must be for him, as for anyone experiencing it later, a revelation, an unexpected and unprecedented resolution of an eternally familiar need.

On shapes:

They are unique elements in a unique situation.

They are organisms with volition and a passion for self-assertion.

They move with internal freedom, and without need to conform with or to violate what is probable in the familiar world.

They have no direct association with any particular visible experience, but in them one recognizes the principle and passion of organisms.

The presentation of this drama in the familiar world was never possible, unless everyday acts belonged to a ritual accepted as referring to a transcendent realm.

Even the archaic artist, who had an uncanny virtuosity found it necessary to create a group of intermediaries, monsters, hybrids, gods and demi-gods. The difference is that, since the archaic artist was living in a more practical society than ours, the urgency for transcendent experience was understood, and given official status. As a consequence, the human figure and other elements from the familiar world could be combined with, or participate as a whole in the enactment of the excess which characterize this improbable hierarchy. With us the disguise

must be complete. The familiar identity of things has to be pulverized in order to destroy the finite associations with which our society increasingly enshrouds every aspect of our environment.

Without monsters and gods, art cannot enact our drama: art's most profound moments express this frustration. When they were abandoned as untenable superstitions, art sank into melancholy. For me the great achievements of the centuries in which the artist accepted the probable and familiar as his subjects were the pictures of the single human figure—alone in a moment of utter mobility.

But the solitary figure could not raise its limbs in a single gesture that might indicate its concern with the fact of mortality and an insatiable appetite for ubiquitous experience in face of this fact. Nor could the solitude be overcome. It could gather on beaches and streets and in parks only through coincidence, and, with its companions, form a tableau vivant of human in-communicability.

I do not believe that there was ever a question of being abstract or representational. It is really a matter of ending this silence and solitude, of breaching and stretching one's arms again.

winter 1947–48

Two Statements from The Tiger's Eye

A PICTURE lives by companionship, expanding and quickening in the eyes of the sensitive observer. It dies by the same token. It is therefore a risky and unfeeling act to send it out into the world. How often it must be permanently impaired by the eyes of the vulgar and the cruelty of the impotent who would extend their affliction universally!

1947

———

THE progression of a painter's work, as it travels in time from point to point, will be toward clarity; toward the elimination of all obstacles between the painter and the idea, and between the idea and the observer. As examples of such obstacles, I

give (among others) memory, history or geometry, which are swamps of generalization from [which] one might pull out parodies of ideas (which are ghosts) but never an idea in itself. To achieve this clarity is, inevitably, to be understood.

1949

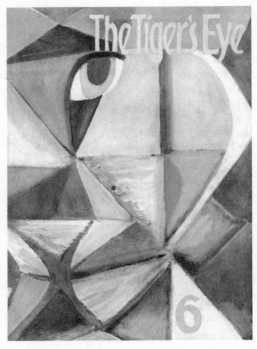

John Stephan: Cover of *The Tiger's Eye* 6, December 1948.

BARNETT NEWMAN

No American painter has argued more strenuously for art's peremptory power than Barnett Newman (1905–1970). In essays first published in the late 1940s in *The Tiger's Eye*—a short-lived, adventuresome magazine that also featured work by Pollock, Rothko, and Still—Newman made the case for an art grounded in pure, elemental sensation. Newman relished the role of the contrarian; it came naturally to a native New Yorker who was convinced, like so many New Yorkers, that to be controversial was to feel alive. While Newman took pride in his familiarity with the philosophical traditions, he also delighted in dismissing nearly all the great philosophers, declaring at one point that "aesthetics is for the artists as ornithology is for the birds." And at a time when expressionist paint handling was the rage, he worked with solid planes of smoothly applied color, only occasionally interrupted by the vertical bands he called "zips." He aimed for something "real" and "concrete," and was emboldened by his studies of Native American art, singling out for praise the totem poles of the Northwest and the burial mounds of the Midwest. His paintings, which had met with a good deal of skepticism in the paint-happy 1950s, were eventually embraced by a younger generation of artists who were looking for a way beyond the perfervid emotions of Abstract Expressionists such as Willem de Kooning and Franz Kline.

The First Man Was an Artist

A SCIENTIST has just caught the tail of another metaphor. Out of the Chinese dragon's teeth, piled high in harvest on the shelves of Shanghai's drugstores and deep in the Java mud, a half million years old, he has constructed Meganthropus palaeo-javanicus, "man the great," the giant, who, the paleontologists now tell us, was our human ancestor. And for many, he has become more real than Cyclops, than the Giant of the Beanstalk. Those unconvinced by the poetic dream, who reject the child's fable, are now sure of a truth found today, 500,000 years old. Shall we artists quarrel with those who need to wait for the weights of scientific proof to believe in poetry? Or shall we let them enjoy their high adventure laid out in mud and in drugstore teeth? For truth is for them at last the Truth.

Quarrel we must, for there is the implication in this pale-ontological find of another attempt to claim possession of the poetic gesture: that the scientist rather than the artist discovered the Giant. It is not enough for the artist to announce with arrogance his invincible position: that the job of the artist is not to discover truth, but to fashion it, that the artist's work was done long ago. This position, superior as it may be, separates the artist from everyone else, declares his role against that of all. The quarrel here must include a critique of paleontology, an examination of the new sciences.

In the last sixty years, we have seen mushroom a vast cloud of "sciences" in the fields of cultures, history, philosophy, psychology, economics, politics, aesthetics, in an ambitious attempt to claim the nonmaterial world. Why the invasion? Is it out of fear that its materialistic interpretation of physical phenomena, its narrow realm of physics and chemistry, may give science a minor historical position if, in the larger attempt to resolve the metaphysical mysteries, the physical world may take only a small place? Has science, in its attempt to dominate all realms of thought, been driven willy-nilly to act politically so that, by denying any place to the metaphysical world, it could give its own base of operations a sense of security? Like any state or church, science found the drive to conquer necessary to protect the security of its own state of physics. To accomplish this expansion, the scientist abandoned the revolutionary scientific act for a theological way of life.

The domination of science over the mind of modern man has been accomplished by the simple tactic of ignoring the prime scientific quest: the concern with its original question, *what?* When it was found that the use of this question to explore all knowledge was utopian, the scientist switched from an insistence on it to a roving position of using any question. It was easy for him to do so because he could thrive on the grip mathematical discipline had, as a romantic symbol of purity and perfection, on the mind of man. So intense is the reverence for this symbol, scientific method, that it has become the new theology. And the mechanics of this theology, so brilliant is the rhythm of its logic-rite, its identification of truth with proof, that it has overwhelmed the original ecstasy of scientific quest, scientific inquiry.

For there is a difference between method and inquiry. Scientific inquiry, from its beginnings, has perpetually asked a single and specific question, *what?* What is the rainbow, what is an atom, what a star? In the pursuit of this question, the physical sciences have built a realm of thought that has validity because the question is basic for the attainment of descriptive knowledge and permits a proper integration between its quest, the question *what* constantly maintained, and its tool, mathematics or logic, for the discovery of its answer. Scientific method, however, is free of the question. It can function on any question, or, as in mathematics, without a question. But the choice of quest, the kind of question, is the basis of the scientific act. That is why it is so pathetic to watch the scientist, so proud of his critical acumen, delude himself by the splendor of the ritual of method, which, concerned only with its own relentless ceremonial dance, casts its spell not only over the lay observer but also over the participating scientist, with its incessant drumbeat of proof.

Original man, what does it matter who he was, giant or pygmy? What was he? That is the question for a science of paleontology that would have meaning for us today. For if we knew what original man was, we could declare what today's man is not. Paleontology, by building a sentimental science around the question *who* (who was your great-grandfather?), cannot be excused for substituting this question for the real one, because, according to the articles of faith that make up scientific method, there is not, nor can there ever be, sufficient proof for positive answer. After all, paleontology, like the other nonmaterial sciences, has entered a realm where the only questions worth discussing are the questions that cannot be proved. We cannot excuse the abdication of its primal scientific responsibility because paleontology substituted the sentimental question *who* for the scientific *what*. Who cares who he was? What was the first man, was he a hunter, a toolmaker, a farmer, a worker, a priest, or a politician? Undoubtedly the first man was an artist.

A science of paleontology that sets forth this proposition can be written if it builds on the postulate that the aesthetic act always precedes the social one. The totemic act of wonder in front of the tiger-ancestor came before the act of murder. It is important to keep in mind that the necessity for dream is stronger than any utilitarian need. In the language of science,

the necessity for understanding the unknowable comes before any desire to discover the unknown.

Man's first expression, like his first dream, was an aesthetic one. Speech was a poetic outcry rather than a demand for communication. Original man, shouting his consonants, did so in yells of awe and anger at his tragic state, at his own self-awareness and at his own helplessness before the void. Philologists and semioticians are beginning to accept the concept that if language is to be defined as the ability to communicate by means of signs, be they sounds or gestures, then language is an animal power. Anyone who has watched the common pigeon circle his female knows that she knows what he wants.

The human in language is literature, not communication. Man's first cry was a song. Man's first address to a neighbor was a cry of power and solemn weakness, not a request for a drink of water. Even the animal makes a futile attempt at poetry. Ornithologists explain the cock's crow as an ecstatic outburst of his power. The loon gliding lonesome over the lake, with whom is he communicating? The dog, alone, howls at the moon. Are we to say that the first man called the sun and the stars *God* as an act of communication and only after he had finished his day's labor? The myth came before the hunt. The purpose of man's first speech was an address to the unknowable. His behavior had its origin in his artistic nature.

Just as man's first speech was poetic before it became utilitarian, so man first built an idol of mud before he fashioned an ax. Man's hand traced the stick through the mud to make a line before he learned to throw the stick as a javelin. Archaeologists tell us that the ax head suggested the ax-head idol. Both are found in the same strata, so they must have been contemporaneous. True, perhaps, that the ax-head idol of stone could not have been carved without ax instruments, but this is a division in metier, not in time, since the mud figure anticipated both the stone figure and the ax. (A figure can be made out of mud, but an ax cannot.) The God image, not pottery, was the first manual act. It is the materialistic corruption of present-day anthropology that has tried to make men believe that original man fashioned pottery before he made sculpture. Pottery is the product of civilization. The artistic act is man's personal birthright.

The earliest written history of human desires proves that the meaning of the world cannot be found in the social act. An examination of the first chapter of Genesis offers a better key to the human dream. It was inconceivable to the archaic writer that original man, that Adam, was put on earth to be a toiler, to be a social animal. The writer's creative impulses told him that man's origin was that of an artist, and he set him up in a Garden of Eden close to the Tree of Knowledge, of right and wrong, in the highest sense of divine revelation. The fall of man was understood by the writer and his audience not as a fall from Utopia to struggle, as the sociologicians would have it, nor, as the religionists would have us believe, as a fall from Grace to Sin, but rather that Adam, by eating from the Tree of Knowledge, sought the creative life to be, like God, "a creator of worlds," to use Rashi's phrase, and was reduced to the life of toil only as a result of a jealous punishment.

In our inability to live the life of a creator can be found the meaning of the fall of man. It was a fall from the good, rather than from the abundant, life. And it is precisely here that the artist today is striving for a closer approach to the truth concerning original man than can be claimed by the paleontologist, for it is the poet and the artist who are concerned with the function of original man and who are trying to arrive at his creative state. What is the raison d'être, what is the explanation of the seemingly insane drive of man to be painter and poet if it is not an act of defiance against man's fall and an assertion that he return to the Adam of the Garden of Eden? For the artists are the first men.

1947

The Sublime Is Now

THE invention of beauty by the Greeks, that is, their postulate of beauty as an ideal, has been the bugbear of European art and European aesthetic philosophies. Man's natural desire in the arts to express his relation to the Absolute became identified and confused with the absolutisms of perfect creations—with the

fetish of quality—so that the European artist has been continu-
ally involved in the moral struggle between notions of beauty
and the desire for sublimity.

The confusion can be seen sharply in Longinus, who, despite
his knowledge of non-Grecian art, could not extricate himself
from his platonic attitudes concerning beauty, from the prob-
lem of value, so that to him the feeling of exaltation became
synonymous with the perfect statement—an objective rhetoric.
But the confusion continued on in Kant, with his theory of
transcendent perception, that the phenomenon is *more* than
phenomenon; and in Hegel, who built a theory of beauty, in
which the sublime is at the bottom of a structure of *kinds of
beauty*, thus creating a range of hierarchies in a set of relation-
ships to reality that is completely formal. (Only Edmund Burke
insisted on a separation. Even though it is an unsophisticated
and primitive one, it is a clear one and it would be interesting
to know how closely the surrealists were influenced by it. To
me Burke reads like a surrealist manual.)

The confusion in philosophy is but the reflection of the strug-
gle that makes up the history of the plastic arts. To us today
there is no doubt that Greek art is an insistence that the sense
of exaltation is to be found in perfect form, that exaltation is
the same as ideal sensibility—in contrast, for example, with the
Gothic or baroque, in which the sublime consists of a desire to
destroy form, where form can be formless.

The climax in this struggle between beauty and the sublime
can best be examined inside the Renaissance and the reaction
later against the Renaissance that is known as modern art. In
the Renaissance the revival of the ideals of Greek beauty set the
artists the task of rephrasing an accepted Christ legend in terms
of absolute beauty as against the original Gothic ecstasy over
the legend's evocation of the Absolute. And the Renaissance
artists dressed up the traditional ecstasy in an even older tradi-
tion—that of eloquent nudity or rich velvet. It was no idle quip
that moved Michelangelo to call himself a sculptor rather than a
painter, for he knew that only in his sculpture could the desire
for the grand statement of Christian sublimity be reached. He
could despise with good reason the beauty cults who felt the
Christ drama on a stage of rich velvets and brocades and beauti-
fully textured flesh tints. Michelangelo knew that the meaning

of the Greek humanities for his time involved making Christ the man into Christ who is God; that his plastic problem was neither the medieval one, to make a cathedral, nor the Greek one, to make a man like a god, but to make a cathedral out of man. In doing so he set a standard for sublimity that the painting of his time could not reach. Instead, painting continued on its merry quest for a voluptuous art until in modern times the impressionists, disgusted with its inadequacy, began the movement to destroy the established rhetoric of beauty by the impressionist insistence on a surface of ugly strokes.

The impulse of modern art was this desire to destroy beauty. However, in discarding Renaissance notions of beauty, and without an adequate substitute for a sublime message, the impressionists were compelled to preoccupy themselves, in their struggle, with the culture values of their plastic history, so that instead of evoking a new way of experiencing life they were able only to make a transfer of values. By glorifying their own way of living, they were caught in the problem of what is really beautiful and could only make a restatement of their position on the general question of beauty; just as later the cubists, by their dada gestures of substituting a sheet of newspaper and sandpaper for both the velvet surfaces of the Renaissance and the impressionists, made a similar transfer of values instead of creating a new vision, and succeeded only in elevating the sheet of paper. So strong is the grip of the *rhetoric* of exaltation as an attitude in the large context of the European culture pattern that the elements of sublimity in the revolution we know as modern art, exist in its effort and energy to escape the pattern rather than in the realization of a new experience. Picasso's effort may be sublime but there is no doubt that his work is a preoccupation with the question of what is the nature of beauty. Even Mondrian, in his attempt to destroy the Renaissance picture by his insistence on pure subject matter, succeeded only in raising the white plane and the right angle into a realm of sublimity, where the sublime paradoxically becomes an absolute of perfect sensations. The geometry (perfection) swallowed up his metaphysics (his exaltation).

The failure of European art to achieve the sublime is due to this blind desire to exist inside the reality of sensation (the objective world, whether distorted or pure) and to build an

art within a framework of pure plasticity (the Greek ideal of beauty, whether that plasticity be a romantic active surface or a classic stable one). In other words, modern art, caught without a sublime content, was incapable of creating a new sublime image and, unable to move away from the Renaissance imagery of figures and objects except by distortion or by denying it completely for an empty world of geometric formalisms—a *pure* rhetoric of abstract mathematical relationships—became enmeshed in a struggle over the nature of beauty: whether beauty was in nature or could be found without nature.

I believe that here in America, some of us, free from the weight of European culture, are finding the answer, by completely denying that art has any concern with the problem of beauty and where to find it. The question that now arises is how, if we are living in a time without a legend or mythos that can be called sublime, if we refuse to admit any exaltation in pure relations, if we refuse to live in the abstract, how can we be creating a sublime art?

We are reasserting man's natural desire for the exalted, for a concern with our relationship to the absolute emotions. We do not need the obsolete props of an outmoded and antiquated legend. We are creating images whose reality is self-evident and which are devoid of the props and crutches that evoke associations with outmoded images, both sublime and beautiful. We are freeing ourselves of the impediments of memory, association, nostalgia, legend, myth, or what have you, that have been the devices of Western European painting. Instead of making *cathedrals* out of Christ, man, or "life," we are making [them] out of ourselves, out of our own feelings. The image we produce is the self-evident one of revelation, real and concrete, that can be understood by anyone who will look at it without the nostalgic glasses of history.

1948

Ohio, 1949

STANDING before the Miamisburg mound, or walking inside the Fort Ancient and Newark earthworks, surrounded by these simple walls made of mud, one is confounded by a multiplicity

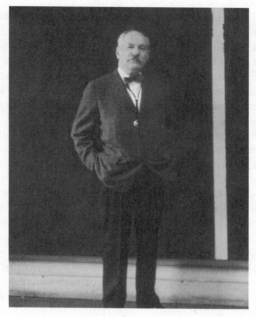

Alexander Liberman: Barnett Newman in
front of *Onement VI* (1953), 1961.

of sensations: that here are the greatest works of art on the
American continent, before which the Mexican and Northwest
Coast totem poles are hysterical, overemphasized monsters; that
here in the seductive Ohio Valley are perhaps the greatest art
monuments in the world, for somehow the Egyptian pyramid
by comparison is nothing but an ornament—what difference if
the shape is on a table, a pedestal, or lies immense on a desert?
Here is the self-evident nature of the artistic act, its utter sim-
plicity. There are no subjects—nothing that can be shown in a
museum or even photographed; [it is] a work of art that cannot
even be seen, so it is something that must be experienced there
on the spot: The feeling [is] that here is the space; that these
simple low mud walls make the space; that the space outside,

the dramatic landscape looking out over a bridge one hundred feet high, the falling land, the chasms, the rivers, the farmlands and far-off hills are just picture postcards, and somehow one is looking out as if inside a picture rather than outside contemplating any specific nature. Suddenly one realizes that the sensation is not one of space or [of] an object in space. It has nothing to do with space and its manipulations. The sensation is the sensation of time—and all other multiple feelings vanish like the outside landscape.

What is all the clamor over space? The Renaissance deep space as a heroic stage, the impressionist flat space, cubist space, shallow space, positive and negative space, trompe l'oeil enigmatic space, the pure space—the space of "infinity"—of Mondrian's universe. There is so much talk about space that one might think it is the subject matter of art, as if the essence of musical composition were the question of whether Mozart wrote in ¾ or ⁴/₈ time.

The love of space is there, and painting functions in space like everything else because it is a communal fact—it can be held in common. Only time can be felt in private. Space is common property. Only time is personal, a private experience. That's what makes it so personal, so important. Each person must feel it for himself. Space is the given fact of art but irrelevant to any feeling except insofar as it involves the outside world. Is this why all the critics insist on [space], as if all modern art were an exercise and ritual of it? They insist on having it because, being outside, it includes them, it makes the artist "concrete" and real because he represents or invokes sensations in the material objects that exist in space and can be *understood*.

The concern with space bores me. I insist on my experiences of sensations in time—not the *sense* of time but the physical *sensation* of time.

1949

PEGGY GUGGENHEIM

Although she often complained that she was one of the poor Guggenheims, Peggy Guggenheim (1898–1979) proved to be a great patron of the arts, both in Europe and in New York, where during World War II she ran what was surely among the most adventuresome galleries the city has ever seen. She would always prefer the Old World to the New, and spent her later years in the Venetian palazzo that became the final resting place of her extraordinary collection. But she was never more in the thick of things than during the five years (1942 to 1947) that her Art of This Century gallery was radicalizing sophisticated taste in Manhattan. With a sure instinct for whom to turn to when in need of advice—she was married to Max Ernst for a time and counted Marcel Duchamp among her treasured counselors—Guggenheim managed in a few years to show not only Pollock, but also Rothko, Hofmann, and a host of other new artists. Her gallery, designed by Frederick Kiesler, an architect with a taste for biomorphism, was itself a wonder, with its curving walls and paintings suspended from the wall on angular armatures. Though sometimes dismissed as a wealthy adventuress with a taste for bohemian men—her conquests were said to include Samuel Beckett—Peggy Guggenheim was by any measure one of the essential tastemakers of her time. Admirers of her easygoing, picaresque memoirs have included not only the novelist Gore Vidal, but also Alfred H. Barr, Jr., the founding director of the Museum of Modern Art.

Art of This Century

FINALLY I found a top story in West 57th Street for my museum. I didn't know how to decorate it, and Putzel, as usual on hand said, "Why don't you get Kiesler to give you a few little ideas?" Frederick Kiesler was one of the most advanced architects of this century. So I accepted Putzel's suggestion, never dreaming that the few little ideas would end up in my spending seven thousand dollars.

Kiesler was a little man about five feet tall, with a Napoleonic complex. He was an unrecognized genius, and I gave him a chance, after he had been in America for fifteen years, to do something really sensational. He told me that I would not be known to posterity for my collection, but for the way he presented it in his revolutionary setting.

Kiesler really created a wonderful gallery—very theatrical and extremely original. If the pictures suffered from the fact that their setting was too spectacular and took away people's attention from them, it was at least a marvellous décor and created a terrific stir.

The only condition I had made was that the pictures should be unframed. Otherwise Kiesler had *carte blanche*. I had expected that he would insert the pictures into the walls. I was quite wrong: his ideas were much more original. In the Surrealist gallery he put curved walls made of South American gum wood. The unframed paintings, mounted on baseball bats, which could be tilted at any angle, protruded about a foot from the walls. Each one had its own spotlight. Because of Kiesler's theatrical ideas, the lights, to everybody's dismay, went off every three seconds. That is, they lit only half the pictures at a time. People complained, and said that if they were looking at a painting on one side of the room, the lights suddenly went off and they were forced to look at some other painting that was lit instead of the one they wanted to see. Putzel finally put an end to this and the lighting system became normal. In the abstract and Cubist gallery where I had my desk, near the entrance, I was perpetually flooded in a strong fluorescent light. Two walls, consisting of an ultramarine canvas curtain like a circus tent, attached to the ceiling and floor by strings, curved around the room in various sweeps. The floor was painted turquoise.

The paintings, which were also hung on strings from the ceiling, and at right angles to the walls, looked as though they were floating in space. Little triangular shelves of wood supported the sculptures, which also seemed to float in the air. Kiesler had designed a chair out of plywood and various coloured linoleums, which could be used for seven different purposes. It could serve as a rocking chair, or it could be turned over and used as a stand for paintings or sculpture, or as a bench, or table, and it could also be combined in different ways with planks of wood to increase the seating capacity. The gallery was supposed to seat ninety people for lectures, so there were also little folding chairs covered in ultramarine blue canvas, like the curtain. Kiesler also produced an ingenious stand which, at the same time, served as storage space for the drawings and a place to exhibit them. This saved much space, which I needed.

There was a beautiful daylight gallery that skirted the front of 57th Street, which was used for monthly shows. Here pictures could be shown in frames on plain white walls. In order to temper the light, Kiesler put a flat ninon screen a few inches in front of the window. In one corridor he placed a revolving wheel on which to show seven works of Klee. This wheel automatically went into motion when the public stepped across a beam of light. In order to view the entire works of Marcel Duchamp in reproduction, you looked through a hole in the wall and turned by hand a very spidery looking wheel. The press named this part of the gallery "Coney Island." Behind the blue canvas, I had an office, which I never used, as I wanted to be in the gallery all the time to see what was going on.

The opening night, October 20, 1942, was dedicated to the Red Cross, and tickets were sold for a dollar each. Many of the invitations were lost in the mail, but hundreds of people came. It was a real gala opening. I had a white evening dress made for the occasion, and wore one of my Tanguy ear-rings and one made by Calder, in order to show my impartiality between Surrealist and abstract art. The last days we worked day and night to get the gallery ready in time, but workmen were still on the premises when the press arrived in the afternoon before the opening.

We had great money difficulties. More and more bills kept coming in. Finally, when I realized how much Kiesler's total cost exceeded his estimate, I practically broke with him and refused to let him come to my house, but I maintained a formal museum façade.

I was so excited about my life in the museum that I neglected Max and my home, which did a great deal of harm to our marriage. But we had a lot of parties in the evening and entertained all Breton's and Max's followers, besides the abstract painters, and a great many young American ones.

My first secretary in the gallery, which I named Art of This Century, after my catalogue, was Jimmy Ernst. Later, when he left me, Putzel came to work with me. The first show was dedicated to my collection. Fourteen of Max's paintings and *collages* were on exhibition, more than those of any other painter; naturally, as I owned so many. Kiesler and I had not permitted anyone to see the gallery before it was finished—even Max was

not admitted. When he finally saw his paintings, taken out of all their fancy and expensive frames, he made a great fuss, but when he saw how well all the other paintings looked he decided not to be difficult.

The publicity we got was overwhelming. Photographs appeared in all the papers. Even if the press didn't altogether approve of Kiesler's ultra-revolutionary ideas, at least they talked enough about the gallery to cause hundreds of people to come to see it every day.

The next show was an exhibition for three artists' works: Laurence Vail's decorated bottles, Joseph Cornell's Surrealist objects, and Marcel Duchamp's valise, a little pig-skin suit-case he had invented to contain all the reproductions of his works. I often thought how amusing it would have been to have gone off on a week-end and brought this along, instead of the usual bag one thought one needed.

The third show was dedicated to the works of thirty-one women. This was an idea Marcel had given me in Paris. The paintings submitted were judged by a jury consisting of Max, Marcel, Breton, the critics James Johnson Sweeney and James Soby, Putzel, Jimmy Ernst and myself. Edward Alden Jewell, art critic for the *New York Times*, wrote a long article about this show in which he said, "The elevator man at Art of This Century, who is tremendously interested in art, told me on the way up that he had given the place an extra thorough cleaning because Gypsy Rose Lee, one of the exponents, was coming."

I made Max work very hard for this show. He had to go around to all the women and bring their paintings to the gallery in his car. He was interested in women who painted. There was one called Dorothea Tanning, a pretty girl from the Middle West. She was quite talented, and imitated Max's painting, which flattered him immensely. They now became very friendly and played chess together while I was in the gallery. Soon they became more than friendly and I realized that I should only have had thirty women in the show. This was destined to end our marriage.

Edward Jewell, commenting in the *New York Times* on the opening of the Surrealist gallery said: "It looks faintly menacing—as if in the end it might prove that the spectator would be fixed to the wall and the art would stroll around making comments, sweet or sour, as the case might be."

On one occasion we had a visit from Mrs Roosevelt. Unfortunately this honour was not due to her desire to see modern art. She was brought by a friend to see a photographic exhibition of the Negro in American life. Mrs Roosevelt was extremely cordial and wrote enthusiastically about the exhibition in her column. Before she left I did my best to make her go into the Surrealist gallery, but she retired through the door sideways, like a crab, pleading her ignorance of modern art. An English friend of mine, Jack Barker, had come up in the elevator with Mrs Roosevelt and her friend, and followed them into the gallery, mimicking the gracious high falsettoes with which they greeted me. Mrs Roosevelt, evidently amused by his behaviour, turned to him smiling, and bowed. The embarrassed Barker, unable to recall how well he knew this lady, whose face was so familiar, was uncertain whether to fling himself into her arms, clasp her warmly by the hand, or bow back in a reserved manner. In such a dilemma he decided to ignore the whole thing, and failed to return the gracious salutation.

In London, in 1939, Herbert Read had conceived the idea of holding a spring salon. In 1941, I decided to try it out in New York. I appointed a jury. The members were Barr, Sweeney, Soby, Mondrian, Duchamp, Putzel and myself. The first year it worked very well, and out of the pickings we had a very fine show of about forty paintings. The stars who emerged were Jackson Pollock, Robert Motherwell and William Baziotes. They had all three shown their work in a previous show of *collages* in my gallery. As it was non-commerical, Art of This Century soon became a centre for all *avant-garde* activities. The young American artists, much inspired by the European abstract and Surrealist artists who had taken refuge in New York, started an entirely new school of painting, which Robert Coates, art critic for the *New Yorker*, named Abstract Expressionism.

We had the great joy of discovering and giving first one-man shows not only to Pollock, Motherwell and Baziotes, but also to Hans Hofmann, Clyfford Still and Mark Rothko and David Hare. The group shows included Adolph Gottlieb, Hedda Sterne and Ad Reinhardt.

We also gave one-man shows to de Chirico, Arp, Giacometti, Helion, Hans Richter, Hirshfield, van Doesburg, Pegeen and Laurence Vail and I. Rice Pereira. We also held several spring

salons, gave another woman's show, two *collage* shows, and exhibited the work of various unknown artists.

After the first spring salon it became evident that Pollock was the best painter. Both Matta, the painter who was a friend of mine, and Putzel urged me to help him, as at the time he was working in my uncle's museum as a carpenter. He had once been a pupil of the well-known academic painter, Thomas Benton, and through his terrific efforts to throw off Benton's influence had, in reaction, become what he was when I met him. From 1938 to 1942 he had worked on the W.P.A. Federal Art Project for artists, which was part of the scheme originated by President Roosevelt for reducing unemployment.

When I first exhibited Pollock he was very much under the influence of the Surrealists and of Picasso. But he very soon

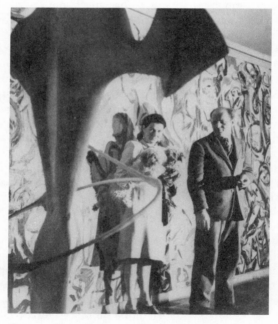

George Karger: Peggy Guggenheim and
Jackson Pollock in front of Pollock's *Mural*,
circa 1946.

overcame this influence, to become, strangely enough, the greatest painter since Picasso. As he required a fixed monthly sum in order to work in peace, I gave him a contract for one year. I promised him a hundred and fifty dollars a month and a settlement at the end of the year, if I sold more than two thousand seven hundred dollars' worth, allowing one-third to the gallery. If I lost I was to get pictures in return.

Pollock immediately became the central point of Art of This Century. From then on, 1943, until I left America in 1947, I dedicated myself to Pollock. He was very fortunate, because his wife Lee Krasner, a painter, did the same, and even gave up painting at one period, as he required her complete devotion. I welcomed a new protégé, as I had lost Max. My relationship with Pollock was purely that of artist and patron, and Lee was the intermediary. Pollock himself was rather difficult; he drank too much and became so unpleasant, one might say devilish, on these occasions. But as Lee pointed out when I complained, "He also has an angelic side," and that was true. To me, he was like a trapped animal who never should have left Wyoming, where he was born.

As I had to find a hundred and fifty dollars a month for the Pollocks, I concentrated all my efforts on selling his pictures and neglected all the other painters in the gallery, many of whom soon left me, as Sam Kootz, the art dealer, gave them contracts, which I could not afford to do.

I commissioned Pollock to paint a mural for my entrance hall, twenty-three feet wide and six feet high. Marcel Duchamp said he should put it on a canvas, otherwise it would have to be abandoned when I left the apartment. This was a splendid idea, and—for the University of Iowa—a most fortunate one, as I gave it to them when I left America. It now hangs there in the students' dining hall.

Pollock obtained a big canvas and tore down a wall in his apartment in order to make room to hang it up. He sat in front of it, completely uninspired for days, getting more and more depressed. He then sent his wife away to the country, hoping to feel more free, and that when alone he might get a fresh idea. Lee came back and found him still sitting brooding, no progress made and nothing even attempted. Then suddenly one day he got up and in a few hours painted a masterpiece.

The mural was more abstract than Pollock's previous work. It consisted of a continuous band of abstract figures in a rhythmic dance painted in blue and white and yellow, and over this black paint was splashed in drip fashion. Max Ernst had once invented, or set up, a very primitive machine to cover his canvases with drip paint. It had shocked me terribly at the time, but now I accepted this manner of painting unhesitatingly.

We had great trouble in installing this enormous mural, which was bigger than the wall it was destined for. Pollock tried to do it himself, but not succeeding, he became quite hysterical and went up to my flat and began drinking from all the bottles I had purposely hidden, knowing his great weakness. He not only telephoned me at the gallery every few minutes to come home at once and help place the painting, but he got so drunk that he undressed and walked quite naked into a party that Jean Connolly, who was living with me, was giving in the sitting-room. Finally, Marcel Duchamp and a workman came to the rescue and placed the mural. It looked very fine, but I am sure it needed much bigger space, which it has today in Iowa.

I felt Pollock had a deep feeling for West American-Indian sculpture, as it came out a lot in his earlier paintings, and in some of those that were to be in his first exhibition. This was held in November, 1943. The introduction to the catalogue was written by James Johnson Sweeney, who helped a lot to further Pollock's career. In fact, I always referred to Pollock as our spiritual offspring. Clement Greenberg, the critic, also came to the fore and championed Pollock as the greatest painter of our time. Alfred Barr bought the "She Wolf," one of the best paintings in this show, for the Museum of Modern Art. Later, Dr Morley asked for the show in her San Francisco Museum, and bought the "Guardians of the Secret."

We did not sell many Pollock paintings, but when he gave us gouaches it was much easier. A lot of these I gave away as wedding presents to my friends. I worked hard to interest people in his work and never tired doing so, even when it involved dragging in and out his enormous canvases. One day Mrs Harry Winston, the famous Detroit collector, came to the gallery to buy a Masson. I persuaded her to buy a Pollock instead.

In 1945, Bill Davis, the collector, who was also a fan of Pollock's, advised me to raise my contract with him to three hun-

dred dollars a month, and in exchange, to take all Pollock's works. Pollock was very generous in giving me presents. At this time I had acute infectious mononucleosis, and during the annual Pollock show had to stay in bed. This distressed Lee Pollock very much, as she said no one could sell anything in the gallery except me, and Putzel had left to set up his own gallery in New York. Poor man, this proved to be a great tragedy, as it ended in his suicide.

Lee was so dedicated to Pollock that when I was sick in bed, she came every morning to try to persuade me to lend them two thousand dollars to buy a house on Long Island. She thought that if Pollock got out of New York he would stop drinking. Though I did not see how I could produce any extra funds I finally agreed to do so as it was the only way to get rid of Lee. Now it all makes me laugh. I had no idea then what Pollock paintings would be worth. I never sold one for more than a thousand dollars and when I left America in 1947, not one gallery would take over my contract. I offered it to them all, and in the end Betty, of the Betty Parsons Gallery, said she would give Pollock a show, but that was all she could do. Pollock himself paid the expenses of it out of one painting Bill Davis bought. All the rest were sent to me, according to the contract, at Venice, where I had gone to live. Of course, Lee had her pick of one painting a year. When the pictures got to Venice, I gave them away one by one to various museums, and now only have two of this collection left, though I also have nine earlier ones dating from 1943 to 1946. And so now Lee is a millionaire, and I think what a fool I was.

In my struggles for Pollock I also had to contend with such things as Dorothy Miller absolutely refusing to include him in an exhibition of twelve young American artists—artists who were obviously what she considered the best we had—which she did in 1946, as a travelling show for the Museum of Modern Art. I complained to Alfred Barr, but he said it was Dorothy Miller's show and nothing could be done about it. I also had great money difficulties to keep both Pollock and the gallery going, and often found myself in the position of having to sell what I called an old master. Thus, I was once forced to part with a marvellous Delaunay of 1912, called "Disks," which I had bought from him in Grenoble, when he was a refugee from

occupied Paris. This picture later turned up in the Museum of Modern Art. Its loss is one of the seven tragedies of my life as a collector.

The second was my stupidity in not availing myself of the opportunity of buying "La Terre Labourée," of Miró, in London in 1939 for fifteen hundred dollars. Now, if it were for sale, it would be worth well over fifty thousand.

The third tragedy was selling a 1936 Kandinsky, called "Dominant Curve" in New York during the war, because I listened to people saying it was a fascist picture. To my great sorrow I later found it in my uncle's collection in an exhibition in Rome.

The fourth was not buying Picasso's "Pêche de Nuit à Antibes," because I had no cash on hand, and did not have enough sense to sell some capital, which my friend and financial adviser, Bernard Reis, told me to do when the picture was offered to me in 1950; and now that, too, is in the Museum of Modern Art.

The fifth is having to sell a Henri Laurens sculpture and a beautiful Klee water-colour in order to pay Nellie van Doesburg's passage to New York; and the sixth, to have all but two of my last remaining Klees stolen from Art of This Century. But the worst mistake of all was giving away eighteen Pollocks. However, I comfort myself by thinking how terribly lucky I was to have been able to buy all my wonderful collection at a time when prices were still normal, before the whole picture world turned into an investment market.

As the gallery was a centre where all the artists were welcome, they treated it as a sort of club. Mondrian was a frequent visitor, and always brought his paintings carefully wrapped up in white paper. I had bought two of his beautiful large charcoal Cubist drawings from a gallery in New York, and these I much preferred to his later works, of which I also had one. When I once asked him to clean one of his own paintings, which always had to be immaculate, he arrived with a little bag and cleaned not only his picture, but also an Arp and a Ben Nicholson relief. He admired Max's and Dalí's paintings very much and said, "They are great artists. Dalí stands a little apart from the others, he is great in the old tradition. I prefer the true Surrealists, especially Max Ernst. They do not belong to the old tradition, they are sometimes naturalists in their own way, but free from tradition. I feel nearer in spirit to the Surrealists, except for the literary part, than to any other kind of painting."

One night Mondrian invited me to his studio, which looked exactly like one of his paintings, and played boogie-woogie music for me on his gramophone. He kept moving strips of paper with which he was planning a new painting, and asked me which combination was best. I am sure he did not take my advice.

In the winter of 1946, I asked Alexander Calder to make me a bed-head, which I thought would be a marvellously refreshing change from our grandmothers' old brass ones. He said he would, but never got around to it. One day I met him at a party and said, "Sandy, why haven't you made my bed?" At this strange question, Louisa, his wife, a beautiful niece of Henry James, pricked up her ears and urged Sandy to get to work. Because of the war, the only available material was silver, which cost more than all the work Sandy did on it. It was not mobile, except for the fact that it had a fish and a butterfly that swung in space from the background, which resembled under-sea plants and flowers. I am not only the only woman in the world who sleeps in a Calder bed, but the only one who wears his enormous mobile ear-rings. Every woman in New York who is fortunate enough to be decorated by a Calder jewel, has a broach or a bracelet, or a necklace.

After Morris Hirshfield's death, Sydney Janis, the dealer, asked me to give him a memorial show. It was very beautiful, and I acquired what I consider his best painting, "Two Women before the Looking-Glass." It portrays the women perfuming themselves, combing and brushing their hair and putting on lipstick. It is unrealistically presented, with the women seen back to front in the mirror. They also have four bottoms, which, when the painting was hung in my entrance hall, received many pin-pricks from sensuous admirers who were passing through the hall.

In the summer of 1945 my great friend Emily Coleman came to see me, and brought with her a fantastic creature called Marius Bewley. I have never met anyone like him in my life. He looked like a priest, which he had once intended to be, and spoke with a strange false English accent. I took to him at once, and immediately asked him to come and be my secretary in the gallery. He accepted just as readily, as he thought the idea very pleasant. Our collaboration was a great success. We became tremendous friends and have remained so ever since, though

Marius left me after a year to go to take a PhD at Columbia University. He was extremely learned and a brilliant writer, and everything he said was brilliant too. He had a marvellous sense of life and of humour. He loved modern pictures, and though he sold very few, he bought a lot from my gallery.

After Marius left me, he sent in his place a very strange young man who couldn't type and who never appeared on time—in fact, some days not at all. I was kept very busy answering the telephone for him, as his friends never stopped phoning him. The only thing he liked to do was to take my Lhasa terriers for walks, as they served as introductions to other fascinating Lhasa terriers who belonged to such distinguished people as Lily Pons, John Carradine and Philip Barry and others. The original Lhasa had been given to Max Ernst, but when we were divorced he had taken it away with him. I had wanted very much to retain this darling dog, Kachina, for half the year, and wished to have this put in the divorce contract, but it was too complicated and I had to content myself, years later, with two of her puppies, which Max sold me at birth.

Much as I loved Art of this Century, I loved Europe more than America, and when the war ended I couldn't wait to go back. Also, I was exhausted by all my work in the gallery, where I had become a sort of slave. I had even given up going out to lunch. If I ever left for an hour to go to a dentist, oculist or hair-dresser, some very important museum director would be sure to come in and say, "Miss Guggenheim is never here." It was not only necessary for me to sell Pollocks and other pictures from current shows, but I also had to get the paintings circulated in travelling exhibitions. The last year was the worst, when my secretary couldn't even type, and this extra burden was added to my chores. I had become a sort of prisoner and could no longer stand the strain. Lévi-Strauss, the French cultural attaché, gave me a letter to the French Consul, saying I had to go abroad to see French and European art, and with this excuse I got to Paris and then to Venice, where Mary McCarthy and her husband, Boden Broadwater, insisted that I accompany them.

On my way there, I decided Venice would be my future home. I had always loved it more than any place on earth and felt I would be happy alone there. I set about trying to find a palace that would house my collection and provide a garden for

my dogs. This was to take several years; in the meantime I had to go back to New York to close the gallery. We ended it with a retrospective show of van Doesburg, which I arranged to have circulated all over the United States. Nellie van Doesburg came to New York from France as my guest, with all the pictures. I had been trying to arrange this during the war, but had not succeeded until it was too late for her to leave France.

I sold all Kiesler's fantastic furniture and inventions. There was terrific bidding for them, and to avoid complications I let them be removed by the cash and carry system. Poor Kiesler never even got one thing as a souvenir, they disappeared so quickly.

Betty Parsons fell heir to my work, spiritually, and as I said, promised Pollock a show. Happy to think that she was there to help the unknown artists, I left my collection in storage and flew to Europe with my two dogs, not to return for twelve years.

1960

HENRY MILLER

Henry Miller (1891–1980), the writer who reshaped a generation's expectations about the novel with the casual erotic bravado of *Tropic of Cancer*, was also a serious watercolorist, with a flair for outrageous faces and a taste for sizzling colors and bold graphic effects. On a number of occasions Miller wrote about his own passionate feeling for the painter's processes—he had begun wielding a brush when he was still a young man—and that immediate engagement informs his essay about the African American artist Beauford Delaney, who, as Miller observed, was "poor in everything but pigment. With pigment he was as lavish as a millionaire." Delaney, who was in his mid-forties when Miller wrote about him for a series of pamphlets published by the avant-garde Alicat Bookshop in Yonkers, New York, had been born in Knoxville, Tennessee, and arrived in Manhattan in time to witness the tail end of the Harlem Renaissance and experience the full force of the Depression. For Miller, the exuberance of Delaney's street scenes and portraits was a rich ore extracted from the vicissitudes of the artist's life. And although Delaney's work looks nothing like that of the Abstract Expressionists who were emerging at the time, his paintings reflect a related romantic spirit.

FROM
The Amazing and Invariable
Beauford Delaney

Yes, he is amazing and invariable, this Beauford. It has been storming now for forty-eight hours, here at Big Sur, and the house is leaking from every cement and stucco pore of its being. That is why my mind dwells on Beauford. How is he faring now in the winter of Manhattan where all is snow and frost? Here it is warm, despite the leaks, despite the gale. We have only one problem—to keep the wood dry. A few sticks of wood in the stove and the place is cozy. But at 181 Greene Street, on that top floor where Beauford works, dreams and eats his paintings, only a roaring furnace kept at a constant temperature of 120 degrees Centigrade can combat the chill of the grave which emanates from the dripping walls, floors and ceilings. And of course there will never be such a furnace at 181 Greene Street.

Neither will the sun's warm rays ever penetrate the single room in which Beauford lives.

It was night when Harry first led me to Beauford's heavenly abode. I shall never forget the forlorn, dismal look of Greene Street as we stood across the way looking up at Beauford's windows to see if he was home. There are streets which seem commemorated to the pangs and frustrations of the artist; having nothing to do with art, shunned by all living as soon as the work of day is done, they are infested with the sinister shadows of crime and with prowling alley cats which thrive on the garbage and ordure that litter the gutters and pavements.

It was only the beginning of Fall. The air was mild outdoors. But in the studio Beauford had the fire going. He was wrapped in several layers of sweaters, a woolen scarf around his neck, and a thick, fuzzy skating cap pulled well down over his ears. In a few moments the fire died out—and remained dead for the rest of the evening. In about twenty minutes the floor became icy cold, the dead cold of cold storage in which cadavers are preserved in the morgue. We sat in our overcoats, collars turned up, hats pulled down over our ears, our hands stuffed deep in our pockets. Just the right atmosphere in which to produce masterpieces, I thought to myself. Rembrandt, Mozart, Beethoven—just the temperature for them! A little more heat and the world would have been the loser. A little more food, a little more kindness, and we would have had more chromos, more musical comedies. Logic, our crazy logic, dictates that the environment of the creative individual must be composed of all the ugly, painful, discordant and diseased elements of life. To prove his genius the artist must transform these elements into durable symbols of beauty, goodness, truth and light. For reward he may, if he is lucky, expect a monument to his glory—a hundred years after his death. But while he is alive, while he is a man walking the earth, while he is a living creator dedicated to the highest pursuits, he must not hope to eat anything but offal, nor associate with any living creature other than beggars and alley cats. Above all he must not ask for creature comforts, for warmth and light, for soft music . . . not even for a glimpse of the sun through his barred windows . . .

When such an individual also happens to have a dark skin, when in a cosmopolitan city like New York only certain doors

are open to him, the situation becomes even more complex. A poor white artist is a miserable sight, but a poor black artist is apt to be a ridiculous figure as well. And the better his work the more cold and indifferent the world becomes. If he were to make Christmas cards people could pity him and dole out scraps of food or cast-off garments, but to aspire to greatness, to make pictures which not even intelligent white people can appreciate, that puts him in the category of fools and fanatics. That makes him just another "crazy nigger."

Beauford was an artist from before birth; he was an artist in the womb, and even before that. He was an artist in Africa, long before the white men began raiding that dark continent for slaves. Africa is the home of the artist, the one continent on this planet which is soul-possessed. But in white North America, where even the spirit has become bleached and blanched until it resembles asbestos, a born artist has to produce his credentials, has to prove that he is not a hoax and a fraud, not a leper, not an enemy of society, especially not an enemy of our crazy society in which monuments are erected a hundred years too late.

This night I speak of Beauford showed us, I remember, some small canvases of street scenes. They were virulent, explosive paintings devoid of human figures. They were all Greene Street through and through, only invested with color, mad with color; they were full of remembrances too, and solitudes. In the empty street from which, by the way, there seemed no egress, a spirit of hunger swept with devastating force. It was a hunger born of remembrance, the hunger of a man alone with his medium in the cold storage world of North America. Here I sit in Greene Street, said the canvases, and I am invisible to all but the eye of God. I am the spirit of hunger for all that has been denied me, one with the street, one with the cold, dead walls. But I am not dead, neither am I cold, nor yet invisible. I am of darkest Africa a luminary, an aurora borealis, a son of a slave in whose veins courses the proudest white blood. I sit here in Greene Street and I paint what I am, my mysterious mixed bloods, my inscrutable mixed hungers, my elegant and most aristocratic solitudes, my labyrinthine pre-natal remembrances. Here there are no sun, moon or stars, no warmth, no light, no companionship. But in me, the amazing and invariable Beauford Delaney, are all the lights, all the stars, all the constellations, all the angels

for companions. I am Greene Street as it looks from the angle of eternity; I am a crazy nigger as he looks when the Angel Gabriel blows his horn; I am solitude playing the xylophone to make the rent come due.

We looked at only a few canvases that evening, the cold driving us out into the open street, but the impression which I carried away was one of being saturated with color and light. Poor in everything but pigment. With pigment he was as lavish as a millionaire. It was a new period for him I learned later. He was in revolt. Against what? Against the imprisonment of Greene Street, no doubt. Against the cold storage technique of the North American lapidaries. Of portraits there seemed to be an endless variety. One friend of his, a man named Dante, he had already painted several times.

"Do him again," I said, "he's a good subject for you."

"I intend to," said Beauford smilingly.

"Do him over and over," I said. "Do him until there's nothing left to do."

"That's just what I'm going to do," said Beauford.

As we descended the dark stairway in which a tiny taper swimming in oil was burning, I wondered if Beauford would have the courage to do Dante fifty or a hundred times. Supposing that for the next five years he were to do nothing but Dante? Why not? Some men paint the same landscape over and over again. Dante was a wonderful landscape for Beauford: he had cosmic proportions, and his skull though shorn of locks was full of mystery. A man studying his friend day in and day out for five years ought to arrive at some remarkable conclusions. With time Dante could become for Beauford what Oedipus became for Freud. But he could never become food and rent, that is certain. Nothing Beauford did with love could earn him anything but love. A sane North American white man would have ditched Dante and made patent medicine bottles or cans of delicious preserved fruits. Or he might have tried his hand at flower pots such as the Academies are stuffed with. He would certainly never elect to live on the top floor of 181 Greene Street and devote himself to painting the living spirit of a tried and true friend. That would be insanity.

Few artists, I hasten to add, have ever impressed me as being more sane than Beauford Delaney. Beauford's sanity is something

to dwell on: it occupies a niche of its own. There are some utterly sane individuals who create the impression that stark lunacy might be a highly desirable state; there are others who make sanity look like a counterfeit check, with God the loser. Beauford's sanity is the sort that one ascribes only to the angels. It never deserts him, even when he is sorely harassed. On the contrary, in crucial moments it grows more intense, more luminous. It never becomes diffracted into bitterness, envy or malice. He sees clearly in good weather and bad, and always warmly, compassionately, understandingly. He sees his own remarkable plight as if it were an object he intended to paint. And if it's sometimes too cold to paint that plight as he sees it, he simply curls up, pulls the blankets over him, and puts out the light. He has no dialectic up his sleeve, no headache powders, no sedatives, no panaceas. He lives in Greene Street, and his address is always 181, even when he is not there. Even in his dreams it is still 181 Greene Street, the amazing and invariable Beauford Delaney dreaming, in a temperature just cool enough to keep a fresh corpse fresh.

In this unbelievable temperature Beauford retains the green vision of a world whose order and beauty, though divine, are within the conception of man. The more men murder one another, bugger one another, corrupt one another, the greener his vision becomes. When the heart of the world becomes blacked out Beauford becomes positively chlorophyllic. At his greenest he has the faculty of coming out of a deep sleep, say about three or four in the morning when the drunks who have been ejected from the night clubs rap at his door, and not once, no never in the long history of 181 Greene Street, attempting to throw them bodily down the stairs. He will admit them, light the stove if there is coal or wood, drink with them, play the guitar, dance, show his paintings (and explain them if necessary), listen to their maudlin stories, give them his bed if they are unable to use their hind legs, and promptly at 8:00 A.M. when the first feeble rays of light penetrate the studio, sit down before his easel and resume work on the portrait of his friend Dante.

This ability to resume work after the most distracting interruptions is one of the great qualities of the artist. Beauford has it to an extraordinary degree. His whole life, one might say, has been a series of uninterrupted interruptions. To resume

work is no task for him because for twenty-five years all he has
demanded of the world is permission to paint. He has been at
it unremittingly, in fair weather and foul, through droughts
and famines, through heat waves and cold spells, through rent
crises, wars, revolutions, strikes, riots, hunger, despair, denigra-
tion, ridicule, humiliation, chagrin and defeat. He paints to-day
even more enthusiastically than when he began. He tackles each
fresh canvas as though it were his first. He uses his pigments
lavishly though he knows not where the next tube will come
from. He blesses himself when he begins and says Amen when
he is through. He never curses his lot because he has never for
a moment questioned his fate. He assumes full responsibility
for success or failure. Should death interrupt the program, he
knows that he will resume work in the next incarnation. His
people have waited for centuries to see justice rendered them.
Beauford is no different from his ancestors: he can bide his time.
Should this Beauford Delaney fail there are other Beaufords, all
endowed with the same spirit, the same endurance, the same
integrity, the same faith.

It is when he talks that Beauford reveals the mysterious
stamina of his race. He speaks a doxology of the blood. He
balances the good with the bad, and the equation comes out
positive. When he gets nebulous is when he is at his best. His
talk then becomes a sort of leafing and budding, an incantation
to growth. Often, in groping for word or image, he closes his
eyes and sways to and fro. Sometimes he repeats the thought,
in different words of course—often through oxymorons—
spiraling round and round the thought as if to draw it up from
the inchoate depths and give it light and form. In these flights
he mints new words, adjectives and adverbs especially; bizarre
as they sound at first, they are always accurate. Many of them
are grand words such as only majestic beings know how to
employ. And always, like heavy incense, there floats above them
the aroma of the doxology—PRAISE GOD FROM WHOM
ALL BLESSINGS FLOW!

He was at his best one evening after the fire had gone out
and he had wrapped himself in sweaters, scarves and blankets.
He was particularly exuberant on this occasion because he had
completed a portrait in a very few sittings and with obvious suc-
cess. It had been an experience for me to sit for this portrait: I

had not only learned something about myself but a great deal about Beauford Delaney. Or rather, I learned something about the artist, something which demands constant corroboration, even by an artist. Harry was there at the time, grinning like a Cheshire cat; he imagined that Beauford had gone off the deep end again. Beauford was talking of realization, of how on occasion a painting will literally grow out of one's hand. This led him to curious divagations about the source of power, the source of inspiration. He spoke of his struggles with the medium and of how, at long last, he felt that he was just beginning to understand what it was all about, just beginning to know what he wanted to do. I smiled. That same day I had heard almost exactly the same words from the lips of another artist, a man I considered to be a master. Many times I have heard artists speak this way, always, it seemed, when they had reached a moment of realization. It was vision which they were acclaiming, not power, not pride or arrogance. "I am only just beginning to see . . ." And with this there was always expressed the devout wish to be able to keep the vision open. "If only I may be permitted to live a few years longer! Now I am on the track of it. I am just beginning to express myself, my own true self." And so on.

Listening to Beauford I was once again made aware of how insignificant the other, physical struggle was. One was no longer conscious of the falling temperature or other discomforts; one thought only of this unfolding power of sight which would spur him on to greater efforts. One could visualize him shooting forward through a maze of productions like a bullet through the threaded barrel of a high-powered rifle. There was no thought of reward, nor even of recognition; his only concern was to create. Rapidly, as he rambled on, I reviewed the stages of his development, putting together as best I could the fragments of his life as he had revealed them from time to time. He had come a long way already, this amazing and invariable Beauford Delaney. He had started from the deep South with absolutely nothing and, after twenty-five years of struggle with a hostile world, had emerged superior to the claims of the world. The great white world seemed to grow smaller and smaller as Beauford talked. It was not that he cursed or derided it—he ignored it. One would not know in what country he was living, to follow his speech.

There was no black and white, no master or slave; there was just the endless stretch of vision in which the imagination of all men dwells. On a dark and lonely night Greene Street was just another specimen of dark and lonely nights everywhere. It was not America, not Manhattan Island, nor the dismal purlieus of Greenwich Village; it was a thoroughfare lined with grim façades through which the human soul wandered in various states of being at various stages of its evolution. It was a state of mind which one triumphed over on good days and succumbed to on bad days. If captured with the brush during a siege of exaltation it could arouse ridicule or indignation on the part of an unseeing beholder; it could also make a sensitive individual bleed with anguish. But it would never bring pocket money, nor heat nor light, nor even apple fritters. It would take its place eventually with all the other canvases hidden away in this unbelievable sarcophagus of a room; it would die from not being looked at; it would make camouflage material for the next war. But somewhere in the universe, despite all physical loss or damage, Greene Street, like Dante, like Beauford's beautiful mother, would live out its dream and in some imperceptible way affect the vision of all other dreamers living and walking through empty thoroughfares lined with grim, hostile walls.

1945

JAMES AGEE

Few American writers have cared as much about the photographic image as James Agee (1909–1955), whose autobiographical novel, *A Death in the Family,* was published posthumously and awarded a 1958 Pulitzer Prize. Agee had a special feeling for the art of the camera, whether the movies he helped to create as a screenwriter and interpreted as a critic or the still photographs that were the subjects of his collaborations with Walker Evans and Helen Levitt. Agee worked twice with Evans, first on their book-length portrait of three Depression-era tenant families, *Let Us Now Praise Famous Men* (1941), and later on a text to accompany Evans's photographs of men and women riding the New York subways, eventually published as *Many Are Called*. Agee was drawn to what Evans called photography's potential as "lyric documentary"—an art that could be, like Agee's prose, both exacting and poetic. He obviously saw such resonances in Helen Levitt's photographs of children on the streets of New York, for which he composed this introduction in 1946. At times, Agee writes quite specifically about some of Levitt's photographs, and readers will have to bear with the numbers in the text that refer to particular plates in *A Way of Seeing*, the collection of Levitt's photographs that only found its way into print in 1965—and is now among the most highly prized photographic books of the twentieth century.

Introduction to
Helen Levitt's A Way of Seeing

HELEN LEVITT was born and educated in New York City. She made these photographs in New York in the 1940s. None of the photographs is intended as a social or psychological document. Several are records of street and sidewalk drawings; most of the others can best be described as lyrical photographs. In this book they are arranged, numbered but without captions, in an order suggested by the essay.

The mind and the spirit are constantly formed by, and as constantly form, the senses, and misuse or neglect the senses only at grave peril to every possibility of wisdom and well-being. The busiest and most abundant of the senses is that of sight. The sense of sight has been served and illuminated by the visual arts

for as long, almost, as we have been human. For a little over a hundred years, it has also been served by the camera. Well used, the camera is unique in its power to develop and to delight our ability to see. Ill or indifferently used, it is unique in its power to defile and to destroy that ability. It is clear enough by now to most people that "the camera never lies" is a foolish saying. Yet it is doubtful whether most people realize how extraordinarily slippery a liar the camera is. The camera is just a machine, which records with impressive and as a rule very cruel faithfulness, precisely what is in the eye, mind, spirit, and skill of its operator to make it record. Since relatively few of its operators are notably well endowed in any of these respects, save perhaps in technical skill, the results are, generally, disheartening. It is probably well on the conservative side to estimate that during the past ten to fifteen years the camera has destroyed a thousand pairs of eyes, corrupted ten thousand, and seriously deceived a hundred thousand, for every one pair that it has opened, and taught.

It is in fact hard to get the camera to tell the truth; yet it can be made to, in many ways and on many levels. Some of the best photographs we are ever likely to see are innocent domestic snapshots, city postcards, and news and scientific photographs. If we know how, moreover, we can enjoy and learn a great deal from essentially untrue photographs, such as studio portraits, movie romances, or the national and class types apotheosized in ads for life insurance and feminine hygiene. It is a good deal harder to tell the truth, in this medium, as in all others, at the level of perception and discipline on which an artist works, and the attempt to be "artistic" or, just as bad, to combine "artistry" with something that pays better, has harmed countless photographs for every one it has helped, and is harming more all the time. During the century that the camera has been available, relatively few people have tried to use it at all consistently as an artist might, and of these very few indeed could by any stretch of courtesy be called good artists. Among these few, Helen Levitt is one of a handful who have to be described as good artists, not loosely, or arrogantly, or promotively, but simply because no other description will do.

In every other art which draws directly on the actual world, the actual is transformed by the artist's creative intelligence, into a new and different kind of reality: aesthetic reality. In

the kind of photography we are talking about here, the actual is not at all transformed; it is reflected and recorded, within the limits of the camera, with all possible accuracy. The artist's task is not to alter the world as the eye sees it into a world of aesthetic reality, but to perceive the aesthetic reality within the actual world, and to make an undisturbed and faithful record of the instant in which this movement of creativeness achieves its most expressive crystallization. Through his eye and through his instrument the artist has, thus, a leverage upon the materials of existence which is unique, opening to him a universe which has never before been so directly or so purely available to artists, and requiring of his creative intelligence and of his skill, perceptions and disciplines no less deep than those required in any other act of aesthetic creation, though very differently deprived, and enriched.

The kind of beauty he records may be so monumentally static, as it is in much of the work of Mathew Brady, Eugène Atget, and Walker Evans, that the undeveloped eye is too casual and wandering to recognize it. Or it may be so filled with movement, so fluid and so transient, as it is in much of the work of Henri Cartier-Bresson and of Miss Levitt, that the undeveloped eye is too slow and too generalized to foresee and to isolate the most illuminating moment. It would be mistaken to suppose that any of the best photography is come at by intellection; it is, like all art, essentially the result of an intuitive process, drawing on all that the artist *is* rather than on anything he thinks, far less theorizes about. But it seems quite natural, though none of the artists can have made any choice in the matter, that the static work is generally the richest in meditativeness, in mentality, in attentiveness to the wonder of materials and of objects, and in complex multiplicity of attitudes of perception, whereas the volatile work is richest in emotion; and that, though both kinds, at their best, are poetic in a very high degree, the static work has a kind of Homeric or Tolstoyan nobility, as in Brady's photographs, or a kind of Joycean denseness, insight and complexity resolved in its bitter purity, as in the work of Evans; whereas the best of the volatile work is nearly always lyrical.

It is remarkable, I think, that so little of this lyrical work has been done; it is perhaps no less remarkable that, like nearly all good photographic art, the little that has been done has been so

narrowly distributed and so little appreciated. For it is, after all, the simplest and most direct way of seeing the everyday world, the most nearly related to the elastic, casual and subjective way in which we ordinarily look around us. One would accordingly suppose that, better than any other kind of photography, it could bring pleasure, could illuminate and enhance our ability to see what is before us and to enjoy what we see, and could relate all that we see to the purification and healing of our emotions and of our spirit, which in our time are beguiled with such unprecedented dangerousness towards sickness and atrophy.

I do not at all well understand the reasons for the failure, but a few possibilities may be worth mentioning in passing. For a long time the camera was too slow, large, and conspicuous to work in the fleeting and half-secret world which is most abundant in lyrical qualities. More recently it has become all but impossible, even for those who had it in the first place, to maintain intact and uncomplicated the simple liveliness of soul and of talent without which true lyrical work cannot be done. As small, quick, foolproof cameras became generally available, moreover, the camera has been used so much and so flabbily by so many people that it has acted as a sort of contraceptive on the ability to see. And more recently, as the appetite for looking at photographs has grown, and has linked itself with the worship of "facts," and as a prodigious apparatus has been developed for feeding this appetite, the camera has been used professionally, a hundred times to one, in ways which could only condition and freeze the visual standards of a great majority of people at a relatively low grade.

As a further effect of this freezing and standardization, photographers who really have eyes, and who dare to call their eyes their own, and who do not care to modify them towards this standardized, acceptable style, have found it virtually impossible to get their work before most of those who might enjoy it; or to earn, through such work, the food, clothing, shelter, leisure, and equipment which would make the continuance of that work possible. Almost no photographer whose work is preeminently worth looking at has managed to produce more than a small fraction of the work he was capable of, and the work, as a rule, has remained virtually unknown except to a few friends and fellow artists. This is true to a great extent,

of course, of artists who work in any field. Yet distinctions, standards, and assumptions exist and have existed for centuries which guarantee a good poet or painter or composer an audience, if generally a small one; and these are not yet formed in relation to photographs. In its broad design, however, this is a familiar predicament, as old as art itself, and as tiresome at least, one may assume, to the artists who suffer the consequences as to the nonartists to whom it is just a weary cliché. I don't propose to discuss who, if anyone, is to blame, being all the less interested in such discussion because I don't think anyone is to blame. I mention it at all only because I presume that the distinction between faithfulness to one's own perceptions and a readiness to modify them for the sake of popularity and self-support is still to be taken seriously among civilized human beings; and because it helps, in its way, to place and evaluate Miss Levitt's work.

At least a dozen of Helen Levitt's photographs seem to me as beautiful, perceptive, satisfying, and enduring as any lyrical work that I know. In their general quality and coherence, moreover, the photographs as a whole body, as a book, seem to me to combine into a unified view of the world, an uninsistent but irrefutable manifesto of a way of seeing, and in a gentle and wholly unpretentious way, a major poetic work. Most of these photographs are about as near the pure spontaneity of true folk art as the artist, aware of himself as such, can come; and an absolute minimum of intellection, of technical finesse, or of any kind of direction or interference on the part of the artist as artist stands between the substance and the emotion and their communication.

It is of absolute importance, of course, that all of these photographs are "real" records; that the photographer did not in any way prepare, meddle with, or try to improve on any one of them. But this is not so important of itself as, in so many of them, unretouched reality is shown transcending itself. Some, to be sure, are so perfectly simple, warm and direct in their understanding of a face or of an emotion that they are likely to mean a great deal to anyone who cares much for human beings: it would be hard to imagine anyone who would not be touched by all that is shown—by all that so beautifully took place in the

unimagined world—in such a photograph as 36. Readers who particularly like children will find here as much to meditate, and understand, or be mystified by, as anyone, so far as I know, has ever managed to make permanent about children. Sociologically and psychologically, the photographs seem to be only the more rich and illuminating because they are never searching out or exploiting, in their subjects, such purposes—far less the still narrower and more questionable purposes of the journalist, humanitarian, or "documentor." There is in fact a great deal that can be seen here by the purely rational mind and eye, or by a person who is, in a purely rational way, interested in people, in relationships, and in cities.

I would not for a moment want to try to persuade any reader who mistrusts the irrational, to suspend his mistrust, and look

Helen Levitt: Photograph 36 from
A Way of Seeing, c. 1942.

further into these pictures. I am nevertheless convinced that the photographs cannot be fully enjoyed, or adequately discussed, on a purely naturalistic or rational basis. Many of them prove, rather, that the actual world constantly brings to the surface its own signals, and mysteries. At its simplest this kind of signaling could be called purely aesthetic; the postures of the girl and boy in 46 and their spacing on the pavement is one of many examples. But even here I think there is more than can be covered by the word aesthetic, even after you have added the great simplicity, power, and complexity of its full human and rational content. I think there is also in this spacing, and in the strange posture of the boy as it relates to bare space and to the young girl, a quality of mystery—a strong undertone even, against the picture's brave and practical melancholy, of terror. Again, I would not insist on this, to the reader who does not recognize it or who is not interested. Now the forces of beauty and fear in this picture might be suspect, if they drew one to enjoy them for their own sake alone, and it is possible, I realize, to enjoy this and many other of the pictures in this precious and limited, inhuman way. But it seems to me that the superrational beauty, fear, and mystery, and the plain strength and sadness of the girl, and her particular moment and stance in our own and in universal existence, all powerfully interdepend upon and enhance one another, reverberating like mirrors locked face to face the illimitable energies set up in the paradox formed in the irrefutably actual as perceived by the poetic imagination. I suspect that only the reader who recognizes this, in his own terms, will thoroughly understand and agree with what I mean by a photograph as a good work of art; or by a lyrical photograph.

The reader who does is in a position fully to enjoy these photographs. He will realize how constantly the unimagined world is in its own terms an artist, and how deep and deft the creative intelligence must be, to recognize, foresee, and make permanent its best moments. Even in the most benignly open, simple-looking kind of portrait he will see this, and it will add its beauty and vitality: the toes of the baby in 55 and the glasses of the man, and the knobbed, shining wood of the chair, and the man's knobbed, polished shoes, and the round foreheads and round heads and faces of the man and the baby, all assemble their delicate order like so many syllables in a line of poetry, to enhance the already great charm of the surface content. The

rifted asphalt and the burnt match in 3 would lose much of their power if a painter had invented them or the photographer had arranged them; as it is they combine with the drawing to testify to the silent cruelty of nature.

Many people, even some good photographers, talk of the "luck" of photography, as if that were a disparagement. And it is true that luck is constantly at work. It is one of the cardinal creative forces in the universe, one which a photographer has unique equipment for collaborating with. And a photographer often shoots around a subject, especially one that is highly mobile and in continuous and swift development—which seems to me as much his natural business as it is for a poet who is really in the grip of his poem to alter and re-alter the words in his line. It is true that most artists, though they know their own talent and its gifts as luck, work as well as they can against luck, and that in most good works of art, as in little else in creation, luck is either locked out or locked in and semi-domesticated, or put to wholly constructive work; but it is peculiarly a part of the good photographer's adventure to know where luck is most likely to lie in the stream, to hook it, and to bring it in without

Helen Levitt: Photograph 46 from *A Way of Seeing*, 1946.

unfair play and without too much subduing it. Most good photographs, especially the quick and lyrical kind, are battles between the artist and luck, and the happiest victories for the artist are draws. Luck can of course spoil as many photographs as it contributes to, or makes, and can seldom do anything for the photographer who lacks an eye for it, unless he is wholly absorbed in some quite different intention, or is thoroughly naïve. It is luck, if you like, that turned the warlike frieze in 21 into a wonderful dance, and gave it its strange frame of electrical wiring; but is it? Is it not more likely, when you look with care at the respective postures and ages of the people in 16, or at the relationship between the woman and the bicycle in 74, that surreptitiously, unknown even to the performers, though in broad daylight, human beings and their streets continually evolve some of their most unutterable meanings, as a dance?

Like most good artists, Miss Levitt is no intellectual and no theorist; she works, quite simply, where she feels most thoroughly at home, and that, naturally enough, is where the kind of thing that moves and interests her is likely to occur most naturally and in best abundance. So there was nothing preconceived about the boundaries she has set around her subject matter. Yet it is worth noticing that in much of her feeling for streets, strange details, and spaces, her vocabulary is often suggestive of and sometimes identical with that of the Surrealists. In other words, there seems to be much about modern cities which of itself arouses in artists a sensitiveness, in particular, to the tensions and desolations of creatures in naked space. But I think that in Miss Levitt's photographs the general feeling is rather that the surrealism is that of the ordinary metropolitan soil which breeds these remarkable juxtapositions and moments, and that what we call "fantasy" is, instead, reality in its unmasked vigor and grace. It is also worth noticing that nearly all the people in her photographs are poor; that most of them are of the relatively volatile strains; that many are children. It is further worth realizing that there is a logic and good sense about this, so far as her work is concerned. In children and adults alike, of this pastoral stock, there is more spontaneity, more grace, than among human beings of any other kind; and of all city streets, theirs are most populous in warm weather, and most abundant in variety and in beauty, in strangeness, and in humor.

A great lyrical artist might still possibly find much, among people and buildings of the middle and rich classes, to turn to pure lyrical account. But it seems hardly necessary to point out that flowers grow much more rarely in that soil, perhaps especially in this country at this time, than weeds and cactuses; and that there is much more in that territory to interest the artist who is fascinated by irony, diagnosis, and the terrifying complexities of self-deceit and of evil, than there is for the lyrical artist. I cannot believe it is meaningless that with a few complicated exceptions, our only first-rate contemporary lyrics have gotten their life at the bottom of the human sea: aside from Miss Levitt's work I can think of little outside the best of jazz. Moreover, specialized as her world is, it seems to me that Miss Levitt has worked in it in such a way that it stands for much more than itself; that it is, in fact, a whole and round image of existence. These are pastoral people, persisting like wild vines upon the intricacies of a great city, a phantasmagoria of all that is most contemporary in hardness of material and of appetite. In my opinion they embody with great beauty and fullness not only their own personal and historical selves but also, in fundamental terms, a natural history of the soul, which I presume also to be warm-blooded, and pastoral, and, as a rule, from its first conscious instant onward, as fantastically misplanted in the urgent metropolis of the body, as the body in its world.

So far, I have avoided any attempt to discuss the "meanings" of the photographs, feeling that this is best left as an affair between the pictures themselves and the reader. By less direct means I have tried to furnish the chance reader who may feel that he lacks it, enough suggestions about such pictures as these, that he may go on to their full enjoyment without further interruption by words. But because I realize that we are all so deeply caught in the tyranny of words, even where words are not needed, that they have sometimes to be used as keys to unlock their own handcuffs, I have tried, from here on, to give a more directly suggestive paraphrase. That this paraphrase is extravagant, and that the "story" the pictures tell is arguable, from a rational point of view, and in some ways very sentimental from any point of view, I realize, with regret. The attempt is not rational because so much that is important in the pictures is not rational and because this is liable, I fear, to be insufficiently

recognized. I am counting on the absolute reality of the pictures, and on the reader's rational use of eye and mind, to dress the boat; and I make this attempt chiefly because I feel that much of the enjoyment of the pictures depends on an appreciation of the tension which they create, and reveal, between the unimagined world, and the imaginable.

The overall preoccupation in the photographs is, it seems to me, with innocence—not as the word has come to be misunderstood and debased, but in its full, original wildness, fierceness, and instinct for grace and form; much may be suggested to some readers by Yeats's phrase, "the ceremony of innocence." This is the record of an ancient, primitive, transient, and immortal civilization, incomparably superior to our own, as it flourishes, at the proud and eternal crest of its wave, among those satanic incongruities of a twentieth century metropolis which are, for us, definitive expressions and productions of the loss of innocence.

We begin not with the creatures of this civilization, but with their hieroglyphs, their rock drawings, their cave paintings. The intuitions of a child with chalk have so utilized a stamped tin wreath (1) as to create a female head which could also be an image of the sun or the moon; and, as a magnet beneath paper aligns a scatter of iron filings, it commands every disparate element within the frame of the photograph into a grandly unified, cryptic significance. Then, the flow and lightness of its drawing as sure as somnambulism, the floated beatitude of an unborn child (2) in a blandly anachronistic baby's dress; its carefully emphasized smile, untouched by any interposition of consciousness between the hand and the source of fullest knowledge, is no more accident than it is intellection.

The first living creature we see (4) is also prenatal: majestic, of uncertain sex, its weapon sheathed at rest, its features obscured, generalized and portentous as those of the celestial image in 1, it stands monarchic, veiled in its placenta. The children in picture 5, peering into the open world from within their primal harbor, have no need of the bridal shroud of birth or of its world-faring replica, the mask; but in their relative postures, and attitudes toward their masks, the three children in 7 are a definitive embodiment of the first walk into the world's first morning. The boys of 9, treed and at home in their jungle's stony shade,

touch the drumhead of this world's mystery beyond the touch of words; the boy of 10 epitomizes for all human creatures in all times that moment when masks are laid aside.

The cardinal occupations of the members of this culture are few, primordial, and royal, being those of hunting, war, art, theater, and dancing. Dancing, indeed, is implicit in nearly all that they do—as in the heroic frieze of 21, and the centrifugal, fire-dance fury of 26; or the quieted boy beside the sleeping lion (31) or, with the exquisite dignity of the greatest of dancers, in the image of the solitary duellist (32). But subtly, ineluctably, the quality of citizenship in this world where all are kings and queens begins to shift and, almost invariably, to decline and to disintegrate. The rock drawings lose their intuitive and hieratic brilliance if not, at first, their poetic vitality; they are no longer prehistoric or in the artist's sense religious; they have become mere bulletins of desire, aggression, and contempt (38). And in each child, from very early, the germ of the death of childhood is at work. In the child of 39, it is enthroned and quiescent; he is merely so bemused, for the moment by the world before his world, that the face has become fetal. The little boy in the next picture (40) still acts with the angelic directness of his world at its most free; the little girls in the same picture embody a later, sadder stage. The children in 42 are already engulfed as deeply in the future as in the present or the past, and I know of no record of man-eating motherhood more accurate or more fearsome. In 43, this is balanced by an image of the gentle elegance possible, in the age that can still survive it whole, to prepropagative love.

Adolescence is a kingdom of fallen and still falling angels, but it is yet a kingdom, with its own kinds of wild animal glamor (45), with profundities of grave purity which are peculiar to it (54); with its unappeasable hunger and pity (63), and its own awful threshold to the world beyond—that Babylonian captivity in which dreams are either manufactured by outside authorities or rest, as a rule, forever unformed and unsatisfied. On this threshold it is still possible to retain something of the ancient genius for gaiety and for symbol (65); but one has also become forcefully aware of what we commonly call reality in its official form, its lowest common denominator.

In that next world, some hold their sexuality in such esteem

(66), or use it with such affectionate comfort (67), that it would
be mistaken to feel that they have fallen through the floors of
two kingdoms into a scullery chaos of gracelessness; they are
indications, rather, that human beings do not inevitably, or any-
how invariably, destroy themselves. And some retain the quality
of delight (68), if not for themselves then at least for others, and
as innocently delicious creatures at large and unconquerable in
a less than delicious world. But the more customary destiny is
much more dark. A woman, crossing a street (74), can seem to
beckon towards blind alleys of unthinkable sorrow and fright.
Picture 78 is so perfect a theatrical tableau that it would be
questionable among such photographs as these if it were in any
way staged or posed, but stands, as it is, as a beautiful example
of nature imitating art. In its pathetic, relatively rational verbos-
ity, moreover, it marks a difference wider than that of race with
the prodigious image (81) of anguish and consolation.

Those who were royal and who have declined into helotry
become royal once more, if only briefly, in the eyes of those
whom they bring forth and enslave themselves to. There is the
warmest and deepest kind of delight, and the only answer to
age save those beyond this world, in the portrait of the men
with the baby (83). I feel it is endearing beyond talking of, and
beyond tears. But I do not know of any image so completely
eloquent as that in the last picture (86), of all that is most gra-
cious, great, and resplendent of well-being and of loveliness,
that loving servitude can mean, and bring in blessing. No one
could write, paint, act, dance, or embody in music, the woman's
sheltering and magnanimous arm, or tilt and voice of smiling
head, or bearing and whole demeanor; which are also beyond
and above any joy or beauty which a child could possibly expe-
rience or embody. She is at once the sweetness of life and the
tenderness of death; the soul victorious in the body's world; the
salvation and immortality of innocence.

As I hope the reader will have found, before reading this last
section, the photographs can speak much more eloquently and
honestly for themselves. It is hoped that in some degree this
introduction may have served not only an immediate but a
more general purpose, of helping to open, for some readers, a
further ability to see and enjoy, without the further interference

of words, still other photographs, good and bad, and the ordinary world. For although it would be foolish to hope that a purification of the sense of sight can liberate and save us, any more than anything else is likely to, it might nevertheless do much in restoring us toward sanity, goodwill, calm, acceptance, and joy. Goethe wrote that it is good to think, better to look and think, best to look without thinking. Such photographs as these can do much to show us what he meant.

1946

CHARLES BURCHFIELD

Charles Burchfield (1893–1967) was the first artist to have a one-man show at the Museum of Modern Art—in 1930, when the museum was only a year old. At thirty-seven he was already the master of a fantastical nature poetry, transforming the American countryside into a realm of moonlight and magic. Working mostly in watercolor, Burchfield extended the mystical tradition in American art of which Albert Pinkham Ryder was one of the greatest exemplars, while probably drawing strength from new developments in European paintings, especially Kandinsky's early abstractions. Although he was of an earlier generation than Pollock and Rothko, in the 1940s the romanticism of Burchfield's nature poetry, by turns ecstatic and apocalyptic, registered the same tremors and traumas that were shaping the Abstract Expressionists. Burchfield lived in upstate New York, in and around Buffalo, for nearly half a century. And in the journals that he kept from his youngest days on, he recorded his responses to the natural world in all their intimacy and intensity.

Journals, 1948–50

GARDENVILLE
JULY 1, 1948

A fine windy day, with deep blue sky and an infinite variety of rain & cumulus clouds— . . .

For a time I thought it was going to be one of those futile days, when no spot seems just exactly right, and I drive endlessly on until complete frustration sets in and I must give up and go home. But then I took a road east from a "corners" (unnamed but which was east of Sardinia according to the signs) which soon turned from macadam to a hard gravelled road. I had not gone far until I came to some widespreading hay meadows, enclosed by deep mysterious woods on all points, excepting, of course, the road outlets, and a point in the north, & then to the northwest, where was afforded a view over rolling blue hills (it was from this direction that the great sweeping phalanxes of clouds proceeded). The sides of the road were solid here and I was able to pull clear off the road, and park under a group of small wild cherry and ash trees.

For a time I merely wandered about revelling in the beauty of the day, as a child might, reaching out to get handfuls of the cold wind, and examining each field flower—self-heal, black-eyed susan, pink and alsike clovers, buttercups, white daisies, yellow & white sweet clovers—as if they were the rarest flowers on earth, as indeed they are!—the timothy was just coming into head, a soft silvery green, which the wind, and a strong burst of sunshine turned into glistening white ripples that raced across the meadows with joyous abandon. Sometimes great cumulous clouds piled up into huge towering masses, overhead, blotting out the sun, and casting a deep shadow over the trees and fields that almost seemed as if it could be felt with the hands—To the north white wind clouds, on a background of deep blue black cumuli, were startling & dramatic—a fine North feeling, especially above a low-lying woods.

A barn-swallow (who stayed all afternoon & evening) kept flying low over the meadow, evidently catching insects, darting with seemingly reckless abandon here & there in great long glides, making sharp angled turns or even an about-face in a split second, or turning half over revealing his orange-tinted breast,—a marvelous creature, the epitome of the day—of wind blown meadows in June or July. The longing to do exactly what he was doing became almost too great to bear.

. . . I finally settled on a spot close to the little clump of saplings where the car was parked—an ideal location, of easy access to the car, and out of sight of any one going along the road. I was alone on the earth, in a windy meadow.

All afternoon painting with great joy & abandon, a sort of child's view of a hayfield, a windblown vista framed in by leaning grasses & flowers, in which I introduced the barn-swallow. At times a songsparrow scolded plaintively at my presence; bob-o'links flew up now & then and flooded the field with their tumultuous out-pourings of song (When will I get at the bob-o-link picture? I become almost sick with longing when I think of the many motifs I have not even started). A wonderful episode, when (I hope) the spirit of God touched, however glancingly, the miserable and unworthy clay that forms my person.

Near six o'clock, exhausted & the sketch seeming complete,— I spread some blankets & lay down for a few moments. Altho at times during the afternoon it had been almost chilly, the sun

now shone full from a comparatively open sky, and flooded the earth with warmth. Twice a red admiral alighted on my picture, a beautiful sight.

JULY 3, 1948

A.M. writing in Studio. The glory of Thursday has come back; as I look at the sketch I made, I rejoice in the fact that after 33 years, I have been able to capture again, and bring to completion, an idea that I jotted down in pencil in that rhapsodic summer. Then I experienced the emotion, but had not the experience or language to put it down in concrete terms; now I have these, and thanks to God, the emotional experience was given me again. Much of this came from watching that swallow—wonderful little creature!

GARDENVILLE
AUGUST 23, 1948

Most of day spent in making studies of grasshoppers, & conventionalizations of them, for a projected grasshopper picture.

AUGUST 24, 1948

To Zimmerman Rd. to do the grasshopper picture. An ideal day for it—hot, dry, the air full of insect sounds.

Set up my easel first, at the edge of the swampy pasture at the north side of the woods—then ate lunch.

All afternoon on the painting—unpremeditated was the introduction of a yellow & black spider (Miranda) feeding on a grasshopper. I found it to be an ideal way of working—i.e. on one day to work out the conventionalizations & abstract motifs, then the next to work on the spot, so as to be able to give *life* to the form invented. I worked boldly & with great absorption.

GARDENVILLE
JANUARY 29, 1949

In studio most of the day. Studying pictures. "The Night of the Equinox," "Song of the Telegraph" and "Return of the

Bluebirds"—These all seem like splendid starts, and it seems to me that I must increase their fantasy character still more and reduce or even eliminate any realistic approach. They must be distilled into pure art forms. The blend of realism & conventionalized fantasy is a compromise and they lose power for that reason.

It seems to me, more than ever, imperative that I somehow get these fantasies in finished concrete form even tho there is no sale for them. How we will live, I do not know.

GARDENVILLE
APRIL 1, 1949

A cold cloudy day, wind from the east. With what elation I set forth, my first country sketching trip since last Dec. 4! . . .

By the time I reached the Big Woods, the snow had almost ceased falling. First for a walk in the ravine; a fine moment— the gaunt bare trees, with fine snow falling between, the distances hazed—the rattle of snow on dead leaves, the little brook singing.

Before lunch—I first chose my sketching spot—(planning to do a crow coming from tree tops motif)—I find a suitable spot readily and set up my easel—then back to the car for lunch. Hepaticas just in bud here.

All afternoon on the sketch, with great pleasure, improvising freely & inventing symbols.—The sky cleared about mid afternoon, but I was able to proceed anyway—Finished about six—the sun setting in a blaze of gold behind the wooded hills to the west. I dug a few hepaticas for B to put in a dish, then got a basket of rotten wood for the rhubarb. Then moved the car to the brow of the hill westward and ate my lunch. A pale moonsliver, almost horizontal. Then home. B thought the sketch one of my best.

GARDENVILLE
APRIL 5, 1949

To the "Big Woods"
A gray sombre day; pleasantly cool.
I had in mind an "eye of God" brooding over a landscape

idea, and chose a small woodland pool as the spot for improvising on the theme. In the pool was the ghostly rotting trunk of a fallen white birch. A wind from the S.W. developed presently, and its soft roar thru the treetops was fine to hear. All day on the sketch, with difficulty in fighting a too realistic approach.

After finishing it, several excursions in the woods for rotten wood. The southern wind carried with it the first drops of rain, pleasant in the face.

APRIL 6, 1949

It became apparent this morning that I had been inhibited yesterday in the "eye of God" motif. So after some experimenting, I made it jet black, and the whole picture gained power.

GARDENVILLE
MAY 12, 1949

A few miles beyond Java Village, an open woods attracted me and I stopped to look at it. Here in the woods there was little evidence of the dry weather and the freeze—All was a maze of yellow-green and emerald leaves, shot with golden yellow sunlight. Gradually I came to the decision to paint here. An idea I had last year of showing the transition of spring to summer came to me; using fading trilliums, & spring beauties & hepaticas gone to seed in the foreground, with a vista showing early summer. I set up my easel, then ate my lunch with great happiness and content. A cool north wind tempered the warm sunlight.

As I proceeded with my sketch, it occurred to me to make the extreme foreground & sides to represent very early spring. Shortly after I started I heard the highly individual (but scarcely charming) call of a scarlet tanager,—& I decided to introduce a motive of vivid red & black in the upper branches to denote the swift & elusive passage of this gorgeous bird.

Once, when I was growing tired, I lay down on a patch of dry dead leaves and let the sun flood me with heat & light. It was a delicious sensation.

Finish after five—

GARDENVILLE
JULY 12, 1949

In the night, it suddenly came to me that a picture of count-less butterflies dancing in hot sunlight would be worthwhile.

JULY 14, 1949

First to Zimmerman Road Cont. The north end unspoiled by the "Conservation Societies" building. A lovely wild spot. Mid morning in the woods. For walk across swampy tract to west woods, recalling old memories.

Driving around in this territory trying to find a subject to fit my mood. Finally, by the hillroad to Genesee road & thence southward toward Springville. Dark under the maples that line the road here.

A wonderful day. Large patch of milkweed in bloom on op-posite side of road (enclosed by old apple trees). Countless butterflies sipping honey—the "butterfly dance" come true. Great tiger swallowtails (I counted them, never less than eight or more than 14), Monarchs, one black swallowtail, & countless silver-spots, bees, and one hummingbird hawk-moth. Every so often the silverspots and more rarely the others, would all fly up and chase each other furiously in small circles. The swallow-tails kept to themselves, usually at one end of the patch. Once I saw five on one plant. The odor of the flowers was too sweet to be borne long.

GARDENVILLE
OCTOBER 26, 1949

A water-color (16 x 48) of the transition of Fall to Winter—which I have been dreaming about ever since the Art School Days. A fantasy—it came off very well. The final form came to me as I lay listening to Sunday's concert.

GARDENVILLE
APRIL 4, 1950

A warm sunshine and shower day, with occasional gusts of wind.

How good it was to be out again, to be "going out painting"— . . .

Arrived at the woods about noon. The sun shining—a strong warm S.W. wind. For a little walk. A bluebird in a field to the left and so, crossing the fence, I went toward it. He settled on a fence post and I was able to get very close and revel in his color to my heart's content. From time to time he flew down to the ground, singing his soft elusive song,—It is always a new-born miracle.

Westward to the old rail fence & then back for lunch, having picked out a spot in the woods for my afternoon's painting.

I had planned to do a song of the song-sparrow coming into a woods, but as the sky became over-cast and a strong wind began its roaring in the tree tops, I changed and decided to try to paint the roar of the wind in the woods. A fine afternoon—At times the wind ceased altogether and a great calm settled over the woods; then in a distant part a soft roaring would commence and grow louder & louder & soon all the trees about me would be clashing & swaying majestically back & forth like inverted pendulums. Soon it began to rain and I had to get the big umbrella. As the day wore on my ideas changed & I began to improvise on other themes, such as wind-blown leaves dancing over the floor of the woods, and big rain-drops hitting them with a great clatter. Bits of sunlight entering into "windows" of the woods, great hemlocks bending before the force of the wind, the branches overhead clashing in anger at the menacing clouds. Will I ever truly be able to express the elemental power & beauty of God's woods?

GARDENVILLE
SEPTEMBER 9, 1950

All day on the Gate-way to September putting in the huge "Insect-Tree" in the August part. For the first time in weeks I let myself go in improvisation and fantasy.

GARDENVILLE
OCTOBER 18, 1950

Out sketching in the "Big Woods"—

A wonderful feeling to be out again after not having painted for so long a time—

A cool sunny day, quiet generally, but at times a strong wind passed thru the tree-tops, and in its wake showers of golden maple leaves fluttered lazily down to the ground. Young hemlocks speckled with leaves.

I worked on a theme that came to me last month—that of a woodland stream, swollen by a heavy fall shower, carrying gay colored leaves as it tumbled down a ravine over rocks and rotting logs. In the background I put a crescent shaped opening in the woods with brilliant sunshine beyond; and had shafts of sunlight slanting down thru the trees.—

Altho I was "rusty"—it was pleasant working. The woods seemed to be full of all sorts of little creatures, mostly chipmunks or grinnies—they kept up a perpetual rustling with their erratic antics, and occasional shrill barking. A few nuthatches.

ROBERT M. COATES

From the 1930s to the 1960s, Robert M. Coates (1897–1973) wrote about art for *The New Yorker*, bringing an easygoing, temperate voice to subjects ranging from the historical to the contemporary; he also contributed fiction to the magazine and published a number of well-received novels and nonfiction books. When Coates is remembered today it is often as the first writer to describe the new work of Pollock and de Kooning as Abstract Expressionist. His strengths as a reviewer were more as a chronicler of events than as an innovative analyst of particular works of art, but as a chronicler he deserves to be more studied than he is. His accounts of now legendary exhibitions—such as *Modern Art in Your Life*, at the Museum of Modern Art in 1949, included here—demonstrate a remarkable ability to describe a museumgoer's immediate experience. And historians who have come to regard American avant-garde art as Cold War propaganda sent overseas with the full support of the U.S. government ought to consider a column that he published in *The New Yorker* in June 1948, about "an extraordinarily violent campaign to discredit" a collection of oil paintings and watercolors assembled by the U.S. State Department. "A sort of drumhead investigation," Coates writes, "was instituted by Congress, during which a number of congressmen made passionately idiotic statements and some higher dignitaries, including even President Truman, made blandly foolish ones, and the State Department was forced to cancel the art part of its project and recall the paintings, which were already on tour." Coates's conclusion was that both the government and the public were "not only ignorant of but positively frightened by modern art." "This campaign," Coates observed only a few years after Hitler's defeat, "was reminiscent of the ones, once popular in Germany, that were based on the notion that all 'modern' artists are Communistic and their work subversive." Coates couldn't help feeling that the art critics were at least partly to blame. "To any critic interested in the advancement of art, it represented a defeat."

Mondrian, Kleenex, and You

THE MUSEUM of Modern Art, for its season's opener, has put on a large crowded exhibition called "Modern Art in Your Life," which sets out to illustrate, in some detail, how the theories of modern painting and sculpture have affected contemporary living. Such a showing, it seems to me, was overdue, and if this

Paul Rand: Cover of catalog for *Modern Art in Your Life*, 1949.

one doesn't entirely succeed in its effort, it should be given credit for a fairly good try. As I have now and then pointed out myself, one of the oddest paradoxes of our time is that the very people who denounce modern art as purposeless, meaningless, and unattractive, or even in some way immoral, are at the same moment, without realizing it, allowing their tastes to be changed by it and their buying habits influenced by it. I'm not talking just of the penetration of tubular furniture into the home. For that matter, tubular stuff is now old hat, and the best modern designers are using plastics, molded or laminated wood, and other more tractable materials. What I mean to say

is that the bold simplicity and clarity of abstract painting and the instant evocativeness of Surrealism have turned out to have practical uses, and there is hardly an industrial designer, whether of fountain pens, kitchen utensils, desk lamps, posters, or window displays (I except only motorcars, and you know what a mess they're in), who doesn't lean heavily on one of these two schools for inspiration. This does not of itself establish Piet Mondrian, Jean Arp, and Salvador Dalí as great artists. But it does prove that the formal principles on which their work is based have much more than mere esoteric value, and it makes a little ridiculous the man who grows red-faced at the sight of a Mondrian while placidly accepting a box of Kleenex obviously designed with the work of that artist in mind.

In the exhibition, you'll find two Mondrians and a Kleenex box, as well as a number of other items demonstrating commercial-artistic affinities. There are also a bookcase designed by George Nelson, a house designed by Marcel Breuer, and an interior by Otto Haessler (these last two represented by photographs, of course) that show how far and in how many directions the influence of Mondrian and the other early Purists has extended; and there are a Shell gasoline ad and a French railway poster that show more than a casual relationship with Léger's "Petit Déjeuner" and Le Corbusier's abstract "Oil on Canvas," which hang nearby. There's an ad for American Overseas Airlines that is pure Dalí, even to the distorted watches (his "The Persistence of Memory" is presented to point up the resemblance), and a small occasional table that is as much Calder as is his stabile called "Spiny," which is included. Jean Arp and Joan Miró are represented, respectively, by a painted-wood relief called "Two Heads" and an early but charmingly fanciful "Composition," and they are echoed by an extremely Arpish cover design for a Columbia record album and an equally Miróesque jacket design for an edition of Rimbaud's poems put out by New Directions.

It should be noted that these comparisons are not meant invidiously, nor does the show present them in that fashion; commercial artists, working in their role of popularizers, have drawn on "pure" art for their motivations since the days of the Pre-Raphaelites. In fact, the emphasis of the exhibition is on trends instead of individuals. As if to make sure of this, the fine-arts

section of paintings, sculpture, and so on is all grouped in one room and divided into Surrealism and abstraction (the latter subdivided into "geometric" and "organic" schools), while the three main industrial trends deriving from each of these are illustrated in a series of small rooms at the sides. This scheme of things has the advantage of discretion, and it emphasizes the varied fields of design in which these schools of art have had their principal effect. The "pure," or geometric, abstractionists, from van Doesburg and Mondrian on, have been most influential on architecture, as the organic men have influenced furniture and other household design and the Surrealists posters and other forms of advertising. There are overlappings, of course, and it seems to me that by ignoring them the show has become arbitrary and confusing. How explain the presence of Miró among the organic abstractionists when he is supposed to be a Surrealist, and how justify placing Braque's "Oval Still Life" in the organic group when Le Corbusier's very similar "Still Life" is labelled "geometric"? The industrial part of the Surrealist section is given over almost entirely to full-scale recreations of Bonwit Teller, Saks Fifth Avenue, and Lord & Taylor windows—a stunt that, though dramatic, overlooks a number of other uses to which Surrealism has been put.

The show has a hasty and helter-skelter air. This, I am sure, derives not from careless planning but from its overemphasis on sheer contemporaneity. The modern-art movement is well over a third of a century old, and so are its commercial uses, and it seems to me that if some light had been thrown on the historical background—say, the early influence of the DeStijl group on typography or of such men as van Doesburg and Gabo on architecture—the exhibit would have had a depth and dignity that are lacking. Even so, it's a lively and interesting event, and it contains a number of pieces that are worth looking at purely as art. In addition to the ones I've mentioned, I would suggest Yves Tanguy's dark "Always Slowly Toward the North," Kurt Seligmann's "Sabbath Phantoms," and Max Ernst's "Napoleon in the Wilderness," all of them in the Surrealist section, as well as the small Archipenko "Standing Woman," Ben Nicholson's "Relief," and Amédée Ozenfant's early "The Vases," among the abstractions.

1949

WILLEM DE KOONING

The poet Robert Creeley called him "Bill the King"—in part because *king* is what *koenig* means in Dutch, but mostly because in the 1950s he was the king of avant-garde New York. De Kooning (1904–1997) was twenty when he arrived in the United States in 1924, a stowaway from his native Holland. By the time he had his first one-man show—of gritty, lyrical black-and-white abstractions, at the Charles Egan Gallery in 1948—he was already a defining figure in the new American art. He was revered for his toughness, his persistence, his skepticism, and his grace—all of which he expressed through paintings by turns violent and gentle, raucous and poetic, representational and abstract. "Content is a glimpse," de Kooning once observed. And both his paintings and his ideas have some of the quality of quick, intense glimpses—although the glimpses were often deeply pondered. His oracular pronouncements were made all the more enigmatic by his thick Dutch accent; those who listened to de Kooning at the Cedar Tavern couldn't be sure if he was talking about "faith" or "fate." He rarely committed himself to print, save for these two statements, both from the beginning of the 1950s; one published in the short-lived artists' magazine *trans/formation*, the other prepared for a symposium at the Museum of Modern Art. In 1952 he completed *Woman I*, the startling erotic—or is it anti-erotic?—totem that riled many of the Abstract Expressionists. What would he do next? For the rest of his working life—he died after a long struggle with Alzheimer's—de Kooning moved between representation and abstraction and the figure and the landscape, an explorer who had foretold his own ambiguous quest way back in 1951, when he said that "spiritually I am wherever my spirit allows me to be."

The Renaissance and Order

In the Renaissance, when people—outside of being hung or crucified—couldn't die in the sky yet, the ideas a painter had always took place on earth. He had this large marvelous floor that he worked on. So if blood was on a sword, it was no accident. It meant that someone was dying or dead.

It was up to the artist to measure out the exact space for that person to die in or be dead already. The exactness of the space was determined or, rather, inspired by whatever reason the person was dying or being killed for. The space thus measured out on the original plane of the canvas surface became a

Harry Bowden: de Kooning in his studio on Fourth
Avenue, 1946.

"place" somewhere on that floor. If he were a good painter, he
did not make the center of the end of that floor—the vanishing
point on the horizon—the "content" (as the philosophers and
educators of commercial art want to convince us nowadays that
they did). The "content" was his way of making the happening
on the floor measurable from as many angles as possible instead.
The main interest was how deep the happening—and the floor
itself—could be or ought to be. The concept he had about
the so-called "subject" established the depth; and with that he
eventually found how high it was and how wide. It was not the
other way around. He wasn't Alice looking into the Looking
Glass. The scene wasn't there yet. He still had to make it.

Perspective, then, to a competent painter, did not mean an
illusionary trick. It wasn't as if he were standing in front of his
canvas and needed to imagine how deep the world could be.
The world was deep already. As a matter-of-fact, it was depth
which made it possible for the world to be there altogether.

He wasn't so abstract as to take the hypotenuse of a two-dimensional universe. Painting was more intellectual than that. It was more intriguing to imagine himself busy on that floor of his—to *be*, so to speak, on the inside of his picture. He took it for granted that he could only measure things subjectively, and it was logical therefore that the best way was from the inside. It was the only way he could eventually project all the happenings on the frontmost plane. He became, in a way, the idea, the center, and the vanishing point himself—and all at the same time. He shifted, pushed, and arranged things in accordance with the way he felt about them. Sure they were not all the same to him. His idea of balance was a "wrought" one or a "woven" one. He loved something in one corner as much as he hated something in another. But he never became the things himself, as is usually said since Freud. If he wanted to, he could become one or two sometimes, but he was the one that made the decision. As long as he kept the original idea in mind, he could both invent the phenomena and inspect them critically at the same time. Michelangelo invented Adam that way, and even God.

In those days, you were subjective to yourself, not to somebody else. If the artist was painting St. Sebastian, he knew very well he wasn't St. Sebastian—nor was he one of the torturers. He didn't understand the other fellow's face because he was painting his own: he understood it better because he himself had a face. He could never become completely detached. He could not get man out of his mind.

There must be something about us, he thought, that determines us to have a face, legs and arms, a belly, nose, eyes and mouth. He didn't even mind that people were flesh-colored. Flesh was very important to a painter then. Both the church and the state recognized it. The interest in the difference of textures—between silk, wood, velvet, glass, marble—was there *only in relation to flesh*. Flesh was the reason why oil painting was invented. Never before in history had it taken such a place in painting. For the Egyptians, it was something that didn't last long enough; for the Greeks, it—and everything else—took on the texture of painted marble and plaster walls. But for the Renaissance artist, flesh was the stuff people were made of. It was because of man, and not in spite of him, that painting was considered an art.

Art was also tied up with effort. Man, and all the things around him, and all that possibly could happen to him—either going to heaven or hell—were not there because the artist was interested in designing. On the contrary, he was designing because all those things and himself too were in this world already. That was his great wonder. The marvel wasn't just what he made himself, but what was there already. He knew there was something more remarkable than his own ability. He wasn't continuously occupied with the petulant possibilities of what "mankind" ought to do. If they were beating something, it wasn't their own breasts all the time. You can see for yourself that he was completely astonished. Never a pose was taken. Everything was gesture. Everything in these paintings "behaved." The people were doing something; they looked, they talked to one another, they listened to one another, they buried someone, crucified someone else. The more painting developed, in that time, the more it started shaking with excitement. And very soon they saw that they needed thousands and thousands of brush-strokes for that—as you can see for yourself in Venetian painting.

The drawing started to tremble because it wanted to go places. The artist was too perplexed to be sure of himself. How do we know, he thought, that everything is really not still, and only starts moving when we begin to look at it? Actually there was no "subject-matter." What we call subject-matter now, was then painting itself. Subject matter came later on when parts of those works were taken out arbitrarily, when a man for no reason is sitting, standing or lying down. He became a bather; she became a bather; she was reclining; he just stood there looking ahead. That is when the posing in painting began. When a man has no other meaning than that he is sitting, he is a *poseur*. That's what happened when the burghers got hold of art, and got hold of man, too, for that matter. For really, when you think of all the life and death problems in the art of the Renaissance, who cares if a Chevalier is laughing or that a young girl has a red blouse on.

It seems that so far, I have a chip on my shoulder. If I brought up Renaissance painting, it is not out of regret or because I think that we lost something. I do feel rather horrified when I hear people talk about Renaissance painting as if it were some

kind of buck-eye painting good only for kitchen calendars. I did it also because it is impossible for me ever to come to the point. But when I think of painting today, I find myself always thinking of that part which is connected with the Renaissance. It is the vulgarity and fleshy part of it which seems to make it particularly Western. Well, you could say, "Why should it be Western?" Well, I'm not saying it should.

But, it is because of Western civilization that we can travel now all over the world and I, myself, am completely grateful for being able to sit in this ever-moving observation car, able to look in so many directions. But I also want to know where I'm going. I don't know exactly where it is, but I have my own track. I'm not always sure I'm on it, but sometimes I think I am.

In a recent issue of *Life* magazine (the half-century number), it is the pages on art which made it obvious that we are in the right direction. Everything else is dated. I mean this of course in relation to what was presented in that issue. Different directions in art were presented but, for my part, I picked Marcel Duchamp.

There is a train track in the history of art that goes way back to Mesopotamia. It skips the whole Orient, the Mayas and American Indians. Duchamp is on it. Cézanne is on it. Picasso and Cubists are on it; Giacometti, Mondrian and so many, many more—whole civilizations. Like I say, it goes way in and back to Mesopotamia for maybe 5,000 years, so there is no sense in calling out names. The reason I mention Duchamp is because he was one of the artists in *Life*'s half-century number. But I have some feeling about all these people—millions of them—on this enormous track, way into history. They had a peculiar way of measuring. They seemed to measure with a length similar to their own height. For that reason they could imagine themselves in almost any proportions. That is why I think Giacometti's figures are like real people. The idea that the thing that the artist is making can come to know for itself, how high it is, how wide and how deep it is, is a historical one—a traditional one I think. It comes from man's own image.

I admit I know little of Oriental art. But that is because I cannot find in it what I am looking for, or what I am talking about. To me the Oriental idea of beauty is that "it isn't here." It is in a state of not being here. It is absent. That is why it is so

good. It is the same thing I don't like in Suprematism, Purism and non-objectivity.

And, although I, myself, don't care for all the pots and pans in the paintings of the burghers—the genre scenes of goodly living which developed into the kind sun of Impressionism later on—I do like the idea that they—the pots and pans, I mean— are always in relation to man. They have no soul of their own, like they seem to have in the Orient. For us, they have no character; we can do anything we please with them. There is this perpetual irritability. Nature, then, is just nature. I admit I am very impressed with it.

The attitude that nature is chaotic and that the artist puts order into it is a very absurd point of view, I think. All that we can hope for is to put some order into ourselves. When a man ploughs his field at the right time, it means just that.

Insofar as we understand the universe—if it can be understood —our doings must have some desire for order in them; but from the point of view of the universe, they must be very grotesque. As a matter-of-fact, the idea of "order" reminds me of something Jack Tworkov was telling me that he remembered of his childhood.

There was the village idiot. His name was Plank and he measured everything. He measured roads, toads, and his own feet; fences, his nose and windows, trees, saws and caterpillars. Everything was there already to be measured by him. Because he was an idiot, it is difficult to think in terms of how happy he was. Jack says he walked around with a very satisfied expression on his face. He had no nostalgia, neither a memory nor a sense of time. All that he noticed about himself was that his length changed!

1950

What Abstract Art Means to Me

THE first man who began to speak, whoever he was, must have intended it. For surely it is talking that has put "Art" into painting. Nothing is positive about art except that it is a word. Right from there to here all art became literary. We are not yet living

in a world where everything is self-evident. It is very interesting to notice that a lot of people who want to take the talking out of painting, for instance, do nothing else but talk about it. That is no contradiction, however. The art in it is the forever mute part you can talk about forever.

For me, only one point comes into my field of vision. This narrow, biased point gets very clear sometimes. I didn't invent it. It was already here. Everything that passes me I can see only a little of, but I am always looking. And I see an awful lot sometimes.

The word "abstract" comes from the light-tower of the philosophers, and it seems to be one of their spotlights that they have particularly focused on "Art." So the artist is always lighted up by it. As soon as it—I mean the "abstract"—comes into painting, it ceases to be what it is as it is written. It changes into a feeling which could be explained by some other words, probably. But one day, some painter used "Abstraction" as a title for one of his paintings. It was a still life. And it was a very tricky title. And it wasn't really a very good one. From then on

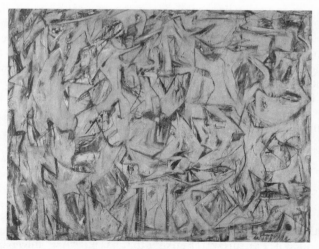

Willem de Kooning: *Excavation*, 1950. Oil on canvas, 81 × 100¼ in.

the idea of abstraction became something extra. Immediately it gave some people the idea that they could free art from itself. Until then, Art meant everything that was in it—not what you could take out of it. There was only one thing you could take out of it sometime when you were in the right mood—that abstract and indefinable sensation, the esthetic part—and still leave it where it was. For the painter to come to the "abstract" or the "nothing," he needed many things. Those things were always things in life—a horse, a flower, a milkmaid, the light in a room through a window made of diamond shapes maybe, tables, chairs, and so forth. The painter, it is true, was not always completely free. The things were not always of his own choice, but because of that he often got some new ideas. Some painters liked to paint things already chosen by others, and after being abstract about them, were called Classicists. Others wanted to select the things themselves and, after being abstract about them, were called Romanticists. Of course, they got mixed up with one another a lot too. Anyhow, at that time, they were not abstract about something which was already abstract. They freed the shapes, the light, the color, the space, by putting them into concrete things in a given situation. They *did* think about the possibility that the things—the horse, the chair, the man—were abstractions, but they let that go, because if they kept thinking about it, they would have been led to give up painting altogether, and would probably have ended up in the philosopher's tower. When they got those strange, deep ideas, they got rid of them by painting a particular smile on one of the faces in the picture they were working on.

The esthetics of painting were always in a state of development parallel to the development of painting itself. They influenced each other and vice versa. But all of a sudden, in that famous turn of the century, a few people thought they could take the bull by the horns and invent an esthetic beforehand. After immediately disagreeing with each other, they began to form all kinds of groups, each with the idea of freeing art, and each demanding that you should obey them. Most of these theories have finally dwindled away into politics or strange forms of spiritualism. The question, as they saw it, was not so much what you *could* paint but rather what you could *not* paint. You could *not* paint a house or a tree or a mountain. It

was then that subject matter came into existence as something you ought *not* to have.

In the old days, when artists were very much wanted, if they got to thinking about their usefulness in the world, it could only lead them to believe that painting was too worldly an occupation and some of them went to church instead or stood in front of it and begged. So what was considered too worldly from a spiritual point of view then, became later—for those who were inventing the new esthetics—a spiritual smoke-screen and not worldly enough. These latter-day artists were bothered by their apparent uselessness. Nobody really seemed to pay any attention to them. And they did not trust that freedom of indifference. They knew that they were relatively freer than ever before *because* of that indifference, but in spite of all their talking about freeing art, they really didn't mean it that way. Freedom to them meant to be useful in society. And that is really a wonderful idea. To achieve that, they didn't need *things* like tables and chairs or a horse. They needed ideas instead, social ideas, to make their objects with, their constructions—the "pure plastic phenomena"—which were used to illustrate their convictions. Their point was that until they came along with their theories, Man's own form in space—his body—was a private prison; and that it was because of this imprisoning misery—because he was hungry and overworked and went to a horrid place called home late at night in the rain, and his bones ached and his head was heavy—because of this very consciousness of his own body, this sense of pathos, they suggest, he was overcome by the drama of a crucifixion in a painting or the lyricism of a group of people sitting quietly around a table drinking wine. In other words, these estheticians proposed that people had up to now understood painting in terms of their own private misery. Their own sentiment of form instead was one of comfort. The beauty of comfort. The great curve of a bridge was beautiful because people could go across the river in comfort. To compose with curves like that, and angles, and make works of art with them could only make people happy, they maintained, for the only association was one of comfort. That millions of people have died in war since then, because of that idea of comfort, is something else.

This pure form of comfort became the comfort of "pure form." The "nothing" part in a painting until then—the part that was not painted but that was there because of the things in the picture which were painted—had a lot of descriptive labels attached to it like "beauty," "lyric," "form," "profound," "space," "expression," "classic," "feeling," "epic," "romantic," "pure," "balance," etc. Anyhow that "nothing" which was always recognized as a particular something—and as something particular—they generalized, with their book-keeping minds, into circles and squares. They had the innocent idea that the "something" existed "in spite of" and not "because of" and that this something was the only thing that truly mattered. They had hold of it, they thought, once and for all. But this idea made them go backward in spite of the fact that they wanted to go forward. That "something" which was not measurable, they lost by trying to make it measurable; and thus all the old words which, according to their ideas, ought to be done away with got into art again: pure, supreme, balance, sensitivity, etc.

Kandinsky understood "Form" as *a* form, like an object in the real world; and an object, he said, was a narrative—and so, of course, he disapproved of it. He wanted his "music without words." He wanted to be "simple as a child." He intended, with his "inner-self," to rid himself of "philosophical barricades" (he sat down and wrote something about all this). But in turn his own writing has become a philosophical barricade, even if it is a barricade full of holes. It offers a kind of Middle-European idea of Buddhism or, anyhow, something too theosophic for me.

The sentiment of the Futurists was simpler. No space. Everything ought to keep on going! That's probably the reason they went themselves. Either a man was a machine or else a sacrifice to make machines with.

The moral attitude of Neo-Plasticism is very much like that of Constructivism, except that the Constructivists wanted to bring things out in the open and the Neo-Plasticists didn't want anything left over.

I have learned a lot from all of them and they have confused me plenty too. One thing is certain, they didn't give me natural aptitude for drawing. I am completely weary of their ideas now.

The only way I still think of these ideas is in terms of the

individual artists who came from them or invented them. I still think that Boccioni was a great artist and a passionate man. I like Lissitzky, Rodchenko, Tatlin and Gabo; and I admire some of Kandinsky's painting very much. But Mondrian, that great merciless artist, is the only one who had nothing left over.

The point they all had in common was to be both inside and outside at the same time. A new kind of likeness! The likeness of the group instinct. All that it has produced is more glass and an hysteria for new materials which you can look through. A symptom of love-sickness, I guess. For me, to be inside and outside is to be in an unheated studio with broken windows in the winter, or taking a nap on somebody's porch in the summer.

Spiritually I am wherever my spirit allows me to be, and that is not necessarily in the future. I have no nostalgia, however. If I am confronted with one of those small Mesopotamian figures, I have no nostalgia for it but, instead, I may get into a state of anxiety. Art never seems to make me peaceful or pure. I always seem to be wrapped in the melodrama of vulgarity. I do not think of inside or outside—or of art in general—as a situation of comfort. I know there is a terrific idea there somewhere, but whenever I want to get into it, I get a feeling of apathy and want to lie down and go to sleep. Some painters, including myself, do not care what chair they are sitting on. It does not even have to be a comfortable one. They are too nervous to find out where they ought to sit. They do not want to "sit in style." Rather, they have found that painting—any kind of painting, any style of painting—to be painting at all, in fact—is a way of living today, a style of living, so to speak. That is where the form of it lies. It is exactly in its uselessness that it is free. Those artists do not want to conform. They only want to be inspired.

The group instinct could be a good idea, but there is always some little dictator who wants to make his instinct the group instinct. There *is* no style of painting now. There are as many naturalists among the abstract painters as there are abstract painters in the so-called subject-matter school.

The argument often used that science is really abstract, and that painting could be like music and, for this reason, that you cannot paint a man leaning against a lamp-post, is utterly ridiculous. That space of science—the space of the physicists—I am truly bored with by now. Their lenses are so thick that

seen through them, the space gets more and more melancholy. There seems to be no end to the misery of the scientists' space. All that it contains is billions and billions of hunks of matter, hot or cold, floating around in darkness according to a great design of aimlessness. The stars *I* think about, if I could fly, I could reach in a few old-fashioned days. But physicists' stars I use as buttons, buttoning up curtains of emptiness. If I stretch my arms next to the rest of myself and wonder where my fingers are—that is all the space I need as a painter.

Today, some people think that the light of the atom bomb will change the concept of painting once and for all. The eyes that actually saw the light melted out of sheer ecstasy. For one instant, everybody was the same color. It made angels out of everybody. A truly Christian light, painful but forgiving.

Personally, I do not need a movement. What was given to me, I take for granted. Of all movements, I like Cubism most. It had that wonderful unsure atmosphere of reflection—a poetic frame where something could be possible, where an artist could practise his intuition. It didn't want to get rid of what went before. Instead it added something to it. The parts that I can appreciate in other movements came out of Cubism. Cubism *became* a movement, it didn't set out to be one. It has force in it, but it was no "force-movement." And then there is that one-man movement, Marcel Duchamp—for me a truly modern movement because it implies that each artist can do what he thinks he ought to—a movement for each person and open for everybody.

If I *do* paint abstract art, that's what abstract art means to me. I frankly do not understand the question. About twenty-four years ago, I knew a man in Hoboken, a German who used to visit us in the Dutch Seamen's Home. As far as he could remember, he was always hungry in Europe. He found a place in Hoboken where bread was sold a few days old—all kinds of bread: French bread, German bread, Italian bread, Dutch bread, Greek bread, American bread and particularly Russian black bread. He bought big stacks of it for very little money, and let it get good and hard and then he crumpled it and spread it on the floor in his flat and walked on it as on a soft carpet. I lost sight of him, but found out many years later that one of the other fellows met him again around 86th street. He had

become some kind of a Jugend Bund leader and took boys and girls to Bear Mountain on Sundays. He is still alive but quite old and is now a Communist. I could never figure him out, but now when I think of him, all that I can remember is that he had a very abstract look on his face.

1951

EDWIN DENBY

Nobody else has written about artistic New York with quite the combination of precision and boldness we know from Edwin Denby's work. Born in China, Denby (1903–1983) had a career in Europe as a modern dancer in the 1920s, and moved to the United States in the early 1930s, where he eventually made his mark as the greatest dance critic of the day as well as a poet much admired by those who treasure idiosyncratic diction and atmospheric elegance. Denby and his lifelong friend, the photographer Rudy Burckhardt, were close to de Kooning in the 1930s—they had met when de Kooning's cat turned up on the fire escape outside their Chelsea loft—and they used their small independent incomes to become the first serious collectors of his work. Denby's dance criticism—first collected in *Looking at the Dance* (1949) and *Dancers, Buildings, and People in the Streets* (1965)—offers what has long been recognized as one of the essential chronicles of George Balanchine's creative zenith in New York. But Denby's interests ranged far beyond classical ballet. He was attentive to the work of Paul Taylor, Merce Cunningham, and Robert Wilson, and long before his death he was a legendary figure in bohemian New York, his circle of friends ranging from Arshile Gorky in the 1930s to Franz Kline in the 1950s to Frank O'Hara and Alex Katz in the 1960s. Denby only published three essays about the visual artists he knew, but when taken together with his poems devoted to de Kooning, Kline, and Katz, they comprise an imperishable record of bohemian Manhattan.

The Thirties

Pat Pasloff asked me to write something for the show about New York painting in the thirties, how it seemed at the time. The part I knew, I saw as a neighbor. I met Willem de Kooning on the fire escape, because a black kitten lost in the rain cried at my fire door, and after the rain it turned out to be his kitten. He was painting on a dark eight-foot high picture that had sweeps of black across it and a big look. That was early in '36. Soon Rudy Burckhardt and I kept meeting Bill at midnight at the local Stewart's, and having a coffee together. Friends of his often showed up, and when the cafeteria closed we would go to Bill's loft in the next street and talk some more and make coffee. I remember people talking intently and listening intently

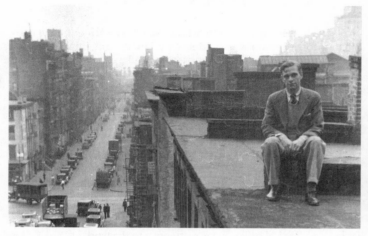

Rudy Burckhardt: Edwin Denby sitting on a roof, 1930s.

and then everybody burst out laughing and started off intent on another tack. Seeing the pictures more or less every day, they slowly became beautiful, and then they stayed beautiful. I didn't think of them as painting of the New York School, I thought of them as Bill's pictures.

These early ones are easy to get into now from the later point of view of the New York School. At the time, from the point of view of the School in Paris, they were impenetrable. The resemblances to Picasso and Miro were misleading, because where they led one to expect seduction and climax, one saw instead a vibration. To start from Mondrian might have helped. One could not get into the picture by way of any detail, one had to get into it all at once, so to speak. It often took me several months to be able to.

I remember walking at night in Chelsea with Bill during the depression, and his pointing out to me on the pavement the dispersed compositions—spots and cracks and bits of wrappers and reflections of neon-light—neon-signs were few then—and I remember the scale in the compositions was too big for me to see it. Luckily I could imagine it. At the time Rudy Burckhardt

was taking photographs of New York that keep open the moment its transient buildings spread their unknown and unequalled harmonies of scale. I could watch that scale like a magnanimous motion on these undistorted photographs; but in everyday looking about, it kept spreading beyond the field of sight. At the time we all talked a great deal about scale in New York, and about the difference of instinctive scale in signs, painted color, clothes, gestures, everyday expressions between Europe and America. We were happy to be in a city the beauty of which was unknown, uncozy, and not small scale.

While we were talking twenty years ago, I remembered someone saying, "Bill, you haven't said a word for half an hour." "Yes," he answered, his voice rising like a New Yorker's to falsetto with surprise, "I was just noticing that, too." He was likely to join in the talk by vehemently embracing a suggestion or vehemently rejecting it. Right off he imagined what it would be like to act on it and go on acting on it. He didn't, like a wit, imitate the appearance of acting on it; he committed himself full force to what he was imagining. As he went on, characteristic situations in his life or those of friends came back to him as vividly as if they had just happened. He invented others. Objections he accepted, or circumvented, or shouted his opposition to. He kept heading for the image in which a spontaneous action had the force of the general ideas involved. And there he found the energy of contradictory actions. The laugh wasn't ridiculousness, but the fun of being committed to the contrary. He was just as interested in the contrary energy. Self protection bored him.

In the talk then about painting, no doctrine of style was settled at Bill's. He belligerently brought out the mysterious paradoxes left over. In any style he kept watching the action of the visual paradoxes of painting—the opposition of interchangeable centers, or a volume continued as a space, a value balancing a color. He seemed to consider in them a craft by which the picture seen as an image unpredictably came loose, moved forward and spread. On the other hand, his working idea at the time was to master the plainest problems of painting. I often heard him say that he was beating his brains out about connecting a figure and a background. The basic connection he meant seemed to me a motion from inside them that they

interchanged and that continued throughout. He insisted on
it during those years stroke by stroke and gained a virtuoso's
eye and hand. But he wanted everything in the picture out of
equilibrium except spontaneously all of it. That to him was
one objective professional standard. That was form the way the
standard masterpieces had form—a miraculous force and weight
of presence moving from all over the canvas at once.

Later, I saw in some Greek temples contradictory forces op-
erating publicly at full speed. Reading the *Iliad*, the poem at
the height of reason presented the irrational and subjective, self-
contradictory sweep of action under inspiration. I had missed
the point in the talks in 22nd Street. The question Bill was
keeping open with an enduring impatience had been that of
professional responsibility toward the force of inspiration. That
force or scale is there every day here where everybody is. Whose
responsibility is it, if not your own? What he said, was "All an
artist has left to work with is his self-consciousness."

From such a point of view the Marxist talk of the thirties was
one-track. The generous feeling in it was stopped by a rigid
perspective, a single center of action, and by jokes with only one
side to them. If one overlooked that, what was interesting was
the peremptoriness and the paranoia of Marxism as a ferment
or method of rhetoric. But artists who looked at painting were
used to a brilliance in such a method on the part of the Paris
surrealists and to a surrealist humor that the political talk did
not have. Politically everybody downtown was anti-fascist, and
the talk went on peacefully. Then when friends who had fought
in Spain returned, their silence made an impression so direct
that the subject was dropped. Against everybody's intention it
had become shameless.

In the presence of New York at the end of the thirties, the
paranoia of surrealism looked parlor-sized or arch. But during
the war Bill told me he had been walking uptown one afternoon
and at the corner of 53rd and 7th he had noticed a man across
the street who was making peculiar gestures in front of his face.
It was Breton and he was fighting off a butterfly. A butterfly
had attacked the Parisian poet in the middle of New York. So
hospitable nature is to a man of genius.

Talking to Bill and to Rudy for many years, I found I did not
see with a painter's eye. For me the after-image (as Elaine de

Kooning has called it) became one of the ways people behave together, that is, a moral image. The beauty Bill's depression pictures have kept reminds me of the beauty that instinctive behavior in a complex situation can have—mutual actions one has noticed that do not make one ashamed of one's self, or others, or of one's surroundings either. I am assuming that one knows what it is to be ashamed. The joke of art in this sense is a magnanimity more steady than one notices in everyday life, and no better justified. Bill's early pictures resemble the later ones in that the expression of character the picture has seems to me of the same kind in early and later ones, though the scope of it and the performance in later ones becomes prodigious.

The general look of painting today strikes me as seductive. It makes the miles of New York galleries as luxurious to wander through as a slave market. Room after room, native or imported, the young prosperity pictures lift their intelligent eyes to the buyer and tempt him with an independent personality. The honest critics, as they pass close to a particularly luscious one, give it a tweak in the soft spots. The picture pinches them in return. At the end of a day's work, a critic's after-images are black and blue. It takes more character to be serious now.

Twenty years ago Bill's great friend was Gorky. I knew they talked together about painting more than anyone else. But when other people were at Bill's, Gorky said so little that he was often forgotten. At one party the talk turned to the condition of the painter in America, the bitterness and unfairness of his poverty and disregard. People had a great deal to say on the subject, and they said it, but the talk ended in a gloomy silence. In the pause, Gorky's deep voice came from under a table. "Nineteen miserable years have I lived in America." Everybody burst out laughing. There was no whine left. Gorky had not spoken of justice, but of fate, and everybody laughed open-hearted.

At a WPA art occasion, I heard that LaGuardia had made a liberal speech about art and society. After the applause, Gorky who was on the reception committee stepped forward unexpectedly and began, "Your Honor, you know about government, and I know about art." Short LaGuardia looked at tall Gorky, who was earnestly contradicting him in a few sentences. I imagine he saw Gorky's seedy sport-clothes and the exhilarating nobility of his point of view and valued them. Maybe he

felt like laughing happily the way we did. The last time I saw Gorky, not long after the war, he was sitting with Bill and Elaine in the diner that used to be at Sixth Avenue across from 8th Street, and I went in and joined them for a coffee. I told them I had just read in a paper that when the war was over there were 175 million more people in the world than before it began. He looked at me with those magnificent eyes of his and said quietly, "That is the most terrible thing I have heard." The beauty of Gorky's painting I understood only last year.

I began this train of thought wondering at the cliche about downtown painting in the depression—the accepted idea that everybody had doubts and imitated Picasso and talked politics. None of these features seemed to me remarkable at the time, and they don't now. Downtown everybody loved Picasso then, and why not. But what they painted made no sense as an imitation of him. For myself, something in his steady wide light reminded me then of the light in the streets and lofts we lived in. At that time Tchelitchev was the uptown master, and he had a flickering light. The current painters seem for their part to tend toward a flickering light. The difference that strikes me between downtown then and now is that then everybody drank coffee and nobody had shows. Private life goes on regardless.

1956

Willem de Kooning

WILLEM DE KOONING was stopped on the street by a young man he hadn't seen before who said bitterly, "Doesn't it bother you to be so famous?" "No," de Kooning said, "but it seems to bother you." De Kooning's fame has been spreading steadily for a decade; there have been complaints about it in the papers.

At the benefit show for Nell Blaine two years ago, I saw on the wall a drawing of his—no larger than a Lucky Strike package—a drawing of a seated woman, as absorbing to look at as a drawing by a Renaissance master, it had that force of volume. Elaine de Kooning told me that when he did it, in the early forties, he said he wasn't going to do any more of those, you could lose your mind doing them. She had picked it up from among the week's litter on the studio floor.

At the time, Bill and Elaine were living on 22nd Street. It was a top floor loft, spacious and high-ceilinged, sunny at the back. When he took it, it had long stood empty. He patched the walls, straightened the pipes, installed kitchen and bath, made painting racks, closets and tables; the floor he covered with heavy linoleum, painting it grey and the walls and ceiling white. In the middle of the place, he built a room, open on top, with walls a bit over six feet high. The bed and bureau fitted into it; a window looked out into the studio. The small bedroom white outside and pink inside seemed to float or be moored in the loft. All of it was Elaine's wedding present. The six months he spent getting it ready were the only time during many years before or later that he put off painting for longer than a couple of days. While they lived there, Saturday afternoons he stopped whatever he was doing and washed the place down.

They didn't live there very long. They were often fifty or a hundred dollars in arrears with the rent. Bill had been a steady tenant of another loft in the same building for several years previous. But now the landlord took to pounding on their door. The dispossess notice went up. The landlord climbed up by the fire-escape and pleaded for the rent through the window. They asked him in for coffee. He told them that he liked them both, but that he had a heart-condition and couldn't stand arrears in the rent. After the loft, they went to live in a tenement on Carmine Street.

Two or three pictures of his had been shown at the Bignou Gallery. They made no stir, but after awhile the Modern Museum invited him to bring photographs of his work. At the door he bought a ticket to go to the office for the interview; and after a friendly chat, since he didn't have carfare left, he walked back to Carmine Street. By the middle forties, though his pictures were extraordinary, he was poorer than ever. His first show was in '48, at the Egan Gallery. In '50, the Modern Museum sent pictures of his to the Venice Biennale, giving him a place of honor together with his friends Gorky and Pollock. Several years later, in his 10th Street loft, he opened a box to show me a handsome suit that had just arrived. He seemed to be wearing, as he had been during the twenty years I had known him then, a hand-me-down given him by a friend. This was his first suit. His fortunes were mending; for some time he had been paying his rent and his color bill; in fact he had been

helping out friends in trouble, and standing everybody to drinks and dinner, and often quite a number were around. In '53 his third show, the first at the Janis Gallery, was crowded day after day; the elevator man said, "The way people are coming to this show, that man must be dead." The show ended with de Kooning in debt to his dealer.

A year ago he came back with a dozen suits from Rome, where he had taken a three months vacation. He came back to a new loft near 12th Street, wonderfully airy and light with slender cast-iron columns, that in the seventies might have been the floor of a department store. The landlord had reconditioned it to suit his tenant, and it was even nearly ready. A little later Bill said, "I thought that now I had this wonderful loft, and some money, and all this experience, and had had this nice vacation, when I started to paint again, it would be easier. It was for two days. Now it's the same it used to be, I don't know how to do it."

I knew how it had been twenty years ago in one or the other loft on 22nd Street, when I used to see him several times a week. A new picture of his, a day or two after he had started it, had a striking, lively beauty; one such sketch that he gave to Rudy Burckhardt who asked him for it at the time, still has it. But at that point Bill would look at his picture sharply, like a choreographer at a talented dancer, and say bitterly, "Too easy." A few days later the picture looked puzzled; where before there had been a quiet place for it to get its balance, now a lot was happening that belonged to some other image than the first. Soon the unfinished second picture began to be pushed into by a third. After a while a series of rejected pictures lay one over the other. One day the accumulated paint was sandpapered down, leaving hints of contradictory outline in a jewel-like haze of iridescence—a young painter recently found such a de Kooning on the street—and then on the sandpapered surface Bill started to build up the picture over again. I can hear his light, tense voice saying as we walked at night, "I'm struggling with my picture, I'm beating my brains out, I'm stuck." Next time I asked about it, "I've an idea I'm trying out, I think I'm getting it," he said shortly. Once or twice after weeks of that, he kicked or slashed the canvas to bits; usually he stowed it on the rack, saying he couldn't finish it. When at the time Mr. Keller of the

Bignou Gallery came to see what he had put aside, and offered him a show, Bill was delighted, and worked harder than ever, but in the end there were only two canvases he was ready to show. His friends would say, "Listen, Bill, you have a psychological block about finishing; you're being very self-destructive, you ought to see an analyst." He burst out laughing, "Sure, the analyst needs me for his material, the way I need my pictures for mine." Those of that time that then looked unintelligible now look beautifully alive and clear all over.

While these pictures were wearing him out, he was day by day for the people who came to see him the most generous and perceptive of friends. He came to a hospital bed where I lay seriously wounded from a drunken brawl the night before, took a sharp look at me and said in a low voice vehemently, "If I could find the man who did that to you, I'd kill him." The same day another friend, an extremely brilliant man, too, came to see me. "Oh, I'm so sorry for what happened," he said smiling, "but tell me, Edwin, didn't you provoke it a little, I don't mean consciously."

De Kooning when I had met him first five or six years earlier had been a young painter cheerfully in earnest living next door. He readily talked and listened, sitting forward on a chair. He admired Picasso enthusiastically. After a while one realized what it meant to him to be a painter. It didn't mean being one of the boys, making the scene or leading a movement, it meant meeting full force the professional standard set by the great Western painters old and new. He wasn't naive, he was undesigning. This was also the time—the mid-thirties—when he met Gorky first. After Gorky's death, to a critic who said Gorky had been influenced by him he wrote, ". . . When about fifteen years ago I walked into Arshile's studio for the first time, the atmosphere was so beautiful that I got a little dizzy, and when I came to, I was bright enough to take the hint immediately . . . I am glad that it is about impossible to get away from his influence. As long as I keep it with myself, I'll be doing all right. Sweet Arshile, bless your dear heart."

As he in the early forties struggled with his unfinishable pictures, day by day de Kooning was also finding out what further try some other theory could suggest to him. Pressed to join a cause, "That's your status quo," he shouted. "I'm not

supporting anybody's status quo." He described an ordinary looking person or incident, and without explanation as he told the facts, the particular gesture he was recognizing in a theory or ideology became so clear everybody laughed. He talked about how a masterpiece made the figures active and the voids around them active as well, as active as possible, it squeezed everything dramatically but somehow the picture opened itself way out, changing the center and the frame. He thought it opened where the eye believed it saw one thing, but knew it saw another, like near and far, resemblance and form, both at once, or funny and fatal, like in a Primitive. He spoke to me about the trouble he had with the projecting thighs of a fullface seated figure. I pointed out that he avoided foreshortening. He said vehemently that it made him sick to his stomach, not in other people's pictures, but when he did it himself. He pointed out the landscape-type scale in the shoulders of a Raphael Madonna in Washington. We talked about the mysteriously powerful nastiness in the hair of a Raphael youth there, who looks at you over his shoulder. A few times as we walked in our neighborhood he pointed to instances—a gesture, a crack, some refuse, a glow—where for a moment nature did it, the mysteriousness you recognize in a masterpiece. I couldn't see it where he pointed to, but for that matter like everybody, I knew the kind of perception he was referring to, the flash called beauty, which is actual. He looked hard to catch exactly what was there. Walking at night with a friend, he suddenly went back a few steps and stood peering intently at the pavement. The other man saw that there was a child's scribble there. De Kooning returned to him, head down, muttering, "They shouldn't be able to." The friend burst out laughing. Bill looked up suspiciously, then burst out laughing too, shouting angrily as he laughed, "But art isn't meant for children." Another night he was walking with Elaine and her teen-age brother down dark Sixth Avenue. Across the Avenue he saw a group of youths come running and laughing out of a side street, knock down one among them, kick him, and still running and laughing, disappear again. Then he saw another boy bend over the victim, and begin to lift him to his feet. As he held him, running and laughing the gang was back, knocked the Samaritan down, kicked him, and ran off laughing around the corner. As Bill looked across at the two bodies, he

realized that the second was that of Elaine's brother, who he thought standing beside her.

In 1950, nearly a decade later, I had been abroad and out of touch for several years, when I heard that several pictures of his painted since I left hung at the Venice Biennale. I was eager to see them. But after reaching Venice a week and more passed before I got to the Biennale Park. I had been walking through the exhibit in a stupefied state for two hours when I entered an empty room hung with de Koonings, Gorkys and Pollocks. I stood glancing around with a smile, ready to have them take me back to the New York that was home, expecting Bill and I would go down to the corner for a coffee. Not at all. The pictures looked at me with no recognition whatever, not even Bill's. I had no private access to them. Standing there as a stranger, I saw the lively weight the color had, the force and sudden grace the excitement had. I realized that the buoyancy around me was that of heroism in painting. That I could see it was due to luck. A week earlier, sitting in front of the Titian Pietà in the Accademia, exasperated by the seasickness Titian was insisting I endure, I angrily looked away from the canvas and happened to recognize the painter Kokoschka, standing to one side, watching with delight the same heaving and crashing storm of gold and silver that I found too rough. I was furious. Ashamed of my squeamishness I had stuck it out with Titian and the Titian-side of his younger competitors, like gales at sea, for a week all over Venice, and had gotten my sealegs. Because my eyes had become adjusted to that range in painting, they could tell me what the New York School was up to. That was how I discovered it; it wasn't through knowing Bill's honesty in daily life. But when I saw it I thought that the Europeans, more used to great painting than I, would see it quicker than I had. Wrong again. It took them seven or eight years more.

Fairfield Porter, himself a leader among New York representational painters, reviewing in 1959 de Kooning's fifth and most recent show, wrote in *The Nation*, ". . . A painting by de Kooning has a certain superiority to one by any other painter, which is that it is first-hand, deep and clear . . . In the same way that the colors are intensely themselves, so is the apparent velocity always exactly believable and appropriate. There is that elementary principle of organization in any art that nothing

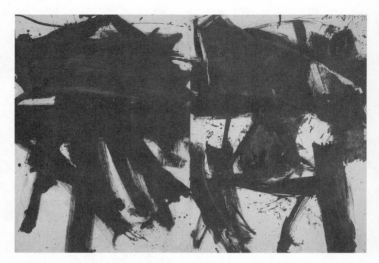

Willem de Kooning: *Black and White Rome S*, 1959. Enamel and collage on paper, 39¼ × 55¾ in.

gets in anything else's way, that everything is at its own limit of possibilities. What does this do to the person who looks at the paintings? This: the picture presented of released possibilities, or ordinary qualities existing at their fullest limits and acting harmoniously together—this picture is exalting. . . . Nor is there in de Kooning's paintings the idea that abstraction is the historically most valid form today . . . Once music was not abstract, but representational . . . In this way de Kooning's abstractions, which are in terms of the instrument, release human significances that cannot be expressed verbally. It is as though his painting reached a different level of consciousness than painting that refers to any sort of program . . . No one else whose paintings can be in any way considered to resemble his reaches his level."

As a professional, de Kooning has developed a number of virtuoso procedures of brush-stroke, of drawing and of composition that other painters here and abroad have taken up. His most recent technical invention has to do with a way of

bypassing the earth-colors which equalizes the rate of drying everywhere on the picture; his most recent compositional one seems to me to have to do with color also.

De Kooning was born in Rotterdam. His father remarried. His mother, a woman of vigorously upright character, kept a bar. At twelve years old he was apprenticed to a housepainting and decorating firm with, to start with, a nominal twelve-hour working day. Later however, and for seven years, he went to evening classes at the Academy. When his sailor friends heard he wanted to go to America, they found him a job as wiper in the engineroom, and showed him how to jump ship over here. Here he was first a house-painter in Hoboken, then a window display man in Manhattan and helped decorating speakeasies. A few pictures of his painted around 1930 are curious but not particularly promising. Twenty years later on 10th Street he was beginning the picture later called "Woman," which became the most widely reproduced painting of the post-war. And by then in intellectual dispute at the Painters Club, like with a blow of a lion's paw, he could tear an opponent's heart out, so fairly everybody else laughed.

About then, back from Italy, I was telling him about the Sistine Chapel ceiling, the smell of shoes where it is, and as you go on looking it makes you so marvelously happy you can see that every way the centuries praise it is reasonable. Not that Michelangelo's mistakes aren't obvious, and I spoke of them. When I stopped, he said, still listening intently, "Yes, right, wrong, right, wrong, right, wrong," striking each with the same hit of his fist like a carpenter driving a heavy nail. Two talks of his on art printed around 1950 belong to the most graphic a painter has offered. In one, near the start, he says, "It is very interesting to notice that a lot of people who want to take the talking out of painting do nothing but talk about it. That is no contradiction however. The art in it is the eternally mute part you can talk about forever. For me, only one point comes into my field of vision. That narrow, biased point gets very clear sometimes. I didn't invent it. It was here already. Everything that passes me I can see only a little of, but I am always looking. And I can see an awful lot sometimes."

Nowadays, when a new picture of his is exhibited, young painters sit around chin in hand scrutinizing it. One of them

pointed to a detail and said to another, "Look at this, he's faking his style." "I saw that," the other answered, "so it's not pure—as far as I can see he's not making style, he's making a picture. As far as I can see, he's way ahead of the field."

Recently a young painter walking at night down Third Avenue near 10th Street, saw him running fast. The young man wondered why de Kooning was running so fast at night. Then he saw Lisbeth, de Kooning's little daughter. They were playing hide-and-seek.

"I'm not so crazy about my style," he said to me recently, "I'd just as soon paint some other way." When he was in Rome last autumn, he told me, he met at a party an American painter of his age, dignified and well dressed, with a nice wife and college son. They were making the rounds of museums and the ruins, they knew about all there was to see, and enjoyed looking at it intelligently. Bill said that when he was young he expected he would later turn into a man such as that, but somehow it hadn't happened.

1965

Katz: Collage, Cutout, Cut-up

KATZ's collages are maliciously small, considering the wide summer light you see. They are real landscapes, often with figures. They have that instantaneous specific identity, the view, the figures, the light and perspective, each thing has it. It all starts to compose—a scene viewed at a happy moment—even if what is going on is fairly ordinary and a bit ridiculous. It is extremely real.

Not real at all. It is a razorblade and paste job, miniature size. Three pearly tints close in value, two heavy ones—some are from nature, some are not. The artist hasn't hidden where he abbreviated. Inspect the little object, no secret how it was made.

The view has been consciously chosen, and so have the few colors to render it. Each color must have been washed flat on a piece of typewriter paper, then the shapes cut out. The shapes seem to have been cut out and pasted up *alla prima*, at high speed; the tiny picture has an all-over zip and grace. But it

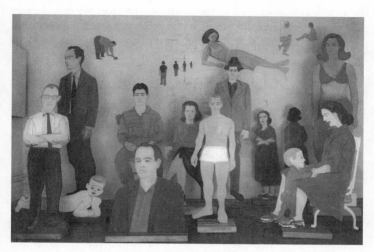

Rudy Burckhardt: Alex Katz Cutouts, 1962.

hasn't any mystique of materials or of assemblage. Katz's collage form is an alternative to the Dada form. With both, I saw the wit first, the large-scale power as a picture several years later, unexpectedly.

When Katz's collages—a first group of them—were shown (at the co-op Tanager Gallery in 1957), their charm was unwelcome. Good painters of his generation looked at them sourly. They pointed out that they were not collages in any deep sense. They even suspected them of making fun of Abstract Expressionism. As for the new Intimists, Fairfield Porter walked over to Katz and asked him abruptly, "Why didn't you paint them in the first place?"

Katz's cutouts were shown in 1961, again at Tanager. This time everybody was in good humor. I had seen the cutout figures as they accumulated in his studio, and after a glance went into the office at the back where he had told me some collages would be on the racks. As I was looking at them, I noticed out of the corner of my eye that Frank O'Hara had come in and was standing a few feet away, absorbed in the show. I quickly turned to speak to him. But he wasn't there; it was the cutout

of Frank that had fooled me. A moment later with a deeper misgiving I realized that the Frank who had fooled me was only three-quarters life size. The joke—Katz's—wasn't nice at all. Quite recently, at Elaine de Kooning's studio, the same cutout fooled me again.

The first of the cutouts made itself. Among the figure paintings Katz was working on, one balked. The figure stayed live, the background dead, whatever he tried. Exasperated, he sliced the figure out of the canvas, and set it up with a wood backing to see what it needed. It didn't need anything. Standing free in the studio it was as live as ever. It looked comical, and it flouted some of the most useful rules about scale and space and edges. He saw he could sharpen its sculptural independence. He asked a number of friends to pose and made portraits in different sizes, painted smoother or rougher, playing the sculptural repertory—the figure standing, seated, reclining, the bust, the wall-relief. No trompe-l'oeil about it. Then he stopped and went back to painting pictures.

Like many of Alex's friends, I have sat for him when he asked me. The sitter has to keep still only now and then. A neighbor looks in, a domestic interruption occurs, Alex tells stories, discusses an event or a mutual friend, all while painting rapidly or sitting back scowling at his canvas. Suddenly he peers at the sitter with concern: "Five minutes more, or do you want to stop now?"—as if he hadn't been aware of his presence until that moment; then he picks up the conversation where he dropped it and paints.

The portrait is finished in a few sittings; I find mine flattering. Friends call it an excellent likeness and I don't mind the small smile on their faces as they say it.

When he asked me to pose last winter he made a full figure 6 inches high. When I went to pose again, he had fourteen cutouts of me, each painted in the free style of the first, and all fourteen identical. He had begun to paste one or several, either whole or lopped off, on identical backgrounds painted dark purple. At the second sitting he made a small half-figure. A week later it had multiplied into identical copies. Looking at it I saw not a flattering likeness, but the very person I catch without warning in a mirror. It was disconcerting. "If you don't like yourself," Alex shouted across the studio, "I won't give your name, I'll just give you a number." There were also several cutouts of his

wife Ada, a half-figure with a wild look mounted with that of me, and a shapely head, beautifully painted, mounted alone, ridiculously cropped. Though uncomfortable, I couldn't help laughing.

As objects, Katz's pieces are unobtrusive. They share a small oddity—I mean the contour line not painted, but actually sliced. The collages use no other edge, it cuts between planes so the shapes rattle and all at once jump into place. In the cut-outs, the painted figure crowds to the edge and abruptly stops on the personal gesture, the stance, the habitual inclination. It gives imagination a bounce. You seem to see the figure breathe. A harder sardonic bounce happens in the reliefs. The intense figure is immured by its abstract contour. Then comes a delayed flash and a sweep. The little picture spreads effortlessly, including everything, and that is the joke.

When Alex began his collages eight or ten years ago, his painting had found a cool high-key color harmony; American Intimist in appearance, its grace of subject and style promised success. But a non-Intimist element started to intrude: the optic flash associated with advertising. It upset the picture's weight—the rest of the painting couldn't keep up with its speed. Some Cubist and abstract pictures had caught the speed, but at the time representationalism could not. Conceptually, it was clear why, not clear why not. Katz made collages on the side while his painting was seeing its way through. Three years later, the first reduplicative portrait of Ada ended the collages. Not long after, when he was hailed as a "New-Figurative," in answer to a questionnaire, "What is your ambition as a painter?" he wrote, "To continue the great tradition of the New York School."

His collages, cutouts and reliefs are foolery hinged on life-likeness, inside painting and outside it. He plays the hinge. You think you see much more of a likeness than the object shows, and you see much less than it shows, its intentness on the real-life identity of its subject. Just where the intentness is, there is a delight in New York School pressures of all-over painting. The question his serious painting deals with is a traditional one:

How can everything in a picture appear faster than thought, and disappear slower than thought? As far as that is a problem, it is a problem for critics; for a painter it is a passion.

1965

The Silence at Night

(The designs on the sidewalk Bill pointed out)

The sidewalk cracks, gumspots, the water, the bits of refuse.
They reach out and bloom under arclight, neonlight—
Luck has uncovered this bloom as a by-product
Having flowered too out behind the frightful stars of night.
And these cerise and lilac strewn fancies, open to bums
Who lie poisoned in vast delivery portals.
These pictures, sat on by the cats that watch the slums,
Are a bouquet luck has dropped here suitable to mortals.
So honey, it's lucky how we keep throwing away
Honey, it's lucky how it's no use anyway
Oh honey, it's lucky no one knows the way
Listen chum, if there's that much luck then it don't pay.
The echoes of a voice in the dark of a street
Roar when the pumping heart, bop, stops for a beat.

"At first sight, not Pollock, Kline scared"

At first sight, not Pollock, Kline scared
Me, in the Cedar, ten years past
Drunk, dark-eyed, watchful, light-hearted
Everybody drunk, his wide chest
Adorable hero, mourn him
No one Franz didn't like, Elaine said
The flowered casket was loathesome
Who are we sorry for, he's dead
Between death and us his painting
Stood, we relied daily on it
To keep our hearts on the main thing
Grandeur in a happy world of shit
Walk up his stoop, 14th near 8th
The view stretches as far as death

"Alex Katz paints his north window"

Alex Katz paints his north window
A bed and across the street, glare
City day that I within know
Like wide as high and near as far
New York School friends, you paint glory
Itself crowding closer further
Lose your marbles making it
What's in a name—it regathers
From within, a painting's silence
Resplendent, the silent roommate
Watch him, not a pet, long listen
Before glory, the stone heartbeat
When he's painted himself out of it
De Kooning says his picture's finished

PARKER TYLER

Parker Tyler (1904–1974) is best known today for his writings on film, including a pioneering study of homosexuality in the movies, *Screening the Sexes* (1972). In the 1940s, as coeditor, with Charles Henri Ford, of the experimental magazine *View*, he played an essential role in New York's artistic coming-of-age, showcasing Surrealist artists and ideas along with those of the Neo-Romantics, who mingled realism and fantasy and were for a time seen by some as significant innovators. Tyler wrote poetry, published a novel written in collaboration with Ford (*The Young and Evil*), and a biography of Tchelitchew, a ringleader of the Neo-Romantics, which was praised by no less an authority than Meyer Schapiro. In writing about Pollock, Tyler gives his paintings what might be called a Neo-Romantic cast, emphasizing the work's mythic, cosmological resonances.

Jackson Pollock: The Infinite Labyrinth

To comprehend the painting of Jackson Pollock, one must appreciate in full measure the charm of the paradox: the apparent contradiction that remains a fact. His work has become increasingly complex in actual strokes, while it has been simplified in formal idea. This is a convenient paradox with which to begin. Even more fundamental is the painter's almost entire abandonment of the paint-stroke, if by "stroke" is meant the single gesture by which the fingers manipulate the handle of a brush or the palette knife to make a mark having beginning and end. The paint, scattered sometimes in centrifugal dots, is primarily poured on his surfaces (sometimes canvas, sometimes board) and poured in a revolving continuity, so that the thin whorls of color not only form an interlacing skein but also must endure the imposition of an indefinite number of skeins provided by other colors. Thus the paint surface becomes a series of labyrinthine patinas—refined and coarse types intermingling, save in the case of small and simple works which resemble large oriental hieroglyphs. The relief resulting from the physical imposition of one color on another is important to the visual dimension of these works and unfortunately is almost totally lost in reproduction.

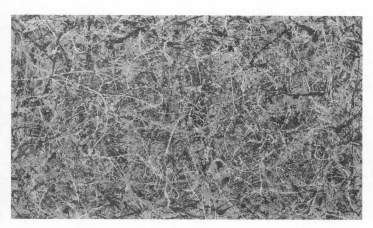

Jackson Pollock: *Number 1*, 1949. Enamel and metalic paint on canvas, 63 × 102½ × 2⅛ in.

The relation of Pollock's "paint stream" to calligraphy supplies another paradox. For it has the continuity of the joined letter and the type of curve associated with the Western version of Arabic handwriting—yet it escapes the monotony of what we know as calligraphy. It is as though Pollock "wrote" non-representational imagery. So we have a paradox of abstract form in terms of an alphabet of unknown symbols. And our suspense while regarding these labyrinths of color is heightened by the awareness that part of the point is that this is a cuneiform or impregnable language of image, as well as beautiful and subtle patterns of pure form.

On ancient stelae, sometimes defaced by time, certain languages have come down to us whose messages experts have labored to interpret. The assumption is that every stroke is charged with definite if not always penetrable meaning. But in these works of Pollock, which look as fresh as though painted last night, a definite meaning is not always implicit. Or if we say that art always "means something," Pollock gives us a series of abstract images (sometimes horizontally extended like narrative murals) which by their nature can never be read for an

original and indisputable meaning, but must exist absolutely, in the paradox that any system of meaning successfully applied to them would at the same time not apply, for it would fail to exhaust their inherent meaning.

Suppose we were to define these paintings, as already indicated, as "labyrinths"? The most unprepared spectator would immediately grasp the sense of the identification. But a labyrinth, from that of Dedalus in the myth of the Minotaur to some childish affair in a comic supplement, is a logically devised system of deception to which the creator alone has the immediate key, and which others can solve only through experiment. But even if the creator of these paintings could be assumed to have plotted his fantastic graphs, the most casual look at the more complex works would make it evident that solution is impossible because of so much superimposition. Thus we have a deliberate disorder of hypothetical hidden orders, or "multiple labyrinths."

By definition, a labyrinth is an arbitrary sequence of directions designed, through the presentation of many alternatives of movement, to mislead and imprison. But there is one true way out—to freedom. A mere unitary labyrinth, however, is simple, while in the world of Pollock's liquid threads, the color of Ariadne's affords no adequate clue, for usually threads of several other colors are mixed with it and the same color crosses itself so often that alone it seems inextricable. Thus, what does the creator tell us with the images of his multiple labyrinths like so many rhythmic snarls of yarn? He is conveying a paradox. He is saying that his labyrinths are by their nature insoluble; they are not to be threaded by a single track as Theseus threaded his, but to be observed from the outside, all at once, as a mere spectacle of intertwined paths, in exactly the way that we look at the heavens with their invisible labyrinths of movement provided in cosmic time by the revolutions of the stars and the infinity of universes.

The perspective that invites the eye: this is the tradition of painting that Pollock has totally effaced; effaced not as certain other pure-abstract painters have done, such as Kandinsky and Mondrian, who present a lucid geometry and define space with relative simplicity, but deliberately, arbitrarily and extravagantly. In traditional nature-representation, the world seen is *this* one;

the spectator's eye is merely the precursor of his body, beckoning his intelligence to follow it in as simple a sense as did the axial symmetry of renaissance perspective. But the intelligence must halt with a start on the threshold of Pollock's rectangularly bounded visions, as though brought up before a window outside which there is an absolute space, one inhabited only by the curving multicolored skeins of Pollock's paint. A Pollock labyrinth is one which has no main exit any more than it has a main entrance, for every movement is automatically a liberation—simultaneously entrance and exit. So the painter's labyrinthine imagery does not challenge to a "solution," the triumph of a physical passage guided by the eye into and out of spatial forms. The spectator does not project himself, however theoretically, into these works; he recoils from them, but somehow does not leave their presence: he clings to them as though to life, as though to a wall on which he hangs with his eyes.

In being so overwhelmingly non-geometrical, Pollock retires to a locus of remote control, placing the tool in the hand as much apart as possible from the surface to be painted. In regularly exiling the brush and not allowing any plastically used tool to convey medium to surface, the painter charges the distance between his agency and his work with as much *chance* as possible —in other words, the fluidity of the poured and scattered paint places maximum pressure against conscious design. And yet the design *is* conscious, the seemingly uncomposable, composed.

Pollock's paint flies through space like the elongating bodies of comets and, striking the blind alley of the flat canvas, bursts into frozen visibilities. What are his dense and spangled works but the viscera of an endless non-being of the universe? Something which cannot be recognized as any part of the universe is made to represent the universe in totality of being. So we reach the truly final paradox of these paintings: being in non-being.

1950

LINCOLN KIRSTEIN

Lincoln Kirstein (1907–1996) was one of America's great polymaths. Mostly now remembered as the man who brought George Balanchine to the United States and established the New York City Ballet, he also founded two magazines, *Hound and Horn* and *Dance Index,* and helped develop the American Shakespeare Festival. His writing, in a richly figured style that brings to mind Henry Adams, Henry James, and Ezra Pound, encompasses seminal studies of the dance; a poetic epic of World War II, *Rhymes of a PFC*; pioneering essays on the photography of Walker Evans and Henri Cartier-Bresson; a much admired memoir, *Mosaic*; and monographs devoted to artists, including Augustus Saint-Gaudens, Elie Nadelman, and Tchelitchew. Kirstein combined an unwavering commitment to the arts in his own time with an equally forthright insistence on the enduring centrality of classical values. He followed his instincts, encouraging early experiments with photographic murals for a show at the Museum of Modern Art in 1932 and championing Stravinsky and Balanchine's barrier-breaking 1957 collaboration on *Agon*, even as he railed against the Abstract Expressionists and celebrated the work of painters such as Paul Cadmus and Andrew Wyeth who were dismissed by the cognoscenti as hopelessly conservative. Kirstein never wavered in his support for Elie Nadelman's daring modern classicism, in essays such as the one included here; with an exhibition at the Museum of Modern Art in 1948; and with a 1973 monograph that showcased Kirstein's prose at its ripest and most adventuresome.

Elie Nadelman: Sculptor of the Dance

ELIE NADELMAN'S sculpture reveals many dazzling, indeed baffling aspects of his mercurial talent. One of his life-long interests was Theatre, primarily the theatre of gesture—the significant arrested pose, the unique isolated position which is both synthesis of cumulative action and static description of movement. His private proscenium framed music-hall, concert-stage, theatrical and social dancing, and the circus.

Nadelman felt his immediate masters in the depiction of the contemporary scene were Constantin Guys, Gavarni, Daumier and Degas; he also admired Lautrec and Seurat, both of them

devotees of circus, variety-shows and public balls. Unlike most of these, Nadelman made no portraits of individual dancers; he was less captivated by personality than by a search for epitome. He devoted himself for twenty years to the capture of an essential silhouette which might represent a human style and an historic epoch, yet, at the same time demonstrate by its classic, residual stance and mass, the lineal descent of the past into our own period. He showed the dance as a description of his time, and as a traditional rite whose ceremonial fulfillment in entrance, performance and recognition of and by an audience comes down to us in an unbroken inheritance from antiquity. The dance for Nadelman was at once a psychological and a theatrical expression, compacted of the impulse to exhibit the performer's body, to please with it, to dare and compete by it,—a demonstration of the human organism in its intense physicality, beautiful and grotesque; silly and splendid; exaggerated and modish.

Elie Nadelman was born in Poland in 1882. Educated in Warsaw, he went to Munich in 1902 where he admired the circus, the opera (still in the lively atmosphere of Wagnerian modernism), and the music-halls with their roster of French can-can dancers, Hungarian violinists, Italian jugglers and British magicians. He lived in Paris from 1903 until 1914, when he came to New York. Almost at once, he fell in love with the folk-arts of Pennsylvania German potters and calligraphers, the wood-carvers of Salem and Charleston, and the ubiquitous journeyman limning of eighteenth and nineteenth century America. He was an innovator in this enthusiasm; before he started collecting pottery, painting and carving, few people considered that anything worthy of this nature had been created in the United States save by the Sioux or the Navajo. The Nadelman Museum of Folk Arts in Riverdale, New York, showed the sources of our handicraft in Europe, leading to prime examples by master-craftsmen in the United States. When the sculptor and his wife lost their fortune, the collection entered many important public and private collections, where, although dispersed, it may still be seen.

Nadelman found that American vaudeville also contained a rich and active deposit of folk tradition. When he came to America, variety was in its sunset glory, a peak of virtuosity and

competition, just before the birth of the talking-film and radio killed it. In his parlor hung a superb set of Venetian *Commedia dell'arte* characters; he saw in music-hall and burlesque the same incisive statements of telling gesture imbedded in the long history of Western European theatrical improvisation, tricks, gags and routine. He collected theatrical photographs from the seventies through the twenties—from Niblo's Garden and Coster & Bials to the Ziegfeld Follies and National Winter Garden Burlesque.

He saw social-dancing as a behaviouristic portrait of his times, but he was neither merely the sympathetic social historian nor the clever European visitor. He managed, after intense observation, to choose permanent elements in a transient fad like the Tango, and, selecting the most characteristic as well as the most traditional elements in a season's craze, erect in two wooden images, the monument of a decade. But his process was rigorously selective; among his sketches are many rejected ideas; a drummer with a battery of traps and cymbals, a wheelchair on the Atlantic City board-walk, a circus-rider on her horse. These notations he never developed because he seems to have felt they were insufficiently compact; their forms comprised too many disjunct elements. He went so far as to make an elaborate Cellist in plaster, complete with his baroque instrument. But it became too complicated, and never reached final form in wood. He could not weld a composition of cello in relation to cellist in that fixed solidity he usually found.

Nadelman's first one-man show was held at the Galerie Druet in Paris, April, 1909. It created more interest than any modern sculpture since the Rodin exposition at the Universal Exhibition of 1900. Nadelman here introduced his analytical method applied to form and volume in the human figure which anticipated Cubism, showing himself a master-craftsman, and though still very young, already entirely capable of handling many intractable materials, from stone and tinted bronze to wood and ceramics. His whole early work was like the promulgation of a thesis, a living lecture on the nature of sculpture, demonstrating the use of a personal analytical hand and eye applied to human anatomy. His derivation from classical antiquity was apparent; he was playfully known as "Phidiasohn" or "Praxitilman." He had conceived his method of decomposition and reconstruction

of formal elements in seclusion. After his first show, he emerged more into the world of salons. He talked much with Leo and Gertrude Stein, who were already patrons of Modernism. He read Baudelaire, whose poetry and criticism first defined the cultural climate of the great cities of the West, after the Industrial Revolution; whose attitude contained a philosophy and almost a religion of urban, dandiacal modernity; whose great introduction to Constantin Guys announced the essence of *la vie moderne*, as a style, a *coup de grace* to the academic classicism of Jacques-Louis David. Nadelman, instead of feeling himself a contemporary classicist as he was inclined to be judged on the strength of his early marbles, became the sculptor, *par excellence* of contemporary life, innovator and precursor of our own "modern" art. He alone managed the civil dress and habitual gestures of the twentieth century, or at least its early, influential decades, and gave them a uniform typicality as definitive as Guardi, Daumier or Seurat gave theirs.

An enormous number of Nadelman's drawings are extant; but before 1914, there are none which show any direct observation of society. The most immediate expression of modernism he had reached was to have certain early bronze and marble neo-Classic heads wear a *cloche* hat, which might have been either Greek, Roman or Parisian. Just before the war broke out, he was in Belgium, vacationing at a sea-side pension in Ostend, where he made a sketch of his landlady surprising a pair of lovers—possibly her own daughter with her young man. This sketch, later reworked in many compositions, was the basic idea upon which one whole aspect of his carving was founded. Later, he was to reject the Landlady entirely; the Lovers became Dancers, evolving from waltzers, or a rag-time pair into their perfection of rhythmic elegance in his cherry-wood "Tango."

Guillaume Apollinaire, poet, art-critic and novelist, who had already described Nadelman in 1911 as working "crowned with roses," defined the epoch immediately preceding the first world war, in his *roman à clef, La Femme Assise*:

> . . . the year 1914 commenced with mad excitement. As in the days of Gavarni, the period was dominated by the Carnival. Dancing was all the fashion; they danced Everywhere, Everywhere having taken the place of the masked-balls. . . . Life seemed to grow light-hearted, and perhaps later, when with the

Tango, the Maxixe, the Furlana, the war and its *bombes-funè-bres** would be forgotten, one might say of the peaceful portion of the year 1914, as in Gavarni's famous lithograph: 'They will be pardoned much because they danced so much!'

. . . They lacked a Gavarni in 1914, but dancers, men and women, were not lacking . . . for the Tango, that marvelous and lascivious dance which seemed born upon a Transatlantic luxury-liner. . . .

Nadelman's double figure was cut finally in red cherry, a grainless wood preferred by Biedermeier craftsmen. He did not show the fashionable Tango as a transformed folk-dance from the pampas, but as a dance of the *bajo*—the lower Port of Buenos Aires—an intense, tightly controlled, almost fatalistic duet. Further, after a series of sketches, alterations, developments, he made it an inscription of ironic elegance canonizing the high society of international capitals, *thé-dansants* at Ritz hotels, a world that dressed to be seen in public ball-rooms, no longer the feudal society of the *faubourgs* and private *hôtels*. The Tango was epidemic; one danced in spite of the threat of war, or on account of it.

Nadelman drew seven sketches of dancers, starting off bravely enough and collapsing at the end of a week; on each sketch he wrote only the name of its day: *Lundi, Mardi, Mercredi*, ending up with a double exclamation for *Dimanche!!* These thumb-nail drawings build up his notion of the relentless obsession of the fad. Apollinaire asked:

. . . One never dances more than in the time of revolution and war and what peculiar poet has thus invented that entirely prophetic common ground: *to dance* as on the edge of a volcano? [†]

Nadelman's dancers are also toys, clothes-horses, parodies of fashion-plates, fused into a figure. He found, after much observation and search, a type of head and body, expanded from his drawings in simple profile, entirely personal to him, yet derived from persistent tradition. His Man is a clown, but

*A pun on *pompes-funèbres*: funerals. The Maxixe and the Furlana were two less popular competitors of the Tango, which enjoyed a season's popularity in 1913–14.

[†] No poet, but the Comte de Salvandy, speaking at a fête given by the Duc d'Orléans to the King of Naples, 1830.

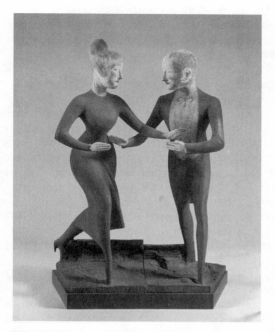

Elie Nadelman: *Tango*, circa 1920–24.
Painted cherry wood and gesso, three units,
35⅞ × 26 × 13⅞ in.

scarcely comic; rather, he is surprised, impudent, part Pierrot, an intellectual frame for a fool or a dandy. His Woman is also a doll, a form-fitting fashion model, a Columbine, her bust swelling in a pouter-pigeon's neat strut; her tiny high heels hardly tapping the parquet, a preposterous support for so looming a superstructure.

In the artist's studio, after his death, were found interleaved among actual drawings, many photographs and scraps torn from magazines (*The Police Gazette, Vanity Fair, Film Fun, Variety*, etc.), of vaudeville and musical-comedy teams, clippings of social-dancers from *Town Topics* or the society-columns of the daily press; old tobacco-cards carrying portraits of half-forgotten singers and dancers from Lillian Russell to Eva Tanguay.

Nadelman rarely used documents directly. Often, we know he acquired a particular photograph long after he finished the sculpture to which it would seem to refer; but he saved them, and added to these scraps constantly as a comforting corroboration. He kept to the central line of absolute significance in the gestures. He was always after that formal proportion which could best express his own comment on naive, but consciously contrived extravagance. We do not find, among his scrap-books, pictures of fashionable hostesses of the epoch, *Saloneuses* clothed by Paquin, Callot or Poiret. Rather, he preferred a parody, or inflation of fashion as blown up by artists of the music-halls; a theatricalized civil-dress, which was no longer every-day clothing, however luxurious, but already transformed, for projection from a stage, into a costume. From this costume, Nadelman created a uniform in silhouette, a badge for his times. His type of blocked profile and egg-head was taken over and used by many other artists. We find Nadelman-figures in paintings and lithographs of George Bellows, of Guy Péne du Bois, of John Held Jr., of Rockwell Kent (in his early role of Hogarth Jr.), or Erté, the fashion designer and Fish, the caricaturist.

The Tango dancers, Man and Woman, passed through many changes before they found their final position of frontal convergence. We can follow Nadelman's drawings step by step, almost as in the sequence of an animated cartoon, where first the dancers clasp each other tightly, then divide, rejoin in a stiffer confrontation, almost without physical contact, and finally, in the only pencil drawing of the series, dashed off in a few blocked, comprehensive lines—the partners stand separate yet interlaced, together and apart, a residual and conclusive symbol for all the formal meetings and divisions in the dance.

There are numerous subtle differences between Nadelman's plaster model and the definitive sculpture in wood. In plaster, the Lady is in complete *décolletage*; the Man has his bow-tie looped in high-relief; he sports a sharply indented white dress waistcoat. In wood, the Lady wears a high-necked gown. White gesso over so great an area of shoulders would have been disturbing in its denial of the texture of the natural surface of the ruddy wood. Likewise, the Man's vest is reduced; his tie is not rendered in bent wire, but lightly indicated in ink-blue paint. Both hair-arrangements are simplified in detail, capped onto the

shape of each head; ears are flattened out, and everything small-scaled and delicately particularized in plaster is larger and more monumental in cherry. Swallow-tailed, sheathed in their own sweeping movement, the two dancers converge with a tension which almost anticipates a sharp electrical flash, if and when they should touch. They do not touch; it is the Tango, yet *noli me tangere*; the provocation, the piquancy, the steady flirtation; balance, as on a tight-rope, is maintained at finger-tip length.

The ballet, as such, did not much interest Nadelman, as it had Degas. Nadelman, with Daumier, Lautrec and Seurat, was more attracted by the music-hall, the circus or the social-dance. Although the original Ballet Russe of Serge Diaghilew first played America at the moment when Nadelman was beginning to consider his wooden figures, he was less impressed by the artificial Orientalism so splendidly and freshly framed by Leon Bakst, than with the cruder entertainers of the Irving Place or National Winter Garden burlesque. What appealed to him in Variety was the formal perfection and traditional presentation of each brief routine, the intense personal projection with which individual artists managed to invest a completely unsurprising set of serviceable gestures—the absolute authority of focussing a theatre full of waiting people on the flick of a wrist or the stretch of a toe; the science indeed, of maintaining attention and crowning it by summoned applause. A dancer is revealed by the rising curtain; the first appearance is framed by the isolated pose of entrance, which is a visual fanfare to the entire routine. A performer, at first immobile, can arrest and stagger an audience in the calculation of a sequence of gestures by which a dance is animated, quitting one established pose for a more fluent and violent set of actions, each of which leads logically to the smash finale. Nadelman's "High Kicker" recalls Seurat's "La Chahut," which he might have seen at least in reproduction, but there were high-kickers also in Egypt; through the Middle Ages, on many cathedral portals, Salome kicked high. Nadelman's witty profile is entirely plastic, although his painted version gains from a judicious play of white gesso wiped off to show the red cherry cheeks beneath. From the front or back, from every conceivable view, the figure kicks. Each leg seems to have its scissor-shift. The criss-cross and opposition of arms and legs releases the figure into one grand precipitated act.

Nadelman observed dancing so closely that while his end results in carved wood seem the essence of clean simplicity, his innumerable sketches of variants are almost like chips from a chisel which slowly released the image in its patient block.

It is a commonplace that Burlesque was vulgar; many artists have shown its cruel, naked, stripped rawness. Nadelman refined all coarseness into a subtle fixity of ostentation. Where Lautrec was savage or Daumier agonized, Nadelman (along with Seurat), while not oblivious to the hoarse laughter of the halls, saw through to the mocked grace inside.

Nadelman collected ship's figure-heads for his museum of folk-art—the hewn images of Negro and Indian, American Eagles and Scottish Chiefs. The large carvings from a single block followed the dominant curvature and grainage in a tree-trunk. "Columbia," "Hibernia," "Britannia," or the "Lily G. of New Bedford" swelled their breasts to take the split wave along the cleavage of the oak bolt from which they were cut. Similarly, Nadelman would imagine his "Equestrienne" in one single large confining curve, which could be contained within the limits of one of his composite cherry-wood blocks, which he had built up for him out of matched boards, glued securely against warping, since there was no fruit-tree thick enough in its own single trunk. In the plaster model, developed from various drawings, he raised her arms, and turned her whip into a wire hoop, but the result did not satisfy him and this figure was never cut in wood. With the loss of his large studio in 1934, this piece and all the other models for the wood, were destroyed by workmen sent to clear out the building.

Cousin to the "Equestrienne" is the "Concert Singer," in her flattened reverse S-curve, all bust and bustle, as she clasps her hands about to clear the birdy throat before launching into a song of Tosti or Reynaldo Hahn. Although this figure was not cut in wood either, the arrangement of its feet, with their extreme attenuation of needle heel and whittled toe, was the ultimate model for several other of Nadelman's best wooden carvings—his Hostess, and the attendant series of women of fashion or the stage. Indeed the Concert Singer, though lost, was not forgotten for fifteen years, when she would be recalled in other variants among his late plaster figurines.

The "Chef d'Orchestre" is at once *prémier danseur*, clown,

and a virtuoso accompanying the orchestra which he also directs. He is something, too, of a priest who conducts a public ceremony: the rites of our concert-halls. He initiates his congregation into its exposure to music while he conducts his band into the exposition of their score. Nadelman's Orchestral Leader seems bathed in his own limelight, focussed on a boiled shirt-front, centered in the split arena, pinned between the crowds on stage and in the hall by two thousand pairs of eyes. A bifurcated monolith, his profile as serious and engraved as a bull-fighter's, the sculptor has found here the precise posture to indicate the entire science and showiness of the bravura conductor from Berlioz to Leonard Bernstein. Its Clown's head is not funny; soberly and impersonally, it is the Dandy. Nadelman does not show us a monster of vanity, an acrobat of the podium; the figure has a miniature dignity and vast distinction. He is in absolute control—of himself, his orchestra and his audience. Also, it can be read as a symbol of the mind behind performance, the Interpreter of creator—composer or choreographer, whose idea moves through the bodies of others, yet without whom there would be no performance at all. Nadelman understood the Performer, his concentrated yet extroverted exhibit of himself, transfixed in performance, intense, brief, evanescent; when gone, final and lost, yet leaving behind some essence almost more alive in memory than any other focus of recollection save love itself. All we have left of a memorable evening in the theatre, to help us relive electric moments, are meaningless programs with dead lists of names, a few inadequate and fading photographs, or a phonograph record. Nadelman contrived a synthesis of some of these moments, and left us images as thrilling and as permanent as the performances themselves.

Around 1924, Nadelman began studies for a new set of statues which he was to realize in Galvano-plastique, a modern industrial process, less expensive than bronze, but able to achieve its monumental effect. Plaster is electroplated with a deposit of copper; the skin of metal can be colored or otherwise patined. It has the exact surface of bronze, if not its complete lasting power. It is grosser in grain and scale, but Nadelman, with his instinctive mastery of material, made plaster models entirely suitable to the new medium, indeed enhancing their novel elegance through a supremacy over its coarseness, by a transformation

of dead weight into balloon-like, almost elephantine delicacy. Elephants are dainty in their hugeness, and so are Nadelman's Amazons and Acrobats, his Circus-riders and Dancers. He appropriated the shape and proportion of Arena queens, ladies of the Beef Trust, of two-a-day burlesque when it was still circus instead of strip-tease. Those older music-hall artists, whose portraits we still treasure, were massive, solid, muscular; plastically satiated. Female, they are also almost lady-giantesses; not freaks, but definitely of some superhuman species, who respire only in the humid atmosphere of tanbark and grease-paint. But, as always, with Nadelman, they are clad in their own replenished dignity, mistresses of mare or python, trapeze or slack-wire—really toe-dancers—their whole awesome bulk supported on the tiniest of spindled attachments, floating or balanced rather than standing in the ring.

Nadelman frequently laid colour on his metal and wooden figures; this colouring was applied, not as ornamental enrichment, but as further explanation of the character of the form itself. The colour was always the simplest, a line bounding the edges of a leotard on a svelte trunk; masses of hair as a Prussian-blue cap, or the loop of a thin ribbon to accent bust, neck or waist, like a beauty-spot. Frequently, the colour indicated in drawings or plaster sketches disappeared almost entirely in his finished work, although often one finds some subtle trace of it, a last accent of sober sophistication.

When Nadelman lost his large studio, he made no more big figures. He began, perforce, the investigation of another range of vision, small in size, but almost more monumental in scale than his previous work. For ten years he modelled small bodies in clay, recut them in plaster, marked the plaster with pencil corrections or decorations, intending they should all be cast in terra cotta. His untimely death ended plans for the installation of an electric kiln in the small studio hidden within his Riverdale house. But he knew well the properties of baked clay. Before 1932 he had made several handsome series of ceramic ornaments in glazed and unglazed clays. He owned a collection of original Tanagrine fragments as well as a comprehensive library of books about antique fired-earth processes and collections. His late small plaster figures were ceaseless studies in form, surface texture, gesture and proportion. He had always in mind the type of

modelling best expressed within the limitations of baked earth. He invented a huge repertory of figures, most of them related directly or indirectly to the dance. For these, his sources were a combination of Tanagra and Alexandrian baroque souvenirs, European and American burlesque or vaudeville, and his own previous researches and comments. While they recall the Near East, and the late splendor of Hellenistic extravagance, they are never simple pastiche. He also looked at photographs of the Denishawn Dancers in their approximation of Siamese Court dances; almost any sort of theatrical dancing moved him to model. He was not looking for authentic reproductions of an historic style of movement, but merely for movement authentically plastic, of any type.

Nadelman's late figures are much smaller and hence less immediately arresting in pose or profile than those in metal and wood. But they have their own penetrating character. In every mass or form—the fluency, balance and weight is loaded with a buoyant yet grandiose meaning. The slouch, drag and disdain of the burlesque-queen is here; her parody of high-world elegance; her devastating impersonation of a more expensive, more snobbish, more exclusive modishness. The cutting, almost surgical comment of burlesque, so marvelously understood as social and emotional climate in E. E. Cummings' fantastic play, "Him," is sometimes pre-supposed by Nadelman. But the sculptor drapes and veils it as a scaled-down, microscopic floor-show. His Girls, too, are fancy Dolls: wide-eyed, bangled with curls, crowned with Tanagra tiaras, baby-faced, petulant as spoiled princesses of a naughty court, yet they are also doped and dreamy; sleep-walkers through the heavy-scented dream of raw footlights and unbelievable make-up.

And yet each little lady has her impending, floating or regal, drawling entrance. *Femmes-bébés*, they are kin to all spectacular courtesans from Messalina to Cleo de Merode. They are flowers from the folk-lore of cities; the vision of theatre, circus, opera, ballet, which boys who live in the provinces, and who have only seen pictures, or posters, know must be the living magic of white nights on the boulevards or on Broadway. They are a child's hope of what the realized promise of the stage must be, the galaxy "over-the-footlights" in its fantastic stellar truth. No exposition of so intellectual and evanescent a subject-matter

could succeed save in a miniature art. If one is willing to follow through Alice's deep door, this tiny world comes alive: the dancers dance; the naked bodies are transparently clothed in jeweled spangles, in feathers and womanliness; the curls seem faintly gilded coils and snakes; the tiny rose-bud faces gleam with pouting and provocation, suffused in their tidy, morbid glamor, and despite any definition, they remain mysterious, relics of the practice of glamorous cults in our huge nocturnal towns whose meaning we sense but cannot say.

1948

TENNESSEE WILLIAMS

During the 1940s, the playwright Tennessee Williams (1911–1983) spent some summers in Provincetown, long a gathering place for New York artists. It was there, in the years leading up to the career-defining opening of *A Streetcar Named Desire* on Broadway late in 1947, that Williams was friendly with Hans Hofmann, who ran a school in the summers, as well as Lee Krasner, who had studied with Hofmann in the 1930s, and Jackson Pollock, who was married to Krasner. Williams's 1969 play, *In the Bar of a Tokyo Hotel*, is said to be based on his recollections of Pollock's and Krasner's famously stormy marriage. As for his brief appreciation of Hans Hofmann's paintings, written for a group exhibition at the Kootz Gallery, who can wonder that this supreme master of the theatrical dreamscape was drawn to the painter's extravagant sensibility?

An Appreciation

HANS HOFMANN is one of the few contemporary painters who have actually taken a step forward in a significant direction. Many others are what is called "advanced" but instead of actually advancing they have made various little private excursions leaving tracks like those of field-mice in a thin sheet of snow. I do not mean that Hofmann has made a solitary advance but that he walks abreast of the few who have likewise contributed to what progress has been made. His step is in logical sequence to the historical advance of such a painter as Van Gogh who infused the ideas of the Impressionists with a revolutionary vision, and if Vincent were alive today I think he would see in Hans Hofmann a logical inheritor of his passion for seeing more deeply.

The forward step is easily distinguishable from the lateral excursions. It has the authority of pure vision. Van Gogh had that. Picasso has it although he does not exercise it in all of his work. And Hans Hofmann also has a place with those giants who move straight into the light without being blinded by it.

It is a relief to turn from the reasonably competent and even gifted painters who paint as if their inspiration were drawn from Esmeralda's Dream-book to this bold and clear-headed man who paints as if he understood Euclid, Galileo and Einstein, and

as if his vision included the constellation of Hercules toward which our sun drifts. In his work there is understanding of fundamental concepts of space and matter and of the dynamic forces, identified but not explained by science, from which matter springs. He is a painter of physical laws with a spiritual intuition; his art is a system of co-ordinates in which is suggested the infinite and a causality beyond the operation of chance.

Now at the beginning of an age of demented mechanics, all plastic art is created under a threat of material destruction, for even at the base of pigment are the explosive elements of the atom. Hans Hofmann paints as if he could look into those infinitesimal particles of violence that could split the earth like an orange. He shows us the vitality of matter, its creation and its destruction, its angels of dark and of light. Philosophically his work belongs to this age of terrifying imminence, for it contains a thunder of light from the source of matter. Pure light, pure color, the pure design of pure vision may alone be philosophically indestructible enough to retain our faith, no matter what else falls in ruin, even our honor and endurance, until the time when truth can come out of exile and it is no longer dangerous to show compassion and the world is once more habitable by men of reason.

1948

ANTON MYRER

If Anton Myrer (1922–1996) is remembered at all today, it is as the author of best-selling novels dealing with World War II and its aftermath —*Once an Eagle* (1968) and *The Last Convertible* (1978). Entirely forgotten is his first work of fiction, *Evil Under the Sun* (1951), which includes an unparalleled glimpse of life inside the Hofmann School in Provincetown. Myrer was married for a time to the painter Judith Rothschild, who was deeply affected by her studies with Hofmann. Drawing on his experiences with Rothschild and her artist friends, Myrer crafted, in *Evil Under the Sun*, the figure of Carl Roessli, an inspiring teacher in the Hofmann mold, whose sly dialectical approach pushes the most sophisticated as well as the least sophisticated students to question everything they're doing.

FROM
Evil Under the Sun

MOVEMENT in silence.

In sweeping gesticulation they strove, ringed round the nude figure assise. All movement one, effort universal in the large room; muted the sun through the great skylight, muted the sounds of movement. Paul Kittering narrowed his eyes, stroked, stroked again, boldly black on the virginal white sheet awaiting his impaling; partook of the dry charcoal-scrape, the shuffle of rubber soles on cement, the alternating fixation of effort. Ahead of him the model sat, sheathed in firm flesh, her head proud, erect, challenging; legs placed firmly, flat-footed, left arm crossed above knees, shoulders in proud hostility. Impervious, defiant in her rich, imposing nudity.

(*what poor mortal hand or eye*
dare frame thy fearful nudity)

Paul Kittering frowned again, shook his head. Thinking of her as a person again. Moving in her thoughts I float disturbed.

He passed his hand slowly around his left eye. To transcend the person. How do others see her? See ourselves as others . . . A study. Vehicle to esthetic realization, means to the grand end; from the body to the vision, flesh to idea. Do they—all? . . . Free me. I cannot. What is she thinking now? Despise us, does

she? Laughing, hating? Perhaps I can never be a painter. . . .
Though it is true: we *are* abstractions, all of us.

He turned his head, his eyes roving, guarded. To his left Romain Jaurès swung short arcs before his beard, peered sunk in thought, scowled blackly, his body curved; involved, repulsed. A question mark in dotted line, chrome yellow. Beyond him Esther Zauberin, kinky hair awry, hunched in prehensile fury: a clawed asterisk concentric on a fiery star of David. Barbara, staring in serene languor, blond-silk tossing lazily: flowing oval form, lapped in ultramarine. The lot of us. Mike over there—red-shirted Mike jabs black bulbous forms against the paper's white; ducks, weaves; smudges, jabs again. Off-center triangle in vermilion, rampant. All of us symbols.

And I? He shifted uncertainly, barely smiling. What am I? A St. Bernard holding a rose in its teeth. No; too literal, we're abstracting. Sine-curves interlaced, tangential, in burnt sienna, against a cross askew . . .

He shifted his weight again, eased his buttocks against the tall stool behind him, lifted his right leg to one of its rounds. Tired already. Fuzzy, starting to ache; will it ever carry its weight? Rag and a bone and a hank of hair.

(*and how the ladies used to laugh to see*
my uncle pete
knock out a beat
on his collapsible—on his detachable—knee)

Looking down he stared aimlessly at his right trouserleg. Beneath the cloth the cicatrice. Look sir, my wounds; I got them in my country's service. . . . So far, so far away now the fury. All the furrows of assault below the fabric. Why is there no relation? Harry rocking crates onto a hand-truck, clank and roar up the ramp and down, up ramp down. Russ: *Palmer House? Right you are* flips the meter lever, ticking in and out of shiny beetles, whistles, lights. Turk pulls the tractor wheel, joggled, swaying, checks the cultivator blades. And I—plastering a canvas rectangle with yellow ochre . . . What would they say? *Jesus, Kit, what the hell is it, anyway—a bunch of gears? Hey, Kit's off his trolley. Yeah, doin some of thet crayzee modern art, ain't thet it?* . . . Their faces, wrinkled, grinning leanly. Forget me not. When this you see remember me. The departed time, the one now alien; in a hushed charcoal-scrape nirvana . . . The circles

no longer concentric, roar and quiet, curse and anguish; death and life. A million, million miles . . . Where are the great laws that wheel above us, serene, immutable?

"Time," a voice called.

From a rude chair the defiant body rose swiftly, naked, immediate, drew on a dressing gown, and picking up a shiny-covered book began to read. In the expectant hush and rustle Carl Roessli stepped silently from the rear entrance. Between two easels at a far wall he stopped momentarily, a short figure, head thrust forward on wide shoulders, arms akimbo; dark eyes under bushy brows contemplating the group. Then he moved forward among the students.

At Elaine Brandt's easel he stopped, squared off to the large sheet of paper, feeling the students moving behind him. "Yes—but here . . . see, Miss Brandt." He drew his thumbnail along one line, moved it over an area to the left. "Look . . . You must forget about yourself . . . You will have to begin again on it."

"All over again?" Her large eyes blinked back at him rapidly; brilliant, troubled eyes.

"Yes," he said, smiling gently. "You must learn to see what you are trying to do fully, and then it will all be there, isn't that so? Let me see . . ." He leaned forward, smiling, raising his voice, "Could you—for just a minute or so?"

Nodding, expressionless, the blond defiant figure rose, disrobed and assumed the pose instantly in sleight of ease, effortless.

"Thank you," he said to her in the resonant voice. Turning to Elaine Brandt he asked, "Do you mind?"

"No, no—not at all . . ."

He picked up a piece of charcoal and peered at the drawing, studying it, his lower lip working slowly. Of course she minds. Always does, can feel it in the electrical sensations she gives off every time I ask her. So precious . . .

In one corner of the paper he marked off a rectangle and began to sketch in it with short, heavy strokes, bits of charcoal snapping and splintering ahead of him, spraying black fragments, minute, ludicrous, around his fingers. "Here; now, this part of the thigh. You have not *felt* it rightly: it is in shadow here; here, it becomes another plane. All planes have meaning; they are areas which exert a force. They must be given

a significance, a *relation* to each other; this—must relate—to this here." He pointed a finger. "It is the dynamic relationship between these areas that makes for the tension, the movement." He pointed to his little sketch. "Do you see how *here* this area relates to this one—how each gives the other a meaning?"

"I see," she said.

Does she see? Cannot forget that she is Elaine Brandt. And the preciosity . . . What will it take? The awareness of one's own insignificance. So small a thing, actually; ja—still, there is something there, I know that. It is to me to rouse it. She is seeking, but she cannot see in order to find—does not yet know it; it is her vision, it is diffused, blurred so badly . . . Those large, frightened eyes.

"It is the concept, you must remember that, Miss Brandt; you must try to forget about yourself as a person when you are painting. The figure of the model there by itself is nothing, either; it is what you do with it that will give it life, that will make it be *so*. You are making a pictorial statement on a two-dimensional surface; it has nothing to do with personalities . . . Try again on it. And be bold; plunge into it, and think nothing of the sketch as such; it is a step, nothing more. Think of it as that. . . . All right," he said to the model, who rose again, robed herself silently. "Thank you." The figure nodded, opened the book's shiny cover.

A very austere person, that. But a very fine model. A splendid body. Lithe power of animals; full, alive. Creates a response to the problem; and she has good control, too . . .

He moved on through the forest of easels, the white rectangles of paper, eyes following him.

"Ah—the primitive," he said, smiling. He looked in warm delight down at the shriveled little body, the bright eyes fastened on him, snapping, attentive; the thin, cracked-leather face. Mrs. Munner. Ja. Such vitality. Incredible.

With the students crowding in behind him he sat down on her stool, holding the board upright on his knees, peering at the literal, great-boned body worked in labored strokes, crosshatching areas, the facial features awry, contorted. His eyes crinkled, furrowed over at the corners he smiled, slowly nodding: "Well, that is one vision."

Crowding closely the laughter burst out around him; rippled, tearing, derisive.

"No, don't laugh," he said. He looked around at them, the laughing young faces, lean, round, bobbing. How easy to be arrogant. Youth in the face of age—age unknown which does not conform to their price-tag of excellence. So easy to laugh in sophistication at the primitive's tortured crampings. Butt of the swift. The parties for the Douanier . . . Oh, they have much, much to learn. "Don't laugh," he repeated, his voice booming, gentle. "We are all," his eyes swept the silent faces, "*all* trying to see what is reality—and there are many ways of seeing reality. No one can afford to mock another's attempts to come upon it. . . . It is a great error to despise representational painting; if academic art obeys the laws of the canvas it is just as valid. What of the old masters—Rembrandt, El Greco, Goya, the Italians?" He shook his head in quiet irritation, watching them. "Beware of dismissing other visions as worthless or ridiculous. Truth is never ridiculous. . . . Look here," he raised the board high in his left hand, partly facing them, pointing with his finger, "do you see how this relates to this—and to this? Much of this is seen very well here. Do you see how this here—this line of the arm, the quality of this area—and this place of the thigh and calf—all work together to give the entire form a totality, an integration?"

Pointing he watched their eyes. Ja. Now nod. Nod at teacher. Don't see, most of them; don't want to. Blinded by the crude and unsophisticated line. They have learned to ridicule awkward honesty already; God help them when they are fifty or sixty.

"Very good, Mrs. Munner." He smiled down at the bright eyes, intense, silent; bony hands folded in the meager lap, two shriveled brown leaves. "Keep on as you are going. Good."

He moved on, came to Esther Zauberin's work, studied it, conscious of her black-lashed eyes upon him, bold and flat, measuring. The same. Her own self-importance she places above the grand laws. Meaningless defiance. Will she ever *want* to learn, to listen? What will bring her to a humility of spirit? The cancer of the American woman; her bubonic plague . . .

"You don't accept the logic of the paper," he said, still looking at the easel.

"What?" she said in the thin, strident voice. "What do you mean?"

"For every act," Carl Roessli said evenly, "there is a logical consequence, isn't that so? Nothing must be arbitrary; everything follows a logic." He turned toward her now, speaking in

firm, slow enunciation, watching gently her bold and angry eyes. She mocked the primitive the most, too; ja, natürlich. "If you are attacking the problem of the human body realistically the consequences of such a decision are very different from what they would be if you, say, decide to abstract it. But *either* way you have to accept the consequences; that is, you must understand everything from that point of view." Perhaps this way. Ja; if she can see it as a logic. "But there is even another consequence you have to accept in the moment you say: 'I am going to paint.' This is the esthetic logic of the paper itself. This you can *never* escape no matter how you draw." He turned to her work. "Now you see, here—where you have decided to divide your composition—you have not accepted the consequences of this space *here*; these places—here and here—are holes in your surface; they recede, and there is nothing in your construction to bring them forward again. It has destroyed the surface of your work. The Drang—the force of movement in and out—is not balanced . . . Just to post a figure in space does not necessarily imply a good painting. . . ."

"But what about Matisse's drawings, then?"

Ah. Ja.

"I said *nothing* must be arbitrary; but Matisse makes the eye accept the *felt logic* of his canvas, isn't that so?"

"But why should I accept this logic? What is this logic that I should accept it? Suppose—suppose I don't want to?"

Na—smiling now; but only to cover the fury. To fight so the timeless values!

"You don't have to," he said, smiling quietly, gesturing with one hand. "When you go skiing you don't have to accept the law of gravity; but if you lose your balance you will fall down all the same. You don't have to accept this other logic either, but it is always in operation, just the same. And if you lose your balance you must accept the penalty of falling." He paused, shifted his weight from his left foot. "Try it again. . . . Cover with your hand, like this, you see? Cover it over and then restate it if it does not seem right. . . . Remember, *nothing can be arbitrary* in individual expression."

He moved by her averted, angry eyes, pulling at his beard slowly. The Great I Am . . .

He paused, crossed his arms on his chest. The Merrill girl. Smooth face, smooth hair; and such sightless eyes . . . Well, I

Hofmann with students in Provincetown, circa 1941.

will give her more time on this pose. She is beginning to grasp a few things, ja; but she needs longer, much longer. Look at her work next time. . . . So groomed, these young women; so terribly smoothed out. Never a deep bold line in their faces. Never a trace of agony. Smooth wax glaze from forehead to chin; over their whole bodies. They have nothing to do with the men; like another race of beings, they are. Have they become incapable of feeling anything, these groomed ones? Na, no time for that now.

Ja—the novice. Kittering. A good eye, a good eye; but . . . "You must learn to trust more," he said to the large, lined face. "Yes, you have the vision of what you want to do; but you do not trust it enough yet. You see things very plastically, which is as it should be—but it is as though you know the language but are too hesitant to speak it. . . . This is good; but here, for instance—*here* it seems to me that your line is weak. Unresolved. This line here, where it curves—it is not stated firmly; it is not—*inevitable*. Do you know what I mean?"

The tall figure, listening, nodded slowly.

"Every line, every area must seem to be inevitable—as though in *this* context," Carl Roessli tapped the drawing lightly, "there can be no other way for it to be, ja?" He measured the deep-set, attentive eyes with his own, steadily, and said, "If you dare to imagine, you must also dare to act. Isn't that so? . . . That's good," he nodded at the drawing, moving away from it. "Keep at it."

At Romain Jaurès' easel he stopped and stared, frowning; picked up a piece of charcoal again. "Mr. Jaurès, the parts . . . Yes, this is good; and this, here, this is good, and this here—" he gestured with the charcoal stub, "—but what does it all *mean*? See—this is all like a—like a pasting-together of things . . . There must be more than just a pleasing arrangement of shapes and lines; that is charming, ja—but it is not a picture; it is not an entity, it does not work toward anything. The parts, Mr. Jaurès . . ." He paused. "The parts must relate to the whole."

He followed some of the clean, well-formed areas with the charcoal, not touching the paper. So nice; so—stylish. Ja, that is the word. Great technical skill, very good competence—but no heart. He does not see as a painter must see; there is no—no involvement. It is design, not art. It does not move, does not stir one. . . . Looking down now at his trousers. Ah. Smear on the left leg; he listens without hearing me. Old man, old fool—for not applauding, back-patting the technical excellence. Chagrined. Why cannot he see that it is not a question of approbation or censure?

"We are all trying, *all* of us," Carl Roessli said aloud, "to come to a pure vision of the things around us. No one has a monopoly on vision; there is no belted Teutonic Order of an elect-who-have-arrived, who sit alone at a great table and scoff at all the rest. . . . We are all trying to see more, to increase our comprehension, our awareness; we all have to free ourselves from the—the crampedness of our living, the blinders that we wear, that we draw down over our eyes—over our spirit, too. . . . Try to see, Mr. Jaurès; try to free your mind from *personal* concerns; let your seeing of things grow."

Moving on, he asked: "Miss Coleman here? Miss Strind? Mr. Guerin?" Smiles, head-shakings, murmurs followed him.

Too bad; would like to see what that Coleman girl would do with this pose.

Ah, ja. The Irishman over there; that fantastic red shirt. I must see if he . . . Ja, the same problem he's struggling with. Over and over. Of course. But what a fighter he is; it is wonderful.

For a few moments he studied the composition; shifted, began to speak, studied longer, absently scratching his beard's underside with his thumb. Then he turned and clapped Mike Doyle lightly on the shoulder and said, smiling, "Ja, it's a very hard problem, isn't that so?"

"You said it," Mike Doyle replied flatly, not angrily, nodding.

After another minute Carl Roessli said, "You must remember, Mr. Doyle, art is many things. . . . Don't be too quick to turn your back on the great truths which people like Mondrian and Picasso and Braque made possible. Don't completely forsake the good things that the cubist order made for."

"The order," Mike Doyle said. He snorted, rubbed his hands on solid, dungareed thighs. "Yeah, sure, the order—you got to have that, I know that; but there's a hell of a lot more to it than this preservation-of-the-surface routine. That's the way I see it. You know what I think?" He jabbed a thumb back at his collar bone. "I think abstract painting's turned into a lousy lullaby in rhythm."

"A what, please?" Carl Roessli leaned toward him, his head cocked, harkening.

"Uh? Oh, you know—just a tired-out old game, dead and cold as a slab. Two-dimensional building blocks, that's what it is. Building blocks."

"Ja, it can become that," Carl Roessli said with a tiny smile, his eyes twinkling. "There are many kinds of meaning; and everyone has to find his own way to the expression of it. But you must not think that the inclusion of symbolic or literary meaning in a painting *necessarily* increases its greatness; in fact, the opposite is more often true. . . ."

"Can't see it." Mike Doyle grinned broadly, shook his head. "Too far away from people. After the air becomes just so rarefied, nobody gets to breathe any more." He threw out his stubby arms. "That high-wire stuff may be nice to watch for a while; but what has it got for people? What I'm looking for is something that'll have meaning for every guy walking along the street—a way he can sink his teeth into the painting, and

respond to it; and I'm going to find it, too. Art has got to be a—a wide kind of force, not a lousy upper-crust cocktail-circle. Sherry and olives at five . . . That's where I stand on it, anyway."

"Yes." Carl Roessli wagged his silvered skull slowly, smiling in the muted light. *A very violent boy; and a real fighter. It is a good composition, too. Well seen. Whether he can ever resolve this or not . . . He is at a very crucial place, actually; and he must go his own way on this, now.*

"Keep looking at things, Mr. Doyle," he said aloud, looking into the wide, even eyes. "Go back and look at some Picassos of the mid-thirties. Do you know Rouault well?"

"No."

"Well, go and study him carefully. Somebody in class here will have a book of reproductions, or if not you can come and borrow mine. You may find some of what you're after with him. And keep on with it."

"I hear you talking," Mike Doyle said.

Smiling faintly, Carl Roessli moved off, looked at his watch. *Already. Well.*

"Recess," he said aloud. The figures started toward the door and Carl Roessli passed slowly through them to the back entrance, the left leg dragging a little. *Taking too much time with each person again. I always do. What was it he said—*I hear you talking? *Amazing; always something new . . . That other thing, too, what . . . ? in rhythm; something in rhythm.*

He opened the door to his own part of the house, smiling, shaking his head. *A most irreverent person. Smart-alecks and hootings. The Irish—it is as though the Irish have infected all the Americans, in a way . . . The Celtic: it errs on the side of froth, despises profundity often, is not entirely . . . But it is good, though; good to see a genuine one.*

1951

HANS HOFMANN

Hans Hofmann (1880–1966) arrived in the United States in the 1930s as a refugee from Germany. Born in Bavaria, Hofmann had known Matisse and Picasso in Paris in the early years of the new century and opened a school in Munich during World War I, a school so famous it eventually drew students from America, among them the sculptor Louise Nevelson. Hofmann's teachings fused an exalted Romantic spirit, one he saw exemplified in the music of Beethoven, with an instinctive feeling for bold, Fauvist color and intricate, Cubist design. In New York—where he established his school in 1933 and taught for twenty-five years—he was a galvanic force, encouraging an open-ended approach to the art of painting, inspiring young artists to move freely between abstraction and representation. His classroom conversation, in a thick German accent sometimes virtually indecipherable, depended on ideas at once visceral and spiritual—a struggle to bring the work of art alive that was epitomized in his mysterious idea of "push/pull." The young American artists in turn had a liberating effect on Hofmann, encouraging this man who had felt inhibited as a painter to strike out in new directions and create in his later years a body of work more richly varied than that of any other Abstract Expressionist. For some years Hofmann worked on a treatise on painting, never published; his best-known essay, "The Search for the Real," appeared in conjunction with an exhibition at the Addison Gallery of American Art in Andover in 1948. Hofmann's impact can be felt everywhere in mid-century art. Critics including Clement Greenberg and Harold Rosenberg were open in acknowledging the debt. And the list of artists who either studied with him or felt the force of his ideas amounts to a roll call of American painters and sculptors between 1930 and 1960.

FROM

The Search for the Real in the Visual Arts

ART is magic. So say the surrealists. But how is it magic? In its metaphysical development? Or does some final transformation culminate in a magic reality? In truth, the latter is impossible without the former. If creation is not magic, the outcome cannot be magic. To worship the product and ignore its development leads to dilettantism and reaction. Art cannot result from sophisticated, frivolous, or superficial effects.

The significance of a work of art is determined then by the

quality of its growth. This involves intangible forces inherent in the process of development. Although these forces are surreal (that is, their nature is something beyond physical reality), they, nevertheless, depend on a physical carrier. The physical carrier (commonly painting or sculpture) is the medium of expression of the surreal. Thus, an idea is communicable only when the surreal is converted into material terms. The artist's technical problem is how to transform the material with which he works back into the sphere of the spirit.

This two-way transformation proceeds from metaphysical perceptions, for metaphysics is the *search* for the essential nature of reality. And so artistic creation is the metamorphosis of the external physical aspects of a thing into a self-sustaining spiritual reality. Such is the magic act which takes place continuously in the development of a work of art. On this and only on this is creation based.

Still it is not clear what the intrinsic qualities in a medium actually are to make the metamorphosis from the physical into the spiritual possible. Metaphysically, a thing in itself never expresses anything. It is the relation between things that gives meaning to them and that formulates a thought. A thought functions only as a fragmentary part in the formulation of an idea.

A thought that has found a plastic expression must continue to expand in keeping with its own plastic idiom. A plastic idea must be expressed with plastic means just as a musical idea is expressed with musical means, or a literary idea with verbal means. Neither music nor literature are wholly translatable into other art forms; and so a plastic art cannot be created through a superimposed literary meaning. The artist who attempts to do so produces nothing more than a show-booth. He contents himself with visual storytelling. He subjects himself to a mechanistic kind of thinking which disintegrates into fragments.

The plastic expression of one relation must in turn be related to a like expression of another relation if a coherent plastic art is to be the outcome. In this way the expression of a work of art becomes synonymous with the sum of relations and associations organized in terms of the medium of expression by an intuitive artist.

The relative meaning of two physical facts in an emotionally

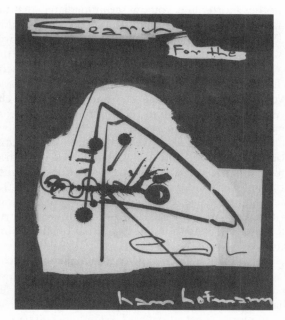

Hans Hofmann: Study for the title page of
the essay collection *Search for the Real,* 1948.
Ink on paper, 17 × 14 in.

controlled relation always creates the phenomenon of a third
fact of a higher order, just as two musical sounds, heard simul-
taneously create the phenomenon of a third, fourth, or fifth.
The nature of this higher third is non-physical. In a sense it is
magic. Each such phenomenon always overshadows the mate-
rial qualities and the limited meaning of the basic factors from
which it has sprung. For this reason Art expresses the highest
quality of the spirit when it is surreal in nature; or, in terms of
the visual arts, when it is of a surreal plastic nature.

Let us explain our philosophical perceptions with the help
of a practical example: take a sheet of paper and make a line on
it. Who can say whether this line is long or short? Who can say
what its direction is? But when, on this same sheet of paper, you

make another shorter line, you can see immediately that the first line is the longer one. By placing the second line so that it is not exactly under the first line, you create a sense of movement which will leave no doubt as to the direction in which the first line moves, and in which direction the second is opposed to it.

Was it necessary to enlarge the first line to make it the longer one? We did not have to touch that line or make any change. We gave it meaning through its relation to the new line; and in so doing, we gave simultaneous meaning also to this new line, meaning which it could not have had otherwise. The dominating thought of any relation is always reflected in both directions. But it is the multi-reflex of a particular thought with respect to an over-all idea that finally lifts an artistic expression into the realm of magic. In other words, it is the surreal content of the work that absorbs and overshadows the structure and the physical foundation. The spiritual quality dominates the material.

But, is this all that happened when you made these two lines? You may think so, but that is by no means the case. You started out on an empty piece of paper. The paper is no longer empty. What has happened? Is there nothing but a combination of two lines on an empty sheet of paper? Certainly not! The fact that you placed one line somewhere on the paper created a very definite relationship between this line and the edges of your paper. (You were not aware perhaps that these edges were the first lines of your composition.) By adding another line you not only have a certain tension between the two lines, but also a tension between the unity of these two lines and the outline of your paper. The fact that your two lines, when considered either separately, or as a unit, have a definite relation to the outline, makes the lines and the paper a unified entity which (since lines and paper are physically different) exists entirely in the intellect.

From the beginning, your paper is limited, as all geometrical figures are limited. Within its confines is the complete creative message. Everything you do is definitely related to the paper. The outline becomes an essential part of your composition. Its own meaning, as a limitation, is related to the multi-meanings of your two lines. The more the work progresses, the more it becomes defined or qualified. It increasingly limits itself. Expansion, paradoxically, becomes contraction.

Expansion and contraction in a simultaneous existence is a characteristic of space. Your paper has actually been transformed into space. A sensation of movement and countermovement is simultaneously created through the position of these two lines in their relation to the outline of the paper. Movement and countermovement result in tension. Tensions are the expression of forces. Forces are the expression of actions. In their sur-real relationship, the lines may now give the idea of being two shooting stars which move with speed through the universe. Your empty paper has been transformed by the simplest graphic means to a universe in action. This is real magic. So your paper is a world in itself—or you may call it, more modestly, only an object, or simply a picture with a life of its own—a spiritual life—through which it can become a work of art.

> Your two lines carry multi-meanings:
> They move in relation to each other.
> They have tension in themselves.
> They express active mutual forces.
> This makes them into a living unit.
> The position of this unit bears a definite relation
> to the entire paper.
> This in turn creates tensions of a still higher order.
> Visual and spiritual movements are simultaneously
> expressed in these tensions.
> They change the meaning of your paper as it
> defines and embodies space.
> Space must be vital and active—a force impelled
> pictorial space, presented as a spiritual and
> unified entity, with a life of its own.
> This entity must have a life of the spirit without
> which no art is possible—the life of a creative
> mind in its sensitive relation to the outer
> world.
> The work of art is firmly established as an
> independent object; this makes it a picture.
> Outside of it is the outer world.
> Inside of it, the world of an artist.

A consciousness of limitation is paramount for an expression of the Infinite. Beethoven creates Eternity in the physical

limitation of his symphonies. Any limitation can be subdivided infinitely. This involves the problem of time and relativity. A glimpse heavenward at a constellation or even at a single star only *suggests* infinity; actually our vision is limited. We cannot perceive unlimited space; it is immeasurable. The universe, as we know it through our visual experience, is limited. It first came into existence with the formation of matter, and will end with the complete dissolution of matter. Where there is matter and action, there is space.

Pictorial space exists two dimensionally. When the two dimensionality of a picture is destroyed, it falls into parts—it creates the effect of naturalistic space. When a picture conveys only naturalistic space, it represents a special case, a portion of what is felt about three-dimensional experience. This expression of the artist's experience is thus incomplete.

The layman has extreme difficulty in understanding that plastic creation on a flat surface is possible without destroying this flat surface. But it is just this conceptual completeness of a plastic experience that warrants the preservation of the two dimensionality. A plastic approach which is incomplete conceptually will destroy the two dimensionality, and being incomplete in concept, the creation will be inadequate.

Depth, in a pictorial, plastic sense, is not created by the arrangement of objects one after another toward a vanishing point, in the sense of the Renaissance perspective, but on the contrary (and in absolute denial of this doctrine) by the creation of forces in the sense of *push and pull*. Nor is depth created by tonal gradation—(another doctrine of the academician which, at its culmination, degraded the use of color to a mere function of expressing dark and light).

Since one cannot create "real depth" by carving a hole in the picture, and since one should not attempt to create the illusion of depth by tonal gradation, depth as a plastic reality must be two dimensional in a formal sense as well as in the sense of color. "Depth" is not created on a flat surface as an illusion, but as a plastic reality. The nature of the picture plane makes it possible to achieve depth without destroying the two-dimensional essence of the picture plane. Before proceeding, however, the artist must realize the necessity of differentiating between a line and a plane concept.

A plane is a fragment in the architecture of space. When a number of planes are opposed one to another, a spatial effect results. A plane functions in the same manner as the walls of a building. A number of such walls in a given relation creates architectural space in accordance with the idea of the architect who is the creator of this space. Planes organized within a picture create the pictorial space of its composition. In an old master composition, the outline of a figure was considered as a plane and as such the figure became plastically active in the composition. The old masters were plane conscious. This makes their pictures restful as well as vital, irrespective of the dramatic emphasis.

A line concept cannot control pictorial space absolutely. A line may flow freely in and out of space, but cannot independently create the phenomenon of *push and pull* necessary to plastic creation. *Push and pull* are expanding and contracting forces which are activated by carriers in visual motion. Planes are the most important carriers, lines and points less so.

The forces of *push and pull* function three dimensionally without destroying other forces functioning two dimensionally. The movement of a carrier on a flat surface is possible only through an act of shifting left and right or up and down. To create the phenomenon of *push and pull* on a flat surface, one has to understand that by nature the picture plane reacts automatically in the opposite direction to the stimulus received; thus action continues as long as it receives stimulus in the creative process. *Push* answers with *pull* and *pull* with *push*. For example, the inside pressure of a balloon is in balance in every direction. By pressing one side of the balloon, you will disturb this balance, and, as a consequence, the other end will swallow up the amount of pressure applied. Needless to say, this procedure can be reversed. Exactly the same thing can happen to the picture plane in a spiritual sense. When a force is created somewhere in the picture that is intended to be a stimulus in the sense of a *push* the picture plane answers automatically with a force in the sense of *pull* and vice versa.

The function of *push and pull* in respect to form contains the secret of Michelangelo's monumentality or of Rembrandt's universality. At the end of his life and at the height of his capacity, Cézanne understood color as a force of *push and pull*. In his

pictures he created an enormous sense of volume, breathing, pulsating, expanding, contracting through his use of color. His watercolors were forever exercises in this direction. Only very great painting becomes so plastically sensitive, for the expression of the deepest in man calls for unexpected and surprising associations.

1948

CLEMENT GREENBERG

No American art critic has been more widely read, discussed, and debated than Clement Greenberg (1909–1994). A native New Yorker, he first threw down the gauntlet with "Avant-Garde and Kitsch" in 1939, announcing that there was an unbridgeable gap between high art and popular culture. And he kept up his full-throated defense of the purity of modern art—and his razor-sharp critique of what he saw as the nihilism of Duchamp and his kind—through seminal essays such as "Modernist Painting" (1961) and "Counter-Avant-Garde" (1971). Greenberg was a key figure at *Partisan Review*, the left-wing anti-Soviet magazine that shaped intellectual life in the 1940s; it was there and in *The Nation* that many of his most important essays appeared. An early and vociferous supporter of Pollock, de Kooning, and the other artists who would soon be known as the Abstract Expressionists—Greenberg preferred to call their work "'American-Type' Painting"—he in fact had an uneasy relationship with many artists, especially in the 1950s, who found his ideas and his personality autocratic. While Greenberg's writings of the 1940s can demonstrate a wide-ranging openness and curiosity, as time went on his insistence on the centrality of formal values left him increasingly unwilling to even discuss the role of narrative, metaphor, or subject matter in the visual arts. His 1961 essay collection, *Art and Culture,* became a defining text for artists, critics, and curators in the 1960s and 1970s, as Greenberg's enthusiasm for the pared-down abstract language spoken by the sculptor David Smith and the painters Barnett Newman, Kenneth Noland, and Morris Louis was having a decisive impact on taste in the museums and the academy. Whether or not one accepts Greenberg's strenuously austere vision of artistic experience, there is no denying the power of his beautifully plainspoken prose.

Review of an Exhibition of Willem de Kooning

DECIDEDLY, the past year has been a remarkably good one for American art. Now, as if suddenly, we are introduced by Willem de Kooning's first show, at the Egan Gallery, to one of the four or five most important painters in the country, and find it hard to believe that work of such distinction should come to our notice without having given preliminary signs of itself long before. The fact is that de Kooning has been painting almost all his life, but only recently to his own satisfaction. He has saved

one the trouble of repeating "promising." Having chosen at last, in his early forties, to show his work, he comes before us in his maturity, in possession of himself, with his means under control, and with enough knowledge of himself and of painting in general to exclude all irrelevancies.

De Kooning is an outright "abstract" painter, and there does not seem to be an identifiable image in any of the ten pictures in his show—all of which, incidentally, were done within the last year. A draftsman of the highest order, in using black, gray, tan, and white preponderantly he manages to exploit to the maximum his lesser gift as a colorist. For de Kooning black becomes a color—not the indifferent schema of drawing, but a hue with all the resonance, ambiguity, and variability of the prismatic scale. Spread smoothly in heavy somatic shapes on an uncrowded canvas, this black identifies the physical picture plane with an emphasis other painters achieve only by clotted pigment. De Kooning's insistence on a smooth, thin surface

Hans Namuth: *Clement Greenberg*, 1950.

is a concomitant of his desire for purity, for an art that makes demands only on the optical imagination.

Just as the cubists and their more important contemporaries renounced a good part of the spectrum in order to push farther the radical renovation of painting that the fauves had begun (and as Manet had similarly excluded the full color shade in the eighteen sixties, when he did his most revolutionary work), so de Kooning, along with Gorky, Gottlieb, Pollock, and several other contemporaries, has refined himself down to black in an effort to change the composition and design of post-cubist painting and introduce more open forms, now that the closed-form canon—the canon of the profiled, circumscribed shape—as established by Matisse, Picasso, Mondrian, and Miró seems less and less able to incorporate contemporary feeling. This canon has not been broken with altogether, but it would seem that the possibility of originality and greatness for the genera-tion of artists now under fifty depends on such a break. By ex-cluding the full range of color—for the essence of the problem does not lie there—and concentrating on black and white and their derivatives, the most ambitious members of this genera-tion hope to solve, or at least clarify, the problems involved. And in any case black and white seem to answer a more advanced phase of sensibility at the moment.

De Kooning, like Gorky, lacks a final incisiveness of composi-tion, which may in his case, too, be the paradoxical result of the very plenitude of his draftsman's gift. Emotion that demands singular, original expression tends to be censored out by a really great facility, for facility has a stubbornness of its own and is loath to abandon easy satisfactions. The indeterminateness or ambiguity that characterizes some of de Kooning's pictures is caused, I believe, by his effort to suppress his facility. There is a deliberate renunciation of will in so far as it makes itself felt as skill, and there is also a refusal to work with ideas that are too clear. But at the same time this demands a considerable exertion of the will in a different context and a heightening of consciousness so that the artist will know when he is being truly spontaneous and when he is working only mechanically. Of course, the same problem comes up for every painter, but I have never seen it exposed as clearly as in de Kooning's case.

Without the force of Pollock or the sensuousness of Gorky,

more enmeshed in contradictions than either, de Kooning has it in him to attain to a more clarified art and to provide more viable solutions to the current problems of painting. As it is, these very contradictions are the source of the largeness and seriousness we recognize in this magnificent first show.

1948

The Role of Nature in Modern Painting

"And where there is no concern for reality how can you limit and unite plastic liberties."—Juan Gris in a letter to Daniel-Henry Kahnweiler, quoted in the latter's *Juan Gris: His Life and Work* (translated by Douglas Cooper)

"The difference between expressionism and cubism is that of the painter's object."—Daniel-Henry Kahnweiler, *Ibid*

ONE of the important problems of contemporary art criticism is to ascertain how cubism—that purest and most unified of all art styles since Tiepolo and Watteau—arrived at its characteristic form of purity and unity. We know how much French painting of the forty-five years previous to cubism had contributed by its effort towards a more immediate and franker realization of painting as a physical medium, with the new recognition this entailed of the two-dimensionality of the picture plane and of painting's right to be independent of illusion. But this recognition was shared in the twentieth century by the nabis, the fauves, and the French and German expressionists as well as the cubists. The latter, however, established a larger and much more viable style than did the other schools, a style within which at least four artists have produced masterpieces that reach any of the summits of past art, and a style, moreover, to which contemporary visual sensibility refers for its most authoritative standard. And so we ask what it was that enabled cubism to win this supremacy. We remember that Matisse painted his strongest pictures, between 1910 and 1920, while under its influence. And it was cubism's influence that made the difference between promise and realization in Klee's case. Whereas Kandinsky, an artist of genius, never achieved anything even at his best that

can stand up to the productions of Picasso, Braque, Gris, and Léger in their prime, precisely because of his failure to make a real contact with cubism.

The decisive difference between cubism and the other movements appears to lie in its relation to nature. The paradox of French painting between Courbet and Cézanne is that, while in effect departing further and further from illusionism, it was driven in its most important manifestations by the conscious desire to give an account of nature that would be more accurate or faithful *in context* than any before. The context was the medium, whose claims—the limitations imposed by the flat surface, the canvas's shape, and the nature of the pigments—had to be accommodated to those of nature. The previous century of painting had erred in not granting the claims of the medium sufficiently and Cézanne, in particular, proposed to remedy this while at the same time giving an even more essentially accurate transcription of nature's appearance. As it turned out, the movement that began with Cézanne eventually culminated in abstract art, which permitted the claims of the medium to override those of nature almost entirely. Yet before that happened, nature did succeed in stamping itself so indelibly on modern painting that its stamp has remained even in an art as abstract as Mondrian's. What was stamped was not the appearance of nature, however, but its logic.

Cubism, which effected the break with the appearance of nature, set itself originally to the task of establishing on a flat surface the completest possible conceptual image of the structure of objects or volumes. While the impressionists had been interested in the purely visual sensations with which nature presented them at the given moment, the cubists were mainly occupied with the generalized forms and relations of the surfaces of volumes, describing and analyzing them in a simplified way that omitted the color and the "accidental" attributes of the objects that served them as models. Taking their cue from Cézanne, they sought for the decisive structure of things that lay permanently under the accidents of momentary appearance, and to do this they were willing to violate the norms of appearance by showing an object from more than one point of view on the same picture plane. But in the end they did not find a completer way of describing the structure of objects on a

flat surface—blueprints and engineer's drawings could do that more adequately and had already withdrawn the task from the province of art. Instead, the cubists found the structure of the picture. They had never forgotten that; in fact, it was their main purpose, and their quest for a better way of transcribing the relations of volumes had been conceived of not as a scientific project but as a quest, ultimately, for a means of creating more firmly organized pictures; this, they had thought, required a truer, completer imitation of nature.

But Picasso and Braque discovered that it was not the essential description of the visible relations of volumes in nature or the more emphatic rendition of their three-dimensionality that could guarantee the organization of a pictorial work of art. On the contrary, to do these things actually disrupted that organization. By dint of their efforts to discover pictorially the structure of objects, of bodies, in nature, Picasso and Braque had come—almost abruptly, it would seem—to a new realization of, and new respect for, the nature of the picture plane itself as a material object; and they came to the further realization that only by transposing the internal logic by which objects are organized in nature could aesthetic form be given to the irreducible flatness which defined the picture plane in its inviolable quality as a material object. This flatness became the final, all-powerful premise of the art of painting, and the experience of nature could be transposed into it only by analogy, not by imitative reproduction.* Thus the painter abandoned his interest in the concrete appearance, for example, of a glass and tried instead to approximate by analogy the way in which nature had married the straight contours that defined the glass vertically to the curved ones that defined it laterally. Nature no longer offered appearances to imitate, but principles to parallel.

The Renaissance painter, too, had learned to organize his picture from nature. But for him it was the logic of appearance that mattered rather than the logic of somatic structure. He ordered his illusions by analogy with the Renaissance view of

* The process by which cubism, in pushing naturalism to its ultimate limits and over-emphasizing modeling—which is perhaps the most important means of naturalism in painting—arrived at the antithesis of naturalism, flat abstract art, might be considered a case of "dialectical conversion."

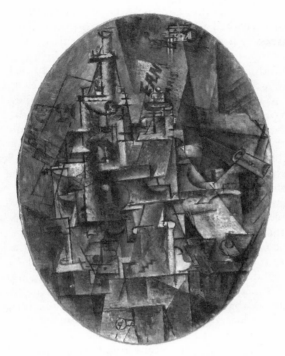

Pablo Picasso: *Bottle, Glass, and Fork*, 1911–12.
Oil on canvas, 28⁵/₁₆ × 20¹¹/₁₆ in.

the world as a free space in which separate forms move. The cubists, viewing the world as a continuum, a dense somatic entity (as was dictated by their age), had to strive to organize the picture—itself an object—by analogy with the single object abstracted from surrounding space and by analogy with the space relations between the different parts of one and the same object. Pictorial space became more cohesive and cramped, not only in depth, but also in relation to the edges of the canvas. (One can, for that matter, already notice in Manet how much more crowded the picture begins to be toward its edges. Think, by contrast, of the immense space in which Rembrandt's figures swim.)

The positivist aesthetic of the twentieth century, which refuses the individual art the right to refer explicitly to anything beyond its own realm of sensations, was driving the cubist painter toward the flat, non-illusionist picture in any case, but it is doubtful whether he would have been able to make such superlative art of it as he did without the guidance of nature. Forced to invent an aesthetic logic *ex nihilo* (which never happens in art anyway), without reference to the logic by which bodies are organized in actual space, the cubists would never have arrived at that sense of the totality, integrity, economy, and indivisibility of the pictorial work of art—an object in its turn too—which governs genuine cubist style. By drawing an analogy with the way in which an object's form and identity possess every grain of the substance of which it is composed, the cubists were able to give their main problem, that of the unity of the flat picture plane, a strict and durable solution.

As the poem, play, or novel depends for its final principle of form on the prevailing conception of the essential structure that integrates an event or cluster of events in actuality, so the form of a picture depends always on a similar conception of the structure that integrates visual experience "in nature." The spontaneous integrity and completeness of the event or thing seen guides the artist in forming the invented event or object that is the work of art. This seems to me to be always true, but it is particularly important to point it out in the case of cubism since cubism has evolved into abstract art, and abstract art seems—but only seems—to conceal its relation to nature.

Picasso, Braque, Gris, Léger, Klee are never able to dispense with the object in nature as a starting point, no matter how far they may go at times toward the abstract. Without the support of nature, Picasso and Braque would not have had the means of organizing their beautiful collages, utterly remote from the models as they seem, into the intense unities which they are. The integrity, the self-subsistent harmonious fact of mandolin, bottle, or wineglass called up an echo that was largely unrecognizable no doubt, but which became as valid, because of its form, within the order of art as the original perception of the mandolin or bottle was within the order of practical experience.

Other, later masters have been able to do without the object as a starting point. But I feel that outright abstract painting, including Mondrian's, when it is successful, establishes its

aesthetic right in the same way, ultimately, as did the master-pieces of cubism—by referring to the integrity of objects in nature. Mondrian's pictures certainly do. It is not because they are abstract that the works of the later Kandinsky and his followers fail to achieve coherence and substantiality, remaining for the most part mere pieces of arbitrary decoration; it is because they lack a sense of style, a feeling for the unity of the picture as an object; that is, they lack almost all reference to the structure of nature. The best modern painting, though it is mostly abstract painting, remains naturalistic in its core, despite all appearances to the contrary. It refers to the structure of the given world both outside and inside human beings. The artist who, like the nabis, the later Kandinsky, and so many of the disciples of the Bauhaus, tries to refer to anything else walks in a void.

1949

"American-Type" Painting

THE latest abstract painting offends many people, among whom are more than a few who accept the abstract in art in principle. New painting (sculpture is a different question) still provokes scandal when little that is new in literature or even music appears to do so any longer. This may be explained by the very slowness of painting's evolution as a modernist art. Though it started on its "modernization" earlier perhaps than the other arts, it has turned out to have a greater number of *expendable* conventions imbedded in it, or these at least have proven harder to isolate and detach. As long as such conventions survive and can be isolated they continue to be attacked, in all the arts that intend to survive in modern society. This process has come to a stop in literature because literature has fewer conventions to expend before it begins to deny its own essence, which lies in the communication of conceptual meanings. The expendable conventions in music, on the other hand, would seem to have been isolated much sooner, which is why the process of modernization has slowed down, if not stopped, there. (I simplify drastically. And it is understood, I hope, that tradition is not dismantled by the avant-garde for sheer revolutionary effect, but in order to maintain the level and vitality of art under the

steadily changing circumstances of the last hundred years—and that the dismantling has its own continuity and tradition.)

That is, the avant-garde survives in painting because painting has not yet reached the point of modernization where its discarding of inherited convention must stop lest it cease to be viable as art. Nowhere do these conventions seem to go on being attacked as they are today in this country, and the commotion about a certain kind of American abstract art is a sign of that. It is practiced by a group of painters who came to notice in New York about a dozen years ago, and have since become known as the "abstract expressionists," or less widely, as "action" painters. (I think Robert Coates of the *New Yorker* coined the first term, which is not altogether accurate. Harold Rosenberg, in *Art News*, concocted the second, but restricted it by implication to but three or four of the artists the public knows under the first term. In London, the kind of art in question is sometimes called "American-type painting.") Abstract expressionism is the first phenomenon in American art to draw a standing protest, and the first to be deplored seriously, and frequently, abroad. But it is also the first on its scale to win the serious attention, then the respect, and finally the emulation of a considerable section of the Parisian avant-garde, which admires in abstract expressionism precisely what causes it to be deplored elsewhere. Paris, whatever else it may have lost, is still quick to sense the genuinely "advanced"—though most of the abstract expressionists did not set out to be "advanced"; they set out to paint good pictures, and they "advance" in pursuit of qualities analogous to those they admire in the art of the past.

Their paintings startle because, to the uninitiated eye, they appear to rely so much on accident, whim, and haphazard effects. An ungoverned spontaneity seems to be at play, intent only on registering immediate impulse, and the result seems to be nothing more than a welter of blurs, blotches, and scrawls— "oleaginous" and "amorphous," as one British critic described it. All this is seeming. There is good and bad in abstract expressionism, and once one can tell the difference he discovers that the good owes its realization to a severer discipline than can be found elsewhere in contemporary painting; only it makes factors explicit that previous disciplines left implicit, and leaves implicit many that they did not.

To produce important art it is necessary as a rule to digest the major art of the preceding period, or periods. This is as true today as ever. One great advantage the American abstract expressionists enjoyed in the beginning was that they had already digested Klee and Miró—this, ten years before either master became a serious influence in Paris. Another was that the example of Matisse was kept alive in New York by Hans Hofmann and Milton Avery at a time when young painters abroad tended to overlook him. Picasso, Léger, and Mondrian were much in the foreground then, especially Picasso, but they did not block either the way or the view. Of particular importance was the fact that a large number of Kandinsky's early abstract paintings could be seen in New York in what is now the Solomon Guggenheim Museum. As a result of all this, a generation of American artists could start their careers fully abreast of their times and with an artistic culture that was not provincial. Perhaps it was the first time that this happened.

But I doubt whether it would have been possible without the opportunities for unconstrained work that the WPA Art Project gave most of them in the late '30s. Nor do I think any one of them could have gotten off the ground as well as he did without the small but relatively sophisticated audience for adventurous art provided by the students of Hans Hofmann. What turned out to be another advantage was this country's distance from the war and, as immediately important as anything else, the presence in it during the war years of European artists like Mondrian, Masson, Léger, Chagall, Ernst, and Lipchitz, along with a number of European critics, dealers, and collectors. Their proximity and attention gave the young abstract-expressionist painters self-confidence and a sense of being in the center of art. And in New York they could measure themselves against Europe with more benefit to themselves than they ever could have done as expatriates in Paris.

The justification for the term, "abstract expressionist," lies in the fact that most of the painters covered by it took their lead from German, Russian, or Jewish expressionism in breaking away from late Cubist abstract art. But they all started from French painting, got their fundamental sense of style from it, and still maintain some sort of continuity with it. Not least of

all, they got from it their most vivid notion of an ambitious, major art, and of the general direction in which it had to go in their time.

Picasso was very much on their minds, especially the Picasso of the early and middle '30s, and the first problem they had to face, if they were going to say what they had to say, was how to loosen up the rather strictly demarcated illusion of shallow depth he had been working within, in his more ambitious pictures, since he closed his "synthetic" Cubist period. With this went that canon of drawing in faired, more or less simple lines and curves that Cubism imposed and which had dominated almost all abstract art since 1920. They had to free themselves from this too. Such problems were not attacked by program (there has been very little that is programmatic about abstract expressionism) but rather run up against simultaneously by a number of young painters most of whom had their first shows at Peggy Guggenheim's gallery in 1943 to 1944. The Picasso of the '30s—whom they followed in reproductions in the *Cahiers d'Art* even more than in flesh-and-blood paintings—challenged and incited as well as taught them. Not fully abstract itself, his art in that period suggested to them new possibilities of expression for abstract and quasi-abstract painting as nothing else did, not even Klee's enormously inventive and fertile but equally unrealized 1930–1940 phase. I say equally unrealized, because Picasso caught so few of the hares he started in the '30s—which may have served, however, to make his effect on certain younger artists even more stimulating.

To break away from an overpowering precedent, the young artist usually looks for an alternative one. The late Arshile Gorky submitted himself to Miró in order to break free of Picasso, and in the process did a number of pictures we now see have independent virtues, although at the time—the late '30s—they seemed too derivative. But the 1910–1918 Kandinsky was even more of a liberator and during the first war years stimulated Gorky to a greater originality. A short while later André Breton's personal encouragement began to inspire him with a confidence he had hitherto lacked, but again he submitted his art to an influence, this time that of Matta y Echaurren, a Chilean painter much younger than himself. Matta was, and perhaps

still is, an inventive draughtsman, and in some ways a daring painter, but an inveterately flashy and superficial one. It took Gorky's more solid craft, profounder culture as a painter, and more selfless devotion to art to make many of Matta's ideas look substantial. In the last four or five years of his life he so transmuted these ideas, and discovered so much more in himself in the way of feeling to add to them, that their derivation became conspicuously beside the point. Gorky found his own way to ease the pressure of Picassoid space, and learned to float flat shapes on a melting, indeterminate ground with a difficult stability quite unlike anything in Miró. Yet he remained a late Cubist to the end, a votary of French taste, an orthodox easel painter, a virtuoso of line, and a tinter, not a colorist. He is, I think, one of the greatest artists we have had in this country. His art was largely unappreciated in his lifetime, but a few years after his tragic death in 1948, at the age of forty-four, it was invoked and imitated by younger painters in New York who wanted to save elegance and traditional draughtsmanship for abstract painting. However, Gorky finished rather than began something, and finished it so well that anybody who follows him is condemned to academicism.

Willem de Kooning was a mature artist long before his first show in 1948. His culture is similar to Gorky's (to whom he was close) and he, too, is a draughtsman before anything else, perhaps an even more gifted one than Gorky and certainly more inventive. Ambition is as much a problem for him as it was for his dead friend, but in the inverse sense, for he has both the advantages and the liabilities—which may be greater—of an aspiration larger and more sophisticated, up to a certain point, than that of any other living artist I know of except Picasso. On the face of it, de Kooning proposes a synthesis of modernism and tradition, and a larger control over the means of abstract painting that would render it capable of statements in a grand style equivalent to that of the past. The disembodied contours of Michelangelo's and Rubens's nude figure compositions haunt his abstract pictures, yet the dragged off-white, grays, and blacks by which they are inserted in a shallow illusion of depth—which de Kooning, no more than any other painter of the time, can deepen without risk of second-hand effect—bring the Picasso of the early '30s persistently to mind. But there are even more

essential resemblances, though they have little to do with imitation on de Kooning's part. He, too, hankers after *terribilità*, prompted by a similar kind of culture and by a similar nostalgia for tradition. No more than Picasso can he tear himself away from the human figure, and from the modeling of it for which his gifts for line and shading so richly equip him. And it would seem that there was even more Luciferian pride behind de Kooning's ambition: were he to realize it, all other ambitious painting would have to stop for a while because he would have set its forward as well as backward limits for a generation to come.

If de Kooning's art has found a readier acceptance than most other forms of abstract expressionism, it is because his need to include the past as well as forestall the future reassures most of us. And in any case, he remains a late Cubist. And then there is his powerful, sinuous Ingresque line. When he left outright abstraction several years ago to attack the female form with a fury greater than Picasso's in the late '30s and the '40s, the results baffled and shocked collectors, yet the methods by which these savage dissections were carried out were patently Cubist. De Kooning is, in fact, the only painter I am aware of at this moment who continues Cubism without repeating it. In certain of his latest *Women*, which are smaller than the preceding ones, the brilliance of the success achieved demonstrates what resources that tradition has left when used by an artist of genius. But de Kooning has still to spread the full measure of that genius on canvas.

Hans Hofmann is the most remarkable phenomenon in the abstract expressionist "school" (it is not really a school) and one of its few members who can already be referred to as a "master." Known as a teacher here and abroad, he did not begin showing until 1944, when he was in his early sixties, and only shortly after his painting had become definitely abstract. Since then he has developed as one of a group whose next oldest member is at least twenty years younger. It was only natural that he should have been the maturest from the start. But his prematureness rather than matureness has obscured the fact that by 1947 he started and won successful pictures from ideas whose later and more single-minded exploitation by others was to constitute their main claim to originality. When I myself not so long ago

complained in print that Hofmann was failing to realize his true potentialities, it was because I had not caught up with him. Renewed acquaintance with some of his earlier work and his own increasing frequency and sureness of success have enlightened me as to that.

Hofmann's pictures in many instances strain to pass beyond the easel convention even as they cling to it, doing many things which that convention resists. By tradition, convention, and habit we expect pictorial structure to be presented in contrasts of dark and light, or *value*. Hofmann, who started from Matisse, the Fauves, and Kandinsky as much as from Picasso, will juxtapose high, shrill colors whose uniform warmth and brightness do not so much obscure value contrasts as render them dissonant. Or when they are made more obvious, it will be by jarring color contrasts that are equally dissonant. It is much the same with his design and drawing: a sudden razor-edged line will upset all our notions of the permissible, or else thick gobs of paint, without support of edge or shape, will cry out against pictorial sense. When Hofmann fails it is either by forcing such things, or by striving for too obvious and pat a unity, as if to reassure the spectator. Like Klee, he works in a variety of manners without seeming to consolidate his art in any one of them. He is willing, moreover, to accept his bad pictures in order to get in position for the good ones, which speaks for his self-confidence. Many people are put off by the difficulty of his art—especially museum directors and curators—without realizing it is the difficulty of it that puts them off, not what they think is its bad taste. The difficult in art usually announces itself with less sprightliness. Looked at longer, however, the sprightliness gives way to calm and to a noble and impassive intensity. Hofmann's art is very much easel painting in the end, with the concentration and the relative abundance of incident and relation that belong classically to that genre.

Adolph Gottlieb and Robert Motherwell have likewise gotten less appreciation than they deserve. Not at all alike in their painting, I couple them for the moment because they both stay closer to late Cubism, without belonging to it, than the painters yet to be discussed. Though one might think that all the abstract expressionists start off from inspired impulse, Motherwell

Nina Leen: *The Irascibles.* Back row: Willem de Kooning, Adolph Gottlieb, Ad Reinhardt, Hedda Sterne; middle row: Richard Pousette-Dart, William Baziotes, Jackson Pollock, Clyfford Still, Robert Motherwell, Bradley Walker Tomlin; front row: Theodoros Stamos, Jimmy Ernst, Barnett Newman, James C. Brooks, Mark Rothko. November 24, 1950.

stands out among them by reason of his dependence on it, and by his lack of real facility. Although he paints in terms of the simplified, quasi-geometric design sponsored by Picasso and Matisse and prefers, though not always, clear, simple color contrasts within a rather restricted gamut, he is less of a late Cubist than de Kooning. Motherwell has a promising kind of chaos in him but, again, it is not the kind popularly ascribed to

abstract expressionism. His early collages, in a kind of explosive Cubism analogous to de Kooning's, have with time acquired a profound and original unity, and between 1947 and 1951 or so he painted several fairly large pictures that I think are among the masterpieces of abstract expressionism: some of these, in broad vertical stripes, with ocher played off against flat blacks and whites, bear witness to how well decoration can transcend itself in the easel painting of our day. But Motherwell has at the same time painted some of the feeblest pictures done by a leading abstract expressionist, and an accumulation of these over the last three or four years has obscured his real worth.

Gottlieb is likewise a very uneven artist, but a much more solid and accomplished one than is generally supposed. He seems to me to be capable of a greater range of controlled effects than any other abstract expressionist, and it is only owing to some lack of nerve or necessary presumptuousness that he has not made this plainer to the public, which accuses him of staying too close to the grid plans of Klee or Torres-Garcia, the Uruguayan painter. Over the years Gottlieb has, in his sober, pedestrian way, become one of the surest craftsmen in contemporary painting, one who can place a flat, uneven silhouette, that most difficult of all things to adjust to the rectangle, with a rightness beyond the capacity of ostensibly stronger painters. Some of his best work, like the "landscapes" and "seascapes" he showed in 1953, tends to be too difficult for eyes trained on late Cubism. On the other hand, his 1954 pictures, the first in which he let himself be tempted to a display of virtuosity and which stayed within late Cubism, were liked better by the public than anything he had shown before. The zigzags of Gottlieb's course in recent years, which saw him become a colorist and a painterly painter (if anything, too much of one) between his departures from and returns to Cubism, have made his development a very interesting one to watch. Right now he seems one of the least tired of all the abstract expressionists.

Jackson Pollock was at first almost as much a late Cubist and a hard and fast easel-painter as any of the abstract expressionists I have mentioned. He compounded hints from Picasso's calligraphy in the early '30s with suggestions from Hofmann, Masson, and Mexican painting, especially Siqueiros, and began with a kind of picture in murky, sulphurous colors that startled

people less by the novelty of its means than by the force and originality of the feeling behind it. Within a notion of shallow space generalized from the practice of Miró and Masson as well as of Picasso, and with some guidance from the early Kandinsky, he devised a language of baroque shapes and calligraphy that twisted this space to its own measure and vehemence. Pollock remained close to Cubism until at least 1946, and the early greatness of his art can be taken as a fulfillment of things that Picasso had not brought beyond a state of promise in his 1932–1940 period. Though he cannot build with color, Pollock has an instinct for bold oppositions of dark and light, and the capacity to bind the canvas rectangle and assert its ambiguous flatness and quite unambiguous shape as a single and whole image concentrating into one the several images distributed over it. Going further in this direction, he went beyond late Cubism in the end.

Mark Tobey is credited, especially in Paris, with being the first painter to arrive at "all-over" design, covering the picture surface with an even, largely undifferentiated system of uniform motifs that cause the result to look as though it could be continued indefinitely beyond the frame like a wallpaper pattern. Tobey had shown the first examples of his "white writing" in New York in 1944, but Pollock had not seen any of these, even in reproduction, when in the summer of 1946 he did a series of "all-over" paintings executed with dabs of buttery paint. Several of these were masterpieces of clarity. A short while later he began working with skeins of enamel paint and blotches that he opened up and laced, interlaced, and unlaced with a breadth and power remote from anything suggested by Tobey's rather limited cabinet art. One of the unconscious motives for Pollock's "all-over" departure was the desire to achieve a more immediate, denser, and more decorative impact than his late Cubist manner had permitted. At the same time, however, he wanted to control the oscillation between an emphatic physical surface and the suggestion of depth beneath it as lucidly and tensely and evenly as Picasso and Braque had controlled a somewhat similar movement with the open facets and pointillist flecks of color of their 1909–1913 Cubist pictures. ("Analytical" Cubism is always somewhere in the back of Pollock's mind.) Having achieved this kind of control, he found himself

straddled between the easel picture and something else hard to define, and in the last two or three years he has pulled back.

Tobey's "all-over" pictures never aroused the protest that Pollock's did. Along with Barnett Newman's paintings, they are still considered the *reductio ad absurdum* of abstract expressionism and modern art in general. Though Pollock is a famous name now, his art has not been fundamentally accepted where one would expect it to be. Few of his fellow artists can yet tell the difference between his good and his bad work—or at least not in New York. His most recent show, in 1954, was the first to contain pictures that were forced, pumped, dressed up, but it got more acceptance than any of his previous exhibitions had—for one thing, because it made clear what an accomplished craftsman he had become, and how pleasingly he could use color now that he was not sure of what he wanted to say with it. (Even so, there were still two or three remarkable paintings present.) His 1951 exhibition, on the other hand, which included four or five huge canvases of monumental perfection and remains the peak of his achievement so far, was the one received most coldly of all.

Many of the abstract expressionists have at times drained the color from their pictures and worked in black, white, and gray alone. Gorky was the first of them to do so, in paintings like *The Diary of a Seducer* of 1945—which happens to be, in my opinion, his masterpiece. But it was left to Franz Kline, whose first show was in 1951, to work with black and white exclusively in a succession of canvases with blank white grounds bearing a single large calligraphic image in black. That these pictures were big was no cause for surprise: the abstract expressionists were being compelled to do huge canvases by the fact that they had increasingly renounced an illusion of depth within which they could develop pictorial incident without crowding; the flattening surfaces of their canvases compelled them to move along the picture plane laterally and seek in its sheer physical size the space necessary for the telling of their kind of pictorial story.

However, Kline's unmistakable allusions to Chinese and Japanese calligraphy encouraged the cant, already started by Tobey's example, about a general Oriental influence on American abstract painting. Yet none of the leading abstract expressionists

except Kline has shown more than a cursory interest in Oriental art, and it is easy to demonstrate that the roots of their art lie almost entirely within Western tradition. The fact that Far Eastern calligraphy is stripped and abstract—because it involves writing—does not suffice to make the resemblances to it in abstract expressionism more than a case of convergence. It is as though this country's possession of a Pacific coast offered a handy received idea with which to account for the otherwise inexplicable fact that it is now producing a body of art that some people regard as original.

The abstract-expressionist emphasis on black and white has to do in any event with something more crucial to Western than Oriental pictorial art. It represents one of those exaggerations or apotheoses which betray a fear for their objects. Value contrast, the opposition and modulation of dark and light, has been the basis of Western pictorial art, its chief means, much more important than perspective, to a convincing illusion of depth and volume; and it has also been its chief agent of structure and unity. This is why the old masters almost always laid in their darks and lights—their shading—first. The eye automatically orients itself by the value contrasts in dealing with an object that is presented to it as a picture, and in the absence of such contrasts it tends to feel almost, if not quite as much, at loss as in the absence of a recognizable image. Impressionism's muffling of dark and light contrasts in response to the effect of the glare of the sky caused it to be criticized for that lack of "form" and "structure" which Cézanne tried to supply with his substitute contrasts of warm and cool color (these remained nonetheless contrasts of dark and light, as we can see from monochrome photographs of his paintings). Black and white is the extreme statement of value contrast, and to harp on it as many of the abstract expressionists do—and not only abstract expressionists— seems to me to be an effort to preserve by extreme measures a technical resource whose capacity to yield convincing form and unity is nearing exhaustion.

The American abstract expressionists have been given good cause for this feeling by a development in their own midst. It is, I think, the most radical of all developments in the painting of the last two decades, and has no counterpart in Paris (unless in the late work of Masson and Tal Coat), as so many other things

in American abstract expressionism have had since 1944. This development involves a more consistent and radical suppression of value contrasts than seen so far in abstract art. We can realize now, from this point of view, how conservative Cubism was in its resumption of Cézanne's effort to save the convention of dark and light. By their parody of the way the old masters shaded, the Cubists may have discredited value contrast as a means to an illusion of depth and volume, but they rescued it from the Impressionists, Gauguin, van Gogh, and the Fauves as a means to structure and form. Mondrian, a Cubist at heart, remained as dependent on contrasts of dark and light as any academic painter until his very last paintings, *Broadway Boogie Woogie* and *Victory Boogie Woogie*—which happen to be failures. Until quite recently the convention was taken for granted in even the most doctrinaire abstract art, and the later Kandinsky, though he helped ruin his pictures by his insensitivity to the effects of value contrast, never questioned it in principle. Malevich's prophetic venture in "white on white" was looked on as an experimental quirk (it was very much an *experiment* and, like almost all experiments in art, it failed aesthetically). The late Monet, whose suppression of values had been the most consistently radical to be seen in painting until a short while ago, was pointed to as a warning, and the *fin-de-siècle* muffling of contrasts in much of Bonnard's and Vuillard's art caused it to be deprecated by the avant-garde for many years. The same factor even had a part in the underrating of Pissarro.

Recently, however, some of the late Monets began to assume a unity and power they had never had before. This expansion of sensibility has coincided with the emergence of Clyfford Still as one of the most important and original painters of our time—perhaps the most original of all painters under fifty-five, if not the best. As the Cubists resumed Cézanne, Still has resumed Monet—and Pissarro. His paintings were the first abstract pictures I ever saw that contained almost no allusion to Cubism. (Kandinsky's relations with it from first to last became very apparent by contrast.) Still's first show, at Peggy Guggenheim's in 1944, was made up predominantly of pictures in the vein of an abstract symbolism with certain "primitive" and Surrealist overtones that were in the air at that time, and of which Gottlieb's "pictographs" represented one version. I was put

off by slack, willful silhouettes that seemed to disregard every consideration of plane or frame. Still's second show, in 1948, was in a different manner, that of his maturity, but I was still put off, and even outraged, by what I took to be a profound lack of sensitivity and discipline. The few large vertically divided areas that made up this typical picture seemed arbitrary in shape and edge, and the color too hot and dry, stifled by the lack of value contrasts. It was only two years ago, when I first saw a 1948 painting of Still's in isolation, that I got a first intimation of pleasure from his art; subsequently, as I was able to see still others in isolation, that intimation grew more definite. (Until one became familiar with them his pictures fought each other when side by side.) I was impressed as never before by how estranging and upsetting genuine originality in art can be, and how the greater its pressure on taste, the more stubbornly taste will resist adjusting to it.

Turner was actually the first painter to break with the European tradition of value painting. In the atmospheric pictures of his last phase he bunched value intervals together at the lighter end of the color scale for effects more picturesque than anything else. For the sake of these, the public soon forgave him his dissolution of form—besides, clouds and steam, mist, water, and light were not expected to have definite shape or form as long as they retained depth, which they did in Turner's pictures; what we today take for a daring abstractness on Turner's part was accepted then as another feat of naturalism. That Monet's close-valued painting won a similar acceptance strikes me as not being accidental. Of course, iridescent colors appeal to popular taste, which is often willing to take them in exchange for verisimilitude, but those of Monet's pictures in which he muddied—and flattened—form with dark color, as in some of his "Lily Pads," were almost as popular. Can it be suggested that the public's appetite for close-valued painting as manifested in both Turner's and Monet's cases, and in that of late Impressionism in general, meant the emergence of a new kind of taste which, though running counter to the high traditions of our art and possessed by people with little grasp of these, yet expressed a genuine underground change in European sensibility? If so, it would clear up the paradox that lies in the fact that an art like the late Monet's, which in its time pleased banal taste and still

makes most of the avant-garde shudder, should suddenly stand forth as more advanced in some respects than Cubism.

I don't know how much conscious attention Still has paid to Monet or Impressionism, but his independent and uncompromising art likewise has an affiliation with popular taste, though not by any means enough to make it acceptable to it. Still's is the first really Whitmanesque kind of painting we have had, not only because it makes large, loose gestures, or because it breaks the hold of value contrast as Whitman's verse line broke the equally traditional hold of meter; but just as much because, as Whitman's poetry assimilated, with varying success, large quantities of stale journalistic and oratorical prose, so Still's painting is infused with that stale, prosaic kind of painting to which Barnett Newman has given the name of "buckeye." Though little attention has been paid to it in print, "buckeye" is probably the most widely practiced and homogeneous kind of painting seen in the Western world today. I seem to detect its beginnings in Old Crome's oils and the Barbizon School, but it has spread only since the popularization of Impressionism. "Buckeye" painting is not "primitive," nor is it the same thing as "Sunday painting." Its practitioners can draw with a certain amount of academic correctness, but their command of shading, and of dark and light values in general, is not sufficient to control their color—either because they are simply inept in this department, or because they are naively intent on a more vivid naturalism of color than the studio-born principles of value contrast will allow. "Buckeye" painters, as far as I am aware, do landscapes exclusively and work more or less directly from nature. By piling dry paint—though not exactly in impasto—they try to capture the brilliance of daylight, and the process of painting becomes a race between hot shadows and hot lights whose invariable outcome is a livid, dry, sour picture with a warm, brittle surface that intensifies the acid fire of the generally predominating reds, browns, greens and yellows. "Buckeye" landscapes can be seen in Greenwich Village restaurants (Eddie's Aurora on West Fourth Street used to collect them), Sixth Avenue picture stores (there is one near Eighth Street) and in the Washington Square outdoor shows. I understand that they are produced abundantly in Europe, too. Though I can see why it is easy to stumble into "buckeye" effects, I cannot understand

fully why they should be so universal and so uniform, or the kind of painting culture behind them.

Still, at any rate, is the first to have put "buckeye" effects into serious art. These are visible in the frayed dead-leaf edges that wander down the margins or across the middle of so many of his canvases, in the uniformly dark heat of his color, and in a dry, crusty paint surface (like any "buckeye" painter, Still seems to have no faith in diluted or thin pigments). Such things can spoil his pictures, or make them weird in an unrefreshing way, but when he is able to succeed with, or in spite of them, it represents but the conquest by high art of one more area of experience, and its liberation from *Kitsch*.

Still's art has a special importance at this time because it shows abstract painting a way out of its own academicism. An indirect sign of this importance is the fact that he is almost the only abstract expressionist to "make" a school; by this I mean that a few of the many artists he has stimulated or influenced have not been condemned by that to imitate him, but have been able to establish strong and independent styles of their own.

Barnett Newman, who is one of these artists, has replaced Pollock as the *enfant terrible* of abstract expressionism. He rules vertical bands of dimly contrasting color or value on warm flat backgrounds—and that's all. But he is not in the least related to Mondrian or anyone else in the geometrical abstract school. Though Still led the way in opening the picture down the middle and in bringing large, uninterrupted areas of uniform color into subtle and yet spectacular opposition, Newman studied late Impressionism for himself, and has drawn its consequences more radically. The powers of color he employs to make a picture are conceived with an ultimate strictness: color is to function as hue and nothing else, and contrasts are to be sought with the least possible help of differences in value, saturation, or warmth.

The easel picture will hardly survive such an approach, and Newman's huge, calmly and evenly burning canvases amount to the most direct attack upon it so far. And it is all the more effective an attack because the art behind it is deep and honest, and carries a feeling for color without its like in recent painting. Mark Rothko's art is a little less aggressive in this respect. He, too, was stimulated by Still's example. The three or four

massive, horizontal strata of flat color that compose his typical picture allow the spectator to think of landscape—which may be why his decorative simplicity seems to meet less resistance. Within a range predominantly warm like Newman's and Still's, he too is a brilliant, original colorist; like Newman, he soaks his pigment into the canvas, getting a dyer's effect, and does not apply it as a discrete covering layer in Still's manner. Of the three painters—all of whom started, incidentally, as "symbolists" —Rothko is the only one who seems to relate to any part of French art since Impressionism, and his ability to insinuate contrasts of value and warmth into oppositions of pure color makes me think of Matisse, who held on to value contrasts in something of the same way. This, too, may account for the public's readier acceptance of his art, but takes nothing away from it. Rothko's big vertical pictures, with their incandescent color and their bold and simple sensuousness—or rather their *firm* sensuousness—are among the largest gems of abstract expressionism.

A concomitant of the fact that Still, Newman, and Rothko suppress value contrasts and favor warm hues is the more emphatic flatness of their paintings. Because it is not broken by sharp differences of value or by more than a few incidents of drawing or design, color breathes from the canvas with an enveloping effect, which is intensified by the largeness itself of the picture. The spectator tends to react to this more in terms of décor or environment than in those usually associated with a picture hung upon a wall. The crucial issue raised by the work of these three artists is where the pictorial stops and decoration begins. In effect, their art asserts decorative elements and ideas in a pictorial context. (Whether this has anything to do with the artiness that afflicts all three of them at times, I don't know. But artiness is the great liability of the Still school.)

Rothko and especially Newman are more exposed than Still to the charge of being decorators by their preference for rectilinear drawing. This sets them apart from Still in another way, too. By liberating abstract painting from value contrasts, Still also liberated it, as Pollock had not, from the quasi-geometrical, faired drawing which Cubism had found to be the surest way to prevent the edges of forms from breaking through a picture surface that had been tautened, and therefore made exceedingly

sensitive, by the shrinking of the illusion of depth underneath it. As Cézanne was the first to discover, the safest way to proceed in the face of this liability was to echo the rectangular shape of the surface itself with vertical and horizontal lines and with curves whose chords were definitely vertical or horizontal. After the Cubists, and Klee, Mondrian, Miró, and others had exploited this insight it became a cliché, however, and led to the kind of late Cubist academicism that used to fill the exhibitions of the American Abstract Artists group, and which can still be seen in much of recent French abstract painting. Still's service was to show us how the contours of a shape could be made less conspicuous, and therefore less dangerous to the "integrity" of the flat surface, by narrowing the value contrast its color made with that of the shapes or areas adjacent to it. Not only does this keep colors from "jumping," as the old masters well knew, but it gives the artist greater liberty in drawing—liberty almost to the point of insensitivity, as in Still's own case. The early Kandinsky was the one abstract painter before Still to have some glimpse of this, but it was only a glimpse. Pollock has had more of a glimpse, independently of Still or Kandinsky, but has not set his course by it. In some of the huge "sprinkled" pictures he did in 1950 and showed in 1951, value contrasts are pulverized as it were, spread over the canvas like dusty vapor (the result was two of the best pictures he ever painted). But the next year, as if in violent repentance, he did a set of paintings in black line alone on unprimed canvas.

It is his insights that help explain why a relatively unpopular painter like Still has so many followers today, both in New York and California (where he has taught); and why William Scott, the English painter, could say that Still's was the only completely and originally American art he had yet seen. This was not necessarily a compliment—Pollock, who may be less "American," and Hofmann, who is German-born, both have a wider range of power than Still—but Scott meant it as one.

The abstract expressionists started out in the '40s with a diffidence they could not help feeling as American artists. They were very much aware of the provincial fate around them. This country had had good painters in the past, but none with enough sustained originality or power to enter the mainstream of Western art. The aims of the abstract expressionists were diverse

within a certain range, and they did not feel, and still do not feel, that they constitute a school or movement with enough unity to be covered by a single term—like "abstract expression-ist," for instance. But aside from their culture as painters and the fact that their art was all more or less abstract, what they had in common from the first was an ambition—or rather the will to it—to break out of provinciality. I think most of them have done so by now, whether in success or failure. If they should all miss—which I do not think at all likely, since some of them have already conclusively arrived!—it will be at least with more resonance than that with which such eminent predecessors of theirs as Maurer, Hartley, Dove, and Demuth did not miss. And by comparison with such of their present competitors for the attention of the American art public as Shahn, Graves, Bloom, Stuart Davis (a good painter), Levine, Wyeth, etc., etc., their success as well as their resonance and "centrality" is assured.

If I say that such a galaxy of powerfully talented and original painters as the abstract expressionists form has not been seen since the days of Cubism, I shall be accused of chauvinist exag-geration, not to mention a lack of a sense of proportion. But can I suggest it? I do not make allowances for American art that I do not make for any other kind. At the Biennale in Venice this year, I saw how de Kooning's exhibition put to shame, not only that of his neighbor in the American pavilion, Ben Shahn, but that of every other painter present in his generation or under. The general impression still is that an art of high distinction has as much chance of coming out of America as a great wine. Literature—yes: we now know that we have produced some great writing because the English and French have told us so. They have even exaggerated, at least about Whitman and Poe. What I hope for is a just appreciation abroad, not an exaggera-tion, of the merits of "American-type" painting. Only then, I suspect, will American collectors begin to take it seriously. In the meantime they will go on buying the pallid French equiva-lent of it they find in the art of Riopelle, De Stael, Soulages, and their like. The imported article is handsomer, no doubt, but the handsomeness is too obvious to have staying power. . . .

"Advanced" art—which is the same thing as ambitious art today—persists in so far as it tests society's capacity for high art. This it does by testing the limits of the inherited forms and

genres, and of the medium itself, and it is what the Impressionists, the Post-Impressionists, the Fauves, the Cubists, and Mondrian did in their time. If the testing seems more radical in the case of the new American abstract painting, it is because it comes at a later stage. The limits of the easel picture are in greater danger of being destroyed because several generations of great artists have already worked to expand them. But if they are destroyed this will not necessarily mean the extinction of pictorial art as such. Painting may be on its way toward a new kind of genre, but perhaps not an unprecedented one—since we are now able to look at, and enjoy, Persian carpets as pictures—and what we now consider to be merely decorative may become capable of holding our eyes and moving us much as the easel picture does.

Meanwhile there is no such thing as an aberration in art: there is just the good and the bad, the realization and the unrealized. Often there is but the distance of a hair's breadth between the two—at first glance. And sometimes there seems—at first glance—to be no more distance than that between a great work of art and one which is not art at all. This is one of the points made by modern art.

1955

Modernist Painting

MODERNISM includes more than art and literature. By now it covers almost the whole of what is truly alive in our culture. It happens, however, to be very much of a historical novelty. Western civilization is not the first civilization to turn around and question its own foundations, but it is the one that has gone furthest in doing so. I identify Modernism with the intensification, almost the exacerbation, of this self-critical tendency that began with the philosopher Kant. Because he was the first to criticize the means itself of criticism, I conceive of Kant as, the first real Modernist.

The essence of Modernism lies, as I see it, in the use of characteristic methods of a discipline to criticize the discipline itself,

not in order to subvert it but in order to entrench it more firmly in its area of competence. Kant used logic to establish the limits of logic, and while he withdrew much from its old jurisdiction, logic was left all the more secure in what there remained to it.

The self-criticism of Modernism grows out of, but is not the same thing as, the criticism of the Enlightenment. The Enlightenment criticized from the outside, the way criticism in its accepted sense does; Modernism criticizes from the inside, through the procedures themselves of that which is being criticized. It seems natural that this new kind of criticism should have appeared first in philosophy, which is critical by definition, but as the 19th century wore on, it entered many other fields. A more rational justification had begun to be demanded of every formal social activity, and Kantian self-criticism, which had arisen in philosophy in answer to this demand in the first place, was called on eventually to meet and interpret it in areas that lay far from philosophy.

We know what has happened to an activity like religion, which could not avail itself of Kantian, immanent, criticism in order to justify itself. At first glance the arts might seem to have been in a situation like religion's. Having been denied by the Enlightenment all tasks they could take seriously, they looked as though they were going to be assimilated to entertainment pure and simple, and entertainment itself looked as though it were going to be assimilated, like religion, to therapy. The arts could save themselves from this leveling down only by demonstrating that the kind of experience they provided was valuable in its own right and not to be obtained from any other kind of activity.

Each art, it turned out, had to perform this demonstration on its own account. What had to be exhibited was not only that which was unique and irreducible in art in general, but also that which was unique and irreducible in each particular art. Each art had to determine, through its own operations and works, the effects exclusive to itself. By doing so it would, to be sure, narrow its area of competence, but at the same time it would make its possession of that area all the more certain.

It quickly emerged that the unique and proper area of competence of each art coincided with all that was unique in the nature of its medium. The task of self-criticism became to

eliminate from the specific effects of each art any and every effect that might conceivably be borrowed from or by the medium of any other art. Thus would each art be rendered "pure," and in its "purity" find the guarantee of its standards of quality as well as of its independence. "Purity" meant self-definition, and the enterprise of self-criticism in the arts became one of self-definition with a vengeance.

Realistic, naturalistic art had dissembled the medium, using art to conceal art; Modernism used art to call attention to art. The limitations that constitute the medium of painting—the flat surface, the shape of the support, the properties of the pigment—were treated by the Old Masters as negative factors that could be acknowledged only implicitly or indirectly. Under Modernism these same limitations came to be regarded as positive factors, and were acknowledged openly. Manet's became the first Modernist pictures by virtue of the frankness with which they declared the flat surfaces on which they were painted. The Impressionists, in Manet's wake, abjured underpainting and glazes, to leave the eye under no doubt as to the fact that the colors they used were made of paint that came from tubes or pots. Cézanne sacrificed verisimilitude, or correctness, in order to fit his drawing and design more explicitly to the rectangular shape of the canvas.

It was the stressing of the ineluctable flatness of the surface that remained, however, more fundamental than anything else to the processes by which pictorial art criticized and defined itself under Modernism. For flatness alone was unique and exclusive to pictorial art. The enclosing shape of the picture was a limiting condition, or norm, that was shared with the art of the theater; color was a norm and a means shared not only with the theater, but also with sculpture. Because flatness was the only condition painting shared with no other art, Modernist painting oriented itself to flatness as it did to nothing else.

The Old Masters had sensed that it was necessary to preserve what is called the integrity of the picture plane: that is, to signify the enduring presence of flatness underneath and above the most vivid illusion of three-dimensional space. The apparent contradiction involved was essential to the success of their art, as it is indeed to the success of all pictorial art. The Modernists have neither avoided nor resolved this contradiction; rather,

they have reversed its terms. One is made aware of the flatness of their pictures before, instead of after, being made aware of what the flatness contains. Whereas one tends to see what is in an Old Master before one sees the picture itself, one sees a Modernist picture as a picture first. This is, of course, the best way of seeing any kind of picture, Old Master or Modernist, but Modernism imposes it as the only and necessary way, and Modernism's success in doing so is a success of self-criticism.

Modernist painting in its latest phase has not abandoned the representation of recognizable objects in principle. What it has abandoned in principle is the representation of the kind of space that recognizable objects can inhabit. Abstractness, or the non-figurative, has in itself still not proved to be an altogether necessary moment in the self-criticism of pictorial art, even though artists as eminent as Kandinsky and Mondrian have thought so. As such, representation, or illustration, does not attain the uniqueness of pictorial art; what does do so is the associations of things represented. All recognizable entities (including pictures themselves) exist in three-dimensional space, and the barest suggestion of a recognizable entity suffices to call up associations of that kind of space. The fragmentary silhouette of a human figure, or of a teacup, will do so, and by doing so alienate pictorial space from the literal two-dimensionality which is the guarantee of painting's independence as an art. For, as has already been said, three-dimensionality is the province of sculpture. To achieve autonomy, painting has had above all to divest itself of everything it might share with sculpture, and it is in its effort to do this, and not so much—I repeat—to exclude the representational or literary, that painting has made itself abstract.

At the same time, however, Modernist painting shows, precisely by its resistance to the sculptural, how firmly attached it remains to tradition beneath and beyond all appearances to the contrary. For the resistance to the sculptural dates far back before the advent of Modernism. Western painting, in so far as it is naturalistic, owes a great debt to sculpture, which taught it in the beginning how to shade and model for the illusion of relief, and even how to dispose that illusion in a complementary illusion of deep space. Yet some of the greatest feats of Western painting are due to the effort it has made over the last

four centuries to rid itself of the sculptural. Starting in Venice in the 16th century and continuing in Spain, Belgium, and Holland in the 17th, that effort was carried on at first in the name of color. When David, in the 18th century, tried to revive sculptural painting, it was, in part, to save pictorial art from the decorative flattening-out that the emphasis on color seemed to induce. Yet the strength of David's own best pictures, which are predominantly his informal ones, lies as much in their color as in anything else. And Ingres, his faithful pupil, though he subordinated color far more consistently than did David, executed portraits that were among the flattest, least sculptural paintings done in the West by a sophisticated artist since the 14th century. Thus, by the middle of the 19th century, all ambitious tendencies in painting had converged amid their differences, in an anti-sculptural direction.

Modernism, as well as continuing this direction, has made it more conscious of itself. With Manet and the Impressionists the question stopped being defined as one of color versus drawing, and became one of purely optical experience against optical experience as revised or modified by tactile associations. It was in the name of the purely and literally optical, not in the name of color, that the Impressionists set themselves to undermining shading and modeling and everything else in painting that seemed to connote the sculptural. It was, once again, in the name of the sculptural, with its shading and modeling, that Cézanne, and the Cubists after him, reacted against Impressionism, as David had reacted against Fragonard. But once more, just as David's and Ingres' reaction had culminated, paradoxically, in a kind of painting even less sculptural than before, so the Cubist counter-revolution eventuated in a kind of painting flatter than anything in Western art since before Giotto and Cimabue—so flat indeed that it could hardly contain recognizable images.

In the meantime the other cardinal norms of the art of painting had begun, with the onset of Modernism, to undergo a revision that was equally thorough if not as spectacular. It would take me more time than is at my disposal to show how the norm of the picture's enclosing shape, or frame, was loosened, then tightened, then loosened once again, and isolated, and then tightened once more, by successive generations of Modernist

painters. Or how the norms of finish and paint texture, and of value and color contrast, were revised and re-revised. New risks have been taken with all these norms, not only in the interests of expression but also in order to exhibit them more clearly as norms. By being exhibited, they are tested for their indispensability. That testing is by no means finished, and the fact that it becomes deeper as it proceeds accounts for the radical simplifications that are also to be seen in the very latest abstract painting, as well as for the radical complications that are also seen in it.

Neither extreme is a matter of caprice or arbitrariness. On the contrary, the more closely the norms of a discipline become defined, the less freedom they are apt to permit in many directions. The essential norms or conventions of painting are at the same time the limiting conditions with which a picture must comply in order to be experienced as a picture. Modernism has found that these limits can be pushed back indefinitely before a picture stops being a picture and turns into an arbitrary object; but it has also found that the further back these limits are pushed the more explicitly they have to be observed and indicated. The crisscrossing black lines and colored rectangles of a Mondrian painting seem hardly enough to make a picture out of, yet they impose the picture's framing shape as a regulating norm with a new force and completeness by echoing that shape so closely. Far from incurring the danger of arbitrariness, Mondrian's art proves, as time passes, almost too disciplined, almost too tradition- and convention-bound in certain respects; once we have gotten used to its utter abstractness, we realize that it is more conservative in its color, for instance, as well as in its subservience to the frame, than the last paintings of Monet.

It is understood, I hope, that in plotting out the rationale of Modernist painting I have had to simplify and exaggerate. The flatness towards which Modernist painting orients itself can never be an absolute flatness. The heightened sensitivity of the picture plane may no longer permit sculptural illusion, or *trompe-l'oeil*, but it does and must permit optical illusion. The first mark made on a canvas destroys its literal and utter flatness, and the result of the marks made on it by an artist like Mondrian is still a kind of illusion that suggests a kind of third dimension. Only now it is a strictly pictorial, strictly optical

third dimension. The Old Masters created an illusion of space in depth that one could imagine oneself walking into, but the analogous illusion created by the Modernist painter can only be seen into; can be traveled through, literally or figuratively, only with the eye.

The latest abstract painting tries to fulfill the Impressionist insistence on the optical as the only sense that a completely and quintessentially pictorial art can invoke. Realizing this, one begins also to realize that the Impressionists, or at least the Neo-Impressionists, were not altogether misguided when they flirted with science. Kantian self-criticism, as it now turns out, has found its fullest expression in science rather than in philosophy, and when it began to be applied in art, the latter was brought closer in real spirit to scientific method than ever before—closer than it had been by Alberti, Uccello, Piero della Francesca, or Leonardo in the Renaissance. That visual art should confine itself exclusively to what is given in visual experience, and make no reference to anything given in any other order of experience, is a notion whose only justification lies in scientific consistency.

Scientific method alone asks, or might ask, that a situation be resolved in exactly the same terms as that in which it is presented. But this kind of consistency promises nothing in the way of aesthetic quality, and the fact that the best art of the last seventy or eighty years approaches closer and closer to such consistency does not show the contrary. From the point of view of art in itself, its convergence with science happens to be a mere accident, and neither art nor science really gives or assures the other of anything more than it ever did. What their convergence does show, however, is the profound degree to which Modernist art belongs to the same specific cultural tendency as modern science, and this is of the highest significance as a historical fact.

It should also be understood that self-criticism in Modernist art has never been carried on in any but a spontaneous and largely subliminal way. As I have already indicated, it has been altogether a question of practice, immanent to practice, and never a topic of theory. Much is heard about programs in connection with Modernist art, but there has actually been far less of the programmatic in Modernist than in Renaissance or

Academic painting. With a few exceptions like Mondrian, the masters of Modernism have had no more fixed ideas about art than Corot did. Certain inclinations, certain affirmations and emphases, and certain refusals and abstinences as well, seem to become necessary simply because the way to stronger, more expressive art lies through them. The immediate aims of the Modernists were, and remain, personal before anything else, and the truth and success of their works remain personal before anything else. And it has taken the accumulation, over decades, of a good deal of personal painting to reveal the general self-critical tendency of Modernist painting. No artist was, or yet is, aware of it, nor could any artist ever work freely in awareness of it. To this extent—and it is a great extent—art gets carried on under Modernism in much the same way as before.

And I cannot insist enough that Modernism has never meant, and does not mean now, anything like a break with the past. It may mean a devolution, an unraveling, of tradition, but it also means its further evolution. Modernist art continues the past without gap or break, and wherever it may end up it will never cease being intelligible in terms of the past. The making of pictures has been controlled, since it first began, by all the norms I have mentioned. The Paleolithic painter or engraver could disregard the norm of the frame and treat the surface in a literally sculptural way only because he made images rather than pictures, and worked on a support—a rock wall, a bone, a horn, or a stone—whose limits and surface were arbitrarily given by nature. But the making of pictures means, among other things, the deliberate creating or choosing of a flat surface, and the deliberate circumscribing and limiting of it. This deliberateness is precisely what Modernist painting harps on: the fact, that is, that the limiting conditions of art are altogether human conditions.

But I want to repeat that Modernist art does not offer theoretical demonstrations. It can be said, rather, that it happens to convert theoretical possibilities into empirical ones, in doing which it tests many theories about art for their relevance to the actual practice and actual experience of art. In this respect alone can Modernism be considered subversive. Certain factors we used to think essential to the making and experiencing of art are shown not to be so by the fact that Modernist painting

has been able to dispense with them and yet continue to offer the experience of art in all its essentials. The further fact that this demonstration has left most of our old value judgments intact only makes it the more conclusive. Modernism may have had something to do with the revival of the reputations of Uccello, Piero della Francesca, El Greco, Georges de la Tour, and even Vermeer; and Modernism certainly confirmed, if it did not start, the revival of Giotto's reputation; but it has not lowered thereby the standing of Leonardo, Raphael, Titian, Rubens, Rembrandt, or Watteau. What Modernism has shown is that, though the past did appreciate these masters justly, it often gave wrong or irrelevant reasons for doing so.

In some ways this situation is hardly changed today. Art criticism and art history lag behind Modernism as they lagged behind pre-Modernist art. Most of the things that get written about Modernist art still belong to journalism rather than to criticism or art history. It belongs to journalism—and to the millennial complex from which so many journalists and journalist intellectuals suffer in our day—that each new phase of Modernist art should be hailed as the start of a whole new epoch in art, marking a decisive break with all the customs and conventions of the past. Each time, a kind of art is expected so unlike all previous kinds of art, and so free from norms of practice or taste, that everybody, regardless of how informed or uninformed he happens to be, can have his say about it. And each time, this expectation has been disappointed, as the phase of Modernist art in question finally takes its place in the intelligible continuity of taste and tradition.

Nothing could be further from the authentic art of our time than the idea of a rupture of continuity. Art *is*—among other things—continuity, and unthinkable without it. Lacking the past of art, and the need and compulsion to maintain its standards of excellence, Modernist art would lack both substance and justification.

1960

CLYFFORD STILL

Clyfford Still (1904–1980) was born in Spokane, Washington, taught in San Francisco in the 1940s, and lived for many years on a farm in Maryland, where he died at the age of seventy-five. Although he had important exhibitions in New York in the 1950s, he prided himself on standing apart from the art establishment, and took a famously curmudgeonly attitude toward critics and curators, even those who admired his work. He was lean and handsome, with the unyielding temperament of a prophetic figure. His finest works—they date from the late 1940s through the 1950s—are tough and austere, with something of the openness and astringency of the American West. Still insisted that his jagged, dramatic canvases be experienced without context or exegesis, the painting an indissoluble, oracular expression.

Statement

THAT pigment on canvas has a way of initiating conventional reactions for most people needs no reminder. Behind these reactions is a body of history matured into dogma, authority, tradition. The totalitarian hegemony of this tradition I despise, its presumptions I reject. Its security is an illusion, banal, and without courage. Its substance is but dust and filing cabinets. The homage paid to it is a celebration of death. We all bear the burden of this tradition on our backs but I cannot hold it a privilege to be a pallbearer of my spirit in its name.

From the most ancient times the artist has been expected to perpetuate the values of his contemporaries. The record is mainly one of frustration, sadism, superstition, and the will to power. What greatness of life crept into the story came from sources not yet fully understood, and the temples of art which burden the landscape of nearly every city are a tribute to the attempt to seize this elusive quality and stamp it out.

The anxious men find comfort in the confusion of those artists who would walk beside them. The values involved, however, permit no peace, and mutual resentment is deep when it is discovered that salvation cannot be bought.

We are now committed to an unqualified act, not illustrating outworn myths or contemporary alibis. One must accept total

responsibility for what he executes. And the measure of his greatness will be in the depth of his insight and his courage in realizing his own vision.

Demands for communication are both presumptuous and irrelevant. The observer usually will see what his fears and hopes and learning teach him to see. But if he can escape these demands that hold up a mirror to himself, then perhaps some of the implications of the work may be felt. But whatever is seen or felt it should be remembered that for me these paintings had to be something else. It is the price one has to pay for clarity when one's means are honoured only as an instrument of seduction or assault.

1952

An Open Letter to an Art Critic

Dear K:

Riffling through some old magazines a few days ago, an article by you in a 1959 *Evergreen Review* stopped me abruptly. For, as you must remember, it dealt with the art dealers and galleries in New York, with special emphasis on the importance of their walls to the artists during the 1940's and 1950's, and the alleged role they played for the artist and public then and now. The issues involved are strangely up to date in view of the quickly shifting relationships among dealers and their stables of painters today, and the numerous articles, and several books about to appear, purporting to be a history of those years and institutions. That they are mainly a record of fantasy rather than fact, and shameless hypocrisy wrapped in saccharine words of dedication has become obvious to all who know the record. It is unfortunately to your discredit that yours was one of the first articles to initiate this sordid parade of falsification and apology.

When I first saw your article, K, I was so outraged by it that I went to my typewriter and wrote you a letter. When I had finished it, I realized that it was too late; what you had done was not born of ignorance, but of positive motive and in full awareness of the facts. So I put the letter away in my files and wrote the short statement of disappointment which you received.

But as events have turned and locked into one another, I think that *now* is not too late. This time, however, I am sending what I wrote to you, as an open letter. It is a rebuke and reminder, however small, to those whose commercial ambitions and indifference obscured all that was worthy of attention in those critical years, and reduced the artist to his present level of competitor with political double-talk, the Broadway flea market, and the collectivist castration ward.

That I speak in the first person qualifies no points I mention. The few whom I had invited to walk with me in those first years in New York quickly abdicated in favor of fear or ambition or, in two conspicuous cases, proved themselves to have been already dedicated to the machine of exploitation, only posing as men of integrity until their goals of success had been achieved.

This, then, is the letter I wrote to you on June 11, 1959 but did not send:

Dear K:

Yesterday my attention was drawn to a small magazine called *Evergreen Review* and in particular to an article in it written by you. I read it very carefully because most of the people, their actions, and the consequences thereof, have for many years been familiar and of deep concern to me.

Now there is a body of interesting fact indirectly related to those gas-chamber white walls you extol so generously. It is one of the great stories of all time, far more meaningful and infinitely more intense and enduring than the wars of the bull-ring, or the battlefield—or of diplomats, laboratories, or commerce. For it was in two of those arenas some thirteen years ago that was shown one of the few truly liberating concepts man has ever known. There I had made it clear that a single stroke of paint, backed by work and a mind that understood its potency and implications, could restore to man the freedom lost in twenty centuries of apology and devices for subjugation. It was instantly hailed, and recognized by two or three men that it threatened the power ethic of this culture, and challenged its validity. The threat was vaguely felt and opposed by others who presented an almost unified front in defense of their institutions.

Remember, I was invited, even begged by many dealers to show my work on their walls. I was told I must not fail friends

of delicate conviction, nor "believers in painting" who needed my company, nor the "lovers of art" who would welcome blows for the new world to come. That I accepted briefly their urgings as being in good faith is one of the mistakes I can never permit myself to forget. But in those years I learned beyond all doubt that it was a time of testing, a time for rigor without compromise. The details are too numerous and vicious to recount here. Certainly the characters who ran those sordid gift-shoppes knew every nerve and how to press it. Unwillingness to join the herd invited malicious interpretations of one's work and acts. Glib praise to the right people denied one the right to speak the truth; museum—politicians and hucksters determined all values, and those who sold out ranged themselves in the ranks of authority—for the price of a flunky's handout. Thus in those dead rooms the way was prepared for self-contempt, for clowns, for the obscenity that degrades the discipline of true freedom and perverts the idea that marks the moment of elevation.

The little men were numbered and took their place in file. Oh, some alibied their abdication with insolence, some with syntheses of fashionable devices, some with simulated protest, and some with gestures of futility. Others were indifferent because they had always been thus. The ambitious, the shrewd, the frustrated, each found his niche in the activity that satisfied his desires. These above all, the public understood and any quarrel they provoked was specious, a mere barroom debate, a lovers' wrangle.

Be assured, few truths were ever really seen on the sterile walls of those who now beg for remembrance and honor. The professionals? They admit they would not or could not look at my work. For those walls and their owners abetted—demanded, the empty, the socio-literary, the blatant effect that arrested the jaded and insensitive for a moment in their boring rounds.

The painters? One group of them begged one of the most eminent dealers you mention with approbation, for any terms when he threw them out after collecting the paintings demanded in their preposterous contract. I saw their confusion and weakness and offered to speak out in their behalf. They crawled back like whipped dogs to him when he was ready to re-admit them. For, as the affluent one among them expressed it, "He might be useful to us some day." Another dealer, rated as

a queen among queens in the hierarchy of galleries, demanded with a coolness that would make Shylock blush, 33⅓% of the value of a painting from one of the impecunious in her stable who had given it to a dentist for his dental bill. Each gallery impresario performed his or her dutifully promoted role and the men they exploited were each in time brought to heel. It is a tale repeated only with slight variation in nearly every gallery, without honor, or courage, or evidence of shame.

I mention the above incidents only to confirm the issue in general. The men and their work and their agents became as one, and no borrowed images, political illustration, Bauhaus sterilities, symbols of potency, pseudo-religious titles, nor any concealment behind that most faceless of apologies "Art," should hide the puerility and meanness of their purpose and games. And they all are amply worthy of the contempt and hatred they secretly exchange with one another even unto their death.

It has always been my hope to create a free place or area of life where an idea can transcend politics, ambition and commerce. It will perhaps always remain a hope. But I must believe that somewhere there may be an exception.

Meanwhile, I must charge you not to give life to those, who, whimpering from their morbid cribs, would be remembered as they were not, and given an honor they schemed to shame when one defended his name and his purpose.

The truth is usually hard and sometimes bitter, but if man is to live *it* must live. What transpired and became clear to some in the last three decades is known by a very few, and those few would hide for expediency what they know; only its influence and parodies are commonly evident. It remains a tremendous untold story, a testing of men and minds in the shadows. The memory of it still haunts those who worked to use and betray the spirit from which it was born. Dig out the truth and one man is a match for all of them. Accept their premises and you will walk on your knees the rest of your life.

1963

DWIGHT RIPLEY

Born to a considerable fortune, Dwight Ripley (1908–1973) was very much a part of the halcyon days of the New York School, in the 1940s and 1950s. Ripley was friends with Clement Greenberg and Peggy Guggenheim, and bankrolled the early years of the Tibor de Nagy Gallery. There artists ranging from Helen Frankenthaler to Larry Rivers showed at the beginning of their careers, and Ripley exhibited his own drawings, comedic visions dedicated to imaginary vacation spots and enchanted flora and fauna. Ripley's poetry—in a 1952 chapbook, *Spring Catalogue*, and the unpublished poems included here—reflects an easygoing, playful aspect of the mid-century mood that is sometimes overlooked. But Ripley was as serious as he was playful, and with his partner, the botanist Rupert Barneby, made important scientific discoveries while studying the plant life of the American West.

An Alphabetical Guide to Modern Art

Afro is all the rage in Rome
But not so pop. away from home.

Balthus' children, racked with puberty,
Are strictly hams—a shade too Schuberty.

You wanna worm's-eye view of Hell?
Then buy a box from Joe Cornell.

When Mona Williams balked at cash,
Dalí gave *her* a big mustache.

Max Ernst can do without a Mona;
He paints the rocks of Arizona.

Freilicher's not of Art the Einstein
If *she* keeps painting Arnold Weinstein.

I've never even dimly seen
The why of Mr. Balcomb Greene.

Dressed to the teeth by Fath, Miss Hartigan
Would still be wearing a woolly cartigan.

The ghost of Ingres now guides the pencil
Of Larry (when he's lost his stencil).

Our little Dwightsky has the sensky
Not to invest in A. Jawlensky.

You scared of color? Scared of Line?
Then concentrate on Mr. Kline.

Dwight Ripley: *Vase of Flowers, 1954*. Ink on paper.

The ardent fans of Alfred Leslie
Are less than those of Elvis Presley.

Scholars agree the Golden "Fleece"
Was really found by Pierre Matisse.

In Amy Vanderbilt's opinion
Nivola's almost *too* Sardinian.

Ossorio goes to endless pains
To exorcise those sugar-canes.
(*I* find his pix unsympathetic—
Or are they merely diabetic?)

Some have a taste for barley-water,
Quaker Oats—and Fairfield Porter.

I'd sooner eat a pail of dirt
Than own a pic by Walter Quirt.

The dangling dongs and dugs of Rivers
Give some the hots and me the shivers.

The Stills at christening sharply differed:
He wanted "Cliff," she wanted 'Clyfford'.

Faced with the work of Mr. Twombly,
A Chink from Chile muttered, "*Homble!*"

Utrillo's lucrative monotony
Is worse than systematic botany.

V is for Vail, who gave up oils
To nurse his bottles and his boyles.

If Walkowitz and Kiesler wed,
They'd need a ladder for their bed.

Xceron, my dears, is so convenient
I'll hold my tongue and play it lenient.

Ylla? She's dead. Among photogs
A queen still reigning—cats and dogs.

After too many William Zorachs
I need a bellyful of Borax.

c. 1951

Alphabetical Guide No. 2

The South has said ta-ta to slavery.
We must abolish Milton Avery.

Bring me a hankie, gun and sack:
I'll rob a bank and buy a Braque.

Bilious I am, but I have *no* bile
Faced with a Sandy Calder mobile.

So-called misogynist de Kooning
Has all the ladies simply swooning.

O Jimmy Pretty-boy, thou durnst
Ignore the importance of being Ernst.

I murmured once to J.J. Sweeney,
"Poor Leonor! Completely Fini."

The girls of VOGUE were once by Petty;
Now they are all by Giacometti.

The dough derived from western copper
Has never bought an Edward Hopper.

I is for "I," the middle name
Of every artist new to fame.

I sometimes think, if Gloria Swanson
Could paint she'd paint like Buffie Johnson.

And who or what is Cardinal Sinsky?
That Dwightsky hasn't *one* Kandinsky.

It dawned on me one day last summer
That Léger should have been a plumber.

What are the words for R. Magritte?
"Obnoxious," "anal," "bland," "effete."

Nagy? No, *no*. Pronounce it Nodge.
He's more a sweetie than a stodge.

To be succinct, concise and brief:
I do not care for Miss O'Keeffe.

Up for induction, looking quizzical,
Pereira muffed her metaphysical.

Q is for Queerness shining bright
In every picture by your aunt Dwight.

For Rouault, one critique sufficed:
He only painted clowns—and Christ.

An artist in Madrid cried, "Vamos!
No puedo soportar a Stamos."

We're all so deathly tired of panning
The work of Dorothea Tanning.

U is for Un—: unsold, unbought,
Undisciplined and undistraught.

And if your visions's 20-20,
You'll hate the cover by Vicente.

Though Sidney Wolfson owns a Me,
I'll never ask the man to tea.
(To hell, *mon vieux*, with X Y Z.)

c. 1951

Acrostic for Jackson Pollock

Jokes are no. Jeraniums are no. And
Alpine developments of the sea's themes,
Carpathian sponges, are yet less: for now our dream's
Komplexity's devoid of tricks or sand.
Spiced winds are grand but
Often, as now, such sighs do not attract,
Nor limestone scenes do aught but contradict.

Prince of the optimystic midnight and the
Occasional crime, angel who won't
Listen for a moment to tears or giggles beyond the ungaunt,
Libidoless large world of your immensity,
O know that I am forever now to be
Classified, indexed in, most utterly one with,
Kontained forever within your guilty truth!

c. 1951

ROBERT MOTHERWELL

Robert Motherwell (1915–1991) never achieved the inviolable fame that came to older artists, such as Pollock, de Kooning, and Rothko, with whom he was associated in the 1950s. But his series of *Elegies to the Spanish Republic*, their ascetic black-and-white orchestrations keyed to the calamitous history of the Spanish Civil War, have long been admired as an essential mid-century achievement, filtering the social and political turmoil of the 1930s through the more personal rhetorical voice of the postwar period. Motherwell, who came from a wealthy West Coast family, had studied at Harvard and Columbia, and he had a knowledge of French language and literature that made him a natural companion for the Surrealists who were in exile in the United States in the 1940s. For many years he was admired as much for his intellectual as for his painterly gifts, and when compared with most writings by American artists, Motherwell's are certainly thick with literary references. He coedited *Possibilities* with Harold Rosenberg, publishing essential statements by Pollock and Rothko, and his 1951 anthology, *The Dada Painters and Poets,* was immensely influential, setting in motion a postwar revaluation of Dada's anarchic spirit. Included here are a statement, "Black or White," written for a 1950 group show at the Kootz Gallery dedicated to the New York School's fascination with the limited palette, and Motherwell's statement for the 1951 panel at the Museum of Modern Art for which Calder and de Kooning also prepared remarks.

Black or White

Are we to mark this day with a white or a black stone?

Don Quixote, II, ii, 10

THERE is so much to be seen in a work of art, so much to say if one is concrete and accurate, that it is a relief to deal on occasion with a simple relation.

Yet not even *it*, no more than any other relation in art, is *so* simple.

The chemistry of the pigments is interesting: ivory black, like bone black, is made from charred bones or horns, carbon black is the result of burnt gas, and the most common whites—apart

from cold, slimy zinc oxide and recent bright titanium dioxide
—are made from lead, and are extremely poisonous on contact
with the body. Being soot, black is light and fluffy, weighing a
twelfth of the average pigment; it needs much oil to become
a painter's paste, and dries slowly. Sometimes I wonder, laying
in a great black stripe on a canvas, what animal's bones (or
horns) are making the furrows of my picture. A captain on the
Yukon River painted the snow black in the path of his ships for
twenty-nine miles; the black strip melted three weeks in advance
of spring, and he was able to reach clear water. Black does not
reflect, but absorbs all light; that is its essential nature; while
that of white is to reflect all light: dictionaries define it as snow's
color, and one thinks of the black slit glasses used when skiing.
For the rest, there is a chapter in *Moby Dick* that evokes white's
qualities as no painter could, except in his medium.

Indeed, it is our medium that rescues us painters. "The black
grows deeper and deeper, darker and darker before me. It men-
aces me like a black gullet. I can bear it no longer. It is mon-
strous. It is unfathomable.

"As the thought comes to me to exorcise and transform this
black with a white drawing, it has already become a surface.
Now I have lost all fear, and begin to draw on the black surface"
(Arp). Only love—for painting, in this instance—is able to cover
the fearful void. A fresh white canvas is a void, as is the poet's
sheet of blank white paper.

But look for yourselves. I want to get back to my white-
washed studio. If the *amounts* of black or white are right, they
will have condensed into quality, into feeling.

1950

What Abstract Art Means to Me

THE emergence of abstract art is one sign that there are still
men able to assert feeling in the world. Men who know how to
respect and follow their inner feelings, no matter how irrational
or absurd they may first appear. From their perspective, it is
the social world that tends to appear irrational and absurd. It

is sometimes forgotten how much wit there is in certain works of abstract art. There is a certain point in undergoing anguish where one encounters the comic—I think of Miró, of the late Paul Klee, of Charlie Chaplin, of what healthy and human values their wit displays . . .

I find it sympathetic that Parisian painters have taken over the word "poetry," in speaking of what they value in painting. But in the English-speaking world there is an implication of "literary content," if one speaks of a painting as having "real poetry." Yet the alternative word, "aesthetic," does not satisfy me. It calls up in my mind those dull classrooms and books when I was a student of philosophy and the nature of the aesthetic was a course given in the philosophy department of every university. I think now that there is no such thing as *the* "aesthetic," no more than there is any such thing as "art," that each period and place has its own art and its aesthetic—which are specific applications of a more general set of human values, with emphases and rejections corresponding to the basic needs and desires of a particular place and time. I think that abstract art is uniquely modern—not in the sense that word is sometimes used, to mean that our art has "progressed" over the art of the past—though abstract art may indeed represent an emergent level of evolution—but in the sense that abstract art represents the particular acceptances and rejections of men living under the conditions of modern times. If I were asked to generalize about this condition as it has been manifest in poets, painters, and composers during the last century and a half, I should say that it is a fundamentally romantic response to modern life— rebellious, individualistic, unconventional, sensitive, irritable. I should say that this attitude arose from a feeling of being ill at ease in the universe, so to speak—the collapse of religion, of the old close-knit community and family may have something to do with the origins of the feeling. I do not know.

But whatever the source of this sense of being unwedded to the universe, I think that one's art is just one's effort to wed oneself to the universe, to unify oneself through union. Sometimes I have an imaginary picture in mind of the poet Mallarmé in his study late at night—changing, blotting, transferring, transforming each word and its relations with such care—and I

think that the sustained energy for that travail must have come from the secret knowledge that each word was a link in the chain that he was forging to bind himself to the universe; and so with other poets, composers, and painters . . . If this suggestion is true, then modern art has a different face from the art of the past because it has a somewhat different function for the artist in our time. I suppose that the art of far more ancient and "simple" artists expressed something quite different, a feeling of *already* being at one with the world . . .

One of the most striking aspects of abstract art's appearance is her nakedness, an art stripped bare. How many rejections on the part of her artists! Whole worlds—the world of objects, the world of power and propaganda, the world of anecdotes, the world of fetishes and ancestor worship. One might almost legitimately receive the impression that abstract artists don't like anything but the act of painting . . .

What new kind of *mystique* is this, one might ask. For make no mistake, abstract art is a form of mysticism.

Still, this is not to describe the situation very subtly. To leave out consideration of what is being put into the painting, I mean. One might truthfully say that abstract art is stripped bare of other things in order to intensify it, its rhythms, spatial intervals, and color structure. Abstraction is a process of emphasis, and emphasis vivifies life, as A. N. Whitehead said.

Nothing as drastic an innovation as abstract art could have come into existence, save as the consequence of a most profound, relentless, unquenchable need.

The need is for felt experience—intense, immediate, direct, subtle, unified, warm, vivid, rhythmic.

Everything that might dilute the experience is stripped away. The origin of abstraction in art is that of any mode of thought. Abstract art is a true mysticism—I dislike the word—or rather a series of mysticisms that grew up in the historical circumstance that all mysticisms do, from a primary sense of gulf, an abyss, a void between one's lonely self and the world. Abstract art is an effort to close the void that modern men feel. Its abstraction is its emphasis.

Perhaps I have tried to be clear about things that are not so very clear, and have not been clear about what is clear, namely, that I love painting the way one loves the body of woman, that if painting must have an intellectual and social background, it is only to enhance and make more rich an essentially warm, simple, radiant act, for which everyone has a need . . .

1951

WELDON KEES

Weldon Kees (1914–1955?) was a poet, a painter, a novelist, and an art critic—and in his brief life he was admired for nearly everything he did. By the time he vanished at the age of forty-one—his car was found near the Golden Gate Bridge—he was a figure to be reckoned with in bohemian circles in New York, Provincetown, and San Francisco. Whether he was composing stories based on his early years in Nebraska, filling canvases with phantasmagorical figures, or writing poems about the plight of urban man (some were published in *The New Yorker*), he found an attentive audience among his contemporaries. He was Clement Greenberg's successor as art critic at *The Nation,* a post he held from 1948 to 1950. Although there has been a revival of interest in his poetry in recent years, to his contemporaries Kees was one of the great unfulfilled talents, undone by a failed marriage, alcoholism, and depression. For years after his disappearance—he almost certainly committed suicide—there were unconfirmed sightings, mostly in Mexico.

Robert Motherwell

PAINTING should be music. Painting should be literature. Painting should be propaganda, an anecdote or an arrow pointing to a path of salvation. Painting should be a vertical or horizontal window that opens on a world of ladies with parasols and appealing children, cows in gently flowing streams, a bunch of flowers, or a bowl of fruit good enough to eat. These were, on various occasions, the beliefs of the past. They are also the beliefs of your Aunt Cora, the people next door, half Fifty-seventh Street, and Mr. Truman.

The beliefs to which the most advanced painters of our own time give their allegiance were foreshadowed by Flaubert, who, interrupting himself from his torments with the world-haunted manuscript of Madame Bovary, parted company with his own century to set down this unfulfilled desire: "What I should like to write is a book about nothing at all, a book which would exist by virtue of the mere internal strength of its style, as the earth holds itself unsupported in the air. . . ."

"A book which would exist by virtue of the mere internal strength of its style. . . ." This is the literary equivalent of the canvases of Robert Motherwell. He has pushed the major

emphasis of abstract painting to one kind of Ultima Thule. The Cubists, even while engaged in breaking down subject matter, still clung to it, with however slippery a grasp, and the master-pieces of Cubism proclaim the entrance of a new concept of space while paying a mocking but not unaffectionate tribute to a limited, enclosed world of bottles, guitars, wine glasses, news-paper headlines, playing cards, sliced lemons, and the human figure. Even in their collages—which may have originated in the spectacle of the peeling hoardings of Paris—collages in which paper and paint are arranged lovingly for their own sakes, this subject matter persists.

In Motherwell, however, a new kind of subject matter be-comes manifest. It is paint itself. The paintings are quite simply "about" paint. Fathered, curiously enough, in view of his most recent work, by Mondrian and continuously nourished by Pi-casso, from whom Motherwell "lifts" objects and passages with complete acknowledgment (and in a manner far more likable and disarming than do those painters who are merely under the influence of some particular period of the Spaniard). Mother-well assumes the full consequences of the furthest tendency of abstract art. His circular forms are not oranges or abstractions of oranges, heads or abstractions of heads; his rectangles, blots, blurs, and brushstrokes assert nothing but their own existence, their own identity and individuality. They are objects from their own world, and that world is the world of paint. Motherwell's insistence upon this concentration and definition is as fierce as Céline's insistence of hell on earth or the insistence of the air on its own transparency.

Motherwell's achievements in collage are well known. It is dogma in certain advanced quarters to speak with disfavor of collage—in Paris, where John Steinbeck is admired, they are reportedly bored by it—and Motherwell perhaps has been in-fected a bit by these views. The vicissitudes of taste, of fashion, play major roles in the world's comedy; it was not so long ago that the Dadaists, who conceived of collage as a refuse heap, were using it as a device aimed at the annihilation of paint-ing. They were serious if unsuccessful except for their nuisance value. Since the collages of Picasso, few artists have attempted the medium until recently, and some, like Dove, turned col-lage into something charming and sentimental; if there were

avant-garde valentines, one would have to look no further. Motherwell, picking it up where it had been dropped in the twenties by Picasso, refurbished it with his own personality and highly charged color sense, with fresh surfaces and materials, to produce works of great spontaneity and power. They easily rank with his paintings.

"I begin painting with a series of mistakes," Motherwell has written with candor of a sort usually unflaunted by artists. "My pictures have layers of mistakes buried in them—an X ray would disclose crimes—layers of consciousness, of willing." Here is a clue to the sources of the unique in Motherwell, to the quality that encloses him in his own particular glass case. It is division, that schism in the mind that comprises so much of our modernity, a rupture from whose conflicts we may make art or by which we may be destroyed. In Motherwell, these conflicts define themselves as a declared, full-fledged, and recognized war. On one side are ranged recklessness, savagery, chance-taking, the accidental, "quickened subjectivity," painting, in the words of Miró, "as we make love; a total embrace, prudence thrown to the wind, nothing held back"; on the other, refinement, discrimination, calculation, taste—how Motherwell avoided French blood and birthplace is a puzzling question—"layers of consciousness, of willing." It is out of the continual encounters and contests of these opposites that his paintings, marked everywhere on their surfaces with signs of battle, emerge.

1948

Adolph Gottlieb

THE atmosphere in art circles, here in New York at least, seems increasingly grayer, a good deal emptier than in years, and charged with stasis. One would set this down with more hesitation had not the grayness taken on such body and richness of late, and did not so many people in a position to know speak of it and let it influence their action. The torpor and despondency that have pervaded literary circles for some time seem to have widened their area of saturation.

Adolph Gottlieb: *Quest*, 1948. Oil on canvas, 30 × 38 in.

Yet more than a few painters continue to produce at a higher level than the "cultural situation" apparently provides for. The demand for their work is infinitesimal. A hypothetical gallery that depended solely on the sales of the works of the nine or ten best-known advanced painters would do well to show the profits of a neighborhood candy store. One of the most important, celebrated, and influential painters in the country had for years found it impossible to market his work; the situation of even such a hard-pressed and badgered forerunner as Pissarro, for instance, seems enviable by comparison. One sale a year, to many painters, is a refreshing novelty. In a sense it is difficult not to agree with Herbert Read's assertion that cabinet painting has lost all economic and social justification. Such a point of view will, of course, be meaningless to those who snap up the works of such facile academic fabricators as Walter Stuempfig, whose "glowing light" and aged-in-the-wood literalism have brought comfort to *Life*, the art journals, and all earnest admirers of exhausted modes.

From an economic standpoint the activities of our advanced painters must be regarded as either heroic, mad, or compulsive; they have only an aesthetic justification, and even this, one feels, has become increasingly meager. Morale has dwindled; it would be hard to name a painter who is working at a high and steady level of intensity—here or in Europe—in a sense remotely approaching that of Cézanne, Van Gogh, or the Cubists early in their careers. One is continually astounded that art persists at all in the face of so much indifference, failure, and isolation. Van Gogh could write, "Now it is getting grimmer, colder, emptier, and duller around me," while still insisting that "surely there will come a change for the better." Today we are not likely to insist too strongly on the chances of so interesting a modulation. And in these times, if we were dealing with Van Gogh as a contemporary, we should handle things differently: he would be "recognized," would show annually on Fifty-seventh Street, be stroked, complimented, sell a few canvases, go to cocktail parties, and be *tamed*. Not tamed too much, however. He might even find it possible to write that "it is getting grimmer, colder, emptier, and duller . . . and things go along, worsening only a little."

If advanced painters suffer from the knowledge that their canvases, after the usual three weeks exposure to the light, are destined for a long period of dust-gathering in the racks of a gallery or in their own studios, they can take little more comfort from the proportions of their audience. An exhibition that attracts as many persons as go to fill up a movie house for one performance is successful in the extreme. Such gallery-goers will consist almost exclusively of other painters, collectors (most of whom are not collecting at the moment), art critics, students, art instructors, and museum officials, dealers from other galleries, relatives, and friends. Unable to gain a living from what he is most capable of doing, the contemporary American painter, like the poet, turns to the classroom. Today more painters than ever are teaching, for our society is fantastically devoted to the idea that the young be instructed and that still more painters be encouraged so that any valid work they produce may be ignored more completely. From the foundations responsible for fellowships and grants a serious painter can expect nothing: these act as mechanisms which function marvelously in supplying

blue ribbons to the second-rate; it is scarcely news that the Guggenheim Foundation in particular has shown unerring skill in rejecting the applications of those artists whose work most deserves aid. And so it goes.

The past decade has accounted for an unprecedented burgeoning among a new school of Abstractionists, whose originality and seriousness exist in their own terms—and in truly *international* terms—rather than as a minor branch of the School of Paris. We may be, as James Thrall Soby has pointed out, "at the beginning of an era in which the artists of the Western world will try to communicate from country to country instead of through the Parisian switchboard." Meanwhile the problem of communication of a much more modest, immediate, and local variety remains overwhelming.

In this atmosphere it is heartening to note the development and modifications in the work of Adolph Gottlieb, at the Kootz Gallery. Gottlieb's reputation has thus far rested on the steady production of pictographs—diversified rectangles enclosing hieroglyphic forms—notable for their diversity and sense of the mysterious. Though many of the canvases in his new show retain this formula without strain or exhaustion—to some extent through a shift to a more airy and paler range of color than he has used before—the most striking canvases are those in which his forms have broken loose from their pictographic enclosures to declare a new sense of independence and motion. Outstanding, too, is a stunning isolated canvas of a single totemistic figure of black sand—a figure that seems the sum of a pictograph's parts. This willingness to change and experiment at a crucial stage of his career is perhaps the most important aspect of the most interesting show of this artist's work in some years.

1950

MARK TOBEY

Half a century before the Pacific Rim became a much discussed social and cultural dynamic, Mark Tobey (1890–1976) was widely admired as an American artist nourished by the art and ideas of Asia. A world traveler with a longtime base of operations in Seattle, Tobey was deeply involved with the Baha'i religion, and spent his last decades in Switzerland. His work is suffused with an open-ended lyricism, much indebted to the calligraphic spontaneity and unbounded spaces of Chinese and Japanese ink painting. There is a quietism and inwardness about Tobey's work that many associate with the Pacific Northwest, a region also home to the idiosyncratic naturalism of Morris Graves. Tobey's work had been shown at the Museum of Modern Art as early as 1930. Some believe that his decentralized abstractions, exhibited in New York in the 1940s, had a decisive impact on the Abstract Expressionists, encouraging the turn toward what would come to be referred to as the "all-over" composition, a painting in which no area was given precedence and all areas were treated equally. In 1958, Tobey became the first American since Whistler to win a Grand Prize at the Venice Biennale.

Reminiscence and Reverie

On the third floor of Manning's Coffee Shop in the Farmers' Market in Seattle confronting the Sound, the windows are opaque with fog. Sitting here in the long deserted room, I feel suspended—enveloped by a white silence.

Two floors below, the farmers are bending over their long rows of fruit and vegetables; washing and arranging their produce under intense lights shaded by circular green shades. Above, where I sit, the world seems obliterated from all save memory; abstracted without the feeling of being divorced from one's roots.

My eye keeps focusing upon the opaque windows. Suddenly the vision is disturbed by the shape of a gull floating silently across the width of window. Then space again.

In opposing lines to the gull's flight, the Sound moves northward through the Inland Passage: ALASKA. Named by the Indians, "The Great Country." The name eats with a neon intensity in my mind. It is true that trains run daily out of Seattle to

Mark Tobey: *Threading Light*, 1942. Tempera
on board, 29¼ × 19¾ in.

points East and South, but my mind takes but little cognizance
of this fact. To me Seattle seems pocketed. There is only one
way out: ALASKA, towards the North! Swerving to the left,
there is the Orient, although in San Francisco I feel the Orient
rolling in with the tides. My imagination, it would seem, has
its own geography.

In Portland one must go East or South; there is very little
West from Portland. There is no Alaska from Portland. The
pioneers there must have moved differently from here.

"How is Alaska now?"

"Changing fast."

"But the people. . . ."

"Oh, they're wonderful, but the old way of living can't last much longer."

Do you wish to go to Alaska, farther away from the roots of European culture? The Northwest is closer. To go there would mean more teaching, more lectures. There would be endless paintings of dogs and favorite spots, and more uplift work. Uplift work begins when you leave Grand Central Station.

"My little boy, he's only six. . . ."

"Yes, yes. I know all children are gifted. . . ."

"But we thought that if we could find a teacher. . . ."

"Just give him materials and be interested in art yourself."

A night in London with forty years behind me in America, my land with its great East-West parallels, with its shooting-up towers and space-eating lights—millions of them in the vast night sky. I traversed this country by train, the Atlantic by boat—pivoted in London and awoke in a pastoral landscape. Surely it seemed that Pan still lived behind the old oak trees where in the evening the white owls flew soundlessly.

England is small, and America large, but any American who stays long enough in England will sense the mysticism that pervades the land, and will seek a cottage hidden from all save the sky and earth. Turner remembered.

England collapses, turns Chinese with English and American thoughts. Thousands of Chinese characters are turning and twisting; every door is a shop. The rickshaws jostle the vendors, their backs hung with incredible loads. The narrow streets are alive in a way that Broadway isn't alive. Here all is human, even the beasts of burden. The human energy spills itself in multiple forms, writhes, sweats and strains every muscle towards the day's bowl of rice. The din is terrific.

All is in motion now. A design of flames encircles the quiet Buddha. One step backward into the past and the tree in front of my studio in Seattle is all rhythm, lifting, springing upward!

I have just had my first lesson in Chinese brush from my friend and artist Teng Kwei. The tree is no more a solid in the earth, breaking into lesser solids bathed in chiaroscuro. There is pressure and release. Each movement, like tracks in the snow, is recorded and often loved for itself. The Great Dragon is breathing sky, thunder and shadow; wisdom and spirit vitalized.

"The evening river is level and motionless."

Wisconsin is far away. The Wisconsin in my mind is often very far away. It comes back sometimes by itself like a wandering dog.

It is Fall. The leaves are being raked under the great elms darkening in the evening light. Slowly they become weighted with darkness. Across the river they are burning the grass on the Minnesota bluffs. Myriads of colored streamers reflect in the river below.

The cave is hard to reach, but from the opening one looks down upon the Mississippi a mile wide and islanded in the center. Between the cave and the river are the Indian mounds; rounded forms full of fantastic objects never found. They are burned hard and brown in the August sun, but in the Spring, the first crocus will unfurl itself there. To the north is Trempealeau Bay where lives the Egyptian yellow lotus, and to the south a chain of seven lakes. At night through the screen window the train on the Minnesota side looks like a child's toy. Its windows are small light squares linked to light squares moving towards Winona.

The train is gone. The night breathes in silence—breathes to the moon, to space mysterious and tantalizing. We artists must learn to breathe more, also.

You are you whether walking backward or forward. The artist is a part of the still-life. The apples are wax: The plates painted paper. The apples look real in the painting.

> "We look at the mountain to see the painting,
> then we look at the painting to see the mountain."

"You are too mystical."

"What supremely rational person can keep from going to sleep?"

This is the age of words, and the age of the fear of words.

> "Suddenly a wave carries the moon away."

Two men dressed in white jeans with white caps on their heads are climbing over a large sign of white letters. Of course, the words spell something, but that's unimportant. What is important is their white, and the white of the letters.

The loop is small in the beginning, but widens with the strength of the arm. Horizons are small or vast. It sometimes takes several centuries for the light of an El Greco to be seen.

Our mind is a night sky.

Harrison Fisher and Howard Chandler Christy, these two stars and others like them lighted my steps as a young man in Chicago. The Gibson Girl was beginning to fade out, but I can still see her in the moon. A little later, Remington flashed like a comet before my eyes. Soon my eyes began to discern others, as the stately stars of the renaissance swung into view.

The light grew dazzling and confusing as I found *Simplicissimus* and *Jugend* unfolding Lembach, von Stuck, Leo Putz and others, while Sorolla and Zuloaga moved circularly into Chicago, and out again. Hal's brush was lashed to Sargent's as the "handling bug" bit deeply into all those like myself. Leyendecker for sheer technique took the cake.

But there was escape, too, even in those days, for there was Whistler living in the gray mists with a faded orange moon. The nocturne transformed itself into dreamy rooms with Chopin's music creating a mood that softened the hard core of self. Bohemia reigned even in Chicago, and a good reign it was. The titanic!

The paths were clear, or so they seemed in those days. To be a millionaire, the President of the United States, or an artist was to take the pilgrimage to the Mecca of all painting—PARIS!

The imagination can be murdered without sentence; done away while learning to embalm. The walls are hung with painted corpses. Even a street scene or still-life can be one. Why don't art schools have classes on how to remain aware?

I found myself suddenly annoyed when in Japan at the Nara Museum—all the titles were in Japanese. Being a Japanese or an American is at best a mysterious affair. Babies are born, no doubt, with a universal potential. Alas, the ancestors live in the parents. In China they worship their ancestors. The graves of the farmer class lie in the field as the blue-clad farmer plows nearby.

In the West we worship our ancestors' bureaus; their commodes and old chairs. "It was my great-great-grandfather's," he said, carefully covering it again, and putting it away in the red plush box.

The Mississippi flows through the nights—through the days. Forever in my time an old hayrack loaded almost beyond recognition moves slowly up the soft dusty road. I will await its lumbering presence to say, "Hello," to old man Nichols perched high above the straining horses. His hat is pulled down to shade his eyes from the late afternoon sun. He'll hardly turn his head as he passes, but I'll hear the soft, hollow "Hello."

Wisconsin is before Chicago, and Harrison Fisher is before Michelangelo. To rediscover the past is to move forward. There is no surcease when we constantly destroy what we have built. The future is carved with the implements we created before it was upon us. The past offers the art student different roads, all converging towards his present. Today's present appears different, more confusing; voices cry from all quarters. It used to be dangerous to know. Today it's dangerous not to know. What was close and established must now make room for newcomers. There is much groaning and some growls. Art, forever free, seeks freedom from man's tyranny.

The arts of the Far East are being brought to our shores, as perhaps never before. The Pacific hiatus is closing. The Oriental is no longer a slant-eyed mystery living in a dim and remote past. The old line of the migrations is completing the circle. The snake has seen its own tail.

He was a Japanese and had a shop in San Francisco before the last war.

"When I was very young," he said, "my mother would awaken me early in the morning and we would go into the garden to hear the morning-glories open."

Cherry bloom and dignitary.

> "Thou was not made for death, immortal Bird!
> No hungry generations tread thee down."

1951

1. Morris Graves, *Time of Change*, 1943. Tempera on paper, 24 × 30 in.

2. John Graham, *Two Sisters (Les Mamelles d'outre-mer)*, 1944. Oil, enamel, pencil, charcoal, and casein on composition board, 47⅞ × 48 in. The Museum of Modern Art, New York, NY. Alexander M. Bing Fund.

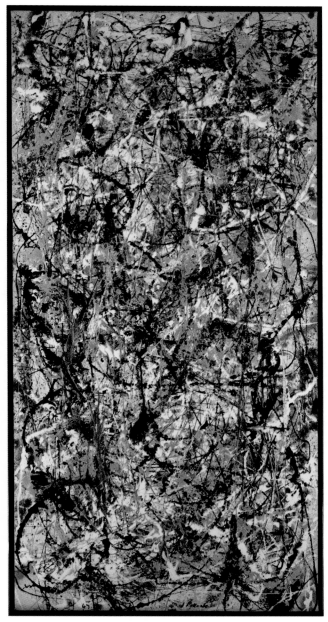

3. Jackson Pollock, *Cathedral*, 1947. Enamel and aluminum paint on canvas, 71½ × 35¹⁄₁₆ in. Dallas Museum of Art. Gift of Mr. and Mrs. Bernard J. Reis.

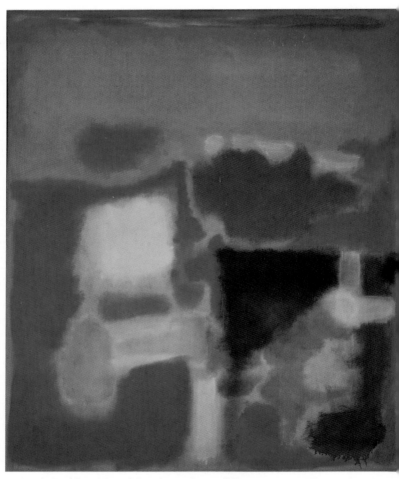

4. Mark Rothko, *No. 1 (No. 18)*, 1948–49. Oil on canvas, 67^{11}/$_{16}$ × 55^{14}/$_{16}$ in. The Frances Lehman Loeb Art Center, Vassar College, Poughkeepsie, NY. Gift of Mrs. John D. Rockefeller 3rd.

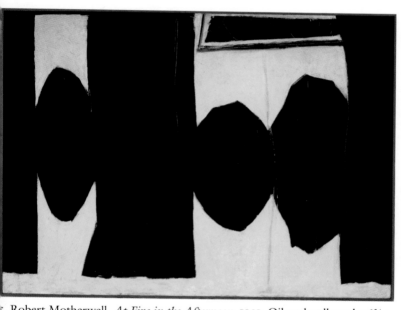

5. Robert Motherwell, *At Five in the Afternoon*, 1950. Oil on hardboard, 36¾ × 48½ in. de Young Museum, San Francisco, CA. Bequest of Josephine Morris.

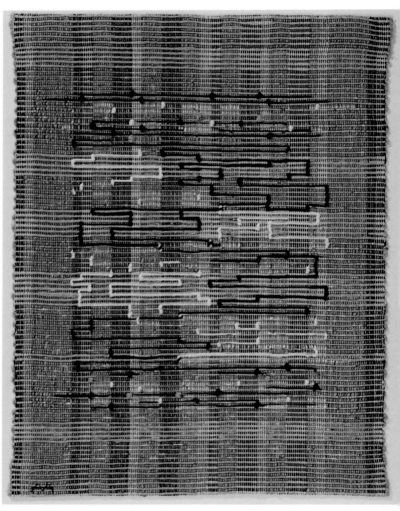

6. Anni Albers, *Black-White-Gold I*, 1950. Cotton, lurex, jute pictorial weaving, 25⅛ × 19 in. The Josef and Anni Albers Foundation, Bethany, CT.

7. Charles Burchfield, *Gateway to September*, 1945–56. Watercolor on joined paper, 42 × 56 in. Hunter Museum of American Art, Chattanooga, TN. Gift of the Benwood Foundation.

8. Barnett Newman, *Vir Heroicus Sublimis*, 1950–51. Oil on canvas, 95⅜ × 213¼ in. The Museum of Modern Art, New York, NY. Gift of Mr. and Mrs. Ben Heller.

9. Clyfford Still, *1951-T No. 3*, 1951. Oil on canvas, 94 × 82 in. The Museum of Modern Art, New York, NY. Blanchette Hooker Rockefeller Fund.

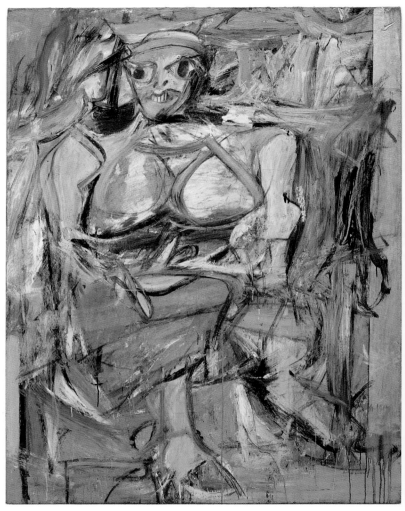

10. Willem de Kooning, *Woman, I*, 1950–52. Oil on canvas, 75⅞ × 58 in. The Museum of Modern Art, New York, NY.

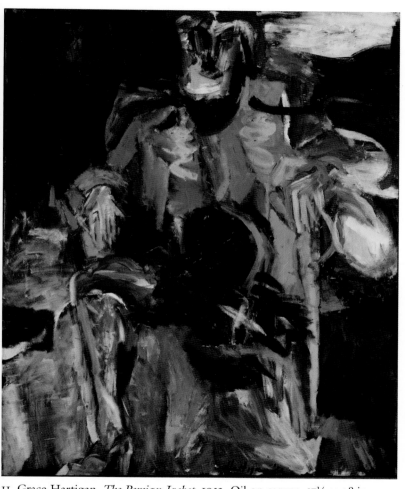

11. Grace Hartigan, *The Persian Jacket*, 1952. Oil on canvas, 57½ × 48 in. The Museum of Modern Art, New York, NY. Gift of George Poindexter.

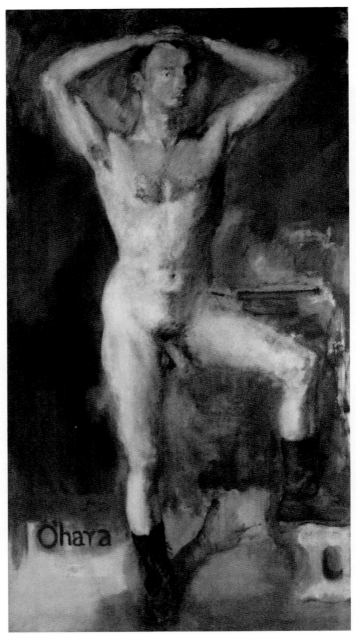

12. Larry Rivers, *O'Hara Nude with Boots*, 1954. Oil on canvas,
97 × 53 in.

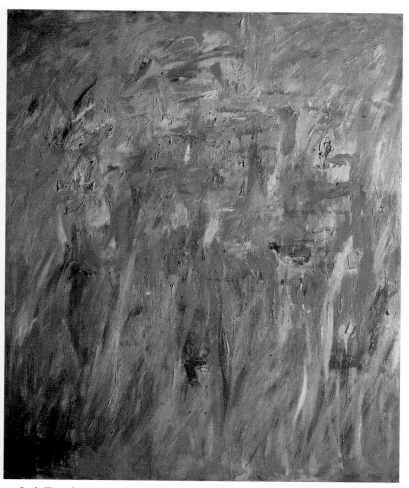

13. Jack Tworkov, *Pink Mississippi*, 1954. Oil on canvas, 60 × 50 in. Estate No. 470. Collection of The Rockefeller University, NY.

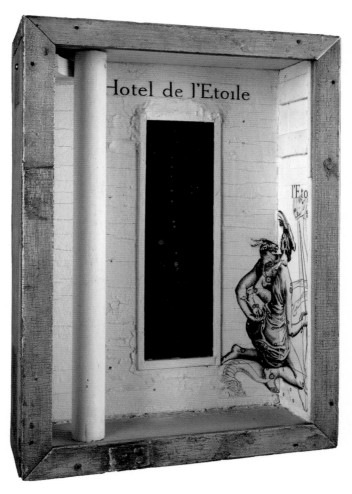

14. Joseph Cornell, *Untitled (Hôtel de l'Etoile)*, 1954. Box construction, 19 × 13⅝ × 8⅛ in. The Art Institute of Chicago. Lindy and Edwin Bergman Joseph Cornell Collection.

15. Robert Rauschenberg, *Bed*, 1955. Combine painting: oil and pencil on pillow, quilt, and sheet on wood supports, 75¼ × 31½ × 8 in. The Museum of Modern Art, New York, NY. Gift of Leo Castelli in honor of Alfred H. Barr Jr.

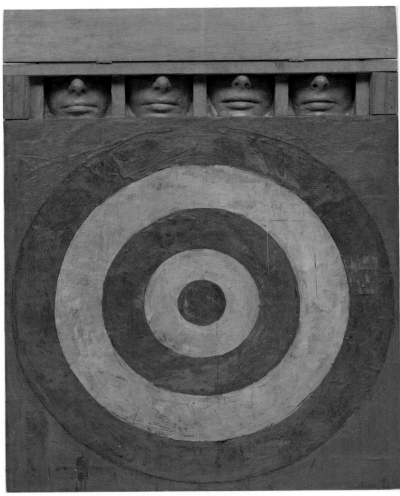

16. Jasper Johns, *Target with Four Faces*, 1955. Encaustic on newspaper and cloth over canvas surmounted by four tinted-plaster faces in wood box with hinged front, overall with box open, 33⅝ × 26 × 3 in.; canvas 26 × 26 in.; box (closed) 3¾ × 26 × 3½ in. The Museum of Modern Art, New York, NY. Gift of Mr. and Mrs. Robert C. Scull.

7. Helen Frankenthaler, *Giralda*, 1956. Oil on canvas, 94 × 83½ in.

18. Alfred Leslie, *Quartet #1*, 1958. Oil on canvas, 84 × 98 in.

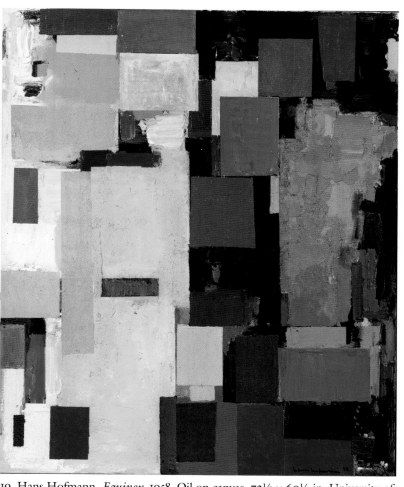

19. Hans Hofmann, *Equinox*, 1958. Oil on canvas, 72⅛ × 60¼ in. University of California, Berkeley Art Museum and Pacific Film Archive. Gift of the artist.

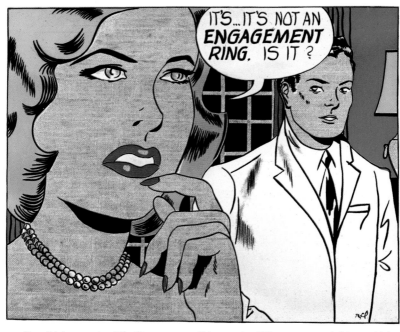

20. Roy Lichtenstein, *The Engagement Ring*, 1961. Oil on canvas, 67¾ × 79½ in.

21. James Rosenquist, *Silver Skies*, 1962. Oil on canvas, 78¼ × 198½ in. Chrysler Museum of Art, Norfolk, VA. Gift of Walter P. Chrysler Jr.

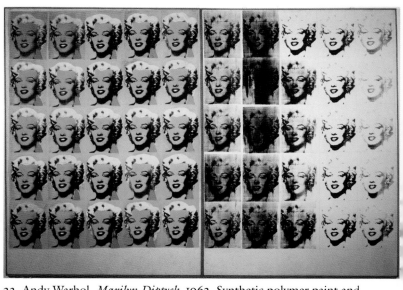

22. Andy Warhol, *Marilyn Diptych*, 1962. Synthetic polymer paint and silkscreen ink on canvas, 82 × 57 in. Tate Gallery, London, Great Britain.

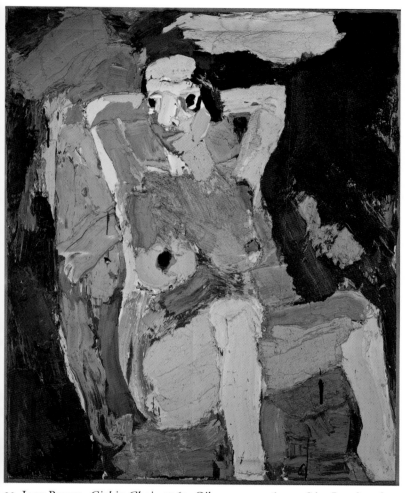

23. Joan Brown, *Girl in Chair*, 1962. Oil on canvas, 60 × 48 in. Los Angeles County Museum of Art, Los Angeles, CA. Gift of Mr. and Mrs. Robert H. Ginter.

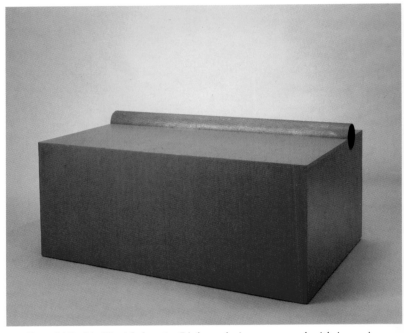

24. Donald Judd, *Untitled*, 1963. Light cadmium on wood with iron pipe, 19½ x 45 x 30½ in. Hirshhorn Museum and Sculpture Garden, Smithsonian Institution, Washington, DC. Joseph H. Hirshhorn Purchase Fund, 1991.

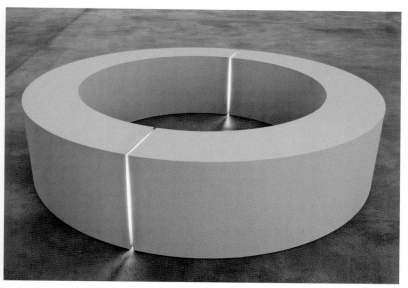

25. Robert Morris, *Untitled (Ring of Light)*, 1965–66. Painted wood and fiberglass and fluorescent light, two units, each 23½ × 14 in., diameter 96¾ in.

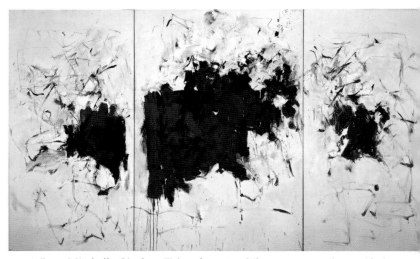

26. Joan Mitchell, *Girolata Triptych*, 1964. Oil on canvas, 76¾ × 118¾ in.

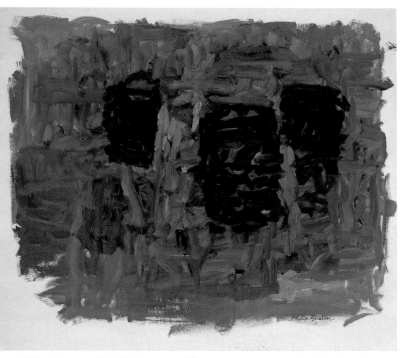

27. Philip Guston, *The Light*, 1964. Oil on canvas, 69 × 78 in. Modern Art Museum of Fort Worth. Museum purchase, The Friends of Art Endowment Fund.

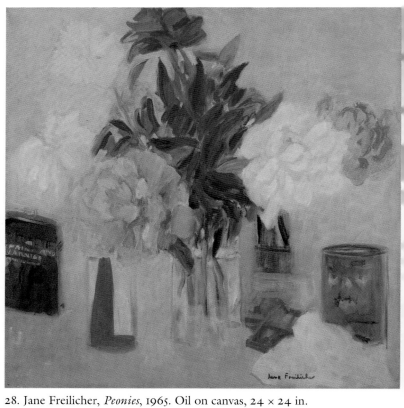

28. Jane Freilicher, *Peonies*, 1965. Oil on canvas, 24 × 24 in.

29. Jess, *The Enamord Mage: Translation #6*, 1965. Oil on canvas mounted on wood, 24½ × 30 in.

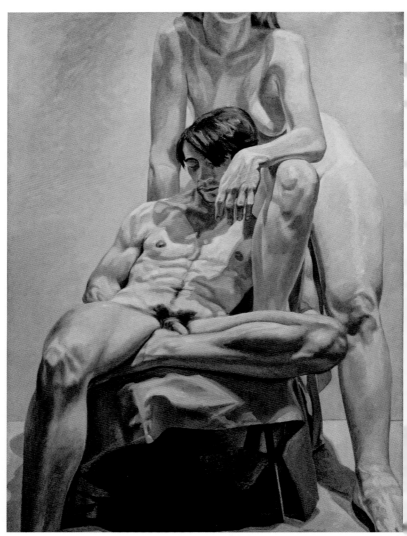

30. Philip Pearlstein, *Models in the Studio*, 1965. Oil on canvas, 72 × 53 in.

31. Romare Bearden, *Black Manhattan*, 1969. Collage paper and polymer paint on board, 25½ × 21¼ in. Schomburg Center for Research in Black Culture, The New York Public Library.

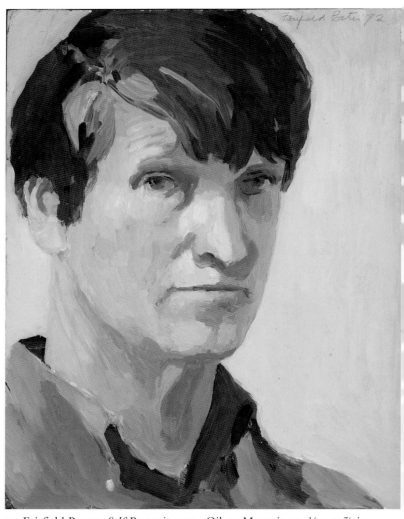

32. Fairfield Porter, *Self-Portrait*, 1972. Oil on Masonite, 14¼ × 10⅞ in. Parrish Art Museum, Water Mill, NY. Gift of the Estate of Fairfield Porter.

KENNETH REXROTH

The poet Kenneth Rexroth (1905–1982) will forever be associated with San Francisco, where he lived for some forty years and did much to define the city's vigorous artistic and intellectual spirit. Rexroth was combative and opinionated, but with no taste for the strict ideological battles that were common back East. He was a self-described anarchist, a close student of Asian literature, and took an early interest in the group of poets who would become known as the Beats, acting as master of ceremonies on the legendary night in 1955 at the Six Gallery when Allen Ginsberg read "Howl." Rexroth wrote about the visual arts only occasionally, focusing in essays on Mark Tobey and Morris Graves on painters who shared his imaginative affinity with the arts of Asia.

The Visionary Painting of Morris Graves

IT is not well known around the world that there existed in the nineteenth-century United States a very considerable visionary art. William Blake and his disciples, Samuel Palmer and Edward Calvert, Francis Danby and John Martin, the later Turner, the Pre-Raphaelites, Odilon Redon, Gustave Moreau, the Nabis, were popular in America and had considerable influence. Most of the painters of this tendency are now forgotten, but one, Albert Pinkham Ryder (1847–1917), has survived in popular esteem as one of America's greatest artists. In our own time visionary painting has been at a discount all over the world, in spite of some interest stirred up a generation ago by the Sur-realists, but it is quite possible that the re-evaluation which has brought back Palmer, Calvert, and Redon, may in time to come restore many more forgotten reputations, even Moreau, who, say what you will, is the master of Rouault at least.

It is to this tendency of American painting that Morris Graves belongs. However, he is beyond question a richer and more skillful artist than any of his predecessors, and, to put it simply, a better, "greater" painter than any of them, except possibly Ryder. In recent years a whole new school of American paint-ing, abstract-expressionism, has come to maturity and begun to influence painting around the world. Painters such as Rothko, Still, Pollock, Motherwell, de Kooning, and Ferren now seem

to be the forerunners of what may be the international style of the coming decade. Morris Graves, however, stands apart from the expressionist group, as, at the other extreme of contemporary style, does a figure of comparable stature, Ben Shahn.

Morris Graves is less provincial, far more a "citizen of the world" than any of his predecessors of the visionary school. It is curious to reflect on this fact, a symptom of the terrific acceleration of the civilizing process of this continent, for Graves was born, raised, and came to maturity as an artist in the Pacific Northwest, a region that was a wilderness until the last years of the nineteenth century. Greatly as I admire Graves's work, it must be admitted that certain of its characteristics are those found, not at the beginning, but at the end of a cultural process—hypersensitivity, specialization of subject, extreme refinement of technique. Nothing could show better the essentially world-wide, homogeneous nature of modern culture than that this successor to the great Sung painters sprang up in a region that was created out of a jungle-like rain forest by the backwash of the Alaska gold rush.

People in the rest of the United States and in Europe have difficulty in adjusting to the fact that the Pacific Coast of America faces the Far East, culturally as well as geographically. There is nothing cultish about this, as there might be elsewhere. The residents of California, Oregon, and Washington are as likely to travel across the Pacific as across the continent and the Atlantic. Knowledge of the Oriental languages is fairly widespread. The museums of the region all have extensive collections of Chinese, Japanese, and Indian art. Vedantist and Buddhist temples are to be seen in the coast cities. And of course there are large Chinese and Japanese colonies in every city, and proportionately even more Orientals in the countryside. It is interesting to note that besides the direct influence of the Orient on them, the Seattle painters, Graves, Tobey, and Callahan, the Portland painter, Price, the San Francisco abstract-expressionists, have all avoided the architectural limited-space painting characteristic of Western Europe from the Renaissance to Cubism, and show more affinity to the space concepts of the Venetians. Venice, of course, was for centuries Europe's chief window on the East, an enclave of Byzantine civilization, and the first contact with China. There are drawings by Tintoretto that might have been

done in his contemporary China. I do not believe that this has been a conscious influence in most cases, but rather an example of what anthropologists call convergence.

Graves was born in 1910 in the Fox Valley of Oregon and has lived in the state of Washington, in or near Seattle, all his life, except for short visits to Japan in 1930, to the Virgin Islands in 1939, to Honolulu in 1947, and a year in Europe in 1948, after his personal style was fully developed and "set." He studied at the Seattle Museum, with the old master of Northwest painting, Mark Tobey, and had his first one-man show there in 1936. His first New York shows were in 1942 at the Willard Gallery and the Museum of Modern Art. His paintings are now to be found in the permanent collections of most of the major American museums, including the Metropolitan in New York.

Except for the emphasis on deep complex space and calligraphic skill which he learned from Tobey, but which he could just as well have learned from the Far Eastern paintings in the Seattle Museum, Graves's style, or styles, his special mode of seeing reality and his techniques of handling it, have come, like the spider's web, out of himself, or, at the most, out of the general cultural ambience of a world civilization, syncretic of all time and space. Therefore, influences and resemblances which seem certain to a historian of art may never in actual fact have existed. Since today Graves's painting is an extremely specialized view of reality and his concept of space differs from that usually thought of as the contribution of modern painting, it is fruitful to compare him in his development with other painters of other times around the world, always realizing that, with the exception of Chinese, specifically Sung, and Japanese, specifically Ashikaga, and particularly the painter Sesshu, Graves himself may never have known of any resemblance let alone influence.

The first of Graves's paintings after his apprentice days are in a rather thick medium, often laid in like cloisonné between broad, abrupt, dark, single brush strokes. The colors are all "local." There is no attempt to achieve deep space or movement in space by juxtaposition of color. In fact the color is limited to a small gamut of earths, dull reds, browns, and yellows, with occasionally a slate blue. The line, however, has a great deal of snap, while the movement is very shallow, almost Egyptian. If there are receding planes in these pictures, they are kept to a

minimum and the lines stick to the silhouette, never crossing from plane to plane to fill the space. The thing that identifies these paintings immediately is a peculiar, individual sense of silhouette, a silhouette defined by an eccentric calligraphic stroke.

As is well known, a highly personal line of this type comes late, if at all, to most artists. Yet it seems to have been the first thing Graves developed. I can think of nothing quite like it. The brush drawings of the early Jean de Bosschére—not the commercial book illustrations but rather those for his own *Portes Fermées*—have somewhat the same feeling. I rather doubt that Graves has ever seen these.

This is also somewhat the style of the earliest Klees. It is generally identified with the magazine *Simplicimuss*, a German satirical publication of the years before the First War. Graves, very likely, has never heard of it.

Already in this period, which incidentally was roughly that of the WPA Art Project (1935–42), Graves was beginning to concentrate on birds and sometimes small animals as masks of man and as symbols of the personae, the forces, operating in man—a kind of transcendental Aesop.

Certainly the best picture of this period is a large *Game Cock* (1933), many times life size, caught in a thick perimeter that whips across the picture plane like jagged lightning. There is no sign of the easy line so attractive to young artists who are beginning to pay attention to their drawing—the decorative sweeps of Beardsley, Botticelli, or the Book of Kells, those perennial favorites of the innocent. Neither is there any of the impressionist line of the Rodin water colors, the other and great influence on the young—and on Matisse and his descendants. This line is tooled to the last millimeter and, with the exception of the Bosschéres I spoke of, there is nothing like it except certain painted ceramics, Greek and Oriental, some Romanesque illumination, and the akimbo linearity of the Moissac Portal. It is simply not a line usually found in painting. Later this cock was to be repainted, smaller, more compact and secretive, in the two *Game Cocks* of 1939.

In his early twenties Graves had begun to concentrate on calligraphy, under the influence of Mark Tobey's "white writing," which Tobey himself was just then beginning. Graves shared practically on equal terms with the older man in its development.

At this time too Graves took a short trip to Japan and later

traveled in the eastern United States and the Caribbean. The paintings of this period parallel—they cannot really be said to be influenced by—the major paintings of Tintoretto in the treatment of the picture space as a saturated manifold quivering with three-dimensional lines, really tracks of force. The best analogy is to the whorls of iron filings in a magnetic field. But in this case the field is both three dimensional and possessed of more than two poles, and all of varying intensity. This space concept reaches its highest development only in the Venetian baroque in the West, but of course it is basic in the greatest periods of Sung and Ashikaga ink painting.

In writing of Sesshu, I have said, "The brush, which never departs from the calligraphy of the square Chinese characters, is as quick, precise, powerful, and yet effortless as Japanese sword play. 'The sword,' say the Zen fencing masters, 'finds channels opened for it in space, and follows them without exertion to the wound.' This is the central plastic conception of Sesshu. The picture space is thought of as a field of tangled forces, a complex dynamic web. The brush strokes flow naturally in this medium, defining it by their own tensions, like fish in a whirlpool of perfectly clear water."

Both Tobey and Graves can be considered as direct descendants of Sesshu. In Graves there is an additional factor, a deliberate formal mysteriousness, a conscious seeking for uncanny form, analogous to that found in primitive cult objects—sacred stones and similar things. There are several series of studies of just such objects—stones and driftwood—notably the nine water colors of 1937 called *Purification*.

From 1939 to 1942 were the years of the *Little Known Bird of the Inner Eye, Bird in Moonlight*, and *Blind Bird*, now in the New York Museum of Modern Art collection, paintings which achieved an instantaneous fame when they were first exhibited. Every critic seems to have been aware that here was a really different yet thoroughly competent artist.

Incidentally, the haunted, uncanny character of these pictures, which reaches its height, representationally at least, in *Young Rabbit and Foxfire* and *Bird with Possessions* of 1942, owes little or nothing to Surrealism. There is much more conscious knowledge of mystery, and much less unconscious Freudian or Jungian symbolism.

On into the war years the mastery of calligraphy developed,

until finally the line, sometimes "white writing," sometimes black, reaches a climax in the *Joyous Young Pine* series of 1944, *Black Waves* (1944), *In the Air* (1943), and the two great ideographs called *Waning Moon* (1943), in the Seattle Art Museum. These paintings are fully the equal of anything, East or West, of the kind. *Waning Moon* passes out of the realm of ordinary painting altogether and can be compared only with the ominous, cryptic characters which Shingon monks write on six-foot sheets of paper while in trance.

To 1945 belongs the series called *Consciousness Assuming the Form of a Crane*. I own what I consider the best of these, and for nine years I have found its ephemeral simplicity inexhaustible. In these paintings the old dynamic hyperactive space of Sesshu has been surpassed. The background is a vague cloudy diagonal drift of red and green, overcast with a frost of white. From this, in a few faint strokes of white with touches of somber red, emerges a slowly pacing, more than life-size crane-being rising from flux into consciousness, but still withdrawn, irresponsible, and stately. There is nothing exactly like this in the world's art, for it is not simply a literary or a mystical notion but a plastic one as well. Form, an ominous, indifferent form, emerges from formlessness, literally seems to bleed quietly into being.

The great dragon painters of the Orient whose dragons are confused with and only half emerge from vortexes of clouds and rain were seeking the same kind of effect, but of course their paintings are far more active. Graves's *Cranes* are not active at all. They are as quiet as some half-caught telepathic message.

In 1948, Graves traveled in Europe. Much of this time was spent at Chartres. Just before leaving America he had done a series of what can only be described as intensely personal portraits of Chinese Shang and Chou bronzes. Objects of great mystery in their own right, in Graves's paintings they become visions, supernatural judgments of the natural world. *Individual State of the World*, with its use of Graves's recurrent minnow, symbol of the spark of spiritual illumination, is representative of this series. Contemporary with these bronzes is a series of vajras (Buddhist ritual bronze thunderbolts), lotuses, and diamonds of light which can be considered as illustrations for that great refusal to affirm either being or non-being, the *Prajnaparamita Sutra*.

No one has seen what Graves did at Chartres. In conversation he has told me how he spent the better part of a cold foggy winter there, painting every day, details of the cathedral, fragments of statues, bits of lichened masonry, and several pictures of the interior of the cathedral in early morning—the great vault, half filled with thick fog, dawn beginning to sparkle in the windows. When he came back to America and reviewed the year's work he destroyed it all. I have a feeling that the painting in the Fredericks collection, *Ever Cycling*, may have survived from this time.

Shortly after this, Graves abandoned ink, gouache, and water color on paper, and returned to oil. From 1950 to the present [1955], most of the paintings are in the vein of *Guardian*—or the *Spirit Bird Transporting Minnow from Stream to Stream* of the Metropolitan collection—geese, hawks, and eagles, most of them over life size, many with mystifying accessories such as black suns or golden antlers. It would seem, looking at a sizable collection of these recent paintings, that Graves has, at least temporarily, abandoned the surcharged, dynamic, baroque space of the calligraphic paintings and returned to the intact object. Again, there is considerable resemblance to the bird painters of the Far East—the famous pair of ducks of the Sung Dynasty in the British Museum, or the early falcon painters of the Kano school. These new paintings share with them a concentration on maximum surface tension, a sense of absolutely full occupation of their separate volume, like formed globules of quicksilver, or drops of viscid oil. This particular formal quality does have a parallel in contemporary art, notably in Brancusi's sculpture of a *Fish* and those dreaming ovoids he calls *Birth*, and more especially in the most successful of Hans Arp's swollen, amoeboid figures. Piero della Francesca, of course, is the outstanding example of what might be called overloaded volume in the Renaissance. This, by the way, is a quality that must be distinguished from Picasso's excessive specific gravity—in his case a directly representational device masquerading as "significant form." Picasso and most of his disciples simply paint things to look many times as heavy as they actually are. In Graves's recent work there is always a sense of ominous, impending meaning, as if these human-eyed birds were judging the spectator, rather than he them, and in terms of a set of values incomprehensible to our sensual world.

It is none too easy to sum up such an accomplishment as that of Graves. Certainly he is one of the greatest calligraphers of all time—not just a "master of line" but a creator of significant ideographs and, beyond that, a creator of a new and strange significance of the ideograph as well. Graves has also been one of the many around the world who in this generation have freed painting from the exhausted plasticism, the concentration on architecture alone, which formed the residue of subsiding Cubism. This he has accomplished not merely, or even primarily, by illustrative, but by plastic means, by discovering a new world of form antipodal to the Poussin rigor of Cubism. Graves has opened the plastic arts to a whole range of experience hardly found in the external world at all, let alone in art. He has created a series of objects, masks, personae, which act both as objects of contemplation, and, in contemplation, as sources of values which judge the world the spectator brings to them. On the whole this judgment has little room or time for those values known to the popular mind as "American," but which are really those of our acquisitive mass Western civilization.

Jacques Maritain asks somewhere, "What kept Europe alive for so long after it had obviously been stricken with a fatal disease?" and answers his question, "The prayers of the contemplatives in the monasteries." I am not prepared to enter into a metaphysical defense of petitionary prayer, or a sociological one of monasticism, but the empirical evidence for the social, perhaps even biological necessity for contemplation, is, in these apocalyptic hours, all too obvious. Civilizations endure as long as, somewhere, they can hold life in total vision. The function of the contemplative is contemplation. The function of the artist is the revelation of reality in process, permanence in change, the place of value in a world of facts. His duty is to keep open the channels of contemplation and to discover new ones. His role is purely revelatory. He can bring men to the springs of the good, the true, and the beautiful, but he cannot make them drink. The activities of men endure and have meaning as long as they emanate from a core of transcendental calm. The contemplative, the mystic, assuming moral responsibility for the distracted, tries to keep his gaze fixed on that core. The artist uses the materials of the world to direct men's attention back to it. When it is lost sight of, society perishes.

Although the mystique behind such evaluation is overtly Oriental, even Buddhist or Vedantist, and hence anti-humanistic, I do not feel that this type of explication is really relevant. The perfected mystic, of course, would not seek to express himself at all. In the last analysis it is the artist, the contemplator and fabricator, who speaks and judges through these embodied visions. And the united act of contemplation and shaping of reality is in its essence the truest and fullest human deed. Morris Graves has said of his own work: "If the paintings are confounding to anyone —then I feel that words (my words, almost anyone's words) would add confusion. For the one to whom the message is clear or even partially clear or challengingly obscure—then, for them, words are obviously excessive. To the one whose searching is not similar to ours—or those who do not feel the awful frustrations of being caught in our individual and collective projection of our civilization's extremity—to those who believe that our extroverted civilization is constructively progressing— those who seeing and tasting the fruits and new buds of self-destructive progress are still calling it good, to them the ideas in the paintings are still preposterous, hence not worth consideration."

1955

WILLIAM CARLOS WILLIAMS

William Carlos Williams (1883–1963) was no stranger to the affinities between poetry and painting that Horace long ago enshrined with the phrase "ut pictura poesis"—often translated "as in painting, so in poetry." Everybody even casually acquainted with American poetry knows about the red wheelbarrow on which so much depends, one of many striking images Williams summons in his poetry; and what is perhaps his friend Charles Demuth's most famous painting, *The Figure 5 in Gold,* was inspired by a Williams poem. Williams was a regular visitor to gatherings in the New York home of Walter Arensberg, where important modernist paintings hung on the walls; he wrote on more than one occasion about the work of Charles Sheeler, a very close friend; and a late collection of poems, *Pictures from Brueghel,* included a cycle inspired by the Netherlandish painter's panoramic scenes. Sheeler was among many artists of Williams's generation who took a particular interest in the forthrightness of American folk art, the subject of this essay written relatively late in Williams's career.

Painting in the American Grain

How not to begin an article on American primitives in painting: You don't begin speaking about Giotto and Fra Angelico or even Bosch or Van Eyck, but of a cat with a bird in his mouth— a cat with a terrifying enormous head, enough to frighten birds, or of a six-foot Indian in a yellow breech clout . . . Washington apart from its official aspect is a quiet, old-fashioned city fit home, the only fit home for a collection of primitives such as this that smacks of the American past . . .

As you enter the place—there are a total of 109 paintings of all sizes—the first thing that hits your eyes is the immediacy of the scene I should say the color! They were putting down what they had to put down, what they saw before them. They had reds to use and greens and flesh tints and browns and blues with which they wanted to surround themselves in shapes which they recognized. A beloved infant had died. If only they could bring it to life again! An artist was employed to paint a counterfeit presentment of the scene: as it stood again in the garden by an obelisk near a weeping willow and a cat which arched its back

and purred. It would bring comfort to the bereaved parents. That is how the artist painted it.

No matter what the skill or the lack of it, someone, somewhere in Pennsylvania—all trace of the painters that we may identify them has been lost—wanted on his walls a picture of Adam and Eve in the garden before the Fall. There is no serpent here, no sign even of God, just the garden and its bountiful blessings. Wild beasts are at Adam's feet or at least one panther is there. The sky is luminous, this was not painted in a potato cellar, the trees are luxuriant, hoar grape clusters hang from the trees and there at their ease sit together our primordial parents naked and unashamed bathed in sunlight. Who shall say the plenty of the New World so evident about them was not the true model that has been recorded—so innocently recorded the beholder in whom no rancor has as yet intruded.

A head, a head of a young woman in its title designated as *Blue Eyes* caught my eye at once because of the simplicity and convincing dignity of the profile. The hair was black and chopped off short to hang straight at the neck line. The complexion was clear, there was a faint smile to the lips, the look, off to the right, was direct but feature of the thing was for me not the blue eyes but the enormous round chin perfectly in proportion that dominated the face and the whole picture. No one can say that chin was not real and that it was put down to be anything than what it was. It is a world not a chin that is depicted.

A record, something to stand against, a shield for their protection, the savage world with which they were surrounded. Color, color that ran, mostly, to the very edge of the canvas as if they were afraid that something would be left out, covered the whole of their surfaces. One of my first views of the whole show, the big room, was of the *Sisters in Red*. Both my wife and eye were amazed. They were talking to us. The older girl, not more than six, had dark hair and looking at us directly was the most serious, even slightly annoyed. The younger sister, holding a flower basket, was a blond with wavy hair, wore an alert, a daring expression of complete self-assurance, the mark of a typical second-child complex, that made her to me a living individual. I fell in love with her—and with my wife all over again

for she too was a second child. The brilliant red dresses from which decently projected the snow-white pantalettes ironed no doubt that morning and dainty slippers completed an arresting picture.

A picture of the burning of Charlestown by the British with Boston untouched across the harbor once again emphasized for me the importance for these people of the recording of events. Titles in this case were superimposed upon the canvas, Charlestown on one side and Boston on the other and between them, incongruously, Bunker Hill. Smoke was billowing to a sky already filled with masses of round clouds that rose above the flame and smoke in the distance.

Intimate scenes of rural life, a scene showing a side view of four cows and two horses, the barn and beyond that a house— a clapboard house, painted white, which completed the scene, aside from three young trees. An obvious pride of possession and of the care which are owed such things.

There is a different pride, which we see in a grouping that fills one canvas, again to the very edge, called *The Plantation*. Apparently it is near the sea, for a full-rigged ship occupies the foreground. Above rises a hill. The theme is formally treated and not without some skill by the artist. The perspective is elementary. Clusters of grapes larger than the ship's sails come in from the right meeting two trees, one on each side, that reach the sky framing the plantation house, with its garden, in the center distance toward the picture's upper edge. Birds are flying about, and down the hill nearer the foreground, linked by paths, are the farm buildings and at the water's edge a warehouse.

A portrait of a woman past middle life arrested me by the hollow-cheeked majesty of its pose. A plain white bonnet, from which the two white strings which lie symmetrically on either side of her flat breasts above her hands complete the oval, complete the whole. A single tree, formally pruned and cut off so only partially shown completes the picture. This portrait is accompanied by a similar one of her husband. They are serious individuals. The principal interest for me apart from the impression they give of their pride and reticence is the colors the unknown artist has used in drawing them. Nowhere except in El Greco have I seen green so used in the shadows about the face.

You will find here another of Hicks's *Peaceable Kingdoms* but

Anonymous: *The Plantation*, circa 1825. Oil on wood, 19⅛ × 29½ in.

that hardly needs further comment at this late date. The same for *Penn's Treaty with the Indians.*

Henry James said, It is a complex thing to be an American. Unconscious of such an analysis of their situation, these artists as well as their sitters reacted to it nevertheless directly. They scarcely knew why they yearned for the things they desired but to get them they strained every nerve.

The style of all these paintings is direct. Purposeful. The artist was called upon to put down a presence that the man or woman for whom the picture was painted wanted to see and remember, the world otherwise was for the moment put aside. That dictated the realistic details of the situation and also what was to be excluded. The selection of significant detail was outstanding.

The kind of people that called for the paintings determined their quality. They were in demand of something to stand against the crudeness that surrounded them. As Wallace Stevens put it:

> I placed a jar in Tennessee,
> And round it was, upon a hill.
> It made the slovenly wilderness
> Surround that hill.

The wilderness rose up to it,
And sprawled around, no longer wild.

These were talented, creative painters. They had to be. They had no one to copy from. They were free as the wind, limited only by their technical abilities and driven by the demands of their clients. The very difficulties, technical difficulties, they had to face in getting their images down only added to the intensity of their efforts and to the directness of the results. It gave them a style of their own, as a group they had a realistic style direct and practical as Benjamin Franklin. Nothing was to daunt them.

The circumstances surrounding the painting of Abraham Clark and his children, 1820, are known. Mr. Clark had just lost his beloved wife. He had gone into his garden with his six small children to read for them from the Bible. There he instructed the artist to paint him with the remainder of his family about him. The father, in profile, his thumb in the Bible no doubt at the passage from which he had been reading, sat to the right under the trees. The boys closely grouped, the baby on the knee of the oldest bareheaded before him. They all look alike, an obvious family. All are serious as befits the occasion. One leans his elbow against a tree. Their colorful faces stand out no doubt, in the clear light of the Resurrection upon the forested and carefully painted background. The fifth son—apparently they were all boys—carries a pet hen carefully in his arm. We are deeply moved by it all.

Across the room in the big gallery is a large portrait of a young woman, Catalynje Post, 1730, wearing a flowered apron. She has a white lace cap on her head. Her arms are bare halfway to the wrists. She wears a low-necked dress and a necklace of pearls. Her hands crudely painted, are placed one at the waist upon the hem of the colored apron, the other at the throat playing with an ornament which her fingers find there. A four-petaled flower and some carefully placed roses are seen occupying spaces in the background. But the feature of the ensemble is the slippered feet, standing at right angles one to another flat before the eye, they have high heels and pointed toes and must have been the pride of their possessor. The artist had difficulty with the nose which is presented full face or almost full face, his struggle to master the difficulty has not prevented him however,

from presenting the picture or showing a realistic portrait of a young woman.

There are still lifes which I wish there were room to comment on. Fruit, in one case a watermelon with its red flesh, attracts the eye and the palate. One group symmetrically arranged on an oblong table, recognizable as of Shaker make, particularly fascinated me. Curtains hang, always symmetrically, across the top. At either side are plates, painted flat, with fruit knives. A bowl, it might be that of which Wallace Stevens speaks, is filled in the exact center of the picture making of it an obvious decoration, with melons, grapes, apples, perhaps an orange, peaches, and pears.

It was the intensity of their vision, coupled with their isolation in the wilderness, that caused them one and all to place and have placed on the canvas veritable capsules, surrounded by a line of color, to hold them off from a world which was most about them. They were eminently objective, their paintings remained always things. They drew a line and the more clearly that line was drawn, the more vividly, the better. Color is light. Color is what most distinguishes the artist, color was what these people wanted to brighten the walls of their houses, color to the last inch of the canvas.

It was so with the portrait painted in 1800 of the Sargent family, artist unknown, the gayest and one of the largest pictures in the exhibition. It is the portrait of a cocky little man, in an enormous—to make him look tall—beaver hat (you can't tell me that the artist was not completely wise to the situation) surrounded by his wife and little daughters in white and flouncy dresses. The wife is sitting, sideface, with a new baby in her arms. The room is suffused with light. A toy spaniel frisks joyfully upon the rag rug, the canaries are singing joyfully—at least one of them is—in their cages between the pictures on the gaily papered walls. The paneled door is open. Every corner of the painting is distinct and bathed in light. It is a picture of a successful man.

There are in the same room two pictures, among the earliest of these shown, 1780, two large canvases of men heavily clad and in top hats, coursing hounds in the half-light of dawn and near sundown: the *Start* and *End of the Hunt*. True to the facts the light in both cases is dim which presented practical

difficulties to the artist. These pictures are among the most crudely painted of those shown but the record they present is filled for all that with something nostalgic and particularly moving. It brings to mind, as it was meant to do, another day which even then was fast vanishing. The artist was faced by the facts and the difficulties they made for him but he faced them in the only way he knew, head on.

There is also in the same room a picture, undated, entitled *The Coon Hunt*. That, too, presented a scene which must have been familiar to the men of that time. It is moonlight. Half the party, carrying a lighted lantern, are approaching through a forest of partly felled trees. The quarry is on a high limb above their heads. The dogs are bounding into the air at the tree's base. The other half of the party is resting.

It is all part of their lives that they had to see re-enacted before them to make it real to them so that they could relive it and re-enjoy it and it must be depicted by the artist so that it could be recognized—awkward as he may be.

In the middle room, apart from two Rembrandt-like portraits of an aging burgher and his comfortable and smiling wife, among the best painted pictures in the exhibition, are two of the most interesting imaginative pictures of all. I don't quite know what they meant but suspect that the intention is to represent the travels of a man who has seen much of the world, has made money, perhaps retired from his labors and come home to rest and enjoy his memories. Each of the pictures presents, one overtly, a volcano in the distance, in the background a range of high mountains, perhaps the Andes, before a foreground crowded with all the appurtenances of a commercial civilization of those times, bathed to the minutest detail, in the fullest light. The artist means, as he was no doubt instructed to do, to have you see into every part of his canvas; cities, factories, virtual palaces, railroad trains, alas, giving out smoke, rivers with waterfalls are to be seen prominently displayed. It is a pride of wealth which must have decorated a great house now all forgotten.

Many more such pictures showing the lives of our people in the late eighteenth and early nineteenth century are shown in this noteworthy collection of our unknown artists' work. I must not forget to mention a picture labeled *Twenty-Two Houses and a Church* depicting just that. Only the outlines of the buildings

covering several acres are shown with their surrounding fences painted white except in the foreground where a darker color is used—the only art aside from the spacing of the buildings displayed. Light, as in all the primitives, is everywhere. Not a single human figure is to be seen in the village, the buildings alone are recorded. The paintings have a definite style of their own, a forthrightness, a candor and a practical skill not to be gainsaid, that gives them a marked distinction separate from European schools of painting with which they had not the time or the opportunity to acquaint themselves. So that, collectively, they represent not individual paintings so much as a yearning in the new country for some sort of an expression of the world which they represent.

It was a beginning world, a re-beginning world, and a hopeful one. The men, women, and children who made it up were ignorant of the forces that governed it and what they had to face. They wanted to see themselves and be recorded against a surrounding wilderness of which they themselves were the only recognizable aspect. They were lonely. They were of the country, the only country which they or their artists knew and so represented.

This is a collection of paintings, lovingly assembled by a couple, Mr. and Mrs. Garbisch, for their home on the eastern shore of Maryland. They found almost at once that the scope of what they had to choose from far exceeded their plans. They are called "American Primitives," the work of gifted artists whose names are for the most part lost in the shuffle of history.

1954

MARIANNE MOORE

In the 1920s Marianne Moore (1887–1972) was deeply involved with the avant-garde magazine *The Dial*, where there was always a strong emphasis on the visual arts. Her portrait was sculpted by Gaston Lachaise in 1924, and her poetry contains allusions to artists ranging from Leonardo to Magritte. In "The Steeple-Jack" she observes that "Dürer would have seen a reason for living / in a town like this, with eight stranded whales / to look at." One imagines it was Moore's feeling for the animal kingdom, a theme in so many of her poems, that attracted her to the work of Robert Andrew Parker, a young artist when she wrote about him in 1947 who over the course of what is by now a long career has dedicated himself to the charms, foibles, intricacies, and idiosyncrasies of animals of all kinds, including the human kind. Parker's work tends to be intimate, with a particular emphasis on the graphic arts. Moore would surely appreciate a 2009 collection of hand-colored prints entitled *An Alphabet: Amazons to Zapata*, in which Zapata is a frisky chihuahua.

Robert Andrew Parker

ROBERT ANDREW PARKER is one of the most accurate and at the same time most unliteral of painters. He combines the mystical and the actual, working both in an abstract and in a realistic way. One or two of his paintings—a kind of private calligraphy—little upward-tending lines of actual writing like a school of fish—approximate a signature or family cipher.

His subjects include animals, persons—individually and en masse; trees, isolated and thickset; architecture, ships, troop movements, the sea; an ink drawing of an elm by a stone wall between meadows. His *Sleeping Dog* is the whole in essence: simplicity that is not the product of a simple mind but of the single eye—of rapt, genuine, undeprecatory love for the subject. The dog's pairs of legs curve out parallel, his solid cylinder of tail laid in the same direction, the eye seen as a diagonal slit in the nondescript pallor of whitish skin; they focus thought on treatment, not just on the dog. A cursive ease in the lines suggests a Rembrandt-like relish for the implement in hand; better yet, there is a look of emotion synonymous with susceptibility to happiness. Entwined in a Beethoven-like Lost Grochen of

Robert Andrew Parker: *Baboon*, 1985.
Watercolor on paper, 19⅜ × 25⅜ in.

rhythms, the chalk-gray and dead-grass tones of *Celery and Eggs, No. 2*, have resulted in something elate. The rigidly similar forms, in dark blue, of the audience in *Mario and the Magician* perfectly enunciate the suspense in the story, that one has never known how to define.

His Holiness Pope Pius XI's cloak of flawless violet, lined with ermine, against a black ground, is a triumph of texture, with tinges of lemon defining the four conjoined ridges of the Papal cap. In his satiric tendency and feeling for tones, Robert Parker resembles Charles Demuth; goes further; his wide swaths of paint with a big brush, and washes of clear color touched by some speck or splinter of paint—magenta or indigo—spreading just far enough, are surely in the same category with the De-muth cerise cyclamen and illustrations for Henry James. Robert

Parker is not afraid of sweet-pea pink for the face of a soldier in khaki or for the dress of a lady with orange-gold hair. He has plenty of aplomb in his juxtaposings of rust, blood red, shrimp pink and vermilion. He is a specialist in marine blues, blue that could be mistaken for black, faded denim, sapphire-green and—thinking of *Oarsmen*—a Giotto-background blue or telephone-pole-insulator aquamarine. The design of the men and boat (*Oarsmen*) is integrated with the sea as seeds are set in a melon—the men braced by resistance to the mounding weight of deep water; the crisscross of the oars, uninterferingly superimposed on the vastness of a sea without sky. Payne's gray is another specialty of Mr. Parker's, as in the etched-over *Head of a Lady*, and in the fainter gray scene but explicit turrets and rig of the cruiser, *Admiral Hipper*.

Robert Parker is a fantasist of great precision in his studies of troop movements, seen in the *Invasion of an Island*, from the "Gyoncho" series—and in the balanced color pattern, dominated by white, of *East Yorkshire Yeomanry Disembarking from H.M.S. Cressy*—its caraway-seed multitudes pouring down the ship's sides in streams like sand in an hourglass, the sea choked with landing boats repeated to infinity. For this science of tea-leaf-like multitudes, there is an antecedent, if not counterpart, the swarming, seed-compact, arc- or circle-designed battle scenes in central Greece painted by Panaghiotes Zographos (1836–1840) for General Makryannis (reproductions in *Eikones*, April 1956). As multitudinous, although unaware of the Greek scenes, Mr. Parker manages to be epic without being archaic. His *October, 1917* is intensely his own. A platoon—sabers up—seen from the side, reduplicates identical-identical-identical boots that are as black as the men's tunics are flaming vermilion—with an effect resembling the leaves of a partly open book standing upright.

We have here masterpieces of construction plus texture, together with a passion for accuracies of behavior, as where, in the semi-frowning fixity of the eyes, in his portrait of Mrs. Parker, the artist has happily caught her unselfconscious naturalness. Warren Hennrich, moreover, has for his "Field Exercises" (*Wake* magazine, June 1945) the perfect illustration, in Robert Parker's *The Retreat from Caporetto*—a deadly uniformity of faces smothered by their own helmets:

Harmonious men
In harmonious masses

Suspend at attention
Bright, gleaming cuirasses,

And then march away
In monotonous classes.

They follow the outline
Of bordering grasses,

Anonymous men
In anonymous masses.

Mr. Parker has an eye: typified by the waiting horse, down on one haunch; by the flick-back of the hoof of a horse in motion, or rearing. *Hussar, 1900, South Africa*, charging with raised saber, down-darting tapered boot, and counterpoint of galloping hoofs, rivals *The Attack, No. 1*'s diversified unity. The excitement here is not all in sabers and furious action. Humor lurks in the beach scenes of distorted perspective; in the slightly over-curled-in claws and rumpled topknot of the *Fairy Shrimp* trundling along like a feather duster; in *Ugly Animal*, and *Another Dog*.

On no account should Mr. Parker's capacity for grandeur be underestimated—as embodied in the reverie at dusk aspect of *An Imaginary Monument to a Lancer, No. 1*, and in two rather similar equestrian statues, grand without being accidentally ironic—the rider in one, silhouetted against a glare of magenta fire; the other, massive above an ascending burst of yellowish fire.

Robert Parker is thirty—tall, slender, and meditative—born in Norfolk, Virginia. He is unmistakably American, reliable— in the sense pleasing to Henry James. That his likings and proficiencies should range wide and that, so young, he should have depth and stature unvitiated by egotism, seems remarkable. He is in a sense like Sir Thomas Browne, for whom small things could be great things—someone exceptional—*vir amplissimus*.

1957

DWIGHT MACDONALD

Dwight Macdonald (1906–1982) had an enduring fascination with the place of cultural experience in a democratic society, which he explored in early essays for *Partisan Review* and later as a staff writer for *The New Yorker* and a film critic for *Esquire*. Like so many who were involved with *Partisan Review* in the early 1940s, he was an anti-Soviet leftist who eventually came to believe that for all their imperfections the western democracies offered the best chance for a just society. At the same time he worried about the fate of the arts in capitalist culture, and in what is perhaps his most famous essay, "Masscult and Midcult" (1960), argued that a watered-down version of avant-garde art was being sold to a middle-class audience that couldn't recognize the real thing. Alfred H. Barr, Jr., the founding director of the Museum of Modern Art, was a subject heaven sent. And in his 1953 *New Yorker* profile of Barr, excerpted here, Macdonald uses his razor-sharp intelligence and his satirist's eye to anatomize an institution that unlocked the mysteries of modern art for the education and entertainment of the American public.

FROM
Action on West Fifty-Third Street

ALL in all, since its founding the Museum has thought up and put on five hundred and forty-seven shows, whether of art or more prosaic subjects. In 1932, some of the trustees began to worry about the rate at which the staff was using up new ideas, their fear being that it might presently run out of them. Barr reassured the trustees with a memo outlining a ten-year exhibition program. If of late there have perhaps been signs of combat fatigue—as when the Museum put on two major Rouault shows within eight years and two automobile shows in three—the wonder is that there have not been more. By no means all the shows the Museum has offered have been of a pioneering or experimental nature. There are the substantial group shows, like the Cézanne–van Gogh–Seurat–Gauguin one with which it opened; one-man shows of masters like Picasso, Matisse, Braque, and Klee; informative surveys, like those of Cubism and abstract art in 1935 and of the Fauves of last year; big general retrospectives, like the Museum's fifteenth-anniversary

Philip Johnson: Abby Aldrich Rockefeller Sculpture Garden,
Museum of Modern Art, east view, 1953.

"Art in Progress" show in 1944; and great primitive-art shows,
like "African Negro Art" in 1935, "Arts of the South Seas" in
1946, and "Ancient Arts of the Andes," which will open next
month. But there have also been some very odd shows indeed,
in which ingenuity sometimes seems mixed with desperation:
shows of delphiniums grown by Edward Steichen; of "Large-
Scale Modern Painting" (canvases measuring six feet or more
in one dimension or the other); of "Objects As Subjects" (still-
lifes); of "Mystery in Paint" (mysterious things); of "The Ani-
mal Kingdom in Modern Art"; and of "The Most Beautiful
Shoe Shine Stand in the World" (a shoeshine stand). There's
no business like show business.

Two reasons may be given for the Museum's dramatic, enter-
prising, multifarious character. One is that Barr planned it
that way. His was the flair for showmanship, the conviction
and drive, the notion of a "multi-departmental" museum that

would rove far beyond the classic confines of the fine arts. The other reason is economic. The Metropolitan has an endowment of $62,000,000 and the city pays part of its operating expenses; the Museum of Modern Art has an endowment of $1,600,000 and it pays for everything itself. The former is thus in the position of a *rentier*, living on income from capital, while the latter is an entrepreneur, dependent on its own exertions. As the word implies, an entrepreneur has to be enterprising, and this fact does a good deal to explain the nine-ring circus and the side-shows. As late as 1940, the Museum of Modern Art's income from endowment funds was less than $20,000, and even last year it was only $72,000, which covered about one-fifteenth of its expenses. Fourteen-fifteenths of its budget, therefore, must be raised either in the form of contributions or by its own operations. The relative importance of these two sources has changed in an interesting way since the Museum was founded. In 1930, it received $107,500 in contributions (almost all from trustees) and less than one-fifth of that amount from membership dues, the sale of catalogues, and other sources of operating revenue. Since then, the balance has slowly tilted the other way, until today the Museum is self-supporting to an extent rarely achieved by an art museum. Of the $1,059,000 that went for its expenses last year, nearly two-thirds ($675,000) came from operating income (including $162,000 in admission fees and $146,000 in membership dues) and just over one-third ($354,000) from contributions, leaving a slight ($30,000) deficit. Originally open free to the public, the Museum has charged admission since 1939. It is something of an entrepreneurial triumph to induce people to pay sixty cents to get into an art museum.

Barr, who has done more than anyone else to give the Museum of Modern Art its form and character, lives with his wife, Margaret, and their sixteen-year-old daughter, Victoria, in a modest apartment at Ninety-sixth Street and Madison Avenue. The furniture is sparse, simple, and modern, and the walls are hung with many pictures, including a big Miró, two Picasso drawings, a small and lovely Juan Gris, and a Burchfield water color. "All our spare cash, which we can't spare, goes into buying pictures, which we can't afford," says Mrs. Barr. Born Margaret

Scolari-Fitzmaurice, in Rome, she is the daughter of an Italian art dealer and an Irish mother. Upon coming to this country, in the twenties, she taught Italian at Vassar for four years. She met Barr in 1929, at the Museum's opening show, and they were married the following year. Although, like her husband, Mrs. Barr has a degree in art history, and although she is a woman of great energy and competence, who has worked closely with her husband on a number of his books, she has steered clear of any official connection with the Museum. "That was one of the wisest decisions we ever made," she says.

The Barrs spend their summers in a cottage, designed by Barr, in Greensboro, Vermont. Another cottage, nearby, is occupied by his mother, who, at eighty-five, is an ardent liberal in both politics and art and approves of her son's taste in painting. (She has one other son, Andrew Wilson Barr, who is a partner in the public-accounting firm of Price Waterhouse & Co.) For Barr, the summers are a refreshing change of scene, since he is very fond of nature, but hardly a vacation. He writes most of the day, knocking off in the late afternoon to swim, chop down some of the cedars that persistently invade his land, or take a bird walk. Birds are second only to art among his interests, with chess a poor third. It is ironical that looking at art and looking at birds should be Barr's favorite occupations, for his eyes, while keen, tire easily. By night, they are often too worn-out for him to be able to read, and when he has insomnia, which is much of the time, he listens by the hour to records or to the small-hour disc-jockey programs. One reason Barr has trouble sleeping is that he is a great worrier. He takes things hard, and ponders and puzzles and broods. Then he usually purges himself with an exercise in his most congenial mode of self-expression— writing. (He has never painted.) Like his mother, he is a political liberal, and these days he worries a good deal about freedom of expression in the arts. He recently gave considerable time to the successful fight to rescind the ban on Rossellini's movie "The Miracle." As an articulate worrier, he is the Museum's chief writer of letters to the editor. A typical example is one the *Saturday Review of Literature* published in August, 1950:

> I suppose it is natural for the editor of a literary magazine to feel that he may cut an article before he publishes it, but cutting—or

"cropping"—a painting is a different matter. Without warning your readers you have actually cropped large strips off both sides of this picture [Picasso's "Three Musicians," which the Museum had recently acquired], thus seriously damaging what is generally considered one of the half dozen greatest compositions in modern painting. . . . In France literary people, including many of the greatest, are seriously interested in contemporary painting and sculpture. . . . Here in America the literary world seems comparatively blind so far as the visual arts are concerned.

The personality of the man who shaped the Museum is as low-keyed and ascetic as that of his creation is vivid and worldly. Barr has a sound knowledge not only of art and ornithology but of politics, history, military strategy, popular songs, and other subjects, weighty and trivial—a range of interests his fellow-workers find awe-inspiring. Such a range is not usual in the world of art, whose denizens, like those of the allied worlds of music and the theatre, tend to be culturally one-sided. Barr is also respected for his rock-bound integrity; he is probably the only person on record who, when asked if he had a minute, has replied "No." The recipient of this blunt intelligence did not take it amiss, for the chill wind of honesty in Barr is tempered by courtesy and a shy concern for the people who work with him. "Alfred will think about any problem you bring him, no matter whether he's directly concerned or not," says D'Amico, the director of the People's Art Center. "He never makes you feel as if you had asked a foolish question."

One disconcerting habit Barr has is that of thinking before he speaks. "If you say, 'It's a nice day,' Alfred has to stop and decide if it really is a nice day before he answers," William Lieberman, who has worked with Barr in various capacities for many years and is now head of the Museum's print department, said not long ago. "On more complicated issues, he may turn and look out of the window for what seems an eternity. It's not that he's bored or rude. He's just thinking. When he finally does say something, it comes out in organized sentences, with beginnings, middles, and ends, and he doesn't take it back later." It is all the more difficult to know what is going on inside Barr's head because his expression has the impassivity commonly associated with Orientals. When he visits a gallery, he inspects the pictures carefully and methodically, without revealing his

reactions by so much as the twitch of an eyelid; this is some-
times unnerving to dealers, always to artists. He indicates en-
thusiasm by silence, which might be helpful if he did not also
fall silent when he is irritated. No one has ever heard him raise
his voice in anger, though there are some who think they have
detected, in moments of great stress, a slight grinding of the
teeth.

1953

HAROLD ROSENBERG

Nearly all the snappiest literary coinage in postwar New York—"action painting," "the tradition of the new," "the herd of independent minds," "the anxious object"—originated with Harold Rosenberg (1906–1978). Involved with *Partisan Review* early on, Rosenberg was the art critic for *The New Yorker* in the 1960s and 1970s and a member of the Committee on Social Thought at the University of Chicago; his friend Saul Bellow immortalized him as the art critic in a short story, "What Kind of Day Did You Have?," where the eminent intellectual, much in demand on the lecture circuit, finds himself stranded at an airport and calls his mistress to his side. Rosenberg's gift was for the quick, spectacular insight, whether describing American artists as guerilla fighters ("Coonskins") in "Parable of American Painting" or emphasizing process over product in "The American Action Painters." In the mythology of the New York School, there has been a tendency to see a great divide between the supporters of Rosenberg and the supporters of Greenberg, with Rosenberg celebrating the unpredictability of immediate experience while Greenberg insists on the essential role of timeless formal values. There is certainly much truth to this characterization; Greenberg wrote an essay in which he directly criticized "The American Action Painters" (though he got the name of the essay wrong). But they were also both very much part of the same story—both acknowledged a deep debt to the art and ideas of Hans Hofmann; both sought to describe the new kinds of experiences they discovered in the work of Pollock, de Kooning, and Newman; and both had reservations about the increasingly fast-paced art world of the 1960s, although Rosenberg was certainly more sympathetic than Greenberg to a resurgent Dadaist spirit. Greenberg, with his theoretical consistency, is doubtless the more enduring of the two critics. But it may well be Rosenberg's blunt, brilliant, fundamentally improvisational approach that most truly reflects the artistic spirit of the 1950s and 1960s.

The American Action Painters

"J'ai fait des gestes blancs parmi les solitudes."

Apollinaire

"The American will is easily satisfied in its efforts to realize itself in knowing itself."

Wallace Stevens

WHAT makes any definition of a movement in art dubious is that it never fits the deepest artists in the movement—certainly not as well as, if successful, it does the others. Yet without the definition something essential in those best is bound to be missed. The attempt to define is like a game in which you cannot possibly reach the goal from the starting point but can only close in on it by picking up each time from where the last play landed.

MODERN ART? OR AN ART OF THE MODERN?

Since the War every twentieth-century style in painting has been brought to profusion in the United States: thousands of "abstract" painters—crowded teaching courses in Modern Art—a scattering of new heroes—ambitions stimulated by new galleries, mass exhibitions, reproductions in popular magazines, festivals, appropriations.

Is this the usual catching up of America with European art forms? Or is something new being created? For the question of novelty, a definition would seem indispensable.

Some people deny that there is anything original in the recent American painting. Whatever is being done here now, they claim, was done thirty years ago in Paris. You can trace this painter's boxes of symbols to Kandinsky, that one's moony shapes to Miró or even back to Cézanne.

Quantitatively, it is true that most of the symphonies in blue and red rectangles, the wandering pelvises and bird-bills, the line constructions and plane suspensions, the virginal dissections of flat areas that crowd the art shows are accretions to the "School of Paris" brought into being by the fact that the mode of production of modern masterpieces has now been all too clearly rationalized. There are styles in the present displays

Willem de Kooning: Dust jacket for Harold
Rosenberg's *The Tradition of the New*, 1959.

which the painter could have acquired by putting a square inch
of a Soutine or a Bonnard under a microscope. . . . All this is
training based on a new conception of what art is, rather than
original work demonstrating what art is about to become.

At the center of this wide practicing of the immediate past,
however, the work of some painters has separated itself from
the rest by a consciousness of a function for painting different
from that of the earlier "abstractionists," both the Europeans
themselves and the Americans who joined them in the years of
the Great Vanguard.

This new painting does not constitute a School. To form a
School in modern times not only is a new painting conscious-
ness needed but a consciousness of that consciousness—and

even an insistence on certain formulas. A School is the result of the linkage of practice with terminology—different paintings are affected by the same words. In the American vanguard the words, as we shall see, belong not to the art but to the individual artists. What they think in common is represented only by what they do separately.

GETTING INSIDE THE CANVAS

At a certain moment the canvas began to appear to one American painter after another as an arena in which to act—rather than as a space in which to reproduce, re-design, analyze or "express" an object, actual or imagined. What was to go on the canvas was not a picture but an event.

The painter no longer approached his easel with an image in his mind; he went up to it with material in his hand to do something to that other piece of material in front of him. The image would be the result of this encounter.

It is pointless to argue that Rembrandt or Michelangelo worked in the same way. You don't get Lucrece with a dagger out of staining a piece of cloth or spontaneously putting forms into motion upon it. She had to exist some place else before she got on the canvas, and paint was Rembrandt's means for bringing her there, though, of course, a means that would change her by the time she arrived. Now, everything must have been in the tubes, in the painter's muscles and in the cream-colored sea into which he dives. If Lucrece should come out she will be among us for the first time—a surprise. To the painter, she *must* be a surprise. In this mood there is no point to an act if you already know what it contains.

"B—is not modern," one of the leaders of this mode said to me. "He works from sketches. That makes him Renaissance."

Here the principle, and the difference from the old painting, is made into a formula. A sketch is the preliminary form of an image the *mind* is trying to grasp. To work from sketches arouses the suspicion that the artist still regards the canvas as a place where the mind records its contents—rather than itself the "mind" through which the painter thinks by changing a surface with paint.

If a painting is an action the sketch is one action, the painting that follows it another. The second cannot be "better" or more

complete than the first. There is just as much in what one lacks as in what the other has.

Of course, the painter who spoke had no right to assume that his friend had the old mental conception of a sketch. There is no reason why an act cannot be prolonged from a piece of paper to a canvas. Or repeated on another scale and with more control. A sketch can have the function of a skirmish.

Call this painting "abstract" or "Expressionist" or "Abstract-Expressionist," what counts is its special motive for extinguishing the object, which is not the same as in other abstract or Expressionist phases of modern art.

The new American painting is not "pure" art, since the extrusion of the object was not for the sake of the aesthetic. The apples weren't brushed off the table in order to make room for perfect relations of space and colour. They had to go so that nothing would get in the way of the act of painting. In this gesturing with materials, the aesthetic, too, has been subordinated. Form, colour, composition, drawing, are auxiliaries, any one of which—or practically all, as has been attempted logically, with unpainted canvases—can be dispensed with. What matters always is the revelation contained in the act. It is to be taken for granted that in the final effect, the image, whatever be or be not in it, will be a *tension*.*

DRAMAS OF AS IF

A painting that is an act is inseparable from the biography of the artist. The painting itself is a "moment" in the adulterated mixture of his life—whether "moment" means the actual minutes

*"With regard to the tensions it is capable of setting up in our bodies the medium of any art is an extension of the physical world; a stroke of pigment, for example, 'works' within us in the same way as a bridge across the Hudson. For the unseen universe that inhibits us an accidental blot or splash of paint may thus assume an equivalence to the profoundest happening.

"If the ultimate subject matter of all art is the artist's psychic state or tension (and this may be the case even in nonindividualistic epochs), that state may be represented either through the image of a thing or through an abstract sign. The innovation of Action Painting was to dispense with the representation of the state in favour of enacting it in physical movement. The action on the canvas became its own representation. This was possible because an action, being made of both the psychic and the material, is by its nature a sign—it is the trace of a movement whose beginning and character it does not in itself

taken up with spotting the canvas or the entire duration of a lucid drama conducted in sign language. The act-painting is of the same metaphysical substance as the artist's existence. The new painting has broken down every distinction between art and life.

It follows that anything is relevant to it. Anything that has to do with action—psychology, philosophy, history, mythology, hero worship.* Anything but art criticism. The painter gets away from art through his act of painting; the critic can't get away from it. The critic who goes on judging in terms of schools, styles, form—as if the painter were still concerned with producing a certain kind of object (the work of art), instead of living on the canvas—is bound to seem a stranger.

Some painters take advantage of this stranger. Having insisted

ever altogether reveal (e.g., Freud's point about love-making being mistaken in the imagination for an assault); yet the action also exists as a 'thing' in that it touches other things and affects them.

"In turning to action, abstract art abandons its alliance with architecture, as painting had earlier broken with music and with the novel, and offers its hand to pantomime and dance. One thinks of Rilke's

> Dance the orange. The warmer landscape,
> fling it out of you, that the ripe one be radiant
> in homeland breezes!

"In painting, the primary agency of physical motion (as distinct from illusionary representation of motions, as with the Futurists) is the line, conceived not as the thinnest of planes, nor as edge, contour or connective but as stroke or figure (in the sense of 'figure skating'). In its passage on the canvas each such line can establish the actual movement of the artist's body as an aesthetic statement. Line, from wiry calligraphy to footwide flaunts of the house painter's brush, has played the leading part in the technique of Action Painting, though there are other ways besides line of releasing force on canvas."
From "Hans Hofmann: Nature into Action," by HR., *Art News*, May 1957.

*Action cannot be perfected without losing its human subject and being transformed thereby into the mechanics of man-the-machine.

"Action never perfects itself; but it tends toward perfection and away from the personal. This is the best argument for dropping the term 'Abstract Expressionism,' with its associations of ego and personal *Schmerz*, as a name for the current American painting. Action Painting has to do with self-creation or self-definition or self-transcendence; but this dissociates it from self-expression, which assumes the acceptance of the ego as it is, with its wound and its magic. Action Painting is not 'personal,' though its subject matter is the artist's individual possibilities."
 H.R., "A dialogue with Thomas B. Hess." *Catalogue of the Exhibition: Action Painting, 1958.* The Dallas Museum For Contemporary Arts.

that their painting is an act, they then claim admiration for the act as art. This turns the act back toward the esthetic in a petty circle. If the picture is an act, it cannot be justified *as an act of genius* in a field whose whole measuring apparatus has been sent to the devil. Its value must be found apart from art. Otherwise the "act" gets to be "making a painting" at sufficient speed to meet an exhibition date.

Art—relation of the painting to the works of the past, rightness of color, texture, balance, etc.—comes back into painting by way of psychology. As Stevens says of poetry, "it is a process of the personality of the poet." But the psychology is the psychology of creation. Not that of the so-called psychological criticism that wants to "read" a painting for clues to the artist's sexual preferences or debilities. The work, the act, translates the psychologically given into the intentional, into a "world"—and thus transcends it.

With traditional esthetic references discarded as irrelevant, what gives the canvas its meaning is not psychological data but *rôle*, the way the artist organizes his emotional and intellectual energy as if he were in a living situation. The interest lies in the kind of act taking place in the four-sided arena, a dramatic interest.

Criticism must begin by recognizing in the painting the assumptions inherent in its mode of creation. Since the painter has become an actor, the spectator has to think in a vocabulary of action: its inception, duration, direction—psychic state, concentration and relaxation of the will, passivity, alert waiting. He must become a connoisseur of the gradations between the automatic, the spontaneous, the evoked.

"IT'S NOT THAT, IT'S NOT THAT, IT'S NOT THAT"

With a few important exceptions, most of the artists of this vanguard found their way to their present work by being cut in two. Their type is not a young painter but a re-born one. The man may be over forty, the painter around seven. The diagonal of a grand crisis separates him from his personal and artistic past.

Many of the painters were "Marxists" (WPA unions, artists' congresses); they had been trying to paint Society. Others had

been trying to paint Art (Cubism, Post-Impressionism)—it amounts to the same thing.

The big moment came when it was decided to paint . . . just TO PAINT. The gesture on the canvas was a gesture of liberation, from Value—political, esthetic, moral.

If the war and the decline of radicalism in America had anything to do with this sudden impatience, there is no evidence of it. About the effects of large issues upon their emotions, Americans tend to be either reticent or unconscious. The French artist thinks of himself as a battleground of history; here one hears only of private Dark Nights. Yet it is strange how many segregated individuals came to a dead stop within the past ten years and abandoned, even physically destroyed, the work they had been doing. A far-off watcher unable to realize that these events were taking place in silence might have assumed they were being directed by a single voice.

At its center the movement was away from, rather than toward. The Great Works of the Past and the Good Life of the Future became equally nil.

The refusal of values did not take the form of condemnation or defiance of society, as it did after World War I. It was diffident. The lone artist did not want the world to be different, he wanted his canvas to be a world. Liberation from the object meant liberation from the "nature," society and art already there. It was a movement to leave behind the self that wished to choose his future and to nullify its promissory notes to the past.

With the American, heir of the pioneer and the immigrant, the foundering of Art and Society was not experienced as a loss. On the contrary, the end of Art marked the beginning of an optimism regarding himself as an artist.

The American vanguard painter took to the white expanse of the canvas as Melville's Ishmael took to the sea.

On the one hand, a desperate recognition of moral and intellectual exhaustion; on the other, the exhilaration of an adventure over depths in which he might find reflected the true image of his identity.

Painting could now be reduced to that equipment which the artist needed for an activity that would be an alternative to both utility and idleness. Guided by visual and somatic memories of paintings he had seen or made—memories which he did his best

to keep from intruding into his consciousness—he gesticulated upon the canvas and watched for what each novelty would declare him and his art to be.

Based on the phenomenon of conversion the new movement is, with the majority of the painters, essentially a religious movement. In almost every case, however, the conversion has been experienced in secular terms. The result has been the creation of private myths.

The tension of the private myth is the content of every painting of this vanguard. The act on the canvas springs from an attempt to resurrect the saving moment in his "story" when the painter first felt himself released from Value—myth of past self-recognition. Or it attempts to initiate a new moment in which the painter will realize his total personality—myth of future self-recognition.

Some formulate their myth verbally and connect individual works with its episodes. With others, usually deeper, the painting itself is the exclusive formulation, a Sign.

The revolution against the given, in the self and in the world, which since Hegel has provided European vanguard art with theories of a New Reality, has re-entered America in the form of personal revolts. Art as action rests on the enormous assumption that the artist accepts as real only that which he is in the process of creating. "Except the soul has divested itself of the love of created things . . ." The artist works in a condition of open possibility, risking, to follow Kierkegaard, the anguish of the esthetic, which accompanies possibility lacking in reality. To maintain the force to refrain from settling anything, he must exercise in himself a constant No.

APOCALYPSE AND WALLPAPER

The most comfortable intercourse with the void is mysticism, especially a mysticism that avoids ritualizing itself.

Philosophy is not popular among American painters. For most, thinking consists of the various arguments that TO PAINT is something different from, say, to write or to criticize: a mystique of the particular activity. Lacking verbal flexibility, the painters speak of what they are doing in a jargon still involved in the metaphysics of *things*: "My painting is not Art; it's an Is."

"It's not a picture of a thing; it's the thing itself." "It doesn't reproduce Nature; it is Nature." "The painter doesn't think; he knows." Etc. etc. "Art is not, not not not not. . . ." As against this, a few reply, art today is the same as it always has been.

Language has not accustomed itself to a situation in which the act itself is the "object." Along with the philosophy of TO PAINT appear bits of Vedanta and popular pantheism.

In terms of American tradition, the new painters stand somewhere between Christian Science and Whitman's "gangs of cosmos." That is, between a discipline of vagueness by which one protects oneself from disturbance while keeping one's eyes open for benefits; and the discipline of the Open Road of risk that leads to the farther side of the object and the outer spaces of the consciousness.

What made Whitman's mysticism serious was that he directed his "cosmic 'I'" towards a Pike's-Peak-or-Bust of morality and politics. He wanted the ineffable in *all* behavior—he wanted it *to win the streets.*

The test of any of the new paintings is its seriousness—and the test of its seriousness is the degree to which the act on the canvas is an extension of the artist's total effort to make over his experience.

A good painting in this mode leaves no doubt concerning its reality as an action and its relation to a transforming process in the artist. The canvas has "talked back" to the artist not to quiet him with Sibylline murmurs nor to stun him with Dionysian outcries but to provoke him into a dramatic dialogue. Each stroke had to be a decision and was answered by a new question. By its very nature, action painting is painting in the medium of difficulties.*

Weak mysticism, the "Christian Science" side of the new move-

* "As other art movements of our time have extracted from painting the element of structure or the element of tone and elevated it into their essence, Action Painting has extracted the element of decision inherent in all art in that the work is not finished at its beginning but has to be carried forward by an accumulation of 'right' gestures. In a word, Action Painting is the abstraction of the *moral* element in art; its mark is moral tension in detachment from moral or esthetic certainties; and it judges itself morally in declaring that picture to be worthless which is not the incorporation of a genuine struggle, one which could at any point have been lost."

H.R., The Dallas Museum *Catalogue*, above.

ment, tends in the opposite direction, toward *easy* painting—never so many unearned masterpieces! Works of this sort lack the dialectical tension of a genuine act, associated with risk and will. When a tube of paint is squeezed by the Absolute, the result can only be a Success. The painter need keep himself on hand solely to collect the benefits of an endless series of strokes of luck. His gesture completes itself without arousing either an opposing movement within itself nor the desire in the artist to make the act more fully his own. Satisfied with wonders that remain safely inside the canvas, the artist accepts the permanence of the commonplace and decorates it with his own daily annihilation. The result is an apocalyptic wallpaper.

The cosmic "I" that turns up to paint pictures, but shudders and departs the moment there is a knock on the studio door, brings to the artist a megalomania which is the opposite of revolutionary. The tremors produced by a few expanses of tone or by the juxtaposition of colors and shapes purposely brought to the verge of bad taste in the manner of Park Avenue shop windows are sufficient cataclysms in many of these happy overthrows of Art. The mystical dissociation of painting as an ineffable event has made it common to mistake for an act the mere sensation of having acted—or of having been acted upon. Since there is nothing to be "communicated," a unique signature comes to seem the equivalent of a new plastic language. In a single stroke the painter exists as a Somebody—at least on a wall. That this Somebody is not he seems beside the point.

Once the difficulties that belong to a real act have been evaded by mysticism, the artist's experience of transformation is at an end. In that case what is left? Or to put it differently: What is a painting that is not an object, nor the representation of an object, nor the analysis or impression of it, nor whatever else a painting has ever been—and which has also ceased to be the emblem of a personal struggle? It is the painter himself changed into a ghost inhabiting The Art World. Here the common phrase, "I have bought an O—" (rather than a painting by O—) becomes literally true. The man who started to remake himself has made himself into a commodity with a trademark.

MILIEU: THE BUSY NO-AUDIENCE

We said that the new painting calls for a new kind of criticism, one that would distinguish the specific qualities of each artist's act.

Unhappily for an art whose value depends on the authenticity of its mysteries, the new movement appeared at the same moment that Modern Art *en masse* "arrived" in America: Modern architecture, not only for sophisticated homes, but for corporations, municipalities, synagogues; Modern furniture and crockery in mail-order catalogues; Modern vacuum cleaners, can openers; beer-ad "mobiles"—along with reproductions and articles on advanced painting in big-circulation magazines. *Enigmas for everybody.* Art in America today is not only nouveau, it's news.

The new painting came into being fastened to Modern Art and without intellectual allies—in literature everything had found its niche.

From this liaison it has derived certain superstitions comparable to those of a wife with a famous husband. Superiorities, supremacies even, are taken for granted. It is boasted that modern painting in America is not only original but an "advance" in world art (at the same time that one says "to hell with world art").

Everyone knows that the label Modern Art no longer has any relation to the words that compose it. To be Modern Art a work need not be either modern nor art; it need not even be a work. A three thousand-year-old mask from the South Pacific qualifies as Modern and a piece of wood found on a beach becomes Art.

When they find this out, some people grow extremely enthusiastic, even, oddly enough, proud of themselves; others become infuriated.

These reactions suggest what Modern Art actually is. It is not even a Style. It has nothing to do either with the period when a thing was made nor with the intention of the maker. It is something that someone has had the social power to designate as psychologically, esthetically or ideologically relevant to our epoch. The question of the driftwood is: *Who* found it?

Modern Art in America represents a revolution of taste—and serves to identify the caste conducting that revolution.

Responses to Modern Art are primarily responses to claims to social leadership. For this reason Modern Art is periodically attacked as snobbish, Red, immoral, etc., by established interests in society, politics, the church. Comedy of a revolution that restricts itself to weapons of taste—and which at the same time addresses itself to the masses: Modern-design fabrics in bargain basements, Modern interiors for office girls living alone, Modern milk bottles.

Modern art is educational, not with regard to art but with regard to life. You cannot explain Mondrian's painting to people who don't know anything about Vermeer, but you can easily explain the social importance of admiring Mondrian and forgetting about Vermeer.

Through Modern Art the expanding caste of professional enlighteners of the masses—designers, architects, decorators, fashion people, exhibition directors—informs the populace that a supreme Value has emerged in our time, the Value of the NEW, and that there are persons and things that embody that Value. This Value is a completely fluid one. As we have seen, Modern Art does not have to be actually new; it only has to be new to *somebody*—to the last lady who found out about the driftwood—and to win neophytes is the chief interest of the caste.

Since the only thing that counts for Modern Art is that a work shall be NEW, and since the question of its newness is determined not by analysis but by social power and pedagogy, the vanguard painter functions in a milieu utterly indifferent to the content of his work.

Unlike the art of nineteenth-century America, advanced paintings today are not bought by the middle class.* Nor are they by the populace. Considering the degree to which it is publicized and feted, vanguard painting is hardly bought at all. It is *used* in its totality as material for educational and profit-making enterprises: color reproductions, design adaptations, human-interest stories. Despite the fact that more people see and hear about works of art than ever before, the vanguard artist has an audience of nobody. An interested individual here

*The situation has improved since this essay appeared in 1952. Several younger collectors have appeared who are specializing in the new American painting—and to some degree the work of Americans has entered the world art market.

and there, but no audience. He creates in an environment not of people but of functions. His paintings are employed not wanted. The public for whose edification he is periodically trotted out accepts the choices made for it as phenomena of The Age of Queer Things.

An action is not a matter of taste.

You don't let taste decide the firing of a pistol or the building of a maze.

As the Marquis de Sade understood, even experiments in sensation, if deliberately repeated, presuppose a morality.

To see in the explosion of shrapnel over No Man's Land only the opening of a flower of flame, Marinetti had to erase the moral premises of the act of destruction—as Molotov did explicitly when he said that Fascism is a matter of taste. Both M's were, of course, speaking the driftwood language of the Modern Art International.

Limited to the esthetic, the taste bureaucracies of Modern Art cannot grasp the human experience involved in the new action paintings. One work is equivalent to another on the basis of resemblances of surface, and the movement as a whole a modish addition to twentieth-century picture making. Examples in every style are packed side by side in annuals and travelling shows and in the heads of newspaper reviewers like canned meats in a chain store—all standard brands.

To counteract the obtuseness, venality and aimlessness of the Art World, American vanguard art needs a genuine audience—not just a market. It needs understanding—not just publicity.

In our form of society, audience and understanding for advanced painting have been produced, both here and abroad, first of all by the tiny circle of poets, musicians, theoreticians, men of letters, who have sensed in their own work the presence of the new creative principle.

So far, the silence of American literature on the new painting all but amounts to a scandal.

1952

Parable of American Painting

"The American is a new man who acts on new principles: he must therefore entertain new ideas and form new opinions."

J. Hector St. John de Crèvecoeur

"Cursed be that mortal inter-debtedness . . . I would be as free as air: and I'm down in the whole world's books."

Herman Melville

PEOPLE carry their landscapes with them, the way travelers used to cart along their porcelain chamber pots. The stronger their sense of form the more reluctant they are to part with either.

Since the eye sees through a gridiron of style and memory, it is not so easy for a man to be "new" as Crèvecoeur implies.

BRADDOCK'S DEFEAT

For me the most dramatic example of the newcomer's illusion of being elsewhere is Braddock's Defeat. I recall in my grammar-school history book a linecut illustration which shows the Redcoats marching abreast through the woods, while from behind trees and rocks naked Indians and coonskinned trappers pick them off with musket balls. Maybe it wasn't Braddock's defeat but some ambush of the Revolutionary War. In any case, the Redcoats march in file through the New World wilderness, with its disorder of rocks, underbrush and sharpshooters, as if they were on a parade ground or on the meadows of a classical European battlefield and one by one they fall and die.

I was never satisfied with the explanation that the Redcoats were simply stupid or stubborn, wooden copies of King George III. In my opinion what defeated them was their skill. They were such extreme European professionals, even the Colonials among them, they did not *see* the American trees. Their too highly perfected technique forbade them to acknowledge such chance topographical phenomena. According to the assumptions of their military art, by which their senses were controlled, a battlefield had to have a certain appearance and structure,

Saul Steinberg: *Portrait of Harold Rosenberg*, 1972.
Watercolor, crayon, and graphite, 14⅙ × 10¼ in.

that is to say, a style. Failing to qualify, these American trees
and rocks from which come such deadly but meaningless stings
are overlooked. The Redcoats fall, expecting at any moment
to enter upon the true battlefield, the soft rolling greenswards
prescribed by the canons of their craft and presupposed by every
principle that makes welfare intelligible to the soldier of the
eighteenth century.

The difficulty of the Redcoats was that they were in the
wrong place. The dream-world of a style always moves ahead of
the actual world and overlays it; unless one is of the unblinking
wilderness like those Coonskinners behind the trees.

In honor of the dream-defeated Braddock, I call the hal-
lucination of the displaced terrain, originating in style, Red-
coatism. In American it is an experience of the first importance.

If Crèvecoeur were right and the American were a "new man acting on new principles," Redcoatism as a mental condition should have ceased to exist with the departure of Cornwallis. The fact is, however, that the art-entranced Redcoat, in a succession of different national uniforms, dominates the history of American art. Like Braddock, painting in this country has behaved as if it were elsewhere—to the point where artists have often emigrated physically in order to join their minds in some foreign country. What has counted with the art corps has been the Look, from the British Look of Colonial portraiture, through the Düsseldorf Look, the Neo-Classic Look, down to the Last-Word Look of abstract art today. The uniforms change, Redcoatism endures.

Of course the sharpshooting individuals—we shall speak of them later—have the last word. But granted that what counts in the art of any nation, since the Renaissance, at any rate, is primarily the works of its individual masters, American art has differed in this respect: that the triumphs of individuals have been achieved against the prevailing style or apart from it, rather than within it or through it.

The issue is not that American painting is influenced by Europe; the painting of all European countries has also been influenced. The issue is Redcoatism, the difficulty for the artist of finding here a spot on which to begin. But a starting point in experience is indispensable if the artist is to prevail against the image of Great Painting that slides between him and the canvas he is working on.

The first American playwrights could think of nothing less to compose than Shakespearean tragedies in blank verse. Had it not been for a will to bad art in order to satisfy the appetites of the street, the American theatre would never have come into being.

What marks the paintings of America's past as provincial is not their inferior general level—the low quality of Dutch poetry or British music in a given period does not make it provincial— but the absence in them of any continuing visual experience that demands recognition. Copley's later canvases did enter as a force into the continuity of *British* historical painting. But until very recently no American painter, or assumption put into practice about painting, has had the power of emanating into world art as Whitman or Poe did into literature, so that it became

possible to say that Nietzsche or Tolstoy was a Whitmanite, that Gide and Lorca Whitmanize and that through Baudelaire the cue to modern poetry was given by Poe.

To be legitimate, a style in art must connect itself with a style outside of art, whether in palaces or dance halls or in the dreams of saints and courtesans. Physically, America has been moving away from style (more exactly, from styles). Eighteenth-century Boston, Philadelphia, Richmond, are "works of art" in the British mode, L'Enfant's Washington in the mode of the incredible. The frontier, however, is not a "landscape"—Gainsborough could not have painted it. Nor are the later cities. They are raw *scene*.

No wonder that the edges of the canvas meant nothing to the Hudson River panoramists. Geography (history, too) becomes in America an endless roll of uncomposed appearances, as in the cycloramas depicting famous Indian battles and the Civil War. Or if an attempt at composition is made, it is by arbitrary means, with the result that the form becomes mechanical, as in the Currier & Ives street scenes whose parts are articulated like a fire engine of those days.

America's steady backing away from style explains why British portrait painting in Colonial Philadelphia is better painting than German Expressionism in twentieth-century Texas, which does not justify any style.

The discovery of *modern* art by Americans in the first decades of this century did not rid them of their old habit of misplacing themselves; in the mirror of post-Impressionism they mistook their cultural environment instead of their physical one. By the 'twenties, under the banner of Experiment, everyone had learned how to manipulate a Look, sometimes three or four, developed out of the crisis of French, German or Italian painting. The profusion of codes to obey gave rise to an illusion of self-liberation: instead of the Redcoat, single Uhlans, Hussars, Swiss Guards marching in step to distant rhythms. Yet American art was no closer than before to a reality of its own.

COONSKINISM—OR THE MADE-UP

What could Braddock do among those sudden trees? One thing only: call for straighter ranks, a more measured step, louder banging on the drums. In Europe an art could be slowly modified and still keep its form; here, it either had to stand fast on its principles or risk becoming no art at all.

"I, for my poems—What have I?" exclaimed Walt Whitman, taking that risk. "I have all to *make*."

Crèvecoeur's mistake lay in assuming that every American was aware that he had to begin anew. His determination took it for granted that if a man is in a given situation his consciousness will be there with him. Crèvecoeur should have reflected more deeply on the fact that the Dutch superimposed a small Amsterdam on the tip of Manhattan and that the Pilgrims built not a New World but a New England. In art there have been few examples of the "American" in Crèvecoeur's sense of a psyche designed by history for the constant production of novelties. What's more, the "new men" have tended not to stay new but to settle into a self-repeating pattern.

To be a new man is not a condition but an effort—an effort that follows a revelation in behalf of which existing forms are discarded as irrelevant or are radically revised. The genuine accomplishments of American art spring from the tension of such singular experiences. In honor of Braddock's foes I call this anti-formal or trans-formal effort Coonskinism. The fellows behind the trees are "men without art," to use Wyndham Lewis' label for Faulkner and Hemingway. This does not mean that they do not know how to fight. They have studied manoeuvers among squirrels and grizzly bears and they trust their knowledge against the tradition of Caesar and Frederick. Their principle is simple: watch the object—if it's red, shoot!

Obviously, this proposition can be valid only in a particular situation. The Coonskinners win, but their method can hardly be considered a contribution to military culture. It has a closer tie with primitive art, which also learns from its subject and which, like Whitman, *has* nothing but has all *to make*.

Creation by a mind devoid of background, or deliberately cleansed of it, results in primitive art. The best painting in America is related to the primitives in its methods of overcoming

ignorance through the particular problem to be solved. Copley
contrives his New England style through carefully studying
his models during unusually numerous sittings. His American
portraits owe more to the British style of his sitters than to the
contemporaneous British manner in painting. When he goes
to England, he can no longer paint in the same way and his
portraiture declines. Perhaps Copley missed in the Britons in
Britain the conflict of style with non-style which had stimulated
him in their American imitators. Waterhouse, in his *Painting
in Britain*, points out that Copley's best British portraits are of
children, who are made to look "unEnglish."

Coonskinism is the search for the principle that applies, even
if it applies only once. For it, each situation has its own exclu-
sive key. Hence general knowledge of his art does not abate
the Coonskinner's ignorance nor relieve him of the need to
improvise. Melville's masterpiece begins by being a novel and
becomes in turn some fragments of a play, a scientific and his-
torical treatise, an eye-witness report. Out of the Bible, Homer,
the newspapers, opera, Whitman puts together poetry from
which the appearance of poetry has managed to depart. Art
is similarly subsumed in the intense prose of Eakins' paintings
which find their problems in the manner in which a pair of well-
worn feet hold on to the floor or in the shine of the skin on
the back of an old man's hand. If Eakins' realism tends towards
the nonLook, Ryder's romance of being privately in a cosmos
tends in the same direction. It is not, as the academicians say of
artists like Copley or Eakins, that in them Truth conquers over
Beauty, it is that both Truth and Beauty are for them the result
of a specific encounter.

As made-up art, folk painting in America is the mass-product
of Coonskinism, as academic painting is the continuing output
of Redcoatism. American artists have moved in both directions
between these two extremes, self-taught limners turning into
august Redcoats, learned academicians—from Allston to Edwin
Dickinson—shedding their red coats, hopping behind trees and
aiming with the stubborn concentration of Coonskinners.

Under these circumstances American folk painting cannot be
separated from its fine art, as it makes sense to do in other coun-
tries. Folk art has no development; its successes are a sum of
individual pot shots; in sum, it lacks history. But in the United

States, fine art also lacks history and its best examples consist of individual inventions which do not carry over into the future. Nor does any of its imported styles reach a culmination; it ends by being replaced. An historical exhibition of American painting is not complete unless it presents the Coonskin antithesis to the prevailing Redcoatism. Audubon, for instance, is very close to folk art, being largely a self-taught peerer through trees who derived his style from absorption in his subject matter; yet he is, without a doubt, a much superior painter to, say, Bierstadt—in fact, Audubon is the first important painter who belongs thoroughly to the United States. Nor can many American painters and sculptors be found who equal as artists the draftsmen of Currier and Ives. (I have seen enlarged details of their New York scenes that are a match for Seurat.)

Coonskin doggedness is a major characteristic of America's most meaningful painters. Not one—Copley, Audubon, Eakins, Ryder, Homer, Marin, Stuart Davis, de Kooning—in whom this quality is not predominant. To make one's own art, one must be able to overcome an enormous amount of doubt and waste of time.

Coonskinism as a principle won ascendancy in American painting for the first time during World War II. With no new styles coming from Europe—and for deeper reasons than transportation difficulties—American artists became willing to take a chance on unStyle or antiStyle. Statements in interviews and catalogues emphasized the creative bearing of such elements of creation as the mistake, the accident, the spontaneous, the incomplete, the absent. The esthetic watchword of the new American painting might almost have been adapted from Melville's: "So far as I am individually concerned and independent of my pocket, it is my earnest desire to write those sorts of books which are said to fail."

At the same time Redcoatism, no longer overfed, reached new degrees of refinement. The American practitioners of Cubism, Neo-Romanticism, Neo-Plasticism, highly conscious of their debt, were able to accumulate a balance of their own.

Today, Coonskinism itself in the form of "free" abstract expression is in danger of becoming a style—as I reminded Crèvecoeur, the new man does not automatically stay that way. With most of the pioneers of 1946, the transformation of the Coonskinner into a Redcoat has already taken place.

What is historically unique is that American Coonskinism has become the prevalent Style of Europe's newest paintings. The Europeans of the '50's have captured the look of the made-up in American art, though their pictures fail to achieve the reality and the feeling of being made-up. The uneasy insistence and individual self-consciousness that go with discovery and give the new American painting its vitality and point are lacking in the Europeans.

Coonskinism has become the Redcoatism of Europe. Once again, the hallucination of the displaced terrain. But this time everything in reverse—Art copying non-Art, rocks and trees carefully laid out as an obstacle-run on the parade ground. It is the setting of a comedy.

1953

Evidences

ONE will be struck directly by the resemblance of these photos to reproductions of advanced contemporary paintings. Aaron Siskind's collection is like the catalogue of a show of "best Americans" that may take place next month in a leading New York art gallery. Here are the dual picture planes, the calligraphy, the post-Cubist balances, the free strokes and aerial perspectives, the accidental landscapes, galaxies hinted in stains, of half a dozen vanguard styles. Illuminated by these, the camera's eye has plucked from fences, beaches, rocks, strips of material, images of possible canvases as if someone had had the ingenuity to paint them. Perhaps someone will paint them. Certainly, they contain an intelligence of painting from which many painters can profit.

Siskind's photos are inseparable from painting. Yet they have nothing to do with that movement in photography, abetted by professional vanity, that seeks to establish the photograph as "fine art" to be hung alongside the canvas on the walls of museums and galleries. These magnificent black and whites disdain "interpretation" and the devices—blurring, angle shots, foreshortening, double exposure—by which "creative" photography attempts to simulate the effects of modern modes in painting. No fake Seurats, Renoirs, Mondrains, re-discovered

Aaron Siskind: *Chicago 30, 1949*, 1950. Gelatin silver print, 13¹³⁄₁₆ × 17⁵⁄₈

in the streets and fields with the aid of the dark room. Siskind has retained as fully as in a news shot the classical function of photography as a reporter, "a direct communications medium," as Steichen calls it. Like the best of his painter contemporaries he has simplified his means in order to concentrate on the act of choice.

Instead of scenes that seem like paintings, Siskind's pictures *are* paintings as they appear on the printed page—which is where people today see most of the paintings that they see. They are reproductions, though reproductions that have no originals. Or, if you prefer, they are reproductions of "works" which came into being through the collaboration of anonymous men and nature, when neither they nor it were engaged in their more typical creations.

These indifferent compositions, often animated by the chemistries of decay, which were on display anywhere, have here been made part of our art culture by a man who combines in himself the faculties of the artist and the connoisseur. He has gathered them as evidences of the response of the physical world to the

freshest assertions of art, as one might have shown the new influence of Rubens on the female form had it been possible to take photos in the early years of the seventeenth century.

Siskind has used the camera to make a book on modern art. It is a book that *teaches* in the same degree as a book on Picasso or on post-Impressionism. Our sensual pleasure in its shapes and textures—it is in his wonderful grasp of surfaces by the modulations of his greys that Siskind almost makes us forget that these are not paintings—will be one with our intellectual pleasure in recognizing them as extensions of our esthetic tradition. In turn, they reveal possibilities in that tradition that have often gone unperceived by painters. Siskind's photos comment on art today, not in terms of particular artists or schools, but as a general development of experience and knowledge.

As pictures to be *perused*, these photographs have the grand advantage over other book art that their qualities are all here, on the page. A reproduction of a painting is at best a substitute, and a poor one. It is art living under reduced circumstances; it cannot engage our interest without raising questions, concerning the scale, color, texture, etc. of the original, which it cannot answer. In looking at an art reproduction the mind is divided between the present image and the one that is absent. In a Siskind photo we may forget its source. Neither our delight nor our learning would be in any sense augmented if we were told that this blackness was a night sky or a piece of tar paper. Though "ready-mades" and "found" art are today accepted as authentic works, no one could be so naif as to imagine that the actual object from which Siskind drew his image could match the beauties he has brought to the print. Whatever was there before he clicked his shutter would not look like this until his impeccable choosing determined in what light, from what distance, in what quantity, it was to be seen. In each of these photos it is the separate and unique making, as well as the inspired selecting, that we experience; were the pictured boards or stretches of sand to be physically delivered to us, nothing in them could make up for the loss of Siskind's eye and mind.

As reproductions of works of art made by nobody and recorded by genius, these photos bring to photography an order of thought generally lacking in it. Unlike a painting, which we get into deeper the more we look at it, finding the artist himself

in the hue, line, rhythm of paint strokes, the photograph, within whose areas of light and darkness the hand does not intervene, can catch and hold us only through its overall effect, that is, its idea. Yet cameramen take it for granted that a "good" photo speaks for itself, a meaning being somehow guaranteed by the reality of the thing in the picture. This assumption of intrinsic significance is a fallacy that photography shares with its twins, the newspaper and naturalistic literature. The fact is that most photographs, however charged with the mood or story reference of the "frozen instant," simply stare back at you with the dumb stare of physical fact.

The inanity of duplicated "life" was less noticeable when photos were met with mainly in the family album—what and who Aunt Sadie in her graduation dress was, or why anyone should want to look at her likeness, could be settled by memory and sentiment. Today, however, with the picture weeklies, tabloids, and armies of amateurs in every land intent on packing all that exists into the one-eyed black valise, the illusionary realm of photography has taken on an independent life. Out of the capacity of the machine to produce resemblances has risen a world of aimless artifice that stands between both nature and art. In it reality is rectangular and instantaneous; translated into these dimensions the bearded Cuban revolutionist, the inside of a mushroom, a Paris merry-go-round, a pitcher's wind up, the skull of a war victim, become equivalents. The natives of Africa seem to have been justified in their fear of being kidnaped into the cubic void where, converted into tastefully composed moments, creatures lose their solidity and flicker in an infinity of "scenes." The black and white universe has become the agency of an immense stupefaction, which its refraction into false hues threatens to make still more acute.

Against the break-up of experience into bits of scattered appearance, Siskind uses the camera to establish the continuity of contemporary visual understanding as well as of his own personality—"the start," he says, "is from a previous picture." This is another way of saying that Siskind makes a *moral* use of the camera. Through this eye trained to look by modern art (which is something more than being trained to look at modern art), the seen world recovers its human unity in the unity of plastic norms freed of local associations. Each of his studies

penetrates the idea of its subject and joins it to the objective system of the art of this century. In this context, the smear, the bubble, the odd bit of lettering, seems less random than the Eiffel Tower or a president addressing a crowd.

People who believe that paintings ought to be like photographs believe that photographs can be like paintings. Siskind has not fooled himself into trying to make of his pictures the vocabulary of an artistic identity. His work is as removed from the obsessive patterning of the "abstract" photographer as from the symbolism of the film impressario of blasted trees and ghostly monuments. With the instinct of a master for the philosophic basis of his medium, he has comprehended the camera as an instrument turned outward to variety rather than as a tool for inscribing a signature. As a group and separately, his images evoke a commonly accessible world—though one which, unlike that of "boy and his dog," has as its strict entrance requirement an educated sensibility. What this is, Siskind here demonstrates in practice, page by page.

1959

Mobile, Theatrical, Active

It should be plain in this second half of the twentieth century that painting and sculpture have been striving to become something different than pictures on the wall or forms quietly standing in a corner of a room or garden. Traditionally, of course, works of art don't *do* anything, beyond presenting themselves to be observed. No doubt, most current art is still intended for contemplation—though "contemplation" seems an odd word with which to describe the scrutiny of an enormous Mickey Mouse. Each year sees new variations on Cubist construction and design, Impressionist, neo-Impressionist, Fauvist, Expressionist and primitivist "returns to Nature," adaption of folk and lunatic art, dream painting and geometrical abstraction. But the creations that have struck deepest into the public imagination as typical of the past twenty years shows an unmistakable impulse to erupt into the life around them. Paintings

swell into protuberances, are metamorphosed into free-standing cutouts, collect into themselves articles from the refuse pile or the five and ten. Sculptures crawl along the floor, join the collector's family at the dinner table, are electrified to blink on and off, emit sounds. Dalí's quip about Calder's mobiles that "the least one can ask of a piece of sculpture is not to move," seems hopelessly out of date. Today, Calder's kite-suspension principle has been augmented by numerous other species of airborne art, as in the "magic" of a twisted strip of metal foil that hangs from the ceiling on an invisible thread and seems to rise slowly out of a looking glass lake.

In addition to art wafted by air currents, liquid-, motor- and electronically driven art now abounds between 57th Street in New York and La Cienega Boulevard in Los Angeles. A large exhibition of contemporary painting and sculpture is as likely as not to combine the features of a midway, an auto-racing arena, a children's toy garden. The contour of a mountain top is outlined by a blazing neon tube; objects flop hypnotically on eccentric gears; enormous perforated sheets bearing colored patterns slice rhythmically across each other; steel whips spun at high speed form the shapes of a changing urn; a brightly painted abstraction powered by a photoelectric cell responds to the approach of the spectator by graciously leaning forward to greet him.

Along with active art appears the artist-actor. In "Happenings" painters and sculptors build props, compose scenes and perform. Among younger artists it has become the vogue to complement one's painting by taking part in stage plays and experimental movies. Larry Rivers, who years ago proved himself a talented film comedian, performs professionally on the saxophone and designs stage sets—his latest creation, a mammoth assembly of paintings and objects representing the Russian Revolution, has the character of a backdrop waiting for its opera. Rauschenberg performs with a dance group, Warhol in films and in the public relations and fashion worlds. Oldenburg's giant hamburgers and his other canvas and plaster food sculpture belong to the family of props he produced for his Happenings. Art galleries have been converted into shooting galleries, bedrooms, theatres for "light ballets," *dolce vita* swimming pools.

Today's art is not merely shown; it puts on a show and solicits audience participation. Action Paintings invite the spectator's engagement in the artist's creative act. In Happenings cooperating audiences have been amused, tortured and mystified. Exhibitions endeavor to provide a total setting or, in the jargon of the art world, an "environment." Whether by standing before Rothko's tinted air curtains or Gottlieb's cosmic emblems or in a roomful of Newman's expanding rectangles—or, by contrast, in the midst of noise-making Pop objects and reliefs—the spectator is transported into a staged situation where he is enveloped by the art work rather than confronted by it. At times he becomes part of the artist's composition and himself a work of art— a game of ambiguities commented on with incomparable brilliance in the drawings of Saul Steinberg. The white plaster casts that George Segal makes of his friends and patrons transform them literally into sculptures. In this age without ghosts, a Segal is a solidified wraith, a materialized *alter ego*. It is the routine you in your absence from your routine. Rothko de-materializes the physical world and the canvas, Segal petrifies the human presence into mere appearance. His plaster gas-station attendant belongs to the order of the Coca Cola dispenser and tires for sale that are part of his setting. The silence of sculpture has been converted into a rhetoric of everyday pathos.

Animated art and audience participation have expanded the psychic tensions produced by postwar American Action Painting into a panorama of public responses that range from the collective aesthetic thrills of fabricated environments, through Pop art slapstick and mimicry, to the mass hypnosis of optical and "kinetic" sensory manipulation. Half a century ago the Futurists, inspired by the new visual sensations of speeding in an automobile or observing the earth in the "aerial perspective" of an airplane, attempted to represent landscapes in motion. Current art, equipped with knowledge gleaned from psychological, photographic and color-chemistry laboratories, creates its effects of movement by operating directly upon the nervous system itself. Painting and sculpture pass from images that exploit the mass-media residue in our consciousness to visual contrivances that seize hold of our eyes and shake them like dice in a box or dive under the picture surface with them and drown them in a sea of afterimages.

The performance of artists as showmen to the crowds of the new American art world has caused some people to conclude that painting and sculpture have lost their bearing and are about to vanish into show biz. The fact is, however, that art as action and performances by painters embody the principle of continuity that links together the vanguard art movements of the past fifty years. The impulse to turn from the art *object* to the art *event* is present in the Dada and Surrealist demonstration that followed the World War, in the placards, May Day Floats and educational murals of the 1930's (with their slogan "Art is a weapon"), and in the interweavings of thrown pigment and fierce brush slashes of the Action Painters. Devising rôles and costumes was as characteristic of the 1940's as it is in the 1960's. Gorky performed with elegance the traditional part of the suffering genius dreaming of an idyllic homeland, Pollock in blue jeans and squatting on his heels that of the direct-action cowboy among dry big-city talkers, de Kooning that of the neat Dutch house painter, Clifford Still that of the Savonarola of aesthetic absolutes.

The character of a performance is determined by its audience —or by the absence of an audience. The history of American art in the past twenty years is outlined by the retreat of the Abstract Expressionist painters from the street and public places to the studio in the years following the war, and the gradual re-emergence of the artists and their successors into the contemporary landscape of mass communications, standard commodities and the laboratory. Almost all the originators of America's abstract art had been steeped in the political art of the Depression: Pollock had been influenced by Left-wing Mexican mural painting; Rothko had composed tableaux of the city poor; de Kooning had executed constructions for Artist Union demonstrations; Reinhardt and Motherwell had dabbled in Marxism.

The abstract sign-making and art as gesture which this generation introduced after the war arose from the need to re-direct bohemian and radical social action into the controllable arena of the canvas. The artist's will to change the world was replaced by the will to transform himself through the activity of art. This meant changing art, too. Instead of conceiving the contemporary as that which conveyed the social theme favored at the moment, the artist was moved to restore contact with the

tradition of formal innovation that had spurred art since Impressionism—the tradition reflected in the title of Ezra Pound's book: *Make It New*. They turned specially toward the last of the vanguard European movements, dada and Surrealism. The crux of the matter, as Hofmann had been insisting all through the 1930's, was that art must be *creative*. In the popular view, the new is whatever carries the latest date: in art the new is a creation that changes art itself. Merely to apply existing styles and techniques to radical subject matter produces not painting but illustration, and with regard to art is reactionary. Hope for the artist lay not in finding a new formula for "stylizing" objects or ideas but in entering the historic stream of creative *activity*, whether carried on by the Florentine masters or by witch doctors of the Congo.

Having shed their social aims and their stylistic preconceptions, the American Abstract Expressionists sought revelations through fusing into the movement of the brush the energies inherent in nature, the artist, the material with which he worked. In the interval of painting the artist affirmed his identity on levels of experience extending from his self-awareness as an artist, his absorption of the art of the past, his feelings as an individual, his half-conscious intimations. The movements of hand and body brought into being a coherence of signs to which both he and the spectator could respond with fresh stirrings of the imagination in time to come.

The vision of art and the artist as mutually developing and defining each other was shared by most of the post-war pioneers. The new American abstract art was not the product of a school or an ideology, but its motive of creative action gave rise to certain common aesthetic features. Since the work was regarded not as an end in itself but as incident in the artist's continuous activity of creation, its nature was to be "unfinished," a condition characteristically expressed in sketchy composition, blank areas of canvas, messy surfaces. Preconceived ideas and even a definite style were shunned as fixing the artist in a vise of self-repetition. "Formulation of belief has a way of losing its brightness and of fencing one in," wrote Tomlin. "I fight in myself," said Still, "any tendency to accept a fixed, sensuously appealing, recognizable style." Artists sought forms carrying multiple meanings, as in the ambiguous figurations of Gorky.

The psychologically suggestive pantomime of the Action Painter was complemented by the myth-making imagery of other Abstract Expressionists, the sign-bearing tablets of Adolph Gottlieb and Mark Tobey, the later empyrean landscapes of Gottlieb, the lunar regions of Baziotes' earlier canvases. Gorky's and Rothko's linear shapes automatically traced upon random washes suggested an inchoate mythology, as did the jutting shapes of David Smith's metal sculpture and the dripped-metal mazes of Lassaw. Rothko, whose post-political phase originated in a prolonged meditation on ancient myth and tragedy, later emptied his surface to surround the spectator with lofty panels that diffuse the hooded light of a grotto. The leaders of Abstract Expressionism were divided almost evenly between Action Painters, whose sign language arose spontaneously out of the act of painting, and myth seekers, who conceived or adopted signs and brought them to life through handling and color. Their works, though highly distinct technically—e.g., heavy impastos versus smooth, evenly applied zones of hue—were related in that a picture of either type could be "read" for its symbolism but had the deeper intention to communicate not a concept but a total psychic effect.

When an act loses its purpose it degenerates into play-acting and is performed not to produce a result but to win applause. As with all art movements, some of the practitioners of Abstract Expressionism saw it almost from its birth as an opportunity to charm. It is often very hard to tell desperation put on for show from desperation actually felt. The fake and the real become grown together and feed each other. By the middle of the 1950's the pervading acridity of the years immediately following the war, brought on by memories of the war dead, the return of the mutilated, the images of the death camps, of Hiroshima, had been largely dissipated. The feeling of crisis was no longer pressing, no longer *popular*. Many artists chose to forget it, except as a position to be assumed in interviews. To maintain the tone of the critical issues of the epoch in the midst of the lasting American prosperity, the displays of national power, the moratorium on politics, demanded a steady historical outlook possessed by very few. Other concerns seemed more relevant—for instance, the new status of art as a professional career.

Within a decade after the public first became aware of the

"gestures in the solitudes" of the action painters, American abstract art was leading a cheering squad in the Rose Bowl. The art world had swelled to include hundreds of galleries, collectors large and small, contemporary arts councils in major cities, travelling exhibitions of the latest novelties, university art departments and museums, visiting artists and lecturers, as well as a host of specialists and service people: art editors, curators, art historians, archivists, biographers, publishers, columnists, TV and radio programmers, photographers, catalogue writers. Soon the art world could be said to include the White House and, with the passage of a Federal Arts Bill, even the Congress. Not only is the new public of prodigious size and growing rapidly, it is a sophisticated public: art to it means *modern* art, not Montmartre street scenes or models in gypsy costumes. It is shocked neither by the morally outrageous nor by the aesthetically unfamiliar; the absence in a canvas of a semblance or a message causes it no mental anguish. The challenging "But what does it mean?" or the verdict "He's nuts!" is heard no more.

The recruitment of a vanguard audience for painting and sculpture was bound to transform the conditions of their creation and, in time, the character of the work itself. Putting on a show developed a stronger appeal than the act of painting carried to a hesitant pause in the privacy of the studio. With the methods of Abstract Expressionism being taught in universities and art schools, with hundreds of young artists and art students repeating its catchwords—creative tension, self-projection into the unknown, the unfinished painting, ambiguous forms—and aping the personal as well as the technical mannerisms of the "masters," Abstract Expressionism took on the character of an Academy.

The ground had been laid for a reaction against the conception of art as a passionate affirmation of mysteries without a key. Opposition took several forms. The most obvious consisted of negating in principle the attitude toward art which was now being parodied in practice. Against the Academy of contrived emotional paint surfaces, it brought into being an anti-Academy of cool professionalism and thin, inexpressive pigments. Repudiating any intellectual role for artists, the reaction attacked the bohemianism of Action Painters, their immersion in the disturbance of the times, their doubts about the future of painting,

their rejection of formulas. It proposed as an alternative a formal aestheticism which extolled precision, objectivity, technical progress—it saw, for example, the contribution of Jackson Pollock as an "advance" on the space concepts of the Cubists but ignored the innovations in automatism and chance with which he had solved his frustrations. Claiming to be carrying forward the evolution of art as art, anti-Abstract Expressionism brought to the galleries an art of bland color patterns that resembled the abstract art of thirty years earlier.

In contrast to the program of pedantic formalism, there also appeared various creative responses to Abstract Expressionism and to the changed social situation of American painting. Among the first to turn significantly from mythologizing abstraction was Larry Rivers, who had studied with Hans Hofmann and was imbued with the procedures of Gorky and de Kooning. Having caused a minor sensation with his early life-size close-ups of undressed friends and members of his family, Rivers undertook a truly popular subject, one he could count on to exist in the mind of every grade-school graduate: "Washington Crossing The Delaware"—this copy-book theme he painted in a *tachiste* style that the advanced would identify as ultra up to date. With his provocative nudes and "history paintings," Rivers was a forerunner in bringing back into art the common man (or in recognizing that he was already there)—not as a political abstraction, as in the posters and murals of the 1930's, but as one who, like the artist, found pleasure in pictures and exaltation in the notion of a masterpiece. Through painting the commonly known and appealing, Rivers provided a link between Action Painting and the "New Realist" or "Pop" art of street images and everyday objects: signs, ads, food, appliances.

Other links were the paintings and sculptures of Robert Rauschenberg and Jasper Johns. While Rivers took from Abstract Expressionism only what would enable him to satisfy his appetites, Rauschenberg and Johns re-examined this mode through the eyes of its audience. The audience-conscious art of Rivers, Rauschenberg and Johns was the pivot on which painting and sculpture swung from exploring the artist's own mind to analyzing and manipulating the mind of the spectator.

Another development out of Action Painting in the direction of Pop art was the Happening, to date the most extreme

movement of painting toward the performing arts. Instead of "acting on the canvas," and trusting to the survival of the event in the traces of the pigment, painters and sculptors brought their personalities into play as actors before an actual crowd. As in Action Painting, the production of the art object was subordinated to the activity of the artist, now turned producer-director-actor. Action Painting showmanship had brought into being the mammoth canvases of Pollock and Kline as literal "arenas" for the duel of the artist with his emerging image. The viewer had been drawn into the action on the canvas as a collaborator in establishing its significance. In the Happening the image making of artists was carried over directly into the public event. The Happening thus became an alternative to painting—a rival medium that carries to its logical conclusion the "aesthetics of impermanence." But the logical conclusion most applicable in art is to avoid logical conclusions.

With the audience acknowledged as a factor on every plane of the artist's situation—by 1960 prices had begun to catch up with the magnitude of the public interest—art has been accommodating itself to its new position *in* society. As in the 1930's, but without the unrest and political conscience of that period, artists have been taking account of the powers that control their environment. Most directly pressing upon art for more than a century has been the presence of art's gargantuan double, commercial art—including printed and display advertising, industrial design, product packaging, teaching aids, visual entertainment from the comic book to the Big Screen.

Commercial art *is* art, not only in being unquestioningly received as such by most people but in belonging to a tradition —one might say *the* tradition—of making art that moves its beholders and satisfies their tastes.

Endlessly versatile, the commercial crafts appropriate from painting and sculpture each new style, "look" or device and adapt it to serve practical ends never intended by its originator, as in calendars made of Monets, linoleum designs and skyscrapers of Mondrians. At the same time, commercial art constantly challenges painting and sculpture to state what purpose they serve and why they should continue to hold their ancient privileges.

The artist's revenge has been to exploit for his own artistic

ends the ever-present art of machine-produced objects and machine-reproduced images. Since Duchamp, some fifty years ago, presented his "ready mades"—shovels, toilet bowls, window frames—and the Cubists pasted bus transfers, theatre announcements and newsphotos into their compositions, the creations of the artist and of the business-world artisan have tended to cross breed; at times their products have come so closely together as to be distinguishable only by the label and the place of display.

It is to the credit of Pop art that it brought this relationship between art, mass manufacture and mass communication into the open without fear of overstepping the line between the canvas and the showcard, the mural and the billboard. With Pop artists such as Oldenburg, Rosenquist and Warhol the studio is no longer the cell of the philosopher or the lair of the romantic "wild beast"; it has reverted to the workshop of the artisan equipped to carry out projects with efficiency and skill. But though the Pop artist voluntarily adopts the artisan approach of the worker in the mass media, he does not relinquish the independence of the "expressionist." He manufactures an image like a designer under orders, but he is his own "idea man" and his own art director. The freedom retained by the Pop artist in handling cultural stereotypes automatically lends to Pop art an air of irony. Why should Rosenquist, who quit painting billboards in order to practice art, paint art that looks like billboards? Does Lichtenstein enlarge comic strips because, as he has said, he has always been attracted to Mickey Mouse and Donald Duck? In that case, why not go to work for Disney? The answer to these questions is that the Pop artist has chosen to function simultaneously on two planes: the plane of mass-communication styles and techniques and the plane of art.

This plane is represented by the self-consciousness of Pop art about art history and its acceptance of conventional aesthetic values: harmonious composition, well-ordered space, neatly rendered surfaces, fluid drawing. Oldenburg, for instance, has insisted publicly that his enormous pie slices and canvas typewriters are actually experiments in form and color. Lichtenstein's Ben Day dots have inevitably reminded his admirers of Seurat, and his drawings of waves have evoked allusions to Hokusai. This pedantry emphasizes that the chief novelty of

Pop is displacement: from the food store into the art store, from the ad or comic book into art history. The mixture of genres has produced some beautiful works—for example, Tom Wesselman's "Great American Nude #66," in painting quality reminiscent of Milton Avery, but with an exquisite touch of humor in the resemblance of the nude's nipples to the rubber caps with which things are stuck on kitchen walls. Oldenburg has modelled everyday objects in styles ranging from the Action Painting of his "Seven Up" reliefs to the naturalistic rendering of the fading tints of a used tea bag modelled in plaster and as large as a tennis racket.

In addition to displacement, Oldenburg, Rosenquist and Lichtenstein exploit the blow-up, as does Alex Katz (not a Pop artist) in his wall-sized faces. Both displacement and juggling of scale are inheritances from Surrealism, with its tiny men and elephantine butterflies. Pop art took on most quickly with people acquainted with dadaism and Surrealism—and with people acquainted with nothing but eager to enjoy art easily after the strain of trying to respond to the riddles of Abstract Expressionism.

Another species of "cool" art, Optical painting, or "perceptual abstraction," attacks the individualism of Abstract Expressionism from the standpoint of scientific impersonality. The Op artists, however, retain, almost to a man, the will to the *active* work of art. "My aim," writes one, "is the multi-functioned behavior of clearly defined forms." The proponents of these patterned works in squares, circles, moiré, claim that they alone represent a "machine-age aesthetic" that celebrates not men but forces. In Europe, which to all appearances has taken the lead over the United States in this category of painting and sculpture, "anonymous" groups, conceiving art as an extension of research in visual-perception laboratories, experiment with film and light screens in controlling radiance, rhythm and the metamorphosis of shapes. "Op" art is far more extreme than Pop in subjugating art to the social power, this time the power of science. It has exchanged the billboard for the optometrical chart. With its nervous mechanics of line and color and its waving and quaking surfaces, there is something harsh and didactic about this art, even when its effect upon the eye is soothing. Its light is neither of the day nor the night but of neon. There

is a prevailing overtone of a locked room and of things spied through an aperture.

As with Pop, the human, as opposed to the didactic, side of Op and kinetic art is entertainment. Pop and Op meet in the new science-fiction sculpture that has lately been flooding the galleries, in games and in inventions that parallel fairground and circus exhibits. Plastic, metal and wood forms painted in kiddy-land colors provide pseudo-scientific models of missiles, death-ray guns and outer-space travel. "The most romantic place on earth," an artist declares in his exhibition announcement, "is Cape Kennedy." A show of toys fabricated by well-known sculptors varies from Pop use of colored automobile tires to an Op-designed rubber ball and a scientifically weighted rocking horse by an outstanding kinetic artist. The repertory of illusionistic tricks displayed in the flickering and blazing of kinetic paintings turn an Op exhibition into a hippodrome of "magicians." The spectator, softened up by proofs of how easily his eye can be deluded, experiences a sheepish pleasure. No species of American art has been more attractive to children, and no art of the past twenty years has been greeted with more acclaim by people who admire an artist who "knows what he is doing." Op arouses, too, the enthusiasm of people utterly bored with painting and sculpture and convinced that it has no place in the rational and technological world of tomorrow. They see in Op an early phase in the liquidation of the old arts into "programmed" effects delivered by film and tape—a "theatre of the senses."

It would be intellectually convenient if the movement (or drift) of art toward playing for and upon its public took in all the significant painting and sculpture of the past twenty years. This is, of course, not the case. History, including the history of art, is not that single-minded. Motives, moods, styles overlap and co-exist. Alongside new art movements, and deep inside of them, old modes are revived and made to yield excellent and original creations.

In sum, the entire vocabulary of art styles developed in this century and earlier is in vigorous use. Yet despite cross-movements and the persistence of conservative picture-making, the trend of painting and sculpture toward "performance" is striking in its continuity. On occasion, work originating in this impulse

extends past painting and repudiates it, out of impatience with inherited forms and the wish to pledge itself to the future. For most artists, however, a more complete action is attainable with a pencil or brush than with an instrument panel; they are suspicious also of means whose effect on the senses is so powerful as to reduce the spectator to passivity, in the manner of the movies. Another reason for "performance" painters to refuse to abandon painting is that, in action, limits, such as the rectangle of the canvas, serve as a counterforce. To avoid flabbiness, new or mixed genres are obliged to develop substitute constraints, in the form either of arbitrary rules of work or a code of inner rejections.

So "painting" remains. On the other hand, all traditional elements and values of art are subject to tampering. While it is still customary to hear paintings analyzed in terms of various depths of space, the picture surface as a fixed reference for the eye has become as irrelevant as the vanishing point. What should be the limits of tampering with the inherited ingredients of art is for each artist to decide. Is it legitimate to paste bits of newspaper into a painting like the Cubists or like de Kooning and Johns, or to cut out the canvas or affix a piece of driftwood to it like Pollock, but forbidden to insert a TV set into it like Wesselman or suspend a pair of boots from it like Rosenquist or affix the head of a goat like Rauschenberg?

To these questions aesthetics has no answers. The boundaries of painting are subject to dissolution both by the authority of the inner evolution of styles and by the functions of painting vis à vis the art public. The continued existence of painting as an art becomes increasingly at issue not through the behavior of aesthetic radicals but because of the absence of any objective check upon invention. As numerous 20th century artists have divined, the ultimate formal invention demanded by painting is the invention that does away with painting—why bother with timid reductive concepts? On the other hand, when any aesthetic invention to which the art audience responds is counted as art, art has become one of the mass media. With *doing* replacing *making*, values in painting can be as completely dependent on audiences as they are in night club entertainment.

There is, however, an aspect of art that shields itself against the verdict of applause. I refer to the activity of the artist, which

in acts of creation has a value distinct from that of the object in which it terminates. In such acts, dimensions of experience may be attained which are never entirely accessible to the spectator, including the artist himself as spectator. To grasp the work he must reach toward it in a creative act of his own.

To this chain of creation art owes its survival. By it the intrinsic tension between artist, work of art and art public is renewed—within the social organization of art or in opposition to it.

1964

MARY McCARTHY

The novelist and essayist Mary McCarthy (1912–1989) was by no means indifferent to the visual arts. She published two books about Italian art and culture—*The Stones of Florence* and *Venice Observed*—and in her last novel, *Cannibals and Missionaries,* asked readers to weigh the relative value of artistic masterpieces and human lives in the context of a story about terrorists hijacking a plane. McCarthy had started out writing about the theater for *Partisan Review,* and she was well acquainted with the overlapping literary and artistic circles in mid-century New York. In her review of Harold Rosenberg's first essay collection, *The Tradition of the New*, she takes a rare albeit glancing look at contemporary art.

An Academy of Risk

"This man is dangerous"—the old post-office ads alerting the community to a malefactor at large, armed and with a record, are joyously brought to mind by the bold figure of Harold Rosenberg in his book of collected essays, *The Tradition of the New*. The man who invented the term action painting is an actionist critic. All his life, as these essays show, he has been interested only in action, in the "act," a favorite word with him, succinct as a pistol-shot. Before action painting, there was the action poem (the poem as destructive agent—Baudelaire, Rimbaud, Rilke, Valéry), and political action (Marxism). To Mr. Rosenberg, action and the imitation of an action—drama—are essentially the same. He is exhilarated by the hero in history, which means that he sees history as a stage of sublime or ridiculous gestures; the hero's historical "task," what used to be called the deed, is find-ing the appropriate gesture. This requires a willed transforma-tion of the merely given self, as in the evolution of the dramatic character of the Bolshevik, a secular convert; in some instances, the "transformation" may be only a disguise for a bald spot, like a toupée, which turns the historical drama into comedy. In either case, Mr. Rosenberg, who has commandeered a loge seat for the performance by the authority of his intellect, genially applauds. He knows that the problem of action is serious, dead serious for our pistol-point time, and yet his very fascination

with the problem makes him also a critical spectator, indeed an ideal connoisseur of the spectacle. His geniality, which has something of the pirate in it, is a product of detachment, a quality which, contrary to common belief, is often found in the true actionist in his moments of leisure—the balletomane commissar, the bandit-chief in the forest watching a Cossack sword-dance. The performer of deeds can be objective, just because he appreciates acting. Hamlet, with the Players, got the pun too, which runs like a mystification through language.

The great joy of this book is its zestful freedom, again the result of objectivity. The essays, written over the past twenty years, have been assembled in four sections, on painting, poetry, politics, and intellectual history, and are interrelated in a way that at first appears casual, until the light dawns and the reader becomes aware that he is following the greatest show on earth—the international human comedy of modern times, a mixture of genres, from tragedy to vaudeville, whose only heroes, finally, are artists. Thanks to his detachment, Mr. Rosenberg views the twentieth century as all of a piece: a century of the new, of invention, transformation, remaking, fresh gestures. In other words, Mr. Rosenberg's idea is that if you don't remake yourself in this century, somebody else will remake you—in a gas chamber. If modern history is a panoramic stage, it is also a scientific laboratory for the production of new human beings, new identities. The action painter who "gesticulates" on canvas so that he may see himself, as it were, in silhouette and discover who he is, is experimenting on himself just as Rimbaud did, and as the Communists did to manufacture, out of the "iron" process of logic, the figure of the Bolshevik, and the Nazis in their concentration-camp workshops, to make a new "scientific" humanity—as well, incidentally, as a new kind of lampshade. The purge indeed (Mr. Rosenberg does not happen to mention this, but he would surely agree) is the first obligatory step, whether it is the infantile castor-oil purge of Mussolini, the mass purges of the Soviet Union, the brainwashing of the Korean prisoners-of-war, the pseudo-purge of religious conversion, the prefrontal lobotomy, or the self-purgation of the artist. Mr. Rosenberg is not afraid of this amalgam, as it would have been called in the thirties. When Anthony West declared in *The New Yorker* that the poems of Baudelaire led straight to the death-camps, he was

asserting in a hysterical way a Philistine and semi-totalitarian doctrine of "responsibility"; Mr. Rosenberg sees a connection between all these modern events that is neither causal nor criminal. His detachment permits him to observe a likeness-in-difference without feeling obliged to confess up and withdraw his support from Rimbaud, Baudelaire, or de Kooning.

Similarly, Mr. Rosenberg's eagle's-eye view of the twentieth century has made him the first to discern tendencies and correspondences that became only slowly visible, if visible at all, to other critics. In an essay on the Fall of Paris, written in 1940, he rapidly sketches out the whole idea of Malraux's *Musée Imaginaire* (1949); it might be objected that Mr. Rosenberg did not "do" anything with his idea while Malraux made a book out of it, but a better way of putting it is that Malraux "got" a book out of it, i.e., labored it to yield him a return. Mr. Rosenberg was also the first to see through the guilty-liberal racket and the mass-culture racket; in a number of essays now grouped under the general heading, "The Herd of Independent Minds." This new body of parasitic literature—the *True Story* confessions of ex-Communists and ex-liberals and the mass-culture symposia—produced for kicks for a mass audience, is itself of course a sociological phenomenon, reflecting the vast growth of a class of professional intellectuals who are the tour-directors of modern society on a cruise looking for itself. The architects, designers, psychiatrists, museum men, questionnaire sociologists, "depth" sociologists, students of voting habits and population patterns, are all engaged in providing identities ("Tell me how you voted and I'll tell you who you are" or vice versa), showing their publics how they can yet be somebody through art-appreciation, music appreciation, good-design-appreciation, self-appreciation, i.e., knowing Values. As Mr. Rosenberg says, "Today everybody is already a member of some intellectually worked-over group, that is, an audience."

Mr. Rosenberg himself is a permanent revolutionist in politics and the arts. Still, sitting in his loge seat in the intervals of partisanship, he enjoys the farce by which the New is converted into the Old, by being turned into a profit-commodity, as modern painting has been by fashion designers, educators, and wallpaper firms; this in fact is the Handwriting on the Wall. Art movements "sold" to the consumer are consumed in both

senses. The position of the revolutionary critic is itself comically subject to erosion under these circumstances—a point Mr. Rosenberg has noted.

His sense of proportion and balance prevents him, almost everywhere ("Politics as Dancing" is the exception), from being mastered by one of his ideas so that he would fail to see its implications. This knowing what you are letting yourself in for constitutes audacity. Take action painting; while arguing strenuously for it, Mr. Rosenberg perceives where the hitch is. Action painting cannot lay claim to being judged aesthetically; by being an act, an experiment, it deliberately renounces the aesthetic as its category, for it cannot be recognized by the pleasure-faculty as objects of beauty are. If, indeed, by some accident—the passage of time or fading—such a painting became beautiful, it would cease to be an act, since the element of risk and hazard would depart from it, and it would come, as it were, to rest. In the same way, an act in history by becoming strikingly beautiful or noble slides out of the historical arena into a constructed frame—such actions, incidentally, are usually acts of sacrifice or heroic immolation. They become, precisely, a picture: a tableau or a statue. But if an action painting cannot be judged aesthetically, how can it be judged? Not at all, cheerfully admits Mr. Rosenberg, though he qualifies this somewhat by saying that a genuine action painting can be told from a fake by the amount of struggle in it. This criterion, though, is highly arbitrary—how is the struggle to be measured and who is to be the judge? Mr. Rosenberg, then, is taking a risk, with his eyes open, of polemicizing for a kind of art of which no one can say whether it is beautiful or ugly or in between, but only that it is something, that it exists and represents a decision. This decisive coming into existence, in fact, is action painting's best plea for itself—a plea entered in history's court, which is where Mr. Rosenberg always argues. And it is true that the most convincing argument that can be made, really, for action painting (Mr. Rosenberg does not make it) is that Mr. Rosenberg himself, in his earlier essays on poetry, described exactly those qualities that action painting would later have. This suggests either that Mr. Rosenberg like a god invented action painting out of his own brain (and the movement certainly seems to have clarified from the date of his naming it) or that its appearance was inevitable

in the history of art; that is, Mr. Rosenberg's prediction or hypothesis validates the painting, and the painting validates Mr. Rosenberg's hypothesis. This is perhaps untenable logically, but in practice such a coincidence really does hint that there is something to action painting.

In Mr. Rosenberg's opinion, this painting has assumed the binding authority of a historical necessity. We are forced to accept it as we accept other historical changes and advances. If we don't, we admit ourselves to the Academy, which (excuse me, Mr. Rosenberg) seems to me another version of the ashcan of history; if we don't accept it, in short, we are dead. Mr. Rosenberg is at once allured and repelled by the ever-present dead; the problem of burial is central to his book. Some of its finest passages touch on this theme; for example this, about Melville: ". . . while from the silent recesses of the office files, he drew forth the white-collared tomb deity, Bartleby." The spectral death-in-life of other contemporary critics, moreover, is made clammily apparent by contrast with Mr. Rosenberg's own vitality. His phrasing is a gleeful boyish exploit: "it would be just as well to bump the old mob off the raft"; ". . . to the tattoo artist on Melville's Pacific Island who covered the village headman with an overall design previously tried out on some bottom dog used as a sketch pad, the problem [of the audience] did not present itself." He is picturesque without forcing, like some veteran trapper or scout chatting on in the American lingo. The range of the voice is remarkable, and so is the control of volume. The accusation sometimes made against him, that he is abstract, is absolutely untrue of his writing, which moves from graphic image to graphic image (sometimes as in a really great comic strip) and is sensitive as a hearing-aid to sound. This plain talk nearly persuades you that he is right, not only in general, but in every particular of his reasoning, for what he presents is the picture of a man in a state of buoyant health. To resist his theories at any point it is necessary to draw back from this blast of vitality and ask, for instance, whether the theory of action painting is not just a new costuming of the old Marxist myth, in which the proletariat, having so long been acted on by history, decides to act into history and abolish it. By the violence of his "attack" on the canvas, the action painter abolishes art. But is it really possible to abolish art? Will not the aesthetic as a

category of human experience perversely assert itself, as history did in the Soviet Union by refusing to come to an end? This in fact is happening to the school of action painters and was bound to happen regardless of the activities of museum people and popularizers. Once you hang an act on your living-room wall, a weird contradiction develops, which is inherent in the definition (or myth) of action painting itself; an "event" or gesture becomes, at worst, just as much an art-object as the piece of driftwood on the coffee table or the seashell on the Victorian whatnot. At best, it becomes art. The truth is, you cannot hang an event on the wall, only a picture, which may be found to be beautiful or ugly, depending, alas, on your taste. This applies to a Cimabue "Crucifixion" just as much as to a Pollock or an African mask. You can decide of a new painting or a painting new to you that it is "interesting," but this only means that you are postponing, for the moment, the harder decision as to whether it is good or bad; a painting cannot stay "interesting," or if you keep on calling it that you have made "interesting" into an aesthetic judgment—a judgment, by the way, which leads, by the broad path, to the populous cemetery of the Academy, where all but the immortal are buried by Father Time.

1959

JACK TWORKOV

Although Jack Tworkov (1900–1982) was not an innovator on anything like the scale of Rothko, de Kooning, or Pollock, for a time in the 1950s and 1960s his open-hearted gestural compositions made him one of the best known and best loved of the Abstract Expressionists. The gonzo personality often associated with the New York School was alien to Tworkov, who in reflections published in the important artists' magazine *It Is* managed to bring a saving sanity to accounts of a famously tumultuous period.

A Cahier Leaf

JOURNAL

How often have I heard artists say, "I want to come to the canvas without any preconceptions." This is the bravest note sounded by the younger painters. But it is an absurd statement. Just as a person crying "silence" necessarily violates the silence. So one of their pre-conceptions is to work without any pre-conceptions.

How is it that R. who was the last to make the statement to me works so consistently in a post-Mondrian manner, so that all the pictures of his that I have seen, if they were put together, would look like one piece. Seems to me that all that is important in his work is precisely pre-conceived; he is on the contrary, entirely imprisoned in his style.

To approach the canvas without any pre-conceptions is in a sense impossible. Many painters approach their canvas without any preliminary drawing, or any preliminary image. Yet they each end up with a characteristic work that cannot be mistaken for anyone else's, because they are, however freely they approach their work, already committed to certain forms, to certain colors, materials, and to certain manners of manipulation. Klines always come out Klines and Pollocks always come out Pollocks. In Pollock's case even the interior rhythm and total image of the canvas—all that's left to develop freely—is frequently monotonously the same.

The artist who claims to work without any pre-conceptions

269

wants to accomplish at least three aims: He wants (a) to empty his mind so that somehow some energy from his sub-conscious will take over and endow his work with an element of strength or newness with which to surprise himself; (b) to empty his mind in order to be able to take advantage more quickly of any favorable development in the work; (c) to empty his mind so as to shake off the ideas of the work of others which are constantly present with him in order to develop the most personal style possible.

In a word, all that the statement amounts to is that the artist has constantly to battle his own pre-conceptions about painting, and the ideas of painting by the most famous artists, which just because the artists are famous, engage him with so much more force than he is ever willing to admit.

The intensity of this struggle poses the question whether the struggle is a reasonable one, whether the artist conceives this problem realistically.

There is no conscious device for springing open the door to the unconscious. This happens, if it happens at all, through simple absorption in the work, through a simple yielding of the urgings of one's mind to unambitiousness, to unself-consciousness through self acceptance. All of which state one may have from the start if one is a genius, but one is still fortunate to achieve it at the end of a lifetime.

No artist is an artist all by himself. He is an artist only by virtue of the fact that he voluntarily permits other artists to act on him, and that he has the capacity to react in turn. The artist who acts as if he could have conceived his art by himself, sealed off from other artists and their work and their thoughts, is stupid—he merely tries to conform to the idiotic romantic image of the artist as a primeval energy, as a demi-urge. The continual inter-action of ideas among artists is the very condition for the existence of an artist. There could no more be one artist than there could be one man. It is inconceivable for a person totally outside the field of art to be an artist. An artist can invent something only within the realm of art.

The artist instead of trying to obey the ideas of others in order to be more himself, ought perhaps to acknowledge that all outside ideas are really part of him. He ought to accept the others as facts of himself. Thus he becomes free to use whatever he can in whatever way he can. By releasing himself from the

struggles of what he considers not himself, he becomes richer at once. More possibilities loom up for him. Instead of being in a constant state of anxiety, he can be in a constant state of absorption.

1958

Statement

ANY show of liveliness, or even of life, can be put to ridicule. Note Barney Newman's screw about a certain kind of painting as the "frenzy-weapons of the hootchy-cootchy dancer." Offhand he is right, except that history has a way of extracting from the period-style (whatever it may be) that element of the nontemporal, the universal, against which, all humor, all jokes flatten and die.

Every style has its vulgarities. To insure against the vulgar manipulations of a style you must insure against life itself. Only "nothing" is safe—absolutely safe.

Nevertheless I feel the purity of a work is often flawed by the obtrusion of memory with its hidden wish for self-confession and its load of desire and pain. The purely esthetic is more attractive and I too am drawn to it. But my painting has not been merely a matter of willing. My life keeps leaking into the picture and my life too is not solely of my making. Also I've been burned and I am shy of programs or any rigid commitment. If I have a slogan it is "no commitment"; at a moment when there is admittedly little common ground, the best morality is not to have any. To will decision and clarity is to invite getting stuck with the mere appearance of it. We generally can arrange only the most minor aspects of our work as of our life.

If you have to have simplicity at all costs, simplicity can become a big lie.

Above any esthetic view or the problems history imposes on us the thing is still to work closest to one's own feeling; to risk the contradictions of all esthetic dicta, all professions, to find necessity, despite all confusions, deep in one's life, which happens to be, at bottom, everybody else's life too.

1958

Four Excerpts from a Journal

APRIL 26, 1952

The enthusiastic clash of ideas that takes place in the Club has one unexpected and, in my belief, salutary effect—it destroys, or at least reduces, the aggressiveness of all attitudes. One discovers that rectitude is the door one shuts on an open mind.

The Club is a phenomenon—I was at first timid in admitting that I liked it. Talking has been suspect. There was the prospect that the Club would be regarded either as bohemian or as a self-aggrandizing clique. But now I'm consciously happy when I'm there. I enjoy the talk, the enthusiasm, the laughter, the dancing after the discussion. There is a strong sense of identification. I say to myself these are the people I love, that I love to be with.

Fred McDarrah: Artists club panel discussion, March, 20, 1959.

Here I understand everybody, however inarticulate they are. Here I forgive everyone their vices, and I'm learning to admire their virtues. How dull people are elsewhere by comparison. I think that 39 East 8th is an unexcelled university for an artist. Here we learn not only about all the possible ideas in art, but learn what we need to know about philosophy, physics, mathematics, mythology, religion, sociology, magic. I am amazed at the eagerness of philosophers, priests, poets, musicians, mathematicians, dancers, necromancers to come to us, to talk to us, to educate and entertain us. Now it is my ambition to hear a tycoon from Wall Street speak to us about finance and a prince speak to us about royalty, simply because it occurs to me that these two topics have not been touched upon yet at the Club.

SEPTEMBER 25, 1953

The Puritans were willing to uproot themselves and their families and face every conceivable danger, cross a vast and unknown ocean, wrest a virgin shore from savage folk, undergo starvation, sickness, and sudden death, in order to build a society in their own image. They were confident of the outlines of the future.

Today their daughters dance in Bikini suits on the shores where their ships landed. They accomplished much, those ancient Puritans, but little of what had been closest to their hearts. They were but one event in a crisscrossing of chains of events of such magnitude that what lay within the orbit of their imagination could only amount to very little. There is no foreseeable future. Man acts on his environment but his deeds do not necessarily accomplish his heart's desire. In 1917, no Marxist could have imagined the shape and color of the first socialist country and seen the Soviet Union of today. If he could have, he probably would not have raised his hand to make his dream come true.

If the Pilgrim had been shown a vision of the America of 1953, he would never have boarded the ship.

But America is from our view infinitely better than what the Pilgrim could have built if he'd had his will for 300 years. In fact we thank God he did not succeed.

Destiny's fools are the avant-garde. A man cannot make his

life, but whatever he makes, that's his life. And since we never make and cannot make the same things, everything keeps changing.

SEPTEMBER 14, 1953

All that exists is contained.

The transformations from seed to grape to wine mark a succession of containers.

Blood is contained. We are a vessel for blood. Let the blood out of the container and life ceases.

What contains, contains semen, blood and wine, is as nearly a miracle as its content. And the transfer from vessel to vessel, from fruit to flagon, from parent to offspring—a chain of vessels—is the business of life and industry. And the sanitary industries for the removal of waste, of decay from the body, from the house or the city, are a system of transferring from vessel to vessel.

Considered in this thought is the idea of individuality. The egg contained in the egg-shell—thus in a boundary—is separated from all other eggs. The blood contained in the body—contained, not running out all over—is bounded and contained within a periphery, making an entity distinct from other blood-entities. Universality is in number, in discreteness, not in continuousness, in a running out all over as if there were no boundary. In the many there is number, awareness, universality. In the one is substance.

A container must be closed to what it contains. But it can be open to other substances. A basket designed to contain pebbles may leak sand. A net is closed to fish and open to the water, as it must be. To be closed and open is a necessary and simultaneous function of all vessels. A completely closed vessel is the end. A completely open vessel is without substance.

SEPTEMBER 8, 1953

Picasso very often turns to the primitive and paints like a primitive. Matisse allowed his early start to be influenced by children's work. But neither artist displays anything in his nature that could be called innocent. To paint like a primitive would

have been inconceivable to Cézanne. Yet what really impresses about Cézanne's style, as much as its complexity, is its complete unselfconscious innocence.

Picasso and Matisse are extremely facile. Either one could as well have been a stage designer, a chic window-display artist, an engineer, an industrial designer or a magnificent ultra-smart tailor. They would have been modern and successful at whatever work they might have turned to. Such facility was by his nature denied to Cézanne. He turned to art, I suspect, because he would have failed at nearly everything else. He nearly failed at art. Yet more than Matisse or Picasso he is the very image of the artist in our time. Picasso is modern but he is not necessarily of our time. If he had been born in the Renaissance he would have carved out his career with the same authoritarian vehemence. Not Cézanne. It is possible for him to be an artist only in the peculiar conditions of our time, at this moment only, when the artist ceases to be a master-craftsman, entrepreneur, the servant of prince, church, or merchant. Cézanne has almost none of the virtues or talents which make a career in society. He lacks the guile, the scheming, the carefully built up façade, the ruthlessness, the readiness for treachery. True, he longs for success, for a recognition even from the most hostile and unlikely quarters, but he longs always in terms that are manifested in his paintings, through his paintings, for his paintings.

Cézanne is the very image of the artist in our time: the alienated intellectual, deeply concerned with meaning, awkward with all those who get along smoothly in life, and especially awkward in fashionable settings, slightly incompetent, and lost beside those whose religion is to get on in the world. He is a person, however, who in his innermost center has a fierce pride and sure conviction about the values of the artist in the world.

IRVING SANDLER

When Irving Sandler, who was born in 1925, came to write his memoirs, he called the book *A Sweeper-Up After Artists*. The phrase—taken from a poem by Frank O'Hara, who referred to Sandler as "the *balayeur des artistes*"—is perfect for this important figure in mid- and late twentieth-century American art. Sandler has done double duty as a critic and a historian. And his easygoing and temperate personality has made him an irreplaceable witness to all the passions and partisanship of the decades when American art was coming of age. The painter Al Held called him "Our Boswell of the New York scene." As a young man Sandler frequented the Cedar Tavern and was at various times the manager of the Tanager Gallery (a cooperative enterprise on Tenth Street), the administrator of the Artists Club, and a critic for *Art News* and the *New York Post*. His four-volume history of the New York School, beginning with *The Triumph of American Painting* (1970), is universally recognized as one of the foundational texts of modern art history. Sandler's strongest critical writing reflects his genial, sympathetic spirit, a good example being this portrait of Joan Mitchell, which was published in a 1959 Grove Press anthology, *School of New York: Some Younger Artists*, edited by the novelist and critic B. H. Friedman.

Joan Mitchell

THERE are transparent instants, "almost supernatural states of soul," as Baudelaire called them, during which "the profundity of life is entirely revealed in any scene, however ordinary, that presents itself before one. The scene becomes its symbol." Joan Mitchell has experienced such moments in childhood. Memories of the settings where these events took place—Chicago near Lake Michigan—become the source of her painting images. The exaltation that these scenes inspired remains so poignant that it eclipses common everyday occurrences. A yearning for the unattainable past moment develops, becoming so intense that it approaches the elated frame of mind she was originally in. A lack of yearning for any length of time causes inquietude, despondency, a sedulous longing for the yearning. Mitchell paints to reawaken her desire. The literal description of specific landscapes is unimportant, for the scenes that initially moved her were probably quite ordinary. They are feeling material, not

painting material. Scenes from her present environment—New York City—may serve as references or to reanimate past attitudes; they are significant mainly as catalysts. In the endeavor to repossess a former instant and to ease an existing longing, the painting itself becomes a surrogate for the recalled landscape—its symbol. It becomes the link between past and present. By drawing on the primal source of wonder, the present is transcended.

Like many city-dwellers, Mitchell is "up against a wall looking for a view," the luxury of a view. "If I looked out of my window, what would I paint?" One does not feel space unless one is hemmed in. Her pictures become the windows she makes in her walls; they replace the walls. The dynamism of the city is one element that she has felt in the canvases of older, so-called abstract expressionists or action painters she admires—Gorky, de Kooning, Kline, Pollock, Guston, and others. She has also responded to their attempt to discover an immediate image in the process of painting. Mitchell would agree with de Kooning that "painting isn't just the visual thing that reaches your retina—it's what is behind it and in it. I'm not interested in 'abstracting' or taking things out or reducing painting to design, form, line, and color. I paint this way because I can keep putting more and more things in—drama, anger, pain, love, a figure, a horse, my ideas about space. Through your eyes it again becomes an emotion or an idea. It doesn't matter if it's different from mine as long as it comes from the painting which has its own integrity and intensity."

A concern with the primacy of the act of painting has led Mitchell to explore its technical aspects "so that the commands of the mind may never be distorted by the hesitations of the hand" (Baudelaire). She has achieved a profound mastery of the mechanics of painting; in this she is distinguished among her contemporaries. However, virtuosity in itself does not interest her. She finds self-conscious painting boring. Nor does she indulge in abandon. She does not close her eyes and hope for the best, but paints from a distance, studying the canvas for long periods of time. The freedom in her work is quite controlled. When she can make herself available to herself, when she can get into the act of painting and be free in the act, then she wants to know what her brush is doing. Spontaneity is combined with

clarity. She prefers the word "accuracy," which might be defined as making emotion specific in paint. Each area of the canvas must be charged with feeling. The picture is held together by the inexplicable passion that permeates it.

The characteristic gesture in Mitchell's painting is the swift, arcing, arm-long stroke that slices generously to the canvas edges, carving out huge spaces, or tiny ones that expand. The colored lines generally do not break the picture frame but are contained within it, caught back in vertical and horizontal elements. Pictures made in the early fifties are of muted grays. They have the feeling of the city on a misty day; the grim geometry is so softened that a skyscraper begins to resemble a tree; the city, a panoramic landscape. The image in later works, such as *Hudson River Dayline* (1956), is more articulated. A throbbing blue core, suggestive of the impress of water, is bordered by bare canvas which might be clouds and shore. In other paintings of this period, the brilliantly colored centers evoke animated streets—windows or views in the gray jungle. In *Artichoke* (circa 1956), the central image opens up; the white areas formed by interlacing green lines act as color, background, interval, binding, and light. Bridges, the amalgams of city and water, have always been a favorite subject. In *Bridge*, a diptych of 1956, one feels the sensation of girders and height, the varied meanings implicit in spanning a void. The line in recent canvases, such as *Lady Bug* (1957), becomes fleshier and more staccato; white areas contract under its flection. Colors interact more with one another than with white. Harsh elements assert themselves and contrast tensely with poetic motifs.

Joan Mitchell considers herself a "conservative" in that her pictures are in the tradition of de Kooning, Kline, etc. (the word is not without ironic implications considering that abstract expressionism is some fifteen years old). However, her painting is never imitation or parody. A vision of landscape sifted through exultant memory has made it deeply personal.

1959

FIELDING DAWSON

As a very young man the writer Fielding Dawson (1930–2002) attended Black Mountain College in North Carolina, the adventuresome school where Josef Albers presided for a time and figures ranging from Willem de Kooning to Buckminster Fuller and Merce Cunningham were involved in the famous summer institutes. Dawson, who in later years wrote a good deal of fiction, will surely be remembered for two nonfiction works based on those early experiences, *The Black Mountain Book,* which he tinkered with over the years, and *An Emotional Memoir of Franz Kline,* his fleeting yet stringent recollections of one of the most beloved of the Abstract Expressionist painters.

FROM
An Emotional Memoir of Franz Kline

I woke hearing him clearing his throat and shuffling around in his slippers; sounds of china and silverware but I stayed in bed and for a while gazed at the large stretched canvases stacked against the walls, then I dressed and went into the front of the loft. He was standing at the stove watching the old kettle. I said good morning, and he replied huskily,

"Hi, Fee, how're you?"

I laughed, and he chuckled in a mumble, rubbed his face with his hands and fought in his throat.

"Wow!" he said quickly.

He put two cups in two saucers on the table, put a silver spoon by each; the kettle was beginning to jiggle. I asked him if I could help and he shook his head saying he had it.

We drank coffee, and smoked.

From the smell of gas I knew he had just lit the iron steam heaters, along the wall under the windows, and as we chattered, the heaters gurgled and began to cough. I laughed and remarked at the humanity of the sound. Franz said yeah,

"They're thirsty."

I became enthusiastic and anxious.

"How do you like it here?" I blurted.

"It's okay," he said. "The trucks get up kind of early, hear that? All day long."

Trucks outside, being loaded and unloaded filled the air with a constant crash. I stammered,

"But—you—get used to it.—Don't you?"

While I was angry and embarrassed at my failure to ask a question—or make a statement without a question mark at the end, didn't he think so? Or, did he get used to the noise? Yes, he said.

"Until they surprise me."

He made the loft larger, and twenty years beyond me made me tense. I wasn't anywhere near sure if I could say anything solid I was so little. I saw the loft years later and it was small, and it must have been embittering to paint and live there, after the 9th Street loft 32 East 10th was small and dark.

He later moved to 100 East 10th, and that didn't work (Pete Martin and Jackie Miller took it next), and he went to a beautiful top floor place on Avenue B, too small, more for a writer, and so he moved again, to Sixth Avenue, third floor and next door to the Five Brothers bar. But the apartment doors were too small, he couldn't get his paintings out. I helped him look for a place one day, and found a large and light, high-ceilinged room with smaller rooms for kitchen and bedroom, plus a porch overlooking backyards and trees; on 14th Street near Eighth Avenue, near the Blarney Rose, and Jimmy Rosati.

Except to gaze and drink up the character of his paintings and loft, I couldn't take my eyes off him, I was, me too, emotionally gurgling and steaming. Thirsty.

Franz was a powerfully generous man, and he expected me to respond with due respect, yet in my youthful sensitivity I fell over backwards and staggered in my tracks by his generosity—as when he was talking to somebody, and at a subtle mention of a name, Musial, or Guston, Franz secretly passed me the softest smile and the most amazing wink. He knew how I felt about Guston, and was letting me know he knew, letting me know I knew that he knew that. He approved of close listening, and those moments were perfect in the back and forth exchange; complete, as I blushed crimson, grinning, times when, I was compelled to move to his side, and there were times when he put his arm around my waist, and touched me and I was speechless, and near tears.

The man sitting across the table from me was the figure of

my lost father and the found Artist; April, 1953, at a wooden table in a wooden loft where every object held meaning. The chairs, particularly the rocking chair; his toy iron trains on little stretches of track. Wherever he moved, they went with him. They were imbued with him, and his touch was on them. His signature looks like a train. Sense of power, motion, identity and emotion; mountains and valleys of Pennsylvania and childhood. He had a sense of engines. Those cigarette lighters seemed like engines, and his intuitive concepts of structure and energy gave completion a factual stand in his sense of the formidable square, and like Dickens he gave things human traits, laughing the way a car looked at him.

Trains and trucks and cars and ships moved by engine, creating tension and conflict; there's a quality of his painting in big storms, and I was drinking coffee with him, inside his world-loft-relation to each thing there, to all those things, with himself in the center.

I REMEMBER the hardware store in Provincetown where we discovered the sash brushes with long slender varnished dowel-like handles that gracefully curved into the shining metal heel, the bristles were shining black and had a nice bounce: cut on the angle for sashwork. He turned to me, bright-eyed.

"Terrific, eh?"

He worked it against his palm, eyes fixed on it. It was really a brush. I was a writer, though, and it was a sash brush, so I was doing some invisible sashwork in the air, deftly; he was thinking how he could use it. He bought at least four, I bought one. Did he ever use them? They were always among the rows of brushes on his paint table—ready in case. I have a memory, or possibly I still hear him talking, it is they didn't work out, and I can hear him say he'd keep them anyway because they looked so good.

He was, in his true sense, his local world, trusting his experience implicitly, and some of us, critics and artists, thought he was naive. But we had to do a lot of homework to resist his local magic; maybe we didn't understand him—yet he would say why should we?

The critic moves in his egoistic world, and the artist moves

John Cohen: Franz Kline at the Cedar
Tavern, 1959.

in his experiential world, also egoistic, but the critic-ego is cen-
tered around objectivity and intellect, and the artist-ego is sub-
jective and generally emotional. Paint is personal, paint is im-
bued with sex and soul and a critic can't go there—it's like a few
things. It's unlike anything.

His house in Provincetown and his studio on 14th Street
were great places and there wasn't a thing in either that wasn't
him, except the touches of Betsy, which turned into their life.

But inexorably Franz, just Franz. Just him in the terrible
times of tears and violence, of his recklessness, and delight, was
the representation of Kline, which he defended, with himself,
and tears and violence in a wheeling circling in—on that big
wall we built—those huge canvases, stapled by his tough fist,

and the sound of staples biting in makes me a little dizzy; but his pictures, black and white, some had color and then they were all color, they wheeled freely, simply swung and commanded a certain face which only the artist Kline could enter, and yet in a sonic and ruthless mysticism those big paintings wouldn't let him in, and he stared at them, brush in hand, outside his own.

In 1959 and 1960 he told me he was having trouble covering large areas; he also said he couldn't seem to do the one that would knock him out. Again and again, in Provincetown he went at it, and a perfect example of his going at it, to it, and into it happened in 1960, in a metaphor. He had begun a painting and couldn't get anywhere with it, but working, a door in the new studio the carpenter Sawyer had built, caught Franz's attention, and midstream he changed his picture, painted a vertical, rather squarish, rectangle, later called it Sawyer. But when Sawyer died in 1961 the door he'd built became a painting by Kline called Sawyer because Sawyer had built a door that Franz had seen, and called it Sawyer, he warmly told me, because Sawyer's door had been the way into the painting's completion. Franz would never call it *Door*—Sawyer had built it, not the door—and Franz had seen—it was as if they saw each other, as "I saw yer"—Sawyer being carpenter, delete the *y*, and anyway their excellent relationship; affection for each other; incident in time that became a metaphor of prediction which, because it wasn't seen, reads now as irony; ironic that Franz died so soon after Sawyer, who built the fateful metaphor.

His last painting, whether it is or isn't doesn't matter, is vertical, large and predominantly red; about six by eight feet—I saw it after he died so it might make it bigger. I had gone into the gallery and become preoccupied by the first paintings I saw, it was a memorial show, and turning to move into the front rooms and look, I saw it, two rooms away, burning at me, and as I walked towards it I wished I could have told him he had done the one he wanted. To its left and perfectly placed, was the small, maybe fifteen inch square collage which I had remembered, that he had clearly used to begin the big, last or not, red painting, face of the mythical creator radiating outward to tell me for the millionth time how real Franz had been, and how true he had been to himself with his signatorial straightforward narrative style, glowing with personal mysticism, surely

the most painful thing of all: that emotional generosity and perception so large in the paint which we had counted on through all our changes.

. . .

He hopped around shyly, getting into his pants, and I did the dishes, while he shaved I had another cup of coffee, and as we left he touched my arm, and warmly said,

"Let's go for a walk."

My eyes brightened and I laughed shyly; in spite of myself I had admitted love.

We walked down 10th Street to Third Avenue, and in complicated contrasts of trucks and bodies and light and dark, Franz disappeared. There were dozens of doorways, trashcans, bums and whores and signs hanging around—the Reginald Marsh paintings are real except it was daytime, or I thought it was, jeun Telemachus stumbling around peering into one place after another, I decided I should take matters in my own hands, and starting out at the corner I went into every hockshop, drygoods place, cutrate joint, bar and grubby luncheonette and found a narrow little place I hadn't noticed before, and bewitched by the mess of New York, and darkness cast by the Elevated, I went in; the place was cave dark, and I groped around moving deeper in a gathering deep smell of sweat, age, and cloth. My eyes became accustomed to the darkness. Franz was talking to a small Jewish man who was complaining about money.

"Well, unh—"

"Meester Kline, your suit," he hissed, "ees ready." He had worked very hard on it, etc., and I saw Franz pay him. What a city exchange! I looked around the place. Beyond heaps of suits and coats and a sewing machine, racks of jackets and pants, the narrow rectangle revealed incredibly shaped contrasts of light and dark colors and doorway sunshine; the light outside, angling down through the overhead Elevated, was stunning.

"Let's go, Fee."

We went outside. I was amazed and bewildered.

"Where are we?"

He laughed. "On Third Avenue between 9th and 10th Streets. Get a little lost there?"

"I sure did!"

We walked through the odd reality of persistent existence.

So many sleazy jerks! Wow! In a long ear-splitting crash the Elevated train raced overhead toward its next stop, making me dizzy. Then we were on a crosstown street, and then we crossed a wide avenue, turned left and entered the doorway of a slummy-looking building, went up a couple of flights of dark and shaky stairs. We went sideways into a corner and Franz knocked on a heavy metal door. We heard footsteps, and Franz looked at me warmly smiling. He winked and my blood raced. I was about to crack apart. A heavy smashing sound of metal made me jump, and another, more hollow, whack, made me step back. The door opened, and behind the almost silhouetted figure I saw a long beautifully clean loft, warmly filled with sunlight.

The fellow was short, about Franz's size, and around his age, and also like Franz, stocky, with white hair and freckled handsome face, strong deep crystal blue eyes that were, at that moment, brilliant in friendship.

"Franz!" the fellow cried, in an accent. He looked at me with a smile welcoming me. Franz said,

"Bill, this is the other guy from Black Mountain I told you about—Fee Dawson. Fee, this is Bill de Kooning."

I was shattered in happiness—de Kooning raised his eyebrows as we shook hands, saying with amazing kindness,

"Well—would you like to come in?"

I, on wooden legs went at Franz's side into the place where I had not ever dreamed I'd be. Windows lined one wall; no paintings were on the walls, but the marks of art were on a far wall opposite the door, and the character of chairs and sofa and tables gave it a powerful lived-in aura, that I felt intensely, as Franz, turning the Mercator projection upside down again, said,

"Fee's come down from Black Mountain on his spring vacation."

"Do you like it there?" de Kooning cried, pointing to a sofa, "Sit down. Right." Franz and I sat on the sofa, a coffee table in front of us, de Kooning drew up a chair on the other side of the coffee table, and faced us. I said I loved Black Mountain.

De Kooning said gravely, "I was there." With such straight alertness I shuddered, and stammered I knew he had been there, and I added I wished I could have been there then.

"It was different, then," he said.

I nodded. He asked,

"Who's teaching there now?"

I told him Joe Fiore was teaching painting; de Kooning looked at Franz, and Franz nodded. "I thought so," de Kooning said. "Yeh, I know him. He's good."

I said Charles Olson was teaching writing.

"He wrote a book on Melville," de Kooning said.

"Yes. It's called, *Call Me Ishmael.*"

"That's right! I read it!" He reflected a moment. Then he nodded, "I kind of remember it."

He asked me, "You like Melville?"

I said aggressively, "I sure do."

Franz and de Kooning grinned, and de Kooning stood up and gestured, spreading his hands apart indicating Franz and myself, generously asked, "How about a drink?"

We beamed.

We began with whiskey and water over ice, and Franz showed us the suit he had gotten, and I was bending with laughter as Franz shyly grinned, de Kooning said, with a feminine lilt,

"Why I think that's a *lovely* suit!" He turned to me, eyes positively sparkling, "Don't you?"

"It's terrific," I said.

De Kooning chuckled the word incredible into his drink; then quickly, "Franz—put it on!"

Not the pants, too shy, but he put on the coat. It was one of many miracles.

A double-breasted pin stripe with a Brooks label nobody had had for at least a few years, but on Franz it looked great. And cleaned and pressed, on him with a white shirt and tie, shoes polished, he was just a little out of our time, but the very image of his own. He never stopped being himself. It also startled me, in every sense that day, de Kooning too, de Kooning was really de Kooning, sitting a little sideways in his chair looking Franz up and down, nodding his head in inner amusement—the muse in amuse—friendship, and I had the sudden sense I was in the company of friendly kings. The living loft was full of sunlight and I was dazzled. I wanted to be me like they were them, and live in a big place and do my own, with sunlight coming in the windows. I was out of my head.

Franz was tugging at the coat and turning around asking if it was too tight.

He looked at us. "Do you think it's too tight?"

I nodded that it was a trim fit, de Kooning was murmuring superlatives—he jumped up, put the glass down and said, enthusiastically,

"I bought a new coat!"

I laughed, Franz was chuckling and putting on his other coat, and de Kooning asked us, in such accepted friendship that I had the sense I was an Alice with a couple of Alices, in wonderland,

"Do you want to see my new coat?"

We said we did.

He went towards the front door, and disappeared on the left of it, into a closet, reappearing with a topcoat to end all topcoats, a topcoat no one else could wear. He put it on—got into it, rather, and marched towards us, stopping, standing still, grinning, eyes glowing.

It was dazzling. And there, inside it, his house, was de Kooning.

There was a knock on the door. Twin sisters came in chattering. Nancy said hello to me, and greeted Franz. I was introduced to Joan, and the afternoon swerved doubtfully to a party atmosphere.

The girls, in just that instant, were lovely and bright and I was clear off my pins anyway, New York; New York flashed in dreamy daily sequences that made my senses whirl.

But it was real, all real. I loved those girls with their bright minds, and their talent, and I loved the men and their lives and their art; I had no sense of that world ever ceasing.

FEBRUARY, 1954

I was in the Army, just finished with basic training. I was stationed at Camp Kilmer, New Jersey, processing to go to Germany. I had visited New York twice, in the two and a half weeks, on weekends, and the third visit was the last, and inevitably the final hours rolled around. It was Sunday, and I walked around a cold New York with a tight heart. That night I saw Franz in the Cedar and told him goodbye. He was worn out from a hard couple of days, but said to sit with him and have a drink. I said I had to get the bus back to Kilmer and he put his hand on my back and smiled.

"Fee."

Franz Kline: *Accent Grave*, 1955. Oil
on canvas, 75³⁄₁₆ × 51¹¹⁄₁₆ in.

I sat with him and we had whiskey and beer and his voice
picked up rhythms of sentiment and real emotion. We had an-
other drink. He pursed his lips when he sipped whiskey, and he
put the shotglass on the bar and looked into it, turning it on
the bar; he sipped his beer. He looked into my eyes and I was
going to sail away.

"Will you write?" I asked emotionally.

"You know I will."

I began to belch in anxiety, and he took my arm, and smiled
into my eyes, the bright brown wood-grain of his irises sharp-
ened, and his black pupils deepened. I lowered my eyes in awe
of his love and power. He smiled differently. "Are you ready?"

"Let's go," he said.

I said so long to Sam and John, and all the others, and Franz
and I ran out the door into the evening's first snowfall.

We ran up University Place, and there was a cab—

"HO—HEY" he called, and the cab slowed, Franz waved and cleared his throat; his voice was husky and I always had a rather childish and feminine love when he would start calling and clearing his throat. I was laughing as the driver opened the door.

I embraced Franz, and we shook hands. We looked at each other.

"Goodbye, Franz—I'll see you in about two years."

"So long, Fee," faithful, and forever no other one than himself. "Don't forget to write," he warmly said, and I got in the cab.

Franz gave the smiling cabby some money, and said,

"Take him to the bus station; take good care of him."

"I sure will," the cabby said, and as we drove away I could see Franz wave once, and then turn and start back to the bar. Without me. I sat back, wiped my eyes and stared out at the passing city and the snow.

HE did write, and I wrote too. He sent me the announcement of his last show at Egan's, and I had it up on my wall locker door.

Before I end this first circle, and return to the Cedar, there was an Army incident that's worth telling.

The last Inspector General Inspection I took part in was in the spring of 1955. I was coming home in June, and I rather lightheartedly laid my gear out.

The door opened and all the officers came in and started checking soldiers and the displays.

My wall locker was open, and on my door I had Franz's announcement. The sharp black and white action was visible clear across the room. Underneath that I had the title page of a small book of two of my stories—*Krazy Kat and One More*—that was due to be published by Jonathan Williams. Underneath was a fine picture of a beautiful woman I had met at Black Mountain.

On the wall locker shelf I had books neatly showing. *Don Quixote*; *The Idiot*; *The Brothers Karamazov*; the first issues of *The Black Mountain Review*; Robert Creeley's *The Gold Diggers*, and Charles Olson's *In Cold Hell, In Thicket*.

I was standing at attention, when a big beefy two star General with hard eyes came my way. He looked me up and down while fullbird Colonels, and Majors, looked at my mess kit, boots, etc. The only one star I had ever seen was on a license plate, but this General had two—two on each shoulder—and he was standing facing me, but I knew his eyes were looking at my wall locker door. Franz's announcement; the title page of my book, and the beautiful woman. His eyes swung back to mine. The corner of his mouth moved up.

"You a writer, Dawson?"

I nodded and smiled briefly. "Yes sir."

He glanced at my wall locker again, and again returned his eyes to mine. But his look had changed, and he made a little larger smile, nodded once and moved away.

1967

WILLIAM GADDIS

The Recognitions, the enormously complicated first novel by William Gaddis (1922–1998), tells the story of a young artist, Wyatt Gwyon, who wants to revive the painterly magic of the Flemish masters of the Renaissance and finds himself, at least for a time, becoming a forger, his lofty ambitions utterly debased. Published in 1955, *The Recognitions* includes some richly textured accounts of artistic life in downtown New York at the time, among them this scene in which Recktall Brown, a corrupt art collector and dealer, visits Gwyon's studio for the first time.

FROM
The Recognitions

HE opened the door more widely. —Come in, he said, in a tone which seemed to reassure him, for he repeated it. —Come in . . . Who are you?

The visitor extended his hand as he entered, a stubby hand mounting two diamonds set in gold on one finger. —My name is Recktall Brown.

He took the hand and said his own name in reply, distantly, as though repeating the name of an unremembered friend in effort to recall him.

Recktall Brown entered and strode to the middle of the room, looking round it through heavy glasses which diffused the pupils of his eyes into uncentered shapes. —Good thing you brought her in, he said, and waved the diamonds at the dog where it lay on the floor, licking itself. —She hates the rain. Then he turned, a strange ugliness, perhaps only because it looked that a smile would be impossible to it.

—Would you . . . like a drink?

—No. Not now. Not now.

—Yes, but . . . there, yes, sit down.

Recktall Brown dropped into a heavy armchair facing the open door of the studio. He tapped the diamonds on the arm of the chair while he continued to look around the room, his head back, his face highly colored with the redness of running up flights of stairs; yet he breathed quietly, almost imperceptibly, for his stoutness absorbed any such evidence before it reached the double-breasted surface of his chest. —I know your name.

He smiled, a worse thing than the original, turning for a moment to the man who stood watching him as he poured brandy into a glass, and said, —Yes, I . . . I think I know your name, but in what connection . . .

—A publisher? A collector? A dealer? Recktall Brown sounded only mildly interested. —People who don't know me, they say a lot of things about me. He laughed then, but the laughter did not leave his throat. —A lot of things. You'd think I was wicked as hell, even if what I do for them turns out good. I'm a business man.

—But . . . how did you know my name?

—What's your business?

—I'm a draftsman.

—And an artist? Recktall Brown was looking beyond him to the studio, and back at him as he approached and sat on the couch.

—I . . . do some restoring.

—I know.

—You know? He sat forward on the couch, holding the glass between his knees, and looked at his visitor and away again, as though there were some difficulty which he could not make out.

—You did some work for me.

—For you?

—A Dutch picture, a picture of a landscape, an old one.

—Flemish. Yes, I remember it. That painting could hang in any museum . . .

—It does. The hand which carried the diamonds was folded over the other before him. —You couldn't tell it had been touched. Even an expert couldn't tell, without all the chemical tests and X-rays, an expert told me that himself.

—Well, I tried, of course . . .

—Tried! You did a damn good job on it. He looked around the room with an air of detached curiosity, and finally asked what the funny smell was. Because the glasses obliterated any point in his glance, it was difficult to tell where he was looking, but he seemed aware that he was being watched with an expression of anxiety almost mistrust, not of him, but an eagerness to explain anything which might be misunderstood. His questioning was peremptory.

—Lavender. I use it as a medium sometimes. The smell seems to stay.

—A medium?

—To mix colors in, to paint with.

—You do a lot of work here, don't you.

—Well, I . . . I've been doing some of my work at home. This drafting, bridge plans.

—No. The painting, the painting, Recktall Brown said impatiently.

—Oh, this restoring, this . . . patching up the past I do.

—You don't paint? You don't paint pictures yourself?

—I . . . No.

—Why not?

—I just . . . don't paint.

Recktall Brown watched him wipe his perspiring forehead, and drink part of the brandy quickly. —All this work, all these books, you go to all this trouble just to patch up other people's work? How come you've never painted anything yourself?

—Well I have, I have.

—What happened, you couldn't sell them?

—Well no, but . . .

—Why not?

—Well people . . . the critics . . . I was young then, I was still young.

—What are you now, about forty?

—Forty? Me, forty?

—Why not, you look forty. He took a cigar from his pocket, and continued his gaze at the man across from him. —So they didn't like your pictures. What happened, the critics laugh you out of town?

—Well they . . .

—And you got bitter because nobody gave your genius any credit.

—No, I . . .

—And you couldn't make any money on them, so you quit?

—No, it . . .

—And you decided the only thing you could do was patch up other people's pictures.

—No, damn it, I . . .

—Don't get mad, I'm just asking you. He had unwrapped

the cigar, and he raised it to his ear, rolling it between fingers as thick as itself. —Don't you want me to ask you?

—Why yes, yes. And I'm not angry, but, damn it . . .

—Why, do you want to tell me you can do more than patch up old pictures? There was no sound of dryness as he rolled the cigar, lowered it to trim the end off with a gold penknife, and thrust it among uneven teeth.

—Of course I can.

—But you won't, because they won't all stand up and cheer and pay you a big price.

—It isn't that, it isn't those things. They don't matter . . .

—Don't matter? Don't tell me they don't matter, my boy. That's what anybody wants, Recktall Brown said, lighting the cigar. —Everybody to stand up and cheer. There's nothing so damn strange about that.

—But it all . . . it isn't that simple now.

—Now?

—In painting, in art today . . .

—Art today? The uneven teeth showed in a grin through the smoke. —Art today is spelled with an *f*. You know that. Anybody knows it, he added patiently and waited, offering an oppressive silence which forced an answer.

—It's as though . . . there's no direction to act in now.

—That's crazy. You read too much. There's plenty to do, if anybody's got what you've got.

—It isn't that simple.

The smoke from a cigarette mingled with that of his cigar, and he asked, —Why not? and smiled patiently.

—People react. That's all they do now, react, they've reacted until it's the only thing they can do, and it's . . . finally there's no room for anyone to do anything but react.

—And here you are sitting here with all the pieces. Can't you react and still be smart?

—All right then, here I am with all the pieces and they all fit, everything fits perfectly and what is there to do with them, when you do get them together? You just said yourself, art today . . .

—Today? Maybe you put the pieces together wrong.

—What do you mean?

As the smoke rose before him, it became apparent what was wrong. It was the ears. They were hardly ear-shape at all, their

convolutions nearly lost in heavy pieces of flesh hung to the sides of the head, each a weight in itself. —You look forty years old and you talk like you're born yesterday, Recktall Brown said. He stared through his glasses, and the voice he heard was more distant, hardly addressed to him in its first words, —In a sense an artist is always born yesterday.

—Come on now, my boy . . .

—Damn it, am I the only one who feels this way? Have I made this all up alone? If you can do something other people can't do, they think you ought to want to do it just because they can't.

Recktall Brown gestured with his cigar, and an ash fell from it like a gray bird-dropping. —So you're going to stay right here, drawing pictures of bridges, and patching up . . .

—Those bridges, those damned bridges.

—What's wrong with them.

—Who are they all, driving over those bridges as though they grew there. They don't . . . they don't . . .

—They don't give you the credit.

—No, it isn't that simple.

—I'm afraid it is, my boy.

—Damn it, it isn't, it isn't. It's a question of . . . it's being surrounded by people who don't have any sense of . . . no sense that what they're doing means anything. Don't you understand that? That there's any sense of necessity about their work, that it has to be done, that it's theirs. And if they feel that way how can they see anything necessary in anyone else's? And it . . . every work of art is a work of perfect necessity.

—Where'd you read that?

—I didn't read it. That's what it . . . has to be, that's all. And if everyone else's life, everyone else's work around you can be interchanged and nobody can stop and say, This is mine, this is what I must do, this is my work . . . and then how can they see it in mine, this sense of inevitableness, that this is the way it must be. In the middle of all this how can I feel that . . . damn it, when you paint you don't just paint, you don't just put lines down where you want to, you have to know, you have to know that every line you put down couldn't go any other place, couldn't be any different . . . But in the midst of all this . . . rootlessness, how can you . . . damn it, do you talk to people? Do you listen to them?

—I talk business to people. Recktall Brown drew heavily on his cigar, watched the cigarette stamped out, the brandy finished.

—But . . . you're talking to me. You're listening to me.

—We're talking business, Recktall Brown said calmly.

—But . . .

—People work for money, my boy.

—But I . . .

—Money gives significance to anything.

—Yes. People believe that, don't they. People believe that.

Recktall Brown watched patiently, like someone waiting for a child to solve a simple problem to which there was only one answer. The cigarette, lit across from him, knit them together in the different textures of their smoke.

—You know . . . Saint Paul tells us to redeem time.

—Does he? Recktall Brown's tone was gentle, encouraging.

—A work of art redeems time.

—And buying it redeems money, Recktall Brown said.

—Yes, yes, owning it . . .

—And that's why you sit around here patching up the past. Recktall Brown leaned forward, resting his elbows on his broad knees.

—That's why old art gets the prices, he said. —Everybody agrees on it, everybody agrees it's a masterpiece. They copy them right and left. You've probably done copies, yourself.

—Not since I studied. And who wants them? Who wants copies.

Recktall Brown watched him get up suddenly, and walk over to the window, there the rain streaked the glass into visibility.

—Nobody wants copies. He ground out his cigar in an ashtray.

—The ones who can pay want originals. They can pay for originals. They expect to pay. He paused, and then raised his tone.

—As long as an artist's alive, he can paint more pictures. When they're dead, they're through. Take the old Dutch painters. Not even the best ones. Some small-time painter, not a great one, but known. Exclusive, like . . . like . . .

—The Master of the Magdalene Legend, came from across the room, blurred against the window.

—No chance of him not selling. Suppose some of his pictures, some of his unknown pictures, turned up here and there. They might turn up a little restored, like the kind of work you

do. Look at that canvas in there, what is it? He did not look at the canvas inside the door of the studio where he motioned, but at the perspiring face that turned toward it.

—Nothing. A canvas I prepared two or three years ago. I never . . .

—Well just suppose, Recktall Brown went on, not allowing him to interrupt, —suppose you did some restoring on it. If you worked there for a while you might find an undiscovered picture there by Master what-ever-he-was. It might be worth ten thousand. It might be worth fifty. He got to his feet, and walked quietly toward the back turned on him. —Can you tell me you've never thought of this before?

—Of course I have. They were suddenly face to face. —It would be a lot of work.

—Work! Do you mind work? Recktall Brown reached out his two heavy hands, and took the arms before him. —Is there any objection you've made all this time, over all the work you have done, and can't do, that this doesn't satisfy?

—None, except . . .

—Except what?

—None.

Recktall Brown let go of him, and took another cigar out of his pocket. His mouth seemed sized to hold it, as he unwrapped it, trimmed the end, and thrust it there. —The critics will be very happy about your decision.

—The critics . . .

—The critics! There's nothing they want more than to discover old masters. The critics you can buy can help you. The ones you can't are a lot of poor bastards who could never do anything themselves and spend their whole life getting back at the ones who can, unless he's an old master who's been dead five hundred years. They're like a bunch of old maids playing stoop-tag in an asparagus patch. His laughter poured in heavy smoke from his mouth and nostrils. Then he took off his glasses, looking into the perspiring face before him, and a strange thing happened. His eyes, which had all this time seemed to swim without focus behind the heavy lenses, shrank to sharp points of black, and like weapons suddenly unsheathed they penetrated instantly wherever he turned them.

When Esther came in alone she paused in the entrance to the living room, not listening to the music but sniffing the air. Then she jumped, startled. —I didn't see you, I didn't see you standing there . . . She sniffed again. —That funny smell, she said. The smell of the dog, weighted with cigar smoke, had penetrated everywhere. —Has someone been here? She turned on a light. —What's the matter, who was it? She stopped in the middle of taking off her wet hat. —Recktall Brown? she repeated. —Yes, I've heard something about him. What was it. Something awful. She coughed, and got her hat off. —I'm glad I can't remember what it was. As she crossed the room she said, —What *is* that music?

In the doorway of the bedroom she stopped. —Do you remember that night? she asked. —In that Spanish place? . . . She stood looking at his back, and finally said, —Oh nothing. She put her hand to her hair. —Nothing, she repeated, turning toward the bedroom, —but I liked you better flamenco.

"Most people make a practice of embellishing a wall with tin glazed with yellow in imitation of gold, because it is less costly than gold leaf. But I give you this urgent advice: to make an effort always to embellish with fine gold and with good colors, especially in the figure of Our Lady. And if you try to tell me that a poor person cannot afford the outlay, I will answer that if you do your work well, and spend time on your paintings, and good colors, you will get such a reputation that a wealthy person will come to compensate you for your poor clients; and your standing will be so good as a person who uses good colors that if a master is getting one ducat for a figure, you will be offered two; and you will end by gaining your ambition. As the old saying goes, 'Good work, good pay.' And even if you were not adequately paid, God and Our Lady will reward you for it, body and soul."

—What in the world are you reading?

—I don't know, Otto said closing the *Libro dell' Arte*, staring at its worn spine before he put it down. —It was something of his.

JACK KEROUAC

No writer could have been a better choice to introduce Robert Frank's first, groundbreaking book of photographs, *The Americans* (1958), than Jack Kerouac. Kerouac (1922–1969) had only the year before published *On the Road*, his loose-limbed, devil-may-care account of a cross-country trip with friends, and Frank's photographs, with their off-kilter, improvisational compositions, offer an equally open-ended interpretation of mid-century American experience. Kerouac celebrates the unforeseeable narrative twist and Frank cultivates the unexpected visual situation. Both men are hipster documentarians, casting a cool, skeptical, infinitely attentive urban eye on America's jerry-built ambitions and crumbling dreams.

Introduction to Robert Frank's The Americans

THAT crazy feeling in America when the sun is hot on the streets and the music comes out of the jukebox or from a nearby funeral, that's what Robert Frank has captured in tremendous photographs taken as he traveled on the road around practically forty-eight states in an old used car (on Guggenheim Fellowship) and with the agility, mystery, genius, sadness and strange secrecy of a shadow photographed scenes that have never been seen before on film. For this he will definitely be hailed as a great artist in his field. After seeing these pictures you end up finally not knowing any more whether a jukebox is sadder than a coffin. That's because he's always taking pictures of jukeboxes and coffins — and intermediary mysteries like the Negro priest squatting underneath the bright liquid belly *mer* of the Mississippi at Baton Rouge for some reason at dusk or early dawn with a white snowy cross and secret incantations never known outside the bayou — Or the picture of a chair in some cafe with the sun coming in the window and setting on the chair in a holy halo I never thought could be caught on film much less described in its beautiful visual entirety in words.

The humor, the sadness, the EVERYTHING-ness and American-ness of these pictures! Tall thin cowboy rolling butt outside Madison Square Garden New York for rodeo season, sad, spindly, unbelievable — Long shot of night road arrowing forlorn into

Robert Frank: *Bar—Las Vegas, Nevada*, photograph, 1955.

immensities and flat of impossible-to-believe America in New
Mexico under the prisoner's moon — under the whang whang
guitar star — Haggard old frowsy dames of Los Angeles lean-
ing peering out the right front window of Old Paw's car on a
Sunday gawking and criticizing to explain Amerikay to little
children in the spattered back seat — tattooed guy sleeping
on grass in park in Cleveland, snoring dead to the world on
a Sunday afternoon with too many balloons and sailboats —
Hoboken in the winter, platform full of politicians all ordinary
looking till suddenly at the far end to the right you see one of
them pursing his lips in prayer politico (yawning probably) not
a soul cares — Old man standing hesitant with oldman cane
under old steps long since torn down — Madman resting under
American flag canopy in old busted car seat in fantastic Venice
California backyard, I could sit in it and sketch 30,000 words
(as a railroad brakeman I rode by such backyards leaning out of
the old steam pot) (empty tokay bottles in the palm weeds) —
Robert picks up two hitch hikers and lets them drive the car, at
night, and people look at their two faces looking grimly onward
into the night ("Visionary Indian angels who *were* visionary

Indian angels" says Allen Ginsberg) and people say "Ooo how mean they look" but all they want to do is arrow on down that road and get back to the sack — Robert's here to tell us so — St. Petersburg Florida the retired old codgers on a bench in the busy mainstreet leaning on their canes and talking about social security and one incredible I think Seminole half Negro woman pulling on her cigarette with thoughts of her own, as pure a picture as the nicest tenor solo in jazz . . .

As American a picture — the faces don't editorialize or criticize or say anything but "This is the way we are in real life and if you don't like it I don't know anything about it 'cause I'm living my own life my way and may God bless us all, mebbe" . . . "if we deserve it" . . .

Oi the lone woe of Lee Lucien, a basketa pitty-kats . . .

What a poem this is, what poems can be written about this book of pictures some day by some young new writer high by candlelight bending over them describing every gray mysterious detail, the gray film that caught the actual pink juice of human kind. Whether 'tis the milk of humankind-ness, of human-kindness, Shakespeare meant, makes no difference when you look at these pictures. Better than a show.

Madroad driving men ahead — the mad road, lonely, leading around the bend into the openings of space towards the horizon Wasatch snows promised us in the vision of the west, spine heights at the world's end, coast of blue Pacific starry night — nobone half-banana moons sloping in the tangled night sky, the torments of great formations in mist, the huddled invisible insect in the car racing onward, illuminate — The raw cut, the drag, the butte, the star, the draw, the sunflower in the grass — orangebutted west lands of Arcadia, forlorn sands of the isolate earth, dewy exposures to infinity in black space, home of the rattlesnake and the gopher — the level of the world, low and flat: the charging restless mute unvoiced road keening in a seizure of tarpaulin power into the route, fabulous plots of landowners in green unexpecteds, ditches by the side of the road, as I look. From here to Elko along the level of this pin parallel to telephone poles I can see a bug playing in the hot sun — swush, hitch yourself a ride beyond the fastest freight train, beat the smoke, find the thighs, spend the shiney, throw the shroud, kiss the morning star in the morning glass — madroad driving men

ahead. Pencil traceries of our faintest wish in the travel of the horizon merged, nosey cloud obfusks in a drabble of speechless distance, the black sheep clouds cling a parallel above the steams of C.B.Q. — serried Little Missouri rocks haunt the badlands, harsh dry brown fields roll in the moonlight with a shiny cow's ass, telephone poles toothpick time, "dotting immensity" the crazed voyageur of the lone automobile presses forth his eager insignificance in noseplates & licenses into the vast promise of life. Drain your basins in old Ohio and the Indian and the Illini plains, bring your Big Muddy rivers thru Kansas and the mudlands, Yellowstone in the frozen North, punch lake holes in Florida and L.A., *raise* your cities in the white plain, cast your mountains up, bedawze the west, bedight the west with brave hedgerow cliffs rising to Promethean heights and fame — plant your prisons in the basin of the Utah moon — nudge Canadian groping lands that end in Arctic bays, purl your Mexican rib-neck, America — we're going home, going home.

Lying on his satin pillow in the tremendous fame of death, Man, black, mad mourners filing by to take a peek at Holy Face to see what death is like and death is like life, what else? — If you know what the sutras say — Chicago convention with sleek face earnest wheedling confiding cigarholding union boss fat as Nero and eager as Caesar in the thunderous beer crash hall leaning over to confide — Gaming table at Butte Montana with background election posters and little gambling doodads to knock over, editorial page in itself —

Car shrouded in fancy expensive designed tarpolian (I knew a truckdriver pronounced it "tarpolian") to keep soots of no-soot Malibu from falling on new simonize job as owner who is a two-dollar-an-hour carpenter snoozes in house with wife and TV, all under palm trees for nothing in the cemeterial California night, ag, ack — In Idaho three crosses where the cars crashed, where that long thin cowboy just barely made it to Madison Square Garden as he was about a mile down the road then — *"I told you to wait in the car"* say people in America so Robert sneaks around and photographs little kids waiting in the car, whether three little boys in a motorama limousine, ompious & opiful, or poor little kids can't keep their eyes open on Route 90 Texas at 4 A.M. as dad goes to the bushes and stretches — The gasoline monsters stand in the New Mexico flats under big sign

says SAVE — the sweet little white baby in the black nurse's arms both of them bemused in Heaven, a picture that should have been blown up and hung in the street of Little Rock showing love under the sky and in the womb of our universe the Mother — And the loneliest picture ever made, the urinals that women never see, the shoeshine going on in sad eternity —

Wow, and blown over Chinese cemetery flowers in a San Francisco hill being hammered by potatopatch fog on a March night I'd say nobody there but the rubber cat —

Anybody doesnt like these pitchers dont like potry, see? Anybody dont like potry go home see Television shots of big hatted cowboys being tolerated by kind horses.

Robert Frank, Swiss, unobtrusive, nice, with that little camera that he raises and snaps with one hand he sucked a sad poem right out of America onto film, taking rank among the tragic poets of the world.

To Robert Frank I now give this message: You got eyes.

And I say: That little ole lonely elevator girl looking up sighing in an elevator full of blurred demons, what's her name & address?

1958

TRUMAN CAPOTE

Observations, with photographs by Richard Avedon, texts by Truman Capote, and graphic design by Alexey Brodovitch, was the height of sophisticated elegance when published in 1959. And it is without a doubt among the most influential photographic books of the twentieth century. Capote (1924–1984) published his novella *Breakfast at Tiffany's* the year before *Observations* appeared, and like Avedon, who although still in his mid-thirties was already something of a legend in the fashion industry, Capote knew how to combine the otherworldly attentiveness of an aesthete with an equally passionate engagement with the passing parade. Capote's crystalline descriptive technique, which many believe he brought to a pitch of perfection with *In Cold Blood* (1966), may well owe something to the lessons of the all-seeing photographic eye.

On Richard Avedon

RICHARD AVEDON is a man with gifted eyes. An adequate description; to add is sheer flourish. His brown and deceivingly normal eyes, so energetic at seeing the concealed and seizing the spirit, ceasing the flight of a truth, a mood, a face, are the important features: those, and his born-to-be absorption in his craft, photography, without which the unusual eyes, and the nervously sensitive intelligence supplying their power, could not dispel what they distillingly imbibe. For the truth is, though loquacious, an unskimping conversationalist, the sort that zigzags like a bee ambitious to depollen a dozen blossoms simultaneously, Avedon is not, not very, articulate: he finds his proper tongue in silence, and while maneuvering a camera— his voice, the one that speaks with admirable clarity, is the soft sound of the shutter forever freezing a moment focused by his perception.

He was born in New York, and is thirty-six, though one would not think it: a skinny, radiant fellow who still hasn't got his full growth, animated as a colt in Maytime, just a lad not long out of college. Except that he never went to college, never, for that matter, finished high school, even though he appears to have been rather a child prodigy, a poet of some talent,

and already, from the time he was ten and the owner of a box camera, sincerely embarked on his life's labor: the walls of his room were ceiling to floor papered with pictures torn from magazines, photographs by Muncaczi and Steichen and Man Ray. Such interests, special in a child, suggest that he was not only precocious but unhappy; quite happily he says he was: a veteran at running away from home. When he failed to gain a high-school diploma, his father, sensible man, told him to "Go ahead! Join the army of illiterates." To be contrary, but not altogether disobedient, he instead joined the Merchant Marine. It was under the auspices of this organization that he encountered his first formal photographic training. Later, after the war, he studied at New York's New School For Social Research, where Alexey Brodovitch, then Art Director of the magazine *Harper's Bazaar*, conducted a renowned class in experimental photography. A conjunction of worthy teacher with worthy pupil; in 1945, by way of his editorial connection, Brodovitch arranged for the professional debut of his exceptional student. Within the year the novice was established; his work, now regularly appearing in *Harper's Bazaar* and *Life* and *Theatre Arts*, as well as on the walls of exhibitions, was considerably discussed, praised for its inventive freshness, its tart insights, the youthful sense of movement and blood-coursing aliveness he could insert in so still an entity as a photograph: simply, no one had seen anything exactly comparable, and so, since he had staying power, was a hard worker, was, to sum it up, seriously gifted, very naturally he evolved to be, during the next decade, the most generously remunerated, by and large successful American photographer of his generation, and the most, as the excessive number of Avedon imitators bears witness, aesthetically influential.

"My first sitter," so Avedon relates, "was Rachmaninoff. He had an apartment in the building where my grandparents lived. I was about ten, and I used to hide among the garbage cans on his back stairs, stay there hour after hour listening to him practice. One day I thought I must: must ring his bell. I asked could I take his picture with my box camera. In a way, that was the beginning of this book."

Well, then, this book. It was intended to preserve the best of Avedon's already accomplished work, his observations, along with a few of mine. A final selection of photographs seemed

impossible, first because Avedon's portfolio was too richly stocked, secondly because he kept burdening the problem of subtraction by incessantly thinking he must: must hurry off to ring the doorbell of latter-day Rachmaninoffs, persons of interest to him who had by farfetched mishap evaded his ubiquitous lens. Perhaps that implies a connective theme as regards the choice of personalities here included, some private laurel-awarding system based upon esteem for the subjects' ability or beauty; but no, in that sense the selection is arbitrary, on the whole the common thread is only that these are some of the people Avedon happens to have photographed, and about whom he has, according to his calculations, made valid comment.

However, he does appear to be attracted over and again by the mere condition of a face. It will be noticed, for it isn't avoidable, how often he emphasizes the elderly; and, even among the just middle-aged, unrelentingly tracks down every hard-earned crow's-foot. In consequence there have been occasional accusations of malice. But, "Youth never moves me," Avedon explains. "I seldom see anything very beautiful in a young face. I do, though: in the downward curve of Maugham's lips. In Isak Dinesen's hands. So much has been written there, there is so much to be read, if one could only read. I feel most of the people in this book are earthly saints. Because they are obsessed. Obsessed with work of one sort or another. To dance, to be beautiful, tell stories, solve riddles, perform in the street. Zavattini's mouth and Escudero's eyes, the smile of Marie-Louise Bousquet: they are sermons on bravado."

One afternoon Avedon asked me to his studio, a place ordinarily humming with hot lights and humid models and harried assistants and haranguing telephones; but that afternoon, a winter Sunday, it was a spare and white and peaceful asylum, quiet as the snow-made marks settling like cat's paws on the skylight.

Avedon was in his stocking-feet wading through a shining surf of faces, a few laughing and fairly afire with fun and devil-may-care, others straining to communicate the thunder of their interior selves, their art, their inhuman handsomeness, or faces plainly mankindish, or forsaken, or insane: a surfeit of countenances that collided with one's vision and rather stunned it. Like immense playing cards, the faces were placed in rows that spread and filled the studio's vast floor. It was the finally final

collection of photographs for the book; and as we gingerly paraded through this orchard of prunings, warily walked up and down the rows (always, as though the persons underfoot were capable of crying out, careful not to step on a cheek or squash a nose), Avedon said: "Sometimes I think all my pictures are just pictures of me. My concern is, how would you say, well, the human predicament; only what I consider the human predicament may be simply my own." He cupped his chin, his gaze darting from Dr. Oppenheimer to Father Darcy: "I hate cameras. They interfere, they're always in the way. I wish: if I just could work with my eyes alone!" Presently he pointed to three prints of the same photograph, a portrait of Louis Armstrong, and asked which I preferred; to me they were triplets until he demonstrated their differences, indicated how one was a degree darker than the other, while from the third a shadow had been removed. "To get a satisfactory print," he said, his voice tight with that intensity perfectionism induces, "one that contains all you intended, is very often more difficult and dangerous than the sitting itself. When I'm photographing, I immediately know when I've got the image I really want. But to get the image out of the camera and into the open is another matter. I make as many as sixty prints of a picture, would make a hundred if it would mean a fraction's improvement, help show the invisible visible, the inside outside."

We came to the end of the last row, stopped, surveyed the gleaming field of black and white, a harvest fifteen years on the vine. Avedon shrugged. "That's all. That's it. The visual symbols of what I want to tell are in these faces. At least," he added, beginning a genuine frown, the visual symbol of a nature too, in a fortunate sense, vain, too unrequited and questing to ever experience authentic satisfaction, "at least I hope so."

1959

AARON SISKIND

Long before photographs were widely displayed in galleries and muse-
ums, the work of Aaron Siskind (1903–1991) was prized by the Abstract
Expressionist painters and regularly exhibited at the Charles Egan Gal-
lery, where de Kooning had had his first one-man show in 1948 and
Joseph Cornell, Franz Kline, and Philip Guston were also represented.
Siskind frequently focused his camera on weather-worn surfaces and
curious bits of signage, discovering in such quotidian situations an
abstract play of forms that inspired enthusiastic responses from critics
who did not generally write about photography, including Elaine de
Kooning, Harold Rosenberg, and Thomas Hess.

Statement

WHEN I make a photograph I want it to be an altogether new
object, complete and self-contained, whose basic condition is
order—(unlike the world of events and actions whose perma-
nent condition is change and disorder).

The business of making a photograph may be said in simple
terms to consist of three elements: the objective world (whose
permanent condition is change and disorder), the sheet of paper
on which the picture will be realized, and the experience which
brings them together. First, and emphatically, I accept the flat
plane of the picture surface as the primary frame of reference
of the picture. The experience itself may be described as one
of total absorption in the object. But the object serves only a
personal need and the requirements of the picture. Thus, rocks
are sculptured forms; a section of common decorative iron-
work, springing rhythmic shapes; fragments of paper sticking
to a wall, a conversation piece. And these forms, totems, masks,
figures, shapes, images must finally take their place in the tonal
field of the picture and strictly conform to their space environ-
ment. The object has entered the picture, in a sense; it has been
photographed directly. But it is often unrecognizable; for it
has been removed from its usual context, disassociated from its
customary neighbors and forced into new relationships.

What is the subject matter of this apparently very personal
world? It has been suggested that these shapes and images are

underworld characters, the inhabitants of that vast common realm of memories that have gone down below the level of conscious control. It may be they are. The degree of emotional involvement and the amount of free association with the material being photographed would point in that direction. However, I must stress that my own interest is immediate and in the picture. What I am conscious of and what I feel is the picture I am making, the relation of that picture to others I have made and, more generally, its relation to others I have experienced.

1965

RANDALL JARRELL

The poet and essayist Randall Jarrell (1914–1965) hardly ever wrote about the visual arts, although his comic novel, *Pictures from an Institution*, includes some indelibly hilarious descriptions of art objects and arts education, and as an author of children's books he was memorably matched with Maurice Sendak. Jarrell's brief against Abstract Expressionism—first published in 1957 in *Art News*, a magazine strongly supportive of the movement—may not be all that substantial a piece of criticism. But it stands as a reminder that even a decade after the end of World War II, the New York School painters were receiving a less than enthusiastic reception from at least one highly cultivated American. I do not think he was alone.

Against Abstract Expressionism

A DEVIL'S advocate opposes, as logically and forcibly as he can, the canonization of a new saint. What he says is dark, and serves the light. The devil himself, if one can believe Goethe, is only a sort of devil's advocate. Here I wish to act as one for abstract expressionism.

Continued long enough, a quantitative change becomes qualitative. The latest tradition of painting, abstract expressionism, seems to me revolutionary. It is not, I think, what it is sometimes called: the purified essence of that earlier tradition which has found a temporary conclusion in painters like Bonnard, Picasso, Matisse, Klee, Kokoschka. It is the specialized, intensive exploitation of one part of such painting, and the rejection of other parts and of the whole.

Earlier painting is a kind of metaphor: the world of the painting itself, of the oil-and-canvas objects and their oil-and-canvas relations, is one that stands for—that has come into being because of—the world of flesh-and-blood relations, the "very world, which is the world / Of all of us,—the place where, in the end, / We find our happiness or not at all." The relation between the representing and the represented world sometimes is a direct, mimetic one; but often it is an indirect, farfetched, surprising relation, so that it is the difference between the subject and the painting of it that is insisted upon, and is a principal

source of our pleasure. In the metaphors of painting, as in those of poetry, we are awed or dazed to find things superficially so unlike, fundamentally so like; superficially so like, fundamentally so unlike. Solemn things are painted gaily; overwhelmingly expressive things—the Flagellation, for instance—painted inexpressively; Vollard is painted like an apple, and an apple like the Fall; the female is made male or sexless (as in Michelangelo's *Night*), and a dreaming, acquiescent femininity is made to transfigure a body factually masculine (as in so many of the nude youths on the ceiling of the Sistine Chapel). Between the object and its representation there is an immense distance: within this distance much of painting lives.

All this sums itself up for me in one image. In George de La Tour's *St. Sebastian Mourned by St. Irene* there is, in the middle of a dark passage, a light one: four parallel cylinders diagonally intersected by four parallel cylinders; they look like a certain sort of wooden fence, as a certain sort of cubist painter would have painted it; they are the hands, put together in prayer, of one of St. Irene's companions. As one looks at what has been put into—withheld from—the hands, one is conscious of a mixture of emotion and empathy and contemplation; one is moved, and is unmoved, and is something else one has no name for, that transcends either affect or affectlessness. The hands are truly like hands, yet they are almost more truly unlike hands; they resemble (as so much of art resembles) the symptomatic gestures of psychoanalysis, half the expression of a wish and half the defense against the wish. But these parallel cylinders of La Tour's—these hands at once oil-and-canvas and flesh-and-blood; at once dynamic processes in the virtual space of the painting, and spiritual gestures in the "very world" in which men are martyred, are mourned, and paint the mourning and the martyrdom—these parallel cylinders are only, in an abstract expressionist painting, four parallel cylinders: they are what they are.

You may say, more cruelly: "If they are part of such a painting, by what miracle have they remained either cylindrical or parallel? In this world bursting with action and accident—the world, that is, of abstract expressionism—are they anything more than four homologous strokes of the paintbrush, inclinations of the paint bucket; the memory of four gestures, and of the four convulsions of the Unconscious that accompanied

them? . . . We need not ask—they are what they are: four oil-and-canvas processes in an oil-and-canvas continuum; and if, greatly daring, we venture beyond this world of the painting itself, we end only in the painter himself. A universe has been narrowed into what lies at each end of a paintbrush."

But ordinarily such painting—a specialized, puritanical reduction of earlier painting—is presented to us at its final evolution, what it always ought to have been and therefore "really" was. When we are told (or, worse still, shown) that painting "really" is "nothing but" this, we are being given one of those definitions which explain out of existence what they appear to define, and put a simpler entity in its place. If this is all that painting is, why, what painting was was hardly painting. Everyone has met some of the rigorously minded people who carry this process of reasoning to its conclusion, and value Piero della Francesca and Goya and Cézanne only in so far as their paintings are, in adulterated essence, the paintings of Jackson Pollock. Similarly, a few centuries ago, one of those mannerist paintings in which a Virgin's face is setting after having swallowed alum must have seemed, to a contemporary, what a Donatello Virgin was "really" intended to be, "essentially" was.

The painting before abstract expressionism might be compared to projective geometry: a large three-dimensional world of objects and their relations, of lives, emotions, significances, is represented by a small cross section of the rays from this world, as they intersect a plane. Everything in the cross section has two different kinds of relations: a direct relation to the other things in the cross section, and an indirect—so to speak, transcendental—relation to what it represents in the larger world. And there are also in the small world of the picture process many absences or impossible presences, things which ought to be there but are not, things which could not possibly be there but are. The painter changes and distorts, simplifies or elaborates the cross section; and the things in the larger world resist, and are changed by, everything he does, just as what he has done is changed by their resistance. Earlier painters, from Giotto to Picasso, have dealt with two worlds and the relations between the two: their painting is a heterogeneous, partly indirect, many-leveled, extraordinarily complicated process. Abstract expressionism has kept one part of this process, but has rejected as

completely as it could the other part and all the relations that depend on the existence of this other part; it has substituted for a heterogeneous, polyphonic process a homogeneous, homophonic process. One sees in abstract expressionism the terrible aesthetic disadvantages of directness and consistency. Perhaps painting can do without the necessity of imitation; can it do without the possibility of distortion?

As I considered some of the phrases that have been applied to abstract expressionism—revolutionary; highly non-communicative; non-representational; uncritical; personal; maximizing randomness; without connection with literature and the other arts; spontaneous; exploiting chance or unintended effects; based on gesture; seeking a direct connection with the Unconscious; affirming the individual; rejecting the external world; emphasizing action and the process of making the picture—it occurred to me that each of them applied to the work of a painter about whom I had just been reading. She has been painting only a little while, yet most of her paintings have already found buyers, and her friends hope, soon, to use the money to purchase a husband for the painter. She is a chimpanzee at the Baltimore Zoo. Why should I have said to myself, as I did say: "I am living in the first age that has ever bought a chimpanzee's paintings"? It would not have occurred to me to buy her pictures—it would not have occurred to me even to get her to paint them; yet in the case of action painting, is it anything but unreasoning prejudice which demands that the painter be a man? Hath not an ape hands? Hath not an animal an Unconscious, and quite a lot less Ego and Superego to interfere with its operations?

I reminded myself of this as, one Saturday, I watched on Channel 9 a chimpanzee painting; I did not even say to myself, "I am living in the first age that has ever televised a chimpanzee painting." I watched him (since he was dressed in a jumper, and named Jeff, I judged that he was a male) dispassionately. His painting, I confess, did not interest me; I had seen it too many times before. But the way in which he painted it! He was, truly, magistral. He did not look at his model once; indeed, he hardly looked even at the canvas. Sometimes his brush ran out of paint and he went on with the dry brush—they had to remind him that the palette was there. He was the most active, the most truly sincere, painter that I have ever seen; and yet, what did it

all produce?—nothing but that same old abstract expressionist painting . . .

I am joking. But I hope it is possible to say of this joke what Goethe said of Lichtenberg's: "Under each of his jokes there is a problem." There is an immense distance between my poor chimpanzee's dutiful, joyful paintings and those of Jackson Pollock. The elegance, force, and command of Pollock's best paintings are apparent at a glance—are, indeed, far more quickly and obviously apparent than the qualities of a painter like Chardin. But there is an immense distance, too, between Pollock's paintings and Picasso's; and this not entirely the result of a difference of native genius. If Picasso had limited himself to painting the pictures of Jackson Pollock—limited himself, that is, to the part of his own work that might be called abstract expressionism—could he have been as great a painter as he is? I ask this as a typical, general question; if I spoke particularly I should of course say: If Picasso limited himself in anything he would not be Picasso: he loves the world so much he wants to steal it and eat it. Pollock's anger at things is greater than Picasso's, but his appetite for them is small; is neurotically restricted. Much of the world—much, too, of the complication and contradiction, the size and depth of the essential process of earlier painting—is inaccessible to Pollock. It has been made inaccessible by the provincialism that is one of the marks of our age.

As I go about the world I see things (people; their looks and feelings and thoughts; the things their thoughts have made, and the things that neither they nor their thoughts had anything to do with making: the whole range of the world) that, I cannot help feeling, Piero della Francesca or Brueghel or Goya or Cézanne would paint if they were here now—could not resist painting. Then I say to my wife, sadly: "What a pity we didn't live in an age when painters were still interested in the world!" This is an exaggeration, of course; even in the recent past many painters have looked at the things of this world and seen them as marvelously as we could wish. But ordinarily, except for photographers and illustrators—and they aren't at all the same—the things of our world go unseen, unsung. All that the poet must do, Rilke said, is praise: to look at what is, and to see that it is good, and to make out of it what is at once the same and

better, is to praise. Doesn't the world need the painter's praise any more?

Malraux, drunk with our age, can say about Cézanne: "It is not the mountain he wants to realize but the picture." All that Cézanne said and did was not enough to make Malraux understand what no earlier age could have failed to understand: that to Cézanne the realization of the picture necessarily involved the realization of the mountain. And whether we like it or not, notice it or not, the mountain is still there to be realized. Man and the world are all that they ever were—their attractions are, in the end, irresistible; the painter will not hold out against them long.

1957

JOHN GRAHAM

Born in Kiev, the painter John Graham (1886–1961) was already an ardent modernist when he arrived in New York in the 1920s, and by the 1930s he had become a galvanic figure for American friends, among them David Smith and Willem de Kooning. Graham's wide-ranging enthusiasms were infectious. He taught younger Americans to grapple with unfamiliar works by Picasso, to absorb the contemporary implications of Ingres's Neoclassicism, and to understand the African sculpture of which Graham was a collector and connoisseur. Graham was an extravagant and enigmatic personality who sported military regalia, spun myths around his Russian past, and in 1937 published *System and Dialectics of Art*, a brilliant and prickly treatise on the nature of artistic experience that was once a familiar sight in Manhattan studios. He could be extraordinarily generous with his knowledge and contacts, organizing a famous group show in 1942 that featured de Kooning, along with Jackson Pollock and Lee Krasner, who first met at the time. Although Graham painted abstractly early in his career, by the time of his death in London he had spent several decades developing an allegorical representational style that was sui generis, with figures sometimes set in a maze of enigmatic symbolic forms.

Excerpts from an Unfinished Manuscript Titled "Art"

ART in all its forms, painting, music, architecture, literature, dance, drama, has never been used for decorative purposes or for entertainment. Up until the eighteenth century it was a secret, sacred language used in adoration, evocation, conjuration of this world's forces or spirits. Only since the eighteenth century have some countries, considering themselves emancipated and enlightened, reduced art, in all its manifestations to entertainment, which eventually has degenerated into a debauch of irresponsible speculation and shameless grimacing, which in turn leads humanity to utter desolation. Humanity as a result is running away from order, control and discipline into a slavery which, on the subconscious level, all human beings so ardently desire. The power of repetition is the most powerful weapon humanity knows. By means of repetition, publicity and propaganda exploit human vanity and the death instinct. One

can sell to human beings black pages under the guise of a book, or blank canvas as a profound painting, etc. It is only a matter of how much money you are willing to spend on publicity or propaganda.

Intellectuals are people who know all the labels, but the meaning of none. They speak an international crooks' jargon which is no more than a phonetic jibber-jabber, such as: "creative art," "form," etc., a logical nonsense. Only Divine Powers or Forces can create something from nothing. Man, at best, can imitate, adopt, interpret, elucidate, arrange, organize, analyze, synthetize, compose, comment, reveal. Leonardo never pretended to do more.

Good design, good taste, originality, talent, all are contrary to art. Talent is an impediment because it lulls its possessor into easy effects and clouds the issues to the public. Knowledge is the only art weapon, if you have talent *on top* of it, so much the better. Charm, good taste, good design, good composition, originality are contrary to art. If you fill a room with 10,000 beginners and put a nude model in front of them, all their drawings will be highly original, their personalities will have a free play due to the lack of *knowledge*, charm of freshness, innocent awkwardness, which all is cute but has no value, only a *potential* value, which is no value at all. Any farm boy coming to the big town dresses in a flashy haywire style, then he learns the civilized ways and acts like everyone else and should he reach a high peak of development he might revert to flashy clothes, *but*, with a special discernment, with *controls* applied. If you let 10,000 beginners draw from a nude model, every day, in the same pose for ten years, all their drawings will look *alike* and no originality, which is exactly the purpose of education, or knowledge in art will remain. Except, maybe one of the 10,000 will show some imperceptible personal touch on top of his perfect technique; this is art! *Maybe!* Talent, every one has, talent for something, but to have *knowledge* is difficult. In the whole world perhaps two or three men had knowledge, men like Leonardo, Raphael, Cranach, Cellini, Giovanni Bellini, Antonello da Messina, Donatello, Carpaccio, Franz Krüger, Ingres. They never wanted to be original because originality is merely a lack of perfection and a commercial trademark which distinguishes one tooth-paste from the other. Art does not need it, it arrives higher, it arrives

at perfection, a vertiginous, perilous defiant perfection, which does not rely upon the "personal," queer, quirk, or "personal" brash stroke. To achieve perfection one must rely upon only one thing: knowledge, the knowledge of a *figura* in its Dante-esque meaning, the effigy, the revealing image or truth yet in terms of drab reality. It is not given to many to pierce the mystery of perfection. It is not given to many to view and see perfection. As Cézanne put it, "nothing looks more commonplace than a masterpiece." Giovanni Bellini or Antonello da Messina look plain, serene, above the turbulent vortex, above good and evil, indifferent, in a frozen zone.

The real article never looks the part. A man who looks like a poet is never a poet, and a real poet never looks like one.

Only artificial things are good, because they represent the domination of superior sense over the brute instincts. Natural impulses are only too eager to break loose and do some mischief. At all times, culture could have been achieved only by means of: inhibitions, repressions, controls, discipline, order.

A civilization is measured by the quality of its art; an art is estimated by the tenor of its civilization.

Purity, a complete purity, hermetically sealed, is the measure of all greatness.

The primitive, naïve or simplified art is without value because it is void of repressions and controls.

What is the difference between simple walking and tightrope walking? The very nature of control is a subject of admiration due to the architecture of the human mind.

Man cannot invent or imagine something which does not already exist in the world. The most monstrous monster invented by the most imaginative artist has *only* the elements of monsters already in nature.

There is nothing in books that does not exist in nature. In art, all elements of nature are present, but reorganized. Since all the books that have been written depict things already existing, they consequently represent only second-hand information about things, and not exhaustive information about things, and not exhaustive information at that. Intellectuals, whose knowledge is derived from books, draw their information naturally from the second-hand sources, and consequently have a second-hand knowledge of life. Machines are made from books and

thus offer third-hand information about nature. People who man machines, consequently, have a third-hand knowledge of things. A businessman who markets the goods produced by the machines has a fourth-hand information about life, and so on. The intellectual, essentially, is a middleman with a vague idea of basic earthy values, adulterated with some nebulous, speculative information. An intellectual's purpose in life is to fill up the international latrines.

Many people call themselves "artists," which is a logical absurdity; there is no such profession. "Artist" is a qualitative adjective denoting a certain perfection in one's profession. The best shoemaker, baker, musician, painter, architect, in their respective communities, may be called artists or monsters. When a man becomes an outstanding master in his craft, people may call him artist. The knowledge of a craft implies honesty and sense of responsibility.

Humanity loves its saints to be served rare, *saignants.*

The Intellect is a source of ignorance: the more you study in a conventional way the more ignorant you become. Our intellect is a useless tool because, it is a victim and a slave of sensory perceptions, which condition the intellect, likes and dislikes, judgment. Only an intellect free of sensory perceptions, free of conditions, desires and attachment, may become a workable tool.

The things we know impede us from seeing things we do not know.

All great crafts possess a secret teaching and formulas. The basis of all art was architecture. In Greek, "architecture" means super-secret. The secret, sacred doctrine or teaching has been lost. A modern architect does not know anything, he cannot even design a window, a simple organic window, like one sees in Renaissance buildings. There was a secret, sacred model or cipher of declension, one cipher in each case or even for all cases. Perhaps there is *one* single model for all vases of all countries! From this single number, or measure, everything is refracted, multiplied, divided, assembled. A secret angle of deviation, *La Divina Proportione*, is based on it. A secret cipher, secret angle or angle of deviation, or refraction, angle of cleavage, projection, the ratio of Forms. The secret model is not just a model, but a special, particular cipher distilled through

hermetic processes to arrive at a fateful number which assumes total command of all situations and combinations to lead to a perfect command of all situations and combinations, to lead to a perfect solution.

Fragments of the Secret Teaching are scattered all over the world, through the most incongruous crafts. Those who know can recognize these fragments and gather them together, perhaps in hope of reconstructing the initial marvel.

Painting is a very definite, limited and precise proposition, like any proposition in, say, philosophy or mathematics, or the like, or tennis, dentistry or boxing. Tennis is a game with standards, little courts and rules. You may come up with a baseball bat and hit the tennis ball miles away; it is, perhaps, much better than tennis, but it is not tennis. Dentistry is an art which teaches how to pull out teeth, according to certain rules; you may come up with a big bat and with one stroke knock out all the teeth from someone's mouth. No doubt, it is much better, but it is not dentistry. Painting is confined to certain given problems and given methods of resolving them. Anything else, more drastic, more dramatic, more daring you might wish to do is, no doubt, better, but it is not painting. For one thing, "modern artists" are too timid and too conventional, to be really devastating. Attacking canvases with rollers, broomsticks, etc., is constipated. Why not do a painting as long as Fifth Avenue and as wide as Manhattan? This is daring; and pound it with cannons instead of paltry broomsticks. Which all goes to show that painting is just painting and not bricklaying or boxing or anything else which, no doubt, is better, but is not painting.

Art in all its manifestations, at all times, was a form of religious ritual worship subject to rules much stricter than mere painting in the nineteenth century. These strict, ritual rules made painting, and other arts, open only to those who were naturally gifted.

If you examine all existing tapestries of the fifteenth century, you will find that they are all beautiful and perfect in every aspect of craft, composition and art. How do you account that today in ten thousand paintings you will hardly find one palatable? There must be an explanation. It is because the epoch itself was better, stricter and the craft itself was more rigorous and exclusive, and men were inspired not by "art" but by a religious

fervor or craft fervor. All this is to show that instead of trying for greater so-called "freedom of expression" or destruction of the world around and of themselves, so-called "artists" should try to devote themselves to a detached subject and to their own craft, try to convey a message and not to produce a pretty decoration. The purpose of life in society, art and civilization, is: the greater order, discipline, control and inhibitions to produce and organize culture, a culture that functions in concert, like an organism. In Zen, the archer must reach such technical and spiritual perfection as to identify himself to such an extent with the target, that the target becomes himself. Perfection means that the arrow, sent out by the archer, hits the archer himself, square in the solar-plexus, thus realizing the perfect Sunburst, because self-immolation *is* the ultimate aim of archery, and of itself. The Greeks knew it and so did the Egyptians. Hence the secret of Egyptian and Greek statuary is that every male figure of a divinity or warrior is always wide-open, *defenseless*, ready for the great Ritual Immolation, the *secret* purpose of all arts, of all endeavor! This heroic task is not for the feeble-minded, soft, scheming, pettyfoggers, doubledealers and scavengers. The artist's job is a Hector's task and nothing less. Those who are not equipped with Hector's heart, aim and perspicacity, should keep their profane hands off the domain of art.

Complete Innocence is: the power integral. Complete Knowledge is the force integral. The difference between the power and the force is that the power is a rightful, faultless prerogative while force is the actual ability to execute.

Silence is: wisdom integral.

Immolation or human blood is beauty integral. All great artists were attracted by St. Sebastian, not because he was a great saint of the church, which he was not, but because he provided the most blood for display. Caligula and Nero were the greatest artists, philosophers, moralists and dandies. Cheap, middle-class historians cannot understand them. Caligula and Nero were the supermen, beyond good and evil, like angels in a frozen zone. They knew it.

ALFRED RUSSELL

Although nearly forgotten today, the painter Alfred Russell (1920–2007) was very much a figure in New York in the late 1940s and early 1950s, when his abstract paintings were in exhibitions at the Kootz and Sidney Janis galleries. Russell, who had an abiding fascination with geometric structures and classical themes, never really saw abstraction and representation as irreconcilable values, and in compositions that call to mind the labyrinthine Mannerist style of the early sixteenth century he forged an idiosyncratic and highly personal modern vision. "Toward Meta-Form"—a statement published in 1960 in *It Is,* a magazine associated with the Abstract Expressionists—captures the layered richness of his pictorial imagination.

Toward Meta-Form

TODAY the informal, expressive, sensitive and subjective nuances of form make up the corpus of art structure. *L'art autre* is the idiom, the colloquial language, the argot, the code of mass communications from which we build our world picture—which has become fixed, rigid, stagnant and a commodity on the art market.

We have an intuitive familiarity with the tangled web of Georg Kantor space and seem to plot our way ultimately by means of indeterminate quantic signposts, obeying the implacable laws of chance and their dogma. Yet form in art, in physics, in language and in perception is still veiled in mystery, and the simple basic solids which we think we know are unfamiliar to us. Some say that as a result our ability to intuit the new space and its metaphors suffers—our form-sense is atrophied. Our minds need the forms of Pythagoras, Plato and Euclid as a vehicle, as medium, as casual link in the visualization of the new reality—space-time physics, relativity, contingental metaphysics, being and nothingness—and its processes.

The need for a solid image, a logical configuration, a working model self-contained and obeying the classical laws of mechanics, has been stated by most abstract thinkers of recent times. Cannot the graphs and the coördinate paths of quanta-wave energy, the geodesic lines of space (Riemannian space), and line

drawings illustrating simultaneity, rotation, space-time mani-
folds and other theoretical systems be considered as forms in
the traditional Euclidian sense of the word "form"? In his essay,
"The Relation of Sense Data to Physics," Bertrand Russell says,
"Logical constructions are to be substituted for inferred enti-
ties." Max Planck has stated that there is a need to adopt the
idea of our physical world to the requirements of reason. The
non-Euclidean geometries of Bolyai, Lobachewski and F. Klein
tried to produce, within the framework of Euclidean geom-
etry, a model of the non-Euclidean world which would be

Alfred Russell: *The Wrath of Achilles*
(Hiroshima Forces), 1959. Oil on
canvas, 57 × 33 in.

immediately comprehensible to our three-dimensional vision. The constructions to be seen at the Henri Poincairé Institute in Paris, as well as models of organic molecular structure, crystallography and nuclear structure, are examples of the possibilities of representing the theory, the event and the process of reality as a tactile solid or, in Bernard Berenson's words, as "tactile vision."

Although Cézanne, the cubists, constructionists and neoplastic painters have similarly tried to create a new reality of solid forms and their relationships, it is obvious today that their credo has not changed the visual data, the "look," of contemporary art. The aspirations, the motivations and real world of contemporary art are far in advance of its tactile sensibility, which is tentative and left to chance. Painting as an object of the vision is open to limitless and extra visual-tactile interpretations in which its inherent and necessary meanings are often completely lost.

Etienne Gilson's "Painting and Reality" defines paintings as physical beings—more precisely, solid bodies—endowed with an individuality of their own. Each work of art is a completely self-sufficient system of internal relations, regulated by its own laws and judged from the point of view of its own structure. But if the nature of solids, their internal relations and laws, are no longer understood or valued, I believe even the informal art, *l'art autre*, will be of little meaning.

Therefore I believe a reconsideration of the logic of solids is necessary today, but this study must be limited to the specific problem of depicting basic polyhedra on a flat surface and, as observed from those forms, lines and plane relationships. A reading of Plato's description (*Timaeus*, 53–55) of the miraculous evolution (from scalene and right-angle equilateral triangles) of the pyramid, octahedron, icosahedron and dodecahedron will remind you of the awesome seriousness of this problem. It is in Luca Pacioli di Borgo's *De Divina Proportione*, illustrated by Leonardo, that we may find one of the most complete and clear graphic revelations of the logic of form as it was known to antiquity. Axes, extensions, bisections, arcs, tangents and harmonic divisions submit the polyhedra to the whole repertoire of Euclidean logic, producing new and unexpected forms, sudden transmutations of forms and chain reactions leading to extraordinary formal discoveries. Pacioli's discovery of the

sixty possible superimpositions of the icosahedron enabled F. Klein, four hundred years later, to map out his solution of fifth-degree equations in his multi-dimensional geometry. Dürer's almost Faustian obsession with the mysterious logic of solids, amorphism and shifting systems of coördinates, as revealed in his sketchbooks of the 1520's, is a relatively untouched source of whole new form concepts. But the whole history of art can be explored for this form sense: Uccello, Piero della Francesca, Alberti, Brunelleschi, Pellerin, Cousin, Bosse, Zuccari and Schön, for example.

This, of course, is a long-term project and unlikely to appeal to today's artist. For some strange reason, art historians and aestheticians have left most of this material untouched or, at most, have treated it superficially. As has been stated by Gilson, they don't want to make art too easy for artists and too difficult for critics and historians. A more practical solution for the artist is a study of descriptive and projective geometry by means of such books as the famous *Anschauliche Geometrie* of David Hillbert and Cohn Vassen (Berlin, 1922). By means of schematic line drawings addressed to our immediate, visual, intuitive understanding, we may extend our ability to represent the three-dimensional image of form and its logical implications. Through such specific subjects as surfaces of revolution, ellipsoid and hyperboloid solids, plane and multi-dimensional lattices, discontinuous groups of motions, unit cells, projective configurations, stereographic projection, curvature of surfaces, and the twisting of space curves, geodesics and topology of polyhedra can and must become part of our visual data, our formal documentation and daily form-sense.

Mondrian's statement, "Form is limited space, concrete only through its determination," and Cézanne's ambition to construct a geometry of visual appearances are still pointing the way to the future.

The refinements and hidden nuances and still-unexplored regions of form have only been suggested by such men as Matila Ghyka in *Esthétique des Proportions*, D'Arcy Thompson in *Growth of Form* and Theodor Cook in *Curves of Life*. The works of Brancusi, Gabo, Pevsner, Moholy-Nagy, Max Bill and Le Corbusier are but hints to the new generation of artists of the unfathomable enigmas and splendor of geometric solids.

Buckminster Fuller's Synergetic-Energetic Geometry and his Dymaxion seem again to tackle the problems left unsolved by Leonardo and Dürer and point the way to a new liberation of the imagination.

The artists of today and tomorrow will say with Hölderlin:

> As my heaven is of iron
> So am I myself of stone.

1960

JOSEPH CORNELL

Joseph Cornell (1903–1972) brought a Yankee astringency to his tenderhearted Surrealist dreamscapes. Inspired in the 1930s by the half-comic, half-nightmarish collages that Max Ernst created by cutting up nineteenth-century engravings, Cornell developed his own kind of three-dimensional collage, tumbled and fractured salutes to night skies, childhood games, pinball machines, and the artistic and literary glories of the faded European capitals Cornell visited only in his dreams. Cornell experimented with the cinematic arts and collected photographs and memorabilia associated with great ballerinas, both living and dead, sometimes assembling this material in elaborate albums. He lived most of his life in Queens, with his mother and a brother who suffered from cerebral palsy, and in his later years the house became a pilgrimage site for artists and writers bewitched by his work. In his diaries Cornell kept a record of his forays into Manhattan, where he visited museums, galleries, libraries, and the city's then-formidable array of secondhand bookshops, collecting much of the material that later went into his work. Manhattan, as refracted in these glancing diaristic impressions, sometimes suggests the layered images and ideas in those boxes that he created when he was back home in Queens.

From the Diaries

Great Dog

1/7/56 12:30 PM

Splendid clear spread of stars
On to pre Christmas elation
of sky gazing

García Lorca, Edwin Honig (New Directions, 1944)
Bought 1/7/56 pm
Satie "Gymnopédies"
day of shooting fire escape window Mulberry St. & bridge
Brooklyn side
Sheree North Dream
see diary 2/13/56 renewal of inspiration for future (Suzanne)

1/11/56

another rainy morning like
yesterday all over again
almost—at the breakfast
table—kitchen—homemade
coffee cake and cream—
a dwadler for the apricot fée
(★ of yesterday)
College Point bus

indifferent kind of mood again
just skirting going under
(i.e. not a crisp awakening as
desired, around 6—*getting in the clear*)
damnable torpor that seems diabolically
hard to keep out
this instead at 11:15 pm

just now—looking toward grey drab scene past the creek to the
causeway traversal yesterday—the gulls!
very distant—and it must be the same horde that frequents the
miniature golf links
seen night after apricot fée
3:00 same day
young *girl in red coat* church quiet mood
wouldn't have meant much this morning without yesterday—
although should be something to catch the eye—on such a
colorless morning—swarming like bees!

1/15/56 2:15 AM COLD, OVERCAST

beautiful Watts portrait of Ellen Terry

The Watts "Ellen Terry" on the bed from this morning—
clean up etc., how distant—yet what a reminder of heart in
the unresolved mood of this Wednesday morning preoccupa-
tion with something seemingly fruitless can enter into (help
along) such an unfoldment as on Wednesday—after library

("The Laurel and the Thorn"—Watts (same Terry)—theatre
Chalk Garden etc.)—after just a simple thing like this held
on to bring something altho hard to nail down with words—
accentuating (commentary on) not a really healthy state of
mind (because unnecessarily complex)

THURS. 2/9/56

—a feeling "came over" me this morning in a kind of reac-
tionary state—the pleasure of yesterday morning, the unex-
pected such as yesterday—the Barrault—Rimbaud played first
turning out to be a prime pleasure—sunniness for days—brief
joy arriving home before 5—coming out vs "intoxicated" lin-
gering in El ride—Corona—in certain landscape panorama—
appreciation of variation of light on pigeons and freight
cars—poem—spring like but misty

2/13/56

all of a sudden—the warm miracle, the "music"—here in the
plate glass window of the cafeteria with *Lorca* (late morning
snack and breakfast) watching the passing scenes—late winter
like blustery early spring—the passing scene—Kaleidoscope of
small town monotony brightened by the same warm sun near
meridian—orange buses—sense now of people individuals—
all the common place because warm (the common colors)
jewel-like—sense of drama—as potent as theater

FOR STAN SUZANNE*

not the vibrant extreme this morning from depression into
exultation—accomplishment cellar work before starting—
always a satisfaction in itself regardless of following day
the Lorca book became vibrant inspiration for film—not
Lorca verses themselves so much as own feeling for city and
life etc.

*Stan Brakhage, Suzanne Miller

2/15/56

How beautifully the resolution—coming late in day after
vile kind of reaction—bed instead of regular start for town—
rather what is lost sight of—gradual adjustment to later go-
ings at times—and this warm kind of loosening up vs. former
tense church attendance—Wildenstein gallery after Stable
Musée Jacquemart-André reminder—recapture—of golden
days of gallery trotting (Rudi Suzanne inspiration Rimbaud)

THE STARRY FLOOR—in children's room library—
★ Pavlova memorial exhibition
Lorca records seen in Record Hunter
Beaux-Arts article on Van Eyck–Pintoricchio read kitchen
night again seemingly completely different fervent feeling
about day—as tho routine, set events shuffled with a fairy
touch

★ Stars exceptionally resplendent—SICKLE bright and clear
overhead midnight
Color about 7 sunrise tho misty pink blue false dawn? then
clouding over rainy leaving house gradual clearing up to cold
and clear *above all* the warm sense pervading the minutiae of
things and people

2/24/56 FRIDAY

(noted following morning breakfast)
"portrait"—★ altho brief
reflection of straight profile of a young woman pulling into
Main St.—synthetic blonde but angelic impact—red white
and blue silk stole wrapped around back of head tied under
chin—against black snowy night creek area—"double ex-
posure" of primary orange signal—not unlike Parmigianino
detail (cut off one) in "Madonna with Long Neck"

10:10 PM some leisure after refreshment—sleep not too com-
mon—almond paste butter strip from Nedick's 14 St—
dialectic of one in Main St.—Tuesday morning of this week—
diametrically opposite mood

FEB. 24, 1956 5 P.M.

—at 3:30 went "dead" after so-so trip into town—bus down 6
ave—Bickford nice doughnut and drink
Berliner stamps—Record Hunter Mahler # 7 "Night"
Morgan Library Altman's Cerrito green stationery
and now Nedick's the warm music almost breaking—but
undercurrent nervousness—cat card like Magritte for Stan—
school kids and teens by Morgan crossing Madison
Donne quote to Tchelitchew
Ondine green large ape inspiration 100001 time for mounting
mediums patch of color much margin
bag in Altman's to collect "loot"—the accelerated sense of
treasure and 4th Avenue browsing lost since anticipation of
early morning—Mozart #25 came 1st movement playful mo-
tive breaking thru—"clear"—now again—overcast sunny look
after almost spring touch—the new lights on now—twilight
mystery setting in (dialectics of home thoughts Mother
and Robert for this mood seldom noted in endless diary
scribblings)
6:25 en route El subway *snow!* skyline dirty haze—mean
cold—found "Lélia"—neck pressure—borderline mood—
nervousness but not on verge of uncontrollable—
last eve—saw teenager for 1st time in year—seems completely
changed—even physically—hardly recognized her—had
been to library many times without seeing her (Barbara)—
memories of Xmas package for her year ago left anon—period
of "Scarlatti Parrot" (Xmas 1955)—things like this of which
one might expect such an opportunity to do more than just
a diary note—come and go too easily (from former changed
state of mind)

3/8/56

Friday sunny cold—Nedick's—unlike wonderful morning of
a week ago yesterday wonderful?—neck pressure actually but
good working out none the less—for an exhilarating jaunt—
and then the check from STABLE with its impact—warm
very warm inside the Nedick's
Robert waiting to get up—yellow beige walls—Bickford's too
crowded

MARCH 20, 1956

flavor vs mere cataloguing
"aftermath" ★ of *yesterday*
a superb moment
pulling out the box of Cerrito material from under bed—after
months of inattention
sense of vintaging, as last look also months ago—in garage at
similar GC44 material—morning just before noon—stuffing
of boxes from closet to cellar *tonic feeling* accomplishment at
home (vs wanderlust and its sometimes frustrations)
player in kitchen
late at night—just listening to voices on "I Puritani"—had for
months (this Angel recording) still awaiting night time (seem-
ingly hard to come by—in any event—the superb intonation
of the bass of Bruno (1st on record)—deeper appreciation of
this "Bellini accent."

3/21/56

first early morning jaunt since week ago Flushing Main
St. (Suzanne 1st films) and Lorca book in *Bickford's*—to-
day *Nedick's*—relaxed mood but not the same *élan*—why try
to keep capturing it in words—sunny and clear mid 30's—nice
taste of almond paste in butter strip
lack of that electric something but decent enough jaunt—
sluggish reaction last evening after some good touches cellar
morning—maniacal
—frustration and stagnation thinking of explorations in pic-
tures, literature, music etc.
sense of "illumination" bookstore on 6 ave—a touch of
sylphide too vs atmosphere in that section—l'Ondine
abondante

one of these resolutions all day drab up to around 4—then
the warm "music"—joy of being in the crowds and city—all
minutiae permeated with a warm humanity—the sudden
overemotionalism (Stern's book center) Rembrandt and girl
by window—Cassirer etc.

Joseph Cornell: *Portrait of Ondine*, 1940. Mixed media.

MAR. 26, 1956 (MONDAY)

break-thru at around 6—from going into tailspin of groggi-
ness heavy stale sleep
some "Italiana" Rossini elation but tempered also "Etudes
Symphoniques" first L-P Geza Anda (Schumann)
some good work in cellar on bird boxes—bringing back "Lis-
sandro the Lampmaker" from desuetude
good work also on purple macaw (?) tall box
last evening or late aft. a spurt just from nowhere after day of
inactivity and feeling toward boxes

the "moment" vs. too many words
politeness of Italian usher, anticipation of colorful picture,
these occasions (like Grand Central newsreel only last Friday)
vs. desultory rambling—sense of appreciation of environment

apron at Lighthouse
mood of "peace"

N.D. APRIL

"after" = designating one experience
 when events seem to burst & flower after black dead end
 (seemingly impenetrable darkness of thought)

false kind of energy that makes of getting all over town like
nothing at all
escapism desperate state even tho mentally dull

APRIL 6, 1956 (FRIDAY)

sunny chilly but accent of spring in early bird song, in cellar
not before 8 AM
WQXR turning in blind
 spark flash
"Granados" Rondo alla Aragonesa
bringing a restaurant in being reminded of Spanish girl in
Main St. business let out last eve—evocation of Raquel Meller
mixed up day—too difficult to put down here—
by loft window—this sense of treasure suddenly amidst the
commonplace talking for some time to friend
Expressivity of eyes music of language
yesterday expansive mother out for day joy putting out wash
vs. tension of last week Robert and home
"backyard sunniness" simplicity of joy
day of extremes important put down flavor

4/28–29/56

"It is a sin to believe that aught can overpower omnipotent
and eternal life, and this life must be brought to light by the
understanding."
Subway verse copied in STERNS underground
just casually going by Lamb's responsible for this quickening
and sense of being closer to church work

MAY 14, 1956 (SATURDAY) 1:30 A.M.

Just now by the kitchen the music Lalo's NAMOUNA "seep-
ing back" and the realization again of the only approx. value

of diary notes when such sublime moments cannot be put
down—the times omitted when flavoring "dates and places
events etc."

now—how far away awakening with its measure of freshness
instead of depression (stale sleep so many mornings last year
or so)

breakfast home redeeming yesterday's dreary mood in Main
St. (chocolate from jaunt yesterday) remembering moment
of "break" the blonde child with her frankness and appeal by
carriage getting frozen custard
an unusual clearing from Sat. morn.—interesting if not es-
pecially inspiring variant of Saturday mornings—so far away
from the movie shootings of past months no real warmth
contacts reminded strongly of *Pasta* "couronne" light in sky
scraper of 3 or 4 yrs ago
unusually even mood for going home early 3:15—lifted invalu-
ably above former tension—this beautiful peace that has come
so often in various activities and interests about town—con-
tinued even mood at home—gratitude all day for sublime
mood of Robert (his joie de vivre and sustenance all day)

unusually good reading SOUL & BODY evening by stove
no lunch freedom from appetite nagging

MAY 23, 1956, FOR MAY 20 AND 21

". . . she (Mme. Klossowska) and Rilke had hit upon the plan
of doing a group of "window" poems for which she was to
provide the illustrations. Rilke had conceived the idea of the
window as a symbol, thinking of its forms, its significance,
characteristically developing it as he had the fountain, the
rose, the mirror. The book appeared some years later as *Les
Fenêtres* (Librarie de France, Paris, 1927) etc."
above as noted on p. 433 of *Letters of Rainer Maria Rilke*
Vol. 2. taken down from shelf after long period of inatten-
tion—for purpose of showing Mother Rodin passages—this
renewal very welcome, with its perspective, prompting, lift
needed for late Sunday night reaction and inertia.

entry here for both diary and WINDOW section of the Fanny
Cerrito exploration
next morning in cellar a rare sunny day with its gracious over-
tone of early morning freshness

MAY 20 (SUNDAY NIGHT) 1956

thru the cellar window the squirrel and catbird, robin at
the bird table under the quince tree with its petals falling—
the rose pink of azalea bush in full bloom—strong sense
of significant form, drama and poetry accentuated by the
"spectacle" thrice familiar but from the dark of the under-
ground the garden incident thus framed imbued with the
poetry & drama of everyday life that brings joy and inspira-
tion beyond esthetics

proved to be a day of effective clearing of dust and disorder of
boxes & sense of satisfaction increasingly rare—mingling with
current thoughts of Ondine (her thrush is back—window of
the Bertrand poem—the film project.)

5/24/56

from the depressed awakening to unfoldment in so many
areas rainy day became Ondine's creatively—lyrically.
much too cool (chilly even) for that overtone of delicious
warmth that of itself transforms everything into experience
but pleasant withal

here you are scribbling again!—above nagging appetite

Cher Matta
 I should have said in a letter just mailed to you—très
 simplement—

 "ONDINE'S thrush is back."

5/20/56 (SUNDAY)

★ Gaspard de la Nuit

earlier
 complete in itself (this experience in anticipation of waiting)
 new actress, etc.
 experimental working

5/26/56 (SATURDAY)

and the quince tree petals making a medieval tapestry of the lawn

resolution of mean mood in cellar, approaching the sublime "early morning" of Monday and Tuesday—birds under the quince tree in early summer shadows sun gradually illuminating the quiet atmosphere of the rustic effects, birds and feeding etc.

This morning played Schumann FANTASIE which brought back the best of the Emily Brontë reading of yesterday (Stark) visit to Carolee Schneemann—spirit of nickelodeon in the piano piece

Rainy Sunday morn. (5/27/56) and that unexpected spark almost nonexistent recently—ORIENTAL tin of Huntley and Palmer opened (bought before Xmas!)—sudden surprise of pink center (shortcake) and extravagant joy "linking up" with the Voiture book inscribed July 1818 month and year of Emily Brontë's birth—picturesqueness and quaintness of colorful design of box (Persian or Chinese but heightened in color scheme—pastiche)—vividness of script in book.

all very awkward to catch a precious moment of fleeting beauty good start despite groggy night—sole remembered touch little "Lois Smith" neighborhood tot seen on my way to school, bus, etc. dressed up in grey (bluish), hair nicely groomed—adorable dream touch

MAY 29, 1956 (TUESDAY) (DAY BEFORE
DECORATION DAY)

calm instead of anxiety of getting to dentist with Robert some
measure of early morning freshness upon awakening, cellar
door thru window looking at birds feed—sunlight on grass
outside
Robert to dentist early—sunny—found self above heaviness
for lifting, trip, etc.

one of those visitations or moods just (hovering on deep de-
pression) and exultation in endless unfoldment of city doings
in many directions (and the accompanying energy for this

Joseph Cornell: *Ann—In Memory*, 1954.
Construction, 12¾ × 10½ × 3¼ in.

seemingly endless inclination (thirst whatever it is)—by night
(at home) that feeling with remorse at not having come home
directly with one record (over West) instead of the ratrace
aspect of spending (new Brontë interest, etc.)—nervous
kind of reaction sometimes (often) at home that should be
the signal for metaphysical work—late snack around one
AM—reversal and groggy awakening—delaying resume of late
part of city journey, as follows:
LIFES (on 6 AVE.)
Joyce record do.
Dublin pictures do (after sparking in Flushing Main St. Li-
brary yesterday)
sulphide marble (large) Sixth Avenue also (!)
STARS (collage) Marboro
pictures at Fredrix (Gauguin)
Brontës in Ireland
"The Bewitched Parsonage"
"Henrietta" L.W. Reese (Briggs)
browsing at Dayton's (saw L-P of "Lilac" of Carl Ruggles
to consider for Centuries of June)
SONNAMBULA piano from library of Ricardo Viñes (su-
preme find) the Viñes item bringing a flood of quiet satisfac-
tion and elation (week ago Déodat de Séverac same stand)—
delightful end-papers of fantasy of Romantic period—superb
accent of the times—documentation of Spanish bookstores
took in before books the Bible House demolition—almost
through to the front facade—windows reminding of original
Cerrito experience at Traphagen's 1940
napoleon and hot drink at Sagamore cafeteria (not overemo-
tional as often the case here and on such occasion)
aspect of day flavored by early getting Robert to dentist and
this kind of bonus or "extra" aspect with this unfoldment on
a sunny (rare) day appreciation inside Schulte's of the high
Victorian ceilings (balcony browsing amidst Brontë books)

on the verge of that magical feeling about many things of the
past—and healthy sense—not too nostalgic—the changing
scene on Third Ave.

DECORATION DAY 1956

vile reaction (partial) stint of work done on clean-up
deep sleep mid-day heavy shower
good dining room clean-up of books, etc.
in evening—getting into the heart of Anne Brontë (and in-
formation at same time)—also poignancy of Branwell (Char-
lotte's reaction to his passing) simultaneous with WQXR
Mozart Piano Concerto #22 (Serkin)—kitchen table (quiet
reading vs. T.V.)

THURSDAY MORNING 5/31/56

again that freshness of early morning no words can express—
cellar about 6:30 and feeling of at one with environment,
quiet of garden, early morning light, slight mist, people pass-
ing in distance, etc. east window—"framing"—some of the
ONDINE feeling standing by the wash tubs with the cool air
blowing in—the peaceful outlook on the feeding table under
the quince tree

JUNE 11, 56

rich wonderful day
after remarkable experience of "getting into" Suzanne and
Mulberry St. films—also TOWER HOUSE color
took to lab early this Monday morn. area of Seventh Ave.
and 48 over to Sixth and 45—picking up Satie piano in this
unexpected sunny morning felicity of city life with its endless
reminders of other times (earlier periods) but the summer ex-
perience (atmosphere) lending a transcendental touch of joy
found also fine cut-out in Music Room (44 St.) Schubert-
Liszt, with its "promise" for an unknown actress in new film
over to Richard Decker's for lion, squirrel, rooster sulphide
marbles down Lexington to 51st St. and home
 Vogue check came in mail ("oeil de boeuf" $200)
second trip to Main St. fussy items at bank—then bus to
College Point—plethora of little touches bordering on the
ethereal GC 44—

ALEXANDER CALDER

Alexander Calder (1898–1976) did more than any other twentieth-century artist to set sculpture in motion. The mobiles he began creating in the 1930s—his friend Marcel Duchamp named them—are abstract constructions that join diverse forms in dynamic relationships. Born in Philadelphia—both his father and his grandfather were sculptors—Calder brought an international perspective to American art, spending critical periods of his life in France and forging lasting friendships with Europeans ranging from the painters Léger and Miró to the architect Alvar Aalto. Already a celebrated figure among the avant-garde in the 1930s, Calder had a retrospective at the Museum of Modern Art in 1943, and in his later years was extraordinarily popular with the American public, in part because of the growing reputation of the miniature circus he had begun performing in the late 1920s and in part because his large commissioned works were becoming a recognizable part of the American landscape. His work, both the mobiles and what came to be called the stabiles, is by turns biomorphic and geometric, witty and dramatic—sneaky, silly, sensuous, saturnine, and sublime. Calder was originally trained as an engineer and was by nature not inclined to philosophical speculation, so his written statements tend to be terse and specific, although in his letters and off-the-cuff comments he could be quite playful. The remarks included here were presented at the Museum of Modern Art symposium in 1951 to which de Kooning also made a contribution. Calder's revolutionary metal creations, both the mobiles and the stabiles, had a deep and still too little acknowledged impact on the work of younger American sculptors ranging from David Smith to Richard Serra.

What Abstract Art Means to Me

My entrance into the field of abstract art came about as the result of a visit to the studio of Piet Mondrian in Paris in 1930.

I was particularly impressed by some rectangles of color he had tacked on his wall in a pattern after his nature.

I told him I would like to make them oscillate—he objected. I went home and tried to paint abstractly—but in two weeks I was back again among plastic materials.

I think that at that time and practically ever since, the underlying sense of form in my work has been the system of the

Rollie McKenna: Alexander Calder in his Roxbury
studio, circa 1953.

Universe, or part thereof. For that is a rather large model to
work from.

What I mean is that the idea of detached bodies floating in
space, of different sizes and densities, perhaps of different colors
and temperatures, and surrounded and interlarded with wisps
of gaseous condition, and some at rest, while others move in
peculiar manners, seems to me the ideal source of form.

I would have them deployed, some nearer together and some
at immense distances.

And great disparity among all the qualities of these bodies,
and their motions as well.

A very exciting moment for me was at the planetarium—
when the machine was run fast for the purpose of explaining its
operation: a planet moved along a straight line, then suddenly

made a complete loop of 360° off to one side, and then went off in a straight line in its original direction.

I have chiefly limited myself to the use of black and white as being the most disparate colors. Red is the color most opposed to both of these—and then, finally, the other primaries. The secondary colors and intermediate shades serve only to confuse and muddle the distinctness and clarity.

When I have used spheres and discs, I have intended that they should represent more than what they just are. More or less as the earth is a sphere, but also has some miles of gas about it, volcanoes upon it, and the moon making circles around it, and as the sun is a sphere—but also is a source of intense heat, the effect of which is felt at great distances. A ball of wood or a disc of metal is rather a dull object without this sense of something emanating from it.

When I use two circles of wire intersecting at right angles, this to me is a sphere—and when I use two or more sheets of metal cut into shapes and mounted at angles to each other, I feel that there is a solid form, perhaps concave, perhaps convex, filling in the dihedral angles between them. I do not have a definite idea of what this would be like. I merely sense it and occupy myself with the shapes one actually sees.

Then there is the idea of an object floating—not supported— the use of a very long thread, or a long arm in cantilever as a means of support seems to best approximate this freedom from the earth.

Thus what I produce is not precisely what I have in mind— but a sort of sketch, a man-made approximation.

That others grasp what I have in mind seems unessential, at least as long as they have something else in theirs.

1951

BEN SHAHN

Although Ben Shahn (1898–1969) was shaped as an artist by the social upheavals of the 1930s, his work has a freestanding graphic delicacy and power that earned him an ardent following well into the 1950s, when the country was less sympathetic to an art based on protest and polemic. Through his paintings, prints, posters, and book illustrations, Shahn conveyed an ebullient humanism, whether the subject was the trial and execution of the Italian anarchists Sacco and Vanzetti in the late 1920s or the Old Testament themes that sometimes engaged him in later years. In 1954 he was one of two painters chosen to represent the United States at the Venice Biennale; the other one was Willem de Kooning. Selected to give the Norton Lectures at Harvard, Shahn chose to speak about what he called "the shape of content," arguing that the formal values celebrated by Greenberg and other critics meant the most when they were married with themes urgently important to the artist. When published in paperback, *The Shape of Content* became something of a bestseller, and although there have always been those who are inclined to dismiss his viewpoint as middlebrow, Shahn's ideas still merit serious consideration.

FROM
The Shape of Content

I WOULD not ordinarily undertake a discussion of form in art, nor would I undertake a discussion of content. To me, they are inseparable. Form is formulation—the turning of content into a material entity, rendering a content accessible to others, giving it permanence, willing it to the race. Form is as varied as are the accidental meetings of nature. Form in art is as varied as idea itself.

It is the visible shape of all man's growth; it is the living picture of his tribe at its most primitive, and of his civilization at its most sophisticated state. Form is the many faces of the legend—bardic, epic, sculptural, musical, pictorial, architectural; it is the infinite images of religion; it is the expression and the remnant of self. Form is the very shape of content.

Think of numbers alone, and their expression in form, of three, for instance. Who knows how far back into time the idea of the triad extends? Forms in threes appeared everywhere in

early art. But then the Trinity arose in Christian theology—the Father, the Son, and the Holy Ghost, and was a new form-generating concept. It became desirable to turn the idea of Trinity into every possible medium, to turn it to every use. The challenge to formulate new expressions of three, to symbolize further the religious idea, actually became a sort of game. How vast is the iconography of three alone—the triptych, the trefoil window, the three-petaled fleur-de-lis, used everywhere; the triskelion in its hundreds of forms—three angels interwoven, three fish interwoven, three legs interwoven, three horses interwoven, and the famous trefoil knot with three loops; the divisions of churches into three, of hymns into three; the effort to compose pictures into threefold design. *Form—content.*

But the three, the Trinity, was only one small part of the stimulus to form which arose out of the vivid Christian legend: think of the immense and brilliant iconography which remains detailed for us and our delight—the Lion for Mark, the Ox for Luke, the Eagle for John, the Angel for Matthew; Lamb and Serpent and Phoenix and Peacock, each with its special meaning; symbols of keys and daggers and crosses, all challenging the artists and artisans and architects and sculptors to new kinds of invention. Sin and Temptation, Piety, and a thousand virtues and vices all transmuted into the materials of art, into form, remaining for us in mosaics, in frescoes, in carvings, forming capitals, cupolas, domes, inner walls and outer façades, tombs, and thrones. Wherever something was made, the legend turned it into form. *Wonderful form; wonderful content.*

Think also of the ancient epics of Greece, Persia, Egypt, and Rome, each with its profusion of image and incident, its *dramatis personae*, its hierarchy, its complicated rites, its fierce families—every such item a point of departure for the artist, a touchstone of form for the poet, a basis for elaboration, a vessel for personal content, a subject for craft, for excellence, for style, for idea. *Form—content.*

Form and content have been forcibly divided by a great deal of present-day aesthetic opinion, and each, if one is to believe what he reads, goes its separate way. Content, in this sorry divorce, seems to be looked upon as the culprit. It is seldom mentioned in the consideration of a work of art; it is not in the well-informed vocabulary. Some critics consider any mention of

content a display of bad taste. Some, more innocent and more modern, have been taught—schooled—to look at paintings in such a way as to make them wholly unaware of content.

Writing about art is more and more exclusively in terms of form. Characteristic comment from the magazines upon one artist's work will read as follows: "The scheme is of predominantly large areas of whites, ochres, umbers and blacks which break off abruptly into moments of rich blues with underlayers of purple." Of another artist, it is written: "White cuttings expand and contract, suspended in inky black scaffoldings which alternate as interstices and positive shapes." Of a third, we read, "There is, first, a preoccupation with space broken into color through prisms and planes. Then the movement alters slightly and shifts toward the large field of space lanced by rectilinear lines that ride off the edge of the canvas—" and so on. From time to time the critic himself will *create* a content by describing the work in terms of some content-reference, as when one of the above uses the term "scaffolding"—seeming to hunger for some object that he may be able to hang onto. Or when another writer describes a nonobjective work as "an ascetic whirlpool of blacks and whites, a Spartan melodrama, alleviated only by piquant whispers of turquoise, yellow or olive . . ."

Such a nostalgia for content and meaning in art goes counter to the creed as it is set forth by the true spokesmen for the new doctrine. I have already mentioned the credo of that early modern who demanded that art display "nothing from life, no knowledge of its affairs, no familiarity with its emotions." A contemporary writer, Louis Danz, asks that the artist "deny the very existence of mind." Ezra Pound has called art "a fluid moving over and above the minds of men."

An eminent American critic speaking recently in London dwelt at length upon "horizontality" and "verticality" as finalities in art. Throwing upon a screen reproductions of one work by Jackson Pollock, and one page from the ancient Irish "Book of Kells," the critic found parallel after parallel between the two works—the two qualities named above, a certain nervousness of line common to the two, the intricately woven surface.

Coming at length to the differences between the two works, the critic pointed out that the "Book of Kells" was motivated by strong faith—by belief that lay outside the illuminated page.

But Pollock had no such outside faith, only faith in the material paint. Again, the "Book of Kells" revealed craftsmanship, the craftsmanlike approach, but no such craftsmanship entered into the work of Pollock.

Necessarily the surface effects which can arise out of such art are limited. One writer divides such painting into categories according to the general surface shapes, his categories being (1) Pure Geometric, (2) Architectural and Mechanical Geometric, (3) Naturalistic Geometric (I wonder what that means!), (4) Expressionist Geometric, (5) Expressionist Biomorphic, and so on.

Among all such trends, there are the differences. There is some factor that decides whether a work shall be rounded, geometrical, spiral, blurred, or whatever it is in shape.

Those differences are in point of view. Sometimes the point of view is stated by the artist himself; more often, certainly more prolixly, it is stated by the theorist, or aesthetician or critic. I wish to discuss certain of these points of view, and show—if I can—how a point of view conditions the paint surface which the artist creates.

Let us begin with the paint-alone point of view—the contention that material alone is sufficient in painting, the attitude that holds that any work of art should be devoid not only of subject, or of meaning, but even of intention itself.

I suppose that the most monumental work in this direction is the great canvas—occupying a whole wall—done by Clyfford Still and exhibited by the Museum of Modern Art a few years ago. The canvas is done in a dull all-over black, and has a single random drip of white coming down to (I would judge) about a foot from the top of the painting. There is nothing more. Then there are the paintings of Mark Rothko, sometimes much more colorful but also immense in size; there are the blurred squares of color done by Ad Reinhardt. And there are many painters who work in forms of paint almost entirely static in their effect. The work of these three painters is perhaps as content-less as anything to be seen currently, although there is always Malevitch's "White on White," which still holds first place in the competitive race against content.

Distinguished in appearance from such static work as I have just described is the painting of the late and very noted Jackson

Pollock, whose pictures are, as everyone knows, tangled sur-
faces of threaded paint, sometimes splashed paint, sometimes
dripped paint. There are the legion followers of Pollock among
our young painters; there is the Frenchman Mathieu; there are
several young artists whose paintings consist of one or two long
agitated strokes.

These painters are of the paint-alone school too, but in their
case it is the *act* of painting which is emphasized. The act is
in some cases looked upon as therapeutic; in other cases it
is looked upon as automatic. Then the artist becomes actor,
sometimes in a drama of his own psyche, sometimes in a vast

Ben Shahn: Drawing used to illustrate essay in
The Shape of Content, 1957.

time-space drama, in which case he becomes only the medium (it is held) for great forces and movements of which he can have no knowledge, and over which he can have no control.

Thus Pollock spoke of the "paroxysm of creation." Mathieu, going further, dressed himself in the most eccentric of costumes in order to make his painting, "The Battle of the Bouvines." According to the critic, he was "dressed in black silk; he wore a white helmet and shoes and greaves and cross-bars. . . . It was our good fortune [he says] to witness the most unpredictable of ballets, a dance of dedicated ferocity, the grave elaboration of a magic rite . . ." And later, "Mathieu regards everything as totally absurd and shows this constantly in his behavior which is characterized by the most sovereign of dandyisms. He understands with complete lucidity all the dizzying propositions in the inexhaustible domain of the abstract, on which he has staked his whole life, every possible type of humanism having been rejected . . ."

The differences in such art surfaces are not differences of paint alone. They are differences of idea, differences of point of view, differences of objective. They are, even in this most extreme wing of non-content painting, simply differences of content.

I have said that form is the shape of content. We might now turn the statement around and say that form could not possibly exist without a content of some kind. It would be and apparently is impossible to conceive of form as apart from content. Even the ectoplasm of Sir Oliver Lodge and the homeliest household ghost have a content of some kind—the soul, the departed spirit. If the content of a work of art is only the paint itself, so be it; it has that much content. We may now say, I believe, that the form of the most nonobjective painting consists of a given quantity of paint, shaped by content; its content consisting in a point of view, in a series of gestures, and in the accidental qualities of paint.

But there is a great deal of other content that enters into the turns and twists of abstract-to-nonobjective form. There is, for instance, mission, and even social milieu. Socially, we must note that there has been no other time in history when just this art could have taken place. It had to be preceded by Freud; it must necessarily be directed toward a public conversant with Freud, and in many cases the very suppositions upon which

contemporary art is based are derived from Freud. Further, it had to be preceded by Picasso, by Kandinsky, by Klee, by Miró, by Mondrian, for its forms, whatever new departures they may have taken, are an inheritance from the earlier group of great imaginers.

All this is content within content-less art, but there is even more; there is a certain sort of proclamation involved, an imperative, a mission, to announce that *this is art*; that this is man even—at least the only kind of man that counts. The public itself is not worthy; it is only anonymous. Worth itself inheres only in the special few, the initiate.

Form is the visible shape of content. The forms of the most extreme varieties of the paint-alone aesthetic differ from those of other art because the content differs. And if content is the difference, we might wonder how the new content looks alongside the old.

A year or so ago I was one of the judges for the Pennsylvania Academy annual exhibition. When we, the judges, walked into the immense room where we were finally to decide on prizes, a curious sight met us. The new paintings stood around the wall on the floor before the places where they were to be hung. The old pictures, the Pennsylvania "Treasures," were still in place above them. I remember experiencing a certain thrill of pride as I noted the contrast. The new pictures constituted a very river of color around the floor; they glowed richly. And, in comparison, the older paintings, certainly constituting some of the very finest in pre-impressionist art, seemed almost a gray-to-tan monotone. I felt proud of my contemporaries, and of painting. The forms of the new work stood out bold and clear, and the colors were infinite. Invention and variety competed and seemed almost to obliterate the work hanging on the walls. I felt a little sad that the older artists were so limited in their use of color and that their work dimmed so alongside the new.

Later, as I sat at lunch, I kept remembering the Eakins—the Winslow Homer paintings, too, but mostly the Eakins—the "Cello Player." What was it about Eakins that was so compelling? There was no boldness of design there. Colors, elegant and muted, but not used for design—used actually quite descriptively. Perhaps it was partly realism, but then realism alone quite often leaves me cold. There was another kind of content in

the Eakins painting; there was a certain intellectual attitude—a complete dedication to comprehending something, someone outside himself. There was an intensity of honesty, a personal simplicity present in the work itself. Odd, that by departing utterly from himself, an artist could so reveal himself.

What a departure, what a contradiction to the canons of art which we hold so inviolate today! Eakins, full of content, full of story, of perfection of likeness, of naturalness, of observation of small things—the look of wood and cloth and a face—seeking to reveal character in his painting, loving the incidental beauty of things, but loving even more the actual way of things—sympathy, honesty, dedication, visible apprehensible shape. *Form—content.*

Almost anyone will tell you that, in terms of form, Eakins simply does not exist. But again, we must look upon form as the shape of content: with Eakins, no less than with de Kooning, or Stamos or Baziotes, form is the right and only possible shape of a certain content. Some other kind of form would have conveyed a different meaning and a different attitude. So when we sit in judgment upon a certain kind of form—and it is usually called lack of form—what we do actually is to sit in judgment upon a certain kind of content.

I have mentioned some of the surface shapes which are characteristic of contemporary painting, and some of the classifications into which painting is put, depending upon whether it displays a rounded shape, squarish, angular, or some other sort of shape. I have pointed out that even with the renouncement of content, some content does remain, if only of verticality and horizontality.

There is little art being produced today that does not bear some imprint of the great period of the "Isms" when painting was freed from that academic dictatorship which had laid down so many rules about both form and content. Every branch of the rebellion of the Isms had, as we know, a content of ideas, and that content charted the course which it would pursue, as Cubism, for instance, pursued the cube, the cone, and the sphere, as Surrealism pursued the subconscious, and Dadaism, perversity.

Out of those ideas there emerged a new universe of forms, an aesthetic rebirth. Both the forms and the ideas are necessarily

present to some degree in the work of us who have come later, and who are familiar with the ideas and images thus generated. Content, purpose, idea all provide new direction and new shape, but all are united in a certain modernity, in the sharing of a common art inheritance.

Abstraction is perhaps the most classic of the contemporary points of view. It sometimes seems to have much in common with that art which has sought to reject content, but actually it has not, for in the case of abstraction content is its point of departure, its cue, and its theme. To abstract is to draw out the essence of a matter. To abstract in art is to separate certain fundamentals from the irrelevant material which surrounds them. An artist may abstract the essential form of an object by freeing it from perspective, or by freeing it from details. He may, for instance, interpret Jazz—an idea, a content—by abstracting out of a confusion of figures and instruments just the staccato rhythms and the blare. In Stuart Davis' paintings of jazz, for example, or in Matisse's, blaring sound becomes blaring color; rhythm of timing becomes rhythm of forms. Content, particularly with Davis, is not just jazz; it is the interpretation of an age with its shocks, its neon-lighted glare, its impacts on all the senses, its violent movements in which the eye glimpses everything and grasps nothing—a highly intellectual content formulated into a single immediate impression.

If Abstraction itself is the most classic of the modern modes, Abstract Expressionism, so-called, is the most prevalent. One might be entitled to expect of this view—judging from its name—that it would take almost as many outward forms as there are inward, or expressive, differences between artists.

Actually, I think that the varieties of form in Abstract Expressionist art are fewer than we might expect. Although the title is a loose one, and can be expanded to include almost anything, it seems usually to be applied to about three or four directions in form. It may indicate that painting which takes the form of whirls and swirls upon a surface, or it may be applied to painting in squares, or geometric patterns. Sometimes its shapes are rounded, having, I believe it is said, a biologic connection. Sometimes the forms may have an angular or spiked look. The theory underlying Abstract Expressionism has points in common with completely nonobjective views. Performance

is likely to be held an essential part of the art process—the act, as against a controlled objective. But, as to the result, I think that this view admits of content—that content being the true impulsive compulsive self, revealed in paint.

If art seeks to divorce itself from meaningful and associative images, if it holds material alone as its objective, then I think that the material itself ought to have the greatest possible plasticity, the greatest potentialities for the development of shapes and the creating of relationships. For that reason I think that the sculpture which has been created with a view to being form alone has been a great deal more successful and interesting than has been the painting in that vein. The sculptor sets out with two pre-existing advantages: one, that he must have craftsmanship, and the other, that he works in the round. He does not have to simulate depth nor create illusions of depth because he works in volume—in three-dimensional form.

Thus Noguchi, working in marble, is able to develop relationships in three dimensions rather than two and yet retain both simplicity and unity. He has at his disposal the advantages of light and space, and the natural translucence and glow of marble, all of which he exploits and reveals with great elegance.

Henry Moore is one of the great contemporary imaginers who has brought new materials and new concepts into sculptural form. He discovers the naturally heroic character of bronze and exploits feelingly the graining and fine surfaces of wood. Undoubtedly his most remarkable feat has been the surrounding of open space and his use of such space as a sculptural material. But beauty and craft and idea are still paramount with Moore, and he never obliterates these qualities in the shock of the new.

Unique in any age is Calder, who is, I think, the only one of the modern people who has actually and physically introduced a time dimension into his work. (It is sometimes held that the work of certain of the "paroxysmic" kind of painters represents a sort of time-space extension, that it expresses the action of immense physical forces; but I cannot escape the conviction that such an identification is more romantic than real; that it expresses only a wish to be identified with the new, to participate in the vitality and centralness of a science—of physics—which has so greatly shaped the mood and sense of our time.) Calder's

work requires no terminology to identify it with that which is modern. It reads at once, and for anyone, and for a long time. While its shapes and forms are of an abstract genre, its meanings involve that return to nature, to first principles, which seems to be an indispensable condition of any great work of art or movement in art. Calder, once an engineer himself, but also son and grandson of sculptors, undoubtedly brought to engineering an eye for beauty, a sensitivity to aesthetic meanings which would wholly escape the usual engineer. Thus, in stress and balance, in sequences of motion, in other basic and natural and probably common principles, he saw tremendous aesthetic potentialities, and put them to work.

The result for us who watch the continuously interdependent movements, the varieties of form balanced daringly and with delicate precision, is to experience the perfect union of nature and art. Here is sculpture that creates endless patterns in space—time-rhythms. Of course Calder's own great sense of play enters into all this, adding its own peculiar gaiety to the forms.

And then there are other interesting and diverse kinds of content that find expression in contemporary sculpture. I remember listening to a remarkable speech on the qualities of black alone which David Smith delivered spontaneously before an aesthetics conference a few years ago. It would be hard to believe that so much could be said of black—of its qualities, of its personal meanings, of its variety—unless we look at David Smith's sculpture where it is all so feelingly expressed.

In painting, there are additional kinds of content which help to set the look and the shape and the colors of the work that we see today. There is a certain moody poetic content, sometimes an emotional attitude toward nature—toward the sea, strange places, aspects of the city, even objects which have some odd emotional connection. Such content is sometimes expressed formally in abstract paintings which have only a vague reminiscence of actual things. Again, it may be present in actual scenes or objects strongly overbalanced by some one quality, so that only the feeling is present, as in Loren MacIver's painting of Venice—the Venice of lights only. Or there are Reuben Tam's seascapes, the moon or the sun in black, or swallowed by the sea. There are many extremely fine painters who work in this

vein, and it constitutes to my mind one of the highest and most worthy expressions in the modern idiom.

Then there are the avowedly figurative painters whose point of departure is idea, attitude toward things and people, content of all kinds, not excluding story content. Even among such painters, and I include myself among them, the impress of abstraction and expressionism is strong. The variations in form, in the look of painting, may be greater among the artists of this vaguely defined and scattered group than among artists of some of the other groups, simply because they have little in common aside from the fact that most of them work in objective images—things, places, and people. Not in any other age but ours would such a painter as Jack Levine—satirist of manners, observer, commentator, craftsman, and, in a sense, traditionalist—be aligned with such a painter as Tamayo—the designer, the imaginer, originator of strange beasts and men in all the possible mutations of red. What have they in common? That they paint content, figures! Nor would Philip Evergood be placed alongside Kuniyoshi, or Jacob Lawrence or Hyman Bloom, except that all are "content" painters.

Content, in the view of Panofsky, is "that which a work betrays but does not parade." In his book, *Meaning in the Visual Arts*, he calls it "the basic attitude of a nation, a period, a class, a religious persuasion—all this qualified by one personality, and condensed into one work. It is obvious," says Mr. Panofsky, "that such an involutionary relationship will be obscured in proportion as one of the two elements, idea or form, is voluntarily emphasized or suppressed. A spinning machine," he says, "is perhaps the most impressive manifestation of a functional idea, and an abstract painting is probably the most expressive manifestation of pure form. But both have a minimum of content."

Form arises in many ways. Form in nature emerges from the impact of order upon order, of element upon element, as of the forms of lightning or of ocean waves. Or form may emerge from the impact of elements upon materials, as of wind-carved rocks, and dunes. Form in living things too is the impinging of order upon order—the slow evolving of shapes according to function, and drift, and need. And other shapes—the ear, the hand—what mind could devise such shapes! The veining of leaves, of nerves, of roots; the unimaginable varieties of shape of aquatic things.

Forms of artifacts grow out of use, too, and out of the accidental meetings of materials. Who again could dream of or devise a form so elegant as that of the chemical retort, except that need and use, and glass and glass-blowing all met to create form? Or the forms of houses, the Greek, the Roman, the extremely modern, or the gingerbread house; these the creations out of different materials, and tools, and crafts, and needs—the needs of living and of imagining.

Forms in art arise from the impact of idea upon material, or the impinging of mind upon material. They stem out of the human wish to formulate ideas, to recreate them into entities, so that meanings will not depart fitfully as they do from the mind, so that thinking and belief and attitudes may endure as actual things.

I do not at all hold that the mere presence of content, of subject matter, the *intention* to say something, will magically guarantee the emergence of such content into successful form. Not at all! How often indeed does the intended bellow of industrial power turn to a falsetto on the savings bank walls! How often does the intended lofty angels choir for the downtown church come off resembling somehow a sorority pillow fight!

For form is not just the intention of content; it is the embodiment of content. Form is based, first, upon a supposition, a theme. Form is, second, a marshaling of materials, the inert matter in which the theme is to be cast. Form is, third, a setting of boundaries, of limits, the whole extent of idea, *but no more*, an outer shape of idea. Form is, next, the relating of inner shapes to the outer limits, the initial establishing of harmonies. Form is, further, the abolishing of excessive content, of content that falls outside the true limits of the theme. It is the abolishing of excessive materials, whatever material is extraneous to inner harmony, to the order of shapes now established. Form is thus a discipline, an ordering, according to the needs of content.

In its initial premises, content itself may be anything. It may be humble or intimate, perhaps only the contemplation of a pine bough. Or it may strive toward the most exalted in idea or emotion. In such an initial theme lies the cue, the point of departure, the touchstone of shape. But from that point, from the setting of theme, the development of form must be a penetration of inner relationships, a constant elimination of

nonpertinent matter both of content and of shape. Sometimes, if extreme simplicity is an objective, an artist's whole effort must be bent toward the casting aside of extra matter. Sometimes, if the theme is exalted, tremendous energy must be poured into the very act of reaching toward, of seeking to fulfill the boundaries of that theme which has been set. Perhaps the most heroic performance in this direction that the world has ever known—at least on the part of one man—was the creation of the Sistine ceiling by Michelangelo. Here was the setting of a formal plan so vast that its enactment alone became an almost superhuman task; moreover, there was the establishment of a pitch of feeling which could not be let down or diminished in any place—and which was not diminished!

Content, I have said, may be anything. Whatever crosses the human mind may be fit content for art—in the right hands. It

Ben Shahn: Drawing used to illustrate essay in
The Shape of Content, 1957.

is out of the variety of experience that we have derived varieties of form; and it is out of the challenge of great idea that we have gained the great in form—the immense harmonies in music, the meaningful related actions of the drama, a wealth of form and style and shape in painting and poetry.

Content may be and often is trivial. But I do not think that any person may pronounce either upon the weight or upon the triviality of an idea before its execution into a work of art. It is only after its execution that we may note that it was fruitful of greatness or variety or interest.

We have seen so often in past instances how content that was thought unworthy for art has risen to the very heights. Almost every great artist from Cimabue to Picasso has broken down some pre-existing canon of what was proper material for painting. Perhaps it is the fullness of feeling with which the artist addresses himself to his theme that will determine, finally, its stature or its seriousness. But I think that it can be said with certainty that the form which does emerge cannot be greater than the content which went into it. For form is only the manifestation, the shape of content.

1957

ISAMU NOGUCHI

More than any other artist of his time, Isamu Noguchi (1904–1988) knew how to make East and West meet. This ingathering of apparently alien traditions was rooted in Noguchi's beginnings, for his father was a well-known Japanese poet and his mother was an America writer and after living as a baby in Los Angeles he spent some years in Japan as a boy. Immensely talented and energetic, Noguchi began in the 1920s as a sculptor in a classical European tradition but eventually felt the pull of modernism and managed to find work as Brancusi's assistant in Paris, where he saw that contemporary forms could be fused with ancient feelings. The autobiographical pages included here—they are from *A Sculptor's World*—describe critical experiences in the 1950s in Japan, where Noguchi began to see that an antediluvian craftsmanship could be the catalyst for what was already becoming a many-faceted originality, an achievement that embraced not only sculpture, but also the design of stage sets, gardens, ceramics, lamps, and furniture. Noguchi was a wizard with many materials, turning paper, fabric, bamboo, wood, clay, stone, and even metal into sensuous, surprising abstract visions.

FROM

A Sculptor's World

1948

THE winds of the imagination by now blew on me with force from the East.

It has often been pointed out to me that when I have achieved a certain success of style, then I abandon it. There is no doubt a distrust on my part for style and for the success that accrues from it. There is another factor: after a period of introspection—this time six years—there comes an urge to break out. After the elation and effort that go with preparing an exhibition, comes a depression. Following my show fourteen years previously, I had gone to Mexico. This time I was determined to get away from everything. The reasons I gave myself were varied. On the one hand, I had over the years developed a horror of the politics of art, the narrow outlook of critics and dealers with their pet discoveries and pat judgements (like the rites attending fashion,

advertising, and the Stock Exchange). I felt myself no part of this, and wanted no part of it.

The suicide of Arshile Gorky shortly before had moved me deeply. I blamed it largely on his wishful involvement with the snobbish world. He had finally broken into the sacred circle through the intercession of André Breton. I had introduced them. This had nothing to do with his genius; he had already freed his art by his discovery of nature, the beauty of the Virginia countryside, and through his happy family life; but it was Breton who opened the gates to his recognition. His creativity rose with his confidence. But when cancer undermined him, did he not feel doubly betrayed? By expectations to which he was now unequal, by friends and family to whom he felt he could only be a hero?

I shall never forget his anguished voice calling me that morning of his death. Dawn was breaking as he stood at the gate. In his hands were two rag dolls, a traction collar stretched his neck, the tears streamed down his cheeks. I thought he had come to me as to a fellow immigrant out of his past. We talked a long while. He wanted to go to his country place.

If only I had paid more heed to my premonitions. I did not know their shape. We went to his doctor. Finally I called Wilfredo Lam and together we drove him to Connecticut. His neighbor Peter Bloom called. We looked at unfinished canvases. There was almost a note of joy as Arshile walked tall among his apple trees. That night he met his fate.

What was the purpose of all this striving? How superficial and cruel the recognition! I have thought of each day since as an undeserved gift. Somehow, I have sought to express myself more fully, to make contact with a larger world, more free and more kindly than the one that had killed my friend.

My depression was increased by the ever-present menace of atomic annihilation. This was, no doubt, a theme of art. But prophecy, I had long decided, had better be left to painters.

With these thoughts—a mixture of gloom and vague hopes for the future—I devised a plan of action. To find out, if possible, what sculpture was fundamentally about, to see for myself its relations to people, to space, and its uses in the past. Sculpture, I felt, had become captive, like the other arts, to coterie points of view. There must be some larger, more noble, and more essentially sculptural purpose to sculpture.

Of course, there is no better way of learning than to write a book. I applied to the Bollingen Foundation for a travelling fellowship to prepare material for a book on leisure (which allows for meditation on the meaning of form in relation to man and space). The subject, however vague, must challenge the imagination, for I was forthwith awarded the opportunity to study it wherever I wished.

I started my education from the beginning: that is the prehistoric caves, menhirs, and dolmens of France and England; then on to the *piazze* and gardens of Italy and to Gaudí in Barcelona. Following this, a month in Greece, and up the Nile. For six months I wandered as a pilgrim all over India and then to other far lands and temples, Angkor Wat, and the magical island of Bali, the island where life and art are one.

The evidence of the past attests to the place of sculpture in life and in the ritual of communion with spirit, with tranquility. Precepts of the Buddha, like the great temple of Borobudur, are a symphony of sculpture. There is no vaster concept of sculpture than the temples of Elora hewn out of the mother rock. Yet these were all part of a culture long dead. Do the ideas and aspirations that made them apply to us still?

1950

My final stop was Japan, which I approached with trepidation. My previous experience of it in 1931 had not been entirely happy and I hardly expected war to have improved matters.

How great was my delight, therefore, to find it altogether different. War had indeed improved my own relationship to the Japanese people in the most startling manner. Where there had been a certain reserve before, there was now open friendliness. Indeed, nowhere have I experienced such spontaneous good will expressed between all people as there in Japan in the spring of 1950. My own explanation of this is that the war had leveled the barriers and hope was now everybody's property. The disillusionment in war and the loss of one's own particular rights brings with it a recognition of the humanity of all, including Americans.

As an American, I expected to be treated as a foreigner. This was certainly true to a degree. How could it be otherwise, with my Japanese forgotten since my last visit twenty years before?

Yet there was an eager approach to brotherhood, which other Americans, too, can attest to. I was immediately swamped by all the artists, and their various groups seeking my participation. I felt like the pigeon harbinger after the Deluge. I stayed with the remaining members of my father's family. At the end of the war in 1945, which was a time of celebration in New York, I was asked to write a piece for the *Japan Times*—which had brought a letter from my father:

> . . . Takagi, my elder brother whom you lived with while in Japan, passed away under the noise of fire. But the other people whom you know are all safe. If you come to Japan again, you will see her in an entirely different aspect. I am getting old and feel so sad and awful with what happened in Japan.

To escape this new deluge of attention in Tokyo and to continue my studies for the Bollingen Foundation, I asked the artist Hasegawa Saburo to help me travel and re-experience the beauty of ancient temples and gardens, and to imbibe the tranquility of Zen. (In 1931, I had the similar assistance of a young sculptor, Sasamura, who practiced meditation before dawn wherever we went.)

When I returned to Tokyo after this memorable trip, there was a clamor for me to hold some sort of exhibition. I had nothing to show but some photographs. An exhibition would require my making sculptures, so I went to the pottery center of Seto and did thirteen terracottas—with a facility that had, it seemed, survived these many years.

Everything happened at once. It was suggested that I should do something for Keio University, where my father had taught for forty years. I became preoccupied with this as my own act of reconciliation to my father and to the people.

1951

The execution of this memorial was to be carried out the following year, but I was able to include some studies for it in the exhibition I then held at the Mitsukoshi Department Store. In particular there was a large plaster model of a sculpture like the circle made by thumb and index finger, which I inadvertently called *Mu*, meaning nothingness, a Zen term well-known in Japan,

but provoking innumerable wisecracks and cartoons. (A small marble version is in the Museum of Modern Art, New York.)

It seems ridiculous that all this could have taken place within four months. Money was running out, and I decided that I had better return to the USA to somehow find the means to resume living in Japan.

New York was totally unreal. I lived only with thoughts of how to get back to Japan. The book for the Bollingen Foundation was a box of notes and photographs. I felt inadequate to bring order into the manuscript. How can one write with wisdom unless one's own problems are solved? How to grasp the meaning of leisure at this breakneck pace?

I applied for an extension of the fellowship. At the same time I pursued a suggestion that I might do a garden for the new Reader's Digest Building which Antonin Raymond was doing in Tokyo. A possible ticket to Japan, it was also a way to learn about gardens, in which I was interested and which were important to my book.

In New York I met Yoshiko (Shirley) Yamaguchi, an actress from Japan. We later married, but at this time we both had different reasons for going to Japan. Mine was to make a garden in the middle of Tokyo, across the moat from the Emperor. This is how I was introduced to the practical knowledge of garden making. Through working in the mud with the Uekiya (gardener).

During a break in this activity I found time to take a trip to Hiroshima, to which I was drawn, as many Americans are, by a sense of guilt. I wished somehow to add my own gesture of expiation. The result was an invitation to submit designs for two bridges spanning the approach to "Peace Park," extended to me by the architect, Tange Kenzo, and the Mayor of Hiroshima, Mr. Hamai.

Meanwhile, my future wife, Yoshiko, being a movie star, had suddenly to go to Hollywood. I therefore packed up and followed, and somehow managed to design the bridges there, on a dresser. The execution and more sculptural determination, of course, had to wait for my next trip to Japan.

On this dresser, too, I mapped out the initial studies for a Playground for the United Nations which were later developed in New York.

Noguchi working on ceramic sculpture in his Kita Kamakura studio, Japan, 1952.

1952

I returned to Japan in the early Spring of 1952 to continue with the memorial at Keio and the work on the *Hiroshima Bridges.* As a result I was asked to design a *Memorial to the Dead* for Hiroshima. At the same time I became married.

This was in May, with a large party, in the grounds of the lovely Japanese inn, Hanya En. On this occasion, the imperial Gagaku musicians, breaking precedent, came in their courtly attire and played their ancient and eerie music.

Looking for a place to live, I remembered the lovely small valley of rice fields between hills and a cluster of old thatched-roof

houses near Kita Kamakura where Rosanjin Kitaoji lived, the greatest living potter of Japan. I had been there on a previous trip, when I looked him up after following the trail of his pottery as I came across it in famous restaurants. Rosanjin san was surprisingly gentle (he was famous for his caustic tongue) and offered me a farmhouse 200 years old which he had had transported to the hill facing his, as a view and as a retreat. "Live in it as long as you like," he said.

We moved in, amidst much fixing and the building of an adjacent studio. Actually there was no level land on which to build, so I cut into the hill beyond the bathhouse. The earth was so hard I had to use a pick, and I conceived the idea of using the bare cut surface as one end of the studio open to the rice fields. With this in mind, I carved into it a fire place; then cut a trench on the other side to take care of water seepage. I was filled with joy and energy. As soon as the studio was finished, I made all kinds of sculptures and other objects, using the clay Rosanjin san gave me. These were fired in his kiln. Also, I took a trip south to "Imbe" with my patron to use the famous earth of Bizen in the workshop of Kaneshige Toyo. The results of these two firings constituted a large exhibition at the newly built Modern Museum in nearby Kamakura. About two-thirds of the work was then packed and shipped to New York.

My other preoccupation at this time was the development of *akari*, the new use of lanterns that I had conceived on my previous trip. It was a logical convergence of my long interest in light sculptures, *lunars*, and my being in Japan. Paper and bamboo fitted in with my feeling for the quality and sensibility of light. Its very lightness questions materiality, and is consonant with our appreciation today of the less thingness of things, the less encumbered perceptions.

The name *akari* which I coined, means in Japanese light as illumination. It also suggests lightness as opposed to weight. The ideograph combines that of the sun and moon. The ideal of *akari* is exemplified with lightness (as essence) and light (for awareness). The quality is poetic, ephemeral, and tentative. Looking more fragile than they are *akari* seem to float, casting their light as in passing. They do not encumber our space as mass or as a possession; if they hardly exist in use, when not in use they fold away in an envelope. They perch light as a feather,

some pinned to the wall, others clipped to a cord, and all may be moved with the thought.

Intrinsic to such other qualities are handmade papers and the skills that go with lantern-making. I believe *akari* to be a true development of an old tradition. The qualities that have been sought are those that were inherent to it, not as something oriental but as something we need. The superficial shapes or functions may be imitated, but not these qualities.

1968

ANNI ALBERS

Anni Albers (1889–1994), born in a wealthy German Jewish family in Berlin, had set out to be a painter. However at the Bauhaus, where she enrolled in 1922, she found herself along with many other female students pushed into the textile studio—and there, working with the brilliant artist Gunta Stölz, she discovered her true vocation. Even before immigrating to the United States in 1933 with her husband, Josef Albers, whom she met at the Bauhaus, Anni Albers had produced some of the most beautiful abstract weavings of the century, compositions with a rhythmic subtlety that brings to mind the paintings of her greatest contemporaries, including Mondrian, Kandinsky, and Klee. And in the United States, even as she designed for industrial production, she produced abstract weavings unprecedented in their geometric intricacy and metaphoric richness, evoking seasons and landscapes through her orchestrations of dissonant materials, textures, and colors. She and her husband made many trips to Mexico, and in her writings she emphasizes the grandeur of pre-Columbian textiles, which she sees as a vital source of inspiration for the modern artist. By the time of her death, Anni Albers was beginning to be recognized as a major figure in the modern movement.

Tapestry

TAPESTRY weaving is a form of weaving that reaches back to the earliest beginnings of thread interlacing, is still with us today, and may have a future noteworthy in its promise. Taken in its widest meaning, the term encompasses the various techniques that can be used to mark off different areas of color and surface-treatment from each other in the woven plane. In a narrower sense the term refers to a technique of weaving, or variation of it, where a weft thread, covering the warp completely, passes only over the surface of those sections of the weaving that are to be built of it. The thread then interlocks at the borderlines, either with neighboring weft threads that meet it or with a warp thread, before turning back, after a change of shed, into its own field.

It is a form of weaving that is pictorial in character, in contrast to pattern weaving, which deals with repeats of contrasting areas. It works with forms meaningful both in themselves

and through their relatedness within the pictorial organization. The variform elements and their free placement within the limits of a given design demand the greatest possible freedom of the structural scheme; in fact, they demand such independence from mechanization of the weaving process that hardly any of the time-saving inventions of the past hundreds or thousands of years of textile history can be utilized in this work. It is art work; and, as in other plastic arts, it demands the most direct— that is, the least impeded—response of material and technique to the hand of the maker, the one who here transforms matter into meaning.

If we think of a tapestry as an articulation in terms of forms made of threads, examples of such work go back to the earliest experiments in cloth construction. In fact, it seems as if the emerging awareness of a fabric's usefulness, when linked with the increased ease of its fabrication, tended to dilute its magic potentiality as an art medium. Throughout the centuries, the use of threads in the language of form has given way more and more to their use in service of the practical. The utilitarian side of the fabric's character so powerfully dominates our estimate of it today that we easily appraise even a tapestry, that is, a woven picture, in terms of its possible practical advantages before recognizing its merit as a formulation in pictorial terms, that is, as a work dealing with form per se.

Since we know already that only the most versatile principle of fabric construction can be used to build varied forms in varied placements in varied colors and surface treatments, we must look for the most basic technique. For, with every time-saving device that helped toward faster, and therefore increased, production, the necessary mechanization of a specific operation limited the range of the process in general. The most fundamental thread construction, of course, is the plain weave: the alternate interlacing of warp and weft threads. But whereas this construction is based on a balanced distribution of warp and weft and serves today to produce our basic utilitarian fabric, namely our millions of yards of muslin, tapestry weaving is based on an off-balance distribution, that is, a widely spaced warp covered by the weft. As noted before, it has the added distinction that the weft does not travel from selvage to selvage but moves only within the specific areas of color or surface-treatment to which

it belongs. It is the manner of the interlocking of the wefts at the turning points or at their turn around a warp thread that differentiates the various tapestry techniques from each other and thereby affects the formal structure of the design.

One of the earliest pictorial works made of threads is a weaving in which floating warp threads set in a plain-weave field form the design. It was excavated in 1946 by Junius Bird, Curator of Archaeology of the American Museum of Natural History, New York, at a site in northern Peru where he found textiles dating back to 2500 B.C. It shows a bird which is thought out in regard to form and structure with superior intelligence. We easily forget the amazing discipline of thinking that man had already achieved four thousand years ago. Wherever meaning has to be conveyed by means of form alone, where, for instance, no written language exists to impart descriptively such meaning, we find a vigor in this direct, formative communication often surpassing that of cultures that have other, additional methods of transmitting information. Today, words generally carry by far the greatest load of our expressive manifestations.

Along with cave paintings, threads were among the earliest transmitters of meaning. In Peru, where no written language in the generally understood sense had developed even by the time of the Conquest in the sixteenth century, we find—to my mind not in spite of this but because of it—one of the highest textile cultures we have come to know. Other periods in other parts of the world have achieved highly developed textiles, perhaps even technically more intricate ones, but none has preserved the expressive directness throughout its own history by this specific means. In this light we may reevaluate what we have been made to think of as the high points of the art of weaving: the famous great tapestries of the Gothic, the Renaissance, the Baroque; the precious brocades and damasks from the Far East; the Renaissance fabrics. Tremendous achievements in textile art that they are, they play first of all the role of monumental illustrations or have decorative supporting parts to play. They are responsible, I think, for textiles being relegated to the place of a minor art. But regardless of scale, small fragment or wall-size piece, a fabric can be great art if it retains directness of communication in its specific medium.

This directness of communication presupposes the closest

interaction of medium and design. A painted face obeys other laws of formation than a woven face, and the more clearly the process relates to the form, the stronger the resultant impact will be. Much of the potency of textile art has been lost during centuries of efforts to produce woven versions of paintings, often based on cartoons of the great painters of the past—on Raphael's, for instance. But trespassing into another art form, however great that form may be, does not necessarily bring forth great art works. On the contrary, the original concept as well as the transposition suffers by the very fact of indirectness. This does not mean that no great tapestries have been created in the Gothic or later periods. The Unicorn Tapestries surely are great works of art, and they are truly weaverly in their components. But many of the large wall-size hangings in our museums are not as great as their size or their placement may encourage us to believe. And a number of present-day efforts on the part of those trying to revive a declining tradition are misdirected because, again, they turn to those outside the field to excite new vitality where work has grown dull. Examples are the work of the famous French tapestry workshops which today are producing technically expert pieces that are often, however, of mainly decorative value. Only in exceptional cases, for instance, in the examples illustrated here, where artists worked mainly with flat areas, are they works of art.

Works of art, to my mind, are the ancient Peruvian pieces, preserved by an arid climate and excavated after hundreds and even thousands of years. There are those, large or small, of the Tiahuanaco period, for instance—tapestries in the pictorial as well as the technical sense—showing the deities of their Pantheon; or works from other periods, full of the life of their world. There are also the highly intelligent and often intricate inventions of lines or interlocking forms. Their personages, animals, plants, stepforms, zigzags, whatever it is they show, are all conceived within the weaver's idiom. Where clear outlines are wanted, the threads are maneuvered into position to do this, sometimes in surprising and ingenious ways varying in inventiveness from piece to piece. A unique method, for instance, is that of interlocking not only the weft but the warp itself. Where relief effects are believed to strengthen the presentation, they are added and worked out imaginatively and skillfully, as are other

desirable supports. Of infinite phantasy within the world of threads, conveying strength or playfulness, mystery or the reality of their surroundings, endlessly varied in presentation and construction, even though bound to a code of basic concepts, these textiles set a standard of achievement that is unsurpassed.

Coptic weavings, of course, also belong among inspired works in textiles, and by some they are considered to head the list. They are developed from the basic weaving structures, and thus the figures preserve the essential weaving formation. There is often in them a truly textile juxtaposition of flat and fuzzy areas. However highly developed they are, though, their more limited scope becomes apparent when they are compared with the more adventurous use of threads in the ancient American pieces.

A technique that has been used in the Near East and Far East is Soumak. By wrapping a weft thread around one or two warp threads, possibly changing colors as it crosses from selvage to selvage and reversing the direction of wrapping on the return trip, a flat, ribbed, close, heavy fabric can be produced, suited for pictorial textiles.

There are, of course, many high points in the art of weaving, in many periods and many places, that could be cited as examples of the successful interaction of medium and form. I will be accused of crass one-sidedness in my feeling of awe for the textile products of Peru, which I advance as the most outstanding examples of textile art. But it is here, I believe, that we can learn most. It is here we can learn that playful invention can be coupled with the inherent discipline of a craft. Our playfulness today often loses its sense of direction and becomes no more than a bid for attention, rather than a convincing innovation. Limitlessness leads to nothing but formlessness, a melting into nowhere. But it is form—whatever form it may be—that is, I feel, our salvation.

At present we are still groping. The efforts of weavers in the direction of pictorial work have only in isolated instances reached the point necessary to hold our interest in the persuasive manner of art. Experimental—that is, searching for new ways of conveying meaning—these attempts to conquer new territory even trespass at times into that of sculpture.

In our time, though, and for some time to come, threads can, I believe, serve as an expressive medium. And the practical

aspect of the nomadic character of things made of threads supports that belief. We move more often and always faster from place to place, and we will turn to those things that will least hinder us in moving. Just as our clothes are getting lighter and are increasingly geared to movement, so also will it be with other things that are to accompany us. And if these include a work of art that is to sustain our spirits, it may be that we will take along a woven picture as a portable mural, something that can be rolled up for transport. The Far East, of course, had this idea already long ago in the form of scrolls. Perhaps we can find for it our own form.

1965

DAVID SMITH

There is no question that David Smith (1906–1965) was the greatest sculptor to emerge in the United States in the second half of the twentieth century. Already something of a master in the 1940s, by the time he died in a car accident at the age of fifty-nine, he had developed more than one fresh visual vocabulary as he pushed the language of abstract sculpture in unexpected directions. Smith, who worked with equal ease on an intimate and a monumental scale, never felt compelled to stick to one signature style, as did so many of his contemporaries among the painters. His work ranges from rococo extravagance to machine-age asceticism, incorporating materials including cast bronze, scrap iron, and shimmering stainless steel, the surfaces sometimes painted in brilliant colors. On the fields around his home near Lake George in upstate New York, his sculptures were displayed in all their variegated grandeur, a cycle of symphonic variations, a gathering of monumental totems and talismans, with intimations of the landscape and the figure. Like Calder, Smith conceived of himself in the mold of the old Yankee craftsman, only a craftsman who rejected utilitarian forms in favor of the free play of form. While Clement Greenberg, an enthusiastic supporter, tended to emphasize the pure abstract value of Smith's variations on the language of cubism, the truth was that Smith worked without recourse to any particular set of principles and was responsive to multiplying metaphoric possibilities—to storytelling, surrealist magic, and art historical reference. Smith's writings, instinctively poetic, reflect his imaginative reach.

The Landscape

I have never looked at a landscape without seeing
other landscapes
I have never seen a landscape without visions
of things I desire and despise
lower landscapes have crusts of heat—raw epidermis
and the choke of vines
the separate lines of salt errors—the monadnocks
of fungus
the balance of stone—with gestures to grow
the lost posts of manmaid boundaries—in molten
shade a petrified paperhanger who shot the duck

a landscape is a still life of Chaldean history
it has faces I do not know
its mountains are always sobbing females
it is bags of melons and prickle pears
its woods are sawed to boards
its black hills bristle with maiden fern
its stones are Assyrian fragments
it flows the bogside beauty of the river Liffey
it is colored by Indiana gas green
it is steeped in veritable indian yellow
it is the place I've traveled to and never found
it is somehow veiled to vision by pious bastards
and the lord of Varu the nobleman from Gascogne
in the distance it seems threatened by the destruction
of gold

1947

David Smith: Group of sculpture at Bolton Landing, circa 1960. Photograph by the artist.

The Question—what is your hope

I would like to make sculpture that would rise from
water and tower in the air—
that carried conviction and vision that had not
existed before
that rose from a natural pool of clear water
to sandy shores with rocks and plants
that men could view as natural without reverence or awe
but to whom such things were natural because they were
statements of peaceful pursuit—and joined in the
phenomenon of life
Emerging from unpolluted water at which men could bathe
and animals drink—that
harboured fish and clams and all things natural to it
I don't want to repeat the accepted fact,
moralize or praise the past or sell a product
I want sculpture to show the wonder of man, that flowing
 water,
rocks, clouds, vegetation, have for the man in peace who
glories in existence
this sculpture will not be the mystical abode
of power of wealth of religion
Its existence will be its statement
It will not be a scorned ornament on a money changer's temple
or a house of fear
It will not be a tower of elevators and plumbing with every
room rented, deductions, taxes, allowing for depreciation
amortization yielding a percentage in dividends
It will say that in peace we have time
that a man has vision, has been fed, has worked
it will not incite greed or war
That hands and minds and tools and material made a symbol
to the elevation of vision
It will not be a pyramid to hide a royal corpse from pillage
It has no roof to be supported by burdened maidens
It has no bells to beat the heads of sinners
or clap the traps of hypocrites, no benediction
falls from its lights, no fears from its shadow
this vision cannot be of a single mind—a single concept,

it is a small tooth in the gear of man,
it was the wish incision in a cave,
the devotion of a stone hewer at Memphis
the hope of a Congo hunter
It may be a sculpture to hold in the hand
that will not seek to outdo by bulky grandeur
which to each man, one at a time, offers a marvel of
close communion, a symbol which answers to the holder's
 vision,
correlates the forms of woman and nature, stimulates the
recall sense of pleasurable emotion, that momentarily
rewards for the battle of being

c. 1946–47

The Question—what are your influences—

from the history of art and the myth of woman
from the half of a part chewed chicken rib cage
and out of a fried salted mackerel spine
the structure of August hatched moths that come off the
 mountains
the color of moths that blind in my arc
out of Beethoven's E flat major, opus 31 and
the statement about intent he made at the time
from brush marks on a wall
the personages that grain pine boards
the grease spots on paper
the creatures in foliage
the statements of nature—the underlying structure
which forms the object, its whole or its parts—
related by associations not yet befouled by commerce
the nature of accident made by man as they fall in unity
as if directed by genes and generations
From Lahey's thrust, from Sloan's cones and cubes
from Matulka's cubist concept and aggressive inquiry
from Graham's erratic finesse from Davis' conversations
over ale at McSorley's or Stewarts over coffee, his
caustic disdain for the stuffed shirts in our professional

world, his enthusiasm for Pine Top Smith
From all my friends and contemporaries
Directives too come from the way swallows dart
the way trees fall
the shape of rocks
the color of a dry doe in brown
the way bark grows on basswood sprouts
the head of a turtle—the vertebrae
the memory of the soup it made
and the 52 ping pong balls it never laid
the roll of the mountains after the day's work
on the walk from the shop to my house
the way stars track
from bugs and butterflies under magnification
dividing to find the common denominators
the antennae, body movement to shape, the joints of the legs
and feet, squared by the memory of fish and the behavior of
 man
the ecstasy of a piano sonata and black coffee at midnight
the pieces finished outside the shop
the piece underway—the piece finished conceptually
the odds on the wall, the patterns in the rafters,
the stack of materials, the tools to form it and the work to
 come
the memory of 1 Atlantic Avenue, the odds on the wall,
the ship ventilators that hung from the rafters, the
rusty rows of forging tongs
the banks of hardies, the forging beds, the babbit ladles
the stacks of buffalo horn
the boxes of barrier reef pearl shell
the baskets of pistol handles in various stages of finish and
 polish
the rows of every revolver frame ever made, the clatter of
barge fuel pumps, the backwater roll of an incoming ferry
the crunch of Levy the barge oiler walking thru the cinder
yard out the gate for coffee
from the way booms sling
from the ropes and pegs of tent tabernacles
and side shows at country fairs in Ohio
from the bare footed memory of unit relationships on

locomotives sidling thru Indiana,
from hopping freights, from putting the engines together and
working on their parts in Schenectady
From everything that happens to circles
and from the cultured forms of woman and the free growth
of mountain flowers
From no one, individually, but selections
from the cube root of all in varying
context.

c. 1950

————————

there is something rather noble about junk—selected junk—
junk which has in one era performed nobly in function for
common man—has by function been formed by the smithy's
 hand alone
and without bearings roll or bell has fulfilled its function,
 stayed behind, is not yet relic or antique or precious
which has been seen by the eyes of all men and left for me—
to be found as the cracks in sidewalks
as the grain in wood
as the drop in grass
out of a snow hummock
as the dent in mud from a bucket of poured storms
as the clouds float and
as beauties come
to be used, for an order
to be arranged—to be now perceived
by new ownership

c. 1953

Dream

A dream is a dream never lost
I've had it inside a 4-8-4 on the top of a Diesel Engine,
they have been in a size dream.
I found an old flatcar
asked for, and was given it—

Had I used the flatcar for the base
and made a sculpture on the top
the dream would have been closer

I could have loaded a flatcar with
vertical sheets, inclined planes, uprights—
with holes, horizontals supported—

I could have made a car with
the nude bodies of machines,
undressed of their details and teeth—

I could have made a flatcar with
a hundred anvils of varying sizes and character
which I found at forge stations.

I could have made a flatcar with
painted skeletal wooden patterns

In a year I could have made a train

the flatcar I had is now melted

1962

HOWARD NEMEROV

The poet Howard Nemerov (1920–1991) grew up in a well-to-do and sophisticated New York family (his sister was the photographer Diane Arbus), studied at Harvard, and was a fighter pilot during World War II. Those wartime experiences surely shaped his response to David Smith's *Four Soldiers*, published in an exhibition catalogue in 1952. In a later poem—"The Painter Dreaming in the Scholar's House," dedicated to the memory of two painters, the European Paul Klee and the American Paul Feeley—Nemerov extended his exploration of the visual artist's particular powers, describing the creation of "an allegory of the mind." "It is archaic speech," he wrote of Klee's genius for making the invisible visible, "that has not yet / Divided out its cadences in words." The same might be said of some of David Smith's finest sculpture.

Four Soldiers:
A Sculpture in Iron by David Smith

Piece by piece recruited from the odd
Detritus of an iron age gone wrong—
Turnbuckle, poker, unidentified
Flanges and bolts—so soldiers get along,
Staggering but yet rigid about the trunk,
One on hands and knees, wounded or else drunk.

David Smith: *Four Soldiers*, 1952, iron. Photograph by the artist.

Although it was an iron discipline
Did this to them, they gained their gaiety
On honorable service; being done
Out of mortality, they are set free
As though by natural virtue in the rust
That answers to their privacy in dust.

Soldier, it is the warfare of the world
Weathers you, and this ruin alone is glory;
Faithfully suffer for the ruining lord
His timely work, and earn a place in the story.
May the machine this way redeem the part
And nature for some time consent to art.

1952

LOUISE BOURGEOIS

Born in Paris, the sculptor Louise Bourgeois (1911–2010) only began to make her mark in New York in the mid-century years. The Surrealist fascination with a mythic unconscious pushed Bourgeois to explore her own private cosmology and to return, time and again, to what she said were the traumas of a middle-class French upbringing, with a gentle, steady, long-suffering mother and a domineering, womanizing, impossible-to-satisfy father. What distinguishes Bourgeois's totemic assemblages and allegorical prints and drawings from the nostalgia so often associated with the Surrealists is her instinctively blunt, elegant power—a directness and abruptness in the handling of materials that, no matter how strongly she may have felt the pull of the Old World, seems very much in keeping with New York's pioneering spirit. For many years Bourgeois was something of an artist's artist, much admired by contemporaries but little known in the wider world. A retrospective at the Museum of Modern Art in 1982 marked a dramatic turning point in her career. And in the years leading up to her death at the age of ninety-eight, even as Bourgeois continued to work on an intimate scale, creating a powerful series of sewn and stuffed figures suggesting ghosts from a childhood nightmare, she was being hailed for her monumental public works, especially a sculpture of a spider, titled *Maman,* by turns frightening and consoling.

An Artist's Words

An artist's words are always to be taken cautiously. The finished work is often a stranger to, and sometimes very much at odds with what the artist felt or wished to express when he began. At best the artist does what he can, rather than what he wants to do. After the battle is over and the damage faced up to, the result may be surprisingly dull—but sometimes it is surprisingly interesting. The mountain brought forth a mouse, but the bee will create a miracle of beauty and order. Asked to enlighten us on their creative process, both would be embarrassed, and probably uninterested. The artist who discusses the so-called meaning of his work is usually describing a literary side-issue. The core of his original impulse is to be found, if at all, in the work itself.

Just the same, the artist must say what he feels: My work grows from the duel between the isolated individual and the shared awareness of the group. At first I made single figures without

any freedom at all; blind houses without any openings, any relation to the outside world. Later, tiny windows started to appear. And then I began to develop an interest in the relationship between two figures. The figures of this phase are turned in on themselves, but they try to be together even though they may not succeed in reaching each other.

Gradually the relations between the figures I made became freer and more subtle, and now I see my works as groups of objects relating to each other. Although ultimately each can and does stand alone, the figures can be grouped in various ways and fashions, and each time the tension of their relations makes for a different formal arrangement. For this reason the figures are placed in the ground the way people would place themselves in the street to talk to each other. And this is why they grow from a single point—a minimum base of immobility which suggests an always possible change.

In my most recent work these relations become clearer and more intimate. Now the single work has its own complex of parts, each of which is similar, yet different from the others. But there is still the feeling with which I began—the drama of one among many.

The look of my figures is abstract, and to the spectator they may not appear to be figures at all. They are the expression, in abstract terms, of emotions and states of awareness. Eighteenth-century painters made "conversation pieces"; my sculptures might be called "confrontation pieces."

1954

On the Creative Process

THERE is a long lapse between the first creative vision and the final result; often it is a matter of years. For instance, hollow forms appeared first in my work as details, and then grew in importance until their consciousness was crystallized by a visit to the Lascaux caves with their visible manifestation of an enveloping negative form, produced by the torrent of water that has left its waves upon the ceiling: my underlying preoccupation had been constant, but it had taken me seven years to develop and give it final shape.

There has been a similar gradual development from rigidity to pliability. When I was asked to give a fourth side to the flat back of a statue called *Spring*, which had been conceived as a stiff caryatid, I found it impossible to do: rigidity then seemed essential. Today it seems futile and has vanished. In the past my work fought, sustained and challenged; my new work, in which modeling and building up has replaced hacking away, can roll and wear out, and settle down to a peaceful existence.

Though the titles of many of my pieces refer to nature or the human figure, they are not abstractions in the usual sense. Rather they arise out of a state of awareness provoked by a revealed and fleeting vision of nature. Its very elusiveness gave me the desire to fix it, for fear of not finding it again. If the work holds any magic I consider it successful. This personal vision which some people say the artist wants to impose on others, in fact only becomes clear to the artist himself from the finished work. When he sees it, he knows he has finished his work.

mid-1960s

Form

Restif de la Bretonne
Colette, Willy
Apollinaire, Guillaume
Breton, André
Céline
Artaud, Antonin
Mailer, Norman

Form: *la vie des hommes*, the visual abstract, the language of forms, or "the style is the man," "the style is of today."

Abstracted, the forms if correct should have a direct impact even unconscious.

The work has to stand by itself and it is the form that will guarantee its survival.

Vocabulary is how we communicate, find ways to stimulate through signs and symbols, directed at our five senses.

The forms have a language understood by a few. You cannot understand erotic forms if you are completely innocent

Louise Bourgeois: *Sleeping Figure*, 1950. Painted balsa wood, 74½ × 11⅝ × 11¾ in.

and a symbol is a symbol only if what it stands for is known. The standing for is almost an equating but rather an analogy. Symbols can be literal and literary as in Surrealism or they can be suggestive as in abstract art. The rhythm then will be suggestive: slow, rapid, sudden, repetitious, with different intervals and intensities. To understand the language or vocabulary of a given artist, in a non-descriptive mode, there must be on the part of the spectator an attentive and receptive attitude with deference, endurance, and patience, and if I am not readily understood I do not mind—as time goes by people will see new things in the work—things that the artist did not put there or did not know he had put there—the successive analogies or associations of subjects to symbols will be read and reinterpreted—e.g. the oozing out of milk (mother) water (spring

in mother earth)—saliva in snails—lava in volcano—creates an ambivalence of feelings that goes from pleasure to fear.

The work should stand by itself—without explanation after it leaves the studio the piece begins a life of its own for better or for worse—the intention of the maker does not matter anymore—the "message" may not be understood or forgotten. The artist may be long dead and the work goes on along its way.

As time goes by people will see in it things that we did not put there, did not intend to put there or did not know we put there and yet are there (that is the problem of the degree of planning an artist controls).

For instance those four sculptures shown on the screen are shown as "erotic" art—I respect what classification they have given (put in) but I do not think of them as such. I do not plan to be erotic and doubt if I am but if when you come in their presence the esthetic shoe is an erotic one—who am I to tell you it was not so?

Content is a concern with the human body, its aspect, its changes, transformations, what it needs, wants and feels—its functions.

What it perceives and undergoes passively, what it performs. What it feels and what protects it—its habitat.

All these states of being, perceiving, and doing are expressed by processes that are familiar to us and that have to do with the treatment of materials, pouring, flowing, dripping, oozing out, setting, hardening, coagulating, thawing, expanding, contracting, and the voluntary aspects such as slipping away, advancing, collecting, letting go—

Pornography has the same content as eroticism: without being art it is completely literal and over-explicit—if not obvious it leaves nothing to be discovered.

The content is today the erotic message—everything that takes place as a result of the presence of two people. Pleasure, pain, survival, in public or in private, in a real or imaginary world.

late 1960s

PHILIP GUSTON

Philip Guston (1913–1980) was born in Montreal and grew up in Southern California, where his early paintings were influenced by the work of the Mexican muralists, who sought to portray a society in all its amplitude and variety, much as the masters of the Renaissance had sometimes done. Even back then, there was a strain of delicacy and quietism in Guston's paintings, and this blossomed as he turned to abstraction around 1950, producing incandescent, shimmering canvases composed of little more than strokes of silvery white, rose, and terra-cotta paint. In two brief essays, published in the 1960s, Guston, by then universally recognized as a key figure in the School of New York, spoke about his abstractions in terms of an existential search for wisdom, for nature, for what he called the final destiny of form—a search whose anxieties he saw reflected even in the seemingly serene images of the fifteenth-century Italian painter Piero della Francesca. Guston was always a restless spirit, and in the years around 1970 he began to reintroduce naturalistic elements into his work, creating a universe of weird, bulbous faces and objects, by turns comic and tragic, childish and nightmarish, with echoes of the social realist work of his earlier days. Nobody could deny that Guston's new paintings signaled a dramatic break with the gently enigmatic power of his most famous abstractions, and this stylistic shift not surprisingly inspired considerable unease among painters and critics, at least initially. But by the time of his death, Guston's late style had been embraced by a younger generation. Here, so many believed, was a new kind of pictorial freedom, a grand riposte to Clement Greenberg's autocratic separation between avant-garde and kitsch.

Piero della Francesca: *The Impossibility of Painting*

A CERTAIN anxiety persists in the painting of Piero della Francesca. What we see is the wonder of what it is that is being seen. Perhaps it is the anxiety of painting itself.

Where can everything be located, and in what condition can everything exist? In *The Baptism of Christ*, we are suspended between the order we see and an apprehension that everything may again move. And yet not. It is an extreme point of the "impossibility" of painting. Or its possibility. Its frustration. Its continuity.

Piero della Francesca: *The Flagellation of Christ*, circa 1469.
Oil and tempera on panel, 23 × 32½ in.

He is so remote from other masters; without their "completeness" of personality. A different fervor, grave and delicate, moves in the daylight of his pictures. Without our familiar passions, he is like a visitor to the earth, reflecting on distances, gravity and positions of essential forms.

In the *Baptism*, as though opening his eyes for the first time, trees, bodies, sky and water are represented without manner. The painting is nowhere a fraction more than the balance of his thought. His eye. One cannot determine if the rhythm of his spaces substitute themselves as forms, or the forms as rhythms. In *The Flagellation*, his thought is diffuse. Everything is fully exposed. The play has been set in motion. The architectural box is opened by the large block of the discoursers to the right, as if a door were slid aside to reveal its contents: the flagellation of Christ, the only "disturbance" in the painting, but placed in the rear, as if in memory. The picture is sliced almost in half, yet both parts act on each other, repel and attract, absorb and enlarge, one another. At times, there seems to be no structure at all. No direction. We can move spatially everywhere, as in life.

Possibly it is not a "picture" we see, but the presence of a necessary and generous law.

Is the painting a vast precaution to avoid total immobility, a wisdom which can include the partial doubt of the final destiny of its forms? It may be this doubt which moves and locates everything.

1965

Faith, Hope and Impossibility

THERE are so many things in the world—in the cities—so much to see. Does art need to represent this variety and contribute to its proliferation? Can art be that free? The difficulties begin when you understand what it is that the soul will not permit the hand to make.

To paint is always to start at the beginning again, yet being unable to avoid the familiar arguments about what you see yourself painting. The canvas you are working on modifies the previous ones in an unending, baffling chain which never seems to finish. (What a sympathy is demanded of the viewer! He is asked to "see" the future links.)

For me the most relevant question and perhaps the only one is, "When are you finished?" When do you stop? Or rather, why stop at all? But you have to rest somewhere. Of course you can stay on one surface all your life, like Balzac's Frenhofer. And all of your life's work can be seen as one picture—but that is merely "true." There *are* places where you pause.

Thus it might be argued that when a painting is "finished," it is a compromise. But the conditions under which the compromise is made are what matters. Decisions to settle anywhere are intolerable. But you begin to feel as you go on working that unless painting proves its right to exist by being critical and self-judging, it has no reason to exist at all—or is not even possible.

The canvas is a court where the artist is prosecutor, defendant, jury and judge. Art without a trial disappears at a glance: it is too primitive or hopeful, or mere notions, or simply startling, or just another means to make life bearable.

You cannot settle out of court. You are faced with what seems like an impossibility—fixing an image which you can tolerate.

What can be Where? Erasures and destructions, criticisms and judgments of one's acts, even as they force change in oneself, are still preparations merely reflecting the mind's will and movement. There is a burden here, and it is the weight of the familiar. Yet this is the material of a working which from time to time needs to see itself, even though it is reluctant to appear.

To will a new form is inacceptable, because will builds distortion. Desire, too, is incomplete and arbitrary. These strategies, however intimate they might become, must especially be removed to clear the way for something else—a condition somewhat unclear, but which in retrospect becomes a very precise act. This "thing" is recognized only as it comes into existence. It resists analysis—and probably this is as it should be. Possibly the moral is that art cannot and should not be made.

All these troubles revolve around the irritable mutual dependence of life and art—with their need and contempt for one another. Of necessity, to create is a temporary state and cannot be possessed, because you learn and relearn that it is the lie and mask of Art and, too, its mortification, which promise a continuity.

There are twenty crucial minutes in the evolution of each of my paintings. The closer I get to that time—those twenty minutes—the more intensely subjective I become—but the more objective, too. Your eye gets sharper; you become continuously more and more critical.

There is no measure I can hold on to except this scant half-hour of making.

One of the great mysteries about the past is that such masters as Mantegna were able to sustain this emotion for a year.

The problem, of course, is more complex than mere duration of "inspiration." There were pre-images in the fifteenth century, foreknowledge of what was going to be brought into existence. Maybe my pre-image is unknown to me, but today it is impossible to act; as if pre-imaging is possible.

Many works of the past (and of the present) complete what they announce they are going to do, to our increasing boredom. Certain others plague me because I cannot follow their intentions. I can tell at a glance what Fabritius is doing, but I am spending my life trying to find out what Rembrandt was up to.

I have a studio in the country—in the woods—but my paintings look more real to me than what is outdoors. You walk outside; the rocks are inert; even the clouds are inert. It makes me feel a little better. But I do have a faith that it is possible to make a living thing, not a diagram of what I have been thinking: to posit with paint something living, something that changes each day.

Everyone destroys marvelous paintings. Five years ago you wiped out what you are about to start tomorrow.

Where do you put a form? It will move all around, bellow out and shrink, and sometimes it winds up where it was in the first place. But at the end it feels different, and it had to make the voyage. I am a moralist and cannot accept what has not been paid for, or a form that has not been lived through.

Frustration is one of the great things in art; satisfaction is nothing.

Two artists always fascinate me—Piero della Francesca and Rembrandt. I am fixed on those two and their insoluble opposition. Piero is the ideal painter: he pursued abstraction, some kind of fantastic, metaphysical, perfect organism. In Rembrandt the plane of art is removed. It is not a painting, but a real person—a substitute, a golem. He is really the only painter in the world!

Certain artists do something and a new emotion is brought into the world; its real meaning lies outside of history and the chains of causality.

Human consciousness moves, but it is not a leap: it is one inch. One inch is a small jump, but that jump is everything. You go way out and then you have to come back—to see if you can move that inch.

I do not think of modern art as Modern Art. The problem started long ago, and the question is: Can there be any art at all? Maybe this is the content of modern art.

1966

MORTON FELDMAN

As a young man the composer Morton Feldman (1926–1987) was captivated by the twelve-tone music of Arnold Schoenberg and Anton Webern. And in his mature work he pushed beyond those still-radical ideas, rejecting all the traditional assumptions about musical form and development in works built of muted sonorities that persisted for very long periods of time. Feldman found support for his experiments among a group of friends that included the composers John Cage and David Tudor and the artists Robert Rauschenberg, Philip Guston, and Willem de Kooning. In the pungent memoirs that he devoted to downtown New York in the 1950s, Feldman caught some of the easy-going exhilaration of those years when modernism had not yet lost its youthful, romantic glow.

Philip Guston: The Last Painter

YEARS ago there was a game Philip Guston and I used to play. We were the last artists. Remember Alexander Pope's "Art after art goes out, and all is night"? As in all eschatological fantasies, the "end of the world" was in truth the end of an era.

It is significant that in all these years, Philip Guston and John Cage are equally important to me. With Cage we were still the last artists, but now it was "Art after art goes out, and all is *light*." Actually, I think of myself as a double agent. Kierkegaard confesses that if he hadn't been a philosopher, he would have been a police spy.

During those years we all talked constantly about an imaginary art in which there existed almost nothing. In a sense it was a three-way conversation, though I never brought the ideas of one to the attention of the other, and as far as I know, Guston and Cage never talked about it together. Again it was my role as double agent in keeping intact a precarious balance in the family.

More than philosophic toy, "nothing" is a crucial point of arrival and departure for being the last artists. It is obvious that we don't begin with nothing, less obvious that after years of working one arrives at very little. Especially as we clear away

the debris that resulted from believing that what is historical is equally personal, or that what is personal also fits into history.

"Nothing" is not a strange alternative in art. We are continually faced with it while working. In actual life, this experience hardly exists. We live from moment to moment, an invisible gestalt shaping the form of our lives.

In art we exist from poem to poem, from painting to painting. We are confronted with the fact, or rather it is more in evidence, that we have very little to bring, extremely little to say. We experience "nothing," then, not unlike the medieval Kabalists, who understood it as that ultimate place where it becomes possible to speculate about God. Whatever insight was found was expressed metaphorically.

If we assume that Guston's paintings are in themselves a metaphor, we must then understand that just this assumption has been the subject of his continuous parable. As we make a metaphor about creation, it has made a metaphor about us.

Each of Guston's paintings is a sentence, neither negating the last, nor redeeming the next. At what point do we break into this discourse? At what point can we withdraw, at the risk of missing any part of this fevered commentary? Willem de Kooning once said it is his final stroke that makes the picture. With Guston's final painting, all his work will be at rest.

I remember taking a long walk with John Cage along the East River. It was a gorgeous spring day. At some point he exclaimed, "Look at those sea gulls. My, how free they are!" After watching the birds I remember saying, "They're not free at all—every moment is in search of food."

That is the basic difference between Cage and Guston. Cage sees the effect, he ignores its cause. Guston, obsessed solely with his own causality, destroys its effect. They are both right, of course, and so am I. We complement each other beautifully. Cage is deaf, I am dumb, Guston is blind.

If art has its doppelgänger in culture, then Guston is Art, while Cage is Culture. Though indispensable to each other, both are impenetrable. Like a Tolstoyan marriage, they have everything to do with each other, but will have nothing to do with each other. Guston's work is indispensable to the art continuum. It has no real place in contemporary culture. Whereas

our contemporary culture would be quite different without John Cage. Culture is more "idea" than art. It has, as its own tradition, the revelation of process. It is discreet in not being appreciative of the special flavor of an artist. Art has its own tradition in the revelation of feeling. It is equally discreet in not being appreciative of how a work is made.

Guston is of the Renaissance. Instead of being allowed to study with Giorgione, he observed it all from the ghetto—in the marshes outside of Venice where the old iron works were. I know he was there. Due to circumstance, he brought that art into the diaspora with him. That is why Guston's painting is the most peculiar history lesson we have ever had.

As I write, *Attar* is hanging on the other side of my room. I have the feeling that if I moved it to another wall, it would be an entirely different painting. It seems to be reflecting rather than ordinating phenomena. As the tones vibrate, they recede beneath the pigment and return, but with another bowing. In music we would say the sound was sourceless due to the minimum of attack. This explains the painting's complete absence of weight. But the sensation of what you see *not coming from what is seen* is characteristic of all Guston's work.

The fact that we see how the paint is applied gives no clue to this overall impression. Guston's drawings evoke the same sensation. It is as though a great pianist were to sit down at your piano, hold his fingers very much as you do, and then begin to play. Something else takes over. The analytic faculties do not give the answer.

Adding to all this, the paintings often "perform" only as the viewer begins to leave them. Not long ago Guston asked some friends, myself among them, to see his recent work at a warehouse. The paintings were like sleeping giants, hardly breathing. As the others were leaving I turned for a last look, then said to him, "There they are. They're up." They were already engulfing the room. We got into the elevator with our friends.

1966

Give My Regards to Eighth Street

"But to tell it all just as it happened because of course a great deal had happened not only to me and to everybody else I knew but to everything else. Once more Paris is not as it was."

—Gertrude Stein

NOT long ago I saw the Elgin Marbles. I didn't faint, as they say Shelley did, but I certainly had to sit down. Nothing knocks us out like this anonymity—this beauty without a biography. The artist himself loves the idea. What artist hasn't longed to get away from the human effort he puts into his work? What artist doesn't have the illusion that the Greeks did their work without human effort? Even the "timelessness" of Giacometti seems to us more a reference to a buried civilization than to a buried colleague. Nietzsche with his Greeks, John Cage with his Zen—always this need for an idealized, depersonalized art.

Sainte-Beuve, for example, was so carried away by a passion for Classicism that he never said a good word about Balzac, Stendhal, Baudelaire or Flaubert. The critic's ideal has always been the process without the artist. If it wasn't Classicism, it was Expressionism or Cubism—whatever it is, the artist gets in his way. More and more today there is this feeling of "By all means, let's have art, but no names, please."

But the fifties in New York have to do with names, names, names. That's why they're worth writing about.

When I met John Cage in 1950, I was twenty-four years old. He was living then on the top floor of an old building on the East River Drive and Grand Street. Two large rooms, with a sweeping expanse of the river encircling three sides of the apartment. Spectacular. And hardly a piece of furniture in it.

Richard Lippold had a studio next door. Sonia Sekula, an unusually gifted painter (she reminded me of Elisabeth Bergner), lived on the floor below. Soon after John and I met, an apartment became vacant on the second floor, and I too moved into "Bosa's Mansion," as it was called in honor of our landlord. It was great fun, a sort of pre-hippie community. But instead of drugs, we had art.

There was sometimes more activity in the hallways than our studios, what with John running into my place with a new idea

for a piece, or me rushing into his. Visitors too were shifted from floor to floor. I met Henry Cowell in this way. Cowell came to visit John, and John brought him down to meet me. He sat down at my piano, played a few of his pieces, and talked for hours. What a delightful and kind man he was.

One day there was a knock at my door. It was John. "I'm going over to see a young painter called Robert Rauschenberg. He's marvelous, and his work is marvelous. You must meet him." Five minutes later we were both in John's Model A Ford, on the way to Rauschenberg's studio on Fulton Street. Rauschenberg was working on a series of black paintings. There was one big canvas I couldn't stop looking at.

"Why don't you buy it?" Rauschenberg said.

"What do you want for it?"

"Whatever you've got in your pocket."

I had sixteen dollars and some change, which he gleefully accepted. We immediately put the painting on top of the Model A, went back to "Bosa's Mansion" and hung it on the wall. That was how I acquired my first painting.

One day it was arranged that John, Lippold and I were to be jointly interviewed for a magazine article. I suggested that we get together with the editor at my place for lunch, and said I would make cheese blintzes. John thought it was a wonderful idea, and said he would bring the salad. I told him salad was unnecessary. Lippold then offered to make soup. I finally persuaded him that soup was also unnecessary. Neither of them understood my lunch plans, but finally gave in. As a concession to John, I served the blintzes in his Japanese wooden bowls. Everybody enjoyed them, though I don't think Lippold was ever convinced about the soup. After the lunch, the three of us were photographed together in a hearse belonging to Lippold.

John and I occasionally took a lift uptown in this hearse, which Lippold used to transport his sculptures. Cars on the East River Drive always kept at a respectful distance. Once I rode in the back part and amused myself by smiling out the window at passing motorists.

John and I spent a lot of time playing cards. One afternoon my friend Daniel Stern came over with a pair of dice. John came down immediately, and we told him how the game was played. John made his first throw standing up and just dropping the

dice to the floor. We explained the procedure was to bend your knees as far down as possible, then throw the dice. This he did. He also started to shake them (we hadn't told him to do that), and before letting them go he cried out, to our amazement, "Baby needs a new pair of shoes."

It was Daniel Stern who also introduced us to the world of science-fiction writers. He knew the editor of a science-fiction magazine called *Galaxy*, and took us over to meet him one evening. This editor, because of a phobia about going outdoors, ran the magazine from his apartment. A huge telescope in the middle of the living room brought him closer to whatever was happening in the Stuyvesant Town street below, and a poker game went on almost every night.

For about two years John and I went to this house every week. There were always several card games going. The editor's wife gave the players change from a bus driver's changemaker, which she wore strapped around her waist and worked with lightning speed. There was a lot of talk about science fiction, also about Dianetics, a currently popular technique that was said to bring back memories of the womb. As I recall, John and I, with our crazy ideas about music, fitted in very well.

One could in those days sit around for hours, talking wild ideas that sounded very like the theorizing you find in Russian novels. John, of course, was involved with Zen, but in spite of the terseness of Zen, it seemed to fill up the evenings just as well. What was surprising was that John actually invented unprecedented ways to write a music that contained these Zen ideas. One would think I would have gotten more involved with the ideas, since I was so deeply interested in the music they produced. It didn't work that way. The more interested I got in Cage's music, the more detached I became from his ideas. I think this happened to Cage too. As his music developed through the years, he talked less and less about Zen. At most he would give it a sort of warm pat on the shoulder, like some old friend he was leaving in a comfortable hotel bar in Tokyo while he himself began his trek across the Gobi Desert.

John, who lived on practically no money, gave marvelously sumptuous parties. Once I was introduced to a man who looked like a Viennese matinee idol. It was Max Ernst. I had recently read in some book about the bizarre Surrealist behavior of

Ernst. I watched him uneasily all night, waiting for something to happen, but his behavior remained impeccable.

Another of these parties introduced my music to many of John's friends. The people who came—painters, writers, sculptors—were all new to me. On another evening, David Tudor played some now forgotten piano pieces of mine for Virgil Thomson and George Antheil. This was my first introduction to the musical world. Until then I had known only a few composers my own age.

The faces of these people. The faces of gifted people. Max Ernst. Philip Guston. David Hare. Virgil Thomson. De Kooning. Marvelous faces. Unforgettable faces.

John Cohen: The Cedar Tavern, 1959. Mercedes Matter and Philip Guston seated in the foreground, Frank O'Hara standing, at right.

Two of John's most influential lectures were first given at the Artists' Club, located then on Eighth Street. The first lecture was called "Nothing," the second, "Something"—or perhaps it was the other way around. Boulez, on his first visit to America, also spoke at the club. He was totally unknown here; and it was John who arranged this talk. He also took Boulez around to many of the studios. John was so proud of the New York painters.

Then, of course, there was the Cedar Bar, where I became friends with painters my own age. Mimi and Paul Brach, Joan Mitchell, Mike Goldberg, Howard Kanovitz. I think it was at the Cedar that I first met the poet Frank O'Hara—but O'Hara deserves a volume to himself.

One evening, when I was still a newly arrived immigrant at the Cedar Bar, Elaine and Willem de Kooning casually took my arm as they passed, and said, "Come on over to Clem Greenberg's." There were just a few people when we got there. After a while I found myself listening to Greenberg, who was talking about Cézanne. De Kooning showed signs of impatience and seemed to be trying to control his anger. He finally broke out with "One more word about Cézanne, and I'll punch you in the nose!" Greenberg, very startled, had been saying only very intelligent and perceptive things. It was hard for him to understand that what de Kooning resented was his having ideas on the matter at all. "You have no right to talk about Cézanne," de Kooning snapped. "Only I have the right to talk about Cézanne."

Walking into Greenberg's, I remember the feeling of not knowing just who anybody was. But as I left that night, I knew who de Kooning was. I didn't feel he was arrogant. I didn't feel he was rude. For me, coming from a background where the emotional life was a buried discourse, this kind of vulnerability was like my introduction not only to the art world, but to reality itself. It took me out of my romantic dream of what it was to be an artist, into the reality of it. It also showed me, through Greenberg, that the real philistines are those that most "understand" you.

Until the fifties, the overall trend of American painting was chiefly preoccupied with capturing a certain ethnic, regional flavor, the art itself being a conceptual shortcut to this. Even an

artist like Dove seems to come to art somewhat like a gentle-
man farmer. He has genius, but it is still a sort of landed-gentry
genius.

The Whitney Museum in Greenwich Village was the strong-
hold of this Wasp Bohemia. The beautiful building, taken over
now by the New York Studio School, still stands on Eighth
Street. I lectured there recently, and while wandering through
the upper floors looked in on what used to be Mrs. Whitney's
studio. This room was like a page out of a Henry James novel.

In contrast to all this charming Americana, one remembers
the power, the impact of those first Abstract Expressionist shows
at the Betty Parsons, Egan and Kootz Galleries. In this context,
an artist like Bradley Tomlin, who had gone over to the Abstract
Expressionists, stood out almost like a traitor to his class.

I continually think of Tomlin. I think of him at the table in
the Cedar. Aristocratic, aloof, most often alone—still, he came.
Occasionally, too, Motherwell, bringing in what Willa Cather
somewhere called the "world shine"—a young Hamilton ad-
justing his lace cuff at Valley Forge.

As I have written elsewhere, there were two diametrically
opposed points of view I had to cope with in those days—one
represented by John Cage, the other by Philip Guston. Cage's
idea, summed up years later in the words "Everything is music,"
had led him more and more toward a social point of view, less
and less toward an artistic one. Like Mayakovsky, who gave up
his art for society, Cage gave up art to bring it together with
society.

Then there was Guston. He was the arch crank. Very little
pleased him. Very little satisfied him. Very little was art. Always
aware in his own work of the rhetorical nature of the complica-
tion, Guston reduces, reduces, building his own Tower of Babel
and then destroying it.

Personally, I have never understood the term "Action Paint-
ing" as a description of the work of the fifties. The closest I can
come to its meaning is that the painter tries for a less predeter-
minate structure. This does not mean, however, that there was
an indeterminate intention. If indeed there is an emphasis on
action, it is the attempt to capture a certain spontaneity always
inherent in drawing, and now applied to larger forces. Guston's
drawings, for instance, have the look of paintings, while his

paintings have the feel of drawings. To varying degrees, one can say the same of much of the work done in the fifties.

My quarrel with the term "Action Painting" is that it gave rise to the erroneous idea that the painter, now being "free," could do "anything he liked." But it is not at all true that the more one is free, the more things one has to choose from. Actually, it is the academician who has the alternatives. Freedom is best understood by someone like Rothko, who was free to do only one thing—to make a Rothko—and did so over and over again.

It is not freedom of choice that is the meaning of the fifties, but the freedom of people to be themselves. This type of freedom creates a problem for us, because we are not free to *imitate* it. In every other era, the Messianic aspect of art has always been sought for in some organizing principle, since this principle is, and always has been what saves us in art. What is hard to understand about the fifties is that these men did not want to be saved in art. That is why, in terms of influence (and who thinks in any other terms?), they have not made what is sometimes called an "artistic contribution." What they did was to make the whole notion of artistic contribution a lesser thing in art.

Ryder once said about one of his paintings that it had everything—everything but what he wanted. What Ryder wanted was the fifties. Ryder was aware that it is not the "unifying principle" and not the "artistic achievement" that make the experience behind a work of art. To me it has never seemed an accident that he walked the same pavement on University Place. In temperament, in the emotional tradition of his work, he was the first Abstract Expressionist.

Nietzsche teaches us that only the first five steps of an action can be planned. Beyond that, on any long-range basis, one must invent a dialectic in order to survive. Until the fifties the artist believed that he could not, must not, improvise as the bull charged—that he must adhere to the formal ritual, the unwasted motion, the accumulated knowledge that reinforces the courage of the matador, and that allows the spectator the ecstasy of feeling that he too, by knowing all that must be known to survive in the bullring, has himself defied the gods, has himself defied death.

To survive without this dialectic is what the fifties left us. Before that, American painting had concerned itself with efficient

solutions. The Abstract Expressionists were making bigger demands on their gifts and their energies.

Their movement took the world by storm. Nobody now denies it. On the other hand, what are we to do with it? There is no "tradition." All we are left with is a question of character. What training have we ever had to understand what is ultimately nothing more than a question of character? What we are trained for is analysis. The entire dialectic of art criticism has come about through the analysis of bad painting.

Take Franz Kline. There is no "plastic experience." We don't stand back and behold the "painting." There is no "painting" in the ordinary sense, just as there is no "painting," for that matter, in Piero della Francesca or Rembrandt. There is nothing but the integrity of the creative act. Any detail of the work is sufficient to establish this. The fact that these details accumulate and make what is known as a work of art, proves nothing. What else should an artist do with his time?

Now, almost twenty years later, as I see what happens to work, I ask myself more and more why everybody knows so much about art. Thousands of people—teachers, students, collectors, critics—everybody knows everything. To me it seems as though the artist is fighting a heavy sea in a rowboat, while alongside him a pleasure liner takes all these people to the same place. Every graduate student today knows exactly what degree of "*angst*" belongs in a de Kooning, can point out disapprovingly just where he has let up, relaxed. Everybody knows that one Bette Davis movie where she went out of style. It's another bullring, with everybody knowing the rules of the game.

What was great about the fifties is that for one brief moment—maybe, say, six weeks—nobody understood art. That's why it all happened. Because for a short while, these people were left alone. Six weeks is all it takes to get started. But there's no place now where you can hide out for six weeks in this town.

Well, that's what it was like to be an artist. In New York, Paris, or anywhere else.

1971

AD REINHARDT

The Abstract Expressionists were a pugnacious bunch. And Ad Reinhardt (1913–1967) was the most pugnacious of them all. He came of age in the 1930s and never lost that decade's rabble-rousing spirit. Abstraction was always holy writ with Reinhardt, and in his later years he simplified his geometric forms again and again, until finally his canvases were painted entirely in black, with a symmetrical set of forms in blacks so subtly contrasted that you could only discern the differences if you looked long and hard. The unrelieved seriousness of Reinhardt's work in the studio could have made him appear an almost intolerably dour figure, except that there was also an irrepressibly playful and mischievous side to his personality. From the 1930s until the end of his life he worked simultaneously in a comedic mode, producing cartoons that brilliantly lampooned the stuffiness of the art world as well as writings in which he thumbed his nose at the pretensions of so many creative types. Radical social change always interested Reinhardt far less than radical artistic change. In the 1930s he was one of the ringleaders of the American Abstract Artists, a group who banded together to exhibit their work and picketed the Museum of Modern Art in order to dramatize what they saw as their underrepresentation there. Reinhardt was always glad to argue for art-for-art's-sake as the one and only true religion. And as time went on, his message became increasingly extreme—an elegant, boldface rant, unlike anything anybody else would have dared do. Reinhardt styled himself the existentialist loner in writings that are a celebration of negativity, so irredeemably dark that they generate their own kind of revelatory black light.

Abstract Art Refuses

It's been said many times in world-art writing that one can find some of painting's meanings by looking not only at what painters do but at what they refuse to do.

A glance at modern-art history shows that for Courbet—no antiques or angels, no traditional authorities or academies, no classical idealisms or romantic exoticisms, no fantasies, no world beyond our world. For Manet and Cézanne—no myths or messages, no actions or imitations, no orgies, no pains, no dreams, no stories, no disorders. For Monet, no subjects or objects, no fixities or absolutes, no chiaroscuro or plasticities, no textures or compositions, no timelessness, no terror, no studio setups, no

imaginary scenes, no muddy colors. For the cubists—no pictures or puzzles, no closed or natural forms, no fixed arrangements, no irrationalism, no unconsciousness. For Mondrian—no particularities or local elements, no irregularities or accidents or irrelevancies, no oppression of time or subjectivity, no primitivism, no expressionism.

And today many artists like myself refuse to be involved in some ideas. In painting, for me no fooling-the-eye, no window-hole-in-the-wall, no illusions, no representations, no associations, no distortions, no paint-caricaturings, no cream pictures or drippings, no delirium trimmings, no sadism or slashings, no therapy, no kicking-the-effigy, no clowning, no acrobatics, no heroics, no self-pity, no guilt, no anguish, no supernaturalism or subhumanism, no divine inspiration or daily perspiration, no personality-picturesqueness, no romantic bait, no gallery gimmicks, no neo-religious or neo-architectural hocus-pocus, no poetry or drama or theater, no entertainment business, no vested interests, no Sunday hobby, no drug-store museums, no free-for-all history, no art history in America of ashcan-regional-WPA-Pepsi-Cola styles, no professionalism, no equity, no cultural enterprises, no bargain-art commodity, no juries, no contests, no masterpieces, no prizes, no mannerisms or techniques, no communication or information, no magic tools, no bag of tricks-of-the-trade, no structure, no paint qualities, no impasto, no plasticity, no relationships, no experiments, no rules, no coercion, no anarchy, no anti-intellectualism, no irresponsibility, no innocence, no irrationalism, no low level of consciousness, no nature-mending, no reality-reducing, no life-mirroring, no abstracting from anything, no nonsense, no involvements, no confusing painting with everything that is not painting.

1952

Art-As-Art

THE one thing to say about art is that it is one thing. Art is art-as-art and everything else is everything else. Art-as-art is nothing but art. Art is not what is not art.

The one object of fifty years of abstract art is to present art-as-art and as nothing else, to make it into the one thing it is only,

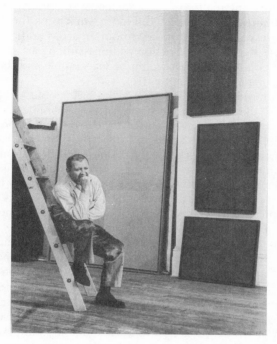

Fred McDarrah: Reinhardt in his studio, 1962.

separating and defining it more and more, making it purer and emptier, more absolute and more exclusive—non-objective, non-representational, non-figurative, non-imagist, non-expressionist, non-subjective. The only and one way to say what abstract art or art-as-art is, is to say what it is not.

The one subject of a hundred years of modern art is that awareness of art of itself, of art preoccupied with its own process and means, with its own identity and distinction, art concerned with its own unique statement, art conscious of its own evolution and history and destiny, toward its own freedom, its own dignity, its own essence, its own reason, its own morality and its own conscience. Art needs no justification with "realism" or "naturalism," "regionalism" or "nationalism," "individualism" or "socialism" or "mysticism," or with any other ideas.

The one content of three centuries of European or Asiatic

art and the one matter of three millennia of Eastern or Western art, is the same "one significance" that runs through all the timeless art of the world. Without an art-as-art continuity and art-for-art's-sake conviction and unchanging art spirit and abstract point of view, art would be inaccessible and the "one thing" completely secret.

The one idea of art as "fine," "high," "noble," "liberal," "ideal" of the seventeenth century is to separate fine and intellectual art from manual art and craft. The one intention of the word "aesthetics" of the eighteenth century is to isolate the art experience from other things. The one declaration of all the main movements in art of the nineteenth century is of the "independence" of art. The one question, the one principle, the one crisis in art of the twentieth century centers in the uncompromising "purity" of art, and in the consciousness that art comes from art only, not from anything else.

The one meaning in art-as-art, past or present, is art meaning. When an art object is separated from its original time and place and use and is moved into the art museum, it gets emptied and purified of all its meanings except one. A religious object that becomes a work of art in an art museum loses all its religious meanings. No one in his right mind goes to an art museum to worship anything but art, or to learn about anything else.

The one place for art-as-art is the museum of fine art. The reason for the museum of fine art is the preservation of ancient and modern art that cannot be made again and that does not have to be done again. A museum of fine art should exclude everything but fine art, and be separate from museums of ethnology, geology, archaeology, history, decorative arts, industrial arts, military arts, and museums of other things. A museum is a treasure house and tomb, not a counting-house or amusement center. A museum that becomes an art curator's personal monument or an art-collector-sanctifying establishment or an art-history manufacturing plant or an artists' market block is a disgrace. Any disturbance of a true museum's soundlessness, timelessness, airlessness, and lifelessness is a disrespect.

The one purpose of the art academy university is the education and "correction of the artist"-as-artist, not the "enlightenment of the public" or the popularization of art. The art college should be a cloister-ivyhall-ivory-tower-community of artists,

an artists' union and congress and club, not a success school or service station or rest home or house of artists' ill-fame. The notion that art or an art museum or art university "enriches life" or "fosters a love of life" or "promotes understanding and love among men" is as mindless as anything in art can be. Anyone who speaks of using art to further any local, municipal, national, or international relations is out of his mind.

The one thing to say about art and life is that art is art and life is life, that art is not life and that life is not art. A "slice-of-life" art is no better or worse than a "slice-of-art" life. Fine art is not a "means of making a living" or a "way of living a life," and an artist who dedicates his life to his art or his art to his life burdens his art with his life and his life with his art. Art that is a matter of life and death is neither fine nor free.

The one assault on fine art is the ceaseless attempt to subserve it as a means to some other end or value. The one fight in art is not between art and non-art, but between true and false art, between pure art and action-assemblage art, between abstract and surrealist-expressionist anti-art, between free art and servile art. Abstract art has its own integrity, not someone else's "integration" with something else. Any combining, mixing, adding, diluting, exploiting, vulgarizing, or popularizing abstract art deprives art of its essence and depraves the artist's artistic consciousness. Art is free, but it is not a free-for-all.

The one struggle in art is the struggle of artists against artists, of artist against artist, of the artist-as-artist within and against the artist-as-man, -animal, or—vegetable. Artists who claim their artwork comes from nature, life, reality, earth or heaven, as "mirrors of the soul" or "reflections of conditions" or "instruments of the universe," who cook up "new images of man"—figures and "nature-in-abstraction"—pictures, are subjectively and objectively rascals or rustics. The art of "figuring" or "picturing" is not a fine art. An artist who is lobbying as a "creature of circumstances" or logrolling as a "victim of fate" is not a fine master artist. No one ever forces an artist to be pure.

The one art that is abstract and pure enough to have the one problem and possibility, in our time and timelessness, of the "one single grand original problem" is pure abstract painting. Abstract painting is not just another school or movement or style but the first truly unmannered and untrammeled and

unentangled, styleless, universal painting. No other art or paint-ing is detached or empty or immaterial enough.

The one history of painting progresses from the painting of a variety of ideas with a variety of subjects and objects, to one idea with a variety of subjects and objects, to one subject with a variety of objects, to one object with a variety of subjects, then to one object with one subject, to one object with no subject, and to one subject with no object, then to the idea of no object and no subject and no variety at all. There is nothing less sig-nificant in art, nothing more exhausting and immediately ex-hausted, than "endless variety."

The one evolution of art forms unfolds in one straight logi-cal line of negative actions and reactions, in one predestined, eternally recurrent stylistic cycle, in the same all-over pattern, in all times and places, taking different times in different places, always beginning with an "early" archaic schematization, achieving a climax with a "classic" formulation, and decaying with "late" endless variety of illusionisms and expressionisms. When late stages wash away all lines of demarcation, framework, and fabric, with "anything can be art," "anybody can be an art-ist," "that's life," "why fight it," "anything goes," and "it makes no difference whether art is abstract or representational," the artists' world is a mannerist and primitivist art trade and suicide-vaudeville, venal, genial, contemptible, trifling.

The one way in art comes from art working and the more an artist works the more there is to do. Artists come from artists, art forms come from art forms, painting comes from painting. The one direction in fine or abstract art today is in the painting of the same one form over and over again. The one intensity and the one perfection come only from long and lonely rou-tine preparation and attention and repetition. The one original-ity exists only where all artists work in the same tradition and master the same convention. The one freedom is realized only through the strictest art discipline and through the most similar studio ritual. Only a standardized, prescribed, and proscribed form can be imageless, only a stereotyped image can be form-less, only a formularized art can be formulaless. A painter who does not know what or how or where to paint is not a fine artist.

The one work for a fine artist, the one painting, is the paint-ing of the one-size canvas—the single scheme, one formal

device, one color-monochrome, one linear division in each di-
rection, one symmetry, one texture, one free-hand brushing,
one rhythm, one working everything into one dissolution and
one indivisibility, each painting into one overall uniformity and
non-irregularity. No lines or imaginings, no shapes or compos-
ings or representings, no visions or sensations or impulses, no
symbols or signs or impastos, no decoratings or colorings or
picturings, no pleasures or pains, no accidents or ready-mades,
no things, no ideas, no relations, no attributes, no qualities—
nothing that is not of the essence. Everything into irreducibility,
unreproducibility, imperceptibility. Nothing "usable," "manipu-
latable," "salable," "dealable," "collectible," "graspable." No
art as a commodity or a jobbery. Art is not the spiritual side of
business.

The one standard in art is oneness and fineness, rightness
and purity, abstractness and evanescence. The one thing to say
about art is its breathlessness, lifelessness, deathlessness, con-
tentlessness, formlessness, spacelessness, and timelessness. This
is always the end of art.

1962

ROBERT CREELEY

The poet Robert Creeley (1926–2005) brought a laconic attentiveness and a sly wit to his writings about the visual arts. A student and teacher at Black Mountain College in the 1950s as well as the editor of the short-lived *Black Mountain Review*, Creeley was always attuned to the school's fundamental belief in the unity of the arts, writing with easy sympathy about the lives and works of the painters, sculptors, and photographers who were his friends. Like Morton Feldman's reminiscences of the 1950s in New York, Creeley's writings reflect the experience of a younger generation that had come of age amid the expanding possibilities of the postwar years and was relatively free of the angst that haunted painters who had struggled through the Depression.

Harry Callahan: A Note

WHAT the eye is given to see, as image, in any sense, is a curious occasion. What is it, that they point to, for us to see? The new house with the dirt for lawn, the new tooth, the hat that does not fit, etc. And in the eye at last convolutions of precisely the despair, of no new house (not enough), of the tooth of no one at all, hat I never wore. I hate it all—pictures! What can I do

Harry Callahan: *New York*, 1945.

with them, except ache to be there—? Or to get away as fast as possible, turning the page.

So that the subtlety (immense) of Callahan's photographs must, of necessity, be already another thing: not "pointer," or reminiscence, or even "experiment," but fact. In them there is no movement to any image beyond the one, given. We will never see the face of the boy, or of the woman, or will (to remark it), the white pigeon light. It will always be (flat) winter with trees, trampled grass, window curtains and reflections, and paint. These are (as seen) images also of an isolation; that must in fact be almost another 'given,' to not drive the forms home to pasture, to 'where else,' in short. There is no quicker eye to see, nor mind, equally, to seize upon the instant, of chance. All of which (words) here go flaccid against the dry, clear "eye" of it all.

1957

John Chamberlain

THERE is a handle to the world that is looked for, a way of taking it in hand. But not as something familiar, nor as some reference to something else. Senses of Chamberlain's sculptures that want to return them to "crushed automobiles" seem to me as absurd as trying to put mother back together again. Surely what has happened is something too.

Things, then, are large or small objects, having the fact of space in whatever dimension becomes them. Space—such as we are given to conceive—is already the dimension of our own. We measure by what we are, as things, in what relations are possible to us. The small man sees the door as large, the large man as small, etc. But what things move more complexly in how they are, come forward insistently, disobliging all such scale, and will be other than big or small—as if we stood finally on our hands, and the so-called bottom disappeared at our feet.

"A new world is only a new mind," says Williams, and equally a new world is not only but wholly a new thing. Our sense of history looks for conformities of acts and effects, and in that respect does us poor service in the arts. Skills are accumulated but

John Chamberlain: *Essex*, 1960. Automobile
parts, 108 × 80 × 43 in.

the effects of those skills have at each moment to be recognized.
There are such things now present that the sciences have no
vocabulary wherewith to describe them. They are confronted
as facts of literal presence.

You will not live long if you look always for what was there,
assuming the world to be no more than the time track of your
particularities. A sudden crash, a disfigurement, the loss of
anything not simply a pencil or some wish, and all becomes a
present so huge it falls on you, crushing you more than that
auto-mobile you thought so neatly to remember. It was there,
but now you are contained in a thing already changing, bring-
ing you into its terms—and your house shrinks, far off, and
things are bright and twisted.

But what things are is, again, more complex, and more dis-
tinct than some incidental violence done you. In that sense they

used to say, stand back—but these things neither invite nor reject. It is the virtue of a mountain not to care—or not, at least, in such words as we use. Here as well to be liked is not an issue.

One wants a world wherein all that is possible occurs, neither as *good* nor *bad*—however terrifying. It must happen. These things have come from such time that no one remembers it, and from such space they assert their own. It is all here.

1964

On the Road: Notes on Artists and Poets 1950–1965

COMING of age in the forties, in the chaos of the Second World War, one felt the kinds of coherence that might have been fact of other time and place were no longer possible. There seemed no logic, so to speak, that could bring together all the violent disparities of that experience. The arts especially were shaken and the *picture of the world* that might previously have served them had to be reformed. Of course, the underlying information of this circumstance had begun long before the time with which I am involved. Once the containment of a Newtonian imagination of the universe had been forced to yield to one proposing life as continuous, atomistic, and without relief, then discretions possible in the first situation were not only inappropriate but increasingly grotesque. There was no *place*, finally, from which to propose an objectively ordered reality, a world that could be spoken of as *there* in the convenience of expectation or habit.

The cities, insofar as they are intensively conglomerate densities of people, no doubt were forced to recognize the change previous to other kinds of place. The *neighborhood* had been changing endlessly, ever since the onslaught of the Industrial Revolution, and *change*, like it or not, had become so familiar a condition that there was even a dependence on the energy thus occurring. Nothing seemingly held firm and so one was either brought to a depressed and ironically stated pessimism concerning human possibilities, or one worked to gain location in the insistent flux, recognizing the nature of its shifting energies as intimate with one's own.

Jonathan Williams: Dan Rice and Robert
Creeley, Black Mountain College, 1955.

Put another way, this situation increasingly demanded that
the arts, *all* of them—since no matter how disparate their pre-
occupations may sometimes appear, their roots are always fact
of a commonly shared intuition or impulse—that these articu-
lations and perceptions of the nature of human event *yield* the
assumption of discrete reality, of objects to be hung on walls
merely to be looked at, or words rehearsing agreed to patterns
of valuation and order, of sounds maintaining rationally derived
systems of coherence, that the *human event* itself be permitted
to enter, again, that most significant of its own self-realizations.

Hindsight, of course, makes all such statement far more tidy
and generalized than it ever in fact was or could be. As a young
man trying to get a purchase on what most concerned me,
the issue of my own life and its statement in writing, I truly
knew little if anything of what might be *happening*. I had gone
through a usual education in the east, had witnessed in shock
the terrifying confusion of humans killing one another, had

wobbled back to college, married (mistakenly) in the hope of securing myself emotionally, had wandered into the country just that I had no competence to keep things together or to find employment in the city, even left the country itself, with my tolerant wife, hoping that some other culture might have news for me I could at last make use of and peace with. But the world, happily or unhappily, offers only one means of leaving, and I was returned without relief again and again to the initial need, a means of making articulate the world in which I and all like me did truly live.

Most stable in these preoccupations was the sense that any *form*, any ordering of reality thus implied, had somehow to come from the very condition of the experience demanding it. That is to say, I could not easily refer to a previous mode of writing that wasn't consequence of my own literal experience. I couldn't write like Eliot, for example, I couldn't even depend upon Stevens, whose work then much attracted me. So it was that I became increasingly drawn to the proposals of Ezra Pound ("We must understand what is happening . . .") and to the work itself of William Carlos Williams.

> From disorder (a chaos)
> order grows
> —grows fruitful.
> The chaos feeds it. Chaos
> feeds the tree.
> (Descent)

Then, in 1950, a chance contact with Charles Olson gained through a mutual friend, Vincent Ferrini, changed my mind entirely and gave me access at last to that which I had so hungered to have, a way of thinking of the *process* of writing that made both the thing said and the way of saying it an integral event. More, his relation to Black Mountain College, which led to my own, found me that company I had almost despaired of ever having. So put, my emphasis here seems almost selfishly preoccupied with *me*—but I was, after all, one of many, all of whom had many of these same feelings and dilemmas. I expect that one of the first tests of the artist is his or her ability to maintain attention and activity in an environment having apparently very little concern or interest in what seems so crucial

to oneself. *Company*, thus, is a particularly dear and productive possibility for anyone so committed. Mine was answer to every wish I had ever had.

Living in Europe, in France and then in Mallorca, I had come to know some painters, like they say. Ezra Pound had generously put me in touch with René Laubiès, the first to translate selections from the *Cantos* into French, and I found him a warm and intelligent friend. However, I felt rather gauche and heavy around his work, which was in some respects an extension of usual School of Paris preoccupations—that is, he did work to realize a thing in mind, a *sign* or *symbol* that had value for him apart from its occasion in the work itself. His dealer was Paul Fachetti, happily, and it was at his gallery that I first saw Jackson Pollock's work, a show of small canvasses giving some sense of the *mode* but sans the *scale* that finally seems crucial for him. In any case, these paintings stuck in my head very firmly so that even now I can recall them without difficulty. Lawrence Calcagno and Sam Francis were also showing at Fachetti's, but neither made much impression on me, despite I was delighted they were Americans.

Possibly I hadn't as yet realized that a number of American painters had already made the shift I was myself so anxious to accomplish, that they had, in fact, already begun to move away from the insistently *pictorial*, whether figurative or non-figurative, to a manifest directly of the *energy* inherent in the materials, literally, and their physical manipulation in the act of painting itself. *Process*, in the sense that Olson had found it in Whitehead, was clearly much on their minds.

My arrival in Black Mountain the spring of 1954 was equally a coming to that *viability* in the language of an art without which it, of necessity, atrophies and becomes a literature merely. Robert Duncan, in recent conversation, recalls that that was then his own intent, "to transform American literature into a viable *language*—that's what we were trying to do . . ." Speaking of Frank O'Hara, he notes that extraordinary poet's attempt "to keep the *demand* on the language as *operative*, so that something was at issue all the time, and, at the same time, to make it almost like chatter on the telephone that nobody was going to pay attention to before . . . that the language gain what was assumed before to be its *trivial* uses. I'm sort of fascinated

that *trivial* means the same thing as *three* (Hecate). Trivial's the *crisis*, where it always blows. So I think that one can build a picture, that in all the arts, especially in America, they are *operative*. We think of art as *doing something*, taking hold of it as a *process . . .*"

At Black Mountain these preoccupations were insistent in the activities of both poets and painters. For the latter, the information centered in the work of the Abstract Expressionists, many of whom had been either visitors or teachers there—although their large public approval was yet to come. What fascinated me was that they, as I, were entirely centered upon the requalification of the occasion of painting or sculpture, the sense of what it was given to *do*. Again, a *literature*, in this case art history and criticism, had grown over the viable condition of the possibility. So, as John Chamberlain once put it, "a sculpture is something that if it falls on your foot it will break it," both foot and sculpture. It weighs a lot. It sits on a so-called pediment. In contrast he wanted a new vocabulary to speak of what a sculpture might be, terms like "fluff" or "glare." When asked why he had used discarded automobile parts for much of his early work, his answer was that Michelangelo had had, apparently, a lot of marble sitting in his backyard, but junked automobiles were what Chamberlain found in his. *Material* was in that way instantly crucial again, regaining the tensions, the instant to instant recognition of the nature of what *was* in hand as mind took hold of it, that any art must have access to if it is to stay active. John Altoon saw the School of Paris as so much "polishing of stones," what R. B. Kitaj calls a "patinazation," a concern with decorative texture that precluded active perception of the possibilities of the *act* of painting itself.

In like sense, *all* assumptions of what a painting was were being intensively requalified. Hence the lovely definition of that time: *a painting is a two-dimensional surface more or less covered with paint.* Parallel is Williams' definition of a poem: *a large or small machine made of words.* In each case there is the marked attempt to be rid of the overlay of a speciously "historical" "appreciation," a "tradition" which is finally nothing more than congealed "taste" or "style," which Duncan notes is distinctly different from art. "No man needs an art unless he himself has to put things together—to find an equillibration . . ."

Style is predicated on the habit of discrimination previous to experience of the objects thus defined, whether these be so-called "art objects" or simply the clutter of a dump or city street. Duncan's point is that "the objects are not arriving [in perception or consciousness] that way, nor are the objects of thought arriving that way . . ." The collage or assemblage art of Wallace Berman, George Herms, and Larry Jordan—all working in San Francisco in the fifties—makes use of a *conglomerate*, coming out of what people discard, out of *any* time.

Possibly the attraction the artists had for people like myself—think of O'Hara, Ashbery, Koch, Duncan, McClure, Ginsberg; or Kerouac's wistful claim that he could probably paint better than Kline—has to do with that lovely, usefully uncluttered directness of perception and act we found in so many of them. I sat for hours on end listening to Franz Kline in the Cedar Bar, fascinated by literally all that he had to say. I can remember the endless variations he and Earl Kerkam spun on the "It only hurts when I smile" saga, and if that wasn't instance of initial story telling (an *art*), I don't think I'll ever know what was or is. Kline could locate the most articulate senses of human reality in seemingly casual conversation, as I remember he once did, painfully, moving, by means of the flowers, from a flower shop a friend had just opened to the roses he had brought to the pier to welcome his bride—to find that she had had a breakdown in passage. Those flowers gave us both something to hold on to.

It may also have been simply the *energy* these people generated, and we may have been there simply to rip it off in a manner Wyndham Lewis warned against long ago. Writers have the true complication of using words as initial material and then depending on them as well for a more reflective agency. It would be absurd to qualify artists as non-verbal if, by that term, one meant they lacked a generative vocabulary wherewith to articulate their so-called feelings and perceptions. The subtlety with which they qualified the possibility of *gesture* was dazzling. So Michael McClure speaks of having "totally bought Abstract Expressionism as spiritual autobiography" and of Pollock as "so integral [to his own life and thought] that his work began immersing my way of thinking in such a subtle way so early I can't tell you when . . ."

To recall it, the insistent preoccupation among writers of the

company I shared was, as Olson puts it in his key essay, *Projective Verse* (copyright 1950 by *Poetry New York*), "what is the process by which a poet gets in, at all points energy at least the equivalent of the energy which propelled him in the first place, yet an energy which is peculiar to verse alone and which will be, obviously, also different from the energy which the reader, because he is a third term, will take away?" Duncan recalls that painters of his interest were already "trying to have something *happen* in painting" and that painting was thus "moving away from the inertness of its being on walls and being looked *at . . .*" *Action* painting was the term that fascinated him, and a question such as "to what degree was Still an Action painter?" He recognized "that you see the energy back of the brush as much as you see color, it's as evident, and that's what you experience when you're looking." He notes the parallel with a work of his own at this time, "The Venice Poem," which is "shaped by its own energies" rather than by a dependence on the pictorial or descriptive. Most emphatically, it is "not shaped to carry something outside of itself."

In his *Autobiography*, published in 1951, Williams reprints the opening section of *Projective Verse*, feeling it "an advance of estimable proportions" insofar as Olson was "looking at the poems as a field rather than an assembly of more or less ankylosed lines." Earlier, seeing the text in manuscript, he had responded enthusiastically, noting that "Everything leans on the verb." These terms of *energy* and *field* are insistently in mind as is his attempt to desentimentalize accumulated senses of poetry by asserting its *thingness*. He uses his friend, the painter Charles Sheeler, as context: "The poem (in Charles' case the painting) is the construction in understandable limits of his life. That is Sheeler; that, lucky for him, partial or possible, is also music. It is called also a marriage. All these terms have to be refined, a marriage has to be seen as a thing. The poem is made of things—on a field."

This necessity, to regain a focus not overlaid with habits of *taste* and the *conveniences* of the past as these located the terms usual in criticism, be it of art or of writing, occurs throughout the arts at this time. At a retrospective show of his early work (in company with Claes Oldenburg and George Segal) Jim Dine said it was his own battle with "art history," his specific attempt

to test and find alternatives for its assumptions. In like sense I once heard John Cage, speaking to a group of hostile and "classically" oriented music majors at a New York university, point out that the music with which they were engaged had to do with *concept* and its understanding, whereas the music to which he was committed had to do with *perception* and its arousal. He also made the point that their music occupied only one fourth of the spectrum from a theoretic silence to white noise. Being an American, as he said, he felt that wasteful, and was also particularly interested in the possibilities of what's called *noise* itself. Just as Williams had to fight all his life the curious stigma which labelled him "antipoetic" (a term unintentionally provided by Wallace Stevens in an early review of his work, which Stevens wanted thus to separate from saccharine notions

John Cohen: Exterior of The Cedar Tavern, 1959.

of poetry), there is an intense battle at this time in writing to use a specific diction common to lives then being lived. No doubt the implicit *energy* of such language is itself attractive, but the arguments against it, coming primarily from the then powerful New Critics, made its use an exhausting battle. Allen Ginsberg remembers coming offstage after his early readings of *Howl* often so nervously worn out and shocked by the public antagonism, that he'd go to the nearest toilet to vomit. In contrast—and in grotesque parallel indeed to what was the literal condition of the "world" at that time—we both remembered the authoritative critical works of the time we were in college, books with titles like *The Rage for Order* and *The Well Wrought Urn*. Whatever was meant by *The Armed Vision*, the guns were seemingly pointed at us.

There was also the idea, call it, that poets as Ginsberg or myself were incapable of the formal clarities that poetry, in one way or another, has obviously to do with. Even now, at public readings in which I've read a sequence of poems whose structure had persistently to do with the parallel *sounds* of words having marked recurrence, someone inevitably (and too often one of my colleagues in teaching) will ask me if I've ever considered using rhyme? It blows my mind! I can't for the life of me figure out *where* they are in so-called time and space. As Pound pointed out, we don't all of us occupy the same experience of those situations, no matter we may be alive together in the same moment and place.

When my first wife and I decided at last to separate in 1955, we met in New York to discuss the sad responsibilities of that fact. At one point, locked in our argument, I remember we were walking along Eighth Street not far from the Cedar Bar, and suddenly there was Philip Guston, across the street, waving to us. My wife had not met him, and I had but recently, thanks to Kline—and had found him a deeply generous and articulate man. Most flattering was the fact he knew my work, although at that time it would have been hard to find it in any easily public condition. (It's worth noting that de Kooning, Kline, and Guston—the three I knew best—were all of them "well read" to put it mildly and seemingly kept up with the new work of that time as actively as the writers themselves did. Guston especially had marked information of a great range of "literary

interest. "A poem in *For Love* called "After Mallarmé" is actually
a translation of a poem of Jouve's which Guston quoted to me,
having brought me up to his loft, with characteristic kindness,
to show me the few paintings still there just previous to his first
show with Sidney Janis. My "translation" is what I could make
of the French he quoted, in my scattered recollection of it after
we'd parted.) In any case, my wife had become increasingly
suspicious of what she felt were the true incompetences of my
various heroes, i.e., Kline painted the way he did because he
couldn't draw, and Williams wrote in his fashion, because he
couldn't rhyme. So here was one she could physically confront,
and she didn't waste her time about it. Guston had brought
us into a restaurant that had just opened, and so was giving
out free *hors d'oeuvres*—to his and my delight. Once we were
seated, she let him have it: *how do you know when a painting is
finished* (painting the way you do). He answered very openly
and clearly. Given the field of the painting, so to speak, given
what might energize it as mass, line, color *et al*—when he came
to that point where any further act would be experienced as a
diminishment of that tension (when there was nothing more to
do, in short), that was when he felt the painting was finished.
She let the matter rest, but I knew she felt almost complacently
dissatisfied. "He doesn't know what he is doing—he's just fool-
ing around." She, like so many others then and now, did feel
that there must be an intention factually outside the work itself,
something to be symbolized there, some content elsewhere in
mind there expressed, as they say. But that a *process*—again to
emphasize it—might be felt and acted upon as crucial in itself
she had not considered. So a statement such as Olson's "We do
what we know before we know what we do" would be only a
meaningless conundrum at best. I guess she thought we were
all dumb.

Far from it, for whatever use it proved. There was, first of
all, a dearly held to sense of one's *professionalism*, as Duncan
reminded me, and all of us *practiced* the art which involved us
as best we could. He spoke of the "upsurge in the comprehen-
sion of the language" in each art, and "not only writing, or
painting, was going on, but *reading*," a veritable checking out
of all the possibilities inherent in the physical situation and as-
sociative values pertaining. So painters are working "from a very

solid comprehension of the visual language they come from, including anyone who may be looking." They know, as do the poets related, the *state* of the language—in a sense parallel to the scientist's saying something is in a volatile or inert *state*—so that "we do convey what we mean" and there is attention to what is happening in *every* part of the work, to keep "a tension throughout."

The diversity of possibilities gained by such an intensive inquiry is still the dominant condition. At times it may seem almost too large an invitation to accept, and in any situation where it is used either for convenience or habit, an expectable bag of tricks, then whatever it may have generated is at an end. This is to say, more vaguely, what Ezra Pound means by "You cannot have literature without *curiosity* . . ." Or Olson's qualification of *attention* as, "the exaction must be so complete, that the assurance of the ear is purchased at the highest—forty-hour-a-day—price . . ." There is also the dilemma clear in the story Chamberlain tells of his first wife: "She said she wanted to be a singer, but what she really wanted to be was famous." Good luck.

Possibly the complex of circumstances which made the years 1950 to 1965 so decisive in the arts will not easily recur. No one can make it up, so to speak. Bu there were clearly years before, equally decisive, and there will no doubt be those now after. This clothesline is at best an invention of pseudo-history, and the arts do not intend to be history in this way, however much they use the traditions intimate to their practice. When Duncan last saw Olson, in hospital a few days before his death, he said to him, "Important as history was to you, there are no followers—and as a matter of fact that isn't what happened in poetry." Olson grinned, and Duncan added, "It *was* an adventure. . . ."

It's always an *adventure*, thank god. When Rauschenberg arrived at the Art Students League in New York, one of his teachers, Morris Kantor, felt that his wife, who'd come with him, really had the more practical competence as a painter. But what Rauschenberg had as curiosity was fascinating, e.g., he'd put a large piece of butcher paper just in front of the door by which students came and went, and would leave it there for a day or so, and then examine it intently, to see the nature of pattern and imprint that occurred. Characteristically it is Rauschenberg who

questions that an "art object" should live forever necessarily, or that it should be less valued than a car which manages to stay in pristine state for a very few years indeed.

What seems most to have been in mind was not the making of *models*, nor some hope of saving a world. As Duncan said of Olson's sense of a city, "You have to confront it and get with it," not "straighten it out. Optimism and pessimism have nothing to do with being alive." The question more aptly is, "How much aliveness is found in living in a city," as much to the point now as when Whitman made his own extraordinary catalog. Moral as the arts are in their literal practice, I do think they abjure such program in other respects. At least they do not serve easily such confined attention, however humanly good. I am sure that Allen Ginsberg, despite the persistent concern he has shown for the moral state of this country, would nonetheless yield all for that moment of consciousness that might transform him.

But none of this, finally, has anything to do with such argument at all. As Wittgenstein charmingly says, "A point in space is a place for an argument." You'll have to tell mother we're still on the road.

Placitas, New Mexico
August 28, 1974

ELAINE DE KOONING

In the 1950s, Elaine de Kooning (1918–1989) was as well-known for her art writing as for her paintings, bringing a distinctive dramatic attack to everything she did. The canvases for which she will be remembered are portraits that reimagine the glamorous turn-of-the-century style of Sargent and Boldini in light of the swashbuckling verve of the Abstract Expressionists; they include not only a cycle dedicated to President Kennedy, but also representations of some of the art critics with whom de Kooning was close friends, especially Harold Rosenberg and Thomas Hess. "Pure Paints a Picture," her parody of the *Art News* articles profiling artists at work, suggests the wit and high spirits that endeared her to artists of several generations and no doubt first drew her and Willem de Kooning together in what was a famously stormy alliance.

Pure Paints a Picture

"If any paint remains on the picture-surface at the end of a day's work, I have failed," states Adolf M. Pure, noted Anti-Post-Abstract-Impressionist. "And to fail," continues the enigmatic painter, "should be the highest aspiration of the fine-artist."

Brought up by a distant cousin on his father's side, young Adolf's creed developed early. His cousin, who sterilized milk-cans for a farmers' co-operative, often brought the tiny child to work with him, and this experience, Pure contends, first gave him the idea of becoming an artist. "I have always been thrilled by seeing impurities removed in any fashion." Here the artist expresses a fundamental principle of his art. "Purity cannot be created *directly*, nor does it exist beforehand in nature. It must be achieved negatively, i.e., by the removal of impurities. This negative approach is absolutely necessary for Correct painting, its only disadvantage being that it makes Correct painting seem much easier to beginners than the usual incorrect variety. However, the *only* way to arrive at Correct, Pure or Fine Art is by a series of rejections." This necessitates having a great many materials in his studio which he must not use. "A painting must have no color," explains Pure; therefore his shelves are lined with tubes of color that he never touches. (Permanent green

light and alizarin crimson are the pigments he most prefers to reject.) The advantage of this attitude, he points out, is that, although it seems wasteful, actually it results in a saving of money, since you only have to buy your colors once, but you can reject them over and over again.

Black is no color, he discovered when he was an artist under thirty-five, and since he could not reject a color that did not exist, there followed the well-known series of totally black canvases. Later, for a short period, Pure dallied with the notion that a painting must *not* have *no* color, and from there to the concept that *no* painting must *not* have *no* color, but he gave up this avenue of investigation for obvious reasons and returned to using simple no-color, or black.

"There are three other important Noes to be mastered: no image, no scrimmage and, last but not least, no subject matter." However, one high-strung spectator, peering into the darkness of Pure's canvases, claims to have discovered the subject—a graveyard at night. This is erroneous. "Art can be corrected but, alas," Pure sighs, "the public cannot."

When his dealer finally complained of the monotony of his canvases, Pure, after stifling a brief impulse to reject his dealer, countered the non-existence of black as a color with the non-existence of white. (He is, he admits, secretly troubled by persistent rumors in the scientific world that white is not only not no-color, it is, in the form of light rays, the sum of *all* colors and that black—or, at least, dark-brown—is the sum of all pigments. "But we live in this world," says Pure bravely, "and we must make the best of it. It's all right to have ideas but there's no use leaning on them too much.")

With his recent employment of white, however, Pure does not mean to imply that he finds monotony as a principle unnecessary to Correct painting. "The trouble with most contemporary painting," Pure has often been heard to observe in the drugstore where he dines nightly, "is that it lacks monotony. No fine-minded artist can create without an understanding of monotony. The value of monotony is yet to be ascertained.

"Nobody can tell what pure art *is*, exactly, but I can tell you what it is *not*, absolutely, and I'll tell you. The ten Nots to be memorized (in the order of their importance) are: 1) edible 2) credible 3) frangible 4) visible 5) salable 6) scrutable

7) remarkable 8) tenable 9) lovable 10) able. *The more pure your art is, the more you can give less.*"

All of Pure's compositions are circles. "The circle is the only form that has no straight lines," he claims. The artist cannot explain his intense dislike of any and all straight lines. "Perhaps," he ruminates, "it is because all straight lines seem to be going some place; they're too *active*: activity is the ultimate impurity. Art can't be too quiet," claims the artist, who is, for that reason, dissatisfied with his favorite artists, "the Quiet Ones," from Giotto, Ingres, Seurat, through Mondrian. "They are simply not quiet *enough*," says Pure, who suspects it is because straight lines, although often carefully disguised, can be discerned in all their paintings.

"A circle is as quiet as possible. There's no doubt about that," he announces cheerfully. But to arrive at a method for arriving at a circle took Pure several years. "A free-hand circle is out of the question," Pure remarks. "A circle to be a true circle must be a perfect circle." He disdains the easy way out: "A compass is an impure thing, full of associations of other things that have nothing to do with art, like the discovery of America, probably, or the pyramids. Besides, it's too direct." Paradoxically enough, Pure finally realized that he had the solution in the core of his own philosophy: the concept of rejection. To arrive at a circle, one had simply to begin with a square and discard the corners and where was the square? "Sort of like taking a round peg out of a square hole," Pure explains.

The circular form makes the stretcher a difficult problem but one which Pure has dealt with ingeniously. The stretcher for the work-in-progress, not illustrated here (now called *No-White— No-Black*, but this is not its title), is a bicycle wheel. These, his favorite stretchers, were, in the past, removed from Red Riders and Speed Kings to be found in the neighborhood, but "lately," Pure observes, "everybody seems to lock his bicycle in the cellar." This explains why Pure's recent canvases are larger. The two huge pictures which almost won second prize at a recent national annual were stretched on wheels he found while vacationing in Flushing last summer near a helicopter crash. "Every calamity has its useful side," quips the sunny-natured painter, delighted with his discovery of helicopter wheels, which he now gets through a friend in the F.B.I.A.A. at auction.

The term "canvas" describes a Pure picture inaccurately. It might better be called "foam-rubber." ("The thickness is not important, it's the resiliency that matters," says Pure of his ideal material. "And furthermore, Art should be porous. On this count, the esthetic implications of foam-rubber have not been plumbed.") Also, the term "painting" is inaccurate. Rather, one should refer to Pure's pictures as "injections." Two large syringes (Eimer & Amend) are his most important instruments. ("The trouble with most contemporary art," Pure maintains, "is that the paint is *on* the picture not *in* it.") A pair of scissors (for cutting off corners), several eyedroppers, rolls of cotton and gauze, a flask of glycerine, a small bottle of stain remover (potassium manganite), a bleach (mercury chloride and water) and a book of highly absorbent blotting sheets (for drying the picture) complete Pure's "painting kit." "A kit is a semantic problem," the artist often exclaims thoughtfully as he pursues his never-ending search for new materials which are then stored in the refrigerator for future rejection.

A tall, thin man with a dry smile, Pure, whose income is rather limited, although adequate, built his own studio on the roof of a large building in Yonkers. There is only one window, a port-hole which he removed from the Normandy after it caught fire several years ago. This window is always heavily curtained. "I prefer to work in the dark," Pure explains, "figuratively and otherwise." Except for an immense filing cabinet, a refrigerator, his easel—"a nail in space"—on which he pivots his stretchers, his studio, although square, is bare. Being an experienced leaf and branch reader, Pure finds the rubber tree an invaluable source of information about his fellow artists, critics, dealers, etc.—although it is much misunderstood by outsiders. The tree also offers him innumerable directions on how to paint which he refuses to take. "It's sort of like a wife to me," he notes.

Almost as important as the tree is his file of Renaissance and Baroque reproductions. This file inspires him with the emotion most necessary to any creative effort: disgust. "Without disgust, life wouldn't be worth living," says Pure. "Disgust has permeated my happiest moments. Disgust has added real meaning to all my relationships—jobs, friendships, marriages. I wouldn't dream of beginning a picture unless sufficiently filled with disgust."

Fifteen minutes of thumbing through his print collection is usually enough to offer a day's supply of the proper emotion. Another fifteen minutes of washing his hands and Pure is ready to begin work. After donning the cap, mask and white gown that make up his painting uniform ("the air is full of enemies," says the artist) and the bare-foot sandals that he wears winter and summer ("because my feet have claustrophobia"), he sterilizes the foam rubber surface on which he is to work. Then filling his syringe with black (he no longer uses Argyrol but now prefers a derivative of D.D.T.), Pure begins to fill certain pores of the foam rubber until a square is formed. The corners of the square (as described earlier in this article) are then discarded leaving a perfect circle. In forty-five minutes, the picture is finished. "To work on a painting more than forty-five minutes is to be a Bohemian," Pure declares. "Art should take as little time as possible. It should also take as little space as possible. For my next show, which I will paint next week, I am going to use dimes for stretchers. But except for this one instance, which is purely abstract, there should be no relation between art and money. Art is always getting involved with things outside itself and that keeps it from being fine. Take food. For one thing, food is an ugly word. For another, I don't like the taste of it. Never did. But we don't have time to go into that. What I mean is, I don't approve of the relationship between food and life and artists. Too interdependent. An artist is dependent *on* food *for* life. It's an unhealthy relationship! Commonplace, too. Food is food; life is life; an artist is an artist. Why this confusion between the boundaries? Everything should have its own place, its own entity, its own integrity. Of course, since this world isn't perfect, you can't be an artist without a little life, and you can't have life without a little food; just keep it to a minimum—and cold, of course."

Since his work takes so little of his time, Pure devotes the rest of his day to more conventional activities. Sixteen hours out of the twenty-four are spent sleeping. "An artist should be unconscious as much of the time as possible—get the *habit* of unconsciousness, so to speak; otherwise ideas might creep into his work and ideas are harder to get rid of than roaches once they get a foothold." He sleeps on a bed with no sheets,

naturally. He has even removed the mattress-cover. "I love the touch of foam-rubber next to my skin," he says. "It's the one indulgence I allow myself."

A methodical man, he spends an hour every morning before breakfast writing letters to editors and museum directors. "Can't skip a morning. Have to keep a close check. Can't tell *who* they'll be enthusiastic about next." An ardent and conscientious guardian of the morality of the contemporary art world, Pure dislikes getting paid for his helpful criticism of fellow artists. "It's a labor of love," he explains.

After breakfast—a spoonful of wheat-germ and yogurt—Pure spends three hours reading all the art publications from cover to cover and carefully files favorable reviews for future attack. A humanitarian, Pure is troubled by other artists' success even more than his own. "They're not on guard against it," he explains. News of the sale of a friend's painting plunges Pure into an abyss of gloom. "The trouble with most contemporary artists is they're riding two horses. You can't be an artist *and* a success. You've got to take your choice. As I've often said before, to be a Fine-artist, you've got to be a failure. Of course, I *don't* mean a failure at being a success, or a failure at being a failure (like poor rich X . . .) or, naturally, a success at being a success; I mean a success at being a failure." This distinction, Pure notes sadly, is mainly lost on his students (he has six teaching jobs), some of whom get over-enthusiastic and try to become failures immediately. "It takes time—years—to fail," says Pure. "What do these kids think . . . it's easy?"

On being asked about sculpture, Pure replied, "Sculpture is no problem. Nobody likes sculpture."*

1957

*During the author's absence from New York in the summers of 1954–56, notes on the artist's style and techniques were recorded by Esteban Vicente.

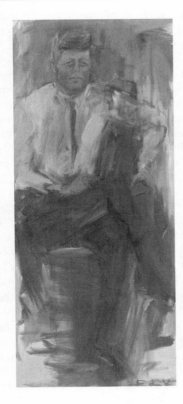

Elaine de Kooning:
John F. Kennedy, 1963.
Oil on canvas, 102½ ×
44 × 1½ in.

Painting a Portrait of the President

PRESIDENT Kennedy was off in the distance, about twenty yards away, talking to reporters, when I first saw him—and for one second, I didn't recognize him. He was not the grey, sculptural newspaper image. He was incandescent, golden. And bigger than life. Not that he was taller than the men standing around; he just seemed to be in a different dimension. Also not revealed by the newspaper image were his incredible eyes with large violet irises half veiled by the jutting bone beneath the eyebrows.

One of the reasons I was asked to do the portrait is that, with luck, I can start and finish a life-size portrait in one sitting

(after a couple of preliminary sessions of sketches to determine the pose and familiarize myself with my impression of the sitter). After years of working on my portraits (mostly of friends) for months at a time, I found myself getting bogged down in overly conscious effort and discovered that by working swiftly I could enter into an almost passive relationship to the canvas and get closer to the essential gesture of the sitter. However, working at top speed this way, I require absolute immobility of the sitter. This was impossible with President Kennedy because of his extreme restlessness: he read papers, talked on the phone, jotted down notes, crossed and uncrossed his legs, shifted from one arm of the chair to the other, always in action at rest. So I had to find a completely new approach.

I began with fragmentary sketches—first in charcoal then in casein, sometimes just heads, sometimes the whole figure. For the first session (during a Medicare Conference), I sat on top of a 6-foot ladder to get an unimpeded view of him. Concentrating on bone structure, most of my first sketches made him look twenty years younger. This was also because the positions he assumed were those of a college athlete. I made about thirty sketches at the first session and rushed back to a big studio that had been turned over to me by the Norton Gallery, made further drawings combining different aspects, and finally, after a couple of days, decided on the proportions and size of the first canvas—4 by 8 feet.

In succeeding sessions of sketching, I was struck by the curious faceted structure of light over his face and hair—a quality of transparent ruddiness. This play of light contributed to the extraordinary variety of expressions. His smile and frown both seemed to be built-in to the bone. Everyone is familiar with the quick sense of humor revealed in the corners of his mouth and the laugh lines around the eyes, but what impressed me most was a sense of compassion.

Everyone has his own private idea of President Kennedy. The men who worked with him had one impression, his family another, the crowds who saw him campaigning another, the rest of the world, which saw him only in two dimensions, smiling or frowning on a flat sheet of paper or a TV screen, still another— and this last, by far the most universal. Beside my own intense, multiple impressions of him, I also had to contend with this

"world image" created by the endless newspaper photographs, TV appearances, caricatures. Realizing this, I began to collect hundreds of photographs torn from newspapers and magazines and never missed an opportunity to draw him when he appeared on TV. These snapshots covered every angle, from above, below, profile, back, standing, sitting, walking, close-up, off in the distance. I particularly liked tiny shots where the features were indistinct yet unmistakable. Covering my walls with my own and these photographs, I worked from canvas to canvas (the smallest 2 feet high, the largest 11), always striving for a composite image.

1964

MEYER SCHAPIRO

Meyer Schapiro (1904–1996) was a legendary figure in his lifetime. This art historian made seminal contributions to the understanding of early Christian, Romanesque, and medieval art, even as he pioneered the serious study of nineteenth- and twentieth-century painting, helped to found the liberal-socialist magazine *Dissent,* and forged profound connections with contemporary artists, among them Willem de Kooning and Barnett Newman. Schapiro's family had emigrated from Lithuania to New York when he was three, and as an adult he epitomized a particularly American kind of cosmopolitanism. He brought a generous-hearted independence to his wide-ranging explorations, eager to assimilate a variety of social, psychological, and semiotic ideas, even as he mounted striking challenges to the theories of seminal thinkers, including Freud and Heidegger, whose writings on art he subjected to searching critiques. In the 1930s Schapiro had taken the French painter Léger to the Morgan Library to see a Spanish Romanesque manuscript that was said to have a profound influence on the artist, and in the early 1950s it was Schapiro who convinced de Kooning that *Woman I,* which the artist did not know what to do with, was in fact complete. In the postwar years Schapiro was involved in helping to organize some contemporary exhibitions, and the two essays included here come out of a time when he saw himself as a proselytizer, making the case for avant-garde art as a fundamentally liberal act—an unfettered exploration of the human imagination. Though Schapiro never had the taste for fierce ideological debate that animated contemporaries such as Greenberg and Rosenberg, his ideas have their own kind of polemical power—a power that only gradually takes hold of a reader.

The Liberating Quality of Avant-Garde Art

In discussing the place of painting and sculpture in the culture of our time, I shall refer only to those kinds which, whether abstract or not, have a fresh inventive character, that art which is called "modern" not simply because it is of our century, but because it is the work of artists who take seriously the challenge of new possibilities and wish to introduce into their work perceptions, ideas and experiences which have come about only in our time.

In doing so I risk perhaps being unjust to important works

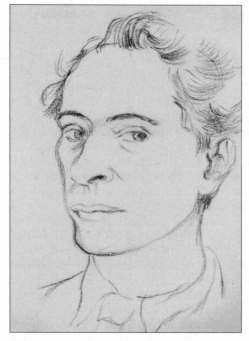

Meyer Schapiro: *Self-Portrait*, 1960.
Conté crayon on paper, 7 × 5 in.

or to aspects of art which are generally not comprised within the so-called movement.

There is a sense in which all the arts today have a common character shared by painting; it may therefore seem arbitrary to single out painting as more particularly modern than the others. In comparing the arts of our time with those of a hundred years ago, we observe that the arts have become more deeply personal, more intimate, more concerned with experiences of a subtle kind. We note, too, that in poetry, music and architecture, as well as in painting, the attitude to the medium has become much freer, so that artists are willing to search further and to risk experiments or inventions which in the past would

have been inconceivable because of fixed ideas of the laws and boundaries of the arts. I shall try to show, however, that painting and sculpture contribute qualities and values less evident in poetry, music and architecture.

It is obvious that each art has possibilities given in its own medium which are not found in other arts, at least not in the same degree. Of course, we do not know how far-reaching these possibilities are; the limits of an art cannot be set in advance. Only in the course of work and especially in the work of venturesome personalities do we discover the range of an art, and even then in a very incomplete way.

In the last fifty years, within the common tendency towards the more personal, intimate and free, painting has had a special role because of a unique revolutionary change in its character. In the first decades of our century painters and sculptors broke with the long-established tradition that their arts are arts of representation, creating images bound by certain requirements of accord with the forms of nature.

That great tradition includes works of astounding power which have nourished artists for centuries. Its principle of representation had seemed too self-evident to be doubted, yet that tradition was shattered early in this century. The change in painting and sculpture may be compared to the most striking revolutions in science, technology and social thought. It has affected the whole attitude of painters and sculptors to their work. To define the change in its positive aspect, however, is not easy because of the great diversity of styles today even among advanced artists.

One of the charges brought most frequently against art in our time is that because of the loss of the old standards, it has become chaotic, having no rule or direction. Precisely this criticism was often made between 1830 and 1850, especially in France, where one observed side by side works of Neo-Classic, Romantic and Realistic art—all of them committed to representation. The lack of a single necessary style of art reminded many people of the lack of clear purpose or common ideals in social life. What seemed to be the anarchic character of art was regarded as a symptom of a more pervasive anarchy or crisis in society as a whole.

But for the artists themselves—for Ingres, Delacroix and Courbet—each of these styles was justified by ideal ends that

it served, whether of order, liberty or truth; and when we look back now to the nineteenth century, the astonishing variety of its styles, the many conflicting movements and reactions, and the great number of distinct personalities, appear to us less as signs of weakness in the culture than as examples of freedom, individuality and sincerity of expression. These qualities corresponded to important emerging values in the social and political life of that period, and even helped to sustain them.

In the course of the last fifty years the painters who freed themselves from the necessity of representation discovered wholly new fields of form-construction and expression (including new possibilities of imaginative representation) which entailed a new attitude to art itself. The artist came to believe that what was essential in art—given the diversity of themes or motifs—were two universal requirements: that every work of art has an individual order or coherence, a quality of unity and necessity in its structure regardless of the kind of forms used; and, second, that the forms and colors chosen have a decided expressive physiognomy, that they speak to us as a feeling-charged whole, through the intrinsic power of colors and lines, rather than through the imaging of facial expressions, gestures and bodily movements, although these are not necessarily excluded—for they are also forms.

That view made possible the appreciation of many kinds of old art and the arts of distant peoples—primitive, historic, colonial, Asiatic and African, as well as European—arts which had not been accessible in spirit because it was thought that true art had to show a degree of conformity to nature and of mastery of representation which had developed for the most part in the West. The change in art dethroned not only representation as a necessary requirement but also a particular standard of decorum or restraint in expression which had excluded certain domains and intensities of feeling. The notion of the humanity of art was immensely widened. Many kinds of drawing, painting, sculpture and architecture, formerly ignored or judged inartistic, were seen as existing on the same plane of human creativeness and expression as "civilized" Western art. That would not have happened, I believe, without the revolution in modern painting.

The idea of art was shifted, therefore, from the aspect of imagery to its expressive, constructive, inventive aspect. That does not mean, as some suppose, that the old art was inferior

or incomplete, that it had been constrained by the requirements of representation, but rather that a new liberty had been introduced which had, as one of its consequences, a greater range in the appreciation and experience of forms.

The change may be compared, perhaps, with the discovery by mathematicians that they did not have to hold to the axioms and postulates of Euclidian geometry, which were useful in describing the everyday physical world, but could conceive quite other axioms and postulates and build up different imaginary geometries. All the new geometries, like the old one, were submitted to the rules of logic; in each geometry the new theorems had to be consistent with each other and with the axioms and postulates. In painting as in mathematics, the role of structure or coherence became more evident and the range of its applications was extended to new elements.

The change I have described in the consciousness of form is more pronounced in painting and sculpture than it is in any other art. It is true that music and architecture are also unconcerned with representation—the imaging of the world—but they have always been that. The architect, the musician and the poet did not feel that their arts had undergone so profound a change, requiring as great a shift in the attitude of the beholder, as painting and sculpture in the beginning of our century. Within the totality of arts, painting and sculpture, more than the others, gave to artists in all media a new sense of freedom and possibility. It was the ground of a more general emancipation.

Even poets, who had always been concerned with images and with language as a medium that designates, poets too now tried to create a poetry of sounds without sense. But that movement did not last long, at least among English-speaking poets, although it was strong at one time in Russia and exists today in Holland and Belgium.

That sentiment of freedom and possibility, accompanied by a new faith in the self-sufficiency of forms and colors, became deeply rooted in our culture in the last fifty years. And since the basic change had come about through the rejection of the image function of painting and sculpture, the attitudes and feelings which are bound up with the acceptance or rejection of the environment entered into the attitude of the painter to

the so-called abstract or near-abstract styles, affecting also the character of the new forms. His view of the external world, his affirmation of the self or certain parts of the self, against devalued social norms—these contributed to his confidence in the necessity of the new art.

Abstraction implies then a criticism of the accepted contents of the preceding representations as ideal values or life interests. This does not mean that painters, in giving up landscape, no longer enjoy nature; but they do not believe, as did the poets, the philosophers and painters of the nineteenth century, that nature can serve as a model of harmony for man, nor do they feel that the experience of nature's moods is an exalting value on which to found an adequate philosophy of life. New problems, situations and experiences of greater import have emerged: the challenge of social conflict and development, the exploration of the self, the discovery of its hidden motivations and processes, the advance of human creativeness in science and technology.

All these factors should be taken into account in judging the significance of the change in painting and sculpture. It was not a simple studio experiment or an intellectual play with ideas and with paint; it was related to a broader and deeper reaction to basic elements of common experience and the concept of humanity, as it developed under new conditions.

In a number of respects, painting and sculpture today may seem to be opposed to the general trend of life. Yet, in such opposition, these arts declare their humanity and importance.

Paintings and sculptures, let us observe, are the last handmade, personal objects within our culture. Almost everything else is produced industrially, in mass, and through a high division of labor. Few people are fortunate enough to make something that represents themselves, that issues entirely from their hands and mind, and to which they can affix their names.

Most work, even much scientific work, requires a division of labor, a separation between the individual and the final result; the personality is hardly present even in the operations of industrial planning or in management and trade. Standardized objects produced impersonally and in quantity establish no bond between maker and user. They are mechanical products with only a passing and instrumental value.

What is most important is that the practical activity by which

we live is not satisfying: we cannot give it full loyalty, and its rewards do not compensate enough for the frustrations and emptiness that arise from the lack of spontaneity and personal identifications in work: the individual is deformed by it, only rarely does it permit him to grow.

The object of art is, therefore, more passionately than ever before, the occasion of spontaneity or intense feeling. The painting symbolizes an individual who realizes freedom and deep engagement of the self within his work. It is addressed to others who will cherish it, if it gives them joy, and who will recognize in it an irreplaceable quality and will be attentive to every mark of the maker's imagination and feeling.

The consciousness of the personal and spontaneous in the painting and sculpture stimulates the artist to invent devices of handling, processing, surfacing, which confer to the utmost degree the aspect of the freely made. Hence the great importance of the mark, the stroke, the brush, the drip, the quality of the substance of the paint itself, and the surface of the canvas as a texture and field of operation—all signs of the artist's active presence. The work of art is an ordered world of its own kind in which we are aware, at every point, of its becoming.

All these qualities of painting may be regarded as a means of confirming the individual in opposition to the contrary qualities of the ordinary experience of working and doing.

I need not speak in detail about this new manner, which appears in figurative as well as abstract art; but I think it is worth observing that in many ways it is a break with the kind of painting that was most important in the 1920's. After the first World War, in works like those of Léger, abstraction in art was affected by the taste for industry, technology and science, and assumed the qualities of the machine-made, the impersonal and reproducible, with an air of coolness and mechanical control, intellectualized to some degree. The artist's power of creation seems analogous here to the designer's and engineer's. That art, in turn, avowed its sympathy with mechanism and industry in an optimistic mood as progressive elements in everyday life, and as examples of strength and precision in production which painters admired as a model for art itself. But the experiences of the last twenty-five years have made such confidence in the values of technology less interesting and even distasteful.

In abstraction we may distinguish those forms, like the square and circle, which have object character and those which do not. The first are closed shapes, distinct within their field and set off against a definite ground. They build up a space which has often elements of gravity, with a clear difference between above and below, the ground and the background, the near and far. But the art of the last fifteen years tends more often to work with forms which are open, fluid or mobile; they are directed strokes or they are endless tangles and irregular curves, self-involved lines which impress us as possessing the qualities not so much of things as of impulses, of excited movements emerging and changing before our eyes.

The impulse, which is most often not readily visible in its pattern, becomes tangible and definite on the surface of a canvas through the painted mark. We see, as it were, the track of emotion, its obstruction, persistence or extinction. But all these elements of impulse which seem at first so aimless on the canvas are built up into a whole characterized by firmness, often by elegance and beauty of shapes and colors. A whole emerges with a compelling, sometimes insistent quality of form, with a resonance of the main idea throughout the work. And possessing an extraordinary tangibility and force, often being so large that it covers the space of a wall and therefore competing boldly with the environment, the canvas can command our attention fully like monumental painting in the past.

It is also worth remarking that as the details of form become complicated and free and therefore hard to follow in their relation to one another, the painting tends to be more centered and compact—different in this respect from the type of abstraction in which the painting seems to be a balanced segment of a larger whole. The artist places himself in the focus of your space.

These characteristics of painting, as opposed to the characteristics of industrial production, may be found also in the different senses of the words "automatic" and "accidental" as applied in painting, technology and the everyday world.

The presence of chance as a factor in painting, which introduces qualities that the artist could never have achieved by calculation, is an old story. Montaigne in the sixteenth century already observed that a painter will discover in his canvas strokes which he had not intended and which are better than anything

MEYER SCHAPIRO

he might have designed. That is a common fact in artistic creation.

Conscious control is only one source of order and novelty: the unconscious, the spontaneous and unpredictable are no less present in the good work of art. But that is something art shares with other activities and indeed with the most obviously human function: speech. When we speak, we produce automatically a series of words which have an order and a meaning for us, and yet are not fully designed. The first word could not be uttered unless certain words were to follow, but we cannot discover, through introspection, that we had already thought of the words that were to follow. That is a mystery of our thought as well.

Painting, poetry and music have this element of unconscious, improvised serial production of parts and relationships in an order, with a latent unity and purposefulness. The peculiarity of modern painting does not lie simply in its aspect of chance and improvisation but elsewhere. Its distinctiveness may be made clear by comparing the character of the formal elements of old and modern art.

Painters often say that in all art, whether old or modern, the artist works essentially with colors and shapes rather than with natural objects. But the lines of a Renaissance master are complex forms which depend on already ordered shapes in nature. The painting of a cup in a still-life picture resembles an actual cup, which is itself a well-ordered thing. A painting of a landscape depends on observation of elements which are complete, highly ordered shapes in themselves—like trees or mountains.

Modern painting is the first complex style in history which proceeds from elements that are not pre-ordered as closed articulated shapes. The artist today creates an order out of unordered variable elements to a greater degree than the artist of the past.

In ancient art an image of two animals facing each other orders symmetrically bodies that in nature are already closed symmetrical forms. The modern artist, on the contrary, is attracted to those possibilities of form which include a considerable randomness, variability and disorder, whether he finds them in the world or while improvising with his brush, or in looking at spots and marks, or in playing freely with shapes—inverting,

adjusting, cutting, varying, reshaping, regrouping, so as to maximize the appearance of randomness. His goal is often an order which retains a decided quality of randomness as far as this is compatible with an ultimate unity of the whole. That randomness corresponds in turn to a feeling of freedom, an unconstrained activity at every point.

Ignoring natural shapes, he is alert to qualities of movement, interplay, change and becoming in nature. And he provokes within himself, in his spontaneous motions and play, an automatic production of chance.

While in industry accident is that event which destroys an order, interrupts a regular process and must be eliminated, in painting the random or accidental is the beginning of an order. It is that which the artist wishes to build up into an order, but a kind of order that in the end retains the aspect of the original disorder as a manifestation of freedom. The order is created before your eyes and its law is nowhere explicit. Here the function of ordering has, as a necessary counterpart, the element of randomness and accident.

Automatism in art means the painter's confidence in the power of the organism to produce interesting unforeseen effects and in such a way that the chance results constitute a family of forms; all the random marks made by one individual will differ from those made by another, and will appear to belong together, whether they are highly ordered or not, and will show a characteristic grouping. (This is another way of saying that there is a definite style in the seemingly chaotic forms of recent art, a general style common to many artists, as well as unique individual styles.) This power of the artist's hand to deliver constantly elements of so-called chance or accident, which nevertheless belong to a well defined, personal class of forms and groupings, is submitted to critical control by the artist who is alert to the rightness or wrongness of the elements delivered spontaneously, and accepts or rejects them.

No other art today exhibits to that degree in the final result the presence of the individual, his spontaneity and the concreteness of his procedure.

This art is deeply rooted, I believe, in the self and its relation to the surrounding world. The pathos of the reduction or fragility of the self within a culture that becomes increasingly

organized through industry, economy and the state intensifies the desire of the artist to create forms that will manifest his liberty in this striking way—a liberty that, in the best works, is associated with a sentiment of harmony and achieves stability, and even impersonality through the power of painting to universalize itself in the perfection of its form and to reach out into common life. It becomes then a possession of everyone and is related to everyday experience.

Another aspect of modern painting and sculpture which is opposed to our actual world and yet is related to it—and appeals particularly because of this relationship—is the difference between painting and sculpture on the one hand and what are called the "arts of communication." This term has become for many artists one of the most unpleasant in our language.

In the media of communication which include the newspaper, the magazine, the radio and TV, we are struck at once by certain requirements that are increasingly satisfied through modern technical means and the ingenuity of scientific specialists. Communication, in this sense, aims at a maximum efficiency through methods that ensure the attention of the listener or viewer by setting up the appropriate reproducible stimuli that will work for everyone and promote the acceptance of the message. Distinction is made between message and that which interferes with message, i.e. noise—that which is irrelevant. And devices are introduced to ensure that certain elements will have an appropriate weight in the reception.

The theory and practice of communication today help to build up and to characterize a world of social relationships that is impersonal, calculated and controlled in its elements, aiming always at efficiency.

The methods of study applied in the theory of communication have been extended to literature, music and painting as arts which communicate. Yet it must be said that what makes painting and sculpture so interesting in our time is their high degree of non-communication. You cannot extract a message from painting by ordinary means; the usual rules of communication do not hold here, there is no clear code or fixed vocabulary, no certainty of effect in a given time of transmission or exposure. Painting, by becoming abstract and giving up its representational function, has achieved a state in which communication

seems to be deliberately prevented. And in many works where natural forms are still preserved, the objects and the mode of representation resist an easy decipherment and the effects of these works are unpredictable.

The artist does not wish to create a work in which he transmits an already prepared and complete message to a relatively indifferent and impersonal receiver. The painter aims rather at such a quality of the whole that, unless you achieve the proper set of mind and feeling towards it, you will not experience anything of it at all.

Only a mind opened to the qualities of things, with a habit of discrimination, sensitized by experience and responsive to new forms and ideas, will be prepared for the enjoyment of this art. The experience of the work of art, like the creation of the work of art itself, is a process ultimately opposed to communication as it is understood now. What has appeared as noise in the first encounter becomes in the end message or necessity, though never message in a perfectly reproducible sense. You cannot translate it into words or make a copy of it which will be quite the same thing.

But if painting and sculpture do not communicate they induce an attitude of communion and contemplation. They offer to many an equivalent of what is regarded as part of religious life: a sincere and humble submission to a spiritual object, an experience which is not given automatically, but requires preparation and purity of spirit. It is primarily in modern painting and sculpture that such contemplativeness and communion with the work of another human being, the sensing of another's perfected feeling and imagination, becomes possible.

If painting and sculpture provide the most tangible works of art and bring us closer to the activity of the artist, their concreteness exposes them, more than the other arts, to dangerous corruption. The successful work of painting or sculpture is a unique commodity of high market value. Paintings are perhaps the most costly man-made objects in the world. The enormous importance given to a work of art as a precious object which is advertised and known in connection with its price is bound to affect the consciousness of our culture. It stamps the painting as an object of speculation, confusing the values of art. The fact that the work of art has such a status means that the approach

to it is rarely innocent enough; one is too much concerned with the future of the work, its value as an investment, its capacity to survive in the market and to symbolize the social quality of the owner. At the same time no profession is as poor as the painter's, unless perhaps the profession of the poet. The painter cannot live by his art.

Painting is the domain of culture in which the contradiction between the professed ideals and the actuality is most obvious and often becomes tragic.

About twenty-five years ago a French poet said that if all artists stopped painting, nothing would be changed in the world. There is much truth in that statement, although I would not try to say how much. (It would be less true if he had included all the arts.) But the same poet tried later to persuade painters to make pictures with political messages which would serve his own party. He recognized then that painting could make a difference, not only for artists but for others; he was not convinced, however, that it would make a difference if it were abstract painting, representing nothing.

It was in terms of an older experience of the arts as the carriers of messages, as well as objects of contemplation, that is, arts with a definite religious or political content, sustained by institutions—the Church, the schools, the State—that the poet conceived the function of painting. It is that aspect of the old art which the poet hoped could be revived today, but with the kind of message that he found congenial.

Nevertheless in rejecting this goal, many feel that if the artist works more from within—with forms of his own invention rather than with natural forms—giving the utmost importance to spontaneity, the individual is diminished. For how can a complete personality leave out of his life work so much of his interests and experience, his thoughts and feelings? Can these be adequately translated into the substance of paint and the modern forms with the qualities I have described?

These doubts, which arise repeatedly, are latent within modern art itself. The revolution in painting that I have described, by making all the art of the world accessible, has made it possible for artists to look at the paintings of other times with a fresh eye; these suggest to them alternatives to their own art.

And the artist's freedom of choice in both subject and form opens the way to endless reactions against existing styles.

But granting the importance of those perceptions and values which find no place in painting today, the artist does not feel obliged to cope with them in his art. He can justify himself by pointing to the division of labor within our culture, if not in all cultures. The architect does not have to tell stories with his forms; he must build well and build nobly. The musician need not convey a statement about particular events and experiences or articulate a moral or philosophical commitment. Representation is possible today through other means than painting and with greater power than in the past.

In the criticism of modern painting as excluding large sectors of life, it is usually assumed that past art was thoroughly comprehensive. But this view rests on an imperfect knowledge of older styles. Even the art of the cathedrals, which has been called encyclopedic, represents relatively little of contemporary actuality, though it projects with immense power an established world-view through the figures and episodes of the Bible. Whether a culture succeeds in expressing in artistic form its ideas and outlook and experiences is to be determined by examining not simply the subject-matter of one art, like painting, but the totality of its arts, and including the forms as well as the themes.

Within that totality today painting has its special tasks and possibilities discovered by artists in the course of work. In general, painting tends to reinforce those critical attitudes which are well represented in our literature: the constant searching of the individual, his motives and feelings, the currents of social life, the gap between actuality and ideals.

If the painter cannot celebrate many current values, it may be that these values are not worth celebrating. In the absence of ideal values stimulating to his imagination, the artist must cultivate his own garden as the only secure field in the violence and uncertainties of our time. By maintaining his loyalty to the value of art—to responsible creative work, the search for perfection, the sensitiveness to quality—the artist is one of the most moral and idealistic of beings, although his influence on practical affairs may seem very small.

Painting by its impressive example of inner freedom and inventiveness and by its fidelity to artistic goals, which include the mastery of the formless and accidental, helps to maintain the critical spirit and the ideals of creativeness, sincerity and self-reliance, which are indispensable to the life of our culture.

1957

On the Humanity of Abstract Painting

THE notion of humanity in art rests on a norm of the human that has changed in the course of time. Not long ago only the heroic, the mythical and religious were admitted to high art. The dignity of a work was measured in part by the rank of its theme.

In time it became clear that a scene of common life, a landscape or still life could be as great a painting as an image of history or myth. One discovered too that in the picturing of the non-human were some profound values. I do not mean only the beauty created by the painter's control of color and shapes; the landscape and still life also embodied an individual's feeling for nature and things, his vision in the broadest sense. Humanity in art is therefore not confined to the image of man. Man shows himself too in his relation to the surroundings, in his artifacts, and in the expressive character of all the signs and marks he produces. These may be noble or ignoble, playful or tragic, passionate or serene. Or they may be sensed as unnameable yet compelling moods.

At the threshold of our century stands the art of Cézanne, which imposes on us the conviction that in rendering the simplest objects, bare of ideal meanings, a series of colored patches can be a summit of perfection showing the concentrated qualities and powers of a great mind. Whoever in dismay before the strangeness of certain contemporary works denies to the original painting of our time a sufficient significance and longs for an art with noble and easily-read figures and gestures, should return to Cézanne and ask what in the appeal of his weighty art depends on a represented human drama. Some of his portraits, perhaps—although to many observers, accustomed to

the affability of old portraiture, Cézanne's appeared only a few decades ago mask-like and inhuman, a forerunner of the supposed loss of humanity in twentieth-century art. But are those portraits of Cézanne greater for us, more moving, even more dramatic, than his pictures of fruit and rumpled cloth?

The humanity of art lies in the artist and not simply in what he represents, although this object may be the congenial occasion for the fullest play of his art. It is the painter's constructive activity, his power of impressing a work with feeling and the qualities of thought that gives humanity to art; and this humanity may be realized with an unlimited range of themes or elements of form.

All this has been said often enough; it is granted, and still one clings to Cézanne's apple and doubts in principle that high accomplishment in art is possible where the imagination of colors and forms is divorced from the imaging of the visible world.

Architecture, which represents nothing, is a permanent challenge to that theoretical belief. If a building communicates the values of the home or temple, it is through the splendor of its freely invented forms. However bound to materials and functions, these forms are an expression, not a representation, of the familial or sacred.

The charge of inhumanity brought against abstract painting springs from a failure to see the works as they are; they have been obscured by concepts from other fields. The word "abstract" has connotations of the logical and scientific that are surely foreign to this art. "Abstract" is an unfortunate name; but "non-objective," "non-figurative," or "pure painting"—all negative terms—are hardly better. In the nineteenth century, when all painting was representation, the abstract in art meant different things: the simplified line, the decorative or the flat. For the realist Courbet, a militantly positive mind, it was the imaginary as opposed to the directly seen; to paint the invisible, whether angels or figures of the past, was to make abstract art. But Constable could say: "My limited and abstracted art is to be found under every hedge and lane."

Abstract painting today has little to do with logical abstraction or mathematics. It is fully concrete, without simulating a world of objects or concepts beyond the frame. For the most part, what we see on the canvas belongs there and nowhere

else. But it calls up more intensely than ever before the painter at work, his touch, his vitality and mood, the drama of decision in the ongoing process of art. Here the subjective becomes tangible. In certain styles this quality may be seen as a radical realization of the long-developed demand in Western art for the immediate in experience and expression, a demand which, in the preceding art, had found in landscape and still life, and even portraiture, its major themes. If mathematical forms are used, they are, as material marks, elements of the same order of reality as the visible canvas itself. And if a painter ventures to paste on the surface of the canvas bits of objects from without—newsprint and cloth—these objects are not imitated but transported bodily to the canvas, like the paint itself.

An abstract painter entering a room where a mathematician has demonstrated a theorem on the blackboard is charmed by the diagrams and formulas. He scarcely understands what they represent; the correctness or falsity of the argument doesn't concern him. But the geometrical figures and writing in white on black appeal to him as surprising forms—they issue from an individual hand and announce in their sureness and flow the elation of advancing thought. For the mathematician his diagram is merely a practical aid, an illustration of concepts; it doesn't matter to him whether it is done in white or yellow chalk, whether the lines are thick or thin, perfectly smooth or broken, whether the whole is large or small, at the side or center of the board—all that is accidental and the meaning would be the same if the diagram were upside down or drawn by another hand. But for the artist, it is precisely these qualities that count; small changes in the inflection of a line would produce as significant an effect for his eye as the change in a phrase in the statement of a theorem would produce in the logical argument of its proof.

For the artist these elementary shapes have a physiognomy; they are live expressive forms. The perfection of the sphere is not only a mathematical insight, we feel its subtle appearance of the centered and evenly rounded as a fulfillment of our need for completeness, concentration and repose. It is the ecstatically perceived qualities of the geometrical figure that inspired the definition of God as an infinite circle (or sphere) of which the center is everywhere and the circumference nowhere. In

another vein, Whitman's description of God as a square depends on his intense vision of the square as a live form:

> Chanting the square deific, out of the one advancing, out of the sides;
> Out of the old and new—out of the square entirely divine;
> Solid, four-sided (all the sides needed) . . . from this side
> Jehovah am I.

The same form occurred to Tolstoy in his *Diary of a Madman* as an image of religious anguish: "Something was trying to tear my soul asunder but could not do so. . . . Always the same terror was there—red, white, square. Something is being torn and will not tear."

I shall not conclude that the circle or square on the canvas is, in some hidden sense, a religious symbol, but rather: the capacity of these geometric shapes to serve as metaphors of the divine arises from their living, often momentous, qualities for the sensitive eye.

This eye, which is the painter's eye, feels the so-called abstract line with an innocent and deep response that pervades the whole being. I cannot do better than to read to you some words written from the sensibility to uninterpreted forms by an American over fifty years ago, before abstract art arose.

"How does the straight line feel? It feels, as I suppose it looks, straight—a dull thought drawn out endlessly. It is unstraight lines, or many straight and curved lines together, that are eloquent to the touch. They appear and disappear, are now deep, now shallow, now broken off or lengthened or swelling. They rise and sink beneath my fingers, they are full of sudden starts and pauses, and their variety is inexhaustible and wonderful."

From the reference to touch some of you have guessed, I'm sure, the source of these words. The author is a blind woman, Helen Keller. Her sensitiveness shames us whose open eyes fail to grasp these qualities of form.

But abstract art is not limited to the obvious geometric forms. From the beginning it has shown a remarkable range. It includes whole families of irregular shapes—the spontaneous mark and the patched or spreading spot—elements that correspond in their dynamic character to impulse and sensation and act upon us also by their decided texture and color. Abstract

painting shares this variety with modern representational art, and like the latter has already a broad spectrum of styles which recall the Classic, Romantic and Impressionist by their structure of color and form. The objections to the masters of abstract painting are much like those that have been addressed to the great masters of the nineteenth century: they are too dry, too intellectual, too material, too decorative, too emotional, too sensual and undisciplined. In general, those who reject abstract painting reject, for the same reasons, the newer kinds of representation as well.

Abstract painting is clearly open to a great span of expression; it is practiced differently by many temperaments, a fact that by itself challenges the idea of its inhumanity. We recognize the individual in these works no less than in representations. And in some the artist appears as an original personality with an impressive honesty and strength.

In recent work, puzzled and annoyed observers have found an artless spontaneity which they are happy to compare with the daubings of the monkey in the zoo. This monkey is the fated eternal companion of the painter. When the artist represented the world around him, he was called the ape of nature; when he paints abstractly, he is likened to the monkey who smears and splatters. It seems that the painter cannot escape his animal nature. It is present in all styles.

Although this art has given up representation, it cannot be stressed enough that it carries further the free and unformalized composition practiced by the most advanced artists at the end of the last century in their painting from nature. In older figurative art with complex forms, the composition could be seen as an implicit triangle or circle, and indeed this habit of regarding structure as a vaguely geometric design was responsible for much of the weakness and banality of academic art. In abstract painting such large underlying schemes are no longer present. Even where the elements are perfectly regular, the order of the whole may be extremely elusive. The precise grid of black lines in a painting by Mondrian, so firmly ordered, is an open and unpredictable whole without symmetry or commensurable parts. The example of his austere art has educated a younger generation in the force and niceties of variation with a minimum of elements.

The problem of abstract art, like that of all new styles, is a problem of practical criticism and not of theory, of general laws of art. It is the problem of discriminating the good in an unfamiliar form which is often confused by the discouraging mass of insensitive imitations. The best in art can hardly be discerned through rules; it must be discovered in a sustained experience of serious looking and judging, with all the risks of error.

The demand for order, through which the new is condemned, is often a demand for a certain kind of order, in disregard of the infinity of orders that painters have created and will continue to create. I do not refer here to the desire for a new order, but rather to the requirement of an already known order, familiar and reassuring. It is like the demand for order in the brain-injured that has been described by a great physician and human being, the neurologist Kurt Goldstein: "The sense of order in the patient," he writes, "is an expression of his defect, an expression of his impoverishment with respect to an essentially human trait: the capacity for adequate shifting of attitude."

Looking back to the past, one may regret that painting now is not broader and fails to touch enough in our lives. The same may be said of representation, which, on the whole, lags behind abstract art in inventiveness and conviction; today it is abstract painting that stimulates artists to a freer approach to visible nature and man. It has enlarged the means of the artist who represents and has opened to him regions of feeling and perception unknown before. Abstraction by its audacities also confirms and makes more evident to us the most daring and still unassimilated discoveries of older art.

The criticism of abstract art as inhuman arises in part from a tendency to underestimate inner life and the resources of the imagination. Those who ask of art a reflection and justification of our very human narrowness are forced in time to accept, reluctantly at first, what the best of the new artists have achieved and to regard it in the end as an obvious and necessary enrichment of our lives.

1960

MARCEL DUCHAMP

For half a century Marcel Duchamp (1887–1968) was the King of the Dadaists, albeit a rather diffident and enigmatic monarch—a lover of art who doubted the value of art, a rabble-rouser who as often as not disdained the limelight. Although he was born and died in France, he spent critical decades of his life in the United States. Duchamp's *Nude Descending a Staircase* created a sensation at the Armory Show in New York in 1913. In the 1920s and 1930s, he was instrumental in shaping the exhibition and appreciation of modern art in America, especially through the Société Anonyme, which he founded in collaboration with the collector Katherine Dreier and the photographer Man Ray. It did not seem to bother Duchamp that for many years Dada's anti-art ethic was overshadowed by the beguiling dream worlds of Surrealism. He was content to have many people believe he had given up art for chess, while he secretly labored in a studio on West 14th Street on *Étant donnés*, a work only unveiled after his death. Duchamp had made what was probably his most radical contribution to art—the found objects he dubbed "Readymades"—around the time of World War I. The "Readymade"—a work of art that undercut the very idea of art—was a time bomb that took a long time to explode, only beginning to inspire widespread enthusiasm as the painterly heroics of the Abstract Expressionists gave way to an increasingly skeptical and anarchic mood in the mid-1950s. It was then that younger artists, among them Jasper Johns and Robert Rauschenberg, found their way to Duchamp, who was living quietly in New York. The two brief, characteristically enigmatic statements here date from those years when Duchamp was emerging from the shadows, a historical figure suddenly relevant, his jokes and conundrums now center stage. Fifty years after Duchamp's death many people believe he is as important if not more important than Picasso. That would have seemed nothing less than astonishing when Duchamp appeared at the Museum of Modern Art in 1961, on a panel organized at the time of the exhibition *The Art of Assemblage*.

The Creative Act

LET us consider two important factors, the two poles of the creation of art: the artist on one hand, and on the other the spectator who later becomes the posterity.

To all appearances, the artist acts like a mediumistic being

who, from the labyrinth beyond time and space, seeks his way out to a clearing.

If we give the attributes of a medium to the artist, we must then deny him the state of consciousness on the esthetic plane about what he is doing or why he is doing it. All his decisions in the artistic execution of the work rest with pure intuition and cannot be translated into a self-analysis, spoken or written, or even thought out.

T. S. Eliot, in his essay on "Tradition and the Individual Talent," writes: "The more perfect the artist, the more completely separate in him will be the man who suffers and the mind which creates; the more perfectly will the mind digest and transmute the passions which are its material."

Millions of artists create; only a few thousands are discussed or accepted by the spectator and many less again are consecrated by posterity.

In the last analysis, the artist may shout from all the rooftops that he is a genius; he will have to wait for the verdict of the spectator in order that his declarations take a social value and that, finally, posterity includes him in the primers of Art History.

I know that this statement will not meet with the approval of many artists who refuse this mediumistic role and insist on the validity of their awareness in the creative act—yet, art history has consistently decided upon the virtues of a work of art through considerations completely divorced from the rationalized explanations of the artist.

If the artist, as a human being, full of the best intentions toward himself and the whole world, plays no role at all in the judgment of his own work, how can one describe the phenomenon which prompts the spectator to react critically to the work of art? In other words how does this reaction come about?

This phenomenon is comparable to a transference from the artist to the spectator in the form of an esthetic osmosis taking place through the inert matter, such as pigment, piano or marble.

But before we go further, I want to clarify our understanding of the word "art"—to be sure, without an attempt to a definition.

What I have in mind is that art may be bad, good or indifferent, but, whatever adjective is used, we must call it art, and

bad art is still art in the same way as a bad emotion is still an emotion.

Therefore, when I refer to "art coefficient," it will be understood that I refer not only to great art, but I am trying to describe the subjective mechanism which produces art in a raw state—*à l'état brut*—bad, good or indifferent.

In the creative act, the artist goes from intention to realization through a chain of totally subjective reactions. His struggle toward the realization is a series of efforts, pains, satisfactions, refusals, decisions, which also cannot and must not be fully self-conscious, at least on the esthetic plane.

The result of this struggle is a difference between the intention and its realization, a difference which the artist is not aware of.

Consequently, in the chain of reactions accompanying the creative act, a link is missing. This gap which represents the inability of the artist to express fully his intention; this difference between what he intended to realize and did realize, is the personal "art coefficient" contained in the work.

In other words, the personal "art coefficient" is like an arithmetical relation between the unexpressed but intended and the unintentionally expressed.

To avoid a misunderstanding, we must remember that this "art coefficient" is a personal expression of art "*à l'état brut*," that is, still in a raw state, which must be "refined" as pure sugar from molasses, by the spectator; the digit of this coefficient has no bearing whatsoever on his verdict. The creative act takes another aspect when the spectator experiences the phenomenon of transmutation; through the change from inert matter into a work of art, an actual transubstantiation has taken place, and the role of the spectator is to determine the weight of the work on the esthetic scale.

All in all, the creative act is not performed by the artist alone; the spectator brings the work in contact with the external world by deciphering and interpreting its inner qualifications and thus adds his contribution to the creative act. This becomes even more obvious when posterity gives its final verdict and sometimes rehabilitates forgotten artists.

1957

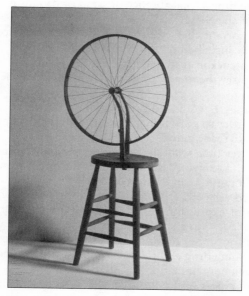

Marcel Duchamp: *Bicycle Wheel*, created
1913.

Apropos of "Readymades"

In 1913 I had the happy idea to fasten a bicycle wheel to a
kitchen stool and watch it turn.

A few months later I bought a cheap reproduction of a winter
evening landscape, which I called "pharmacy" after adding two
small dots, one red and one yellow, in the horizon.

In New York in 1915 I bought at a hardware store a snow
shovel on which I wrote "in advance of the broken arm."

It was around that time that the word "readymade" came to
mind to designate this form of manifestation.

A point which I want very much to establish is that the choice
of these "readymades" was never dictated by esthetic delecta-
tion.

This choice was based on a reaction of visual indifference with

at the same time a total absence of good or bad taste . . . in fact a complete anesthesia.

One important characteristic was the short sentence which I occasionally inscribed on the "readymade."

That sentence instead of describing the object like a title was meant to carry the mind of the spectator towards other regions more verbal.

Sometimes I would add a graphic detail of presentation which in order to satisfy my craving for alliterations, would be called "readymade aided."

At another time wanting to expose the basic antinomy between art and readymades I imagined a "reciprocal readymade": use a Rembrandt as an ironing board!

I realized very soon the danger of repeating indiscriminately this form of expression and decided to limit the production of "readymades" to a small number yearly. I was aware at that time, that for the spectator even more than for the artist, art is a habit forming drug and I wanted to protect my "readymades" against such contamination.

Another aspect of the "readymade" is its lack of uniqueness . . . the replica of a "readymade" delivering the same message; in fact nearly every one of the "readymades" existing today is not an original in the conventional sense.

A final remark to this egomaniac's discourse:

Since the tubes of paint used by the artist are manufactured and ready made products we must conclude that all the paintings in the world are "readymades aided" and also works of assemblage.

1961

GRACE HARTIGAN

Grace Hartigan (1922–2008) was part of the generation that came of age in Manhattan after World War II, in a period of dizzy economic expansion and social transformation. While she certainly knew some hardscrabble times, by her early thirties Hartigan found her work receiving a good deal of attention, not only among a group of peers that included the poet Frank O'Hara and the painter Larry Rivers, but also at the Museum of Modern Art, where her painting *The Persian Jacket* entered the permanent collection and she was featured in the 1956 exhibition *12 Americans*, along with Philip Guston and Franz Kline. Hartigan's journals offer valuable insights into a rapidly changing scene, where women artists of course dealt with prejudice but also recognized fresh possibilities. Like a number of artists of her day, she aimed to unite the freedom the Abstract Expressionists had won for contemporary painting with a renewed attention to the masterpieces in the museums.

Statement

IN the last year I have become increasingly aware of what I must do. Gide said an artist should want only one thing and want it constantly. I want an art that is not "abstract" and not "realistic"—I cannot describe the look of this art, but I think I will know it when I see it.

I no longer invite the spectator to walk into my canvases. I want a surface that resists, like a wall, not opens, like a gate.

I have found my "subject," it concerns that which is vulgar and vital in American modern life, and the possibilities of its transcendence into the beautiful. I do not wish to *describe* my subject matter, or to reflect upon it—I want to distill it until I have its essence. Then the rawness must be resolved into form and unity; without the "rage for order" how can there be art?

1956

From the Journals, 1952

APRIL I

Maybe what I want aside from more "content" or meaning is more architecture in painting. Something like art for the museums as Cézanne said. I do want a certain stillness about a picture—but emotionally meaningful. All very difficult since when strong emotion begins to show obviously then the work becomes expressionism.

Looking at Seurat reproductions, enchanted by the vibrant "stillness" of the form.

Destroyed all yesterday's work and to-days. Intensely dissatisfied.

APRIL 2

Working now with a theme, as I did with "Massacre," hoping something will come that way. Doing drawings on Jarrell's poem "The Knight, Death and the Devil" which in turn was based on Dürer's engraving. No reason why painting shouldn't be premeditated and sustained in this particular way, with every license to change and leave the sketches of course.

A great difference between the "expressionistic" and the "baroque."

APRIL 3

Drawing more to-day, not too well. Most interested in "The Knight" which I did yesterday.

Strange how old hat the extreme can look when the basis isn't firm enough. Thinking of José [de Rivera]'s sculpture—he sent me a catalog. How he loathes the "humanistic" in art. All that Bauhaus business is so dead. It's a mistake to try to be new, "up-to-date."

[Robert] Goodnough's review of my show came out in *Art News* with a reproduction of "Portrait of W." Looks good. The review is serious with a good point made about the brushing. I do feel most of these pictures are history for me. I'm facing the unknown again, the pain of it all.

APRIL 8

Spent most of yesterday at the Met seeing the Cézanne show. I am filled with it, and the overwhelming need to make my own work more solid. They all talk of Cézanne these days— the Club—but in a way that's so dry. I am most interested in the bather pictures, the large one and all the small ones. He was doing something there—the way he opened up a back for instance. I want to use this in some way. I want to draw from him as well as from Rubens, Delacroix, Brueghel and of course Titian and Tintoretto. I tried to see some of my favorites yesterday but they are all put away while the Met is being re-done. I must go again Monday and look at that Delacroix—also the

Walt Silver: Photograph of Grace Hartigan
in front of a self-portrait, 1952.

small Seurat study. I have a book of Rembrandt drawings which are wonderful though I must admit of all the things at the Met only the little Bathsheba really excites me.

I'd like to try painting cool blues, greens, greys, black and white for a while.

APRIL 9

I am feeling a little bitter right now. Not one sale, and again the problem of working at a job to pay debts—we owe together about $400 or $500—my disillusionment with Helen [Frankenthaler] and Clem [Greenberg], my disgust with all my paintings. And that seductive monster Spring wanting me to hope all over again. It takes more than a lifetime to paint, and then all these added anxieties!

I've been making some small drawings from Cézanne—what a genius! But I must put him aside when I face the canvas or I'm completely inhibited.

APRIL 10

Making nothing but muddy, awkward messes, what agony. It's as though I'd forgotten how to paint. Anxieties, doubts, unrest.

Two drawings—"The Knight" and "Death." One painting study—"The Devil."

APRIL 11

Painting on "Death, The Knight and The Devil." I hate what comes out of me but there it is—a nightmare of messy brushwork.

Good Friday—I feel myself crucified to-day.

APRIL 14

All morning at the Met, seeing Cézanne again.

The big pictures are back from the gallery this afternoon—what a farce.

D, The K & the D doesn't look too bad to me.

APRIL 18

Tuesday I begin work at a drafting job for about two months. It means giving up painting entirely for that period, but I hope to save enough money to paint without interruption thru the whole summer. One thing it will do which is good at this time—cut off daily phone conversations with John [Bernard Myers], hence all gossip and petty arguments, involvements in politics of the stinking art world. I'll see a few people in the evening from time to time and generally try to mull over what I feel about my working direction. Feel a need to cut myself off from everything.

The "Fifteen Americans" show is mediocre—I must have been blind all along about Pollock. There is no doubt that all that business has watered down, it seems empty to me.

JUNE 2

The nightmare is over for a while and I'm back to work. I feel strange in the studio, the host turned somehow into guest.

It's good to be with myself again, terrifying but at least the terrors are my own, and not those of the outer world. I'm in complete chaos about painting, what to do, where to begin again? Al [Leslie] and I were saying this last night—he hasn't painted since his marriage. He intends to start on an 11 ft × 11 ft canvas, but I feel that wouldn't help me any longer. I do need a prop in some way, perhaps it will be "nature."

JUNE 3

Sketched from the model last night at Larry [River]'s. I think it's good for me again and I'm interested in what is coming out. My approach is far different from the others—Nell [Blaine],

Larry, [Robert] de Niro, Jane [Freilicher], Leatrice [Rose]—the remnants of the European impressionist and expressionist tradition. I may be subjective, but if this is all the exploring that the younger artists are going to do then I haven't much hope for painting. I feel alone.

Oil study from Titian.

JUNE 4

Bought paint—still the canned crap, can't afford better. Also chicken wire, plaster and wire cutters. Going to work on a "sculpture."

JUNE 5

Sculpture yesterday, painting to-day.

The usual difficulties.

JUNE 6

Painting small oil from Tiepolo's "Trojan Horse."

I don't know what I'm after but whatever it is, if I must look conservative—reactionary—timid—or even (horrors) feminine—in the process then it must be. I think I know how really strong I am, and if a great painter like Matisse could paint weakly and timidly to clear his eyes for what was to come then I can too. I don't fear painting a bad picture or a weak one now. Oh, the mystery of the image. Nature, you monster you. I was on the edge of succumbing to the need of looking "modern"—abstract—contemporary.

All of which is fashion, not painting, and is most dangerous.

The Tiepolo didn't come off yet but St Serapion (after Zurbarán) has something I think.

JUNE 9

St Serapion still looks interesting this morning, terribly awkward.

Worked more on The Knight, Death, and the Devil. I must say it's a peculiar picture. In spite of my ideas and dreams of a calm painting I am far from it. I suppose it takes years to achieve a real calm—look what Cézanne went through.

I feel the tremendous need for self-discipline and I'm painting from reproductions. Not with deep space, but certainly not flat or even as up to the surface as my own work has been. I'm filled with enthusiasm, this has been a good day. I feel I've learned a great deal.

JUNE 10

Worked more on oil study from Rubens. Now reworking The K, D, & D with more fidelity to the engraving.

JUNE 12

Finished The Knight, Death and the Devil. I like it but fear I couldn't exhibit it. Very puzzled as to my motives, but feel I must trust my instincts. Want to attempt something from nature directly, will try the little park and trees with passersby from the front window.

JUNE 13

D, K & D bothers me—I think it's still too "all-over," an idea which I must discard while still maintaining a picture up to the surface.

That's why St Serapion is good, also the drawings I've been doing from the model. They keep an image but strongly hold the surface at the same time. Will work more on D K & D with this in mind.

The idea of painting from the window is definitely out for me—at least now anyhow. It's too confusing.

The way D K & D is in this stage I may as well ask Larry and Jane over and we three can sign it. I think I should work from more architectural reproductions at this time. My romanticism is so strong I needn't encourage it. Botticelli might be good—Poussin also.

JUNE 16

Worked more this morning on K D & D—it still doesn't have that coming together that would make it live. Must leave it alone for a while now. Working on a Botticelli "Venus."

JUNE 17

Been staring at K D & D. It seems tight and "closed" compared with the freedom, boldness and openness of "The Massacre." But it has a tenseness which interests me. I have felt that Massacre sprawls too much.

JUNE 20

I feel to-day like Conrad after he finished "Nostromo"—after it he could think of nothing more to write. I can't go on and on painting after the masters—but as long as I'm feeling the pictures I guess it will run its own course.

Jane, Larry, John Myers, John Ashbery, Jimmy Schuyler and Frank were over Wednesday and were very enthusiastic, particularly over K D & D. Larry and I had quite an argument over the spatial solution of the bottom part of St Serapion—but I think he was arguing falsely from his own timidity. I'm not interested in pat spacial solutions. I'd rather have something which interests me even if it doesn't work well.

I'm in a dilemma over the Rubens Tribute Money which I'm working on now. I don't know quite how to treat the heads—there is a tremendous implication in painting a face, I can't deny it.

It was in April 1948 that I left Ike. Ever since then—four years—I've been painting away from "nature," non-objectively almost. So I am now faced with an overwhelming strangeness and difficulty. Guilt too, I suppose. The "am I modern" fear, worry that I'm succumbing to outside influences (Larry, Jane, de Kooning), these worries are ego difficulties of course, but there are more plastic worries.

I'm making a small oil now from the photo of Helen [Frankenthaler] and me laughing. The great problem is how to keep the heads away from caricature and expressionism, and in the realm of true moving painting. Al solved that so well in his "Christ Dead" and the numerous self-portraits. Paint, not line, is one of the clues. I may visit the Frick and Met later to-day and study some paintings.

JUNE 23

Just ordered 5 yards of 5' duck. Have several plans for paintings but have reached the end of my canvas. Like to do a "Carousel" picture about as large as "Months and Moons" with some of the horror I feel about "fun." Also want to do a large male nude based on the O'Hara drawings, a painting of the Terrible Angel from Rilke, and a dancer something maybe on the ballet "The Cage."

JUNE 24

Started the O'Hara painting to-day. I was lying awake thinking of it last night and became eager to get at it. Didn't have any canvas the right size so I turned "Sacuda" from Mexico over and am painting this on the reverse side.

JUNE 30

Haven't painted since Barbara Guest was over. Walt [Silver] and I have been sick with food poisoning of some sort. I've become unbearably restless and it feels good now to be in the studio.

Saw the "Demoiselles d'Avignon" again at the Mod. Museum and something clicked, who knows what.

Must work a lot more on the O'Hara figure.

The Molyneux collection has some breathtaking tiny Renoirs. It's unbelievable that he could get so much on so small a surface. I think it takes great maturity and control. The 15 Americans upstairs looked terribly sprawling and empty.

Must get more architecture in my painting.

Another thing I found through a talk with de Kooning is that what I'm looking for in my painting is my "world," my content. It's a very serious thing, and I must have time to be quiet with myself in order to find it. In a way I understand why Al and Esta have retreated so. It is impossible to keep one's stability in the midst of other people's chaotic lives.

JULY 9

Working on a drawing—"Terrible Angel." I think it is the only theme of those I listed previously of which I could make something. The others are too specific to allow play. The carousel theme might work out because I feel a possibility of strangeness involved. But I believe now that I can't work directly with nature, that all the clues are indirect and finding them will be the process of a lifetime. I could do the O'Hara picture because it isn't Frank, it's a symbol of something else for me, I don't know what. Such things as demons, gods, death, heroes, devils, saints—the "themes" that were used before "genre" painting came in are more my "world." This is one thing Al and I have in common, although I think it is absolutely unconscious with

him. This way we're different from Jane, Larry, Helen, Harry [Jackson], and also from de Kooning, Tworkov. This is apart from plastic considerations of course—these are impossible to discuss truly, and any attempt to do so ends up in the dryest kind of classroom jargon.

I don't mean by this that I'm interested in "lofty" themes, but that when I try to paint a specific person, incident or place I feel too restricted, too bound to *it* (the idea) and not to the painting. This is all very well but now where to begin?

Beethoven once said "I dread the beginning of these large works. Once into the work and it goes." I feel the same about the start of a painting. I'm attempting a "Hunt" on the Rubens' wolf-hunt. The thing for me now is to know from the start of a painting what each thing "is"—ie a wolf hunter, horse, dog, etc. Then from there I can go deeper and deeper into myself.

JULY 11

"Who, if I cried out, would hear me among the angelic orders?

Beauty is nothing but the beginning of Terror we're still just able to bear."

JULY 14

I have a pornographic photograph in which two men are wearing masks. It gives the most peculiar aura, like an Ensor painting. Too bad his show isn't on now, I think I could get much more from it. In a way his horror sense was his limitation rather than his release, he became more involved with his source than he was with the painting itself.

The heat is oppressive to-day, but I have a feeling I want to open up the "figures" in this "hunt" painting so I intend to work in spite of it.

PM

I feel like a mother who has given birth to an idiot—I know it
lives so I can't destroy it—but I hate it.

JULY 17

Been much too self-consciously analytical about painting and
subject material lately. What interests me at this time is finding
my "subject." It's important to keep working, the problems will
resolve better that way.

It's been so hot I've felt lethargic, but now I'm working on a
painting of John Ashbery, hoping to get away from the violence
and "expressionism" of "The Hunt."

JULY 21

Walt came down to the studio with me for lunch, and was
struck by the "ugliness" of the newest pictures. Also by their
complete "unsaleability." He makes it so fortunate for me that
I don't have to worry about sales—it would ease the pressure
of course if I sold from time to time. But he said it would only
mean "little luxuries"—which I certainly am only too willing
to do without as long as I have all my time free.

God knows how long it will be before I sell anything. Even after
Walt so carefully built up the sale of "Rough Ain't It" (such an
easy picture to like!), the girl's husband couldnt stand the sight
of it in the house.

1952

FRANK O'HARA

By the time Frank O'Hara (1926–1966) died at the age of forty—run over by a dune buggy on Fire Island—he was one of artistic New York's defining figures. Lean, quick, and easygoing, this downtown poet who frequented the Cedar Tavern and the Artists Club (where painters, sculptors, and their friends debated the issues of the day) was also a respected curator at the Museum of Modern Art, where he organized exhibitions of the work of Robert Motherwell and Reuben Nakian. He effortlessly bridged the distance between the studios where the new art was being created and the galleries and museums where it was being presented to a growing audience. O'Hara certainly had a gift for friendship; after his death it was said that nearly everybody he knew had regarded him as their closest friend. No poet was better at catching the caffeinated rhythms of Manhattan, with its layered sights, sounds, and emotions. These poems, dazzlingly informal, bring a new kind of happy-go-lucky exuberance to the wildly unpredictable metaphors and juxtapositions that O'Hara had always admired in the writings of the French Surrealists. There may be no writer whose work comes closer to matching the improvisatory spirit of the painters who were redefining American art.

Fred McDarrah: Frank O'Hara at the Museum of Modern Art, January 20, 1960.

Why I Am Not a Painter

I am not a painter, I am a poet.
Why? I think I would rather be
a painter, but I am not. Well,

for instance, Mike Goldberg
is starting a painting. I drop in.
"Sit down and have a drink" he
says. I drink; we drink. I look
up. "You have SARDINES in it."
"Yes, it needed something there."
"Oh." I go and the days go by
and I drop in again. The painting
is going on, and I go, and the days
go by. I drop in. The painting is
finished. "Where's SARDINES?"
All that's left is just
letters, "It was too much," Mike says.

But me? One day I am thinking of
a color: orange. I write a line
about orange. Pretty soon it is a
whole page of words, not lines.
Then another page. There should be
so much more, not of orange, of
words, of how terrible orange is
and life. Days go by. It is even in
prose, I am a real poet. My poem
is finished and I haven't mentioned
orange yet. It's twelve poems, I call
it ORANGES. And one day in a gallery
I see Mike's painting, called SARDINES.

1957

David Smith: The Color of Steel

THE Terminal Iron Works in Bolton Landing, N.Y., has become by now a landmark in American art. You drive out of town into the hills and meadows and the T.I.W., as the signs for turn-offs say, is in a hollow beside the road at the entrance to the drive which dips down at the studio and then climbs up the hill to David Smith's house. When I was there recently the studio held one large unfinished sculpture (welded but unpainted) and three others in various stages of progression. Outside the studio huge piles of steel lay waiting to be used, and along the road up to the house a procession of new works, in various stages of painting, stood in the attitudes of some of Smith's characteristic titles: they stood there like a *Sentinel* or *Totem*, or *Ziggurat*, not at all menacing, but very aware.

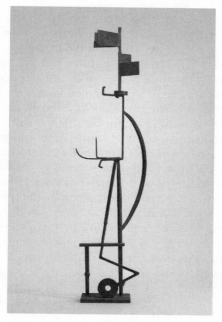

David Smith: *Sentinel I*, 1956. Steel, 89⅝ × 16⅞ × 22⅝ in.

The process of painting the sculptures is a complicated one: the very large ones, which is to say almost all the ones done recently, require more than twenty coats, including several of rust-resistant paint of the kind used on battleships, and many coats of undercolor to hide the brilliant orange-yellow of the basic coats; these undercoats frequently give a velvety texture to the surface (like the iron hand in the velvet glove), and eventually disappear under a final color or colors, or show through, as Smith conceives the final piece. In some cases parts of a piece will be painted different colors, only to disappear under an overall layer of paint as the ultimate image emerges.

The house commands a magnificent view of the mountains and its terrace overlooks a meadow "fitted" with cement bases on which finished stainless steel and painted sculptures were standing. Around the other sides of the house more unfinished works were placed for Smith to ponder. The effect of all these works along the road and around the house was somewhat that of people who are awaiting admittance to a formal reception and, while they wait, are thinking about their roles when they join the rest of the guests already in the meadow.

The contrast between the sculptures and this rural scene is striking: to see a cow or a pony in the same perspective as one of the *Ziggurats*, with the trees and mountains behind, is to find nature soft and art harsh; nature looks intimate and vulnerable, the sculptures powerful, indomitable. Smith's works in galleries have often looked rugged and in-the-American-grain, which indeed they are in some respects, but at Bolton Landing the sophistication of vision and means comes to the fore strongly. Earlier works, mounted on pedestals or stones about the terrace and garden, seem to partake of the physical atmosphere, but the recent works assert an authoritative presence over the panorama of mountains, divorced from nature by the insistence of their individual personalities, by the originality of their scale and the exclusion of specific references to natural forms.

For twenty-five years Smith has been at the forefront of the sculptural avant-garde, in quality if not that long in reputation. Like Arshile Gorky, Smith took, assimilated, synthesized and made personal many developments in international modern art movements which had hitherto not found their way into American sculpture without a nullifying gaucherie. Because of

the far-reaching effects of these explorations, Smith has sometimes been mistaken for an eclectic artist, but this is not at all the case. His has not been a taming of the impulses discovered in the germinal works of the first half of the century, but a roughening, a broadening, a sharpening of usage, depending on his needs at the time. And in so doing, Smith brought out aspects of the sculpture of Picasso, González and Giacometti which had before seemed minor, if not entirely hidden.

But this was in the early work. The new sculptures are of painted steel, of stainless steel or of bronze. The bronzes are least different from earlier work of Smith, though they face that medium with new images in mind. The stainless steel sculptures continue a direction which first reached monumental proportions in *Fifteen Planes* (shown at the Venice Biennale, 1958). They are tall, glittering, leggy works, usually with several flat surfaces meeting like still-lifes above the verticals which hold them aloft. Seen in full sunlight, with the stainless steel *Sentinels* which continue another direction of his work, their polished and ground surfaces carry the eye over highly elaborate changes of tone without violating the flatness of the plane. They look severe and dashing; to continue the meadow-party idea, they are the sort of people who are about to walk away because you just aren't as interesting as they are, but they're not quite mean enough to do it. The working of the surface in this medium, as Smith does it, has the kind of severe, ironic frivolity Velázquez brought to the marvelously detailed costume of a mean-looking Spanish nobleman. But of course it is really all a matter of light, light sinking, light dashing into the surface, light bouncing back at you.

Many of the painted works are also monumental in size. Unlike Calder or Nakian, or for that matter his own previous painted sculpture, Smith does not usually use a single color for a whole piece here, unless it is opaque enough to let variations and undertones show through. Nor is the color usually applied to separate parts, but rather to shift their functions as visual elements of a single image. In some pieces the color spreads over one plane onto a segment of the next and then to a third, like a drape partially concealing a nude. This is no longer the constructivist intersection of colored planes, nor is the color used as a means of unifying the surface. Unification is approached

by inviting the eye to travel over the complicated surface exhaustively, rather than inviting it to settle on the whole first and then explore details. It is the esthetic of culmination rather than examination. Smith uses modeling in some areas; over-painting where the whole surface of a form vibrates with the undercolor; effects of the brush; the interchange of color areas with the parts of the steel construction of which they expound the quality and ring changes on the structure. Sometimes the reference is directly to a specific painting, as in the piece dedicated to Kenneth Noland, which presents its three-dimensional head like a target whose rings had been pushed and pulled out of kilter, as if in answer to the painter's request for a three-dimensional version of himself. But it is never sculpture *being* painting, it is sculpture looking at painting and responding in its own fashion. In a world where everything from sponges dipped in paint to convertibles crushed into shapes by power presses have been put to sculptural usage, this new development in Smith's work is, oddly enough, the boldest and most original statement about the nature of sculptural perception. On the simplest level he has focused new attention on the plastic forces within the metal by providing a determinable surface (paint) which does not violate its nature, or by working the stainless steel surfaces with the freedom that belongs to drawing paper; on the more complicated visual level of communicatory imagery he has extended the expressive possibilities of three-dimensional forms.

Using the inspiration of the material's quality as a start, Smith does not hesitate to urge change, advancement or concealment, as the image of a particular work takes form. Having contemplated the materials at length, he bears no relation to the sensitive person staring soulfully at a seashell, driftwood or a nail, and taking it home never to *see* it again, a trap which not every "assemblage" sculptor manages to avoid. He is brutal enough to be bored and ashamed enough to be ambitious. He has no false humility before the material world, and asks no humility of it. In the works which used "found" objects, such as the *Agricola* series, the impulse was not to cherish the "poetry" of the part, but to give it a presence according to what its formal function might become. He never makes memorabilia. Nor does he ask the materials to be attractive, just to co-operate.

The logic of Smith's move from painting (1927) to three-

dimensional objects and then to sculpture in the following six years has been well examined elsewhere. From the first he occasionally used paint on his sculptures. But there is no evidence from the way the sculptures were painted that the painting of them represented any nostalgia for the act of painting itself. The interest, from the beginning works of 1933 on, seems to have been in the control of the look of the surface as it performed to create the whole: a typical example of what I mean is the *Egyptian Landscape* of 1951, where the red paint on the steel parts creates the feeling of the somber heat of molten metal, and the Nile-green of the painted bronze forms summons a more hieratic quality than bronze patinas usually provide. But thinking over some of the works of other periods in his development, most of the painted pieces seem as much patinaed as painted: they do not stand apart by virtue of the different means employed. A work incorporating found parts, like *The Five Spring*, with a rusty patina (none of them are actually rusted), presents a greater difference in color quality when compared to blue-patinaed bronzes like *O Drawing*, than when compared to *Pillar of Sunday* or *Australia*, though the latter are painted, respectively, red and black. Again, in the *Iron Woman* of 1954–58, the faint rubbings of yellow in the scratches and abrasions of the oval planes point up the silkiness of the stainless steel as a quality of the metal itself, not as the introduction of an enhancing element which is foreign to it. But the fact that the painted pieces were painted does already have a significance which bears on the more recent work: apparently Smith intends to preserve the look of these pieces as close to their first moment of completion as possible, to preserve the state of the sculpture's original inception. If one of them should rust or be nicked, he would strip it down to the bare metal and restore it to its original color and texture. It is interesting that he is not tempted to alter a given piece in the light of subsequent developments of his own sensibility, he simply makes sure that its own being is intact.

Smith has always been known for his esthetic curiosity and inventiveness, for rapid and drastic changes in style whenever the new interest seized him. The new painted steel works are not so much the result of a change in outlook as outgrowths of several non-conflicting ideas in the recent past, particularly the *Tank Totems* and the *Sentinels*. They move into a scale which

he had never previously been able to afford and for which he is fully equipped. They have an odd atmosphere of grandeur and, at the same time, delight, like seeing a freshly washed elephant through the eyes of a child: the *Ziggurats* in particular induce a sort of naive wonder which lasts long after one has left them. Despite the size of these works, they have an atmosphere of affection for the huge slabs of steel, for the hoisting and welding of them, for the impulse to see them join and rise. Smith once said if he had the money he'd like to make a sculpture as big as a locomotive, and I think if Smith were asked to make a real locomotive he wouldn't care if it ever ran so long as he had the use of all that metal. The humor which had previously characterized Smith's work at certain times, often sarcastic or satiric, now seems to have been transformed into this delight towards the material and, coupled with the formidable structural achievement of the works, gives them an amiability and a dignity which is the opposite of pretentiousness. In addition to the formal uses to which paint is put, mentioned above, I consider that the painting of these pieces also represents a sort of diary of the development of the forms: in each piece he has gathered together the separate impulses of the construction of the parts by the notation of the painted surfaces, so that as the formal functioning of a plane changes as the total image demands it to function in a different way, the painting of it will have some of the quality of the original inspiration for its existence. There is then the interplay of the steel forms, as they relate strictly to the elements of the construction, with the memory of these forms, provided by the paint, resonantly adding to the formal structure the feelings of the artist as he worked.

Smith had already made a considerable success in this direction with his early *Helmholtzian Landscape*, but these new works move into an area of seemingly infinite exploration. Smith wants to do a great deal in each sculpture, as an artist he is very inclusive, and this development provides him with the range and the means to give us everything he wants. The best of the current sculptures didn't make me feel I wanted to *have* one, they made me feel I wanted to *be* one.

1961

Art Chronicle I

THE other day I was at the Guggenheim Museum to see the ABSTRACT EXPRESSIONISTS AND IMAGISTS show again, but before going into the show itself it may be worthwhile, or at least different, to say something nice about the building itself. From long before construction work started on it, it had been a controversial thing, and it stayed so throughout the work on it, its opening, and its first several shows—every detail of its design was discussed everywhere from the newspaper to The Club, and rumors that its then-director might quit because he hated the floor, or the wall, or the dome, or the lighting, or even the elevator, were circulated. (He did leave subsequently, but apparently not because of F.L.W.) The Museum is, of course, worthy of all this attention, and it has many merits not shared by other institutions of a similar or identical nature (and a few disadvantages: I don't like bumping into those pillars when I'm talking to somebody): it's wonderful looking from the outside, and when you enter the flat exhibition space on the ground floor the effect of the works near at hand, the ramps and over them glimpses of canvases, and then the dome, is urbane and charming, like the home of a cultivated and mildly eccentric person. The elevator is a good idea too; I wonder if anyone has ever taken it down? And apart from the one-way thing about it, it takes off the curse of most elevators, which is that when you go up in an elevator in the day-time you are usually going to some unpleasant experience like work or a job interview, but here you are going up for pleasure. When you get to the top, and before beginning the descent (an opposite experience from that of Dante, since most often the important works are hung down in the "straight" gallery just above the main level), you used to get a miniature retrospective of Kandinsky from the Museum's own collection, and right now there is a rather mute and interesting small show of newspapers, letters (as in H and F), and books by Chryssa. The downward stroll, then, is enhanced by the glimpses you've been sneaking (from the top this time) at the pictures on the lower ramps, and you get lots of surprises: things that looked especially inviting or dramatic from a partial look turn out to be totally uninteresting and others you hadn't bothered to anticipate are terrific (though this operation

Postcard of the Guggenheim Museum, circa 1960.

isn't invariable). Finally about this ramp, it almost completely
eliminates the famous gallery-going fatigue. Your back doesn't
ache, your feet don't hurt, and the light on the paintings, the
variety of distance chosen for them to be against or away from
the wall and towards you, is usually quite judicious—people
who find it so hard to "see" the picture in the lighting of the
Guggenheim should try going to the average studio in which
most New York artists work before they complain. (I know
museums aren't supposed to be studios, I'm talking about look-
ing at really good paintings or sculptures, which frequently has
little to do with locale or condition.) Anyhow, I like the whole
experience, the "bins" where you come around a semi-wall and
find a masterpiece has had its back to you, the relation between
seeing a painting or a sequence of them from across the ramp
and then having a decent interval of time and distraction inter-
vene before the close scrutiny: in general my idea is that this
may not be (as what is) the ideal museum, but in this instance
Frank Lloyd Wright was right in the lovable way that Sophie
Tucker was to get her gold tea set, which she described as, "It's
way out on the nut for service, but it was my dream!"
 New York gallery-goers are used to feeling that no matter

what they are looking at, the institution in question will dish it up to them with the appropriate importance so far as installation goes, hence the accusation that the Guggenheim makes certain paintings look inferior to their intrinsic quality. This is of course a fallacy: position in installation and lighting has nothing to do with esthetic importance. Actually, the only truly important new works to be shown in New York last and this season were the Matisse cut-outs at the Museum of Modern Art, and they could have been hung outdoors in the garden without jeopardizing their importance in the slightest (so long as it didn't rain). I am not saying that the abstract show at the Guggenheim shouldn't have been hung differently, since certain pictures did kill their neighbors and vice versa, but it had nothing to do with positioning for strategic importance. But the Bonnard in the Guggenheim's first show after its opening did not suffer from the light and the position, as often remarked, it is simply a property of Bonnard's mature work, and one of its most fragile charms, to look slightly washed-out, to look what every sophisticated person let alone artist wants to look: a little "down," a little effortless and helpless. He was never a powerful painter, per se.

At the opening of the abstract show at the Guggenheim several people were going around saying, "At last it looks like a real museum here," which is a terribly funny notion when you think that the abstract expressionist movement is basically anti-museum in spirit, and its members were the only organized group to send out a letter of protest about the museum to the newspapers even before construction on the building had begun. The thing is that with this show the Guggenheim became part of New York, in that it featured New York's favorite art movement. And no matter how much Wright himself may have hated painting and sculpture, the physical setup of the building does nothing to hurt that movement.

The selection is another matter: what the title implies is a summary of achievement, but what you get is recent works by most of the important members of the movement. This is very interesting, if you want to look at paintings. Unfortunately many people wanted to see a justification, packaged in a new Sherry's container, with a card saying, "Because of this show you are entitled to keep on admiring abstract expressionism."

Hence the criticism the Guggenheim has gotten about the quality of the show, some of it near hysteria: "A WEAK HOFMANN! HOW COULD THEY!" None of the reviewers seems to have thought, "How could he!"

What does happen in the show, without disturbing anybody's reputation, is a shift in the emphasis of who is doing the interesting work: some artists maintain their vitality, others look terribly dull, younger members zoom to the fore, all on the foreadmitted basis of one recent work, so no images are toppled permanently. This is a perfectly fair thing to have happen and gives the show an air of free-wheeling accuracy. This is all living art and the show reflects the living situation: just as Al Held and Joan Mitchell and Philip Guston will absorb the imagination of one season, so do Michael Goldberg and Robert Motherwell and Franz Kline another. It depends on what you see and when it's shown and it keeps you fresh for looking and for the excitement of art. A lot of people would like to see art dead and sure, but you don't see them up at the Cloisters reading Latin.

The present show also, precisely because it is mainly made up of recent works, reflects another very human situation; the relation between artists of a given tendency is frequently very close. Why this should be a matter of concern to anyone but the artists themselves is beyond me, since the alternatives to this fortuitous happening are blindness or hypocrisy. Nevertheless, the viewer should make more distinctions than the artist, he has time and room for it, he is merely looking and experiencing, where the artist is creating something, whether in his own or another's image, no small feat in either case.

In a capitalist country fun is everything. Fun is the only justification for the acquisitive impulse, if one is to be honest. (The Romans were honest, they thought it was all girls, grapes and snow.) The Guggenheim Museum is fun, and as such it justifies itself. Abstract expressionism is not, and its justifications must be found elsewhere. Not to say it as justification, but simply as fact, abstract expressionism is the art of serious men. They are serious because they are *not* isolated. So out of this populated cavern of self come brilliant, uncomfortable works, works that don't reflect you or your life, though you can know them. Art is not *your* life, it is someone else's. Something very difficult for the acquisitive spirit to understand, and for that matter the spirit of joinership that animates communism. But it's there.

So what's good in this show and how does it look? Well it *looks* very good, as a matter of fact it looks better than it is. Not wanting to do a hugger-mugger in the Louvre, the dross always is self-effacing and disappears. So you are left with some terrific stuff:

one of the most interesting Brooks' in years, where the artist's exceptional skill at handling paint masses is roughened up somewhat and gets to a kind of baroque literalness, joining Clyfford Still in his firmness about stopping-points;

a magnificent Motherwell, the kind of painting that everyone must dream of doing if they want to do anything at all: it has everything, it shimmers with a half-concealed light, it draws when it wants to, and withal it has an opulence and a majesty which is completely uncharacteristic of the American sensibility unless you think your mother went to bed with an Indian;

earlier I hinted at Al Held's show at the Poindexter Gallery last season, and his picture is terrific here—he is a wonderful artist, at the same time sensitive and blunt, related, and how gratifyingly, to the Gorky of the late 30s, and he is a clearer of the eye and mind; Held reminds you that color, form, shape (and there is a difference between form and shape), and nuance are still not giving the game over to the enemy—you don't have to become a clock anymore if you're near a Held, he is not painting about position in time;

the Raymond Parker looked very beautiful and I for one hope that I never see another Parker with a thick gold band around it. It crowds the space too much, it falsifies the delicate balance and subtle correspondence of his near tones, and it is to the credit of the Guggenheim that it took it the way it was, though why the same manner wasn't adopted for his one-man show there earlier this year I can't imagine, even if it did manage to be impressive despite this handicap;

in relation to the other examples, I think the wrong Frankenthaler was chosen, expert as it is, for the content of the show, but more about her later. The Rauschenberg ditto, because if you think he should be in the show at all, it is as an imagist rather than an expressionist (both should be preceded by an abstract-, natch), and he should have been represented in force rather than in retirement, as is true in another way of the hangings of the Joan Mitchell and the Alfred Leslie, who are too sure of hand and distinguished of spirit to suffer this treatment

without a sullen smile—one must simply see them elsewhere, yet they make their presence felt or I wouldn't mention them;

de Kooning has shown several single pictures recently of such a beauty that one wonders, if he ever does get around to having a show of the new abstractions, whether the Sidney Janis Gallery won't just go into an apotheosis, and the one here is no exception—I wish I could give credence to the next remark by thinking of a single indifferent work by de Kooning but I can't so here goes anyway: he is the greatest painter after Picasso and Miró;

but not to run on, the *hits* of the show are mostly on the "mezzanine" floor, the flat gallery where the absolutely superb Pollock, Still and Newman establish an aristocracy for American art which is unequalled anywhere, in the developments after World War II.

Where else is the big, brave art happening? Certainly not in Paris, where artisanship has claimed and cured even the most demented intentions to the point where seeing Helen Frankenthaler's recent show, or a single fugitive Kline, or something from the Spanish School (Tàpies or Canogar or Saura), is a sock in the eye along the rue de Seine. Of the younger generation there is only Riopelle, a gigantic spirit, with Soulages and Alechinsky trailing formalistically (and authentically) up towards the stars.

A lot of interesting things are happening right here which make Paris and Rome seem quite dull and insensitive by comparison. There is, of course, the construction-of-esthetic-objects movement, which since the exhibition at the Museum of Modern Art will probably be designated fairly clearly as assemblagists. This is a very courageous direction because it deliberately vies with the fondness one feels for a found object, challenging in intimacy as well as structure all the autobiographical associations that a found object embodies. In Claes Oldenburg's recent exhibition THE STORE (107 East 2nd Street—the best thing since L. L. BEAN), you find cakes your mother never baked, letters you never received, jackets you never stole when you broke into that apartment, and a bride that did not pose for Rembrandt's famous Jewish ceremony. Somehow Oldenburg is the opposite of Britain's "kitchen sink" school: he can make

a stove (with roast) or a lunch-counter display case lyrical, not to say magical. And he actually does do what is most often claimed wrongly in catalog blurbs: transform his materials into something magical and strange. If Red Grooms was the poet of this tendency and Jim Dine is the realist, then Oldenburg is the magician. His enormous cardboard figure at the Green Gallery, with its great legs stretched toward one on the floor, was sheer necromancy. Compared to these three artists, and adding to it Lucas Samaras and George Brecht, the European artists exploring this field are very dull. And the direction in itself must be taken quite apart from the work of Jasper Johns or Jean Follette or Robert Rauschenberg, each of whom has a separate and individual tradition behind their work, no matter what their influence may have joined together.

Rauschenberg had recently a very beautiful show at the Castelli Gallery and one unprecedented to my knowledge. It began as a group show, and gradually more Rauschenbergs moved in, while other works moved amiably out, as if to say, "Okay, Bob, this turn seems right for you, so take it, maestro, from Bar R." It was a beautiful show, and an event more interesting than many of the "happenings" down town. The gallery kept changing the paintings, which gave an unusual urgency to gallery-going. If I hadn't been very lucky, I would have missed seeing *Blue Eagle*, a modern work which nobody should be deprived of. One should add that his (our) experience of the *Dante Illustrations* which Rauschenberg exhibited last year have left none of us less the richer for any occasion in the future. Doré had never the pertinence for his society that those works have for ours, nor the beauty, nor the perception. So we all have that, too.

In the opposite camp, the "tradition of the new" traditional abstract-expressionist movement, lie Norman Bluhm's paintings, although jet or explode may be a more accurate word. A great deal has been written about the influence of Pollock, but that is all about the *look*, the technique which is best known (Pollock had several). Bluhm is the only artist working in the idiom of abstract-expressionism who has a spirit similar to that of Pollock, which is to say that he is *out*—beyond beauty, beyond composition, beyond the old-fashioned kind of pictorial ambition. And Jasper Johns is somehow in this area, a very misunderstood artist, whose art presents to many something easily

assimilable and understood, but Johns is one of the most mysterious artists of our time, an artist whose work is *not* formal, in the sense that it is understood and expounded. He has the experience, which may or may not be unfortunate for him, of seeing his paintings greeted with delight because the images are recognizable when they are filled with pain. At least that is one way of feeling them: one may say that the meticulously and sensually painted rituals of imagery express a profound boredom, in the Baudelairean sense, with the symbols of an oversymbolic society, as Oedipus unconsciously exposed the errors of a familial sentimentality based on disgust.

Bluhm's art, on the other hand, and they are arbitrarily juxtaposed, has the other Grecian impulse which inspired fountains, temples and conquest. Johns's business is to resist desire, Bluhm unconsciously inspires it. But more, of course, must be thought about both.

1962

Larry Rivers: A Memoir

I FIRST met Larry Rivers in 1950. When I first started coming to New York from Harvard for weekends Larry was in Europe and friends had said we would like each other. Finally, at for me a very literary cocktail party at John Ashbery's we did meet, and we did like each other: I thought he was crazy and he thought I was even crazier. I was very shy, which he thought was intelligence; he was garrulous, which I assumed was brilliance—and on such misinterpretations, thank heavens, many a friendship is based. On the other hand, perhaps it was not a misinterpretation: certain of my literary "heroes" of the *Partisan Review* variety present at that party paled in significance when I met Larry, and through these years have remained pale while Larry has been somewhat of a hero to me, which would seem to make me intelligent and Larry brilliant. Who knows?

The milieu of those days, and it's funny to think of them in such a way since they are so recent, seems odd now. We were all in our early twenties. John Ashbery, Barbara Guest, Kenneth Koch and I, being poets, divided our time between the literary

bar, the San Remo, and the artists' bar, the Cedar Tavern. In the San Remo we argued and gossipped: in the Cedar we often wrote poems while listening to the painters argue and gossip. So far as I know nobody painted in the San Remo while they listened to the writers argue. An interesting sidelight to these social activities was that for most of us non-Academic and indeed non-literary poets in the sense of the American scene at the time, the painters were the only generous audience for our poetry, and most of us read first publicly in art galleries or at The Club. The literary establishment cared about as much for our work as the Frick cared for Pollock and de Kooning, not that we cared any more about establishments than they did, all of the disinterested parties being honorable men.

Then there was great respect for anyone who did anything marvelous: when Larry introduced me to de Kooning I nearly got sick, as I almost did when I met Auden; if Jackson Pollock tore the door off the men's room in the Cedar it was something he just did and was interesting, not an annoyance. You couldn't see into it anyway, and besides there was then a sense of genius. Or what Kline used to call "the dream." Newman was at that time considered a temporarily silent oracle, being ill, Ad Reinhardt the most shrewd critic of the emergent "art world," Meyer Schapiro a god and Alfred Barr right up there alongside him but more distant, Holger Cahill another god but one who had abdicated to become more interested in "the thing we're doing," Clement Greenberg the discoverer, Harold Rosenberg the analyzer, and so on and so on. Tom Hess had written the important book. Elaine de Kooning was the White Goddess: she knew everything, told little of it though she talked a lot, and we all adored (and adore) her. She is graceful.

Into this scene Larry came rather like a demented telephone. Nobody knew whether they wanted it in the library, the kitchen or the toilet, but it was electric. Nor did he. The single most important event in his artistic career was when de Kooning said his painting was like pressing your face into wet grass. From the whole jazz scene, which had gradually diminished to a mere recreation, Larry had emerged into the world of art with the sanction of one of his own gods, and indeed the only living one.

It is interesting to think of 1950–52, and the styles of a whole group of young artists whom I knew rather intimately. It was a

liberal education on top of an academic one. Larry was chiefly
involved with Bonnard and Renoir at first, later Manet and
Soutine; Joan Mitchell—Duchamp; Mike Goldberg—Cézanne–
Villon–de Kooning; Helen Frankenthaler—Pollock-Miró; Al
Leslie—Motherwell; De Niro—Matisse; Nell Blaine—Helion;
Hartigan—Pollock-Guston; Harry Jackson—a lot of Matisse
with a little German Expressionism; Jane Freilicher—a more
subtle combination of Soutine with some Monticelli and
Moreau appearing through the paint. The impact of THE NEW
AMERICAN PAINTING on this group was being avoided rather
self-consciously rather than exploited. If you live in the studio
next to Brancusi, you try to think about Poussin. If you drink
with Kline you tend to do your black and whites in pencil on
paper. The artists I knew at that time knew perfectly well who
was Great and they weren't going to begin to imitate their
works, only their spirit. When someone did a false Clyfford
Still or Rothko, it was talked about for weeks. They hadn't read
Sartre's *Being and Nothingness* for nothing.

Larry was especially interested in the vast range of possibili-
ties of art. Perhaps because of his experience as a jazz musician,
where everything can become fixed so quickly in style and be-
come "the sound," he has moved restlessly from phase to phase.
Larry always wanted to see something when he painted, unlike
the then-prevalent conceptualized approach. No matter what
stylistic period he was in, the friends he spent most time with
were invariably subjects in some sense, more or less recogniz-
able, and of course his two sons and his mother-in-law who
lived with him were the most frequent subjects (he was sepa-
rated from his wife, Augusta). His mother-in-law, Mrs. Bertha
Burger, was the most frequent subject. She was called Berdie by
everyone, a woman of infinite patience and sweetness, who held
together a Bohemian household of such staggering complexity
it would have driven a less great woman mad. She had a natural
grace of temperament which overcame all obstacles and irrita-
tions. (During her fatal illness she confessed to me that she had
once actually disliked two of Larry's friends because they had
been "mean" to her grandsons, and this apologetically!) She
appears in every period: an early Soutinesque painting with a
cat; at an Impressionistic breakfast table; in the semi-abstract
painting of her seated in a wicker chair; as the double nude, very

realistic, now in the collection of the Whitney Museum; in the later *The Athlete's Dream*, which she especially enjoyed because I posed with her and it made her less self-conscious if she was in a painting with a friend; she is also all the figures in the Museum of Modern Art's great painting *The Pool*. Her gentle interestedness extended beyond her own family to everyone who frequented the house, in a completely incurious way. Surrounded by painters and poets suddenly in mid-life, she had an admirable directness with esthetic decisions: "it must be very good work, he's such a wonderful person." Considering the polemics of the time, this was not only a relaxing attitude, it was an adorable one. For many of us her death was as much the personal end of a period as Pollock's death was that of a public one.

I mention these details of Rivers' life because, in the sense that Picasso meant it, his work is very much a diary of his experience. He is inspired directly by visual stimulation and his work is ambitious to save these experiences. Where much of the art of our time has been involved with direct conceptual or ethical considerations, Rivers has chosen to mirror his preoccupations and enthusiasms in an unprogrammatic way. As an example, I think that he personally was very awed by Rothko and that this reveals itself in the seated figures of 1953–54; at the same time I know that a rereading of *War and Peace*, and his idea of Tolstoy's life, prompted him to commence work on *Washington Crossing the Delaware*, a non-historical, non-philosophical work, the impulse for which I at first thought was hopelessly corny until I saw the painting finished. Rivers veers sharply, as if totally dependent on life impulses, until one observes an obsessively willful insistence on precisely what he is interested in. This goes for the father of our country as well as for the later Camel and Tareyton packs. Who, he seems to be saying, says they're corny? This is the opposite of Pop Art. He is never naive and never over-sophisticated.

Less known than his jazz interests are Larry's literary ones. He has kept, sporadically, a fairly voluminous and definitely scandalous journal, has written some good poems of a diaristic (boosted by Surrealism) nature, and collaborated with several poets (including myself) who have posed for him, mainly I think to keep them quiet while posing and to relax himself when not painting or sculpting. The literary side of his activity

has resulted mainly in the poem-paintings with Kenneth Koch, a series of lithographs with me, and our great collaborative play *Kenneth Koch, a Tragedy* which cannot be printed because it is so filled with 50s art gossip that everyone would sue us. This latter work kept me amused enough to continue to pose for the big nude which took so many months to finish. That is one of Larry's strategies to keep you coming back to his studio, or was when he couldn't afford a professional model. The separation of the arts, in the "pure" sense, has never interested him. As early as 1952, when John Myers and Herbert Machiz were producing the New York Artists' Theatre, Larry did a set for a play of mine, *Try! Try!* At the first run-through I realized it was all wrong and withdrew it. He, however, insisted that if he had done the work for the set I should be willing to rewrite to my own satisfaction, and so I rewrote the play for Anne Meacham, J. D. Cannon, Louis Edmonds and Larry's set, and that is the version printed by Grove Press. Few people are so generous towards the work of others.

As I said earlier, Larry is restless, impulsive and compulsive. He loves to work. I remember a typical moment in the late 50s when both Joan Mitchell and I were visiting the Hamptons and we were all lying on the beach, a state of relaxation Larry can never tolerate for long. Joan was wearing a particularly attractive boating hat and Larry insisted that they go back to his studio so he could make a drawing of her. It is a beautiful drawing, an interesting moment in their lives, and Joan was not only pleased to be drawn, she was relieved because she is terribly vulnerable to sunburn. As Kenneth Koch once said of him, "Larry has a floating subconscious—he's all intuition and no sense."

That's an interesting observation about the person, but actually Larry Rivers brings such a barrage of technical gifts to each intuitive occasion that the moment is totally transformed. Many of these gifts were acquired in the same manner as his talents in music and literature, through practice. Having been hired by Herbie Fields' band in his teens he became adept at the saxophone, meeting a group of poets who interested him he absorbed, pro or con, lots of ideas about style in poetry, and attending classes at Hans Hofmann's school plunged him into activities which were to make him one of the best draftsmen

in contemporary art and one of the most subtle and particular colorists. This has been accomplished through work rather than intellection. And here an analogy to jazz can be justified: his hundreds of drawings are each like a separate performance, with its own occasion and subject, and what has been "learned" from the performance is not just the technical facility of the classical pianists' octaves or the studies in a *Grande Chaumière* class, but the ability to deal with the increased skills that deepening of subject matter and the risks of anxiety-dictated variety demand for clear expression. When Rivers draws a nose, it is my nose, your nose, his nose, Gogol's nose, and the nose from a drawing instruction manual, and it is the result of highly conscious skill.

There is a little bit of Hemingway in his attitude toward ability, toward what you do to a canvas or an armature. His early painting, *The Burial*, is really, in a less arrogant manner than Hemingway's, "getting into the ring" with Courbet (*A Burial at Ornans*), just as his nude portrait of me started in his mind from envy of the then newly acquired Géricault slave with the rope at the Metropolitan Museum, the portrait *Augusta* from a Delacroix; and even this year he is still fighting it out, this time with David's *Napoleon*. As with his friends, as with cigarette and cigar boxes, maps, and animals, he is always engaged in an esthetic athleticism which sharpens the eye, hand and arm in order to beat the bugaboos of banality and boredom, deliberately invited into the painting and then triumphed over.

What his work has always had to say to me, I guess, is to be more keenly interested while I'm still alive. And perhaps this is the most important thing art can say.

1965

LARRY RIVERS

With his swashbuckling personality, Larry Rivers (1923–2002) was never an artist who could easily be ignored. He was a jazz saxophonist before he turned his attention to painting, studying with Hans Hofmann in 1947–48. A mere five years later he was razzing the art world's reputation for high seriousness, with a painterly send-up of Emmanuel Leutze's nineteenth-century academic history painting, *Washington Crossing the Delaware,* which was immediately bought by the Museum of Modern Art. Rivers brought a hipster informality to his impressions of the Revolutionary War—and of a dying Civil War veteran, a Cedar Tavern menu, and a cigar box bearing a reproduction of Rembrandt's *Syndics.* Rivers is often said to have prefigured Pop Art, and he was certainly among the first to bring an element of camp into contemporary painting, with his cheerful embrace of commercial imagery and his ironic salutes to the old masters in the museums. In 1992 Rivers published *What Did I Do?,* an autobiography in which he savored a life lived in the fast lane. Among the friends he discussed was Frank O'Hara, whom Rivers famously painted in the nude save for a pair of boots. The essay here—originally published in *Location,* a short-lived magazine edited by Harold Rosenberg and Thomas Hess—recounts Rivers's collaboration with O'Hara on a cycle of lithographs. They also worked together on a comic play, *Kenneth Koch: A Tragedy,* a remarkable slapstick rendition of an afternoon at the Cedar Tavern.

Life Among the Stones

As a student or young painter I had the notion that there was an intrinsic good in painters and poets working together. It seemed like socialism in its smallest and most personal form. There was a glorious halo around the idea of each inspiring the other. It was Paris and the books were full of it. A gorgeous Matisse book with a yellow cover, the words I didn't understand surrounded by beautifully drawn leaves, seemed to alter and lift up my dreary days. I saw a book where Picasso did something with Eluard and other books with other "greats" who had gotten together. At that time it seemed to me that my heroes in their energetic prance through life were responding to the ideas of beauty and madness contained in poetry. Until a few years ago I never dusted off that notion to see what it was and until this

moment I've never tried to clarify what I was doing when Frank O'Hara and I, and Kenneth Koch and I, put our marks on the same surface.

Maybe I'm an artist but I have gone from a baby to having the soul of a nail. I get a physical thrill in being cruel. My cruelty consists of destroying the ease I see in the presence of cliché and vogue.

Let's see—it started with this Siberian lady Tanya who came to my house in the summer of 1957. Her life at the time called for an activity. She found it and dedicated herself with a gentle fury to the production of lithographs. It had some other beginning, but when she arrived in '57 the final form of her dedication had emerged. She wanted me to work on lithograph stones with a poet. She had the devotion, the press, and she would print. She had just come from Barney Rosset; she had asked him what poet would be good for this project. At the time Barney was about to publish a book of Frank O'Hara's poems. He suggested Frank and (dopey fate) Frank was my guest when she arrived. On the basis of what had been gestating in us for many years we agreed to do it. We entered, O holy, into a direct relationship with the past. We were grown up but we wanted to taste that special lollypop Picasso, Matisse, Miró, Apollinaire, Eluard and Aragon had tasted and find out what it was like. *What* lollypop?

I have known O'Hara since 1950. I've read almost all of his work. He wrote a poem about my *George Washington* called "On First Seeing Larry Rivers' Washington Crossing the Delaware at the Museum of Modern Art." His long marvelous poem "2nd Avenue," 1953, was written in my plaster garden studio overlooking that avenue. One night late I was working on a piece of sculpture of him. Between poses he was finishing his long poem. Three fat cops saw the light and made their way up to make the "you call this art and what are you two doing here" scene that every N.Y. artist must have experienced. Every night when we met in the Cedar Bar with Kenneth Koch and John Ashbery and other notables he "just happened to have" his latest poem on him. He helped me stretch canvases and was the subject matter of every fifth thing I did. There is no doubt in my mind if the idiots and garbage collectors who shovel up ideas for Hollywood and T.V. run out of material, even further than now,

Hans Namuth: *Larry Rivers and Frank O'Hara* at work on
Stones, 1958.

our lives could easily be made into a cornball modern Vie de
Bohème. Instead of calling it Moulin Rouge with a dwarf and a
few whores it could be called "The Cedar Bar" with fags, dope
addicts, and an endless and exhausting amount of "names."
I think we saw each other constantly. If at those times who's
fucking who and how miserable someone is making someone
else took up a good deal of time so did "What did you paint
or write or think today?" I just reread a few paragraphs. Maybe
all this sounds like Molly Berg reminiscing about her Yiddishe
Mama with a Greenwich Village variation on the theme. It must
be excused or rather I insist it be accepted as part of this ex-
perience I'm trying to describe. This Siberian lady didn't just
find some painter and some poet who would work together.
She asked two men who really knew each other's work and life
backwards which means to include all the absurdity and civi-
lization a lively mind sees in friendship and art. Since it wasn't

what we did separately and alone it would have to be a peculiar extension of our social life which by 1957 had undergone quite a few changes. And how were two super-serious, monstrously developed egos to find in this situation a way of allowing a complete and undiluted exposition of their two talents. Obviously the feelings for being involved in this were much more developed in us than some concrete ideas necessary to carry this Trans-Siberian, Paris, New York project through. The height of romance? Corny identification with historical figures? So what. I always thought that the reasons for doing something in art were a boring concern and of no use except perhaps as shit for your enemies to throw at you. It rarely determines quality. It could make you feel like a good person or part of a "right-thinking" group but the worst reasons for doing something could produce the best thing. Don't make it easy for yourself.

Frank O'Hara wasn't going to write a poem that I would set a groovy little image to. Nor were we going to assume the world was waiting for his poetry and my drawing which is what the past "collaborations" now seem to have been. Our self image, mind you, was no less grandiose than those old Parisians but it was another time and we had our own balls to take care of.

The lithograph stone surface is very smooth. The marks going on it can be made with a rather difficult to handle, almost rubbery crayon or with a dark liquid called Touche. I had never seen any of the necessary equipment before this and if I wasn't thinking about a Picasso or Matisse print I thought printmaking the dull occupation of pipe-smoking corduroy deep-type artisans. Whatever you do comes out opposite to the way you put it down. In order for the writing to be read it must be done backwards. It is almost impossible to erase, one of my more important crutches. Technically it was really a cumbersome task. One needed the patience of another age, but our ignorance and enthusiasm allowed us to jump into it without thinking about the details and difficulties. Each time we got together we decided to choose some very definite subject and since there was nothing we had more access to than ourselves the first stone was going to be called "us." Oh yes, the title always came first. It was the only way we could get started. U and S were written on the top center of the stone backwards. I don't know if he wrote it. I remember decorating the letters

to resemble some kind of flag and made it seem like the letters for our country. Then I put something down to do with his broken nose and bumpy forehead and stopped. From a round hand-mirror I eked out a few scratches to represent my face. The combination of the decorated U and S, his face and mine, made Frank write ". . . they call us the farters of our country . . ." I did something, whatever I could, which related in some way to the title of the stone and he either commented on what I had done or took it somewhere else in any way he felt like. If something in the drawing embarrassed him he could alter the quality by the quality of his words or vice versa. Sometimes I would designate an area that I was sure I was going to leave empty. He might write there or if I did put something down I would direct him to write whatever he wished but ask that it start at a specific place and end up a square or rectangular thin or fat shape of words over or around my image. With these images vague or not vague and his words we were at once re-marking about some subject and decorating the surface of the stone. There was a photo of Rimbaud and his depressed friend Verlaine in the studio. I began to make a drawing looking at it. We then remembered a ballet night at the City Center. During an intermission we were making our way down the wide stair-case from the cheap seats to the mezzanine when our mutual friend and my dealer John Myers thinking he was being funny screamed out for general use "there they are all covered with blood and semen." This is a reference to something said about Rimbaud and Verlaine that Verlaine's wife hounded him with for his whole life. After recalling this Frank decided to use it and in a delicate two-line series he began writing. By this time we were using a mirror as he wrote which told us whether the writing that was going down backwards would be correct when it was printed. His first two lines had to do the poetry of Rim-baud and Verlaine. He brought the lines up to my drawing and stopped. I liked the drawing so far and didn't want it altered or whatever his words might do. He then went on about the staircase and something about the ballet. I waited till he was through and in the spaces left (I directed the space between the lines and the general distribution) I tried a staircase . . . no good. Here I found out how hard it was to get rid of any-thing—in order to erase you must scrape with a razor. Finally I began making bullets that were also penises with legs, Simple

Simon's response to what Frank had written about the corps de ballet. If there is "art" somewhere in this lithograph its presence remains a mystery. We thought we'd try harder on the next one. Sometimes a month or more would pass before my calendar of events and his fused into a free afternoon or evening.

We were fully aware by now that Frank with his limited means was almost as important as myself in the overall *visual* force of the print. If the small history at the beginning of this piece seemed not especially pertinent maybe now you can guess why I brought it up. Frank without realizing it was being called upon to think about things outside of poetry. Besides what they seemed to mean he was using his words as a visual element. The size of his letters, the density of the color brought on by how hard or softly he pressed on the crayon, where it went on the stone (which many times was left up to him) were not things that remained separated from my scratches and smudges. Frank by this time had been around my painting and N.Y. painting for quite a while and was an assistant curator at the Museum of Modern Art. The general conception of flat space in painting was already as much a part of him as it was of me. If a self-conscious display of growing grass can be presented as an experience and shown in an art gallery and we seriously consider a composer's score as a visual phenomenon, it is apparent that a poet will begin to see his writing in a little wider scope than the level of his semantic struggle. Especially if he is writing in the presence of another spirit and especially if his words get beyond the scale of typewriter letters.

One stone was dedicated to Music. This one is a little more old-fashioned: our unintegrated style. Frank decided he wanted to write something first and see how I would respond. He wrote it on paper and when it got to the stone its shape changed. He had to arrange it all somewhere in the bottom third of the stone. I read it through. "You are someone who is crazy about a violinist in the New York Philharmonic Orchestra" struck me as being very funny. It was hard to see exactly how I might use it to take care of my two-thirds. The rest of the writing was tender and in the realm of feeling. A good poem but for the kind of mind I have, useless. I kept reading the first part over and over and finally the title and violin made me decide to do my own version of Batman. Violinman.

That was the music stone. MUSIC? ? ? More balls than music,

Polonius. I think our point of view can be summed up as "Anything is possible if we turn to it" or "You name it we do it." What else do we have? Any of us? Being thought "modern." That begins to feel like a good boy. Or the other great placater of our time "I don't know if it is any good but I did it first." How weak to create out of that simple and socially acceptable idea.

The hope beneath this venture of tough togetherness seems to be the same as in opera or ballet. That is, the assault on the senses, in this case, coming from two directions, pictorial and poetic, will be twice as strong and moving. "YA got da woids an da pichers." It took two years to make twelve of these stones. There were changes in our work outside of this, in our lives (whew), in our faces (Oy) and these changes are reflected in the differences between the first and last stones. It wasn't a struggle. That crap has to come to an end. If there was difficulty it was in finding a way to think about it. I spoke here a lot about Frank's response to the physical necessity of arranging his words in relation to my image. How did I respond to the meaning of his words? I think the charged breath of making something on my neck kept me from reacting other than "What can I use in his words to begin." I hardly saw it as a poem. They weren't poems. After a stone was finished I read his words in a more normal way. They delighted me or made me think or made me think of Frank. I had no idea of emotional content. I never entertained the idea of matching the "mood" of his words. It was always some specific object I could think about doing. We decided to do a LOVE stone.

I distributed male and female over the surface with a few genitalia for the sex of it. He wrote in between and on the drawing and never even mentioned man or woman or bodies or sex. How do you put that in your pipe and smoke it? Here's how. You say it is like the relationship between people who live under the same roof. There are moments where every feeling or action grows out of a direct response to what is said, to what is being done or who's got a hand somewhere. And then there are hours and days of solo. Everything is happening in the same space under similar conditions but the movements are barely responding to anything except what has been with you from birth and is turned in without fanfare at death. And how should art change that. Better yet. Why?

Larry Rivers and Frank O'Hara: *Stones: Love*, 1958.
Lithograph, 18 × 24 in.

My life with Kenneth Koch was not among the stones. We worked on the same surface but the surface was either paper or canvas. Where "Stones" with Frank O'Hara was visually limited in range, being closer to drawing, my things with Kenneth Koch were closer to "straight" painting with his words in charcoal supplying an additional graphic element to my own. With another force involved like color, the physical dimensionality of impasto in which words could be buried and come out, the familiar conditions of the surface, plus the Kenneth Koch personality and atmosphere, another "look" would necessarily emerge. And it did. He was very conscious of the part he played as an artist. If he had difficulty deciding things it was more to do with *where* and *how* he should write than with *what* he should write. Nothing surprised me. It seems as if I've known Kenneth Koch ever since I came down from the hills of the Bronx. He too was a devoted member of the *Painting Poetry Ideas and Sex Party* that met nightly at the Cedar Bar in the late forties and early

fifties. It doesn't embarrass me but perhaps at this point in the
piece it is too boring to go into our publicly allowable history.
For this purpose it is enough to say I admire his work very
much and find what is peculiar in him difficult and marvelous.
In 1957 I directed his poetry and jazz series at the Five Spot.
He knew my work when I wanted no more than Bonnard. As
for this situation no one commissioned us to work together.
Perhaps he wanted to see what it would look like. Curiosity?
Love? Competition? As I said before, a meaningless concern.

Kenneth has a response to words that I find odd and unique.
It is very strong for it remains clear to you what his interest is.
He hears Dick Tracy separated from *Dick Tracy*. He finds it for
you as you can no longer see it. It sounds different. And when
it appeared in my red blushes in pencil it seemed to bring to the
area an unexpected circus. I would begin with a nice fat color
and as I went back to clean the brushes he put something on
the surface. I rarely witnessed directly his putting the words
down. If he couldn't immediately think of something I would
go somewhere else in the studio and smoke or think etc. I
hardly knew what he was driving at but usually enjoyed it.

If the conceit beneath the "Stones" with Frank O'Hara was
"Anything is possible if we turn to it" or "You name it we do
it" with "Post Cards" and "New York 1950–60" with Ken-
neth it was "If we do it, anything is possible, and its name is
marvelous." In the traditional sense our artistic personalities
were not always comfortably compatible. The sentimentality
surrounding an object or a fact or a situation can be a point
at which I might feel ready to begin something using it in my
own way. He is quite a McCarthy. Instead of communists he
finds sentimentality everywhere and it governs to a great degree
his choice of ideas, words, organization and so forth. It is his
strength and leads him to little-nibbled pastures. From the in-
side looking out our "N.Y. 1950–60" seems like a busy field on
which there are, according to where you look, combinations
of mutual self-absorption, his open-ness to my color, my off
the cuff responses to his sudden rain of words, ideas of space,
uncritical and disgusting delight in our past, and if it is good, a
constant reminder that everything, everything, even the nausea
associated with being dumped by someone, is of some use. It
was like a colorfully decorated gossip column where the content

is so obscure you are forced to look for something else to distract yourself. What it was for us was chunks of the canvas devoted to mutually experienced parties, neighborhoods, resorts, houses, studios, people and restaurants. The purple that had Frank O'Hara's profile in it became a five cent postage stamp with a Kochian remark nearby. And so forth and so on until the canvas is covered and each of us becomes worried about his end of the affair . . . And so we say goodbye to the natives standing on the shore knowing we won't be remembered for what we tried but what we did.

1963

JAMES SCHUYLER

"A few days are all we have," James Schuyler (1923–1991) announced in the opening of one of his greatest poems. "So count them as they pass." Schuyler was a master of the quicksilver mood, unrivalled when it came to capturing the shifting qualities of light, weather, sights, seasons, and love affairs. Along with Frank O'Hara, John Ashbery, and Kenneth Koch, he was part of a loose-knit fraternity, hard to define, that came to be known as the New York School poets, suggesting a literary counterpoint to the New York School painters. Schuyler and Ashbery collaborated on a comic novel about life in suburbia, *A Nest of Ninnies* (1969), highly praised by W. H. Auden. Among the painters, Schuyler was especially close to Fairfield Porter, whose representational canvases, with their at-an-angle impressions of the natural world, suggest a kindred sensibility—an idiosyncratic lyricism. Schuyler, who was in and out of psychiatric hospitals, lived for some years with Porter and his wife, Anne, also a poet. Schuyler's gift for the telling image is shown to advantage in his criticism for *Art News*, where in the 1950s he wrote some of the short reviews the magazine published to accompany nearly every one-person show in the city.

Statement on Poetics

NEW YORK poets, except I suppose the color-blind, are affected most by the floods of paint in whose crashing surf we all scramble.

Artists of any genre are of course drawn to the dominant art movement in the place where they live; in New York it is painting. Not to get mixed up in it would be a kind of blinders-on repression, like the campus dry-heads who wishfully descend tum-ti-tumming from Yeats out of Graves with a big kiss for Mother England (subject of a famous Böcklin painting: just when did the last major English poet die? not that Rossetti isn't fun . . .). The big thing happening at home is a nuisance, a publicity plot, a cabal; and please don't track the carpet. They don't even excoriate American painting; they pretend it isn't there.

Considering the painters' popular "I kissed thee ere I killed thee" attitude toward Paris, admiring, envious and spurning, and the fact (Willa Cather pointed it out a long time ago) that the best American writing is French rather than English oriented, it's not surprising that New York poets play their own

variations on how Apollinaire, Reverdy, Jacob, Eluard, Breton took to the School of Paris. Americans are, really, mightily un-French, and so criticism gets into it: John Ashbery, Barbara Guest, Frank O'Hara, myself, have been or are among the poets regularly on the staff of *ARTnews*. In New York the art world is a painter's world; writers and musicians are in the boat, but they don't steer.

Harold Rosenberg's Action Painting article is as much a statement for what is best about a lot of New York poetry as it is for New York painting. "It's not that, It's not that, It's not that . . ." Poets face the same challenge, and painting shows the way, or possible ways. "Writing like painting" has nothing to do with it. For instance, a long poem like Frank O'Hara's *Second Avenue*: it's probably true to deduce that he'd read the *Cantos* and Whitman (he had); also Breton, and looked at de Koonings and Duchamp's great Dada installation at the Janis Gallery. Or to put it another way: Rrose Selavy speaking out in Robert Motherwell's great Dada document anthology has more to do with poetry written by the poets I know than the Empress of Tapioca, The White Goddess: The Tondalayo of the Doubleday Bookshops.

Kenneth Koch writes about Jane Freilicher and her paintings. Barbara Guest is a *collagiste* and exhibits; Frank O'Hara decided to be an artist when he saw Assyrian sculpture in Boston. John Ashbery sometimes tried to emulate Léger; and so on. Of course the father of poetry is poetry, and everybody goes to concerts when there are any: but if you try to derive a strictly literary ancestry for New York poetry, the main connection gets missed.

1959

The Painting of Jane Freilicher

SOME of the best painting in New York is done by painters who are unaffiliated, either by themselves or by critics and reviewers, with any school. Figurative is a better word for what they have in common than realist, though neither is satisfactory. Most, like Fairfield Porter, Alex Katz, Jane Wilson, John Button, Robert Dash and Paul Georges, have a wide range of

subjects: figure, interior, landscape. Others, like Philip Pearl-
stein, concern themselves only with the figure. There are also
those who work on a small, rather intimate scale: Elias Gold-
berg, Lawrence Campbell, Ina Garsoian. And there is the rather
chilling Andrew Wyeth and the glazed chintzes of John Koch;
but then, fool-the-eye has found its public since antiquity, nor
is much of Op and Pop lacking in its particular appeal. Among
the best of these, the most personal and most persuasive colorist
is Jane Freilicher.

If one were to look for antecedents of her paintings, two
would be Rubens and Bonnard. In her first show (Spring 1952,
at the Tibor de Nagy Gallery, where she still exhibits), a *Leda
and the Swan* and a then vast-seeming *Football Game* had a
Rubens looseness, as though the energy of action in the latter
and of repose in the former, caused the forms to fly apart a little,
making the lines and strokes that defined them also include the
air disturbed by gesture, as Rubens often did in his sketches.

The Bonnard connection is more elusive; she has never bor-
rowed his "little touch" (as a lot of New York painters did in the
'50s, usually getting the effect of a sweater knit by loving hands
at home) nor his affectionately smudged contiguity of shapes
across the canvas. Nevertheless, it is an affectionate alertness
that her work shares with his: that alertness to the witty subjects
constantly presented to the eye, along with the means and will
to make something out of them. And like him, she has always
celebrated the Impressionists' legacy, to see fully all the color
there is to be seen. Some painters' eyes are more sensitive than
others, they see more color, just as a dog detects more subtle
and distant scents.

Another painting in Jane Freilicher's first show was of a
clump of palm trees. A few weeks earlier this had been an ape
sitting under some banana leaves. It was done from a postcard
(as a number of her pictures have been over the years) of a very
real-looking beast. But in the casual imaginativeness of painting,
it became what it was like, rather than what it was. The solipsism
was the painting's, not the painter's.

For a few years after that show, her studio was a small fifth-
floor apartment whose views and interior she began to paint.
The windows were framed in clumsy neo-classic tenement
woodwork and the view to the northeast, beyond patchy brick

apartment houses, took in huge gasometers and the towering, belching smokestacks of a power station near the East River. This view she painted several times, usually in the violet light of early evening.

In addressing herself to the actual, her paintings in part became much tighter: within one of these views some objects seemed more sharply seen than others: a length of window frame caught the eye, as though slightly magnified. This inconsistency within the picture creates exactly New York as it is: out of the visually deafening plethora the eye is forced to abstract detail in varying sequences. Another kind of inconsistency was the differing perspectives within an interior. Floor boards might be more of a rising wedge than a recession, while a chunky chest parallel to them turned its front flatly at right angles to the canvas. This delicate adjustment of perspective was not derived—as has been suggested—from Cézanne; it was arrived at by accepting and putting down the small shifts the eyes make in moving the gaze from object to object to undiscriminated distance.

This inconsistency, begun within individual paintings, soon created paintings apparently not consistent one to the other. The courage to experiment had the effect of making a good part of the gallery-going public wary. A Jane Freilicher show signally lacked that authoritarian look, public-spirited and public-addressed, stamped on so much postwar work like a purple "OK to Eat" on a rump of beef. The big, cold, dramatic gesture may be welcome, but can't tell us much about the distinctions and nuances that most delight and sharpen apprehension.

The reward of not painting shows was learning to paint her own solutions.

The most time-consuming pictures of this period were a series of portraits. Going after both the voluptuousness of flesh and anatomical fact, her native and extreme spontaneity was driven into detail. The way the rattan of a chair was painted was what most caught the attention; or the fall of a piece of cloth seemed more at ease than the sitter. Is that bad? I doubt it: most sitters do seem rather stunned at finding themselves there.

But it seems only natural that subjects which, so to speak, flowed more easily off her brush should at the same time have attracted her. Among them were some superb paintings of flowers, such as a small runny one that got the rich mashed look of

bunched violets, and the way their darkness ignites whatever is around them. (She has always an uninsistent respect for the character of what she paints; not its thing-ness, but its own alive-ness.)

And she continued to paint invented and found subjects—a group of figures based on her own reflection, or a chunk lopped off Mexico, or an aspect of Torcello, from a postcard, that embeds it in the everyday rather than the monumental past.

In the '50s she and her husband began to spend their summers on the South Fork of Long Island, near the village of Water Mill and nearer still to the ocean: a flat landscape bound off by dunes, under a high and often blazing sky.

This landscape moved her, in the first years, to a kind of painting that developed away from the thing seen. *From a Volkswagen* spread around the pendent shape of a Volkswagen window a disarray of big, open brushing of agglomerated color, like the nearby fields where goldenrod and wild mallows mix in the sharp grass. Or, in others, what form the picture had was in the placing of a thick line, painted at a stroke, as though the horizon could be picked up like a stick and placed where she wished: high, low, or sometimes running from top to bottom (*The Green Stripe*).

Further acquaintance bred greater reserve, as though the effort was to deliver as much extent of land and sky as thinly and brilliantly as possible. These pictures were almost altogether abstract: there were landscape references, but often only in the kinetic twist of, say, the place where a road hits a distant tilted field that lifts up to bulky clouds of greater substance than what lies under them. These abstract paintings, whose "nature references" partook not at all of the blurry disguises of so-called Abstract-Impressionism, seemed almost empty. They left a visual after-taste of high thin color, the palest yellow and a lot of white; and the sense of a big space vivified with the least and most effective means.

The landscapes painted subsequently have followed on the abstractions as naturally as a change of focus.

Her color now is built up from white: "There did seem to be a change," she says, "when I really got started painting landscapes. I think I began thinking of color as, 'How much light does a picture hold?' Alex Katz and Fairfield Porter think this

way, and it can make a picture very luminous. A lot of painters seem to think of it as a matter of weight. This works okay, I guess, but I'm more interested in light."

Succulence and bigness are qualities of her latest work. A still life is set up as far from the easel as it can get. But instead of reducing it to a point of emphasis in the interior the eye comprehends, it is brought up close, right on top of the canvas, right on top of you. This not only eliminates niggling, but gives the color of the flowers—hot and cold peonies, flushed mallows—its breadth, so they appear as prismatic hunks within the light-returning, arbitrary prism of the painting.

The scale of objects goes unadjusted (mediocrity in painting is often merely an inability to leave things as they are). If a bowl is too big, that is how big it is; if stems are floppy, then let them slump. It is as they are that they caught her attention, so why fiddle?

The duality in her work, the imagined and the real, has turned out a mutual enhancement. A landscape is translated to canvas with the ease of the imagined, an invention has the casual presence of reality. In a large nude, seated, seen from the back, the buttocks are not squashed and spread to give an impression of sitting-downness; rather, we are given the curving fullness, verisimilitude sacrificed to a more convincing truth. The gain is great.

In her latest paintings, a still life is often combined with an interior and a landscape, a wide view seen through a glass wall divided by studs into panels. What might seem a progression of planes is dealt with only as color: a stud is related by its brightness to what is next to it, field or flowers. In a black-and-white photograph a bowl of flowers may seem a silhouetted mass, but in fact it is not. Only the light-absorbency of deep reds and orange is described, and the same with a burnt-over potato field in August: a great distance is brought up to the surface of the picture so that a play of light moves over it at different speeds, flashing, sauntering and standing still. Detail is minimal, nor is the brushwork onomatopoeic. An arabesque of paint is a stroke securely attached to a thin scrubbing it abuts on. Illusion is replaced by paint, and everything seems bigger, more itself. Seductiveness is not an aim.

While abstract painting has, in large part, gone toward a

calculated placement, the best figurative painters have availed themselves of the unexpectedness of nature, where the right place for a thing is where you find it. In Jane Freilicher's pictures the emotional force of an object is allowed its compositional weight. There may be more to a bowl of cosmos than there is to a wide and rather empty view, although the emptiness can be subject and constructing force. Structure is an improvisation, composed as painted, not a skeleton to be fleshed out. The result is freshness, like that of ocean air and constantly changing light.

"Usually," she says, "I tip the horizon up, which makes the picture more two-dimensional." And, "I don't think I 'frame' a picture in the old-fashioned way. Usually it's a color or something in the landscape—an expansiveness—that gets me started. Of course a landscape goes on forever but a picture doesn't. So very soon it has a composition or a form of its own."

And, "I'm interested in landscape, but there's a paradox: it's depressing to get that realistic look, 'Why, that's just the way it looks!' or, 'I know that time of day.' At the same time I don't want really to lose the place. It's like the difference between Andrew Wyeth and Bonnard."

1966

Short Reviews from Art News

HELEN FRANKENTHALER

Helen Frankenthaler (Tibor de Nagy Gallery) has her fifth show in New York. To sum up at the beginning: it is in work of this quality that the continuity of free abstract painting, the kind particularly associated with Jackson Pollock, is found: working directly with the medium, not from motifs or sketches; the variety of handling; getting what is inside outside, where it can be evaluated, worked on further or left alone: the liberation and control of having painted and being a painter; the fact of being one among many with something special to paint about that others have seen and experienced (Helen Frankenthaler does not paint in Pollock's shadow; that would be a real misapprehension). There are three big paintings: the horizontal *Blue*

Atmosphere (13 feet by 3 feet, 10 inches) dense but aerated, in which a winged shape, like a bat or a big moth, is flying; on the left, there may be a wall of color. The saturated *Giralda*, with the calligraphic Moorish heart shape breaking through itself in a black variation within which there are white scrubbings. The *Lorelei*, with a chunk of sky, the river flowing right into the dam-like (Switzerland?) slanting, somewhat vacant panel on the right. Among the pictures closer to easel size: *Solstice*, in which a grey disc with a red eye flowers out of the white and earth colors that marvelously have not changed to muddiness. *Cosmopolitan*, tacky, strong, reminded this writer of a chance encounter with the painter one hot clear Sunday on Torcello: perhaps some of the pink crackling in the blueness is a memory of Venice? *Planetarium*, holding a starry globe (in color, the way stars really are), on the right, an interstellar panel into which the paint drifts like wind. The open, thoroughly achieved *Venus with a Mirror*: human or animal shapes, an image, a reflection, a mirror. And there's more.

1957

Helen Frankenthaler (Andre Emmerich Gallery) followed her recent retro-spective at the Jewish Museum with a show that, without violating her achieved style, made a remarkable shift in the character of her work. Subtlety, even on a big scale, matters. She is a painter who has always relied on her awareness of her unconscious, finding in its immediacy a relevance as subject matter, a taking-off point which, usually, was not the "subject" of the picture. An abstract painting may contain plainly sexual symbols; but that scarcely constitutes their plastic worth: any scribbled-on Ohrbach's ad in the subway would be hustled into a museum, or at least a gallery, if that were so. Part of Miss Frankenthaler's special courage was in going against the think-tough and paint-tough grain of New York School abstract painting. Often pale (not weak), soaked in (only sometimes), quickly dwelt upon—she not only chanced beauty in the simplest and most forthright way, like a river reflecting clouds and evening, but she has relied upon a sensibility altogether feminine. This year she put to vivid use opaque light color on a smooth white ground: blues, splatters, black for narrative, and the secured

slipping of the pigment implying and provoking a sense of a new certainty. In a richly enjoyable show, the play between complex and simple, brushed and smooth, tattered and drawn, of *Figure with Thoughts*, free with an intricate precision of balance, makes this her finest canvas to date.

1960

ALFRED LESLIE

Alfred Leslie (Tibor de Nagy Gallery) crowns his show with a canvas (or rather, four assembled in one) 12 feet by 10. With bars and splatters, it is like a novel whose persons are seasons and places: at the lower right there is blue for swimming, there are snowstorms and industrial black, an intense night-blue, an impossible green. One sees the sources of Leslie's style— particularly de Kooning—but the particular drama is his own. His pictures remind one again of the kinship between advanced painting and the performing arts: like a pianist who distorts the line without losing it, whose *rubato* is his signature. Leslie's energy exhilarates. In color, he has gone more toward subtle unpleasantness, meatier (so to speak) to the eye. The strokes that bend and pull the paint alternate between broad and fibrous. Leslie has elegance and fierceness: working together and apart, they leave an impression of a train-de-luxe tearing through the mountains at night, a mysterious maroon flash.

1957

————————

The first time I saw Alfred Leslie's work was at the de Nagy Gallery, when it was on 53rd Street just east of Third Avenue. It was his first one-man show, with the saggy bedsheet picture, and the glopped-together newspaper collages. There was one tar-and-newsprint collage that slung along to you, right there, without any editorializing, so much of the excitement of the moment of its improvising that I was startled quite a bit to be shown, in the back room, an academically successful and sensitive self-portrait, painted in his teens. He began, it seemed, and still seems, ahead of the game.

So much for history.

Trying to write about *Castro!!*, I kept going back to the notes

taken down at Leslie's studio. They got closer to a sense of the picture than my afterthoughts: you can't always count on *l'esprit d'escalier* (English translation: "biting the pillow").

Notes:

Leslie began painting on sectionalized canvases (i.e. four stretched canvases make one painting) for easier maneuverability (from Long Island summer studio to city to gallery, etc.). Physical maneuverability of no importance (*Castro!!*).

In the middle of making a film and of a recurrent illness, he found a sudden spontaneity, and most important, *assurance*. The picture may turn out wrong: "But I can always destroy it."

"Where the edges meet is almost like a dissolve."

Note varieties of speed.

Note off-placement of the "cuts" (joinings of quarterings).

Splatters are—actually—fragments; or like quartz fractures.

A completely fresh painting over a painting, enough of what was there showing through to create, not mere drama, a sense of genesis, the way a remark or manner may give a clue to what a family or a town was like; though that is all you will ever know.

Big area at right: dramatic deep red that folds emphatically on itself like cloth (cadmium red medium).

Guiding along upper edge of red "into" picture: black with white splatters painted over.

Right, bottom: relatively unpainted white, without splashes and runnels.

Upper left below green (permanent green light) white brushed so the layer below shows through.

White vertical at left: white over black over red.

End of Notes

Here is a speech from *The Chekhov Cha-Cha*, a play by Alfred Leslie. It comes near the end. The speaker is a painter. He has exhausted himself painting, exhausted, that is, himself and his money. The setting is an automobile and a girl is driving:

Listen . . . among the things I hate is ideas as programs; that's what's happening today . . . cute-ism . . . do you know what that is . . . "Everybody is marketing but no one is plowing" . . . you can pass it off in private—you can bury it under analogy; (I hate

analogies . . .) You want the pitch . . . At least part of it, kid . . .
Number one there are no facts and no observations. There are
tons of critical appeals at either end and in the middle. Do you
know who believes in the glamorous critical appeal . . . idiots
at the least . . . Is Catullus a thinker or a poet. Isn't everything
obvious after it's pointed out? Except a work of art. You have to
pursue that . . . that's worth pursuing . . . except if you have to
chase it . . . you'll never get it. (He stops, is embarrassed to have
shouted and above all to have gotten angry over an idea . . .)

Alfred Leslie's paintings are as serious as they look. A repro-
duction of one of them, writing about one of them, is only an
introduction to the real thing.

1959

ILYA BOLOTOWSKY

Ilya Bolotowsky (Grace Borgenicht Gallery), rectilinear abstrac-
tionist, shows after a season's absence. In the hanging gardens
of pure painting, Bolotowsky's gift seems to flourish somewhere

Ilya Bolotowsky: *White Circle*, 1958. Oil on canvas,
60¾ in.

between Diller and Reinhardt, less august than the latter, more aerial than the former. In some of the new pictures, a frosty white overlay almost blocks out bright cubes. This new use of silkily-stroked white, freezing and altering the suggestiveness of lines and squares is most dramatic in the gauzy path that drops down the center of *White Linear*. The linear elements that emerge in it, vestiges of rectangle edges are sharp and clear as twigs against the sky. The others, like *Red, Violet, Blue*, the blocks and stripes move in squads, flat yet with a city solidarity, like that of buildings massing along Central Park in a deep mauve evening. Bolotowsky also brings a playfulness to his large-scale work: *Yellow Rectangle* balances a narrow rod of deep yellow against the shapes like pale vitreous tiles, as though it were the clue and handle to a kitchen in a De Stijl heaven.

1958

Ilya Bolotowsky (Grace Borgenicht Gallery) even further complicated his rectilinear purities. One device was to set off a big area—white or red—against a traffic of smaller ones. The effect was like a skyscraper rising out of a congestion of cabs. Bolotowsky's good humor and wit were present as ever, fitting squares into circles, setting silky whites against one another or sliding greys about like shuffled cards.

1961

CY TWOMBLY

Cy Twombly (Stable Gallery), fleeing for his creative life from the white hell of Black Mountain, shows Siberian slabs (those diamonds they've found there, what makes them so sure they're not just frozen tears?). Fabulously under-priced.

JOHN CAGE

John Cage (Stable Gallery) exhibits scores in autograph of his own compositions as works of visual art. And they are. Painting in this century has taken cognizance of the act and look of writing as an expressive end (Tobey is a painter Cage had

admired and collected)—just as the graphologist is the high-brow astrologer of today. In the conventionally-notated *Haikus* of 1952, Cage's plastic instinct, and gift, is plain: the exquisite touch of the pen, the scale of the bar to the page, the placing of the bar at the bottom, leaving a relative vast white emptiness for the music to fill. The words printed out large-scale in *Water Music* are definitely reminiscent, in their orthography, of Satie (celebrated by Cage in the latest *Art News Annual*). The major work, a new *Concerto for Piano and Orchestra* (its premiere will be in New York on May 15), includes each page as a different conception in composing and notation. Some look Euclidean, others mysterious (how are the outlines of two grand pianos to be played?), some have areas like contour maps. All recall in their spareness Stendhal's ideal of prose, a sinewy and direct simplicity, whose use is its expressivity and thereby creates a new esthetic and a new beauty.

1958

CALVIN TOMKINS

Calvin Tomkins (born 1925) began his chronicles of the art world for *The New Yorker* with this 1962 essay on Jean Tinguely's *Homage to New York,* designed to self-destruct in the garden of the Museum of Modern Art. Tomkins's cool, incisive, lightly ironic journalistic style was just right for the exploding art scene of the 1960s, which he presented to readers of *The New Yorker* through profiles of Marcel Duchamp, John Cage, Robert Rauschenberg, Jasper Johns, and Leo Castelli. Since then he has brought the same steadiness and aplomb to half a century's work, time and again zeroing in on the sweet spot where art and fashion meet. Tomkins is also the author of an admirably lucid and straightforward full-length biography of Duchamp.

FROM
Beyond the Machine

Doomsday, a Thursday, dawned grey and wet. The temperature, which had been below freezing for the three weeks that Tinguely had been at work on the machine, rose slightly, and a light snow that had been falling since the previous night turned into a cold rain, which kept up intermittently all day. Over on Fifth Avenue, the St. Patrick's Day parade bravely drummed and blared its way uptown. Hordes of high-school children in green cardboard hats passed the Fifty-fourth Street wall and stopped to look into the garden, where workmen were struggling to move Tinguely's creation from the dome to the central court. The workmen kept slipping and sliding in the wet slush, and there were accidents. The Addressograph machine was damaged. Tinguely became tense. In his black boots, open storm jacket, and two-day-old beard, he looked like a Cuban revolutionary, and for the first time his spirits seemed a trifle subdued.

Robert Rauschenberg, the New York neo-Dadaist painter, showed up early, bringing a device he had made called a "money thrower." (Tinguely had suggested to several New York artists that they contribute to the master machine, in a sort of Bauhaus effort, and Rauschenberg, whose "combine paintings" are in some ways even farther out than Tinguely's creations, had promised to add a mascot.) This took the form of two heavy

springs held in tension by a thin cord, with silver dollars inserted between the coils; when the cord was disintegrated by flash powder, the springs would fly up and scatter the silver dollars. Rauschenberg waited patiently for several hours to have his money thrower connected. "I felt privileged to be able to hand him a screwdriver," Rauschenberg says. "There were so many different aspects of life involved in that big piece. It was as real, as interesting, as complicated, as vulnerable, and as gay as life itself."

After a great deal of searching, Billy Klüver had managed to fill a request of Tinguely's for several bottles full of powerful chemical stinks. He arrived carrying these gingerly, and set them down near the partly assembled machine. Klüver also brought several containers of titanium tetrachloride, for making smoke, several previous methods having proved unsatisfactory. He asked Tinguely if it was all right to put the containers in the bassinet. Tinguely said it was. Time was running so short that decisions were being made on the spur of the moment.

Georgine Oeri, a New York art critic and teacher who had grown up in Tinguely's home town of Basel, came by to wish him luck. She found him patiently in slush that was nearly ankle-deep, under a fitful rain. Apartment dwellers on Fifty-fourth Street, across from the garden, were waiting at their windows. Some of the spectators in the garden were growing restless. David Sylvester, a British art critic, made a conspicuous departure, saying, "I don't like tuxedo Dada." Two noted Abstract Expressionist painters followed him, muttering angrily. Kenneth Tynan, the theatre critic, was asked by a reporter to make a statement. "I'd say it was the end of civilization as we know it," Tynan replied cheerfully.

The big orange meteorological balloon was inflated and raised to the top of its mast. It looked like the moon rising, and the crowd hushed expectantly. Half an hour more went by while Tinguely and Klüver dashed back and forth between the dome and the machine. At seven-twenty, nearly an hour after the event had been scheduled to begin, Klüver discovered that they had neglected to saw through one leg of the machine. He sawed it quickly. The creation phase was now completed. The machine stood twenty-three feet long and twenty-seven feet

high, its white, dripping structure cleanly outlined against the dark evergreens behind it, its eighty bicycle wheels poised for action. The destruction could now begin.

"At seven-thirty I was finished," Klüver wrote in his subsequent log of the event. "'*On va?*' '*On va,*' said Jean. He looked as calm as if he were about to take a bus. Not once did we go over and check everything. The end of the construction and the beginning of the destruction were indistinguishable." Klüver put in the plug, the machine gave a convulsive shudder, rattled, and immediately broke down. The belt driving the piano mechanism had slipped off its wheel as soon as the motor started up. Klüver tried frantically to fix it, his fingers numb with cold. "*Laisse-moi faire*, Billy!" Tinguely called out. A blown fuse was replaced. The piano started to play again, but other belts had jumped off and only three notes were working.

The big meta-matic clanked into operation. Instead of rolling down past the paintbrushes, though, the paper rolled itself

David Gahr: Jean Tinguely's *Homage to New York* in the garden of the Museum of Modern Art, March 17, 1960.

up the wrong way and flapped derisively atop the machine; Tinguely had accidentally reversed the belt when he was attaching it to the painting arm. When he saw what had happened, he grabbed Klüver's arm and pointed, doubling up with laughter. From that moment on, it was clear that the machine would proceed about its destruction in its own way, but the audience, unaware that Tinguely's machines hardly ever work as they are supposed to, gave a collective groan.

What happened next was pure, vintage Tinguely. Thick, yellow, strong-smelling smoke billowed from the baby's bassinet, where Klüver had put the titanium tetrachloride, and was caught by the blast from the powerful fan that had been supposed to blow the meta-matic painting toward the audience. Having waited an hour and a half to see the show, the spectators now found themselves enveloped in a choking cloud that completely obscured their view of the machine. They could hear it, though. Most of the percussion elements were working splendidly, and the din was tremendous.

When the smoke finally cleared, the machine could be seen shaking and quivering in all its members. Smoke and flames began to emerge from inside the piano, which continued to sound its melancholy three-note dirge; a can of gasoline had been set to overturn onto a burning candle there. The radio turned itself on, but nobody could hear it. Rauschenberg's money-thrower went off with a brilliant flash. An arm began to beat in sepulchral rhythm on the washing-machine drum. At this point, the bottles of strong-smelling liquids were supposed to slide down from their rack and break, but the strings holding them failed to snap. The meteorological balloon refused to burst—there was not enough compressed air in the bottle.

The second meta-matic worked perfectly, producing a long black painting that immediately wound itself up again. The two texts unrolled, but the horizontal one began to sag, instead of winding itself up. "Do you remember that little ring you picked up and asked about?" Tinguely shouted to Klüver. "It was to hold the paper roll-up!" The vertical text had finished unrolling, and its loose end hung teasingly over the burning piano. Tinguely was beside himself with wonder and delight. Each element of his machine was having its chance to be, as he said later, "a poem in itself." A photographer took his picture standing in

front of the machine, arms outspread, smiling, with the words "Ying Is Yang" on the horizontal text just above his head.

The piano was really blazing now. "There is something very odd about seeing a piano burn," George Staempfli has since said. "All your ideas about music are somehow involved." For the museum authorities, a good deal more than ideas about music was involved. They had not anticipated a fire, and were understandably sensitive on that subject in view of the museum's second-floor fire the year before, which had destroyed almost two hundred thousand dollars' worth of paintings. The concealed fire extinguisher was supposed to go off at the eighteenth minute, but the flames had spread through the whole piano and burned out a vital connection. Black smoke poured from the machine. With a limping, eccentric motion, the small suicide carriage broke away from the main machine, its flag waving. Then it stopped. Tinguely helped it along tenderly toward the pool, but its motor was too weak, and it never got there. The Addressograph machine started up, thrashing and clattering. It had been too badly damaged in transit, though, and it fell over after a minute or so, stone dead. Brilliant-yellow smoke flashes now began going off all over the machine.

Some twenty minutes after the start of the destruction, the resistors in the sawed-through supports began to melt the joints. The mechanism sagged but did not collapse entirely, because some crossbars at the bottom stubbornly refused to give way. The other small carriage suddenly shot out from under the piano, its Klaxon shrieking, the smoke and flames pouring from its rear end. It headed straight for the audience, caromed off a photographer's bag, and rammed into a ladder on which a correspondent for *Paris-Match* was standing; he courageously descended, turned it around, and sent it scuttling into the N.B.C. sound equipment. Tinguely suddenly began to worry for fear the fire extinguisher in the piano would explode from the heat, and he wanted firemen to put out the blaze. Klüver found a fireman in attendance, who seemed to be enjoying the show. He listened to Klüver's pleading and then, with apparent reluctance, signalled to two museum guards, who ran out with small extinguishers and applied them to the piano fire. The audience booed the men angrily, assuming that they were spoiling the show. A *Times* photographer who went inside

the museum a few minutes later overheard the fireman talking to headquarters on the telephone. "There are these machines, see," he was saying, "and one of them is on fire, but they tell me it's a work of art, see, and then this guy tells me *himself* to put it out, see, and the crowd yells 'No! No!'"

One of the guards ran into the museum and returned trundling a big extinguisher, with which he doused the piano and the surrounding machinery. He was furiously booed. The audience had seen everything go wrong, and now, it seemed, it was to be denied the machine's climactic act of self-destruction. More boos, interspersed with a few cheers, attended the final anticlimax as the fireman and the two guards attacked the sagging machine with axes, knocking down the piano, the big meta-matic, and the mast that held the balloon. At the end, though, there was a rousing cheer for the dying monster. The crowd descended on the debris for souvenirs, and managed to add to the general discomfort by breaking every one of the stink bottles. But if the audience felt frustrated, the museum authorities were in a state approaching shock; some of them were so angry about the fire that they refused to attend a reception held at George Staempfli's following the event. As Philip Johnson, a trustee, said later, "It was not a good joke."

Not everyone agreed with Johnson. The newspaper reviews were mixed, most of them treating it as a crazy stunt that failed to come off. There were so few downright hostile reactions that the *Nation* was moved to comment sourly, "This is what social protest has fallen to in our day—a garden party." The only critic (aside from Dore Ashton, in a later article) to write about "Homage" at any length was the *Times'* John Canaday. Although he called the show a "fiasco," he saw the machine as "an object of bizarre attraction, if not of classical beauty," and "a legitimate work of art as social expression, even if it pooped a bit." Returning to the subject in a Sunday column, he said that the machine was at least honest in its destructiveness, and that Tinguely himself "deserved a nod of recognition for an elaborate witticism on a subject of deadly seriousness, man's loss of faith."

That sort of interpretation was fine with Tinguely, and so were all the others. To him, the machine was anything that anyone said it was—social protest, joke, abomination, satire—but,

in addition, it was a machine that had rejected itself in order to become humor and poetry. It was the opposite of the skyscrapers, the opposite of the Pyramids, the opposite of the fixed, petrified work of art, and thus the best solution he had yet found to the problem of making something that would be as free, as ephemeral, and as vulnerable as life itself. It had evolved, after all, "in total anarchy and freedom," and he had been as surprised as any other spectator by this evolution. All the unforeseen accidents and failures delighted Tinguely. The fact that only three notes of the piano worked moved him deeply. As he said afterward, "It was very beautiful, I thought, and absolutely unplanned that one part of the piano should continue to play for almost fifteen minutes while the rest was being consumed by fire—those three notes still playing in the midst of the fire, calmly, sadly, monotonously, just those three. Many people told me afterward that for them it was a terrible thing. One woman told me later that she had wept, she found it so sad. It *was* sad, in many respects. It was also funny. I laughed a great deal while it was happening. I was the best spectator. I had never seen anything like that."

1962

MAY SWENSON

As much as it was a place to go to look at art, the Museum of Modern Art was always a place to see and be seen—good for a lunch date, a movie, a flirtation in the sculpture garden. Woody Allen, in his story "The Whore of Mensa," imagined a call girl service that included "a thin Jewish brunette [who] would pretend to pick you up at the Museum of Modern Art." And the poet May Swenson (1913–1989) wrote playfully about all the artistic experiences you could have at the Modern without looking at a single painting or sculpture.

At the Museum of Modern Art

At the Museum of Modern Art you can sit in the lobby
on the foam-rubber couch; you can rest and smoke,
and view whatever the revolving doors express.
You don't have to go into the galleries at all.

In this arena the exhibits are free and have all
the surprises of art—besides something extra:
sensory restlessness, the play of alternation,
expectation in an incessant spray

thrown from heads, hands, the tendons of ankles.
The shifts and strollings of feet
engender compositions on the shining tiles,
and glide together and pose gambits,

gestures of design, that scatter, rearrange,
trickle into lines, and turn clicking through a wicket
into rooms where caged colors blotch the walls.
You don't have to go to the movie downstairs

to sit on red plush in the snow and fog
of old-fashioned silence. You can see contemporary
Garbos and Chaplins go by right here.
And there's a mesmeric experimental film

constantly reflected on the flat side of the wide
steel-plate pillar opposite the crenellated window.
Non-objective taxis surging west, on Fifty-third,
liquefy in slippery yellows, dusky crimsons,

pearly mauves—an accelerated sunset, a roiled
surf, or cloud-curls undulating—their tubular ribbons
elongations of the coils of light itself
(engine of color) and motion (motor of form.)

1963

ALLAN KAPROW

Allan Kaprow (1927–2006) studied with Hans Hofmann and started out as a painter. But by the end of the 1950s he was certainly not alone in feeling that Abstract Expressionism had run its course. John Cage's lectures at the New School were an important influence, spurring a growing enthusiasm for the breakaway spirit of a resurgent Dadaism and Duchamp's cool but invigorating skepticism. By the early 1960s, Kaprow was influencing a loose-knit movement of like-minded artists, musicians, and theater people who presented their variegated actions and events under the general rubric of Fluxus; the key figures included La Monte Young, George Brecht, Dick Higgins, George Maciunas, Yoko Ono, and Nam June Paik. The Happenings that Kaprow began presenting were a mix of sight, sound, and action, combining elements of painting, assemblage, dance, and theater for unique events, with small audiences observing and sometimes participating in experiences that were reported to be by turns bewildering, bizarre, and sometimes just plain boring. Kaprow's 1966 anthology, *Assemblages, Environments & Happenings,* with a striking burlap binding designed by Kaprow himself, has long been recognized as an essential document of the period. It was in the 1958 essay included here, "The Legacy of Jackson Pollock," that Kaprow made his most striking contribution to the history of art in our time, arguing that the reaction against painting was precipitated by Pollock's gestural paintings.

The Legacy of Jackson Pollock

THE tragic news of Pollock's death two summers ago was profoundly depressing to many of us. We felt not only a sadness over the death of a great figure, but also a deep loss, as if something of ourselves had died too. We were a piece of him: he was, perhaps, the embodiment of our ambition for absolute liberation and a secretly cherished wish to overturn old tables of crockery and flat champagne. We saw in his example the possibility of an astounding freshness, a sort of ecstatic blindness.

But there was another, morbid, side to his meaningfulness. To "die at the top" for being his kind of modern artist was to many, I think, implicit in the work before he died. It was this bizarre implication that was so moving. We remembered van Gogh and Rimbaud. But now it was our time, and a man some of us

Fred McDarrah: Kaprow building a wall collage
from ripped canvas, September 10, 1959.

knew. This ultimate sacrificial aspect of being an artist, while not
a new idea, seemed in Pollock terribly modern, and in him the
statement and the ritual were so grand, so authoritative and all-
encompassing in their scale and daring that, whatever our pri-
vate convictions, we could not fail to be affected by their spirit.

It was probably this sacrificial side of Pollock that lay at the
root of our depression. Pollock's tragedy was more subtle than
his death: for he did not die at the top. We could not avoid
seeing that during the last five years of his life his strength had
weakened, and during the last three he had hardly worked at
all. Though everyone knew, in the light of reason, that the man
was very ill (his death was perhaps a respite from almost certain
future suffering) and that he did not die as Stravinsky's fertil-
ity maidens did, in the very moment of creation/annihilation
—still we could not escape the disturbing (metaphysical) itch
that connected his death in some direct way with art. And the

connection, rather than being climactic, was in a way, inglorious. If the end had to come, it came at the wrong time.

Was it not perfectly clear that modern art in general was slipping? Either it had become dull and repetitious as the "advanced" style, or large numbers of formerly committed contemporary painters were defecting to earlier forms. America was celebrating a "sanity in art" movement, and the flags were out. Thus, we reasoned, Pollock was the center in a great failure: the New Art. His heroic stand had been futile. Rather than releasing the freedom that it at first promised, it caused not only a loss of power and possible disillusionment for Pollock but also that the jig was up. And those of us still resistant to this truth would end the same way, hardly at the top. Such were our thoughts in August 1956.

But over two years have passed. What we felt then was genuine enough, but our tribute, if it was that at all, was a limited one. It was surely a manifestly human reaction on the part of those of us who were devoted to the most advanced artists around us and who felt the shock of being thrown out on our own. But it did not seem that Pollock had indeed accomplished something, both by his attitude and by his very real gifts, that went beyond even those values recognized and acknowledged by sensitive artists and critics. The act of painting, the new space, the personal mark that builds its own form and meaning, the endless tangle, the great scale, the new materials are by now clichés of college art departments. The innovations are accepted. They are becoming part of textbooks.

But some of the implications inherent in these new values are not as futile as we all began to believe; this kind of painting need not be called the tragic style. Not all the roads of this modern art lead to ideas of finality. I hazard the guess that Pollock may have vaguely sensed this but was unable, because of illness or for other reasons, to do anything about it.

He created some magnificent paintings. But he also destroyed painting. If we examine a few of the innovations mentioned above, it may be possible to see why this is so.

For instance, the act of painting. In the last seventy-five years the random play of the hand upon the canvas or paper has become increasingly important. Strokes, smears, lines, dots

became less and less attached to represented objects and existed more and more on their own, self-sufficiently. But from Impressionism up to, say, Gorky, the idea of an "order" to these markings was explicit enough. Even Dada, which purported to be free of such considerations as "composition," obeyed the Cubist esthetic. One colored shape balanced (or modified or stimulated) others, and these in turn were played off against (or with) the whole canvas, taking into account its size and shape—for the most part quite consciously. In short, part-to-whole or part-to-part relationships, no matter how strained, were a good 50 percent of the making of a picture (most of the time they were a lot more, maybe 90 percent). With Pollock, however, the so-called dance of dripping, slashing, squeezing, daubing, and whatever else went into a work placed an almost absolute value upon a diaristic gesture. He was encouraged in this by the Surrealist painters and poets, but next to his their work is consistently "artful," "arranged," and full of finesse—aspects of outer control and training. With the huge canvas placed upon the floor, thus making it difficult for the artist to see the whole or any extended section of "parts," Pollock could truthfully say that he was "in" his work. Here the direct application of an automatic approach to the act makes it clear that not only is this not the old craft of painting, but it is perhaps bordering on ritual itself, which happens to use paint as one of its materials. (The European Surrealists may have used automatism as an ingredient, but we can hardly say they really practiced it wholeheartedly. In fact, only the writers among them—and only in a few instances—enjoyed any success in this way. In retrospect, most of the Surrealist painters appear to have derived from a psychology book or from each other: the empty vistas, the basic naturalism, the sexual fantasies, the bleak surfaces so characteristic of this period have impressed most American artists as a collection of unconvincing clichés. Hardly automatic, at that. And, more than the others associated with the Surrealists, such real talents as Picasso, Klee, and Miró belong to the stricter discipline of Cubism; perhaps this is why their work appears to us, paradoxically, more free. Surrealism attracted Pollock as an attitude rather than as a collection of artistic examples.)

But I used the words "almost absolute" when I spoke of the diaristic gesture as distinct from the process of judging each

move upon the canvas. Pollock, interrupting his work, would judge his "acts" very shrewdly and carefully for long periods before going into another "act." He knew the difference between a good gesture and a bad one. This was his conscious artistry at work, and it makes him a part of the traditional community of painters. Yet the distance between the relatively self-contained works of the Europeans and the seemingly chaotic, sprawling works of the American indicates at best a tenuous connection to "paintings." (In fact, Jackson Pollock never really had a *malerisch* sensibility. The painterly aspects of his contemporaries, such as Motherwell, Hofmann, de Kooning, Rothko, and even Still, point up at one moment a deficiency in him and at another moment a liberating feature. I choose to consider the second element the important one.)

I am convinced that to grasp a Pollock's impact properly, we must be acrobats, constantly shuttling between an identification with the hands and body that flung the paint and stood "in" the canvas and submission to the objective markings, allowing them to entangle and assault us. This instability is indeed far from the idea of a "complete" painting. The artist, the spectator, and the outer world are much too interchangeably involved here. (And if we object to the difficulty of complete comprehension, we are asking too little of the art.)

Then Form. To follow it, it is necessary to get rid of the usual idea of "Form," i.e., a beginning, middle, and end, or any variant of this principle—such as fragmentation. We do not enter a painting of Pollock's in any one place (or hundred places). Anywhere is everywhere, and we dip in and out when and where we can. This discovery has led to remarks that his art gives the impression of going on forever—a true insight that suggests how Pollock ignored the confines of the rectangular field in favor of a continuum going in all directions simultaneously, *beyond* the literal dimensions of any work. (Though evidence points to a slackening of the attack as Pollock came to the edges of many of his canvases, in the best ones he compensated for this by tacking much of the painted surface around the back of his stretchers.) The four sides of the painting are thus an abrupt leaving off of the activity, which our imaginations continue outward indefinitely, as though refusing to accept the

artificiality of an "ending." In an older work, the edge was a far more precise caesura: here ended the world of the artist; beyond began the world of the spectator and "reality."

We accept this innovation as valid because the artist understood with perfect naturalness "how to do it." Employing an iterative principle of a few highly charged elements constantly undergoing variation (improvising, as in much Asian music), Pollock gives us an all-over unity and at the same time a means to respond continuously to a freshness of personal choice. But this form allows us equal pleasure in participating in a delirium, a deadening of the reasoning faculties, a loss of "self" in the Western sense of the term. This strange combination of extreme individuality and selflessness makes the work remarkably potent but also indicates a probably larger frame of psychological reference. And for this reason any allusions to Pollock's being the maker of giant textures are completely incorrect. They miss the point, and misunderstanding is bound to follow.

But given the proper approach, a medium-sized exhibition space with the walls totally covered by Pollocks offers the most complete and meaningful sense of his art possible.

Then Scale. Pollock's choice of enormous canvases served many purposes, chief of which for our discussion is that his mural-scale paintings ceased to become paintings and became environments. Before a painting, our size as spectators, in relation to the size of the picture, profoundly influences how much we are willing to give up consciousness of our temporal existence while experiencing it. Pollock's choice of great sizes resulted in our being confronted, assaulted, sucked in. Yet we must not confuse the effect of these with that of the hundreds of large paintings done in the Renaissance, which glorified an idealized everyday world familiar to the observer, often continuing the actual room into the painting by means of trompe l'oeil. Pollock offers us no such familiarity, and our everyday world of convention and habit is replaced by the one created by the artist. Reversing the above procedure, the painting is continued out into the room. And this leads me to my final point: Space. The space of these creations is not clearly palpable as such. We can become entangled in the web to some extent and by moving in and out of the skein of lines and splashings

can experience a kind of spatial extension. But even so, this space is an allusion far more vague than even the few inches of space-reading a Cubist work affords. It may be that our need to identify with the process, the making of the whole affair, prevents a concentration on the specifics of before and behind so important in a more traditional art. But what I believe is clearly discernible is that the entire painting comes out at us (we are participants rather than observers), right into the room. It is possible to see in this connection how Pollock is the terminal result of a gradual trend that moved from the deep space of the fifteenth and sixteenth centuries to the building out from the canvas of the Cubist collages. In the present case the "picture" has moved so far out that the canvas is no longer a reference point. Hence, although up on the wall, these marks surround us as they did the painter at work, so strict is the correspondence achieved between his impulse and the resultant art.

What we have, then, is art that tends to lose itself out of bounds, tends to fill our world with itself, art that in meaning, looks, impulse seems to break fairly sharply with the traditions of painters back to at least the Greeks. Pollock's near destruction of this tradition may well be a return to the point where art was more actively involved in ritual, magic, and life than we have known it in our recent past. If so, it is an exceedingly important step and in its superior way offers a solution to the complaints of those who would have us put a bit of life into art. But what do we do now?

There are two alternatives. One is to continue in this vein. Probably many good "near-paintings" can be done varying this esthetic of Pollock's without departing from it or going further. The other is to give up the making of paintings entirely—I mean the single flat rectangle or oval as we know it. It has been seen how Pollock came pretty close to doing so himself. In the process, he came upon some newer values that are exceedingly difficult to discuss yet bear upon our present alternative. To say that he discovered things like marks, gestures, paint, colors, hardness, softness, flowing, stopping, space, the world, life, death might sound naive. Every artist worth his salt has "discovered" these things. But Pollock's discovery seems to have a peculiarly fascinating simplicity and directness about it. He

was, for me, amazingly childlike, capable of becoming involved in the stuff of his art as a group of concrete facts seen for the first time. There is, as I said earlier, a certain blindness, a mute belief in everything he does, even up to the end. I urge that this not be seen as a simple issue. Few individuals can be lucky enough to possess the intensity of this kind of knowing, and I hope that in the near future a careful study of this (perhaps) Zen quality of Pollock's personality will be undertaken. At any rate, for now we may consider that, except for rare instances, Western art tends to need many more indirections in achieving itself, placing more or less equal emphasis upon "things" and the relations between them. The crudeness of Jackson Pollock is not, therefore, uncouth; it is manifestly frank and uncultivated, unsullied by training, trade secrets, finesse—a directness that the European artists he liked hoped for and partially succeeded in but that he never had to strive after because he had it by nature. This by itself would be enough to teach us something.

It does. Pollock, as I see him, left us at the point where we must become preoccupied with and even dazzled by the space and objects of our everyday life, either our bodies, clothes, rooms, or, if need be, the vastness of Forty-second Street. Not satisfied with the suggestion through paint of our other senses, we shall utilize the specific substances of sight, sound, movements, people, odors, touch. Objects of every sort are materials for the new art: paint, chairs, food, electric and neon lights, smoke, water, old socks, a dog, movies, a thousand other things that will be discovered by the present generation of artists. Not only will these bold creators show us, as if for the first time, the world we have always had about us but ignored, but they will disclose entirely unheard-of happenings and events, found in garbage cans, police files, hotel lobbies; seen in store windows and on the streets; and sensed in dreams and horrible accidents. An odor of crushed strawberries, a letter from a friend, or a billboard selling Drano; three taps on the front door, a scratch, a sigh, or a voice lecturing endlessly, a blinding staccato flash, a bowler hat—all will become materials for this new concrete art.

Young artists of today need no longer say, "I am a painter" or "a poet" or "a dancer." They are simply "artists." All of life will be open to them. They will discover out of ordinary things

the meaning of ordinariness. They will not try to make them extraordinary but will only state their real meaning. But out of nothing they will devise the extraordinary and then maybe nothingness as well. People will be delighted or horrified, critics will be confused or amused, but these, I am certain, will be the alchemies of the 1960s.

1958

SUSAN SONTAG

Especially at the beginning of her career, in the 1960s and 1970s, the novelist and essayist Susan Sontag (1933–2004) wrote about an extraordinarily wide range of subjects. Her first essay collection, *Against Interpretation* (1967), encompassed discussions of novels, movies, plays, and paintings, as well as "Notes on Camp," the discourse on a sensibility that may well remain her most famous essay. Sontag prided herself on bringing the latest developments in art and literature to the attention of an intellectual audience that sometimes hesitated before embracing the new. "Happenings: An Art of Radical Juxtaposition"— originally published in the short-lived magazine *The Second Coming*— showcases Sontag's role as the avid yet dispassionate observer of an explosive cultural scene.

Happenings: An Art of Radical Juxtaposition

THERE has appeared in New York recently a new, and still esoteric, genre of spectacle. At first sight apparently a cross between art exhibit and theatrical performance, these events have been given the modest and somewhat teasing name of "Happenings." They have taken place in lofts, small art galleries, backyards, and small theaters before audiences averaging between thirty and one hundred persons. To describe a Happening for those who have not seen one means dwelling on what Happenings are not. They don't take place on a stage conventionally understood, but *in* a dense object-clogged setting which may be made, assembled, or found, or all three. In this setting a number of participants, *not* actors, perform movements and handle objects antiphonally and in concert to the accompaniment (sometimes) of words, wordless sounds, music, flashing lights, and odors. The Happening has no plot, though it is an action, or rather a series of actions and events. It also shuns continuous rational discourse, though it may contain words like "Help!", *"Voglio un bichiere di acqua,"* "Love me," "Car," "One, two, three . . ." Speech is purified and condensed by disparateness (there is only the speech of need) and then expanded by ineffectuality, by the lack of relation between the persons enacting the Happening.

Those who do Happenings in New York—but they are not just a New York phenomenon; similar activities have been reported in Osaka, Stockholm, Cologne, Milan, and Paris by groups unrelated to each other—are young, in their late twenties or early thirties. They are mostly painters (Allan Kaprow, Jim Dine, Red Grooms, Robert Whitman, Claes Oldenburg, Al Hansen, George Brecht, Yoko Ono, Carolee Schneemann) and a few musicians (Dick Higgins, Philip Corner, La Monte Young). Allan Kaprow, the man who more than anyone else is responsible for stating and working out the genre, is the only academic among them; he formerly taught art and art history at Rutgers and now teaches at the State University of New York on Long Island. For Kaprow, a painter and (for a year) a student of John Cage, doing Happenings since 1957 has replaced painting; Happenings are, as he puts it, what his painting has become. But for most of the others, this is not the case; they have continued to paint or compose music in addition to occasionally producing a Happening or performing in the Happening devised by a friend.

The first Happening in public was Allan Kaprow's *Eighteen Happenings in Six Parts*, presented in October, 1959, at the opening of the Reuben Gallery, which Kaprow, among others, helped to form. For a couple of years, the Reuben Gallery, the Judson Gallery, and later the Green Gallery, were the principal showcases of Happenings in New York by Kaprow, Red Grooms, Jim Dine, Robert Whitman, and others; in the recent years, the only series of Happenings were those of Claes Oldenburg, presented every weekend in the three tiny back rooms of his "store" on East Second Street. In the five years since the Happenings have been presented in public, the group has enlarged from an original circle of close friends, and the members have diverged in their conceptions; no statement about what Happenings are as a genre will be acceptable to all the people now doing them. Some Happenings are more sparse, others more crowded with incident; some are violent, others are witty; some are like haiku, others are epic; some are vignettes, others more theatrical. Nevertheless, it is possible to discern an essential unity in the form, and to draw certain conclusions about the relevance of Happenings to the arts of painting and theater. Kaprow, by the way, has written the best article yet to

appear on Happenings, their meaning in general in the context of the contemporary art scene, and their evolution for him in particular, in the May, 1961, *Art News*, to which the reader is referred for a fuller description of what literally "happens" than I shall attempt in this article.

Perhaps the most striking feature of the Happening is its treatment (this is the only word for it) of the audience. The event seems designed to tease and abuse the audience. The performers may sprinkle water on the audience, or fling pennies or sneeze-producing detergent powder at it. Someone may be making near-deafening noises on an oil drum, or waving an acetylene torch in the direction of the spectators. Several radios may be playing simultaneously. The audience may be made to stand uncomfortably in a crowded room, or fight for space to stand on boards laid in a few inches of water. There is no attempt to cater to the audience's desire to see everything. In fact this is often deliberately frustrated, by performing some of the events in semi-darkness or by having events go on in different rooms simultaneously. In Allan Kaprow's *A Spring Happening*, presented in March, 1961, at the Reuben Gallery, the spectators were confined inside a long box-like structure resembling a cattle car; peep-holes had been bored in the wooden walls of this enclosure through which the spectators could strain to see the events taking place outside; when the Happening was over, the walls collapsed, and the spectators were driven out by someone operating a power lawnmower.

(This abusive involvement of the audience seems to provide, in default of anything else, the dramatic spine of the Happening. When the Happening is more purely spectacle, and the audience simply spectators, as in Allan Kaprow's *The Courtyard*, presented in November, 1962, at the Renaissance House, the event is considerably less dense and compelling.)

Another striking feature of Happenings is their treatment of time. The duration of a Happening is unpredictable; it may be anywhere from ten to forty-five minutes; the average one is about a half-hour in length. I have noticed, in attending a fair number of them over the last two years, that the audience of Happenings, a loyal, appreciative, and for the most part experienced audience, frequently does not know when they are over, and has to be signalled to leave. The fact that in the audiences

one sees mostly the same faces again and again indicates this is not due to a lack of familiarity with the form. The unpredictable duration, and content, of each individual Happening is essential to its effect. This is because the Happening has no plot, no story, and therefore no element of suspense (which would then entail the satisfaction of suspense).

The Happening operates by creating an asymmetrical network of surprises, without climax or consummation; this is the alogic of dreams rather than the logic of most art. Dreams have no sense of time. Neither do the Happenings. Lacking a plot and continuous rational discourse, they have no past. As the name itself suggests, Happenings are always in the present tense. The same words, if there are any, are said over and over; speech is reduced to a stutter. The same actions, too, are frequently repeated throughout a single Happening—a kind of gestural stutter, or done in slow motion, to convey a sense of the arrest of time. Occasionally the entire Happening takes a circular form, opening and concluding with the same act or gesture.

One way in which the Happenings state their freedom from time is in their deliberate impermanence. A painter or sculptor who makes Happenings does not make anything that can be purchased. One cannot buy a Happening; one can only support it. It is consumed on the premises. This would seem to make Happenings a form of theater, for one can only attend a theatrical performance, but can't take it home. But in the theater, there is a text, a complete "score" for the performance which is printed, can be bought, read, and has an existence independent of any performance of it. Happenings are not theater either, if by theater we mean plays. However, it is not true (as some Happening-goers suppose) that Happenings are improvised on the spot. They are carefully rehearsed for any time from a week to several months—though the script or score is minimal, usually no more than a page of general directions for movements and descriptions of materials. Much of what goes on in the performance has been worked out or choreographed in rehearsal by the performers themselves; and if the Happening is done for several evenings consecutively it is likely to vary a good deal from performance to performance, far more than in the theater. But while the same Happening might be given several nights in a row, it is not meant to enter into a repertory which can be

repeated. Once dismantled after a given performance or series of performances, it is never revived, never performed again. In part, this has to do with the deliberately occasional materials which go into Happenings—paper, wooden crates, tin cans, burlap sacks, foods, walls painted for the occasion—materials which are often literally consumed, or destroyed, in the course of the performance.

What is primary in a Happening is materials—and their modulations as hard and soft, dirty and clean. This preoccupation with materials, which might seem to make the Happenings more like painting than theater, is also expressed in the use or treatment of persons as material objects rather than "characters." The people in the Happenings are often made to look like objects, by enclosing them in burlap sacks, elaborate paper wrappings, shrouds, and masks. (Or, the person may be used as a still-life, as in Allan Kaprow's *Untitled Happening*, given in the basement boiler room of the Maidman Theater in March, 1962, in which a naked woman lay on a ladder strung above the space in which the Happenings took place.) Much of the action, violent and otherwise, of Happenings involves this use of the person as a material object. There is a great deal of violent using of the physical persons of the performers by the person himself (jumping, falling) and by each other (lifting, chasing, throwing, pushing, hitting, wrestling); and sometimes a slower, more sensuous use of the person (caressing, menacing, gazing) by others or by the person himself. Another way in which people are employed is in the discovery or the impassioned, repetitive use of materials for their sensuous properties rather than their conventional uses: dropping pieces of bread into a bucket of water, setting a table for a meal, rolling a huge paper-screen hoop along the floor, hanging up laundry. Jim Dine's *Car Crash*, done at the Reuben Gallery in November, 1960, ended with a man smashing and grinding pieces of colored chalk into a blackboard. Simple acts like coughing and carrying, a man shaving himself, or a group of people eating, will be prolonged, repetitively, to a point of demoniacal frenzy.

Of the materials used, it might be noted that one cannot distinguish among set, props, and costumes in a Happening, as one can in the theater. The underwear or thrift-shop oddments which a performer may wear are as much a part of the whole

Robert R. McElroy: Jim Dine in the *Car Crash* at the Reuben Gallery, November 1–6, 1960.

composition as the paint-spattered papier-mâché shapes which protrude from the wall or the trash which is strewn on the floor. Unlike the theater and like some modern painting, in the Happening objects are not *placed*, but rather scattered about and heaped together. The Happening takes place in what can best be called an "environment," and this environment typically is messy and disorderly and crowded in the extreme, constructed of some materials which are rather fragile, such as paper and cloth, and others which are chosen for their abused, dirty, and dangerous condition. The Happenings thereby register (in a real, not simply an ideological way) a protest against the museum conception of art—the idea that the job of the artist is to make things to be preserved and cherished. One cannot hold on to a Happening, and one can only cherish it as one cherishes a firecracker going off dangerously close to one's face.

Happenings have been called by some "painters' theater," which means—aside from the fact that most of the people who do them are painters—that they can be described as animated paintings, more accurately as "animated collages" or "*trompe*

l'oeil brought to life." Further, the appearance of Happenings can be described as one logical development of the New York school of painting of the fifties. The gigantic size of many of the canvases painted in New York in the last decade, designed to overwhelm and envelop the spectator, plus the increasing use of materials other than paint to adhere to, and later extend from, the canvas, indicate the latent intention of this type of painting to project itself into a three-dimensional form. This is exactly what some people started to do. The crucial next step was taken with the work done in the middle and late fifties by Robert Rauschenberg, Allan Kaprow, and others in a new form called "assemblages," a hybrid of painting, collage, and sculpture, using a sardonic variety of materials, mainly in the state of debris, including license plates, newspaper clippings, pieces of glass, machine parts, and the artist's socks. From the assemblage to the whole room or "environment" is only one further step. The final step, the Happening, simply puts people into the environment and sets it in motion. There is no doubt that much of the style of the Happening—its general look of messiness, its fondness for incorporating ready-made materials of no artistic prestige, particularly the junk of urban civilization—owes to the experience and pressures of New York painting. (It should be mentioned, however, that Kaprow for one thinks the use of urban junk is not a necessary element of the Happening form, and contends that Happenings can as well be composed and put on in pastoral surroundings, using the "clean" materials of nature.)

Thus recent painting supplies one way of explaining the look and something of the style of Happenings. Yet it does not explain their form. For this we must look beyond painting and particularly to Surrealism. By Surrealism, I do not mean a specific movement in painting inaugurated by André Breton's manifesto in 1924 and to which we associate the names of Max Ernst, Dalé, de Chirico, Magritte, and others. I mean a mode of sensibility which cuts across all the arts in the 20th century. There is a Surrealist tradition in the theater, in painting, in poetry, in the cinema, in music, and in the novel; even in architecture there is, if not a tradition, at least one candidate, the Spanish architect Gaudí. The Surrealist tradition in all these arts is united by the idea of destroying conventional meanings, and

creating new meanings or counter-meanings through radical
juxtaposition (the "collage principle"). Beauty, in the words of
Lautréamont, is "the fortuitous encounter of a sewing machine
and an umbrella on a dissecting table." Art so understood is
obviously animated by aggression, aggression toward the pre-
sumed conventionality of its audience and, above all, aggres-
sion toward the medium itself. The Surrealist sensibility aims to
shock, through its techniques of radical juxtaposition. Even one
of the classical methods of psychoanalysis, free association, can
be interpreted as another working-out of the Surrealist prin-
ciple of radical juxtaposition. By its accepting as relevant every
unpremeditated statement made by the patient, the Freudian
technique of interpretation shows itself to be based on the same
logic of coherence behind contradiction to which we are accus-
tomed in modern art. Using the same logic, the Dadaist Kurt
Schwitters made his brilliant *Merz* constructions of the early
twenties out of deliberately unartistic materials; one of his col-
lages, for example, is assembled from the gutter-pickings of a
single city block. This recalls Freud's description of his method
as divining meaning from "the rubbish-heap . . . of our obser-
vations," from the collation of the most insignificant details; as
a time limit the analyst's daily hour with the patient is no less
arbitrary than the space limit of one block from whose gutter
the rubbish was selected; everything depends on the creative
accidents of arrangement and insight. One may also see a kind
of involuntary collage-principle in many of the artifacts of the
modern city: the brutal disharmony of buildings in size and
style, the wild juxtaposition of store signs, the clamorous layout
of the modern newspaper, etc.

The art of radical juxtaposition can serve different uses, how-
ever. A great deal of the content of Surrealism has served the pur-
poses of wit—either the delicious joke in itself of what is inane,
childish, extravagant, obsessional; or social satire. This is par-
ticularly the purpose of Dada, and of the Surrealism that is
represented in the International Surrealist Exhibition in Paris in
January, 1938, and the exhibits in New York in 1942 and 1960.
Simone de Beauvoir in the second volume of her memoirs de-
scribes the 1938 spook-house as follows:

> In the entrance hall stood one of Dalí's special creations: a taxi
> cab, rain streaming out of it, with a blonde, swooning female
> dummy posed inside, surrounded by a sort of lettuce-and-chicory

salad all smothered with snails. The "Rue Surréaliste" contained other similar figures, clothed or nude, by Man Ray, Max Ernst, Dominguez, and Maurice Henry. Masson's [was] a face imprisoned in a cage and gagged with a pansy. The main salon had been arranged by Marcel Duchamp to look like a grotto; it contained, among other things, a pond and four beds grouped around a brazier, while the ceiling was covered with coal bags. The whole place smelled of Brazilian coffee, and various objects loomed up out of the carefully contrived semi-darkness: a fur-lined dish, an occasional table with the legs of a woman. On all sides ordinary things like walls and doors and flower vases were breaking free from human restraint. I don't think surrealism had any direct influence on us, but it had impregnated the very air we breathed. It was the surrealists, for instance, who made it fashionable to frequent the Flea Market where Sartre and Olga and I often spent our Sunday afternoons.

The last line of this quote is particularly interesting, for it recalls how the Surrealist principle has given rise to a certain kind of witty appreciation of the derelict, inane, *démodé* objects of modern civilization—the taste for a certain kind of passionate non-art that is known as "camp." The fur-lined teacup, the portrait executed out of Pepsi-Cola bottle caps, the perambulating toilet bowl, are attempts to create objects which have built into them a kind of wit which the sophisticated beholder with his eyes opened by camp can bring to the enjoyment of Cecil B. DeMille movies, comic books, and *art nouveau* lampshades. The main requirement for such wit is that the objects not be high art or good taste in any normally valued sense; the more despised the material or the more banal the sentiments expressed, the better.

But the Surrealist principle can be made to serve other purposes than wit, whether the disinterested wit of sophistication or the polemical wit of satire. It can be conceived more seriously, therapeutically—for the purpose of reeducating the senses (in art) or the character (in psychoanalysis). And finally, it can be made to serve the purposes of terror. If the meaning of modern art is its discovery beneath the logic of everyday life of the alogic of dreams, then we may expect the art which has the freedom of dreaming also to have its emotional range. There are witty dreams, solemn dreams, and there are nightmares.

The examples of terror in the use of the Surrealist principle

are more easily illustrated in arts with a dominant figurative tradition, like literature and the film, than in music (Varèse, Scheffer, Stockhausen, Cage) or painting (de Kooning, Bacon). In literature, one thinks of Lautréamont's *Maldoror* and Kafka's tales and novels and the morgue poems of Gottfried Benn. From the film, examples are two by Buñuel and Dalí, *Le Chien Andalou* and *L'Âge d'Or,* Franju's *Le Sang des Bêtes,* and, more recently, two short films, the Polish *Life Is Beautiful* and the American Bruce Connor's *A Movie,* and certain moments in the films of Alfred Hitchcock, H. G. Clouzot, and Kon Ichikawa. But the best understanding of the Surrealist principle employed for purposes of terrorization is to be found in the writings of Antonin Artaud, a Frenchman who had four important and model careers: as a poet, a lunatic, a film actor, and a theoretician of the theater. In his collection of essays, *The Theater and Its Double,* Artaud envisages nothing less than a complete repudiation of the modern Western theater, with its cult of masterpieces, its primary emphasis on the written text (the word), its tame emotional range. Artaud writes: "The theater must make itself the equal of life—not an individual life, that individual aspect of life in which *characters* triumph, but the sort of liberated life which sweeps away human individuality." This transcendence of the burden and limitations of personal individuality—also a hopeful theme in D. H. Lawrence and Jung— is executed through recourse to the preeminently collective contents of dreaming. Only in our dreams do we nightly strike below the shallow level of what Artaud calls, contemptuously, "psychological and social man." But dreaming does not mean for Artaud simply poetry, fantasy; it means violence, insanity, nightmare. The connection with the dream will necessarily give rise to what Artaud calls a "*theater of cruelty,*" the title of two of his manifestoes. The theater must furnish "the spectator with the truthful precipitates of dreams, in which his taste for crime, his erotic obsessions, his savagery, his chimeras, his Utopian sense of life and matter, even his cannibalism, pour out, on a level not counterfeit and illusory, but interior. . . . The theater, like dreams, must be bloody and inhuman."

The prescriptions which Artaud offers in *The Theater and Its Double* describe better than anything else what Happenings are. Artaud shows the connection between three typical features of

the Happening: first, its supra-personal or impersonal treatment of persons; second, its emphasis on spectacle and sound, and disregard for the word; and third, its professed aim to assault the audience.

The appetite for violence in art is hardly a new phenomenon. As Ruskin noted in 1880 in the course of an attack on "the modern novel" (his examples are *Guy Mannering* and *Bleak House!*), the taste for the fantastic, the *outré*, the rejected, and the willingness to be shocked are perhaps the most remarkable characteristics of modern audiences. Inevitably, this drives the artist to ever greater and more intense attempts to arouse a reaction from his audience. The question is only whether a reaction need always be provoked by terrorization. It seems to be the implicit consensus of those who do Happenings that other kinds of arousal (for example, sexual arousal) are in fact less effective, and that the last bastion of the emotional life is fear.

Yet it is also interesting to note that this art form which is designed to stir the modern audience from its cozy emotional anesthesia operates with images of anesthetized persons, acting in a kind of slow-motion disjunction with each other, and gives us an image of action characterized above all by ceremoniousness and ineffectuality. At this point the Surrealist arts of terror link up with the deepest meaning of comedy: the assertion of invulnerability. In the heart of comedy, there is emotional anesthesia. What permits us to laugh at painful and grotesque events is that we observe that the people to whom these events happen are really underreacting. No matter how much they scream or prance about or inveigh to heaven or lament their misfortune, the audience knows they are really not feeling very much. The protagonists of great comedy all have something of the automaton or robot in them. This is the secret of such different examples of comedy as Aristophanes' *The Clouds, Gulliver's Travels*, Tex Avery cartoons, *Candide, Kind Hearts and Coronets*, the films of Buster Keaton, *Ubu Roi*, the Goon Show. The secret of comedy is the dead-pan—or the exaggerated reaction or the misplaced reaction that is a parody of a true response. Comedy, as much as tragedy, works by a certain stylization of emotional response. In the case of tragedy, it is by a heightening of the norm of feeling; in the case of comedy, it is by underreacting and misreacting according to the norms of feeling.

Surrealism is perhaps the farthest extension of the idea of comedy, running the full range from wit to terror. It is "comic" rather than "tragic" because Surrealism (in all its examples, which include Happenings) stresses the extremes of disrelation—which is preeminently the subject of comedy, as "relatedness" is the subject and source of tragedy. I, and other people in the audience, often laugh during Happenings. I don't think this is simply because we are embarrassed or made nervous by violent and absurd actions. I think we laugh because what goes on in the Happenings is, in the deepest sense, funny. This does not make it any less terrifying. There is something that moves one to laughter, if only our social pieties and highly conventional sense of the serious would allow it, in the most terrible of modern catastrophes and atrocities. There is something comic in modern experience as such, a demonic, not a divine comedy, precisely to the extent that modern experience is characterized by meaningless mechanized situations of disrelation.

Comedy is not any less comic because it is punitive. As in tragedy, every comedy needs a scapegoat, someone who will be punished and expelled from the social order represented mimetically in the spectacle. What goes on in the Happenings merely follows Artaud's prescription for a spectacle which will eliminate the stage, that is, the distance between spectators and performers, and "will physically envelop the spectator." In the Happening this scapegoat is the audience.

1962

JAMES BALDWIN

The novelist and essayist James Baldwin (1924–1987) is not generally associated with the visual arts. This brief essay, composed for a 1964 exhibition, salutes Beauford Delaney, who was a generation older than Baldwin and was a mentor as well as a friend. Both men were gay African Americans who felt the pull of Paris in the years after World War II, and Baldwin clearly recognized Delaney not only as a formidable painter but also as an exemplary figure—an offbeat American original. Delaney, much admired for the jazzy urgency of both representational and abstract compositions, was an enormously charismatic personality who inspired prose not only by Baldwin but also by Henry Miller, another writer who knew expatriate artistic bohemia as both an ardent participant and an acute observer. Excerpts from Miller's essay on Delaney can be found earlier in these pages.

On the Painter Beauford Delaney

I LEARNED about light from Beauford Delaney, the light contained in every thing, in every surface, in every face. Many years ago, in poverty and uncertainty, Beauford and I would walk together through the streets of New York City. He was then, and is now, working all the time, or perhaps it would be more accurate to say that he is *seeing* all the time; and the reality of his seeing caused me to begin to see. Now, what I began to see was not, at that time, to tell the truth, his painting; that came later; what I saw, first of all, was a brown leaf on black asphalt, oil moving like mercury in the black water of the gutter, grass pushing itself up through a crevice in the sidewalk. And because I was seeing it with Beauford, because Beauford caused me to see it, the very colours underwent a most disturbing and salutary change. The brown leaf on the black asphalt, for example—what colours were these, really? To stare at the leaf long enough, to try to apprehend the leaf, was to discover many colours in it; and though black had been described to me as the absence of light, it became very clear to me that if this were true, we would never have been able to see the colour; black: the light is trapped in it and struggles upward, rather like that grass pushing upward through the cement. It was humbling

Beauford Delaney: *James Baldwin*, 1963.
Pastel, 37½ × 31½ in.

to be forced to realise that the light fell down from heaven, on everything, on everybody, and that the light was always changing. Paradoxically, this meant for me that memory is a traitor and that life does not contain the past tense: the sunset one saw yesterday, the leaf that burned, or the rain that fell, have not really been seen unless one is prepared to see them every day. As Beauford is, to his eternal credit, and for our health and hope.

Perhaps I am so struck by the light in Beauford's paintings because he comes from darkness—as I do, as, in fact, we all do. But the darkness of Beauford's beginnings, in Tennessee, many years ago, was a black-blue midnight indeed, opaque, and full of sorrow. And I do not know, nor will any of us ever really know, what kind of strength it was that enabled him to make so

dogged and splendid a journey. In any case, from Tennessee, he eventually came to Paris (I have the impression that he walked and swam) and for a while lived in a suburb of Paris, Clamart. It was at this time that I began to see Beauford's painting in a new way, and it was also at this time that Beauford's paintings underwent a most striking metamorphosis into freedom. I know this sounds extremely subjective; but let it stand; it is not really as subjective as it sounds. There was a window in Beauford's house in Clamart before which we often sat—late at night, early in the morning, at noon. This window looked out on a garden; or, rather, it would have looked out on a garden if it had not been for the leaves and branches of a large tree which pressed directly against the window. Everything one saw from this window, then, was filtered through these leaves. And this window was a kind of universe, moaning and wailing when it rained, light of the morning, and as blue as the blues when the last light of the sun departed.

Well, that life, that light, that miracle, are what I began to see in Beauford's paintings, and this light began to stretch back for me over all the time we had known each other, and over much more time than that, and this light held the power to illuminate, even to redeem and reconcile and heal. For Beauford's work leads the inner and the outer eye, directly and inexorably, to a new confrontation with reality. At this moment one begins to apprehend the nature of his triumph. And the beauty of his triumph, and the proof that it is a real one, is that he makes it ours. Perhaps I should not say, flatly, what I believe—that he is a great painter, among the very greatest; but I do know that great art can only be created out of love, and that no greater lover has ever held a brush.

1965

PHILIP LEIDER

Philip Leider (born 1929) was the editor of *Artforum* in its first decade, from the time the magazine was founded in San Francisco in 1962, through a move to Los Angeles in 1965, and relocation to New York in 1967. As both an editor and a writer, Leider did much to define the magazine's adventuresome spirit in its early years. With New York–based art magazines paying relatively little attention to work done on the West Coast, Leider brought focus and energy to accounts of new developments in painting and assemblage in Northern and Southern California and beyond. And as art criticism became increasingly polemical in the 1960s, Leider remained sympathetic to a variety of different voices and viewpoints. He encouraged fresh investigations of older modernist and formalist values; he welcomed the latest Minimalist and Conceptualist thinking; and he was open to hard-to-define developments, including a return to realism that some found antimodernist if not downright reactionary.

Bruce Conner: A New Sensibility

HE can visualize the loveliest flesh charred beyond recognition. The data which informs his work is that of the extermination camps, Hiroshima, horror comics, sexual psychopathology, lunatic feminine adornment. "I would hate," said a woman at one of his openings, "to be his wife." One can appreciate her uneasiness: could he not transform her most enticing postures into a "Black Dahlia," with its nail pounded maniacally into the heart of the matter? What must he see as she draws on those nylons, those silken underthings, those bangles and gee-gaws which he discards into his work as into a skid-row bargain store? Looking at his work, one conceives a mentality which must obsessively re-cast all it observes into the imagery of the most unutterable horrors of our times.

That imagery comes to him ready-made out of the history of this century; the logic of its usage derives from the experiences of the generation he addresses. In a piece called "Oven" for example, we are presented with a squat, repugnant box, with a small opening at its front. Clinging to this mouth of the oven are a scattering of human, or human-appearing, hairs, tightly curled, tough, immediately pubic in association. The simulta-

neous evocation of the crematories and the erotic charges the atmosphere with depthless evil—and guilt. But the piece, hideous in the extreme, speaks a language universal to this generation, contains a logic we understand all too well. The point is not simply an ugly pun, turning on the slang usage of the word "oven" for the female genitalia. It refers to an even more murky connection between the sexual and the maniacal, the never-ending dark dialogue of the sexual sickness and the social sickness.

Disordered sexuality with its persistent association of disordered society is thematic in Conner's work. "Black Dahlia" uses a semi-pornographic pin-up photo as a fuse to ignite an explosion of psychotic imagery. The feathers and fringes, the length of rubber hose, and, above all, the murderous central nail are imagery out of Krafft-Ebing (but the tattering of comic-strips in the lower right-hand corner directs our attention elsewhere). In another piece, a similar photograph will be found dangling from a string; in another, we will find it partly obscured in a welter of junk. The pornographic references can be found as ubiquitously in Conner's work as the mutilated silk stockings, and for much the same reason: both refer to the undercurrent of aberrated sexuality which Conner never disassociates from society.

If the imagery in Bruce Conner's work is revolting, it at the same time addresses itself to a generation which does not have the moral authority to question his bad taste. The "notorious" and often-exhibited "Child" is one of the few of Conner's works in which his genuine sense of pity, terror and outrage is not hidden. It is, therefore, doubly infuriating to see people turn from this piece pale with rage and disgust. The data of the work is drawn from the greatest massacre of children in recorded history; that single charred body fixes a guilt which a dozen Disneylands cannot diminish.

We appear to be entering a period in which an artist's medium will be as private to him as his signature. Bruce Conner's medium is most often "silk stocking, wax, and assorted lost objects." The silk stocking which is so universal in his work, serves several purposes. First, it is usually the container in which the rest of the work is packed; remove it and the entire construction would fall out like an overturned drawer. Being transparent, and being capable of having its transparency made more or less

Bruce Conner: *Child*, 1959–60. Mixed
media, 35⅝ × 17 × 16½ in.

perfect by tightening or loosening or by choice of gauge, it
serves this technical purpose admirably. Secondly, it adapts to,
and often augments the tone of the piece as a whole. When the
piece is a comical one, the stocking adds to the humor; but used
in a piece like "Child," it immeasurably intensifies the horror,
and used in a piece like "Black Dahlia" it heightens its quality
of demented sexuality. Thirdly, being itself primarily a discarded
object, it serves as a kind of transition to the innumerable and
uncategorizable discarded objects to be found in almost all of
Conner's works.

Unlike almost all other artists working with discarded ob-
jects, Conner does not treat these as "found objects," but as
lost objects. There is no attempt to give them a new life, or to
bring to us a new awareness of them. He throws them into his

constructions exactly as they are thrown into drawers or onto the tables of "Thrift" shops. Fringes, feathers, tatters of lace, marbles, old hardware, old five-and-dime-store "jewelry" are simply discarded into the work, at random. (In one work, "The Snore," they are packed into little bundles and stored into the work as if it were some old lady's attic.) The effect is a tone of total hopelessness, a sense of unrelieved depression, a sense of wretchedness, melancholy, despair—and death. The death symbol in Conner's work is always the dead object, and the dead object is always present. Overtly, Conner's concern would appear to be less with death itself than with the hideous forms death has taken in our times: mass murder, atomic bombing, torture, mutilation. But the omnipresent dead objects are "memento mori," pure and simple. Composed for the most part of long-disused feminine adornment, they say, like Yorick's skull, "Now get you to my lady's chamber, and tell her, let her paint an inch thick, to this favour she must come."

One of the reasons Conner fits so awkwardly into the "assemblage" category is precisely this refusal to "treat" discarded objects. He does not present us with a "found object" and offer it to us for re-examination. He does not isolate objects in peculiar contexts, forcing us to see them new. He does not employ objects in ingenious ways completely foreign to their original uses. Discarded objects serve his singular purpose precisely in their passive, unreactivated state. This is one of the many things that distinguish Conner, not only from most "assemblage" makers, but from the Dadaists and the neo-Dadaists with whom he has so often, and so inaccurately, been grouped. Comparison to Dubuffet is also misleading: where Dubuffet is elegant, Conner is brutal; where Dubuffet challenges the conceptions of art and beauty held by an entire civilization, Conner is totally indifferent. Goya, and, perhaps, Ensor would seem to more closely approximate the tradition and the content which is of interest to him, but the truth seems to be that with Bruce Conner we are dealing with an almost unique phenomenon.

It is difficult to define the characteristics of a completely new sensibility. Intelligence seems to have little to do with it; technical mastery or innovation does not necessarily appear hand in hand with it. What we get is simply a completely new way of seeing the world, which, once communicated to us, never leaves

our old way the same again. In literature, whose communication is much more direct than that of the visual arts, the appearance of a new sensibility sends a kind of shock wave around the world; one thinks, for example, of the peculiar addition to their understanding shared by all people who have read Kafka, or Celine. In Kafka, intelligence runs high, in Celine not. Celine revolutionized the literary uses of his language, Kafka employed a conventional prose. But both have in common the communication of a way of responding to the world so unique, so entirely new, that no one reading them ever sees the world in quite the same way again as before.

Painting rarely offers us this experience embodied in the work of a single person, though the great schools of painting often communicate, in a manner much less dramatic because much less direct, the experience of a new sensibility. It is all the more exciting then, facing the work of Bruce Conner, to realize that what we are confronting is a uniquely new way of seeing things, a strange re-casting of experience in terms of a sensibility we have not before encountered. It is a rare phenomenon.

1962

Joan Brown

IN 1955, aged 17, Joan Brown enrolled as a freshman at the California School of Fine Arts in San Francisco. In 1959 she received her B.F.A.; in 1960, aged 22, she 1) received her M.F.A.; 2) held her first one-man show in New York, at the Staempfli Gallery; 3) became the youngest artist to be shown in the Whitney Museum's "Young America" exhibition. Since this modest entry into the art world, her work has found its way into the collections of the Museum of Modern Art and the Albright Art Gallery, among those of many other important institutions and individuals. Even magazines like Look and Mademoiselle cannot seem to resist her, lavishing upon her all the screwball awards and honors for eminent ladies with which they periodically come up.

An observer accustomed to a more stately, time-consuming biography, tends to find his comprehension somewhat stunned

by this sort of progression. Can one so young be so deserving? Are the times such that one can simply be run through an art school as if on a conveyor belt, flopping out into success at the other end? Is there not, regardless of the amount of native talent, a process of self-discovery, maturation, experience, through which there is simply no short-cut, which an artist must undergo? It would seem, at least in Joan Brown's case, not, for her work offers some of the finest and most exciting examples of the rich mood (and mode) that has been developing in San Francisco over the past decade.

If there is a San Francisco style, a San Francisco attitude, that style and that attitude can be found epitomized in her paintings. That it was not her intelligence that went into the formation of this sensibility is irrelevant; that it was not out of her lifetime that the years of labor and experimentation came is simply her good fortune; what is important, and what is fascinating, is that the product of that intelligence and those labors appears in her work in pristine form. What is important is that what she inherited she did not adulterate, and that what she brings to her inheritance is a strong and considerable talent.

The situation into which Joan Brown happened to be born had been developing at the California School of Fine Arts since the days when Clyfford Still was teaching there, in the middle and late forties. They were the days when Still, Rothko, Pollock, and Gottlieb, among others, sought to embody in painting a new kind of energy by releasing into it a sign at once abstract and concrete, having no reference in nature, but sounding within the viewer a response out of a common, primeval and mysterious consciousness. Communication on this level could not be easily talked about, and indeed a great part of the Still legacy in San Francisco is a mistrust of verbalization which easily became a mistrust of intellectuality: an entire complex of anti-intellectual attitudes remains characteristic of San Francisco art and artists. Corollary to a hesitancy to explain came a solemnity in the face of the high seriousness of this art, an attitude of fierce dedication which precluded concern with the fashionable aspects of the art world, and a distinct aversion for all its commercial aspects. (Still's subsequent removal of himself to isolation, his refusal to be handled by a commercial dealer and his refusal to exhibit his works except under the most exacting

conditions has been often regarded as an irritating pose in East-
ern art circles; in San Francisco it remains a subject of total
admiration.) Lastly, and perhaps most important from the point
of view of the image that was to evolve, was a total and violent
rejection of any consideration of the painting as decoration.
Above all, the form was to reflect the content, and a surface
of tough, moody, coarse, and even ugly paint in muted colors,
much worked-upon, was preferred to anything that might be
called "attractive." (A tolerance for inexpensive materials—Joan
Brown works, to the persistent dismay of her dealers, in the
cheapest paints—derives in some part, at least, from this disdain
for the decorative qualities of the media.) Lastly, the scale of
the work was to correspond to its seriousness: the large painting
became fundamental to the San Francisco style. These ideas,
germinating in the San Francisco atmosphere, remained em-
bodied after Still's departure, not only in his students, but in
early works by himself, Rothko, Pollock and Gorky at the San
Francisco Museum of Art. They formed the prevailing sensibil-
ity of the San Francisco Art Institute (the current name for the
School) and reached succeeding generations of students primar-
ily through the influence of Elmer Bischoff and Frank Lobdell.

Lobdell's own work, with certain modifications, reflects the
tradition perfectly. Bischoff, a figurative painter, embodies the
tradition in his person, and it is interesting that Lobdell's stu-
dents are universally attracted to Bischoff, almost never because
of his work, but because of his "attitude." (Joan Brown's figura-
tive work is among the strongest and most intense figurative
painting being done on the West Coast, and the reason for its
compelling qualities is that it is informed by the "attitude" of
the Still tradition. It has nothing in common with what is usu-
ally known as "California Figurative" painting, which drifts, for
the most part, with neither attitude nor tradition to drive it.)

What Joan Brown's work typifies is not, however, the com-
plex of ideas and methods which derive directly from Clyfford
Still, but the assimilation, and considerable distortion, of Still's
teachings, by succeeding groups of San Francisco artists, who
have pushed, twisted, ground and hammered Still's tradition
into the image of San Francisco painting today. That image
is not Still's image, though it is vastly informed by Still's at-
titude and method. Some of the elements of the Still tradition

have been abandoned; some have been intensified; some have been completely misinterpreted. What we are dealing with is the progress of a mood.

For one, the idea of the "sign" as a totemic, primeval, and mythic communication has been steadily abandoned. In its place emerges simply the shape, or the "thing." Joan Brown's titles, for example, consistently refer to "things": "Things in the Sky at Night," "Trying to Spear Things," "Things in Landscape." The "shape" or "thing" can be almost any form at all, and is not above being a joking reference to the shape of a car fender, a comic-strip lightning bolt, a penis or a breast or a vagina. A tendency to draw the shape from the vulgar (meaning low-brow) more than from the austere is characteristic of the entire trend of newer young painters in San Francisco, and this derives, not from the pop art movements recently so prominent, but from the congeniality of that other element of tradition—anti-intellectualism. From what they are certain is the kiss-of-death of rationalism and intellectuality, they protect themselves with hillbilly music, comic strips, and monosyllables. This kind of anti-intellectuality is not what Still had in mind. What was to Still's group simply a mistrust of (and despair of) verbalizing, is for this group a rejection of the total verbal milieu.

A part of the attitude that remains, however, without modification is the total seriousness in the confrontation of art, and an intact sense of the distance between its mission and its mongers. "The attitude" combines a solemnity about art with a total rejection of standard art attitudes, particularly those of the Eastern artists. Joan Brown, whose dislike of New York artists and New York art is overt: "Those New York artists. All they do is visit each other's studios and talk a lot of baloney about art."

Intensified to the point of fanaticism in this area of San Francisco painting is the hatred of art as decoration, and to this can be attributed, more than to any other single factor, the sense of honesty, vitality and promise of the second generation of the San Francisco school, as opposed to the sense of chic, facility and compromise of the second generation of the New York School. Joan Brown, at the current stage of her career, holds more promise than Michael Goldberg, for example, does at the current stage of his.

This, in spite of the fact that she is, and will be, capable of

committing some pretty horrible messes to canvas. For some-where along the line the price of a stubborn and willful dumb-ness has to be paid. The vitality, and the sense of a totally un-contaminated image that currently marks the best of her work and the work of her San Francisco contemporaries is only one side of the coin. On the other side are canvas after canvas ex-ploiting "discoveries" that were commonplace to the Fauves, enormous dislocations of scale, and inept paint handling as an alternative to decorative paint handling. Whether or not the price of total commitment to a mood is ultimately even higher than this remains to be seen.

1963

KATE STEINITZ

For some thirty years, beginning in the 1920s, the Italian immigrant Simon Rodia worked single-handedly in the Watts section of Los Angeles, creating an extraordinary architectural fantasy, with surfaces encrusted in broken bits of crockery and soda bottles and spiky, open-work steel towers silhouetted against the sky. In the 1950s, with what came to be known as Watts Towers derelict and under threat of demolition, a number of artists, critics, and curators—including Alfred H. Barr, Jr., the founding director of the Museum of Modern Art—put their prestige behind a successful campaign to save this extraordinary structure, now recognized as a homegrown invention that can bear comparison with Antonio Gaudí's great Sagrada Familia in Barcelona. Kate Steinitz (1889–1975)—who published this account of a visit with Rodia in *Artforum* in 1963—had collaborated with Kurt Schwitters on a children's book in Germany before emigrating to the United States in 1935. She settled in Los Angeles, where she became best known for her archival work at the Leonardo da Vinci Library, producing catalogues still much admired.

A Visit With Sam Rodia

At the end of the SLA* Convention, on June 2, 1961, I had scheduled a visit to Sam Rodia in Martinez. I would meet Sam for the first time, bring him presents from the Committee† and some money. I also had assembled some photographs of portraits of his heroes, Galileo, Columbus and Copernicus. I had rented a tape recorder; my hosts agreed to drive me to Martinez; young William B. Walker, Librarian of the Brooklyn Museum came along to assist me with camera and tape recorder.

We arrived at Martinez at 10:30 a.m. Not far from the center of the city we found Laird's Market, where Sam's nephew Mr. Sullivan is employed. There was a sort of shipping center with a gas station and finally Sam's house, an old wooden barrack stretching backwards from a stone facade with the sign of

*Special Libraries Association
†The Committee for Sam Rodia's Towers in Watts, formed to preserve the Towers from their contemplated demolition by the Los Angeles Building and Safety authorities. The Towers were subsequently proven to be safe.

View of the spires of Watts Towers, circa 1955.

an orthodontist. We found the side entrance from the alley. While my hosts drove on and Bill Walker deposited the presents in the next-door-appliance-shop I went ahead investigating. Over the old rotten staircase I came into a narrow drab corridor, second floor. There were numbered doors at each side, all closed and locked except one at the end. I approached this open door quickly—but it was not Sam's door. It was a toilet with a younger man sitting there peacefully, not anticipating female visitors in this man's house. I retired quickly and waited patiently. When the man had finished he approached me. I asked for Sam's room. "Door 1 and 2," said the man. But both doors were locked, No. 1 with an old padlock. Sam was not in. "You will find him," said the younger man, "he is in and out. He hangs most of the time around the gas station." When I returned to the street I saw my friends talking to an old man.

They had started taking a walk and had asked him for the way. He had answered, talking somewhat confused about world conditions. I recognized Sam, surprised to find him very small, less tall than my own five feet.

Sam stood at the street crossing next to the stop sign at the curb; small, tanned and wrinkled, apparently shrunk, because his old gray suit was hanging loose around his bones. I approached him joyfully; he smiled back so that his bad lower teeth appeared; the upper teeth were lacking. He took his old gray hat off, politely. I took his hand. "Are you really Sam Rodia?" "Yeas, Ma'm," he answered in his own cadenza on the yes. "Sam, I am one of your friends of Los Angeles, a friend of Mae, who gave you the drawing of the Towers. I come in order to bring you a few things from our friends and to tell you that we love you and admire you." He laughed: "Thank you, thank you, Lady, you should not do that." I gave him the blanket in the leatherette case; he peeped in and said: "Lady, thank you no . . . no I have blankets, no, no . . . No, no, I cannot accept this, take it back Lady." "No Sam, I can't take it back, your friends would be very angry if I would not deliver this envelope with their greetings . . . And see, Sam, I have also some pictures for you, pictures of Galileo, Copernicus and Kepler, all in one picture." (It was a photograph of Stefano della Bella's title page to the Galileo edition, 1632.) "And here is Columbus and another picture of Copernicus." "Thank you, thank you, Lady . . ." I explained that I was able to bring him these pictures because I was working with old books all day long as a librarian. "And this is Bill Walker, also a librarian." He shook hands with Bill. "You have a beautiful nice son, Lady," he said "a very nice son." We did not contradict. We did not want to confuse the issue. Bill played the son of Kate Steinitz very well. I repeated that we work all day with books and encyclopedias. Sam smiled with appreciation. He liked the fact that we were librarians. It agreed with the yarn he was spinning. He always liked to talk, and after his start with repeated "Thank yous" he talked on for 2 hours without interruption, lively, with dramatic gestures. Now and then we put a few words in to guide his talk to our special points of interest. We wanted to hear about his way of living and find out what we could do to improve it, and, if possible, we wanted his story of the origin and the making of the Towers. But any time we asked

questions or made remarks, Sam politely lifted his hat; several times he laid it down on the pavement. Making a real elegant courtesy with Italian grandezza he took up his own thread of the conversation: "Excuse me Lady, but I said before . . ." and on he went, ignoring our remarks. Sam rambled along on the same lines which we knew from Hale's and Wisniewsky's tape recordings of 1952, when they made their film. Some of Sam's sentences had remained the same, word for word.

We would have liked to see Sam's living quarters; perhaps we would take the tape recorder upstairs and sit down, talking. But Sam was not in the mood. "No, Lady, you must not see that house. I am a poor man, you should not see that." Therefore —no change of place during the two hours of conversation with Sam or rather during his two hour monologue. We three kept standing at the street crossing, the sun shining bright upon the red stop sign, upon the gray dwarf-like Sam, and upon us two librarians:

"God made them all, men and animals, monkeys and elephants, spiders and snakes; we should not kill 'em, because God made 'em. There are only two faces, black and white, and Jesus Christ was a Jew, but don't you know this? People don't want to see it. And people had only one name; now we have two names. Some are good, some are bad. You have to be good, good, good, or you are bad, bad. They live bad today; no respect, no love from children to parents; they buy machines and go away.

"A man makes money, but no pay gold. And first has to pay money to Union; else no work, no pay. Too much money to Union. And his wife gets in the family way. So he must build another room to his house. And she gets again family way: 'Papa, Papa must build another room.' And wife wants machine. So must buy machine, no save money. You do not know a man from what he makes, but what he saves. And child is born in hospital. Man should die at home, all family come, stand around, no family in hospital."

Sam goes back into history, in loose but correct sequences, though with short-cuts. I ask him where he learned all that. From the encyclopedia?

"Yes Lady, from the great English ENCYCLOPEDIA . . ."

"Sam, did you own an Encyclopedia? Did you study it in your house?"

"Ooo—Noo—Lady, I never could buy that book . . . And I read the Bible . . . they don't read the Bible now . . ."

"Sam, did you read the Bible in English or in Italian? . . . Or Spanish?"

"Lady, I do not know . . . Just the Bible . . . Cannot read no more . . . too old, bad eyes."

"But Sam can't you get eye glasses?"

"I have glasses—but no good, cannot read . . . and they don't go to church Sundays; they take machines and drive away . . ."

"Sam, are you going to church?"

"Lady, I am too old, I no go to church . . . too old. But old people live, cannot die; young virtuous men die young; mother of children die young. Bad men live. Bad women live . . . And what they wear; women wear pants, look what they wear, nothing up and nothing down, and painted face and toe nails." Sam makes a very expressive gesture to describe a very low neckline and the shortest possible skirt line.

"But you are alright, Lady . . ." He looks to see whether I am decently dressed. His eye catches my self-winding steel watch, and the glass beads around my neck.

"Lady no wear gold watch, no wear gold necklace, ladies used to wear gold."

"But Sam, this is a good self-winding watch; I never have to wind it; I like it . . ."

"But what is it—you can't sell it, or what do you get? Nothing. You can sell gold watch and gold necklace . . . But you cannot even get gold watches. I wanted to give one to my nephew; could not get gold watch."

"Woman should be the Angel of the House; not go to work, woman gets sick every month. Woman stay at home, angel of the house, can sew pretty curtains . . ." Sam talks about present-day conditions. Sam is well aware of prices, salaries, cost of living.

"Sam, how do you know all that?"

"Lady, when I was night-watchman at court, I heard the boys talk."

"Was this here in Martinez, Sam, or in Los Angeles?"

"I said it Lady, I was night-watchman . . . I heard a lot.

"Do you know Lady, Washington was an Englishman, and Lincoln was an Englishman. Many Presidents Englishmen . . ."

Sam does not admire the Roosevelts.

"The first Roosevelt ruined the United States, the second finished it up. Great men Columbus and Buffalo Bill."

"Sam, you got around a lot in the United States. Have you been East?"

And Bill Walker tells him that he is from Brooklyn.

"Yes, my son! The Great Brooklyn Bridge . . . I have seen the great Brooklyn Bridge."

I said a few words about the construction of bridges, trying to get Sam to speak of the construction of the Towers.

"Lady, when Marconi invented Telegraph, needed copper wire. You need what another man made. No copper wire—no inventing telegraph. I also needed tools, I had to buy tools. I could not build towers without tools . . ."

"Yes, Sam, we know your good tools. You impressed them into the cement of the wall."

His eyes were twinkling. For the first time he spoke of the making of the Towers.

"You built them strong, Sam, with your tools . . . But how did you start building the Towers?"

"Yes Lady, and I built them all without scaffold, just with tools."

"Sam, they say you had very good cement. What cement was this?"

I was not able to understand what Sam said about the cement; but he mumbled something on "galvanized iron," "chickenwire" and, mumbling, he starts demonstrating: his hands go gently around the signpost as if he would cover it with cement, and set it with mosaic. I try to get a picture of his hands . . .

Sam, though opposed to machines, tolerates the camera, but he does not pay much attention to it. Anytime I step back to get at least a distance of 3 feet, Sam follows me, apparently concerned not to lose a listener. Several times when he came too close, I had to hand the camera to Bill Walker, who stood in the distance from Sam.

"But how did you start the Towers?"

"Lady, this is something. I was drinking. No wife, she passed away . . . No son, no daughter. I was drinking three days and three nights. I really drank. So I started work on Towers. No more drink—just build Towers. No more, never again drink."

"Sam, why don't you come with us to Los Angeles and see the Towers well kept and standing firmly? . . . Your friends would like you to come . . . !"

Sam put his hand on his heart, in emotion, his eyes were shining.

"No, Lady, that I cannot do; I am too old, not travel; cannot see the Towers, cannot stand see Towers . . . You know I made a ceiling, all with mirrors, do you know? . . ."

"Sam, all the mirrors are there. They are very beautiful. This little hallway with the mirrors is one of my favorite spots . . . and the ship is there too. Say Sam, is this Marco Polo's ship?"

"No Lady, Columbus ship. But Columbus died with his arm and leg in chains."

And back he goes to spin his yarn; he goes in circles without any sign of getting tired.

But I am exhausted, standing two hours in the sun, on one spot. We see our friends in the distance returning from their long walk; we are getting hungry.

"Sam come on, have lunch with us."

"No Lady, no teeth, cannot eat."

"Well Sam, you can have soup . . ."

But Sam refuses firmly, with a most polite "Thank you, Lady."

He takes the leatherette case, containing the blanket and our other presents. He takes it with a firm grip and turns toward his house. Bill quickly gets the flowerpot, which he had checked in the appliance store. He presents the pink chrysanthemum to Sam. This seems to please Sam most of all. He gives us a big smile, or rather a real grin.

"Thank you my son; thank you Lady, you have a nice beautiful son."

This was the happy end of our visit.

1963

JESS

Jess (1923–2004), a California native, began studying at the California School of the Arts in San Francisco in 1949, when the school was developing its own West Coast response to Abstract Expressionism, with a faculty that included Clyfford Still. Along with his partner, the poet Robert Duncan, Jess played a critical role in the art scene in San Francisco in the 1950s and 1960s. He always marched to his own drummer, engaging with literary subjects, poetic metaphors, classical imagery, and homoerotic passions at a time when less-is-more was still holy writ among many who prided themselves on their advanced taste. The collages he called *Paste-Ups*—where images clipped from popular magazines mingle with statues of Greek gods—have a phantasmagorical power. Jess's offbeat sensibility is sometimes said to prefigure or parallel some of the interests of the Pop Artists, an association he comments on with off-the-cuff brilliance in this unpublished letter to a master's student at Iowa State.

Letter to Jerry Reilly

Dear Jerry Reilly: March 23, 1964

I usually try not to verbalize my aesthetics, so your letter blasted a week plucking away at my snarling mind. I have been admonished that this sort of engagement is good for me and will eventually lead to claritas; yet I only discover the knot to be more tenuous than it is Gordian, besides writhing where swords aren't. Thus, to remind me and you of the specific knot this letter worries, I shall recopy at the outset your proposed agenda:

1.) Do you consider "Pop Art" to be reaction against, as opposed to a continuation of the ideas expressed by the Abstract Expressionists?

2.) Which do you believe is the dominant cultural influence in this country which has led to the development of "Pop Art"?

3.) Does "Pop Art" have universal validity, or is it more exclusively American?

4.) In your opinion, which aspects of "Pop Art" will become more emphasized as this art form continues to develop?

Preface:

It would be clownish in me to talk as if I thought myself in the main swim of PopArt, its gallery and museum hoopla, nor

do I know personally other artists so calld. Just as it surprised me when the MuseumofModernArtofNewYork chose a slight piece of mine for its Assemblage survey, it was also a surprise to be alignd in Oakland's show PopArtUSA. Till then I had next to no recognition other than what is best for the artist, that is, from friends and fellow spirits. This is no sneer, for Oakland brought me to see other fellows I had not known existed. The point is that I am insistently a Romantic artist, poetic artist, who-knows-what-someday-pigeonholes-me artist; and I am sure all my paintings, paste-ups and assemblies are well-included in an intense aesthetic as such. Now, assemblage is descriptive of a technical way of building up a work and does not preclude classicism, mysticism, romanticism, etc., and it occurrd as well in earlier centuries. And although PopArt as a term is a bit more restrictive in suggesting specific image-selection, its content may be treated romantically, as Victorian circus affiche demonstrate. It is a fancy-makeup follow of the official art realm that "fine art" is reserved to what the critic's and curator's often belated recognitions spotlite. In this way do I entertain myself as PopArtist. But the fine Lichtensteins and Rosenquists that I have seen are most akin to me by virtue of their heartrending nostalgic immediacy; as I feel akin to assemblagistes Cornell and Herms in the mortality of beauty and their contemplation of epiphany.

1.) I entered the initiation of painting via abstract expressionism of 1949 and was intimately involved therewith for five years (although many of us in San Francisco in disgust with New Yorkery dialectics workd it out "nonobjectively"). Thereafter, I turnd, not exclusively, to allusive figurative development. I did not proceed in reaction to the ideas of AbsExism, nor do I think the ideas sufficiently engendering to say it was in extension of them—rather, it was that when I had explored my area of engagement (romantically), I knew what availd in the work ahead of me. I might say that I use images and symbols and signs as if they were sheer paint and color and texture, with their interrelations and progressions within the work coming as a sensitized record of fluxions and intensions produced thru themselves. But, I do not by this preclude using these elements by this process to arrive at traditional composition or any form whatsoever that carries the full force of the religious (that is to say, aesthetic) experience at the opening or the central eye.

2.) I cannot simply state a Dominant Influence by anything less than a constellation, where my paste-ups and assemblies are concernd: 1. Yes, popular art—a. at the mass-product level, often having come of Art Nouveau and De Stijl of even Bauhaus. b. or of the romantically material Victorian (both these in advertising, cartoon, illustration, objet, insignia, label, and so on). and c. that which is made in response by primitive and child artist. 2. The psychic individuation of things, hermetically presented by Dada and passionately presented by Surrealism (Schwitters, Magritte, Duchamp, Ernst, et al). 3. The intense recollection of childhood ('20s–'30s) and the child's awareness (drawing, games, toys, foods, decorations, comics, fairytale illustrations, cinema, advertizing, machines, signals . . .). 4. Likewise of adolescence ('30s–'40s) upon entering the intense conflicts of intellect, sex, war, social activities of all sorts (money and its tally, political cartoon, engineering and scientific diagram, graffiti, pulp illustration . . .). Now, where did my own consciousness first register the most of this gatherd together in a single work of art? The roadside and cityscape of Southern California. But all over the world the spawning cities and mercantile empires were making like scenes: despite any possible European pretension to a nonmercantile aesthetic, Eiffel towerd first toward nonsensical grandeur.

3.) Validity be damnd! it is false dialectic. Creation valid? destroy to create? can you value it, sell it? Again, Nationalistic Americanism! I take exception to John Coplans, who has written the best comments on PopArt that I've read. He appears to feel that the most important striving in art done in America has been the national differentiation away from European aesthetics. Neither AbsExism, Assemblage, N-Objism, nor PopArtery represents the full stream of excellence or fresh vitality in Painting done in America, and future analysis of the art record will easily reveal what names obscure, a variety of divergent painters moving everywhere to fill the reservoirs of the world-soul. PopArt named as a "Movement" is such with critics, galleries, and museums (thereafter supplied by compliant artists) insofar as they wish to trace an eddy in the river of artwork, but the codification is not moving, is not universal to the work traced. One moving universal throughout PopArt of like order to AbsExism's choice of paint-structure or to Assemblage's diverse-materials.

The focusing of the artists' eyes on popular emblems is not restricted to America or to this century! It is merely that the focus of museum-eyes is so restricted. A universality lies in the need for the "highest" form in art, the most—is in the devoted work, the spiritual record. Aestheticians must give account of the spiritual field encompassing any important artwork; they may not remain smug in an enumeration of psychologic, moral, philosophic, historic, or geographic phases. PopArt is powerful in its use of the spirit powers of the sign—for good and for evil and for sheer casting of glamours and screens—it is close to Magic then. And otherwhere, in a Puritanism almost moslem in vehemence, AbsExism is positively against an evil power that can entangle the maker of significant images, is not to be tempted to such an engagement and strife, and in pure spirit avoids the perilous magic image, rather using those aspects it deems holier, animistic and geometric, of stroke and surface and area. In both PopArt and Assemblage it is fearfully universal that most often diabolic humors are invoked. To know if they are "valid," one must exchange them oneself.

4.) To remain moving, PopArt might intensify its obvious-ness till it reaches the hermetic enigma. Open to it is even greater magnification of detail. Marvels of repetition and re-versal. A sharper address can be made to the immediate passing moment and the immediately Poppd past. Emphasis will always be on the Grand Perishable—the Billboard Ozymandias—but possibly to be refracted further in an imaginary ocular: I think of Percival Lowell's enchanting sketches of the canals of Mars, as printed in the old sunday supplement American Weekly—but under nearsighted scansion of a reading glass.

I beg you to forgive the Bad Dreams which the prolixity of this response may have invoked; the fault pertains to me, not them.

Most truly,
 Jess

ROBERT DUNCAN

The poet Robert Duncan (1919–1988) and the artist Jess, a couple for more than thirty years, were both idiosyncratic mythologists, reconciling a modern sensibility with experiences magical and mystical. While their work forms two distinct, freestanding achievements, they were also kindred creative spirits, fascinated by the interpenetrating realms of words and images; they shared a great passion for richly illustrated children's books and collaborated on some experimental volumes of their own. Jess produced elaborate posters and brochures for Duncan's readings, and one of his most engrossing paintings, *The Enamord Mage,* is a portrait of the poet. Duncan, for his part, wrote this elaborate appreciation of Jess's paintings, originally published in the 1971 catalogue of an exhibition at the Odyssia Gallery in New York. The sequence of paintings discussed here are what Jess called his *Translations,* richly impastoed compositions, many based on photographs or old scientific illustrations. Both Jess and Duncan had a taste for intricate ideas, and a reader must bear with the references to "Ex. 2" or "Figure 202." Ex, the art historian Michael Auping explains, "refers both to *example,* an illustration of a precept, as well as to the fact that Jess is an ex-scientist." (Before studying art Jess had studied chemistry and worked in the Army Corps of Engineers.)

FROM
Iconographical Extensions

THE whole sequence is a picture book, belonging then to the great primary tradition that extends from the illustrated walls of the Cro-magnon man's galleries to the emblematic and magical art of the Renaissance and the revival of enigma and visionary painting in the Romantic Movement. Its original may have been a child's coloring book, for each painting is a picture translated from a drawing, an engraving, a lithograph, or a photograph, in sepia or in black and white, into the density and color of oils. Still again, its original may have been a child's scrapbook or paste-up book, for the variety and readiness of its recognitions of what belongs. Paste-up or coloring book, the original the painter presents to us is just now coming into being in our mind out of whatever was—it is the primer of a new need in vision aroused in him by the demand of a missing beginning hidden in the disclosures of what he comes to see as his tradition.

*

His series of copies presented here belong to a larger constellation again of works in progress—romantic paintings, paste-ups, drawings and illustrations, constructions in studious play with playthings rescued from throw-aways of the world about him—in which he works to transform our household, our way of living, and beyond, to illustrate, with all the glow and depth of color, the interplay of possible forms and boundaries, and the mysteries of light and dark, our being. As, in turn, he sees his Translations as, in Translation 11, *Fig. 2 – A Field of Pumpkins Grown for Seed* (even as he has come to see the paintings of his beloved Renaissance and Romantic Movement) "grown for seed," scattered abroad in the imaginations of men to give rise to new visionary generations. Our *being,* here, is ultimately generative in picture, in continual imaginative reproduction.

*

It is important that they are copies, redundancies or visible *ideas* (where we must remember that the word *idea* comes from the verb *idein*, meaning *to see*), making visible what the painter comes to see in the process of making it visible. His relation to the visible is as immediate as he draws from what he sees in an 1895 engraving from a painting by Dvorak as Cézanne's is as he draws from Mont-Sainte-Victoire. Each is painstakingly faithful in translating what he sees into his own world of paint and color. It is important that their work is fictional; what their eyes see they translate out of sight into factors of the picture they are creating. The painting by Cézanne becomes a primer to the eye seeing the mountain. The painting by Jess becomes primary to his originals.

*

Translation 3, *Ex. 2 – Crito's Socrates,* rightly suggests to us the lead of Plato's theory of the work of art as a copy of a copy of the original; and we might recall Ben Jonson's: "It was excellently said of Plutarch, poetry was a speaking picture, and picture a mute poesy" and from his *De pictura*: "Picture is the invention of Heaven, the most ancient, and most akin to Nature. It is itself a silent work, and always of one and the same habit." Like the surrealists, Jess surrounds his pictures with texts and undermines our taking them for granted with titles that disturb

any easy sense of what we see as apparent. The Translations in
the visible world have their "originals," and their accompanying
"Imagist Texts," as Max Ernst's *Visible Poems* are introduced
by poetic propositions; and visible signs, handwriting, passages
of printed texts enter into the paintings themselves, as in the
paintings of Magritte words come into play. All the operations
of the visual field are admitted into the intelligence of the paint-
ing. The eye that sees the printed word reads the image. Puns,
tricks of translations, abound. In Translation 5, *Ex. 4 – Trinity's
Trine,* the picture of the Truth—at once of Science and of Re-
ligion—as seen in the laboratory trompe, suggests the rebus of
the trompe in *trompe-l'oeil.*

In Translation 6, *The Enamord Mage* (related in the series
3-6-9 to *Ex. 2* above) the phantasy and the glamor of the paint-
er's color takes over the real of his world. In Translation 9 in

Jess: *The Nonsense School: Translation #9,*
1965. Oil on canvas mounted on wood.

this series, *The Nonsense School*, whatever can be pictured comes into the picture. The "rules" of this universe are entirely pictorial, beyond what is visually sensible. For Jess, as for Jack Spicer, as Jess's evocation of Burgess and of Edward Lear and Lewis Carroll means to bring to our mind, phantasy and the humors of creative play beyond the boundaries of our senses—here his concern with the astral world portrayed in Lloyd's strange American novel *Etidorhpa* comes into the picture—carry important intuitions of the Real. The Real? the Irreal? the Surreal? the Subreal? The Nature of the World the Artist is at work to realize in his Creation.

*

Pli selon pli, translation leads to and from translation. But there are no established orders here, every order in the order of another order appears significantly disordered. In order that we see what *Crito's Socrates* comes to mean, we must follow the lead of the god, that will bring us along our way to the picture of the Beatles as the Jumblies, copied from the Bubblegum card. Fold according to fold, we must hold in one habit a conglomerate of ideations: the recognition of a divine informing world of images that moves the picturing artist, the recognition of the creation emerging as he works as a world to which he is faithful, the free play of fictions potential in each realization in which each work of art is a seed of art.

*

The "abstract expressionists" or "action" painters—particularly here Clyfford Still, Edward Corbett, and Hassel Smith, who were his teachers in the West in his school days—created a new iconography that continues to be relevant to the language of the later painting. The vocabulary of color and mass, of texture and of the actual activity of painting, became paramount in the intention of the painter; he sought to picture in the painting the process of the painting's realization. A picture of painting itself emerged, no longer to be taken merely as the medium of images but as an immediate presentation. The eye disturbed began to see that beyond representational meanings, beyond symbolic figures, beyond the psychological readings of the organization of the canvas, the very process of painting was itself a primary

meaning from which structures of various meaning were built up. What had been taken before to be an "effect" was seen now to be an "event."

*

So, in Jess's painting, we are led to see, permeating the world of representations that meet our eyes, the primary world of actual paint and of the painter's work in painting out of which his representations rise. We are immediately aware of the underlying layers of paint. At the interstices minute flickers of earlier periods in the painting are active where between continents, states, localities of surface areas, they are exposed. Under the skin of surface paint, globs of thickened pigment are brought into the play of the process, so that everywhere in the layers of illusion and illustration arising from the visual syntax of color and mass, of boundary and reference, the painter pictures the painting itself.

*

"Abstract" for the American movement in the late 1940s was a misnomer, for the terms were not so much *drawn from* a reality as *creative of* a reality. "Action" painting, a field of creative activity, working *with* what happened and *in* its happening, an art of recognitions and participation—the force of the great painting of the generation preceding Jess's work was to present the experience of the immediate act of the painting itself.

"Expressionist" intentions in which the techniques of the artist, his architectures and equilibrations of the picture, are still media of something behind the painting to be communicated, passed into initiatory intentions in which the painting became itself the ground of a primary revelation. The painting as the medium of the painter's experience of the world, either then *impressionistic* (conveying how he saw the world) or *expressionistic* (conveying how he felt about the world) remained; but now the painting as an immediate event of a world come into play. A Still or a Corbett in the fanaticism of their turning against a representational play, striving to banish from the field as they worked every activity in which the potentiality of images arose to their eye, found themselves confronted by the image of the painting itself. Whatever else it might succeed in avoiding— the world of angels or of men, of mountains or of blue—the

painting represented the world of paint. For some—indeed, for many—the world of paint was less real than the world of angels or of men, of flowers or of mountains. For such too, it seems outrageous that a poem should have to do with the very process of its own creation. Sing love, sing ocean, sing peace or war, but do not sing of Song!

But in the complex world of vision, when we are looking at a painting, though a two-fold, a three-fold, a four-fold field of realities may emerge, extensions of visual language in which the full range of man's experience may come into play, there is but one ground of that play and that is the primary ground of the action painters, the properties of the canvas and the oils as they give rise to recognitions in the creative will. In the master generation of the action painters, the creative will had returned to affirm the primacy of that creativity itself over all representations. And, acknowledged in the ever-active presence of the paint in the picture, that primacy remains an important principle in Jess's work.

PUNS, RHYMES, AND MULTIPHASIC ORGANIZATIONS

A pun is an element that sets into motion more than one possibility of statement. This brush-stroke at once appears as a member of the painter's language of painting—we see it as a statement of the act of painting, or as a statement of paint—and as a member of the image of a foot. In Celtic design, ground is everywhere possibly figure; figure, ground. In a field of interacting melodies a single note may belong to both ascending and descending figures, and, yet again, to a sustaining chord or discord. A rhyme is a member in whose force of identity we remark—remember or anticipate—the presence of another member. In composition by field, a color does not glow in itself or grow dim, but has its glow by rhyme—a resonance that arises in the total field of the painting as it comes into that totality. The "completion" of the painting is the realization of its elements as "puns" or "rhymes." The painter works not to conclude the elements of the painting but to set them into motion, not to bind the colors but to free them, to release the force of their interrelationships.

*

What was once thought of as a tradition, a doctrine of images handed across from Egypt, Babylonia, the Semitic and Grecian world, into the Hellenistic, and from the Hellenistic revived in the Renaissance as its treasury; or what in our time has been proposed as a dialectic of styles—as Picasso, for instance, presented a mimesis of historical styles and destruction of styles as the drama of his work—in Jess's imagination is neither linear nor directional but pervasive. Each element is present in and informs every other element—in the time of Man, as in the individual canvas. To see the face rightly, one must see the skull in the face; to see the skull rightly, one must see the face. Likewise texts and images are members of one operation: the picture is "translation," the word is "imagist," for the mind that addresses the whole of human meanings toward which the arts point. The word imagines; the painting speaks. And in turn, the word refers to a series of texts, as the painting refers to a series of visual events in time.

*

The immediately apparent series of Figures 1 thru 8 with the propositional Figure 202 and Examples 1 thru 7 should suggest that Jess's Translations series is built up of cross-series. "Fig." may mean Figment as well as Figure or, mindful of the insistence upon pun and upon nonsense, it may mean that the artist does or does not give a *fig* to or for art; as "Ex." may mean "X" or "Ex-" as well as Example. In the sequences of the paintings chronologically arranged, the serial relationships become more complex, cross-patternings appear where we begin to realize we have to do in seeing with the play of visual humors. In painting we see by the tricking of a surface in lights and darks that arise entirely in the interplay of colors, depths and heights that float upon the skin of the canvas, and Jess brings into this interplay a wide range of dictions and contradictions to keep us aware of the world of paint alive in the world of image, a grammar of purely visual depths and heights orchestrated by actual depths and heights of paint, embedded figures and raised backgrounds, conglomerations of pigment that catch actual light and cast actual shadows, thus bringing the activity of the medium into the illusion it is to carry at the visual skin in which the painter's

art has cast its own spell of light and dark. The activity of the translation is now itself a text to be translated, the terms of the magic translated into the surface of the spell it casts.

*

The play with the terms of the painting extends throughout his concept as he works; he means to release in full the elements of his world into potential meanings. "Figures" are not only elementary terms of the visual gestalt, where the eye reads potentialities of figure and ground in order to apprehend the plastic intent of the artist, but "figures" are also numbers, and where there are numbers given, we might be aware that color and area have in turn their own numbers in sequences, in proportions and ratios, in which there arise rhyme and reason, melody and harmony, disjunction and possibilities of discord, in the composition of the canvas. The play of number is the secret of the music of painting as well as of poetry and the organizations of music proper.

In *The Nonsense School*, figures of the painting are doing their figures: the figure 8 (the number which also appears on the back of the player, the Son of Art, whom we see facing the Lords of Xibalba in *Montana Xibalba*) appears on its side in the figure beyond figuring—the formula for the square root of minus infinity written on the blackboard. Is this nonsense proposition of some time/space, the proposition of the time/space of the world of the painting, the entirely *created* time and space of the merely seen? In *Ex. 6 – No-Traveller's Borne*, Jess refers to a "scientific" plate, which, illustrating no known earth in no known space, and, further, no possible earth in no possible space, is a found nonsense object, supposedly showing actual cosmos but actually showing the cosmos of the space and time we know only in the terms of its being painted, having the reality of the fictional. Where Jess allies himself clearly with the grand masters of phantasmal nonsense that arise in the nineteenth century in the genius of the Romantic Movement—with Edward Lear and Lewis Carroll, as, in his translation of the *Galgenlieder* he allied himself with Christian Morgenstern—the modality of the picture is everywhere problematic. It is essential that the figure is absolutely what it appears: it is pictorial, but it is not only pictorial, it is a happening of the painting, but it is also

an element in the mode of the picture as rebus. It belongs to a playful nonsense, but this play, like the play in *Alice in Wonderland*, has everywhere a momentous, hallucinatory aura. Its playground the artist reminds us is the playing field of Xibalba. It is in this dimension, in the modality in which art and death confront each other, that the ultimate instrumentality of art is revealed to be a trick or joke, but this is a trick or a joke that is essential to the nature of man's life. The pun—the lowest form of humor—the oracular double-speak in spelling and grammar, the way of telling the truth in what seems to be all an illusion or lie, this is the secret of man's game with the demonic powers. "Remember too," Jess adds, "I configure-eight." The set of Translations and their Imagist Texts as they are presented in this show in this complex game of associations, in which the paintings are cards, the arcana of an individual Tarot, a game of initiations, of evocations, speculations, exorcisms, may be related to the field of dream and magic in art which we inherit in the tradition of the Surrealists. A play at once sinister and rightful, like Lewis Carroll's play with words, but here, a play with the properties of paints and picturing.

1971

H. C. WESTERMANN

H. C. Westermann (1922–1981) studied at the School of the Art Institute of Chicago, and his enigmatic wood constructions exude a funky humor that has come to be associated with a number of artists who at least for a time lived or worked in Chicago, including Jim Nutt, Roger Brown, and Ed Paschke. Westermann's offbeat inventions owe much to the dreams and conundrums of the Dadaists and the Surrealists, but he brings his own brand of homespun weirdness to these exquisitely crafted boxes and chests. The voice in Westermann's correspondence, collected after the death of this poker-faced humorist, suggests the laid-back matter-of-factness of a man who knows his way around a power tool. (The letters are addressed to his sister Martha and her husband, Mike Rammer, and to his dealer Allan Frumkin. The "Joanny" referred to in the first letter is his wife, the artist Joanna Beall.)

Three Letters

April 27, 1964

Dear Martha and Mike:

We received your fine letter + are always glad to hear from you. Thanks. Things sound very normal there. I'll bet you will be glad when the house is finished. That sure has been a big job. This (*referring to illustration in the right hand margin*) is a huge willow tree down in the field from our cottage + it is very yellow now + soon the leaves will become green. They are beautiful trees but are not very structural. Last fall a wasp became trapped in my shop + I kept him alive all winter by feeding him sugar water + then a couple of weeks ago when the weather got warmer, he got the call + left. I think this was quite amazing. He actually got to know me + look for his sugar water, + we became great pals. But he had to go. And I could get very near him + he never minded. Joanny sold a fine piece of hers to a very good collector in N.Y. It was a beauty. We are looking for a large covered truck now and intend to move out there sometime this summer probably. We hope. We have just about "run out of gas" here. We still have a little more work however + then packing. You know. How are the artist kids? I love their drawings you know. Joanny has been some wonderful

paintings lately. I think she is one of the finest artists in the country. I sure love that girl + we are also great pals, + have so much fun together. And she's a terrific sculptor.

You know the N.Y. art scene is about the phoniest thing there is. Its a joke + its fantastic how many of them "pirate" from other artists. In Chicago in 1954 I had a terrific technical problem with a piece I was working on + I was very broke. I had some beautiful ¾" maple shelves that I had gotten from a carpentry job I had. Well I devised my system of laminating + solved my problem + from this technique I developed + finally went on to laminating ¾" plywood + for very good reasons. Well since then in the N.Y. art magazines I have read articles by artists about how they invented laminating + since 1960, ha ha. But these people, + I have seen their work, have never used it right. They use it decoratively which is horrible. So that's the way it works. I have never stolen from another artist + if I had I would certainly give the artist credit.

And then you have the cheap gossip amongst the artists + critics that is devastating—literally horrible lies. Oh boy this is really vicious. Last year I had (a very bad) critic call me a has been "playboy." For some reason this guy hates me + I've never met him. Joanny + I work constantly + go to a party about once a year. This is a joke. These critics love to attack you personally (which has nothing to do with your work). Its horrible!! My own work + destiny I can control but these horrible politics + "brown nosing" + gossip is beyond me. I hate it. Well this is about the size of it. They all attend too many parties and don't work. Well all my love anyway + I think of you.

<div style="text-align: right">Love,
Cliff</div>

<div style="text-align: right">February 17, 1965</div>

Dear Allan:

I received your good letter + appreciate your writing. I'm glad things are going well & Maryan's show is underway. I'd like to see it. He's a real fine artist. I sure like him & his wife. They have been very nice to us. I don't think I ever thanked you for January's check. I did receive this month's check too + wish to thank you for both of them. And appreciate you trying

to get them here earlier. I know you're constantly harassed &
ole Cliff doesn't like to add to it, Allan, + hound you. I really
hate that. I know you try your damndest. I'll let you be the
judge on sending these new ones to England—You know what
you're doing. However:

#1—I don't like England (or *France*) in relationship to Art, etc.

#2—By the time you get these back they will be beat up + dirty
+ of course they won't all be there (they should all be shown to-
gether, as they are closely related + each is an outgrowth of the
proceeding one. For instance all the round ones are suns, of a
sort I think—& one missing from the group wouldn't be right.

#3—I am an *American* artist + don't give one God damn about
the international scene (which is pretty weak in general).

#4—I think this direction + form I am following is a good
one + I believe it's honest. By the time, when + if you showed
these, I think other artists in N.Y. would be trying the same.
You know how many N.Y. artists imitate a form or technique
etc. + steal from others no matter whether it's good or bad.
Let's face it.

I have a lot of pride in my work—it's not like the other artists'
work + I don't want it to be. I want it to be mine (or something
of the spirit, maybe something a hell of a lot better + of a higher
order than me). I don't think I'm precious or that my work is
"above" showing in England—that's not the point. Or whether
I like England or France or Switzerland (they did make the
cuckoo clock though).

Now you mentioned what happens in the next couple of
months. (Oh yeh when I say my work is not like the other
artists—I don't mean to intimidate their efforts, as there are a
lot of very fine "other" artists). Well now I think the way these
are developing + they are "swinging" I think I am good for four
or five more months of these. I'm just coming into my own now
+ am really excited with them + they are larger now. These last
two are 20" × 30" solid mahogany pieces (not glued up either)
+ they are beautiful. It's next to impossible to draw these as the
reliefs look + have an entirely different feeling. Now supposing
I sent these 12 reliefs off to England—It would be like starting
again. I need the ones I've done to study (very important) +
the more I have the more good I get out of studying them. I
know this must be hard for you to understand.

These things are very introspective + meditative + the thought

of splitting them up until I am finished with this series is very revolting. As a consequence each new one is really a revelation + exciting. For instance I've been studying #1, #2, + #3 + it's helped me with #11. You see I learn from my own efforts + not somebody else's. Even the size is related to the proceeding one. I'm not saying if you sell these they should all go together—that's not it (however one is a triptych).

And I do not want to have to work on these with the idea of "hurry, hurry, hurry, remember the London show." I have been working long + hard but it's been exciting + not under pressure. Well ole Allan I'm an odd duck aren't I? But I do love you guys anyway + I'm not trying to tell you what to do. I sure love ole Dennis!

Sincerely, Cliff

———————

Dear Allan:

This is the 14th
one + is carved
out of a solid piece
of Hon. Mahogany 20×20
" thick — The title
"Manifesto of the
GREAT SOCIETY". It
turned out real good +
the carving is really
paying now. Oh
— I heard
that "music" Allan!

The last one:
the women from
"Angel Island", you know, the one with the arrow, is finished too.
I've found that carving does not have to be carving
in the conventional sense + I can see it is an
completely unlimited technique or direction, as you will —
the real possibilities have only been scratched at. These
have been exciting ones + of course the later ones are
a better expression than the early ones (mine I mean)
I failed to mention that I made
two small pieces (3 dimension) as I did the
carvings: one is a teak wood ship (an extension of
those I did in Chicago + its a good one.

②

I don't know how this came about after so many years but I had this strong desire to do it. And the other one is called "THE SLOB" —

The colors of this piece are beautiful & the piece seems to work — I've been studying it off and on for weeks now.

I am going to let the carvings go for a while now & do two fairly large pieces (in the round) that I have been planning & am ready to go on.

It seems that the grocery store next door discards wooden boxes every day (good ones) & I have been trying to figure, ever since we came, what I could use them for. Finally I got it & hence they will be used in one of these two pieces (hundreds of them)

Its a fantastic idea & the piece will take weeks to make. Well Allen ole friend —

I realize this is strictly an "I", "I", "I" letter & I apologize — However I've never been so excited working — Things are "selling" now. Tell Dennis we sure loved his fine letter & say hello to Frankie boy.

Say Hello to Jean!

↑ REAL
HAMMER —
A "CHEAP"
ONE

22"
"TA HELL
WITH FACILITIES"

SOLID
ALUMINUM
(The metal
nut that "god
damned sculp-
metal")

THE SLOB
H.H. WESTERMAN

ROBERT ROSENBLUM

The art historian Robert Rosenblum (1927–2006) brought to his studies of twentieth-century art a mind deeply attuned to the classical and romantic strands in eighteenth- and nineteenth-century art, which were the subject of his most important book, *Transformations in Late Eighteenth Century Art* (1967). In "The Abstract Sublime," published in *Art News* in 1961, Rosenblum rejected a purely formal interpretation of the work of Pollock, Rothko, and Newman, arguing that Abstract Expressionism owed more than had heretofore been acknowledged to the ecstatic nature poetry of nineteenth-century landscape painting. This iconographic reading of the Abstract Expressionists—which Rosenblum expanded in a 1973 book, *Modern Painting and the Northern Romantic Tradition*—has proven both immensely influential and enduringly controversial.

The Abstract Sublime

"IT's like a religious experience!" With such words, a pilgrim I met in Buffalo last winter attempted to describe his unfamiliar sensations before the awesome phenomenon create by seventy-two Clyfford Stills at the Albright Art Gallery. A century and a half ago, the Irish Romantic poet Thomas Moore also made a pilgrimage to the Buffalo area, except that his goal was Niagara Falls. His experience, as recorded in a letter to his mother, July 24, 1804, similarly begged prosaic response:

> I felt as if approaching the very residence of the Deity; the tears started into my eyes; and I remained, for moments after we had lost sight of the scene, in that delicious absorption which pious enthusiasm alone can produce. We arrived at the New Ladder and descended to the bottom. Here all its awful sublimities rushed full upon me. . . . My whole heart and soul ascended towards the Divinity in a swell of devout admiration, which I never before experienced. Oh! bring the atheist here, and he cannot return an atheist! I pity the man who can coldly sit down to write a description of these ineffable wonders: much more do I pity him who can submit them to the admeasurement of gallons and yards. . . . We must have new combinations of language to describe the Fall of Niagara.

Moore's bafflement before a unique spectacle, his need to abandon measurable reason for mystical empathy, are the very ingredients of the mid-twentieth-century spectator's "religious experience" before the work of Still. During the Romantic movement, Moore's response to Niagara would have been called an experience of the "Sublime," an aesthetic category that suddenly acquires fresh relevance in the face of the most astonishing summits of pictorial heresy attained in America in the last fifteen years.

Originating with Longinus, the Sublime was fervently explored in the later eighteenth and early nineteenth centuries and recurs constantly in the aesthetics of such writers as Burke, Reynolds, Kant, Diderot, and Delacroix. For them and for their contemporaries, the Sublime provided a flexible semantic container for the murky new Romantic experiences of awe, terror, boundlessness, and divinity that began to rupture the decorous confines of earlier aesthetic systems. As imprecise and irrational as the feelings it tried to name, the Sublime could be extended to art as well as to nature. One of its major expressions, in fact, was the painting of sublime landscapes.

A case in point is the dwarfing immensity of Gordale Scar, a natural wonder of Yorkshire and a goal of many Romantic tourists. Re-created on canvas between 1811 and 1815 by the British painter James Ward (1769–1855), *Gordale Scar* is meant to stun the spectator into an experience of the Sublime that may well be unparalleled in painting until a work like Clyfford Still's. In the words of Edmund Burke, whose *Philosophical Enquiry into the Origin of Our Ideas of the Sublime and the Beautiful* (1757) was the most influential analysis of such feelings, "Greatness of dimension is a powerful cause of the sublime." Indeed, in both the Ward and the Still, the spectator is first awed by the sheer magnitude of the sight before him. (Ward's canvas is 131 × 166 inches; Still's, 114½ × 160 inches.) At the same time, his breath is held by the dizzy drop to the pit of an abyss; and then, shuddering like Moore at the bottom of Niagara, he can only look up with what senses are left him and gasp before something akin to divinity.

Lest the dumbfounding size of these paintings prove insufficient to paralyze the spectator's traditional habits of seeing and thinking, both Ward and Still insist on a comparably bewildering

structure. In the Ward the chasms and cascades whose vertiginous heights transform the ox, deer, and cattle into lilliputian toys are spread out into unpredictable patterns of jagged silhouettes. No laws of man or man-made beauty can account for these God-made shapes; their mysterious, dark formations (echoing Burke's belief that obscurity is another cause of the Sublime) lie outside the intelligible boundaries of aesthetic law. In the Still, Ward's limestone cliffs have been translated into an abstract geology, but the effects are substantially the same. We move physically across such a picture like a visitor touring the Grand Canyon or journeying to the center of the earth. Suddenly, a wall of black rock is split by a searing crevice of light, or a stalactite threatens the approach to a precipice. No less than caverns and waterfalls, Still's paintings seem the product of eons of change; and their flaking surfaces, parched like bark or slate, almost promise that this natural process will continue, as unsusceptible to human order as the immeasurable patterns of ocean, sky, earth, or water. And not the least awesome thing about Still's work is the paradox that the more elemental and monolithic its vocabulary becomes, the more complex and mysterious are its effects. As the Romantics discovered, all the sublimity of God can be found in the simplest natural phenomena, whether a blade of grass or an expanse of sky.

In his *Critique of Judgment* (1790) Kant tells us that whereas "the Beautiful in nature is connected with the form of the object, which consists in having boundaries, the Sublime is to be found in a formless object, so far as in it, or by occasion of it, *boundlessness* is represented" (I, Book 2, §23). Indeed, such a breathtaking confrontation with a boundlessness in which we also experience an equally powerful totality is a motif that continually links the painters of the Romantic Sublime with a group of recent American painters who seek out what might be called the "Abstract Sublime." In the context of two sea meditations by two great Romantic painters, Caspar David Friedrich's *Monk by the Sea* of about 1809 and Joseph Mallord William Turner's *Evening Star*, Mark Rothko's paintings reveal affinities of vision and feeling. Replacing the abrasive, ragged fissures of Ward's and Still's real and abstract gorges with a no less numbing phenomenon of light and void, Rothko, like Friedrich and Turner, places us on the threshold of those shapeless infinities

discussed by the aestheticians of the Sublime. The tiny monk in the Friedrich and the fisher in the Turner establish, like the cattle in *Gordale Scar*, a poignant contrast between the infinite vastness of a pantheistic God and the infinite smallness of His creatures. In the abstract language of Rothko, such literal detail—a bridge of empathy between the real spectator and the presentation of a transcendental landscape—is no longer necessary; we ourselves are the monk before the sea, standing silently and contemplatively before these huge and soundless pictures as if we were looking at a sunset or a moonlit night. Like the mystic trinity of sky, water, and earth that, in the Friedrich and Turner, appears to emanate from one unseen source, the floating, horizontal tiers of veiled light in the Rothko seem to conceal a total, remote presence that we can only intuit and never fully grasp. These infinite, glowing voids carry us beyond reason to the Sublime; we can only submit to them in an act of faith and let ourselves be absorbed into their radiant depths.

If the Sublime can be attained by saturating such limitless expanses with a luminous, hushed stillness, it can also be reached inversely by filling this void with a teeming, unleashed power.

J.M.W. Turner: *Snowstorm*, 1842. Oil on canvas, 36 × 48 in.

Turner's art, for one, presents both of these sublime extremes. In his *Snowstorm*, first exhibited in 1842, the infinities are dynamic rather than static, and the most extravagant of nature's phenomena are sought out as metaphors for this experience of cosmic energy. Steam, wind, water, snow, and fire spin wildly around the pitiful work of man—the ghost of a boat—in vortical rhythms that suck one into a sublime whirlpool before reason can intervene. And if the immeasurable spaces and incalculable energies of such a Turner evoke the elemental power of creation, other work of the period grapples even more literally with these primordial forces. Turner's contemporary John Martin (1789–1854) dedicated his erratic life to the pursuit of an art which, in the words of the *Edinburgh Review* (1829), "awakes a sense of awe and sublimity, beneath which the mind seems overpowered." Of the cataclysmic themes that alone satisfied him, *The Creation*, an engraving of 1831, is characteristically sublime. With Turner, it aims at nothing short of God's full power, upheaving rock, sky, cloud, sun, moon, stars, and sea in the primal act. With its torrential description of molten paths of energy, it locates us once more on a near-hysterical brink of sublime chaos.

That brink is again reached when we stand before a *perpetuum mobile* of Jackson Pollock, whose gyrating labyrinths re-create in the metaphorical language of abstraction the superhuman turbulence depicted more literally in Turner and Martin. In *Number 1A, 1948* we are as immediately plunged into divine fury as we are drenched in Turner's sea; in neither case can our minds provide systems of navigation. Again, sheer magnitude can help produce the Sublime. Here, the very size of the Pollock —68 × 104 inches—permits no pause before engulfing; we are almost physically lost in this boundless web of inexhaustible energy. To be sure, Pollock's generally abstract vocabulary allows multiple readings of its mood and imagery, although occasional titles (*Full Fathom Five, Ocean Greyness, The Deep, Greyed Rainbow*) may indicate a more explicit region of nature. But whether achieved by the most blinding of blizzards or the most gentle of winds and rains, Pollock's work invariably evokes the sublime mysteries of nature's untamable forces. Like the awesome vistas of telescope and microscope, his pictures leave us dazzled before the imponderables of galaxy and atom.

The fourth master of the Abstract Sublime, Barnett Newman,

explores a realm of sublimity so perilous that it defies comparison with even the most adventurous Romantic explorations into sublime nature. Yet it is worth noting that in the 1940s Newman, like Still, Rothko, and Pollock, painted pictures with more literal references to an elemental nature; and that more recently, he has spoken of a strong desire to visit the tundra, so that he might have the sensation of being surrounded by four horizons in a total surrender to spatial infinity. In abstract terms, at least, some of his paintings of the 1950s already approach this sublime goal. In its all-embracing width (114½ inches), Newman's *Vir Heroicus Sublimis* puts us before a void as terrifying, if exhilarating, as the arctic emptiness of the tundra; and in its passionate reduction of pictorial means to a single hue (warm red) and a single kind of structural division (vertical) for some 144 square feet, it likewise achieves a simplicity as heroic and sublime as the protagonist of its title. Yet again, as with Still, Rothko, and Pollock, such a rudimentary vocabulary creates bafflingly complex results. Thus the single hue is varied by an extremely wide range of light values; and these unexpected mutations occur at intervals that thoroughly elude any rational system. Like the other three masters of the Abstract Sublime, Newman bravely abandons the securities of familiar pictorial geometries in favor of the risks of untested pictorial intuitions; and like them, he produces awesomely simple mysteries that evoke the primeval moment of creation. His very titles (*Onement, The Beginning, Pagan Void, Death of Euclid, Adam, Day One*) attest to this sublime intention. Indeed a quartet of the largest canvases by Newman, Still, Rothko, and Pollock might well be interpreted as a post–Second World War myth of Genesis. During the Romantic era, the sublimities of nature gave proof of the divine; today, such supernatural experiences are conveyed through the abstract medium of paint alone. What used to be pantheism has now become a kind of "paint-theism."

Much has been written about how these four masters of the Abstract Sublime have rejected the Cubist tradition and replaced its geometric vocabulary and intellectual structure with a new kind of space created by flattened, spreading expanses of light, color, and plane. Yet it should not be overlooked that this denial of the Cubist tradition is not only determined by formal needs, but also by emotional ones that in the anxieties of

the atomic age suddenly seem to correspond with a Romantic tradition of the irrational and the awesome as well as with a Romantic vocabulary of boundless energies and limitless spaces. The line from the Romantic Sublime to the Abstract Sublime is broken and devious, for its tradition is more one of erratic, private feeling than submission to objective disciplines. If certain vestiges of sublime landscape painting linger into the later nineteenth century in the popularized panoramic travelogues of Americans like Bierstadt and Church (with whom Dore Ashton has compared Still), the tradition was generally suppressed by the international domination of the French tradition, with its familiar values of reason, intellect, and objectivity. At times, the counter-values of the Northern Romantic tradition have been partially reasserted (with a strong admixture of French pictorial discipline) by such masters as van Gogh, Ryder, Marc, Klee, Feininger, Mondrian; but its most spectacular manifestations—the sublimities of British and German Romantic landscape—have only been resurrected since 1945 in America, where the authority of Parisian painting has been challenged to an unprecedented degree. In its heroic search for a private myth to embody the sublime power of the supernatural, the art of Still, Rothko, Pollock, and Newman should remind us once more that the disturbing heritage of the Romantics has not yet been exhausted.

1961

SIDNEY TILLIM

Beginning in the late 1950s, the painter and critic Sidney Tillim (1925–2001) produced a rich and paradoxical body of criticism, little known today. While Tillim's complex and divided sympathies have made him a difficult figure to keep in focus, the reach and variety of his writing were symptomatic of the fast-paced developments of the 1960s, when modernism was giving way to a variety of postmodernisms. As an artist, Tillim moved back and forth between abstraction and representation and more and less painterly approaches. In his writing, although he became known for his forceful defense of a return to realism in the 1960s, he somehow combined an admiration for Greenberg's razor-sharp modernist arguments with an avidity for photographic history and a keen eye for popular culture.

Month in Review, January 1962

THERE probably hasn't been anything like it in New York since the Van Gogh exhibition of 1949–50, and for popular curiosity and cumulative newspaper coverage I would not be surprised if we had to go all the way back to 1913 and the Armory Show to equal it. I am referring of course to the remarkable concatenation of exhibitions at the Metropolitan Museum of Art and the Museum of Modern Art since the end of November which—attracting thousands of visitors, some of whom apparently did not know one museum from the other—sent attendance records soaring at both institutions. A $2,300,000 wink at the auction of the Erickson collection by the Metropolitan's director, James J. Rorimer, brought Rembrandt's *Aristotle Contemplating the Bust of Homer* to the museum's Great Hall—plus 86,770 visitors in just one four-hour day, Sunday, November 26. It is reasonable to suppose that such overflow attendance may have contributed to the substantial crowds which found their way upstairs and through a labyrinth of galleries to the other special exhibition in residence, "101 Masterpieces of American Primitive Painting," which had been installed on November 17 prior to a three-year national tour.

Meanwhile, the Museum of Modern Art swept to a new one-day attendance record on November 19 (also a Sunday),

Crowds viewing Rembrandt's *Aristotle Contemplating a Bust of Homer* at the Metropolitan Museum of Art in November 1961.

when over 6,300 visitors descended upon it to view the twelve stained-glass windows which Marc Chagall has designed for a synagogue in the new Hadassah-Hebrew University Medical Center in Jerusalem—a commission from Hadassah, the Women's Zionist Organization of America. The side attractions at this time happened to be "The Last Works of Matisse" (a group of stupefyingly magnificent colored-paper cut-outs) and fifty-eight studies for the Dartmouth murals by the late José Clemente Orozco. It was inevitable that in the excitement an oversight might be committed. For much to its mortification, the Modern learned—on the forty-seventh day of the Matisse exhibition—that *Le Bateau*, a sailboat and its reflection represented by two wedges of blue, had been hanging upside

down all that time. No less mortified probably were the ladies who asked the guards at the Metropolitan where the Chagall windows were or the lady at the Modern who turned to her friends, stuck her hands on her hips under her coat and said, "So where's the famous Rembrandt?"

If great throngs of ladies made it difficult to see the Chagall windows on two successive visits, the installation of the exhibition did not help matters either—through no fault of René d'Harnoncourt, director of the museum who designed it. He apparently had to take what space was available, and it turned out to be the walls above the staircase between the second and third floor, with sketches occupying a narrow corridor that led into a room much too small for the last three or four windows. It was impossible to see a single window in its entirety, and where there was room to back up, a wall or skyline of human bodies cut off a part of one window or another. It is my understanding, however, that the museum originally intended to install only four windows—incidentally, they were all illuminated from behind with fluorescent lighting—but Chagall objected, perhaps rightly so since the Hadassah ladies had a right to see the entire commission. (Chagall received only his expenses.) But it meant that there was no scale in the exhibition remotely comparable to what the windows will project *in situ,* in a low tower over the synagogue area.

Each of the twelve windows symbolizes one of the twelve tribes of Israel. Chagall took as his text the forty-ninth chapter of Genesis and the thirty-third chapter of Deuteronomy and, observing the Biblical injunction against human images, confined himself—with the exception of the green and red hands of Jacob blessing Issachar—to animal, vegetable, architectural and celestial symbolism. The arrangements are utterly lacking in hieratic quality, with birds, fishes, torahs, menorahs, flowers and Hebrew words trapped by dikes of lead which, rather than clarifying the masses and rhythms of the composition, give a disconcerting effect of craquelure, especially in the negative areas. Generally a single color prevails in each window, such as blue in *Reuben,* yellow in *Levi,* red in *Judah,* and so on, even though Chagall chose more than fifty colors to work with and retouched them considerably by hand before they were

fired a second time. I hesitate to attribute the dilute quality of the color to modern technology as compared to medieval craftsmanship. In recent years Chagall's sense of color has lost much of its brilliance, just as his sense of fantasy has hardened into a process (his Bible etchings are a significant exception). I believe, indeed, Chagall depended too much on color, which in the absence of figural hierarchy is either splotchy or uncertain of its dimension. Areas of comparative opacity contrast with those of translucency, where the overpainted detail surrenders its cumulative textural weight to admitted shafts of illumination. And if Chagall attempted to adjust his imagery to the frontal requirements of stained glass, his desire for tonal color was a contradiction.

In short, Chagall's major formal miscalculation was an attempt to achieve a painterly equivalent in stained glass—which also relates to his failure to achieve a sufficient degree of abstraction. The evidence of the final gouache sketches which are shown with an earlier series of preparatory studies supports my thesis since they show a distinct conflict between textual, hierarchical and aesthetic prerogatives. It just may be impossible to create an organically sound stained-glass window today when art is dominated by secular considerations.

Because of these secular ambitions, a certain obscurity necessarily confounded one's efforts to get at the symbols. We are simply unaccustomed today to seek out the arcane significance of fishes and wolves, especially when they are from the hand of an artist to whose sense of the irrational they have always been attributed. In fact, according to a conservative rabbi who was acting as a guide for his adult study group from Connecticut, Chagall had implemented textual directions with symbols of his own—something that would have been unimaginable in the Catholic Middle Ages, where even Beauty was dedicated to the greater glory of God. It is only when we permit external factors to affect our perceptions, when we recognize that the taint of secularism hovering in Chagall's windows and the barely suppressed nationalism of the Hadassah commission make common cause for the meaning of Israel as a Jewish state to the Jewish people, that we can set our scholasticism aside and recognize these windows—whatever failures they present as art—as a valid symbol of the endurance of the children of Abraham.

If Chagall has struggled with uncertain conventions, Matisse worked with the certainty of those he had established all by himself. His paper murals and figures are unique in the history of modern art. They represent at once the distillation and apotheosis of a lifelong theme (the female figure), a lifelong goal (that of giving pleasure) and a lifelong faith (color).

Virtually all of these more than forty "last" works were completed between 1950 and 1954. Matisse finished his design for a rose window for the Union Church of Pocantico Hills (New York) just a few days before his death on November 3, 1954. It helps, I think, to know that Matisse in his final years was confined either to his bed or a wheel chair, for his physical immobility seems to have inspired a monumentality, an exuberance and even an affirmation that doubtlessly enabled him to forget his infirmity. The exhibition included designs for murals, stained-glass windows and church vestments. Selected by Monroe Wheeler, Director of Exhibitions and Publications, who also wrote the text for one of the most visually impoverished of the museum's catalogues in years, most of these designs came from European collections and were seen for the first time in this country.

Matisse cut directly into specially gouache-tinted papers with scissors. He said, "Cutting colored papers permits me to draw in the color. For me, it is a matter of simplification. Instead of establishing a contour, and then filling it in with color—the one modifying the other—I draw directly in the color." And so he did. The results were a series of dancing, diving, seated and posing maidens; exotic floral motifs; purely abstract designs of crisp, overlapping planes of vibrant color; and frankly decorative friezes of stylized plant motifs—all of which will keep layout artists and decorators supplied with ideas for years to come. But what really makes them impressive is their scale. A design for a wall ceramic, *The Swimming Pool,* measures over seven feet in height and is a quarter-inch short of being fifty-four feet long. And it works—because it projects its relationship to architecture immediately. Blue figures swoop and leap like dolphins into an even, horizontal crest of white mounted on raw linen. The forms are analogies of real swimmers, freely distorted to emphasize aquatic buoyancy.

From a plastic point of view a series of blue and white figures is perhaps even more remarkable. Here no edge is incommensurate with the negative area it also defines, and the white ground is drawn up into the anatomy of sensual masses so that there is none of the spotting of shapes on the surface that characterizes the more decorative pieces.

When this spotting occurs—as in the *Large Decoration with Masks*—it is usually because Matisse did not draw in the color but simply designed with it. This was apparently intentional, as Matisse seemed to oscillate between richness and austerity of invention. Seen in this light, the single-figure studies may have been a reaction to sheerly sensory decorations which are sumptuous enough yet require a more particular environment than, say, the independent figures. Matisse could overdo color too, and interestingly enough, when he did so his motifs became correspondingly complex, eliciting his taste for lavish and exotic Eastern ornamentation. *The Sorrows of the King* is a tapestry of blues, greens, black, orange and yellow, and it founders on a story line which encouraged a degree of naturalism that was inimical to the spirit of Matisse's sense of contour. Color sometimes overpowered the edges—which he clipped with reckless facility—because it imbued mass with a density greater than that of its contour, which in effect was a line.

In fact, it is selling Matisse short to emphasize his glories as a colorist. If he drew in color, it was to define and animate space. His decorations are decorations because there is no effort to restitute an integrated surface; but while the other works have decorative *values,* color is used dimensionally to hollow the plane while its opacity recovers for it the two-dimensionality that is a dogma of modern art. Therefore, his visual last testament is best summed up by the most abstract works, such as *The Snail* and *Souvenir of Oceania,* both dominated by tropically lush shards and rectangles of color, each of which shows a suspension of forms over the void of the shattered plane—which becomes a positive element in the final synthesis. Matisse was the last of the great French sensual formalists, with the possible exception of Braque, and in this respect fulfilled the rational Romanticism that connects French modernism to Delacroix. Not incidentally, a "rational Romanticist" is also how Iris Murdoch characterized Sartre.

With Chagall and Matisse commanding the Modern's upper stories, the allocation of the Orozco exhibition to the walls far below street level was not without its irony, however unintentional. Orozco became the "hairy ape" deep in the bowels of a pleasure ship, saying "I make it go!" Chagall had transformed "shtettel" (village) life into poetic fantasy, Matisse had circumvented the French Revolution to become an aristocrat of the pleasure principle, but Orozco clung grimly to the fate of the human race via the social upheavals in Mexico, which his art, like that of his compatriots Siqueiros, now languishing in a Mexican jail, an unrepentant Communist, and the late Diego Rivera, documented with great power and great bitterness as well. Orozco, who died in 1949, was probably the profoundest artist of the three. At least I sense no opportunism in him, nor exhibitionism, but no less than his comrades he left an art that has somewhat dated. He was a Michelangelo among Social Realists but a Social Realist nevertheless.

The Dartmouth murals for which these studies—color sketches, life drawings and progressive compositional ideas—were made, were commissioned by the college in 1932. Orozco was given a professor's salary, free choice of subject and three thousand square feet of wall space in the college library. By 1934 he had completed a panoramic visual and allegorical history of Western civilization, based largely on Mexican material, which traced the emergence of the Pre-Columbian tribes from migration to modern times (enter Capitalism) and on to a final Migration of the Spirit, where Christ Himself protests the abuses of civilization by cutting down His cross.

The most eloquent studies are, to my mind, those of hands—the fist and forearm of a priest, the half-clenched hand of Knowledge and the clutching, tentacular extremity of a Miser—each distinctively denoting a precise and literal expressive function. One feels in these hands an empathy that at least partially reflects the fact that Orozco himself had only one hand. He lost his left hand—and was partially blinded—as the result of a student experiment with gunpowder. And this loss probably inspired him to "prove" himself as a draftsman. That Orozco could draw "classically" there is no doubt. In fact, the contrast between the general realism of many of these studies and the

stylized expressionism of his mural style introduces a personally tragic note, for in transferring details to the wet plaster, Orozco filtered out any aesthetic refinements that might have compromised the almost brutal vitality he gave to his taut, angular and dense compositions. It may be true that his actual formal mastery was only for "show," but I cannot help feeling that this attitude was encouraged by his politics—and at the expense of his art.

Of the "101 Masterpieces of American Primitive Painting" at the Metropolitan Museum, much of what I wrote last month about "The Nude in American Painting," a survey exhibition at the Brooklyn Museum, can also be said of these paintings from the collection of Edgar William and Bernice Chrysler Garbisch. Allowing for differences of chronology and certain apparent differences of technical accomplishment, the fundamental truth is the same. Art had a hard time being born and taking hold in America. And because of these exigencies a refreshing innocence, not unrelated to the hopes early Americans held for their country, characterizes their early experiments with culture. Such experiments were at first tentative and awkward (the primitives); later they became overweeningly ambitious, and finally in our century disillusioned (the painters of the nude).

A graphic idea of the difficulties facing the first artists in America can be gained from the fact that after barely more than 350 years of history the names of many of our pioneer "limners" have been lost, whereas Chinese literature preserves the names of thousands of artists—dating back to more than a millennium before Christ—whose works have disappeared. What Oskar Hagen describes as the archaic phase of colonial art was only just beginning at a time when Vermeer was active in Delft. "The plowman that raiseth grain is more serviceable to mankind than the painter who draws only to please the eye," wrote an unknown New Englander, in 1719, according to Hagen.

Thus it was that "face painters" were the only ones who could make anything like a go of it, at first, and they had a hard time. Virtually all of the early eighteenth-century paintings in the Garbisch collection are portraits, among them relatively advanced works by John Hesselius, 1745; Joseph Badger, 1755; John Durand, 1768; and Benjamin West, 1756. West, of course, concluded a successful career as president of the Royal Society

in London, where he established himself after a tour of the Continent that radically and in some respects fatally altered his "primitive" style.

But the fact that primitives like West could go to Europe—that is, that they knew enough about art and theory to go there at all—should certainly suggest that a blanket description of the painters in this group as "primitives" is misleading. There are many who can be rightly classed as primitives, close in spirit to Grandma Moses if not Rousseau, but just as many merely shared the country's cultural immaturity. (Copley, who is not included, matured quite rapidly after a primitive beginning and like West he too moved on to England.) The work is grim and even agrarian, you might say, stiff with a Puritan conscience that unbends a little here, a little there. The importation of English mezzotints was an important influence which emerges in the restrained but studied elegance easing the relentless and frequently unsmiling images of the Colonialists. In short, there are relatively few traumatized styles; the gaucherie in many instances is the result of an ambitious amateurism rather than inspired primitivism.

In fact, it is not safe to call any American work before the early nineteenth century "primitive" in the modern sense, and even after that a distinction must be made between folk art and authentic primitive styles. Edwards Hicks, who died in 1849, was a primitive, perhaps the only one we have had who can be compared to Rousseau. But the unknown artist who painted *George Washington on a White Charger* about 1830 is more of a folk artist. There is a noticeable decline in the quality of the amateur art after the mid-nineteenth century, though A. Logan's *The Circus*, about 1784, is a decided exception. Otherwise sentimentality, and frequently sheer ineptitude, claims many works which are interesting largely as historical documents. Popular art of the late nineteenth century rightly belongs to Messrs. Currier and Ives. However, there was nothing as primitive in the exhibition as the reproduction of the color plates in the expensive catalogue.

1962

Franz Kline (1910–1962)

WHEN a well-known figure in the arts in the United States dies, the length and location of the obituary that he receives in *The New York Times* is probably an accurate reflection of both his national and international status and news value. By this yardstick, writers have usually fared better than painters, one reason being that until fairly recently they were far more likely to be widely known. Thus, the deaths of Ernest Hemingway and William Faulkner rated the front page, while the death of Franz Kline last May was relegated to the inside obituary page. Though the *Times*' linage on art has noticeably increased of late and while Kline's was the lead obituary, it is plain that there was some editorial uncertainty just where Kline—and, by extension modern American art—fitted into a respectable picture of the nation's cultural life.

Still, Franz Kline was one of the most important American Abstract Expressionists and the first prominent one to die since Abstract Expressionism matured into an international influence —the first time Amerian art has achieved this lofty status. Jackson Pollock's death, coming at an earlier stage in the fortunes of action painting, provided the "school" with a martyr figure who embodied a cause artists like Kline carried forward with a success they still seem not to have assimilated. But Kline's death occurred at a moment that is riddled with counter-revolutionary ideas. So the drama that attends all such deaths in art is magnified because Kline's work near the end had begun to show the diminution of force and certainty that has similarly afflicted the major living artists in the action-painting stable.

But if anything in art died with Kline it was the personal tradition of Kline, which like all the dominant abstract statements in art is non-transferable because so personal. Kline's having achieved this singularity means that he had the force of originality and with it the seemingly built-in fatality that is apparently unavoidable in the genre. Once the illumination has been achieved, night must inevitably fall. Kline experienced his lonely perfection, and his death achieves a tragic poignancy by what it leaves unanswered in the realm of alternatives he might later have adopted.

Kline the man was an exceptional person. Not the least of

his qualities was his availability. He was a man easy of access, but he possessed a toughness at the core that made one sure he was not merely eager to please. From brief personal experience and firsthand reports his generosity was remarkable. Kline also had such a sense of the ludicrous that it was impossible for him to be affected by bustling admiration. But he was not a simple man. No simple man could have resisted the pressures of life and fame with so perfected a sense of privacy, however awry it sometimes seemed. It is still too soon to discuss the tragedy and perhaps personal desperation his gregarious façade concealed. But he was a Romantic who rejected Romanticism, and therein lies the measure of both his success and failures.

1962

Philip Pearlstein and the New Philistinism

It is a long time since modernist art seriously offended anyone, at least in a way that was enduringly significant culturally. "Le Déjeuner Sur L'herbe," or, rather the scandal provoked by it, has become one of modernism's most durable legends, and the cultivated bourgeoisie, assimilated to the tradition of the new, is now among that tradition's most enthusiastic patrons. It not only expects to be shocked but counts on it as the most valid and visible criterion of esthetic judgment, which ironically assures it that (its) tradition is safe. It takes, in fact, extreme gestures to arouse the public conscience and—since figurative painting has fallen on hard times—these most frequently occur outside the plastic arts, as in the case of Lenny Bruce or Jack Smith's "underground" film, "Flaming Creatures."

But even these seem exceptions to the rule of increasing permissiveness in the arts, since it is generally sensed, I believe, that these flareups of an antediluvian morality are increasingly anachronistic. For while they provoke, in those cases that actually reach the courts (that is, prior to their receiving foundation support), charades of liberal indignation, the fact is that culture has become a kind of imprimatur for the public dissemination of what was once regarded as immoral, obscene or perverse. It was not, Stanley Kauffman complained, that many heterosexual

dramas today are really about homosexuals, but that real homosexual drama, with the participants undisguised as man and wife, has yet to be written. In short, virtually anything short of live orgies goes today—from smearing strawberry jam on a nude at a Happening or dancing in the nude (Bob Morris and Yvonne Rainer) in a discreet but decidedly ambiguous embrace.

How then explain the generally hostile artistic and moral reaction to the nudes of Philip Pearlstein? In recent months, at least one of Pearlstein's nudes was banned from an exhibition at a fashionable girl's college; another was defaced at an exhibition at the University of North Carolina; an exhibition of his in the Northwest aroused considerable resentment; a noted collector returned one of his paintings which the collector had chosen from a reproduction, and, in my presence, a youngish Midwest matron, who apparently knew where the artistic action was, said that she couldn't have a Pearlstein hanging around the house where her kids could see it. In New York, where everyone is much more sophisticated about these things, so that an exhibition of sculptured feces is simply recognized for the desperate exhibitionism it is, they simply say that Pearlstein can't draw, or that he is "academic." They say this, however, with considerable feeling. Yet only last season, Larry Rivers' far more scatological and scarcely better drawn full length nude portrait of Frank O'Hara was just another painting in his retrospective at the Jewish Museum. Furthermore, increasing quantities of "erotic" art, in which the drawing is usually execrable, are noticeable each season.

The explanation of this seeming disparity of esthetic and moral standards and values is to be found, I believe, in the social role art has played in this century. That is, it has had virtually no social role whatsoever, despite the efforts of the Dadaists, the Surrealists, the Futurists and, lately, optical and kinetic artists to relate it to some extra-esthetic discipline in pursuit of a meaningful relationship to the world at large. Instead it has been almost completely occupied with form as content and style as the ultimate objective. All the modernist movements have been short-lived because they could not support for long a conflict between proposed social objectives and the esthetic imperatives upon which they had been superimposed. The "crisis" esthetic of modernist art was the inevitable expression of this profound

misunderstanding which it tragically proceeded to magnify. And it killed Abstract Expressionism.

The Rivers portrait of O'Hara is wholly a product, and a superficial one, of this bifurcated tradition. Its scatology does not offend because, besides being intended to amuse, it is immediately recognized as an expression of modern style, as gesture rather than image. O'Hara's phallus and combat boots, insofar as they are titillating at all, merely link the work to the anti-bourgeois tradition of the avant-garde. This exploitation of vanguard "alienation" confirms an essentially stylish and self-conscious pose while, like most of the art of this century, trying to appear otherwise.

On the other hand, a typical Pearlstein nude, in which the genitals are rarely as obvious as in any of Rivers' earlier nudes, establishes so corporeal a presence that, despite its seeming somnambulant apathy, it bursts through the limits of style. The nude, in other words, regains its existential dignity. Not that Pearlstein is not concerned with style—art is style, and he is concerned with it in its highest sense; but, rather, like the few artists who have engaged more or less the same pictorial problems, he is committed to freeing modern style of the illusions that have been imposed by a century of disordered taste. I might add that I believe that artists at the other extreme from realism, artists such as Frank Stella and Donald Judd, are similarly committed to the cause of a dis-illusioned style, the main difference being the function of the erotic element. In the latter it is completely repressed; in Pearlstein it is simply sublimated in a logical object—the figure.

What I am trying to suggest is that the dismay and anger which has greeted Pearlstein's work stems largely from his violation of the ritualized ambiguity of modern sensibility. Furthermore, the offense to taste that one of his paintings is apparently capable of provoking in the sophisticated modern collector or artist or one of respectability's old guard is no less significant. It testifies to a source of power in his work other than that of style. (The same holds true for Judd's austere receptacles.)

A Pearlstein nude is first of all very large, larger, in fact, than life. Two such giants, and Pearlstein's nudes are now invariably composed in pairs, are exceedingly visible. One is made acutely aware of the mountains that are knuckles, knees and elbows, of the corrugations that are the soles of the feet, of the simian

limbs that are toes and fingers, of the lunar valleys that fall between protuberant scapulae. One sees fibrous ropes that are muscles and one is impressed with the fact that the eyes, when they close, clang shut with a monumental and irreparable crack. These figures when they stand are obstinate yet somehow vulnerable; when they sit they fall into a kind of depressive stoop; when they recline they give in entirely to their ennui. They are, however, painted from life, and it is not the least of his achievements that Pearlstein translates the model's ancient function into a new visual presence whereby a pose becomes a metaphor of form and perception in which, if idealism is absent, heroism is not. It represents a new kind of grand manner, real yet transcendent. Pearlstein's scale, in conjunction with his particular subject, is a measure of his attitude toward both art and life—a noble banality. And if the work, or rather, certain of its anatomical details, give offense, it is not merely that sex is not yet so public that its instruments can be described with impunity, but that the simple moral offense is compounded by making sex (or even sexlessness) part of a heroic image when sex is still largely not admitted as one of man's more virtuous pursuits.

It is, however, not the sexual element which disturbs—sex there was in abundance in the art of 19th-century academicians —but the absence of a necrophile but prophylactic classicism, masquerading as beauty, that would make sex respectable. Ironically, the controversy stirred up among artists by Pearlstein's work revolves around a similar objection. For the esthetic issue of a heroic style that is devoid of idealism is a preoccupation with volume whose alternately craggy, tuberous, tough and otherwise uningratiating, even ungainly, character is devoid of the hallmarks of traditional draftsmanship. Inevitably, his critics frequently accuse him of being unable to draw or of processing outmoded "academic" problems, projecting onto him their own feeling of deprivation in respect to the problem of drawing the figure. For between abstractionism in art and traditional figurative painting nothing has been introduced until now as an alternative to either. The natural, the inevitable tendency is to fall back on traditional canons of good drawing in order to rationalize the rejection of a style whose extremity of dispassion makes all but the most correspondingly extreme abstractionist work either a compromise or a pastiche.

The mistake that Pearlstein's critics have made is not to have

realized, even now, that the evolution of his draftsmanship (which has indeed improved since his first exhibition of figures over three years ago) was not in the direction of an obsolete classicism of line but of a tough sense of mass and volume as extricated from the confounding and dissipated bravura of Abstract Expressionism. The huge landscapes that preceded his figures were, from the painterly point of view, incredibly packed affairs which recapitulated the problem of the relationship between mass and edge from Cézanne to Abstract Expressionism and with it the problem of the credible representation of depth. But by the time of his first figure exhibition, Pearlstein had pulled his sense of form together, and with it color, previously as broken and as flaked as his forms, coagulated into a contiguous form surface, lurid of hue yet refreshingly local. It was not, however, until his second exhibition in November, 1964 (in all, Pearlstein has had more than a dozen one-man shows), that his scale was to make evident that he was more interested in a heroic concept of mass than an ideal version of form. And with the achievement of scale, he locked into place an appropriately majestic sense of structure, a distinctive feature of which is the lopping off of the figure wherever it encountered the canvas edge. (The significance of cropping in modernist composition is too complex an issue to add to the discussion at this point. Suffice it to say that cropping in modernist art was first used to conscious advantage by Degas and that it is of considerable importance that it should emerge again in the best figurative painting presently being done.)

Meanwhile, a more fundamental misunderstanding exists in respect to Pearlstein's intentions. Pearlstein's critics, that is, critics of post-abstractionist realism generally, fail to perceive that figurative art can be as "abstract" and as powerful as any other style. Specifically, they ignore the fact that Pearlstein paints in a manner that is not only common but inevitable among abstractionists, as formal considerations increasingly dominate the nature and form of their expression. Which is to say that Pearlstein's paintings form a series which deals with a single formal problem—the depiction of a credible, highly structured illusionistic space within the picture frame. As Michael Fried has pointed out, serial painting is "an institution that arose during Impressionism in concomitance with the exploration throughout a number

of pictures of a single motif, but which has come increasingly to have the function of providing a context of mutual elucidation for the individual paintings comprising a given series." That Pearlstein's figures form such a series is an aspect not only of their modernity but evidence of their concern with the relevant formal problems of modernist art. He has simply transferred them to a non-symbolic context. Why he has done this is mainly a matter of expressive preference. Otherwise, there is a complete organization (structuring) of the picture surface for a total, or "field" effect rather than a less monumental format in which the objects are not assimilated to the structure but insist on an independent narrative identity. By these standards, Giotto was a "field" painter. Pearlstein's critics have failed, in other words, to see the painting for the subject; and moral repugnance follows "sui generis."

Yet it is precisely on the grounds of this serial style that Pearlstein may prove vulnerable to criticism. The serial approach is eminently suitable for a style as refined symbolically as abstractionist art has become. For in the absence of pronounced particularity the slightest adjustment carries considerable formal and expressive weight, though the hair-splitting frequently involved threatens to make sincerity a new version of absurdity. For Fried, this appears to be precisely the source of the heroism of the artists he admires. In figurative painting, however, where images replace symbols and where literal facts present an entire new range of possibilities, repeated manipulation of one or two figures does not allow the complexity, that is, the renewed involvement with particularity, to pursue its implications, especially that of greater involvement with illusion. In historical context the function of illusionistic volume is the creation of a new space as an antidote to the merely decorative surfaces most abstractionist art had become. Continued serialization of this idea can reverse the intention and produce a no less mechanical image, as opposed to one that is constantly being discovered anew.

I am, however, far from sure that figurative serialization is nearly so fatal as all this seems to imply. For one thing, it is, as I have already suggested, a link with the modernist tradition which, if it is as self-critical as some critics assume, may be approaching a climactic self-confrontation. For another, and more

important—in fact, it is the momentary heart of the matter—it provides a refuge of impersonality while the implications of subject and feeling are being explored, testing the space as it were for its hospitality to change.

Nevertheless there has been some attrition of concentrated illusionistic power in several of Pearlstein's recent paintings. Two or three paintings in his most recent group, which was another in his series of mostly larger than life-size figures, are perhaps equal to those of his 1964 exhibition; but elsewhere the sense of discovery (and recovery) does not appear to be so strong. Though allowance should be made for seeing the pictures under cluttered studio conditions, it is especially noticeable in his drawings in which the outside contour is not as searching as it was in the smaller drawings done around the time of his second figure exhibition. (As in photographs, a graphic image does not work on a large scale.) The loss is confirmed by a couple of small paintings in which the sudden reduction of scale hardly accommodates the powerful generalizations he is capable of when he tackles monumental sizes. Yet the smaller paintings in his previous exhibition were better for having been better drawn to their scale. At the moment Pearlstein is, then, more capable of subtlety than variety as is evident, for instance, in the depiction of shadowy flesh tints on the thigh of one of his reclining women. For as he spins out his serialization of the figure, a greater mastery of technique leads not to mere facility but to greater concentration on the particular rather than the general which so far has been his strong suit.

Portentous, then, are his recent efforts at portraiture. In exceptionally visualized studies of Alex Katz and dealer Allan Frumkin, the difference of scale (the Katz portrait is perhaps one-third life size, or so memory suggests; the Frumkin portrait is Michelangelesque in its figurative proportions) produced little variation of quality, as involvement with the sitter, or the problem of taking a likeness, appears to have renewed the act of discovery. The Frumkin portrait is probably Pearlstein's best painting since his last exhibition, and one of his best figurative paintings besides.

The continuity of formal development in art is probably dependent on some semblance of continuity in the social experience, or, in other words, a measure of certainty as opposed to

constant change. In the past, such certainty as has befallen the artist, most frequently success, has usually translated itself artistically into self-mannerism. A dedication to an image replaces the idea of an evolving style for which it is usually confused by the public while the artist himself confuses it with "maturity." It is true of course that the number of ideas anyone has in art is limited, and that repetition is to a certain extent a matter of course. This is another reason why there have been so many palace revolutions in modernist art. Consequently, the revival of the figure, and post-abstractionist realism generally, represents an effort to establish a basis for the creative principle upon something else besides ideas, besides the Logos of style itself. It means, I believe, an effort to restore the erotic principle, of which Camp is an indicative parody, to form. In the long run, vitality is the only principle of certainty in a changing world, and vitality without the sexual principle is inconceivable.

There is thus a measure of truth, however misplaced, in the response which has greeted Pearlstein's work. As I have suggested, the artistic reaction and the moral one are related, and obviously the audience, characteristically, one has to suppose, is getting his signals but interpreting them wrongly. But hardly enough time has passed for us to determine if history is repeating itself, that is, if a new division of taste between art and what I would call the new respectability is taking place. But that philistinism has completed its modern cycle and has come home to roost in the avant-garde can no longer be doubted.

1966

JOHN CAGE

The Los Angeles–born composer John Cage (1912–1992) was a pioneer in the use of untraditional instruments and sounds and even in the use of silence—and he had an impact that extended far beyond the musical world. Cage was a student of Arnold Schoenberg early on; he moved in Peggy Guggenheim's circle in New York during World War II. In the late 1940s Cage became involved with the dancer and choreographer Merce Cunningham in what turned out to be a lifelong personal and professional collaboration. And in a series of classes that he taught at The New School from 1956 to 1958, Cage developed ideas about the importance of anti-art and absurdism that influenced Allan Kaprow and a number of other New York artists. Along with Robert Rauschenberg and Jasper Johns, Cage and Cunningham had felt the strong impact of Duchamp and his ideas in the 1950s, and over the years the four men were involved in now legendary projects, experiments in sound and sight held together by the genius of Cunningham's choreography. The best known of Cage's books is the 1961 *Silence,* and his best known piece of music is the 1952 *4′33″,* four-and-a-half-minutes of silence, divided into three movements. Well before the end of his life, Cage was recognized not only in the United States but in Europe and Asia as one of modernity's mystery men, by turns impish and austere, mesmerizing and maddening. He was sui generis, bewildering audiences with deafening electronic effects and beguiling them with tales of his mushroom hunting, which he embraced as an avant-garde avocation.

Jasper Johns: Stories and Ideas

(Passages in italics are quotations from Jasper Johns
found in his notebooks and published statements.)

On the porch at Edisto. Henry's records filling the air with Rock 'n' Roll. I said I couldn't understand what the singer was saying. Johns (laughing): That's because you don't listen.

Beginning with a flag that has no space around it, that has the same size as the painting, we see that it is not a painting *of* a flag. The roles are reversed: beginning with the flag, a painting was made. Beginning, that is, with structure, the division of the whole into parts corresponding to the parts of a flag, a painting

608

Walt Silver: Jasper Johns seated in front of a *Target* painting, 1955.

was made which both obscures and clarifies the underlying structure. A precedent is in poetry, the sonnet: by means of language, caesurae, iambic pentameter, license and rhymes to obscure and clarify the grand division of the fourteen lines into eight and six. The sonnet and the United States flag during that period of history when there were forty-eight states? These are houses, Shakespeare in one, Johns in the other, each spending some of his time living. ¶ I thought he was doing three things (five things he was doing escaped my notice).

He keeps himself informed about what's going on particularly in the world of art. This is done by reading magazines, visiting galleries and studios, answering the telephone, conversing with friends. If a book is brought to his attention that he has reason to believe is interesting, he gets it and reads it (Wittgenstein, Nabokov, McLuhan). If it comes to his notice that someone else had one of his ideas before he did, he makes a mental or actual note not to proceed with his plan. (On the other hand, the casual remark of a friend can serve to change

a painting essentially.) There are various ways to improve one's chess game. One is to take back a move when it becomes clear that it was a bad one. Another is to accept the consequences, devastating as they are. Johns chooses the latter even when the former is offered. Say he has a disagreement with others; he examines the situation and comes to a moral decision. He then proceeds, if to an impasse, to an impasse. When all else fails (and he has taken the precaution of being prepared in case it does), he makes a work of art devoid of complaint.

Sometimes I see it and then paint it. Other times I paint it and then see it. Both are impure situations, and I prefer neither.

Right conduct. He moved from objecting to not objecting. Things beneath other people to do are not that way for him. America. ¶ Walking with him in the garden of the Museum of Modern Art, she said, "Jasper, you must be from the Southern Aristocracy." He said, "No, Jane, I'm just trash." She replied, "It's hard to understand how anyone who's trash could be as nice as you are." Another lady, outraged by the beer cans that were exhibited in the gallery, said, "What are they doing here?" When Johns explained that they were not beer cans but had taken him much time and effort to make, that if she examined them closely she would notice among other things fingerprints, that moreover she might also observe that they were not the same height (i.e. had not come off an assembly line), why, he asks, was she won over? Why does the information that someone has done something affect the judgment of another? Why cannot someone who is looking at something do his own work of looking? Why is language necessary when art so to speak already has it in it? "Any fool can tell that that's a broom." The clothes (conventions) are underneath. The painting is as naked as the day it was born. ¶ What did I say in Japan? That the Mona Lisa with mustache or just anything plus a signature equals addition, that the erased de Kooning is additive subtraction, that we may be confident that someone understands multiplication, division, calculus, trigonometry? Johns.

The cigars in Los Angeles that were Duchamp-signed and then smoked. Leaning back, his chair on two legs, smiling, Johns

said: My beer cans have no beer in them. Coming forward, not smiling, with mercy and no judgment he said: I had trouble too; it seemed it might be a step backward. Whenever the telephone rings, asleep or awake he never hesitates to answer. ¶ *An object that tells of the loss, destruction, disappearance of objects. Does not speak of itself. Tells of others. Will it include them? Deluge.*

Why this palaver about structure? Particularly since he doesn't need to have any, involved as he is with process, knowing that the frame that will be put around the all that he makes will not make the environment invisible? Simply in order to make clear that these flags-numbers-letters-targets are not subjects? (That he has nothing to say about them proves that they are not subjects rather than that he as a human being is absent from them. He is present as a person who has noticed that *At every point in nature there is something to see.* And so: *My work contains similar possibilities for the changing focus of the eye.*) Structures, not subjects—if only that that will make us pause long enough in our headstrong passage through history to realize that Pop Art, if deducted from his work, represents a misunderstanding, if embarked upon as the next step after his, represents a non-sequitur. He is engaged with the endlessly changing ancient task: the imitation of nature in her manner of operation. The structures he uses give the dates and places (some less confined historically and geographically than others). They are the signature of anonymity. When, dealing with operative nature he does so without structure, he sometimes introduces signs of humanity to intimate that we, not birds for instance, are part of the dialogue. Someone, that is, must have said Yes (*No*), but since we are not now informed we answer the painting affirmatively. Finally, with nothing in it to grasp, the work is weather, an atmosphere that is heavy rather than light (something he knows and regrets); in oscillation with it we tend toward our ultimate place: zero, gray disinterest.

It does not enter his mind that he lives alone in the world. There are in fact all the others. I have seen him entering a room, head aloft, striding with determination, an extraordinary presence inappropriate to the circumstance: an ordinary dinner engagement in an upstairs restaurant. There were chair and tables,

not much room, and though he seemed to be somewhere else in a space utterly free of obstructions he bumped into nothing. Furthermore he reached the table where I was sitting and recognized me immediately. Another time he was working. He had found a printed map of the United States that represented only the boundaries between them. (It was not topographical nor were rivers or highways shown.) Over this he had ruled a geometry which he copied enlarged on a canvas. This done, freehand he copied the printed map, carefully preserving its proportions. Then with a change of tempo he began painting quickly, all at once as it were, here and there with the same brush, changing brushes and colors, and working everywhere at the same time rather than starting at one point, finishing it and going on to another. It seemed that he was going over the whole canvas accomplishing nothing, and having done that, going over it again, and again incompletely. And so on and on. Every now and then using stencils he put in the name of a state or the abbreviation for it, but having done this represented in no sense an achievement, for as he continued working he often had to do again what he had already done. Something had happened which is to say something had not happened. And this necessitated the repetitions, Colorado, Colorado, Colorado, which were not the same being different colors in different places. I asked how many processes he was involved in. He concentrated to reply and speaking sincerely said: It is all one process.

Conversing in a room that had both painting and sculpture in it and knowing as he does that there is a difference between them, he suddenly laughed for he heard what he had just said (I am not a sculptor). I felt suddenly lost, and then speaking to me as though I were a jury he said: But I *am* a sculptor, am I not? This remark let me find myself, but what I found myself in was an impenetrable jungle. There are evidently more persons in him than one. (A) having painted a picture gives it the title *Flag*. (B) having made a sculpture gives it the title *Painted Bronze*. (A) referring to (B)'s work says beer when to be in character he would say ale. (C) is not concerned with structure nor with sculpture (*Jubilee*). (D) (*Painting with Two Balls*) is concerned with both. (E) has a plan: *Make something, a kind of object which as it changes or falls apart (dies as it were) or increases in its parts*

(grows as it were) offers no clue as to what its state or form or nature was at any previous time. Physical and Metaphysical Obstinacy. Could this be a useful object? (F) experimentally inclined, among other ways of applying paint, stood on his head to make *Skin*. (G) sees objects in poetic interpenetration (*Fool's House*). (H) stands sufficiently far away to see panoramically (*Diver*). (I) records history [*Make Shirl Hendryx's shoe in sculpmetal with a mirror in the toe—to be used for looking up girl's dresses. High School Days. (There is no way to make this before 1955.)*]. (J) is concerned with language, (K) with culture sacramentally (*Tennyson*). (L) makes plans not to be carried out. (M) asks: *Can a rubber face be stretched in such a way that some mirror will reorganize it into normal proportion?* (N) is a philosopher: "———" *differs from a* "———." (O) studies the family tree. (P) is not interested in working but only in playing games. (Q) encourages himself and others *to do more rather than less.* (R) destroys the works he finishes and is the cause of all the others. (S) made *The Critic Sees.* (T) ¶ Both Johns and we have other things to do (and in a multiplicity of directions), but that he let his work have the American flag as its structure keeps us conscious of that flag no matter what else we have in mind. How does the flag sit with us, we who don't give a hoot for Betsy Ross, who never think of tea as a cause for parties? (If anyone speaks of patriotism, it is nowadays global: our newspapers are internationally inclined.) The flag is nothing but The Stars and Stripes Forever. The stars are placed in the upper left hand corner of the field of stripes. But even though the whole thing is all off center it gives us the impression symmetry does, that nothing is in the wrong place. The flag is a paradox in broad daylight: proof that asymmetry is symmetry. That this information was given before so to speak the work was begun is a sign, if one needed one, of generosity which, alas, passeth understanding. Looking around his thoughts, he sees them in the room where he is. The clock doesn't always tell the same time. The dining room table in the dining room does. *We're not idiots.* Just as, answered, the telephone presents an unexpected though often recognized voice, so a table should speak, provoking, if not surprising, at least a variety of responses. Eating is only one. The dining room table will not do. It is taken apart, stored, then sent to the south. Another, a loan not a possession, but having

a history of many uses, is brought in. That it is round is its concern. It might have been square or rectangular. Its surface, however, stimulates the tendency to do something, in this case a process of bleaching and staining. And the chairs around it: the removal of varnish and the application of paint. The result is nothing special. It looks as though something had been tried and had been found to work: to have many uses, not focussing attention but letting attention focus itself.

He does not remember being born. His earliest memories concern living with his grandparents in Allendale, South Carolina. Later, in the same town, he lived with an aunt and uncle who had twins, a brother and sister. Then he went back to live with his grandparents. After the third grade in school he went to Columbia, which seemed like a big city, to live with his mother and stepfather. A year later, school finished, he went to a community on a lake called The Corner to stay with his Aunt Gladys. He thought it was for the summer but he stayed there for six years studying with his aunt who taught all the grades in one room, a school called Climax. The following year he finished high school living in Sumter with his mother and stepfather, two half-sisters and his half-brother. He went to college for a year and a half in Columbia where he lived alone. He made two visits during that period, one to his father, one to his mother. Leaving college he came to New York, studying in an art school for a little over six months. After applying for a scholarship, he was called into an office and it was explained that he could have the scholarship but only due to his circumstances since his work didn't merit it. He replied that if his work didn't merit it he would not accept it. Later, working in a bookstore on 57th Street, he went to see an exhibition at the Stable Gallery. Leo Steinberg seeing him asked if he was Michael Goldberg. He said: I am Jasper Johns. Steinberg said: That's strange; you look so familiar. Johns said: I once sold you a book. Clothes do not make him. Instead, his influence at rare and unexpected moments extends to his clothes, transforming their appearance. No mask fits his face. Elegance. ¶ He went to the kitchen, later said lunch was ready. Wild rice with Boleti. Duck in a cream sauce with Chanterelles. Salad. Hazelnut cake with Coffee.

The thermostats are fixed to the radiators but lead ineffectually to two bare wires. The Jaguar repaired and ready to run sits in a garage unused. It has been there since October. An electrician came to fix the thermostats but went away before his work was finished and never returned. The application for the registration of the car has not been found. It is somewhere among the papers which are unfiled and in different places. For odd trips a car is rented. If it gets too hot, a window is opened. The freezer is full of books. The closet in the guest room is full of furniture. There is, and anyone knows there is, a mystery, but these are not the clues. *The relationship between the object and the event. Can they ② be separated? Is one a detail of the other? What is the meeting? Air?*

The situation must be Yes-and-No not either-or. *Avoid a polar situation.* A target is not a paradox. Ergo: when he painted it he did not use a circular canvas. ¶ How lucky to be alive the same time he is! It could have been otherwise. ¶ Conversation takes place whether the telephone rings or not and whether or not he is alone in the room. *(I'm believing painting to be language, . . .)* Once he does something, it doesn't just exist: it replies, calling from him another action. *If one takes delight in that kind of changing process one moves toward new recognitions (?), names, images.* The end is not in view; the method (the way one brush stroke follows another) is discursive. Pauses. Not in order through consideration to arrive at a conclusion. (Staying with him is astonishing: I know perfectly well that were I to say I was leaving he would have no objection, nor would he if I said I was not going.) A painting is not a record of what was said and what the replies were but the thick presence all at once of a naked self-obscuring body of history. All the time has been put in one (structured?) space. He is able, even anxious, to repair a painting once it is damaged. A change in the painting or even someone looking at it reopens the conversation. Conversation goes on faithful to time, not to the remarks that earlier occurred in it. Once when I visited him he was working on a painting called *Highway.* After looking at it I remarked that he had put the word right in the middle. When I left he painted over it so that the word, still there, is not legible. I had forgotten that this ever happened. He hasn't. ¶ *Three academic ideas which*

have been of interest to me are what a teacher of mine (speaking of Cézanne and cubism) called "the rotating point of view" (Larry Rivers recently pointed to a black rectangle, two or three feet away from where he had been looking in a painting, and said ". . . like there's something happening over there too."); Marcel Duchamp's suggestion "to reach the Impossibility of sufficient visual memory to transfer from one like object to another the memory imprint"; and Leonardo's idea . . . that the boundary of a body is neither a part of the enclosed body nor a part of the surrounding atmosphere. ¶ A target needs something else. Anything in fact will do to be its opposite. Even the space in the square in which it is centrally placed. This undivided seemingly left over area miraculously produces a duplex asymmetrical structure. Faces.

Make this and get it cast. (Painting with ruler and "gray.") Sculpt a folded flag and a stool. Make a target in bronze so that the circles can be turned to any relationship. ~~All the numbers zero through nine.~~ *0 through 9. Strip painting before tying it with rope (Painting with a rope). Do Not Combine the 4 Disappearances. A through Z.* He didn't do this because it seemed like a jewel. (The individual letters disappear into a single object.) Perhaps there's a solution. *It moves. It moved. It was moved. It can, will, might move. It has been moved. It will be moved (can't have just it).*

Does he live in the same terror and confusion that we do? *The air must move in as well as out—no sadness, just disaster.* I remember the deadline they had: to put up a display, not in windows on a street but upstairs in a building for a company that was involved in sales and promotion. Needing some printing done they gave me the job to do it. Struggling with pens and india ink, arriving at nothing but failure, I gradually became hysterical. Johns rose to the occasion. Though he already had too much to do, he went to a store, found some mechanical device for facilitating lettering, used it successfully, did all the other necessary things connected with the work and in addition returned to me my personal dignity. Where had I put it? Where did he find it? That his work is beautiful is only one of its aspects. It is, as it were, not interior to it that it is seductive. We catch ourselves looking in another direction for fear of becoming jealous, closing our eyes for fear our walls will seem to be empty. Skulduggery.

Jasper Johns: *Map*, 1961. Oil on canvas 78 × 123⅛ in.

Focus. Include one's looking. Include one's seeing. Include one's using. It and its use and its action. As it is, was, might be (each as a single tense, all as one). A = B. A is B. A represents B (do what I do, do what I say).

The demand for his work exceeds the supply. The information that he has stretched a canvas, if, that is, it was not already commissioned, produces a purchase. He conceives and executes an exclusive plan: the portfolios of lithographs. Two rows of numbers, o 1 2 3 4 above, 5 6 7 8 9 below, the two rows forming a rectangle having ten equal parts; centered below this and separated by space is a single number of greater size but in a smaller area. (The two rectangles are not equal: together they produce asymmetry.) Because there are ten different numerals, and because each single lithograph shows only one of them in the lower rectangle, there are ten different lithographs in each portfolio, one for each numeral. The edition is one of thirty sets: a third in different colors on white, ten in black on off-white, the rest in gray on natural linen. (All the papers have as watermark the artist's signature.) The working process employed two stones: a large one upon which the two structures appear, a smaller one having the inferior rectangle alone. As the

work proceeded, due partly to things that happened outside his control, partly to his own acts, the stones passed through a graphic metamorphosis showing both utter and subtle changes. The smaller stone, given its own color or value (sometimes barely differentiated from the color or value given the larger one), appears on only a single lithograph of a given portfolio, on in fact that lithograph having the large number corresponding to the number of that portfolio. Beyond these three sets of ten, three portfolios exist *hors de commerce*. They alone show the total work, but each of them is unique, printed in the different inks on the different papers. The world he inhabits us in? One in which once again we must go to a particular place in order to see what there alone there is to see. The structure above is as unchanging as the thirteen stripes of our flag. The structure below changes with each number just as the number of stars changes with each change in history. (The paradox is not just in space but in time too: space-time.) The alphabets were arranged that way in a book. He derived from them his own similar arrangement of numbers. *Competition as definition of one kind of focus. Competition (?) for different kinds of focus. What prize? Price? Value? Quantity?* Given the title and date of one of his works, he sometimes can remember it only vaguely, other times not at all. ¶ He is a critic. No matter how inspired it may have been, he refuses another's leap to a conclusion if it reveals that what was to be done was not done. He is puzzled by a work that fails to make clear distinctions (e.g. between painting and sculpture). Shrugging his shoulders he smiles. Grimly determined he makes *The Critic Sees*. ¶ The more hurricanes the better, his house is insured. Compact, opaque, often highly colored, cryptocrystalline . . . He is Other for whom to have been born is captivity. Alone he accepts the stricture as a wild animal can. Gazed at, he is of necessity arrogant.

The charcoal *o through 9* began with an undivided space. But it was not the beginning. It was analysis of a painting in progress that used superimposed numbers as structure. It was not the work he was working on.

History of art: a work that has no center of interest does the same thing that a symmetrical one does. Demonstration: what

previously required two artists, Johns does alone and at the same time. ¶ I drove to his studio downtown. He was sitting looking at an unfinished painting (which is one of the ways he does his work): all the colors in profusion; the words red, yellow, and blue cut out of wood hinged vertically to the edges of two separately stretched canvases, the mirrored imprints of the letters legible on both; one letter not in wood but in neon; the wooden ones with magnets permitting fixing and changing the position of objects—a beer can, a coffee can, paint brushes, a knife, no fork or spoon, a chain, a squeegee, and the spool from a supply of solder. The next day uptown he was working on the gray numbers, the sculpmetal ones *(Overcome this module with visual virtuosity. Or Merce's foot? (Another kind of ruler.) Foreign colors and images.).* And the same day laboriously on the shoe with the mirror in the toe. We wonder whether, if chinaberry trees meant the same to us as they do to him (Spanish moss too, and the seashore and the flat land near it that makes him think the world is round, Negroes, the chigger-ridden forest and swamps that limit the cemeteries and playgrounds, the churches, the schools, his own house, in fact, all up on stilts against probable inundation, azaleas and oleanders, palm trees and mosquitoes, the advent of an outlandish bird in the oak outside the screened porch, the oak that has the swing with an automobile tire for sitting, the swing that needs repair (the ropes are frayed), the shark's teeth, the burrs in the sand on the way to the beach, the lefthanded and righthanded shells, and grits for breakfast)—well, we just wonder.

He told me that he was having a recurrence of them, that he had had them some years before, dreams in which the things he saw and that happened were indistinguishable from those of the day. I must have changed the subject for he told me nothing more. When I mentioned this to her, she told me what he had said: that going one day into the subway he had noticed a man selling pencils to two women—a man whose legs had been cut off, who moved about by means of a platform with wheels. That night Johns was that man, devising a system of ropes and pulleys by which to pull himself up so that he would be able to paint on the upper parts of the canvas which were otherwise out of his reach. He thought too of changing the position of

the canvas, putting it flat on the floor. But a question arose: How could he move around without leaving the traces of his wheels in the paint? The cans of ale, *Flashlight*, the coffee can with brushes: these objects and the others were not found but were made. They were seen in some other light than that of day. We no longer think of his works when we see around us the similar objects they might be thought to represent. Evidently these bronzes are here in the guise of works of art, but as we look at them we go out of our minds, transformed with respect to being.

All flowers delight him. He finds it more to the point that a plant after being green should send up a stalk and at its top burst into color than that he should prefer one to others of them. The highest priority is given, if he has one out of the ground, to putting a plant in the earth. Presented with bulbs from the south, impatient for them to bloom, he initiated a plan for a sped-up succession of seasons: putting them to freeze on the terrace and then in the warmth of an oven. Flowers, however, are not left to die in a garden. They are cut and as many varieties as are blooming are placed together in a fierce single arrangement, whether from the garden, the roadside, or the florist's: one of these, two of those, etc. (Do not be fooled: that he is a gardener does not exclude him from hunting; he told me of having found the blue Lactarius in the woods at Edisto.) Besides making paintings that have structures, he has made others that have none (*Jubilee* for instance). I mean that were two people to tell what the division of that rectangle is into parts they would tell two different things. The words for the colors and the fact that a word is not appropriately colored ("You are the only painter I know who can't tell one color from another"), these facts exercise our faculties but they do not divide the surface into parts. One sees in other words a map, all the boundaries of which have been obscured (there was in fact no map); or we could say one sees the field below the flag: the flag, formerly above, was taken away. Stupidly we think of abstract expressionism. But here we are free of struggle, gesture, and personal image. Looking closely helps, though the paint is applied so sensually that there is the danger of falling in love. We moderate each glance with a virtuous degree of blindness.

¶ We do not know where we stand, nor will we, doubtless, ever. It is as though having come to the conclusion that going to sleep is a thing not to do, he tells us so that we too may stay awake, but before the words have left his lips, he leaves us in order that he himself may sleep. ("We imagine ourselves on a tightrope only to discover that we are safe on the ground. Caution is unnecessary." Nevertheless we tremble more violently than we did when we thought we were in danger.) When he returned to New York from the south, she asked him how it had been. He said: It was warm. There were no mosquitoes. You could even sit out in the yard. (I missed the polka dots in the area above the lower lefthand corner. Strange; because that's what I was thinking about: the paintings *o through 9* that are covered with polka dots.) Seeing her window over the kitchen sink, he said: That's what I want to have, a window over the kitchen sink so that I can look out to the terrace. She said: What you need is a door, so that you don't have to go to the front of the house and then all the way back on the outside again. But, he said, I don't want to go out, just look out. And then asked (imagining perhaps there was something he could learn from her to do): Do you go out? She admitted she didn't. They laughed. She pointed out the plant on the sill with last year's peppers on it and new blossoms but showing no signs of their becoming this year's peppers. He said: Maybe they need to be pollenated. And shortly with kleenex he was botanist, dusting and cross-dusting the flowers.

Take *Skin I, II, III, IV.* What a great difference there is between these and anything his works before or after could have led us to expect! As his generosity continues unabated, we waste the breath we have left muttering of inscrutability. Had he been selfish and singleminded it would have been a simple matter for anyone to say Thank You.

Even though in those Edisto woods you think you didn't get a tick or ticks, you probably did. The best thing to do is back at the house to take off your clothes, shaking them carefully over the bathtub. Then make a conscientious self-examination with a mirror if necessary. It would be silly too to stay out of the woods simply because the ticks are in them. Think of the mushrooms

(Caesar's among them!) that would have been missed. Ticks removed, fresh clothes put on, something to drink, something to eat, you revive. There's scrabble and now chess to play and the chance to look at TV. *A Dead Man. Take a skull. Cover it with paint. Rub it against canvas. Skull against canvas.*

1964

JASPER JOHNS

Jasper Johns was born in Georgia in 1930, grew up in South Carolina, and was catapulted to fame with a show at the Leo Castelli Gallery in 1958 that featured paintings of targets and American flags; his work was immediately on the cover of *Art News,* and three paintings were reserved by the Museum of Modern Art. By the early 1960s, Johns's work was widely seen as prefiguring Pop Art, although his sympathy for Duchamp's austere aesthetics and his subtly sumptuous painterly effects always marked him as something of a mandarin sensibility, at least when compared with the unabashedly populist inclinations of Warhol and Lichtenstein. While his work has been the subject of many elaborate interpretations, including a catalogue written by the novelist Michael Crichton, Johns has himself published very little, beyond this cryptic statement for the Museum of Modern Art's 1959 *16 Americans,* one of a series of ongoing exhibitions focusing on contemporary artists, and the "Sketchbook Notes," first published in 1965 in the little magazine *Art and Literature,* of which John Ashbery was an editor.

Statement

SOMETIMES I see it and then paint it. Other times I paint it and then see it. Both are impure situations, and I prefer neither.

At every point in nature there is something to see. My work contains similar possibilities for the changing focus of the eye.

Three academic ideas which have been of interest to me are what a teacher of mine (speaking of Cézanne and cubism) called "the rotating point of view" (Larry Rivers recently pointed to a black rectangle, two or three feet away from where he had been looking in a painting, and said ". . . like there's something happening over there too."); Marcel Duchamp's suggestion "to reach the Impossibility of sufficient visual memory to transfer from one like object to another the memory imprint"; and Leonardo's idea ("Therefore, O painter, do not surround your bodies with lines . . .") that the boundary of a body is neither a part of the enclosed body nor a part of the surrounding atmosphere.

Generally, I am opposed to painting which is concerned with conceptions of simplicity. Everything looks very busy to me.

1959

Jasper Johns: *Painted Bronze*, 1960. Bronze
painted with oil, 13½ x 8 in.

Sketchbook Notes

MAKE neg. of part of figure & chair. Fill with these layers—
encaustic (flesh?), linen, Celastic. One thing made of another.
One thing used as another. *An arrogant object.* Something to
be folded or bent or stretched. (SKIN?) Beware of the body
and the mind. Avoid a polar situation. Think of the edge of
the city and the traffic there. Some clear souvenir—A photo-
graph (A newspaper clipping caught in the frame of a mirror)
or a fisherman's den or a dried corsage. Lead section? Bronze

junk? Glove? Glass? Ruler? Brush? Title? Neg. female fig.? Dog? Make a newspaper of lead or Sculpmetal? Impressions? Metal paper bag? Profile? Duchamp (?) Distorted as a shadow. Perhaps on falling hinged section. Something which can be erased or shifted. (Magnetic area) In *WHAT* use a light and a mirror. The mirror will throw the light to some other part of the painting. Put a lot of paint & a wooden ball or other object on a board. Push to the other end of the board. Use this in a painting. Dish with photo & color names. Japanese phonetic "NO" (possessive, "of") stencilled behind plate? Determine painting size from plate size—Objects should be *loose* in space. Fill (?) the space loosely. RITZ (?) CRACKERS, "if the contents of this package have settled," Etc. Space everywhere (objects, no objects), MOVEMENT. Take flashlight apart? Leave batteries exposed? Break orange area with 2 overlays of different colors. Orange will be "underneath" or "behind." Watch the imitation of the shape of the body.

The watchman falls "into" the "trap" of looking. The "spy" is a different person. "Looking" is and is not "eating" and "being eaten." (Cézanne?—each object reflecting the other.) That is, there is continuity of some sort among the watchman, the space, the objects. The spy must be ready to "move," must be aware of his entrances and exits. The watchman leaves his job & takes away no information. The spy must remember and must remember himself and his remembering. The spy designs himself to be overlooked. The watchman "serves" as a warning. Will the spy and the watchman ever meet? In a painting named SPY, will he be present? The spy stations himself to observe the watchman. If the spy is a foreign object, why is the eye not irritated? Is he invisible? When the spy irritates, we try to remove him. "Not spying, just looking"—Watchman.

Color chart, rectangles or circles. (Circles on black to white rectangles.) Metal stencil attached and bent away. OCCUPATION—Take up space with "what you do." Cut into a canvas & use the canvas to reinforce a cast of a section of a figure. The figure will have one edge coming out of the canvas "plane" & the other edge will overlap cut or will show the wall behind. A chain of objects (with half negative?) Cast RED, YELLOW, BLUE or cut them from metal. Bend or crush them. String them up. (OR) Hinge them as in FIELD

PAINTING. Bend them. Measurements or objects or fields which have changed their "directions." Something which has a name. Something which has no name. Processes of which one "knows the results." Avoid them. City planning, etc.

One thing working one way
Another thing working another way.
One thing working different ways
at different times.

Take an object.
Do something to it.
Do something else to it.
 " " " " "

Take a canvas.
Put a mark on it.
Put another mark on it.
 " " " " "

Make something.
Find a use for it.
AND / OR
Invent a function.
Find an object.

from Art and Literature 4, 1965, 185–192.
Copyright © by Jasper Johns/Licensed by VAGA, New York, NY.

ROBERT RAUSCHENBERG

Robert Rauschenberg (1925–2008) and Jasper Johns were living to-gether in New York in the late 1950s when Leo Castelli first came to see their work. Although Johns was embraced by the New York art world more rapidly than Rauschenberg, they were both included in *16 Americans*, at the Museum of Modern Art in 1959, and there is probably no single statement in the history of American art that has been more influential than Rauschenberg's few words about the gap between art and life. Rauschenberg had studied at Black Mountain College, and the first works he exhibited in New York in the early 1950s were abstract paintings that were all white or all black. But by the time that Castelli began exhibiting his work, he had for some years been concentrating on what he called his *Combines*. These assemblages trumped the Dadaist or Surrealist fascination with the found object through their extravagant scale and disarming thematic dissonance; nobody has ever adequately explained why a goat wears a tire around its midriff in *Monogram* (1955–59). Perhaps the most famous of the early works is *Bed* (1955), Rauschenberg's own pillow, sheet, and quilt, upended and emblazoned with strokes and drips of oil paint. By the 1960s Rauschenberg was incorporating photographic images in many of his collages and assemblages, and from then on he refused to settle on any one medium, celebrating a mixed-media eclecticism that proved immensely influential as modernism was eclipsed by postmodernism in the final decades of the twentieth century.

Statement

ANY incentive to paint is as good as any other. There is no poor subject.

Painting is always strongest when in spite of composition, color, etc. it appears as a fact, or an inevitability, as opposed to a souvenir or arrangement.

Painting relates to both art and life. Neither can be made. (I try to act in that gap between the two.)

A pair of socks is no less suitable to make a painting with than wood, nails, turpentine, oil and fabric.

A canvas is never empty.

1959

LEO STEINBERG

The Russian-born art historian Leo Steinberg (1920–2011) made formidable contributions to our understanding of Leonardo da Vinci, Michelangelo, and Picasso, balancing an original visual sensibility with a profound grasp of the relevant scholarly material. All the while, Steinberg was pursuing an interest in contemporary art, from the 1962 *Harper's Magazine* essay, "Contemporary Art and the Plight of its Public," to *Encounters with Rauschenberg,* published in 2000. Reacting against a formalist reading of twentieth-century art, Steinberg brought traditional iconographic thinking to bear on contemporary subjects, exchanging Greenberg's idea of flatness for what he dubbed the "flatbed picture plane," ample enough to contain Rauschenberg's heterogeneous impulses and images. Steinberg collected many of his writings on twentieth-century art in 1972 in the volume *Other Criteria*—a title that perfectly captures his searching, skeptical intelligence.

Contemporary Art and the Plight of its Public

A FEW words in defense of my topic, because some of my friends have doubted that it was worth talking about. One well-known abstract painter said to me, "Oh, the public, we're always worrying about the public." Another asked: "What is this plight they're supposed to be in? After all, art doesn't have to be for everybody. Either people get it, and then they enjoy it; or else they don't get it, and then they don't need it. So what's the predicament?"

Well, I shall try to explain what I think it is, and before that, *whose* I think it is. In other words, I shall try to explain what I mean by "the public."

In 1906, Matisse exhibited a picture which he called *The Joy of Life,* now in the Barnes Foundation in Merion, Pennsylvania. It was, as we now know, one of the great breakthrough paintings of this century. The subject was an old-fashioned bacchanal—nude figures outdoors, stretched on the grass, dancing, making music or love, picking flowers, and so on. It was his most ambitious undertaking—the largest painting he had yet produced; and it made people very angry. Angriest of all was Paul Signac, a leading modern painter, who was the vice-president of the Salon des Indépendants. He would have kept the picture out,

and it was hung only because that year Matisse happened to be on the hanging committee, so that his painting did not have to pass a jury. But Signac wrote to a friend: "Matisse seems to have gone to the dogs. Upon a canvas of two and a half meters, he has surrounded some strange characters with a line as thick as your thumb. Then he has covered the whole thing with a flat, well-defined tint, which however pure, seems disgusting. It evokes the multicolored shop fronts of the merchants of paint, varnishes, and household goods."

I cite this affair merely to suggest that Signac, a respected modern who had been in the avant-garde for years, was at that moment a member of Matisse's public, acting typically like a member of his public.

One year later, Matisse went to Picasso's studio to look at Picasso's latest painting, the *Demoiselles d'Avignon*, now in the Museum of Modern Art in New York. This, we now know, was another breakthrough for contemporary art; and this time it was Matisse who got angry. The picture, he said, was an outrage, an attempt to ridicule the whole modern movement. He swore that he would "sink Picasso" and make him regret his hoax.

It seems to me that Matisse, at that moment, was acting, typically, like a member of Picasso's public.

Such incidents are not exceptional. They illustrate a general rule that whenever there appears an art that is truly new and original, the men who denounce it first and loudest are artists. Obviously, because they are the most engaged. No critic, no outraged bourgeois, can match an artist's passion in repudiation.

The men who kept Courbet and Manet and the Impressionists and the Postimpressionists out of the salons were all painters. They were mostly academic painters. But it is not necessarily the academic painter who defends his own established manner against a novel way of making pictures or a threatened shift in taste. The leader of a revolutionary movement in art may get just as mad over a new departure, because there are few things so maddening as insubordination or betrayal in a revolutionary cause. And I think it was this sense of betrayal that made Matisse so angry in 1907 when he saw what he called "Picasso's hoax."

It serves no useful purpose to forget that Matisse's contribution to early Cubism—made at the height of his own

creativity—was an attitude of absolute and arrogant incomprehension. In 1908, as juror for the avant-garde Salon d'Automne, he rejected Braque's new landscapes "with little cubes"—just as, by 1912, the triumphant Cubists were to reject Duchamp's *Nude Descending a Stair.* Therefore, instead of repeating that only academic painters spurn the new, why not reverse the charge? Any man becomes academic by virtue of, or with respect to, what he rejects.

This academization of the avant-garde is in continuous process. It has been very noticeable in New York during the past few years. May we not then drop this useless, mythical distinction between—on one side—creative, forward-looking individuals whom we call artists, and—on the other side—a sullen, anonymous, uncomprehending mass, whom we call the public?

In other words, my notion of the public is functional. The word "public" for me does not designate any particular people; it refers to a role played by people, or to a role into which people are thrust or forced by a given experience. And only those who are beyond experience should be exempt from the charge of belonging to the public.

As to the "plight"—here I mean simply the shock of discomfort, or the bewilderment or the anger or the boredom which some people always feel, and all people sometimes feel, when confronted with an unfamiliar new style. When I was younger, I was taught that this discomfort was of no importance, firstly because only philistines were said to experience it (which is a lie), and secondly because it was believed to be of short duration. This last point certainly appears to be true. No art seems to remain uncomfortable for very long. At any rate, no style of these last hundred years has long retained its early look of unacceptability. Which could lead one to suspect that the initial rejection of so many modern works was a mere historical accident.

In the early 1950's certain spokesmen for what was then the avant-garde tried to argue differently for Abstract Expressionism. They suggested that the raw violence and the immediate action which produced these pictures put them beyond the pale of art appreciation and rendered them inherently unacceptable. And as proof they pointed out, with a satisfied gnashing of teeth, that very few people bought these pictures. Today we

know that this early reluctance to buy was but the normal time lag of ten years or less. By the late 1950's, the market for Abstract Expressionist art was amazingly active. There was nothing inherently unacceptable about these paintings after all. They just looked outrageous for a season, while we of the reluctant public were coming around.

This rapid domestication of the outrageous is the most characteristic feature of our artistic life, and the time lapse between shock received and thanks returned gets progressively shorter. At the present rate of taste adaptation, it takes about seven years for a young artist with a streak of wildness in him to turn from *enfant terrible* into elder statesman—not so much because he changes, but because the challenge he throws to the public is so quickly met.

So then the shock value of any violently new contemporary style is quickly exhausted. Before long, the new looks familiar, then normal and handsome, finally authoritative. All is well, you may say. Our initial misjudgment has been corrected; if we, or our fathers, were wrong about Cubism a half-century ago, that's all changed now.

Yes, but one thing has not changed: the relation of any new art—while it is new—to its own moment; or, to put it the other way around: every moment during the past hundred years has had an outrageous art of its own, so that every generation, from Courbet down, has had a crack at the discomfort to be had from modern art. And in this sense it is quite wrong to say that the bewilderment people feel over a new style is of no great account since it doesn't last long. Indeed it does last; it has been with us for a century. And the thrill of pain caused by modern art is like an addiction—so much of a necessity to us, that societies like Soviet Russia, without any outrageous modern art of their own, seem to us to be only half alive. They do not suffer that perpetual anxiety, or periodic frustration, or unease, which is our normal condition, and which I call "The Plight of the Public."

I therefore conclude that this plight does matter because it is both chronic and endemic. That is to say, sooner or later it is everybody's predicament, whether artist or philistine, and therefore worth taking seriously.

When a new, and apparently incomprehensible, work has appeared on the scene, we always hear of the perceptive critic who hailed it at once as a "new reality," or of the collector who recognized in it a great investment opportunity. Let me, on the other hand, put in a word for those who didn't get it.

Confronting a new work of art, they may feel excluded from something they thought they were part of—a sense of being thwarted, or deprived of something. And it is again a painter who put it best. When Georges Braque, in 1908, had his first view of the *Demoiselles d'Avignon*, he said: "It is as though we were supposed to exchange our usual diet for one of tow and paraffin." The important words here are "our usual diet." No use saying to a man, "Look, if you don't like modern painting, why don't you leave it alone? Why do you worry about it?" There are people for whom an incomprehensible shift in art, something that really baffles or disturbs, is more like a drastic change—or better, a drastic reduction in the daily ration on which one has come to depend—as during a forced march, or while in prison. And so long as there are people who feel about art in this way, it is uninteresting to be told that there also exist certain snobs whose pretended feelings disguise a real indifference.

I know that there are people enough who are quite genuinely troubled by those shifts that seem to change the worth of art. And this should give to what I call "The Plight of the Public" a certain dignity. There is a sense of loss, of sudden exile, of something willfully denied—sometimes a feeling that one's accumulated culture or experience is hopelessly devalued, leaving one exposed to spiritual destitution. And this experience can hit an artist even harder than an amateur. This sense of loss or bewilderment is too often described simply as a failure of esthetic appreciation or an inability to perceive the positive values in a novel experience. Sooner or later, we say, the man—if he has it in him—will catch on, or catch up. But there is no dignity or positive content in his resistance to the new.

But suppose you describe this resistance as a difficulty in keeping up with another man's sacrifices or another man's pace of sacrifice. Let me try to explain what I mean by the "sacrifice" in an original work of art. I think again of the *Joy of Life*

by Matisse, the picture that so offended his fellow painters and critics. Matisse here disturbed certain habitual assumptions. For instance, one had always assumed that, faced with a figurative painting, one was entitled to look at the figures in it, that is, to focus on them one by one, as he wished. The painted figures, "magnets to the eye" in Vasari's phrase, offered enough seeming density to sustain the long gaze. Thus, from all his experience with art, a man felt entitled to some pleasurable reward if he focused on painted figures, especially if these figures were joyous, female, and nude. But in this picture, if one looks at the figures distinctly, there is a curious lack of reward. There is something withheld, for the figures lack coherence or structural articulation. Their outlines are traced without regard to the presence or the function of the bone within, and some of the figures are insulated by a heavy dark padding—those lines "as thick as your thumb" that Signac complained about.

In the old days, one's first reaction would have been to exclaim —"This man can't draw." But we have the painter's preliminary studies for the individual figures of this picture—a succession of splendid drawings—and these show Matisse to have been one of the most knowing draftsmen who ever lived. Yet, after so many preparatory sketches, he arrives, in the completed painting, at a kind of draftsmanship in which his skill seems deliberately mortified or sacrificed. The heavy outlines that accost these figured nymphs prevent any materialization of bulk or density. They seem to drain energy away from the core of the figure, making it radiate into the space about them. Or perhaps it is our vision that is shunted away, so that a figure is no sooner recognized than we are forced to let it go to follow an expanding, rhythmical system. It is somewhat like watching a stone drop into water; your eye follows the expanding circles, and it takes a deliberate, almost a perverse, effort of will to keep focusing on the point of first impact—perhaps because it is so unrewarding. And perhaps Matisse was trying to make his individual figures disappear for us like that swallowed stone, so that we should be forced into recognizing a different system.

The analogue in nature to this kind of drawing is not a scene or stage on which solid forms are deployed; a truer analogue would be a circulatory system, as of a city or of the blood, where stoppage at any point implies a pathological condition, like a

blood clot or traffic jam. And I think Matisse must have felt that "good drawing" in the traditional sense—that is, line and tone designating a solid form of specific character with concrete location in space—that such drawing would have tended to trap and arrest the eye, to stabilize it at a concentration of density, thereby drawing attention to the solids themselves; and this was not the kind of vision that Matisse wanted brought to his pictures.

It is lucky for us not to have been polled in 1906, because we should certainly not have been ready to discard visual habits which had been acquired in the contemplation of real masterpieces, and to toss them overboard, overnight, for one painting. Today this kind of analysis has become commonplace, because an enormous amount of this century's painting derives from Matisse's example. The free-flowing color forms of Kandinsky and of Miró, and all those paintings since, which represent reality or experience as a condition of flux, owe their parentage or their freedom to the permissions claimed in this work.

But in 1906 this could not have been foreseen. And one almost suspects that part of the value of a painting like this accrues to it in retrospect, as its potential is gradually actualized, sometimes in the action of others. But when Matisse painted this picture, Degas was still around, with ten more years of life in him. It was surely still possible to draw with bite and precision. No wonder that few were ready to join Matisse in the kind of sacrifice that seemed implied in his waving line. And the first to acclaim the pictures was no fellow painter but an amateur with time on his hands: Leo Stein, the brother of Gertrude, who began, like everyone else, by disliking it, but returned to it again and again—and then, after some weeks, announced that it was a great painting, and proceeded to buy it. He had evidently become persuaded that the sacrifice here was worthwhile in view of a novel and positive experience that could not otherwise be had.

So far as I know, the first critic to speak of a new style in art in terms of sacrifice is Baudelaire. In his essay on Ingres he mentions a "shrinkage of spiritual faculties" which Ingres imposes on himself in order to reach some cool, classical ideal—in the spirit, so he imagines, of Raphael. Baudelaire doesn't like Ingres; he feels that all imagination and movement are banished from

his work. But, he says, "I have sufficient insight into Ingres' character to hold that with him this is a heroic immolation, a sacrifice upon the altar of those faculties which he sincerely believes to be nobler and more important." And then, by a remarkable leap, Baudelaire goes on to couple Ingres with Courbet, whom he also doesn't have much use for. He calls Courbet "a mighty workman, a man of fearsome, indomitable will, who has achieved results which to some minds have already more charm than those of the great masters of the Raphaelesque tradition, owing, doubtless, to their positive solidity and their unabashed indelicacy." But Baudelaire finds in Courbet the same peculiarity of mind as in Ingres, because he also massacred his faculties and silenced his imagination. "But the difference is that the heroic sacrifice offered by M. Ingres, in honor of the idea and the tradition of Raphaelesque Beauty, is performed by M. Courbet on behalf of external, positive, and immediate nature. In their war against the imagination, they are obedient to different motives; but their two opposing varieties of fanaticism lead them to the same immolation."

Baudelaire has rejected Courbet. Does this mean that his sensibility was unequal to that of the painter? Hardly, for Baudelaire's mind was, if anything, subtler, more sensitive, more adult than that of Courbet. Nor do I think that Baudelaire, as a literary man, can be accused of being typically insensitive to visual or plastic values. His rejection of Courbet simply means that, having his own ideals, he was not prepared to sacrifice the things that Courbet had discarded. Courbet himself, like any good artist, pursued only his own positive goals; the discarded values (for example, fantasy, "ideal beauty") had long lost their positive virtue for him, and thus were no loss. But they were still felt as a loss by Baudelaire, who perhaps imagined that fantasy and ideal beauty were yet unexhausted. And I think this is what it means, or may mean, when we say that a man, faced with a work of modern art, isn't "with it." It may simply mean that, having a strong attachment to certain values, he cannot serve an unfamiliar cult in which these same values are mocked.

And this, I think, is our plight most of the time. Contemporary art is constantly inviting us to applaud the destruction of values which we still cherish, while the positive cause, for the sake of which the sacrifices are made, is rarely made clear. So

that the sacrifices appear as acts of demolition, or of dismantling, without any motive—just as Courbet's work appeared to Baudelaire to be simply a revolutionary gesture for its own sake.

Let me take an example from nearer home and from my own experience. Early in 1958, a young painter named Jasper Johns had his first one-man show in New York. The pictures he showed—products of many years' work—were puzzling. Carefully painted in oil or encaustic, they were variations on four main themes:

Numbers, running in regular order, row after row all the way down the picture, either in color or white on white.

Letters, arranged in the same way.

The American Flag—not a picture of it, windblown or heroic, but stiffened, rigid, the pattern itself.

And finally, Targets, some tricolored, others all white or all green, sometimes with little boxes on top into which the artist had put plaster casts of anatomical parts, recognizably human.

A few other subjects turned up in single shots—a wire coat hanger, hung on a knob that projected from a dappled gray field. A canvas, which had a smaller stretched canvas stuck to it face to face—all you saw was its back; and the title was *Canvas*. Another, called *Drawer*, where the front panel of a wooden drawer with its two projecting knobs had been inserted into the lower part of a canvas, painted all gray.

How did people react? Those who had to say something about it tried to fit these new works into some historical scheme. Some shrugged it off and said, "More of Dada, we've seen this before; after Expressionism comes nonsense and anti-art, just as in the twenties." One hostile New York critic saw the show as part of a sorrowful devolution, another step in the systematic emptying out of content from modern art. A French critic wrote, "We mustn't cry 'fraud' too soon." But he was merely applying the cautions of the past; his feeling was that he was being duped.

On the other hand, a great number of intelligent men and women in New York responded with intense enthusiasm, but without being able to explain the source of their fascination. A museum director suggested that perhaps it was just the relief from Abstract Expressionism, of which one had seen so much

in recent years, that led him to enjoy Jasper Johns; but such negative explanations are never adequate. Some people thought that the painter chose commonplace subjects because, given our habit of overlooking life's simple things, he wanted, for the first time, to render them visible. Others thought that the charm of these paintings resided in the exquisite handling of the medium itself, and that the artist deliberately chose the most commonplace subjects so as to make them *invisible*, that is, to induce absolute concentration on the sensuous surface alone. But this didn't work for two reasons. First, because there was no agreement on whether these things were, in fact, well painted. (One New York critic of compulsive originality said that the subjects were fine, but that the painting was poor.) And, secondly, because if Johns had wanted his subject matter to become invisible through sheer banality, then he had surely failed—like a debutante who expects to remain inconspicuous by wearing blue jeans to the ball. Had reticent subject matter been his intention, he would have done better to paint a standard abstraction, where everybody knows not to question the subject. But in these new works, the subjects were overwhelmingly conspicuous, if only because of their context. Hung at general headquarters, a Jasper Johns flag might well have achieved invisibility; set up on a range, a target could well be overlooked; but carefully remade to be seen point-blank in an art gallery, these subjects struck home.

It seems that during this first encounter with Johns's work, few people were sure of how to respond, while some of the dependable avant-garde critics applied tested avant-garde standards—which seemed suddenly to have grown old and ready for dumping.

My own first reaction was normal. I disliked the show, and would gladly have thought it a bore. Yet it depressed me and I wasn't sure why. Then I began to recognize in myself all the classical symptoms of a philistine's reaction to modern art. I was angry at the artist, as if he had invited me to a meal, only to serve something uneatable, like tow and paraffin. I was irritated at some of my friends for pretending to like it—but with an uneasy suspicion that perhaps they did like it, so that I was really mad at myself for being so dull, and at the whole situation for showing me up.

And meanwhile, the pictures remained with me—working on me and depressing me. The thought of them gave me a distinct sense of threatening loss or privation. One in particular there was, called *Target with Four Faces*. It was a fairly large canvas consisting of nothing but one three-colored target—red, yellow, and blue; and above it, boxed behind a hinged wooden flap, four life casts of one face—or rather, of the lower part of a face, since the upper portion, including the eyes, had been sheared away. The picture seemed strangely rigid for a work of art and recalled Baudelaire's objection to Ingres: "No more imagination; therefore no more movement." Could any meaning be wrung from it? I thought how the human face in this picture seemed desecrated, being brutally thingified—and not in any acceptable spirit of social protest, but gratuitously, at random. At one point, I wanted the picture to give me a sickening suggestion of human sacrifice, of heads pickled or mounted as trophies. Then, I hoped, the whole thing would come to seem hypnotic and repellent, like a primitive sign of power. But when I looked again, all this romance disappeared. These faces—four of the same—were gathered there for no triumph; they were chopped up, cut away just under the eyes, but with no suggestion of cruelty, merely to make them fit into their boxes; and they were stacked on that upper shelf as a standard commodity. But was this reason enough to get so depressed? If I disliked these things, why not ignore them?

It was not that simple. For what really depressed me was what I felt these works were able to do to all other art. The pictures of de Kooning and Kline, it seemed to me, were suddenly tossed into one pot with Rembrandt and Giotto. All alike suddenly became painters of illusion. After all, when Franz Kline lays down a swath of black paint, that paint is transfigured. You may not know what it represents, but it is at least the path of an energy or part of an object moving in or against a white space. Paint and canvas stand for more than themselves. Pigment is still the medium by which something seen, thought, or felt, something other than pigment itself, is made visible. But here, in this picture by Jasper Johns, one felt the end of illusion. No more manipulation of paint as a medium of transformation. This man, if he wants something three-dimensional, resorts to a plaster cast and builds a box to contain it. When he paints

on a canvas, he can only paint what is flat—numbers, letters, a target, a flag. Everything else, it seems, would be make-believe, a childish game—"let's pretend." So, the flat is flat and the solid is three-dimensional, and these are the facts of the case, art or no art. There is no more metamorphosis, no more magic of medium. It looked to me like the death of painting, a rude stop, the end of the track.

I am not a painter myself, but I was interested in the reaction to Jasper Johns of two well-known New York abstract painters: One of them said, "If this is painting, I might as well give up." And the other said, resignedly, "Well, I am still involved with the dream." He, too, felt that an age-old dream of what painting had been, or could be, had been wantonly sacrificed—perhaps by a young man too brash or irreverent to have dreamed yet. And all this seemed much like Baudelaire's feeling about Courbet, that he had done away with imagination.

The pictures, then, kept me pondering, and I kept going back to them. And gradually something came through to me, a solitude more intense than anything I had seen in pictures of mere desolation. In *Target with Faces*, I became aware of an uncanny inversion of values. With mindless inhumanity or indifference, the organic and the inorganic had been leveled. A dismembered face, multiplied, blinded, repeats four times above the impersonal stare of a bull's-eye. Bull's-eye and blind faces—but juxtaposed as if by habit or accident, without any expressive intent. As if the values that would make a face seem more precious or eloquent had ceased to exist; as if those who could hold and impose such values just weren't around.

Then another inversion. I began to wonder what a target really was, and concluded that a target can only exist as a point in space—"over there," at a distance. But the target of Jasper Johns is always "right here"; it is all the field there is. It has lost its definitive "Thereness." I went on to wonder about the human face, and came to the opposite conclusion. A face makes no sense unless it is "here." At a distance, you may see a man's body, a head, even a profile. But as soon as you recognize a thing as a face, it is an object no longer, but one pole in a situation of reciprocal consciousness; it has, like one's own face, absolute "Hereness." So then surely Jasper Johns's *Target with*

Faces performs a strange inversion, because a target, which needs to exist at a distance, has been allotted all the available "Hereness," while the faces are shelved.

And once again, I felt that the leveling of those categories, which are the subjective markers of space, implied a totally nonhuman point of view. It was as if the subjective consciousness, which alone can give meaning to "here" and "there," had ceased to exist.

And then it dawned on me that all of Jasper Johns's pictures conveyed a sense of desolate waiting. The face-to-the-wall canvas waits to be turned; the drawer waits to be opened. That rigid flag—does it wait to be hoisted or recognized? Certainly the targets wait to be shot at. Johns made one painting using a lowered window shade which, like any window shade in the world, waits to be raised. The empty hanger waits to receive somebody's clothes. These letters, neatly set forth, wait to spell something out; and the numbers, arranged as on a tot board, wait to be scored. Even those plaster casts have the look of things temporarily shelved for some purpose. And yet, as you look at these objects, you know with absolute certainty that their time has passed, that nothing will happen, that that shade will never be lifted, those numbers will never add up again, and the coat hanger will never be clothed.

There is, in all this work, not simply an ignoring of human subject matter, as in much abstract art, but an implication of absence, and—this is what makes it most poignant—of human absence from a man-made environment. In the end, these pictures by Jasper Johns come to impress me as a dead city might—but a dead city of terrible familiarity. Only objects are left—man-made signs which, in the absence of men, have become objects. And Johns has anticipated their dereliction.

These, then, were some of my broodings as I looked at Johns's pictures. And now I'm faced with a number of questions, and a certain anxiety.

What I have said—was it *found* in the pictures or read into them? Does it accord with the painter's intention? Does it tally with other people's experience, to reassure me that my feelings are sound? I don't know. I can see that these pictures don't necessarily look like art, which has been known to solve far more difficult problems. I don't know whether they are art at all, whether they are great, or good, or likely to go up in price.

And whatever experience of painting I've had in the past seems as likely to hinder me as to help. I am challenged to estimate the aesthetic value of, say, a drawer stuck into a canvas. But nothing I've ever seen can teach me how this is to be done. I am alone with this thing, and it is up to me to evaluate it in the absence of available standards. The value which I shall put on this painting tests my personal courage. Here I can discover whether I am prepared to sustain the collision with a novel experience. Am I escaping it by being overly analytical? Have I been eavesdropping on conversations? Trying to formulate certain meanings seen in this art—are they designed to demonstrate something about myself or are they authentic experience?

They are without end, these questions, and their answers are nowhere in storage. It is a kind of self-analysis that a new image can throw you into and for which I am grateful. I am left in a state of anxious uncertainty by the painting, about painting, about myself. And I suspect that this is all right. In fact, I have little confidence in people who habitually, when exposed to new works of art, know what is great and what will last.

Modern art always projects itself into a twilight zone where no values are fixed. It is always born in anxiety, at least since Cézanne. And Picasso once said that what matters most to us in Cézanne, more than his pictures, is his anxiety. It seems to me a function of modern art to transmit this anxiety to the spectator, so that his encounter with the work is—at least while the work is new—a genuine existential predicament. Like Kierkegaard's God, the work molests us with its aggressive absurdity, the way Jasper Johns presented himself to me several years ago. It demands a decision in which you discover something of your own quality; and this decision is always a "leap of faith," to use Kierkegaard's famous term. And like Kierkegaard's God, who demands a sacrifice from Abraham in violation of every moral standard; like Kierkegaard's God, the picture seems arbitrary, cruel, irrational, demanding your faith, while it makes no promise of future rewards. In other words, it is in the nature of original contemporary art to present itself as a bad risk. And we the public, artists included, should be proud of being in this predicament, because nothing else would seem to us quite true to life; and art, after all, is supposed to be a mirror of life.

I was reading Exodus, Chapter 16, which describes the fall of manna in the desert; and found it very much to the point:

> In the morning, the dew lay round about the host, and when [it] was gone up, behold, upon the face of the wilderness there lay a small round thing, as small as the hoar-frost on the ground. And when the children of Israel saw it, . . . they wist not what it was. And Moses said unto them, This is the bread which the Lord hath given to you to eat. . . . Gather of it every man according to his eating. . . . And the children of Israel did so, and gathered, some more, some less. And when they did mete it with an omer, he that gathered much had nothing over, and he that gathered little had no lack; they gathered every man according to his eating. . . . But some of them left of it until the morning, and it bred worms and stank. . . .
>
> And the House of Israel called the name thereof Manna; . . . and the taste of it was like wafers made with honey. And Moses said, . . . Fill an omer of it to be kept for your generations; that they may see the bread [that] fed you in the wilderness. . . . So Aaron laid it up before the testimony to be kept. . . .

When I had read this much, I stopped and thought how like contemporary art this manna was; not only in that it was a God-send, or in that it was a desert food, or in that no one could quite understand it—for "they wist not what it was." Nor even because some of it was immediately put in a museum—"to be kept for your generations"; nor yet because the taste of it has remained a mystery, since the phrase here translated as "wafers made with honey" is in fact a blind guess; the Hebrew word is one that occurs nowhere else in ancient literature, and no one knows what it really means. Whence the legend that manna tasted to every man as he wished; though it came from without, its taste in the mouth was his own making.

But what clinched the modern art analogy for me was this Command—to gather of it every day, according to your eating, and not to lay it up as an insurance or investment for the future, making each day's gathering an act of faith.

1962

ANDY WARHOL

Embraced in the 1960s as the quintessential Pop Artist, Andy Warhol (1928–1987) saw his career go through something of a decline in the 1970s, when many in the art world believed he had lost his cheerful sting with a long series of portraits of society figures, commissions done to make a buck. Warhol's *Campbell's Soup Cans* and *Marilyns* were almost instantaneously established as classics in the museums and the history books. But his increasingly variegated activities were met with skepticism by an art world hard pressed to reconcile his reputation as a painter with his activities as a filmmaker, a magazine publisher, and the impresario of druggy escapades at a studio he called the Factory, where Warhol masterminded art production on a heretofore unprecedented scale. If the increasingly fast-paced art world of the 1980s was more responsive to Warhol's eclecticism, it was the enormous retrospective at the Museum of Modern Art in 1989 that definitively established him in many people's minds as not only the quintessential Pop Artist but also one of the essential artists of the twentieth century, right up there with Picasso, Matisse, Mondrian, and Duchamp. In the years since the MoMA retrospective, every aspect of Warhol's production—including his movies, his still photographs, his later abstract paintings, and the immense versions of Leonardo's *Last Supper* done not long before he died—has been subjected to the most searching scholarly attention and has received nearly universal praise. Warhol's 1963 interview with the critic Gene R. Swenson is required reading for anybody interested in Pop Art.

What Is Pop Art?

SOMEONE said that Brecht wanted everybody to think alike. I want everybody to think alike. But Brecht wanted to do it through Communism, in a way. Russia is doing it under government. It's happening here all by itself without being under a strict government; so if it's working without trying, why can't it work without being Communist? Everybody looks alike and acts alike, and we're getting more and more that way.

I think everybody should be a machine.
I think everybody should like everybody.
[SWENSON]*Is that what Pop Art is all about?*
Yes. It's liking things.

And liking things is like being a machine?

Yes, because you do the same thing every time. You do it over and over again.

And you approve of that?

Yes, because it's all fantasy. It's hard to be creative and it's also hard not to think what you do is creative or hard not to be called creative because everybody is always talking about that and individuality. Everybody's always being creative. And it's so funny when you say things aren't, like the shoe I would draw for an advertisement was called a "creation" but the drawing of it was not. But I guess I believe in both ways. All these people who aren't very good should be really good. Everybody is too good now, really. Like, how many actors are there? There are millions are there? Millions of painters and all pretty good. How can you say one style is better than another? You ought to be able to be an Abstract-Expressionist next week, or a Pop artist, or a realist, without feeling you've given up something. I think the artists who aren't very good should become like everybody else so that people would like things that aren't very good. It's already happening. All you have to do is read the magazines and the catalogues. It's this style or that style, this or that image of man—but that really doesn't make any difference. Some artists get left out that way, and why should they?

Is Pop Art a fad?

Yes, it's a fad, but I don't see what difference it makes. I just heard a rumor that G. quit working, that she's given up art altogether. And everyone is saying how awful it is that A. gave up his style and is doing it in a different way. I don't think so at all. If an artist can't do any more, then he should just quit; and an artist ought to be able to change his style without feeling bad. I heard that Lichtenstein said he might not be painting comic strips a year or two from now—I think that would be so great, to be able to change styles. And I think that's what's going to happen, that's going to be the whole new scene. That's probably one reason I'm using silk screens now. I think somebody should be able to do all my paintings for me. I haven't been able to make every image clear and simple and the same as the first one. I think it would be so great if more people took up silk screens so that no one would know whether my picture was mine or somebody else's.

It would turn art history upside down?

Yes.

Is that your aim?

No. The reason I'm painting this way is that I want to be a machine, and I feel that whatever I do and do machine-like is what I want to do.

Was commercial art more machine-like?

No, it wasn't. I was getting paid for it, and did anything they told me to do. If they told me to draw a shoe, I'd do it, and if they told me to correct it, I would—I'd do anything they told me to do, correct it and do it right. I'd have to invent and now I don't; after all that "correction," those commercial drawings would have feelings, they would have a style. The attitude of those who hired me had feeling or something to it; they knew what they wanted, they insisted; sometimes they got very emotional. The process of doing work in commercial art was machine-like, but the attitude had feeling to it.

Why did you start painting soup cans?

Because I used to drink it. I used to have the same lunch every day, for twenty years, I guess, the same thing over and over again. Someone said my life has dominated me; I liked that idea. I used to want to live at the Waldorf Towers and have soup and a sandwich, like that scene in the restaurant in *Naked Lunch*. . . .

We went to see *Dr No* at Forty-second Street. It's a fantastic movie, so cool. We walked outside and somebody threw a cherry bomb right in front of us, in this big crowd. And there was blood. I saw blood on people and all over. I felt like I was bleeding all over. I saw in the paper last week that there are more people throwing them—it's just part of the scene—and hurting people. My show in Paris is going to be called "Death in America." I'll show the electric-chair pictures and the dogs in Birmingham and car wrecks and some suicide pictures.

Why did you start these "Death" pictures?

I believe in it. Did you see the *Enquirer* this week? It had "The Wreck that Made Cops Cry"—a head cut in half, the arms and hands just lying there. It's sick, but I'm sure it happens all the time. I've met a lot of cops recently. They take pictures of everything, only it's almost impossible to get pictures from them.

Why did you start with the "Death" series?

I guess it was the big plane crash picture, the front page of a newspaper: 129 DIE. I was also painting the *Marilyns*. I realized that everything I was doing must have been Death. It was Christmas or Labor Day—a holiday—and every time you turned on the radio they said something like, "4 million are going to die." That started it. But when you see a gruesome picture over and over again, it doesn't really have any effect.

But you're still doing "Elizabeth Taylor" pictures.

I started those a long time ago, when she was so sick and everybody said she was going to die. Now I'm doing them all over, putting bright colors on her lips and eyes. My next series will be pornographic pictures. They will look blank; when you turn on the black lights, then you see them—big breasts and . . . If a cop came in, you could just flick out the lights or turn on the regular lights—how could you say that was pornography? But I'm still just practicing with these yet. Segal did a sculpture of two people making love, but he cut it all up, I guess because he thought it was too pornographic to be art. Actually it was very beautiful, perhaps a little too good, or he may feel a little protective about art. When you read Genet you get all hot, and that makes some people say this is not art. The thing I like about it is that it makes you forget about style and that sort of thing; style isn't really important.

Is "Pop" a bad name?

The name sounds so awful. Dada must have something to do with Pop—it's so funny, the names are really synonyms. Does anyone know what they're supposed to mean or have to do with, those names? Johns and Rauschenberg—Neo-Dada for all these years, and everyone calling them derivative and unable to transform the things they use—are now called progenitors of Pop. It's funny the way things change. I think John Cage has been very influential, and Merce Cunningham, too, maybe. Did you see that article in the *Hudson Review* [*The End of the Renvaissance?*, Summer, 1963]? It was about Cage and that whole crowd, but with a lot of big words like radical empiricism and teleology. Who knows? Maybe Jap and Bob were Neo-Dada and aren't any more. History books are being rewritten all the time. It doesn't matter what you do. Everybody just goes on thinking the same thing, and every year it gets more and more

alike. Those who talk about individuality the most are the ones who most object to deviation, and in a few years it may be the other way around. Some day everybody will think just what they want to think, and then everybody will probably be thinking alike; that seems to be what is happening.

1963

FROM

The Philosophy of Andy Warhol

At a certain point in my life, in the late 50s, I began to feel that I was picking up problems from the people I knew. One friend was hopelessly involved with a married woman, another had confided that he was homosexual, a woman I adored was manifesting strong signs of schizophrenia. I had never felt that I had problems, because I had never specifically defined any, but now I felt that these problems of friends were spreading themselves onto me like germs.

I decided to go for psychiatric treatment, as so many people I knew were doing. I felt that I should define some of my own problems—if, in fact, I had any—rather than merely sharing vicariously in the problems of friends.

I had had three nervous breakdowns when I was a child, spaced a year apart. One when I was eight, one at nine, and one at ten. The attacks—St. Vitus Dance—always started on the first day of summer vacation. I don't know what this meant. I would spend all summer listening to the radio and lying in bed with my Charlie McCarthy doll and my un-cut-out cut-out paper dolls all over the spread and under the pillow.

My father was away a lot on business trips to the coal mines, so I never saw him very much. My mother would read to me in her thick Czechoslovakian accent as best she could and I would always say "Thanks, Mom," after she finished with Dick Tracy, even if I hadn't understood a word. She'd give me a Hershey Bar every time I finished a page in my coloring book.

When I think of my high school days, all I can remember, really, are the long walks to school, through the Czech ghetto with the babushkas and overalls on the clotheslines, in

McKeesport, Pennsylvania. I wasn't amazingly popular, but I had some nice friends. I wasn't very close to anyone, although I guess I wanted to be, because when I would see the kids telling one another their problems, I felt left out. No one confided in me—I wasn't the type they wanted to confide in, I guess. We passed a bridge every day and underneath were used prophylactics. I'd always wonder out loud to everybody what they were, and they'd laugh.

I had a job one summer in a department store looking through *Vogue*s and *Harper's Bazaar*s and European fashion magazines for a wonderful man named Mr. Vollmer. I got something like fifty cents an hour and my job was to look for "ideas." I don't remember ever finding one or getting one. Mr. Vollmer was an idol to me because he came from New York and that seemed so exciting. I wasn't really thinking about ever going there myself, though.

But when I was eighteen a friend stuffed me into a Kroger's shopping bag and took me to New York. I still wanted to be close with people. I kept living with roommates thinking we could become good friends and share problems, but I'd always find out that they were just interested in another person sharing the rent. At one point I lived with seventeen different people in a basement apartment on 103rd Street and Manhattan Avenue, and not one person out of the seventeen ever shared a real problem with me. They were all creative kids, too—it was more or less an Art Commune—so I know they must have had lots of problems, but I never heard about any of them. There were fights in the kitchen a lot over who had bought which slice of salami, but that was about it. I worked very long hours in those days, so I guess I wouldn't have had time to listen to any of their problems even if they had told me any, but I still felt left out and hurt.

I'd be making the rounds looking for jobs all day, and then be home drawing them at night. That was my life in the 50s: greeting cards and watercolors and now and then a coffeehouse poetry reading.

The things I remember most about those days, aside from the long hours I spent working, are the cockroaches. Every apartment I ever stayed in was loaded with them. I'll never forget the humiliation of bringing my portfolio up to Carmel Snow's

office at *Harper's Bazaar* and unzipping it only to have a roach crawl out and down the leg of the table. She felt so sorry for me that she gave me a job.

So I had an incredible number of roommates. To this day almost every night I go out in New York I run into somebody I used to room with who invariably explains to my date, "I used to live with Andy." I always turn white—I mean whiter. After the same scene happens a few times, my date can't figure out how I could have lived with so many people, especially since they only know me as the loner I am today. Now, people who imagine me as the 60s media partygoer who traditionally arrived at parties with a minimum six-person "retinue" may wonder how I dare to call myself a "loner," so let me explain how I really mean that and why it's true. At the times in my life when I was *feeling* the most gregarious and looking for bosom friendships, I couldn't find any takers, so that exactly when I was alone was when I felt the most like not being alone. The moment I decided I'd rather be alone and not have anyone telling me their problems, everybody I'd never even seen before in my life started running after me to tell me things I'd just decided I didn't think it was a good idea to hear about. As soon as I became a loner in my own mind, that's when I got what you might call a "following."

As soon as you stop wanting something you get it. I've found that to be absolutely axiomatic.

Because I felt I was picking up the problems of friends, I went to a psychiatrist in Greenwich Village and told him all about myself. I told him my life story and how I didn't have any problems of my own and how I was picking up my friends' problems, and he said he would call me to make another appointment so we could talk some more, and then he never called me. As I'm thinking about it now, I realize it was unprofessional of him to say he was going to call and then not call. On the way back from the psychiatrist's I stopped in Macy's and out of the blue I bought my first television set, an RCA 19-inch black and white. I brought it home to the apartment where I was living alone, under the El on East 75th Street, and right away I forgot all about the psychiatrist. I kept the TV on all the time, especially while people were telling me their problems, and the television I found to be just diverting enough so the problems people

told me didn't really affect me any more. It was like some kind of magic.

My apartment was on top of Shirley's Pin-Up Bar, where Mabel Mercer would come to slum and sing "You're So Adorable," and the TV also put that in a whole new perspective. The building was a five-floor walk-up and originally I'd had the apartment on the fifth floor. Then, when the second floor became available, I took that, too, so now I had two floors, but not two consecutive ones. After I got my TV, though, I stayed more and more in the TV floor.

In the years after I'd decided to be a loner, I got more and more popular and found myself with more and more friends. Professionally I was doing well. I had my own studio and a few people working for me, and an arrangement evolved where they actually lived at my work studio. In those days, everything was loose, flexible. The people in the studio were there night and day. Friends of friends. Maria Callas was always on the phonograph and there were lots of mirrors and a lot of tinfoil.

I had by then made my Pop Art statement, so I had a lot of work to do, a lot of canvases to stretch. I worked from ten a.m. to ten p.m., usually, going home to sleep and coming back in the morning, but when I would get there in the morning the same people I'd left there the night before were still there, still going strong, still with Maria and the mirrors.

This is when I started realizing how insane people can be. For example, one girl moved into the elevator and wouldn't leave for a week until they refused to bring her any more Cokes. I didn't know what to make of the whole scene. Since I was paying the rent for the studio, I guessed that this somehow was actually *my* scene, but don't ask me what it was all about, because I never could figure it out.

The location was great—47th Street and Third Avenue. We'd always see the demonstrators on their way to the UN for all the rallies. The Pope rode by on 47th Street once on his way to St. Patrick's. Khruschev went by once, too. It was a good, wide street. Famous people had started to come by the studio, to peek at the on-going party, I suppose—Kerouac, Ginsberg, Fonda and Hopper, Barnett Newman, Judy Garland, the Rolling Stones. The Velvet Underground had started rehearsing in one part of the loft, just before we got a mixed-media roadshow

together and started our cross-country in 1963. It seemed like everything was starting then.

The counterculture, the subculture, pop, superstars, drugs, lights, discothèques—whatever we think of as "young-and-with-it"—probably started then. There was always a party somewhere: if there wasn't a party in a cellar, there was one on a roof, if there wasn't a party in a subway, there was one on a bus; if there wasn't one on a boat, there was one in the Statue of Liberty. People were always getting dressed up for a party. "All Tomorrow's Parties" was the name of a song the Velvets used to do at the Dom when the Lower East Side was just beginning to shake off its immigrant status and get hip. "What costumes shall the poor girl wear/To all tomorrow's parties . . ." I really liked that song. The Velvets played it and Nico sang it.

In those days everything was extravagant. You had to be rich to be able to afford pop clothes from boutiques like Paraphernalia or from designers like Tiger Morse. Tiger would go down to Klein's and Mays and buy a two-dollar dress, tear off the ribbon and flower, bring it up to her shop, and sell it for four hundred dollars. She had a way with accessories, too. She'd paste a ditsy on something from Woolworth's and charge fifty dollars for it. She had an uncanny talent for being able to tell which people who came into her shop were actually going to buy something. I once saw her look for a second at a nice-looking well-dressed lady and say, "I'm sorry, there's nothing for sale for you here." She could always tell. She would buy anything that glittered. She was the person who invented the electric-light dress that carried its own batteries.

In the 60s everybody got interested in everybody else. Drugs helped a little there. Everybody was equal suddenly—debutantes and chauffeurs, waitresses and governors. A friend of mine named Ingrid from New Jersey came up with a new last name, just right for her new, loosely defined show-business career. She called herself "Ingrid Superstar." I'm positive Ingrid invented that word. At least, I invite anyone with "superstar" clippings that predate Ingrid's to show them to me. The more parties we went to, the more they wrote her name in the papers, Ingrid Superstar, and "superstar" was starting its media run. Ingrid called me a few weeks ago. She's operating a sewing machine now. But her name is still going. It seems incredible, doesn't it?

In the 60s everybody got interested in everybody.
In the 70s everybody started dropping everybody.
The 60s were Clutter.
The 70s are very empty.

When I got my first TV set, I stopped caring so much about having close relationships with other people. I'd been hurt a lot to the degree you can only be hurt if you care a lot. So I guess I did care a lot, in the days before anyone ever heard of "pop art" or "underground movies" or "superstars."

So in the late 50s I started an affair with my television, which has continued to the present, when I play around in my bedroom with as many as four at a time. But I didn't get married until 1964 when I got my first tape recorder. My wife. My tape recorder and I have been married for ten years now. When I say "we," I mean my tape recorder and me. A lot of people don't understand that.

The acquisition of my tape recorder really finished whatever emotional life I might have had, but I was glad to see it go. Nothing was ever a problem again, because a problem just meant a good tape, and when a problem transforms itself into a good tape it's not a problem any more. An interesting problem was an interesting tape. Everyone knew that and performed for the tape. You couldn't tell which problems were real and which problems were exaggerated for the tape. Better yet, the people telling you the problems couldn't decide any more if they were really having the problems or if they were just performing.

During the 60s, I think, people forgot what emotions were supposed to be. And I don't think they've ever remembered. I think that once you see emotions from a certain angle you can never think of them as real again. That's what more or less has happened to me.

I don't really know if I was ever capable of love, but after the 60s I never thought in terms of "love" again.

However, I became what you might call *fascinated* by certain people. One person in the 60s fascinated me more than anybody I had ever known. And the fascination I experienced was probably very close to a certain kind of love.

1975

CLAES OLDENBURG

Born in Stockholm in 1929, Claes Oldenburg grew up in Chicago and studied at Yale University and the School of the Art Institute of Chicago. Living in New York in the late 1950s, he was caught up in the excitement around Happenings and other nontraditional forms of art making, and began producing sculptural objects of cloth, plaster, papier mâché, and paint. His breakthrough came in 1961, when he opened in a street-level space on East 2nd Street what he called *The Store*, an exhibition of plaster sculptures that the critic Sidney Tillim described as "a combination of neighborhood free enterprise and Sears and Roebuck. Its inventory included candy bars and wedding gowns, pastries and men's suits, bread, corsets, bacon and eggs, sandwiches." By the time Oldenburg published *Store Days* in 1967, a book commemorating this art exhibition-cum-Happening, he was exhibiting in more conventional gallery spaces, creating witty, oversized versions of quotidian objects ranging from a hamburger to a bathtub, many of them done in fabric, some stuffed and set on the floor, others unstuffed and allowed to hang limp on the wall. In more recent decades, Oldenburg has been best known for public sculpture, with an eraser, an electric plug, and a clothespin reimagined on a monumental scale, much of the work done in collaboration with Coosje van Bruggen, a curator whom Oldenburg married in 1977 and who died in 2009.

FROM
Store Days

I AM for an art that is political-erotical-mystical, that does something other than sit on its ass in a museum.

I am for an art that grows up not knowing it is art at all, an art given the chance of having a starting point of zero.

I am for an art that embroils itself with the everyday crap & still comes out on top.

I am for an art that imitates the human, that is comic, if necessary, or violent, or whatever is necessary.

I am for an art that takes its form from the lines of life itself, that twists and extends and accumulates and spits and drips, and is heavy and coarse and blunt and sweet and stupid as life itself.

I am for an artist who vanishes, turning up in a white cap painting signs or hallways.

Robert R. McElroy: Claes Oldenburg's *The Store*, 107 East Second Street, December 1961.

I am for art that comes out of a chimney like black hair and scatters in the sky.

I am for art that spills out of an old man's purse when he is bounced off a passing fender.

I am for the art out of a doggy's mouth, falling five stories from the roof.

I am for the art that a kid licks, after peeling away the wrapper.

I am for an art that joggles like everyones knees, when the bus traverses an excavation.

I am for art that is smoked, like a cigarette, smells, like a pair of shoes. I am for art that flaps like a flag, or helps blow noses, like a handkerchief.

I am for art that is put on and taken off, like pants, which develops holes, like socks, which is eaten, like a piece of pie, or abandoned with great contempt, like a piece of shit.

I am for art covered with bandages. I am for art that limps and rolls and runs and jumps. I am for art that comes in a can or washes up on the shore.

I am for art that coils and grunts like a wrestler. I am for art that sheds hair.

I am for art you can sit on. I am for art you can pick your nose with or stub your toes on.

I am for art from a pocket, from deep channels of the ear, from the edge of a knife, from the corners of the mouth, stuck in the eye or worn on the wrist.

I am for art under the skirts, and the art of pinching cockroaches.

I am for the art of conversation between the sidewalk and a blind mans metal stick.

I am for the art that grows in a pot, that comes down out of the skies at night, like lightning, that hides in the clouds and growls. I am for art that is flipped on and off with a switch.

I am for art that unfolds like a map, that you can squeeze, like your sweetys arm, or kiss, like a pet dog. Which expands and squeaks, like an accordion, which you can spill your dinner on, like an old tablecloth.

I am for an art that you can hammer with, stitch with, sew with, paste with, file with.

I am for an art that tells you the time of day, or where such and such a street is.

I am for an art that helps old ladies across the street.

I am for the art of the washing machine. I am for the art of a government check. I am for the art of last years raincoat.

I am for the art that comes up in fogs from sewer-holes in winter. I am for the art that splits when you step on a frozen puddle. I am for the worms art inside the apple. I am for the art of sweat that develops between crossed legs.

I am for the art of neck-hair and caked tea-cups, for the art between the tines of restaurant forks, for the odor of boiling dishwater.

I am for the art of sailing on Sunday, and the art of red and white gasoline pumps.

I am for the art of bright blue factory columns and blinking biscuit signs.

I am for the art of cheap plaster and enamel. I am for the art

of worn marble and smashed slate. I am for the art of rolling cobblestones and sliding sand. I am for the art of slag and black coal. I am for the art of dead birds.

I am for the art of scratchings in the asphalt, daubing at the walls. I am for the art of bending and kicking metal and breaking glass, and pulling at things to make them fall down.

I am for the art of punching and skinned knees and sat-on bananas. I am for the art of kids' smells. I am for the art of mama-babble.

I am for the art of bar-babble, tooth-picking, beerdrinking, egg-salting, in-sulting. I am for the art of falling off a barstool.

I am for the art of underwear and the art of taxicabs. I am for the art of ice-cream cones dropped on concrete. I am for the majestic art of dog-turds, rising like cathedrals.

I am for the blinking arts, lighting up the night. I am for art falling, splashing, wiggling, jumping, going on and off.

I am for the art of fat truck-tires and black eyes.

I am for Kool-art, 7-UP art, Pepsi-art, Sunshine art, 39 cents art, 15 cents art, Vatronol art, Dro-bomb art, Vam art, Menthol art, L&M art, Ex-lax art, Venida art, Heaven Hill art, Pamryl art, San-o-med art, Rx art, 9.99 art, Now art, New art, How art, Fire sale art, Last Chance art, Only art, Diamond art, Tomorrow art, Franks art, Ducks art, Meat-o-rama art.

I am for the art of bread wet by rain. I am for the rats' dance between floors. I am for the art of flies walking on a slick pear in the electric light. I am for the art of soggy onions and firm green shoots. I am for the art of clicking among the nuts when the roaches come and go. I am for the brown sad art of rotting apples.

I am for the art of meowls and clatter of cats and for the art of their dumb electric eyes.

I am for the white art of refrigerators and their muscular openings and closings.

I am for the art of rust and mold. I am for the art of hearts, funeral hearts or sweetheart hearts, full of nougat. I am for the art of worn meat-hooks and singing barrels of red, white, blue and yellow meat.

I am for the art of things lost or thrown away, coming home from school. I am for the art of cock-and-ball trees and flying cows and the noise of rectangles and squares. I am for the art of crayons and weak grey pencil-lead, and grainy wash and sticky oil paint, and the art of windshield wipers and the art of the finger on a cold window, on dusty steel or in the bubbles on the sides of a bathtub.

I am for the art of teddy-bears and guns and decapitated rabbits, exploded umbrellas, raped beds, chairs with their brown bones broken, burning trees, firecracker ends, chicken bones, pigeon bones and boxes with men sleeping in them.

I am for the art of slightly rotten funeral flowers, hung bloody rabbits and wrinkly yellow chickens, bass drums & tambourines, and plastic phonographs.

I am for the art of abandoned boxes, tied like pharaohs. I am for an art of watertanks and speeding clouds and flapping shades.

I am for U.S. Government Inspected Art, Grade A art, Regular Price art, Yellow Ripe art, Extra Fancy art, Ready-to-eat art, Best-for-less art, Ready-to-cook art, Fully cleaned art, Spend Less art, Eat Better art, Ham art, pork art, chicken art, tomato art, banana art, apple art, turkey art, cake art, cookie art.

add

Im for an art that is combed down, that is hung from each ear, that is laid on the lips and under the eyes, that is shaved from the legs, that is brushed on the teeth, that is fixed on the thighs, that is slipped on the foot.

square which becomes blobby

1967

GENE R. SWENSON

Gene R. Swenson's "The New American 'Sign Painters,'" published in
Art News in 1962, is by many reckonings the first essay ever published
about Pop Art. Swenson (1934–1969) studied art history at New York
University's prestigious Institute of Fine Arts and then, in what would
turn out to be a tragically circumscribed career, began making a name
for himself as a critic responsive to new work by Robert Indiana, James
Rosenquist, and Tom Wesselman; "What is Pop Art?"—his series of in-
terviews published in *Art News* in 1963 and 1964—is now recognized
as a foundational text. Swenson was only thirty-five when he died in a
car crash, on a visit to his home state of Kansas.

The New American "Sign Painters"

A GOLDEN hand with a pointing finger (applied in gold leaf
to a piece of now broken glass) hangs on a wall in Stephen
Durkee's studio. It was once a sign of commerce and direction;
now the hand, slightly etched and reworked by its owner, points
nowhere and is a sign with a life of its own. The shining hand
tells us more about its owner and his attitudes toward the world
than about its original context.

This kind of sign has recently appeared in the paintings of
a number of younger artists. Words, trade marks, commercial
symbols and fragments of billboards are molded and fused into
visual statements organized by the personality of the artist; they
cannot be understood through formulas or some conventional
pattern of visual grammar one or more remove from experi-
ence. The artists have shared—for the last few years, at least—a
common interest in the ubiquitous products of their artisanal
cousins, the painters of commercial signs and designers of ad-
vertising copy.

Like all artists who are unwilling to imitate, these painters
force a re-examination of the nature of painting and its chang-
ing relation to the world. James Dine and Robert Indiana are
proving that, as Rauschenberg puts it, "there is no poor sub-
ject." Roy Lichtenstein, James Rosenquist and Andrew Warhol
are proving you can have recognizable references (so-called
images) without regressing to earlier fashions. Richard Smith

and Stephen Durkee, with their striking individuality and their formal sensitivity, bring diversity and depth to the newest phase of the continuing revolution that characterizes painting in the twentieth century.

The content of their work is direct. It points to objects that are commonplace. Their techniques are without ceremony or pretence. Ordinary objects which prick our associative faculties, along with a technique almost shocking in its simplicity, create the tone of this new painting. At the same time, although composed of fragments which may derive from Wall Street and Madison Avenue, the subject of these works, to use a phrase of George Heard Hamilton, "is not what the world looks like, but what we mean to each other."

Both James Dine and Robert Indiana regularly introduce words into their paintings. In a painting dominated by two necktie shapes, Dine prints the word "TIE" twice. On a strip that looks like a riveted metal plate, Indiana stencils the words "THE AMERICAN REAPING COMPANY." Like words on signboards they insist on our attention. They are not subordinated to the composition as in a Cubist collage, nor are they used as a psychological pun as in some Surrealist painting (for example, when an image of a pipe bears the inscription, "this is not a pipe").

The visual references in the works of Dine and Indiana are readily and easily recognized. Dine sews buttons down the center of a canvas that is painted in the pattern of a heavy overcoat. He puts twelve cloth neckties into one picture, covers it all with green paint and calls it *Twelve Ties in a Landscape*. Indiana makes more subtle and oblique references. In *The American Dream*, the circle with highway numbers stenciled on it is the same yellow and black as stop signs; the double row of triangles in *The Great Reap* suggests the cutting edge of a mowing machine. He uses words to conjure unlikely presences. *The American Gas Works*, a black, yellow and white painting with those words stenciled in it, conjures a metaphorical meter-reader; the incongruity of his imaginary presence is heightened by the decorative elegance of "hard edge" visual variations of the theme. The words and numbers stenciled into the painting tighten the composition and, like arrows, indicate the direction the eye should travel. The meter-clocks lack hands, but the

painting is kept from fantasy by the vigor of its color, the straightforwardness of the composition and the tension between a beautiful appearance and incongruous subject matter. Dine's concern with the abstract nature of the anatomy and its coverings is bold and questioning; Indiana's concern with unsuspected artistic juxtapositions is subtle and concrete.

There is something impudent in these works, something so simple-minded and obvious as to be unexpected. We find Dine mocking the meanings we conventionally invest in words and images. Both the word and the image in his work may refer to something well-known, like hair; in combining the two Dine has changed them both and revealed our arbitrary ideas of them. The image is merely an illusion as we read into the work; yet it would also be an illusion to believe that we see only black, brown and flesh-colored oil paints squeezed out of a tube. The printed word seems superfluous; even in terms of pure composition the dotted "I" between "HA" and "R" is somewhat irrelevant. The redundant word underscores both the liveliness of objects and the deadness of definitions. The word and image have been willfully related until they—and our ideas of them—seem naked and slightly obscene. Repetition has blurred their commonness.

Both Dine and Indiana come from the Midwest; twenty-seven-years old, Dine was born and raised in Ohio; Indiana, six years older, was born and raised in Indiana and Illinois. Both now live and work in New York; they are aware of each other's work, but disclaim mutual influences.

Dine even dissociates his present work from the "Happenings" he himself was doing merely a year or two ago. The sculpture of one of his associates in the "Happenings," Claes Oldenburg, can be (and has been) superficially linked to Dine's work; but Oldenburg's papier-mâché pastries deal—as one of their major interests—with the difference between illusion and reality. That difference is largely irrelevant to Dine's work; Dine takes for granted that the way in which each of us knows the world is "reality" to us and "illusion" to anyone who disagrees with us.

Indiana, if he admits influences at all, prefers to associate his work with that of his friends Ellsworth Kelly and Jack Youngerman. His present style seems to have grown out of an interest

in an old circular copper stencil he found when he moved into his loft; he liked the shapes of the lettering and their purely formal possibilities. When he finally used the stencil, however, the resulting words and even statements were not simply forms and their meanings not simply spice in an abstract composition; they were used by him to express concrete, vivid meanings—to convey the substance of an esthetic idea on which his forms then commented.

Roy Lichtenstein, James Rosenquist and Andrew Warhol have all had actual experience with commercial art. Thirty-nine-year-old Lichtenstein, a native of New York who now lives and teaches in New Jersey, had brief experience with industrial design and display work while living in Ohio. Several years ago he did some experiments using comic book designs as the formal basis for Abstract-Expressionist painting; in his recent work he has straightforwardly used the colors, stencils, and Ben-Day dots of the comic strips as basic elements in his style.

Lichtenstein places a large face of a girl in one of his pictures; the girl may be pure although we cannot be sure, especially since the words "It's . . . It's not an ENGAGEMENT RING, is it?" are written in the balloon next to her. To the left of the girl is a smaller man: size is the principal indication of space in these paintings. Partly because they are stenciled, the outlines do not contain mass or volumes, the space between them is as vacant as that between the wires of a mobile. The dots seem to waver like molecules; because of the regularity and the amount of white space between them, however, the screen of dots (by convention a solid in the comic strips) suggests merely a transparent plane. The picture is a stringent but amusing exposure of visual as well as social habits.

Although Lichtenstein attempts to make his color seem mass-produced, the objects he reproduces (for example, a kitchen range or a baked potato) seem neatly chosen and carefully arranged; they are not merely symbols of a type, just as his people are not merely symbols of general human traits. He is sometimes forced to vary the color he uses for the dots to make them seem the same "mass-produced" color as his solid areas; his paintings force us to find something important, amusing or inflated in a cliché, in an ordinary event or in tabloid heroism.

James Rosenquist, born in North Dakota in 1933, learned

some of his present techniques while painting twenty-foot-high faces of mothers and other All-Americans on Times Square. As a commercial billboard painter he had to try to see the images he painted with his mind's eye, asking himself how they looked three blocks behind him. The size and familiarity of the objects in his paintings at the present time, and the explosive force with which they are presented, seem to place us between the picture and the position from which its fragments were meant to be seen; the space of the picture comes forward to surround us.

Rosenquist uses recognizable fragments of our environment as echoes. The radiator grill of an automobile, canned spaghetti and two people kissing have ready associations and everyday references, although they are likely to have been dulled through commercial familiarity; by combining them in *I Love You with My Ford* Rosenquist has pointed up the death of our senses which has made these three things equally indifferent and anonymous.

The painting is also concerned with how love is made. The upper section, an obsolescent '49 Ford, comments on things which change (car models), or persist (making love in cars). The progressive enlargement of scale in the three sections parallels the increasing intimacy and loss of identity in the sexual act. The artist changes his palette from grisaille to a vivid orange in the lower section. Like the interlocking forms which tie the left and right panels together visually, every aspect is ultimately seen for its importance to the whole. It is not simply rebellion when Rosenquist says, "I want to avoid the romantic quality of paint." He speaks in the tradition of anti-Romantic Realist Courbet (not anti-Romantic Classicist Ingres), objecting to imitated moods and rarified atmospheres (not to the ignoring of rules).

Andrew Warhol was born in Philadelphia in 1931 and now lives in New York; until recently, he depended entirely on commercial shoe designs and advertising layouts for a living. Partially in reaction to the artificial neatness of the commercial designs, he often used to make a drip or blot in the painting he did for his own interest; he made those "accidents," however, seem quite painterly—they had a beauty often found in the intentional "carelessness" of some New York School painting. In one painting of an old can of Campbell's soup, the texture of the weathered tin surface behind the tattered label has a

quality of lofty elegance. In a black-and-white painting of an enormous Coke bottle done early in 1961, nervous scratches are made in an enclosed area and a "mistake" is corrected with some handsome white paint brushwork. A recent black Coke bottle has none of those references to art; the painted bottle is larger and a trademark to its right runs off the right-hand side of the picture as if the 6-foot-high canvas were not large enough. The older picture provided a setting and its own scalar referents; the sense of a disproportionately increased scale in the later work results from the bottle being related to the familiar object we often hold in our hand rather than to the size of the stretchers on which the canvas is tacked. Our awareness is not so much of a Coca-Cola billboard as of the shrunken size of the world we occupy; an image from a sign, never intended to be so consciously seen in focus, is stripped of its original significa-tion. Far from symbolizing a civilization, the image loses even its ability to symbolize a product. It signifies a specific common object; the shape, size and color of its presentation characterize an attitude toward objects to which we seldom pay conscious attention, but which make up the preconceptions of our every-day visual experience.

Art of the recent past not only provides a perspective on our environment; it is part of that environment, and one of espe-cially intimate appeal to the artist. The formal debt of Richard Smith and Stephen Durkee to Newman and Rothko is clear; the significance of their adaptation is the radically different tone they bring to their work. Scale seems to be their closest link with the works of the two older painters; certain images which they use, however, relate to things outside the picture and produce a scale more analogous to that of Lichtenstein, Warhol and Rosenquist. Abstract painting often suggests spe-cific moods, sometimes even objects; in a picture such as Franz Kline's *Shenandoah*, a landscape may be suggested by a few abstract brushstrokes. In a Smith painting (as in an Indiana), an image (or word) transforms the work's abstract elements into comments on the concreteness of the image (or the word); in a Durkee, as in a Dine, specific objects are drawn as explicitly as possible, yet it is not their concreteness but their abstract qualities which are most striking.

Durkee may simply copy markings from the back of a truck,

or refer to a lion from a circus poster with a few sketchy lines, or paint consecutive numbers in such a manner as to suggest the passage of time. One of his most impressive qualities is his attention to detail—the delicacy of his expression and the distinctions which it implies. Two acrobats hang from a trapeze which has no visible support in one of his pictures. Their physical posture and their proportions are so stiff and stylized that one might suppose Durkee had based them on an old advertisement or a cut-out (actually they were suggested by two broken wooden dolls he used in a construction); they also have delicately varied outlines and shadows—as if the artist had been unable to rid himself of sympathy for his subject and intended to give them an inner quality deserving of our sympathy. (Durkee once hired a commercial sign painter when he wanted perfect slickness and its quality of utter indifference towards the subject-matter.) The parable of one man depending on another might seem tired or commonplace without these details to give it intensity and vibrancy.

The distinctions he makes in *Flowers* are less subtle, but he maintains a similar tension between dubbed-in morality and intense concern. The three images are signs for three definite objects, although they may also be seen as symbols for the human, the mechanical and the natural. The relationship of each object to us (how we know and use it) is implied as well: the eye is closest and most abstract, the spokes of the bicycle wheels look like flowers, the natural object is known only through words. The various kinds and degrees of tension between image, scale and abstraction produce a sense of the vividness and complexity to be discovered in our examination of visual cliché.

Durkee was born near New York in 1938 and has lived in the city most of his life. Last year one of his neighbors in lower Manhattan was a thirty-year-old Englishman, Richard Smith, who has since returned to London. Both had their first one-man shows in New York in 1961.

Smith's *Billboard*, for the most part an orange surface varied only in the texture of the paint, has eight relatively small green rectangles around the top edge and along the sides with a strip of red across the bottom; with a few lines, Smith changes the red to bricks and transforms the entire tone of the painting. The unusual simplicity of the "billboard" image and its remarkable

consistency with a beautiful solid-color expanse are both refreshing and unaffected. *McCall's*, the magazine that capitalized on the word "togetherness," is also the name of Smith's painting of a giant red, white and green heart. The heart shape is in part simply a device, no more concerned with its traditional meaning than the magazine's advertising campaign was concerned with human relations. Unlike the advertisements, the heart does to some degree revive old meanings while making its comment upon modern society; most of all, however, it moves us by the splendid beauty of its color and form. This beauty has the same irrelevance to the picture's subject and the same importance to the picture's comment that Christianity has to any good Baroque crucifixion. Like Lichtenstein, Rosenquist and Warhol, Smith focuses on exhausted symbols and brings them to life with an exploded scale; the comment and tone of the picture are most effective not because they pretend to be universally truthful but because they are genuine and present concerns of the artist.

Does the work of these painters constitute a "movement"? One observer who believes that it does has dubbed it "commonism"; a few of the artists find that label unobjectionable if not very illuminating. As we have observed, many similarities can be found in their work. Nevertheless Richard Smith's most recent painting, for example, is quite different from the two works discussed above and probably should *not* be called "sign painting" —even though, as Lawrence Alloway observed, it continues to show "approximations to marquee scale . . . combined with the soft-focus and dazzle of slick magazine color photography." Artists exhibiting such vigor and imagination as these are not likely to be confined by any idea or label for long.

The seven young painters described here revitalize our sense of the contemporary world. They point quite coolly to things close at hand with surprising and usually delightful results. A nineteenth-century landscape painter once said that Manet's *Fifer* looked like a tailor's signboard. To this Zola responded, "I agree with him, if by that he means that . . . the simplification effected by the artist's clear and accurate vision produces a canvas quite light, charming in its grace and naïveté and acutely real."

1962

JOHN BERNARD MYERS

John Bernard Myers (1920–1987) was involved with avant-garde mari-
onette shows and the Surrealist-Romantic magazine *View* in the 1940s,
before becoming the director of the new Tibor de Nagy Gallery in
1951; this was a joint venture with a business partner, the Hungarian
refugee who gave the gallery its name, and Dwight Ripley, who paid
the rent in the early years. With advice from figures including Green-
berg and de Kooning, Myers showcased an emerging generation of
artists, with solo exhibitions by Larry Rivers, Grace Hartigan, Helen
Frankenthaler, and Fairfield Porter. He also engaged with the work of
their poet friends, publishing through Tibor de Nagy Editions some of
the first writings of John Ashbery, Frank O'Hara, and Kenneth Koch,
and spearheading the Artists Theater, where painters and poets col-
laborated for the stage. *Tracking the Marvelous*, Myers's 1983 memoir,
is an indelible portrait of the mid-century years, suggesting how the
darker Surrealist sensibilities of the 1940s gave way to a spirit of joyful
play in the 1950s. "Junkdump Fair Surveyed," written in 1964 in the
wake of the Pop Art explosion and published in *Art and Literature*, is
Myers's riposte to an American art scene that was growing by leaps and
bounds, with money, fashion, and vanguard art suddenly symbiotically
related in ways still relatively unfamiliar in New York.

Junkdump Fair Surveyed

for Lee Krasner Pollock

THIS season, the season of 1963–64, there have been myriads
of "cultural" events which gave impetus to conversation before,
during and after dinner; the art world seems to exist to pro-
vide a good share of *frissons* that keep the conversation going.
Whereas in the fifties art gossip relied on which artist was mov-
ing to which gallery, how much Ben X. paid for a Pollock, who
got whose studio (the regular, simple, ordinary gossip of any art
community)—the tone has now changed. There are no rallying
cries, no aesthetic polemics, no discussion clubs: there is at best
internecine art warfare. As in Goethe's puppet play, *Junkdump
Fair*, New York has become a fantastic free-for-all, the most
energetic of centers. The emphasis has changed, the art world
has become democratized, the whole populace wants to be in
on the goings-on.

Art and Literature

An International Review

3

John Cage———————«26 Statements re Duchamp»
shbery———————«The Skaters»————————Mitchell Sisskind
«On a Sculpture of Dr. Albert Einstein»————John Hopkins
vanted was Company»———————Leon Polk Smith
———«The Painting of Leon Polk Smith»————André Masson
———«Some Notes on the Unusual Georges Bataille»
rges Bataille————————«Eponine»
——John Bernard Myers————«Junkdump Fair Surveyed»
M. Fogel————«Gardens gardens Gardens Toads»————Roland
————«The World as Object»————————Max Kozloff
————«An Interpretation of Courbet's Atelier»
Tucci————————«Unconjugable Lives»
————Robert Rauschenberg————————«Öyvind Fahlström»
Öyvind Fahlström————«A Game of Characters»
ob——«The Dice-Cup»————Paul Bowles————«The Garden»

Cover of *Art and Literature* 3 (Autumn–Winter 1964). John Bernard Meyers's "Junkdump Fair Surveyed" was published in this issue.

It is not difficult to say what caused this, although some of the reasons are complex. There is, for instance, the proliferation of galleries. In 1950 there was a handful, perhaps six that showed serious contemporary painting and sculpture. At the moment there are about three hundred and fifty galleries, of which the majority exhibit new work and in all sorts of media and tendencies. Each gallery has the problem of how to get the attention of critics and public (the public has become enormous.) The presentation of novelty shows (mixed media, sight and sound, sound and movement, multiple vision, toys for adults, Happenings,

etc.)—continues to be one of the main techniques to catch the crowd and the press.

One's mail bulges with catalogues and announcements: a series of boxes within boxes, a balloon to be blown up, a sheet of paper large as a school map inside a cardboard tube, a booklet the size of a postage stamp. The sheer dexterity (and sometimes wit) which goes into the design of eye-catching announcements is astonishing. It is as though each gallery were stating its claims with the ardour that goes into the selling of pharmaceuticals or vacuum cleaners. The clever come-on is "in"; blurbs by poets or critics are "out." Perhaps the best illustration of the new approach can be found in the jazzy advertisements of *Art International* where the artist himself is sometimes seen with leather jacket and motorcycles, or happily leaping out of the surf wearing a bikini. Sober advertising is on the skids but so is the day of the sober consumer.

We apparently live in the Age of Culture (rather like living in von Horath's *Age of the Fish*). We become brighter, nay *better* people to the extent that we make the sign of the cross as we murmur A-r-t. ("In a time of confused aims, art helps us to become reconciled to ourselves. The 'cultured' man is not as snobs and slobs think—the man who knows many 'things,' but who knows much about himself. Those who shun art are seeking to escape themselves."—Editorial in the *Kansas State Collegian*, April, 1964.)

The seekers of culture promenade Madison Avenue stopping here for a moment or there for ten minutes. Starting from 57th Street they look at the plaster effigies of George Segal (Green), the laminated wood figures (faucets for penises) of Mike Nevelson (Amel), the object-painting of Appel (Jackson), the landscapes of Leonid (Durlacher), the windshield wipers of D'Arcangelo (Fischbach), the flowers of Hartl (Peridot), American folk objects (Willard). Up the Avenue go the pilgrims, seeking special grace, trying to "know themselves." Their eyes are greedy for ever greater benedictions, their fervor rarely slackens. Up, up, up the Avenue, sometimes making a foray to left or to right: Moskowitz's window shades (Castelli), Indiana's exhortations to Eat/Die (Stable), Rosalind Drexler's painted-over, cut-out lovers (Kornblee), spacemen by Hoyendunck (Elkon).

If all the pilgrims cannot buy, the new collectors (with far

less looking) do, and they buy with the mixed feelings of a New Jersey Dry Cleaning tycoon who gives liberally to Our Lady of Perpetual Help—just in case. His Plenary Indulgences (so often bought for so very little) provide a host of blessings. He is no longer regarded as just a sharpie installing Launder-mats in Teaneck or Peapack. He can with his freshly acquired works of art become a Contributor to the Museum and, with his snappy little wife, get invited to pre-opening dinner parties and shake hands with a Rockefeller or pass the buns to Mrs. E. Bliss Parkinson or have a short chat with Dr. Edgar Wind or listen to Barney Newman tell how it really happened in the pioneer years. Before you know it he's elected to a committee or becomes a Friend Of. He can then sit in judgment as to which art work will have the honor of being a New Acquisition.

But the fun is only started: with his new *persona* he gets invited to art parties at which he can indulge a sneaking wish to wear a purple blazer, he can do the Twist with the nicest art tarts, and—after the party—at the Chuck Wagon, experience a brief encounter. Aglow with his "self-knowledge" the new collector begins to feel he's more than just another collector. He is an Eye. He will bring to the attention of certain deal-ers those artists whose work has passed the cold glance of this Eye. If the artist is really a good fellow, Mr. Eye will promise to convert his present nowhere-status to that of New Acquisi-tion. Maybe to the Whitney Museum. The new collector no longer bothers to go to the galleries. He makes his way to the artists' studios where, as an arbiter of taste, he will buy what he wants—cheaper. He also finds it useful to invest in *one* favourite gallery, there to push his pet "discoveries." Our Lady smiles ever more indulgently and at this point the new collector begins to receive public acclaim: his collection, his apartment, his snappy little wife appear in full color in *Time*, *Vogue*, the *Ladies Home Journal*. At the Venice Biennale he rents an excursion boat (Biennale Flottante!) and is photographed with the Mayor of Venice, the Contessa Volpi, and finally (at last!) Peggy Gug-genheim. More material for the conversations at dinner because the new collector has, indeed, become one of the big topics: what dress his wife wore, who snubbed her, what gaffe she made at Jasper Johns's opening. The older collectors begin to shake heads and start worrying about how to keep him out of their

clover. They don't like the purple jacket, and the Laundermat biz in Peapack seems vulgar. But how can they squeeze him off a committee when he owns 22 Rauschenbergs, 4 Klines and 7 Gorkys—along with the stuff he's *really* crazy about?

The artists, needless, to say, are in general delighted. There's always a little "ice" to be had from the shenanigans of the new type collector—for instance, stronger social contacts and extra dividends in publicity.

These are regarded as the two most important problems facing Today's Artist. The newspapers keep switching horses; the art magazines are too slow; the intellectuals are undependable. But publicity is a basic necessity and nothing should be overlooked—certainly not radio and, above all, TV.

The artist feels he *needs* TV appearances and the Telly has been going in for art more and more. We can watch, mesmerized, as Al Leslie paints himself (in a canvas resembling somehow a Coca-Cola ad) while diffidently confiding to his audience that his true goal is domestic serenity and a bit of financial security. Channel 13 features regular art programs on such variegated topics as The Impact of Hard Edge, New Attitudes Toward Our Environment, ("don't change it, just accept it"), The Systematic Derangement of the Senses, Is Pop Here to Stay? Thus at the Cedar Bar one hears how splendid Mrs. Jackson Pollock looked televised, or what a lousy make-up job they did on Henry Geldzahler. Channel 2, a big national network, gives us regular art talks by Aline Saarinen with guest art-stars, or the Pietà, or the latest Pop.

But even TV is not enough. At this writing a new publicity shove has come with the World's Fair. Stories on the rejection of an outdoor mural called *The Thirteen Most Wanted Criminals*, stories completing the beatification of Robert Moses, proud boasting stories detailing acres of sculpture, paintings, murals, plus the architecture of the future.

Not even the World's Fair, however, topped the opening of the Huntington Hartford Gallery of Modern Art* (referred to by some as Ca d'Oro in Columbus Circle). Needless to say the collection is mostly boring, but that did not deter the hoopla surrounding the grand premiere. In order to squeeze in all the

*The Gallery of Modern Art and The Huntington Hartford Collection.

guests, there had to be five separate openings (care was taken lest anyone suppose one opening grander than another) with not only the founder, Mr. Hartford, but Salvador and Gala Dalí and Edward Stone, the architect, standing in a receiving line under Dalí's widescreen *Columbus Discovering America*. Seldom has the public been so wined and dined, no, not since the hey-day of the Gonzagas.

Is it any wonder then that the religiosity surrounding art is beyond all exaggeration? Artist, dealer, collector, museum official and art-lovers wear out their knees in genuflecting at its altar.

The general feeling of the less intoxicated sections of the New York Scene appears to be that it is probably a good thing that the fanaticism of aesthetic piety, "Cultural" sentimentality and their attendant "rehearsed responses" should go as far as ever it can go. Perhaps it will clear the air. Perhaps this will ultimately serve to differentiate what are in effect two widely separate audiences. Just as there now seems to be one whole public for Richard Rodgers and also another, and quite a different one, for Stravinsky; so too, it may turn out with art, through today's vast enlargement of the art audience and art consumer. One hopes there *will* be a deep cleavage between what David Hare calls public art and private art. One had never thought of that cleavage as anything but artificial; one had surely never thought of it as a good thing. But the fact is that the considerable variety of hit-parade art like hit-parade music is here to stay. The novelty exhibitions, the kicky Happenings, the bizarrerie of the new art personalities and the total identification of commercialism with "avant-gardism" simply cannot be waved aside. There it is, like Carol Channing's toothy grin and loudly belted "Hello, Dolly."

There are those who feel regret, there is wistful pressing of noses against the window of past hope. The dream of a New York School is fading more rapidly than had ever been reckoned. The delightful openness of New Yorkers to new experience, to fresh perception, turns out to be a passion for the latest in gooseflesh. Being cultured rather than civilised, Americans have small powers of assimilation. With them it has always been—on to the new! Brilliant talents are being given the go-by

despite the fact that the best American art developed in the past twenty years is still being created by the same people. Even in a "civilized" country, it should be remembered—and not so long ago—the French Impressionists suffered a forty-year period of neglect, too soon referred to as old hat by their bourgeois contemporaries. The speed-up is many times faster in America. It is becoming the fashion to lump together such recent (and such varied) talents as Giorgio Cavallon, James Brooks, and de Kooning by calling them "Abstract Expressionists." And with that out of the way, they are securely comprehended. They have been definitively "understood" and set to one side. On to the next!

Perhaps it was a mistake to have taken too seriously the idea of a New York School since New York does not resemble past communities—Venice, Siena, Amsterdam or even Paris. The city lacks the kind of cohesion, even among the so-called educated classes, to support or understand a School. Would it not have been wiser in the long run for New York to have remained artistically international by closer ties with artists in other countries who were opening themselves and their work to similar tendencies? Would this not have prevented the triumph of Junk-dump Fair and commercialism? Some of us should have known better than to push an "American-type art" which, despite the fact that it led the world, also made it possible for the doors to be thrown open wide to the worst excesses of American middle- and low-brow nonsense. The argument that Paris had too much of a grip on the international art market and had to be broken, is good propaganda for an American market but was never really a sufficient excuse for severing so many ties with Europe, and on a scale which now seems preposterous.

Even now the younger critics insist that a "European" look is not to be encouraged. But *what* is a "European" look? Or for that matter, *what* is "American-type painting?" Had the so-called Second Generation (painters who came up in the fifties and who at that time ranged from 23 to 35 in age) been *less* concerned with the "American" style, would they not have been freer to develop without the approval of "American-art" hipsters? Perhaps this fear of loss of position contributed to the break-down of courage which led so many of them to eventual collapse. For what *do* we witness around us now but a series of collapses, and with heart-breaking rapidity.

Everyone asks the same question: "What happened?" Many painters in their forties and fifties wear a look—as grey as evening—which is a combination of surprise and incomprehension. "Where were *you* when the shit hit the fan?"—a general query. No good to say it was ever thus, that there have always been changes, *this* coming in and *that* going out. The citadel has been stormed, the ramparts have been scaled. The plastic arts (for so long the most *interesting* manifestation of the human spirit) have been grabbed up by the crowd of job-holders from museum and press, commercial daubers with a ravenous hunger for prestige, status-seeking, profit-motivated collectors, and the art dealers with a flair for Big Business.

What will happen in the coming period? No one dare guess. Ken Noland, Frank Stella, Ellsworth Kelly, Ad Reinhardt, for example, maintain positions which are almost unassailable. De Kooning, lacking a major show in several years, becomes a target for the critical avant-garde. The new intelligentsia rarely discuss Motherwell, Guston, or Gottlieb, and then only with pious nods. Newman retains his perennial position as a subject for argument.

There is almost no criticism of real distinction. Hilton Kramer, Harold Rosenberg, Nico Calas are "fuori," Sidney Tillim, Barbara Rose, Michael Fried and Robert Rosenblum are "indentro" (both up-town and downtown). All the new opinion makers, as well as familiar voices like Clement Greenberg* and William Rubin (Manny Farber is off the scene), remain totally involved with art history. One's difficulty with them is not that they don't *LOOK* (they drill holes through art works), but rather that their focus is too centered upon the "resistant" art work (the more it resists the more likely it is to be good). This of course breaks down when you consider how easy it is to enjoy a Kelly, a Rothko, or a Nakian.

One small corner remains untouched. It is perhaps this little corner in which a few, a very few indeed, live like marvelous snobs (perhaps they *are* snobs) quite indifferent to the critics, to fashion, the market. These few have their own "bright particular faith," their own uninfluenced taste. They couldn't care less about being on committees, or passing the peppermill to Mrs.

*Greenberg's essay for his exhibition in Los Angeles called "Post Painterly Abstraction" is an instance of his continued power to influence taste.

Wellington Koo. They are the few who surround themselves with, think about, love and stand up for the most disparate pictures, objects, statues—in short they are the rare, civilised individuals who know and care about what they intend.

I know of one collector in whose house you might find along with past art a perfect Rothko, a Joseph Cornell box, a Wols etching, a David Smith, a Braque still-life, a Pollock, a Hopper, a Morris Louis, a Vicente, a Balthus child, a Spaventa bronze, a Bultman drawing, a Hepworth marble, a Giacometti, a de Kooning woman, a Helen Frankenthaler gouache, a Miró ceramic, a photograph by Atget, a Stankiewicz, a Tworkov, an Olitski, a De Niro, and a bunch of yellow lilies in oil by Gwendolyn Smith, a dear old friend who presented it as a birthday present.

1964

FAIRFIELD PORTER

Fairfield Porter (1907–1975) grew up in Illinois, attended Harvard, and moved to New York in 1928. His family's real estate interests freed him of financial cares for many years, as he struggled to find his voice as a thinker and a painter, for a time engaging with Marxist ideas and experimenting with Social Realist themes. He came into his own as an artist in the 1950s, fusing the intimate domestic visions of Bonnard and Vuillard with a frank, open brushwork that owed much to his friends among the Abstract Expressionists, especially de Kooning. Living on Long Island in the winter and on an island off the coast of Maine in the summer, Porter developed an idiosyncratic pastoral vision. Although he was closer to de Kooning's age than to that of Larry Rivers or James Schuyler, Porter's bonds were especially strong with the generation of painters and poets emerging in the wake of World War II; for some years Schuyler lived with Porter and his wife, the poet Anne Porter, and their children. Porter was tough-minded and romantic, a man with a penetrating analytical imagination who wanted to catch life's most evanescent moments. "So far as it has merit," he wrote in 1974, "a painting is a fact, arbitrary and individual." Like Marsden Hartley before him, Porter was a twentieth-century American artist whose writings are nearly as absorbing as his paintings. Especially in his work as art critic for *The Nation* from 1959 to 1961, Porter countered the idea of modern art as a single consistent development with a moving insistence on the singularity and particularity of each artist's vision. His collected criticism makes an impressive volume, as edited by the painter Rackstraw Downes in *Art in Its Own Terms* (1979). It was a retrospective at the Boston Museum of Fine Arts in 1983 that sealed Porter's reputation as one of the major American artists of his time.

The Paintings of E. E. Cummings

A⊤ first you notice the variety of Cummings' paintings. Next you see what to an adult, though not necessarily to a child, is a humorous device: accurate observation of selected detail. Cummings is a mimic. He makes fun of trees, of textures, of gestures, of movements, and particularly of clouds. I am thinking of the water-colors of New Hampshire mountains. The contour of the mountains is not an edge, it is a line of motion. The picture is about what the sun does, what a particular cloud or tree does. There is concentration on a detail which resists

assimilation, which will be itself. It is out of context, it provides sharpness, like the realistic arrow in an abstraction by Klee. The variety of Cummings' paintings is of a different sort from that of some typical modern artist like Picasso, in whose work you are aware of a temperamental display of strong emotions and of the force of a realized ambition to do well what he wants to do. The personality of Cummings' paintings directs your interest toward external phenomena. These phenomena are not the linear or plane definition of things, not the space displaced, or the weight, nor, as in Picasso's abstractions, an analysis of what is like what and what is unlike what, but rather the impact of the whole of something in sensuous instead of conceptual terms. Therefore light and texture are his media. He is concerned with motion instead of weight. Like Marin, like an oriental painter, he perceives with his intuition more than through postulates. And because of this intuitiveness, because he is direct, and not verbal, his painting is not literary. (Isn't it true also of his writing, that it is not literary, that he uses words not for their meaning so much as sensuously?) In the small oils of nudes and oil portraits there is less mimicry, but just as much sensuousness. He lets the paint do what it can: the textures are not decided, they are allowed. The lines result from the relations of patches of light and color, which determine the form. The impact of nature guides him, he guides the paint, there is little force. In these paintings the mimicry of motions becomes sensitivity for delicate relations of value.

There are other paintings, large landscapes or nudes, where the interest of the artist was in the more usual problems of spaces, areas, anatomy, and so on. He was no longer witty, he was lost in what he was doing, and the painting grew up to an independence of its creator, to gain a life of its own.

In a painting of a locomotive straining forward the motion is shown by the same technical method Benton has used, and though there is something conceptual about this, still in Cummings's painting it is not so much the weight or volume of the train as the noise and looks of its rush past that is presented. It is a painting of a man using his ears and eyes, not philosophical talent or creative ambition. By the last phrase I mean the compulsion that many artists have to create a world or a formal order of which the artist is either the master or the prophet.

Cummings, for instance, has no system. This distinguishes him from even such poetical impressionists as Sisley or Pissarro. He does not belong to a current fashion. And though all Western painters do not care to limit themselves by manifestos, even Miró or Picasso who will not adhere to the abstractionists or surrealists, are formed by an inner logic: they do have a system. So did the impressionists. They were and are all Westerners. Cummings reminds me of the answer made by the Japanese painter in Malraux's "Man's Fate" to the question, "Why do you paint?" which ran something like this: "I have seen the work of your Western painters, and the more they paint lines that do not represent objects, the more they paint the state of their own souls. For me it is things that count." What counts for Cummings is external phenomena. He paints wittily, sensuously, and with love, and for him love is a fact, not an idea.

1946

Richard Stankiewicz

". . . Is it to sit among mattresses of the dead,
bottles, pots, shoes and grass and murmur aptest eve:
Is it to hear the blatter of grackles and say
Invisible priest; *is it to eject, to pull*
The day to pieces and cry stanza my stone?
Where was it one first heard of the truth? The the."

THE sculpture of Richard Stankiewicz is welded together from junk: scrap iron, pieces of discarded machinery, and broken castings. It is to sculpture what the collages of Schwitters, glued together from transfers, tickets, wrappings, and pieces of advertisements are to painting. As Wallace Stevens in *The Man on the Dump* associates nouns and adjectives one would not naturally associate, so Stankiewicz associates a spring, a weight, and the casting from the top of a gas cooking stove to make a non-machine frozen into immobility by its own rust. "Where was it one first heard of the truth?" Stankiewicz' creativeness is childish and barbaric. He uses things for purposes that were not intended, or only partly so, as the early Christians used pieces of temples for their basilicas, or as a child makes wheels for his

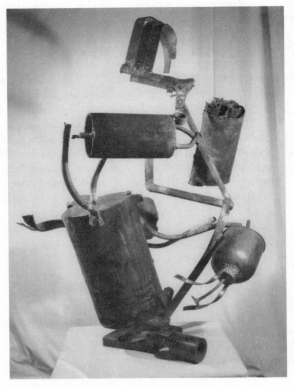

Richard Stankiewicz: *Untitled*, 1960. Iron.

cart out of crayons. The original material still shows. Respect for the material is common enough in art; it is part of the organic theory. But his material has already been used once and it retains the quality of some previous construction, which was mechanical and functional.

As a stone carver sees the statue in the stone—Michelangelo said carving was easy, because all the sculptor had to do was cut the stone away from the statue—so Stankiewicz sees a beginning with his outer vision, which is sensitive to entirely new relationships between the given parts. Modelers in clay

and other welders (who are closer to modelers than to carvers) shape material to a pre-existent image. His is not pure art, because it is related to what it reminds you of. His machines look as though they might run. There is an ambiguous representation—has he made a birdbath, a sun-dial, the emergency steering gear on the afterdeck of a ship, a winch, or what? The ambiguity gives it a mischievous life of its own, a resistance to classification, a stubborn humor, that comes from the form contradicting the function. There is the sort of life that inanimate objects have, especially (or perhaps only) manufactured objects. A child sees this life in objects whose function he does not understand, or whose function he takes so much for granted that function inadequately comprehends its reality. A California Indian who owned a car that he knew how to repair, said to an anthropologist, "You white people think everything is dead." Stankiewicz shows everything to be alive. The child and the Indian feel in things a consciousness (which may be a projection of their own consciousness), an awareness that reflects their own consciousness. Stankiewicz does not have to make things over in man's image, nor in an animal's, though he does this sometimes. In his material he finds how to communicate with things, and he is capable of something better than surrealism. Surrealism can be an easy way out. Surrealism makes compound monsters. Stankiewicz can perceive below the surface as well as make things up. He sees a vitality in things before he gives them artistic life, which is neither a functional purpose nor workability, but the vitality that has rubbed off onto things from the humanity that went into their manufacture; and this vitality is as adventitious and as important as the smell of someone else's clothes. The curved edge of a lamp shade, of a doorknob, of a keyhole, of a spring, is a center of awareness where impressions are received and exchanged.

He releases this life in things before a new artistic life is made. The liveliness is strongest when it is not illustrated. His most abstract sculptures that represent least have the most individual life. This life is one that strengthens through rusting and industrial decay.

His sculpture, using junk, is a creation of life out of death, the new life being of a quite different nature than the old one that was decaying on the junk pile, on the sidewalk, in the

used-car lot. In its decay there is already a new beginning before Stankiewicz gets hold of it. At his best he makes one aware of a vitality that is extra-artistic. His respect for the material is not a machinist's respect, but the respect of someone who can take a machine or leave it, who respects even the life of things, which is more than mechanical.

1959

John Graham

JOHN GRAHAM once resembled an elegant Lenin, and perhaps the resemblance would still obtain had Lenin lived longer. With new acquaintances he may discuss Sadism; with acquaintances of longer duration his conversation includes magical speculations and moralistic concerns about esthetic worth. The absolute edges of his paintings and drawings frequently enclose one wandering eye, which he explains as giving life to the face. It is the life of a prisoner trying to escape. There is a conflict between life which escapes, and its contemplation, which is art. It is similar to the wandering eyes in the busts supporting the mantelpiece in Cocteau's film, *Beauty and the Beast*. It is life where life is not expected, as though the artist were a headsman, the effects of whose surgical task had not entirely run their course. And if the content of a man's work is the chief content of his life, it is obvious from Graham's painting that the chief content of his life is love of art.

He is an aristocratic Russian who served as a cavalry officer in the Czar's armies, then, with a Russian law degree, he emigrated to the United States and studied art. He comes to art the aristocratic way: through connoisseurship. He has an eye for quality. Wherever he lives, his home is a museum: its furnishings, from antique and second-hand shops and the five-and-dime store, reassemble a consistent workable house of no particular period in which each chair, painting or cooking utensil is set aside from such things by his recognition (which a visitor immediately senses) of a unique artistic or craft excellence. His houses illustrate a frame for civilized life. But he is not like a modern architect whose plan embodies his imagination of life as it ought

to be, but never has been, lived; for Graham seems to imagine life as it has been lived. However, the life in his houses, where everything has its place as part of a whole, in spite of the ordinariness of the objects, or their uniqueness, is not life lived, but life contemplated, even when contemplation is contemplation-in-use. He is an appreciator who remains on the outside. He has a gift for imitation and for understanding things without losing his separateness.

His connoisseurship was expressed in his assembling of the Crowninshield collection of African art. His eye for special quality showed in an exhibition that he organized in the early 'forties including work by the then unknown Pollock and de Kooning. His imitative gift was revealed in the Picassoesque paintings of the 'twenties. And, in 1946, his one-man show at the Pinacotheca Gallery presented along with some Ingres-like red and black ladies such as *Cave Canem* (whose content resembles that of a presumed Leonardo, *Lady with the Ermine*), imitations of early de Kooning women in green and brick orange. This constituted a sincere tribute to the originality of de Kooning, who, having not yet had a one-man show of his work, was still unrecognized by the general public.

Graham has verbalized his ideas in a book, *System and Dialectics of Art* (published around 1936). Written in a Stalinist dialectical manner of questions posed and answered by the author, it contains occasional Russianisms, such as the omission of the article, and an uncertainty about where to place it. Thus: "Artist creates for society," sounds more abstract than "the artist," as though not only were there a connection between all artists, but as though there existed further a generalized entity, "Artist," the god of artists. It may be that his taste for generalization and distaste for particularity which he expresses in this book come from the structure of Russian.

He places the understanding of culture before creation, as a necessary condition to creation. "Barbarians, nomads, are people of action. . . . Only after settling down do people begin to own objects . . . they begin to collect. With collecting the conquest of the outside world by action ceases and the conquest of the inner world by reflection begins."

He defines the artist's desire to create in the same words as the desire to collect, with the exception that he gives more

space to the latter, expanding it far beyond the definition of the desire to create. He writes: "The desire to collect is the necessity to re-establish the lost primordial contacts and the need to arrest eternal motion and to contemplate." Similarly, "Artist creates because of (conscious or unconscious) desire to arrest motion and to contemplate . . . the desire to collect also comes from the painful fact that most people have lost contact with nature, with SPACE, with matter, they have lost contact with themselves, and are thus incapable of direct communication with other human beings. This is particularly true where Protestant civilization has castrated people of their most natural elemental senses. As a consequence of irrevocable and drastic impairment of their ability to perceive, such people are unable to judge the specific weight of many matters. The impairment of any special sense does not end the matter, however. One of the instruments for reckoning being faulty the whole complement of instruments is out of gear and the concert action is absent. The reason men of high culture collect is that they have been disappointed at lack of understanding in present-day human society. . . .

"In collecting and classifying works of art one must realize that antiquity or age in itself has no meaning or value whatsoever. The things that matter are: a) plastic value [constructive art value in specified space] b) quality [care exerted] c) authenticity [belonging to the epoch or the artist] d) epoch [some epochs have more form significance than others] e) rarity f) state of preservation"—sometimes imperfect preservation is preferable, he says, as in Classical fragments, for Classical things "are over-crowded with irrelevant details. . . . Noses are superfluous because they obstruct the vision of the head. . . . There is only one infallible gauge in collecting, it is intuition perfected by personal, tactile experience. . . . One should never tamper with objects of antiquity, never restore, improve, polish, shine or paint."

The purpose of collecting is "to develop individual culture (source of general cultures)." Again about art, "The purpose of art in *particular* is to re-establish a lost contact with the unconscious (actively by producing works of art and passively by contemplating works of art), with the primordial racial past and to keep and develop this contact in order to bring to the

conscious mind the throbbing events of the unconscious mind.
. . . Conscious mind is . . . only a clearing house for the powers
of the unconscious. The abstract purpose of art is to . . . estab-
lish personal contact with static eternity. The concrete purpose
of art is to lift repressions."

Graham has an expatriate's ambivalence and an aristocrat's
sense of status. He writes from the outside, as though the cul-
ture he admires were the activity of a class he respects and
understands, even envies. But Graham remains aloof from the
artist, separated by his understanding. He is separated first of
all from Russia by his exile, and though he used to admire the
Revolution, he does no longer. He used to admire Picasso,
and does no longer, probably finding in Picasso's eclecticism
something too close to his own aloofness. He has beautifully
expressed the nature of the Anglo-American culture of his
adopted country, its strength and weakness, which have and
do separate him again, not only from America, but from West-
ern civilization, which seems to be going the American way.
"Protestanto-Puritanism" "casts into discard ritual or form
and substitutes subject matter—to the exclusion of form." And
Protestantism "substitutes the particular for the general (de-
tail worship), humor for joy, efficiency for aspiration, veracity
for imagination, conscientiousness for honesty, cleanliness for
beauty. . . ." It "has established subject matter as a paramount
consideration and aim in itself, substitutes for real articles, thrift
as a Christian virtue and thus laid the foundations of *capital-
ism*," to which Graham added later in his own handwriting in
the copy of the book I saw, "and consequently of communism."
"In Puritanic culture the repressions meted out to the children
are of an insidious character, *operating from inside,* disarming
gently, depriving the young growth of a chance to rebel. . . .
The result is a civilization deprived of the means of control and
direction of instincts, deprived of emotional life, equipped only
to move in the physical, subject matter, matter-of-fact, matter-
of-action, brutal world. Human beings deprived of emotional
life, hollowed inside like the trunk of a tree, are doomed to live
in the *horror vacui* and contemplate the material world without
being able to find any meaning attached to it, or have any access
to it. Alongside . . . the negative aspects . . . there are crude
but substantial virtues, such as:—ability to work, veracity, self

respect, ability to endure [physical], poise, courtesy, eagerness to learn. . . . These civilizations coupled with the most advanced politico-economical ideology stand the chance eventually, so to say, of saving the world on these sound, rugged bases. Cultural refinements will come later and perhaps there will be no need for them. For the present these Puritanic virtues are deadly to the European (Western) culture and art."

Graham's art is the exact opposite to that of, say, Eakins, whose art is the epitome of these deadly virtues. Graham bases his painting and drawing on the art which expressed the West at its height. He went through a period of Picassoesque painting, which he has repudiated, but which has the same essential nature as his present Ingres- or Uccello-like style. It derives from the paintings and drawings of the pre-Puritan, pre-Protestant West, it is not of the epoch to which he belongs. Neither does he believe that this epoch can have any significant painting. However at the same time he believes in art, and even more in a culture that expresses itself artistically.

"The edge ought to be absolutely spontaneous and final." And he says that volume and time are fictitious—in fact his greatest consistency is to perpetrate the absurd—that art "should lead humanity on to heroic action of no value." But today the "heroic action of no value" engaged in by humanity—the construction of vehicles for interplanetary travel, or of powerful machines of immense destruction—these actions would not seem to derive from art; but more perhaps from ideology, especially that of revolutionary states, which, for the end of independence from the central nations of the West, stimulate their populations to heroic and active starvation. Graham's painting illustrates what he understands about the culture he cares for, and when he creates, he makes objects like the most admired ones in the collections of his cultivated men. He wishes to create the contents of his museums. He competes as an artist with the historians who supply the dealers who sell to him as a collector. His beautiful decisive edges, clean as a surgeon's incision, imitate part of the impulse of Uccello. His Ingres-Uccello-Raphael type of feminine beauty embodies his idea of art as a ceremonial affair. "The value of the strange and the absurd lies in their suggestion of a possible unknown, supernatural, life eternal. For enigma is only a symbol of deity and deity is only a symbol of continuity or life eternal."

The difference between Graham and Uccello, who Graham would emulate, is that Uccello pushed consciousness to its limits—perspective was a way of organizing and clarifying the experience of space; but for Graham the value of method lies in its potentialities for mystification. So in the end Graham goes to magic instead of to science. The magical elements in his women are their life in the fixity of his line; volume in flatness; the look of something that no longer exists, the dream of a more powerful past in which concepts come ahead of facts. The clarity of his space has the limitation of modern magic. The ceremony he believes in, is, like Houdini's, relegated to the vaudeville stage. For today magic is disappointing in its triviality and inconsequentiality. The face and bust of the lady in *Cave Canem,* and her dog, have a stony polish, and her hair and dress are brittle arabesques. The construction is in the cutting line, not in the bloody, morbid color. Graham's magic is papery; the paintings are like decorations for *The Mask of the Red Death.*

1960

Against Idealism

BERENSON said that it was an English and American vice to try to limit the means of your expression.

Artistic manifestos indicate where the artist directs his attention. His attention is directed to the place that interests him as most important to him, and this place is either his conception of where reality resides or of what he is sure he knows. Artistic "realism" is usually conceived as an interest in things as they appear to be. This is neither the scientific idea of reality, nor the idea of most philosophies. However realism depends on using the help of science to reproduce appearance.

The opposition between "realism" and "abstraction" is a misleading one. Both realists and abstractionists think they embody an ideal of art of which each work is the shadow: the realist making a reflection of the natural world and the abstractionist making a reflection of the world of ideas in the largest sense, which of course includes non-verbal ideas. Both think that what is real about art exists in the realm of Whitehead's "eternal objects" and no matter how much either one pretends to prefer

either reality or unreality (like Clive Bell), this reality or unreality is an eternal object which an artist of whatever persuasion constantly refers to whenever he makes something. So is the opposition between "Humanism" and whatever a humanist thinks is non-humanist, unclear. It can mean, for an artist who wants to represent appearances, a preference for representing the human figure. It can also mean putting concern for man's welfare ahead of indifference to it. Such art chooses a content of social consciousness, and such a content in turn usually implies a criticism of the social order. This art wavers between a satire that is most effectively put into words, and sentimentality. Yet it is not possible for an artist to put into his products anything that remains untouched by the artist's nature.

It was fashionable a few years ago to disparage, in the cause of abstraction or non-objectivity, what the abstractionists called "illusion," as if their own products were without illusion. A few years ago at the Museum of Modern Art in New York there was simultaneously exhibited in adjoining galleries the works of Jackson Pollock and of Balthus. And on the stairs leading up to these two exhibitions hung the museum's purchase, de Kooning's *Woman*. I suppose most people would agree to include Balthus among realists, and Pollock among non-objectivists. In this example of his work de Kooning falls into neither category, though it would certainly be included with the anti-illusionists. Balthus has always used the illusion of appearance. What was the effect of these paintings? Balthus' paintings, based on the use of illusion as it was understood at the time, gave the strongest sense of the actual presence of something—what? I suppose the presence of the personality of the painter. Certainly the sense of a directed and still unresolved emotion. The Pollocks communicated rather a sense of consistency. The de Kooning had least sense of the continuity and flatness of the paint surface: most of all three artists' works his was like something floating in the atmosphere, it was phantom-like, and like all ghosts, illusory. Pollock's paintings and de Kooning's one painting belonged to the category (invented not by artists but by critics) of "abstract expressionism." Expressionism is meant to mean art in which the content is an expression of strong emotions: but the effect of Pollock's painting is one of all emotion spent: these are the aftermarks, from which whatever emotional pressure may have

gone into their making has evaporated completely leaving behind, as it were, stains. Balthus, who would be called the most "realist" and full of illusion presented in these paintings strong emotional pressure, which was far from having evaporated. De Kooning, who might be classified as anti-illusionist and expressionist, showed in his painting not an evaporation of emotion so much as the ghost of emotion, consistent with the ghostliness of his form. His painting was both formally and emotionally ghostly. In this painting, de Kooning, eschewing illusory representation, gave up also any illusion of material presence, resulting in a weak emotional presence. Homer's phrase, "the silly dead" refers to this emotional feebleness of ghosts.

Today when a painting is criticized by another painter as "too realistic" or praised as not realistic, the painter-critic refers to the belief that reality is not known through sight alone, but conceptually. The purely visual painting is never considered as realistic as the conceptual one. A concept is an ideal that can be referred to. It is an "eternal object." In other words, what is "too realistic" refers not to appearance, but to knowledge, and what is known is assumed in this criticism to be beyond appearance. A painter who presents something that is limited to the reality known to sight alone, is not criticized or praised for realism. This idea of realism in painting goes back at least as far as Giotto. In Florentine and North Italian art the sense that gives you the closest apprehension of reality beyond appearance, is the sense of touch. The painters of these schools tried to stimulate the observer's tactile sense in all kinds of ways, for you are convinced of the existence of something if it is suggested or if you believe that it is tangible. Not until the Impressionists was it thought sufficient to appeal to the sense of sight alone. They made the most complete break that has ever been made from the real as equivalent with the tangible to the real as equivalent with the visible. This idea still meets much resistance, though if you ask someone which one of his five senses he would most mind losing, he is almost certain to agree that sight is the most precious. And attached to this predominance of vision is also an unspoken feeling that what you can only see may not really exist: it needs to be verified. Empiricism casts doubts on the validity of knowledge gained through the senses alone, to propose that through the senses alone you can know nothing beyond

them. Yet science, based on sense experience, has good reason (the success of the scientific method) to think that you can know the real from a beginning in sense impressions. The scientific method also supports the belief that reality is attained through a process of reduction, as von Liebig thought that he knew what was essential to the life of plants from an analysis of their ashes after he had burned them up. Pasteur's discovery of the importance of micro-organisms has never quite erased the commonest scientific habit of thinking that reduction leads to the ultimately real, and that since life reduces to death, death is the eternal object of which life is the shadow.

Impressionism can be claimed to have reduced sensations to the primary one of sight: no painting before Impressionism relied exclusively on sight alone. Rather than reduction however, this may be an acceptance of human limitation and a refusal to believe that what you know immediately is only a shadow of something beyond that is more real. Impressionism has never been completely accepted, partly because of the pre-Impressionist emphasis on the tangible and partly because of the prestige that scientific method gives to the belief that truth follows from a reductive process. Seurat first tried to validate Impressionism by reducing it to a scientific theory of light. Cézanne was unhappy with Impressionism, and his wanting to make of Impressionism something solid and enduring like the art of the museums, plus his preoccupation with the contour, shows that he thought that tactility should be restored to primary dignity. Then his suggestion that nature could be reduced to the forms of solid geometry was taken up by Cubism, representing a further retreat from Impressionism. Cubism is based on a theory of knowledge that distrusts sight, and attempts to go beneath sight to "essentials." The Cubists have in common with the pre-Impressionist realists a belief in reality as that to which shadowy actuality refers. Still, Cubism is saved by the playfulness of its most distinguished practitioners. It led to a cutting loose of geometry from nature, in the geometrical abstractionists, then to further generalization in Constructivism, which leans on topology, which is generalized geometry, or on mathematics as a whole, which is still more general. The teachers at the Bauhaus, with absolute logic and humorless consistency got furthest away from the actual, and they attempted

to turn art into a science subservient to industry, as the totali-
tarians try to make art serve the state. Art as idea is most purely
achieved by the neo-plastic artists. Their primary colors and
ruled lines come out of the mind and even their pigment is like
a distillation of itself, leaving no place for the senses except as
guided by conscious reason.

In all of these schools art is placed under the control of some
limiting idea. The originality of New York school painting is
that like Impressionism, which expresses the obvious fact that
if it were not for seeing, there would be no painting, it returns
to seeing. If the real is what can be seen, it follows that seeing
is real. Since these painters work in studios empty of properties,
what they see is their paintings, and as the subject is the way the
painting looks, then what the paint does, including what it does
accidentally, becomes valid. These painters have the harmoni-
ous relationship to paint as it is that a Japanese gardener has
to nature as it is. Ad Reinhardt carrying non-objectivity to the
logical extreme of disembodied estheticism, plays in New York
school painting the role that Seurat played in Impressionism.
He tries to validate it by reducing it to an ideal.

A manifesto proclaims a division between the artist as direc-
tor and the work he directs. This split is unnecessary if the artist
accepts himself and takes his work for granted. This acceptance
requires getting past science, philosophy and sociology to an
assertion of what art itself does that other disciplines do not
do. To follow them limits art. There is an artistic theory of
knowledge different from a scientific or philosophical one. The
artist can direct his attention to what he is sure of. This is not
an idea, not an eternal object, it is actual, and it has immediacy.
The artist can profitably forgo the scientific or philosophical
attempt at grandeur and keep to what he knows, which is what
everyone knows and does not dare accept, because he fears that
knowledge is not reliable until it is explained, or rationalized,
or proved; until, that is, it can be controlled by repetition like
a scientific experiment. Art permits you to accept illogical im-
mediacy, and in doing so releases you from chasing after the
distant and the ideal. When this occurs, the effect is exalting.

1964

Joseph Cornell

THE boxes of Joseph Cornell were first exhibited in the Julian
Levy Gallery, in the early 'thirties. The exhibition was called
"Toys for Adults." The title suggests that Julian Levy, whose
gallery specialized in surrealism, was not certain that the boxes
could be included within the category of art, or were to be
taken as seriously as surrealism, or had the literary quality that
surrealism had restored to the visual arts.

Nineteenth century civilization, more than that of any previ-
ous century, was dominated by the written word. And so were
its visual arts. Literature comes into painting from criticism,
usually written by writers. And though, probably first influenced
by the independent assertion of the Impressionists, criticism
has for some time disparaged a literary content in the visual
arts, this disparagement is a verbal thing, and civilization is still
dominated by the written word. As much as any articulation of
ideas in words, it is literary criticism that led to the develop-
ment of schools in modern art. It is the economic pressure on
scholarship exerted by the universities that leads to the naming
of movements in the arts, and once a movement is named, it is
justified by words, and the literature around it gives it critical
validity. Even the separation of form from content and the de-
scription of form in words makes form into a kind of verbal con-
tent owing its life to the way this formality is expressed. Visual
form, once expressed in words, is form translated; and having
made this translation, criticism refers to it, and it becomes no
longer necessary for the critic to see what he is talking about.
He starts talking about the words that replace his experience.
Indeed the most avant-garde critics like Marshall McLuhan and
Harold Rosenberg have substituted for seeing a manipulation of
the symbols brought into being by this verbal translation. They
resemble the science fiction fantasy of a super brain kept alive in
some fluid for consultation and direction: the pure intelligence,
the super-boss.

Surrealism imitated the literature of the subconscious written
in the early part of this century: this literature gives it its validity
in criticism, and surrealism could be said to illustrate this litera-
ture as Gérôme illustrated the historical novel. Sometimes the
quality of this content can be measured by Freud's supposed

remark to Salvador Dalí that he found himself more interested in Dalí's conscious than his unconscious mind. Though Joseph Cornell's boxes do not seem to be visual art pure and separate from literature, it is not easy to say what their content is. They escape the classification of criticism. They also escape formal classification: are they sculpture, collage, painting? Because they are three-dimensional, they communicate their quality as badly by photograph as sculpture does. Rather than directly to volume and space, they allude to emotions and memories associated with them like a poetic material, and instead of illustrating poetry, they compete with it. Some of the remarks by Albert Béguin in his preface to a collection of the poems of Gérard de Nerval come closer to expressing the quality of Cornell than art criticism could. These remarks about Nerval's sonnets are applicable: "Their mystery is of such a unique quality that their emotional power possesses the [spectator] without his wishing to translate their secret into less secret language. . . . A language allied thus to facts which the [artist] alone is aware of should be least communicable of all, but here on the contrary, because his choice obeys no other than an affective reference, because he tends to seize a secret universe, drawn from true awareness . . . the [spectator] is touched to the heart." "Like all true poets, he invites us to see things in a light in which we do not know them, but which turns out to be almost that one in which we have always hoped one day to see them bathed."

As in sculpture and painting the elements of Cornell's boxes are partly volume and space, but Cornell uses them for their associated allusions. Moholy-Nagy said that the illiterate man of the future would be the one who did not use a camera: this remark has journalistic impact and the Bauhaus romanticism about machinery. Cornell uses his elements as though they were words, but what they allude to have no verbal equivalents. In this sense they are not literary and you can no more substitute a verbal program for one of his boxes than you could do so for one of Cézanne's paintings—as on the contrary you could express a nineteenth century salon machine or a twentieth century painting by de Chirico in a written description.

The boxes are 12 by 15 inches more or less, or the size of call boxes, such as in old fashioned elevators or in a butler's pantry indicate by number the floor or room from which a call comes.

A sheet of glass in front is held in a carefully and imperfectly made frame, whose mitered corners do not fit tightly. The finish looks worn and handled, and a foreign newspaper may be varnished over the surface. The inside is usually white, clean, cracked and peeling. The contents vary greatly. There may be a round column on one side establishing the space of the room, and a horizontal bar from which hangs a piston ring. There are actual objects like wooden parrots on a perch, coarse screening, springs, cork balls like fishing rod floats, wine glasses whole or broken, clay pipes, a bearing plate of a pocket watch, a dried starfish, gears, bits of driftwood whose shape indicates that they were once part of something used, nails, coins; sand colored navy blue, pink, yellow or white. There is collage material: letters in foreign languages, signs (Hôtel de l'Etoile, Grand Hôtel Bon Port, Apollinaris), a Florentine milliner's notice in slightly inaccurate English, astrological and astronomical charts and diagrams as if cut out of a dictionary, stamps, photographs of portraits by Bronzino, mirrors and peeling colored patterns. There is a sort of box that is meant to be picked up, with loose sand in layers separated according to color by an inner sheet of glass, in which the bottom layer shakes over a background of incised rays in a white or navy blue surface, and with a loose piston ring or broken spring moving in it. His favorite colors suggest provincial European hotels: white, Parcheesi yellow, pink, and French blue-gray.

A list of the contents is misleading, because it does not tell about Cornell's sense of how little is enough, like an actor's sense of timing or the Japanese sensitivity to the value of emptiness and the isolated object. As composer he is director and stage designer both, with the director's feeling for the emotional value of each actor's part, and the most efficient use of the space allotted to him.

Any artist, and in Cornell's case the parallel is closest to a poet, has a style which determines and is the particularity of his communication. Those boxes that resemble most a room, a subjective container of the soul, are, even when the printed reference is to a hotel, like the stateroom of a ship; the round column recalling the structure of the hull that obtrudes in all except the most elegant first class staterooms of ocean liners built to make the passengers forget they are at sea. The color is white, thick,

caked and scrubbed; it is ship-shape even where it is worn, like the many coats of thick paint that never quite succeed in protecting the iron from the corrosive effects of salt and spray. The reminiscence of a ship cabin brings the suggestion that the room is on a journey. The view out the window is the stars, the constellations, which as abstractions of the stars are constructions of the human spirit. The sand in the sand boxes is conceptual nature, the abstraction of number, which is also a construction of the human spirit. The starfish is dry and mathematical, a particular realization of the eternal concept five. The bits of driftwood, usually fragments of something artificial, imply nature indirectly, as does the caked and scrubbed paint of his interiors. The view may be a photograph of a work of art, or a mirror. He implies nature through its effects, the effect of time, another human abstraction, or of number, with a suggestion of vast distance and quantity. So far is the distance (astronomical), so great is the number of grains of sand (impractical to count), so many the combinations of these numbers as the box is shaken, so many the combinations of patterns as they catch on the rayed incisions of the background and the spring and piston rings slide around in them, that it is as though he were telling us that this small space contains infinity and eternity. Infinity, in short, is not a matter of physical size. This is mathematically accurate. It is for example demonstrable that a line of infinite length and definite pattern can be contained in any space, say a postage stamp. The present recalls the childhood of the Medici, and this present place, this ship-shape cabin of the soul, is one end of a line reaching light years away in space-time, to the most distant constellations, which themselves, like the astronomical or astrological charts, are smaller or larger, depending on how you regard them; they are varying imagined forms that contain these distances, as they are in their turn contained in the subjective box of the whole. The cabin of the mind reaches back in time and across the ocean to Bronzino. The mental box of sand, by analogy and like a book, can hold within its small and determinate volume Cantor's theorems of transfinite numbers.

Nature in Cornell is not nature directly experienced by the senses. The sensuous world is only implied. It is presented after having been experienced and translated by the abstractions of art, mechanics, mathematics and science. Nature appears most

directly in its limitations as the enclosed box whose corners do not fit perfectly, and whose insides, for all their whiteness and order, are worn by the defence against time.

His content has something that has not been seen in works of visual art since the Renaissance, and that gradually disappeared from them during the seventeenth century, which is an inclusion within itself of references to the highest reaches of the human spirit, without pedantry, artistically and imaginatively. Unlike Cornell though, the Renaissance was triumphant and extrovertive, while he is introvertive and melancholy and includes the spectator in his awareness. Cornell's nature is an abstract matrix through which journeys the cabin of the mind. What floor, what room does the call come from? It comes from sixteenth century Florence, it comes from Antares; and to answer it requires a journey in a carefully made, worn and imperfect ship. He could say with Nerval, "I have carried my love like prey off into solitude." (J'ai emporté mon amour comme une proie dans la solitude.)

1966

A Painter Obsessed By Blue

No color isolates itself like blue.
If the lamp's blue shadow equals the yellow
Shadow of the sky, in what way is one
Different from the other? Was he on the verge of a discovery
When he fell into a tulip's bottomless red?
Who is the mysterious and difficult adversary?

If he were clever enough for the adversary
He should not have to substitute for blue,
For a blue flower radiates as only red
Does, and red is bottomless like blue. Who loves yellow
Will certainly make in his life some discovery
Say about the color of the sky, or another one.

That the last color is the difficult one
Proves the subtlety of the adversary.
Will he ever make the difficult discovery
Of how to gain the confidence of blue?
Blue is for children; so is the last yellow
Between the twigs at evening, with more poignancy than red.

A furnace with a roar consumes the red
Silk shade of a lamp whose light is not one
Like birds' wings or valentines or yellow,
Able to blot out the mysterious adversary
Resisted only by a certain blue
Illusively resisting all discovery.

Did it have the force of a discovery
To see across the ice a happy red
Grown strong in heart besides intensest blue?
In this case the blue was the right one,
As a valentine excludes the adversary,
That will return again disguised in yellow.

If it were possible to count on yellow
Dandelions would constitute discovery:
But all at once the sudden adversary
Like a nightmare swallows up the red,
To dissipate before the starry one,
The undefended wall of blue.

Blue walls crumble under trumpets of yellow
Flowers—one unrepeatable discovery—
And red prevails against the adversary.

undated

HILTON KRAMER

Before he began a nearly two-decade career at *The New York Times* in 1965, Hilton Kramer (1928–2012) had written for *Partisan Review, The New Republic, The Nation,* and served as editor of *Arts Magazine.* At the *Times,* Kramer brought a deep and discerning understanding of the visual arts and their philosophical underpinnings to a sophisticated general readership. Kramer, who was much influenced by the thinking of T. S. Eliot, believed that tradition was an integral part of the great modern experiment, and he saw in certain representational artists a continuing modern spirit even as he responded with skepticism to what others saw as the radically innovative spirit of Pop Art, Neo-Dadaism, and Conceptual Art. After leaving the *Times* to found *The New Criterion* in 1982, Kramer came to be seen as an increasingly conservative figure, a label he willingly and even gladly embraced. His first two books—*The Age of the Avant-Garde* and *The Revenge of the Philistines*—are an enduring portrait of art and culture in New York from the 1960s to the 1980s.

Edward Hopper: An American Vision

EDWARD HOPPER has long been a living classic of American art. This is not always the happiest fate for an American artist. Often it means only that a lucky formula was hit upon early in a career that was thereafter sustained by a ready audience. The history of American art is strewn with the corpses of artists whose success, won through the clever and persistent rehearsal of a single theme, masks a terrible paucity of energy and ideas. Yet in the case of Hopper, whose work is certainly not lacking in formulas and repetitions, this classic status has been well earned and looks assured for the future. The current retrospective exhibition of his work at the Whitney Museum confirms him as an artist of unique, if narrow, vision—a vision that bequeaths little to the aesthetics of paintings but which nonetheless penetrates American experience with a particularly incisive eye.

The Americanness of Hopper's art is by no means fortuitous. It is a quality the artist has consciously pursued. Those dazzling bravura flourishes that were once the standard export of French painting and that, in Hopper's youth, were still the distinguishing marks of high style among his ambitious coevals, are

nowhere to be found in his own mature art. Hopper mastered his French manner very early, as the succulent surfaces of two pictures at the Whitney—*"Le Pavillon de Flore, Paris"* and *"Le Quai des Grands Augustins, Paris"* (both 1909)—make unmistakably clear. But from the twenties onward, he deliberately and painstakingly expunged this alien elegance in the interests of a native subject matter—and a native emotion—which the prevailing Gallic pastiche could hardly accommodate.

In the decade following World War I, Hopper settled on a vein of imagery that has been his special glory ever since. Recognizably American in its architectural and landscape subjects and in the character of its urban desolation, this imagery has established a repertory of scenes and motifs—the lonely, nocturnal glimpses of nearly deserted restaurants, theaters, and hotel rooms; the white clapboard houses and fantastic nineteenth-century mansions of New England, with their peculiar geometry of mansard roofs and dormer windows—which are now among the standard visual archetypes of our native imagination. Without investing it with false heroics or inappropriate rhetoric, Hopper raised this imagery to the level of poetry, where it stands free of both easy sentiment and facile historical encumbrances.

To effect so confident a transmutation of commonplace materials, Hopper developed a style remarkably dry, dispassionate, and plainspoken in its visual effects. At the center of this style is an obsession with light—the natural light of the sun as it defines the broad planes and geegaw oddities of old houses, and the cold, artificial light of the modern city as it isolates moments of boredom, loneliness, and private ennui. Parker Tyler once spoke of Hopper's method as "alienation by light," and it is indeed this obsession—and his characteristic ways of accommodating it to the diversity of his subjects—that confers a vivid consistency on everything Hopper has produced in the last four decades.

He approaches the composition of a painting rather as a theatrical director might set the scene of a play. The specific *mise en scène* is selected—the lunch counter or filling station late at night, the hotel room early in the morning, the many-angled clapboard structure in the afternoon sun—and is then drawn in such a way that the crux of the pictorial drama consists almost entirely of the play of light and shadow in the scene depicted.

Details are minimized and broad optical contrasts boldly emphasized in order to secure a maximum visual power from a relatively few pictorial elements.

It is Hopper's skill in shifting the center of expressive gravity away from the sheerly anecdotal and onto this more purely visual drama of light and shadow that keeps his art from falling into literary theatricalism. And it is this same luminist rigor, together with his gift for a stark pictorial geometry which never engulfs its themes but, on the contrary, delivers them to the eye with a beguiling and affecting modesty, that separates Hopper from the multitude of inferior artists who essayed similar American subjects in the twenties and thirties. By exerting an incomparably greater visual pressure on the materials of anecdote, Hopper's art transcends the limits of pictorial storytelling without repudiating the intrinsic human interest which such storytelling still holds, even for the sophisticated public.

Thus, while figures are not infrequent in Hopper's pictures, they are almost never "characters" or personalities. They are never portraits of specific individuals who might interest us, even visually, apart from their pictorial roles. Hopper's figures are mainly types rather than persons. Their pictorial function is to convey an emotion rather than a "biography," and this is a function that, given the unity of Hopper's style, they can discharge only by becoming fixtures in an environment they never dominate. Their presence sharpens but does not itself create the prevailing mood of Hopper's world, as one can see easily enough in those pictures—among them, Hopper's best—in which the atmosphere of alienation and ennui dramatically persists, even though there are no figures at all to be seen.

The exhibition at the Whitney, covering the period 1906–63 and consisting of paintings, watercolors, prints, and drawings, brings us many of Hopper's most famous works, together with some—especially the prints and drawings—that are relatively unfamiliar even to Hopper enthusiasts. Among the former are "Gas" (1940) and "New York Movie" (1939), both owned by the Museum of Modern Art; "Nighthawks" (1942), from the Art Institute of Chicago; "Pennsylvania Coal Town" (1947), from the Butler Institute; and a dozen or more nearly perfect watercolors of New England houses. Among the latter are the rarely seen etchings Hopper produced in 1915–18 when he was

Edward Hopper: *Pennsylvania Coal Town*, 1947. Oil on canvas, 28 × 40 in.

doing very little painting. The exhibition—184 works in all—thus constitutes the strongest possible showing of an artist who has worked slowly but steadily for nearly sixty years, and is, incidentally, one of the most impressive events ever staged at the Whitney.

Certainly, Hopper's place in American art history looks secure. His art continues the line of Eakins and Homer, and does so under conditions, aesthetic and otherwise, that have not been conducive to so forthright a confrontation of American experience. The mode he practiced could very easily have degenerated, as it did with so many of his contemporaries, into something utterly parochial and provincial.

Not the least of Hopper's distinctions is the firm will with which he has sustained and purified his vision in the face of so many countervailing currents. At the Whitney, where his assembled life's work creates a complete world of its own, one might be tempted to take this exemplary steadiness for granted. But when one encounters his pictures elsewhere, particularly in

those large surveys of contemporary American art—mixtures
of fireworks and fire sales—which are among the minor afflic-
tions of our cultural life, one has the exhilarating sensation of
meeting an artist who knows his own mind, who sees the world
with his own eye.

1964

RALPH ELLISON

Invisible Man, the book that Ralph Ellison (1914–1994) published in 1952, is widely recognized as one of the essential American novels, an unyielding account of a young man's confrontation with the twentieth-century maelstrom. Although he labored on a second novel until his death, the only other books that Ellison published during his lifetime were essay collections, in which he defined the American spirit through his understanding of the African American spirit. For Ellison, democracy and excellence were aspects of a single equation, and he traced that story through the art of jazz, of which he was a great aficionado, as well as through the work of his close friend, the painter and collagist Romare Bearden.

The Art of Romare Bearden

I regard the weakening of the importance given to objects as the capital transformation of Western art. In painting, it is clear that a painting of Picasso's is less and less a "canvas," and more and more the mark of some discovery, a stake left to indicate the place through which a restless genius has passed . . .

—André Malraux

THIS series of collages and projections by Romare Bearden represents a triumph of a special order. Springing from a dedicated painter's unending efforts to master the techniques of illusion and revelation which are so important to the craft of painting, they are also the result of Bearden's search for fresh methods to explore the plastic possibilities of Negro American experience. What is special about Bearden's achievement is, it seems to me, the manner in which he has made his dual explorations serve one another, the way in which his technique has been used to discover and transfigure its object. In keeping with the special nature of his search, and by the self-imposed "rules of the game," it was necessary that the methods arrived at be such as would allow him to express the tragic predicament of his people without violating his passionate dedication to art as a fundamental and transcendent agency for confronting and revealing the world.

To have done this successfully is not only to have added a

dimension to the technical resourcefulness of art, but to have modified our way of experiencing reality. It is also to have had a most successful encounter with a troublesome social anachronism which, while finding its existence in areas lying beyond the special province of the artist, has nevertheless caused great confusion among many painters of Bearden's social background. I say *social*, for although Bearden is be self-affirmation no less than by public identification a Negro American, the quality of his *artistic* culture can by no means be conveyed by that term. Nor does it help to apply the designation "black" (even more amorphous for conveying a sense of cultural complexity), and since such terms tell us little about the unique individuality of the artist or anyone else, it is well to have them out in the open where they can cause the least confusion.

What, then, do I mean by anachronism? I refer to that imbalance in American society which leads to a distorted perception of social reality, to a stubborn blindness to the creative possibilities of cultural diversity, to the prevalence of negative myths, racial stereotypes and dangerous illusions about art, humanity and society. Arising from an initial failure of social justice, this anachronism divides social groups along lines that are no longer tenable, while fostering hostility, anxiety and fear, and in the area to which we now address ourselves it has had the damaging effect of alienating many Negro artists from the traditions, techniques and theories indigenous to the arts through which they aspire to achieve themselves.

Thus in the field of culture, where their freedom of self-definition is at a maximum, and where the techniques of artistic self-expression are most abundantly available, such artists are so fascinated by the power of their anachronistic social imbalance as to limit their efforts to describing its manifold dimensions and its apparent invincibility against change. Indeed, they take it as a major theme and focus for their attention, and they allow it to dominate their thinking about themselves, their people, their country and their art. But while many are convinced thats imply to recognize social imbalance is enough to put it to riot, few achieve anything like artistic mastery, and most fail miserably through a single-minded effort to "tell it like it is."

Sadly, however, the problem for the plastic artist is not one of

"telling" at all, but of *revealing* that which has been concealed by time, custom and our trained incapacity to perceive the truth. Thus it is a matter of destroying moribund images of reality and creating the new. Further, for the true artist, working from the top of his times and out of a conscious concern with the most challenging possibilities of his form, the unassimilated and anachronistic—whether in the shape of motif, technique or image—is abhorrent evidence of conceptual and/or technical failure, of challenges unmet. Although he may ignore the anachronistic through a preoccupation with other pressing details, he can never be satisfied simply by placing it within a frame. For once there, it becomes the symbol of all that is not art and a mockery of his powers of creation. So at his best he struggles to banish the anachronistic element from his canvas by converting it into an element of style, a device of his personal vision.

As Bearden demonstrated here so powerfully, it is of the true artist's nature and mode of action to dominate all the world and time through technique and vision. His mission is to bring a new visual order into the world, and through his art he seeks to reset society's clock by imposing upon it his own method of defining the times. The urge to do this determines the form and character of his social responsibility, spurs his restless exploration for plastic possibilities, and accounts to a large extent for his creative aggressiveness.

But it is here precisely that the aspiring Negro painter so often falters. Trained by the circumstances of his social predicament to a habit (no matter how reluctant) of accommodation, such an attitude toward the world seems quixotic. He is, he feels, only one man, and the conditions which thwart his freedom are of such enormous dimensions as to appear unconquerable by purely plastic means, even at the hands of the most highly trained, gifted and arrogant artist. "Turn Picasso into a Negro and *then* let me see how far he can go," he will tell you, because he feels an irremediable conflict between his identity as a member of an embattled social minority and his freedom as an artist. He cannot avoid, nor should he wish to avoid, his group identity, but he flounders before the question of how his group's experience might be given statement

through the categories of a nonverbal form of art which has been consciously exploring its own unique possibilities for many decades before he appeared on the scene. It is a self-assertive and irreverent art which abandoned long ago the task of mere representation to photography and the role of storytelling to the masters of the comic strip and the cinema. Nor can he draw upon his folk tradition for a simple answer. Beginning with the Bible and proceeding all the way through the spirituals, blues, novels, poems and the dance, Negro Americans have depended upon the element of narrative for both entertainment and group identification. Further, it has been those who have offered an answer to the question, always crucial in the lives of a repressed minority, of who and what they are in the most simplified and graphic terms who have won their highest praise and admiration. Unfortunately there seems to be (the African past notwithstanding) no specifically Negro American tradition of plastic design to offer him support.

How then, he asks himself, does even an artist steeped in the most advanced lore of his craft and most passionately concerned with solving the more advanced problems of painting as *painting* address himself to the perplexing question of bringing his art to bear upon the task (never so urgent as now) of defining Negro American identity, and of pressing its claims for recognition and for justice? He feels, in brief, a near-unresolvable conflict between his urge to leave his mark upon the world through art and his ties to his group and its claims upon him.

Fortunately for them and for us, Romare Bearden has faced these questions for himself, and since he is an artist whose social consciousness is no less intense than his dedication to art, his example is of utmost importance for all who are concerned with grasping something of the complex interrelations between race, culture and the individual artist as they exist in the United States. Bearden is aware that for Negro Americans these are times of eloquent protest and intense struggle, times of rejection and redefinition, but he also knows that all this does little to make the question of the relation of the Negro artist to painting any less difficult. If the cries in the street are to find effective statement on canvas, they must undergo a metamorphosis. In painting, Bearden has recently observed, there is little room for the lachrymose, for self-pity or raw complaint,

and if they are to find a place in painting, this can only be accomplished by infusing them with the freshest sensibility of the times as it finds existence in the elements of painting.

During the late thirties when I first became aware of Bearden's work, he was painting scenes of the Depression in a style strongly influenced by the Mexican muralists. This work was powerful, the scenes grim and brooding, and through his depiction of unemployed workingmen in Harlem he was able, while evoking the Southern past, to move beyond the usual protest painting of this period to reveal something of the universal elements of an abiding human condition. By striving to depict the times, by reducing scene, character and atmosphere to a style, he caught something of both the universality of Harlem life and the "harlemness" of the national human predicament.

I recall that later, under the dual influences of Hemingway and the poetic tragedy of Federico García Lorca, Bearden created a voluminous series of drawings and paintings inspired by Lorca's *Lament for Ignacio Sánchez Mejías*. He had become interested in myth and ritual as potent forms for ordering human experience, and it would seem that by stepping back from the immediacy of the Harlem experience, which he knew both from boyhood and as a social worker, he was freed to give expression to the essentially poetic side of his vision. The products of this period were marked by a palette which, in contrast with the somber colors of the earlier work and despite the tragic theme with its underlying allusions to Christian rite and mystery, was brightly sensual. But despite their having been consciously influenced by the compositional patterns of the Italian primitives and Dutch masters, these works were also resolutely abstract.

It was as though Bearden had decided that in order to possess his world artistically, he had to confront it not through propaganda or sentimentality, but through the finest techniques and traditions of painting. He sought to re-create his Harlem in the light of his painter's vision, and thus avoided the defeats suffered by many of the aspiring painters of this period who seemed to have felt that they had only to reproduce, out of a mood of protest and despair, the scenes and surfaces of Harlem in order to win artistic mastery and accomplish social transfiguration.

It would seem that for many Negro painters even the *possibility*

of translating Negro American experience into the modes and conventions of modern painting went unrecognized. This was, in part, the result of an agonizing fixation upon the racial mysteries and social realities dramatized by color, facial structure and the texture of Negro skin and hair. Again, many aspiring artists clung with protective compulsiveness to the myth of the Negro American's total alienation from the larger American culture—a culture which he helped to create in the areas of music and literature, and where in the area of painting he has appeared from the earliest days of the nation as a symbolic figure —and allowed the realities of their social and political situation to determine their conception of their role and freedom as artists.

To accept this form of the myth was to accept its twin variants, one of which holds that there is a pure mainstream of American culture which is "unpolluted" by any trace of Negro American style or idiom, and the other (propagated currently by the exponents of *Negritude*) which holds that Western art is basically racist, and thus anything more than a cursory knowledge of its techniques and history is irrelevant to the Negro artist. In other words, the Negro American who aspired to the title "artist" was too often restricted by sociological notions of racial separatism, and these appear not only to have restricted his use of artistic freedom, but to have limited his curiosity about the abundant resources made available to him by those restless and assertive agencies of the artistic imagination which we call technique and conscious culture.

Indeed, it has been said that these disturbing works of Bearden's (which literally erupted during a tranquil period of abstract painting) began quite innocently as a demonstration to a group of Negro painters. He was suggesting some of the possibilities through which commonplace materials could be forced to undergo a creative metamorphosis when manipulated by some of the nonrepresentational techniques available to the resourceful craftsman. The step from collage to projection followed naturally, since Bearden has used it during the early forties as a means of studying the works of such early masters as Giotto and de Hooch. That he went on to become fascinated with the possibilities lying in such "found" materials is both an im-

portant illustrative instance for younger painters and a source for our delight and wonder.

Bearden knows that regardless of the individual painter's personal history, taste or point of view, he must nevertheless pay his materials the respect of approaching them through a highly conscious awareness of the resources and limitations of the form to which he has dedicated his creative energies. One suspects also that as an artist possessing a marked gift for pedagogy, Bearden has sought here to reveal a world long hidden by the clichés of sociology and rendered cloudy by the distortions of newsprint and the false continuity imposed upon our conception of Negro life by television and much documentary photography. Therefore, as he delights us with the magic of design and teaches us the ambiguity of vision, Bearden insists that we see in depth and by the fresh light of his creative vision. He knows that the true complexity of the slum dweller and the tenant farmer requires a release from the prison of our media-dulled perception and a reassembling in forms which would convey something of the depth and wonder of the Negro American's stubborn humanity.

Being aware that the true artist destroys the accepted world by way of revealing the unseen, and creating that which is new and uniquely his own, Bearden has used Cubist techniques to his own ingenious effect. His mask-faced Harlemites and tenant farmers set in their mysteriously familiar but emphatically abstract scenes are nevertheless resonant of artistic and social history. Without compromising their integrity as elements in plastic compositions, his figures are expressive of a complex reality lying beyond their frames. While functioning as integral elements of design, they serve simultaneously as signs and symbols of a humanity that has struggled to survive the decimating and fragmentizing effects of American social processes. Here faces which draw upon the abstract character of African sculpture for their composition are made to focus our attention upon the far from abstract reality of a people. Here abstract interiors are presented in which concrete life is acted out under repressive conditions. Here too the poetry of the blues is projected through synthetic forms which visually are in themselves tragicomic and eloquently poetic. A harsh poetry this, but poetry

nevertheless, with the nostalgic imagery of the blues conceived as visual form, image, pattern and symbol—including the familiar trains (evoking partings and reconciliations) and the conjure women (who appear in these works with the ubiquity of the witches who haunt the drawing of Goya) who evoke the abiding mystery of the enigmatic women who people the blues. Here too are renderings of those rituals of rebirth and dying, of baptism and sorcery which give ceremonial continuity to the Negro American community.

By imposing his vision upon scenes familiar to us all, Bearden reveals much of the universally human which they conceal. Through his creative assemblage he makes complex comments upon history, society and the nature of art. Indeed, his Harlem becomes a place inhabited by people who have in fact been *resurrected*, re-created by art, a place composed of visual puns and artistic allusions where the sacred and profane, reality and dream are ambiguously mingled. Resurrected with them in the guise of fragmented ancestral figures and forgotten gods (really masks of the instincts, hopes, emotions, aspirations and dreams) are those powers that now surge in our land with a potentially destructive force which springs from the very fact of their having for so long gone unrecognized and unseen.

Bearden doesn't impose these powers upon us by explicit comment, but his ability to make the unseen manifest allows us some insight into the forces which now clash and rage as Negro Americans seek self-definition in the slums of our cities. There is beauty here, a harsh beauty that asserts itself out of the horrible fragmentation which Bearden's subjects and their environment have undergone. But, as I have said, there is no preaching; these forces have been brought to eye by formal art. These works take us from Harlem through the South of tenant farms and northward-bound trains to tribal Africa; our mode of conveyance consists of every device which has claimed Bearden's artistic attention, from the oversimplified and scanty images of Negroes that appear in our ads and photojournalism, to the discoveries of the School of Paris and the Bauhaus. He has used the discoveries of Giotto and Pieter de Hooch no less than those of Juan Gris, Picasso, Schwitters and Mondrian (who was no less fascinated by the visual possibilities of jazz than by the compositional rhythms of the early Dutch masters), and

he has discovered his own uses for the metaphysical richness of African sculptural forms. In brief, Bearden has used—and most playfully—all of his artistic knowledge and skill to create a curve of plastic vision which reveals to us something of the mysterious complexity of those who dwell in our urban slums. But his is the eye of a painter, not a sociologist, and here the elegant architectural details which exist in a setting of gracious but neglected streets, and the buildings in which the hopeful and the hopeless live cheek by jowl, where failed human wrecks and the confidently expectant explorers of the frontiers of human possibility are crowded together as incongruously as the explosive details in a Bearden canvas—all this comes across plastically and with a freshness of impact that employs neither sociological cliché nor raw protest.

Where any number of painters have tried to project the "prose" of Harlem, a task performed more successfully by photographers, Bearden has concentrated upon releasing its poetry, abiding rituals and ceremonies of affirmation, creating a surreal poetry compounded of vitality and powerlessness, destructive impulse and the all-pervading and enduring faith in their own style of American humanity. Through his faith in the powers of art to reveal the unseen through the seen, his collages have transcended their immaculateness as plastic constructions. Or to put it another way, Bearden's meaning is identical with his method. His combination of technique is in itself eloquent of the sharp breaks, leaps in consciousness, distortions, paradoxes, reversals, telescoping of time and surreal blending of styles, values, hopes and dreams which characterize much of Negro American history. Through an act of creative will, he has blended strange visual harmonies out of the shrill, indigenous dichotomies of American life, and in doing so has reflected the irrepressible thrust of a people to endure and keep its intimate sense of its own identity.

Bearden seems to have told himself that in order to possess the meaning of his Southern childhood and Northern upbringing, and to keep his memories, dreams and values whole, he would have to re-create and humanize them by reducing them to artistic style. Thus in the poetic sense these works give plastic expression to a vision in which the socially grotesque conceals a tragic beauty, and they embody Bearden's interrogation of the

empirical values of a society that mocks its own ideals through a blindness induced by its myth of race. All this, ironically, by a man who visually, at least (he is light-skinned and perhaps more Russian than "black" in appearance), need never have been restricted to the social limitations imposed upon easily identified Negroes. Bearden's art is therefore not only an affirmation of his own freedom and responsibility as an individual and artist, but is an affirmation of the irrelevance of the notion of race as a limiting force in the arts. These are works of a man possessing a rare lucidity of vision.

1968

LOUIS FINKELSTEIN

The painter Louis Finkelstein (1923–2000) was fascinated by Abstract Expressionism's philosophic underpinnings, and in the small group of essays he published during his lifetime he pursued metaphysical speculations that may have had their origins in conversations at the Cedar Tavern and the Artists Club, the loose-knit organization that encouraged a free exchange of ideas among painters, sculptors, and their friends. Finkelstein wrote about the painterly brushstroke as a carrier of multiple meanings, celebrating fresh possibilities for abstract ideation and representational expression available to the artist who believed that tradition was not irreconcilable with the spirit of the avant-garde. In "New Look: Abstract-Impressionism," published in *Art News* in 1956, he argued that if Monet's *Water Lilies* now looked like precursors of the abstract work of Pollock and de Kooning, there was no reason that Pollock and de Kooning might not in turn precipitate new forms of naturalism. In his own work, Finkelstein almost invariably turned to the landscape, reimagining perceptual experience as raucous calligraphic experience.

Painting as Painting

To say what painting is reminds me of the Indian story of the blind men and the elephant where each one, grasping a different part, gave a variant account of what an elephant was, except that for painting the elephant does not stand still. For it is a characteristic of painting to change its nature, to alter its boundaries, and to present different aspects of itself in different instances. Each new aspect often appears as *against* painting and only later is seen as constituting part of it. Indeed I have personally heard at least several of the participants in the current exhibition voice the intent of destroying painting. One can only point out that to whatever extent they have failed lies their success. This is only relatively more evident in the 20th century than previously. By Botticelli's standards, Altdorfer is no painter. So that for each successive painting we encounter, we should expect to ask, "That is painting?" and answer, "Oh well, then *that* is what painting is." Which is to say that we should never expect it to operate on particular principles or be comprised of certain qualities.

Nevertheless, our experience of paintings is such that whenever we come to feel rewarded by a particular one, it is with the sense of being informed about the nature of painting as a whole. We recognize more things as coming into the universe of discourse, and this enriches and illumines anew many other things we had thought we fully understood. It may seem at first blush absurd to speak of a given work as informing our understanding of painting when we cannot give it credit for exemplifying a principle (or, for that matter, give it credit or discredit for breaching a principle). But that is precisely the point. Painting asks us to discover its principles after the fact, after we have made the intuitive, empathic contact. Words may help lead us toward this but no words will ever do the whole job. It is not ever a matter of thick paint, thin paint, spatial or flat, rough edge, hard edge, or even four sides, but rather that these paltry elements continually reveal to us extensions of human possibility. It is only in the realization of this transformation that we discover the essence of painting. Which means that we discover it again and again.

What unites the paintings in this exhibition is not that they exhaust or even display the full universe of what could be called painting as painting, but that they disclose a certain range within that universe. At a first approximation we would call it *painterly* or even *painty* painting. *Painterly* originally was conceived as opposed to *linear* or draftsmanly, and denoted the pictoral means which started around 1500 in the work of da Vinci, Giorgione and Titian, which continued down to Manet and the other Impressionists, and which is the predominantly sensuous, visually immediate, and therefore experientially direct mode of expression. Stylistically its characteristics include broken color, loose spontaneous brushstrokes, a rich play of dark and light and color, open form, and an overall unity of optical and kinetic suggestion as differentiated from conceptual clarification, explicitness and systematic order. Although oil paint can be used in other ways, *painterly* implies a full exploitation of the resources of oil paint as distinguished from tempera and fresco. Lately, the term *painterly* is opposed to *post-painterly,* which connotes hard edges, smooth flat areas, closed concise forms, and often the use of acrylic or similar new plastic paints.

But the listing of such physically patent, objective character-

istics, while it may satisfy a certain type of historian, is only a first approximation. It does not satisfy our quest for what painting is about. It does not convey the meaning of Franz Kline's exuberant declaration, "When Van Gogh painted he painted with paint." However tautologically obscure this statement may appear at first glance, it implies a kind of *embrace* of painting, a sense of its tasks which is shared in various ways by the artists here represented. One does not wish to make a church out of this; the premises are broad, the exemplifications particular.

The broadest premise seems to be this: that in painting one thing, we painters paint many. Note that this is the exact opposite of the post-painterly premise that the painting is only what is painted. The premise is actually composed of two assertions. The first assertion is of the law of relation, that in a painting there are not only elements but also interactions between elements, hence a *structure*. In this respect all the participants owe a debt to and derive from Cézanne. The second assertion is that the painting is more than it appears to be because its references are open-ended. This might be called the law of suggestion—that the meaning of things is poeticized, multiple, mobile, because our actual ways of experiencing are innately multiple, associative and infinitely variable. One thinks here not only of the dynamic metamorphoses of de Kooning, but also of those quirky shuddering shapes of Guston, which, in their harlequin colors and pulsating surfaces suggest more the actual passage of the real world through our lives than any merely denotable object. This law also indicates the debt of abstract expressionism to surrealism, but it extends far beyond either surrealist practice or abstract expressionism as a closed set of circumstances.

From the coalescence of the law of suggestion and the law of relation come the various nuances of process and psychology which are the property of individual painters. Most generally these imply that the artist does not know *a priori* what he is about. This is like the five-year old who said she was painting a picture of God, and who, when asked how she knew what He looked like, replied, "That's why I'm painting Him." Certain impulses, certain starting points serve as clues to the inner need of the artist and only after their actual relations and actual suggestions are received can these needs be assessed. Process in painting is never employed for its own sake or for merely

creating the marks of a process so much as to authenticate and to specify a capacity to feel.

Whether the painting be explicitly or only tangentially representational, the artist in working imputes a certain character, a certain significance to the several elements beyond what they could "objectively" be held to possess. The *subjective form*, the felt sense of the data, is not simply formal or descriptive but attitudinal, associative, kinesthetic, etc.; that is, it has many levels of reference. As the various impulses are put together the unity of the work is due to the continuity through time of the self of the artist, who discloses what had not been known before. From this comes the valuation of sincerity which, for the artist of classicizing temperament, is not at all an issue, as contrasted with the Kline ideal of "pouring yourself down the drain." Performance and the fluency of performance indicate the full release into spontaneity of all the motives of the artist, so that his ability, freely, within the fleeting instant, to construe an appearance as having meaning marks the genuineness of self-realization. Hofmann was particularly important in instilling the capacity for such release.

In this context the more objective stylistic consideration which one would associate not only with Hofmann but with a number of artists represented, namely, the integrity of the picture plane, should be viewed as sharply differing from the affirmation of flatness as a purely architectural or formal quality. The picture plane is made whole, because the response is *through the medium*. That is, the art form, in this case painting, is adequate to express what is expected of it and will, through disclosing itself, disclose truths of experience. Each art form, be it poetry or drama or the novel, is constantly enriched by the demands which are made upon it. The "flatness" of the picture plane, whatever may be the practice of certain post-painterly painters, is not a mere literal absence of reference to a third dimension, but rather a heightening of the poetic tension between the actually painted elements and the associations and significances they evoke. In this consideration it is probably Matisse more than any other artist from the past who is the guide.

Painting as painting having been distinguished from architecture, it may be well in closing to explicate its nature by a comparison with another of the arts—that of musical performance.

This would be in respect to the directing of the artist's will, and the comparison is intended to be suggestive rather than rigorous. In every truly achieved musical performance, but more evident in the untempered instruments of strings or voice than in the keyed instruments, there is a state of execution beyond what could be called the demands of musical construction. One knows, of course that a written score demands interpretation, that there are differences of opinion as well as cultivated traditions of so interpreting, and that these yield differing awareness of what may be structurally present. Beyond this, however, there is a point where feeling takes over (I am thinking by way of an example of a statement by Lili Kraus that a certain passage in a Mozart concerto never fails to produce a shiver up and down her spine), and imposes a form upon that structure which was not evident before. The great performance, indeed the meaning of performance, is dependent on the capacity of the artist to lodge his will in such a way as to be accessible to feelings rather than problems. It is that final flow of breath, or the pressure of the bow, or the hesitation which differentiates between two notes, ostensibly of the same value, which, uncalled for by the structure as such, and marking, instead, genuine possession by a *meaning* gratuitously and spontaneously invested in that form, imbues the music with larger unities and with life.

What is elicited from the observer is that, in tracing the formal, or simply the physical effects of a performance in paint, he also re-enact its feeling. The process is fraught with shortcomings, and these apply to the artist and spectator alike. There is a great field for license, for self-deception, self-infatuation, morbid introspectiveness, and auto-intoxication. So there are risks, but the alternative would be not to feel at all, and to become detached from feeling and from consequence, which detachment is a kind of 20th century disease of the soul. In spite of its limitations, its sometime obscurity, self-indulgence or posturing, painting as painting is involved in maintaining a certain balance of health.

1968

THOMAS B. HESS

Thomas B. Hess (1920–1978) was one of the most brilliant and influential figures of his day—whether as an editor, an author, or a curator. He was close to de Kooning and Newman, and he wrote about their work and their ideas with a rare combination of philosophic depth and lyric force. His book *Abstract Painting: Background and American Phase*, published in 1951, is a pioneering study, full of accounts of the Abstract Expressionists that remain fresh and incisive more than half a century after they were written. And he was a galvanic editor at *Art News* in the 1950s and 1960s, transforming what had been a relatively stodgy magazine into the house organ of the New York School, with brilliant, adventuresome essays, often written by the poets who were close to the painters or by the painters themselves; the *Art News* annuals, with each installment focused on a theme such as "The Avant-Garde," "The Academy," "Painterly Painting," or "Narrative Art," became cornucopias of first-rate essays, including Meyer Schapiro's seminal "The Apples of Cézanne." Hess was never afraid to express his enthusiastic responses to the art he admired, and his writing and the writing he encouraged at *Art News* have sometimes been dismissed as insufficiently critical or analytical. But the truth is that Hess had a gift for incisive psychological and sociological analysis, acutely describing shifting generational and geographical forces. When it came to locating art in the social context, Hess was every bit the equal of his friend Harold Rosenberg, with whom he founded and edited the magazine *Location* in the early 1960s. In the 1970s Hess covered contemporary art for *New York*. He became the curator of twentieth-century art at the Metropolitan Museum of Art only a year before his untimely death. Perhaps if he had lived longer his work would be better remembered and understood. Surely this bold, brave, ebullient voice still deserves to be heard.

The Battle of Paris, Strip-tease and Trotsky: Some Non-Scenic Travel Notes

1948–49. Paris. November. Grey, Lucid, Umber. Solitary, as travel is an absence, a vacuum to be filled, somehow, with objects or populated by people and opinions and reactions. . . .

Like de Staël: cheery in a high, grey, lucid studio; some gauze wrapped around his neck against drafts, a bottle of 200 proof *essence-de-vin* to cure a cold. We discuss absence, exile, youth,

John Cohen: Thomas Hess at the Art-
ists Club, 1959.

and American painting for which he has a manly contempt. I
tell him that some of his large, heavy (lucid), black-and-white
paintings look like Motherwell's. He shifts to Henry James: *Ce
que Maisie à connu*. He says he never sees other painters, just
poets (Char, Duthuit).

Like Dubuffet: who appeared in his garden with a plate of
oatmeal cookies, both garden and cookies very influenced by
Dubuffet, as well as some cashmere plus-fours. This must have
been an illusion. He, too, sees "Nobody," but talks respectfully
of Paulhan and Malraux. (Staël says Malraux is an imbecile.)

Like Mathieu: who appeared in a John Held, Jr. Rolls at
the Drouin gallery. Place Vendôme. Drive to lunch with the

gallery's shy salesman, one M. Tapié. Mathieu has the fancy engraved silver nameplate of the automobile's previous owner (some *baronne*) still rivetted to the instrument panel; in this way, she gets the traffic tickets. Tapié says, shyly, lost in admiration, that Mathieu drives very fast and that, en route to Spain, he (Mathieu) didn't look at scenery. Mathieu is interested in American, German, Italian, French and Asian artists. A nostalgia for networks.

Like Balthus and Giacometti in their dark studios; neither sees anyone.

Café life is the invention (re-invention) of St. Germain G.I.s—sunburns, palaver about the efficiency of French girls with housekeeping (money-saving love); their "game" of careers seems livelier than the grand French Hermits' if only because they assume that Things are open. For Paris Masters, art is like a long stroll down the wrong end of a telescope.

Compare French (Paris) art chatter with New York's:

The French praise (weakly) a Pal's work, but savagely attack his personality, character, rip it to shreds—his inadequate love-life, his miserliness, what a coward during the war;

New Yorkers praise a Pal as a man ("Don't get me wrong, I love MC***"), but tear his art to pieces with vicious nicknames and insights ("the greater the truth, the greater the libel");

Paris talk is "secret"; New York artists expect the Pal to learn exactly (i.e., 65% worse) what was said, by Cedargram, in 45 minutes (like convicts' grapevine).

In Paris, I think about New York . . . re-reading Trotsky, struck (bemused) by his idea of "The Law of Combined Development"—a "peculiar mixture of backward elements with the most modern factors" (i.e., the art of the 1930s and the mid-'40s) whose force of fusion, explosive nature, is essential to Trotsky's Revolution: ". . . a combining of separate steps . . . an amalgam of archaic with modern forms." But how "backward," if at all, was U.S. "modern" art, 1935? Something to be ascertained, not guessed at or intuited. . . .

1951, Palermo. (Via Messina, Moorish-French-Byzantine Bourbons; the lost honky-tonk from the Yug-zone of Trieste; Antonello da Messina and the Bombproof Madonna by His Very Intelligent Brother-in-Law (Antonello da Saliba); archaic smile, Cracked-lips Tony vs. the Eternal Brother-in-Law. . . .)

But it's a bore to write all these travel notes to fill absence with jotting. Now, if there were a publisher around. . . . Perhaps Phillip Pavia will produce his magazine some day—even if he will end up, six months after, as a caricature of St. Sebastian, only with the arrows in his back. I saw Pavia at "the club" two weeks ago, crowding against walls that Milton Resnick has insisted on repainting his favorite Sing-Sing White (because it is unpleasant, he thinks it must contain Something? The Raw Cult; a fetish). Pavia's Top Sacred idea is a magazine to be named, he whispers, "Second Half"; it pre-empts Franz Kline's suggestion of a *Hobo News* of the art world. He lent me a book on Zen by Suzuki which I'll read as soon as I finish the Heidegger he lent me two years ago; but Palermo is for Walden. . . .

1953, Arles, St. Rémy, Aigues-Mortes, St. Gilles—a tourists' tetragon. And in the low, flat, mournful plains of the Camargue, "Should you meet any of the gallant, spirited, lucid little bulls of the region, whose debonair allure. . . ."

80,000 gypsies met annually at Les Stes. Maries, before Hitler killed them all. . . .

The sea abandoned Aigues-Mortes (Dead Waters) and its stone walls that preach Crusades—8 men abreast for night patrols —pulling back (enfiladed) 30 kilometers to a carnival sardine factory. . . .

At Arles, Vincent ignored the two picturesque town sights: St. Trophyme, a cathedral whose pink sand saints dance in the volumes of crystal, contorted, blood-drenched; and the Roman theater. He preferred the modest walk of Les Alycamps with scurfy trees and Central-Park-type sarcophagi, and the railroad overpass, or a doomed café which, in fact, looks about as doomed as a pigeon. At St. Rémy, he ignored the perfect little Romanesque chapel and the pair of extraordinary Roman monuments—tombs of the Sons of Augustus. This reflects the ambitions of the artist and his lofty purpose. The last modern to tackle successfully a Grand Scene was Corot? Monet stares at Rheims, but the cathedral dissolved in his gaze.

The independence of painting as an art, its independence to embrace all kinds of communication and expression, to claim the widest discourse, parallels the withdrawal by artists from the sites and vistas that are already drunk on esthetic. It is also the metamorphosis of the Madonna to Hebe, to Mme.

Récamier, to Yvette Guilbert, to the Woman, who, grinning, chewing Doublemint, taps on the window of a West 46th Street bar with a dime, brandishing her purple string bag and a copy of the *News*.

1957, Rhodes. A little piazza, grey stones and oleander; pots of basil, dried bunches of oregano, a few Flamboyant-Gothic carvings on the well-head—very Venetian, even the Hebrew numbers on the doorways are still visible. In this ghetto, idealistic Germans, in full retreat, as the war was being lost, came and took away the 800 members of the Jewish community which had lived in Rhodes since a few centuries before Christ. All were killed. The Rhodesians say, "We miss our Jews."

German idealism, the clarity of Hegel; the longing for the "Land where the Citron blooms" . . . (The burned boat of Nemi, another triumph of the Idealistic Philosophy.)

1958, Salonika. On a beach entirely consisting of sun-drenched donkey-shit: reflections on the sins of squeamishness and the 1930s in American art (this is *the* Socialist-Realist locale)—given the Cubism of e.g., Max Weber and the Expressionism of e.g., Hartley, i.e., a couple of wood plows, the "age demanded" or rather the artists with their advanced concepts found the what? via the "Law of Combined Development"—a subway, a sky-scraper, I suppose. The "dialectic" creates the brilliant light . . . illuminated rubble. Absence. Of a building.

1960, Paris. For the past two years, Parisians have been furious about New York art—now I'm accused of being, suddenly, a chauvinist!

Snapshot (Rome, 1959) of a lost Paris client: the Milanese count dreamily combing through photographs of Rauschenbergs and buying them, sight-unseen; a pretty blonde *contessa* sits peacefully by.

But this isn't all that enrages Paris. The artists and writers are in a battle, a mock-riot, to prove:

1) New York never happened.
2) New York stole all its ideas from Paris anyhow.
3) New York has imposed itself here and there, like in Rome, by sneaky chauvinism.

4) New York had something around 1950; now it's pooped.

5) Etc.

The painters and sculptors all see each other all the time (they still deny it a bit) to discuss the scandalous new esthetic robbery. It seems like a very lively situation. Some criticism of works, even, is noticed. A new New Wave (water-finger-painting) almost is dismissed.

Perhaps Paris is on the way back. But one thing is certain: Now is the time of the falsification of history.

Compare the importation to Paris of New York styles and their assimilation and Parisification with the importation to Paris of American strip-tease and its Parisification:

In both cases, alien form is modified by local style (content). E.g., the Paris strip-teaser introduces bits of Existentialistic "plot" into her Broadway routine; costume and choreography suggest the Absurd, her *Angst, Nausée:* Camusky.

The Paris Abstract-Expressionist adds Bonnard's feathers, a gown of pastoral nostalgia, caressed colors, sensual despair.

Relate to Japan?

1960

BARBARA ROSE

Barbara Rose (born 1938) was part of a new generation of art critics who came to contemporary art with a strong background in art history. They were searching for a different kind of critical objectivity, less interested in describing immediate experiences than in establishing historical premises and precedents. Rose's "ABC Art," published in *Art in America* in 1965, set the new Minimal Art in the double historical context of Malevich's Constructivism and Duchamp's Dadaism. Rose was still in her twenties when she published this widely discussed and anthologized essay, and although she would be a name to be reckoned with in the 1970s and the 1980s, she never again wrote an essay that had this kind of impact. The drama of history-in-the-making, palpable in "ABC Art," proved difficult to sustain, and by the 1970s the conversation about Dadaism and Constructivism tended to be cast in the more insistently theoretical language of essays in *Artforum* and *October*.

ABC Art

"I am curious to know what would happen if art were suddenly seen for what it is, namely, exact information of how to rearrange one's psyche in order to anticipate the next blow from our own extended faculties. . . . At any rate, in experimental art, men are given the exact specifications of coming violence to their own psyches from their own counterirritant or technology. . . . But the counterirritant usually proves a greater plague than the initial irritant, like a drug habit."

—MARSHALL MCLUHAN, *Understanding Media*, 1964

"How do you like what you have. This is a question that anybody can ask anybody. Ask it."

—GERTRUDE STEIN, *Lectures in America*, 1935

On the eve of the First World War, two artists, one in Moscow, the other in Paris, made decisions that radically altered the course of art history. Today we are feeling the impact of their decisions in an art whose blank, neutral, mechanical impersonality contrasts so violently with the romantic, biographical Abstract-Expressionist style which preceded it that spectators

are chilled by its apparent lack of feeling or content. Critics, attempting to describe this new sensibility, call it Cool Art or Idiot Art or Know-Nothing Nihilism.

That a new sensibility has announced itself is clear, although just what it consists of is not. This is what I hope to establish here. But before taking up specific examples of the new art, not only in painting and sculpture, but in other arts as well, I would like briefly to trace its genealogy.

In 1913, Kasimir Malevich, placing a black square on a white ground that he identified as the "void," created the first suprematist composition. A year later, Marcel Duchamp exhibited as an original work of art a standard metal bottle-rack, which he called a "ready-made." For half a century, these two works marked the limits of visual art. Now, however, it appears that a new generation of artists, who seem not so much inspired as impressed by Malevich and Duchamp (to the extent that they venerate them), are examining in a new context the implications of their radical decisions. Often, the results are a curious synthesis of the two men's work. That such a synthesis should be not only possible but likely is clear in retrospect. For, although superficially Malevich and Duchamp may appear to represent the polarities of twentieth-century art—that is, on one hand, the search for the transcendent, universal, absolute, and on the other, the blanket denial of the existence of absolute values—the two have more in common than one might suppose at first.

To begin with, both men were precocious geniuses who appreciated the revolutionary element in Post-Impressionist art, particularly Cézanne's, and both were urban modernists who rejected the possibility of turning back to a naïve primitivism in disgusted reaction to the excesses of civilization. Alike, too, was their immediate adoption and equally rapid disenchantment with the mainstream modern style, Cubism. Turning from figurative manners, by 1911 both were doing Cubist paintings, although the provincial Malevich's were less advanced and "analytic" than Duchamp's; by 1913 both had exhausted Cubism's possibilities as far as their art was concerned. Moreover, both were unwilling to resolve some of the ambiguities and contradictions inherent in Analytic Cubism in terms of the more

ordered and logical framework of Synthetic Cubism, the next
mainstream style. I say unwilling rather than unable, because
I do not agree with critic Michael Fried's view that Duchamp,
at any rate, was a failed Cubist. Rather, the inevitability of a
logical evolution toward a reductive art was obvious to them
already. For Malevich, the poetic Slav, this realization forced a
turning inward toward an inspirational mysticism, whereas for
Duchamp, the rational Frenchman, it meant a fatigue so enner-
vating that finally the wish to paint at all was killed. Both the
yearnings of Malevich's Slavic soul and the deductions of Du-
champ's rationalist mind led both men ultimately to reject and
exclude from their work many of the most cherished premises
of Western art in favor of an art stripped to its bare, irreducible
minimum.

It is important to keep in mind that both Duchamp's and
Malevich's decisions were renunciations—on Duchamp's part,
of the notion of the uniqueness of the art object and its dif-
ferentiation from common objects, and on Malevich's part, a
renunciation of the notion that art must be complex. That the
art of our youngest artists resembles theirs in its severe, reduced
simplicity, or in its frequent kinship to the world of things, must
be taken as some sort of validation of the Russian's and the
Frenchman's prophetic reactions.

MORE IS LESS

The concept of "Minimal Art," which is surely applicable to
the empty, repetitious, uninflected art of many young painters,
sculptors, dancers, and composers working now, was recently
discussed as an aesthetic problem by Richard Wollheim (*Arts,*
January, 1965). It is Professor Wollheim's contention that the
art content of such works as Duchamp's found-objects (that
is, the "unassisted readymades" to which nothing is done) or
Ad Reinhardt's nearly invisible "black" paintings is intention-
ally low, and that resistance to this kind of art comes mainly
from the spectator's sense that the artist has not worked hard
enough or put enough effort into his art. But, as Professor
Wollheim points out, a decision can represent work. Consider-
ing as "Minimal Art" either art made from common objects

that are not unique but mass-produced or art that is not much differentiated from ordinary things, he says that Western artists have aided us to focus on specific objects by setting them apart as the "unique possessors of certain general characteristics." Although they are increasingly being abandoned, working it a lot, making it hard to do, and differentiating it as much as possible from the world of common objects, formerly were ways of insuring the uniqueness and identity of an art object.

Similarly, critic John Ashbery has asked if art can be excellent if anybody can do it. He concludes that "what matters is the artist's will to discover, rather than the manual skills he may share with hundreds of other artists. Anybody could have discovered America, but only Columbus *did*." Such a downgrading of talent, facility, virtuosity, and technique, with its concomitant elevation of conceptual power, coincides precisely with the attitude of the artists I am discussing (although it could also apply to the "conceptual" paintings of Kenneth Noland, Ellsworth Kelly, and others).

Now I should make it clear that the works I have singled out to discuss here have only one common characteristic: they may be described as Minimal Art. Some of the artists, such as Darby Bannard, Larry Zox, Robert Huot, Lyman Kipp, Richard Tuttle, Jan Evans, Ronald Bladen, and Anne Truitt obviously are closer to Malevich than they are to Duchamp, whereas others, such as Richard Artschwager and Andy Warhol, are clearly the reverse. The dancers and composers are all, to a greater or lesser degree, indebted to John Cage, who is himself an admirer of Duchamp. Several of the artists—Robert Morris, Donald Judd, Carl Andre, and Dan Flavin—occupy to my eye some kind of intermediate position. One of the issues these artists are attacking is the applicability of generalizations to specific cases. In fact, they are opposed to the very notion that the general and the universal are related. Thus, I want to reserve exceptions to all of the following remarks about their work; in other words, *some of the things I will say apply only in some cases and not in others.*

Though Duchamp and Malevich jumped the gun, so to speak, the avenue toward what Clement Greenberg has called the "modernist reduction," that is, toward an art that is simple,

Dan Flavin: *Icon V (Coran's Broadway Flesh)*, 1962. Oil
and mixed media, 41⅝ × 41⅝ × 9⅞ in.

clear, direct, and immediate, was traveled at a steadier pace
by others. Michael Fried (in the catalogue "Three American
Painters," Fogg Art Museum, 1965) points out that there is "a
super-ficial similarity between modernist painting and Dada in
one important respect: namely that just as modernist painting
has enabled one to see a blank canvas, a sequence of random

spatters, or a length of colored fabric as a picture, Dada and Neo-Dada have equipped one to treat virtually any object as a work of art." The result is that "there is an apparent expansion of the realm of the *artistic* corresponding—ironically, as it were—to the expansion of the pictorial achieved by modernist painting." I quote this formulation because it demonstrates not only how Yves Klein's monochrome blue paintings are art, but because it ought finally to make clear the difference in the manner and kind of reductions and simplifications he effected from those made by Noland and Jules Olitski, thus dispelling permanently any notions that Noland's and Olitski's art are in any way, either in spirit or in intention, linked to the Dada outlook.

Although the work of the painters I am discussing is more blatant, less lyrical and more resistant—in terms of surface, at any rate, insofar as the canvas is not stained or is left with unpainted areas—it has something important in common with that of Noland, Olitski, and others who work with simple shapes and large color areas. Like their work, this work is critical of Abstract-Expressionist paint-handling and rejects the brushed record of gesture and drawing along with loose painterliness. Similarly, the sculpture I am talking about appears critical of open, welded sculpture.

That the artist is critic not only of his own work but of art in general and specifically of art of the immediate past is one of the basic tenets of formalist criticism, the context in which Michael Fried and Clement Greenberg have considered reductive tendencies in modern art. But in this strict sense, to be critical means to be critical only of the formal premises of a style, in this case Abstract Expressionism. Such an explanation of a critical reaction in the purely formal terms of color, composition, scale, format and execution seems to me adequate to explain the evolution of Noland's and Olitski's work, but it does not fully suffice to describe the reaction of the younger people I am considering, just as an explanation of the rise of Neo-Classicism which considered only that the forms of the Rococo were worn out would hardly give one much of a basis for understanding the complexity of David's style.

It seems clear that the group of young artists I am speaking

of were reacting to more than merely formal chaos when they opted not to fulfill Ad Reinhardt's prescription for "divine madness" in "third generation Abstract Expressionists." In another light, one might as easily construe the new, reserved impersonality and self-effacing anonymity as a reaction against the self-indulgence of an unbridled subjectivity, as much as one might see it in terms of a formal reaction to the excesses of painterliness. One has the sense that the question of whether or not an emotional state can be communicated (particularly in an abstract work) or worse still, to what degree it can be simulated or staged, must have struck some serious-minded young artists as disturbing. That the spontaneous splashes and drips could be manufactured was demonstrated by Robert Rauschenberg in his identical action paintings, *Factum I* and *Factum II*. It was almost as if, toward the *Götterdämmerung* of the late fifties, the trumpets blared with such an apocalyptic and Wagnerian intensity that each moment was a crisis and each "act" a climax. Obviously, such a crisis climate could hardly be sustained; just to be able to hear at all again, the volume had to be turned down, and the pitch, if not the instrument, changed.

Choreographer Merce Cunningham, whose work has been of the utmost importance to young choreographers, may have been the first to put this reaction into words (in an article in *trans/formation*, No. 1, 1952): "Now I can't see that crisis any longer means a climax, unless we are willing to grant that every breath of wind has a climax (which I am), but then that obliterates climax, being a surfeit of such. And since our lives, both by nature and by the newspapers, are so full of crisis that one is no longer aware of it, then it is clear that life goes on regardless, and further that each thing can be and is separate from each and every other, viz: the continuity of the newspaper headlines. Climax is for those who are swept away by New Year's Eve." In a dance called "Crises" Cunningham eliminated any fixed focus or climax in much the way the young artists I am discussing here have banished them from their works as well. Thus Cunningham's activity, too, must be considered as having helped to shape the new sensibility of the post-Abstract-Expressionist generation.

It goes without saying that sensibility is not transformed over-

night. At this point I want to talk about sensibility rather than style, because the artists I'm discussing, who are all roughly just under or just over thirty, are more related in terms of a common sensibility than in terms of a common style. Also, their attitudes, interests, experiences, and stance are much like those of their contemporaries, the Pop artists, although stylistically the work is not very similar.

Mainly this shift toward a new sensibility came, as I've suggested, in the fifties, a time of convulsive transition not only for the art world, but for society at large as well. In these years, for some reasons I've touched on, many young artists found action painting unconvincing. Instead they turned to the static emptiness of Barnett Newman's eloquent chromatic abstractions or to the sharp visual punning of Jasper Johns's objectlike flags and targets.

Obviously, the new sensibility that preferred Newman and Johns to Willem de Kooning or his epigoni was going to produce art that was different, not only in form but in content as well, from the art that it spurned, because it rejected not only the premises, but the emotional content of Abstract Expressionism.

The problem of the subversive content of these works is complicated, though it has to be approached, even if only to define why it is peculiar or corrosive. Often, because they appear to belong to the category of ordinary objects rather than art objects, these works look altogether devoid of art content. This, as it has been pointed out in criticism of the so-called contentless novels of Alain Robbe-Grillet, is quite impossible for a work of art to achieve. The simple denial of content can in itself constitute the content of such a work. That these young artists attempt to suppress or withdraw content from their works is undeniable. That they wish to make art that is as bland, neutral, and as redundant as possible also seems clear. The content, then, if we are to take the work at face value, should be nothing more than the total of the series of assertions that it is this or that shape and takes up so much space and is painted such a color and made of such a material. Statements from the artists involved are frequently couched in these equally factual, matter-of-fact descriptive terms; the work is described but not interpreted and

statements with regard to content or meaning or intention are prominent only by their omission.

For the spectator, this is often all very bewildering. In the face of so much nothing, he is still experiencing something, and usually a rather unhappy something at that. I have often thought one had a sense of loss looking at these big, blank, empty things, so anxious to cloak their art identity that they were masquerading as objects. Perhaps, what one senses is that, as opposed to the florid baroque fullness of the *Angst*-ridden older generation, the hollow, barrenness of the void has a certain poignant, if strangled, expressiveness.

For the present, however, I prefer to confine myself mostly to describing the new sensibility rather than attempting to interpret an art that, by the terms of its own definition, resists interpretation. However, that there *is* a collective new sensibility among the young by now is self-evident. Looking around for examples, I was struck by the number of coincidences I discovered. For example, I found five painters who quite independently arrived at the identical composition of a large white or light-colored rectangle in a colored border. True, in some ways these were recapitulations of Malevich's *Black Square on White* (or to get closer to home, of Ellsworth Kelly's 1952 pair of a white square on black and black square on white); but there was an element in each example that finally frustrated a purist reading. In some cases (Ralph Humphrey's, for example) a Magritte-like sense of space behind a window-frame was what came across; other times there seemed to be a play on picture (blank) and frame (colored), though again, it was nearly impossible to pin down a specific image or sensation, except for the reaction that they weren't quite what they seemed to be. In the same way, three of the sculptors I'm considering (Carl Andre, Robert Morris, and Dan Flavin) have all used standard units interchangeably. Again, the reference is back to the Russians— particularly to Rodchenko in Andre's case—but still, another element has insinuated itself, preventing any real equations with Constructivist sculpture.

Rather than guess at intentions or look for meanings I prefer to try to surround the new sensibility, not to pinpoint it. As T.E. Hulme put it, the problem is to keep from discussing the new

art with a vocabulary derived from the old position. Though my end is simply the isolation of the old-fashioned *Zeitgeist*, I want to go about it impressionistically rather than methodically. I will take up notions now in the air that strike me as relevant to the work. As often as possible I will quote directly from texts that I feel have helped to shape the new sensibility. But I do not want to give the impression that everything I mention applies indiscriminately to all the artists under consideration. Where I do feel a specific cause and effect relationship exists between influences of the past and these artists' work, I will illustrate with examples.

MEANING IN THE VISUAL ARTS

"Let us, then, try to define the distinction between *subject matter* or *meaning* on the one hand, and *form* on the other.

When an acquaintance greets me on the street by removing his hat, what I see from a formal point of view is nothing but the change of certain details within a configuration that forms part of the general pattern of color, lines and volumes which constitutes my world of vision. When I identify, as I automatically do, this as an event (hat-removing), I have already overstepped the limits of purely *formal* perception and entered a first sphere of *subject matter* or *meaning* . . . we shall call . . . the factual meaning."

—ERWIN PANOFSKY, *Studies in Iconology*, 1939

The above text and some of the subsequent passages in which Professor Panofsky further differentiates among levels of meaning in art was read by Robert Morris in a work (I hesitate to call it a dance although it was presented in a dance concert at the Surplus Theatre in New York) titled *21.3*. Morris is the most overtly didactic of all the artists I am considering; his dances, or more precisely his events, seem to represent a running commentary on his sculpture as well as a running criticism of art interpretation. At the Surplus Theatre concert he stood before a lectern and mouthed the Panofsky text, which was broadcast from a tape simultaneously. From time to time he interrupted himself to pour water from a pitcher into a glass. Each time he poured out water, the tape, timed to coincide with his action, produced the sound of water gurgling.

Until recently, in his glass and lead pieces, Morris was fairly explicit about putting subject matter (mostly Duchampesque speculations on process and sex or illustrations of Cartesian dualism) into his art. But now that he is making only bloated plywood constructions, which serve mostly to destroy the contour and space of a room by butting off the floor onto the wall, floating from the ceiling, or appearing as pointless obstacles to circulation, he seems to be concentrating on meaning. This victory for modernism has coincided with his retirement from the performing arts in order to concentrate on his role as theoretician. That he chose the passage from Panofsky, which deals with slight changes of detail and the difference between factual and expressive meaning, is significant for the purpose of isolating the kind of matters that preoccupy many of these artists. For the painters and sculptors whom I am discussing here are aware not only of the cycle of styles but of levels of meaning, or influences, of movements, and of critical judgments. If the art they make is vacant or vacuous, it is intentionally so. In other words, the apparent simplicity of these artists' work was arrived at through a series of complicated, highly informed decisions, each involving the elimination of whatever was felt to be nonessential.

ART FOR AD'S SAKE

"Nowhere in world art has it been clearer than in Asia that anything irrational, momentary, spontaneous, unconscious, primitive, expressionistic, accidental, or informal, cannot be called serious art. Only blankness, complete awareness, disinterestedness; the 'artist as artist' only, of one and rational mind, 'vacant and spiritual, empty and marvelous,' in symmetries and regularities only; the changeless 'human content' the timeless 'supreme principle,' the ageless 'universal formula' of art, nothing else . . .

The forms of arts are always preformed and premeditated. The creative process is always an academic routine and sacred procedure. Everything is prescribed and proscribed. Only in this way is there no grasping or clinging to anything. Only a standard form can be imageless, only a stereotyped image can be formless, only a formulaized art can be formulaless."

—AD REINHARDT, "Timeless in Asia," *Art News*,
January, 1960

"Fine art can only be defined as exclusive, negative, absolute, and timeless."

—AD REINHARDT, "Twelve Rules for a New Academy," *Art News*, May, 1957

No one, in the mid-fifties, seemed less likely to spawn artistic progeny and admirers than Ad Reinhardt. An abstract painter since the thirties, and a voluble propagandist for abstract art, Reinhardt was always one of the liveliest spirits in the art world, though from time to time he would be chided as the heretical black monk of Abstract Expressionism, or the legendary Mr. Pure, who finally created an art so pure it consisted of injecting a clear fluid into foam rubber. His dicta, as arcane as they may have sounded when first handed down from the scriptorium, have become nearly canonical for the young artists. Suddenly, his wry irony, aloofness, independence, and ideas about the proper use and role of art, which he has stubbornly held to be noncommercial and nonutilitarian, are precisely the qualities the young admire. It is hard to say how much Reinhardt's constant theorizing, dogmatizing, and propagandizing actually helped to change the climate and to shift the focus from an overtly romantic style to a covertly romantic style.

Of course, Reinhardt's "purity" is a relative matter, too. The loftiness is ultimately only part of the statement; and as he made impersonality one of the most easily recognized styles in New York, so the new blandness is likely to result in similarly easy identification, despite all the use of standard units and programmatic suppression of individuality. In some ways, it might be interesting to compare Reinhardt with the younger artists. To begin with, in Reinhardt's case, there is no doubt that his is classic art (with mystical overtones, perhaps), and there is no doubt that it is abstract, or more precisely that it is abstract painting. Both the concepts of a classical style, toward which an art based on geometry would naturally tend, and that of a genuinely abstract style, are called into question frequently by the ambiguous art of the younger artists. First of all, many use a quirky asymmetry and deliberately bizarre scale to subvert any purist or classical interpretations, whereas others tend to make both paintings and sculptures look so much like plaques

or boxes that there is always the possibility that they will be mistaken for something other than art. Their leaving open this possibility is, I think, frequently deliberate.

A ROSE IS A ROSE IS A ROSE:
REPETITION AS RHYTHMIC STRUCTURING

". . . the kind of invention that is necessary to make a general scheme is limited in everybody's experience, every time one of the hundreds of times a newspaper man makes fun of my writing and of my repetition he always has the same theme, that is, if you like, repetition, that is if you like the repeating that is the same thing, but once started expressing this thing, expressing any thing there can be no repetition because the essence of that expression is insistence, and if you insist you must each time use emphasis and if you use emphasis it is not possible while anybody is alive that they should use exactly the same emphasis."

—GERTRUDE STEIN, "Portraits and Repetition
in *Lectures in America*, 1935

"Form ceases to be an ordering in time like ABA and reduces to a single, brief image, an instantaneous whole both fixed and moving. Satie's form can be extended only by reiteration or 'endurance.' Satie frequently scrutinizes a very simple musical object; a short unchanging ostinato accompaniment plus a fragmentary melody. Out of this sameness comes subtle variety."

—ROGER SHATTUCK, *The Banquet Years*, 1955

In painting the repetition of a single motif (such as Larry Poons's dots or Gene Davis's stripes) over a surface usually means an involvement with Jackson Pollock's all-over paintings. In sculpture, the repetition of standard units may derive partly from practical considerations. But in the case of Judd's, Morris's, Andre's, and Flavin's pieces it seems to have more to do with setting up a measured, rhythmic beat in the work. Judd's latest sculptures, for example, are wall reliefs made of a transverse metal rod from which are suspended, at even intervals, identical bar or box units. For some artists—for example, the West Coast painter Billy Al Bengston, who puts sergeants' stripes in all his paintings—a repeated motif may take on the character of a personal insignia. Morris's four identical mirrored boxes,

which were so elusive that they appeared literally transparent, and his recent *L*-shape plywood pieces were demonstrations of both variability and interchangeability in the use of standard units. To find variety in repetition where only the nuance alters seems more and more to interest artists, perhaps in reaction to the increasing uniformity of the environment and repetitiveness of a circumscribed experience. Andy Warhol's Brillo boxes, silk-screen paintings of the same image repeated countless times, and films in which people or things hardly move are illustrations of the kind of life situations many ordinary people will face or face already. In their insistence on repetition both Satie and Gertrude Stein have influenced the young dancers who perform at the Judson Memorial Church Dance Theatre in New York. Yvonne Rainer, the most gifted choreographer of the group (which formed as a result of a course in dance composition taught by the composer, Robert Dunn, at Merce Cunningham's New York dance studio) has said that repetition was her first idea of form:

"I remember thinking that dance was at a disadvantage in relation to sculpture in that the spectator could spend as much time as he required to examine a sculpture, walk around it, and so forth—but a dance movement—because it happened in time—vanished as soon as it was executed. So in a solo called *The Bells* [performed at the Living Theatre in 1961] I repeated the same seven movements for eight minutes. It was not exact repetition, as the sequence of the movements kept changing. They also underwent changes through being repeated in different parts of the space and faced in different directions—in a sense allowing the spectator to 'walk around it.'"

For these dancers, and for composers like La Monte Young (who conceives of time as an endless continuum in which the performance of his *Dream Music* is a single, continuous experience interrupted by intervals during which it is not being performed), durations of time much longer than those we are accustomed to are acceptable. Thus, for example, an ordinary movement like walking across a stage may be performed in slow motion, and concerts of the *Dream Music* have lasted several days, just as Andy Warhol's first film, *Sleep*, was an eight-hour-long movie of a man sleeping. Again, Satie is at least a partial

source. It is not surprising that the only performance of his piano piece *Vexations*, in which the same fragment is ritualistically repeated 840 times, took place two years ago in New York. The performance lasted 18 hours, 40 minutes and required the participation in shifts of a dozen or so pianists, of whom John Cage was one. Shattuck's statement that "Satie seems to combine experiment with inertia" seems applicable to a certain amount of avant-garde activity of the moment.

ART AS A DEMONSTRATION: THE FACTUAL, THE CONCRETE, THE SELF-EVIDENT

"But what does it mean to say that we cannot define (that is, describe) these elements, but only name them? This might mean, for instance, that when in a limiting case a complex consists of only one square, its description is simply the name of the colored square.

There are, of course, what can be called 'characteristic experiences' of pointing to (e.g.) the shape. For example, following the outline with one's finger or with one's eyes as one points.—But this does not happen in all cases in which I 'mean the shape,' and no more does any other one characteristic process occur in all these cases."

—LUDWIG WITTGENSTEIN, *Philosophical Investigations*, 1953

If Jasper Johns's notebooks seem a parody of Wittgenstein, then Judd's and Morris's sculptures often look like illustrations of that philosopher's propositions. Both sculptors use elementary, geometrical forms that depend for their art quality on some sort of presence or concrete thereness, which in turn often seems no more than a literal and emphatic assertion of their existence. There is no wish to transcend the physical for either the metaphysical or the metaphoric. The thing, thus, is presumably not supposed to "mean" other than what it is; that is, it is not supposed to be suggestive of anything other than itself. Morris's early plywood pieces are all of elementary structures: a door, a window-frame, a platform. He even did a wheel, the most rudimentary structure of all. In a dance he made called *Site*, he mimed what were obviously basic concepts about structure. Dressed as a construction worker, he manipulated flat plywood

sheets ("planes," one assumes) until finally he pulled the last one away to reveal behind it a nude girl posed as Manet's *Olympia*. As I've intimated, Morris's dances seem to function more as *explications du texte* of his sculptures than as independent dances or theatrical events. Even their deliberately enigmatic tone is like his sculpture, although he denies that they are related. Rauschenberg, too, has done dances that, not surprisingly, are like three-dimensional, moving equivalents of his combine constructions and are equally littered with objects. But his dance trio called *Pelican* for two men on roller-skates and a girl in toe shoes has that degree of surprise that characterizes his best paintings.

ART AS CONCRETE OBJECT

"Now the world is neither meaningful nor absurd. It simply is.

In place of this universe of 'meanings' (psychological, social, functional), one should try to construct a more solid, more immediate world. So that first of all it will be through their presence that objects and gestures will impose themselves, and so that this presence continues thereafter to dominate, beyond any theory of explication that might attempt to enclose them in any sort of a sentimental, sociological, Freudian, metaphysical, or any other system of reference."

—ALAIN ROBBE-GRILLET, "Une voie pour le roman futur," 1956,
from *Pour un Nouveau Roman*

Curiously, it is perhaps in the theory of the French objective novel that one most closely approaches the attitude of many of the artists I've been talking about. I am convinced that this is sheer coincidence, since I have no reason to believe there has been any specific point of contact. This is quite the contrary to their knowledge of Wittgenstein, whom I know a number of them have read. But nonetheless the rejection of the personal, the subjective, the tragic, and the narrative in favor of the world of things seems remarkable, even if or even because it is coincidental.

But neither in the new novels nor in the new art is the repudiation of content convincing. The elimination of the narrative element in dance (or at least its suppression to an absolute

minimum) has been one of Merce Cunningham's most extraordinary achievements, and in this the best of the young choreographers have followed his lead. Although now, having made dance more abstract than it has ever been, they all (including Cunningham in *Story*) appear to be reintroducing the narrative element precisely in the form of objects, which they carry, pass around, manipulate, and so forth.

ART AS FACT, DOCUMENT, OR CATALOGUE

"Researchers measured heart beat, respiration, and other intimate body responses during every stage of the sexual excitation cycle. In addition, motion-picture cameras captured on color film not only surface reactions (down to the most fleeting change of skin color) but internal reactions, through a technique of medical photography.
 —Recent newspaper ad for *The Sexually Responsive Woman*

I could have picked any number of statistical quotations about the population explosion, or the number of college graduates in Wilmington, Delaware, but the above quotation illustrates better how we can now treat all matters statistically, factually, scientifically, and objectively. One could bring up in this context not only the flood of art with sexual themes and explicit images, but Warhol's *Kiss* and *Couch* movies as well. Morris's *I* box, in which he exposes himself behind an *L*-shaped flesh-colored door, or his nude dance might also be brought up here. Mainly the point is what we are seeing everywhere is the inversion of the personal and the public. What was once private (nudity, sex) is now public and what was once the public face of art at least (emotions, opinions, intentions) is now private. And as the catalogue, of things again mainly, has become part of poetry and literature, so the document is part of art. As an example I might use Lucas Samaras's documentation of his years in a tiny, cell-like bedroom in West New York, New Jersey, transplanted in its entirety to the Green Gallery, or George Segal's quite literal plaster replicas of real people in familiar situations. In a similar inversion, whereas the unusual and the exotic used to interest artists, now they tend to seek out the banal, the common, and

the everyday. This seems a consequence of the attitude that, among young artists today, nothing is more suspect than "arti-ness," self-consciousness, or posturing. To paraphrase Oscar Wilde, being natural hence is not just a pose, it is being natu-ral. Not only do painters paint common objects, and sculptors enshrine them, but poets seek the ordinary word. (Carl Andre has said that in his poetry he avoids obscene language because it calls attention to itself too much, and because it is not yet sufficiently common.) Along these same lines, one of the most interesting things the young dancers are doing is incorporating non-dance movements into their work.

BLACK HUMOR, IRONY, AND THE *MEMENTO MORI*

"I could die today, if I wished, merely by making a little effort, if I could wish, if I could make an effort."

—SAMUEL BECKETT, *Malone Dies*

"I'l n'y a pas de solution parce qu'il n'y a pas de problème."

—MARCEL DUCHAMP

It is part of the irony of the works I'm discussing—and the irony plays a large part in them—that they blatantly assert their unsaleability and functionlessness. Some, like Artschwager's pseudofurniture or Warhol's Brillo boxes, are not too unwieldy to be sold, but since they approximate real objects with actual uses, they begin to raise questions about the utility of art, and its ambiguous role in our culture. One the one hand art as a form of free expression is seen as a weapon in the Cold War, yet on the other there appears no hope for any organic role for art in the life of the country. The artists, scarcely unaware of the provisional nature of their status, are responding in in-numerable peculiar ways, some of which I've mentioned. Now, besides making difficult, hostile, awkward, and oversize art, an increasing number of artists seem involved in making monu-mental art, too large to fit into existing museums. This is quite amusing, as there is no conceivable use in our society as it ex-ists for such work, although it may endure as a monumental

j'accuse in the case of any future rapprochement. Thus, part of what the new art is about is a subversion of the existing value structure through simple erosion. Usually these acts of subversion are personal rather than social, since it seems to be the person rather than the society that is in danger of extinction at this point.

Using irony as a means, the artists are calling bluffs right and left. For example, when Yvonne Rainer, using dramatic speeches in her dances as she has been, says one thing while she is doing another, she is making a statement about how people behave as well as performing a dance. In fact, the use of taped narratives that either do not correspond with or contradict the action is becoming more frequent among the dancers. The morbidity of the text Rainer chose as "musical accompaniment" for *Parts of Some Sextets*, with its endless deaths and illnesses and poxes and plagues (it was the diary of an eighteenth-century New England minister) provided an ironic contrast to the banality of the dance action, which consisted in part of transporting, one by one, a stack of mattresses from one place to another. Such a setting up of equations between totally dissimilar phenomena (death and play, for example) can be seen in a number of cases. Dan Flavin describes several commemorative sculptures he made this way: "*Icon IV. The Pure Land* is entirely white. The surmounting light is 'daylight' that has a slight blue tint. I built the structure in 1962, finishing it late in the fall. I believe that the conception dates from the previous year. *The Pure Land* is dedicated to my twin brother, David, who died October 8, 1962. The face of the structure is forty-five inches square. It was made of a prefabricated acrylic plastic sheeting that John Anderson cut to size for me." The factual tone does not alter when he describes (in a lecture given in Columbus, Ohio) his marriage: After I left *Juan Gris in Paris* unfinished in 1960, there was a pause of many months when I made no work. During this period I married Sonja Severdija, who happens to be a strong carpenter."

Or consider Carl Andre's solution for war: "Let them eat what they kill." Andy Warhol, whose morbid interest in death scenes has led him to paint innumerable Marilyn Monroes, electric chairs, and car crashes, claims that "when you see a

gruesome picture over and over again, it doesn't really have any effect." Dan Flavin, in a journal entry of August 18, 1962, makes it clear that sentimental notions of immortality are to be ignored as motivations: "I can take the ordinary lamp out of use and into a magic that touches ancient mysteries. And yet it is still a lamp that burns to death like any other of its kind. In time the whole electrical system will pass into inactive history. My lamps will no longer be operative; but it must be remembered that they once gave light."

As a final example, I cite Robert Morris's project for his own mausoleum. It is to consist of a sealed aluminum tube three miles long, inside which he wishes to be put, housed in an iron coffin suspended from pulleys. Every three months, the position of the coffin is to be changed by an attendant who will move along the outside of the tube holding a magnet. On a gravel walk leading to the entrance are swooning maidens, carved in marble in the style of Canova. (This opposition, of the sentimental to the icecold, is similar to the effect he produced in a dance in which two nude figures inch solemnly across the stage on a track to the accompaniment of a particularly lush aria from *Simon Boccanegra*.)

THE INFINITE: NEGATION AND VOID

"I have broken the blue boundary of color limits, come out into the white, beside me comrade—pilots swim in this infinity. I have established the semaphore of Suprematism. I have beaten the lining of the colored sky, torn it away and in the sack that formed itself, I have put color and knotted it. Swim! The free white sea, infinity, lies before you."

—KASIMIR MALEVICH, *Suprematism*, 1919

The art I have been talking about is obviously a negative art of denial and renunciation. Such protracted asceticism is normally the activity of contemplatives or mystics. Speaking of the state of blankness and stagnation preceding illumination, usually known (after St. John of the Cross) as the mystic's Dark Night, Evelyn Underhill says that the Dark Night is an example of the operation of the law of reaction from stress. It is a period of fatigue and lassitude following a period of sustained mystical

activity. How better to describe the inertia most of these works convey, or their sense of passivity, which seems nonetheless resistant rather than yielding. Like the mystic, in their work these artists deny the ego and the individual personality, seeking to evoke, it would seem, that semihypnotic state of blank consciousness, of meaningless tranquility and anonymity that both Eastern monks and yogis and Western mystics, such as Meister Eckhart and Miguel de Molinos, sought. The equilibrium of a passionless nirvana, or the negative perfection of the mystical silence of Quietism require precisely the kind of detachment, renunciation, and annihilation of ego and personality we have been observing. Certain specific correlations may be pointed out to substantiate such allusions. The "continuum" of La Monte Young's *Dream Music* is analogous in its endlessness to the Maya of Hindu cosmology; titles of many of Flavin's works are explicitly religious (*William of Ockham, Via Crucis*). In fact, Flavin calls his works "icons," and it is not surprising to learn that he left a Catholic seminary on the verge of being ordained.

Of course, it is not novel to have mystical abstract art. Mondrian was certainly as much a mystic as Malevich. But it does seem unusual in America, where our art has always been so levelheaded and purposeful. That all this new art is so low-key, and so often concerned with little more than nuances of differentiation and executed in the *pianissimo* we associate with, for example, Morton Feldman's music, makes it rather out of step with the screeching, blaring, spangled carnival of American life. But, if Pop Art is the reflection of our environment, perhaps the art I have been describing is its antidote, even if it is a hard one to swallow. In its oversized, awkward, uncompromising, sometimes brutal directness, and in its refusal to participate, either as entertainment or as whimsical, ingratiating commodity (being simply too big or too graceless or too empty or too boring to appeal), this new art is surely hard to assimilate with ease. And it is almost as hard to talk about as it is to have around, because of the art that is being made now, it is clearly the most ambivalent and the most elusive. For the moment one has made a statement, or more hopeless still, attempted a generality, the precise opposite then appears to be true, sometimes simultaneously with the original thought one had. As Roger Shattuck says

of Satie's music, "The simplest pieces, some of the humoristic works, and children's pieces built out of a handful of notes and rhythms are the most enigmatic for this very reason: they have no beginning middle and end. They exist simultaneously." So with the multiple levels of an art not so simple as it looks.

1965

DONALD JUDD

For a number of years in the early 1960s, the Minimalist sculptor Donald Judd (1928–1994) devoted a considerable amount of time to criticism. Writing mostly for *Arts Magazine*, he developed a laconic prose, with rhythms reminiscent of Stein and Hemingway, that beautifully matched the increasingly impersonal styles developed by Pop, Minimalist, and Color Field artists. While his rejection of most metaphorical and psychological meanings was not unrelated to Greenberg's austere modernism, Judd broke dramatically with Greenberg's insistence on locating contemporary art within some grand historical continuum. The titles of what are probably Judd's two most famous essays—"Local History" and "Specific Objects"—announce a definitive rejection of the sweeping idealism, grounded in German thought from Kant to Hegel, that meant so much to Greenberg. Writing as a practicing artist, Judd was fascinated by the way that artists as varied as Frank Stella, Andy Warhol, Lee Bontecou, and Claes Oldenburg actually put their work together. Aesthetic experience, as Judd describes it, is blunt and bold, the work of art striking the viewer with an unequivocal, undeniable force. Both in New York, where Judd was a pioneer in the development of SoHo as an artists' neighborhood, and in Marfa, Texas, where he created some of his greatest works amid the parched beauty of the American Southwest, Judd reimagined the radical gestures he admired in the work of Pollock and Newman, but on an ever larger scale. He would continue to write, at least from time to time, until the end of his life, clarifying his own intentions and issuing broadsides against an art world he deemed in decline. He gave a two-part essay published in *Art in America* in 1984 the marvelous title "A Long Discussion Not About Master-pieces but Why There Are So Few of Them," with its echo of Stein's "What Are Masterpieces and Why Are There So Few of Them."

Local History

Four years ago almost all of the applauded and selling art was "New York School" painting. It was preponderant in most galleries, which were uninclined to show anything new. The publications which praised it praised it indiscriminately and were uninterested in new developments. Much of the painting was by the "second generation," many of them epigones. Pollock was dead. Kline and Brooks had painted their last good paintings in

Rudy Burckhardt: Donald Judd exhibition at the Green Gallery, 1963.

1956 and 1957. Guston's paintings had become soft and gray—his best ones are those around 1954 and 1955. Motherwell's and de Kooning's paintings were somewhat vague. None of these artists were criticized. In 1959 Newman's work was all right, and Rothko's was even better than before. Presumably, though none were shown in New York, Clyfford Still's paintings were all right. This lackadaisical situation was thought perfect. The lesser lights and some of their admirers were incongruously dogmatic: this painting was not doing well but was the only art for the time. They thought it was a style. By now, it is. This painting, failed or failing in various ways, overshadowed or excluded everything else.

Actually, unregarded, quite a bit was happening. Rauschenberg had been doing what he does since 1954. Public opinion, which is a pretty unhandy thing to attribute opinions to, granted him talent but also thought his work fairly irrelevant, something of an aberrant art. Rauschenberg is somewhat overpraised now, but he was underpraised then. Jasper Johns had already finished his flags and targets in 1959. The interest in them still seems the first public fissure in the orthodoxy. George Ortman was doing his best reliefs and had been working along that line for some time. Their worth has never been adequately acknowledged. Ad Reinhardt had developed his black paintings

around 1955 and was gradually developing them further. They were some of the best and most original paintings being done, and by 1959 they were better than most of those being made by the decelerating Expressionists. One got the impression, though, that they weren't much compared to the latest work by Michael Goldberg or Grace Hartigan; and anyway, anything more or less geometric was thought a dead end. Josef Albers' paintings had recently become very good. Quite a few artists, well-known now, such as Bontecou, Chamberlain and Jensen, had a good start on their present work. More—Oldenburg, for example—had a beginning.

In 1960 there were several unpredicted shows, and things began to be complicated again. In another year, the opinions of the New York School, which had constituted general public opinion in 1959, contracted to just the opinions of the New York School. Some of the shows which progressively changed the situation, either through an advance of simply a change, were Yayoi Kusama's exhibition of white paintings at the Brata in October, 1959; Noland's exhibition at French and Co. that October; Al Jensen's paintings at Jackson in November, 1959; Chamberlain's sculpture at Jackson in January, 1960; Edward Higgins' sculpture at Castelli in May, 1960; Mark di Suvero's enormous sculpture at Green in October, 1960; Frank Stella's aluminum-colored paintings at Castelli that October (universally absurdly reviewed); Lee Bontecou's reliefs at Castelli in November, 1960. Oldenburg opening his Store in December, 1961; Rosenquist showed at Green, and Lichtenstein at Castelli, in February, 1962. With these, and of course other shows, things were wide open again—as they were, though with less people, in the late forties and early fifties.

Right now, things are fairly closed for Abstract Expressionism; that's an exception to the openness. There is a vague, pervasive assumption, like that about geometric art around 1959, that Abstract Expressionism is dead, that nothing new is to be expected from its original practitioners and that nothing will be developed from it, nothing that would be identifiable as deriving from it and that would also be new. It sure looks dead. Frankenthaler is about the only one not showing weak and boring paintings. A lot of the artists and some of their favorite reviewers feel persecuted. It is very obvious, though, that Abstract

Expressionism and Impressionism just collapsed. Brooks, de Kooning, Guston, and Motherwell are adding poor paintings to their earlier good ones, and the loss of the good ones they aren't painting is a major loss for American art. It is also a loss that the younger and secondary ones haven't improved or even stayed even. Joan Mitchell's work, for example, should have improved. So should Grillo's, Francis, Pace, Dugmore, McNeil, Briggs and Leslie should not have declined and should be better. They had, in contrast to Goldberg and Hartigan, for instance, enough ability to imply improvement.

The ordinary chances of art history make it unlikely, though, that this kind of painting will remain moribund. As a general style—in itself death—it will stay dead, but the chances are good that a few of the artists will revive. It is easy to imagine de Kooning going strong again or Joan Mitchell improving. It is likely that someone will derive something new from Abstract Expressionism. If Ellsworth Kelly can do something novel with a geometric art more or less from the thirties, or Rauschenberg with Schwitters and found objects generally—which is a twenty-year jump or more—then someone is going to do something surprising with Abstract Expressionism, with loose paintings.

It isn't necessary for an artist who was once fairly original and current to abandon his first way of working in favor of a new way. The degree of his originality determines whether he should use a new situation or not. This, of course, is the complicated problem of artistic progress. A new form of art usually appears more logical, expressive, free and strong than the form it succeeds. There is a kind of necessity and coherent, progressive continuity to changes in art. It makes sense now to call the shallow depth of Abstract Expressionism old-fashioned. The statement, though, is a criticism only in regard to art developing with or after the art, such as Frank Stella's unspatial aluminum paintings, which made Abstract Expressionism appear less coherent and expressive than possible. It is pretty obvious that a lot of art has become strong and lucid after the point at which it was the most advanced way of thinking. Stuart Davis' paintings, for instance, became much better after 1945. Also, incidentally, the dry, hot quality of the surface and the color and the kind of shapes and other things have probably exerted a steady influence. The paintings are good and have been around for quite a

while, and Davis is still doing them. This has a quiet effect, unlike the abrupt changes that have been influential. Albers' work has been quietly influential too, and probably Calder's, Avery's and maybe Hopper's as well. Although it is true that one form may be better, more advanced, than another, it is also true that art isn't so neat as to be simply linear. There isn't even one line anyway, since the kinds of art are so various.

At any time there is always someone trying to organize the current situation. Some of the troubles afflicting Abstract Expressionism come from that effort. Calling diverse work "Abstract Expressionism" or any of its other labels was an attempt to make a style, at least a category. "Crisis," "revolutionary" and the like were similar attempts to simplify the situation, but through its historical location instead of its nature. The prevailing notion of style comes from the European tradition, where it is supposed to be variations within a general appearance, which a number of artists, a "school," supposedly even a period, may share. (Actually things weren't that simple then, either.) Obviously, Abstract Expressionism wasn't a style. It certainly had a few common characteristics, especially the shallow and frontal depth and the relatively single scheme, a field or simple forms, but these certainly did not have a common appearance. The artists were responsible for eventually making it all look pretty much alike, but the writing about it, which failed to differentiate it sufficiently, helped this along. The failure to criticize and evaluate the various artists was even more serious. A "first generation" justifies a "second generation." That could happen only through an idea of a style, but the growth of a style wasn't what was happening. The epigonous role of the "second generation" should have been stressed rather than its role as the inheritor of the "first generation." One should be skeptical about followers. (There is also the funny practice of using the fact of numerous followers to prove the importance of the leaders.) The bandwagon nature of art in New York also comes out of the urge to make categories and movements. The bandwagon entails a simple-minded acceptance of everything in the lauded category—as happened with Abstract Expressionism—and a simple-minded rejection of everything else. Pop art is discussed and shown in this way, too—leave it alone.

The history of art and art's condition at any time are pretty

messy. They should stay that way. One can think about them as much as one likes, but they won't become neater; neatness isn't even a very good reason for thinking about them. A lot of things just can't be connected. The several complaints of confusion, lack of common goals, uncertainty and rapid change are naïve. Like style, they are meaningless now. Things can only be diverse and should be diverse. Styles, schools, common goals and long-term stability are not credible ideas. And the idea of pop art as the successor to Abstract Expressionism is ridiculous.

The change from the relatively uniform situation of 1959 to the present diverse one did not suddenly occur with pop art in the 1961–62 season. The list of exhibitions a while back shows that it didn't. The change certainly wasn't from one movement to the next. A lot of new artists were already showing. Almost all of them had developed their work as simply their own work. There were almost no groups and there were no movements. The few groups were hardly groups, being only two or three artists rather distantly influencing one another, such as Noland, Louis and, as it turns out, Gene Davis, all working in Washington. It is one of the famous facts of pop art that most of the artists were unaware of one another. But that fact has been turned to prove the grassrootedness of the so-called movement. Obviously movements are handy for publicity, as the accidents of inclusion and exclusion show, but the more serious need for them seems again to lie in the similarity of earlier art. This art, though, came from fairly small, close and coercive societies. Belief and disbelief are much changed. Another point about the present period is that it is not a decline from Abstract Expressionism; it is not an interregnum; it does not have inferior art. Although the present does not have anyone of Pollock's profundity—too many of the artists are too young—there are more good artists. The amount of good work is amazing. There is plenty of mediocre art, but there always is. Another point is that Abstract Expressionist qualities and schemes have had a large influence on most of the new artists. The inventions of the several artists have not been opposed; usually they have been strengthened. The paramount quality and scheme of Abstract Expressionism was the singleness of the format and so of the quality. The more unique and personal aspects of art, which had been subservient before, were stated alone, large and singly.

This was developed further by almost all of the new artists. The supposed "second generation," in contrast, weakened this quality, most often with archaic composition and naturalistic color.

Three-dimensional work, approximating objects, and more or less geometric formats with color and optical phenomena are a couple of the wider categories of new and interesting work. These categories are categories only by the common presence of a single very general aspect. A person could select other common elements which would make other groups. The proportion of things not in common far exceeds the things that are. The things in common are, again, very general and inspecific. They certainly don't form a style. They occur in contradictory or unrelated contexts. Pop-art subject matter is new of course, and interesting, but since it has been used carelessly to lump the various artists together, it is better for the time being to mention aspects which split up pop. Roy Lichtenstein and John Wesley, for example, have something in common in their meta-visual schemes; none of the other pop artists are involved. That Oldenburg's pieces are objects differentiates them from Rosenquist's paintings, for instance, more than the relation of subject matter joins them. And anyway the two kinds of subject matter are very different. Wide-open, constructed, more or less composed sculpture is becoming a crowded category. Mark di Suvero and Chuck Ginnever originated it. This does approach a real category, almost a style, having a particular reference to nature, defined by Kline's paintings, and a general similarity of appearance. However the resemblance came about, and it has been increasing rather than decreasing, the sculpture suffers. Yet, most of the artists working in this way, Tony Magar and Tom Doyle, for instance, are accomplished. These divisions, as wide as they are, certainly don't comprise everything being done in New York.

Many more people painted paintings than made sculptures a few years ago. Also, painting was the more advanced form. Now sculpture is becoming dominant. It isn't often sculpture though, in the sense that a material is sculpted. Quite a few painters, of course, are more unusual than a lot of the sculptors. The most unusual part of three-dimensional work is that which approaches "being an object." The singleness of objects is related to the singleness of the best paintings of the early

fifties. Like the paintings, such work is unusually distinct and intense. Generally it has fewer of the devices of earlier art and more of its own.

A few of Rauschenberg's pieces are more or less objects: the goat with the tire, the box with the chicken and the dolly with the ventilator. The first two have a good deal of compositional painting, but it is fairly adventitious to the few parts, which are composed simply enough to appear at first only juxtaposed. The ventilator is pretty bare. The objectness of these things is obviously that of real objects in simple combinations. Some of George Ortman's reliefs are three-dimensional enough to be objects. They seem to be games or models for some activity and suggest chance, from much through little, controlled and uncontrolled, operating on things both related and unrelated. They suggest probability theory. They are one of the few instances of completely unnaturalistic art. They are concerned with a new area of experience, one which is relevant philosophically as well as emotionally. All of H. C. Westermann's works are objects. In pieces like *A Rope Tree* and a marbled question-mark, Westermann also has something new and philosophical. The enlargement and purposeful construction of the twist of rope and the punctuation mark emphasize, though problematically, their identities and so suggest the strangeness of the identity of anything. The power of Lee Bontecou's reliefs is caused by their being objects. The reliefs are a single image. The structure and the total shape are coincident with the image. The bellicose detail and the formidable holes are experienced as one would experience a minatory object. The quality of the reliefs is exceptionally explicit or specific or single and obsessive. The quality of John Chamberlain's sculpture, in contrast, involves a three-way polarity of appearance and meaning, successive states of the same form and material. A piece may appear neutral, just junk, casually objective; or redundant, voluminous beyond its structure, obscured by other chances and possibilities; or simply expressive, through its structure and details and oblique imagery. The appearance of a mass of colored automobile metal is obviously essential.

Frank Stella says that he is doing paintings, and his work could be considered as painting. Most of the works, though, suggest slabs, since they project more than usual, and since

some are notched and some are shaped like letters. Some new ones, painted purple, are triangles and hexagons with the centers open. The notches in the aluminum paintings determine the patterns of the stripes within. The projection, the absence of spatial effects and the close relation between the periphery and the stripes make the paintings seem like objects, and that does a lot to cause their amplified intensity. Oldenburg's objects involve an analogy between psychological, erotic and otherwise profound forms, on the one hand, and pieces of food and clothing on the other. The two kinds of form are coexistensive, but with different references. Most of Lucas Samaras' works are objects. These are opened books completely covered with pins, points out; glasses flanged with razor blades and filled with bits of reliquiae; a small chest covered with a spiral of colored yarn into which pins are stuck; and other hermetic, defended, offending objects. John Anderson's sculptures are carved from wood and suggest large implements out of the West. The large parts are the expressive ones; there is little subsidiary composition. The wholeness of a piece is primary, is experienced first and directly. It is not something understood through the contemplation of parts. The figures by Ed Kienholz are also objects in a way, not represented but existing on their own. The color, for example, is in the various materials and so exists casually and independently. George Segal's plaster figures are life-size and are usually accompanied by some piece of furniture. They seem both dead and alive, and the specificity of both aspects comes from the real space they occupy, their real size, their real appearance, their artificial material and the real furniture.

Sven Lukin, Ronald Bladen and Scarpitta make reliefs which approach being objects. Dan Flavin has shown some boxes with lights attached. These hang on a wall. Richard Navin exhibited some open pieces, rather like racks for internal organs. Yayoi Kusama has done a couch, a chair and a boat obsessively covered with erect bags painted white. Robert Watts has cast pencils, suckers, and other objects in aluminum. Arakawa exhibited coffins holding Surreal devilfish. George Brecht in extreme understatement, just exhibits something, in one case a blue stool upon which a white glove is lying. Robert Morris exhibited a gray column, a gray slab and a suspended gray slab, all also understated. Other pieces of his produce an idea. Yoshimura does tough

columns and boxes set with plaster hemispheres and shapes cast from jello molds. Nathan Raisen makes compact relief of columnar forms, symmetrical, sometimes intersecting usually black and white and occasionally with sienna. John Willenbecher does black and gray shallow boxes, hung as reliefs, with gold letters, concavities and balls.

Most of the best painting has got to the point where it is nearly flat and nearly without illusionistic space. The majority of Al Jensen's paintings are completely flat. They depend entirely on the texture, the color and the complex patterning. Noland's paintings have a little space. The positions and the colors of the bands, the centered scheme and the flatness of the unprimed canvas reduce the depth of the space considerably; there is less space than in Rothko's or Pollock's paintings. Most of Frank Stella's paintings are nearly flat. Olitski's and Gene Davis' paintings have the minimal amount that Noland's have. Albers and Reinhardt, having formed their work earlier, have somewhat more space, especially Albers. The most illusionistic of the best painting generally is the work by Lichtenstein, Wesley and especially Rosenquist—since they deal with subject matter. Lichtenstein's and Wesley's paintings, being imitations, are not spatial in the same way as Rosenquist's. Because of this flatness, because it is restrictive (in another way it is unrestrictive), and because the apparent alternative of space has been rejected in arriving at the flatness, there is a need for something complicated and ambiguous but, unlike imitated space, actual and definite. Color and optical phenomena have this character. They have been used to some extent all along in modern painting, but never in the scale and with the simplicity that they possess now. Albers' teaching and work have undoubtedly made color and optical phenomena familiar. However, his use of these is very different from their use by the younger painters.

When Stella's concentric lines change direction the extent of the area around them changes. The rows of angles make ambiguous, lively bands across the fairly impassive fields of parallel lines. Stella also uses value sequences and groups of colors. Larry Poons paints polka dots on stained grounds, maroon in one case, yellow ocher in another. The small circles on the maroon are light blue and a medium red. The circles produce an after image alongside themselves. This is both definite and

transitory. The spacing of the polka dots is interesting, being sparse and somewhat casual and accidental, and yet seemingly controlled by some plan. The whole pattern of afterimages is another effect. Neil Williams paints fields of slanted, round-cornered parallelograms. These alternate with a ground, each row being staggered in regard to the rows above and below it. The parallelograms usually don't quite touch, so that the ground is tenuously linked, though it becomes equivalent or even reversed. The fields tend to flow vertically, horizontally or diagonally, depending on which effect one looks at. The emphasis varies with each painting. One painting has parallelograms of somewhat lightened ultramarine blue on what appears to be plain white, but is really white tinted with orange. The tint reinforces the afterimages of the blue oblongs, producing an orange glow after a while. Ad Reinhardt, of course, has made a great thing of close value. He has separated value and color. The paintings seem black at first, and then they divide into a few colors. They are unified through a single value, made absolute and negative, or absolutely negative, and are disunited through several colors, and thus made changeable and ambiguous. Incidentally, Reinhardt's following Poons and Williams here doesn't mean that he shares their fairly direct relationship to the Abstract Expressionists. Also, pigeonholing Reinhardt under optical phenomena only shows how arbitrary pigeonholes are.

The two categories, objects and optical art, have been made from what is happening, are due to the two things selected and are far from being all of what is happening—and are hardly definitive. A whole new category could be made by connecting artists whose work expresses some of the concerns of more or less contemporary philosophy, such as Ortman and Westermann. Jasper Johns to some extent and Lichtenstein and Wesley do work that suggests comment on the comment of meta-linguistics. These are all categories after the fact, ones for discussion; they are not enclosing, working categories.

1964

Specific Objects

HALF or more of the best new work in the last few years has been neither painting nor sculpture. Usually it has been related, closely or distantly, to one or the other. The work is diverse, and much in it that is not in painting and sculpture is also diverse. But there are some things that occur nearly in common.

The new three-dimensional work doesn't constitute a movement, school or style. The common aspects are too general and too little common to define a movement. The differences are greater than the similarities. The similarities are selected from the work; they aren't a movement's first principles or delimiting rules. Three-dimensionality is not as near being simply a container as painting and sculpture have seemed to be, but it tends to that. But now painting and sculpture are less neutral, less containers, more defined, not undeniable and unavoidable. They are particular forms circumscribed after all, producing fairly definite qualities. Much of the motivation in the new work is to get clear of these forms. The use of three dimensions is an obvious alternative. It opens to anything. Many of the reasons for this use are negative, points against painting and sculpture, and since both are common sources, the negative reasons are those nearest commonage. "The motive to change is always some uneasiness: nothing setting us upon the change of state, or upon any new action, but some uneasiness." The positive reasons are more particular. Another reason for listing the insufficiencies of painting and sculpture first is that both are familiar and their elements and qualities more easily located.

The objections to painting and sculpture are going to sound more intolerant than they are. There are qualifications. The disinterest in painting and sculpture is a disinterest in doing it again, not in it as it is being done by those who developed the last advanced versions. New work always involves objections to the old, but these objections are really relevant only to the new. They are part of it. If the earlier work is first-rate it is complete. New inconsistencies and limitations aren't retroactive; they concern only work that is being developed. Obviously, three-dimensional work will not cleanly succeed painting and sculpture. It's not like a movement; anyway, movements no longer work; also, linear history has unraveled somewhat. The new

work exceeds painting in plain power, but power isn't the only consideration, though the difference between it and expression can't be too great either. There are other ways than power and form in which one kind of art can be more or less than another. Finally, a flat and rectangular surface is too handy to give up. Some things can be done only on a flat surface. Lichtenstein's representation of a representation is a good instance. But this work which is neither painting nor sculpture challenges both. It will have to be taken into account by new artists. It will probably change painting and sculpture.

The main thing wrong with painting is that it is a rectangular plane placed flat against the wall. A rectangle is a shape itself; it is obviously the whole shape; it determines and limits the arrangement of whatever is on or inside of it. In work before 1946 the edges of the rectangle are a boundary, the end of the picture. The composition must react to the edges and the rectangle must be unified, but the shape of the rectangle is not stressed; the parts are more important, and the relationships of color and form occur among them. In the paintings of Pollock, Rothko, Still and Newman, and more recently of Reinhardt and Noland, the rectangle is emphasized. The elements inside the rectangle are broad and simple and correspond closely to the rectangle. The shapes and surface are only those which can occur plausibly within and on a rectangular plane. The parts are few and so subordinate to the unity as not to be parts in an ordinary sense. A painting is nearly an entity, one thing, and not the indefinable sum of a group of entities and references. The one thing overpowers the earlier painting. It also establishes the rectangle as a definite form; it is no longer a fairly neutral limit. A form can be used only in so many ways. The rectangular plane is given a life span. The simplicity required to emphasize the rectangle limits the arrangements possible within it. The sense of singleness also has a duration, but it is only beginning and has a better future outside of painting. Its occurrence in painting now looks like a beginning, in which new forms are often made from earlier schemes and materials.

The plane is also emphasized and nearly single. It is clearly a plane one or two inches in front of another plane, the wall, and parallel to it. The relationship of the two planes is specific; it is a form. Everything on or slightly in the plane of the painting must be arranged laterally.

Almost all paintings are spatial in one way or another. Yves Klein's blue paintings are the only ones that are unspatial, and there is little that is nearly unspatial, mainly Stella's work. It's possible that not much can be done with both an upright rectangular plane and an absence of space. Anything on a surface has space behind it. Two colors on the same surface almost always lie on different depths. An even color, especially in oil paint, covering all or much of a painting is almost always both flat and infinitely spatial. The space is shallow in all of the work in which the rectangular plane is stressed. Rothko's space is shallow and the soft rectangles are parallel to the plane, but the space is almost traditionally illusionistic. In Reinhardt's paintings, just back from the plane of the canvas, there is a flat plane and this seems in turn indefinitely deep. Pollock's paint is obviously on the canvas, and the space is mainly that made by any marks on a surface, so that it is not very descriptive and illusionistic. Noland's concentric bands are not as specifically paint-on-a-surface as Pollock's paint, but the bands flatten the literal space more. As flat and unillusionistic as Noland's paintings are, the bands do advance and recede. Even a single circle will warp the surface to it, will have a little space behind it.

Except for a complete and unvaried field of color or marks, anything spaced in a rectangle and on a plane suggests something in and on something else, something in its surround, which suggests an object or figure in its space, in which these are clearer instances of a similar world—that's the main purpose of painting. The recent paintings aren't completely single. There are a few dominant areas, Rothko's rectangles or Noland's circles, and there is the area around them. There is a gap between the main forms, the most expressive parts, and the rest of the canvas, the plane and the rectangle. The central forms still occur in a wider and indefinite context, although the singleness of the paintings abridges the general and solipsistic quality of earlier work. Fields are also usually not limited, and they give the appearance of sections cut from something indefinitely larger.

Oil paint and canvas aren't as strong as commercial paints and as the colors and surfaces of materials, especially if the materials are used in three dimensions. Oil and canvas are familiar and, like the rectangular plane, have a certain quality and have limits. The quality is especially identified with art.

The new work obviously resembles sculpture more than it

does painting, but it is nearer to painting. Most sculpture is like the painting which preceded Pollock, Rothko, Still and Newman. The newest thing about it is its broad scale. Its materials are somewhat more emphasized than before. The imagery involves a couple of salient resemblances to other visible things and a number of more oblique references, everything generalized to compatibility. The parts and the space are allusive, descriptive and somewhat naturalistic. Higgins' sculpture is an example, and, dissimilarly, di Suvero's. Higgins' sculpture mainly suggests machines and truncated bodies. Its combination of plaster and metal is more specific. Di Suvero uses beams as if they were brush strokes, imitating movement, as Kline did. The material never has its own movement. A beam thrusts, a piece of iron follows a gesture; together they form a naturalistic and anthropomorphic image. The space corresponds.

Most sculpture is made part by part, by addition, composed. The main parts remain fairly discrete. They and the small parts are a collection of variations, slight through great. There are hierarchies of clarity and strength and of proximity to one or two main ideas. Wood and metal are the usual materials, either alone or together, and if together it is without much of a contrast. There is seldom any color. The middling contrast and the natural monochrome are general and help to unify the parts.

There is little of any of this in the new three-dimensional work. So far the most obvious difference within this diverse work is between that which is something of an object, a single thing, and that which is open and extended, more or less environmental. There isn't as great a difference in their nature as in their appearance, though. Oldenburg and others have done both. There are precedents for some of the characteristics of the new work. The parts are usually subordinate and not separate in Arp's sculpture and often in Brancusi's. Duchamp's readymades and other Dada objects are also seen at once and not part by part. Cornell's boxes have too many parts to seem at first to be structured. Part-by-part structure can't be too simple or too complicated. It has to seem orderly. The degree of Arp's abstraction, the moderate extent of his reference to the human body, neither imitative nor very oblique, is unlike the imagery of most of the new three-dimensional work. Duchamp's bottle-drying rack is close to some of it. The work of Johns and Rauschenberg and assemblage and low-relief generally,

Ortman's reliefs for example, are preliminaries. Johns's few cast objects and a few of Rauschenberg's works, such as the goat with the tire, are beginnings.

Some European paintings are related to objects, Klein's for instance, and Castellani's, which have unvaried fields of low-relief elements. Arman and a few others work in three dimensions. Dick Smith did some large pieces in London with canvas stretched over cockeyed parallelepiped frames and with the surfaces painted as if the pieces were paintings. Philip King, also in London, seems to be making objects. Some of the work on the West Coast seems to be along this line, that of Larry Bell, Kenneth Price, Tony Delap, Sven Lukin, Bruce Conner, Kienholz of course, and others. Some of the work in New York having some or most of the characteristics is that by George Brecht, Ronald Bladen, John Willenbecher, Ralph Ortiz, Anne Truitt, Paul Harris, Barry McDowell, John Chamberlain, Robert Tanner, Aaron Kuriloff, Robert Morris, Nathan Raisen, Tony Smith, Richard Navin, Claes Oldenburg, Robert Watts, Yoshimura, John Anderson, Harry Soviak, Yayoi Kusama, Frank Stella, Salvatore Scarpitta, Neil Williams, George Segal, Michael Snow, Richard Artschwager, Arakawa, Lucas Samaras, Lee Bontecou, Dan Flavin and Robert Whitman. H. C. Westermann works in Connecticut. Some of these artists do both three-dimensional work and paintings. A small amount of the work of others, Warhol and Rosenquist for instance, is three-dimensional.

The composition and imagery of Chamberlain's work is primarily the same as that of earlier painting, but these are secondary to an appearance of disorder and are at first concealed by the material. The crumpled tin tends to stay that way. It is neutral at first, not artistic, and later seems objective. When the structure and imagery become apparent, there seems to be too much tin and space, more chance and casualness than order. The aspects of neutrality, redundancy and form and imagery could not be coextensive without three dimensions and without the particular material. The color is also both neutral and sensitive and, unlike oil colors, has a wide range. Most color that is integral, other than in painting, has been used in three-dimensional work. Color is never unimportant, as it usually is in sculpture.

Stella's shaped paintings involve several important characteristics of three-dimensional work. The periphery of a piece and the lines inside correspond. The stripes are nowhere near being

discrete parts. The surface is farther from the wall than usual, though it remains parallel to it. Since the surface is exceptionally unified and involves little or no space, the parallel plane is unusually distinct. The order is not rationalistic and underlying but is simply order, like that of continuity, one thing after another. A painting isn't an image. The shapes, the unity, projection, order and color are specific, aggressive and powerful.

Painting and sculpture have become set forms. A fair amount of their meaning isn't credible. The use of three dimensions isn't the use of a given form. There hasn't been enough time and work to see limits. So far, considered most widely, three dimensions are mostly a space to move into. The characteristics of three dimensions are those of only a small amount of work, little compared to painting and sculpture. A few of the more general aspects may persist, such as the work's being like an object or being specific, but other characteristics are bound to develop. Since its range is so wide, three-dimensional work will probably divide into a number of forms. At any rate, it will be larger than painting and much larger than sculpture, which, compared to painting, is fairly particular, much nearer to what is usually called a form, having a certain kind of form. Because the nature of three dimensions isn't set, given beforehand, something credible can be made, almost anything. Of course something can be done within a given form, such as painting, but with some narrowness and less strength and variation. Since sculpture isn't so general a form, it can probably be only what it is now—which means that if it changes a great deal it will be something else; so it is finished.

Three dimensions are real space. That gets rid of the problem of illusionism and of literal space, space in and around marks and colors—which is riddance of one of the salient and most objectionable relics of European art. The several limits of painting are no longer present. A work can be as powerful as it can be thought to be. Actual space is intrinsically more powerful and specific than paint on a flat surface. Obviously, anything in three dimensions can be any shape, regular or irregular, and can have any relation to the wall, floor, ceiling, room, rooms or exterior or none at all. Any material can be used, as is or painted.

A work needs only to be interesting. Most works finally have one quality. In earlier art the complexity was displayed and built

the quality. In recent painting the complexity was in the format and the few main shapes, which had been made according to various interests and problems. A painting by Newman is finally no simpler than one by Cézanne. In the three-dimensional work the whole thing is made according to complex purposes, and these are not scattered but asserted by one form. It isn't necessary for a work to have a lot of things to look at, to compare, to analyze one by one, to contemplate. The thing as a whole, its quality as a whole, is what is interesting. The main things are alone and are more intense, clear and powerful. They are not diluted by an inherited format, variations of a form, mild contrasts and connecting parts and areas. European art had to represent a space and its contents as well as have sufficient unity and aesthetic interest. Abstract painting before 1946 and most subsequent painting kept the representational subordination of the whole to its parts. Sculpture still does. In the new work the shape, image, color and surface are single and not partial and scattered. There aren't any neutral or moderate areas or parts, any connections or transitional areas. The difference between the new work and earlier painting and present sculpture is like that between one of Brunelleschi's windows in the Badia di Fiesole and the façade of the Palazzo Rucellai, which is only an undeveloped rectangle as a whole and is mainly a collection of highly ordered parts.

The use of three dimensions makes it possible to use all sorts of materials and colors. Most of the work involves new materials, either recent inventions or things not used before in art. Little was done until lately with the wide range of industrial products. Almost nothing has been done with industrial techniques and, because of the cost, probably won't be for some time. Art could be mass-produced, and possibilities otherwise unavailable, such as stamping, could be used. Dan Flavin, who uses fluorescent lights, has appropriated the results of industrial production. Materials vary greatly and are simply materials—formica, aluminum, cold-rolled steel, plexiglas, red and common brass, and so forth. They are specific. If they are used directly, they are more specific. Also, they are usually aggressive. There is an objectivity to the obdurate identity of a material. Also, of course, the qualities of materials—hard mass, soft mass, thickness of $\frac{1}{32}$, $\frac{1}{16}$, $\frac{1}{8}$ inch, pliability, slickness, translucency,

dullness—have unobjective uses. The vinyl of Oldenburg's soft objects looks the same as ever, slick, flaccid and a little disagreeable, and is objective, but it is pliable and can be sewn and stuffed with air and kapok and hung or set down, sagging or collapsing. Most of the new materials are not as accessible as oil on canvas and are hard to relate to one another. They aren't obviously art. The form of a work and its materials are closely related. In earlier work the structure and the imagery were executed in some neutral and homogeneous material. Since not many things are lumps, there are problems in combining the different surfaces and colors and in relating the parts so as not to weaken the unity.

Three-dimensional work usually doesn't involve ordinary anthropomorphic imagery. If there is a reference it is single and explicit. In any case the chief interests are obvious. Each of Bontecou's reliefs is an image. The image, all of the parts and the whole shape are coextensive. The parts are either part of the hole or part of the mound which forms the hole. The hole and the mound are only two things, which, after all, are the same thing. The parts and divisions are either radial or concentric in regard to the hole, leading in and out and enclosing. The radial and concentric parts meet more or less at right angles and in detail are structure in the old sense, but collectively are subordinate to the single form. Most of the new work has no structure in the usual sense, especially the work of Oldenburg and Stella. Chamberlain's work does involve composition. The nature of Bontecou's single image is not so different from that of images which occurred in a small way in semiabstract painting. The image is primarily a single emotive one, which alone wouldn't resemble the old imagery so much, but to which internal and external references, such as violence and war, have been added. The additions are somewhat pictorial, but the image is essentially new and surprising; an image has never before been the whole work, been so large, been so explicit and aggressive. The abatised orifice is like a strange and dangerous object. The quality is intense and narrow and obsessive. The boat and the furniture that Kusama covered with white protuberances have a related intensity and obsessiveness and are also strange objects. Kusama is interested in obsessive repetition, which is a single interest. Yves Klein's blue paintings are also narrow and intense.

The trees, figures, food or furniture in a painting have a shape or contain shapes that are emotive. Oldenburg has taken this anthropomorphism to an extreme and made the emotive form, with him basic and biopsychological, the same as the shape of an object, and by blatancy subverted the idea of the natural presence of human qualities in all things. And further, Oldenburg avoids trees and people. All of Oldenburg's grossly anthropomorphized objects are manmade—which right away is an empirical matter. Someone or many made these things and incorporated their preferences. As practical as an ice-cream cone is, a lot of people made a choice, and more agreed, as to its appearance and existence. This interest shows more in the recent appliances and fixtures from the home and especially in the bedroom suite, where the choice is flagrant. Oldenburg exaggerates the accepted or chosen form and turns it into one of his own. Nothing made is completely objective, purely practical or merely present. Oldenburg gets along very well without anything that would ordinarily be called structure. The ball and cone of the large ice-cream cone are enough. The whole thing is a profound form, such as sometimes occurs in primitive art. Three fat layers with a small one on top are enough. So is a flaccid, flamingo switch draped from two points. Simple form and one or two colors are considered less by old standards. If changes in art are compared backwards, there always seems to be a reduction, since only old attributes are counted and these are always fewer. But obviously new things are more, such as Oldenburg's techniques and materials. Oldenburg needs three dimensions in order to simulate and enlarge a real object and to equate it and an emotive form. If a hamburger were painted it would retain something of the traditional anthropomorphism. George Brecht and Robert Morris use real objects and depend on the viewer's knowledge of these objects.

<p style="text-align: right">1965</p>

ROSALIND KRAUSS

Rosalind Krauss (born 1941) was a graduate student in art history at Harvard when she began writing criticism for *Artforum* in the 1960s. Her PhD thesis was a study of the sculpture of David Smith, that great admiration of Clement Greenberg's, and from the outset Krauss embraced Greenberg's interest in formal properties and philosophic possibilities. But from her advocacy of Donald Judd and Minimalism (which Greenberg disdained) to her later concern with Surrealist photography and Structuralist theory, she has aimed to greatly enlarge—and some would even say explode—the formalist agenda. As one of the founders of the journal *October* in 1976, Krauss pressed for an approach to art criticism and art history that reconciled formalist concerns with political and social concerns. Krauss has shown a particular fascination with modern French thought, drawing on ideas in the work of Georges Bataille, Jacques Derrida, Jacques Lacan, and Ferdinand de Saussure. And at a time when art history departments were beginning to embrace the study of contemporary art, Krauss became a force to be reckoned with in the academic world, rejecting in the process the idea of the art critic as a free agent, a sort of intellectual flaneur, that had shaped the attitudes and even the prose styles of John Ashbery, Frank O'Hara, and Harold Rosenberg.

Allusion and Illusion in Donald Judd

". . . forms which do not depend on the balance and adjustment of one part to another for their meaning."

FOR some time Donald Judd has been a major spokesman for works of art which seek, as their highest attainment, total identity as objects. Last year in praise of a fellow sculptor's work, Judd wrote: "Rather than inducing idealization and generalization and being allusive, it excludes. The work asserts its own existence, form and power. It becomes an object in its own right." Thus object art would seem to proscribe both allusion and illusion: any reference to experiences or ideas beyond the work's brute physical presence is excluded, as is any manipulation (through the prescribed observation of that presence) of apparent as opposed to literal space. With this presumptive reduction of art from the realm of illusion—and through

illusionism, of meaning—to the sphere of transparently real objects, the art with which Judd is associated is characterized as intentionally bland and empty: "Obviously a negative art of denial and renunciation."

Approaching Judd's latest work from within this frame of reference, one is totally unprepared for the extraordinary beauty of the sculptures themselves, a beauty and authority which is nowhere described or accounted for in the polemics of object art and which leads one to feel all the more acutely the inadequacy of the theoretical line, its failure to measure up (at least in Judd's case) to the power of the sculptural statement.

In a recent article dealing with the phenomenon of object art, Barbara Rose emphatically recognizes the positive qualities, as opposed to the apparent blankness and denial, of this art, and suggests that these could be located in a mystical experience: "the blankness, the emptiness and vacuum of content is as easily construed as an occasion for spiritual contemplation as it is a nihilistic denial of the world." One cannot here examine this notion as it applies to other sculptors Rose mentions, but at least in the case of Judd's work, which both compels and gratifies immediate sensuous confrontation, the suggestion that his sculpture is the occasion for an experience which completely transcends the physical object does not seem tenable. Nor does a description of Judd's art as meaning something only insofar as it embodies a negation of meaning ("the simple denial of content can in itself constitute the content of such a work") seem to arrive at the richness and plentitude of the works, which are somehow not shorn and dumb, but, rather, insistently meaningful. As Maurice Merleau-Ponty writes, "It is easy to strip language and actions of all meaning and to make them seem absurd, if only one looks at them from far enough away. . . . But that other miracle, the fact that in an absurd world, language and behavior do have meaning for those who speak and act, remains to be understood."

To get at meaning in Donald Judd's recent work necessarily involves brute description of the objects themselves, but significantly such a description cannot simply rest at an inventory of characteristics, even though many of the sculptors persuaded by object art maintain that such an inventory does indeed describe all that the works contain. Rose reports that the artists she deals

with ask that their sculpture be taken as "nothing more than the total of the series of assertions that it is this or that shape and takes up so much space and is painted such a color and made of such a material." But it would seem that in Judd's case the strength of the sculptures derives from the fact that grasping the works by means of a list of their physical properties, no matter how complete, is both possible and impossible. They both insist upon and deny the adequacy of such a definition of themselves, because they are not developed from "assertions" about materials or shapes, assertions, that is, which are given a priori and convert the objects into examples of a theorem or a more general case, but are obviously meant as objects of perception, objects that are to be grasped in the experience of looking at them. As such they suggest certain compelling issues.

One of the most beautiful of the sculptures in Judd's recent Castelli Gallery show was a wall-hung work (now in the Whitney Museum's collection) which is made of a long (approximately twenty feet) brushed aluminum bar, from which, at varying intervals, hangs a series of shorter bars enameled a deep, translucent violet. Or so it appears from the front. The assumption that the apparently more dense metallic bar relates to the startlingly sensuous, almost voluptuous lower bars as a support from which they are suspended is an architectural one, a notion taken from one's previous encounters with constructed objects and applied to this case. This reading is, however, denied from the side view of the object, which reveals that the aluminum bar is hollow (and open at both ends) while the purple boxes below it, which had appeared luminous and relatively weightless, are in fact enclosed, and furthermore function as the supports for the continuous aluminum member. It is they that are attached to the wall and into which the square profile of the aluminum bar fits (flush with their top and front sides), completing their own L-shaped profile to form an eight-by-eight-inch box in section. A view raking along the facade of the sculpture, then, reveals that one's initial reading was in some way an illusion: the earlier sense of the purple bars' impalpability and luminosity is reversed, and a clearer perception of the work can be obtained; but it is still one that is startlingly adumbrated and misleading. For now one sees the work in extension; that is, looking along its length, one sees it in perspective. That one is tempted to read

it as in perspective follows from the familiar repetitive rhythms of the verticals of the violet boxes, which are reminiscent of the colonnades of classical architecture or of the occurrence at equal intervals of the vertical supporting members of any modular structure. Once again, then, Judd's work makes a reference to architecture, or to a situation one knows from previous experience—knowledge gained prior to the confrontation with the object. In this way, it seems to me, Judd brings a reference to a prior experience to bear on the present perception of the work. Or, to put it another way, the work itself exploits and at the same time confounds previous knowledge to project its own meaning. In Renaissance architecture, the even spacing of the colonnade is used to establish harmonious relationships as seen in perspective. The Renaissance mind seized on the realization that the same theorems of plane geometry unite proportion and perspective, and therefore assumed that a series of subjective viewpoints of a building (say, the sequence seen as one travels down the colonnade nave of Brunelleschi's San Lorenzo) would not invalidate an awareness of absolute measurement. It was thus an optical space of measurable quantities that was involved in the Renaissance rationalization of space through perspective.

As was noted before, Judd's sculpture, unless it is seen directly from the front, which is difficult because of its extreme length, demands to be seen in perspective. Yet the work confounds that perspective reading which will guarantee a sense of absolute measurement through proportion, because of the obviously unequal lengths of the violet bars and the unequal distances which separate them. The work cannot be seen rationally, in terms of a given sense of geometrical laws or theorems evolved prior to the experience of the object. Instead, the sculpture can be sensed only in terms of its present coming into being as an object given "in the imperious unity, the presence, the insurpassable plentitude which is for us the definition of the real." In those terms the French philosopher Merleau-Ponty describes perception which "does not give me truths like geometry, but presences." The "lived perspective" of which Merleau-Ponty speaks is very different from the rational perspective of geometrical laws: "What prohibits me from treating my perception as an intellectual act is that an intellectual act would grasp the object either as possible or as necessary. But in perception it is

'real,' it is given as the infinite sum of indefinite series of per-spectival views in each of which the object is given but in none of which it is given exhaustively."

It was noted at the beginning of this discussion that Judd's own criticism would seem to accept only that art which eschews both allusion and illusion. Yet his sculpture derives its power from a heightening of illusion—although not of pictorial illu-sion but of lived illusion. In the case of the sculpture described above, the work plays off the illusory quality of the thing itself as it presents itself to vision alone—which it does persuasively from a front view, in seeming to be a series of flat, luminous shapes; and from a raking view, in the optical disappearance created by its orthogonal recession—as against the sensation of being able to grasp it and therefore to know it through touch. The sculpture becomes, then, an irritant for, and a heightening of, the awareness in the viewer that he approaches objects to make meaning of them, that when he grasps real structures, he does so as meaningful, whole presences.

In constructing what is undoubtedly the most serious and fruitful description of the development of modern (as opposed to simply contemporary) art, Clement Greenberg and Michael Fried have insisted on the importance of that aspect of the art-ist's endeavor which involves a critical confrontation with the most vital work of the recent past. Judd's present sculpture can be situated, in this sense, in a critical relationship to the work with which David Smith was involved just before his death in 1965. This is of course not to say that the works contain some kind of veiled allusion to Smith or are only meaningful as seen in relation to his work; on the contrary, they are entirely mean-ingful on their own terms. Judd seems rather to have sensed in Smith certain sculptural possibilities which are as yet unrealized.

Smith's late *Cubi* pieces, especially *Cubi XXIV* and *Cubi XXVIII*, consist of large stainless steel cylinders and beams, which make up enormous rectangular "frames." Some of these frames are empty; others contain rectilinear volumes which are set with one broad side parallel to the viewer's plane of vision and are rendered further weightless and immaterial by the finish on the steel: a kind of calligraphic sanding of the metal so that the surfaces appear as a flickering, evanescent denial of the mass that supports them. The works wed a purely optical sensation

of openness (the view through the frame) that is the presumed subject of the work, with an increased sense of the palpability and substance of the frame. Smith in this way embraced the modality of illusionism within pictorial space from painting, and used this to powerful sculptural advantage. Yet, to Judd, Smith's suspension of planes within the frame, one balanced off against the other, or even the composition of the frame itself of almost arbitrarily combined geometrical segments, must have seemed to rob the work of necessary lucidity. Smith's worrying of relationships between parts must have appeared to have clouded over the experience of the object with a kind of artiness which to Judd's eyes, at least, was irrelevant. In his work of the past few years, as in the pieces in this show, Judd arrives at sculptural forms which do not depend on the balance and adjustment of one part to another for their meaning.

That this departure from traditional modes of composition is also true of the work of Kenneth Noland has been demonstrated by Michael Fried in his various essays on that painter. In Noland's case composition is discarded for what Fried has called "deductive structure": the derivation of boundaries within the pictorial field from the one absolute boundary given by the physical fact of the picture itself—its framing edge. The importance of Noland's decision to let the shape of the support serve as the major determinant of the divisions within the painting rests in part on its avoidance of an explicit affirmation of the flatness of the canvas, which would dilute the experience of the color by rendering it tactile (or merely the attribute of sculptural entities) rather than a sheerly visual or optical medium. Fried points to the large works of Barnett Newman from the early 1950s as establishing a precedent for a wholly optical statement conjoined with, or dependent upon, deductive structure.

In Noland's most recent exhibition, at the Andre Emmerich Gallery, a type of painting emerged which seemed to me to come from decisions by the painter which in part question the import of his earlier work. This type, found in *Across Center* (1966), a four-foot-high, twenty-foot-long canvas divided into four horizontal, evenly painted bands, has far greater affinities with Newman than anything else Noland has done until now. In *Across Center* color becomes more exclusively the basis of the experience than it had been in the diamond-shaped chevron

paintings of the past year or so, for in those paintings the bounding shape itself had a limiting and closing effect on the color. Moving to a twenty-foot-long expanse of color points to a desire to combat the limits imposed by the shape itself and to promote an experience of the painting, either face-on, in fragment (from a vantage point far enough away to see the painting frontally and whole, the intensity of the colors would be somewhat reduced), or at an angle and therefore in perspective—a sensation promoted by the horizontal bands, which seem to increase the work's apparent diminution in size at the far end of one's vision. The sensation thus produced, that one cannot know absolutely the nature of the shape of the painting, that one's view is always adumbrated, that the work in its entirety is highly illusive, throws one more surely and more persuasively onto an immediate experience with color alone.

It is interesting that both Noland and Judd have arrived at formats that involve the viewer in an experience which is on the one hand more illusive than that of either a normal easel painting or an easily cohesive sculptural form, and on the other more immediate than both. But more important, from within this context of an increased sensuousness, neither artist will desert meaning.

1966

ROBERT SMITHSON

Robert Smithson (1938–1973), only thirty-five when he died in a plane crash, belonged to a generation of artists who wrote to make the case for their own nontraditional art. Like Allan Kaprow, Donald Judd, and Robert Morris, Smithson was perfectly happy to have polemic precede practice. He laid out the thinking behind the elaborate Earth Art projects of his last years—especially *Spiral Jetty*, the monumental construction in the Great Salt Lake in Utah—in writings such as "Entropy and the New Monuments" and "A Tour of the Monuments of Passaic, New Jersey," both published in *Artforum*. Introducing his collected essays in 1979, Philip Leider, who had edited Smithson at *Artforum*, argued that his writings epitomized an art world anxious to move ahead, "a world, in short, that is the shambles of the Cedar Street Bar, one in which 'action' painting is a kind of naïve idiocy, and 'post-painterly abstraction' little better, an art world ready for anything except more of the same." Smithson's writings certainly reflect a restless imagination, eager to embrace not only modern art but the study of geography and geology, and modern science and even science fiction.

The Crystal Land

> Ice is the medium most alien to organic life, a considerable accumulation of it completely disrupts the normal course of processes in the biosphere.
>
> P. A. SHUMKII, *Principles of Structural Glaciology*

THE first time I saw Don Judd's "pink plexiglas box," it suggested a giant crystal from another planet. After talking to Judd, I found out we had a mutual interest in geology and mineralogy, so we decided to go rock hunting in New Jersey. Out of this excursion came reflections, reconstituted as follows:

Near Paterson, Great Notch, and Upper Montclair are the mineral-rich quarries of the First Watchung Mountain. Brain H. Mason, in his fascinating booklet, *Trap Rock Minerals of New Jersey*, speaks of the "Triassic sedimentary rocks of the Newark series," which are related to those of the Palisades. In these rocks one might find: "actinolite, albite, allanite, analcime apatite, anhydrite, apophyllite, aurichalcite, axinite, azurite, babingtonite, bornite, barite, calcite, chabazite, chalcocite,

Robert Smithson: *The Mirror Vortex*,
1965. Stainless steel and three mirrors,
35 × 28 × 28 in.

chalcopyrite, chlorite, chrysocolla, copper, covellite, cuprite, datolite, dolomite, epidote, galena, glauberite, goethite, gmelinite, greenockite, gypsum, hematite, heulandite, hornblende, laumontite, malachite, mesolite, natrolite, opal, orpiment, orthoclase, pectolite, prehnite, pumpellyite, pyrite, pyrolusite, quartz, scolecite, siderite, silver, sphalerite, sphene, stevensite, stilbite, stilpnomelane, talc, thaumasite, thomsonite, tourmaline, ulexite."

Together with my wife Nancy, and Judd's wife, Julie, we set out to explore that geological locale.

Upper Montclair quarry, also known as Osborne and Marsellis quarry or McDowell's quarry, is situated on Edgecliff Road, Upper Montclair, and was worked from about 1890 to 1918. A lump of lava in the center of the quarry yields tiny quartz crystals. For about an hour Don and I chopped incessantly at

the lump with hammer and chisel, while Nancy and Julie wandered aimlessly around the quarry picking up sticks, leaves and odd stones. From the top of the quarry cliffs, one could see the New Jersey suburbs bordered by the New York City skyline.

The terrain is flat and loaded with "middle-income" housing developments with names like Royal Garden Estates, Rolling Knolls Farm, Valley View Acres, Split-level Manor, Babbling Brook Ranch-Estates, Colonial Vista Homes—on and on they go, forming tiny boxlike arrangements. Most of the houses are painted white, but many are painted petal pink, frosted mint, buttercup, fudge, rose beige, antique green, Cape Cod brown, lilac, and so on. The highways crisscross through the towns and become man-made geological networks of concrete. In fact, the entire landscape has a mineral presence. From the shiny chrome diners to glass windows of shopping centers, a sense of the crystalline prevails.

When we finished at the quarry, we went to Bond's Ice Cream Bar and had some AWFUL-AWFULS—"awful big—and awful good . . . it's the drink you eat with a spoon." We talked about the little crystal cavities we had found, and looked at *The Field Book of Common Rocks and Minerals* by Frederic Brewster Loomis. I noticed ice is a crystal: "Ice, H_2O, water, specific gravity—.92, colorless to white, luster adamantine, transparent on thin edges. Beneath the surface the hexagonal crystals grow downward into the water, parallel to each other, making a fibrous structure, which is very apparent when ice is 'rotten.' . . ."

After that we walked to the car through the charming Tudoroid town of Upper Montclair, and headed for the Great Notch Quarry. I turned on the car radio: ". . . countdown survey . . . chew your little troubles away . . . high ho hey hey. . . ."

My eyes glanced over the dashboard, it became a complex of chrome fixed into an embankment of steel. A glass disc covered the clock. The speedometer was broken. Cigarette butts were packed into the ashtray. Faint reflections slid over the windshield. Out of sight in the glove compartment was a silver flashlight and an Esso map of Vermont. Under the radio dial (55-7-9-11-14-16) was a row of five plastic buttons in the shape of cantilevered cubes. The rearview mirror dislocated the road behind us. While listening to the radio, some of us read the Sunday newspapers. The pages made slight noises as they turned;

each sheet folded over their laps forming temporary geographies of paper. A valley of print or a ridge of photographs would come and go in an instant.

We arrived at the Great Notch Quarry, which is situated "about three hundred yards southwest of the Great Notch station of the Erie Railroad." The quarry resembled the moon. A gray factory in the midst of it all, looked like architecture designed by Robert Morris. A big sign on one building said THIS IS A HARD HAT AREA. We started climbing over the piles and ran into a "rock hound," who came on, I thought, like Mr. Wizard, and who gave us all kinds of rock-hound-type information in an authoritative manner. We got a rundown on all the quarries that were closed to the public, as well as those that were open.

The walls of the quarry did look dangerous. Cracked, broken, shattered; the walls threatened to come crashing down. Fragmentation, corrosion, decomposition, disintegration, rock creep, debris slides, mud flow, avalanche were everywhere in evidence. The gray sky seemed to swallow up the heaps around us. Fractures and faults spilled forth sediment, crushed conglomerates, eroded debris and sandstone. It was an arid region, bleached and dry. An infinity of surfaces spread in every direction. A chaos of cracks surrounded us.

On the top of a promontory stood a motionless rockdrill against the blank which was the sky. High-tension towers transported electric cable over the quarry. Dismantled parts of steam shovels, tread machines and trucks were lined up in random groups. Such objects interrupted the depositions of waste that formed the general condition of the place. What vegetation there was seemed partially demolished. Newly made boulders eclipsed parts of a wire and pipe fence. Railroad tracks passed by the quarry, the ties formed a redundant sequence of modules, while the steel tracks projected the modules into an imperfect vanishing point.

On the way back to Manhattan, we drove through the Jersey Meadows, or more accurately the Jersey Swamps—a good location for a movie about life on Mars. It even has a network of canals that are choked by acres of tall reeds. Radio towers are scattered throughout this bleak place. Drive-ins, motels and gas stations exist along the highway, and behind them are

smoldering garbage dumps. South, toward Newark and Bay-onne, the smoke stacks of heavy industry add to the general air pollution.

As we drove through the Lincoln Tunnel, we talked about going on another trip, to Franklin Furnace; there one might find minerals that glow under ultraviolet light or "black light." The countless cream colored square tiles on the walls of the tunnel sped by, until a sign announcing New York broke the tiles' order.

1966

MICHAEL FRIED

As a young critic, Michael Fried (born 1939) was closely associated with Clement Greenberg, writing enthusiastically about Kenneth Noland, Morris Louis, Jules Olitski, Anthony Caro, and other artists the older man admired. Fried was, along with Greenberg, an early dissenting voice on the subject of Minimalism, but in this instance it was the younger man who made the most enduring argument, throwing down the gauntlet with "Art and Objecthood" in *Artforum* in 1967, the widely discussed and debated essay in which he condemns Minimalist sculpture as excessively theatrical—as denying the inwardness and autonomy essential to modernist art. Nobody in the ensuing decades has proven a more dazzling theorist and polemicist, as Fried has reshaped the interconnected thinking of art critics and art historians with studies of art from the eighteenth century onward, including *Absorption and Theatricality: Painting and Beholder in the Age of Diderot* (1980). In a long introduction to his collected criticism, Fried discussed his shifting focus, from art criticism to art history, and argued that there was a clear line to be drawn between the subjectivity of his art criticism and the objectivity of his art historical work. Like many dazzling polemicists, Fried has inspired more than his fair share of controversy. What is unquestionable is that his ideas and opinions—whether the subject is Caravaggio, Courbet, Manet, or the recent photographs of Jeff Wall—always command respect.

New York Letter: Warhol

OF all the painters working today in the service (or thrall) of a popular iconography, Andy Warhol is probably the most single-minded and the most spectacular. His current show at the Stable Gallery appears to have been done in a combination paint and silk-screen technique; I'm not sure about this, but it seems as if he laid down areas of bright color first, then printed the silk-screen pattern in black over them, and finally painted in certain details. The technical result is brilliant, and there are passages of fine, sharp painting as well, though in this latter respect Warhol is inconsistent; he can handle paint well but it is not his chief, nor perhaps even a major concern, and he is capable of showing things that are quite badly painted for the sake of the images they embody. And in fact the success of

individual paintings depends only partly (though possibly more than Warhol might like) on the quality of the paint handling. It has even more to do with the choice of subject matter, with the particular image selected for reproduction—which lays him open to the danger of an evanescence he can do nothing about. An art like Warhol's is necessarily parasitic upon the myths of its time, and indirectly therefore upon the machinery of fame and publicity that markets those myths; and it is not at all un-likely that the myths that move us will be unintelligible (or at best starkly dated) to generations that follow. This is said not to denigrate Warhol's work but to characterize the risks it runs—and, I admit, to register an advance protest against the advent of a generation that will not be as moved by Warhol's beautiful, vulgar, heartbreaking icons of Marilyn Monroe as I am. These, I think, are the most successful pieces in the show, far more successful than, for example, the comparable heads of Troy Donahue—because the fact remains that Marilyn is one of the overriding myths of our time while Donahue is not, and there is a consequent element of subjectivity that enters into the choice of the latter and mars the effect. (Epic poets and pop artists have to work the mythic material as it is given: their art is necessarily impersonal, and there is barely any room for personal predilection.) Warhol's large canvas of Elvis Presley heads falls somewhere between the other two.

Another painting I thought especially successful was the large matchbook cover reading "Drink Coca-Cola"; though I thought the even larger canvas with rows of Coke bottles rather cluttered and fussy and without the clarity of the matchbook, in which Warhol's handling of paint is at its sharpest and his eye for effective design at its most telling. At his strongest—I take this to be in the Marilyn Monroe paintings—Warhol has a painterly competence, a sure instinct for vulgarity (as in his choice of col-ors), and a feeling for what is truly human and pathetic in one of the exemplary myths of our time that I for one find moving; but I am not at all sure that even the best of Warhol's work can much outlast the journalism on which it is forced to depend.

1962

Art and Objecthood

Edwards's journals frequently explored and tested a meditation
he seldom allowed to reach print; if all the world were annihilated
he wrote . . . and a new world were freshly created, though it
were to exist in every particular in the same manner as this world,
it would not be the same. Therefore, because there is continuity,
which is time, "it is certain with me that the world exists anew
every moment; that the existence of things every moment ceases
and is every moment renewed." The abiding assurance is that "we
every moment see the same proof of a God as we should have
seen if we had seen Him create the world at first."

 —Perry Miller, *Jonathan Edwards*[1]

I

THE enterprise known variously as Minimal Art, ABC Art, Pri-
mary Structures, and Specific Objects is largely ideological. It
seeks to declare and occupy a position—one that can be formu-
lated in words and in fact has been so formulated by some of
its leading practitioners. If this distinguishes it from modernist
painting and sculpture on the one hand, it also marks an im-
portant difference between Minimal Art—or, as I prefer to call
it, *literalist* art—and Pop or Op Art on the other. From its in-
ception, literalist art has amounted to something more than an
episode in the history of taste. It belongs rather to the history—
almost the natural history—of sensibility, and it is not an iso-
lated episode but the expression of a general and pervasive
condition. Its seriousness is vouched for by the fact that it is in
relation both to modernist painting and modernist sculpture
that literalist art defines or locates the position it aspires to oc-
cupy. (This, I suggest, is what makes what it declares something
that deserves to be called a position.) Specifically, literalist art
conceives of itself as neither one nor the other; on the contrary,
it is motivated by specific reservations or worse about both, and
it aspires, perhaps not exactly, or not immediately, to displace
them, but in any case to establish itself as an independent art
on a footing with either.

The literalist case against painting rests mainly on two counts:
the relational character of almost all painting and the ubiqui-
tousness, indeed the virtual inescapability, of pictorial illusion.

In Donald Judd's view,

> When you start relating parts, in the first place, you're assum-
> ing you have a vague whole—the rectangle of the canvas—and
> definite parts, which is all screwed up, because you should have
> a definite *whole* and maybe no parts, or very few.[2]

The more the shape of the support is emphasized, as in recent
modernist painting, the tighter the situation becomes:

> The elements inside the rectangle are broad and simple and
> correspond closely to the rectangle. The shapes and surface are
> only those that can occur plausibly within and on a rectangular
> plane. The parts are few and so subordinate to unity as not to
> be parts in an ordinary sense. A painting is nearly an entity,
> one thing, and not the indefinable sum of a group of entities
> and references. The one thing overpowers the earlier painting.
> It also establishes the rectangle as a definite form; it is no lon-
> ger a fairly neutral limit. A form can be used only in so many
> ways. The rectangular plane is given a life span. The simplicity
> required to emphasize the rectangle limits the arrangements
> possible within it.

Painting is here seen as an art on the verge of exhaustion, one
in which the range of acceptable solutions to a basic problem
—how to organize the surface of the picture—is severely re-
stricted. The use of shaped rather than rectangular supports can,
from the literalist point of view, merely prolong the agony. The
obvious response is to give up working on a single plane in favor
of three dimensions. That, moreover, automatically

> gets rid of the problem of illusionism and of literal space, space
> in and around marks and colors—which is riddance of one of
> the salient and most objectionable relics of European art. The
> several limits of painting are no longer present. A work can be as
> powerful as it can be thought to be. Actual space is intrinsically
> more powerful and specific than paint on a flat surface.

The literalist attitude toward sculpture is more ambiguous.
Judd, for example, seems to think of what he calls Specific Ob-
jects as something other than sculpture, while Robert Morris
conceives of his own unmistakably literalist work as resuming
the lapsed tradition of Constructivist sculpture established by

Vladimir Tatlin, Aleksandr Rodchenko, Naum Gabo, Antoine Pevsner, and Georges Vantongerloo. But this and other disagreements are less important than the views Judd and Morris hold in common. Above all they are opposed to sculpture that, like most painting, is "made part by part, by addition, composed" and in which "specific elements . . . separate from the whole, thus setting up relationships within the work." (They would include the work of David Smith and Anthony Caro under this description.) It is worth remarking that the "part-by-part" and "relational" character of most sculpture is associated by Judd with what he calls *anthropomorphism*: "A beam thrusts; a piece of iron follows a gesture; together they form a naturalistic and anthropomorphic image. The space corresponds." Against such "multipart, inflected" sculpture Judd and Morris assert the values of wholeness, singleness, and indivisibility—of a work's being, as nearly as possible, "one thing," a single "Specific Object." Morris devotes considerable attention to "the use of strong gestalt or of unitary-type forms to avoid divisiveness"; while Judd is chiefly interested in the kind of wholeness that can be achieved through the repetition of identical units. The order at work in his pieces, as he once remarked of that in Frank Stella's stripe paintings, "is simply order, like that of continuity, one thing after another." For both Judd and Morris, however, the critical factor is *shape*. Morris's "unitary forms" are polyhedrons that resist being grasped other than as a single shape: the gestalt simply *is* the "constant, known shape." And shape itself is, in his system, "the most important sculptural value." Similarly, speaking of his own work, Judd has remarked that

> the big problem is that anything that is not absolutely plain begins to have parts in some way. The thing is to be able to work and do different things and yet not break up the wholeness that a piece has. To me the piece with the brass and the five verticals is above all *that shape*.

The shape *is* the object: at any rate, what secures the wholeness of the object is the singleness of the shape. It is, I believe, that emphasis on shape that accounts for the impression, which numerous critics have mentioned, that Judd's and Morris's pieces are *hollow*.

2

Shape has also been central to the most important painting of the past several years. In several recent essays I have tried to show how, in the work of Kenneth Noland, Jules Olitski, and Stella, a conflict has gradually emerged between shape as a fundamental property of objects and shape as a medium of painting.[3] Roughly, the success or failure of a given painting has come to depend on its ability to hold or stamp itself out or compel conviction as shape—that, or somehow to stave off or elude the question of whether or not it does so. Olitski's early spray paintings are the purest example of paintings that either hold or fail to hold as shapes, while in his more recent pictures, as well as in the best of Noland's and Stella's recent work, the demand that a given picture hold as shape is staved off or eluded in various ways. What is at stake in this conflict is whether the paintings or objects in question are experienced as paintings or as objects, and what decides their identity as *painting* is their confronting of the demand that they hold as shapes. Otherwise

Frank Stella: *Tuftonboro III*, 1966. Flourescent alkyd and epoxy paints on canvas, 110¼ × 110½ × 3 in.

they are experienced as nothing more than objects. This can be summed up by saying that modernist painting has come to find it imperative that it defeat or suspend its own objecthood, and that the crucial factor in this undertaking is shape, but shape that must belong to *painting*—it must be pictorial, not, or not merely, literal. Whereas literalist art stakes everything on shape as a given property of objects, if not indeed as a kind of object in its own right. It aspires not to defeat or suspend its own objecthood, but on the contrary to discover and project objecthood as such.

In his essay "Recentness of Sculpture" Clement Greenberg discusses the effect of *presence*, which, from the start, has been associated with literalist work.[4] This comes up in connection with the work of Anne Truitt, an artist Greenberg believes anticipated the literalists (he calls them Minimalists):

> Truitt's art did flirt with the look of non-art, and her 1963 show was the first in which I noticed how this look could confer an effect of *presence*. That presence as achieved through size was aesthetically extraneous, I already knew. That presence as achieved through the look of non-art was likewise aesthetically extraneous I did not yet know. Truitt's sculpture had this kind of presence but did not *hide* behind it. That sculpture could hide behind it—just as painting did—I found out only after repeated acquaintance with Minimal works of art: Judd's, Morris's, Andre's, Steiner's, some but not all of Smithson's, some but not all of LeWitt's. Minimal art can also hide behind presence as size: I think of Bladen (though I am not sure whether he is a certified Minimalist) as well as of some of the artists just mentioned.[5]

Presence can be conferred by size or by the look of nonart. Furthermore, what nonart means today, and has meant for several years, is fairly specific. In "After Abstract Expressionism" Greenberg wrote that "a stretched or tacked-up canvas already exists as a picture—though not necessarily as a *successful* one."[6] For that reason, as he remarks in "Recentness of Sculpture," the "look of non-art was no longer available to painting." Instead, "the borderline between art and non-art had to be sought in the three-dimensional, where sculpture was, and where everything material that was not art also was."[7] Greenberg goes on to say:

> The look of machinery is shunned now because it does not go
> far enough towards the look of non-art, which is presumably
> an "inert" look that offers the eye a minimum of "interesting"
> incident—unlike the machine look, which is arty by comparison
> (and when I think of Tinguely I would agree with this). Still,
> no matter how simple the object may be, there remain the rela-
> tions and interrelations of surface, contour, and spatial interval.
> Minimal works are readable as art, as almost anything is today—
> including a door, a table, or a blank sheet of paper. . . . Yet it
> would seem that a kind of art nearer the condition of non-art
> could not be envisaged or ideated at this moment.[8]

The meaning in this context of "the condition of non-art" is
what I have been calling ojecthood. It is as though objecthood
alone can, in the present circumstances, secure something's
identity, if not as nonart, at least as neither painting nor sculp-
ture; or as though a work of art—more accurately, a work of
modernist painting or sculpture—were in some essential respect
not an object.

There is, in any case, a sharp contrast between the literalist
espousal of objecthood—almost, it seems, as an art in its own
right—and modernist painting's self-imposed imperative that it
defeat or suspend its own objecthood through the medium of
shape. In fact, from the perspective of recent modernist paint-
ing, the literalist position evinces a sensibility not simply alien
but antithetical to its own: as though, from that perspective,
the demands of art and the conditions of objecthood were in
direct conflict.

Here the question arises: What is it about objecthood as pro-
jected and hypostatized by the literalists that makes it, if only
from the perspective of recent modernist painting, antithetical
to art?

3

The answer I want to propose is this: the literalist espousal of
objecthood amounts to nothing other than a plea for a new
genre of theater, and theater is now the negation of art.

Literalist sensibility is theatrical because, to begin with, it is
concerned with the actual circumstances in which the beholder
encounters literalist work. Morris makes this explicit. Whereas

in previous art "what is to be had from the work is located
strictly within [it]," the experience of literalist art is of an ob-
ject in a *situation*—one that, virtually by definition, *includes
the beholder*:

> The better new work takes relationships out of the work and
> makes them a function of space, light, and the viewer's field of
> vision. The object is but one of the terms in the newer aesthetic.
> It is in some way more reflexive because one's awareness of
> oneself existing in the same space as the work is stronger than in
> previous work, with its many internal relationships. One is more
> aware than before that he himself is establishing relationships
> as he apprehends the object from various positions and under
> varying conditions of light and spatial context.

Morris believes that this awareness is heightened by "the
strength of the constant, known shape, the gestalt," against
which the appearance of the piece from different points of view
is constantly being compared. It is intensified also by the large
scale of much literalist work:

> The awareness of scale is a function of the comparison made
> between that constant, one's body size, and the object. Space be-
> tween the subject and the object is implied in such a comparison.

The larger the object, the more we are forced to keep our dis-
tance from it:

> It is this necessary, greater distance of the object in space from
> our bodies, in order that it be seen at all, that structures the non-
> personal or public mode [which Morris advocates]. However,
> it is just this distance between object and subject that creates a
> more extended situation, because physical participation becomes
> necessary.

The theatricality of Morris's notion of the "nonpersonal or pub-
lic mode" seems obvious: the largeness of the piece, in con-
junction with its nonrelational, unitary character, *distances* the
beholder—not just physically but psychically. It is, one might
say, precisely this distancing that *makes* the beholder a subject
and the piece in question . . . an object. But it does not fol-
low that the larger the piece, the more securely its "public"
character is established; on the contrary, "beyond a certain size

the object can overwhelm and the gigantic scale becomes the loaded term." Morris wants to achieve presence through object-hood, which requires a certain largeness of scale, rather than through size alone. But he is also aware that the distinction is anything but hard and fast:

> For the space of the room itself is a structuring factor both in its cubic shape and in terms of the kind of compression different sized and proportioned rooms can effect upon the object-subject terms. That the space of the room becomes of such importance does not mean that an environmental situation is being estab-lished. The total space is hopefully altered in certain desired ways by the presence of the object. It is not controlled in the sense of being ordered by an aggregate of objects or by some shaping of the space surrounding the viewer.

The object, not the beholder, must remain the center or focus of the situation, but the situation itself *belongs to* the beholder—it is *his* situation. Or as Morris has remarked, "I wish to emphasize that things are in a space with oneself, rather than . . . [that] one is in a space surrounded by things." Again, there is no clear or hard distinction between the two states of affairs: one is, after all, *always* surrounded by things. But the things that are literalist works of art must somehow *confront* the beholder—they must, one might almost say, be placed not just in his space but in his *way*. None of this, Morris maintains,

> indicates a lack of interest in the object itself. But the concerns now are for more control of . . . the entire situation. Control is necessary if the variables of object, light, space, body, are to function. The object has not become less important. It has merely become less self-important.

It is, I think, worth remarking that "the entire situation" means exactly that: *all* of it—including, it seems, the beholder's *body*. There is nothing within his field of vision—nothing that he takes note of in any way—that declares its irrelevance to the situation, and therefore to the experience, in question. On the contrary, for something to be perceived at all is for it to be perceived as part of that situation. Everything counts—not as part of the object, but as part of the situation in which its objecthood is es-tablished and on which that objecthood at least partly depends.

4

Furthermore, the presence of literalist art, which Greenberg was the first to analyze, is basically a theatrical effect or quality—a kind of *stage* presence. It is a function not just of the obtrusiveness and, often, even aggressiveness of literalist work, but of the special complicity that that work extorts from the beholder. Something is said to have presence when it demands that the beholder take it into account, that he take it seriously—and when the fulfillment of that demand consists simply in being aware of the work and, so to speak, in acting accordingly. (Certain modes of seriousness are closed to the beholder by the work itself, i.e., those established by the finest painting and sculpture of the recent past. But, of course, those are hardly modes of seriousness in which most people feel at home, or that they even find tolerable.) Here again the experience of being distanced by the work in question seems crucial: the beholder knows himself to stand in an indeterminate, open-ended—and

Tony Smith: *Die*, 1962. Steel, 72 ×72 ×72 in.

unexacting—relation *as subject* to the impassive object on the wall or floor. In fact, being distanced by such objects is not, I suggest, entirely unlike being distanced, or crowded, by the silent presence of another *person*; the experience of coming upon literalist objects unexpectedly—for example, in somewhat darkened rooms—can be strongly, if momentarily, disquieting in just this way.

There are three main reasons why this is so. First, the size of much literalist work, as Morris's remarks imply, compares fairly closely with that of the human body. In this context Tony Smith's replies to questions about his six-foot cube, *Die* (1962), are highly suggestive:

> Q: Why didn't you make it larger so that it would loom over the observer?
> A: I was not making a monument.
> Q: Then why didn't you make it smaller so that the observer could see over the top?
> A: I was not making an object.[9]

One way of describing what Smith *was* making might be something like a surrogate person—that is, a kind of statue. (This reading finds support in the caption to a photograph of another of Smith's pieces, *The Black Box* (1963–65), published in the December 1967 issue of *Artforum*, in which Samuel Wagstaff, Jr., presumably with the artist's sanction, observed, "One can see the two-by-fours under the piece, which keep it from appearing like architecture or a monument, and set it off as sculpture." The two-by-fours are, in effect, a rudimentary pedestal, and thereby reinforce the statuelike quality of the piece.) Second, the entities or beings encountered in everyday experience in terms that most closely approach the literalist ideals of the nonrelational, the unitary, and the holistic are *other persons*. Similarly, the literalist predilection for symmetry, and in general for a kind of order that "is simply order . . . one thing after another," is rooted not, as Judd seems to believe, in new philosophical and scientific principles, whatever he takes these to be, but in *nature*. And third, the apparent hollowness of most literalist work—the quality of having an *inside*—is almost blatantly anthropomorphic. It is, as numerous commentators have remarked approvingly, as though the work in question has

an inner, even secret, life—an effect that is perhaps made most explicit in Morris's *Untitled* (1965) a large ringlike form in two halves, with fluorescent light glowing from within at the narrow gap between the two. In the same spirit Tony Smith has said, "I'm interested in the inscrutability and mysteriousness of the thing." [10] He has also been quoted as saying:

> More and more I've become interested in pneumatic structures. In these, all of the material is in tension. But it is the character of the form that appeals to me. The biomorphic forms that result from the construction have a dreamlike quality for me, at least like what is said to be a fairly common type of American dream. [11]

Smith's interest in pneumatic structures may seem surprising, but it is consistent both with his own work and with literalist sensibility generally. Pneumatic structures can be described as hollow with a vengeance—the fact that they are not "obdurate, solid masses" (Morris) being insisted on instead of taken for granted. And it reveals something, I think, about what hollowness means in literalist art that the forms that result are "biomorphic."

5

I am suggesting, then, that a kind of latent or hidden naturalism, indeed anthropomorphism, lies at the core of literalist theory and practice. The concept of presence all but says as much, though rarely so nakedly as in Tony Smith's statement, "I didn't think of them [i.e., the sculptures he 'always' made] as sculptures but as presences of a sort." The latency or hiddenness of the anthropomorphism has been such that the literalists themselves, as we have seen, have felt free to characterize the modernist art they *oppose*, for example, the sculpture of David Smith and Anthony Caro, as anthropomorphic—a characterization whose teeth, imaginary to begin with, have just been pulled. By the same token, however, what is wrong with literalist work is not that it is anthropomorphic but that the meaning and, equally, the hiddenness of its anthropomorphism are incurably theatrical. (Not all literalist art hides or masks its anthropomorphism; the work of lesser figures like Michael Steiner wears anthropomorphism on its sleeve.) *The crucial*

distinction that I am proposing is between work that is funda-
mentally theatrical and work that is not. It is theatricality that,
whatever the differences between them, links artists like Ronald
Bladen and Robert Grosvenor,[12] both of whom have allowed
"gigantic scale [to become] the loaded term" (Morris), with
other, more restrained figures like Judd, Morris, Carl Andre,
John McCracken, Sol LeWitt and—despite the size of some of
his pieces—Tony Smith.[13] And it is in the interest, though not
explicitly in the name, of theater that literalist ideology rejects
both modernist painting and, at least in the hands of its most
distinguished recent practitioners, modernist sculpture.

In this connection Tony Smith's description of a car ride
taken at night on the New Jersey Turnpike before it was fin-
ished makes compelling reading:

> When I was teaching at Cooper Union in the first year or two
> of the fifties, someone told me how I could get onto the un-
> finished New Jersey Turnpike. I took three students and drove
> from somewhere in the Meadows to New Brunswick. It was a
> dark night and there were no lights or shoulder markers, lines,
> railings, or anything at all except the dark pavement moving
> through the landscape of the flats, rimmed by hills in the dis-
> tance, but punctuated by stacks, towers, fumes, and colored
> lights. This drive was a revealing experience. The road and much
> of the landscape was artificial, and yet it couldn't be called a work
> of art. On the other hand, it did something for me that art had
> never done. At first I didn't know what it was, but its effect was
> to liberate me from many of the views I had had about art. It
> seemed that there had been a reality there that had not had any
> expression in art.
>
> The experience on the road was something mapped out but
> not socially recognized. I thought to myself, it ought to be clear
> that's the end of art. Most painting looks pretty pictorial after
> that. There is no way you can frame it, you just have to experi-
> ence it. Later I discovered some abandoned airstrips in Europe
> —abandoned works, Surrealist landscapes, something that had
> nothing to do with any function, created worlds without tradi-
> tion. Artificial landscape without cultural precedent began to
> dawn on me. There is a drill ground in Nuremberg large enough
> to accommodate two million men. The entire field is enclosed
> with high embankments and towers. The concrete approach is
> three sixteen-inch steps, one above the other, stretching for a
> mile or so.

What seems to have been revealed to Smith that night was the pictorial nature of painting—even, one might say, the conventional nature of art. And *that* Smith seems to have understood not as laying bare the essence of art, but as announcing its end. In comparison with the unmarked, unlit, all but unstructured turnpike—more precisely, with the turnpike as experienced from within the car, traveling on it—art appears to have struck Smith as almost absurdly small ("All art today is an art of postage stamps," he has said), circumscribed, conventional. There was, he seems to have felt, no way to "frame" his experience on the road, no way to make sense of it in terms of art, to make art of it, at least as art then was. Rather, "you just have to experience it"—as it happens, as it merely is. (The experience alone is what matters.) There is no suggestion that this is problematic in any way. The experience is clearly regarded by Smith as wholly accessible to everyone, not just in principle but in fact, and the question of whether or not one has really had it does not arise. That this appeals to Smith can be seen from his praise of Le Corbusier as "more available" than Michelangelo: "The direct and primitive experience of the High Court Building at Chandigarh is like the Pueblos of the Southwest under a fantastic overhanging cliff. It's something everyone can understand." It is, I think, hardly necessary to add that the availability of modernist art is not of that kind, and that the rightness or relevance of one's conviction about specific modernist works, a conviction that begins and ends in one's experience of the work itself, is always open to question.

But what was Smith's experience on the turnpike? Or to put the same question another way, if the turnpike, airstrips, and drill ground are not works of art, what are they?—What, indeed, if not empty, or "abandoned," *situations*? And what was Smith's experience if not the experience of what I have been calling *theater*? It is as though the turnpike, airstrips, and drill ground reveal the theatrical character of literalist art, only without the object, that is, without the art itself—as though the object is needed only within a *room*[14] (or, perhaps, in any circumstances less extreme than these). In each of the above cases the object is, so to speak, *replaced* by something: for example, on the turnpike by the constant onrush of the road, the simultaneous recession of new reaches of dark pavement illumined

by the onrushing headlights, the sense of the turnpike itself as something enormous, abandoned, derelict, existing for Smith alone and for those in the car with him. . . . This last point is important. On the one hand, the turnpike, airstrips, and drill ground belong to no one; on the other, the situation established by Smith's presence is in each case felt by him to be *his*. Moreover, in each case being able to go on and on indefinitely is of the essence. What replaces the object—what does the same job of distancing or isolating the beholder, of making him a subject, that the object did in the closed room—is above all the endlessness, or objectlessness, of the approach or onrush or perspective. It is the explicitness, that is to say, the sheer persistence with which the experience presents itself as directed at him from outside (on the turnpike from outside the car) that simultaneously makes him a subject—makes him subject—and establishes the experience itself as something like that of an object, or rather, of objecthood. No wonder Morris's speculations about how to put literalist work outdoors remain strangely inconclusive:

> Why not put the work outdoors and further change the terms? A real need exists to allow this next step to become practical. Architecturally designed sculpture courts are not the answer nor is the placement of work outside cubic architectural forms. Ideally, it is a space, without architecture as background and reference, that would give different terms to work with.

Unless the pieces are set down in a wholly natural context, and Morris does not seem to be advocating this, some sort of artificial but not quite architectural setting must be constructed. What Smith's remarks seem to suggest is that the more effective —meaning effective *as theater*—a setting is made, the more superfluous the works themselves become.

6

Smith's account of his experience on the turnpike bears witness to theater's profound hostility to the arts and discloses, precisely in the absence of the object and in what takes its place, what might be called the theatricality of objecthood. By the same token, however, the imperative that modernist painting defeat

or suspend its objecthood is at bottom the imperative that it *defeat or suspend theater*. And *that* means that there is a war going on between theater and modernist painting, between the theatrical and the pictorial—a war that, despite the literalists' explicit rejection of modernist painting and sculpture, is not basically a matter of program and ideology but of experience, conviction, sensibility. (For example, it was a particular experience that engendered Smith's conviction that painting—that the arts as such—were finished.)

The starkness and apparent irreconcilability of this conflict are something new. I remarked earlier that objecthood has become an issue for modernist painting only within the past several years. This, however, is not to say that before the present situation came into being, paintings, or sculptures for that matter, simply *were objects*. It would, I think, be closer to the truth to say that they *simply* were not.[15] The risk, even the possibility, of seeing works of art as nothing more than objects did not exist. That such a possibility began to present itself around 1960 was largely the result of developments within modernist painting. Roughly, the more nearly assimilable to objects certain advanced painting had come to seem, the more the entire history of painting since Manet could be understood—delusively, I believe—as consisting in the progressive (though ultimately inadequate) revelation of its essential objecthood,[16] and the more urgent became the need for modernist painting to make explicit its conventional—specifically, its *pictorial*—essence by defeating or suspending its own objecthood through the medium of shape. The view of modernist painting as tending toward objecthood is implicit in Judd's remark, "The new [i.e., literalist] work obviously resembles sculpture more than it does painting, but is nearer to painting"; and it is in this view that literalist sensibility in general is grounded. Literalist sensibility is, therefore, a response to the *same* developments that have largely compelled modernist painting to undo its objecthood—more precisely, the same developments *seen differently*, that is, in theatrical terms, by a sensibility *already* theatrical, already (to say the worst) corrupted or perverted by theater. Similarly, what has compelled modernist painting to defeat or suspend its own objecthood is not just developments internal to itself, but the same general, enveloping, infectious theatricality that corrupted literalist

sensibility in the first place and in the grip of which the developments in question—and modernist painting in general—are seen as nothing more than an uncompelling and presenceless kind of theater. It was the need to break the fingers of that grip that made objecthood an issue for modernist painting.

Objecthood has also become an issue for modernist sculpture. This is true despite the fact that sculpture, being three-dimensional, resembles both ordinary objects and literalist work in a way that painting does not. Almost ten years ago Clement Greenberg summed up what he saw as the emergence of a new sculptural "style," whose master is undoubtedly David Smith, in the following terms:

> To render substance entirely optical, and form, whether pictorial, sculptural, or architectural, as an integral part of ambient space—this brings anti-illusionism full circle. Instead of the illusion of things, we are now offered the illusion of modalities: namely, that matter is incorporeal, weightless, and exists only optically like a mirage.[17]

Since 1960 this development has been carried to a succession of climaxes by the English sculptor Anthony Caro, whose work is far more specifically resistant to being seen in terms of objecthood than that of David Smith. A characteristic sculpture by Caro consists, I want to say, in the mutual and naked *juxtaposition* of the I-beams, girders, cylinders, lengths of piping, sheet metal, and grill that it comprises rather than in the compound *object* that they compose. The mutual inflection of one element by another, rather than the identity of each, is what is crucial—though of course altering the identity of any element would be at least as drastic as altering its placement. (The identity of each element matters in somewhat the same way as the fact that it is an arm, or this arm, that makes a particular gesture, or as the fact that it is this word or this note and not another that occurs in a particular place in a sentence or melody.) The individual elements bestow significance on one another precisely by virtue of their juxtaposition: it is in this sense, a sense inextricably involved with the concept of meaning, that everything in Caro's art that is worth looking at is in its syntax. Caro's concentration upon syntax amounts, in Greenberg's view, to "an emphasis on abstractness, on radical unlikeness to nature." And Greenberg

goes on to remark, "No other sculptor has gone as far from the structural logic of ordinary ponderable things."[18] It is worth emphasizing, however, that this is a function of more than the lowness, openness, part-by-partness, absence of enclosing profiles and centers of interest, unperspicuousness, and so on, of Caro's sculptures. Rather, they defeat, or allay, objecthood by imitating, not gestures exactly, but the *efficacy* of gesture; like certain music and poetry, they are possessed by the knowledge of the human body and how, in innumerable ways and moods, it makes meaning. It is as though Caro's sculptures essentialize meaningfulness *as such*—as though the possibility of meaning what we say and do *alone* makes his sculpture possible. All this, it is hardly necessary to add, makes Caro's art a fountainhead of antiliteralist and antitheatrical sensibility.

There is another, more general respect in which objecthood has become an issue for the most ambitious recent modernist sculpture, and that is in regard to color. This is a large and difficult subject, which I cannot hope to do more than touch on here. Briefly, however, color has become problematic for modernist sculpture, not because one senses that it has been applied, but because the color of a given sculpture, whether applied or in the natural state of the material, is identical with its surface; and inasmuch as all objects have surface, awareness of the sculpture's surface implies its objecthood—thereby threatening to qualify or mitigate the undermining of objecthood achieved by opticality and, in Caro's pieces, by their syntax as well. It is in this connection, I believe, that a recent sculpture by Jules Olitski, *Bunga 45* (1967), ought to be seen. *Bunga 45* consists of between fifteen and twenty metal tubes, ten feet long and of various diameters, placed upright, riveted together, and then sprayed with paint of different colors; the dominant hue is yellow to yellow orange, but the top and "rear" of the piece are suffused with a deep rose, and close looking reveals flecks and even thin trickles of green and red as well. A rather wide red band has been painted around the top of the piece, while a much thinner band in two different blues (one at the "front" and another at the "rear") circumscribes the very bottom. Obviously *Bunga 45* relates intimately to Olitski's spray paintings, especially those of the past year or so, in which he has worked with paint and brush at or near the limits of the

support. At the same time, it amounts to something far more than an attempt simply to make or "translate" his paintings into sculptures, namely, an attempt to establish surface—the surface, so to speak, of *painting*—as a medium of sculpture. The use of tubes, each of which one sees, incredibly, as *flat*—that is, flat but *rolled*—makes *Bunga 45*'s surface more like that of a painting than like that of an object: like painting, and unlike both ordinary objects and other sculpture, *Bunga 45* is *all* surface. And of course what declares or establishes that surface is color, Olitski's sprayed color.

7

At this point I want to make a claim that I cannot hope to prove or substantiate but that I believe nevertheless to be true: theater and theatricality are at war today, not simply with modernist painting (or modernist painting and sculpture), but with art as such—and to the extent that the different arts can be described as modernist, with modernist sensibility as such. This claim can be broken down into three propositions or theses:

1. *The success, even the survival, of the arts has come increasingly to depend on their ability to defeat theater.* This is perhaps nowhere more evident than within theater itself, where the need to defeat what I have been calling theater has chiefly made itself felt as the need to establish a drastically different relation to its audience. (The relevant texts are, of course, Brecht and Artaud.)[19] For theater has an audience—it exists for one—in a way the other arts do not; in fact, this more than anything else is what modernist sensibility finds intolerable in theater generally. Here it should be remarked that literalist art too possesses an audience, though a somewhat special one: that the beholder is confronted by literalist work within a situation that he experiences as his means that there is an important sense in which the work in question exists for him alone, even if he is not actually alone with the work at the time. It may seem paradoxical to claim both that literalist sensibility aspires to an ideal of "something everyone can understand" (Smith) and that literalist art addresses itself to the beholder alone, but the paradox is only apparent. Someone has merely to enter the room in which a literalist work has been placed to become that

beholder, that audience of one—almost as though the work in question has been waiting for him. And inasmuch as literalist work depends on the beholder, is incomplete without him, it *has* been waiting for him. And once he is in the room the work refuses, obstinately, to let him alone—which is to say, it refuses to stop confronting him, distancing him, isolating him. (Such isolation is not solitude any more than such confrontation is communion.)

It is the overcoming of theater that modernist sensibility finds most exalting and that it experiences as the hallmark of high art in our time. There is, however, one art that, by its very nature, escapes theater entirely—the movies.[20] This helps explain why movies in general, including frankly appalling ones, are acceptable to modernist sensibility whereas all but the most successful painting, sculpture, music, and poetry is not. Because cinema escapes theater—automatically, as it were—it provides a welcome and absorbing refuge to sensibilities at war with theater and theatricality. At the same time, the automatic, guaranteed character of the refuge—more accurately, the fact that what is provided is a refuge from theater and not a triumph over it, absorption not conviction—means that the cinema, even at its most experimental, is not a modernist art.

2. *Art degenerates as it approaches the condition of theater.* Theater is the common denominator that binds together a large and seemingly disparate variety of activities, and that distinguishes those activities from the radically different enterprises of the modernist arts. Here as elsewhere the question of value or level is central. For example, a failure to register the enormous difference in quality between, say, the music of Elliott Carter and that of John Cage or between the paintings of Louis and those of Robert Rauschenberg means that the real distinctions—between music and theater in the first instance and between painting and theater in the second—are displaced by the illusion that the barriers between the arts are in the process of crumbling (Cage and Rauschenberg being seen, correctly, as similar) and that the arts themselves are at last sliding towards some kind of final, implosive, highly desirable synthesis. Whereas in fact the individual arts have never been more explicitly concerned with the conventions that constitute their respective essences.

3. *The concepts of quality and value*—and to the extent that these are central to art, the concept of art itself—are meaningful, or wholly meaningful, only within *the individual arts. What lies* between *the arts is theater.* It is, I think, significant that in their various statements the literalists have largely avoided the issue of value or quality at the same time as they have shown considerable uncertainty as to whether or not what they are making is art. To describe their enterprise as an attempt to establish a *new* art does not remove the uncertainty; at most it points to its source. Judd himself has as much as acknowledged the problematic character of the literalist enterprise by his claim, "A work needs only to be interesting." For Judd, as for literalist sensibility generally, all that matters is whether or not a given work is able to elicit and sustain (his) *interest.* Whereas within the modernist arts nothing short of *conviction*—specifically, the conviction that a particular painting or sculpture or poem or piece of music can or cannot support comparison with past work within that art whose quality is not in doubt—matters at all. (Literalist work is often condemned—when it is condemned—for being boring. A tougher charge would be that it is merely interesting.)

The interest of a given work resides, in Judd's view, both in its character as a whole and in the sheer *specificity* of the materials of which it is made:

> Most of the work involves new materials, either recent inventions or things not used before in art. . . . Materials vary greatly and are simply materials—formica, aluminum, cold-rolled steel, plexiglass, red and common brass, and so forth. They are specific. If they are used directly, they are more specific. Also, they are usually aggressive. There is an objectivity to the obdurate identity of a material.

Like the shape of the object, the materials do not represent, signify, or allude to anything; they are what they are and nothing more. And what they are is not, strictly speaking, something that is grasped or intuited or recognized or even seen once and for all. Rather, the "obdurate identity" of a specific material, like the wholeness of the shape, is simply stated or given or established at the very outset, if not before the outset; accordingly, the experience of both is one of endlessness, or inexhaustibility,

of being able to go on and on letting, for example, the material itself confront one in all its literalness, its "objectivity," its absence of anything beyond itself. In a similar vein Morris has written:

> Characteristic of a gestalt is that once it is established all the information about it, *qua* gestalt, is exhausted. (One does not, for example, seek the gestalt of a gestalt.) . . . One is then both free of the shape and bound to it. Free or released because of the exhaustion of information about it, as shape, and bound to it because it remains constant and indivisible.

The same note is struck by Tony Smith in a statement the first sentence of which I quoted earlier:

> I'm interested in the inscrutability and mysteriousness of the thing. Something obvious on the fact of it (like a washing machine or a pump) is of no further interest. A Bennington earthenware jar, for instance, has subtlety of color, largeness of form, a general suggestion of substance, generosity, is calm and reassuring—qualities that take it beyond pure utility. It continues to nourish us time and time again. We can't see it in a second, we continue to read it. There is something absurd in the fact that you can go back to a cube in the same way.

Like Judd's Specific Objects and Morris's gestalts or unitary forms, Smith's cube is always of further interest; one never feels that one has come to the end of it; it is inexhaustible. It is inexhaustible, however, not because of any fullness—*that* is the inexhaustibility of art—but because there is nothing there to exhaust. It is endless the way a road might be, if it were circular, for example.

Endlessness, being able to go on and on, even having to go on and on, is central both to the concept of interest and to that of objecthood. In fact, it seems to be the experience that most deeply excites literalist sensibility, and that literalist artists seek to objectify in their work—for example, by the repetition of identical units (Judd's "one thing after another"), which carries the implication that the units in question could be multiplied ad infinitum.[21] Smith's account of his experience on the unfinished turnpike records that excitement all but explicitly. Similarly, Morris's claim that in the best new work the beholder

is made aware that "he himself is establishing relationships as he apprehends the object from various positions and under varying conditions of light and spatial context" amounts to the claim that the beholder is made aware of the endlessness and inexhaustibility if not of the object itself at any rate of his experience of it. This awareness is further exacerbated by what might be called the inclusiveness of his situation, that is, by the fact, remarked earlier, that everything he observes counts as part of that situation and hence is felt to bear in some way that remains undefined on his experience of the object.

Here finally I want to emphasize something that may already have become clear: the experience in question *persists in time,* and the presentment of endlessness that, I have been claiming, is central to literalist art and theory is essentially a presentment of endless or indefinite *duration.* Once again Smith's account of his night drive is relevant, as well as his remark, "We can't see it [the jar and, by implication, the cube] in a second, we continue to read it." Morris too has stated explicitly, "The experience of the work necessarily exists in time"—though it would make no difference if he had not. The literalist preoccupation with time—more precisely, with the *duration of the experience*—is, I suggest, paradigmatically theatrical, as though theater confronts the beholder, and thereby isolates him, with the endlessness not just of objecthood but of *time;* or as though the sense which, at bottom, theater addresses is a sense of temporality, of time both passing and to come, *simultaneously approaching and receding,* as if apprehended in an infinite perspective. . . .[22] That preoccupation marks a profound difference between literalist work and modernist painting and sculpture. It is as though one's experience of the latter *has no* duration—not because one in fact experiences a picture by Noland or Olitski or a sculpture by David Smith or Caro in no time at all, but because *at every moment the work itself is wholly manifest.* (This is true of sculpture despite the obvious fact that, being three-dimensional, it can be seen from an infinite number of points of view. One's experience of a Caro is not incomplete, and one's conviction as to its quality is not suspended, simply because one has seen it only from where one is standing. Moreover, in the grip of his best work one's view of the sculpture is, so to speak, eclipsed by the sculpture itself—which it is plainly meaningless to speak of

as only partly present.) It is this continuous and entire *present-ness,* amounting, as it were, to the perpetual creation of itself, that one experiences as a kind of *instantaneousness,* as though if only one were infinitely more acute, a single infinitely brief instant would be long enough to see everything, to experience the work in all its depth and fullness, to be forever convinced by it. (Here it is worth noting that the concept of interest implies temporality in the form of continuing attention directed at the object whereas the concept of conviction does not.) I want to claim that it is by virtue of their presentness and instantaneousness that modernist painting and sculpture defeat theater. In fact, I am tempted far beyond my knowledge to suggest that, faced with the need to defeat theater, it is above all to the condition of painting and sculpture—the condition, that is, of existing in, indeed of evoking or constituting, a continuous and perpetual *present*—that the other contemporary modernist arts, most notably poetry and music, aspire.[23]

8

This essay will be read as an attack on certain artists (and critics) and as a defense of others. And of course it is true that the desire to distinguish between what is to me the authentic art of our time and other work which, whatever the dedication, passion, and intelligence of its creators, seems to me to share certain characteristics associated here with the concepts of literalism and theater has largely motivated what I have written. In these last sentences, however, I want to call attention to the utter pervasiveness—the virtual universality—of the sensibility or mode of being that I have characterized as corrupted or perverted by theater. We are all literalists most or all of our lives. Presentness is grace.

NOTES

1. Perry Miller, *Jonathan Edwards* (1949; rpt., New York, 1959), pp. 329–30.
2. This was said by Judd in an interview with Bruce Glaser, edited by Lucy R. Lippard and published as "Questions to Stella and Judd" in *Art News* in 1966 and reprinted in *Minimal Art,* ed. Gregory

Battcock (New York, 1968), pp. 148–64. The remarks attributed in the present essay to Judd and Morris have been taken from that interview; from Donald Judd's essay "Specific Objects," *Arts Yearbook,* no. 8 (1965), pp. 74–82; and from Robert Morris's essays, "Notes on Sculpture" and "Notes on Sculpture, Part 2," published in *Artforum* in Feb. and Oct. 1966, respectively, and reprinted in Battcock, ed., *Minimal Art,* pp. 222–35. I have also taken one remark by Morris from the catalog to the exhibition *Eight Sculptors: The Ambiguous Image* at the Walker Art Center, Minneapolis, Oct.–Dec. 1966. I should add that in laying out what seems to me the position Judd and Morris hold in common I have ignored various differences between them and have used certain remarks in contexts for which they may not have been intended. Moreover, I haven't always indicated which of them actually said or wrote a particular phrase; the alternative would have been to litter the text with footnotes.

3. See Michael Fried, "Shape as Form: Frank Stella's Irregular Polygons"; idem, "Jules Olitski"; and idem, "Ronald Davis: Surface and Illusion."

4. Clement Greenberg, "Recentness of Sculpture," in the catalog to the Los Angeles County Museum of Art's 1967 exhibition *American Sculpture of the Sixties* (see Greenberg, *Modernism with a Vengeance 1957–1969,* vol 4 of *The Collected Essays and Criticism,* ed. John O'Brian [Chicago, 1993], pp. 250–56). The verb "project" as I have just used it is taken from Greenberg's statement, "The ostensible aim of the Minimalists is to 'project' objects and ensembles of objects that are just nudgeable into art" (*Modernism with a Vengeance,* p. 253).

5. Greenberg, *Modernism with a Vengeance,* pp. 255–56.

6. Greenberg, "After Abstract Expressionism," *Art International* 6 (Oct. 25, 1962): 30. The passage from which this has been taken reads as follows:

> Under the testing of modernism more and more of the conventions of the art of painting have shown themselves to be dispensable, unessential. By now it has been established, it would seem, that the irreducible essence of pictorial art consists in but two constitutive conventions or norms: flatness and the delimitation of flatness; and that the observance of merely these two norms is enough to create an object which can be experienced as a picture: thus a stretched or tacked-up canvas already exists as a picture—though not necessarily as a *successful* one.

In its broad outline this is undoubtedly correct. There are, however, certain qualifications that can be made.

To begin with, it is not quite enough to say that a bare canvas tacked to a wall is not "necessarily" a successful picture; it would, I think, be more accurate [what I originally wrote was "less of an exaggeration"—*M.F., 1996*] to say that it is not *conceivably* one. It may be countered that future circumstances might be such as to *make* it a successful painting, but I would argue that, for that to happen, the enterprise of painting would have to change so drastically that nothing more than the name would remain. (It would require a far greater change than that which painting has undergone from Manet to Noland, Olitski, and Stella!) Moreover, seeing something as a painting in the sense that one sees the tacked-up canvas as a painting, and being convinced that a particular work can stand comparison with the painting of the past whose quality is not in doubt, are altogether different experiences: it is, I want to say, as though unless something compels conviction as to its quality it is no more than trivially or nominally a painting. This suggests that flatness and the delimitation of flatness ought not to be thought of as the "irreducible essence of pictorial art," but rather as something like the *minimal conditions for something's being seen as a painting;* and that the crucial question is not what those minimal and, so to speak, timeless conditions are, but rather what, at a given moment, is capable of compelling conviction, of succeeding as painting. This is not to say that painting *has no* essence; it *is* to claim that that essence—i.e., that which compels conviction—is largely determined by, and therefore changes continually in response to, the vital work of the recent past. The essence of painting is not something irreducible. Rather, the task of the modernist painter is to discover those conventions that, at a given moment, *alone* are capable of establishing his work's identity as painting.

Greenberg approaches this position when he adds, "As it seems to me, Newman, Rothko, and Still have swung the self-criticism of modernist painting in a new direction simply by continuing it in its old one. The question now asked through their art is no longer what constitutes art, or the art of painting, as such, but what irreducibly constitutes *good* art as such. Or rather, what is the ultimate source of value or quality in art?" But I would argue that what modernism has meant is that the two questions—What constitutes the art of painting? And what constitutes *good* painting?—no longer separable; the first disappears, or increasingly tends to disappear, into the second. (I am, of course, taking issue here with the version of modernism put forward in the introduction to *Three American Painters.*)

For more on the nature of essence and convention in the modernist arts see my essays on Stella and Olitski cited in n. 3 above, as well as Stanley Cavell, "Music Discomposed," and "Rejoinders" to critics of that essay, to be published as part of a symposium by the University of Pittsburgh Press in a volume entitled *Art, Mind and Religion.* [For those essays see Cavell, "Music Discomposed" and "A Matter of Meaning It," in *Must We Mean What We Say? A Book of Essays* (New York, 1969), pp. 180–237.—*M. F., 1996*]

7. Greenberg, *Modernism with a Vengeance*, p. 252.

8. Ibid., pp. 253–54.

9. Quoted by Morris as the epigraph to his "Notes on Sculpture, Part 2."

10. Except for the question-and-answer exchange quoted by Morris, all statements by Tony Smith have been taken from Samuel Wagstaff, Jr., "Talking to Tony Smith," *Artforum* 5 (Dec. 1966): 14–19, and reprinted (with certain omissions) in Battcock, ed., *Minimal Art*, pp. 381–86.

11. This appears in the Wagstaff interview in *Artforum* (p. 17) but not in the republication of that interview in *Minimal Art.*—M. F., 1966

12. In the catalog to last spring's *Primary Structures* exhibition at the Jewish Museum, Bladen wrote, "How do you make the inside the outside?" and Grosvenor, "I don't want my work to be thought of as 'large sculpture,' they are ideas that operate in the space between floor and ceiling." The relevance of these statements to what I have adduced as evidence for the theatricality of literalist theory and practice seems obvious (catalog for the exhibition *Primary Structures: Younger American and British Sculptors,* shown at the Jewish Museum, New York, Apr. 27–June 12, 1966, no page numbers).

13. It is theatricality, too, that links all these artists to other figures as disparate as Kaprow, Cornell, Rauschenberg, Oldenburg, Flavin, Smithson, Kienholz, Segal, Samaras, Christo, Kusama . . . the list could go on indefinitely.

14. The concept of a room is, mostly clandestinely, important to literalist art and theory. In fact, it can often be substituted for the word "space" in the latter: something is said to be in my space if it is in the same room with me (and if it is placed so that I can hardly fail to notice it).

15. In a discussion of this claim with Stanley Cavell it emerged that he once remarked in a seminar that for Kant in the *Critique of Judgment* a work of art is not an object.—*M. F., 1966*

16. One way of describing this view might be to say that it draws something like a false inference from the fact that the increasingly explicit acknowledgement of the literal character of the support has been central to the development of modernist painting: namely,

that literalness as such is an artistic value of supreme importance. In "Shape as Form" I argued that this inference is blind to certain vital considerations, and that literalness—more precisely, the literalness of the support—is a value only within modernist painting, and then only because it has been made one by the history of that enterprise.

17. Clement Greenberg, "The New Sculpture," in *Art and Culture: Critical Essays* (Boston, 1961), p. 144.

18. The statement that "everything in Caro's art that is worth looking at—except the color—is in its syntax" appears in my introduction to Caro's 1963 exhibition at the Whitechapel Art Gallery. It is quoted with approval by Greenberg, who then goes on to make the statements quoted above, in "Anthony Caro," *Arts Yearbook*, no. 8 (1965), reprinted as "Contemporary Sculpture: Anthony Caro," in *Modernism with a Vengeance*, pp. 205–08. Caro's first step in that direction, the elim-ination of the pedestal, seems in retrospect to have been motivated not by the desire to present his work without artificial aids so much as by the need to undermine its objecthood. His work has revealed the extent to which merely putting something on a pedestal confirms it in its objecthood, though merely removing the pedestal does not in itself undermine objecthood, as literalist work demonstrates.

19. The need to achieve a new relation to the spectator, which Brecht felt and which he discussed time and again in his writings on theater, was not simply the result of his Marxism. On the contrary, his discovery of Marx seems to have been in part the discovery of what that relation might be like, what it might mean: "When I read Marx's *Capital* I understood my plays. Naturally I want to see this book widely circulated. It wasn't of course that I found I had unconsciously written a whole pile of Marxist plays; but this man Marx was the only spectator for my plays I'd ever come across" (Bertolt Brecht, *Brecht on Theater*, ed. and trans. John Willett [New York, 1964], pp. 23–24).

20. Exactly how the movies escape theater is a difficult question, and there is no doubt but that a phenomenology of the cinema that concentrated on the similarities and differences between it and stage drama—e.g., that in the movies the actors are not physically present, the film itself is projected *away* from us, and the screen is not experienced as a kind of object existing in a specific physical relation to us—would be rewarding.

21. That is, the actual number of such units in a given piece is felt to be arbitrary, and the piece itself—despite the literalist preoccupation with holistic forms—is seen as a fragment of, or cut into, something infinitely larger. This is one of the most important differences between

literalist work and modernist painting, which has made itself responsible for its physical limits as never before. Noland's and Olitski's paintings are two obvious, and different, cases in point. It is in this connection, too, that the importance of the painted bands around the bottom and the top of Olitski's sculpture *Bunga* becomes clear.

22. The connection between spatial recession and some such experience of temporality—almost as if the first were a kind of natural metaphor for the second—is present in much Surrealist painting (e.g., de Chirico, Dalí, Tanguy, Magritte). Moreover, temporality—manifested, for example, as expectation, dread, anxiety, presentiment, memory, nostalgia, stasis—is often the explicit subject of their paintings. There is, in fact, a deep affinity between literalist and Surrealist sensibility (at any rate, as the latter makes itself felt in the work of the above painters) that ought to be noted. Both employ imagery that is at once holistic and, in a sense, fragmentary, incomplete; both resort to a similar anthropomorphizing of objects or conglomerations of objects (in Surrealism the use of dolls and manikins makes that explicit); both are capable of achieving remarkable effects of "presence"; and both tend to deploy and isolate objects and persons in "situations"—the closed room and the abandoned artificial landscape are as important to Surrealism as to literalism. (Tony Smith, it will be recalled, described the airstrips, etc., as "Surrealist landscapes.") This affinity can be summed up by saying that Surrealist sensibility, as manifested in the work of certain artists, and literalist sensibility are both theatrical. I do not wish, however, to be understood as saying that because they are theatrical, all Surrealist works that share the above characteristics fail as art; a conspicuous example of major work that can be described as theatrical is Giacometti's Surrealist sculpture. On the other hand, it is perhaps not without significance that Smith's supreme example of a Surrealist landscape was the parade ground at Nuremberg.

23. What this means in each art will naturally be different. For example, music's situation is especially difficult in that music shares with theater the convention, if I may call it that, of duration—a convention that, I am suggesting, has itself become increasingly theatrical. Besides, the physical circumstances of a concert closely resemble those of a theatrical performance. It may have been the desire for something like presentness that, at least to some extent, led Brecht to advocate a nonillusionistic theater, in which for example the stage lighting would be visible to the audience, in which the actors would not identify with the characters they play but rather would show them forth, and in which temporality itself would be presented in a new way:

Just as the actor no longer has to persuade the audience that it is the author's character and not himself that is standing on the stage, so also he need not pretend that the events taking place on the stage have never been rehearsed, and are now happening for the first and only time. Schiller's distinction is no longer valid: that the rhapsodist has to treat his material as wholly in the past: the mime his, as wholly here and now. It should be apparent all through his performance that "even at the start and in the middle he knows how it ends" and he must "thus maintain a calm independence throughout." He narrates the story of his character by vivid portrayal, always knowing more than it does and treating "now" and "here" not as a pretence made possible by the rules of the game but as something to be distinguished from yesterday and some other place, so as to make visible the knotting together of the events. (*Brecht on Theater*, p. 194)

But just as the exposed lighting Brecht advocates has become merely another kind of theatrical convention (one, moreover, that often plays an important role in the presentation of literalist work, as the installation view of Judd's six-cube piece in the Dwan Gallery shows), it is not clear whether the handling of time Brecht calls for is tantamount to authentic presentness, or merely to another kind of "presence"—to the presentment of time itself as though it were some sort of literalist object. In poetry the need for presentness manifests itself in the lyric poem; this is a subject that requires its own treatment.

For discussions of theater relevant to this essay see Stanley Cavell's essays "Ending the Waiting Game" (on Beckett's *End-Game*) and "The Avoidance of Love: A Reading of *King Lear*," in *Must We Mean What We Say?* pp. 115–62 and 267–353.

1967

JOHN ASHBERY

Although the poet John Ashbery (born 1927) wrote art criticism for decades for the *Paris Herald Tribune, Art News, New York,* and *Newsweek,* he has sometimes described himself as an accidental art critic. That laid-back attitude, however disarming, is integral to the artistic thinking of a man who once wrote of the work of his friend the painter Jane Freilicher that "most good things are tentative, or should be if they aren't." Educated at Harvard, Ashbery lived in New York in the early 1950s and in Paris for a decade, returning to the United States in 1965, and his transatlantic experiences are reflected in the reach of his critical writing, which embraces not only modern icons such as de Kooning and Warhol but also lesser-known figures on both sides of the Atlantic, including the Englishman Rodrigo Moynihan, the French painter Jean Hélion, and Americans Edwin Dickinson and Nell Blaine. In the long poem "Self-Portrait in a Convex Mirror," published in 1975, a painting by the young Renaissance artist Parmigianino leads Ashbery to reflect that "Each person/Has one big theory to explain the universe/ But it doesn't tell the whole story/And in the end it is what is outside him/That matters." Ashbery always writes without recourse to fixed assumptions, allowing the artist and the artwork to guide him, always looking in art for what is "outside him." Among the New York School poets who have written about art, Ashbery has certainly produced the most impressive body of work. A certain diffidence is a part of his power, guiding him to the unexpected view of the unexpected achievement, as when he praises an exhibition of John Cage's etchings as "a marvelous overdose of spring tonic."

Andy Warhol in Paris

"Le Pop Art" became a respectable *franglais* term in record time. Reporters are always asking Brigitte Bardot and Jeanne Moreau what they think of it; it is the theme of a striptease at the Crazy Horse Saloon; and there is even a Pop Art dress shop in the rue du Bac called Popard, decorated with photomurals of Blondie comic strips.

Perhaps this explains why Andy Warhol, in Paris for the first time for his show here, is causing the biggest transatlantic fuss since Oscar Wilde brought culture to Buffalo in the nineties. He has been photographed at Chez Castel by *Paris-Match* and

Fairfield Porter: *John Ashbery*, 1957. Oil on canvas.

Vogue, and his opening broke all attendance records at the Galerie Ileana Sonnabend.

A shy, pleasant fellow with dark glasses and a mop of prematurely gray hair, Warhol seems both surprised and slightly bored by his success. He claims not to believe in art, although he collects paintings by fellow artists who have little in common with him, such as Joan Mitchell, Willem de Kooning and Fairfield Porter.

His own show consists of dozens of reproductions of photographs of flowers taken from a Kodak ad, in a variety of color schemes but with only two or three basic designs. They are produced by a lithographic process, and Warhol, who hates physical

effort, doesn't have very much to do with their actual creation. "Friends come over to my studio and do the work for me," he yawned. "Sometimes there'll be as many as fifteen people in the afternoon, filling in the colors and stretching the canvases."

The flowers are a change from the Campbell's soup cans which first made him famous. "I thought the French would probably like flowers because of Renoir and so on. Anyway, my last show in New York was flowers and it didn't seem worthwhile trying to think up something new."

Asked how he liked Paris, he became momentarily more animated. "I love it. I never came here before because I didn't believe in it. I traveled all around the world, even to Katmandu, but I never wanted to see Paris. Now I hate to leave. Everything is beautiful and the food is yummy and the French themselves are terrific. They don't care about anything. They're completely indifferent."

Indifference is a quality that rates very high in Warhol's books. His opinion of Pop Art would probably surprise many of his fans, starting with his dealer. He thinks it's finished. Does this mean he's going to stop producing it? "I don't know. Maybe I will. My real interest right now is movies. I make a movie every day."

This is possible because Warhol lets the camera do all the work for him. One of his movies, called *Sleep*, is an eight-hour documentary of a man sleeping. Another is a half-hour short of the critic Henry Geldzahler smoking a cigar.

Though art may be finished, Warhol believes that artists will go on. "Only they'll change. They'll become more like impresarios. They'll organize things rather than do them." He notes that such a trend has already begun in New York. "Everybody's branching out. Claes Oldenburg has bought a movie camera. Jim Dine and Rosenquist have bought movie cameras. Rauschenberg has bought a movie camera and founded his own ballet company."

But Warhol is so far the only artist in his set to have his own fan clubs. I have five of them. Three in New York, one in Massachusetts, one in South Carolina. They're called 'Fannies.' It's nice to have fans. Maybe I won't give up painting after all. Why should I give up something that's so easy?"

The far-out fringe has been very in this week. Another member

is Arman, one of the rare French artists to find favor in New York at the moment. Andy Warhol considers him one of the most indifferent of Frenchmen.

Arman's new work is impersonal and beautiful. As usual, he offers "accumulations"—numberless copies of the same object arranged together in a frame or eternalized in a block of transparent plastic. The pleasantly noncommittal colors of metal dominate in this show. One work is thousands of metal washers behind a sheet of acrylic. Curiously, it has a vivacity that Kandinsky would have admired. Another work, "Prison of Aeolus," assembles several dozen electric fans into a sleek bas-relief.

It is getting harder for artists to come up with something original in the way of invitations, but those designed by Arman for his show deserve an award of some kind. He has spelled out his name and the pertinent data in tiny metallic letters and imprisoned them in a plastic ice cube. Real cool.

1965

Joan Mitchell

JOAN MITCHELL is one of the American artists who live in Paris for extra-artistic reasons and who are different in that way from the Americans who went to live there before the last war. They are not expatriates but *apatrides*. Finding Europe only slightly more congenial than America, they have stayed on for various reasons, some of them "personal"—but do artists ever have any other kind of reason? A personal reason can mean being in love or liking the food or the look of the roofs across the courtyard— or in some cases the art. The *apatrides* of today are usually affected by one or more of these reasons melting together and producing a rather negative feeling of being at home. Far from dreading the day when their money runs out and they have to go back to America, many of them look forward disgruntledly to it. They feel they should have gone back long ago to become successes instead of staying on in this city famous for its angry inhabitants, high living costs and lack of any sustained excitement in the contemporary arts.

Joan Mitchell is a radical example of this kind of American.

Her reasons for living here are strictly personal. That is, she likes her friends, her three dogs, her studio in the plebeian 15th Arrondissement, her frequent trips to the Riviera from where she goes boating to Corsica, Italy and Greece. And that's about it. She rarely goes to the theater, movies or exhibitions (except to friends' openings) and never to parties. Her social life is limited to having friends over to lunch, and sometimes going at night to one of the Montparnasse bars frequented by American painters. She has French friends but few of them are painters. In a word, she does not participate in the cultural life of Paris, and although she can be said to live and work there, the city is little more than a backdrop for these activities. And that is perhaps the secret attraction of Paris for Americans today. Unlike New York and most other capitals, it provides a still neutral climate in which one can work pretty much as one chooses.

And it is precisely this lack of interference, even when it takes the saddening form of dealers and collectors losing sight of one, that is a force in much of the painting being done today by Americans abroad. This is perhaps less true of Joan Mitchell than of the majority of American painters in Paris, since she was established in America before coming to live here, and has continued to show regularly in New York and to return there for visits. Still, one feels that the calm of Paris and the fact that it is far from where the money is being made have affected her work (as well as that of Shirley Jaffe, Kimber Smith, Norman Bluhm, James Bishop, Beryl Barr-Sharrar and others). The exalting and the deadening effects of an abundance of cash and action are alike absent from her work. It looks strong and relaxed, classical and refreshing at the same time; it has both the time and the will to be itself. To the strength, the capacity for immediately sizing up a situation, the instinctive knowledge of what painting is all about which characterize the best postwar art in America, the sojourn in Paris has contributed intelligence and introspection which heighten rather than attenuate these gifts. It seems that such an artist has ripened more slowly and more naturally in the Parisian climate of indifference than she might have in the intensive-care wards of New York.

Joan Mitchell's new paintings continue an unhurried meditation on bits of landscape and air. There are new forms, new images in this new work, but no more than were needed at any

given moment. For instance, one long horizontal painting uses almost unscathed planes of chalky color, their borders meandering but determined, like the lines of a watershed. A lesser painter might have been tempted to turn this discovery into a whole new vocabulary, "change his image." But these unelaborated planes happened to suit Joan Mitchell only once or twice, after which she discarded them, for the time being at least. Again, "Calvi," one of a group of "new black" pictures ("although there's no black in any of them"), floats a dense, dark shape like an almost-square pentagon into the top center of the canvas. (The black in this case turns out to be dark blues and reds.) But the abrupt materialization of this shape strikes few echoes in the other paintings, where calligraphy, sometimes flowing, sometimes congealing, continues patiently, as though in a long letter to someone, to analyze the appearances that hold her attention the longest. (She said recently, "I'm trying to remember what I felt about a certain cypress tree and I feel if I remember it, it will last me quite a long time.")

The relation of her painting and that of other Abstract Expressionists to nature has never really been clarified. On the one hand there are painters who threaten you if you dare to let their abstract landscapes suggest a landscape. On the other hand there are painters like Joan Mitchell who are indifferent to these deductions when they are not actively encouraging them. Is one of these things better or worse than the other, and ought abstract painting to stay abstract? Things are not clarified by artists' statements that their work depicts a "feeling" about a landscape, because in most cases such feelings closely resemble the sight which gave rise to them. What then is the difference between, say, Joan Mitchell's kind of painting and a very loose kind of landscape painting?

There is, first, the obvious fact that the elements don't really very often add up to a legible landscape (the black pentagon in "Calvi" looks no more like a cave than the squares in Mondrian look like skyscraper windows—that is, a confusion might be possible because of the limited number of shapes available, but everything in the intention of the painting is there to steer one away from it). But there are cases when they do. "Girolata" (named after a creek in Corsica, but after the picture was painted), one of the most beautiful of Joan Mitchell's recent

paintings, is a large triptych which does look very much like a fairly literal impression of the face of a cliff pocked with crevices and littered here and there with vines and messy vegetation. Even the colors—grayish mauve, light green, black—are not too far from what they would be in an explicit representation of such a scene. Is this then figurative painting, and if so, what is the meaning of the term Abstract Expressionism?

The answer seems to be that one's feelings about nature are at different removes from it. There will be elements of things seen even in the most abstracted impression; otherwise the feeling is likely to disappear and leave an object in its place. At other times feelings remain close to the subject, which is nothing against them; in fact, feelings that leave the subject intact may be freer to develop, in and around the theme and independent of it as well. This seems to be the case in "Girolata"—for once the feelings were a reflection of the precise look of the creek, or cliff, or whatever; nevertheless it is this reflection rather than the memory it suggests that remains the dominant force in the painting.

The proof of this is that the other, less realistic paintings in the show continue to impress us with their fidelity to what, in these cases, we can only imagine are the painter's feelings, since she does not provide us with the coordinates of a landscape to attach them to. A persistent shape, like a helmet or a horse's skull, doesn't give any clue to what the painter intended, except in one painting where it suggests dark masses of trees at the edge of a river. Elsewhere there are antagonisms and sparrings between shapes whose true nature is left unstated, and sudden lashings of caked or viscous pigment whose inspiration is again no longer in nature but in something in the nature of paint, or of the feeling that takes hold of a painter when he attacks it. Yet there is never any sense of transition; we move in and out of these episodes, coherent or enigmatic ones, always with a sense of feeling at home with the painter's language, of understanding what she is saying even when we could not translate it.

Joan Mitchell calls herself a "visual" painter. She does not talk much about her own work, perhaps not out of reticence, but because the paintings *are* meaning and therefore do not have a residue of meaning which can be talked about. The recent upsurge of conceptual art and the resultant downgrading of

Abstract Expressionism do not particularly surprise or alarm her. Working in Paris, she has always been fairly independent of her fellow artists, American or French, and intends to go on as before.

> There'll always be painters around. It'll take more than Pop or Op to discourage them—they've never been encouraged anyway. So we're back where we started from. There have always been very few people who really like painting—like poetry.
>
> I don't think you can stop visual painters and all the rest is an intellectual problem. Did you see that article on Duchamp in *Time*? He's thankful that intelligence has come back to art and says he can't see any gray matter in Abstract Expressionism. That's why I use a little color.

She likes ideas when they're visual, as in Jasper Johns for instance, but "that particular thing I want can't be verbalized. . . . I like to look out of a window or at photos or pictures or at that awful thing called nature. I'm trying for something more specific than movies of my everyday life: to define a feeling."

1965

Leland Bell

LEE BELL is a painter and a polemicist. Seeing him in his studio, vigorously at work on a number of canvases and meanwhile sounding off on his various pet peeves and enthusiasms, one has the feeling of coming upon an almost extinct variety of whooping crane, alive and well in its environment, happily honking around the pond and causing quite a commotion. For polemics, and by extension commitment—to art, that is—are all but extinct in the art world. Where polemics seems to flourish, it often turns out to be the wishful thinking of artists dedicated to the hopeless task of doing away with the art of the past, and must therefore be construed as a romantic metaphor rather than a practical exercise in persuasion.

Bell's commitment to the past is almost violent. Unlike other New York School diehards, his acrimony is not reserved for such suspect recent American phenomena as earthworks and

Leland Bell: *Self-Portrait*, circa 1965. Oil on
canvas, 20 × 16 in.

"Minimal," but extends right back through "heroic" Abstract
Expressionism to the nineteenth and even the eighteenth cen-
turies. Though he painted abstractly for a while, in the late
1940s, he broke with abstraction—violently, one feels—and
has never made a separate peace with it despite the present
old-master standing of such artists as Kline, Rothko, Newman
and de Kooning. He grudgingly grants points to the last, but
is much more severe about Pollock ("one Pollock in a hundred
really succeeds—there's this phenomenal dryness to them"),
and is even more negative, not to say irascible, about the others.
Yet this is not the sour-grapes irascibility of an artist who has re-
fused to conform to contemporary taste and has thus renounced

the more gratifying forms of New York art-world success. Listening to him fume one day about the wishy-washiness of an Eakins he had seen in Washington hanging near a Bonnard, I realized that his hard line is the reflection of a coherent and completely honest aesthetic attitude. Most important, he does not spare himself: in Bell's opinion, there has never been a major American painter, himself included. However, a few almost measure up. One is Eilshemius, probably his favorite American painter. And he likes a few Ryders, and an occasional Inness. He detests Homer and Eakins. Beyond them there is nothing much except for an occasional Copley, West or Ralph Earle. Among twentieth-century Americans he admires Knaths, as well as his own contemporaries Robert De Niro, Nell Blaine and Al Kresch. One is bemused: obviously he knows what he likes, and probably he is right, but for a nonpainter, and probably even for most painters, an act of faith is necessary to follow his line of argument and to really see the qualities that link such diverse and marginal artists as Earle, Eilshemius and Knaths. Fortunately this act of faith is not inconceivable, thanks not only to his own vigorous powers of persuasion but, more important, to the evident integrity and beauty of his own work.

The art that matters for Bell is French, and his almost running defense of it would give aid and comfort to the French chauvinists who accuse American artists of chauvinism. For his is by no means the customary *idée reçue* that French art was great until 1914, when it ended except for rare anomalies like Picasso's "Bone" period and an occasional mutant like Dubuffet or Giacometti. In fact, it is the "other" tradition in modern French art that Bell values. He does not mention Picasso very much, and though he is quick to defend himself against the charge of neglecting both Matisse and Braque, it is the painters most of us tend to think of, when we think of them, as the secondary ones whom he considers the masters of the twentieth century. First and foremost there is Derain, the mere utterance of whose name puts a catch in Bell's voice. For him Derain is *the* painter, and listening to his impassioned proselytizing one wonders how one could ever have thought otherwise. But there are also Rouault, Dufy, La Fresnaye, Marquet, van Dongen ("he painted the people of their day in their clothes and it worked")— in short, the painters of what we usually think of as the Silver

Age of modern art. Nor does he share the prevailing low opin-
ion of present-day French art: Balthus, Hélion and Giaco-
metti are for him painters whose likes are to be found nowhere
else, and who, despite their few disciples, are important enough
to compensate for the current lack of a French tradition, and far
superior to the masters of the New York School.

Why these painters, or, to simplify, why Derain, since he occu-
pies the summit of the hierarchy that is modern painting as
far as Bell is concerned? Although he can and does wax elo-
quent on the subject, his eloquence, though it persuades, never
quite succeeds in explaining Derain's mastery. And this is as it
should be, since the greatness of art can only be discussed, not
explained—a fact that would seem too obvious to mention in
any but today's pragmatic context. Bell says that no painting
really satisfies him and that Derain's comes the closest. It has
something to do with "color, with classic form, even though
he doesn't always seize the human, pathetic moment. Derain
holds more mystery, more unexpectedness. He takes enormous
chances." I suggested that Derain's seeming "superficiality"
throws many people off, and Bell said that he considers those
dense, closed, glassy surfaces part of the chances. Also, Derain
is for Bell "the biggest odd man out." He likes underdogs,
and, one supposes, rather relishes being one himself—defense
sometimes being the best form of offense.

In a 1960 article called "The Case for Derain as an Immor-
tal," Bell began by describing a 1953 Derain self-portrait which
he considers the most fascinating one of modern times:

> It exists in a state of buoyancy. Nothing is forced or exagger-
> ated. A cheekbone, an earlobe, the smallest element of wrinkle—
> Derain sustains an unflagging love for each part. There is virtu-
> osity without self-interest—virtuosity conquered. . . . I found
> it impossible to grasp its unpretentious and restrained style.
> There are the points, proof of the security of the work's angles,
> asserting the sharpness of locations in space (in the sense of
> Giacometti's sharpness) and the rotundities whose curves are
> caressed and released in surprising sequences. The mysterious
> play between point and roundness seems to exalt the volumes
> of the head. Drawing it was like trying to draw my own head.
> It completely eluded me.

"Virtuosity without self-interest"—such a program, as demanding as it is difficult to spell out in terms of regulations and restrictions, is one Bell has set himself, and his remark about drawing his own head takes on meaning when one realizes that he has been doing just that for more than a decade. His works cluster around a few central themes, one of which is the self-portrait: these in particular give a tantalizing sense of incompleteness pursued almost up to the vanishing point. Each one seems to be saying, "Well, maybe *next* time . . ." Yet there is of course no next time, in Bell's sense that the perfectly satisfying painting has not yet been painted. The most each picture can do is to fulfill a little more of its potentiality than the previous one did, calling attention meanwhile to the results that still have to be achieved. In this, Bell's work suggests Giacometti's. But where the latter artist seems sometimes to have embarked on a hopeless mission, a sort of Penelope's web created only to be rubbed out and rebegun, Bell is not afraid to contemplate completeness, and his pictures are really finished works of art with built-in room for expansion on some hypothetical future occasion. In other words, he is not constructing a metaphor about the impossibility of art's ever becoming, but taking this impossibility into account while continuing to build an art that lives and breathes, that is complete in the sense that a life can be looked on as complete.

Most, but by no means all, of the paintings in Bell's current show at the Schoelkopf Gallery in New York are new variants of themes which have preoccupied him for a number of years. Some of these are traditional studio subjects: nudes, still lifes, self-portraits. But there are other, odder ones: for instance, the recurring theme of a group of three or more figures, half-figures usually, in an interior, sometimes gesturing at a butterfly that has entered the room, or playing cards and drinking wine; or another series about a nude woman recoiling in surprise from a dead bird that her cat has just discovered also. In view of Bell's insistence on absolute painting, the almost anecdotal, genre character of these pictures (remember Greuze's tear-jerker "The Dead Bird"?) can seem surprising. There is the additional fact that in these last two instances, the subject of the painting is something wild from outside that has intruded on the classic calm of the studio. Could Bell be trying to tell us something

in addition to the living but unspecific truth of the painting? Not, I think, if one remembers his comment about Derain's not always seizing "the human, pathetic moment," and other remarks about the psychology of painting. The pathetic moment and the look of psychological truth are inseparable from the picture's plastic qualities, not in the Greuze certainly, but in the painters of the past whom Bell worships: Titian, Louis Le Nain, especially Giotto, whose figures he feels as a great influence on his own. And then of course in Balthus, whose smooth ambiguities are echoed somewhat roughly in Bell's work. Balthus' children playing cards or reading on the floor are to some degree a metaphor of boredom and, by extension, of man's fate, condemned to putter about the universe, halfheartedly trying to make some sense of it; but this idea fuses with the substance of the picture in a way that it does not in, say, a work by Hopper, of whom Bell has remarked that he likes his moods but not the painting. The greatest artists, for Bell at any rate, are those who manage to put in everything—light, drawing, color, story, psychology, the human condition—without any one element's remaining identifiable in the emulsion.

Bell did not mention it (in fact, for one so articulate about the painting of others, he is relatively uncommunicative about his own work and acts almost surprised when questioned about it; one feels he is so close to it that he doesn't need to see it), but these various themes seem to call forth different methods of handling from him. The still lifes, for instance, are done almost lightly in comparison with the figures. They are often large pictures (while the groups of figures can be tiny), and one is conscious of the air between the objects, their casual interplay, the space beyond them. One of his finest pictures is a still life done several years ago when he was teaching in Kansas City, which shows some bluish objects including a broken vase on a table, with a window behind and a car parked outside, without any facile suggestions of a worldview—these objects just conjugate each other nicely, at some distance from each other and as though indifferently. Another still life, with a toy horse, mixing bowl, dish towel and basket, is a similarly good example of Bell's almost carefree manner. The colors are light and noncommittal —white, tan, light green and blue—and one is very conscious of the drawing and the resulting contrapuntal verve.

Somewhat "heavier," to use the convenient rock term, is a large interior with a nude seated on a couch; this is apparently an isolated work not belonging to any series. Again, the architectonic drawing, heightened by the neutral, gray-green washes of color brushed in casually, more like indications to the viewer than a realistic assessment, is the driving force behind the picture, though the lean, sinewy nude with her jutting breasts and thighs has elicited a more detailed, more rounded account than the still-life objects just mentioned. This "deeper" treatment is also observable in portraits of his wife, the fine painter Louisa Matthiasdottir, and their daughter Temma, herself a gifted figurative painter. One portrait of Temma in a magenta skirt, with washes of ocher and cobalt blue in the surrounding room, has a lushness of color and an almost elegiac wistfulness more characteristic of his idol Balthus than of Bell. The blues and ochers also made me think of Cézanne, a painter whom Bell, after elaborately paying his respects to him, is apt to juxtapose with Corot, who for him is the greater master, and all the more so because modern art has tended to deify Cézanne and neglect Corot. In Corot, he says, "It's not the tint that is important, but the weight of the tint." And this would seem to hold true for Bell as well, particularly in works like the portrait of Temma, where the shifting and settling of these weights is allowed an almost fugal treatment.

The groups of figures in an interior occupy an important and special place in Bell's oeuvre. One feels he will have never exhausted the possibilities of these moments of quiet domestic drama, nor have precisely isolated what it is that keeps bringing him back to them. Sometimes the figures—two women and a man, usually—are related in a sedate, sociable way, like figures in a Longhi, without one's being able to tell precisely what has brought them together. Occasionally there seems to be something like a marriage proposal in the offing—one of Bell's favorite pictures is an Eilshemius called "The Jealous Suitor," and nineteenth-century American genre painting is certainly, if distantly, being alluded to here. And then there are the butterfly pictures, with their gesturing figures whose mood, lilting at times, at others verges on something almost violent. Bell has apparently pushed these variations further than any of the others, judging from the amount of them in his studio, some large, some done on tiny bits of composition board ("I really almost

had it down in that one," he said, gesturing toward one of the smallest ones which to the uninitiated eye did not differ greatly from the others). Color here becomes somber, even harsh and gritty: usually a dark red for the dress of the central figure, dark blue and green for the clothes of the other figures and the wall of the room. Also, there seems something almost accidental about it, as though in his haste to "get down" whatever it is, Bell were taking the first colors to hand since, as elements, they are of secondary importance. And here the drawing is modeled out of existence: anatomical forms are summarily indicated, forced into the swirling composition, outlined with heavy bands which the painter says are there merely to help him "keep it all straight" rather than as elements in a preconceived design. These pictures give off something hypnotic: except for Giacometti, one cannot think of an artist who so accurately puts across the idea of a man in the grip of his urge to create, to squeeze the essence out of what is around him, a hopeless task supplied with an inexhaustible stock of hope.

The nudes with a cat and bird, a more recent theme, are also treated in this manner. What is seen seems to matter less than what is being done. These are kinetic pictures, on their way to something else, and this is the source of their fascination. The culmination of what I think of as Bell's "darker" style is the suite of self-portraits he has been working on for years—at least since 1958, when James Schuyler chronicled the growth of one self-portrait, on which occasion the painter said of his sketches for the work: "One could say it's like the failure of a self-portrait. You never make it." These seething, monumental and tragic works are among his strongest. Looking at them one realizes the truth of his observation about Rouault, that he is a classicist, like Corot, not an Expressionist. They are also a link with the little-known abstract paintings he showed at the now-legendary Jane Street Gallery in the 1940s. Although his renunciation of abstraction was total and more vehement than most, there remains an element of ambiguity to it. He said that at the time he had been "putting down big abstract forms before they had meaning for him." And, in the few abstractions he had around the studio, some very impressive indeed, one did feel that these complicated yet monolithic forms were about to break up into recognizable ones. The meaningful particularities of his own face have worn away from repetition; one remains conscious

of "the sharpness of locations in space," "the mysterious play between point and roundness" that he noted in the Derain self-portrait. And yet the face remains human, beleaguered, awesome, like the self-portraits of Rembrandt which, more than any other paintings, leave one speechless by saying everything there is to say.

Glancing around the studio at the uncompleted series of paintings, Bell remarked recently that they were his "prisons." What he would like to do, he said, would be to take his easel outdoors, despite the arctic cold New York was experiencing at the time, and do some landscapes, to clear his head. Perhaps. But prisons, the kind one carries around with one, are not so easily broken out of. It seems likely that in his conflict with imprisoning reality Bell will continue to explore the general character of the struggle.

1970

The Invisible Avant-Garde

THE fact that I, a poet, was invited by the Yale Art School to talk about the avant-garde, in one of a series of lectures under this general heading,* is in itself such an eloquent characterization of the avant-garde today that no further comment seems necessary. It would appear then that this force in art which would be the very antithesis of tradition if it were to allow itself even so much of a relationship with tradition as an antithesis implies, is, on the contrary, a tradition of sorts. At any rate it can be discussed, attacked, praised, taught in seminars, just as a tradition can be. There may be a fine distinction to be made between "a" tradition and "the" tradition, but the point is that there is no longer any doubt in anyone's mind that the vanguard *is*—it's there, before you, solid, tangible, "alive and well," as the buttons say.

Things were very different twenty years ago when I was a student and was beginning to experiment with poetry. At that

* This lecture was given at the Yale Art School in May 1968, one of a series of talks by writers and critics organized by the painter Jack Tworkov as an attempt to explore the phenomenon of the avant-garde in present-day art.

time it was the art and literature of the Establishment that were traditional. There was in fact almost no experimental poetry being written in this country, unless you counted the rather pale attempts of a handful of poets who were trying to imitate some of the effects of the French Surrealists. The situation was a little different in the other arts. Painters like Jackson Pollock had not yet been discovered by the mass magazines—this was to come a little later, though in fact *Life* did in 1949 print an article on Pollock, showing some of his large drip paintings and satirically asking whether he was the greatest living painter in America. This was still a long way from the decorous enthusiasm with which *Time* and *Life* today greet every new kink. But the situation was a bit better for the painters then, since there were a lot of them doing very important work and this fact was known to themselves and a few critics. Poetry could boast of no such good luck. As for music, the situation also was bleak but at least there *was* experimental music and a few people knew about it. It is hard to believe, however, that as late as 1945 such an acceptably experimental and posthumously successful composer as Bartók could die in total poverty, and that until a very few years ago such a respectable composer as Schönberg was considered a madman. I remember that in the spring of 1949 there was a symposium on the arts at Harvard during which a number of new works were performed including Schönberg's Trio for Strings. My friend the poet Frank O'Hara, who was majoring in music at Harvard, went to hear it and was violently attacked for doing so by one of the young instructors in the music department, who maintained that Schönberg was literally insane. Today the same instructor would no doubt attack O'Hara for going to hear anything so academic. To paraphrase Bernard Shaw, it is the fate of some artists, and perhaps the best ones, to pass from unacceptability to acceptance without an intervening period of appreciation.

At that time I found the avant-garde very exciting, just as the young do today, but the difference was that in 1950 there was no sure proof of the existence of the avant-garde. To experiment was to have the feeling that one was poised on some outermost brink. In other words if one wanted to depart, even moderately, from the norm, one was taking one's life—one's life as an artist—into one's hands. A painter like Pollock for instance was gambling everything on the fact that he *was* the greatest

painter in America, for if he wasn't, he was nothing, and the drips would turn out to be random splashes from the brush of a careless housepainter. It must often have occurred to Pollock that there was just a possibility that he wasn't an artist at all, that he had spent his life "toiling up the wrong road to art" as Flaubert said of Zola. But this very real possibility is paradoxically just what makes the tremendous excitement in his work. It is a gamble against terrific odds. Most reckless things are beautiful in some way, and recklessness is what makes experimental art beautiful, just as religions are beautiful because of the strong possibility that they are founded on nothing. We would all believe in God if we knew He existed, but would this be much fun?

The doubt element in Pollock—and I am using him as a convenient symbol for the avant-garde artist of the previous school—is what keeps his work alive for us. Even though he has been accepted now by practically everybody from *Life* on down, or on up, his work remains unresolved. It has not congealed into masterpieces. In spite of public acceptance the doubt is there—maybe the acceptance is there because of the doubt, the vulnerability which makes it possible to love the work.

It might be argued that traditional art is even riskier than experimental art; that it can offer no very real assurances to its acolytes, and since traditions are always going out of fashion it is more dangerous and therefore more worthwhile than experimental art. This could be true, and in fact certain great artists of our time have felt it necessary to renounce the experiments of their youth just in order to save them. The poet Ron Padgett has pointed out that the catalogue of the recent Museum of Modern Art exhibition of Dada and Surrealism praises Picabia's early work but ruefully assumes that with his later work he had "passed out of serious consideration as a painter." Padgett goes on to say:

> A parallel example is provided by de Chirico, who many feel betrayed his own best interests as a painter. Possibly so. But in Picabia's case, the curiosity that compelled him to go on to become a less "attractive" painter is the same that carried his adventure into Dada in the first place, and it is this spirit, as much as the paintings themselves, which is significant.

I think one could expand this argument to cover de Chirico and Duchamp as well. The former passed from being one of the greatest painters of this century to a crotchety fabricator of bad pictures who refuses to hear any good said of his early period, but he did so with such a vengeance that his act almost becomes exemplary. And Duchamp's silence *is* exemplary without question for a whole generation of young artists.

Therefore it is a question of distinguishing bad traditional art and bad avant-garde art from good traditional art and good avant-garde art. But after one has done this, one still has a problem with good traditional art. One can assume that good avant-garde art will go on living because the mere fact of its having been able to struggle into life at all will keep it alive. The doubt remains. But good traditional art may disappear at any moment when the tradition founders. It is a perilous business. I would class de Chirico's late paintings as good traditional art, though as bad art, because they embrace a tradition which everything in the artist's career seemed to point away from, and which he therefore accepted because, no doubt, he felt as an avant-garde artist that only the unacceptable is acceptable. On the other hand a painter like Thomas Hart Benton, who was Pollock's teacher, was at his best a better painter than de Chirico is now, but is a worse artist because he accepted the acceptable. *Life* used to have an article on Benton almost every month, showing his murals for some new post office or library. The fact that *Life* switched its affections from Benton to Pollock does not make either of them any worse, but it does illustrate that Benton's is the kind of art that cannot go on living without acceptance, while Pollock's is of the kind which cannot be destroyed by acceptance, since it is basically unacceptable.

What has happened since Pollock? The usual explanation is that "media" have multiplied to such an extent that it is no longer possible for secrets to remain secret very long, and that this has had the effect of turning the avant-garde from a small contingent of foolhardy warriors into a vast and well-equipped regiment. In fact the avant-garde has absorbed most of the army, or vice versa—in any case the result is that the avant-garde can now barely exist because of the immense amounts of attention and money that are focused on it, and that the only artists who have any privacy are the handful of decrepit stragglers behind

the big booming avant-garde juggernaut. This does seem to be what has happened. I was amazed the other night while watching the news on television when the announcer took up a new book by the young experimental poet Aram Saroyan and read it aloud to the audience from beginning to end. It is true that this took only a couple of minutes and that it was done for purposes of a put-down—nevertheless we know that the way of the mass media is to pass from put-down to panegyric without going through a transitional phase of straight reportage, and it may be only a matter of weeks before Aram Saroyan has joined Andy Warhol and Viva and the rest of the avant-garde on *The Tonight Show*.

Looking back only as far as the beginning of this century we see that the period of neglect for an avant-garde artist has shrunk for each generation. Picasso was painting mature master-pieces for at least ten years before he became known even to a handful of collectors. Pollock's incubation period was a little shorter. But since then the period has grown shorter each year so that it now seems to be something like a minute. It is no longer possible, or it seems no longer possible, for an important avant-garde artist to go unrecognized. And, sadly enough, his creative life expectancy has dwindled correspondingly, since art-ists are no fun once they have been discovered. Dylan Thomas summed it up when he wrote that he had once been happy and unknown and that he was now miserable and acclaimed.

I am not convinced that it is "media" that are responsible for all this—there have always been mediums of one sort or another and they have taken up the cause of the avant-garde only recently. I am at a loss to say what it is, unless that it is that events during the first decades of this century eventually ended up proving that the avant-garde artist is a kind of hero, and that a hero is, of course, what everybody wants to be. We all have to be first, and it is now certain—as it was not, I think, before—that the experimenting artist does something first, even though it may be discarded later on. So that, paradoxically, it is safest to experiment. Only a few artists like de Chirico have realized the fallacy of this argument, and since his course was to reject his own genius and produce execrable art it is unlikely that many artists will follow him.

What then must the avant-garde artist do to remain avant-garde? For it has by now become a question of survival both

of the artist and of the individual. In both art and life today we are in danger of substituting one conformity for another, or, to use a French expression, of trading one's one-eyed horse for a blind one. Protests against the mediocre values of our society such as the hippie movement seem to imply that one's only way out is to join a parallel society whose stereotyped manners, language, speech and dress are only reverse images of the one it is trying to reject. We feel in America that we have to join something, that our lives are directionless unless we are part of a group, a clan—an idea very different from the European one, where even friendships are considered not very important and life centers around oneself and one's partner, an extension of oneself. Is there nothing then between the extremes of Levittown and Haight-Ashbury, between an avant-garde which has become a tradition and a tradition which is no longer one? In other words, has tradition finally managed to absorb the individual talent?

On the other hand, perhaps these are the most exciting times for young artists, who must fight even harder to preserve their identity. Before they were fighting against general neglect, even hostility, but this seemed like a natural thing and therefore the fight could be carried on in good faith. Today one must fight acceptance which is much harder because it seems that one is fighting oneself.

If people like what I do, am I to assume that what I do is bad, since public opinion has always begun by rejecting what is original and new?

Perhaps the answer is not to reject what one has done, nor to be forced into a retrograde position, but merely to take into account that if one's work automatically finds acceptance, there may be a possibility that it could be improved. The Midas-like position into which our present acceptance-world forces the avant-garde is actually a disguised blessing which previous artists have not been able to enjoy, because it points the way out of the predicament it sets up—that is, toward an attitude which neither accepts nor rejects acceptance but is independent of it. Previously, vanguard artists never had to face the problems of integration into the art of their time because this usually happened at the end of a long career when the direction their art would take had long been fixed. When it took place earlier it could be dealt with by an explosion of bad temper, as in the

possibly apocryphal story about Schönberg: when someone finally learned to play his violin concerto he stormed out of the concert hall, vowing to write another one that *nobody* would be able to play.

Today the avant-garde has come full circle—the artist who wants to experiment is again faced with what seems like a dead end, except that instead of creating in a vacuum he is now at the center of a cheering mob. Neither climate is exactly ideal for discovery, yet both are conducive to it because they force him to take steps that he hadn't envisaged. And today's young artist has the additional advantage of a fuller awareness of the hazards that lie in wait for him. He must now bear in mind that *he*, not *it*, is the avant-garde.

A few remarks by Busoni in his book *The Essence of Music* seem to apply to all the arts and also to the situation of the experimental artist today. Busoni's music has the unique quality of being excellent and of sounding like nobody else's; it has not even been successfully imitated. The essays that make up the book were written about the time of World War I when a crisis had developed in German music, involving on the one hand Expressionists like Schönberg, of whom he disapproved, and of conservative Neoclassicists like Reger, of whom he equally disapproved—a crisis which, without going into details, rather parallels that in the arts today. Somehow Busoni alone managed to avoid these extremes by taking what was valid in each and forging a totality.

He wrote:

> I am a worshipper of Form—I have remained sufficiently a Latin for that. But I demand—no! the organism of art demands—that every idea fashion its own form for itself; the organism—not I—revolts against having one single form for all ideas; today especially and how much more in the coming centuries.
>
> The creator really only strives for perfection. And as he brings this into harmony with his individuality a new law arises unintentionally.
>
> The "new" is included in the idea of "Creation"—for in that way creation is distinguished from imitation.
>
> One follows a great example most faithfully if one does not follow it, for it was through turning away from its predecessor that the example became great.

And finally, in an article addressed to his pupils he wrote, "Build up! But do not content yourself any longer with self-complacent experiments and the glory of the success of the season; but turn toward the perfection of the work seriously and joyfully. Only he who looks toward the future looks cheerfully."

1968

SOURCES AND
ACKNOWLEDGMENTS

INDEX

Sources and Acknowledgments

Great care has been taken to locate and acknowledge all owners of copyrighted material included in this book. If any owner has inadvertently been omitted, acknowledgment will gladly be made in future printings.

James Agee, "Introduction to Helen Levitt's *A Way of Seeing*," *A Way of Seeing* (New York: Viking Press, 1965). Copyright © by James Agee. Used by permission of The Wylie Agency LLC.

Anni Albers, "Tapestry," *On Weaving* (Middletown: Wesleyan University Press, 1965). Copyright © 1965 by Anni Albers. Used by permission of Wesleyan University Press.

John Ashbery, "Andy Warhol in Paris," *New York Herald Tribune/International Edition*, May 17, 1965, reprinted in *Reported Sightings: Art Chronicles 1957–1987*, ed. David Bergman (Cambridge: Harvard University Press, 1991). Copyright © 1965 by John Ashbery. "Joan Mitchell," *ARTnews*, April 1965, reprinted in *Reported Sightings*. Copyright © 1965 by John Ashbery. "Leland Bell," *ARTnews*, February 1970, reprinted in *Reported Sightings*. Copyright © 1970 by John Ashbery. "The Invisible Avant-Garde," *Yale Art School*, May 1968, reprinted in *Reported Sightings*. Copyright © 1968 by John Ashbery. Used by permission of Georges Borchardt, Inc., on behalf of John Ashbery.

James Baldwin, "On the Painter Beauford Delaney," *Transition*, 1965. Used by permission of the James Baldwin Estate.

Louise Bourgeois, "An Artist's Words," *Design Quarterly*, no. 30, 1954, reprinted in *Destruction of the Father/Reconstruction of the Father, Writings and Interviews: 1923–1997*, ed. Marie-Laure Bernadac and Hans-Ulrich Obrist (Boston: MIT Press, 1998). Copyright © 1998 by Massachusetts Institute of Technology. "On the Creative Process," *Destruction of the Father/Reconstruction of the Father*. "Form," *Destruction of the Father/Reconstruction of the Father*. Used by permission of the MIT Press, in association with Violette Editions.

Charles Burchfield, "Journals, 1948–50," *Charles Burchfield's Journals: The Poetry of Place*, ed. J. Benjamin Townsend (Albany: SUNY Press, 1993). Copyright © 1992 by the State University of New York. Used by permission. All rights reserved.

John Cage, "Jasper Johns: Stories and Ideas," *Jasper Johns*, The Jewish Museum, 1964, reprinted in *A Year from Monday* (Middletown: Wesleyan University Press, 1967). Copyright © 1967 by John Cage. Used by permission of Wesleyan University Press.

Alexander Calder, "What Abstract Art Means to Me," *Museum of Modern Art Bulletin*, Spring 1951. Copyright © 2013 by the Calder Foundation, New York/Artists Rights Society (ARS), New York.

Truman Capote, "On Richard Avedon," *Observations* (New York: Simon & Schuster, 1959). Used by permission of The Truman Capote Literary Trust.

Robert M. Coates, "Mondrian, Kleenex, and You," *The New Yorker*, October 15, 1949. Copyright © 1949 by The New Yorker Magazine/Condé Nast. Used by permission.

Joseph Cornell, "From the Diaries," Joseph Cornell, *Theater of the Mind: Selected Diaries, Letters, and Files,* ed. Mary Ann Caws (New York: Thames and Hudson, 2000). Copyright © The Joseph and Robert Cornell Memorial Foundation/Licensed by VAGA, New York, NY.

Robert Creeley, "Harry Callahan: A Note," *Black Mountain Review*, Autumn 1957, reprinted in *The Collected Essays of Robert Creeley* (Berkeley: University of California Press, 1989). Used by permission of the University of California Press. "John Chamberlain," *Recent American Sculpture* (New York: Jewish Museum, 1964), reprinted in *The Collected Essays of Robert Creeley.* Used by permission of the University of California Press. "On the Road: Notes on Artists and Poets 1950–1965," Neil A. Chassman et al., *Poets of the Cities of New York and San Francisco* (New York: E. P. Dutton, 1974). Used by permission of the Dallas Museum of Art.

Fielding Dawson, "(from) An Emotional Memoir of Franz Kline," *An Emotional Memoir of Franz Kline* (New York: Pantheon Books, 1967). Used by permission of the Fielding Dawson Estate.

Elaine de Kooning, "Pure Paints a Picture," *ARTnews*, Summer 1957, reprinted in *The Spirit of Abstract Expressionism: Selected Writings* (New York: George Braziller, 1994). Copyright © 1957 by ARTnews, LLC, www.artnews.com. "Painting a Portrait of the President," *ARTnews*, Summer 1964, reprinted in *The Spirit of Abstract Expressionism.* Copyright © 1964 by ARTnews, LLC, www.artnews.com. Used by permission.

Willem de Kooning, "The Renaissance and Order," *Trans/formation* 1, no. 2, 1951. "What Abstract Art Means to Me," *Museum of Modern Art Bulletin,* Spring 1951. Copyright © 2014 by the Estate of Lisa de Kooning. Used by permission.

Edwin Denby, "The Thirties," *The 30s: Painting in New York*, Poindexter Gallery, 1956, reprinted in *Dancers, Buildings and People in the Street* (New York: Horizon Press, 1965). Copyright © Rudolph and Yvonne Burckhardt. "Willem de Kooning," *Dancers, Buildings and People in the Streets.* "Katz: Collage, Cutout, Cut-up," *ARTnews*, January 1965. "The Silence at Night," *Collected Poems* (New York:

Full Court Press, 1975). "At first sight, not Pollock, Kline scared," *Collected Poems*. "Alex Katz paints his north window," *Collected Poems*. Used by permission of the Estate of Edwin Denby.

Marcel Duchamp, "The Creative Act," American Federation of the Arts, 1957, reprinted in *The Writings of Marcel Duchamp,* ed. Michel Sanouillet and Elmer Peterson (New York: Da Capo Press, 1973). Copyright © 1957 by ARTnews, LLC, www.artnews.com. Used by permission. "Apropos of 'Readymades'," Museum of Modern Art, 1961, reprinted in *The Writings of Marcel Duchamp*. Copyright © 2013 by Succession Marcel Duchamp/ADAGP, Paris/Artists Rights Society (ARS), New York.

Robert Duncan, "(from) Iconographical Extensions: On Jess," *A Selected Prose*. Copyright © 1968 by Robert Duncan. Used by permission of New Directions Publishing Corp.

Ralph Ellison, "The Art of Romare Bearden," *Romare Bearden: Paintings and Projections*, SUNY Albany, 1968, reprinted in *The Collected Essays of Ralph Ellison* (New York: The Modern Library, 2003). Copyright © 1977, 1986 by Ralph Ellison. Used by permission of Random House LLC and The Wylie Agency LLC. All rights reserved.

Morton Feldman, "Philip Guston: The Last Painter," *ARTnews Annual,* 1966, reprinted in *Give My Regards to Eighth Street* (Cambridge: Exact Change, 2000). "Give My Regards to Eighth Street," *Art in America*, March/April 1971, reprinted in *Give My Regards to Eighth Street*.

Louis Finkelstein, "Painting as Painting," *Painting as Painting,* Art Museum of the University of Texas at Austin, 1968. Used by permission of the Blanton Museum of Art, the University of Texas at Austin.

Michael Fried, "New York Letter: Warhol," *Art International*, December 20, 1962, reprinted in *Art and Objecthood: Essays and Reviews* (Chicago: University of Chicago Press, 1998). "Art and Objecthood," *Artforum* 5, June 1967, reprinted in *Art and Objecthood*. Used by permission of the University of Chicago Press.

William Gaddis, "(from) *The Recognitions*," *The Recognitions* (New York: Harcourt Brace, 1955). Used by permission of Dalkey Archive Press.

John Graham, "Excerpts from an Unfinished Manuscript Titled 'Art'," *ARTnews*, 1961. Copyright © 1961 by ARTnews, LLC, www.artnews.com. Used by permission.

Clement Greenberg, "Review of an Exhibition of Willem de Kooning," *The Nation*, April 24, 1948, reprinted in *The Collected Essays and Criticism*, ed. John O'Brian (Chicago: University of Chicago Press, 1986–93). "The Role of Nature in Modern Painting," *Partisan Review*, January 1949, reprinted in *Collected Essays and Criticism*.

"'American-Type' Painting," *Partisan Review*, Spring 1955, reprinted in *Collected Essays and Criticism*. "Modernist Painting," *Arts Yearbook*, 1961, reprinted in *Collected Essays and Criticism*. Used by permission of the University of Chicago Press.

Peggy Guggenheim, "Art of This Century," *Out of This Century: Confessions of an Art Addict* (New York: Dial Press, 1946). Copyright © 1960 by Peggy Guggenheim. Foreword copyright © 1979 by Gore Vidal. Used by permission of HarperCollins Publishers.

Philip Guston, "Piero della Francesca: The Impossibility of Painting," *ARTnews*, May 1965. Copyright © 1965 by ARTnews, LLC, www.artnews.com. "Faith, Hope and Impossibility," *ARTnews Annual*, 1966. Copyright © 1966 by ARTnews, LLC, www.artnews.com. Used by permission.

Grace Hartigan, "Statement," *Twelve Americans* (New York: Museum of Modern Art, 1956). Used by permission of the Estate of Grace Hartigan. "From The Journals, 1952," *The Journals of Grace Hartigan*, ed. William T. La Moy and Joseph P. McCaffrey (Syracuse University Press, 2009). Copyright © 2009 by Syracuse University Press. Used by permission of Syracuse University Press.

Thomas B. Hess, "The Battle of Paris, Strip-tease, and Trotsky: Some Non-Scenic Travel Notes," *It Is* 5, Spring 1960.

Hans Hofmann, "(from) The Search for the Real in the Visual Arts," *Search for the Real and Other Essays* (Andover: Addison Gallery of American Art, 1948). Used by permission of the Addison Gallery of American Art, Phillips Academy, Andover, MA.

Randall Jarrell, "Against Abstract Expressionism," *ARTnews*, Summer 1957, reprinted in *Kipling, Auden & Co.: Essays and Reviews 1935–1964* (New York: Farrar, Straus & Giroux, 1980). Copyright © 1980 by Mary von S. Jarrell. Used by permission of Farrar, Straus and Giroux, LLC, and Carcanet Press Limited.

Jess, "Letter to Jerry Reilly," Unpublished letter, March 23, 1964, box 18, folder 4, Jess Collins Papers, The Bancroft Library, University of California, Berkeley. Copyright © 2013. Used by permission of the Jess Collins Trust.

Jasper Johns, "Statement," *16 Americans* (New York: The Museum of Modern Art, 1959). Copyright © 1959 The Museum of Modern Art, New York. Used by permission. "Sketchbook Notes," *Art and Literature* 4, 1965. Copyright © Jasper Johns/Licensed by VAGA, New York, NY.

Donald Judd, "Local History," *Arts Yearbook* 7, 1964, reprinted in *Complete Writings 1959–1975* (Halifax: Nova Scotia College of Art and Design, 2005). "Specific Objects," *Arts Yearbook* 8, 1965, reprinted in *Complete Writings*. Copyright © Judd Foundation/Licensed by VAGA, New York, NY.

Allan Kaprow, "The Legacy of Jackson Pollock," *ARTnews*, 1958, reprinted in *Essays on the Blurring of Art and Life*, ed. Jeff Kelley (Berkeley: University of California Press, 2003). Used by permission of the University of California Press.

Weldon Kees, "Robert Motherwell," *Magazine of Art*, March 1948, reprinted in *Reviews and Essays, 1936–55* (Ann Arbor: University of Michigan Press, 1988). Copyright © 1950 by The American Federation of Arts. Used by permission. "Adolph Gottlieb," *The Nation*, January 7, 1950, reprinted in *Reviews and Essays*. Used by permission from the January 7, 1950, issue of *The Nation*, www.thenation.com.

Jack Kerouac, "Introduction to Robert Frank's *The Americans*," *The Americans* (Paris: Robert Delpire, 1958; New York: Grove Press, 1959). Copyright © by the Estate of Jack Kerouac. Used by permission of SLL/Sterling Lord Literistic, Inc.

Lincoln Kirstein, "Elie Nadelman: Sculptor of the Dance," *Dance Index* 7, No. 6, 1948.

Hilton Kramer, "Edward Hopper: An American Vision," *New York Times*, October 12, 1964, reprinted in *The Age of the Avant-Garde: An Art Chronicle of 1956–1972* (New York: Farrar, Straus & Giroux, 1975). Used by permission of the Estate of Hilton Kramer.

Rosalind Krauss, "Allusion and Illusion in Donald Judd," *Artforum* 5, May 1966. Copyright © 1966 by Artforum. Used by permission of Artforum and Rosalind Krauss.

Philip Leider, "Bruce Conner: A New Sensibility," *Artforum* I, no. 6, December 1962. Copyright © 1962 by Artforum. "Joan Brown," *Artforum* I, no. 12, June 1963. Copyright © 1963 by Artforum. Used by permission.

Dwight Macdonald, "(from) Action on West Fifty-Third Street," *The New Yorker*, December 12, 1953. Copyright © 2012 by Condé Nast/ Dwight Macdonald. All rights reserved. Used by permission.

Mary McCarthy, "An Academy of Risk," *Partisan Review*, Summer 1959, reprinted in *On the Contrary* (New York: Farrar, Straus & Giroux, 1961). Used by permission of the Mary McCarthy Literary Estate.

Henry Miller, "(from) The Amazing and Invariable Beauford Delaney," Alicat Bookshop, 1945, reprinted in *Remember to Remember* (New York: New Directions, 1947). Copyright © 1961 by Henry Miller. Used by permission of New Directions Publishing Corp.

Marianne Moore, "Robert Andrew Parker," *Arts* 32, April 1958, reprinted in *The Complete Prose of Marianne Moore*, ed. Patricia C. Willis. Copyright © 1986 by Clive E. Driver, Literary Executor of the Estate of Marianne Moore. Used by permission of Viking Penguin, a division of Penguin Random House Inc., and David M. Moore, Esq., Administrator of the Literary Estate of Marianne Moore. All rights reserved.

Robert Motherwell, "Black or White," *Black or White*, Kootz Editions, 1950, reprinted in *The Collected Writings of Robert Motherwell* (Oxford University Press, 1993). "What Abstract Art Means to Me," *Museum of Modern Art Bulletin*, Spring 1951, reprinted in *Collected Writings*. Copyright © Dedalus Foundation, Inc./Licensed by VAGA, New York, NY.

John Bernard Myers, "Junkdump Fair Surveyed," *Art and Literature* 3, 1964.

Anton Myrer, "(from) *Evil Under the Sun*," Anton Myrer, *Evil Under the Sun* (New York: Random House, 1951).

Howard Nemerov, "Four Soldiers: A Sculpture in Iron by David Smith," *David Smith*, (New York: Willard-Kleemann Gallery, 1952). Used by permission of the University of Chicago Press.

Barnett Newman, "The First Man Was an Artist," *The Tiger's Eye*, October 1947, reprinted in *Selected Writings and Interviews*, ed. John P. O'Neill (New York: Alfred A. Knopf, 1990). "The Sublime Is Now," *The Tiger's Eye*, March 1948, reprinted in *Selected Writings and Interviews*. "Ohio, 1949," *Selected Writings and Interviews*. Copyright © 2013 by The Barnett Newman Foundation, New York/Artists Rights Society (ARS), New York.

Isamu Noguchi, "(from) *A Sculptor's World*," *A Sculptor's World* (New York: Harper & Row, 1968). Copyright © 2013 by The Isamu Noguchi Foundation and Garden Museum, New York/Artists Rights Society (ARS), New York.

Frank O'Hara, "Why I Am Not a Painter," *Evergreen Review* I:3 1957, reprinted in *The Collected Poems of Frank O'Hara* (New York: Alfred A. Knopf, 1971). Copyright © 1971 by Maureen Granville-Smith, Administratrix of the Estate of Frank O'Hara, copyright renewed © 1999 by Maureen O'Hara Granville-Smith and Donald Allen. Used by permission of Alfred A. Knopf, an imprint of the Knopf Doubleday Publishing Group, a division of Random House LLC. All rights reserved. "David Smith: The Color of Steel," *ARTnews*, December 1961, reprinted in *Standing Still and Walking in New York* (San Francisco: Grey Fox Press, 1975). Copyright © 2014 by Maureen Granville-Smith. Used by permission of Maureen Granville-Smith. "Art Chronicle I," *Kulchur* II:5, Spring 1962, reprinted in *Standing Still and Walking in New York*. Copyright © 2014 by Maureen Granville-Smith. Used by permission of Maureen Granville-Smith. "Larry Rivers: A Memoir," *Larry Rivers* (Waltham: Brandeis University, 1965). Copyright © 1971 by Maureen Granville-Smith, Administratrix of the Estate of Frank O'Hara, copyright renewed © 1999 by Maureen O'Hara Granville-Smith and Donald Allen. Used by permission of Alfred A. Knopf, an imprint of the Knopf Doubleday Publishing Group, a division of Random House LLC. All rights reserved.

Claes Oldenburg, "(from) *Store Days,*" *Store Days* (New York: Something Else Press, 1967). Used by permission of Storebridge, Oldenburg van Bruggen Studio.

Jackson Pollock, "My Painting," *Possibilities,* Winter 1947–8. Copyright © 2013 by The Pollock-Krasner Foundation/Artists Rights Society (ARS), New York.

Fairfield Porter, "The Paintings of E. E. Cummings," *Wake 5,* Spring 1946. "Richard Stankiewicz," *School of New York: Some Younger Artists,* 1959, reprinted in *Art in Its Own Terms: Selected Criticism 1935–1975,* ed. Rackstraw Downes (Boston: MFA Publications, 2008). "John Graham," *ARTnews,* October 1960, reprinted in *Art in Its Own Terms.* "Against Idealism," *Art and Literature* 2, Summer 1964, reprinted in *Art in Its Own Terms.* "Joseph Cornell," *Art and Literature* 8, Spring 1966, reprinted in *Art in Its Own Terms.* "A Painter Obsessed By Blue," *The Collected Poems* (New York: Tibor de Nagy, 1985). Used by permission of the Estate of Fairfield Porter.

Robert Rauschenberg, "Statement," *16 Americans* (New York: The Museum of Modern Art, 1959). Copyright © 1959 The Museum of Modern Art, New York. Used by permission.

Ad Reinhardt, "Abstract Art Refuses," Catalogue of "Contemporary American Painting," University of Illinois, 1952, reprinted in *Art as Art: The Selected Writings of Ad Reinhardt* (University of California Press, 1991). "Art-as-Art," *Art International,* December 1962, reprinted in *Art as Art.* Copyright © 2014 by the Estate of Ad Reinhardt/Artists Rights Society (ARS), New York.

Kenneth Rexroth, "The Visionary Painting of Morris Graves," *Perspectives USA* #10, 1955; reprinted in *World Outside the Window* (New York: New Directions, 1955). Copyright © 1955 by Kenneth Rexroth. Used by permission of New Directions Publishing Corp.

Dwight Ripley, "An Alphabetical Guide to Modern Art," "Alphabetical Guide No. 2," "Acrostic for Jackson Pollock," Unpublished typescripts. Copyright © 2014 by Frank Polach. Used by permission.

Larry Rivers, "Life Among the Stones," *Location* I:1, Spring 1963. Copyright © Estate of Larry Rivers/Licensed by VAGA, New York, NY.

Barbara Rose, "ABC Art," *Art in America,* October 1965. Used by permission of Barbara Rose.

Harold Rosenberg, "The American Action Painters," *ARTnews,* December 1952, reprinted in *The Tradition of the New* (New York: Horizon Press, 1959). Used by permission of the University of Chicago Press. "Parable of American Painting," *ARTnews,* January 1954, reprinted in *The Tradition of the New.* Used by permission of the University of Chicago Press. "Evidences," *Aaron Siskind: Photographs* (New York: Horizon Press, 1959). Used by permission of the Estate of Harold Rosenberg. "Mobile, Theatrical, Active," *The*

Anxious Object (New York: Horizon Press, 1964). Used by permission of the Estate of Harold Rosenberg.

Robert Rosenblum, "The Abstract Sublime," *ARTnews,* February 1961, reprinted in *On Modern American Art: Selected Essays* (New York: Harry N. Abrams, 1999). Copyright © 1961 by ARTnews, LLC, www.artnews.com. Used by permission.

Mark Rothko, "The Romantics Were Prompted," *Possibilities,* Winter 1947–8. "Two Statements from *The Tiger's Eye," The Tiger's Eye,* December 1947 and October 1949. Copyright © 1998 by Kate Rothko Prizel and Christopher Rothko/Artists Rights Society (ARS), New York. Used by permission of Yale University Press.

Alfred Russell, "Toward Meta-Form," *It Is,* Spring 1960. Copyright © 1960 by The Estate of Alfred Russell. Used by permission.

Irving Sandler, "Joan Mitchell," *School of New York: Some Younger Artists* (New York: Grove Press, 1959). Copyright © 1959 by Grove Press, Inc. Used by permission of Grove/Atlantic, Inc. Any third-party use of this material, outside of this publication, is prohibited.

Meyer Schapiro, "The Liberating Quality of Avant-Garde Art," American Federation of Arts, Houston, 1957, reprinted as "Recent Abstract Painting" in *Modern Art: 19th and 20th Centuries* (New York: George Braziller, 1978). "On the Humanity of Abstract Painting," *Proceedings of the American Academy of Arts and Letters,* 1960, reprinted in *Modern Art.* Copyright © 1979, 2011 by George Braziller, Inc. Used by permission of George Braziller, Inc., New York. All rights reserved.

James Schuyler, "Statement on Poetics," *The New American Poetry,* ed. Donald Allen (New York: Grove Press, 1959). "The Painting of Jane Freilicher," *Art and Literature,* 1966, reprinted in *Selected Art Writings,* ed. Simon Pettet (Black Sparrow Press, 1998). "Short reviews from *ARTnews," ARTnews,* 1957–1958, reprinted in *Selected Art Writings.* Used by permission of the Estate of James Schuyler.

Ben Shahn, "(from) *The Shape of Content," The Shape of Content* (Cambridge: Harvard University Press, 1957). Copyright © 1957 by the President and Fellows of Harvard College, renewed 1985 by Bernarda B. Shahn. Used by permission of Harvard University Press.

Aaron Siskind, "Statement," *Aaron Siskind Photographer* (Rochester: George Eastman House, 1965). Used by permission of the Aaron Siskind Foundation.

David Smith, "The Landscape," "The Question—what is your hope," "The Question—what are your influences—," "there is something rather noble about junk," and "Dream," *David Smith by David Smith* (New York: Holt Rinehart Winston, 1968). Copyright © Estate of David Smith/Licensed by VAGA, New York, NY.

Robert Smithson, "The Crystal Land," *Harper's Bazaar,* May 1966,

reprinted in *Robert Smithson: The Collected Writings* (Berkeley: University of California Press, 1996). Copyright © Estate of Robert Smithson/VAGA, New York, NY.

Susan Sontag, "Happenings: An Art of Radical Juxtaposition," *The Second Coming*, 1962, reprinted in *Against Interpretation* (New York: Farrar, Straus & Giroux, 1966). Copyright © 1964, 1966, renewed 1994 by Susan Sontag. Used by permission of Farrar, Straus and Giroux, LLC.

Leo Steinberg, "Contemporary Art and the Plight of its Public," *Harper's*, March 1962, reprinted in *Other Criteria: Confrontations with Twentieth-Century Art* (University of Chicago Press, 1972). Used by permission of the University of Chicago Press.

Kate Steinitz, "A Visit With Sam Rodia," *Artforum* I, no. 11, May 1963. Copyright © 1963 by Artforum. Used by permission.

Wallace Stevens, "Anecdote of the Jar" and "The Man on the Dump," *The Collected Poems of Wallace Stevens*. Copyright © 1954 by Wallace Stevens and renewed 1982 by Holly Stevens. Used by permission of Alfred A. Knopf, an imprint of the Knopf Doubleday Publishing Group, a division of Random House LLC. All rights reserved.

Clyfford Still, "Statement," *15 Americans* (New York: Museum of Modern Art, 1952). Copyright © 1952 The Museum of Modern Art, New York. Used by permission. "An Open Letter to an Art Critic," *Artforum* 2, no. 6, December 1963. Copyright © 1963 by Artforum. Used by permission.

Gene R. Swenson, "The New American 'Sign Painters'," *ARTnews*, September 1962. Copyright © 1962 by ARTnews, LLC, www.artnews.com. Used by permission.

May Swenson, "At the Museum of Modern Art," *To Mix With Time* (New York: Charles Scribner's Sons, 1963). Used by permission of the Literary Estate of May Swenson. All rights reserved.

Sidney Tillim, "Month in Review, January 1962," *Arts Magazine*, January 1962. Copyright © 2014 by the Estate of Sidney Tillim, New York. Used by permission. "Franz Kline (1910–1962)," *Arts Magazine*, September 1962. Copyright © 2014 by the Estate of Sidney Tillim, New York. Used by permission. "Philip Pearlstein and the New Philistinism," *Artforum* 4, no. 9, May 1966. Copyright © 1966 by Artforum. Used by permission.

Mark Tobey, "Reminiscence and Reverie," *Magazine of Art* 44, no. 6, October 1951. Copyright © 2013 by the Estate of Mark Tobey/Artists Rights Society (ARS), New York.

Calvin Tomkins, "(from) Beyond the Machine," *The New Yorker*, February 10, 1962. Copyright © 2012 by Condé Nast/Calvin Tomkins. All rights reserved. Used by permission.

Jack Tworkov, "A Cahier Leaf," *It Is*, Spring 1958, reprinted in *The*

Extreme of the Middle: Writings of Jack Tworkov, ed. Mira Schor (New Haven: Yale University Press, 2009). "Statement," *It Is*, Autumn 1958, reprinted in *The Extreme of the Middle*. "Four Excerpts from a Journal," *It Is*, Autumn 1959, reprinted in *The Extreme of the Middle*. Used by permission of Yale University Press.

Parker Tyler, "Jackson Pollock: The Infinite Labyrinth," *Magazine of Art*, March 1950. Copyright © 1950 by The American Federation of Arts. Used by permission.

Andy Warhol, "What Is Pop Art?," *ARTnews*, November 1963. Copyright © 1963 by ARTnews, LLC, www.artnews.com. Used by permission. "(from) *The Philosophy of Andy Warhol*," *The Philosophy of Andy Warhol: From A to B and Back Again* (New York: Harcourt Brace Jovanovich, 1975). Copyright © 1975 by Andy Warhol. Used by permission of Houghton Mifflin Harcourt Publishing Company and The Wylie Agency LLC. All rights reserved.

H. C. Westermann, "Three Letters," *Letters from H. C. Westermann*, ed. Bill Barrette (New York: Timken Publishers, 1988). Copyright © Dumbarton Arts, LLC/Licensed by VAGA, New York, NY.

Tennessee Williams, "An Appreciation," *Women*, Kootz Editions, 1948, reprinted in *New Selected Essays: Where I Live*. Copyright © 1957 by The University of the South. Used by permission of New Directions Publishing Corp. and Georges Borchardt, Inc., for the Estate of Tennessee Williams. All rights reserved.

William Carlos Williams, "Painting in the American Grain," *ARTnews*, 1954, reprinted in *A Recognizable Image: William Carlos Williams on Art and Artists*, ed. Bram Dijkstra (New York: New Directions, 1978). Copyright © 1954 by William Carlos Williams. Used by permission of New Directions Publishing Corp.

COLOR ILLUSTRATIONS

1. Morris Graves, *Time of Change*, 1943. Courtesy of the Morris Graves Foundation. Digital image by Richard Nicol.

2. John Graham, *Two Sisters (Les Mamelles d'outre-mer)*, 1944. Digital Image Copyright © The Museum of Modern Art/Licensed by SCALA/Art Resource, NY.

3. Jackson Pollock, *Cathedral*, 1947. Copyright © The Pollock-Krasner Foundation/Artists Rights Society (ARS), New York.

4. Mark Rothko, *No. 1 (No. 18, 1948)*, 1948–49. Copyright © 1998 Kate Rothko Prizel and Christopher Rothko/Artists Rights Society (ARS), New York.

5. Robert Motherwell, *At Five in the Afternoon*, 1950. Copyright © Dedalus Foundation, Inc./Licensed by VAGA, New York, NY. Digital Image Copyright © Fine Arts Museums of San Francisco.

6. Anni Albers, *Black-White-Gold I*, 1950. Copyright © 2014 The

Josef and Anni Albers Foundation/Artists Rights Society (ARS), New York. Digital image courtesy of Albers Foundation/Art Resource, NY.

7. Charles Burchfield, *Gateway to September*, 1945–56. Courtesy of the Charles E. Burchfield Foundation.

8. Barnett Newman, *Vir Heroicus Sublimis*, 1950–51. Copyright © 2014 The Barnett Newman Foundation, New York/Artists Rights Society (ARS), New York. Digital Image Copyright © The Museum of Modern Art/Licensed by SCALA/Art Resource, NY.

9. Clyfford Still, *1951-T No. 3*, 1951. Copyright © Clyfford Still Estate. Digital Image Copyright © The Museum of Modern Art/Licensed by SCALA/Art Resource, NY.

10. Willem de Kooning, *Woman, I*, 1950–52, Copyright © 2014 The Willem de Kooning Foundation/Artists Rights Society (ARS), New York. Digital Image Copyright © The Museum of Modern Art/Licensed by SCALA/Art Resource, NY.

11. Grace Hartigan, *The Persian Jacket*, 1952. Courtesy of the Grace Hartigan Estate. Digital Image Copyright © The Museum of Modern Art/Licensed by SCALA/Art Resource, NY.

12. Larry Rivers, *O'Hara Nude with Boots*, 1954. Copyright © Estate of Larry Rivers/Licensed by VAGA, New York, NY.

13. Jack Tworkov, *Pink Mississippi*, 1954. Copyright © Estate of Jack Tworkov/Licensed by VAGA, New York, NY.

14. Joseph Cornell, *Untitled (Hôtel de l'Etoile)*, 1954. Copyright © The Joseph and Robert Cornell Memorial Foundation/Licensed by VAGA, New York, NY.

15. Robert Rauschenberg, *Bed*, 1955. Copyright © Robert Rauschenberg Foundation/Licensed by VAGA/New York, NY. Digital Image Copyright © The Museum of Modern Art/Licensed by SCALA/Art Resource, NY.

16. Jasper Johns, *Target with Four Faces*, 1955. Copyright © Jasper Johns/Licensed by VAGA/New York, NY. Digital Image Copyright © The Museum of Modern Art/Licensed by SCALA/Art Resource, NY.

17. Helen Frankenthaler, *Giralda*, 1956. Copyright © 2014 Helen Frankenthaler Foundation, Inc./Artists Rights Society, NY.

18. Alfred Leslie, *Quartet #1*, 1958. Copyright © Alfred Leslie. Digital image courtesy of Allan Stone Gallery, New York.

19. Hans Hofmann, *Equinox*, 1958. Copyright © 2014 Artists Rights Society (ARS), New York.

20. Roy Lichtenstein, *The Engagement Ring*, 1961. Copyright © Estate of Roy Lichtenstein. Reproduced by permission.

21. James Rosenquist, *Silver Skies*, 1962. Copyright © James Rosenquist/Licensed by VAGA/New York, NY.

22. Andy Warhol, *Marilyn Diptych*, 1962. Copyright © 2014 The Andy

Warhol Foundation for the Visual Arts, Inc./Artists Rights Society (ARS), New York. Digital image courtesy of Tate, London/Art Resource, NY.

23. Joan Brown, *Girl in Chair*, 1962. Copyright © Estate of Joan Brown, Mike Hebel, and Noel Neri. Digital Image © 2014 Museum Associates/LACMA. Licensed by Art Resource, NY.

24. Donald Judd, *Untitled*, 1963. Copyright © Judd Foundation/ Licensed by VAGA/New York, NY.

25. Robert Morris, *Untitled (Ring of Light)*, 1965–66. Copyright © 2014 Robert Morris/Artists Rights Society (ARS), New York. Digital image by Jens Ziehe and courtesy of Sonnabend Gallery/ Sprüth Magers Berlin London.

26. Joan Mitchell, *Girolata Triptych*, 1964. Copyright © Estate of Joan Mitchell. Reproduced by permission.

27. Philip Guston, *The Light*, 1964. Copyright © Estate of Philip Guston.

28. Jane Freilicher, *Peonies*, 1965. Courtesy of Tibor de Nagy Gallery, New York.

29. Jess, *The Enamord Mage: Translation #6*, 1965. Copyright © 2014 by the Jess Collins Trust. Reproduced by permission. Digital image courtesy of Tibor de Nagy Gallery, New York.

30. Philip Pearlstein, *Models in the Studio*, 1965. Courtesy of Philip Pearlstein and the Betty Cuningham Gallery, New York.

31. Romare Bearden, *Black Manhattan*, 1969. Copyright © Romare Bearden/Licensed by VAGA/New York, NY. Digital image courtesy of Schomburg Center, NYPL/Art Resource, NY.

32. Fairfield Porter, *Self-Portrait*, 1972. Courtesy of the Estate of Fairfield Porter and Hirschl & Adler Modern, New York.

BLACK AND WHITE ILLUSTRATIONS

p. 2, Hans Namuth. Copyright © 1991 Hans Namuth Estate. Courtesy of the Center for Creative Photography, University of Arizona; **p. 15**, Alexander Liberman. Courtesy of the Alexander Liberman Photography Archive, The Getty Research Institute, Los Angeles (2000.R.19); **p. 22**, George Karger. Courtesy of Solomon R. Guggenheim Museum Archives, New York; **p. 43**, **p. 45**, Helen Levitt. Courtesy of Helen Levitt Estate; **p. 61**, Paul Rand. Copyright © Estate of Paul Rand. Digital Image Copyright © The Museum of Modern Art/Licensed by SCALA/Art Resource, NY; **p. 65**, Harry Bowden. Courtesy of ArtZone 461 Gallery, San Francisco, CA; **p. 70**, Willem de Kooning. Copyright © 2014 The Willem de Kooning Foundation/Artists Rights Society (ARS), New York. Mr. and Mrs. Frank G. Logan Purchase Prize Fund, restricted gifts of Edgar J. Kaufmann, Jr., and Mr. and Mrs.

Noah Goldowsky, 1952.1, The Art Institute of Chicago. Digital Image Copyright © The Art Institute of Chicago; **p. 78**, Rudy Burckhardt. Copyright © 2014 Estate of Rudy Burckhardt/Artists Rights Society (ARS), New York. Digital image courtesy of Tibor de Nagy Gallery, New York; **p. 88**, Willem de Kooning. Copyright © 2014 The Willem de Kooning Foundation/Artists Rights Society (ARS), New York. Digital image by Paul Hester and courtesy of The Menil Collection, Houston; **p. 91**, Rudy Burckhardt. Copyright © 2014 Estate of Rudy Burckhardt/Artists Rights Society (ARS), New York; **p. 97**, Jackson Pollock. Copyright © 2014 The Pollock-Krasner Foundation/Artists Rights Society (ARS), New York. The Museum of Contemporary Art, Los Angeles, The Rita and Taft Schreiber Collection.

 p. 105, Elie Nadelman. Copyright © Estate of Elie Nadelman. Whitney Museum of American Art, New York, purchase with funds from the Mr. and Mrs. Arthur G. Altschul Purchase Fund, the Joan and Lester Avnet Purchase Fund, the Edgar William and Bernice Chrysler Garbisch Purchase Fund, the Mrs. Robert C. Graham Purchase Fund in honor of John I. H. Baur, the Mrs. Percy Uris Purchase Fund, and the Henry Schnakenberg Purchase Fund in honor of Juliana Force. Digital image by Jerry Thompson; **p. 127**, Hans Hofmann. Copyright © 2014 The Renate, Hans, and Maria Hofmann Trust/Artists Rights Society (ARS), New York. Courtesy of Ameringer | McEnery | Yohe. Digital Image Copyright © The Metropolitan Museum of Art/Art Resource, NY; **p. 134**, Hans Namuth. Copyright © 1991 Hans Namuth Estate. Courtesy of the Center for Creative Photography, University of Arizona; **p. 139**, Pablo Picasso. Copyright © 2014 Estate of Pablo Picasso/Artists Rights Society (ARS), New York. The Cleveland Museum of Art, Leonard C. Hanna, Jr. Fund; **p. 148**, Nina Leen. Courtesy of Time & Life Pictures/Getty Images; **p. 175**, Dwight Ripley. Copyright © 2014 Frank Polach. Reproduced by permission; **p. 188**, Adolph Gottlieb. Copyright © Adolph and Esther Gottlieb Foundation/Licensed by VAGA, New York, NY. Grey Art Gallery, New York University Art Collection. Gift of Mr. and Mrs. Samuel Kootz; **p. 192**, Mark Tobey. Copyright © 2014 Mark Tobey/Seattle Art Museum, Artists Rights Society (ARS), New York. Digital Image Copyright © The Museum of Modern Art/Licensed by SCALA/Art Resource, NY.

 p. 209, Anonymous. Digital Image Copyright © The Metropolitan Museum of Art/Art Resource, NY; **p. 215**, Robert Andrew Parker. Courtesy of Robert Andrew Parker; **p. 219**, Philip Johnson. Digital Image Copyright © The Museum of Modern Art/Licensed by SCALA/Art Resource, NY; **p. 239**, Saul Steinberg. Copyright © The Saul Steinberg Foundation/Artists Rights Society (ARS), NY. Yale University Art Gallery. The Lawrence and Regina Dubin Family Collection, Gift of Dr. Lawrence Dubin, B.S. 1955, M.D. 1958; **p. 246**,

permission. Digital image courtesy of the National Portrait Gallery, Smithsonian Institution/Art Resource, NY; **p. 435**, Meyer Schapiro. Courtesy of the Estate of Meyer Schapiro; **p. 457**, Marcel Duchamp. Copyright © Succession Marcel Duchamp/ADAGP, Paris/Artists Rights Society (ARS), New York. Digital image courtesy of Camera-photo Arte, Venice/Art Resource, NY; **p. 461**, Walt Silver. Copyright © Walt Silver. Courtesy of George Silver. Digital image courtesy of Special Collections Research Center, Syracuse University Libraries; **p. 471**, Fred McDarrah. Courtesy of Getty Images; **p. 473**, David Smith. Copyright © Estate of David Smith/Licensed by VAGA, New York, NY; **p. 494**, Hans Namuth. Copyright © 1991 Hans Namuth Estate. Courtesy of the Center for Creative Photography, University of Arizona; **p. 499**, Larry Rivers and Frank O'Hara. Copyright © Estate of Larry Rivers and Maureen Granville-Smith/Licensed by VAGA, New York, NY. Digital image courtesy of Tibor de Nagy Gallery, New York.

p. 512, Ilya Bolotowsky. Copyright © Estate of Ilya Bolotowsky/Licensed by VAGA, New York, NY. Digital Image Copyright © The Museum of Modern Art/Licensed by SCALA/Art Resource, NY; **p. 517**, David Gahr. Copyright © 2014 Artists Rights Society (ARS), New York/ADAGP, Paris. Digital Image Copyright © The Museum of Modern Art/Licensed by SCALA/Art Resource, NY; **p. 525**, Fred McDarrah. Courtesy of Getty Images; **p. 538**, Robert R. McElroy. Copyright © Estate of Robert R. McElroy/Licensed by VAGA, New York, NY. Copyright © 2014 Jim Dine/Artists Rights Society (ARS), New York. Digital image courtesy of Pace Gallery; **p. 546**, Beauford Delaney. Digital image courtesy of the National Portrait Gallery, Smithsonian Institution/Art Resource, NY; **p. 550**, Bruce Conner. Copyright © 2014 Conner Family Trust, San Francisco/Artists Rights Society (ARS), New York. Digital Image Copyright © The Museum of Modern Art/Licensed by SCALA/Art Resource, NY; **p. 558**, "Watts Towers." Courtesy of Getty Images; **p. 570**, Jess. Copyright © 2014 by the Jess Collins Trust. Reproduced by permission; **p. 581**, **p. 582**, H. C. Westermann. Copyright © Dumbarton Arts, LLC/Licensed by VAGA, New York, NY; **p. 586**, J.M.W. Turner. Digital image courtesy of Tate, London/Art Resource, NY; **p. 591**, "Crowds viewing." Courtesy of Associated Press.

p. 609, Walt Silver. Copyright © Walt Silver. Courtesy of George Silver. Rudi Blesh Papers, Archives of American Art, Smithsonian Institution; **p. 617**, Jasper Johns. Copyright © Jasper Johns/Licensed by VAGA, New York, NY. Digital Image Copyright © The Museum of Modern Art/Licensed by SCALA/Art Resource; **p. 624**, Jasper Johns. Copyright © Jasper Johns/Licensed by VAGA, New York, NY. Digital image courtesy of Jasper Johns Studio; **p. 654**, Robert R. McElroy.

Index

This book is set in 10 point ITC Galliard Pro, a
face designed for digital composition by Matthew Carter
and based on the sixteenth-century face Granjon. The text
paper is acid-free, high-opacity Earthchoice Tradebook and meets
the requirements for permanence of the American National Standards
Institute. The photo insert paper is acid-free and gloss-coated. The
binding material is Verona, a rayon cloth manufactured by
LBS, Des Moines, Iowa. Composition by David Bullen
Design. Printing and binding by Courier
Corporation, Westford, Massachusetts.
Designed by Bruce Campbell.

Extraordinary
HEALING

Extraordinary
HEALING

Trigger a Complete Health
Turnaround in 10 Days or Less

Arthur H. Brownstein, M.D., M.P.H.

RODALE

Notice

The ideas, positions, and statements in this book may in some cases conflict with orthodox, mainstream medical opinion, and the advice regarding health matters outlined in this book or on its cover is not suitable for everyone. Do not attempt self-diagnosis, and do not embark upon self-treatment of any kind without qualified medical supervision. Nothing in this book should be construed as a promise of benefits or of results to be achieved, or a guarantee by the author or publisher of the safety or efficacy of its contents. The author, the publisher, its editors, and its employees disclaim any liability, loss, or risk incurred directly or indirectly as a result of the use or application of any of the contents of this book. If you are not willing to be bound by this disclaimer, please return your copy of the book to the publisher for a full refund.

Library of Congress Cataloging-in-Publication Data

Brownstein, Arthur H., date
 Extraordinary healing: trigger a complete health turnaround in 10 days or less / Art Brownstein.
 p. cm.
 Includes bibliographical references.
 ISBN 13 978–1–59486–439–1 hardcover
 ISBN 10 1–59486–439–X hardcover
 1. Healing. 2. Health. 3. Mind and body. I. Title.
RZ401.B826 2006
615.5—dc22 2006023839

 10 9 8 7 6 hardcover

This book is dedicated to Norman Cousins (1915–1990) and to his surviving family members. A rare and most unusual human being, Cousins was an international emissary of peace; a political advisor to statesmen, politicians, popes, and presidents; a prolific, best-selling author; a musician; a humorist; and an extraordinary healer. Considered "healer of the medical profession" and "founding father of mind-body medicine," he was also a pioneering researcher and outspoken proponent of psychoneuroimmunology, a new branch of medical science that studies the interactions among the mind, the nervous system, and the immune system to help us better understand how our beliefs, thoughts, feelings, and attitudes can affect our physical health.

Even though he was in the middle of intense fundraising and research in psychoneuroimmunology when we met in his office at the UCLA School of Medicine, Norman Cousins took time out of his busy schedule to tell me about the healing system. He spoke at length about why he considered it the most important system in the body, and how research needed to be conducted in this vital area of human health. Although, over the past 15 years, I have since heard and read about the healing system many times, and have gone on to conduct my own clinical studies and observations about it, Norman Cousins was the first one to make me aware of it and its profound importance to humanity's ongoing battle against disease. I credit him for making me a better doctor, and for the inspiration to write this book.

CONTENTS

FOREWORD

Modern medicine rarely succeeds in teaching doctors how to get their patients to actively participate in their own healing. This is one of the major problems with medicine today and with doctors trained to focus on external solutions to their patients' health problems. The modern-day approach of quick-fix solutions and an emphasis on "wonder" drugs often disregards the remarkable potential we all have to awaken our own extraordinary healing powers when we're sick, and to use these healing powers to prevent disease from ever occurring. But in order to use these healing powers that we all have, we must tap into a system of the body that has been virtually ignored until now—the healing system. True and lasting healing can only occur when you work with this strong and seemingly mysterious power within you.

Through the years, I have seen patients with diseases and conditions of all kinds work with their healing systems in a variety of ways to combat sickness and restore their bodies and minds to a healthy state. I have even seen unconscious patients in intensive care units of hospitals heal themselves with a strong will to live that stimulates the healing system to go into high gear. Pay attention to the stories Dr. Brownstein shares in this book. They are all dramatic examples of the incredible power we all have to heal ourselves and the critical importance of looking within for permanent solutions to health problems.

If you are sick or weak, or even if you're just not feeling as good as you'd like to feel, your healing system may be slumbering, but it is just waiting to be called into action—and it is as necessary to your good health as your respiratory system and your digestive system. Try waking it up with the strategies and techniques you'll find in this book, and you'll experience the full range of your potential to

achieve maximum health. Begin with a simple first step: "Program" yourself to think and feel in a positive way about yourself and others, and, before long, you'll see extraordinary changes in the way you feel physically. Use the power of your mind to affect your body, and your healing system will respond in a myriad of ways to your thoughts and attitudes, and it will begin healing and strengthening all of the other systems in your body. Just as patients who are in extreme circumstances, such as in intensive care units of hospitals, can rally and recover, so can you if you learn to acknowledge and work with your own healing powers.

You are about to begin quite an unusual and remarkable book, one that deserves to be read carefully and then kept close at hand for future reference in times of need. Let Dr. Brownstein show you how to strengthen and fortify the extraordinary healing system within you, and you'll see remarkable changes in the health of your mind, body, and spirit.

Claes Frostell, M.D.
Karolinska University Hospital Huddinge
Stockholm, Sweden

ACKNOWLEDGMENTS

Many people are due my thanks for the publication of this book. Many more simply could not be listed here. To them I offer my sincere apologies.

I would like to acknowledge the following people for their contribution to this work:

Norman Cousins was the original inspiration that led to the writing of this book.

Gary David Saldana, M.D., of Kauai, Hawaii, regularly encouraged me for five years and additionally contributed by seeing my patients each week so I would have the time to write.

Dr. Dean Ornish, the first person in the world to prove that heart disease could be reversed, provided a strong, scientific foundation for the ideas presented here. During the 10 years that I was fortunate enough to work with him, I was able to witness, firsthand, the miraculous workings of the healing system in patients with severe, advanced heart disease. I shall be forever grateful to Dr. Ornish for his wisdom and generosity.

Dr. Lee Lipsenthal, medical director of the Ornish Program and originator of the Physician Heal Thyself program, has been a continuous source of encouragement for this project.

Other staff and participants of the Ornish Program I would like to personally thank include Melanie Elliot, R.N.; Ruth Marlin, M.D.; Rob Saper, M.D.; Jim Billings, Ph.D.; Dr. Conrad Knudsen; Dennis Malone; Glenn Perelson; Werner and Eva Hebenstreit; Hank and Phyllis Ginsberg; and the entire Ornish staff.

Erminia M. Guarneri, M.D., cardiologist and current head of the Scripps Clinic Center for Integrative Medicine; Bruno Cortis, M.D.,

cardiologist; and Andy Meyer, M.D., cardiologist, provided lessons in cardiology and how important the heart is to the healing system.

Bernie Siegel, M.D., has been a mentor and friend. His work with Exceptional Cancer Patients therapy, described in his best-selling classic book, *Love, Medicine and Miracles*, and his many other books have been a source of great inspiration in the writing of this book.

Andrew Weil, M.D., colleague and friend, is one of the world's most authoritative experts in the practical and responsible use of complementary and alternative medicines, and one of the first doctors to write about the healing system. I thank him for his courage and wisdom in helping me advance the scientific and practical ideas presented.

Larry Dossey, M.D., colleague and medical expert on spirituality and prayer, has contributed greatly to the ideas included here.

Edgar Mitchell, Ph.D., was an Apollo 14 astronaut who made history by walking on the moon. He went on to found the Institute of Noetic Sciences, which helps fund scientific research on the cutting edge of healing and consciousness. He has been a major source of inspiration over the years in my investigation into the workings of the healing system.

David Simon, M.D., a colleague and conventionally trained neurologist who has studied and written about Ayurveda and yoga, has contributed greatly to this work through his insights and deep understanding of the healing system.

Joan Borysenko, Ph.D., best-selling author and scientist, has been a mentor and source of great inspiration in my personal and professional life. Over the years she has provided me with many case histories and other important clinical evidence shared in these pages.

Herbert Benson, M.D., is a Harvard cardiologist, an expert in the treatment of stress-related illnesses, and the first person in the world to prove that meditation can lower blood pressure. His work has been invaluable to my ongoing investigations into the field of relaxation and how it can benefit our healing systems.

James Banta, M.D., M.P.H., was the medical director of the Peace Corps during the Kennedy administration, former dean of the School of Public Health and Tropical Medicine at Tulane University in New Orleans, and currently is professor of epidemiology at George Washington University School of Medicine, and professor

emeritus at many medical schools around the world. I thank him for sending me to India, where I had the opportunity to study yoga and traditional Indian medicine. Because of him, I was able to observe ancient, natural, effective methods for treating diseases that worked with the healing system.

Larry Payne, Ph.D., founder of the International Association of Yoga Therapists, internationally acclaimed yoga teacher and bestselling author, has been a huge support in my work with the body's healing system and in the writing of this book.

Steve Schwartz, M.D., colleague and classmate in medical school, and his wife, Alma Schwartz, M.D., both long-time advocates of the body's natural ability to heal itself, have made a significant contribution to my career and the birth of this project.

Roberto Masferrer, M.D., military medicine colleague, and world-class neurosurgeon, Dr. Tom Higginbotham, D.O., an osteopathic physician with incredibly gifted healing hands, and Dr. Bud Hockley, dermatologist, have been sources of great support and inspiration in my career and as I put together this material.

David Elpern, M.D., has been a wise colleague and major support for my career over the years. He was kind enough to contribute case histories from his patient archives that I have included within.

Bernard Towers, M.D. (deceased), was my advisor in the department of psychoneuroimmunology for the research I was proposing to do with Norman Cousins at UCLA. He, along with the entire team of researchers in the Norman Cousins Program in psychoneuroimmunology at UCLA, which included George Solomon, M.D., Fawzy Fawzy, M.D., Carmen Clemente, M.D., Herbert Weiner, M.D., and others, contributed to the book's ideas. I thank them all for their pioneering work and early conceptualization of these ideas.

Tuck Craven, M.D.; Betty Craven, M.D.; Professor Len Eisenman, Ph.D., from Jefferson Medical College in Philadelphia; and Dr. Frank Marstellar were all instrumental in my medical education and contributed to many of the ideas expressed here.

Marty Rossman, M.D., and David Bressler, Ph.D., founders of the Academy for Guided Imagery, were my instructors in the two-year clinical training program I completed in guided imagery and healing, and they taught me what a powerful tool imagery can be in the activation of the healing system.

S. Kuvalayananda, pioneering researcher in yoga and founder of the Kaivalyadhama Yoga Institute in India, where I have studied during the past 20 years, and his wise and devoted students, Swami Digambarji; Sri O. P. Tiwari; V. Pratap, Ph. D.; and Dr. Sri Krishna, M. B.B.S., Ph.D., all served as my teachers and caretakers in India and taught me about the invaluable therapeutic benefits of yoga and how it can strengthen and fortify the healing system.

Claes Frostell, M.D., Ph.D., chairman of the department of anesthesiology at the Karolinska Institute in Stockholm, Sweden; Rosario Porrovecchio, M.D., of Italy; and Pedro de Vicente, M.D., of Spain, have all encouraged and inspired me in my work of integrating body, mind, and spirit in support of the healing system.

Virender Sodhi, a brilliant yet down-to-earth Ayurvedic physician and naturopathic doctor, has continued to inspire, encourage, and support my career and the writing of this book.

Rob Ivker, D.O., author of numerous books and past president of the American Holistic Medical Association, as well as Len Wisneski, M.D., a holistic endocrinologist and healer, have supported and encouraged me in this project.

Hawaii-based physicians Ira Zunin, M.D., M.P.H., M.B.A, president of the Hawaii State Consortium of Integrative Medicine; and Terry Shintani, M.D., M.P.H., J.D., founder of the Hawaiian Diet Program, have both, through their work, contributed significantly to the ideas presented in this book.

Tim Crane, M.D.; Donald Traller, P.A.; Robert Teichman, M.D.; Ph.D.; Nicholas Zina, M.D.; Jeff Goodman, M.D.; Ron Burkhart, M.D.; Stephen DeNigris, M.D.; Roger Netzer, M.D.; Bill Evslin, M.D.; Neal Sutherland, M.D.; all my colleagues at the Wilcox Hospital in Kauai; and my colleagues at the University of Hawaii supported and encouraged me in the completion of this project.

The staff, my colleagues and coworkers, and my many patients at the Princeville Medical Clinic; Kilauea North Shore Clinic; Kapaa Clinic; and Family Practice Walk-In Clinic at Wilcox Hospital in Lihue, Kauai, have, over the years, had an open mind to give me feedback on the many unconventional methods I have recommended here.

Debby Young is the best editor in the whole world. Over a four-year period, she was instrumental in helping me to organize, clarify,

and strip down the huge volume of material I had gathered for this book into a cohesive, clear, readable manuscript. Because of her, the ideas flow smoothly and are easy to grasp. Since I have begun working with her, I have become a much better writer. She has also served as my spiritual cheerleader by encouraging me to keep going when I was overwhelmed with both clinical duties and writing. Thank you, Debby.

Bert Holtje and Gene Brissie are my agents and I thank them for representing me in this literary work.

Harry Lynn, president of Harbor Press, published my first book, *Healing Back Pain Naturally*. I thank him for believing in me enough to publish this work, as well. I also want to thank his staff and associates and the rest of the folks at Harbor Press for being so helpful and cooperative.

Nutan, my wife, and Shantanu, my son, allowed me to be away from them for so many hours, which added up considerably over four years, while I wrote. Being married to a physician is hard enough, but to a physician who is also a writer—this is a most cruel and unusual punishment!

My father, S.R. Brownstein, M.D., encouraged me to do my best in all my endeavors while he practiced medicine in a career that spanned 50 years, including a professorship at the UCLA School of Medicine and a private practice in Beverly Hills, California. My mother, Fernlee Brownstein, relentlessly encouraged me to follow in my father's footsteps as a physician over the course of my childhood and early education.

"Natural forces within us are the true healers of disease."

—HIPPOCRATES (460–400 B.C.)

"The inner intelligence of the body is the ultimate and supreme genius in nature."

—THE VEDAS

"The physician is only nature's assistant."

—GALEN (129–199 A.D.)

"The physician knows that his little black bag can carry him only so far and that the body's own healing system is the main resource."

"The physician's ability to reassure the patient is a major factor in activating the body's own healing system."

"The more serious the illness, the more important it is for you to fight back, mobilizing all your resources—spiritually, emotionally, intellectually, and physically."

"We are becoming a nation of sissies and hypochondriacs, a self-medicating society easily intimidated by pain and prone to panic. We understand almost nothing about the essential robustness of the human body or its ability to meet the challenge of illness."

—NORMAN COUSINS

"There is a wide body of evidence suggesting that extraordinary healing, including regression of normally fatal tumors, takes place, with no known scientific explanation."

"We believe if there is one pressing argument for a thoroughgoing, urgent, and even passionate investigation of remarkable recovery, it is this: to discover and utilize the properties of another unmapped meta-system of the body and mind—the healing system."

—Drs. Brendan O'Regan and Caryle Hirshberg

"Your body can heal itself. It can do so because it has a healing system. If you are in good health, you will want to know about this system, because it is what keeps you in good health and because you can enhance that condition. If you or people you love are sick, you will want to know about this system, because it is the best hope for recovery."

—Andrew Weil, M.D.

"Medical students are not really taught about the healing system. They are taught about disease—how to diagnose and how to treat, but they are not taught how the body goes about treating itself. They will point to the immune system and let it go at that. But healing involves not just killing off disease germs or viruses but the process of reconstruction and repair."

—Dr. Omar Fareed

"We are at a turning point in medical history, when, having recognized the outer limits of technological medicine, doctors and lay people are together discovering the vast powers for creating health that we each inherit at birth."

"Far from being a passive victim to disease, the human body rallies its healing forces and removes the offender or repairs damaged tissue with as much vigor as the world's best-trained medical team."

—Hal Zina Bennet

"The land of healing lies within, radiant with happiness that is blindly sought in a thousand outer directions."

—S.S. YUKTESWAR

"When you are sick of your sickness you will cease to be sick."

—LAO TZU

"There is no such thing as an incurable disease, only incurable people."

—BERNIE SIEGEL, M.D.

"There are no incurable diseases, only those for which man has not yet found the cure."

—RACHELLE BRESLOW

"Whenever a new discovery is reported to the scientific world, they say first, 'It is probably not true.' Thereafter, when the truth of the new proposition has been demonstrated beyond question, they say, 'Yes, it may be true, but it is not important.' Finally, when sufficient time has elapsed to fully evidence its importance, they say, 'Yes, surely it is important, but it is no longer new.'"

—MICHEL DE MONTAIGNE (1533–1592)

INTRODUCTION

Your body is an incredible creation. No other machine is like it in the world. For the most part, it is designed to last for about 100 years, and it can repair and heal itself from a whole host of injuries, traumas, illnesses, and diseases. It can do this because, in addition to the other systems of the body, it has a *healing system,* a system so powerful and efficient, so subtle and dynamic, and yet so obvious that it has been largely taken for granted and overlooked by most of modern science. Even if this system were more actively searched for, our most modern diagnostic technologies are currently inadequate to accurately map out the full extent of its realm. As a result, despite its supreme importance, your healing system remains the least studied, the least understood, and the least well known of all of your body's systems.

Although the concept of a healing system may seem relatively new to Western medicine, in reality, the idea that such a system exists is very old. More than two thousand years ago, Hippocrates, considered "the father of Western medicine," declared that "natural forces within us are the true healers of disease." Even today, doctors in China, India, Japan, and other countries in the Far East and Middle East continue to teach their patients how to activate and cooperate with their bodies' natural ability to heal themselves in times of illness and injury. And within the lofty ranks of our own modern medicine, every surgeon who has ever wielded a scalpel has relied on the body's natural ability to heal itself following each and every operation performed.

Norman Cousins, the famous author, healer, and diplomat, first spoke to me about the healing system more than a decade ago. At this time, he was at UCLA, pioneering a new scientific program in psychoneuroimmunology, or PNI, for short, which focused on understanding how the mind and nervous system influence the

functioning of the immune system. His research findings helped usher in an important new era in medicine. When we met, he implored me to investigate and write about the healing system, but it wasn't until I came across the following extraordinary case that I became aware of the significance of Cousins' supplications.

Peter was a patient of mine who had undergone a major operation 25 years earlier, during which a part of one of his lungs had to be removed. To access his lungs, the surgeon surgically removed a rib from his chest wall. As we spoke about the operation, Peter mentioned that even though the entire rib had been removed from his spine to his chest, it had somehow grown back. As a physician, I had never heard of ribs growing back, so I asked whether he had proof. He said he had a copy of his X-ray, which verified that what he said was true. If I hadn't seen the X-ray, I wouldn't have believed it possible. And although the rib was mottled in appearance and distinctly thinner than his other ribs, there it was. One solid rib bone had grown in and connected from his sternum in the very front of his chest to the vertebra in the back of his spinal column.

Although it took his body 25 years to regrow the rib, his X-ray was proof of a healing system that was never discussed in my medical school training and was more amazing than I had ever known. To form a new complete rib where only a blank space existed is akin to salamanders growing new tails or a person growing a new limb. I still have a copy of Peter's X-ray in my office to remind me of how truly amazing this healing system within our bodies really is. It also reminds me that if we would devote more time to its study, we could learn countless other wondrous miracles about this incredible natural healing system that each one of us possesses, including how to access it to achieve optimum health.

Your body's healing system works in ways that modern science hasn't even begun to look at or understand. In addition, it has the titanic responsibility of monitoring all the other systems in your body and making sure that everything in your body is functioning at its optimum. This is especially challenging when our modern way of life, which can be fast-paced and stressful, is inherently very hard on our bodies. For this reason, it is important to get to know your healing system, to learn how to cooperate with it, and to explore and discover ways to strengthen and fortify it in the process.

In this book, I share basic information about your healing system. I also provide simple yet effective, time-honored, scientifically valid, practical strategies, exercises, techniques, and methods to help you take advantage of your natural internal healing resources. These tools will enable you to prevent and overcome a vast array of illnesses while improving the overall quality of your health and life.

Part One describes your extraordinary healing system and how it works, as well as specific strategies and techniques for strengthening and fortifying this remarkable system.

Chapter 1 explains how your body's natural state is one of health, how illness and disease are exceptions rather than the rule, how your body operates on the same principles that work in nature, and how your healing system's primary function is to help you maintain your natural state of health.

Chapter 2 presents evidence that demonstrates the existence of your healing system, with case reports and examples that reveal how your body uses specific mechanisms of repair and restoration of health that are adapted to a wide variety of medical scenarios.

Chapter 3 briefly describes the other important systems in your body that function synergistically and cooperate with your healing system to help keep you healthy.

Chapter 4 presents simple yet powerful strategies and techniques that will teach you how to cooperate with and enhance your healing system, strengthening and fortifying it so it can most efficiently do its job of preventing and healing illness and disease, while creating better overall health.

Chapter 5 covers the important area of nutrition and its role in influencing the performance of your healing system.

Chapter 6 explores the important relationship between your mind and your body, how your thoughts, attitudes, beliefs, and emotions influence your physical health and the functioning of your healing system, and what practical steps you can take to maximize the benefits of this relationship.

Chapter 7 reinforces the power of a strong and vibrant healing system as it relates to the aging process. In this chapter you'll find numerous stories of people who have lived very long lives with optimum health because of their strong healing systems. These stories illustrate the critical point that growing older doesn't have to be

synonymous with sickness and deterioration. This important chapter shows that the most effective path to a long life with good health is to keep your healing system fortified and strong.

Chapter 8 includes stories of extraordinary healing that I've either witnessed myself or have heard about. This is a small sampling of the thousands and thousands of people whose healing systems have enabled them to heal from a wide variety of health problems, from very serious illnesses, such as cancer, to less life-threatening conditions, such as eczema.

Part Two is the prescriptive section of the book. It begins with general strategies to enhance your healing system that take minutes a day, but that will have a powerful cumulative effect on your healing system. Then you'll find step-by-step strategies to help you overcome specific medical problems and heal from a wide variety of common ailments. I organized this section by the systems of the body to make it easier for you to use. Part Two ends with additional relaxation methods, breathing techniques, and guided-imagery techniques to strengthen your healing system.

The bottom line is that you have many more internal healing resources available to you than you are currently aware. If you knew what your healing system was capable of, and how you could bring out its best, you would be able to overcome almost any malady or affliction that life could throw your way. In so doing, you would discover that just as illness does not occur randomly or spontaneously, neither does health. Simple things that you can do to support your healing system can combine to make a huge difference in your health and quality of life.

We are not helpless victims of circumstance. We can do much to heal ourselves from illness, and to live vibrant, healthy, happy lives.

PART ONE

Your Extraordinary
Healing System

CHAPTER 1

Your Healing System
and Your Natural State of Health

Throughout the universe and all of nature, there exists an abundantly flowing, vibrant energy that creates and sustains all of life. On earth, this energy permeates all living forms and is the underlying sustaining principle that allows species to be born, to grow, to multiply, to flourish, and to continue their life cycles for thousands and even millions of years. This energy, or *life force,* as it is often referred to, expresses itself as vitality or "aliveness." Although there may be exceptions, this is the overwhelmingly dominant theme that governs the life of each living creature and species, including human beings. In human beings, this vitality or aliveness expresses itself as a natural state of health.

Health is your body's fundamental, natural state. Health is programmed into the DNA of every one of your cells, as it is programmed into the DNA of the cells of every human being. In fact, if you were to conduct a simple experiment by leaving your body to its own devices, supplying it with just a few basic necessities, you would discover that, for the most part, it can remain healthy all on its own, with very little interference or intervention.

Your body's natural state of health explains why the average current life span for human beings is well over 75 years, with many people living to the age of 100 or more. Without this intrinsic state

of health, humans could not possibly live this long and continue to exist generation after generation. If good health were not our species' natural, fundamental condition, we would have long since perished from the face of the earth.

Your natural state of health serves as a fundamental principle around which your body organizes, balances, and keeps itself vital and strong over the years. Because of this internal organizing principle, your body knows how to adjust and adapt to external forces and changes in the environment while keeping its order and balance. It can right and repair itself from life's myriad challenges, threats, and disturbances. Your body possesses an uncanny resiliency to spring back to health even after it has been subjected to tremendous forces of deprivation, starvation, and torture, life-threatening illnesses, and high-impact accidents.

Your body also displays an inner intelligence or wisdom that supports your natural state of health as you move through the various stages of life. Consider, for example, that your body knows how to grow a complete set of new teeth after you lose your baby teeth. How does the body know how to increase its size as it grows, to create facial hair in men as they go through puberty, and to enlarge the breasts in women? How does it know how to grow a new toenail in the place of the one that has been lost because of a stubbed toe, and to create new skin where the old layer has been lost during an abrasion? How does your body know how to knit together a fractured bone so that it is stronger than before, and to grow new blood vessels in the heart if there is a blockage in the old ones?

How does your body maintain its natural state of health, even when injuries occur and various diseases regularly assault it? How can it mend and heal itself, and return to a state of normal functioning, following infections from viruses, bacteria, fungi, and parasites, or major traumatic injuries and life-threatening illnesses? Think about childhood alone, and all the injuries children sustain, and the tears they shed throughout the early stages of growing up, as they learn to crawl, stand, walk, climb up and down stairs, run, ride a bicycle, and swim. Add to this the multitude of rashes, fevers, and infections they must endure, and it is difficult to imagine that any child could ever make it into adulthood in one piece. And yet, most of us did.

How does your body move forward through the rough and tumble, turbulent times of life and always spring back, continuing, for the most part, past the age of 50, to 75, and even 100 years or more? It accomplishes all this because of its incredible healing system, and the crucial ways in which that system works with your body's other tissues, organs, and systems.

Health Is Natural and Normal; Disease Is Unnatural and Abnormal

Because health is your natural, normal state, illness represents an unnatural, abnormal state. What do I mean by this?

The word *health* is related to the word *healing*, which is a movement toward wholeness and a sense of well-being. When you are healthy, you feel whole and well, and you have a comfortable, vibrant, free-flowing, easy feeling in your body. Your body feels light; your everyday movements and activities feel effortless. This is your natural state of health, a condition associated with a feeling of ease in the body and in the mind.

When you become ill, you lose your health. You lose your feeling of ease, and you become afflicted with "dis-ease." Understood in these terms, *disease* represents nothing more than a temporary departure from your natural state of health.

Disease represents a movement away from your central, orderly, naturally balanced state, into a more chaotic state. This condition is accompanied by a feeling of discomfort or even pain. Each movement in your body becomes difficult and full of effort. You expend great energy performing simple tasks. Your breathing is usually labored. Your heart rate is increased. Your appetite is decreased. Your body feels weak and vulnerable. This is an unnatural and abnormal state for your body.

When you have lost your health, instead of a natural feeling of lightness or ease, your body feels sluggish and heavy. You feel ill at ease because you are out of balance, and your body has become disoriented. It has become a huge distraction for your mind. To think about anything uplifting or creative is difficult, because your mental energies are completely consumed by your disease and discomfort. Your body has become a painful, heavy burden that keeps you from

enjoying your life. Disease is not your body's natural, normal state. On the contrary, it is entirely abnormal and unnatural.

In the science of biology, the word *homeostasis* describes your body as a flexible, fluid form, with an ever-changing internal environment that is naturally resilient, always striving for order and balance. This order and balance that maintain your natural state of health are achieved through homeostasis as your body processes and adjusts to external forces and stimuli to maintain its natural state of health.

When external forces become harmful or toxic, and these forces are large or persistent enough to create significant imbalance in your body, order turns to chaos, with dis-ease, or illness resulting. According to the biological principle of homeostasis, or balance, illness and disease are only temporary states. Any illness or disease, then, when dissected to its essential nature, reflects only this: a breakdown in the orderliness of your body, a state of temporary imbalance and disorder.

Illness and disease not only create temporary, unnatural imbalance in your body; they also are the result of temporary, unnatural imbalances that have been created in the world. For example, in many developing countries, where the scales of material abundance have been tipped toward poverty, scarcity, and a lack of basic human necessities such as food, water, shelter, clothing, sanitation, and education, "diseases of lack" predominate. Enough of the basic human necessities simply are not available. In this deficient environment, the body becomes weak and vulnerable and can fall prey to any of a number of diseases. Alternatively, in the developed Western world, "diseases of excess" prevail, diseases caused by too much: too much food, too much luxury, too much overindulgence, too much stress, and so on. Again, this situation represents imbalanced conditions.

Nobody gets sick by accident, or out of the blue. If you take a closer look at the factors that govern your health, you will discover that illness does not strike randomly. Disease and illness, with very few exceptions, occur at predictable times, and for discernable reasons. Just as sunrise and sunset are predictable and occur in conjunction with the earth's rotation on its axis, just as the tides of the ocean are predictable and occur in conjunction with the lunar phases, so it is with illness and disease.

Listening to Your Body

As I've already mentioned, illness and disease occur when your body's internal environment has become imbalanced and disordered. This is usually the result of nature's basic laws of health being knowingly or unknowingly violated. These laws are simple and systematic. More important, your body, which is connected to nature, is constantly trying to remind you of these laws through its intelligent communications network. In fact, you are probably intuitively aware of what your body requires to remain healthy and strong.

Your body continually provides you with clear, updated information relayed directly from a precise, highly intelligent, early warning system designed to inform you when you are in danger of losing your health. You fall into illness or disease usually when you have ignored your body's basic communications and early warning signs. This occurs in spite of your body's pleading with you to change your unhealthy ways. These physical messages usually start as gentle incantations in the form of bodily discomfort, and then progress to shouting and screaming in the form of debilitating pain.

For instance, Greg, a patient of mine with chronic back problems, was building a house. After bending over, sawing wood, pounding nails, and lifting heavy lumber all day long, in the evening he'd be extremely sore and stiff. The next morning, the pain was so bad he could barely get out of bed. Rather than rest and take it easy, however, he'd take pain killers so he could finish his work. This pattern went on for several weeks, and it seemed to work, until one day he went too far. While he was bending over to lift a heavy laminated beam, he ruptured a disc in his spine and ended up on an operating table, where he underwent emergency spine surgery. As is often the case with many of my other back-pain patients, Greg had had plenty of warning from his body before his rupture; he just chose not to listen. To him, finishing his house was a higher priority than listening to and taking care of his body. As with most illness or injuries that are entirely preventable, Greg could easily have solved his back problem without having to go through surgery if he had taken the time to heed the messages from his body.

Jim, another patient of mine, had chronic obstructive lung disease, a condition very much like asthma. He needed regular

prescriptions for inhalers that contained strong medicines, which he used daily just to be able to breathe. As a complication of his condition, he often came down with serious respiratory infections that required potent antibiotics to stop. Often, he would end up in the emergency room because he couldn't breathe. At these times, he needed oxygen, ventilating assistance, and strong intravenous medications, or he could easily have died. Although his breathing problems would flare up when he smoked, he continued to do so, to the tune of one to two packs of cigarettes a day, his pattern for more than 20 years. His body was constantly hacking, coughing, and spitting up foul-smelling mucous and phlegm. He finally got the message one day after a near-death episode, after which he ended up in the intensive-care unit for two weeks.

It has now been three years since Jim stopped smoking. Funny, he no longer requires inhalers to breathe, he hasn't had a respiratory infection in more than a year, and his chronic obstructive pulmonary disease has vanished. Jim decided to pay attention to his body's messages and work with its natural ability to maintain his health and well-being.

Sally is another patient of mine who ignored her body's messages. Sally was in a lot of pain and had been vomiting yellow, bilious material for two days before she came to my office in obvious distress. Her pain, which had lasted for almost one week, was located in the right upper aspect of her abdomen. She was significantly overweight, of fair complexion, and approximately 40 years of age. Her signs and symptoms pointed to an acute gall-bladder attack, which tests later confirmed to be the problem. In most cases, this condition, brought on largely by a high-fat diet, is completely preventable.

Almost every day for the week preceding her problem, Sally had eaten sausage and fried eggs for breakfast, burgers and fries with a milkshake for lunch, and pizza and ice cream for dinner. Even when her pain increased and the vomiting began, she continued to eat toast with butter, cheese sandwiches, and chocolate candy bars, all high-fat foods. She couldn't understand why she didn't feel better.

After I spoke with Sally at length, she mentioned to me that this wasn't the first incident of this nature. Over the past several years, after having eaten certain rich foods, she had noticed significant

abdominal discomfort, bloating, and belching, things that she attributed to mere "indigestion." Her body had obviously been trying to get her attention to change her diet for a long time.

I placed Sally on a clear, liquid diet for 48 hours and also sent her down to the hospital for laboratory tests and an X-ray to confirm my diagnostic suspicions. After the diagnosis was confirmed, I referred Sally to a surgeon to have her gall bladder removed. During the 48 hours after she had come to see me, during which she drank only water and liquids and ate nothing solid, her vomiting and pain completely stopped, and she told me she hadn't felt that good in a long, long time. However, by then, the wheels of the system were turning, and the surgeon's knife was impatiently waiting. After three days, Sally was wheeled into the operating room, where her gall bladder was removed in less than 2 hours. Sally could have maintained her natural state of health by heeding the messages her body had been giving her. Instead, she ignored them and interfered with her body's natural ability to keep her healthy and strong.

Sam's body was talking to him, too, and, like Sally, he wasn't listening. Sam was a local Hawaiian who drank a case of beer each day and didn't think much about it. He and his buddies had been on this steady regimen for many years. They met at the local beach park after work, drank, and told their stories until well after dark and it was time to go home. One day, after many years of these drinking activities, Sam came in to see me. His abdomen was tender, and his liver was painful and swollen. He was nauseous and dehydrated, and he hadn't been able to eat or drink for more than a week. He was suffering from acute (and chronic) alcoholism that was affecting his liver. His feet and ankles were also extremely swollen, a bad sign that meant he was having circulation problems, as well.

Sam had had plenty of warnings from his body before this episode. He had not only experienced a tender, swollen belly and liver, nausea, and dehydration on several prior occasions, but he had also suffered from DTs (delirium tremens) and shakes when he had tried to quit drinking. After brief periods, however, once the storms of suffering had passed, he had resumed his drinking habits with his buddies.

I was very busy with other patients, and after hearing Sam's story, I thought I wouldn't have much of an impact on helping him

to change his ways. I resigned myself to believing he was just another casualty of alcohol, and I referred him to an internist who could admit him to the hospital. I did, however, give my perfunctory speech about the need to stop drinking, which I thought would only fall on deaf ears.

Two years later, a man showed up in my office for a chest cold. Other than that, he looked healthy and in good, athletic shape. Because of his new beard, I didn't recognize who it was—Sam. He was a totally changed person!

Sam told me that what I had said to him that day did make an impact. He hadn't had a drink in two years. And it showed! Instead, he had been drinking lots of water, exercising, and doing hard physical labor; he had quit smoking, as well. Sam had finally listened to his body, and he was back to his natural state of health.

Who Gets Sick, and Why?

Many people come into my office blaming another family member, or the person sitting next to them on the airplane, for the bronchitis or throat infection they contracted. This attitude is only natural. However, because of the ubiquity of bacteria, viruses, and other organisms in our immediate environment and in the air we breathe, these microorganisms, in and of themselves, are usually not the only cause of the illness. If they were, all of us would be sick all the time. Also, if germs were spread from person to person so easily, then doctors, who spend every day around these germs and around the people who spread these germs, should be the sickest people of all. But they are not. Under normal conditions, bacteria and viruses in our environment usually do not bother us in the least. What, then, has changed that allows us to become infected and affected by them? Is it them, or something in us? Recent research points strongly in favor of the latter. *Epidemiology* is the science that studies disease outbreaks in the world, known as epidemics. A classic model known as the epidemiological triangle exists in this field. The epidemiological triangle illustrates that the existence of disease depends on three factors: 1) the host, which is the person who is the potential target of the disease; 2) the agent, which is the organism or disease-causing factor that initiates or transmits the disease;

and 3) the environment, in which both the host and agent reside or come in contact. Medical science needs to weigh and measure all three factors to help discover the true origins of illness, while it works to solve and prevent future epidemics from occurring.

Whereas previous medical research attributed more importance to the virulence of such agents as bacteria and viruses that caused the diseases, newer medical research places much greater emphasis on host resistance factors, which are factors within us that keep us healthy and help us resist illness. We can think of host resistance factors as the body's internal healing resources. They determine a person's susceptibility to illness and disease and reflect one's natural resiliency. Studying host resistance factors helps us to understand why some people get sick and why others don't, even when they are exposed to the same disease-causing agents; why certain people get sick more often than others; and why certain diseases seem to have an affinity for certain people.

Studies on host resistance factors show that, for people living in the modern, developed world, the most important factors in determining our state of health and susceptibility to illness are based on how well we take care of ourselves, how well we nurture and honor our bodies, and how well we respect our natural state of health. These factors are dependent on the personal choices we make in our every day lives.

Studies on host resistance factors have also led to the realization that, in addition to the immune system, there is another extremely important system in the body that is responsible for its natural resiliency, and its ability to heal itself and keep itself healthy. This system is the body's healing system, the most recently discovered system, and its most important one. The body knows how to heal itself and maintain its natural state of health because of its healing system.

Your Healing System
The Guardian of Your Body's Health

Imagine yourself outside on a beautiful, warm summer day. You're skipping down the street, feeling carefree and light-hearted. All of a sudden, you trip on an oversized crack in the sidewalk. As you feel yourself going down, you instinctively put out your arm to brace

your fall. As you hit the ground and slide along the pavement, you immediately feel pain in your arm. As you slowly rise to your feet, you notice an area where a patch of skin has been ripped off. It is red, raw, and bleeding. Although you're thankful that it's only a scrape, it still hurts like the dickens. In doctor's language, you have just sustained an *abrasion!*

Over the course of the next several days, without much fuss, you watch your body go through interesting yet predictable changes at the site of the abrasion. First, it begins to secrete a clear-looking fluid that eventually turns into a brown, crusty covering that thickens and forms into a scab. When your body sheds the scab after a week or two, just as a snake or lizard sheds its skin, you notice you have a brand-new layer of skin. Several months later, there's not even a scar to mark the sight of the injury. Pretty common, everyday stuff, and yet, at the same time, when you think about the fact that you have new skin, you have to ask yourself, "How did my body know how to do that?"

Your body knows how to heal itself because of its healing system. For the most part, without your even knowing it, your healing system keeps your body resilient by repairing and healing it from a myriad of problems encountered every single day of your life. These events include not only the rapid mending of superficial problems such as abrasions and cuts and bruises on the skin, but also the supervising, monitoring, and continual adjusting of critical physiological processes that occur deep within your body's internal environment. When external forces seek to create imbalance within your body, when order becomes less orderly and may even turn to chaos, when dis-ease, or illness manifests, your healing system works hard to restore order and balance to help you reclaim your natural state of health. Here are just a few ways your healing system works to safeguard your health:

- Your healing system can expand and contract blood vessels to increase blood flow to specific areas of your body that need healing.

- Your healing system can speed up your heart rate and increase the strength of its contractions to rapidly deliver more blood, oxygen, and nutrients to specific sites that need healing; this process includes cases of life-threatening emergencies.

- Your healing system stimulates your glands to produce key hormones to initiate growth and repair processes within the cells of damaged tissues.

- Your healing system can increase body temperature to cause a fever and induce sweating, to remove toxins when an infection is present.

- Your healing system can modify the function of your kidneys to reduce urine output and help conserve water if you're dehydrated.

- Your healing system supervises the amazing process of bone remodeling, of knitting your bones together as it heals fractures.

- Your healing system can increase your breathing rate and lung capacity to bring in more oxygen for your cells and tissues when an illness or injury has occurred.

Your healing system can do all of these things and many, many more. In fact, for as long as you are alive, your healing system remains viable and committed to its role as the guardian of your body's health.

Even if there have been times in the past when you were quite ill and had to struggle against life's most serious adversities and setbacks, your healing system was there for you, attempting to pull you out of your suffering. Even if you are battling an illness right now, underneath the symptoms of illness, you will find your healing system working hard to reestablish balance and order in your body. The fact that you are alive today is indicative of your healing system's functioning to fulfill your body's underlying drive to heal and become healthy once again. Even if your health is currently compromised and not what you would like it to be, you can work with your healing system to strengthen and fortify it and regain your natural state of health.

Eliminating Obstacles to Your Healing System

In many cases, you unknowingly place obstacles in the way of your healing system, creating an unfair burden that hinders its work and jeopardizes its effectiveness. By understanding what these obstacles are and removing them, in many instances, your healing system, now

unshackled to complete its task of healing, can quickly restore normal functioning to your body, enabling it to express its natural state of health.

For example, consider the case of a chronic lung infection in a person who continues to smoke cigarettes. Constant breathing of cigarette smoke is not natural. If cigarette smoking were natural, we'd all have been born with a cigarette in our mouth. Your body was designed to breathe fresh and healthy, clean, natural air. Although it can survive and tolerate cigarette smoke for a certain period of time, after a while, the smoke particles, the carbon monoxide, the tars, and the other toxic substances in the cigarette smoke create a burden on your healing system that causes an imbalance and a breakdown in your health. In this case, removing the harmful obstacle of the cigarette smoke is all that is required for your body to regain its natural state of health. With the burden of the cigarette smoke removed, it is an easy, routine task for your healing system to restore your body to its natural state of health.

Another example is evident with heart disease, the number-one killer in the Western world. Heart disease is caused by excess cholesterol accumulation. High cholesterol levels resulting from a lack of exercise, too many rich and fatty foods, and stress can clog the arteries of the heart and cause a heart attack. Removing these obstacles by restricting fat intake, increasing exercise, and managing stress allows the healing system to restore the body to its natural state of health. It is well known that this simple strategy can reverse even severe, advanced heart disease.

The major diseases of our time, including lung diseases, heart diseases, joint diseases, metabolic diseases, autoimmune diseases, and even cancer, have at their roots major obstacles that have been placed as burdens upon the healing system. Remove these burdens, and healing occurs because now the healing system is free to restore the body to its natural state of health.

Why the Healing System Has Been Overlooked

Sometimes, what we are looking for is right under our noses. This is exactly the case with the body's healing system. Until recently, we missed something very fundamental and essential about how our

bodies work as intelligent, functional, whole living systems. As a consequence, we failed to recognize the significance of the most important system in our entire bodies.

The body's healing system has been overlooked until now for a number of reasons. The primary reason is that conventional medical science focuses, for the most part, on the structure and form of the body, rather than on its function, or how the body works. This view has an impact on medicine in these significant ways:

- Conventional medicine focuses more on structure and form than on function (how the body works), and so diseases and illnesses are viewed as localized problems within specific anatomical areas of the body. Instead of one unit working as a whole, the body is viewed as many individual parts working separately and surgery is often seen as the ultimate treatment for these separate problems.

- Conventional medicine has neglected to acknowledge the central role that energy plays in the body's growth, development, sustenance, and healing. Not recognizing that energy is the real, active, life-promoting, fundamental principle in our bodies, doctors once again tend to focus more on structure and form than on function. But the healing system is not confined to one anatomical area. The body is a functional system based on the flow and movement of energies within it. The body directs healing energy to where it is needed, much like a fireman directs water from the end of his hose to help put out a fire.

- A large part of scientific research has been devoted to the study of external agents of disease, such as bacteria and viruses, and the development of specific drugs, such as antibiotics, to kill them. This research has directed awareness away from the body's inner resources. For the most part, this focus has left us ignorant about how our bodies work and how they heal themselves.

- A large amount of research is currently devoted to genetics, which seeks to link certain diseases to specific gene defects. Genetic defects are currently being blamed for most diseases not caused by external agents such as bacteria, viruses, or injuries. Although genetics certainly has its place in a person's health,

international public health data show that bad genes do not cause most diseases in the world. Most common diseases, such as heart disease, high blood pressure, diabetes, stroke, arthritis, and cancer, are linked to poor diets and unhealthy lifestyles rather than bad genes. Seeking to cure all diseases with genetic engineering through the removal of defective genes, while important for certain rare diseases, completely bypasses the importance of discovering how the body's healing system can help overcome the majority of diseases.

The Growth of Specialties in Medicine

Another significant reason that the healing system has been over-looked is the tremendous amount of information coming from so many different specialty fields in medicine today. Specialists, like surgeons, tend to treat each system of the body as a separate entity, rather than as part of a unified whole.

For example, we now have *cardiology* to study and treat the heart; *dermatology* to study and treat the skin; *neurology* for the nerves; *endocrinology* for the glands; *nephrology* for the kidneys; *pulmonology* for the lungs; *rheumatology* for the joints; *orthopedics* for the bones and muscles; *podiatry* for the feet; *otolaryngology* for the ears, nose, and throat; *urology* for the bladder and related organs; and so on. Because the healing system is integrated within the structure and function of all the other systems of the body, overspecialization has caused us to see only fragments of its existence while we continue to remain unaware of its total presence and significance.

Each specialty focuses on the study of only one system within the human body, and communication among the various specialty fields is often lacking. As a result, we physicians have developed a type of tunnel vision that prevents us from seeing the big picture, and organizing and sorting all of this specialized information into one complete, whole system. At times, it appears the left hand doesn't know what the right hand is doing. This is a major flaw of modern medicine.

The Healing System Is Not a New Discovery

Although many people regard the body's healing system as a recent discovery, in fact, ancient cultures and healers from other parts of the

world have long known about it. Within the healing communities of these societies, whose members lived in close proximity to nature and respected her wisdom, the existence of a healing system has never been challenged. It is only in our modern age of skepticism, in which we need new ideas to be scientifically proven before we can accept them as fact, that the role of the healing system has been questioned.

Even today, most practitioners of the healing arts living abroad operate from the premise that our bodies are linked to nature, and that the body's healing system works with the same intelligent organizational principles that can be found in nature. Further, they believe that by studying these natural principles, we can discover and utilize important, natural, gentle, and supportive modalities that work in harmony with this healing system to help restore and maintain our health. Healing can occur when we work *with*, not *against*, the forces of nature that exist within the human body.

When confronted with a sick patient, any physician who understands the true value of the healing system will try to understand how the body's natural forces of health became unbalanced in the first place. What caused the body to become less orderly and more chaotic, and to fall out of its natural balanced state of health and into a state of disease? Factors such as stress, poor sleeping habits, poor diet, lack of regular exercise, problems at work or working too much, turmoil at home, erratic social relationships, mental and emotional conflict, and so on, are all possibilities. Discovering and investigating these factors is critical for a successful treatment outcome. Once the harmful culprits have been identified, the road back to health becomes clearer. Removing these obstacles and harmful forces allows the healing system to do its job more effectively.

Powerful Evidence of Your Healing System

Western medical science's discovery of the body's healing system is still in its early stages, and so much of the evidence for its existence is indirect. This situation, however, is to be expected of any new field of scientific exploration. Let me explain.

In the field of astronomy, when a new star or planet is first discovered, the first sign of its existence is often glimpsed through observing its influence

on the behavior and orbiting characteristics of its closest known neighbor. Here, motion abnormalities can often be detected with the help of a high-powered telescope. Precise mathematical data about the new entity, based on mass, density, gravitational fields, and orbital motions, result in careful calculations and a closer look through the telescope, until the new star or planet comes into clear focus and is actually seen. Many new stars and planets, and even galaxies, have been discovered in this manner. In the vastness of the universe, if we don't actively look for something, the chances of finding it are almost nil.

Within our bodies also exists an entire, vast universe of its own: the healing system. Because we have spent more efforts investigating external agents of disease and haven't been actively looking for this internal system, we haven't amassed a great deal of information about it. The healing system's tremendous effect on us and how our bodies function is clear, even though we don't have scientific evidence yet of its existence. Given the limitations of our current technologies and mindset, which focus more on anatomical structures and less on energy and function, the healing system would still be difficult to accurately evaluate in all its exquisite detail and sophistication, even if we had been more aggressively looking for it.

If we can shift the current focus of scientific exploration away from the various bacteria and viruses and the pharmaceutical weapons produced to neutralize them, away from quick-fix surgical solutions, away from toxic chemicals to poison our malignancies, and away from "bad genes" that we suspect cause the majority of our other problems, and instead focus more on understanding how our bodies know how to heal themselves, then we will be much further along in learning how to cooperate with our healing systems to prevent illness, heal diseases, and enjoy long and healthy lives beyond our current expectations.

Centenarians

Living Examples of Your Healing System

In nature, each living species has a programmed lifespan, a maximum potential age to which members of that species can live. For example, most insects, such as mosquitoes, gnats, and butterflies, live to a maximum of only one to two weeks. For dogs, the lifespan

is roughly 10 to 12 years. For great white sharks, it is 300 years. For certain reptiles, such as desert tortoises, it is 400 years. For certain trees, such as the Giant Sequoias of Northern California, the lifespan ranges from 2,000 to 3,000 years. For humans, the maximum potential lifespan is about 100 years.

If a group of people ever demonstrated the human body's natural ability to stay healthy, and the existence of its healing system, that group is the *centenarians*, who, by definition, are people who have lived to and beyond 100 years of age. Surprisingly, according to recent demographic surveys, the fastest growing segment of the U.S. population is people over the age of 100. Twenty years ago in the U.S., there were 6,200 reported centenarians. Today, there are more than 64,000 centenarians in the U.S. alone. People today are more health-conscious than they were 20 years ago, so they are better at cooperating with and strengthening their healing systems. This change has enabled more people to live longer. Without the body's incredible ability to heal itself and return to its natural state of health over and over again, how is it possible for so many people to live so long?

By and large, centenarians have learned how to cooperate with their healing systems to reap and enjoy their maximum allotment of time on this earth. And most did it while staying active and maintaining their health until the very end. Looking at their lifestyles, and not merely their genes, we can learn a lot about the many ways that we too can cooperate and work with our healing systems.

Most centenarians I have met, although they are all unique individuals with their own personal stories, share a common bond in how they have lived their lives. Most have eaten moderately, kept active, enjoyed good sleep, rested when necessary, stayed involved with friends and family, and generally enjoyed life. Although their diets, lifestyles, and genes have differed, many have had to endure extreme hardships over the course of their long lives, including the loss of their closest loved ones and family members. Still, most of these people have exhibited what I would call a "lighthearted attitude." It's rare to meet a centenarian without a great sense of humor and a smile on his or her face. An example of this was the world's oldest living Western woman, a French woman who lived to 122 years of age. Although she had lost her eyesight and recently had come to rely on a wheelchair, she had just quit smoking at the age of

121! When interviewed about the secrets of her longevity, she replied that the only thing she knew was that "I only have one wrinkle on my entire body, and I'm sitting on it!" This kind of light-hearted attitude typifies those who have reached the age of 100 or beyond.

The well-known comedian George Burns lived to be more than 100 years old, and he continued to perform and act in movies until his passing. He never stopped smoking cigars; more importantly, he also never stopped smiling and telling jokes! His positive attitude helped to strengthen his healing system and bring his body back to its natural state of health after illness.

I once treated a delightful 95-year-old woman who was dressed in a hot-pink outfit, sunglasses, and a shell necklace, and who had a big smile on her face, despite the fact that she had a large gash on her leg, which prompted her visit to me. She was taking a cruise and had stepped off the ship for a day's shopping in Hawaii. When she removed her sunglasses, I saw a pair of youthful, sparkling, blue eyes that easily revealed her carefree, optimistic attitude toward life. After several minutes of chatting as I attended to her wound, she asked whether I could speed things up. "Why?" I asked.

"Because my older sister is in your waiting room, and I don't want to keep her waiting. We only have one day on your island, and I promised to go bodysurfing with her!"

When I stepped out into the waiting room, I saw her sister, three years her elder. She was also vibrant and smiling, and dressed in a matching red outfit with a straw hat!

Many people come into my office and tell me that they are "getting old and falling apart!" I have had people in their thirties and forties tell me this. Conversely, I have seen many other patients who are learning how to surf and water ski at the age of 70, others who are taking yoga in their eighties and are more supple and graceful than people less than half their age, and still others who are dancing and gardening daily well into their nineties. Youth and health appear to be more connected to our states of mind, and reflect our attitudes more than pure chronology. A positive attitude and a zest for life are critical for enhancing and fortifying your healing system.

Take a lesson from the centenarians, and discover the many ways that you too can enjoy a long, healthy, and rewarding life, free from disease and debility, way beyond your present expectations, by

learning to cooperate with your healing system, and respecting and honoring your natural state of health.

Closing Thoughts on Your Healing System and Your Natural State of Health

Health is your normal and natural state. This condition is founded on universal biological principles that apply to all living species, not just humans. Health is programmed into the DNA of every cell in your body and is the reason why the human species has been able to flourish and survive from one generation to the next for thousands of years. Health is the reason you are alive today. The maximum average potential lifespan for a human being is 100 years or more. Because your natural state is health, any deviation from this natural state represents an unnatural condition. You are actually programmed for good health the day you are conceived.

Disease and illness not only are undesirable conditions, but they also are fundamentally unnatural and abnormal. Their existence represents a departure from the natural laws that govern normal biological processes on earth. When you become ill, it usually means that unnatural, harmful, unhealthy forces have been imposed upon your body that cause it to become temporarily imbalanced and disordered. Restoring order and balance returns your body to its natural state of health. This is the job of your extraordinary healing system, which can be thought of as the guardian of your body's health.

Even though challenges and difficulties may seem to be an almost daily occurrence, your body can rise to meet these challenges and difficulties because it has an extraordinary healing system that has been designed to sustain, repair, and correct imbalances and problems, naturally and automatically. At times, disease may appear overwhelming and all-encompassing, but your healing system can help your body bounce back to reclaim its natural state of health, even in the face of death, and at times when you have abandoned all hope. Through your healing system, your body possesses an uncanny natural resiliency, like a buoy floating in the sea, to right itself in the midst of life's most devastating tempests.

In the next chapter, you will get a closer look at your healing system in action, including the opportunity to examine the evidence for its existence, and to understand what this system does and how it works. You will also discover why learning to cooperate with your healing system, and strengthening and fortifying it, are essential for you to achieve and enjoy optimum health.

CHAPTER 2

Your Healing System in Action

When you think about the number of threats and insults your body sustains over the course of a lifetime, the fact that it can remain healthy at all is truly amazing. To accomplish this incredible task, you need a single system in your body that can supervise and direct all the other systems into a unified, efficient, orchestrated healing response for your protection and the preservation of your natural state of health. That single, supervisory system is your healing system.

Your healing system not only maintains your natural state of health, but whenever you are sick or injured, or whenever your health is threatened, it also is in charge of damage control. It monitors and supervises all processes of repair, growth, and restoration of health and normal functioning of your body's cells, tissues, and organs. In fact, you wouldn't be alive today if it weren't for your body's remarkable healing system.

Illness or injury can strike at any time, and so your body needs a system it can count on to safeguard its health, 24 hours a day, 7 days a week, 365 days a year. In this regard, your body's healing system is a tireless workhorse because it never sleeps or even snoozes. It cannot even afford the luxury of a catnap. It remains alert at all times, ready to spring into action at a moment's notice. Like a 911 emergency-response, paramedic rescue crew, your healing system is

on call continuously—no time off for sick leave, vacations, or even good behavior. It also has tremendous endurance and stamina, and it can remain operational for up to 100 years, or even longer.

Your healing system permeates every organ and tissue in your body; it is not confined to any one structure or specific location. It cannot be surgically removed, or even visibly seen on an X-ray, CAT scan, or MRI, as is the case with most other structures in your body. When you are healthy, it is difficult to even know that such a system exists; however, during times of injury or illness, as your body mounts a healing response, evidence of its existence becomes quite apparent.

Although your healing system is arguably the most important system in your body, you probably have never heard about it before, or, if you have, the information was sparse. Although you may be familiar with the other systems in your body, such as the digestive, respiratory, circulatory, nervous, and immune systems, you probably are reading about the healing system for the very first time. In fact, you may be confusing your healing system with your immune system right now, as many people do.

Differences Between Your Healing System and Your Immune System

When people first hear of the healing system, they often confuse it with the immune system. Even though on one level the two systems may be difficult to tell apart because they work together in a coop-erative effort, on another level they are two very different systems that serve entirely different purposes.

The fundamental difference between the two systems is that your immune system is concerned with defending your body against infections, while your healing system is responsible for repairing tissue damage from injuries or illnesses, and restoring your body to its natural state of health. Your immune system's focus is largely on attacking and protecting your body from foreign invaders. Your healing system focuses more on healing, growth, regeneration, restoration of function, and maintaining health.

For example, if you were to come down with bronchitis, which is an infection in the respiratory system, your immune system would

be expected to attack and eliminate the offending organisms that are causing the infection. However, if you were injured in a car accident and broke your arm, your healing system would be called upon to heal your injuries. Your immune system would not become involved because typically there is no infection with a broken bone. The mending of the broken bone would be a specific function of your healing system.

Similarly, if you had a heart attack, your healing system would immediately become activated. A heart attack is not caused by an infection, and so healing from it does not involve your immune system, but rather your healing system. After a heart attack, your healing system repairs the damage to your heart muscle while it restores normal functioning to your heart.

When you understand that most diseases and injuries are not caused by infection, the distinction between your healing system and your immune system becomes clearer, and the unique role of your healing system becomes much more significant.

All of this having been said, be aware that there are times when the division of labor between your immune system and healing system is not so clear. Your healing system and immune system work together and cooperate with each other to keep you healthy. For example, if your body has sustained damage from an infection, your healing system and immune system will work side by side to repair the damage as they fight against, neutralize, and remove the infectious agents to prevent further damage to your body. Your immune system will attack the infection that caused the problem, and your healing system will actually repair the damage the infection caused to your body.

Listening to Your Healing System

Because your body's natural state is good health, your physical needs are actually quite simple. However, when these needs are not being met, your body is not shy about giving warning signs to prompt you into taking immediate corrective action. When situations of urgency arise, or when you are not healthy, your body, through its communications system, which works closely with your healing system, will

let you know immediately. For your healing system to repair, restore, and sustain your body most effectively, you must learn how to listen to your healing system when it talks to you.

For instance, when your water reserves become low, and there is danger of dehydration, your thirst mechanism kicks in, urging you to drink. When your body is low on energy and you need more calories, your hunger drive is activated, prompting you to eat. When you need sleep or rest, you will begin to yawn, and your eyes will feel heavy, urging you to lie down. When you become chilled in cold weather, your body will begin to shiver, forcing you to put on a sweater or jacket, or to seek shelter. If you eat foods that are too rich or too spicy, or the wrong combination of foods, you'll feel nauseous and might possibly even regurgitate. All these sensations and responses are part of your body's intelligence and communications network, which your healing system monitors and supervises to help restore normal function and maintain your natural state of health.

Two Essential Roles of Your Healing System

Your healing system functions in two critical ways. In its first important role, much like a foreman at a large building site who supervises, organizes, and dispatches workers, equipment, and machinery while he overlooks a construction project, your healing system meticulously monitors, surveys, and observes each and every part of your body to ensure that all organs and tissues remain healthy and function smoothly. It facilitates communication between your body's various systems and their respective cells and tissues. It monitors your body's complex internal environment, where literally millions of powerful chemical reactions occur each day. Your healing system troubleshoots problems anywhere in your body. Just like a mother who cares for and looks after her children, your healing system in its protective and nurturing role safeguards the integrity of your entire body, helping maintain its natural state of health.

In its second vital role, your healing system functions like an emergency-response paramedic crew, jumping into action whenever there is a threat to your health. In this more active phase, your healing system is able to perform a wide range of diverse functions, such

as dispatching nerve messages and impulses; mobilizing immune and inflammatory cells; coordinating the release of powerful chemicals that can raise body temperature, dilate or constrict blood vessels, increase or decrease blood flow to specific areas; and performing many other vital functions. Your healing system directs the activities of the other systems in your body to cooperate with each other in providing a unified, concerted, and effective healing response.

In its first role, you may not even be aware of your body's healing system as it goes about the business of its crucial surveillance work silently and without much fanfare. In the second role, however, the presence of your healing system is much more noticeable, with specific changes that occur in your body as a result of its actions. The dual supervisory and emergency-response roles that your healing system plays in the general functioning of all the systems and structures in your body makes it the most powerful and important system in your body.

How Your Healing System Works

Understanding how your healing system functions requires a different way of thinking about how your body works. Although doing so may seem difficult at first, if you think of your body in terms of energy and function, rather than in terms of matter, structure, and form, it will all make perfect sense. Thinking in terms of energy does not ignore or nullify the existence of certain structures within your body; rather, this view gives you a deeper look into the dynamic forces that govern your health. When these dynamic forces become unbalanced, you can easily see how problems that create illnesses and diseases in your body arise. Armed with this knowledge and insight, you will be able to more effectively remedy these problems by working with, rather than against, your healing system. Let's examine a case that illustrates this point.

Al cut his finger with a kitchen knife while he was slicing vegetables. At first, there was no blood at all, and he imagined that maybe it didn't really happen, and that he'd get off easy. Then, as the first signs of blood began to ooze out of the wound, he realized the puncture was deep. In no time, the bleeding became profuse. Pain,

delayed for several seconds, soon began to pulsate and throb throughout his fingertip and entire hand. Al applied pressure to prevent his blood from spilling onto the floor. After half an hour, he noticed the bleeding had slowed. An hour later, it eventually stopped.

From the very beginning of this incident, and over the course of the next several days, Al's healing system was busy activating a healing response that includes

- The nervous system, which first responds with messages of pain that warn Al an injury has occurred.

- The complex mechanisms of blood clotting, which are a sophisticated interaction of hormones, enzymes, and numerous chemicals and cells within the circulatory system. These components are naturally sticky and join together to seal off the wound to protect the body from further blood loss.

- The layers of the skin, deeper tissues, and various cells, which weave themselves together to form a transitional, intermediate layer of skin and fill in the gap created by the wound.

- The formation of a scab, which protects the deeper, more sensitive layers of new skin and tissues as the healing process continues.

When the scab sloughs off, Al's healing system miraculously manufactures new skin where the old skin had been completely severed. After several weeks, Al's finger looks the way it did before his injury, as if nothing had happened at all.

Even though Al's injury is a relatively simple one, if you look at the sequence of events, the various systems and components involved in the healing of his wound, and the synchronized flow of energy and movement during the entire healing process, you start to develop an appreciation for the degree of complexity and precision, and the incredible organization, speed, and efficiency your healing system requires to perform this specific task.

Keep in mind that your healing system supervises and coordinates all healing responses in your body, including illnesses and injuries that are far more complex and serious than Al's injury. And even though your healing system may appear to be hidden and difficult to pinpoint within any given part of your body, you can begin

to understand the function and purpose of this amazing system by observing its powerful, swift, dynamic and efficient movements, and viewing the results of its actions. The subtle and dynamic aspect of your healing system is one of the reasons it has not been more widely recognized, acknowledged, and accepted until just recently.

The Immune System and the Healing System

The immune system and the healing system are both subtle and dynamic systems, and although they often work together, they serve different functions.

The healing system is even more subtle and more widespread in its distribution throughout the body than the immune system, permeating every organ, tissue, and cell in your body. It is also more powerful, more dynamic, and more diversified in its functions and tasks than your immune system.

Like the healing system, the immune system has many branches, is not limited to one particular area of the body, and operates on the microscopic level of cells and biochemicals. In fact, your immune system collaborates with your healing system and can be thought of as an aspect of the healing system that is concerned with preventing and eradicating infections from the body. The immune system also was poorly understood and not given much importance in the practice of modern medicine until the discovery of AIDS. Fortunately, with the shift of funds and resources, and research being directed from without to within the realm of our own bodies, we have learned more about our body's natural defense system than we ever imagined existed.

Your Healing System and the Other Systems in Your Body

Your healing system utilizes the special properties and functions of other systems in your body, integrating and supervising their activities into one organized, efficient healing response. To understand this more clearly, let's see what happens when you accidentally touch a hot electric iron and burn yourself.

Imagine an iron that is plugged into an electrical socket, sitting upright on the ironing board, and inadvertently left on for half a

day. When you discover the iron and try to put it away, you accidentally touch the very hot bottom.

As soon as you touch the hot iron and hear the sizzling sound of your flesh burning, you instantaneously feel pain as you immediately jerk your hand back. In addition to the incredible burning pain, within a matter of minutes, you begin to notice blisters forming on your fingers and hands in the places that came in contact with the iron. From the vantage point of what is going on inside of your body, let's take a closer look at what is happening, step by step, as your healing system springs into action:

Step 1

Your healing system is immediately activated when you touch the hot iron, as the pain sensors in your fingers and hand send a signal to the brain through your nervous system. Your nervous system, working with your healing system, initiates a reflex response in the muscles of your arm to contract the arm, pulling it away to prevent further contact with the hot iron, which prevents further injury.

Step 2

Almost immediately, in collaboration with the skin, your healing system coordinates a response that first results in redness or inflammation as tiny blood vessels are directed to increase blood flow to the area of the scorched skin.

Step 3

Specialized cells known as *macrophages*, along with red blood cells, white blood cells, oxygen, and other essential nutrients, are pumped into the bloodstream and directed to the injury site to help nourish, fortify, and support the body's repair processes.

Step 4

Shortly thereafter, the skin secretes specific fluids to help form blisters at the burn sites. The blisters serve several protective and healing functions. First, the fluid-filled sacs act like shock absorbers to protect the raw, injured skin that lies underneath. They also act as sealed barriers against the possibility of infection. The fluid inside the blisters also contains nutrients to help nourish and feed the new

layer of skin that will form underneath. Antibodies and immune cells also have been mobilized by the immune system in this fluid. These mechanisms also are under the direction of the healing system, to ward off any microorganisms that might cause infection. In addition, the body releases other important chemicals to cooperate in the healing response.

Step 5

With the healing response well under way, new cells, fluids, and chemicals are continuously pumped in and out of the burn site over the course of the next several days and weeks; the pain begins to subside and the new skin growth accelerates.

Step 6

Soon, the blisters gradually shrink as the fluid is reabsorbed back into the body, with new skin arising to take the place of the previously injured old skin.

Step 7

Continued healing mechanisms are activated on the microscopic level to finish the job, and, if all goes well, not even a scar will be present where the new skin has grown back.

Even with a simple injury such as a minor second-degree burn, you can see that a lot more is going on in your body beneath the surface of the skin than meets the eye. As with the more serious and complicated problems that occur within your body, again it is clear that the body needs a single system that can supervise and direct all the other key systems into one orchestrated and efficient healing response for the protection, self-preservation, and health of your body. This is the incredible job that your healing system does for you.

Healing System Responses vs. Symptoms of Disease
A New Way of Thinking About Your Health

When our healing system is initially activated, we might confuse the changes that occur in our body, which are normal healing responses,

with symptoms of a particular disease. In fact, this is the common mistake most people make, including doctors and the medical profession in general. Again, until very recently, our culture has been disease-oriented in its approach to understanding health and healing, and so we have remained largely ignorant of the healing system and how our bodies continually strive to correct imbalances and keep us healthy.

When things begin to change in our bodies, we automatically assume we are sick, and that something is dreadfully wrong. If our bodies begin to reflect imbalance and function abnormally, if there is some discomfort or pain, our first assumption is most likely that we are becoming sick or that we have an allergy. This is because we are trying to account for our symptoms. This is a natural and normal interpretation of what is happening with our bodies.

Rather than jumping to the conclusion that something is wrong with your body, first try to understand how your healing system may be responding appropriately to correct an imbalance that has occurred. Let me explain what I mean.

Consider sneezing, for example. We usually think of sneezing as a symptom of the common cold, or the beginning of an allergy. In reality, sneezing is a normal healing-system response to expel foreign debris, flush out irritants, remove potential pathogens, rid the body of disease, and help the body maintain its integrity. Sneezing also is a protective mechanism that helps to prevent the further advance of unwanted foreign invaders into the deeper, more delicate structures of the respiratory system, such as our lungs and sinuses, and is another common way that our healing systems safeguard our health.

In addition to sneezing, most people, including doctors, confuse many other common healing responses with symptoms of a disease. These responses include the following:

- *Coughing.* Also considered a symptom of a respiratory illness or condition, coughing is a definitive response from your healing system to expel unwanted debris and invading microorganisms that have penetrated deeper into the respiratory system and are threatening to cause damage to your lungs. In medical circles, a good cough is known as a productive cough in that it successfully brings up phlegm, mucous, microorganisms, and infectious

debris, which effectively clears the airways and makes for easier breathing. Coughing can be powerful; the speed at which foreign particles and debris exit the lungs with a cough has been clocked at approximately 660 mph, about the speed of an F4 Phantom fighter aircraft.

- *Diarrhea.* Usually considered a symptom of an intestinal disease, diarrhea is a healing response that your body uses to eliminate toxins and contaminated material from your colon and large intestines. Diarrhea is fast and efficient, and it helps to flush out what is irritating or offending your intestinal tract. A number of potentially serious intestinal diseases or problems can be eliminated this way. Suppressing diarrhea through artificial medications can be dangerous, and doing so often backfires. When you clog up your body's natural eliminative processes through the suppression of diarrhea, harmful microorganisms have nowhere to go but further inside your body, where they can invade your liver or bloodstream and cause more serious illness. Of course, there are times when too much fluid and electrolyte loss from diarrhea may require medical intervention. However, by seeing diarrhea as a response of your healing system, and seeking out ways to cooperate with that system, you can often make simple, natural adjustments to restore balance and health to your body. These may include drinking more fluids, avoiding irritating foods and substances, and managing stress, which can be harmful to your intestines and digestive system. (We will look more closely at these factors in the chapters that follow.)

- *Fainting.* Fainting occurs when a person temporarily loses consciousness and falls down. The causes of fainting can range from serious to benign, but the loss of consciousness is usually due to of a lack of blood flow to the head and brain. Falling down while fainting represents a compensatory response from your body's healing system. When the body has fallen and lies flat on the ground in a horizontal position, blood flow and oxygen to the brain increase, which can often restore consciousness. Most instances of fainting are totally benign, especially if no serious underlying diseases or conditions exist. However, there are occasions when serious underlying disease is present, and you will

need to be brought to the hospital and treated. However, the correct treatment is to deal with the underlying causes that precipitated the fainting, not just with the fainting itself.

■ *Fever.* Commonly associated with an infection, fever is your healing system's way of heating your body up to kill offending organisms, most of which are extremely temperature sensitive and cannot tolerate excessive heat. Additionally, fever induces sweating, which helps the body eliminate toxins more rapidly. Learning to work with a fever through continuous rehydration (drinking plenty of water), rather than suppressing a fever with artificial medications, will support your healing system and result in a faster, more thorough healing response. Even at times when medical suppression of a fever may be necessary, fluid intake should be encouraged. With any fever, it is prudent to look for the underlying causes of the fever and to treat these, not just suppress the fever. Doing this works with your healing system to help restore health and balance to your body.

■ *Nausea.* Nausea occurs in the small intestines and stomach, and it is a specific response from your healing system that protects your body from more food entering into it. When you feel nauseous, you have lost your appetite for food. Your healing system does this when your body needs to limit solid food intake. Nausea occurs when you have a high fever and are in need of lots of fluids, or when you have a stomach virus or an ulcer, and solid foods would make these conditions worse. Nausea also helps to conserve energy and frees blood flow from the digestive tract so it can be rerouted to other areas of the body that have a greater immediate need for healing energy.

■ *Pus.* Your body's healing system, working with your immune system, produces pus, an unpleasant, smelly, yellowish substance, to help eliminate foreign material, both large and small. Pus commonly occurs with infection. In the case of a splinter or foreign body in the skin, your healing system will form a pus pocket to wall off the splinter, separating it from the rest of your body. Your healing system will attempt to digest and dissolve the splinter or foreign object; if this proves difficult, it will try to push the splinter out of the skin. In addition to fluids secreted

to flush out microorganisms and foreign debris, pus contains white blood cells and digestive enzymes that break down and digest foreign material. In the case of a bacterial infection in any part of the body, the pus produced will attempt to kill off and digest the bacteria while it flushes out the infection.

- *Runny nose and nasal congestion.* Usually considered symptoms of the common cold or allergies, a runny nose and nasal congestion are actually specific responses from your body's healing system. The increased secretions, mucous, phlegm, and congestion are your healing system's way of attempting to flush out any offending organisms or foreign particles that may have invaded the entrance to your respiratory system. Although attempting to suppress these healing responses with nasal decongestants and other drugs gives temporary relief, doing so often backfires; it can prolong an illness and even make things worse. Because the pharmaceutical agents tend to dry up the secretions to eliminate symptoms, they work against the natural processes of your body's healing system to eliminate harmful substances.

- *Swelling and redness.* The first visible signs at the site of any injury, trauma, or infection in the body, swelling and redness, too, are specific responses of your healing system. Whether caused by a bruise, a contusion, a sprain, a fracture, or an infection, swelling is the result of increased fluids from the lymphatic system, leaky blood vessels, and other soft tissues. The fluid helps immobilize the site and serves as a shock absorber to prevent further injury to the area. Redness, known as inflammation, is often accompanied by pain and represents increased blood flow to the area. Inflammation is a complex response from your healing system, working with your immune system, to bring important cells and powerful chemicals to the injured area to help remove toxins, repair damaged tissues, and speed healing.

- *Tearing of the eyes.* Tearing is a specific healing response similar to what occurs in a runny nose. Tearing helps to flush foreign material or microorganisms out of the delicate and sensitive surfaces of the eyes. Sometimes, when infection or irritation is extreme, the eyes will remain glued shut because the tears and secretions have dried up. Keeping the eyelids glued shut is a

further attempt of the healing system to protect the eyes from additional injury or damage.

■ *Vomiting.* Vomiting is a protective mechanism that your healing system uses to eliminate contaminated or noxious material that has somehow entered into your stomach and small intestines. Vomiting is a fast, efficient, and powerful way for your body to rid itself of toxins or other harmful substances. After you have eaten contaminated food, as in food poisoning, vomiting will occur to expel infectious organisms as well as unwanted food and toxins. People usually report feeling much better after they have vomited in these instances. If you have overeaten, eaten foods that are too rich, or drunk too much coffee or alcohol, which act as intestinal irritants and toxins when they're taken in excess, vomiting will occur to clean out and reduce the burden on the digestive system and body.

Although initially you may think these responses are associated only with the individual systems within the body, such as coughing and the respiratory system, or vomiting and the gastrointestinal system, remember that it is the healing system's presence within and its supervisory role over these systems that actually causes these responses. Keep in mind that the healing system is not a separate anatomical system. It is a functional, energetic, intelligent system that permeates every single system in your body.

As you read the rest of this book, think about your body, your bodily sensations, and any changes that are occurring in your body as well-measured responses produced by your body's healing system. Think of them as responses that are intended to correct imbalances and help you maintain your natural state of health, rather than symptoms of disease. Shift your awareness away from your symptoms, your discomfort, and your thoughts of an illness or allergy, even if these are real problems for you. Instead, trust that your healing system is making necessary physiological adjustments to correct imbalances and restore your body to its natural state of health.

I realize this perspective may be a radical departure from how you currently view your body and your health; however, learning to do this will make a significant difference in your health. If you can focus

less on disease and more on health, less on what is wrong with your body, and more on what is functioning properly; if you can turn your attention away from the fear of external causes of disease and agents of disease that lie beyond your control, and instead look with confidence to the hidden treasure chest of healing resources that lies within your very own body, you will be able to reap the benefits of superior health. If you can learn to recognize the many ways your healing system responds to challenges, your dependence on drugs and doctors will be lessened, and the quality of your life will be vastly improved.

Benefits of Recognizing Your Healing System's Responses

You will gain a great deal by recognizing the responses of your healing system. Your healing system

■ Empowers you to discover and make use of the vast supply of healing resources that lie within your own body.

■ Directs your energies and efforts within your own body and away from blaming your discomfort or disease on external causes and forces beyond your control, which can be disempowering.

■ Shifts your focus away from fear-based thinking that can be harmful to your health and well-being.

■ Empowers you to take greater responsibility for your life, and helps you understand the connection between your own actions and thoughts, including your diet and lifestyle, and your health.

■ Lessens your dependence on doctors, drugs, and external agents of treatment.

■ Improves your confidence in your body's ability to remain healthy and heal itself.

■ Helps in planning the treatment and healing of any health problem you might face.

You can see that the benefits of recognizing the power of your remarkable healing system and working with it will have a huge, positive impact on your health and your life.

Note: As you are learning this new way of thinking about your body, do not neglect to see your doctor if any physical discomfort or pain increases or does not go away on its own. Your doctor can be a valuable aid and support for your healing system.

Clinical Evidence of Your Healing System at Work

We've already looked at healing responses in general, and we've seen several different examples of the healing system at work to help heal superficial injuries. Now let's move deeper inside the body as we continue to examine the evidence that clearly demonstrates that your body has a healing system that keeps you alive and healthy. In each of the situations that follow, remember that the healing system is the essential element in the healing process and that, without it, healing would not occur.

Your Healing System and Fractures: Sam's Story

Sam was a 34-year-old senior staff sergeant with 15 years' experience as a veteran paratrooper and combat controller in the United States Air Force. During a routine training mission, he was required to jump from an altitude of 10,000 feet at nighttime over remote jungle terrain. Sam got caught up in a tree as he was landing and broke his ankle in several places. The bone pierced through the skin, making it a compound fracture. This type of injury has a high rate of infection and is notoriously difficult to treat. Infection that sets into the bones is known as *osteomyelitis*, a serious condition that is difficult to eradicate and that complicates the healing system's ability to knit the bones together to heal a fracture.

Sam was taken by airplane back to the Regional Medical Center in the Philippines, where I was required to follow his case to see whether he would ever be able to resume his career duties again. For all intents and purposes, it looked as if his military career was over.

Sam was hospitalized repeatedly, placed on numerous antibiotics, and operated on 11 times over a two-and-one-half-year period, in attempts to knit his bones together. During this period, he wore a cast almost continuously and was never able to walk on his own, relying instead solely on crutches. He underwent numerous painful scrapings and bone grafts in an attempt to clean the surfaces of the bones from infection while the doctors were trying to join the bones together. During these operations, numerous plates and screws were also attached to his bones.

At one point, when it looked as if the fracture might heal, Sam's cast was removed, and he was told he could participate in light

sports. A week later, while he was fielding a grounder during a friendly squadron softball game, Sam's ankle snapped and broke in two pieces as his foot bent out at a 90-degree angle. After this, it was back to the operating room for him, with more scraping, more metal plates and screws, another cast, and more crutches.

After two and one-half years, Sam was not only in jeopardy of losing his job and being medically discharged from the Air Force, he was also being considered for a foot amputation. He consulted with the prosthetic specialist, who began fitting him for a prosthetic (artificial) foot in anticipation of the upcoming operation. This was a frightening proposition for such an active and previously healthy young man.

Back home in the U.S., a brilliant orthopedic surgeon named Robert Becker had invented an electrical bone stimulator to aid the healing system in cases of stubborn-healing fractures. Sam faced the prospect of either having his foot amputated, or having this tiny, electronic device, still in the experimental stages, temporarily implanted next to the fracture site in his ankle. He chose the new device, hoping against hope that it would work.

Several months later, Sam was back with a clean bill of health, jumping out of airplanes. His bones had mended together with the help of a device that worked with the healing system. Dr. Becker knew that, given half a chance, the body's healing system could take over and finish the job. As the famous physician of ancient times, Galen (129–199 AD), once said, "The physician is only nature's assistant."

A fractured bone is not a laughing matter, and it can be extremely painful and disabling. However, because of your healing system, even the largest bone in your body, your femur, under normal circumstances takes only six weeks to completely heal. Even if a fracture is displaced and the broken bones are not perfectly lined up, in most cases, your healing system can knit the bones together and realign them perfectly, so that when the healing has finished, there is little or no evidence that a fracture ever occurred. Even when fractures are complicated, and bones are totally displaced and out of alignment, and metal plates and screws are required to hold the bones together, your healing system can fuse them into one solid form. Without your healing system, fractures would be impossible to heal.

Whether or not a cast or splint is placed around the fracture site, if a fractured bone is allowed to rest and remain immobile, bone remodeling, initiated by your healing system, begins immediately after a fracture has occurred. Bone remodeling, when seen under the microscope, is one of life's true miracles. Tiny cells in the bone matrix, known as *osteoclasts*, digest the bone and release calcium into the bloodstream, while other cells, known as *osteoblasts*, act like civil engineers erecting a new suspension bridge and use the blood-calcium stores to deposit new bone at the fracture site. These deposits facilitate the process of knitting the bone back together again. No modern technological invention, surgical procedure, or synthetic drug can replace your healing system as it performs the important work of repairing a fracture. The natural healing of a fractured bone after it is healed is so effective that the fracture site is often stronger than the surrounding normal bone tissue.

Your Healing System and the Heart: Verne's Story

Verne's heart disease was discovered when he had his first heart attack in the emergency room at the age of 69. He had another attack about a year later. Over the course of the next several years, he was placed on numerous medications while he underwent several procedures, known as *angioplasties*, to unclog his arteries and slow the progression of his disease. But these methods were only temporarily successful. Over time, Verne's heart disease grew worse. He was plagued with constant chest pain, which increased when he walked up stairs or whenever he became angry or upset. It was quite scary.

When I met Verne, his heart disease had progressed to desperate proportions, and his doctors were recommending bypass surgery as the only way to keep him from dying. Even then, because of his advanced condition, they said his prognosis did not look good, and the bypass operation would only buy him a couple of extra years, at best. Verne was not too keen on having his chest cracked open, and by sheer persistence and determination, he was able to enroll in Dr. Dean Ornish's first experimental research study group to investigate whether or not heart disease could be reversed without drugs or surgery.

Dr. Ornish's program is based on the now-proven premise that if you can remove the obstacles to your body's natural healing processes, and work with your healing system, even severe heart

disease can be healed. Dr. Ornish's program is simple and uncomplicated, and it consists of comprehensive lifestyle changes that include a healthy diet, exercise, stress management, and group support. Of course, at the time of his first study, these ideas and methods were considered radical by conventional medical standards. Even to this day, the thought of reversing heart disease is difficult to digest for those steeped in the "old school" ways of thinking about medicine and the treatment of disease.

Verne took to the program enthusiastically, and within several weeks his chest pain went away as his breathing became easier. He began to have more energy and at the same time felt more relaxed. His stress and anger diminished. Gradually, one by one, the 13 different heart medicines he was taking were reduced until he was down to one-half of a baby aspirin, every other day.

Today, at the age of 87, Verne is totally free of heart disease. All of his medical tests—*positron emission tomography* (PET) scans and *coronary angiograms*—have documented complete reversal of his condition. He hikes in alpine altitudes and travels the world extensively with his wife, teaching yoga and lecturing to senior citizens on the merits of the Ornish program and the body's natural ability to heal itself.

Although heart disease is still the number-one killer in the entire Western world, even this deadly condition can be reversed and healed when you learn to cooperate with your healing system, as Verne did, by correcting the unhealthy underlying factors that are causing blockages in the coronary arteries. As is possible for you, Verne discovered the tremendous healing resources within his own body, and, by adopting a healthier lifestyle, he became a partner in his own healing process. Thanks to the groundbreaking work of Dr. Ornish, we now know that by learning to listen to the body and working with its healing system, people can reverse even the most advanced cases of heart disease.

As a direct result of Dr. Ornish's work, we now know that the healing system can stimulate the growth of new blood vessels to the heart when its current blood supply is threatened. This process is known as *neovascularization* or *collaterization*. The new arteries can effectively bypass the old blockage, ensuring a continuous, uninterrupted flow of blood to the heart's muscles. The process can prevent

heart attacks, and it is how you can literally grow your own coronary artery bypass, without having to go through an operation.

Even if you have suffered a heart attack, and the heart's muscle cells seem to have died, new evidence has demonstrated that through your miraculous healing system, and restoring blood flow to these heart muscle cells within a reasonable period of time, they can miraculously come back to life. The medical term for this new discovery, wherein heart tissue that is presumed dead can come back to life when circulation is re-established, is *hibernating myocardium*—like the sleeping bear who reappears when winter is over.

Your Healing System and High Blood Pressure: Mike's Story

Mike was a flight engineer in the Air Force, where he had served for 20 years. He had flown in Vietnam, was married with three children, and loved his job. However, because he had been recently diagnosed with high blood pressure, he was in danger of losing his job and possibly being kicked out of the Air Force. To prevent this from happening, he lost 25 pounds over six months by eating a low-fat diet and running every day for 30 minutes. However, his blood pressure still did not come down. To complicate things further, because of his flying status, he wasn't able to take medications of any kind. I was an Air Force flight surgeon at the time, and he came to me seeking help.

After I reviewed his records and his efforts to lower his blood pressure by losing weight through diet and exercise, I asked Mike whether he was under stress of any kind. He quickly responded with a confident and adamant "No!" This response let me know immediately that I might be in for a difficult case because I had yet to meet someone in the military who wasn't under a certain degree of stress. Additionally, I later found out that Mike was having some troubles with his marriage, which were causing even more stress. In spite of his finest efforts to lower his blood pressure through diet and exercise, stress was contributing to his continued high blood pressure.

After several meetings and long discussions, during which I explained the mechanisms of how prolonged stress can cause high blood pressure, Mike was finally able to own up to the stress in his life. He then consented to learning and practicing the simple, basic

stress-management techniques (see Chapter 6) I recommended, which I thought would activate his healing system and lower his blood pressure.

After only six weeks, Mike's blood pressure returned to normal and remained there for the rest of his career. By removing the unhealthy factors that were responsible for creating the high blood pressure, particularly the extreme stress in his life, Mike's healing system could easily and effortlessly restore his body to its natural state of health. Of course, he still continues his healthy lifestyle, including a low-fat diet, and 30 minutes of exercise and 15 minutes of stress management each day.

As you can see, one of the most significant underlying factors in high blood pressure is stress, which can create significant imbalance in the body's internal environment. Dr. Herbert Benson, associate professor of medicine at Harvard Medical School and chief of the Division of Behavioral Medicine at the New England Deaconess Hospital, has conducted numerous studies on the benefits of stress management in lowering high blood pressure. By practicing simple yet powerful stress-management techniques similar to those taught by Dr. Benson (see Chapter 6), you can help your healing system restore your blood pressure to normal levels.

High blood pressure, or *hypertension*, is known as "the silent killer" because it can lead to more serious, and sometimes deadly, conditions such as heart disease and stroke. Although many medications are currently available for managing high blood pressure, they often have side effects, and, unfortunately, none of them can cure the problem. Once patients begin taking these medications, getting off them is difficult, and many people will be on two or three of them just to manage their high blood pressure.

Just as with heart disease, new evidence is proving that the healing system can reverse and heal high blood pressure once the underlying causes of the disease are addressed and such simple, natural methods as diet, exercise, and stress management are properly implemented. There is no mystery to this malady; the mechanisms for healing high blood pressure are not complex or difficult to understand. As with other diseases, removing the harmful causes of the disease allows the healing system to restore the body to its natural state of health.

Your Healing System and Stroke: Dean's Story

Dean was a young doctor with a heavy load on his heart. Not only was he physically overweight, but he was financially burdened by thousands of dollars of outstanding student loans and a family to support. Working more than 100 hours each week, sleep-deprived, eating high-fat junk food, getting no exercise, having no fun, and constantly fighting with his wife from the stress ended up costing Dean his health.

Dean was suffering from chronic high blood pressure, for which he was treating himself with the drug samples that the pharmaceutical representatives gave him. He was erratic in monitoring his blood pressure, and he didn't want his colleagues to know about his condition. At the young age of 32 years, Dean suffered a massive stroke that left him paralyzed in his right leg and arm. He was in the hospital for many weeks, and he underwent extensive physical therapy and rehabilitation to learn how to move his arm and walk again. He was extremely depressed during the therapy and felt as if he had nothing left to live for.

During this low period of Dean's life, he came across a man who also had had a stroke. But this man had completely recovered and gone on to enjoy greater health than ever before by completely revamping his diet and lifestyle, and learning how to manage his stress through simple yet effective stress-management methods. With his back up against the wall, on disability, and unable to practice his trade, Dean decided to give these methods a try.

He immediately shifted his diet to one that was low fat and consisted mostly of fruits, vegetables, grains, and other whole foods. He started exercising regularly, and he began practicing stress management along with gentle yoga. Even though he didn't consider himself a religious person, he also began to pray regularly to help relax and calm his mind.

His blood pressure slowly normalized, and he was gradually able to get off all his medications. As his health steadily improved over the next two years, he began to feel better than ever before. He eventually returned to active medical practice, and went on to write many best-selling books about his experiences. Because he learned to adopt a healthier lifestyle and incorporate methods that were in harmony with his body's healing system, Dean was able to completely

reverse the effects of his stroke and live a far healthier, more active, and more fulfilling life than before.

Stroke is a serious condition usually caused by either a hemorrhage or a blood clot in the brain. It also can occur as a result of chronic high blood pressure or other circulatory disturbances. Stroke can be fatal. When it's less severe, it can cause paralysis of the extremities, most often on one side of the body, but it can also cause paralysis of the facial muscles, and affect speech, hearing, eyesight, and the ability to swallow.

Although stroke can be prevented by addressing its underlying causes, even after it occurs, the healing system can often miraculously restore the body to its natural state of health. Numerous studies have documented that when one side of the brain is damaged, if the individual receives proper training and makes a sincere effort, the body's healing system can facilitate the transfer of information from the damaged side to the healthy side of the brain to restore normal function to once-paralyzed limbs and muscles.

Your Healing System and Diabetes: Eric's Story

Eric was a 65-year-old, active man with advanced heart disease complicated by longstanding diabetes. For the past 20 years, he injected himself with insulin daily to control his high blood sugar. His usual daily dose of insulin was 45 units, not a small amount. If he didn't use this amount, his blood sugar would skyrocket to dangerous levels.

When Eric attended a one-week retreat for heart patients (many of whom also had diabetes), he was advised that, because of the changes in diet and exercise, and the stress-management program that would be part of the retreat, he would need to cut his daily insulin dose in half, to make sure that he didn't end up in a coma from too-low blood sugar. He was also advised to monitor his own blood sugars six times a day with a self-administered kit, to make sure they stayed at the proper level.

I was his personal physician during this period, and so Eric reported to me daily. On day one, as instructed, he cut his insulin dosage to 22 units. His blood sugar remained normal. On day two, he cut his insulin in half again, to 11 units, and his blood sugar again remained normal. On day three, he halved his insulin again, and he still had normal blood sugar. As word got out about Eric's

dramatic fall in insulin requirements, the staff became nervous and told Eric not to cut down on his insulin so fast. He responded that he was only following the dosages for what he monitored his blood sugar to be, and that they continued to stay normal. By day seven, Eric was completely off insulin. He has remained off insulin to this day, six years later, while his blood sugar continues to stay normal. He has stuck to his diet and exercise and he has continued to practice stress management. He reports his health to be better than ever.

Because he learned to cooperate with his body's healing system before it was too late, Eric was able to demonstrate what most medical experts previously thought to be impossible—he was able to get off insulin (while keeping his blood sugar values normal), something that he had depended on daily for more than 20 years.

Eric's case demonstrates that, once again, even after many years of living with such a chronic, deadly disease as diabetes, the healing system can reverse and heal such conditions. When you recognize that your body has a healing system, and that by instituting simple, natural methods that cooperate with it, your body can restore its natural state of health.

Your Healing System and Arthritis: The Story of Helen's Mother

Helen worked in my medical office and always wore a smile. Her mother, now in her late seventies and the mother of eight children, had developed a severe form of osteoarthritis in her right knee. This situation was very unsettling to her because until the previous six months, she had always walked at least one to two miles a day, and she had looked forward to this exercise time. After consulting with several doctors, she was told the only treatment that would help her would be knee-replacement surgery.

Her daughter Helen understood that sometimes I took a different approach to medicine, and she insisted that her mother see me. When I saw her mother's reports, and the X-rays, I had to agree that things did not look good for her. However, I did prescribe a simple technique that worked with the healing system; the technique improved the flow of synovial fluid inside of the knee and helped to restore mobility to the knee joint. Over the years, I have relied on this technique in my practice, and I have seen the successful rehabilitation of patients;

even those with advanced cases of arthritis improve significantly. If patients practice diligently and patiently over several months, this technique can restore joint function and promote healing in the knee.

Because the technique is so simple, and because it requires active patient participation over an extended period, I took pains to explain to Helen's mother the underlying principles of the practice to help guarantee her adherence to it. When I was satisfied that she understood how the technique worked and why it was important not to look for results right away, I made her promise me that she would practice it faithfully, regularly, and carefully for six to eight months. She agreed.

Within two weeks, Helen's mother noticed significant diminishment of pain and improved function. After one month, she began walking again. After six months, she was pain-free and walking three to four miles a day, dancing like a teenager, and praising me to the moon. To this day, seven years later, she has not missed her daily walks and has remained pain-free. No knee replacement was ever required.

There are many forms of arthritis, including *osteoarthritis, rheumatoid arthritis, gouty arthritis,* and *psoriatic arthritis,* which have as their common denominator the destruction of the joint surfaces, with increased pain and debility. Conventional medicine treats these diseases with powerful suppressive medications (many with unsatisfactory side effects), and the possibility of a joint-replacement operation, but new evidence reveals that by understanding and addressing the underlying factors that determine joint health, as in Helen's mother's case, your healing system can heal and reverse arthritis.

Your Healing System and Intestinal Diseases: Bob's Story

Bob was a pleasant, good-looking construction worker in his early twenties, with a wife and two kids. He loved baseball and was a member of an amateur league. By all outer appearances, Bob seemed completely healthy; however, if you could look inside of his intestines, you would know that he was in pain and suffering from a severe case of Crohn's disease. When I met him, Bob was a patient in the hospital in which I worked, and he was scheduled for surgery as soon as there was an opening in the operating-room schedule. He

was taking high doses of Prednisone and other strong medications to control his symptoms, which included abdominal pain, weight loss, diarrhea, weakness, fatigue, and nausea.

One day, when I was making rounds at mealtime, I noticed that the food Bob was being served was rather hard to chew, rough in texture, and difficult to digest. This food just didn't seem right for someone with his condition, and because I couldn't discount the possible role that his poor diet might be playing in that condition, I asked whether his pain and related symptoms increased after he ate. He confirmed my suspicions by telling me they were definitely worse after he ate. He also told me his condition worsened when he was upset or under stress. This information did not surprise me. I then asked whether his doctor had ever talked to him about his diet or suggested special foods for his condition, or suggested relaxation or stress management. He replied, "No."

I asked Bob whether he would be willing to go on a special diet for a few days, a diet that I believed would improve his condition. I suggested clear liquids, including water, gentle soup broths, juices, herbal teas, and gelatin, and nothing solid. I told him why, explaining the mechanisms of digestion in relation to his disease. He agreed. I also showed him some simple stress-management practices, including gentle relaxation breathing to do, which would calm the nerves in his intestines.

Every day, I checked on Bob to see how he was doing. Each day, he reported remarkable improvement. After just three days, he was completely symptom free. He couldn't believe that something so simple as his diet and learning how to relax could take away the incredible pain and suffering he had been going through for the past seven years with this chronic intestinal condition. After removal of the harmful factors that created imbalance and disorder in his intestines, Bob's healing system was able to restore his body to its natural state of health.

Numerous intestinal diseases, such as *esophageal reflux, gastritis, peptic ulcer disease, irritable bowel syndrome, Crohn's disease, ulcerative colitis*, and *diverticulitis* wreak havoc on millions of people. Many of these conditions are treated with strong medications or surgical procedures, and they may be serious enough to cause death or serve as precursors to other complications, including cancer, which can be

deadly. Colon cancer alone is one of the most common deadly killers in the West.

In my experience, using strong medications to attack these diseases as if they were foreign entities accomplishes temporary results at best and does nothing to address the underlying factors contributing to these diseases. Alternatively, learning to work with the healing system, as Bob did, even though doing this may take longer, also creates longer-lasting results. Working with your healing system by implementing simple, natural methods such as proper nutrition and stress management, along with other modalities that support and cooperate with your healing system, can often heal even serious, long-standing intestinal diseases.

Your Healing System and Middle-Ear Infections: Jesse's Story

Jesse was 4 years old when his parents took him to an ear specialist to consult about the possibility of having tubes surgically implanted in his ears. He had been on antibiotics almost continuously since he was 15 months old, and his ear infections were now chronic. In preschool, his teachers complained that he didn't respond to their verbal commands, and they were concerned about permanent hearing loss. After reading about the possible effects of not having the operation, which included permanent hearing loss, Jesse's parents went home thinking surgery was their only option.

When Jesse's father went for his regular chiropractic adjustment the next day, he happened to mention Jesse's situation to his chiropractor. The chiropractor told him that by adjusting the spine and removing dairy from the diets of affected children, he and many of his colleagues had reported significant successes in children with conditions similar to Jesse's. Many medical doctors, including the well-known author Dr. Andrew Weil, were now also recommending this treatment.

After postponing the conventional tube surgery, Jesse's parents brought him to the chiropractor for treatment. He gently pressed on Jesse's spine, and he educated Jesse's parents about good posture and simple breathing techniques. They also began him on the new diet that promised to decrease the amount of mucous and phlegm in the respiratory system and eustachian tubes of the ears. The chiropractic adjustments continued once a month for nine months.

Two years later, Jesse came into my office. His parents told me he hadn't had a problem with his ears since they saw the ear specialist two years earlier. Furthermore, his hearing was perfect.

Middle-ear infections are extremely common in young children and can be a nightmare for a parent. Sleepless nights, painful screaming, multiple prescriptions for antibiotics, with the eventual placement of tubes that puncture the eardrum and middle-ear chamber, along with the possibility of permanent hearing loss, are not uncommon.

When I first heard about chiropractic adjustments for middle-ear problems, I was skeptical. However, over the years, I have seen enough positive results to know that these treatments often work. Jesse's case is just one example. As remote as the connection might seem, the spinal adjustments help to improve posture and breathing, and they possibly improve the lymphatic drainage of the middle ear.

Because your healing system integrates the function of all the systems in your body, to understand and work with it requires an expanded view of how the various parts of your body are interconnected. Any healing modality or treatment that supports and cooperates with the healing system by addressing and removing the underlying factors of a disease, such as the unusual treatment just described for middle-ear problems, can result in the healing of conditions that appear to have no cure other than surgery. There is no miracle in the restoration of health and healing from any disease once you understand that your body has a healing system—and that healing is its normal, ordinary, everyday job.

Your Healing System and Multiple Sclerosis: Rachelle's Story

Rachelle was a young housewife with three children. She had been diagnosed with a severe, rapidly progressive form of *multiple sclerosis (MS)* after experiencing symptoms of loss of coordination, problems with balance, and visual disturbances. She was placed on strong, suppressive medications and referred to a specialty clinic for patients with multiple sclerosis. She was given a wheelchair and told to get used to it, because soon this would be what she would be spending the rest of her life in.

When Rachelle opened the door to the specialty clinic, she peered inside and saw hundreds of other MS patients, all in wheelchairs,

and all with a look of resignation on their faces. At that moment, she had a premonition that this place would only strengthen her disease. Refusing to give up hope of overcoming her affliction, she fled the scene immediately. That moment marked the beginning of her healing journey.

Against her doctor's advice, Rachelle underwent a series of acupuncture treatments in which she experienced temporary improvement. To see her symptoms go away, even if only briefly, was all the hope she needed to continue to fight to regain her health. She decided to become an active participant in her treatment by reading, researching, and visiting doctors and healers from a wide range of alternative and complementary disciplines and traditions. She began practicing gentle yoga and took a keen interest in her thoughts and attitudes while studying the effect they had on her body. She learned that her mind and her attitude played a key role in the health of her body. She began to take better care of her nourishment, not only with her food, but also with her thoughts. She saw that loving thoughts nourished her body, whereas thoughts borne of low self-esteem and self-hatred were harmful to her body.

After 11 grueling years, Rachelle finally overcame her affliction and was declared disease free. Her classic book, *Who Said So?: A Woman's Fascinating Journey of Self Discovery and Triumph over Multiple Sclerosis*, (Rachelle Breslow, Celestial Arts, 1991) is one of the most compelling stories and critical pieces of evidence for the healing system that I have ever come across. By discovering her healing system, and learning to discard unhealthy habits and thought patterns that served as obstacles to its performance, Rachelle was able to completely reverse and heal from a disease still considered "incurable" by most so-called health experts!

Your Healing System and Kidney Stones: James' Story

James was a captain in the U.S. Air Force and a senior C-130 pilot with the 1st SOS (Special Operations Squadron) reconnaissance squadron based out of the Philippines at Clark Air Base, where I was also stationed as a flight surgeon at the USAF Regional Medical Center in the Department of Aerospace Medicine.

One day, while he was flying a low-altitude mission on a hot day over the jungles of Thailand, James began to feel a terrible pain in

his back, right flank, and groin that seemed to come and go in waves. As the pain radiated from his back to his groin area, becoming stronger and more intense with each wave, it crescendoed to a steady 10 out of 10 on the Richter scale of pain and soon became unbearable. The pain became so excruciating that James, now perspiring profusely, was forced to turn over all the controls of his aircraft to the copilot while he scrambled to lie down in the back. His copilot requested clearance for an emergency landing.

After his copilot landed the plane, James was met by an ambulance that took him to the nearest hospital in Bangkok. In the hospital, he was given intravenous pain medications. He was then immediately evacuated by air ambulance and transferred to the USAF Regional Medical Center in the Philippines, where I worked.

After several hours in the emergency department of our large hospital, and numerous examinations, including X-rays, blood tests, and urine tests, James was told he had a kidney stone. Kidney stones occur as blockages in the kidneys or ureters, and they can be one of the most painful conditions ever to experience. Surgery for kidney stones is not uncommon because they can be life threatening, especially if they are large enough.

Several days later, while James was still in the hospital, after he had received voluminous amounts of intravenous fluids and pain medications, he passed a single, solitary kidney stone. He was uneventfully discharged from the hospital after a few days. At this point, everything looked good.

On follow-up examinations, however, while he was an outpatient, James' urine tests showed elevated urinary calcium, which persisted for days and weeks, and which alarmed his specialists. They suspected an underlying metabolic problem, which could lead to another kidney stone, and despite James' insistence that he felt fine and was ready to return to flying, they would not allow him back in the cockpit. They contended that he was a threat to his and others' flying safety. In the aerospace industry, and in the language of the U.S. Air Force, according to strict flight-safety policies, James was indefinitely "grounded." This meant that his flying career, within both the military and civilian worlds, was essentially over.

I believed in the intelligence and power of James' healing system, and I felt strongly that once the obstacles to its performance

were removed, his healing system could correct the situation. I was convinced that his high urinary calcium was the result of the residual calcium oxalate "sand," which consisted of ultra-fine particles left over from the stone that had recently passed. This conviction was based on the information I received while I was performing a detailed medical history of the events leading up to his kidney-stone incident. Just days before the incident, James had had diarrhea, and he had become severely dehydrated at the time he was flying. While flying, he also became severely overheated in his bulky flight suit and stuffy cockpit, a condition made worse by Thailand's heat. He had also been under significant stress for six months related to an illness in the family. All of these factors predisposed him to a kidney stone.

I encouraged James to drink as much water as he could, to flush out the residual sand that I felt was responsible for his elevated urine calcium. As it turned out, simple water was all his healing system needed to reverse the dangerously high levels of calcium in his body.

Thanks to James' healing system, and his ability to cooperate with it by drinking lots of fluids, abstaining from alcohol and caffeine, and avoiding and managing his stress, about six months from the day of his kidney-stone episode, his urine calcium returned to normal, and he was permanently restored to flying status without any medications and without any waiver.

James has been flying as a senior pilot for Delta Airlines now for more than 15 years. He surfs, has three beautiful children, and hasn't missed a day of flying due to illness during this entire period. He likes to drink water, as you can imagine, and to date has never had an inkling of the kidney stone problems that almost ended his career.

Your Healing System and Cancer: Tony's Story

Tony wears his shaven head proudly, as a battlefield trophy and reminder of his successful victory over Hodgkin's disease, a malignant cancer of the lymph system, which had him down and out for several years.

Tony looks good with his shaved head and mustache. Even though he could grow his hair back if he wanted to, he prefers the look of a monk-warrior. He is in great shape, running four to five miles each day, and working full time in the automotive department of a major, national-chain department store. Although he has an air

of determination about him, at the same time, he's almost always in a cheerful mood, with a little twinkle in his eyes. He is a glowing, vibrant, magnetic person. Here's a man who knows the gift of life and doesn't waste a single second feeling sorry for himself or entertaining negative thinking, in spite of all he's been through.

When I asked Tony where he thought his cancer came from, and to what he attributed his healing, the answers were simple and straightforward. "Doc," he said, "I was under a lot of stress just prior to my diagnosis. I was working too hard and worrying too much. I wasn't having fun, and I was way too serious. I never rested, and everything seemed to get to me. I had a lot of anger that I couldn't release. I felt all bottled up inside. My diet was bad. I wasn't taking good care of myself, and I knew it.

"When I received my diagnosis, I felt that it was a wake-up call," Tony continued. "In a way, it gave me an excuse to be a little selfish again and focus on the needs of my body. I changed my attitude and my ways and decided that I would turn all my troubles over to a higher power. I started taking the time to eat right, exercise, and take care of myself because I realized it was up to me.

"When I shifted gears, it's amazing how my body responded," Tony added. "While my doctors were surprised, I was not the least bit shocked over my complete reversal of cancer. I really feel it was I who brought on my own cancer, and it was I who got me out of that mess by becoming a little more aware of how my attitude, thinking, and behaviors were affecting my body. The entire process of getting ill and then being healed was completely logical to me."

When people start to realize the amazing power of their own healing systems, and start taking responsibility for their own health, as Tony did, they often become empowered to take the necessary steps to help their bodies heal. Although cancer has been and continues to be one of the most feared diseases of modern times, even cancer cannot stand up to the miraculous powers of your healing system once you learn how to remove the obstacles that interfere with its functioning. As you become more aware of the many ways your healing system strives to keep your body healthy, you will discover many more ways to support and cooperate with it to restore your health.

When you are dealing with any major, life-threatening illness and rallying your healing system to come to your support, understanding

the obstacles that are interfering with the performance and function of your healing system is imperative. Some of these obstacles are obvious, such as habitual ingestion of toxic substances, poor diet, stress, and lack of exercise; others are more subtle, such as unhealthy thinking and holding onto anger. Because much unhealthy thinking and behavior is habitual and unconscious, you must first become aware of these unhealthy patterns before you can change them. As we will explore a little later in the book, you will see how your mind exerts a powerful influence on your body's healing system, and what you can do to make the mind an ally in your healing.

Closing Thoughts on Your Healing System in Action

Your body knows how to heal itself because it has a remarkably efficient and intelligent healing system. You can think of your amazing healing system as the field marshal who commands the forces of healing within your body, directing the various elements to maintain your natural state of health. I could have presented many more cases here, but it is clear from the evidence presented so far that you have a healing system that is capable of healing your body from a multitude of afflictions, even when these afflictions have become advanced and things appear pretty hopeless. As long as you are alive, you have healing power.

It is important to remember that, even though the variety of diseases and the number of afflictions you may potentially suffer from on this earth appear vast and staggering, the many ways that your healing system can heal you and keep your body healthy are, by far, infinitely greater.

To understand more thoroughly how your healing system works, and what you can do to work with it, learning about the other systems in your body with which it is allied is important. Your healing system utilizes these other systems and relies on their cooperation to initiate powerful and sophisticated healing responses whenever illness or injury threatens your natural state of health. In the next chapter, you'll learn about the critical relationship between your extraordinary healing system and the other systems in your body, and how they all work together and respond to each other in incredible ways.

CHAPTER 3

The Team Members of
Your Healing System

Your healing system is intimately connected to all of your body's other 12 systems. It is integrated within the structures and cells of these different systems so much so that when your body is in its natural state of health, the cooperation between the healing system and the other systems of the body, and the ways in which they function together, are almost flawless.

To fully understand the connections between the healing system and the other systems of the body, you first need to understand how each system functions individually and performs specialized tasks. The health of each individual system is essential to your overall health and to each system's ability to work efficiently and effectively with your healing system.

Your Skin

Your skin is the most exterior and exposed system in your body. Consisting of several layers and appearing in a variety of colors and shades, your skin is one of the most obvious features that define your body's individuality. Your skin is one continuous organ, and, much like a teddy bear or other stuffed animal's outer lining that holds its stuff-

ing in, your skin can be looked upon as the outer covering of the body that holds in all of your internal structures. Your skin exhibits the following qualities that aid your healing system in many important ways:

- Skin is flexible. It can stretch and expand to tremendous capacities, as demonstrated during pregnancy and extreme cases of obesity. This characteristic helps your skin resist tearing and other injuries, which reduces the burden on your healing system.

- Skin can absorb sunlight. Like a chameleon, your skin can change color, depending on its exposure to the sun. Gradual increases in sun exposure result in the accumulation and deposition of a pigment known as melanin, which results in tanning. Sunlight contains vitamin D, which improves calcium absorption and helps maintain bone density. Tanning increases tolerance to sun exposure, thus allowing for greater amounts of vitamin D to be absorbed and produced. Sunlight also promotes wound healing, prevents infection, and stimulates the immune system, and so the skin's ability to absorb sunlight is a sophisticated mechanism that benefits and supports your healing system.

- Skin holds in your body's fluids. Because your body is 70 percent fluid, maintenance of proper fluid levels is necessary for optimum functioning of your healing system. When water content falls below a certain level, illness and death can ensue. Your skin prevents your body from becoming dehydrated. Dehydration also commonly occurs in burn victims. When someone sustains a severe burn to more than 50 percent of his or her body, death is a real threat as a result of the leakage of fluid out of the body through the damaged skin.

- Skin helps protect your body from infection. Intact skin is a natural barrier to most forms of microorganisms, including viruses and bacteria. When an abrasion or laceration creates a break in your skin, infection can enter into the body and penetrate into the deeper, more vulnerable tissues and cause significant disease, damage, and even death. Your skin is fairly tough and supports your healing system by keeping your body free from infection and invading organisms.

- Skin helps regulate body temperature. Your body is programmed to keep its internal temperature close to 98.6 degrees Fahrenheit, and because of your skin, it can maintain this temperature most of the time. At 98.6 degrees, all the enzyme systems in your body's internal environment function optimally, including those that work with your healing system. Any sudden or sustained reduction in this normal body temperature disrupts the health and integrity of your body. The pores in your skin also regulate body temperature by opening wider and sweating when body temperature rises too high, and by closing to retain heat when body temperature goes too low. Sweating supports your healing system by preventing your body from overheating during periods of extreme physical activity or exceptionally hot weather, when a fever is present, or when you have stress.

- Your skin is capable of absorbing moisture and other substances. Much like a frog, your skin can absorb water and literally drink from the environment. Medical scientists are now making use of the skin's absorption capabilities by creating medicines that are applied to the skin in the form of patches. These medicines include nitroglycerin for heart patients, estrogen for post-menopausal women, nicotine for people attempting to quit smoking, and scopolamine to help prevent motion sickness.

- Skin eliminates toxins and waste products. One important example of the skin's ability to rid the body of toxins is its response when the body has a fever. With a fever, sweating occurs, which helps the body eliminate the toxins caused by the infection. Until modern medicine began encouraging the use of medications to suppress fever, people with high fevers, including those fevers caused by pneumonia, were encouraged to drink lots of fluids and bundle up in heavy blankets to sweat out the toxins until the fever broke.

- Skin plays an important role in touch. Touch is a vital ingredient for physical and emotional health. Human beings require regular, compassionate touching to thrive and survive. Studies done with touching show that the cultures that advocate more touching have less heart disease and mental illness than cultures in which people don't touch very often. Babies who are not held

and touched often develop a condition known as Failure to Thrive syndrome, which can have fatal consequences. Touching is essential to strengthen and fortify your healing system.

Your Hair, Your Nails, and Your Healing System

Hair helps your healing system in several ways, and although hair is usually thought of as separate from skin, your hair is a part of your skin. Each type of hair shape, color, and distribution on the body found throughout the world has been designed to aid our healing systems and keep our bodies healthy in a multitude of ways. For example, in Africa, where temperatures can become extremely hot, tightly curled hair, often referred to as "kinky" hair, serves to keep the head and body cool. Kinky hair acts like an intricately coiled refrigerator system to help trap and cool water vapors (moisture that has evaporated in the form of steam) off the top of the head. Mediterranean body hair, which is more common in warm, arid climates, protects the body from drying out, and from wind and sand. This type of hair helps to conserve fluids and regulate body temperature.

Hair also acts as a sense organ for touch. If your head begins to brush up against an overhanging object that you might not have seen, your hair will meet the object first. The movement of hair will inform you to duck your head quickly to avoid serious injury.

Toenails and fingernails are also specialized parts of your skin, and they help your healing system by protecting the delicate tips of your toes and fingers.

Wound Healing of the Skin

Your skin possesses an uncanny ability to heal itself after a laceration, abrasion, burn, or other injury. Because injuries to the skin may involve the loss of blood along with concomitant injuries to deeper structures within the body, wound healing requires the sophisticated and timely collaboration of many body systems, including the circulatory, the endocrine, the immune, and the nervous systems. Your healing system supervises and directs this remarkable collaboration.

Your Skeletal System

The skeletal system establishes the rigid framework of your body and is made up primarily of bones, which are the densest structures in your body. Intact bones that are thousands of years old can be found on archeological sites.

Your skeletal system works with your healing system in many important ways:

- Bones absorb significant stress loads and protect the body's deeper internal organs and tissues. The ribs, for example, in addition to being involved in the function of respiration, also serve to protect the heart and lungs and other vital structures in the chest cavity. The skull protects and houses the brain, the master organ in the body. The bones in the spine, known singularly as *vertebra*, and collectively as *vertebrae*, are stacked one on top of each other to form the spinal column. The vertebrae support the weight of your head; they also act like flexible conduits, encasing and protecting the delicate spinal cord, which is the main electrical, intercommunicating highway between your brain and body.

- In conjunction with your healing system, bones have an uncanny ability to mend and knit themselves back together in the case of fracture. This capability ensures that your bones will continue to protect the deeper organs and tissues of the body.

- In addition to their protective role, bones, along with muscles, are responsible for movement, which keeps your body healthy and free from disease (see the next section, "Your Muscular System"). For example, the bones of the legs are responsible for walking, running, climbing, and jumping, while the bones in the arms, hands, and fingers are responsible for movement of the upper extremities. The bones in your face participate in facial expression, chewing, and breathing; they also protect the delicate sense organs in the region, such as your eyes, ears, and nose.

- Bones serve as the body's largest pool of calcium. Calcium is required for healthy muscle contractions, heart activity, nerve transmission, and other vitally important functions that aid your healing system in keeping your body healthy.

Your Muscular System

The system that is primarily responsible for movement in your body is the muscular system. Muscles make up approximately 40 percent of your total body weight, and they alone are the heaviest and most dominant system in your body. The muscles in your body serve as key allies to your healing system in the following ways:

- When muscles move and contract, they generate heat, which keeps your body warm. This process supports your healing system by keeping your body functioning at optimum temperatures.

- Regular movement and exercise of the muscles improves circulation by strengthening the heart. A strong heart aids the healing system by improving the delivery of oxygen and vital nutrients throughout your body.

- Muscles have a tremendous capacity to grow, change, and heal. They are dynamic, versatile, and highly plastic. Body builders who continually lift weights over a long period of time can add up to 100 pounds or more of solid muscle tissue to their frames, becoming powerful and strong in the process. Alternatively, yogis in India, through many years of stretching the muscles in their bodies, can mold their bodies into pretzels—they have earned the label of "rubber men" for the incredible flexibility in their joints. Muscles that are strong, flexible, and relaxed create healthy joints and ensure strength and maximum movement, which is essential for the healing system to function most efficiently.

- Muscles also participate in important internal processes that aid your healing system in keeping your body healthy. For example, muscles of respiration participate in breathing, causing movement of the diaphragm and the rib cage, which allows air and oxygen to flow in and out of your lungs.

- Smooth muscles, located inside various vital organs, such as the intestines, the arteries, and the bronchioles in the lungs, are critical to the functioning of these organs and the healing system. They can contract and expand the diameters of these important tubular structures, and in the process, help to direct the movement of vital

body fluids and important gases such as oxygen to specific desti-
nations within your body.

■ The following examples emphasize how indispensable the smooth
muscles are to the health and performance of your healing system.
When the muscles in the arteries contract, the arteries become
narrower; this helps to circulate blood more quickly through your
body. In the digestive system, the movement of food down the
digestive tract, known as *peristalsis*, is caused by the alternating
contraction and expansion of the intestinal muscles; peristalsis
allows the food to pass along the length of the intestines. The
same is true in the lungs, where the muscles that line the breath-
ing tubes, known as the *bronchi* and *bronchioles*, help to regulate
the flow of air in and out of your body.

Your Nervous System

The nervous system is the master communication and electrical arm
of your healing system. Consisting of your brain, the spinal cord, and
the peripheral nerves (like a tree with many branches), your nervous
system processes information and sends and receives messages with
astonishing speed and precision throughout all parts of your body.

With the help of your nervous system, your healing system
knows what is going on in even the tiniest cell in the most remote
region of your body. Because of your nervous system, your healing
system can dispatch a concentrated, orchestrated, and effective heal-
ing response with great accuracy and speed to any area of your body.

Your nervous system consists of two main limbs:

1. The *voluntary nervous system,* which regulates the movements of
 such activities as standing, walking, running, jumping, sitting,
 swimming, and all other activities that you can consciously
 direct.

2. The *involuntary nervous system,* also known as the *autonomic
 nervous system,* which automatically controls vital body
 processes, such as breath, heartbeat, body temperature, visual
 adaptation to light, muscular reflexes, and many others.

Your healing system is exquisitely interconnected to the functioning of your entire nervous system, upon which it depends for specialized roles in communication, the regulation of vital, life-sustaining, physiological processes, and the direction of key mechanisms for the growth, repair, and maintenance of your body's natural state of health.

Sense Organs and Your Healing System

In association with your nervous system, there are highly specialized tissues and structures in your body known as *sense organs*, which include the eyes, ears, nose, tongue, and skin. Information that influences your perception and aids your healing system, and that enables you to safely move about in this world, is fed to your brain through these various sense organs. Sense organs not only allow you to avoid danger, but, more importantly, to interact with life in all its fullness. Information coming in through the senses can also directly alter your body's physiology, exerting a powerful influence on your healing system.

Your Endocrine System (Glands)

The *endocrine* system consists of the major organ-glands in your body; these organ-glands are responsible for the production, secretion, and regulation of all your hormones. *Hormones* are powerful chemical messengers that work with your healing system to influence important physiological processes and vital body functions.

The following hormones and their respective endocrine organs, commonly referred to as *glands*, make up the endocrine system and play major roles in the chemistry of your body's internal environment while they support your healing system through numerous mechanisms:

- Adrenaline, also known as epinephrine, produced by the adrenal glands, is one of the best known of all hormones. Adrenaline is rapidly secreted during emergencies, and in response to fear,

stress, or other states of excitement; it activates the "fight-or-flight" response, which causes the following changes in your body's physiology:

- ◆ increases heart rate
- ◆ increases blood pressure
- ◆ increases respiratory rate
- ◆ increases oxygen consumption
- ◆ dilates pupils
- ◆ affects many other functions that help the body direct resources to effectively deal with any emergency.

- Adrenocorticotropic hormone, or ACTH, produced by your pituitary gland, regulates the production of cortisol from the adrenal gland. Cortisol regulates glucose metabolism, plays a key role in the immune system, and aids the healing system by acting as a powerful, natural anti-inflammatory agent.

- Aldosterone, produced by the adrenal glands, is a powerful hormone that regulates the amount of sodium and fluid levels in the body; it also controls blood pressure.

- Estrogen and progesterone, produced by the ovaries in women, play important roles in menstruation and pregnancy; they also have other wide-reaching effects in the body, such as bone formation, cholesterol metabolism, and the health of the skin.

- FSH (follicle stimulating hormone) and LH (luteinizing hormone), secreted from the pituitary gland, regulate the production of ova, or eggs, in the ovaries of women, where estrogen is produced. These hormones also are involved in the process of menstruation, and they play an important role during pregnancy.

- Growth hormone, produced by your pituitary gland, controls and regulates bone growth and overall growth in your body.

- Insulin is produced in the pancreas and is one of the most important hormones in your body. Insulin regulates glucose metabolism and blood sugar, which are central to the health of your healing system, and to every cell and tissue in your body.

- Interstitial cell-stimulating hormone, or ICSH, stimulates the release of testosterone from the testes in males.

- Melatonin, which is strongly influenced by sunlight and plays a major role in the regulation of moods, is a powerful hormone produced by the pineal gland. Melatonin controls natural sleep and wake cycles, and the production of melanin, the pigment that helps regulate the amount of sunlight that enters into your body.

- Oxytocin, produced by the pituitary gland, regulates the process of labor by stimulating uterine contractions during childbirth. Oxytocin also aids in milk production and secretion during breast-feeding.

- Parathyroid hormone, produced by the parathyroid glands, controls bone metabolism and regulates calcium levels in your blood. Parathyroid hormone also affects calcium absorption in your intestines and calcium resorption in your kidneys. Calcium also is required for the functioning of the heart, as well as other important muscles and nerves in your body.

- Prolactin, secreted from the pituitary gland, regulates lactation and the release of breast milk following childbirth in women.

- Testosterone, produced in the testes in men, is required for testicular development, sexual maturity, the production of sperm, the development of facial and body hair, depth of voice, muscular development, and male libido.

- Thyroid hormone, produced by the thyroid gland, helps to regulate growth and development, metabolism, skin and hair growth, heart rate, body temperature, menstruation, and mood.

- Thyroid stimulating hormone, or TSH, produced by your pituitary gland, controls and regulates the function of the thyroid gland, which is one of the most important glands in your body.

- Vasopressin, or ADH (antidiuretic hormone), produced by the pituitary gland, acts on the kidneys to conserve water by inhibiting urination and also plays a role in blood-pressure regulation.

Your Digestive System

Your digestive system consists of various organs that are connected to your small and large intestines, which combine to form a continuous, hollow, twisted, tube-like structure that extends more than 30 feet from your mouth to your rectum. The following components make up the digestive system: your mouth, tongue, teeth, salivary glands, nose, throat, esophagus, stomach, small intestines, large intestines, rectum, and anus. The digestive system also includes the liver, gall bladder, pancreas, and appendix. Your digestive system, through the delivery of essential nutrients, maintains close ties with your healing system.

Your digestive system is responsible for breaking down, absorbing, and assimilating vital nutrients into your body from the foods you eat. These nutrients provide the fuel for your healing system and for your entire body, helping it grow, repair itself, and maintain its natural state of health. As your body heals from any malady, your digestive system plays a key role in delivering necessary nutrients for the purposes of rebuilding and providing new growth to damaged tissues.

Following digestion, what your body doesn't need or cannot use is eliminated through the large intestines in the form of solid wastes. Elimination aids your healing system by ridding your body of unwanted toxins and waste products.

Your Respiratory System

Your respiratory system consists of the nose, mouth, sinuses, middle ear, throat, tonsils, trachea, larynx, bronchi, bronchioles, alveoli, and lungs. Because of their role in breathing, the ribs and diaphragm are considered ancillary structures of the respiratory system. The health of each of these structures affects the health of your entire respiratory system and, ultimately, your entire body. Your respiratory system directs the flow of air in and out of your body through these various structures.

The respiratory system is responsible for delivering oxygen to your blood, which is then pumped to every cell and tissue in your body. Without oxygen, your cells and tissues cannot live. Your res-

piratory system is also responsible for ridding your body of *carbon dioxide*, a toxic waste product of normal cellular metabolism.

The respiratory system is connected to many other systems, including your nervous, circulatory, lymphatic, and digestive systems. When the body has an oxygen deficit, such as when a person is in shock, has a fever, or has sustained a severe trauma, illness, or injury, or when stress is significant, rates of breathing tend to automatically increase to bring more oxygen into the body. This is just one example of a critical cooperative effort between your respiratory system and your healing system.

Your Circulatory System

The circulatory system consists of your heart and blood vessels, the blood, and all the various constituents in your blood, including your red blood cells. In your heart, the *coronary arteries* are special arteries that bring the blood supply back to the heart itself. If these arteries become clogged, a heart attack can occur. Their health is critical to the health of your heart, upon whose health your healing system and entire body depend.

The circulatory system has many vital functions. It is responsible for

- Pumping and distributing blood, which contains oxygen and other vital nutrients and substances, to every cell and tissue in your body. These nutrients and substances include hormones, antibodies, enzymes, neurotransmitters, vitamins, minerals, and trace elements that are vital to the functioning of your healing system.

- Removing toxic metabolic byproducts, such as carbon dioxide and lactic acid.

- Carrying oxygen from the lungs to the various organs and tissues in your body. Hemoglobin, a very important molecule in red blood cells, accomplishes this task.

- Clotting of the blood. White blood cells, which are crucial for the functioning of the immune system, are essential for blood clotting. Blood clotting is a unique function of the circulatory

system, and it occurs during times of injury to prevent excessive blood loss. Blood clotting represents one of the true miracles of the healing system.

Your Lymphatic System

You can think of your lymphatic system as the blood-purification system. The lymphatic system consists of a series of lymphatic vessels and lymph nodes that are strategically located throughout specific parts of your body. Lymph fluid circulates freely throughout the lymph system; this fluid contains white blood cells, antibodies, and important chemicals of the immune system. Your lymphatic system works closely with your circulatory, immune, and healing systems as it circulates and removes toxins and impurities from your body to keep your tissues and blood free from disease caused by bacteria, viruses, and other invaders.

Your Urinary System

Your urinary system is primarily responsible for acting as a filter for your blood to remove wastes and toxins from your body. The major organs of your urinary system include your kidneys and bladder, and they support your healing system through a number of important functions. These functions include the following:

- Your urinary system helps to conserve and regulate fluid levels in your body.
- Your urinary system filters and purifies the entire blood circulation within your body.
- Your urinary system regulates electrolyte levels, assuring that your body has proper amounts of sodium, potassium, calcium, and other key minerals and trace elements that support vital physiological processes that are essential for your healing system.
- Your urinary system monitors protein concentration in the blood, which is critical to your healing system.

Your Reproductive System

In women, the reproductive system is located in the lower abdomen and pelvic area, and it consists of the ovaries, uterus, cervix, and vagina. The breasts, located in the chest, are also included in this system. The breasts are actually dual-purpose organs, serving as nutritive, lactating glands that deliver milk immediately following childbirth; in addition, they act as attractive forces to the opposite sex, and as tissues of arousal that help promote sexual and reproductive activities. In this way, the breasts serve both an endocrine, secretory function and a reproductive one.

In men, the testes, prostate, seminal vesicles, urethra, and penis make up the reproductive system.

More than any other system in the body, the reproductive system is responsible for helping to differentiate the physical characteristics of men and women. These differences are responsible for the strongly magnetic forces that help foster the sexual attraction between the sexes. The natural result of this attraction, and the main function of your reproductive system, is reproduction and proliferation of the species. Although women can live without a uterus or ovaries, and men can live without testes and a prostate, the reproductive system is essential for the survival of the human race.

The reproductive system maintains an intimate connection with the endocrine system. In addition to having receptors for hormones produced by other organs, the reproductive system produces it own hormones, most notably estrogen in females and testosterone in males. These hormones contribute to overall health, and they can influence emotional and mental states. For instance, estrogen exerts a protective influence on the heart.

Many other systems in the body also are connected to the health and proper functioning of the reproductive system. These include the nervous, endocrine, circulatory, and lymphatic systems.

Your Immune System

Your immune system consists of a complex network of cells and organs that can produce extremely powerful chemicals known as

antibodies. Little was known about your immune system until quite recently. Research is still discovering new facts about this amazing system, whose chief function is to defend your body against infection and other intruders.

The cellular components of your immune system consist largely of white blood cells, with highly specialized roles and functions. You can think of white blood cells as infantrymen who are programmed to destroy any invading enemy in the form of pathogenic bacteria, viruses, fungi, parasites, or other harmful organisms. The division of labor among the many types of white blood cells of your immune system is so detailed, subtle, sophisticated, and precise as to make any other army or military force in the history of the world appear primitive and impotent in comparison.

Antibodies, which are produced in direct response to specific threats and can be likened to molecular cruise missiles, are released into the bloodstream to seek out and destroy unwanted intruders with remarkable speed, accuracy, and precision. Antibodies are present in the blood, produced in large quantities upon demand. They also are in the body's mucous membranes, such as the nose, mouth, respiratory system, intestines, urethra, and other body tissues and cavities that connect to the outside environment.

Your immune system, once thought to be a completely independent system, is now known to be directly linked to your brain and nervous system, and to other systems, as well. For example, white blood cells have been discovered to possess receptors for *neurotransmitters* produced by the brain, which demonstrates a direct chemical link with your brain and nervous system. Other white blood cells have been found to have specific hormone receptors, indicating that your endocrine system communicates directly with your immune system. Even more astonishing is recent evidence that certain white blood cells can produce and secrete hormones that communicate directly with your endocrine system.

As we discussed earlier, your immune system works closely with your healing system; and although the two systems are clearly distinct, in many instances they work together to restore your body to its natural state of health.

Closing Thoughts on the
Team Members of Your Healing System

Even though an entire book could be written on each individual system presented in this chapter, I hope you now have a greater sense of appreciation for how the various systems in your body function individually and together in support of your extraordinary healing system, which orchestrates the processes that keep you healthy. In the next chapter, we will look at the many ways you can cooperate with your healing system by strengthening and fortifying it so that it can work for you most efficiently and effectively.

CHAPTER 4

Strengthening and Fortifying
Your Healing System

Your body's healing system comes prepackaged, completely installed, and fully functional, even before the first breath enters your lungs when you are born. Although the healing system is delivered to you in perfect condition, the choices you make in your everyday life can have a serious impact upon its performance and its activities. Your diet and lifestyle, home and work environment, moods and emotions, thoughts and attitudes, in addition to a multitude of other factors that are within your control, can dramatically alter the behavior and efficiency of your healing system.

You can impede your healing system's ability to perform its programmed mission, and overburden and exhaust its resources, by participating in activities that are harmful to your health. Such obstructions include the following: ignoring the basic needs of your body, putting harmful substances into your body, eating nutrient-poor foods, not drinking enough water, not getting enough sleep and rest, breathing harmful air, subjecting your body to a toxic environment, and living a lifestyle that is stressful and unhealthy.

Additional factors that can be detrimental to the intrinsic strength of your healing system include such unhealthy mental habits as chronic worrying; entertaining thoughts of fear, anger, and rage; mistrusting; holding onto resentment; maintaining a pessimistic and

cynical attitude; focusing on problems and negative circumstances; depression; apathy; and giving up on life altogether. All these self-destructive tendencies exhaust your body's precious resources, interfere with your healing system's ability to do its job properly, and increase the likelihood of a serious, life-threatening illness or chronic debilitating disease taking hold of your body. These negative factors can rob you of your natural state of health and sabotage an otherwise wholesome, vibrant, rich, and rewarding life.

Alternatively, you can strengthen, nourish, and cooperate with your healing system, and even enhance its performance, by learning to listen to your body's valuable communications, understanding what is required to maintain your natural state of health. This will help you fulfill your basic physical needs of wholesome food, water, fresh air, plenty of sleep and rest, and appropriate exercise, while paying attention to your body's early warning signs when danger or illness may be approaching.

As we discussed earlier, your body, which is naturally programmed for health and vitality, can remain free of illness until your final days, which might be well over 100 years. But if you hope to come near this goal, you must cooperate with your healing system, and learn to strengthen and fortify it, to keep it in optimum condition.

Your healing system responds to your deepest intentions and most heartfelt desires. In this respect, you inwardly possess much more power than you may be aware. If you want to be happy, healthy, strong, vibrant, energetic, and active, you need to honor and take proper care of your body, and understand the intimate relationship between your body, mind, emotions, and spirit. If you do, you can make your healing system your most powerful ally in your quest for greater health and wellness.

Prevention
The Key to a Strong Healing System

From a strategic and tactical viewpoint, the best time to strengthen, fortify, and cooperate with your healing system is not when you are sick, but rather when you are healthy. So that your healing system will stand poised and ready to leap into action at the first signs of

distress, it is better for it to be well prepared in advance of any anticipated calamity. As the famous case of the ill-fated Titanic demonstrates, the time to check whether there are enough lifeboats on deck for all the passengers is not when the ship is sinking, but before it leaves the port. The same is true with your healing system. Learning how to strengthen and fortify your healing system is easier when your body is not already under siege from an illness or disease. This doesn't mean that if you are now ill you will not benefit from this knowledge. On the contrary, if you are now ill, you need to focus on this important work more than ever. In fact, your very life depends on it.

Learning how to strengthen and fortify your healing system in the absence of illness or disease gives you the momentum and positive inertia to defeat any illness, should it attempt to violate the integrity and sanctity of your body. To further illustrate this point, consider the plight of a boxer vying for the heavyweight championship of the world. The time to learn how to box for such a fight is not when he steps into the ring against a formidable opponent, but rather during the many hours of preparation when he is in training for the fight. So prepared, he can then step into that ring with confidence and poise, actively calling upon his polished boxing skills to defeat his less-prepared, inferior opponent. This kind of training, preparation, and mindset is required to win. These requirements are exactly the same for your healing system. To emerge victorious from a health challenge, taking the time now to learn how to work with your healing system will give you the edge you need to defeat any condition or formidable disease that life may throw your way.

How to Be Your Own Best Doctor

I meet many people who choose not to visit doctors regularly. I am not speaking about irresponsible people who neglect their health and then, out of fear and denial, refuse to see doctors for their deteriorating health conditions. I am speaking about healthy, mature, independent people who have developed a confidence in their bodies' abilities to meet the physical challenges that face us all in this life. If they should run into a problem, instead

of rushing off to the doctor, these people know how to activate their healing systems by nurturing and listening to their bodies. There is definitely a time and place to ask for help from doctors, but you can minimize these occasions when you learn to rely more on your own healing system. By learning how to listen to your body and apply some simple yet powerful principles and techniques, you will develop a deep-seated inner confidence that your body has the capacity to stay healthy and to heal itself when its health is challenged. Learning to strengthen and activate your healing system will help you prevent illness and heal yourself from any health challenge you may have to face in your life. You can learn to be your own best doctor.

Prescriptions for Strengthening and Fortifying Your Healing System

The following key ingredients constitute essential components of a healthy program aimed at strengthening and fortifying your body's healing system, whether you're focusing on prevention or on healing from an existing health problem. By paying attention to each of these factors and incorporating them into your life, you will be able to most effectively tap into your body's natural ability to heal itself and significantly improve the quality of your life.

Healing System Rx #1: Learn to Listen to Your Body

As we discussed in Chapter 2, your body comes equipped with a healing system that is constantly attempting to communicate with you, 24 hours a day, seven days a week. Through the language your healing system speaks, it sends you valuable information to help you know what its needs are.

For example, when your body is hungry, and you feel hunger pangs in your stomach, your stomach will soon begin to rumble and growl if you don't put something in your belly. When your body is tired and requires sleep, your eyes will feel heavy and you will begin to yawn. When your body needs water, you feel thirsty, which creates a strong urge to drink fluids. Similarly, when your bladder becomes full and requires emptying, you feel the urge to urinate.

In addition to these more obvious forms of communication, your body is constantly sending you other more subtle information. Depending on what kind of listener you are, you may or may not be receiving and processing these other important messages. For instance,

- When you are tense, upset, or under stress, you may notice a tight or heavy sensation in your chest, which makes your breathing slightly difficult. You may also notice your heart skipping a beat or two. You may try to ignore these sensations, as many people do; but if this is an early warning from your heart, it could lead to increased pain known as angina, which occurs when there is a lack of adequate oxygen and blood flow to the heart. These symptoms could be danger signals of an impending heart attack. Ignoring the messages could have disastrous consequences.

- You may feel queasy or notice a knot in your stomach when you are nervous, afraid, or confronted with an unpleasant situation. If the situation is not resolved and is allowed to linger, the sensations might increase, or become persistent, which could be early warning signs of an impending intestinal problem, such as an ulcer.

Even though some of us listen to our bodies some of the time, many of us don't listen until they are actually screaming at us and refusing to cooperate with us until we tend to their needs. Our bodies scream at us by causing intense pain. This pain is the body's ultimate communication strategy to try to get us to wake up to the fact that we are ignoring one or more of its vital needs. To avoid pain and to remain healthy, we need to become better listeners.

To strengthen, fortify, and cooperate with your healing system, it is critical that you first become more aware of your body's needs and learn to listen to its early warning messages, in all their myriad forms. When you become a good listener, your body will not need to shout or scream at you to get your attention, and so you will not need to experience pain, suffering, misery, illness, or disease.

How to Listen to Your Body

The following exercise is a simple yet powerful method to gain access to vitally important messages from your body's healing system:

- Allow yourself quiet alone time. Go into a safe and quiet room, close the door, and take the phone off the hook so you won't be disturbed. If you cannot find a quiet place, try using earplugs. Excuse yourself from your family duties, responsibilities, and obligations for at least 20 to 30 minutes. Make sure everyone in your home understands that you are not to be disturbed until you are finished. You may also want to put on some soft, relaxing music in the background to help set a peaceful, quiet mood.

- Find a comfortable position, preferably lying down on your back. You may place pillows under your knees, or use blankets or pillows anywhere else to help support your body so that you are comfortable. Make sure your body is comfortable before you proceed.

- Gently close your eyes and relax all the muscles in your body, as if it is melting into the surface beneath you.

- As you close your eyes and relax your body, bring your awareness to the area of your stomach and abdomen. Notice the gentle movement in that region. You can even place your hands on top of the area to help you become more aware of this movement. Feel the rhythmical, automatic movement of your breath as it flows in and out of your body. Notice that when the breath flows into your body, your stomach and abdomen gently expand and rise. Notice that when the breath flows out of your body, your stomach and abdomen gently contract and fall. Try not to control the rate or depth of this movement; rather, just let your mind be a passive observer as you watch and observe this gentle, automatic rhythm.

- Every time the breath leaves your body, feel all the muscles in your body releasing tension, and becoming more relaxed.

- Focus your awareness within, becoming aware of how your body feels from the "inside" as you continue to breathe.

- As you become more relaxed, observing the gentle, automatic movement of your breath as it flows in and out of your body, slowly and systematically scan your body, starting from the tips of your toes and moving toward the top of your head. Visit all parts in between, including your heart and chest area; your back and spine; your shoulders and neck; your groin, buttocks, and genitals; and your stomach and abdominal area.

- Notice any areas of discomfort, pain, or tension, which you may not have been aware of before, in these areas. Also notice any areas of relaxation, comfort, and feelings of vitality and health.

- After your allotted time, gently stretch your muscles, and open your eyes. Resume your normal activities. Remember to listen to your body this way regularly.

At first glance, this process may appear to be nothing more than a relaxation exercise. In reality, however, much more is going on. First, when your body is relaxed, your nervous system, which is the main communications link between your mind and body, becomes calmer and more focused. In this state, your mind also becomes quieter, more alert, and concentrated. Because your mind and body are intimately connected, when your body is relaxed, your mental powers for internal listening are also increased.

The awareness you gain from this exercise will spill over into your daily life. You will notice a heightened sensitivity to your body's inner sensations, and to its responses to your environment, the air you breathe, the food you eat, and your mental and emotional state. When you regularly practice listening to your body, you will discover important messages from it that you were unable to hear or feel before. You will become much more aware of the valuable information your body is communicating to you, and you will be better able to use this information to respond to your body's needs. Should imbalances or insults to your body occur, you will be better able to assist your healing system in correcting these imbalances as it restores your body to its natural state of health. By opening the door to better communication and cooperation, learning to listen to your body can become one of the simplest, easiest, and yet most powerful ways to strengthen and fortify your healing system.

Healing System Rx #2:
Pay Attention to Your Personal Hygiene

Your personal hygiene consists of the simple acts you perform daily to help support and care for your body. These actions include such common activities as brushing your teeth, moving your bowels, and bathing. These simple routine habits, which may seem insignificant at first, add up over the days, weeks, months, and years of an entire

lifetime and, in the long run, exert a powerful influence on the performance and efficiency of your healing system. In fact, your personal hygiene can have a much greater impact on your ability to stay healthy and resist diseases than your genes, the medicine you take, or your doctor.

The elements of personal hygiene in the following sections contribute significantly to the health of your body, and they can strengthen and fortify your healing system. They can make a huge difference in the quality of your life, and in your ability to stay well and resist disease. If you want to live a long and happy, healthy life, and you are interested in preventing problems before they develop, or if you are currently struggling to regain your health, pay careful attention to the following elements of hygiene.

Dental Hygiene and Your Healing System

Good health depends on proper digestion. Digestion begins in your mouth with the chewing of food, which depends on the health of your teeth. For this reason, regularly brushing your teeth and observing good dental hygiene is important. When you brush regularly, you prevent the possibility of plaque build-up, cavity formation, and gum disease, all of which can impair digestion, interfere with proper nutrition, and adversely affect your healing system.

Bathing and Your Healing System

Bathing helps preserve the function and integrity of your skin, which is one of your body's primary defense organs. Regular bathing leaves your skin feeling fresh and clean, and it removes bacteria and germs that can accumulate on the surface of your skin. Bodies that are not washed or bathed regularly are more prone to skin infections. Microorganisms, including staph and strep bacteria, can invade your body after first appearing on your skin. Regular bathing can aid your healing system by eliminating these infections at their source.

Elimination and Your Healing System: Bowel and Bladder Hygiene

Because of normal internal metabolic processes, large amounts of toxic wastes are produced and accumulate in your body during each

day. Failure to eliminate waste products and toxins promptly and efficiently contributes to the steady build-up of these materials, which can cause your healing system to bog down and become seriously impaired. Without regular elimination, you will literally drown or suffocate in your own waste. Irregular elimination can contribute to the onset of a number of serious, life-threatening diseases.

Solid, unwanted, toxic-waste products are eliminated through the large intestines in your bowel movements, while liquids are eliminated primarily through the kidneys and bladder, in the urine. Ensuring the health of these organs is essential for your healing system to operate with maximum efficiency.

Tips for Healthy Elimination

- Drink plenty of fluids, including water. Your body is approximately 70 percent fluid, and the more fluids you bring into your body, the more efficiently your healing system can eliminate and remove toxins from it. If your bowels are sluggish and need a little coaxing in the morning, a large cup of hot water or a warm beverage will usually bring fast results.

- Increase your fiber intake throughout the day and at night. Adequate fiber intake ensures more effective elimination of waste products from your intestines, thus reducing the risk of colon cancer and other intestinal diseases. The best sources of fiber include whole grains, seeds and nuts, and fruits and vegetables.

- Increase physical activity, which improves blood flow to the intestines, which helps elimination.

- Avoid low-residue foods, such as processed starches, cheeses, and prepackaged meats and other foods, which lack fiber and can cause constipation.

- Avoid excess alcohol. Alcohol can dehydrate your body, and can cause constipation along with bowel or bladder problems. Alcohol is an intestinal and bladder irritant, and chronic use can contribute to problems with these organs.

- Limit coffee, tea, and caffeinated sodas, because these usually contain tannic acids, which can serve as irritants. Caffeine stimulates the parietal cells in your stomach to produce hydrochloric acid, which, if produced in excess, can damage the lining of your

stomach and intestines, and potentially lead to an ulcer or other intestinal problems.

- Eliminate foods that are highly processed or contain artificial chemical additives. These foods can also irritate and damage the delicate lining of your urinary and digestive systems.

Healing System Rx #3:
Eat a Well-Balanced Diet Consisting of Natural Foods

Food supplies the basic building blocks for the sustenance of every cell and tissue in your body, providing life-supporting energy for metabolic activities, mechanisms of defense, and the processes of repair and restoration governed by your healing system. Just as any other high-powered, performance-oriented machine requires the best fuel, your healing system requires pure and wholesome food to ensure optimum performance and functioning. Here are a few basic but critical guidelines:

- Eat a well-rounded, high-performance diet that includes adequate amounts of protein, carbohydrates, fats and oils, essential vitamins, minerals, and trace elements. Additionally, make sure you are consuming adequate amounts of fluids and fiber.

- Favor fresh fruits and vegetables, whole grains, and legumes, which contain an abundance of all of your body's basic nutritional requirements, over flesh foods. Although flesh foods are excellent sources of protein, you should minimize them in your daily diet because of their tendency toward a higher fat content, lack of fiber, and potential for higher concentration of heavy metals and environmental toxins.

- Minimize eating packaged or processed foods, which often contain preservatives and additives that, while they increase shelf life, may have harmful side effects. Packaged and processed foods generally lack the vitality, fiber, and nutrient quality that fresh and whole foods contain.

- Do not be fanatical in following a restrictive diet. Some flexibility and leniency is necessary to avoid becoming stressed when your food choices are limited or unavailable. The stress of being

too rigid in your diet detracts from whatever benefits your diet might be providing.

■ Make sure your surroundings are pleasant and enjoyable when you eat. Your healing system's ability to remain strong and active is influenced not only by the chemical constituents of the foods you eat, but by your meal patterns and the timing of your meals, in addition to many other factors surrounding food. For example, properly chewing food and the circumstances under which food is eaten also play a role in the digestion and absorption of nutrients. When you take your meals in a peaceful atmosphere, digestion and assimilation are enhanced. (In the next chapter, I'll offer more specific information on nutrition for your healing system.)

Healing System Rx #4:
Get Adequate Exercise and Physical Activity

Movement is a fundamental principle of all matter in the universe, and, along with exercise, it is an important key to a strong and healthy healing system. Movement and exercise are essential for the maintenance of healthy joints and muscles, and they are vital for your circulation and the health of your cardiovascular system. Your daily activity level is an integral part of your body's ability to stay healthy, resist illness, and maintain an active and vibrant healing system.

The Benefits of Exercise for Your Healing System

The benefits of exercise for your healing system are numerous. Because your healing system is connected to all of the other organ systems in your body, any exercise you do regularly will significantly benefit your healing system. Among its many benefits, exercise

■ Energizes and activates your healing system

■ Clears depression

■ Improves circulation to your brain, which improves clarity of thinking

■ Improves overall muscle strength in your body

■ Improves cardiac health

- Improves blood flow to stomach and intestines, which improves digestion and elimination, and reduces constipation
- Improves immune function
- Improves bone and joint health
- Improves the healing time of fractures and joint injuries
- Improves complexion and skin health by increasing blood flow to skin
- Improves blood flow to genitals, which improves sexual function

Just 30 minutes of exercise each day will bring you all of these benefits, and more.

A few of the more common types of exercise are listed in the following sections. Choose one or more, and follow the guidelines listed to strengthen and fortify your healing system.

Walking

Walking is one of the simplest and most natural ways to exercise. In traditional cultures, before the advent of the automobile and motorized transportation, people used their own two legs as their primary means of transport, in addition to their use of domesticated animals. Consequently, there was no need to set aside extra time in the day to exercise, and people in these cultures were generally more fit than those of our modern societies.

If you are extremely busy, walking is a good way to exercise and use this time to listen to music or educational tapes, socialize with friends, brainstorm ideas, or even conduct business meetings. I have often held medical meetings with several close colleagues and friends while we were walking through scenic nature trails in Hawaii, where I live. If you can find creative ways to increase the amount of time you walk, and make walking a part of your daily routine and lifestyle, your healing system will automatically benefit from an otherwise thoroughly enjoyable activity.

Tips for Walking

- Choose a time of day and specific days of the week that work best for you. Try to walk three to five days a week if this is your only exercise.

- Wear comfortable clothing, especially comfortable, supportive shoes. If you live near the beach, and it is not too cold, consider going barefoot.

- Find a safe place to walk, hopefully with interesting scenery. This place could be outside in nature or even indoors in a large mall.

- Avoid heavily trafficked areas if possible because exhaust fumes are unhealthy to breathe, and the noise and distraction of the cars may interfere with your concentration and relaxation.

- Walk with a friend or family member so you have company. Alternatively, you can use this time to be alone.

- You may want to listen to music or educational tapes with a portable tape or CD player as you walk.

- If you are out of shape and haven't done any exercise in quite a while, start with just 10 to 15 minutes a day on a flat, even surface.

- Walk at a pace that's comfortable for you. Recent research indicates that it is more important to walk regularly than to walk briskly. You do not need to force or strain or be uncomfortable in any way.

- If all goes well, after one to two weeks, add 5 minutes per week so that you can eventually build up to 30 to 60 minutes each day.

Bicycling

Bicycling can be an enjoyable way to exercise while you get out and see the world. Bicycling is often considered easier on the joints than running or other exercises. This exercise helps to build up the largest muscles in your body, your legs and lower torso, while it also improves your cardiovascular health.

Tips for Bicycling

- Avoid heavily trafficked areas that have exhaust fumes.

- Start at a comfortable pace and try to ride for 15 to 30 minutes at a time.

- Make sure your bicycle and seat are adjusted to the proper height for your legs.

- Unless you are an expert, avoid strapping your feet into the pedals.
- Maintain proper posture as you ride so that your back and knees are not strained.
 - ◆ To protect your head from a fall, wear a helmet.
 - ◆ Use protective glasses or eyewear for your eyes.

Swimming

If you have access to a pool, pond, lake, or ocean, swimming can be a wonderful form of exercise that provides all of the cardiac and circulation benefits of walking. Swimming is especially beneficial if you have back or knee problems because it is a non-weight-bearing exercise that is gentle on the joints.

Tips for Swimming

- Start out slowly and increase your laps gradually, adding one lap each time you swim.
- Build up to at least 20 to 30 minutes of swimming each day.
- Alternate strokes to give different muscles in your body a more thorough workout.
- Make sure you are comfortable with your breathing as you swim, and that you are not forcing or straining.
- It is better to swim slower and longer than faster and shorter. If you make it enjoyable, the likelihood that you will continue to swim regularly is much greater.

Weight Lifting

Thanks to the many colorful characters in the world of professional bodybuilding, weight lifting has become increasingly popular. Pumping iron and weight training can increase muscle strength and improve your overall physical health. It can also relieve mental and emotional tension, and effectively strengthen and fortify your healing system.

Tips for Weight Lifting

- Start with light weights and move through the full range of motion of the exercise you're doing to ensure proper movement of the muscles being exercised.

- Balance your workout so you are not working all the same muscle groups at one time.

- Focus more on the lower body, including your legs and back, because these muscles are the largest and most important muscles in your body, and they usually are the ones most neglected.

- Stretch in-between and after weight-lifting exercises to avoid stiff muscles and joints.

- Breathe properly as you work out. It is physiologically more correct to exhale as you lift or move a weight, as if you were blowing air into the weight.

- Be smart and accept the help of a personal trainer to orient yourself on a new machine or while you are learning a new routine.

- If your muscles are sore the day after a workout, wait until the pain is completely gone before you work these same muscles again.

- Remember that muscles need rest to grow and become stronger. It is possible to overtrain and injure muscles if you do not allow adequate rest between workouts.

- Never force or strain to the point that you feel pain. Although most gyms encourage the saying "No pain, no gain," from a medical perspective, ignoring pain in your body can result in an injury.

Aerobic Exercise

Aerobic exercise describes any sustained exercise that increases your breathing and heart rate and has the ability to make you break a sweat. Aerobic exercise requires increased air delivery to your body, which results in greater oxygenation of your tissues. You can achieve these results in numerous ways and settings, from brisk walking, running, calisthenics, hiking, biking, swimming, aerobic dancing and exercises, to sports, games, and other fun exercises. Aerobic exercise may also include the exercise you get while working on your job if you perform manual labor or are regularly involved in activities that require the steady movement of your arms or legs over a continuous period of time.

Tips for Aerobic Exercise

- Take 5 to 10 minutes to stretch and warm up before and after exercising.

- If you haven't exercised in a while, start slowly and do only about 10 to 15 minutes at a time for the first week.

- Make sure you are not forcing or straining your muscles or joints, and that you are not gasping for air while you are breathing.

- Slowly build up speed, distances, and length of time exercising, until you can do 30 to 60 minutes at a time.

- If you experience pain that persists in any part of your body, ease off your exercising pace and intensity. If the pain persists even with less exercise, consider stopping altogether. Trying to ignore the pain or force through the pain does not help. Doing this is how serious injuries and problems can develop.

- Remember to rest and allow some down time before you make a transition to your next activity.

Stretching

Stretching can provide tremendous support for your healing system. Stretching is becoming increasingly popular in the United States and Europe with the acceptance and introduction of traditional oriental disciplines such as yoga and tai chi into Western cultures. Even giant Sumo wrestlers in Japan stretch as part of their pre-match warm-ups and rituals. Stretching is also making its way into the medical establishment and is gradually becoming accepted as a first-line intervention in the fields of rehabilitation, sports medicine, and physical therapy for the treatment and prevention of neuro-muscular disorders and injuries, including back pain, post-surgical rehabilitation, and many forms of arthritis and other joint diseases.

When done properly, stretching feels good. Stretching is something that most animals do naturally. When dogs or cats awaken from a nap, the first thing they do is stretch. Children also naturally stretch and assume all kinds of twisting, flexible, and topsy-turvy positions as they play and explore the different muscle groups in their bodies. They do this as part of the natural process of developing the coordination that is such a vital part of their normal growth and development.

As a result of the effects of stress, aging, and increasingly sedentary lifestyles, many people begin to develop severe stiffness and pain and are unable to move their joints adequately as they age. This process sets the stage for a whole host of joint diseases to set in, including arthritis. Stiffness also increases the likelihood of injuries because of the rigidity within the joints. Stretching can help reverse these harmful tendencies.

I have personally benefited from the stretching that comes from yoga, the grandfather of all stretching systems. As an introduction to proper stretching, there is no substitute for attending a gentle yoga class once or twice a week for several months or longer. Because of yoga's increasing popularity, yoga classes are now available in almost every city in the United States, Canada, Japan, and Europe. Before you start a yoga class, make sure the teacher has proper credentials and the class is not too rigorous for you, particularly in the beginning. If you have particular health needs, make sure you call this to the attention of the teacher.

Tips for Stretching

- Set aside 10 to 15 minutes a day when you can be alone to do your stretching. Gradually build up to 30 to 60 minutes a day, either at one time or in divided periods, morning and evening, as your schedule permits.

- If you have never stretched before, and your muscles are stiff, start out slowly and gently. Remember not to force or strain.

- Stretch as far as you can without feeling pain. If you don't stretch far enough, your muscles will not become flexible and healthy. However, if you stretch too far, you will feel pain, and you might damage and tear your muscles.

- Do not bounce or jerk when you stretch. Again, doing this could damage your muscles.

- Breathe slowly and gently when you stretch, so that oxygen can enter into the muscle cells that you are stretching.

- Whenever possible, stretch in the morning, even though your muscles will most likely be stiffer then. This is a great way to start the day.

Healing System Rx #5: Get Enough Sleep and Rest

Sleep is one of the body's most basic physiological functions and one of the most important activities to strengthen and fortify your healing system. When you sleep, your body has a chance to recharge its batteries. Many illnesses are less symptomatic in the morning, thanks to the refreshing and regenerative properties of sleep. In fact, your healing system is most active when you are sleeping and resting, since other physiological processes are held at a minimum and cannot interfere with its work during these periods.

Alternatively, people who suffer from insomnia, or who do not get enough sleep or rest throughout their day, are at risk of becoming sick. Sleep deprivation alters the proper functioning of your healing and immune systems and predisposes you to heart disease, chronic fatigue syndrome, endocrine and metabolic disorders, nervous-system imbalances, stress-related conditions, and other serious health problems.

When you are getting adequate sleep each night, you should wake up feeling rested and refreshed. Taking a nap in the afternoon is also socially acceptable in many cultures, and many studies are now beginning to show that naps can be beneficial. Incorporating a daily 30- to 60-minute power nap into your schedule, at least on weekends, can be a great asset to your healing system.

Alone Time: An Important Form of Rest for Your Healing System

If it runs continuously, any machine or toy will eventually wear down its batteries and stop working. Your body is no different. In fact, many illnesses can be traced to the neglect of this simple, yet important, principle. Just as every ship must come in from the open seas to dock and resupply, so, too, your body must take time off from its incessant activities to allow your healing system to recharge, regenerate, and renew its energies.

Throughout our busy lives, as we give ourselves over to our work, our families, and our friends, we need to take time out to be alone and restore our precious life energies. As part of your regular routine, it is important to experience what I call "alone time" for a brief period each day.

Think of alone time as mandatory solitary confinement—not in a punitive way, but rather as a time for you to rest and heal, to quiet down your engines, to be responsible only to yourself and your body, with no phones to answer, no duties to perform, no scheduled appointments, no commitments, no burdens, no worries, no hurries. Even if your alone time is only 15 or 20 minutes a day, in this state of quiet solitude your batteries can recharge, and your healing system can work more effectively to restore health.

While this need for rejuvenation is only common sense, as a doctor, I am continually amazed at how many people expect their bodies to keep going without recharging their batteries. When these same people become sick and end up in the doctor's office because of frayed nerves, sleep deprivation, and physical exhaustion, most are shocked to learn why they became sick in the first place. They are unable to see the connection between their illnesses and their run-down state. They think their illness is caused by some misfortune or ill luck. The sad fact is that many of these folks have not yet discovered the life-sustaining practice of spending time alone with themselves. They have not learned how to tell their families or their bosses that they need time alone to recharge their batteries. In fact, it is commonly reported that people who suffer from major, chronic, debilitating diseases often complain that they have no time for themselves, that they are just following scripts that other people are constantly imposing on their lives. Insisting on alone time is one way to stand up for the needs of your body.

Learning to say "No" to excessive demands on your life energies is mandatory if you want your healing system to remain strong and healthy. Being alone allows your body time to conserve energy, and it allows your mind time to settle down and focus within so you can listen and cooperate with your healing system. When you are quiet, alone, relaxed, and peaceful, your healing system functions best. Taking the time to be alone is one of the most powerful things you can do to strengthen and fortify your body's healing system.

Healing System Rx #6:
Manage and Minimize the Stress in Your Life

In the field of engineering, stress is defined as the amount of strain experienced by a system as the result of an applied external force or

load. If the system is not flexible, or if it is unable to adapt to the force or load, it can break under the strain. This description is similar to what can happen when you experience stress. If stress is prolonged or too great, your mind and your body can suffer from a breakdown in health.

Although stress can obviously be caused by major disruptive external forces such as natural disasters, political turmoil, and even war, these sources are, for most of us, far less common, less prolonged, and less dangerous than the stress caused by our own thought processes and our fast-paced, hectic lifestyles.

Stress, if not handled properly, can do considerable harm to your healing system, wasting and depleting your precious physical, mental, and emotional energy while it causes fatigue and exhaustion, which renders you susceptible to illness and disease. Stress interferes with your body's natural ability to grow, repair, and restore normal healthy tissues. Your immune system can also become damaged and inefficient with significant and prolonged stress. Stress has been linked to a number of major serious illnesses, including heart disease, high blood pressure, ulcer, stroke, and cancer, and it has been implicated as a significant contributing factor in many others.

Stress is unavoidable at times, but it is important to be able to manage it effectively and to minimize its impact. You can accomplish this through a variety of proven methods and techniques. However, you need to practice and be familiar with these techniques and methods well in advance, so that, when you do experience stress, you can easily apply them to neutralize and handle the stress more effectively. Again, all this is nothing more than sound preventive medicine.

Stress management has been shown to be a vital factor in the successful reversal of major chronic diseases such as heart disease, hypertension, diabetes, and cancer.

Learning to prevent and reduce stress in your life, in addition to managing whatever stress may be currently afflicting you, will allow you to feel much more calm and relaxed. And effectively managing stress will liberate tremendous amounts of energy in your body that your healing system can use. Fatigue will vanish, and your healing system will perform much more efficiently, enabling you to more effectively resist and eliminate illness and disease.

Many popular stress-management techniques are currently taught. All have as their common goal your ability to effectively calm and relax your mind and body, which frees up energy for healing. In Chapter 6, you will be introduced to some of these methods and techniques.

Healing System Rx #7: Enjoy Your Work

Your daily work routine, your work ethics, and your attitudes toward your work influence the functioning and performance of your healing system. For example, you might spend most of your time at work. In this setting, you may have to contend with coworker tensions, bosses, deadlines, company policies, commuting to and from work, and other issues, which require a substantial investment of your life energies. In this respect, your work and your work environment may be having a more significant effect on your physical and mental health than anything else.

Many people work at home, with less energy spent interacting with coworkers and bosses and commuting through dangerous traffic back and forth to an office, but other problems may present themselves, such as the intrusion of work into the home space, and the inability to turn off the work mode when they are interacting with their families.

Many people don't like their jobs, as numerous polls and surveys reveal, and this dissatisfaction can have a damaging effect on the healing system. Toxic emotions that have built up in the form of resentment can exhaust the immune system and deplete internal healing resources. Many people who develop chronic illnesses report feelings of long-term animosity or ambivalence for their work, often feeling hopelessly trapped in a dull and boring routine. Many other fortunate souls, having made peace with their vocation and having found their niche in the world, report that their work is like play. I discovered this positive perspective to be the case with pilots while I was working as a flight surgeon in the Air Force. They would often tell me that they couldn't believe they were being paid to fly; they felt like they should be paying the Air Force for the opportunity to fly.

Pilots and many other people who enjoy their jobs and the company of the people they work with, and of the people they serve, consistently demonstrate superior health. They feel they are part of

a team, and they are uplifted by the sense of performing a valuable service to their community and fellow human beings. These positive feelings work to fortify and strengthen the integrity of their healing systems.

Many cultures consider work to be a form of worship, wherein your work and the services you provide, however humble, are an important opportunity for you to give back to the world. This perspective can enhance your self-worth, uplift your spirits, and generate positive emotions that stimulate your healing system and improve your vitality. In fact, many studies are now revealing that retirees who regularly volunteer their time in local community service enjoy much greater health and live much longer than their peers who do not participate in such activities.

If you are currently unhappy with your work, it is imperative to either change your attitude toward your work so that it can become more meaningful to you, or, if this is impossible, to find work that is more rewarding and enjoyable. Whether you work with others as part of a big company, or you work alone, learning to enjoy your work and focusing on its positive aspects will be health-enhancing, life-promoting, and a great benefit to your healing system.

Healing System Rx #8: Enjoy Your Play

One of the best ways to reduce tension and stress in your life is through play. Play represents a carefree state of mind that is vital to your overall health. This means taking the time to cultivate a sense of humor, and to be spontaneous, creative, and involved in such fun activities as sports, music, dance, the arts, or pursuing your favorite hobbies. I have met many people who did everything wrong from a health standpoint; however, because of their light-hearted attitudes, keen senses of humor, and their ability to play and have fun, they lived well beyond their life expectancy.

In nursery schools, kindergartens, and elementary schools throughout the world, play is an integral part of the daily routine and curriculum for all children. A child who does not know how to play is considered unhealthy and abnormal. This standard should also apply to adults.

Many adults become workaholics who regard play or having fun as a waste of time. On the contrary, most of humanity's greatest

ideas and inventions have come from people who knew how to play and use their powers of imagination. In fact, most inventors claim their greatest ideas came to them not when they were actively pursuing them, but rather when they were involved in fun and frolic and were simply enjoying themselves. Many successful businessmen and professional people understand that, to be truly happy and healthy, it is important to know how to play.

Play is an effective way to strengthen your healing system because it helps you forget about time. In this state of timelessness, you are not worrying about the future or feeling sorrowful, grievous, or guilty about the past. Rather, you are completely absorbed and focused in the here and now. Freed from the mental and emotional forces that drain your energies and interfere with your body's internal processes of repair and regeneration, when you are playing, your healing system gets recharged. When you play, a light-hearted spirit prevails that influences brain biochemistry and causes the release of beneficial hormones, neurotransmitters, and other powerful chemicals that strengthen and support the activities of your healing system. The following story demonstrates the healing power of play.

Derek, a physician and personal friend who had been suffering from severe back pain with *sciatica*, was looking for a quick fix so he could get back to work as soon as possible. However, he couldn't find a surgeon who would operate on him promptly, so in a moment of exasperation he decided to go surfing. In his joy and enthusiasm for being in the ocean and doing something that he loved, he totally forgot about his pain and predicament. When he came out of the water, Derek was surprised to discover that his pain was gone! He became completely healed, and although his condition has not returned to this day, Derek now makes sure to take regular time out of his schedule to go surfing.

Play also encompasses the field of entertainment. Nearly every culture has made use of this aspect of play to pass on important moral, spiritual, or cultural lessons to upcoming generations, often in the forms of traditional songs, dances, poetry, or stories. While you are being entertained, you are usually in a more relaxed frame of mind, detached from your worries and problems. At these times, deep emotions can often be stirred up and released, causing laughter

or tears. Again, these deep emotional responses trigger the release of beneficial hormones and chemicals that serve as powerful stimulants for your healing system. Live events such as concerts, plays, or sporting events carry an added benefit of creating intimacy and a feeling of belonging to a larger community as you share a collective, live energy that occurs when people are gathered together to focus on a common goal or activity. This sense of community can help combat the feelings of isolation and loneliness that often plague people who are struggling with health issues, lending further support to the work of the healing system.

Creativity is another important aspect of play. Pursuing hobbies, including the arts, music, singing, dancing, painting, writing, or participating in any one of a number of other activities involving the use of your hands and your more artistic side can also be a way of strengthening and fortifying your healing system. Many people have overcome life-threatening health conditions by becoming involved in creative projects that were deeply personal, meaningful, and fun for them. In fact, having your creativity stifled is now considered a major risk factor for contracting a chronic disease.

Cultivating the creative aspect of your spirit and remembering to develop a light-hearted attitude that fosters a spirit of play is important. From a health perspective, play needs to be an integral part of your daily life. Play can strengthen your basic natural energy and activate important internal mechanisms of repair and recovery that are an essential part of your healing system.

Balancing Your Work and Play

Both work and play are equally important, but balancing these important activities in your life is essential. Meaningful work lets you provide for your family and your personal needs. It also lifts your self-esteem, helps define your sense of purpose, and provides you with an opportunity to give back to the world. Play keeps you in a carefree, loving frame of mind, connected to your heart, and focused in the present. Play relaxes your body, mind, and nervous system. Maintaining a proper balance between work and play

enables you to experience all these aspects of life, which helps to strengthen and fortify your healing system. Both work and play are important, and both need to be weighed and balanced with each other.

Healing System Rx #9: Develop Effective Social Skills

Since antiquity, people have lived together in families, clans, tribes, and communities to organize themselves, and to nurture and care for each other. Like bees and ants, humans are also social creatures. We depend on each other to make our lives meaningful.

Studies show that good social skills strengthen and fortify our healing systems, and that living a lonely and isolated life can be harmful to those systems.

Many people with serious illnesses have reported significant improvement in their health when they improve their socializing skills. These activities have included visiting with friends, or participating in some kind of volunteer community-support work, either at a day-care center, a senior center, a hospital, or some other charitable organization.

Well-known doctor and author Dr. Bernie Siegel tells a story to help illustrate this point. He tells of a special pass he got from God to visit both Heaven and Hell. In Hell, he saw many bowls of hot, steaming soup being served with long-necked spoons. This soup didn't look too bad until he realized that the hungry people in Hell were unable to feed themselves because the necks of their spoons were too long, and they kept missing their mouths with the spoonfuls of soup. When he got to Heaven, he was surprised to see the same bowls of soup and the same long-necked spoons. However, upon closer observation, he saw that the people in Heaven had learned to place the spoons in each others' mouths, so that everyone got fed.

Fostering a spirit of cooperation and sharing by building and developing strong social ties has been scientifically proven to improve survival. Because of the powerful biochemical effect that emotions exert on your healing system, many studies are now showing that people with inadequate social support who are lonely and socially isolated are at risk for developing serious, life-threatening

physical diseases. According to the research of heart specialist Dr. Dean Ornish, social isolation and a lack of intimacy are considered top risk factors for the development of heart disease, the number-one killer in the Western world.

Good social skills begin with family and are usually learned in childhood. However, as the divorce rate continues to soar, and many families are broken apart, it is clear that many people will have to reach out beyond their families to their friends, colleagues, coworkers, and others to get the support they need to remain healthy. Doing so can strengthen their healing systems and can help to prevent physical illnesses associated with a lack of social support and intimacy.

Animals are also capable of giving and receiving unconditional love and, as pets, can serve as an important form of social support to those who may otherwise be isolated from family or friends. Senior citizens living alone who have pets have been shown to be at much lower risk for developing heart disease and other serious illnesses than those who do not have pets and are living with similar health conditions.

Developing effective social skills allows you to feel supported and connected to others. Knowing that your life counts, that you are important to others, that you make a difference, and that you have a purpose for being here create uplifting, inspiring, life-affirming emotions that help to strengthen and nourish your healing system.

Healing System Rx #10: Utilize Natural Elements That Support Your Healing System

Your body is linked to the world of nature and is dependent on certain key natural elements, including air, sun, water, and the various minerals and nutrients of the earth, for its very survival. Ancient physicians and healers understood this basic principle of health and healing. Of course, now that our medical science has advanced considerably, we have learned a great deal more about these natural elements and the complex ways in which we interact with them. And contrary to what we might expect, with all of the technological advances of modern medicine, the importance of our relationship with these natural elements to our health and healing has only increased.

Natural elements that are critical to the survival of your body can also serve as powerful therapeutic agents and medicines that aid

and support your healing system when you are ill. And used preventively, these natural elements can help to keep you healthy for many years to come. Understanding and making intelligent use of these common resources from nature can significantly strengthen and fortify your healing system.

Air

As you probably know, the air you breathe contains the vital element of oxygen, which nourishes and energizes every cell and tissue in your body and is an essential ingredient to your healing system and your overall state of health. Oxygen is so important that it is the first medical agent administered to a critically ill or injured person, whether the condition is a heart attack, a gunshot wound, or any other serious life-threatening emergency. Oxygen is routinely stored for this purpose in ambulances and in all hospital emergency rooms, operating rooms, and intensive-care units.

Good, clean, fresh air, characteristically found in particular places in the world, can have life-enhancing effects on a person's health. This fact is reflected in better health statistics for those places. Generally, you can find better quality air where there is less industry and less pollution, and where steady breezes, ample water, vegetation, and mountains or hilly terrain help to purify, filter, and increase the quality of the air you breathe. Heavily forested areas usually have excellent air quality because of the voluminous oxygen so many trees produce.

Your body and your healing system deserve the best air you can find. If you find yourself indoors or in any environment with compromised air quality, walk outside or go to another place where there is good air. If you are currently battling an illness or are seeking to improve the quality of your health, pay close attention to the quality of the air you regularly breathe.

Fresh, outdoor air is almost always preferable to indoor air, which can become stale and stagnant, and which tends to attract mold, dust, and dust mites. Indoor air can also play host to toxic fumes, vapors, and other chemical aerosol irritants which, if ventilation is poor, can accumulate and concentrate. Fortunately, many indoor filters, purifiers, and humidifiers are now available to improve the quality of the indoor air you breathe.

Sunlight

In more ways than you may be aware, your health and well-being are directly linked to the sun. The sun not only fuels the reaction of photosynthesis in plants, which produces the oxygen you breathe and the food you eat, but the sun also determines the occurrence of night and day, and so influences the natural cycles that control the rhythmical ebb and flow of the chemistry in your body's internal environment. These cycles, known as *circadian rhythms*, include the most obvious cycle of sleeping and waking. Prolonged or even intermittent disruption of the sleep-wake cycle can be harmful to your healing system and can lead to disease.

The sun particularly influences your endocrine system, including your glands and hormones. Cortisol, an important hormone secreted by the adrenal glands, is markedly increased during hours of sunlight and decreased during hours of darkness. The effects of cortisol are vast and varied; it affects blood-sugar levels and immune function, which have a direct impact on your healing system. The sun also activates your pineal gland, which produces melatonin, a powerful hormone that affects the sleep-wake cycle. Melatonin also influences glucose metabolism, blood pressure, heart function, immune-system activity, and skin pigmentation, all important functions of your healing system.

Since ancient times, the therapeutic value of natural sunlight has been recognized as an essential element in healing. Physicians throughout the ages have prescribed regular sunbathing as an effective treatment for a number of common disorders. For example, the role that sunlight plays in building strong bones is well documented. Natural sunlight is the best source of vitamin D, which is required for calcium absorption in the intestines. Adding sunlight to your life can assist your healing system by ensuring that adequate calcium is absorbed to build strong bones as you grow and age.

Sunlight also aids your healing system in wound healing. It is common knowledge that wounds heal more rapidly when they are exposed to natural sunlight.

Sunshine can lift moods and improve one's outlook on the day. When people are exposed to periods of darkness or extreme lack of sunlight, depression invariably occurs. *Seasonal affective disorder (SAD)* is a common form of depression that occurs during the

winter months in colder, darker climates. SAD is effectively treated with natural sunlight.

The Powerful Effects of Sunlight on Your Healing System

The sun is a powerful natural support for your healing system. Numerous studies have demonstrated the therapeutic role that sunlight plays in improving the health of those afflicted with a variety of specific illnesses and diseases. Here are a few brief examples:

- Sunlight and immune function: Sunlight stimulates immune system activity, and improves immunity.

- Sunlight and infections: Sunlight is a natural disinfectant. The ultraviolet rays in sunlight help kill pathogenic microorganisms such as viruses and bacteria. Where sunlight is scant, and darkness prevails, infections flourish. A famous example of this was the plague epidemic in the Middle Ages, also known as the Dark Ages, during which people characteristically lived in dark, crowded conditions with narrow, cobblestone streets and congested alleyways. This was the perfect breeding ground for rats infested with fleas that harbored the plague bacteria. The plague was also spread from person to person by the human body louse, which cannot tolerate direct sunlight. The plague wiped out millions, and the only people who survived the plague were those living outside of the city limits in the countryside, where they were exposed to fresh air and natural sunlight.

- Sunlight and respiratory infections: Sunlight exposure on the chest, and particularly on the back, helps speed recovery from respiratory infections, including bronchitis, pneumonia, and even tuberculosis, by drying secretions and killing microorganisms. In fact, people with TB (tuberculosis) used to be ordered by their doctors to move to Arizona for this very reason—to take advantage of the dry, sunny climate.

- Sunlight and skin infections: Skin infections, including fungal infections, staph infections, impetigo, and others improve and heal faster with natural sunlight, which acts as a disinfectant, drying agent, and natural antimicrobial agent.

- Sunlight and wound healing: Wound healing improves under the influence of direct sunlight. A wound will heal faster and resist infection more easily in the presence of sunlight.

- Sunlight and bed sores: Sunlight helps to heal bed sores and various skin ulcers.

- Sunlight and blood oxygen: Sunlight helps to oxygenate and purify the blood.

- Sunlight and jaundice: Sunlight helps to cure both neonatal and adult *jaundice*, which is a yellowing of the skin due to the accumulation of *bilirubin* in the blood, most often due to a liver problem. The standard use of hospital florescent lights in the treatment of this condition was pioneered by the discovery that babies with jaundice improved when they were exposed to natural sunlight.

- Sunlight and arthritis: Sunlight has been shown to be an effective adjunct in the treatment of arthritis, including *osteoarthritis, rheumatoid arthritis,* and other forms of arthritis.

- Sunlight and gout: Sunlight helps to break down and eliminate uric acid, lowering its concentration in the blood, and alleviating symptoms of gout.

- Sunlight and psoriasis: Sunlight helps in the treatment of *psoriasis* and helps eliminate the rash that appears as a result of this condition.

- Sunlight improves acne: Sunlight stimulates healthy renewal and regeneration of the outer layers of the skin; improves blood flow, circulation, and sweat-gland activity of the skin; improves lymphatic drainage; helps in the removal of surface oils and toxins; and helps to diminish the intensity of acne outbreaks.

- Sunlight and muscles: Sunlight increases circulation and blood flow to the skin, and improves muscle tone under the area of the skin exposed to the sun.

- Sunlight and weight loss: Regular sunbathing has been prescribed by Russian and Eastern European doctors in the treatment of obesity after it was found that sunlight stimulates thyroid-gland activity, which regulates your metabolism.

- Sunlight and peptic ulcers: Studies in Russia have also shown that sunlight affects the deep organs, including the stomach and intestines, reducing the amount of hydrochloric acid secretion, and helping to cure peptic ulcers.

- Sunlight and high blood pressure: Sunlight helps to normalize and lower blood pressure.

- Sunlight and diabetes: Sunlight normalizes blood sugar. It has been proposed that this occurs in some way through sunlight's interaction with insulin.

- Sunlight and heart disease: Sunlight reduces blood cholesterol levels. It helps to reverse plaque formation in the coronary arteries, which are the arteries that feed the heart, and it can improve blood flow to the heart. Sunlight also reduces plaque formation in the arteries going to the brain, lowering the risk of stroke. Sunlight improves oxygenation in blood and tissues, thus improving oxygen delivery to the heart and other vital organs in the body.

- Sunlight and cancer: Decreased rates of most cancers except those of the skin have been observed in animals and people exposed to regular sunlight.

- Sunlight and aging: Sunlight reduces *free radical* formation in the body; free radicals have been linked to the aging process.

- Sunlight and rickets: *Rickets* is a bone deformity of childhood caused by a lack of vitamin D, which regulates calcium absorption in the intestines. The best source of vitamin D is natural sunlight. Natural sunlight is especially important for mothers who are breast feeding, to help prevent rickets in their children.

- Sunlight and osteoporosis: *Osteoporosis* is a softening of the bones due to a loss of bone density. Increasing calcium intake is generally thought of as the solution to this problem, but regular sunbathing, with the sun being the best source of vitamin D, provides the greatest absorption of calcium in the intestines and is the most natural way to increase calcium in the blood, which leads to increased bone density.

Since some studies have shown that overexposure to the sun can be damaging to your skin, limit your unprotected exposure to 15 minutes per day.

Heat

Besides the sun, other forms of heat can serve as invaluable aids to your healing system. The following list is a small sampling of the

applications of heat and the mechanisms by which heat provides natural support for your body's healing system:

- *Heating pads* relax muscles and improve blood flow, improve oxygenation of tissues, and help reduce swelling. Heating pads are effective in the treatment of back pain, muscle strains and spasms, joint injuries, arthritis, and many other conditions.

- *Hot water bottles* work as heating pads do and are used in similar conditions, including abdominal pain, gas, and constipation.

- *Hot foot baths* keep the feet warm and improve blood flow to the neck and chest area. They also are effective and helpful in the treatment of respiratory diseases.

- *Hot compresses* reduce swelling and help draw toxins out of affected areas. They help improve blood flow to the area being compressed, and they can be very effective in the treatment of abscesses, boils, and other skin infections and health conditions.

- *Hot water, teas, and broths* relieve congestion of mucous membranes. These liquids are often effective in the treatment of throat infections, sinus and nasal congestion, bronchitis, and other respiratory infections. They can also help to relax and soothe your colon and intestines, which aids digestion and elimination.

- *Hot showers* open and clean pores of the skin, helping to eliminate toxins while removing bacteria from skin surfaces.

- *Hot baths* relax and improve blood flow to sore or injured muscles. They are helpful for back pain, muscle pain, painful joints, and neuromuscular injuries.

- *Saunas* utilize heat to induce sweating and eliminate toxins from the body.

- *Steam baths* break up phlegm and mucous in the respiratory tract. They also relieve congestion and help to eliminate toxins from the body.

- *Jacuzzis* provide a hot-water massage to aching joints and muscles.

- *Infrared heat* relieves pain of muscle injuries, strains, sprains, bruises, and tendonitis.

Note: In using heat of any kind, it is important to remember not to overdo it and burn your body.

Water

Water is the most commonly found substance in all biosystems and arguably the most important of all natural elements. Water is so essential and integral to life that scientists exploring other planets will first look for signs of water before they declare the possibility that life exists or may have existed on that planet. You can further appreciate the importance of water when you consider that it is the dominant element in your body, constituting about 70 percent by weight and volume—not surprisingly, about the same percentage of water the surface of the earth contains.

We can look upon water, known as the universal solvent, not only as an essential nutrient for our healing systems, but also as a therapeutic agent and medicine. In addition to keeping our bodies healthy, water is almost always required in abundant amounts as a support for our healing systems when illness or disease sets in.

Maintaining adequate water intake is one of the simplest and most powerful ways to ensure good health and rapid recovery from illness or injury. Inadequate water intake can hamper the performance of your healing system and lead to dehydration, congestion, stagnation, obstruction, infection, and disease. You can determine whether you are getting enough water by monitoring the color of your urine. Dark yellow urine, which occurs when your body is trying to conserve water, invariably means that your body is low on fluids. Clear urine, like tap water, or very light yellow urine, usually indicates adequate water intake. If you are taking certain vitamins, such as the B and C vitamins, your urine can be artificially discolored; in this situation, monitoring whether or not you are getting enough water may be difficult. Also, because your urine tends to be more concentrated when you sleep, it is usually darker first thing in the morning.

When you are ill, increasing your water intake is important, to help improve the flow of fluids in and out of your body. These extra fluids assist your body's healing system to eliminate toxins, which are increased during periods of illness. Many illnesses respond dramatically if you drink only water for 48 hours or more. I have

personally seen cases of many diseases, including respiratory conditions, *gastroenteritis*, gall bladder disease, gout, Crohn's disease, and many others dramatically improve by following this method. The importance of drinking plenty of water daily cannot be overstated.

In addition to drinking water, you can also employ water in many other ways as a natural and valuable support for your healing system. In fact, in Chinese medicine and the ancient medical systems of India, unique and specific internal cleansing techniques employ the use of water to help remove blockages and restore health to particular areas. In the West, water has also been used effectively in nasal douches, enemas, nebulizers, hot compresses, fomentations, Sitz baths, and simple soaking.

Minerals of the Earth and Your Healing System

The science of *nutrition* examines food sources derived from the earth and their biochemical impact on the health of the human body. Proteins, carbohydrates, fats, vitamins, minerals, and trace elements are all derivatives of the natural elements around you, without which you could not live. Scientific discoveries are now revealing that nearly every single mineral element found in the earth's crust and core, from arsenic to molybdenum, has been discovered within the human body in minute quantities. These minerals are not incidental contaminants; rather, controlled studies have determined that they are essential to the body's health.

Many of these vital mineral elements play critical roles within your body's internal environment, functioning as electrically charged chemicals known as *electrolytes*. Some of the more well known of these elements include sodium, potassium, magnesium, calcium, and phosphorous.

Electrolytes play important roles in supporting your healing system, and they participate in such diverse functions as the beating of your heart, regulation of the body's fluid levels, kidney function, brain function and the transmission of nerve impulses, bone formation, and many more. Any disturbance in the intricate balance of these minerals disrupts the flow of electricity and the transmission of electrical impulses in your body, which often causes serious illness, and possibly death. These mineral electrolytes are so important that they are routinely measured and monitored in the blood 24 hours a day in patients admitted to the intensive-care units of all major hospitals.

Salt

Salt is abundant in sea water and found throughout nature. There are many different types of salts throughout the world that consist of various combinations of minerals. However, common table salt, which consists of sodium and chloride and is used in cooking and as a seasoning, is the most well-known, most widely distributed, and biologically most important salt. Salt consisting of sodium and chloride is an essential natural ingredient in all living systems.

In addition to the necessity for a certain amount of dietary salt intake, salt is also a valuable natural support for your healing system. Sodium and chloride are arguably the most important electrolytes in your body, and they play a key role in the functioning of your healing system. Salt also has important therapeutic applications in both the prevention and treatment of various conditions and illnesses. Because of its ability to absorb water and draw fluid out, its preservative effect, and its ability to kill bacteria and other harmful microorganisms, humans have relied on salt for centuries as a valuable aid in curing and preventing infections. Learning to work with salt is a safe and effective, simple yet powerful way to assist the work of your healing system.

The following list is a small example of how salt can assist your healing system:

- *Salt packs, salt soaks, and salt fomentations* are applied externally to intact skin with warm water to help draw out unwanted fluids, swelling, and toxins from various skin and soft-tissue infections, including carbuncles, furuncles, cysts, and abscesses.

- *Salt water* also can be taken internally as an aid in various forms of intestinal cleansing, to prevent and assist in the treatment of food poisoning, diarrhea, and nausea and vomiting. (Note: When taken internally, salt water must be used under qualified medical supervision.)

- *Salt-water gargles* can be very effective in treating pharyngitis, sore throats, and tonsillitis.

- *Salt-water nose drops*, or the use of salt-water nasal douches, can be extremely effective in the treatment of nasal allergies, hay fever, rhinitis, colds, congestion, and sinus infections.

■ *Nebulized saline* is another form of salt water employed as an effective aerosol spray used in the treatment of asthma and other respiratory conditions.

Clay

The therapeutic use of clay as a natural support for the healing system among traditional indigenous cultures is well documented. Pharmaceutical-grade clay, a naturally occurring substance sometimes referred to as *bentonite*, is readily available at most drug or health food stores. Applied to the skin as a paste, clay works well as a natural drawing agent. In addition to its ability to draw off toxins and reduce swelling from infections, clay works with your healing system by supplying valuable trace elements and minerals that are absorbed into the body in minute but significant quantities. Clay applications can speed the healing of insect bites, boils, abscesses, and many other skin conditions; it can be used alone or in combination with other substances, such as aloe, salt soaks, or ginger compresses. Clay is gentle, safe, and effective, even in difficult cases.

Clay also can be taken internally as an intestinal purifier to help absorb toxins from the intestines; it has been employed like this in European folk medicine for centuries as a way to improve colon health and regulate bowel function.

Plants and Herbs and Your Healing System

Throughout the ages, man has relied on the healing properties of various plants and herbs. And although most doctors in modern countries have come to rely on medicines derived from synthetic pharmaceutical compounds, the use of plants and herbs has experienced a dramatic comeback in Western societies in recent years. Herbs and plants, when used with intelligence and discretion, can help strengthen and fortify your healing system.

Many of these natural medicines have proven track records in other countries, including China, Japan, and India. Even until recent times in our own Western medicine, *botany*, which is the study of plants, was a required course in most medical schools. In fact, many modern drugs and medicines have their origins in the natural world of plants.

Here are a few of the most common plants and herbs that are effective in supporting your healing system:

- *Aloe* grows like a succulent cactus. Its leaves contain a clear liquid gel that has healing and antiseptic qualities. Aloe can be applied topically to burns, cuts, scrapes, skin infections, and other injuries in which the raw surfaces of skin have been exposed. Aloe helps not only to fight and prevent infection but also to aid the actual healing process. It is safe and gentle, and it can even be taken internally in limited quantities to help heal ulcers in the mouth, stomach, and intestines.

- *Ashwaganda* is a traditional herbal remedy from India that has been used for thousands of years as a tonic and to enhance natural host resistance factors. Ashwaganda can be taken long term to increase one's stamina and strength.

- *Astragalus* is an ancient plant medicine from China. It is used to bolster defenses and appears to be especially effective for respiratory illnesses.

- *Bilberry* aids in wound healing and is especially effective in assisting the healing system repair damage done to small, fragile blood vessels, particularly those of the eyes and kidneys. Bilberry may also be effective in treating certain types of macular degeneration and other eye diseases, trace blood in the urine, as well as venous insufficiency and varicose veins.

- *Comfrey* is known as "knit bone" in American and European folk medicine for its ability to expedite the healing of fractures. Comfrey also aids in healing wounds of the skin, mucous membranes, respiratory system, and intestines. It can be applied externally as a poultice or taken internally. The leaves or roots of this plant can be used, although the roots are not recommended for internal use.

- *Dong Quai* is a Chinese medicine used to support the health of the female reproductive system, and it has become increasingly popular in the West. It is often used to help alleviate menstrual cramps and balance estrogen metabolism.

- *Echinacea* is a popular herb commonly used in the early stages

of mild respiratory infections; it may also be helpful in wound healing and other conditions.

- *Garlic* is used as a blood purifier. Many people claim to have lowered their blood pressure with garlic. Used in soups, it is often effective for the treatment of a cold or respiratory infection.

- *Ginger* is a root that can be grated and used fresh, or dried or powdered. It can also be used in the form of a tea. Ginger helps to create heat in the body. It is offered on sea voyages as standard fare to soothe the stomach and help prevent motion sickness. As a tea, ginger is very effective in cases of pharyngitis and tonsillitis. It can often curtail the spread of strep throat if the illness is caught in its earlier stages. Ginger can also be applied to the skin in the form of a poultice; it helps to draw out toxins in cases of skin and soft-tissue infections.

- *Gingko* is derived from one of the oldest living plants on the earth. Gingko has been used in Oriental medicine for centuries, and even Western scientific research has verified that it can improve blood flow to the brain, increasing memory and mental alertness, and even eyesight. This herb is also used in the treatment of tinnitus, migraine headaches, vertigo, and as a possible agent in stroke prevention. It may also prove helpful in cases of Alzheimer's disease.

- *Ginseng* is a tonic herb traditionally valued in the Orient for its ability to prolong life, increase energy in the body, and improve sexual stamina. Some studies suggest that ginseng may improve the health of the nervous system, as well as cardiac function in the elderly, by increasing the tone and contractility of heart muscles.

- *Guggal* comes from a tree resin that grows in India. It has been used for centuries to help reduce weight. Studies have also shown guggal to be effective in lowering cholesterol.

- *Kava root* is a traditional medicine from Polynesia that helps relax the nerves. It is used as a muscle relaxant and for mild cases of insomnia and anxiety. Kava root also can be useful for back pain caused by muscle spasms. Because it can induce drowsi-

ness, Kava root should not be used when you are driving or operating mechanical equipment.

■ *Milk thistle* helps to support the health of the liver. Many patients with elevated liver enzymes resulting from chronic hepatitis and other liver conditions have reported significant improvement in their symptoms and laboratory readings of their liver enzymes after they have taken milk thistle for several months. The mechanisms by which milk thistle supports and heals the liver is still unknown, yet a growing number of conventionally trained liver specialists are now recommending it to some of their patients.

■ *Neem* comes from the leaves of the Neem tree in India, which is the traditional food eaten by camels. Neem is used in Ayurvedic medicine from India as a powerful blood purifier.

■ *St. John's wort* is widely prescribed in Europe as an antidepressant. You might need to take this herb for several weeks to notice its effects, and you should not take it with any other conventional psychiatric medication. By itself, St. John's wort is generally quite safe and often effective.

■ *Turmeric* comes from the ginger family. The dried, powdered root is the part of the plant most often used. Turmeric gives curry powder its characteristic yellow color. Turmeric applied to the skin as a paste is often effective in a variety of skin disorders. Taken internally, it helps to improve the health of the liver and eyes. It also is now being used as an adjunct in the treatment and prevention of certain cancers and liver disease.

■ *Valerian* has been used in folk medicine as an aid to anxiety and insomnia, and it is quite effective in mild cases of these conditions. Valerian is also sometimes recommended as a gentle muscle relaxant.

Many natural medicines are quite potent, so it is important to be careful that they do not conflict with any other medicine you are currently taking. As with any new substance you take into your body, if you experience untoward effects, discontinue its use and seek the advice of a qualified health professional for further recommendations.

Closing Thoughts on Strengthening and Fortifying Your Healing System

In time, falling raindrops carve deep canyons and valleys out of mountains. Added to other grains of sand, a tiny grain of sand can make a large beach or vast desert. Similarly, individual health factors, which may seem insignificant and unworthy of our attention when considered alone, form the very foundation for strengthening, fortifying, and activating your healing system when they are added together. In combination, these factors also can substantially improve your overall health and the quality of your life. These factors include listening to your body; paying attention to your personal hygiene; maintaining a healthy diet; doing regular exercise, stretching, and stress management; balancing work and play; developing good social skills; and incorporating healthy natural elements into your daily routine, such as drinking plenty of water, breathing fresh air, getting adequate sunshine, and using natural herbs and minerals when appropriate.

In the next chapter, we will look more closely at the critical role diet and nutrition play in strengthening and fortifying your healing system. By following a few simple dietary and nutritional guidelines, you will not only greatly improve your overall health, but you'll also gain the maximum benefits from your extraordinary healing system.

CHAPTER 5

Fueling Your Healing System

High-performance machines, from racing cars to rocket ships, all require specialized fuels to make them go. Your body is no different. In fact, your body is the greatest of all high-performance machines on this earth, created to last up to 100 years or more. Your body is an engineering masterpiece of nature, more complex, sophisticated, durable, and intelligent than anything ever crafted by man. Your body is adaptable to a variety of climates, environments, and life situations, capable of moving in an infinite number of ways, and of enduring and surviving conditions of extreme hardship and deprivation.

As you already know, your body has been designed with such skill, precision, and expertise that it comes equipped with its own healing system. This extraordinary system is self-contained, self-monitoring, and highly intelligent, and is capable of supervising and initiating mechanisms of repair, restoration, and recovery from a huge assortment of illnesses, injuries, and insults. To accomplish these tasks, your healing system mobilizes specialized cells and stimulates powerful biochemical reactions that can rapidly mend damaged tissues when you are ill or injured. It also maintains a balanced and highly ordered natural state of health when you are not sick or injured. No other machine on this earth can boast of such a

system. And just as with any other high-performance machine, your healing system performs best when it receives special, high-performance fuel. The fuel your healing system requires is wholesome, nutritious food.

A Wholesome Diet for a Strong Healing System

The best way to keep your healing system strong is to eat a balanced, wholesome, simple, natural diet. Such a diet consists of a well-rounded blend of all essential nutrients. These nutrients include adequate amounts of proteins, fats, carbohydrates, vitamins, minerals, trace elements, fiber, fluids, and other vital nutrients such as *phytochemicals* (special health-promoting molecules found in fruits and vegetables). Your daily requirements of these substances will vary according to where you live, what you do, and your basic metabolic requirements.

The Best Fuel for Your Healing System

Fruits, vegetables, grains, legumes, nuts, and seeds provide the purest energy source for your healing system, and these foods are essential for strengthening and fortifying this most important system in your body. In addition, fruits, vegetables, grains, legumes, nuts, and seeds

- Constitute the nutritional foundation for most other mammals, including those with much larger muscle mass than humans. Our primate cousins, including gorillas, chimpanzees, orangutans, baboons, and monkeys, also eat foods almost exclusively from these categories.

- Are generally easier to digest than most flesh foods, and, again, represent the purest energy source for the metabolic demands of your healing system.

- Are lower on the food chain and contain far fewer toxins and environmental pollutants than most foods that are derived from the flesh of other animals.

- Take less time to cook, and are generally safe enough to be consumed raw.

- Have less chance of spoiling and putrefying than animal products do. As a result, the possibility of contamination and food poisoning from these foods is much less.

- Are usually less expensive, and don't require the extensive and continuous refrigeration for transport and storage that flesh foods need.

These simple, wholesome, natural foods are the keys to the health of your healing system. All nutrients are ultimately derived from the soil and atmosphere of the earth, and eating a wide variety of these foods will ensure the best chance of a complete diet.

Use the following list as a guide to the foods that serve as the best fuel for your healing system. Depending on where you live and what is available, you may have many more food choices within these categories of fruits, vegetables, grains, legumes, nuts, and seeds.

- Whole grains, including rice, wheat, oats, rye, corn, and barley

- Leafy greens, including lettuce, spinach, and cabbage

- Roots and stems, including carrots, turnips, potatoes, and onions

- Beans and legumes, including soy beans, pinto beans, sweet peas, black-eyed peas, chickpeas, mung beans, lentils, and peanuts

- Seeds and nuts, including walnuts, pecans, cashews, hazelnuts, and almonds

- Fruits, including apples, oranges, bananas, pineapples, cherries, berries, grapes, apricots, peaches, and watermelon

- Other vegetables, including bell peppers, broccoli, cauliflower, cabbage, squash, tomatoes, chili peppers, okra, and mushrooms

Essential Nutrients for Your Healing System

Before we go on, it is important to discuss briefly the essential nutrients that we mentioned earlier—protein, carbohydrates, fats and oils, vitamins, minerals, trace elements, and phytochemicals—and how they affect your healing system. Doing so will give you a greater understanding of the rationale behind the practical ways to fuel your healing system.

Protein and Your Healing System

Protein provides the structural elements for growth and repair of your bodily tissues, and it is one of the most important nutrients for your healing system. Protein is also the primary nutrient building block for your muscles which, at 40 percent of normal body weight, are the largest and most dynamic, energy-dependent structures in your body. In addition to its predominance in muscle tissue, protein is found in nearly all cells and tissues of your body, including your blood.

Adequate dietary protein intake is required for growth in children; if it is not taken in required amounts, it can result in muscle-wasting disorders in children. But because the daily requirement for protein is only about an ounce a day, a lack of protein today in Western countries is rare. In spite of this, unfortunately, a lingering fear of not getting enough protein drives much of the unhealthy dietary practices currently in vogue in Western countries. This fear results in overeating, which can lead to obesity and can be very harmful to your healing system.

Many people in Western countries have come to depend on meats and animal products as convenient sources of protein. Unfortunately, these foods contain highly saturated animal fats with no fiber, which creates an unnecessary burden on the healing system. Learning to incorporate protein from non-meat sources in your daily diet is a much healthier and safer approach for your healing system.

Carbohydrates and Your Healing System

Carbohydrates are derived from plants. Carbohydrates constitute the major fuel source for your healing system. The old, common name for carbohydrates was *starch*, which we sometimes attribute to the heavier, denser carbohydrates, such as potatoes and certain grain flours that make bread. Starch was erroneously thought to contain "empty calories," but today we know differently. Because carbohydrates provide the greatest overall return of energy of all foods, marathon runners and triathletes typically "carbohydrate load" before a major race by eating lots of pasta and breads. They know from experience that this is the best long term, high-performance fuel for their dynamic bodies.

Grains such as rice, wheat, oats, corn, barley, and millet, in addition to potatoes, are the largest staple food crops in the world, and these have served as traditional sources of carbohydrate nutrient energy for the majority of the world's population for many years. These foods, which contain "complex" carbohydrates, are the longest lasting, slowest burning, and most efficient of all fuel sources for your healing system. Additionally, they usually contain lots of fiber, and so are extremely beneficial to the health of your colon and heart. Foods with complex carbohydrates also are valuable sources of essential vitamins, minerals, and trace elements, and other nutrients such as phytochemicals. To strengthen and fortify your healing system and keep it running smoothly and efficiently, your diet should consist of about 60 percent complex carbohydrates.

Fats and Oils and Your Healing System

Fats and oils are essential for the performance of your healing system. Specifically, they promote healthy skin and nails, and they contribute to the structural integrity of cell membranes in your body, which aids your healing system in preventing infection. Fats and oils also help to protect and coat nerve sheaths, which improves the health of your body's communications. As you know, your healing system depends on an efficient and accurate communications system. Fats and oils also pad and cushion internal organs in your body, protecting them from injury while they insulate and keep your body warm. Because fats are lighter than water and are high-energy nutrients, they are also a convenient way to store fuel that your healing system can use when food intake is inadequate or scarce.

For these reasons, a small amount of fats and oils in your daily diet is necessary for your health. Additionally, some fat-soluble vitamins and other nutrients can be absorbed only with fats and oils. For example, omega-3 fatty acids, found in flaxseed oil and certain fish oils, help the healing system with blood clotting and can be absorbed only with fats and oils.

There are, no doubt, other beneficial nutrients in certain fats and oils that have not yet been discovered. But because fats and oils represent the densest and most concentrated forms of food energy, their over-consumption can contribute to obesity and other health problems, including heart disease, the number-one killer in the Western

hemisphere. Fat intake should be restricted to 10 percent to 25 percent of your total daily calories, depending on your activity level and current health status. For example, Dr. Ornish, at the University of California in San Francisco, found that a 10-percent daily fat intake works best to aid your healing system in reversing heart disease.

Cholesterol is an important type of structural fat that supports the health and integrity of your healing system and, in particular, your cell membranes. In addition to the cholesterol it obtains from your diet, your body can manufacture its own cholesterol from other fats and oils. A diet that exceeds your body's basic daily caloric requirements, however, will create more cholesterol in your body than is needed, and, if this occurs, the excess cholesterol can form blockages that clog arteries and lead to heart disease. Reducing total fat intake, or restricting total calories, while increasing daily activity levels can help lower cholesterol levels and aid your healing system to dissolve blockages, open up clogged arteries, and improve blood flow to your heart.

Vitamins and Your Healing System

Vitamins are naturally occurring compounds that are essential to the healthy functioning of your healing system. They work with your body's various enzyme systems and are critical to the performance of important, life-sustaining processes involved in the growth, repair, and regeneration of healthy as well as damaged tissues. Although vitamins are usually required in much smaller quantities than other basic nutritional elements, such as proteins, fats and oils, and carbohydrates, a diet that doesn't include them at all can impair the functioning of your healing system and result in illness.

Vitamin requirements often change over time, they vary slightly for males and females, and they increase during pregnancy and lactation. Athletic training and recovery from illness and injuries may increase the body's requirements for one or more vitamins. Because the body's biochemical pathways and metabolic processes are complex, subtle, and still remain largely unexplored, it is certain that more vitamins than we currently know about will be discovered in the future and recognized as essential to our healing systems.

The best way to ensure adequate vitamin intake for your healing system is to eat a well-rounded, wholesome diet with plenty of

whole grains, nuts, seeds, fruits, vegetables, and a certain limited amount of fats and oils (again, specific vitamins require fat for absorption). When a problem occurs in a specific area of your body, you may need to supplement normal dietary sources with a specific vitamin, or concentrate on eating foods that contain higher quantities of a specific vitamin, to support the work of your healing system in that area.

Vitamins That Strengthen and Fortify Your Healing System

The list that follows describes the various vitamins that are essential to the health of your healing system. This list is a guide and is not all-inclusive; new vitamins are currently being researched, and many more are still to be discovered. The recommended dietary allowances (RDAs) listed are per-day estimates, based on the findings of the Food and Nutrition Board, National Academy of Sciences, National Research Council. The RDAs are for people 14 years of age and older. They vary slightly for males and females, with requirements changing during pregnancy and lactation, athletic training, and recovery from illness and injuries.

- *Vitamin A* aids your healing system in protecting the health of your eyes; it also promotes healthy skin growth. A lack of vitamin A can cause poor night vision and blindness, as well as skin problems. Recent research suggests that vitamin A also helps prevent certain cancers. Good sources of vitamin A are foods that contain beta carotene, including most orange and yellow fruits and vegetables such as mango, papaya, squash, yams, and carrots. The recommended dietary allowance of vitamin A is 800 micrograms (mcg) to 1,000 micrograms (mcg).

- *Vitamin B_1 (thiamin)* aids your healing system in maintaining the health of your nervous system. A lack of vitamin B_1 can cause beriberi and other disorders of the nervous system and brain. Good sources of vitamin B_1 include whole grains, legumes, vegetables, fruits, and milk. The recommended dietary allowance of vitamin B_1 is 1.1 milligrams (mg) to 1.5 milligrams (mg).

- *Vitamin B_2 (riboflavin)* supports your healing system by protecting the health of your skin and nervous system. A lack of vitamin B_2 has been

linked to dermatological and neurological problems. Good sources of vitamin B_2 include most vegetables, cereals, and grains. The recommended dietary allowance of vitamin B_2 is 1.3mg to 1.7mg.

- *Vitamin B_3 (niacin)* supports your healing system's role in maintaining healthy skin, nerves, and gastrointestinal health. A lack of vitamin B_3, or niacin, can cause *pellagra,* a serious disease. Good sources of vitamin B_3 include grains, nuts, most vegetables, and legumes. The recommended dietary allowance is 15mg to 19mg.

- *Vitamin B_5 (pantothenic acid)* participates in a variety of physiological processes that support your healing system. These include energy metabolism, blood-sugar regulation, and production of antibodies, cholesterol, hemoglobin, and hormones. The recommended dietary allowance is 4mg to 7mg.

- *Vitamin B_6 (pyridoxine)* is used by your healing system to protect the health of your nervous system, blood, and urinary system. A lack of vitamin B_6 has been linked to nervous-system disorders, anemia, and bladder stones. Good sources of vitamin B_6 include whole grains, cereals, nuts, and most vegetables. The recommended dietary allowance is 1.6mg to 2mg.

- *Vitamin B_{12} (cyanocobalamine)* aids your healing system in supporting the health of your central nervous system, and in the production of red blood cells. A lack of vitamin B_{12} causes anemia and nervous-system disorders. Good sources include milk and dairy products, most animal products, and fermented soy products. Because vitamin B_{12} is one of the most potent substances known to mankind, and because your liver has a tremendous capacity to store this vitamin for up to five years, the recommended dietary allowance is very small, at only 2mcg.

- *Folic acid* works in conjunction with vitamin B_{12} to support your healing system's role in maintaining healthy nerves and red blood cells. A lack of folic acid, sometimes seen during pregnancy and alcoholism, can lead to anemia and nervous-system disorders. Good sources of folic acid include grains, cereals, dark green vegetables, and fruits. The recommended dietary allowance is 180mcg to 200mcg.

- *Biotin* aids your healing system in maintaining healthy skin and nerves. A lack of biotin has been implicated in skin and nervous-system problems and may affect cholesterol metabolism. Good sources are soybeans and

grains. The recommended dietary allowance of biotin is 30mcg to 100mcg.

▪ *Vitamin C (ascorbic acid)* aids your healing system by playing an important role in wound healing, collagen formation, immune defense, inflammation, and cancer prevention. Vitamin C deficiency can cause *scurvy*, a disease characterized by fragile blood vessels and impaired wound healing. The best natural source of vitamin C is most fruits, including citrus. Certain vegetables, including red chili peppers, are also good sources of vitamin C. The recommended dietary allowance is 60mg.

▪ *Vitamin D* aids your healing system by playing a key role in calcium metabolism and bone formation. A lack of vitamin D causes rickets and can contribute to osteoporosis and other disorders. Natural sunlight is the best source of vitamin D. Naturally occurring substances in the skin absorb sunlight and are converted into the active form of vitamin D. Vitamin D is now added to milk, cheese, and butter. The recommended dietary allowance is 5mcg.

▪ *Vitamin E (d-alpha-tocopherol)* supports your healing system by playing a key role in wound healing. When applied topically, vitamin E aids in scar formation and helps keep skin healthy and strong. When taken internally, it also acts as an antioxidant, important in the prevention of heart disease and cancer. Good sources of vitamin E include the oil of many seeds and nuts, vegetable oils, and wheat grains. The recommended dietary allowance is 8mg to 10mg.

▪ *Vitamin K* supports your healing system as an essential component of your body's blood-clotting mechanisms. Vitamin K is naturally produced by a specific strain of bacteria that live within your own intestines, where the vitamin is absorbed. Good dietary sources of vitamin K include green tea, spinach, cabbage, and other leafy green vegetables. The recommended dietary allowance is 65mcg to 80mcg.

You can see from these descriptions how important vitamins are to the optimum functioning of your healing system. Be sure you include vitamins in your daily diet, and that you get at least the minimum daily requirements for each one.

Minerals, Trace Elements, and Your Healing System

In addition to vitamins, minerals are also powerful essential nutrients that aid and support your healing system. They are required for growth, repair, and regeneration of tissues, to keep your body healthy and free from disease. Minerals are derived directly from the earth's core, and they have unique properties. They are integral to the structure and function of important enzymes, hormones, and they transport molecules, such as hemoglobin, within the body. As noted earlier, almost every mineral element that exists in the core of the earth has been found to exist in minute quantities in the human body. Even arsenic, generally considered to be a poison, is required in trace amounts by your body.

Trace elements are chemically related to minerals and usually classified in the same nutritional category. The difference between trace elements and minerals is that minerals are required in slightly greater amounts than trace elements, and their functions are a little better understood. We know that trace elements are required for good nutrition and health, but we don't know exactly how much of each one is needed and exactly what each one does. We do know, however, that a deficiency of trace elements in your body results in a failure to thrive, increased susceptibility to disease, and even death. So although they are required in very small amounts, trace elements are absolutely critical to the optimum functioning of your healing system.

Minerals and Trace Elements That Support Your Healing System

Following are the most important minerals and trace elements for the health and functioning of your healing system.

Important Key Minerals

- *Calcium* plays a key role in helping your healing system with bone formation, blood clotting, nerve conduction, and muscle contraction, including the muscles of your heart. Sources of calcium include dairy products, broccoli, leafy green vegetables, and some fruits. Osteoporosis can result from a lack of calcium and increased parathyroid hormone secretion. The

RDA for most men is 800mg/day. For premenopausal women, the RDA is 1000mg/day, and for postmenopausal women and elderly men it is 1500mg/day.

- *Copper* is important for your healing system to regulate cell metabolism, collagen formation, and tissue repair. Sources of copper include fruits, grains, seeds, and nuts. The RDA has not yet been established.

- *Fluoride* supports your healing system and is important in tooth and bone formation. Sources include mineral water, plants, and fruits. Many dentists and pediatricians recommend supplementing with fluoride for children if you are living in an area where the water supply may not be fluoridated. The RDA for fluoride has not yet been established.

- *Iodine* is a key element of thyroid hormones and plays a critical role for your healing system in energy metabolism, including the regulation of body temperature. Iodine deficiency results in the well-known condition of goiter, which produces a large swelling in the neck that is the result of an enlarged thyroid gland. Good sources of iodine include sea water, sea salt, algae, and sea foods. The RDA is 150mcg.

- *Iron* is a central part of the hemoglobin molecule and functions in oxygen transport, which is essential for your healing system to repair and restore the health of organ tissues. In addition to red meats, sources of iron are all red fruits and vegetables, including beets, watermelon, raspberries, cherries, strawberries; dried fruits, including raisins, dates, and figs; beans; and certain leafy vegetables, including spinach. Vitamin C enhances the absorption of iron in your body. The RDA for iron is 10mg.

- *Magnesium* is important for your healing system to regulate energy metabolism and blood pressure. Sources of magnesium include leafy green vegetables and fruits. The RDA for magnesium is 280mg to 350mg.

- *Phosphorous* is important for helping your healing system support bone metabolism. Good sources of phosphorus include fruits, vegetables, and whole grains. The RDA is 800mg to 1200mg.

- *Potassium* is important for your healing system to support the functioning of your heart while helping to conduct nerve impulses in your body. Potassium, along with sodium, also helps your healing system by facilitating water movement in and out of your cells, and by directing water flow in and out of your body. Good sources of potassium are most fruits and

vegetables, including green leaves as well as roots and tubers. The RDA for potassium has not been established.

■ *Sodium* is an important electrical ion in your body that aids your healing system by playing a key role in nerve conduction while regulating the movement of water across cell membranes and tissues. The most common source of sodium is table salt. Keep in mind that too much sodium for certain people has been linked to excess water retention, which can be a problem if you have congestive heart failure, hypertension, and kidney disorders. The RDA for sodium has not yet been established.

■ *Sulfur* is important for helping your healing system aid and support the formation and structural integrity of proteins and other compounds in your body. Good sources of sulfur include both plant and animal proteins. The RDA has not yet been established.

Important Key Trace Elements

Other important minerals, called trace elements, are essential to the health of your body and your healing system, but they are required in minute amounts. These minerals include: arsenic, bromine, boron, chromium, cobalt, manganese, molybdenum, selenium, silicon, tellurium, vanadium, zinc, and quite possibly many others, including cadmium, lithium, silver, and gold. Good sources of trace elements include rich and varied plant life grown in natural, volcanic-derived, organic soil, which is the most fertile source of all minerals on this earth. Even though they are critical to the health of your body and healing system, in general, trace elements are present in the body in such small amounts that determining exactly how much you need every day is difficult.

Vitamin and Mineral Supplements

Research shows that you are better off getting your vitamins, minerals, and trace elements in their most natural form, the foods that you eat, rather than from supplements. This is because vitamins, minerals, and trace elements are better absorbed when they are bound to other natural nutritional elements digested and assimilated by your body. For instance, iron is better absorbed in your intestines in the presence of vitamin C. For this reason, I generally

don't recommend vitamin or mineral supplementation unless you are suffering from a specific vitamin deficiency or a health condition that could be significantly improved through vitamin therapy, or your diet is incomplete in one way or another.

If you choose to supplement your diet, do so with discretion and care. Supplemental vitamins and minerals are concentrated and not in their natural state, and if you take them in excess, they can cause serious health problems. Vitamins and other supplements should never replace a good, wholesome diet. I frequently encounter people who do not focus enough time and thought on their diets but instead rely on their supplemental vitamins and minerals to make up for any deficit in their diets. When it comes to selecting healthy, nourishing foods for your healing system, it is of paramount importance that you take time to listen to and work with your body. When you are just starting out, it is also a good idea to work with your doctor and preferably a reliable nutritionist to help you determine the best nutritional program for your individual health needs.

Phytochemicals: Nature's Medicines

Phytochemicals are naturally occurring chemicals in plants that have both nutritional and health-enhancing effects, and they support your healing system in many ways. Phytochemicals facilitate the processes of growth, repair, and tissue regeneration. They also help prevent certain chronic, degenerative diseases, including cancer and heart disease. Among the better-known phytochemicals are the *carotenoids*, including beta carotene, a parent compound to vitamin A, found in yellow- and orange-colored fruits and vegetables. Carotenoids prevent heart disease and are beneficial in the prevention of certain cancers. *Lycopenes*, found in tomatoes, are also helpful in the prevention of certain cancers, heart disease, and other chronic conditions. Many health experts feel that Italians have such low rates of heart disease and cancer because of their steady diet of tomatoes, which contain lycopenes.

Other phytochemicals play a significant role in supporting your healing system and can help overcome a wide variety of diseases, particularly the prevention and healing of certain cancers, heart disease, and even macular degeneration, the leading cause of blindness

in the elderly. Because these important phytochemicals come from a wide variety of plant sources, it is important to eat a wide variety of colorful fruits and vegetables to make sure your healing system is getting enough of these natural chemicals.

Probiotics and Your Healing System

Probiotics represent another class of compounds important in the nutrition and health of your healing system. Probiotics are produced by certain strains of bacteria that naturally live in your intestinal tract, and they also occur in nature. These strains of bacteria can aid your healing system in combating illness, restoring health, and maintaining proper biochemical balance in your body. More than 500 different strains of bacteria have been discovered to live in your intestines, helping to break down ingested foods while producing valuable metabolic byproducts that are then absorbed and carried to the various cells and tissues in your body. One of these products is vitamin K, which your healing system utilizes as an essential ingredient in blood clotting.

Scientists have discovered, for example, that ingesting *lactobacillus* bacteria, commonly called *acidophilus*, which occurs naturally in yogurt and is now available in supplemented commercial milk preparations and other products, reduces childhood diarrhea, decreases the likelihood of intestinal side-effects while people are taking antibiotics, and prevents yeast infections in women. Probiotics often can successfully combat infections, especially those of the intestinal tract, and possibly those of the respiratory system. They may also reduce the required dosages and possible toxicity of childhood immunizations. Probiotics appear naturally in many traditionally fermented foods, such as vinegar, wine, cheese, yogurt, tempeh, and soy sauce.

Twelve Essential Tips for Fueling Your Healing System

To help strengthen and fortify your healing system with the right fuel, you need to follow a few simple nutritional guidelines. Keep in mind, however, that we all are unique individuals with different nutritional needs that can change and evolve as we grow, age, or

modify our activities or environment. It is important, therefore, that you not cling blindly to any one set of stringent nutritional or dietary formulas that may not be appropriate for you. As a general rule, listen to your body, trust in its inherent wisdom and natural state of health, and respond intelligently to its ever-changing nutritional needs and demands.

Tip #1: Eat a Simple Diet Rich in Fruits, Vegetables, Whole Grains, Seeds, Nuts, Beans, and Legumes

For the sake of high-performance nutrition, most experts are now recommending a simple diet predominantly based on foods obtained from fruits, vegetables, whole grains, beans, legumes, nuts, and seeds. These foods are more balanced and contain a much higher concentration of vitamins, minerals, trace elements, and other valuable nutrients than flesh- and meat-based foods. Plant-based foods also contain more beneficial complex carbohydrates, more unsaturated fats and oils, and, contrary to popular opinion, they are also excellent sources of protein. Numerous studies have clearly established a link between a greater intake of fruits and vegetables and greater health and longevity. Under most conditions, these are the best fuels for your healing system. These foods are also an excellent source of fiber, which is essential for optimal intestinal health. Fiber has been shown to prevent colon cancer as well as heart disease. We also obtain valuable fats and oils from these foods. Plant-based foods contain less saturated fat, and they also contain fewer toxins and less pesticide residues than other foods. Plant-derived proteins, which are plentiful in beans, legumes, nuts, seeds, and grains, are generally more beneficial than protein from meats and animal flesh. When you consume meats or animal products, try to eat less, and try to eat these foods only as condiments or flavorings, as the Chinese and Japanese do. And if you feel so inclined, eat them during special occasions, such as holidays or birthdays, as a form of celebration, as the early hunting-gathering societies did.

The trend toward a healthier diet consisting of simpler, more wholesome, natural foods and fewer flesh foods is supported by the health data from the countries with the largest populations in the world, including China and India, in addition to other countries where people derive the majority of their nutritional requirements

from fruits, vegetables, grains and legumes. In these countries, there is far less heart disease, hypertension and stroke, cancer, diabetes, arthritis, and other chronic degenerative diseases—the so-called "diseases of civilization"—than in countries that derive more of their nutritional requirements from flesh foods and animal products.

Meat and flesh-based foods are convenient sources of protein, which helps maintain the growth and health of muscles, but most studies now reveal that these diets have greater disadvantages than advantages. Most meat-based diets contain harmful substances, such as saturated fats that can clog the arteries in your heart and brain, and environmental toxins, including heavy metals and pesticide residues, which are stored and concentrated in animal tissues. When we compare them to other simple, wholesome, natural foods, meats also lack sufficient fiber and other essential nutrients, such as vitamins, minerals, and trace elements.

Although many people erroneously assume that plant-based diets are lacking in protein, their fear of not getting enough protein from plant sources is not scientifically valid. Studies have proven that it is easy to get abundant protein from a diet that combines grains and legumes with other fruits and vegetables. Other studies have shown that traditional cultures around the world that have survived for centuries on these simple, wholesome, natural foods show little to no evidence of heart disease and cancer.

Many excellent meat substitutes are now available that are derived from soy, legumes, and other vegetable-protein sources. In the more progressive cities in America and Europe, many restaurants now offer these products on their menus, as do most supermarkets and grocery stores.

The average daily protein requirement for most adults is less than 40 grams, which is a little more than an ounce. Whenever there is a question of adequate protein intake, daily protein requirements can be met by combining beans (legumes) or seeds with grains. An example would be eating beans and tortillas, as we commonly do when we eat Mexican food. An even simpler example would be a peanut-butter sandwich on whole-wheat bread. Tofu is also an excellent complete protein, and it can be prepared in many ways. Dairy products, including milk, cheese, butter, and yogurt, are also excellent sources of protein. Many excellent nutrition plans and cookbooks for healthy eating based

on a diet that incorporates more fruits and vegetables are available.

Tip #2: Consume More Fluids, Including Soups, Juices, Herbal Teas, and Water

Your healing system requires adequate fluid intake to function optimally. Because your body is 70 percent fluid, all metabolic processes in your body occur predominantly in a liquid internal environment. For this reason, it is important to drink lots of water throughout the day. The more liquids you consume, the more effectively fluids can circulate in your body, and the more rapidly your body can eliminate toxins. Fluids also aid in the healing of infections and many other congestive and degenerative conditions. Many illnesses can be traced to chronic dehydration resulting from a lack of fluid or water intake. Fresh fruits and vegetables, many of which are more than 95 percent water, are excellent sources of fluid.

Tip #3: Consume More Fiber in Your Diet

Fiber is an essential fuel additive for the health of your colon, heart, and healing system. Adequate fiber intake ensures your ability to eliminate unwanted waste and toxins from your intestines, and it can help prevent cancer and degenerative diseases. Because meat doesn't have fiber, and because most Americans eat more meat than any other food, they usually don't get enough fiber in their diets. This lack of fiber causes problems with elimination, which results in the steady buildup of toxic waste in the body. Waste buildup puts an extra burden and strain on the healing system and can set the stage for illness. The best sources of fiber are predominantly fruits, whole grains, and other plant-derived vegetables, including beans and legumes, nuts and seeds.

Tip #4: Eat Food That Is Prepared Fresh

Consume food that is prepared fresh each day. Don't eat food that is stored in freezers for long periods of time, has been sitting on shelves for a long time, or was prepared months to years in advance and then prepackaged. This food often has lost its vitality and nourishment, and it also may be harmful to your body. Also avoid refined foods, including refined flours, which are devoid of fiber and often contain

harmful additives and preservatives. If you eat breads and pasta, try to eat those made with whole-grain flours. Eat less artificial and refined sugars. Instead, when you crave sweets, eat more fresh fruits and natural sweeteners, such as honey and fruit-derived sweets, including juices and dried fruits. Processed, refined, and packaged foods lack the vitality, freshness, and fiber that your healing system requires to function optimally, and they may cause it to work overtime by creating unhealthy conditions in your body.

Tip #5: Include Raw Foods in Your Daily Diet

Eat at least one portion a day of raw foods, including fresh vegetables and fruits. This raw food could be in the form of a salad with fresh sprouts, or fresh fruits and vegetables, such as carrot sticks or fresh apple pieces. Raw fruits and vegetables are loaded with vitamins, minerals, and trace elements, and they contain a high fiber and fluid content. Make sure, however, that you chew raw foods well because they can be difficult to digest if they're not chewed adequately. Raw fruits and vegetables, with their high fluid and fiber content, assure efficient circulation and elimination in the body, while they provide essential vitamins, minerals, trace elements, and natural sugars for your healing system.

Tip #6: Eat Regular Meals, at Regular Times

Your body's digestive system is set up to handle regular meals. Going all day without eating, and then overeating for dinner, is a common habit that can contribute to digestive problems, overburdening your body and making your healing system sluggish. A steady flow of nutrients works best for your healing system, not starving it all day long and then overloading. Graze on healthy snacks if you get hungry, or if your blood sugar gets low. However, make sure not to spoil your appetite for your meals. Eat more toward the earlier part of the day and less in the evenings.

Tip #7: Take the Time to Plan and Cook Your Meals

Proper nutrition is essential for your health. Although preparing healthy, wholesome food might take a little extra thought and time, just remember that your healing system deserves and requires the best fuel you can give it. Like anything that's worthwhile, proper nutrition

takes planning and preparation. If you wait until you are hungry to decide what you are going to eat, you will most likely grab the nearest food available, which could be fast food or convenient junk food. Take the time to shop for and cook healthy, wholesome foods.

Tip #8: Create a Pleasant Ambiance When You Eat

Eating your food under pleasant circumstances, in a calm, quiet environment, enhances the smell and taste of the food and improves digestion. While eating, use pleasant settings, including quality plates, silverware, and serving utensils. Light a candle or use soft lights at the table. Avoid watching TV while you eat, or eating with the stereo or radio blasting, which can interfere with proper digestion and the assimilation of vital nutrients. Avoid arguing or getting upset for any reason while you eat. If you are upset, it is best to wait until you are calm to eat because emotional upheaval can adversely affect body chemistry and have a negative impact on digestion and your health. Cultivate a spirit of gratitude for the food that you consume. Many cultures around the world consider the ambiance surrounding food, such as how it is prepared, and how it is received, to be equally important to, if not more important than, the biochemical composition of the food.

Tip #9: Chew Your Food Slowly and Thoroughly

The process of digestion begins in your mouth, aided by digestive enzymes secreted by your salivary glands. So chewing your food slowly and thoroughly is important. Doing this makes digestion easier and more efficient for your stomach and intestines.

Most healthy, fresh, wholesome food requires thorough chewing before you swallow it. Proper chewing depends on good teeth, which is why dental hygiene is also an important part of your overall physical health and personal hygiene. Not chewing your food slowly and thoroughly because you are eating when you are in a hurry or upset can cause indigestion and rob your healing system of necessary vital nutrients.

Tip #10: Eat a Wide Variety of Foods

Do your best to satisfy your body's nutritional requirements by eating a wide variety of foods. This variety will ensure the opportunity for a greater selection and utilization of nature's essential nutrients. In the

past, populations that were confined to limited choices in their diets often came down with severe nutritional deficiencies.

Because many vitamins, minerals, trace elements, and other nutritional substances are associated with natural pigments and dyes that contribute to the specific colors of certain fruits and vegetables, many nutritional experts recommend eating as wide a variety of fruits and vegetables as possible, including every color in the rainbow in your diet at least weekly. For all practical and scientific purposes, this approach represents the safest and most reliable way to ensure the highest-octane fuel for your high-performance healing system.

Tip #11: Eat Fewer Rich, Heavy Foods

Rich, heavy foods taken in excess can clog your digestive, lymphatic, and circulatory systems, draining your body of healing energy. Such foods have been linked to a number of diseases, including gout, gall bladder disease, heart disease, diverticulitis, and many others, including cancer.

Rich, heavy foods, which contain a lot of fat, oil, and protein, represent the most difficult of all foods to digest, often taking at least four or five hours, and sometimes even longer. The time and energy required to break down and digest these foods will interfere with the performance of your healing system. The process of digestion can redirect blood flow and energy away from the work your healing system is doing. If you are healing, and you are not undernourished, it is important to keep your diet light. Avoid or minimize rich and heavy foods.

Tip #12: Minimize the Use of Alcohol and Stimulants

Minimize or reduce alcohol intake. Consider eliminating it altogether or saving its use for special, festive occasions. Alcohol, which is a nervous-system depressant and also has negative effects on the liver, can make your healing system sluggish and incompetent.

In addition, minimize or eliminate the use of stimulants, including caffeine, which is commonly found in coffee, tea, and caffeinated sodas. Caffeine stimulates the nervous system and can increase mental agitation and cause stress. Stress constricts your blood vessels and promotes the fight-or-flight response, which interferes with the performance of your healing system.

Closing Thoughts on Fueling Your Healing System

It is important to remember that your body is a high-performance machine, with an extraordinary healing system that requires the highest-performance fuels available from the purest sources. Repair and restoration of damaged tissues require energy, and the energy you consume in the form of food will have a tremendous influence on your healing system and your overall state of health and well-being.

Remember to eat foods that are wholesome and nutritious, fresh and balanced, and that contain plenty of vitamins, minerals, trace elements, fluids, and fiber. These foods include most fruits and vegetables, whole grains, nuts, seeds, soups, herbal teas, juices, and water. Make sure you are getting adequate protein, carbohydrates, fats, and oils in your diet. Eat natural foods that represent every color in the rainbow at least once in a week's time to get enough phytochemicals. Take time to prepare your meals thoughtfully, eat regularly, avoid unhealthy snacking, and chew your food well. If you are attempting to heal yourself from a chronic illness or condition, reduce the amount of flesh food in your diet, or eliminate it altogether. Avoid rich and heavy foods unless you need to put on weight. Also be careful with alcohol and caffeine intake.

There are many excellent resources for nutrition. When it comes to fueling your healing system, respect your individuality, remember to keep an open mind about trying and learning new things, and don't be too rigid or fanatical about following a stringent dietary regimen that has worked for others but may not be right for you. Above all, stay informed, and listen to your body as you focus on fulfilling its ever-changing nutritional needs.

CHAPTER 6

The Power of Your Mind
and Your Healing System

Your mind is your healing system's most powerful ally. Working through your brain and nervous system, your mind can send powerful messages to your body that can dramatically influence the performance of your healing system. Through these mechanisms, a sophisticated communication feedback system sends precise, split-second information from your body back to your brain. Your mind remains in intimate contact with your body's ever-changing internal environment while it works side by side with your healing system. In the words of well-known physician and author Dr. Andrew Weil, "Wherever nerves are, activities of the mind can travel."

All mental activity, whether conscious or unconscious, has a powerful influence on your healing system and can enhance or interfere with its performance. For example, when your mind is in a positive state, immersed in thoughts of love and affection, caring and compassion, enthusiasm, health, happiness, joy, and peace, beneficial chemicals known as *neurotransmitters* or *neuropeptides* that are secreted by your brain can actually infuse your body with positive energy, strengthening your healing system and improving your health. Alternatively, when your mind is in a negative state, with thoughts of pessimism, cynicism, jealousy, anger, hatred, fear, revenge, self-criticism, blame, shame, guilt, and despair, you are

sending negative messages to your body via equally powerful neuro-chemicals that can weaken your healing system and interfere with its ability to do its job effectively. In the words of Robert Eliot, M.D., "The brain writes prescriptions for the body."

When you understand the power of your mind, and its enormous ability to work either for you or against you, you will no longer waste valuable time or energy blaming outside forces, including "fate," "bad genes," "evil microbes," a polluted environment, or other people for your illnesses, diseases, or lack of good health. Outside forces can certainly play a role in disease processes, but, in the final analysis, your health is based more on the personal choices you make for yourself, moment by moment, each day of your life, and your ability to optimize the incredible power of your mind to aid your healing system. You are the one who is ultimately responsible for your health, and so it is imperative that you understand this principle. More than any other power or force in this world, your own mind can serve as your healing system's most qualified and capable partner.

How Your Mind Affects Your Healing System

Your mind works through your brain and nervous system, generating thoughts that are converted into electrical impulses. These electrical impulses travel through the many nerves that are distributed to the various organs and tissues of your body, in much the same way as electricity moves through wires.

For example, when you want to move your arm, before the actual movement, a thought is first generated in your mind that causes electrical impulses to stimulate specific nerves that will in turn direct the muscles in your arm to contract. This sequence of events results in movement in your arm. The part of your nervous system that is responsible for this type of movement is known as the *voluntary nervous system* because the movement is voluntarily brought into action by your own conscious thinking.

Another part of your nervous system, however, known as the *involuntary nervous system, or autonomic nervous system,* is more wide-reaching in its distribution and more powerful in its influence over your body's internal environment. The autonomic nervous system regulates such critical biologi-

cal functions as your heart beat, your breathing, your blood pressure, your digestive processes, your perspiration, your vision, your elimination of waste products, and many others.

Within the autonomic nervous system are the *sympathetic* and *parasympathetic* branches. The sympathetic branch increases activity and movement in your body; this branch is responsible for the well-known fight-or-flight response. The fight-or-flight response occurs when you are feeling threatened or are experiencing stress, and it can be initiated by thoughts of fear, worry, anxiety, panic, and anger. It can be measured by an increase in heart rate, oxygen consumption, breathing, blood pressure, and blood flow to the large muscles of locomotion in your legs and arms. These physiological changes are beneficial to help you "fight or flee" during a crisis or emergency, but they also serve to inhibit the activities of your healing system, which generally requires a more quiet and relaxed internal environment within which to operate. Additionally, when the fight-or-flight response is elicited repeatedly, or prolonged over a lengthy period, it can prove harmful and damaging to your body because it creates too much work for your healing system.

The parasympathetic branch of the autonomic nervous system counterbalances the sympathetic nervous system and the fight-or-flight response by producing a calming effect on your body. This branch is associated with states of rest, relaxation, repair, regeneration, and healing. Thoughts that activate the parasympathetic nervous system include those of relaxation, peace, love, serenity, harmony, and tranquility.

In these ways, your mind plays a pivotal role not just in directing the movement of certain muscles in your body, but, far more importantly, in influencing and modifying the physiological processes of your internal environment in ways that have a direct effect on your healing system. Because your brain can process approximately 600 to 800 thoughts every minute, you can see what an enormous impact your thinking and mental activity can have on the health of your body.

Mind as Healer, Mind as Killer

You can use your mind for your body's ultimate health and healing, or you can use it in a way that turns against you to the detriment of your health. Your mind and your thoughts can cause real physiological

changes in your body, as the *placebo effect* demonstrates. If you learn to use your mind to cooperate with your body's healing system, it can be your healing system's most powerful ally, a loyal servant and friend. If you do not use them properly, your mind and thoughts, through the release of powerful neuropeptides, hormones, and electrical nerve stimulation, can weaken and damage your body's health, interfere with your healing system, and cause premature physical deterioration, disease, and even your ultimate demise. If it is not properly trained and used, your mind can become a definite liability, prove to be your worst enemy, and even kill you. The following story about Jerry, one of my patients, demonstrates the crucial principle that learning how to use your mind for the benefit of your body's health and well-being can literally mean the difference between life and death.

Jerry was a tire salesman from a small town in Texas. He was in his early sixties and had already suffered from one near-fatal heart attack just a year earlier. He was lucky to be alive. His cardiologist had placed him on restricted activities until further notice. However, Jerry could not resist the offer of spending the weekend with his buddies in a small hunting cabin in the mountains of Colorado. Even though he had decided to go on the trip without letting his doctor know, he told himself he would take it easy and not disobey his doctor's orders. He would not push himself or do anything strenuous that might injure his heart.

However, because of the increased altitude in the mountains where Jerry was staying, the oxygen was a little thinner than he was used to—something he had forgotten to take into account. As he was returning to his cabin one evening after an uphill stroll, he began to feel the familiar chest pain and pressure that signaled another heart attack coming on.

At that moment, Jerry made a conscious decision to use the power of his mind to avert a possible heart attack. He simply told himself, "I refuse to have another heart attack!" His mind was so absolutely committed to avoiding the dreaded experience of having a heart attack again that his symptoms subsided, and his pain went away. He has never had another problem with his heart since that day. Of that day, Jerry told me, "Doc, I just made up my mind that it wasn't going to happen to me again! I simply refused to have another heart attack!"

Stories like Jerry's are not uncommon, and they demonstrate that, when constructively applied, your mind can be a powerful ally of your body's healing system. Your healing system is programmed to listen to your mind, so it is important to be conscious of the thoughts and messages you may be sending.

The Merry-Go-Round and the Sorry-Go-Round

Every day, researchers are discovering more ways that your mind and body are connected and influence each other. The intimate relationship between your mind and your body affects your health in many ways. For example, people who are happy, emotionally balanced, and socially well-adjusted enjoy better health and are sick less often. When you are in a good mood and feeling good about yourself, you will most likely want to take better care of your body; eat wholesome, nourishing food; take time to exercise; get enough sleep and rest; and participate in other life-promoting activities that will contribute to your body's overall health. Alternatively, if you become depressed, or if your spirits are low, you will not have the energy to take very good care of yourself. You may not feel like exercising regularly, which can weaken your cardiovascular system and possibly cause you to gain weight as a result of inactivity. All this can put you at risk for heart disease, diabetes, high blood pressure, and other diseases. Or you may not eat healthily or drink enough fluids, which can lead to excessive weight loss and vitamin, mineral, and other nutrient deficiencies, leaving you weak and dehydrated, vulnerable to disease. You may not bathe as regularly as you should, which can lead to skin infections, and the possibility of other infections, as well. Depression can create stress and anxiety, which can have a further negative impact on your health. All of these factors have a negative influence on your healing system.

In the same way that your body is powerfully influenced by your mind, your mind is also influenced by your body. For example, when you are feeling physically fit, exercising regularly, eating good food, getting adequate sleep and rest, and feeling relaxed, your mental faculties will be sharper and clearer, and your attitude and outlook on life will be inspired and enthusiastic. Conversely, certain

physical ailments such as anemia, thyroid dysfunction, nutritional deficiencies, and insomnia are known to cause mental fatigue, lethargy, anxiety, and altered mood states. Hallucinations and mental psychosis can occur with electrolyte imbalance caused by extreme dehydration, heat stroke, or kidney dysfunction. That chronic pain can lead to mental depression is also well-known. Even a cold, cough, or flu can make you feel low and affect your attitude. Additionally, when you feel bad physically, you can easily become frightened and anxious. Under conditions of impaired physical health, mental health is adversely affected, and it is not uncommon for thoughts of impending doom, prolonged suffering, and even death to accompany such illnesses, especially if the illnesses are more severe or prolonged.

Whether you begin with poor physical health that creates poor mental health, or poor mental health that creates poor physical health, you can get caught in a harmful cycle without even realizing what is happening, a cycle that can be difficult to break. With the poor health of your body pulling your mind down, and your low-ered mood and depressed mental health adversely affecting your body, you can tumble down, down, down in a continuing spiral of increased suffering on both mental and physical levels, into worsen-ing physical and mental health.

This cycle is known as the Sorry-Go-Round. The Sorry-Go-Round is a term I like to use to describe the downward spiraling cycle that occurs when poor physical health affects your mental health, which affects your physical health, which affects your mental health, and so on. But this cycle also can first begin with your mental health affecting your physical health. The point is not which came first—the physical or mental problem. It is that they feed off each other and create a harmful downward-spiraling cycle that is difficult to break.

Through the power of your mind, you can become aware of this harmful cycle when it afflicts you, and, once you are aware of it, you can successfully break it by implementing positive, beneficial changes on both physical and mental levels in a two-pronged approach (both physical and mental) that will lead you to what I call the "Merry-Go-Round."

The Merry-Go-Round describes the opposite state, in which your mind and body are cooperating with each other in a positive

way for your optimum health. Contrary to the Sorry-Go-Round, in which a downward spiraling effect of continued negative mental attitudes and degenerating physical health occurs, in the Merry-Go-Round, an upward spiraling effect of positive mental and enhanced physical health perpetuates itself. When your body feels healthy, your mind feels good. When your mind feels good, your body is also likely to feel healthier. When you feel good physically, this uplifts your mood and contributes to a positive mental state. A positive mental state helps to inspire life-affirming, positive, optimistic thoughts that will have beneficial effects on your body's physiology. This kind of positive interaction is what your healing system thrives on.

The Merry-Go-Round strengthens and nourishes your healing system so that it can perform at maximum capacity. This is one of the most obvious reasons you want to ride on the Merry-Go-Round, or, if you have fallen off, to get back on as soon as you can. You can take definite measures to ensure that you ride on the Merry-Go-Round. A few are suggested here to get you started. Remember, a two-pronged approach that implements both mental and physical strategies works best.

- Exercise can be an important strategy to help you get back on the Merry-Go-Round if your mental health and spirits are currently low and slumping. If you or a loved one suffers from depression, studies have shown that exercise can help overcome this problem. This is just one example to demonstrate that the improvement in physical health often results in the improvement of mental health.

- Stress-management techniques, which you will be reading about shortly, can help you avoid the knee-jerk tendency to become fearful, anxious, and scatterbrained in the face of daily problems, and they are another powerful way to stay on the Merry-Go-Round.

- Positively programming your mind for health and healing is another important method to help you get on the Merry-Go-Round. This chapter describes several practical strategies that are based on this important principle.

The health of your healing system depends on your ability and determination to get off the Sorry-Go-Round and get on the Merry-Go-Round. In this chapter, you'll learn various ways to do this, and to enhance and strengthen your healing system so it can do its job effectively and efficiently.

Psychoneuroimmunology and Your Healing System

Psychoneuroimmunology, known as *PNI* for short, is an important new field of medical science that studies the interaction between your mind and your immune system. New findings in this field have a direct bearing on understanding how your healing system works because, as you know, your immune system is linked to your healing system in the defense of your body. Your healing system collaborates with your immune system and depends on the health of your immune system to function at its best.

You may recall that your healing system and your immune system are decidedly different, and they also have certain similarities. One similarity is that they both are affected by your thoughts, emotions, attitudes, and the activities of your mind.

Rigorous and innovative scientific investigation in psychoneuroimmunology is helping us to understand more about the wonderful healing resources that exist within us. It also is helping us to lay to rest several key, erroneous myths about how our bodies function in relation to our minds. One myth was that what goes on in the mind has absolutely nothing whatsoever to do with what goes on in the body, which was taught to young doctors in medical schools for several hundred years. To support this erroneous notion, it was further believed that the immune system, which manages the body's defenses, functioned completely independent of the brain. But, thanks to several important discoveries by researchers working in the field of psychoneuroimmunology, these outdated beliefs have finally been proven wrong. There is now unequivocal proof that your mind talks directly to your immune system. This new understanding is based on the following findings:

- Specialized receptor sites for *neurotransmitters*, which are chemicals produced by the brain, are now known to exist on specific white blood cells.
- Tiny nerves have been discovered that are connected to the lymph nodes. This discovery provides concrete evidence that the immune system and

lymph nodes, which contain white blood cells, are directly connected to the nervous system and the brain.

■ Powerful hormones have been discovered that are produced and secreted by specific white blood cells. This means that the immune system talks to the endocrine system and directly participates in one's emotional experience.

These advances in psychoneuroimmunology lend further scientific evidence to what Hippocrates and other ancient physicians and healers have been telling us for thousands of years: that a positive mental and emotional state can improve the body's ability to heal itself.

Practical Strategies for Using Your Mind to Strengthen Your Healing System

Your mind is your healing system's most valuable and powerful ally, and so it is important to learn how to maximize your mind's incredible power. The following techniques and strategies can help you focus and direct your mind to strengthen your healing system.

Positive Mental Programming

Pilots have one of the most dangerous, difficult, responsibility-laden jobs in the world. Because the lives of many people are in their hands, their sound physical and mental health is of the utmost importance. As a consequence, both the psychological and physical exams for pilots are among the most meticulous and closely scrutinized of any occupation in the world. When pilots are trained, they go through a form of mental training that includes programming their minds into a specific, success-oriented mode. Pilots must focus their thought processes on creating strategic, action-oriented behaviors that will result in a positive outcome and nothing else. Pilots do not have the luxury of entertaining thoughts that will contribute to a negative outcome during the flying mission. Airplanes move fast. If pilots make mistakes, even small ones, in the blink of an eye those mistakes can be fatal, not only for the pilots, but for the flight crew and passengers, as well.

Nowhere is the importance of this mental training for pilots more apparent than during landing. Landing a plane is one of the most challenging and difficult aspects of flying any aircraft. Upon descent and before landing, pilots set their sights for the runway while they are communicating with the control tower. Just as they will line up their airplanes along a certain approach to the runway, they have already focused their minds on a specific train of thoughts that entertain only a preselected sequence of decisions and actions that will produce a successful landing. Some flexibility is required, of course, but all thoughts during this period must be focused on the positive outcome of a safe and successful landing. Pilots cannot entertain any unproductive thoughts that could possibly result in a negative outcome. If pilots were to entertain such foolish thoughts, the sheer weight of their distractive powers would most likely result in a crash. A kind of self-fulfilling prophecy would most likely ensue. Entertaining negative thoughts would prevent the pilots from focusing on the constructive thoughts that are necessary to execute the precise skillful movements required for successful landings.

In the world of health and healing, as in flying, the key role that your mind plays in determining a positive, successful outcome cannot be overstated. When it comes to your health, you simply do not have the luxury of entertaining negative thoughts or negative outcomes. Just like a pilot, you need to set your sights on a positive outcome, believe that outcome is possible for you, and then act on that belief, refusing to allow any unhealthy thoughts of disease and suffering to distract you from your goal. Your healing system needs this positive thinking to function at its best and keep your body and all its systems running smoothly. Without the nourishment and fuel of positive thinking, your healing system will become "distracted" from its critical role in maintaining your health and well-being, and it will not be able to function properly.

For example, If you come down with a respiratory infection or any other illness, and you want to get better, focus your mind on being healthy again by implementing the following mental strategies:

- Set your sights firmly on the goal of being healthy again.
- Mentally repeat that you will get better, and continue to do so until the belief is firmly ingrained in your mind.

■ Make a mental checklist of things you can do to get better soon. For instance, if you have a respiratory infection with a fever, your checklist may look something like this:

Call in sick for work.

Contact your doctor.

Get plenty of rest.

Drink fluids.

Avoid rich, fatty foods.

Keep warm.

Take medicines as needed.

Continue to set your sights on your goal of being healthy, mentally repeating this goal as often as you can.

■ If you cut your finger and are bleeding profusely, the same mental programming would apply, only the checklist would differ somewhat:

Find a clean cloth, cotton ball, or bandage, and apply direct pressure to the wound.

Place your hand above your heart to reduce blood pressure and bleeding.

Once bleeding has stabilized, contact family members or friends to inform them of your injury.

If the wound needs professional attention, seek immediate medical care.

If you are seen by a health professional, follow his/her orders concerning wound care, cleansing and bathing of the wound, and medical follow-up.

Restrict activities as needed to assist the process of wound healing.

Continue to set your sights on the healing of your wound and the restoration of your health. Mentally repeat this goal as often as you can.

Adapt your positive mental programming to fit the needs of your particular situation and condition. Many people have used

positive mental programming successfully to overcome even serious health conditions, including cancer, heart disease, multiple sclerosis, and HIV. The following story is a good example of the powerful effects of positive mental programming.

Jan's Story

Jan was diagnosed with breast cancer, and even though she went through the grueling treatments of a radical mastectomy, chemotherapy, and radiation, she was given only six months to live.

Rather than giving up all hope and becoming another cancer statistic, Jan decided to enlist the help of her mind to rid her body of this dreaded condition. She had read about other people overcoming insurmountable odds to defeat their diseases, and she thought that, if it was possible for them, she might be able to do it, too. Because her life was on the line, she plunged headfirst into researching how she could possibly turn her health around. She committed herself to programming her mind in a positive way.

While Jan was deciding to concentrate on nutrition and natural supplements that could build up her strength and resistance, she also began reading books on how her thoughts and attitudes could stimulate healing mechanisms deep within her body, even though at that time the idea of a healing system was virtually unknown. Practicing several mental techniques that helped her relax, slow down, stop worrying, and develop a better sense of humor, Jan began to focus more on a positive outcome. After several months, she began to feel more energy, vitality, and stamina coming into her body. With these obvious physical signs of improvement, her attitude improved, and she began to actually believe she might be able to follow in the footsteps of others who had similarly overcome cancer. She did all this in spite of the mastectomy she had and the odds that were weighing heavily against her.

Today, 30 years later, Jan is totally cancer free and radiates a spirit of calm reassurance and optimism that is obvious to anyone who meets her. She has long outlived the doctors who first pronounced her death sentence. Through her difficult journey, Jan has come to realize the tremendous healing power of her own mind. She selflessly volunteers her time in assisting other women with breast cancer, encouraging them not to give in to hopelessness and despair,

but, rather, to use the body's greatest ally in healing, the mind, to strengthen and fortify their healing systems through the cultivation of life-affirming, constructive thoughts and positive mental attitudes.

Infusing Your Healing System with Positive Beliefs

Beliefs are powerful thoughts that we hold onto and invest with great energy as if they were true, even though they might not be true. Your beliefs help to shape the way you think and view the world, and often they are backed by the collective support of many people, including family and friends. Your beliefs are also reinforced and influenced by many factors, including your education, the books you read, the media, your colleagues, peers, community, religious preferences, gender, and age, and your own personal thoughts and unique life experiences.

Beliefs can be passed down from one generation to the next. They can extend far back in time, covering centuries, and even millennia. Beliefs often gain strength over time. The more people who share in a similar, common belief, the more powerful that belief becomes. When beliefs become heavily invested with a lot of time and energy, letting go of them and changing them is difficult, even when they are wrong. For example, in medieval Europe, before Christopher Columbus's historic voyage in 1492, the belief was that the world was flat, and that if you sailed too far out to sea, you would fall off the edge of the world. Of course, we now know that this belief was not true, but for hundreds of years, many peoples' lives were affected by this limited view.

Beliefs are constructed of powerful thoughts, and as such they can play a major role in determining your health. Beliefs can significantly influence the performance of your body's healing system through the powerful messages they send to every organ, tissue, and cell in your body. If your beliefs are positive, healthy, and life sustaining, they can work to your advantage. For example, in a well-known study that looked at Harvard University graduates over a 25-year period, those who believed their health was good or excellent at the beginning of the study had significantly fewer illnesses and diseases, far better survival statistics, and reported enjoying much better health at the end of the 25-year study period than those who reported their health as only fair or poor.

The following approaches will help you infuse your healing system with positive beliefs:

- Choose a positive belief that supports your goals of improved health. Examples might be "I believe I can be healed," or "I am becoming strong and healthy."
- Refuse to entertain beliefs that oppose your positive belief about your health.
- Write down your positive belief and repeat it, first saying it out loud to yourself, then whispering it, and then mentally repeating it over and over again as often as you can, whenever you can.
- Read books, watch movies, and participate in activities that nurture, support, and reinforce your positive belief about your health. Such activities might include eating healthy food, getting adequate sleep and rest, going for regular exercise, receiving massages once a week, and so on.
- Seek out and surround yourself with positive, optimistic people who reinforce your positive belief about your health.
- Avoid people who oppose your positive belief. If you have a pessimistic, unsupportive doctor, find one who can be more optimistic and encouraging.
- You may choose as many positive health beliefs as you desire.

Negative beliefs, which are based on fear and pessimistic projections concerning your health, can actually interfere with the performance of your body's healing system and can result in harm to your body. If you sustain such beliefs over a sufficient time period, they can even become self-fulfilling prophecies. Again, recalling Dr. Eliot's famous words, "The brain writes prescriptions for the body," this is only common sense. For example, if you think long and hard about getting cancer, you may be contributing to the physiological processes that will create a toxic internal cellular environment that can actually cause cells to mutate and manifest in cancer. If you think long and hard about getting a heart attack, your thoughts and beliefs can create the internal chemistry within your body that constricts the coronary arteries in your heart and shuts

down the blood supply to your heart muscles, which can contribute to an actual heart attack.

Even though scientific research in these mind-body interactions is still relatively new, a large number of studies already in the medical literature confirm the reality of these destructive mental processes. The good news is that many new studies are now showing that you can transform and overcome these negative influences by focusing more on positive, life-enhancing beliefs and incorporating an optimistic view of the world into your beliefs.

An example of the power of positive beliefs is evident in the story of AIDS. When AIDS was first discovered, just the diagnosis of being HIV positive was enough to kill a person. More than the actual virulence of the virus, this result was due largely to the fear and dread these individuals associated with the mysterious elements of the virus and the disease. Now, people are better informed and not so fearful about HIV and AIDS. Not only has HIV lost its diagnostic shock value, but the long-term survival rates and quality of life also have improved dramatically among people who are HIV positive. For the most part, this change has come about not so much through breakthroughs in miraculous medications, but rather through people becoming empowered to fight back and reclaim their health through a change in their beliefs about HIV. Basketball superstar Magic Johnson is one such example, and there are many others.

Transforming Negative Beliefs into Positive Beliefs

Entertaining and holding onto beliefs that will enhance your health may not be easy, especially if you were raised in a family or environment that taught and encouraged negative beliefs. However, you can succeed by following the strategies described in this chapter.

In fact, many people who have overcome serious, life-threatening afflictions did so by discovering that the roots of their physical suffering were anchored in the muck of unhealthy, negative beliefs they had harbored about themselves and their bodies since childhood. Some of the more commonly reported of these negative

beliefs are these: "You are a bad person," "You do not deserve love," "You do not deserve to be happy," "You need to be punished for your sins," "You deserve to suffer and have pain," or "The only way you can receive attention or love is if you get ill."

For many people who have overcome serious illnesses, healing from the physical aspects of their diseases meant expunging the disease at its psychological roots. They needed to let go of the deeply ingrained, negative beliefs that led to a lifetime pattern of unhealthy, self-destructive thoughts and related behaviors such as smoking, overeating, drinking, drug abuse, staying in abusive relationships, having unsafe sex, and taking unnecessary risks that lead to accidents and injuries. These negative beliefs and behaviors are not unlike those that would cause people to end their lives by putting a bullet in their brains or jumping off of a bridge.

Of those who have successfully healed themselves, many have been able to look back on their diseases as gifts that helped them transform mentally, emotionally, and spiritually into more vibrant, stronger, healthier individuals. The physical cures were merely side benefits they enjoyed along the route of the deeper healing that occurred. The following story is a dramatic example of the power of the mind and how one person healed himself by transforming and overcoming his negative beliefs.

Josh's Story

In his sophomore year of college, Josh was diagnosed with a rare, malignant brain tumor. His type of tumor carried a poor prognosis. Fewer than 12 people in the entire world had had this type of tumor, and no one had lived longer than a year after the diagnosis was made, even with the best treatment that conventional medicine had to offer.

Although Josh was initially devastated by the news, something in his mind refused to buy into his death sentence. He believed in his heart that his body could heal itself. He did not say much to others, but, secretly inside, Josh vowed to defy the statistics. As he set about changing his diet and lifestyle, reducing his stress, and taking the time to listen to his intuition, Josh took a leave of absence from school to concentrate on his deeper healing. After just 4 months, a CT brain scan showed that his tumor had indeed grown

a little smaller. His doctors were amazed and told him to keep doing whatever he was doing. After 9 months, the tumor had shrunk to less than one-third of its original size. After 18 months, 6 months after he should have been dead, Josh's tumor was no longer detectable on the CT scan. Three years later, the tumor still had not recurred. Josh was elated, but he wasn't surprised. Now a doctor himself, Josh counsels his patients on their attitudes while he educates them about their mind and the power of their beliefs to improve the quality of their health. Josh is not against conventional medical treatment to increase the odds of a successful outcome when a patient is faced with a difficult diagnosis, but he believes that the transformation of negative beliefs into positive, healthy ones is imperative. He is living proof that optimistic beliefs can activate internal healing mechanisms and overcome incurable diseases.

Because your body is programmed to obey your mental commands, it is imperative to begin now to program your mind to embrace positive, life-affirming beliefs, as Josh and many others have done. Many methods and techniques are available to help you do this, including self-improvement books and tapes, motivational videos, inspirational TV programs, prayers, mantras, uplifting quotes and sayings, genuinely helpful friends and supportive peer groups, compassionate and wise counselors, and supportive doctors and healers.

Four Basic Positive Beliefs

Whenever you find yourself falling prey to negative beliefs, gently but firmly shift your focus to four core beliefs. (Note: You may want to substitute your own positive beliefs, rather than what is suggested here. In the beginning, however, keep it simple by using no more than four.) You need to reinforce these four basic beliefs and drive them deep into your subconscious mind and body, like driving a railroad spike solidly into the ground with a sledge hammer. Once these beliefs are solidly embedded, they will attract other positive beliefs to your mind and, in turn, infuse your healing system with the positive energy it needs to function at its best.

Belief #1: I am lovable just as I am.
Belief #2: I deserve to be happy, healthy, and fulfilled in my life.

Belief #3: My body has a healing system, and it knows how to heal itself.

Belief #4: My body wants to be healthy.

- Begin repeating these beliefs to yourself, first out loud, and then silently throughout the day.

- Write the beliefs down on a small card. Keep them on your bathroom mirror, in your car, at your office, or in any place where you'll see them several times a day.

- Record the beliefs on a tape recorder or on a message machine.

- Memorize the beliefs, so that whenever you catch your mind in a fearful, doubting, pessimistic, or negative mode, or if your mind strays from your goal of improved physical and mental health, you can bring it back on a constructive track that will strengthen and nourish your healing system.

If you follow this strategy faithfully, you will see how vibrant and alive your body will feel as it responds to your new mental commands. Through these positive, life-affirming beliefs, your healing system will awaken, arise, and shift into high gear to perform smoothly and efficiently for you.

Stimulate Your Healing System with Positive Self-Talk

You probably have seen and heard homeless people in the streets of our cities, talking out loud to themselves. Upon seeing them, the first thought that probably pops into your head is that they are crazy!

The irony is that you and I also talk to ourselves, every day of our lives. The only difference is that when we talk to ourselves, we usually do so quietly, in the silent chambers of our own minds. Our internal dialogues, unlike those of "crazy street people," are generally kept strictly personal and private. These private dialogues are known collectively as *self-talk*. Examples of self-talk include the times when you mentally pat yourself on the back and say, "Good job! Well done!" or when you criticize yourself and say, "You jerk! You messed up again!"

Your self-talk can have a huge impact on the health of your body and your healing system. Self-talk generates thoughts that create

nerve impulses that alter and modify the physiological workings and internal chemistry of your body. Negative self-talk, which focuses on negative thoughts and what is wrong with your life, can be very destructive; it can create both physical and mental problems. Alternatively, positive self-talk, which is based on an optimistic mental attitude that sees problems as challenges and fosters a more positive outlook on life, can create and maintain a strong, resilient healing system and robust good health.

Positive self-talk, on the one hand, centers on such themes as hope, enthusiasm, inspiration, compassion, creativity, beauty, appreciation, optimism, love, generosity, health, and healing, and it exerts a positive, uplifting, life-enhancing influence on your healing system. While you are engaging in positive self-talk, you are your own cheerleader, your own corner man in the heavyweight boxing championship fight for your life.

Negative self-talk, on the other hand, is usually based on the following themes: anger, resentment, revenge, jealousy, hatred, guilt, blame, shame, self-criticism, low self-esteem, pessimism, cynicism, sarcasm, hopelessness, futility, fear, sadness, grief, sorrow, worry, illness, and suffering. By sending unhealthy messages to your body, negative self-talk interferes with the performance of your healing system. Negative self-talk creates tension and a feeling of heaviness in your body; when it becomes habitual or continuous, it tears down your body's health.

More dangerous than most external agents of disease, negative self-talk can sabotage and weaken your body's defenses from the inside as it creates toxic chemical imbalances that can lead to chronic, degenerative diseases. Negative self-talk contributes to poor personal hygiene, and unhealthy diets and lifestyles. Most importantly, negative self-talk sends self-destructive messages to your body that interfere with your healing system.

You are in control of your thoughts and the master of your own internal dialogues. Therefore, you can stimulate your healing system and improve the quality of your health and life by carefully censoring negative, unhealthy thoughts while reinforcing positive, healthy, life-affirming thoughts.

Numerous techniques, strategies, and activities are available to help you program your mind into the language of positive self-talk.

Here are a few of the more well-known techniques that have worked for many of my patients:

- *Affirmations:* These are positive, life-affirming statements that you can verbally or mentally repeat continuously until they become deeply ingrained in your subconscious. With continuous repetition and practice, affirmations eventually become automatic and easily accessible to you when you need them. An example of a rather well-known affirmation is "Every day, in every way, I am getting better and better!" Affirmations are not only life affirming and health enhancing when practiced over time, but they can be comforting and reassuring in the short run, as well.

- *Art and literature:* Being around great works of art, including paintings, writings, and sculpture, can help get you out of the rut of negative self-talk and make you realize that there is more to life than pain, suffering, and sorrow. Participating in the arts can help bring you one step further into the positive realm.

- *Audiotapes:* Books on tape and recordings from inspirational authors can be powerful tools to help you reprogram your mind to focus more on positive self-talk. You can listen to affirmations in tape form while you are driving in your car or while you are at home, until they are deeply ingrained in your psyche.

- *Chanting:* Chants are uplifting and inspiring affirmations or prayers that are rhythmical and melodic in form. They are similar to songs, but simpler and more focused in their purpose. Chants for health and healing can help you shift out of unhealthy negative self-talk into the beneficial realm of positive self-talk. There are many wonderful uplifting and inspiring chants from nearly every culture, including Native American, African, Aboriginal, Sufi, Christian, Muslim, Hindu, Jewish, and Buddhist.

- *Friends and family:* Spending quality time with friends, family, and trusted elders and wise people in whom you can confide also can be very helpful to inspire positive self-talk. Being around people with whom you feel safe, in an environment where you feel warmth, affection, and acceptance, and with those you can look up to and admire, knowing they care for you, can uplift and inspire your self-talk to be more positive.

- *Gratitude journal:* Writing down all your thoughts and feelings about the things in your life you are grateful for can be an effective way to help you shift your focus from seeing a glass that is half empty to one that is half full, and to reroute your thoughts and feelings away from what is *not* working in your life to what *is* working. Many successful people, including Oprah Winfrey, keep a gratitude journal.

- *Hobbies and entertainment:* These enjoyable activities will help you forget about time; they will allow your mind to be absorbed in constructive thought and positive self-talk. It is difficult to talk negatively to yourself when you are engaged in a creative activity that you truly enjoy.

- *Hypnosis:* Hypnosis is another tool that many people have successfully applied to aid their mental reprogramming of habitual, negative self-talk into an internal dialogue that is much more positive and helpful. Many people have found hypnosis to be one of the safest and most effective methods available for quitting smoking. Contrary to popular fears and myths, hypnosis is safe and does not allow another person to take over or control your mind. Rather, most therapists teach self-hypnosis, a technique that shows you how to tap into the hidden powers of your own subconscious mind so that your mind can align itself with your body and work with your healing system.

- *Mantras:* We can liken mantras to prayers and chants that are repeated continuously, either silently or out loud. Most mantras come from the East Indian tradition, but you can adapt any phrase or expression that has meaning for you from your own native language. Effective mantras for healing should be short, rhythmical, and melodic, to facilitate easy repetition. Some mantras are known to be very powerful because they not only help infuse your mind with positive energy through contemplation of their meaning, but, through repetition, their sounds can activate certain life-enhancing vibratory energies in your brain and nervous system. You can use mantras for specific occasions and circumstances; specialized mantras that can be very effective also exist for health and healing. An excellent resource for mantras is *Healing Mantras* by Thomas Ashley-Farrand.

- *Music:* Singing, listening to and playing music, and dancing—especially when it accompanies chanting and singing uplifting songs and sacred music—can help uplift your mind while they improve your self-talk. Engaging in negative self-talk is difficult when your mind is occupied in positive musical activities.

- *Nature:* Immersing yourself and your senses in the beauty and mystery of nature can have a dramatically positive effect on your self-talk.

- *Prayer:* Norman Vincent Peale, in his classic book *The Power of Positive Thinking*, describes the positive impact that prayer has on our thoughts and minds, as well as on our health. In every tradition of the world, prayer is universally recognized for its ability to lift people out of the mundane quagmire of hopelessness and despair, futility and depression. In his two books, *Healing Words* and *Prayer is Good Medicine*, Dr. Larry Dossey cites numerous scientific studies that document the health-enhancing benefits and effectiveness of prayer, even in the face of devastating terminal illness and major life-threatening events. By providing a "senior partner" or "higher authority" to consult with, prayer can serve as a vehicle to take the pressure off your life, remove your fears and worries, manage your stress, and shift your self-talk into a more positive mode.

- *Reading:* Reading uplifting, inspirational books, including auto-biographies of great people who struggled against adversity and overcame major obstacles, can help you focus your self-talk more on the positive aspects of your life. Self-improvement books can also be of great help.

- *Sports and games:* These can help you develop confidence in your body's ability to move and perform like an athlete. Even people with serious handicaps such as amputations of both legs, or people who are wheelchair bound, are now competing on an international level to demonstrate that disease, illness, limitation, and activity restrictions are more a state of mind and can often be overcome with the help of positive self-talk.

- *Visualization and imagery:* These are mental techniques with scientifically proven benefits not only for health and healing, but also in the high-performance, physically demanding world of

professional sports and international athletic competition. By using the visual and imaginative powers of your mind, you can help produce a significant positive shift in your internal dialogues, stimulate your healing system, and promote measurable improvement in your physical health.

The Placebo Effect

The *placebo effect* is a scientific principle that demonstrates just how powerful an influence your mind has on your body. The placebo effect is a unique phenomenon observed during clinical trials for new, potentially useful drugs.

When a study is launched to test the usefulness of a new drug, half of the patients, known as the *experimental group*, will receive a pill that contains the new drug, while the other half, known as the *control group*, will receive a *placebo*, which is a pill that contains no drug at all. Both groups are told what to expect from the new drug, and both groups believe their pill contains the new drug. In nearly every study of this type, a large percentage of those receiving the *placebo*, the pill without the drug, will report physical changes consistent with those expected from the new drug being tested. These changes can be measured and are real; they are not just a figment of the imagination. There is no possible way to explain the placebo effect other than by acknowledging that the mind has the power to make these changes happen in the body.

Emotions and Your Healing System

Emotions are packets of mental and physical energy that move through and attempt to move out of your body, much like a river whose water steadily moves toward its greater destiny of the ocean. The word *emotion* comes from the root *emote*, which means *to move out.*

Your emotions have a profound impact on your physical health, and they play an integral role in the functioning of your healing system. Your emotions are connected to your endocrine system, which includes your pineal, pituitary, thyroid, parathyroid, and adrenal glands, as well as your pancreas and reproductive organs. During emotional experiences, powerful hormones are released into

your bloodstream from these various organs, and these hormones have far-reaching effects on your body and your healing system.

For example, when you are in a highly excitable state, either feeling exuberant joy or intense fear, your adrenal glands release *epinephrine* (*adrenaline*), which can constrict blood vessels, accelerate heart rate, increase blood pressure, and affect lung and kidney function. *Cortisol,* which can suppress your immune function, is also released at these times. All of these functions are critical to your healing system. *Insulin,* which regulates sugar metabolism, is also produced in response to certain emotions, especially when you are feeling frightened, angry, or under stress. These are just a few of the more commonly known hormones associated with your emotions, but you can see what a profound effect they can have on your healing system.

Being in touch with your feelings, understanding what they are and what they mean, is important for the health of your healing system. When you are in touch with how you feel, you usually feel energized and alive. When you are out of touch with your emotions, you tend to feel separated from life, isolated and lonely. Feelings of loneliness and isolation create stress, which, if sustained, can have harmful repercussions on your healing system.

Clear evidence now exists that suppressing emotions can be damaging to your health and your body's healing system. Repressing emotions goes against the natural laws of the universe that require the natural energy of emotions to move out of your body to seek conscious expression. Numerous studies have shown that people who continuously suppress their emotions are more likely to fall prey to serious illnesses, including heart disease, hypertension, diabetes, cancer, autoimmune diseases, and other chronic conditions. Other studies have shown that people who are able to access their feelings and express themselves enjoy better health and greater longevity. Rather than suppressing your feelings and emotions, most medical experts are now recommending that, to prevent illness, it is important to get in touch with your feelings, whatever they are, and then learn to express them in healthy ways.

Healthy feelings create sensations of comfort and ease in your body. Some healthy feelings are joy, happiness, peace, contentment, serenity, satisfaction, and love. Because they release powerful hor-

mones, these feelings are extremely beneficial to the health of your body's internal environment, and they can keep your healing system vibrant and strong for many years. Of course, the most powerful healthy feeling of all is love.

Because feelings are located in our bodies, there are really no negative feelings or emotions, though this probably sounds like a contradiction. Feelings just are, and they cannot be judged on any level by anyone. Even anger, pain, and sadness, generally considered to be "negative" emotions, can be appropriate and beneficial, especially when we acknowledge and release them from our bodies in a timely and sensible manner. The problem occurs when we do not release these emotions, but rather, as we discussed before, we hold onto and contain or suppress them. Under these circumstances, suppression of so-called negative emotions can be harmful. Healing often occurs when the roots of these unhealthy emotions are exposed and then released from your body.

Getting Rid of Emotional Baggage

Unhealthy emotions that are not released from your body can pile up and cause a big mess. Like lugging around too much baggage, or having a backflow of garbage that begins to smell and fester, unhealthy emotions that are not released from your body can create toxic chemistry in your body's internal environment that interferes with your healing system's performance. Releasing your emotional baggage by learning to let go of stored up negative feelings, such as old resentment and anger, will help to lighten the burden that may be dragging down your body and making it sick.

Anger is the most notorious aspect of emotional baggage that, if not released from your body, can be detrimental to your health. Anger leads to resentment, jealousy, hostility, hatred, and rage; if it is suppressed and allowed to build up over time, anger can cause damage to your body's internal environment, particularly your blood vessels and cardiovascular system. Many people have experienced fatal heart attacks or strokes because of their intense anger. Anger that has piled up for years and not been appropriately released can also erupt explosively and violently at the drop of a hat, causing great harm to yourself or others. Seemingly insignificant events can often trigger this stored-up anger. Many of the horrendous crimes

and wars in the world can be traced back to this inappropriate expression of anger. Prolonged, continuous anger disturbs the mind, creating emotional volatility as well as mental instability. When you are angry, you are mad, and it is not by coincidence that insane people were, and still are, referred to as "madmen." Anger that is buried deep and never allowed to come out, so-called "frozen anger," has been implicated in severe forms of depression and mental illness.

Anger wastes energy and may cause actual damage to your body, creating a double burden to your healing system. This is why it is imperative to release anger appropriately and prevent its unhealthy buildup. Once anger is expressed and released appropriately, other emotions are often discovered, most notably, pain. If you can release your anger, feel the pain, and move through the pain, you can discover the most important emotion of all, love.

Here are a few tips for releasing unhealthy emotional baggage:

- Close your eyes and notice any sensation of discomfort in your chest, stomach and abdomen, or in any other part of your body.
- Do your best to put a name that relates to a feeling, such as sadness ("I feel sad"), anger ("I feel angry"), and so on, on this sensation.
- Allow yourself to feel the full extent of your feelings, whether they are anger, resentment, jealousy, guilt, shame, sadness, or sorrow. (There is a saying among behavioral scientists: "You cannot heal what you cannot feel.")
- Speak aloud or write down the name of this sensation or feeling. Try to understand what caused it. See whether there might be other feelings underneath this one that may be encouraging the expression of this feeling.

To further help you release anger and emotional baggage, you might want to try the following activities:

- Write down all you want about your negative emotional experience until you feel you have expressed all you need to say.
- Shout out loud at the top of your lungs everything related to your negative emotional experience while you are driving in your car with the windows rolled up (so nobody can hear you).

- Take a plastic baseball bat and strike a pillow as often and as hard as you like, or punch or kick a punching bag, while repeating out loud an angry, emotionally charged phrase that is appropriate to your anger. (I suggest you do this in a room or area where no one can disturb you, and vice versa.)

- Perform any other physical activity, including lifting weights or aerobics, while you focus on releasing anger and other unhealthy emotions. This process can be cathartic and healing. Remember that the word *emotion* comes from the word *emote*, which means *to move out*. Moving your body can often help anger and other emotional baggage to move out of your body and be released.

- Seek professional counseling or therapy.

- If you've gone beyond the anger to feel your pain, you may notice tears flowing automatically from your eyes as you feel and release your pain. Under these circumstances, the release of pain while you cry can be extremely beneficial for your healing system.

Love: The Most Powerful Emotion of All

Love is the most powerful and important emotion in the world. It is the greatest source of nourishment, strength, and energy for your healing system. Love can be awakened by outside forces, but its true origins emanate from the mysterious depths of your own heart. Love is connected to the creative forces of the universe, and for this reason it can exist beyond the borders of your mind and body, and extend to every human heart. Where there is love, there is healing, even in the face of devastating disease and life's most horrendous trials, tribulations, and suffering.

Since the dawn of civilization, wise men and sages, mystics and philosophers, poets, artists, and healers have all declared that love is the most powerful healing force in the world. Thanks to new medical research, scientists and doctors are now beginning to acknowledge the accuracy of this view. Studies now show that people who report having more love in their lives, even if that love is coming only from their pet dog or cat, live longer and suffer from fewer diseases. In the words of Dr. Bernie Siegel, "Love is the most powerful known stimulant of the human immune system." In the

words of The American Holistic Medical Association's charter declaration, "Love is the most powerful medicine in the world!"

Love is stronger than fear. In fact, love overcomes all fears and doubts. Whenever fears and doubts get the better of you, immediately shift your attention to loving thoughts. Start entertaining thoughts of love for yourself, your family and friends, your pets, and whoever and whatever is near and dear to you. Continue to focus on that which you love. If you can't find anything, it's time to get out your emotional shovel and start digging through the layers of garbage that may be covering up your heart. Keep digging until you reach it. There you will find love as it has always been: ever comforting, ever healing, powerful, generous, timeless, and eternal.

Love is the essential nature of your soul. When you are in pain and feeling bad, either in body, mind, or spirit, remember this. If you have tried everything else and nothing has helped you so far, try love. It will heal you!

Laughter and Humor Are the Best Medicine

When you are laughing, you feel happy and joyful. This positive mental and emotional state has been clinically and scientifically proven to have tremendous health-enhancing effects on your body, working like an elixir on your healing system.

I've met people well into their eighties, nineties, and beyond, who, from a health standpoint, did everything wrong. They smoked, they drank, they overate, and they didn't exercise. What they did right, however, was learn how to laugh and not take life or themselves too seriously. This was the case with Norman Cousins, well-known author of *Anatomy of an Illness*, who, while suffering from a painful, incurable condition, discovered that after just 15 minutes of solid belly laughter while he watched comedy movies, he got two hours of pain-free sleep. He eventually went on to completely heal himself, eradicating all traces of illness from his body by following this prescription of laughter.

Humor and laughter also activate the body's natural pain-control mechanisms that release *endorphins* and *enkephalins*, powerful opiate-like neurochemicals produced by the brain. Laughter can relax the

mind and body and not only neutralize the effects of the fight-or-flight response, but energize and activate your healing system, as well. This is why well-known physicians such as Drs. Patch Adams and Bernie Siegel advocate the health-enhancing benefits of laughing regularly and cultivating a sense of humor in your life.

A Humorous Rx

To increase your laughter and fun, and to strengthen your sense of humor, try the following prescription:

- Watch comedy movies or comedy television shows one to two times a week. If you haven't seen the movie *Patch Adams*, starring Robin Williams, I highly recommend it.
- Watch standup comedians, either in person or on TV.
- Read the comic section or "funnies" regularly in the newspaper, and comedy books and magazines.
- Watch cartoon shows with your children, grandchildren, or friends, or rent a Disney animated movie to watch by yourself if you live alone. Go to Disneyland or Disney World, or to your local amusement or theme park as often as possible.
- Play with children as often as possible.
- Remember to let out the child within you.

Stress and Your Healing System

Stress interferes significantly with the performance of your body's healing system. Stress stimulates and activates your sympathetic nervous system, which initiates the fight-or-flight response. Recall that when the fight-or-flight response is activated, adrenaline is released, which causes excitation and increased activity in your body. Blood flow, nutrients, and energy are shunted away from your body's internal organs and dispatched to the large muscles of movement in your arms and legs so you can fight or flee. Under these conditions, healing and repair mechanisms are put on hold, and with diminished blood flow, nutrients, and energy, your healing system tends to bog down and function poorly. Repeated stress can

have damaging effects on your body such as elevating blood pressure to dangerous levels, restricting blood flow to the heart, and creating inflammatory lesions in the stomach and intestines. Stress creates more work for your healing system and can overtax your body's healing resources.

One definition of stress is *information overload*—too much information coming into our lives too quickly, which can overwhelm us. Although there has always been stress associated with the human condition, today far more information is coming at us from more directions, and at a much faster rate than in the past. It is difficult to decide which information is important and which is not. Your life often depends on taking prompt and responsible action based on correct information, and too much information complicates and confuses this process. Information overload is creating more stress for more people than ever before.

Stress also seems to increase as the pace of life increases around us, resulting in hurried and frenzied activity. The increased speed and pace of our modern lifestyles contributes to more tension and stress around us as we rush to meet more deadlines for an increasing number of responsibilities and activities.

Another definition of stress is a sense of isolation: isolation from friends, family, community, the world, your self, or your higher Self. This isolation may have nothing to do with physical location. Even in the middle of a sprawling metropolis such as New York City, people can feel isolated, disconnected, and lonely. We can perhaps better understand the stress of isolation by examining the popular saying "No man is an island." Because man is inherently a social creature, to remain alone or isolated for long periods is stressful. Prisons apply this principle when they subject troublesome prisoners to solitary confinement as the ultimate form of discipline and punishment.

Because of the potentially damaging effects and negative influence of stress on your healing system, learning how to rest, relax, and manage stress effectively is critical to your health. Stress-management techniques activate the "relaxation response," which completely neutralizes and disarms the fight-or-flight response. These techniques work with your healing system to help activate repair mechanisms that can reverse the effects of chronic, stress-related diseases. Stress-management techniques and strategies can help your body regain

and maintain its natural state of health and vigor. The following story demonstrates the effectiveness of stress management in stimulating the healing system.

Conrad's Story

Conrad was a highly ambitious young man who had always done well in school. He was class valedictorian in high school and earned excellent grades in college. Upon graduation from college, Conrad was placed in a progressive telecommunications company as a junior executive, a position in which he received an excellent salary with many benefits. He worked long hours at his new job because he liked the work and wanted to make a good impression on his bosses.

However, since high school, Conrad had experienced increasingly disturbing digestive-system symptoms of gas and diarrhea. Sometimes he had abdominal pain that woke him from his sleep. These symptoms intensified after he graduated from college. By the time Conrad came to see me on his twenty-eighth birthday, three specialists had already diagnosed him with *inflammatory bowel disease*. He had been placed on a regimen of *corticosteroids*, pain medications, and *gastrointestinal antispasmodics*. These medications initially seemed to help, but now they were losing their effectiveness and made him feel drugged and out-of-sorts. These symptoms interfered with his job performance and his personal life.

When I saw Conrad, I noticed that he appeared very agitated and restless, in addition to his physical symptoms. He told me that, for as long as he could remember, he had always been tense and couldn't relax. I recommended several lifestyle changes to Conrad, including a change in his diet, and I also taught him a simple technique to help him relax and manage his stress.

After just six weeks of relaxation training and practice, Conrad reported marked improvement in his condition. One year later, he was off all medications and had only an occasional flare-up. Four years later, Conrad is essentially symptom free, except when life becomes particularly tense at home or at work. Having made the connection between his mind and his body and how stress can contribute to his inflammatory bowel disease, Conrad knows that relaxation and stress management are not an option, but rather a necessity for his continued good health.

Acceptance and Assertiveness to Reduce Stress

One key to reducing stress in your life can be summed up in the famous serenity prayer that many 12-step programs use: "God grant me the serenity to accept the things I cannot change, courage to change the things I can, and wisdom to know the difference." This wish involves both the acceptance of certain limitations and realities in your life, and the determination to improve those aspects of your life that can be changed. Living by this philosophy can take a tremendous weight off your shoulders, and it can empower you to better your life in myriad ways.

Rather than running away from problems, difficulties, or conflicts, or escaping through various unhealthy distractions such as alcohol, drugs, food, sex, or other self-destructive and irresponsible behavior, be assertive and face your problems head on to help reduce stress. Being assertive requires thinking positively, using your resources, and heeding the advice of those you trust to effectively discover and implement the best solutions for your problems.

Assertiveness and acceptance are powerful ways for you to reduce the stress in your life. They encourage a more creative, solution-oriented approach to life by enabling you to view problems and difficulties as challenges, educational opportunities, and necessary growth experiences for your higher good.

Stress-Management Methods and Techniques

The following proven stress-management methods are simple, powerful, and effective, particularly when you practice them regularly.

Deep Relaxation to Reduce Your Stress

One of the most powerful ways to fortify your healing system is to neutralize the effects of stress by learning how to relax your mind and body. Because none of us were ever taught this skill, however, very few of us know how to do it. Instead, to gain temporary relief from the tensions and pressures around us, most of us have learned to resort to artificial means of relaxing, such as drugs or alcohol. These substances create dependence, have side effects, and ultimately can be harmful to our bodies.

Relaxation is one of the most, if not the most, important first steps on the road to healing. Relaxation neutralizes and reverses the effects of stress and allows your mind, your nervous system, and all the systems in your body to cooperate with your healing system. Relaxation helps to initiate healing mechanisms that operate deep within the organ tissues of your body.

Relaxation has many proven benefits, including the ability to reduce stress, lower blood pressure, improve immune functioning, and calm and stabilize nervous-system activity, and so it is important to learn this invaluable, essential skill. Relaxation goes far beyond sitting back with a six-pack of Budweiser and watching a Monday-night football game. While doing that might be enjoyable, there are other, more powerful ways to relax that naturally calm and soothe both your mind and your body.

Relaxation is the foundation of other powerful mind-body techniques that can support and nurture your body's healing system. Learning how to relax is as easy as learning how to drive a car. In the beginning, all it takes is a little practice.

Here's a deep relaxation technique that is easy and effective:

- Secure a 15- to 20-minute time slot for yourself during which you can be quiet and alone.

- Make sure you won't be disturbed during this 15- to 20-minute period, and that you have no responsibilities to attend to—no phone or pager to answer, no diapers to change, no stove or oven to turn off. Find a room where you can close the door and be free from all distractions. (You might need to wear earplugs or headphones if it is noisy.)

- Lie down on a bed or on the floor, making sure you are in a comfortable position on your back. You may need to place blankets or pillows under your knees, head, and back. Make sure you are not cold.

Note: Before you proceed, you will find it helpful to get a small tape recorder and record your voice as you read the remaining instructions out loud, slowly and calmly. After you have recorded this exercise, you will have your own relaxation tape. You can lie down and let your own words guide you through deep relaxation any time you wish.

- Keep your hands along the side of your body, with your palms facing up, or fold your hands on top of your stomach and abdomen. Gently close your eyes and bring your awareness inside of your body.

- Notice in the area of your stomach and abdomen the slight up-and-down movement that occurs with the movement of your breath as it flows in and out of your body. When the breath flows into your body, your stomach and abdomen gently rise, gently expand. When the breath flows out of your body, your stomach and abdomen gently fall, gently contract.

- Without trying to control the rate or depth of this movement, allow your mind to be a passive observer of the rhythmical flow of your breath as it moves in and out of your body, causing your stomach and abdomen to rise and fall.

- Every time the breath leaves your body, feel all the muscles in your body releasing tension and becoming more relaxed. (Note: A natural relaxation phase occurs in your body during each exhalation of the breath. When you pay close attention to your body and its breathing processes, you can feel this relaxation phase quite distinctly.)

- Now bring your awareness down to your feet and toes. Using your breath and the natural relaxation phase that occurs during each exhalation, gently relax all the muscles in your feet and toes.

- Relax all the muscles in your ankles, lower legs, knees, thighs, hips, pelvic area, buttocks, and lower spine.

- Relax all the muscles in your stomach, abdomen, and chest, as well as the muscles in your middle and upper back, including the area between your shoulder blades.

- Relax all the muscles in your shoulders, arms, forearms, wrists, hands, fingers, and fingertips.

- Relax all the muscles in the back of your neck and head, and those on the top of your head.

- Relax your forehead, and all the muscles around your eyes, ears, and jaws, and all the muscles in your face.

- Relax all the muscles in your body.

- Now slowly bring your awareness to the tip of your nose, where the breath is flowing in and out of your body through your nostrils.

- Without trying to control the rate or depth or the movement, notice the gentle flowing movement of your breath as it comes in and out of your body at this point.

- Observe the breath as if it were separate from you.

- As you continue to observe your breathing for at least 5 to 10 minutes, let your mind and body relax completely.

After you complete this exercise, gently open your eyes and stretch your entire body. Make sure not to rush to your next activity. Take the time to savor the calm and relaxed state you have just experienced. Know that this is not an artificial or contrived state, but rather your natural state of being. Focus on remaining in this calm and relaxed natural state throughout the day, until the next time you are able to do this exercise. Practicing this exercise regularly brings the most effective benefits.

How Deep Relaxation Strengthens and Recharges Your Healing System

Deep relaxation quiets down the nervous system and slows metabolic processes in the body so that the healing system can do its work unimpeded. With these obstacles removed, your healing system can perform more efficiently and effectively. Because the healing system functions best in a quiet, calm environment, deep relaxation is one of the most powerful techniques for strengthening your healing system. Other benefits of deep relaxation include the following:

- You will feel more relaxed throughout each day, and you will feel more peaceful from within, even during difficult and stressful situations.

- You will become much more aware of stressful situations and their effects on your body. You will learn how to avoid unnecessary stress and how to manage stress more effectively by remembering your natural relaxed state.

- You will become much more aware of the harmful consequences of such emotions as fear and anger in your body, and you will be able to move through and release fear and anger much more effectively and swiftly through your ability to relax.

- You will have more energy throughout your day. Stress wastes energy and causes fatigue in your body. The more relaxed you are, the less fatigue you will experience in your life. Releasing tension and becoming more relaxed frees up tremendous amounts of natural energy in your body.

- Relaxation eliminates tension and decreases pain. If you have a chronic medical problem that causes persistent pain, you will experience less pain through the practice of regular relaxation.

- If you suffer from anxiety, phobias, or even depression, you will most likely see improvement in these areas in a relatively short period of time.

- Deep relaxation stimulates your healing system and activates deep internal processes of healing.

As you can see, deep relaxation will benefit you in many ways, physically, mentally, and emotionally.

Breathing to Reduce Your Stress

Because your breath is the link between your mind and your body, working with your breath is one of the most powerful stress-management modalities known. When you are mentally agitated, anxious, or under stress of any kind, your breathing is disturbed and becomes more shallow and rapid. When you are relaxed, your breathing becomes slower and deeper.

Normally, we go about our activities without any awareness of our breathing. However, without your breath, you couldn't live. Your existence depends on the continuous flow of oxygen that comes into your body from the air you breathe.

Improvement in your health occurs when you can breathe in a more relaxed and easy way, which will result from practicing the simple yet powerful breathing techniques in this section. Deep breathing increases lung capacity and builds up the strength of your respiratory system, creating more efficient breathing. Efficient, relaxed

breathing brings in more energy for healing and regeneration for these two critical reasons:

1. With improved breathing comes increased oxygenation of the blood. Increased oxygenation of the blood means greater oxygen delivery to every cell, organ, and tissue in your body.

2. As your breath becomes more efficient, smooth, and relaxed, there is a calming effect on your brain and nervous system, which reduces overall mental and physical tension.

In a powerful way, both of these factors work synergistically to relieve fatigue and create more energy in your body, improving the functioning and performance of your healing system.

Breathing Exercise #1: Breath Awareness

- Find a quiet place where you can be alone for 10 to 15 minutes. Make sure you are absolutely free of all obligations and responsibilities during this time slot.

- You can lie down on your back as in deep relaxation, or you can sit in a chair or on any comfortable, firm surface. Make sure you are in a comfortable position.

- Close your eyes and bring your awareness inside of your body. Notice the gentle movement in your stomach and abdomen. (You obviously will need to keep your eyes open to read the instructions for this exercise. For maximum benefits, however, keep your eyes closed after you have read and familiarized yourself with this technique.)

- Notice that when the breath flows into your body, your stomach and abdomen gently expand and rise.

- Notice that when the breath flows out of your body, your stomach and abdomen gently contract and fall.

- Without trying to control the rate or depth of this movement, continue to observe this automatic movement in your stomach and abdomen as your breath flows in and out of your body.

- Every time the breath flows into your body, feel the oxygen from your blood entering into the cells and tissues of your body,

energizing and strengthening your healing system and entire body.

- Every time the breath leaves your body, feel all the muscles in your body becoming more relaxed.

- Now direct your awareness to the tip of your nose. Watch the breath as it flows in and out of your body. Again, without trying to control the rate or depth of the movement of your breath, focus on seeing the breath as separate from you.

- Every time the breath leaves your body, feel your entire body becoming more relaxed, and your mind becoming more calm, serene, and peaceful. Feel the power of this natural state of calmness and tranquility in your entire body.

- Feel the healing energy from your breath flowing into every cell and tissue of your body, as your body becomes more healthy, vibrant, and alive with each breath your take.

- After breathing like this for 10 to 15 minutes, slowly open your eyes. Before you resume your normal activities, appreciate the power of your breath. Notice its calming influence on your mind and its energizing effect on your body. Know that your breath is always available to you should you begin to feel stressed, anxious, or fatigued at any time. Keep this awareness of breath with you as often as possible. Have as your goal to practice this breathing exercise every day for at least 5 to 10 minutes. If your schedule permits, build up to 30 minutes per day. The best time to do this exercise is in the mornings or evenings, when it is usually more quiet.

Breathing Exercise #2: Breathing with Sound

- Find a quiet place where you can be alone for 10 to 15 minutes. Make sure you are absolutely free of all obligations and responsibilities during this time.

- You can lie down on your back, as in deep relaxation, or you can sit in a chair, on the floor, or on any firm surface. Make sure you are in a comfortable position.

- Gently close your eyes and bring your awareness inside of your body. (You obviously will need to keep your eyes open to read

the instructions for this exercise. For maximum benefits, however, keep your eyes closed after you have read and familiarized yourself with this technique.)

- Open your mouth and breathe in and out slowly. Every time you breathe out, make the sound "aahh," which is the sound that the doctor asks you to make when he or she examines your throat. Make sure this sound is coming from your throat. You can place one hand on the front of your neck in the throat area to check whether your vocal chords are vibrating.

- Next, whisper this same sound as you breathe, making it softer and gentler.

- Next, close your mouth while you continue to make this same gentle, whispering sound; allow the breath to flow in and out of your nose, yet continue to focus on the sound coming from your throat area and vocal cords.

- Gently lengthen and deepen the flow of your breath, but make sure you are comfortable with your breathing.

- Make your breath smooth and flowing as you make this soft, gentle sound, which should feel like a gentle grating sensation in your throat. Make this sound on both inhalation and exhalation. Continue to gently lengthen your breathing.

- Make this sound softer as you continue to breathe in this manner. In fact, make this sound barely audible, so that someone sitting next to you wouldn't be able to hear it.

- Continue to gently lengthen and slow your breathing as much as you can, making sure your breath is smooth and flowing as you make this soft, gentle, grating sound. Make sure you are comfortable with your breathing, and that you are not experiencing any sensations whatsoever of forcing or straining or discomfort.

- Keeping your eyes closed, continue to "breathe with sound" in this fashion.

- If you are doing this technique correctly, you will begin to feel more relaxed, peaceful, and focused in your mind and more energetic in your body.

■ Stay with this technique and these sensations for as long as you like, gradually increasing to a maximum of 15 to 30 minutes at a time.

This is a powerful yogic breathing technique from ancient India known as *Ujjayi Breathing*. The technique not only combats stress by helping to keep the mind calm and focused, but it also improves lung capacity and respiratory function as it brings more energy into your body. Ujjayi Breathing purifies the nervous system and enhances the performance capabilities of your healing system.

Meditation to Reduce Your Stress

Meditation is a simple yet powerful way to manage your stress. It can calm your mind and rejuvenate your body, and in so doing help strengthen your healing system. Meditation is not mystical or magical. It is natural and ordinary, and when done correctly, it can have a tremendous effect on your physical and mental well being.

In the early 1970s, Dr. Herbert Benson at Harvard University documented the beneficial therapeutic effects of meditation and its ability to lower blood pressure. Since then, numerous other studies have demonstrated the wide-reaching, therapeutic benefits of meditation and its ability to help heal many other serious conditions, including heart disease, cancer, and AIDS.

Meditation occurs when you are not thinking about the past or the future, and you are just aware of what is happening in the here and now. We have all experienced a meditative state at one time or another, even if only for a few brief moments. As children, we experience this state of mind much more frequently. Children like to play a lot, and, when they play, they are so intent on their playing that they are often not aware of anything else. They may be hungry, but they will completely forget about food because of their total absorption in their play. This focused state is very much like meditation.

Meditation can help bring back the energy and enjoyment of life that you experienced as a young child. By relaxing your mind and helping focus your awareness in the present moment, meditation lightens the burdens of your past and future, releasing pent-up energies and precious internal resources that are now available for your healing system to use.

There are many techniques for meditation. For meditation to work for you, it is important to find a style or technique that suits your own personal tastes and needs. The following meditation is offered as a sample of what is available to you. Meditating regularly for just 10 to 15 minutes a day, or more if your schedule permits, will result in tremendous improvement in your health.

Drifting Thought-Clouds Meditation

This is a simple meditation technique that takes only a few minutes:

- Find a quiet place where you can be alone for 10 to 15 minutes. Make sure you are absolutely free of all obligations and responsibilities during this time.

- You can lie down on your back, as in deep relaxation, or you can sit in a chair, on the floor, or on any firm surface. Make sure you are in a comfortable position.

- Gently close your eyes and bring your awareness inside of your body. (You obviously will need to keep your eyes open to read the instructions for this exercise. For maximum benefits, however, keep your eyes closed after you have read and familiarized yourself with this technique.)

- Observe your breathing and the gentle movement of your breath as it flows in and out of your body, as described with the previous breathing exercises.

- As you continue to relax and observe your breathing, imagine that you are in a room with very high windows on either side.

- As you breathe and continue to relax, it will be inevitable that certain thoughts may come into your mind. Rather than holding onto these thoughts or reacting to them, just imagine that these thoughts are soft and fluffy clouds gently passing in and out of the windows in the room.

- Continue to relax and observe your breathing, letting any thought that comes into your mind be like a soft and fluffy cloud, gently drifting in and out of the windows in your room.

- Do not let any thought disturb your peaceful, relaxed state of mind; rather, let it go on its way like a soft, fluffy cloud drifting by.

You can do this meditation whenever you feel yourself becoming anxious or tense, or when you are experiencing disturbing thoughts of any kind. When you become proficient at it, you can even do this with your eyes open, in the midst of other activities.

Visualization/Guided Imagery to Help Manage Your Stress and Strengthen Your Healing System

From the Wright Brothers to Alexander Graham Bell and Thomas Edison, all great inventors in the history of the world began with an imaginative idea that came from their minds. Imagination sows the seeds of reality, and it can play a huge role in influencing the performance of your healing system while it helps your body maintain its natural state of health.

Your mind is a powerful force, and whatever imaginative thoughts you dwell on can become a reality in your life. This is especially true for thoughts about your health. Your brain is a powerful, metabolically active transformer of pure electrical energy; as a result, thoughts generated in your brain and directed to certain areas of your body can exert a powerful effect on the physiology of that part of your body. By recognizing the tremendous imaginative power of your mind, you can learn to harness this power and focus the energy it generates to fortify and boost the effectiveness of your body's healing system.

Guided imagery and visualization are powerful techniques that have helped many people overcome such serious life-threatening illnesses as cancer and heart disease by making use of the connection between their minds and bodies, and using the power of their imaginations for healing purposes. For example, pioneer cancer specialist and radiation oncologist Dr. O. Carl Simonton showed that many of his patients were able to successfully increase their immune system activity, stimulate repair and regeneration of damaged tissues, and demonstrate reversal of their diseases by using their minds to imagine their white blood cells removing the tumor cells in their bodies. In his classic book *Love, Medicine and Miracles*, Dr. Bernie Siegel shares the stories of many of his cancer patients who also overcame their diseases through the successful application and use of visualization and imagery techniques. Dr. Marty Rossman, in his book *Healing Yourself*, also shares stories of numerous patients of his who healed themselves through the use of these specific techniques.

You've no doubt heard the saying "A picture is worth a thousand words." Because your mind thinks in terms of pictures or images, it continually processes information by visualizing and imagining anticipated scenarios as you project yourself into the future. This is how your mind thinks and makes plans, and it is one of the most natural and powerful things you do. Your body is influenced by your mental activities, and by this same process you can influence the state of your own health. However, this influence can work for you or against you. Consider, for example, the case of worrying.

Worry is the negative application of your imagination, fearfully projecting your mind into the future and visually imagining worst-case scenarios of events to come. This process causes anxiety, which increases stress. Stress results in the constriction of blood vessels and inhibits the flow of vital bodily fluids, which can result in congestion and accumulation of toxins in various parts of your body. In addition to high blood pressure and heart disease, chronic worrying has been shown to contribute to the formation of ulcers and numerous other illnesses and diseases.

Conversely, numerous studies have also shown that when people learn to harness the constructive forces of their minds and overcome the harmful habit of persistent worrying, their health will invariably improve. For this reason, it is vital that you learn how to use your mind and the power of your imagination to improve your health and the quality of your life. Visualizing or imaging can be an important ally for your healing system as it directs healing energies to specific areas of your body.

How to Begin Guided-Imagery and Visualization Techniques

Guided-imagery and visualization techniques are best performed with your eyes closed and when you are in a relaxed state. Begin as you would with the deep relaxation methods, and the breathing techniques that you just read about in this section. Make sure you are in a comfortable position and your breathing is slow and relaxed. When you feel your mind becoming calm and your body relaxed, introduce the specific imagery and visualization techniques that best suit your needs. Please do not feel limited or restricted in any way by the few suggested techniques listed here. Many wonderful styles of imagery and visualization techniques are available from trained

teachers and professional therapists, from the books listed in the reference section of this book, and from your own creative imagination.

If you are currently trying to heal from any affliction in your body, you will realize the best results by practicing imagery and visualization techniques regularly over an extended period of time, until you are completely healed. For serious, life-threatening conditions, set aside at least 15 to 30 minutes, twice a day, for the practice of imagery and visualization techniques. For illnesses that are not life threatening and are less severe, practicing these techniques once a day for 15 to 30 minutes will be helpful.

Positive Imaging for Activating Your Healing System

- While you are in a relaxed and serene state, keep your eyes closed and your awareness focused within.

- See yourself as very small, standing in the interior of your body.

- See yourself with a clipboard and pencil in hand, and a hard hat on your head, as you monitor and make notes of your body's various internal organ systems.

- Allow an image of your healing system to form in your mind. Without judging, notice the first shape or form that appears.

- See yourself speaking to your healing system. Hear its gentle and confident voice answer back to you. Spend time carrying on a conversation with it, just as you would with any other person. Ask your healing system any question, and tell it anything you wish. Try to get to know it. Make sure you listen carefully to responses to your questions and dialogue. You might want to ask it whether it has a personal name and whether you could use this name in future communications with it.

- After dialoguing and becoming familiar with your healing system on a more personal level, see yourself gently directing your healing system to any area of your body that needs healing or about which you are concerned.

- See yourself calmly and persistently speaking words of encouragement to your healing system and the other systems in your body under its supervision, to make sure your body is functioning optimally and harmoniously.

- See yourself making notes of your healing system's progress as you continue to encourage it to perform its tasks of repair and restoration where they are needed in your body.

- Ask your healing system what it needs from you so that it can continue to do its job most efficiently.

- Thank your healing system for the work it is doing on your behalf.

- Make a point to meet again in the near future.

- Breathe life into these feelings and into your body as you complete this exercise, maintaining positive feelings about what you have just visualized.

- Relax and take a deep breath as you finish this exercise.

- Open your eyes when you are done.

- Write down any insights or thoughts about your experience.

This visualization/guided-imagery technique is only a small sampling of what is available to you. You can modify and apply this technique to suit any health condition that you would like to improve. The beauty of visualization and guided imagery is that they can enable you to gain incredible insights and access key information about the state of your health. Further information about visualization and guided imagery is given in the resource section in the back of this book.

Pray to Reduce Your Stress

Prayer serves as a powerful stress-management tool, perhaps one of the most powerful known to man. Prayer can open a channel of communication for you to dialogue with the wise and infinite powers of our sacred universe that exist outside as well as within you. In this capacity, prayer offers you a way to hand over your problems and worries to a higher power, relieving a lot of tension and stress in the process. Prayer is one of the oldest, most universal, and most effective methods of stress reduction. However, for prayer to work for you, you have to be comfortable with the type of prayer you use, as well as the context, style, and method with which you choose to pray.

Many scientific studies have now been conducted that demonstrate the therapeutic efficacy of prayer. One study even showed clinical improvement in people who were prayed for from a distance and didn't know it. Many of these people didn't even believe in God. In Dr. Larry Dossey's best-selling book *Healing Words*, this fascinating study and others are discussed in great detail.

No matter how embittered or cynical you might have become during your life's journey, it is never too late to attempt to contact this divine source through honest and sincere prayer. Miracles can occur when you do. In fact, consider how you got on this earth and the fact that you are alive right now. Those are in themselves miracles!

Whether or not you have a particular religious or spiritual affiliation, or even if you are an agnostic or an atheist, you can still learn to open your heart and contact the loving, intelligent force and power that created you and sustains your very life.

When you do take the time to unburden your troubles to a higher power, sharing all your pain, sorrow, problems, fears, and disappointments, make sure that you take a few moments to wait for wise counsel in response to your prayers when you have finished. You can often obtain tremendous insights and wisdom in this process. However, higher powers are known to speak very softly and quietly, so to enhance your ability to receive a response to your prayers, first calm your mind by practicing relaxation, breathing, meditation, or all three of these in sequence before you initiate the act of prayer.

Alternatively, you might find it helpful to release your pain, worries, tensions, and fears to the ocean, the sky, the stars, a mountain, or some other special entity, force, or place in nature that comforts and reassures you. You may do the same with a trusted friend, loved one, or wise counsel, or the great unknown mystery of the universe that remains open and receptive to creative ideas, insights, and the healing force of love that exists in your heart.

Peace of Mind and Your Healing System

Your body does not operate in a vacuum. To a large degree, its state of health registers and reflects what is going on in your life, which in turn is a product of your mental habits and thoughts. A crazy,

chaotic, troublesome life, born of a disturbed mind, creates a stress-ful life, creates chronic physical tension, depletes the body's energies, depresses the immune system, repeatedly triggers the fight-or-flight response, and interferes with the performance of your healing system while it renders the body susceptible to illnesses and diseases from both internal and external agents.

When your mind is disturbed, like an out-of-control roller coaster or a furious tempest, it can create violent mood swings that can upset your body's internal balance. These mood swings cause the release of potent hormones and strong chemical modulators that can wreak havoc on your body's internal organs and tissues. A disturbed mind opens the door for a plethora of diseases to enter your body, creating opportunities for a smorgasbord of potentially dangerous disorders that can make your life miserable and quite possibly take you to an early grave. Your healing system cannot possibly operate efficiently under these conditions.

A peaceful mind, conversely, creates a relaxed, healthy body and contributes to a more harmonious internal environment in which your healing system can work smoothly and efficiently. When your mind is at peace, and you are relaxed and tranquil, feelings of love, contentment, happiness, and gratitude naturally and spontaneously arise. These feelings produce powerful hormones and gentle, sooth-ing nerve impulses that bathe and nourish your healing system in a flood of loving, life-giving energy. Just as a calm sea makes for smoother travel for any ship, so too a peaceful and tranquil mind makes for a calmer, smoother, more harmonious internal environ-ment for your body's healing system.

Just as your body's natural state is one of health, so, too, your mind's natural state is one of peace. Keeping your mind calm and relaxed may take some training if you have forgotten what it is like to be peaceful, but it will be well worth the effort. A peaceful mind is essential for a healthy body. If you want to effectively promote the work of your healing system, one of the most important things you can do is to actively recruit your mind in this process by keeping it peaceful and calm. The stress-management techniques described in this chapter, along with the chapter's other prescriptive elements, provide the most powerful, time-proven methods to help you achieve and maintain this most valuable of all possessions.

Closing Thoughts on the Power
of Your Mind and Your Healing System

You have seen in this chapter the powerful influence your mind has over your healing system. Every thought that is registered in your mind has the potential to create powerful chemical changes in your body, changes that affect the processes of healing and repair. Staying calm and relaxed, positive, optimistic, and enthusiastic is vital to maximize the incredible ability of your mind to cooperate with, support, nourish, and strengthen your healing system.

The practical strategies, techniques, and exercises prescribed in this chapter are based on proven clinical experience, but to reap their benefits, just reading them is not enough. Set aside time as suggested to practice one or more of these extremely helpful techniques, so they will become a part of your daily routine and lifestyle, just like brushing your teeth is. If you or a loved one is currently battling a major, life-threatening illness, doing this is not an option; it is a necessity.

The next chapter will reinforce the importance of minimizing stress in your life as we explore how a strong and healthy healing system has enabled many people to achieve great longevity. You'll learn how these people were able to reach the age of 100 or more, and how, by harnessing the energy and power of your extraordinary healing system, you can, too.

CHAPTER 7

Aging, Long-Lasting Health, and Your Healing System

Your ability to live longer is not a matter of mere chance, but is, for the most part, a systematic, self-determined process. Your body comes equipped with its own healing system and can last, on average, 100 years. Of course the choices you make in your everyday life can shorten or lengthen this time. The point of living longer, however, is not just to extend your life, but to enjoy a higher quality of life as you age, and to participate fully in life, remaining enthusiastic and active to the very end of your days. Doing this requires you to be healthy. The process of achieving a long life while remaining healthy is what I call *long-lasting health*.

If you carefully study the lives of people who have enjoyed long-lasting health, you will discover primarily personal health habits, diets, lifestyles, and attitudes that are consistent with the ideas and methods that work with their bodies' healing systems and that have been presented in this book. Understanding and applying these ideas and methods will help you enjoy long lasting health, as well. But you must also be prepared for certain challenges you might have to face as you age. The following story illustrates my point.

An elderly woman was suffering from a painful knee condition that had been troubling her for some time. The pain was only in her right knee, but it was severe enough to make walking difficult. She

couldn't figure out what was causing the pain. Her friends all told her it was the result of old age, and to stop worrying about it. However, because the pain interfered with the quality of her life, she refused to accept this explanation, and she eventually made an appointment with her doctor to find out what was going on.

When this woman went to the doctor's office, the doctor examined her knees thoroughly. He first bent her knees one way and then the other. Then he banged them with a rubber hammer to check their reflexes. She was asked to stand on one leg at a time, and then hop up and down, first with both feet on the floor, then with just the right leg, and then with the left. The doctor also thoroughly examined the other parts of her body. At the conclusion of his exam, he shrugged his shoulders and replied, "I'm sorry, ma'am; I can find nothing seriously wrong with your knee. I'm afraid it's just due to old age."

The woman, by now completely fed up with this type of explanation, replied, "I'm sorry to disagree with you doctor, but there must be another reason, because my other knee is the exact same age and it is perfectly fine. Thank you and have a good day!"

This story illustrates two very simple, yet important points that I want to clarify and emphasize here at the outset of this chapter. Understanding them now will help you to better grasp the challenges of working with your healing system as you age.

First, there is an unhealthy, yet common tendency in our society, and among our medical professionals, to attribute most forms of chronic illness to advancing age. As you age and develop symptoms of one kind or another, it is all too easy to blame these symptoms on old age.

Second, if you want to remain healthy as you age, you will need to educate yourself and learn to ignore negative, pessimistic, fearful, and erroneous ideas about what causes illness. Instead, focus on the important task at hand: working with your healing system to help you achieve long-lasting health, incorporating all the methods, strategies, and techniques that you have learned so far.

Advancing Age Does Not Cause Illness

Even though advancing age and illness are often linked, if you examine the facts and pay careful attention to the underlying causes of

most diseases, you will discover that *old age and illness have nothing to do with each other*. The majority of the diseases that afflict us as we grow older are caused by factors that have nothing to do with age. Let me explain.

If you look around the world and peruse the international public health data, you'll see that the majority of the diseases that afflict us as we age in the Western industrialized societies are virtually absent in poor, developing countries. These diseases include heart disease (the world's number-one killer), high blood pressure, diabetes, emphysema, arthritis, cancer, and many other conditions that are rampant in North America and Europe, but that are rare in places such as Africa and Asia. These diseases, referred to by the late Dr. Albert Schweitzer as "diseases of civilization," have been shown to be directly linked to factors under our own control, such as our diet, lifestyle, and personal health habits. These factors accumulate over a lifetime, and their cumulative effects become increasingly harmful as we age, *but they are not caused by age*. Eventually, they just take their toll.

For example, a person who continually smokes two packs of cigarettes a day for 25 years or more is likely to develop emphysema or lung cancer when he or she reaches 60 or 70 years of age. Does this mean that emphysema and lung cancer are diseases of old age? Absolutely not. It means that these conditions are more likely to occur in people whose bodies have been abused over a long period of time and, for this reason, are more commonly seen with advancing years. If you continually harm your body and fail to respect or cooperate with your healing system, it is a simple fact that, in time, you will most likely become ill. The abuse factor, rather than the age factor, causes the majority of these illnesses.

If you carefully examine other major illnesses, including diabetes, heart disease, arthritis, and cancer, among others, you will almost invariably discover similar underlying factors and mechanisms at play, factors and mechanisms that are much more related to unhealthy diets, lifestyles, and personal health habits than to old age. So I will repeat myself by stating that old age and illness have nothing to do with each other.

As you work with your healing system, remember the importance of adopting an attitude similar to the lady in the story with the painful knee. Make use of the power of your mind and your own

personal health choices to directly influence your healing system, and concentrate your energies on creating positive health for yourself. As long as you are alive, no matter how compromised your health might currently be, your healing system has the capacity to heal your illnesses and improve your health.

How Your Mind Affects Your Healing System As You Age

"You are as old as you think you are" is a common saying in many cultures and folk traditions around the world. According to our modern scientific understanding, this dictum appears to contain much truth. Your attitude about your health and your life has a direct effect on your healing system.

Your mental attitude, and your expectations about your health and health outcomes, which reflect healing-system functioning, are strongly linked. Many studies have demonstrated that a healthy mental attitude not only creates healthier biochemistry in the brain and body, but also is more likely to support a healthy, active lifestyle. Both factors directly benefit your healing system, producing a healthier, disease-free body and a longer life span. A positive attitude will strengthen your healing system, whether you are 30 years old or 103 years old, and it will literally add years to your life.

In his book, *RealAge*, Michael Roizen, M.D., makes clear that, based on scientific studies, your mental attitude can affect your physical health and your body's healing system in two ways: 1) Your mental attitude determines how well you treat your body through your daily personal health habits, and 2) your mental attitude can directly influence your physical health through the brain-body connection, wherein neurochemicals and electrical impulses produced by your brain can cause powerful physical changes in every organ and tissue in your body. These factors have a direct impact on the vitality of your healing system and how you age.

As a consequence of these findings, Dr. Roizen discovered that how old you are in biological years can be very different from how old you are in chronological years. For example, people in their twenties and thirties who abuse their bodies with tobacco, drugs, or

alcohol; live high-stress lives; have poor diets; practice unsafe sex; do not exercise; reflect unhealthy mental attitudes; and exhaust the resources of their healing systems often wear their bodies out by the time they are 40 or 50 years of age. These people often become sick and disabled, dying prematurely from unnatural causes. At any point in time, these people appear much older than their actual age, and, in biological terms, they are much older. These people have not learned how to honor and work with their healing systems, and in the end (which usually comes much sooner than need be), having become old before their time, they pay with their lives. Conversely, other people in their seventies, eighties, nineties, and even hundreds are biologically much younger than their birth dates indicate. They exhibit not only bodies that are far more youthful than their chronological age, but mental attitudes and thinking that are similarly youthful. They have mastered the art of learning how to cooperate with their healing systems, and they are perfect examples of how, by doing so, the rewards of superior and long-lasting health have become theirs.

Elizabeth's Story

The story of Elizabeth, one of my patients, is a good example of how your attitude about your age significantly affects your healing system. Elizabeth, 83 years of age, had regularly practiced yoga for several years, but she had not come to class for about six months. When I asked her why, she said that she had been traveling for an extended period and had neglected to stretch and move her body. She felt embarrassed by how stiff she had become in the interim, especially in her hands and fingers, which had become quite painful. Because of the pain, she decided to see another doctor while she was traveling. He diagnosed her as having arthritis of her hands and fingers. This diagnosis further discouraged her and sent her into a mild depression. She said she was feeling disabled, handicapped, and old, and she commented that she was afraid she could no longer keep up with the younger students.

I urged Elizabeth to return to class. She sheepishly appeared the following morning. I told her to take it easy and not push herself. She did fine. After the class, Elizabeth thanked me for insisting that she return. Since that day, more than three years ago, she hasn't missed a class. Not only has her mental attitude improved and her depression lifted, but her physical flexibility has improved as well,

especially in her hands and fingers. Today, there is no evidence of any arthritis in her hands. By changing her mental outlook about her age and learning to work with her healing system, she was able to regain her health. Elizabeth now appears and behaves much younger than her 83 years, and there's no sign of "old age" setting in any time soon.

Bill's Story: One Among Many

Bill was a patient I met through my work with Dr. Dean Ornish. Bill demonstrated the importance of cultivating a healthy mental attitude about his age while he successfully overcame and reversed his heart disease. At the age of 85, after he had succeeded in winning back his health, Bill was interviewed by a reporter who inquired about his secret to a healthy, vibrant life, which he obviously demonstrated by regularly traveling around the world, hiking in alpine altitudes, and practicing yoga every day. To this question, Bill replied, "Old age is something that happens to someone who is at least 15 years older than me!" This is the kind of attitude that improves the performance of your healing system and contributes to long-lasting health.

In my 10 years of work with Dr. Ornish, I had the opportunity to work with many other wonderful patients. Like Bill, these folks demonstrated remarkably optimistic mental attitudes about their lives and their ages, in spite of their histories of severe, advanced, life-threatening disease. In fact, it turned out that an optimistic mental attitude was critical to strengthening and fortifying their healing systems in their quests to successfully reverse their heart disease, one of the world's most dangerous and deadly of all diseases. An interesting finding that surfaced early on in Dr. Ornish's research supported this observation about the relationship between their attitude and their success in overcoming heart disease.

Before Dr. Ornish's research, numerous studies had concluded that heart disease was an irreversible and incurable disease. These studies had repeatedly demonstrated that once a person developed heart disease, it would continue to progress and get worse as the person got older, eventually killing him or her. Again, this is exactly what would be predicted based on our society's current views about aging and disease. In the early stages of Dr. Ornish's groundbreaking research, which uncovered new evidence about how the heart could heal itself, the general expectation, based on these beliefs, was

that if reversal of heart disease was possible, it would be seen in those patients who were younger and had less severe disease.

Contrary to what was predicted, however, the opposite turned out to be the case: The oldest and sickest patients showed the greatest improvement in the shortest time. These results ran completely counter to what the experts had predicted. Everyone, including Dr. Ornish, was stumped.

Upon further inspection, however, the results began to make sense. The oldest patients with the most advanced heart disease had tried all the latest high-tech interventions, including surgery, without success. Having exhausted their options, they turned to Dr. Ornish out of desperation. Because their lives were on the line, these people were highly motivated to improve their health, much more so than their younger, less-ill peers. They also recognized the need to enlist a positive mental attitude in their quest to overcome their illnesses. Because of their motivation and attitude, regardless of their advanced age, these people demonstrated the greatest adherence to all the elements of Dr. Ornish's program, and they showed the greatest reversal of disease and the most improvement in health in the shortest period of time. Once again, this story illustrates that regardless of your age or the severity of your illness, your healing system is ready to heal you when you start to work with it.

I know of many people with other diseases, including hypertension, diabetes, arthritis, and cancer, who have similar stories. The evidence seems clear. When you harbor a negative mental attitude about your life and fail to take good care of yourself, you impede the function of your healing system and are more likely to age faster, succumb to illness more easily, and die sooner. Conversely, when you learn to positively align your mental attitude and personal health habits with your healing system, you are much more likely to enjoy greater health as you age . . . and to live longer, as well.

How Your Beliefs Affect Aging and Your Healing System

Your attitudes, thoughts, and beliefs about your age and health powerfully influence the performance of your healing system. These

beliefs are strongly shaped by your culture and the society in which you live. For example, if the society in which you live says that old age begins when you reach your fortieth or fiftieth birthday, you will probably start to feel old when you approach this age. If people around you also start telling you that you look old, this will reinforce your inner belief that indeed you are getting old. When you start feeling older, any ache or pain or feeling of discomfort in your body will reinforce this unhealthy belief, which in turn will undermine the work of your healing system and accelerate the aging process.

As I discussed earlier, to wrongly believe that as you grow older your health will continue to deteriorate with each passing day is also common in Western cultures. Further, it is generally believed that there are diseases specific to old age, and that, as you become older, you are destined to contract one or more of these illnesses. Attached to these beliefs is the fear that old age is a natural progression of illnesses and maladies in preparation for the final act of human life, which is death, also considered to be the most painful, tortuous, and terrifying experience of all. (As we shall see later, this scenario needn't be the case.)

These beliefs and attitudes create fearful expectations concerning what kind of fate awaits you as you get older. For example, in the West, particularly in America, older people are looked upon as a burden to society, and old age is considered an illness. Elderly people are often sequestered and farmed out to nursing homes to live out their lives. No one wants to spend his or her final days lonely and isolated, surrounded by four walls, cut off from family, friends, and loved ones, and so the aging view old age as a curse and a punishment. These factors conspire to create a tremendous amount of underlying anxiety about growing old that can interfere with the function of the healing system and accelerate an elderly person's demise.

Because of these negative beliefs and fears about old age, people in the West often try to avoid and deny the aging process altogether. To escape the terrible curse of growing older, people will desperately try to turn back the clock and reclaim their youthful appearance with superficial cover-ups. Coloring their hair when it begins to show gray; using drugs; using hairpieces or surgically transplanted hair to compensate for hair loss; undergoing face lifts, chin lifts, and tummy tucks; receiving hormone injections; overdoing vitamins and supple-

ments; and taking prescription medications to revive sexual vigor are just a few examples that, while they initially might appear to be good ideas, often represent attempts to run away from the deeper fears of growing old. Attempting to look younger on the outside while being terrified about growing older on the inside only feeds into the dehumanizing illusion that your body is all you are and all you have. As long as you fear growing old, a fear that causes mental and physical tensions that interfere with the functioning of your healing system, you will not age gracefully or be able to extend your lifespan in a way that improves the overall quality of your life.

To resolve this internal strife, learning how to relax and accept yourself as you are, in spite of your advancing age, will be helpful. Doing this will set in motion the processes of cooperation between your mind, body, and healing system, and will allow you to enjoy natural, long-lasting health for many years to come. To help you relax and accept yourself as you are, begin regularly practicing the relaxation and stress-management techniques that are recommended in this book. These methods work from the inside out and will prove to be invaluable aids to help you not only look younger, but feel younger, as well.

Expectations and Longevity

By studying people who consistently remain healthy while enjoying great longevity, we can learn a lot about how cultural beliefs and attitudes about aging can benefit our healing systems and contribute to long-lasting health. For example, among the Hunza, who dwell in the mountains of Central Asia and consistently live beyond the age of 100 years, there is considerable lack of disease. His peers consider a 70-year-old Hunza man to be a youngster, and they expect him to remain healthy, active, and productive until well beyond this age. Because of the powerful impact the mind has on the body, the cultural mindset and expectations of the Hunza exert a positive influence on their healing systems, contributing to less illness, greater overall health, and increased longevity. If you expect to be working in the fields and riding your horse when you are 100 years old, as the Hunza typically do, you will have a much greater likelihood of remaining disease free and performing these activities at that age. The Hunza are able to age gracefully, stay healthy, and live longer because they have a much healthier outlook on life at all stages, including old age.

Even in the West, now that people are living longer, what once was considered old age clearly no longer applies to today's standards. As I've previously mentioned, centenarians, people who live to 100 years or more, currently make up the fastest growing segment of the U.S. population. Considering this statistic, there is no medical reason why a 70-year-old person cannot fully participate in an active life, including running a farm, driving a tractor, owning a business, working as a doctor or a mailman, playing tennis, snow skiing, water skiing, surfing, or even hang-gliding or bungee-jumping. In fact, because of these increasing longevity statistics (the average American male now lives to 74 years, the American female to 79 years), the U.S. federal government's Social Security program is presently encouraging senior citizens to continue working past the age of 65, until age 70, before they begin collecting retirement benefits. These longevity statistics create changes in expectations about our health and our capacity for aging as a nation. These changes will, in turn, create better cooperation and support of our healing systems, which will contribute to healthier people, fewer diseases, and still-greater longevity across the board.

The Myth of Age-Related Diseases and Your Healing System

When comparing disease trends around the world, one is struck by the remarkable absence in non-Western countries of diseases that are looked upon as naturally endemic to the West, especially those diseases that are associated with genetics and aging, such as heart disease, diabetes, arthritis, emphysema, cancer, and others. If these diseases were truly due to "old age" and genetics, then we should be seeing widespread prevalence of these diseases in the elderly on a global scale; but we are not. These diseases are specific to Western societies and cultures, and they are due to causes that are anything but natural. As we discussed earlier, unhealthy diets, lifestyles, and mental-emotional factors that cause stress and create chemical imbalances in the body's internal environment are the root causes of these diseases.

One of the better-known studies that demonstrates this fact compared rates of diabetes in older Japanese men who lived in Japan

with those who had moved to Hawaii, and with those who had immigrated to the U.S. mainland. The study observed very low rates of diabetes in the older men living in Japan, where diabetes is quite rare. Rates of diabetes were twice as high in the group that had moved to Hawaii. In the third group that had immigrated to the U.S. mainland, where the men had adopted Western diets and lifestyles, the rates of diabetes were so high that they were identical to those of other Americans of the same age group. This study provided strong evidence that diet, lifestyle, and personal health habits, not age or genetics, were responsible for the increasing rates of diabetes observed in these Japanese men. Other studies have shown similar increases of other common diseases in immigrant populations who left their native countries to settle in North America and Europe.

I share this information so that you will not be fooled by the conventional myths about aging and illness that abound in our society. I don't want you to fall prey to the illusion that there are diseases "out there" that are more powerful than you are. Instead, I want you to understand that the underlying causes of most major diseases are simple factors such as diet, lifestyle, personal health habits, and attitudes that neglect, ignore, and work against your healing system. These factors, which are the ultimate forces in determining whether you will remain healthy or become ill, are within your control. When these factors are aligned in support of your healing system, you can feel confident in knowing that, even as you age, you will be able to conquer and defeat almost every illness and disease that life may throw your way.

Contrary to popular belief, the following major categories of illnesses, often associated with advancing age, are not caused by age-related factors at all. (For specific recommendations for learning to work with your healing system to prevent and overcome these illnesses, refer to Part Two and to earlier chapters.)

Alzheimer's disease is prevalent in the elderly and is associated with memory loss and progressive *dementia*, or loss of intellectual function. Alzheimer's is common in senior citizens who have been neglected and have not received ongoing, adequate intellectual stimulation, or, for one reason or another, have withdrawn from social interaction. Alzheimer's appears to be more of a functional neurological problem than related to a specific anatomical defect. For instance, when the

brain becomes overloaded with information, and stress and tension are present, symptoms worsen. Although experts are trying to discover a genetic link or determine another underlying factor to its cause, a recent 13-year study concluded that social factors are the most significant contributing causes to Alzheimer's disease.

In many cases, symptoms of Alzheimer's can improve through adequate social contact, learning how to relax while calming down the nervous system, practicing regular stress management, and paying closer attention to all of the factors that improve the health of the healing system. Proper diet, along with natural remedies, including gingko, which improves blood flow to the brain, may also be helpful.

Arthritis is a general category of common joint diseases. Arthritis encompasses several different illnesses that have as their common denominator progressive stiffness, swelling, and pain in one or more joints. These illnesses, although more common in old age, often show up in joint areas of the body that have been neglected, have not been used because of previous injury or lack of movement, or have been overused. The most common joints affected include the hands and fingers, toes, knees, hips, and spine. But often more than just physical factors contribute to arthritis; these conditions usually become worse during times of stress, emotional upheaval, or dietary imbalances, or from other causes. The good news is new evidence that, like heart disease, many different forms of arthritis are reversible and curable. Of course, this evidence is not surprising when you understand that your body has a healing system.

Cancer is often erroneously attributed to the aging process by health experts who cite diminished immune function in the elderly as a primary contributing factor. Cancer can affect all age groups, and although certain cancers may occur more frequently in the elderly, other more closely associated risk factors, if avoided, can significantly lower cancer risk. In working with your healing system, preventing cancer is easier than treating it. For this reason, it is better to incorporate early preventive measures that include a healthy diet and lifestyle. If cancer occurs, treating it is easier if it is caught early, and many cases have been arrested and cured in the early stages. Even in advanced stages, however, cancer can be successfully defeated if you enlist the help of your healing system and cooperate with it on every level. There are many case reports of people who have

successfully overcome cancer, even in its advanced stages. Doctors Bernie Siegel and O. Carl Simonton are two cancer doctors who have shared many of these inspirational and courageous stories in their books. The more you learn, the clearer it becomes that advancing age does not cause cancer, and not only the young, but people of all ages who have a strong and effective healing system, conquer it.

Depression is more commonly seen in the elderly, but it can strike at any age. In the elderly for whom a lack of meaning or purpose in life has become pronounced, circumstances are ripe for depression to set in. The danger of depression is that in its more advanced stages it can lead to premature death through suicide. Because depression also acts as a stressor, it can cause harmful physiological effects as well, damaging the healing system and shortening your life span. Depression has been linked to such stress-related disorders as heart disease, diabetes, and cancer. Depression is more common in more intelligent people who, with their superior intellectual skills, tend to become prisoners of their own repeated negative thinking. For these people, learning how to relax, calm the mind, and get involved in activities that uplift the spirits is important. Even though depression is traditionally classified as a mental illness, physical factors often can contribute to this problem. In working with the healing system, a combined mind-body approach is usually the best strategy for reversing and overcoming depression, regardless of your age.

In most cases, you can avoid or reverse depression by staying involved and connected to family, friends, and loved ones; volunteering in meaningful activities; being around children, animals, and nature; developing a sense of gratitude; remembering to have fun and not take life too seriously; and focusing more on the spiritual aspects of life. Whether you are 22 or 82, the same strategies apply, and you will gain the same benefits.

Exercise and simply moving the body can be effective in lifting mild and moderate depression. A wholesome diet, combined with St. John's wort, a natural herbal medication commonly prescribed in Germany, may also be helpful. Learning to let go of unwanted mental and emotional baggage can lighten loads and lift spirits considerably. Practicing self-forgiveness and learning to release anger and hostility are also often helpful. A great book that deals with this subject is Dan

Millman's *The Way of the Peaceful Warrior*, based on the true story of an athlete who overcame depression and went on to win a gold medal in the Olympics. Remember that depression, like the vast majority of diseases, is not an age-related illness.

Diabetes is another disease commonly associated with the aging process, but recent research has shown that the causes of this disease have nothing to do with age. The most common type of diabetes has been linked to a lack of exercise, poor diet, stress, and emotional upheaval. Recent research has suggested that stress is a major contributor to diabetes. The medical community has known for quite some time that stress causes blood-sugar fluctuations that can be harmful. By working with your healing system in learning to manage stress, in addition to incorporating healthy eating and exercise, you can not only prevent but reverse this illness.

Heart disease was once thought to be a natural condition that accompanied the aging process. While it is true that heart disease is more common in the elderly, we have learned through the pioneering research of such noteworthy scientists as Dr. Dean Ornish that other factors in the genesis of heart disease are far more important than age. Factors such as poor diet, stress, lack of exercise, lack of love and intimacy, and repression of emotions have been shown to play a much greater role in the origin of this disorder. As noted earlier, in Dr. Ornish's studies, the oldest patients with the most severe heart disease generally showed the greatest reversal of disease and improvement in their heart health. Learning to work with your healing system, as Dr. Ornish's methods have proven, can both prevent and reverse heart disease, no matter how old you are.

High blood pressure, or *hypertension*, is a disease commonly associated with the elderly and is erroneously attributed to the aging process. Even though high blood pressure is markedly absent in younger people, the cumulative effects of stress and poor diets, along with a lack of exercise and the unhealthy suppression of such emotions as anger and resentment, cause the gradual narrowing and thickening of the arteries, which leads to this disease. Methods for reversing this condition center on diet and lifestyle factors, including learning how to relax, and releasing hostility and tension. More than 30 years ago, Dr. Herbert Benson, Director of the Hypertension Section at Beth Israel Hospital in Boston, in conjunction with

Harvard Medical School, proved that relaxation and meditation could substantially lower and reverse high blood pressure. Supporting your healing system by practicing stress management and incorporating other healthy dietary and lifestyle measures can help prevent and reverse this condition.

Parkinson's disease is another neurological condition associated with the elderly and believed to be caused by a specific biochemical deficiency in the brain. However, Parkinson's symptoms may occur in younger people, such as Michael J. Fox, whose challenges with this disease are well known. Many young Parkinson patients have suffered from trauma to the brain, are under stress, or have abused drugs. Parkinson's also flares up during periods of stress and emotional upheaval. If caught early, Parkinson's may be prevented and managed by proper diet, natural modalities that help improve blood flow to the brain, stress management, and other mind-body methods aimed at restoring balance to the nervous system and strengthening the healing system. Again, this disease is not reserved for the elderly, but can occur in anyone at any age, and it can be treated with the same methods.

Stroke can be a crippling and disabling condition that commonly affects the elderly. However, to associate stroke with the aging process alone is to overlook the key risk factors and underlying conditions that cause stroke, which in most cases are related to stress, diet, and lifestyle. In fact, stroke is an uncommon condition in most developing countries. Although several different mechanisms can result in stroke, the most common is an underlying condition of persistent, uncontrolled high blood pressure, not old age. Stroke is also commonly caused by constant irregular heartbeats, known as *arrhythmias*, which create blood-flow disturbances that can cause small blood clots to pass to the brain. Stroke, regardless of its underlying causes, is entirely preventable. Working with the healing system, a person with normal blood pressure who watches his or her weight, exercises regularly, drinks fluids, manages stress, and participates in the healthy release and expression of emotions will most certainly be successful in avoiding this condition. And even with strokes that already have occurred, successful rehabilitation is often possible thanks to the healing system, which is able to work with the nervous system to help transfer information from the damaged side of the brain to the other side, bringing life back to previously paralyzed limbs.

Remaining Flexible As You Age

Stretching to Support Your Healing System

The axiom "Move it or lose it" seems to be a fundamental principle in the universe, and it certainly applies to the health of our bodies. People tend to slow down and become more sedentary as they age, and so they tend to move less. This lack of movement can lead to stiffness, much like what happens when rust sets into an unused, neglected machine. The stiffness can lead to pain, which in turn discourages further movement. A vicious cycle perpetuates itself, leading to immobility and disability, not just of the joints and limbs, but also of the internal organs. When you stop moving, your healing system weakens, and life expectancy diminishes. To avoid these consequences, gently but persistently stretching the various muscles in your body is important.

Stretching keeps your joints mobile and ensures that your body will remain flexible as you age. For this reason, stretching is one of the most important things you can do to support your healing system and promote long-lasting health. Like a coconut tree in a hurricane, if your body is flexible, it can better endure adverse forces of stress and trauma as you age. If you were a dog or a cat, you would instinctively stretch every time you got up from sleep. All mammals and vertebrates instinctively stretch. Nothing else is as natural and beneficial for your healing system and body as stretching.

Chronic Disease

A Blessing in Disguise

One day while he was being interviewed, Sir William Osler, one of the most famous physicians of the twentieth century, was asked the secret to longevity. He gave an answer that surprised everyone: "Get a chronic disease, and learn to take good care of it!"

How could the secret of long-lasting health and longevity ever be found in having a chronic disease? To have a chronic disease and at the same time be able to extend your life span sounds like a total contradiction. What was on Sir William Osler's mind when he came up with this enigmatic statement?

In his greater wisdom and glory, Dr. Osler went on to clarify what he meant. He explained that having a chronic disease is really a blessing in disguise because it forces you to pay closer attention to your body than you would normally do. In so doing, you benefit all parts of your body, and so your overall health actually can be improved. He further went on to explain that when you have a chronic disease, your body becomes more sensitive, vulnerable, and demanding, and this makes you a better "listener." You become more aware of your body, and you can more effectively identify what causes flare-ups of your disease, whether toxins in the environment, unhealthy foods, irritating substances, stress or emotional upheaval, or other offensive factors. In the process, you have the opportunity to learn how to avoid these factors and lessen the intensity or frequency of the flare-ups. You also have the opportunity to discover how imbalances were created in your body to cause the disease in the first place. These imbalances may have been caused by unconscious, self-destructive habits and tendencies, as well as by unhealthy thoughts and attitudes. With chronic disease, you have the opportunity to learn how to undo the damage, reverse the disease process, and cooperate with your healing system to restore your body to its natural state of health. Doing this requires that you learn to nurture, and be kind and gentle to, your body, exploring ways to fulfill its needs and treat it better.

Having a chronic disease can teach you how to become your own best caregiver, your own full-time doctor, so to speak. And as you learn to cooperate with your healing system in your mission of returning to a natural state of health and wellness, your healing system can help you remain healthy, functional, and symptom free for the rest of your life. This is the hidden meaning behind Sir William Osler's statement that the key to longevity is to get a chronic disease and learn to take good care of it.

In contrast to this approach, as soon as they are diagnosed with a chronic disease, many people give in to fear, negative thinking, and despair. This response only reinforces the disease process and is a sure recipe for an early demise. Even well-meaning doctors often unknowingly support this pessimistic attitude. The following story illustrates the point.

A man I knew was suspected of having prostate cancer. His doctor ordered tests to confirm that he had cancer, and the tests

came back positive. On his first doctor's visit after the diagnosis was established, this man asked his doctor whether he should quit smoking. To his astonishment, his doctor replied, "At this point, what's the use?" With his doctor's negative attitude, he left the office and immediately plunged into a deep depression. Even though the doctor didn't say it in exactly these words, what he heard was "It is too late to do anything at this stage. Face the facts. You are going to die." Six weeks later, the man died.

It is important not to deny the reality of an illness; at the same time, it is more important not to become passive or depressed, or to give in to the popular pessimistic notions about what will happen to you as you become more ill. As the late Norman Cousins used to say, "Don't deny the diagnosis, but defy the verdict!" Because of the connection between your mind and your healing system, remaining optimistic, even when the odds appear to be stacked against you, is crucial.

According to Dr. Osler's wisdom and experience, even if you have been diagnosed with diabetes, or heart disease, or any other chronic condition, it is possible for you to live to be 120 years old. If you watch your diet, regularly exercise, practice stress management, and use other methods and strategies that cooperate with your healing system, you can learn to positively influence your body's internal environment and improve your overall health. If you are currently taking medications, you may gradually be able to reduce your dependence on them and quite possibly get off them altogether. In my own practice, I have seen this happen quite frequently.

If you are sufficiently motivated, and you don't give in to pessimism and despair, a chronic disease can direct and guide you toward a much healthier lifestyle that supports your healing system and improves your overall health. In so doing, the disease can enable you to enjoy long-lasting health. Seen from this perspective, a chronic disease can actually be a blessing in disguise.

I'd like to make an additional point in support of Dr. Osler's wisdom. There is a saying, "You don't miss your water until your well runs dry." In my own experience, I have seen that many people do not honor or value their health unless they are at immediate risk of losing it. In this regard, contracting a chronic, life-threatening disease can serve as a much-needed wake-up call. When you realize your life is on

the line and you are not here forever, it's amazing how quickly you can become motivated to improve the quality of your health and life. With this clarity and sense of urgency, it is often easier to make sweeping, constructive changes in your diet, lifestyle, and personal habits that strengthen and enhance the work of your healing system. When you live your life fully, with the awareness that being alive is truly a blessing, privilege, and unique opportunity, you begin to realize the critical importance of your health and your responsibility to take care of yourself. When you participate in healthful, wholesome activities that support your healing system, your overall health improves, and the prospects for greater longevity increase significantly.

As you learn to take better care of yourself, your illness can serve as your ticket to a longer and happier, more productive life. In fact, many people who have overcome chronic, life-threatening illnesses have looked back and declared that their illnesses were gifts, without which their lives would have never been transformed for the better.

And who is to say that once you have a chronic disease you are stuck with it? Since Dr. Osler's time, in addition to Dr. Dean Ornish's studies that proved heart disease can be reversed, many other studies are now showing similar possibilities for diabetes, arthritis, asthma, multiple sclerosis, cancer, and many other diseases. The same mechanisms that cause disease processes to occur in the first place can be reversed and eliminate the disease from your body. If you are currently plagued by a health problem, the sooner you adopt an active role in supporting and cooperating with your healing system, the faster you can heal and be back on the road to long-lasting health.

Memory Loss and Your Healing System As You Age

A simple fact of living is that, as people age, their brains accumulate more information than they need. Most people who age and have trouble with their memories suffer from a simple case of information overload, otherwise known as "brain clutter." There are just too many useless facts, memories, incidents, or other trivial pieces of information in their heads, stored up over a lifetime, and all these details slow

down the quality of their brain's ability to process information and function efficiently. Although occasionally real organic or physical causes exist for memory loss or brain dysfunction, such as impaired blood flow to the brain or chemical imbalances in the blood, in my experience, the overwhelming majority of memory-loss and brain-dysfunction experiences are not the result of organic causes.

The dangers of memory loss and brain dysfunction are that they can cause disorientation and confusion, which lead to stress and anxiety, which can burden the healing system through the mind-body interactions that we have discussed earlier in this book. If a chronic physical disease is also already present, it can further jeopardize your health by interfering with the work of your healing system.

Many people who develop memory problems as they age contribute to their own difficulties by hanging on to memories and pieces of outdated information that no longer serve their best interests. For one reason or another, they are afraid to move forward with their lives, remaining stuck in the past and living their lives as if the best times were behind them. People who do this are closing the door to future experiences that may be wonderfully uplifting and enlightening. As their memory continues to fail them, they become more and more frightened, stressed, and anxious, and their brain function deteriorates further. This combination can become terribly unsettling and disorienting to their mental health and well-being.

Tips for Improving Memory and Brain Function

Taking an active role in preserving, maintaining, and restoring your very important mental health and well-being is essential. In fact, your survival depends on it. You can take definite actions to cooperate with your healing system in improving your memory and brain function as you age. The following key steps, while not all-inclusive, can serve as a starting point in this process:

- Make sure you have investigated the possibility of underlying organic causes, including chemical imbalances in the blood or your body's internal environment that may be interfering with your brain function. Doing this may necessitate a visit to your family doctor for a checkup.

- Clear your mind of unnecessary pieces of information, includ-

ing phone numbers, facts, figures, memories, or experiences that do not serve your best interests.

■ If you cannot recall a piece of information that you feel is important, don't struggle, strain, or fight. Relax, breathe, calm your mind, and let go. If the information is really important, it will eventually come back to you. Your memory functions best when your mind is calm and relaxed, not when you are upset, tense, or anxious.

■ Make sure your diet is healthy and wholesome, and that you are drinking enough fluids. Avoid excess caffeine, alcohol, and other unhealthy substances that negatively affect your brain.

■ Avoid excess medications or medications that may interfere with your memory.

■ Make sure you are getting enough exercise. Exercise has been shown to improve blood flow to the brain, which improves brain function and memory.

■ Practice stress-management techniques to keep your brain and nervous system calm and relaxed. A naturally calm and relaxed mind is more alert and can concentrate better.

■ Avoid emotional upheaval, including anger and resentment, which compromises clarity and clouds thinking.

■ Experiment with natural supplements such as *gingko biloba* and *gotu cola,* which have been shown to improve blood flow to the brain; these herbs can improve memory and brain function. Make sure they will not conflict with other medications you already may be taking.

■ Consider trying other natural methods, including cranial-sacral therapy, acupuncture, yoga, tai chi, and other gentle, non-invasive, complementary therapies.

Advantages of Aging and Long-Lasting Health

As you advance in years, and whenever you begin to doubt your intrinsic worth, go to your local liquor store and ask to see its selection

and price list of fine wines. You will notice that the older wines are the most expensive. Like a bottle of fine vintage wine, your net worth and value also increase as you age. Aging includes a number of advantages; proudly and nobly embrace them. Old age is a time to look forward to, and long-lasting health will ensure that you can enjoy it more fully.

For example, in the aboriginal culture of Australia, more than 40,000 years old, the elder members are regarded as the wisest and most powerful of all souls, and their people afford them the greatest respect. The culture relies upon their wisdom and experience to guide the aborigines through difficult times, to preside over disputes and to help settle differences, and to be available for consultation in all important matters, including those of a domestic, political, or spiritual nature.

In the Buddhist tradition, elder Buddhists are looked upon as the highest-ranking members of the society. In many other cultures throughout the world, the elder system is still intact. People are honored and valued for their advancing years, not banished, punished, and shamed, as they often are in the West.

As surprising as it may sound, getting older also confers many health advantages. For example, when you are older, you have more experience, more knowledge, and more wisdom about your health. You are more familiar with your body's strengths, weaknesses, and limitations, and you have probably discovered the virtues of moderation. Additionally, over the years that you have aged, you have learned how to feed and nourish your body; how to exercise it; how much water, sleep, and rest it requires; how it tolerates temperature changes; and what kind of clothes it requires to keep warm for each season. In the words of Plato, "It gives me great pleasure to converse with the aged. They have been over the road that all of us must travel and know where it is rough and difficult and where it is level and easy."

As you age, you possess a greater ability to avoid illness and injury. You learn to be more careful and safe in all activities, from walking and climbing stairs to driving. You become better at physical and mental energy conservation for your health and well-being. For example, when you were young, you may have thought that you were invincible, as if you were a superman or superwoman. As a consequence, you may have made some costly mistakes. When you are older, you tend not to be so foolish, to be more thoughtful and deliberate. When you are older, you are ruled not so much by your

hormones or passions as by your common sense, tempered discipline, and your ability to listen to your body and act benevolently on its behalf. When you are older, you tend not to become so swept away or preoccupied with the affairs of the world, but, rather, to become more self-entertaining and self-contained. This process directs your mental energies inward, increasing your bodily awareness, and improving your ability to listen to and cooperate with your healing system.

As you age, you also tend to become more patient and tolerant of pain and physical discomfort, which increases your endurance. This is apparent in the Olympic games in which, in the endurance events such as the marathon race, the top athletes may be as much as 20 years older than athletes who compete in other events such as the sprints. In fact, many octogenarian marathon runners are active in the world today, and many senior athletes are still competing on the master's level in other sports such as golf, tennis, swimming, surfing, water skiing, and snow skiing. These elder athletes demonstrate that, regardless of their ages, they can keep their healing systems vibrant and youthful, stay competitive, and enjoy long-lasting health by remaining active.

With all of these advantages to aging, we should look upon old age as a time of maximum health and enjoyment. By understanding all of the factors that positively influence the performance of our healing systems, and then putting these factors into practice, we can successfully enjoy a superior state of health and a vibrant, active life for the rest of our days.

The Power of Laughter and a Sense of Humor

In previous chapters, we have talked about all of the factors that can improve the performance of your healing system. One of the most important of these factors, if not the most important, appears to be a sense of humor. I say this with good reason.

I have met many people who have lived well into old age and beyond, sometimes reaching 100 years or more, who defied the principles of what most experts would consider a healthy life. Many of these people had poor diets, drank alcohol or smoked excessively, did not exercise regularly, were overweight, and, strictly from a health standpoint, did just about everything else wrong. However,

the persons among this group were rare who didn't also possess a keen sense of humor, an extraordinary ability to allow most difficulties, negative comments, and adverse situations to roll right off their backs. Most of these people understood that, to get the most out of life, they had to have fun.

Many good people miss the boat in this regard. They take their health and their life too seriously. One famous health expert even went so far as to say, "Seriousness is a disease more dangerous than cancer!" Being serious all the time creates tension in the body, which can drain the life force out of your healing system. We've all heard the saying, "All work and no play makes Jack a dull boy." What we haven't heard, and what is also true, is that "All work and no play can make Jack a sick puppy." Many research studies suggest that people who cannot take the time to relax, have fun, and laugh are at serious risk for developing a major illness. Dr. Bernie Siegel, a famous cancer surgeon, tells a story that helps illustrate this point.

A man ran six miles every day for 25 years. He never went to parties, never went to bed after 10:00 PM, never drank or smoked, and was a vegetarian. One day, he suddenly died. He was so upset by this sudden turn of events that when he got to the Pearly Gates he went straight up to God and demanded an immediate explanation for this apparent injustice.

"What the hell are you doing, God?" the man asked. "I've run every day for the past 25 years, never touched alcohol or tobacco, gone to bed early, and eaten only vegetables. I've worked hard my whole life just to remain healthy and live long, and you had to spoil everything by bringing me here. What's your point in doing this?" the man asked.

"My point is that you basically blew it!" God said. "You forgot to have fun and enjoy your life, which were the reasons why you were created!" He exclaimed. "And since you failed to learn your lessons this time, I'm sending you back to Hell for an attitude adjustment!" cried God.

"What will I do there?" queried the man.

"For starters, you'll have to run six miles every day, go to bed before 10:00 PM each night, and eat only vegetables," God declared. He continued, "Next time, try to enjoy your life, and come back when your attitude is a little better!"

Dr. Siegel goes on to make the point that it is important to do things not out of the fear of dying, but rather out of the desire to improve the overall quality of your life. Certainly there was nothing wrong with what the man was doing to improve his health, but his attitude and reason for doing these things were wrong. Again, the goal of long-lasting health is not just to live longer, but to improve the overall quality of your life in the process. If you are not having fun and enjoying your life, you are missing the boat. Just remember the French woman introduced earlier in the book, who lived to the age of 122 and who, when interviewed about the secrets of her longevity, replied that the only thing she knew was that "I only have one wrinkle on my entire body, and I'm sitting on it!"

Almost nothing in the world can keep your healing system as strong, vibrant, and healthy as cultivating and refining the ability to laugh . . . to laugh often, vigorously, and—what is even more powerful—to frequently share raucous belly laughter with your friends or family. Bob Hope passed away at the age of 100 years. I believe he was trying to beat George Burns' age when he died. It is not an accident that these two famous comedians, who earned their living with a sense of humor and making other people laugh, lived so long.

When you are laughing, having fun, and enjoying life, you are releasing tension and creating positive physiology within your body that strengthens and fortifies your healing system. Laughter kills pain by triggering the release of powerful neurochemicals from the brain, such as endorphins and enkephalins, which, as we noted earlier, are naturally occurring opiates much stronger than morphine. Laughter simultaneously stimulates the release of other powerful substances that boost the performance of your healing system. Some scientists have defined laughter as tantamount to "internal jogging," in that all the health benefits of jogging, such as improving the strength of your heart and circulatory system, can also be found in laughter.

Doing What You Love
Contributes to a Long and Healthy Life

Upon his retirement at the age of 89 years, an innovative artist and animator for Walt Disney Studios was recently recognized for his

outstanding contribution to the field for more than 65 years. When asked how he managed to keep going all those years, and what motivated him, he replied, "You gotta love your work!"

When you love what you do, every day is a day of play and enjoyment. When you work at a job that you love, it doesn't feel like work. Loving your work is the healthiest tonic in the world for your body's healing system as it is injected with a continuous supply of dynamic, positive, mental and emotional energy every single day of your life. By the time you reach old age, this positive energy pays off in dividends. The following stories help illustrate this point.

Pop Proctor was a well-known surfer from California who fell in love with the sport when he picked it up at the rather late age of 50. He surfed for more than 40 years and retired from surfing at the age of 97. He died at the age of 99, and it was rumored that he died so young because he retired from surfing too soon.

Albert Schweitzer once told his hospital staff that "I have no intention of dying, so long as I can do things. And if I do things, I have no need to die, so I will live a long, long time." Dr. Schweitzer, who received the Nobel Prize in 1952, remained active until his final days; he lived until the age of 90.

Mrs. Minami was a Japanese-Hawaiian woman who was 101 years of age when I met her. She drank a cup of hot water after each meal and enjoyed perfect regularity. She worked in her garden, which she absolutely adored, every day, rain or shine. When she left me for another doctor because her insurance had changed, she was 103 and still going strong.

Harry Lieberman was an elderly, 78-year-old man who had been alone in a nursing home since the age of 75, silently awaiting his death. To help pass the time, every day at noon he would meet his partner for a game of chess. One day, unbeknownst to him, his partner died. When Harry showed up at the usual time the next day for his chess match, his partner didn't show. The staff, who was informed of his partner's passing and concerned about the effects on Harry, didn't want to break the news to him so suddenly. They told Harry his partner had become ill and had to go to the hospital. They asked Harry if he would like to attend an art class instead, just for the day.

Harry was shuttled off to the nursing home's art class, where he was seated at a table and handed a blank piece of paper, some col-

ored paints, and a brush. He had never held a brush before in his life, and he felt totally awkward. The teacher announced that the class assignment was to paint anything the participants wanted.

While he was holding onto the brush, Harry's mind drifted back to the days when he was a boy growing up in a village in his country of birth, Poland. Slowly, he began to paint what his mind saw. At the end of class, the teacher looked at this painting, thanked him for his attendance, and encouraged him to return the following day.

The following day, however, Harry didn't want to paint another picture. Instead, he looked forward to resuming his chess game with his partner. At the appointed hour, however, when Harry sat down at the chess board and waited for his friend, one of the young volunteers came and informed Harry that his friend was still in the hospital. She encouraged him to please attend the art class one more time. Harry reluctantly agreed.

Now, for the second time in as many days, Harry found himself sitting down with a brush, a blank piece of paper, and some paints. Today's assignment: "Paint anything you want." Again, Harry drifted off to his childhood days and slowly began painting.

At the close of the class, the teacher again came by Harry's table, saw his painting, and made an encouraging comment. He told Harry he wanted him to attend the evening art class at the local junior college. The teacher told Harry that at the very least this would be a chance to get out and meet some new people, especially young, attractive college girls. Hesitant at first, Harry finally agreed.

In the evening of the next day, a van picked Harry up and took him several miles away to the art class at the junior college, where he was ushered inside with more than 40 students, most of them young enough to be his grandchildren. This setting was much different from the dull, sedate, and somber atmosphere of his nursing home.

For the third time in as many days, Harry found himself seated at a desk with a brush, a blank piece of paper, and paints. The assignment: "Paint anything you want." Once again, Harry's mind drifted off to his past as he dipped his brush into the paints and began applying strokes to the paper.

At the close of the class, the teacher walked around the room to critique each student's work. When he came to Harry's painting, he paused for a moment. Then he made a surprising comment.

"Would you be so kind as to autograph this painting for me?" he asked Harry.

Harry was dumbfounded. "Why?" he asked.

The teacher replied, "Because I have a feeling that someday you're going to be a famous artist."

Harry thought to himself, "Right, but first I'll be the next president of America!"

For the next 25 years, Harry Lieberman painted every day and eventually established himself as one of the preeminent artists in the world, painting village scenes from his childhood life in Poland, along with stories from the Old Testament. To this day, his works are displayed prominently in books, museums, and galleries all over the world. Doing what he loved to do, Harry Lieberman lived past the age of 103.

Do what you love, and love what you do. This is the essence of allowing the creative spirit within you to flourish and express itself, producing long-lasting health and a sense of well-being as byproducts. If you suppress or deny this spirit, it will wither up and die, and your health will surely follow. Suppressing or denying your inherent creative instincts, not doing what you love, or not loving what you do, will drain your life force and render your healing system powerless. When this happens, you will become sick.

Many people are allowed to pursue their dreams and are encouraged to follow their hearts from an early age. These are the lucky ones. Others, like Harry Lieberman, discover their true joy and passion when they are at an advanced age. However, regardless of your age, the health-enhancing benefits of putting your heart into what you are doing are undeniable. Organizing your life around doing what you love is one of the wisest and most effective ways to strengthen and fortify your healing system, allowing you the opportunity to enjoy long-lasting health.

Celebrate Your Years and Enhance Your Healing System

Old age is a time for celebration and enjoying the fruits of your labors. It is the time of your "second childhood," a chance to regain your innocence, to see beauty in simple, everyday things, and a time to play and enjoy

yourself. Old age is a time to love, be loved, and to know that love is the fundamental underlying reality in all of life. With all of this to look forward to, it is critical that you keep your health as you age so you can maximize the enjoyment of your golden years. Strengthening and fortifying your healing system as you age is the best insurance policy I know to help you realize this goal.

Many people live healthy, pain-free, disease-free, active lives for a long, long time, and then they leave this world peacefully and gently without any pain or suffering. These people have found ways to cooperate with their body's healing systems, and they have learned to strengthen and fortify them as they have advanced in years. While I'm not denying that someday we all must depart this earth, there is no reason to buy into the false notion that you have to become sick and disabled before it is your time to leave. When you work with your healing system, you can enjoy long-lasting health, and stay healthy, until your final days.

From my own research and experience, I have found the following practical tips to be particularly helpful to strengthen and fortify the healing system as you age:

- Practice the principles, exercises, and techniques described in this book.
- Drink plenty of fluids.
- Eat plenty of fruits and vegetables.
- Get adequate fiber in your diet.
- Practice good bowel hygiene.
- Practice stress management.
- Relax regularly.
- Do breathing exercises.
- Think young. Remember that you are only as old as you think you are.
- Take the time to plan for a bright future.
- Learn to be spontaneous.
- Develop a flexible mindset. Avoid being too set in your ways.
- Do what you love to do.
- Stay active.

- Maintain a viable social support system.
- Stay involved with hobbies and creative activities.
- Be a nonconformist.
- Be adventuresome and try new things.
- Spend time in nature.
- If you get bored, learn to play a musical instrument or paint.
- Sing.
- Dance regularly and often, even if you are alone.
- Avoid getting angry.
- Cultivate and nourish loving relationships with your family and friends.
- Don't foster resentment.
- If you are single, date, or be active in social clubs.
- Spend time outdoors.
- Surround yourself with beauty.
- Have fun, and remember to smile and laugh genuinely from your heart.
- Enjoy comedy and keep a light-hearted attitude.
- Don't take life too seriously.
- Don't take yourself too seriously.
- Spend time with people who are busy and involved in doing something meaningful with their lives.
- Choose your friends and company wisely.
- Don't waste your time.
- Don't do things you don't want to do.
- Be true to your sense of purpose.
- Take the time to reflect on the meaning of life.
- Appreciate the fact that your life is a gift, no matter how difficult it has been.
- Acknowledge all the things in life for which you have to be grateful.
- Honor the dignity of your soul.
- Find a way to give back to the world.

- Perform some form of regular community service that makes you feel good inside.

- Spend time with children; let them teach you how to play and be in the present moment.

- Spend time with animals. If possible, have one or more pets.

- Vow to do at least one thing differently each day.

- Get up early every morning, and go to bed early every night.

- Listen to music that inspires and uplifts you.

- Travel if you can afford it and, if not, try to walk or go in a new direction every day.

- Write in a journal your most memorable experiences.

- Write poetry, even if you've never done it before.

- Wake up each morning and tell the world that it is a better place because you are here.

- Don't waste time being around people who don't inspire you or uplift your spirits.

- Read books and watch movies that inspire and uplift you.

- Read about people older than you who are more active than you.

- Keep connected to your family, friends, and loved ones.

- Remember that if you want to have a true friend, you have to be a true friend.

- Listen to music that stirs your heart and soothes your soul.

- Find a way to share your unique talents, gifts, and experiences with the world.

- Focus on how you can do your part to make this world a little better.

- Appreciate how age has mellowed you and made you a better person.

- Love yourself and your life, even if they aren't perfect.

- If you have faith in God or a higher power, pray for guidance and peace.

- Make peace with your soul. Forgive yourself for all you may have done wrong.

- Cry when you want to, and don't feel ashamed when you do.

> ■ Live from your heart.
>
> Remember that your body possesses an efficient and intelligent healing system that can keep you healthy through a multitude of life's challenges. Celebrate and honor your years on this earth, and enjoy your life!

Living Life to the Fullest Until Your Final Days

I hope I haven't given you the impression that you will live forever. Although I do expect you to live long, stay healthy, and enjoy your life, it would be irresponsible of me to try to deceive you into believing that you can remain on this planet indefinitely. Land is a limited commodity, and unfortunately, when it is our time to go, we have to leave to make room for the next person. Even if you reach the age of 100, 120, or beyond, some day you will experience the process of leaving your body as you depart this world. In many cultures around the world, this process, known as death, is regarded as a natural and sacred event, no less important than birth. In these cultures, death is seen as a release and a blessing, the final chapter of a person's earthbound life in a story that would otherwise be incomplete. Further, in these cultures, death is seen to be not merely an end, but, rather, a new beginning. As a result, the anniversary of the day a person dies is usually remembered and celebrated even more than the person's birthday.

The benefit of accepting that you will not live on this earth forever is that you no longer have to live with the tension the fear of death creates. The acceptance creates a natural state of relaxation. As you know, your healing system works best when you are in a naturally relaxed state, and so overcoming your fear of death greatly improves your vitality and contributes to long-lasting health.

Death is certainly not an experience we should welcome, initiate prematurely, or glorify before its time; nonetheless, it need not be the difficult, painful, miserable experience it is commonly held to be in our society. Death can be a loving, special occasion, a profoundly healing experience for all those who've come to witness the sacred departure of a uniquely created soul. A good death can act as a powerful affirmation and a special blessing to those left behind.

Such deaths, rather than producing tension and prolonging the myth that death is a painful, horrible ordeal, contribute to overall healing by reinforcing the peacefulness, beauty, and serenity of this natural life experience. Such an attitude collectively strengthens and fortifies the healing systems of the individuals within the culture and society, and contributes to long-lasting health in those individuals.

A good death, which can be likened to childbirth, requires preparation. For example, it is well known that mothers who have not attended prenatal classes are usually poorly prepared for labor, and they often suffer far more complications, pain, and trauma than those who are well prepared. The same is true in death. In an ill-prepared-for death, far more complications, pain, and trauma often occur than is necessary. Such an experience reinforces the notion that death is a horrible event and creates fear in those who witness such a death. A vicious cycle perpetuates itself, influencing society's generally fearful perception of death, and creating unnecessary worry and negative outcomes in the process. Ironically, the best way to prepare for a good death is to have a good life.

It is possible to enjoy your final days on this earth and have a positive experience of death. How successful you are at doing this is strongly influenced by your ability to work with your healing system and remain healthy throughout your life, which is largely determined by the choices you make every day. Realize that your time on earth is limited, and then live your life as if it were a privilege, as if each moment counts. Focus on doing what you love to do. For example, a cowboy's dream is to die with his boots on and be buried with his horse. The probability of realizing this dream is increased with each day that he is can saddle up and ride off across the plains with his trusty steed. The same is true for you and any number of activities, hobbies, and vocations that you love to do and that are near and dear to your heart. The more you can organize your life around doing what you love to do, the better the chance that you'll depart this world in an uplifted state, without any sorrows or regrets.

In India, where I have traveled frequently, I have met many people in their eighties, nineties, and older who are active, healthy, respected members of their communities, and who enjoy their lives, totally free from the fear of death and unconcerned about their advancing age. Further, the Sanskrit literature, which dates back

several thousand years, is full of historical accounts of accomplished souls who could accurately predict the time of their death and leave their bodies willfully, peacefully, and with courage.

Similarly, in Japan, Samurai warriors have traditionally greeted each new day with the thought, "Today is a good day to die!" Although this statement might initially appear to be fatalistic, the philosophy actually enriches the warriors' lives and improves their health. By facing their mortality this way, acknowledging that today could be their last day on this earth, they can live without fear and remain more relaxed. This relaxed attitude nourishes and supports their healing systems and helps them achieve long-lasting health. Because the Samurai creed permeates almost every aspect of Japanese society, it is not surprising to see that, on average, people in Japan live much longer than people in the West.

Understanding that you have tremendous control over your life circumstances and your health is the best way to prepare for a good death. It is also the best way to enjoy your life. Like the cowboy, yogi, or Samurai warrior, you can enjoy long-lasting health, and then, when it is your time, exit this world with peace and serenity, courage and conviction, grace and style. When you learn to work with your healing system, you can enjoy long-lasting health, and, when the time comes, experience a peaceful and pain-free death.

Closing Thoughts on Aging, Long-Lasting Health, and Your Healing System

The boundaries for what is considered to be old age are continually being expanded. A 70-year-old man, by today's standards, is now viewed as still young. You can prolong and maintain youthful vigor and health well into your eighties, nineties, and beyond if you work at supporting and nourishing your healing system. Your attitude about aging plays an important role in your longevity and influences physiological mechanisms that can either accelerate or slow down the aging process. If you develop poor health habits based on pessimistic, negative attitudes, you stand a greater chance of becoming ill and dying earlier. But if you are inspired to make the most of your life and your extraordinary healing system, and you are motivated to

stay healthy, you can enjoy a long and fulfilling life. Maintain a positive mental attitude and develop sound personal health habits, and you will exude a spirit of youthfulness and improve your prospects of remaining healthy until your final days. Accept your mortality and understand that you are on the earth for a limited time, and you'll more easily overcome a fear of death. Cultivate a relaxed attitude. Your healing system will benefit significantly, and your attitude will facilitate your goal of achieving long-lasting health.

The Healing System at Work
Personal Stories of Extraordinary Healing

D octors deal with pain, suffering, and illness every day of their lives. Because of this, they tend to view life through a distorted lens that sees disease as normal and health as abnormal. Serving as society's appointed health experts, they are in reality disease experts. In this capacity, doctors exert a profound influence on our way of thinking, and so we have learned to be pessimistic, negative, and fearful when it comes to our bodies.

Going beyond this distorted lens and probing deeper into the miraculous workings of our bodies, however, we will discover a healing system that can overcome nearly every affliction known to man. We will discover that health and well-being are the rule, and illness and disease are exceptions to the rule.

Many people with advanced, serious medical conditions get better when they learn how to cooperate with their healing systems. And although these cases may seem extraordinary, in fact, they are quite ordinary. When you understand that you have a healing system, you should expect healing, regardless of how overwhelmingly the odds may be stacked against you. When you or a loved one is afflicted with an illness or injury, the real question is not "Will healing occur?" but rather "When will healing occur?" The answer is "When you decide to cooperate and work with your healing

system, you will get better and heal; the sooner you do this, the faster you will heal!"

I offer the following stories to help you get to know your healing system better. Because your healing system is within you, it can be activated free of charge. It is ready to work for you "24/7," and it is your most powerful ally on life's journey. All your healing system asks is that you acknowledge its existence, listen to it, and make a concerted effort to cooperate and work with, not against, it.

Ronald's Story of Extraordinary Healing

Ronald Jenkins was 19 years of age and away at college. He was a strapping picture of health, on a full athletic and academic scholarship, and he had never missed a day of school due to illness since he was in kindergarten. Except for routine physical exams and immunizations, Ronald had never seen a doctor or been hospitalized. He was in the prime of his life, and it was all good. Soon, however, his life would change.

While he was a counselor at a youth camp during summer break, Ronald awoke one night with intense abdominal pain. He ran to the bathroom to relieve himself. Projectile diarrhea ensued, not just once, but so many times that Ronald had to spend half the night on the toilet. He began to feel feverish. He thought he might have contracted a case of food poisoning. He drank liquids and rested, thinking he would get better on his own. After one week, however, his symptoms continued without any letup in intensity. For the first time in his life, Ronald sought the help of a doctor.

The doctor diagnosed Ronald with gastroenteritis and treated him with rest, fluids, antibiotics, and anti-inflammatory medicines. After two weeks, however, there was still no improvement, so his doctor referred him to a specialist. The specialist ordered blood tests, X-rays, intestinal scans, and a *colonoscopy*, an exam in which a flexible tube is inserted up the entire length of the large intestines. After much deliberation and discussion, the doctors made the diagnosis of Crohn's disease, a severe inflammatory condition of the small and large intestines. Ronald was placed on a strict protocol of strong

medications, including anti-inflammatories, antimicrobial agents and corticosteroids, and a highly restricted diet.

Ronald didn't do so well on this regimen. His pain and diarrhea continued, and he soon developed other symptoms, as well, such as stiff and painful swollen joints. A strange, blister-type rash appeared on his face. He was constantly nauseous and light-headed. The corners of his mouth began to crack and bleed. Day by day, he felt himself growing weaker, his vital life energy ebbing. He was forced to take a leave of absence from school and move back in with his parents. Fortunately, they were willing to do anything to help Ronald regain his health.

After six months, Ronald appeared to be on death's doorstep. His weight had fallen to an all-time low of 104 pounds, down from his normal weight of 180 pounds. His friends remarked that he looked like a concentration-camp victim. His diarrhea had increased to the point that he couldn't sleep for more than 45 minutes at a time before he would have to get out of bed and run to the toilet to relieve himself. He had no appetite, and his abdomen was bloated and full of gas. He forced himself to eat to stay alive, but he couldn't keep his food in—everything that came in the front door was immediately expelled through the back door.

In a desperate attempt to save Ronald's life, his doctor sent him to the nation's top specialists in gastrointestinal diseases. After reviewing his records and examining him, they all agreed Ronald's was one of the worst cases of Crohn's disease they had ever seen. If his life were to be spared, the consensus was that surgical removal of his colon and a lifetime of immunosuppressive medications was Ronald's only option.

Ronald returned home to contemplate his fate. He became extremely depressed, and even thought of suicide. Because he was malnourished, he had to be fed through a large, intravenous catheter inserted into a vein near his neck. This catheter, which could easily become infected, became Ronald's lifeline.

As Ronald lay in bed wasting away, one of his father's friends suggested something simple but radical. He suggested that if Ronald could regain the balance of natural flora in his intestines, he had a good chance of restoring his health. He based this idea on recent research that suggested that, in addition to the 500 good bacterial

strains that reside in the human intestines, there may be many more types of beneficial bacteria, perhaps up to 10,000 strains. He asked Ronald to try several capsules a day of a special hygienic dirt cultivated for human consumption; this dirt contained many strains of these beneficial bacteria.

At first, Ronald was taken aback by the idea of eating dirt, but, because he was desperate, he was ready to try anything. After long hours of reading, research, and discussions with his father and his father's friend, he realized that what was being proposed was a return to the dietary habits of his ancestors. In those days, before pesticides and artificial fertilizers, people often ate vegetables right out of the fields, ingesting small amounts of beneficial soil organisms with each bite, and, in the process, replenishing their natural intestinal flora. When we think of cows' digestive systems, and how their multichambered stomachs are filled with many beneficial bacteria that help digest their food, this idea is not so radical.

The first day, Ronald took six capsules of hygienic dirt (two at a time, three times a day). The following morning, after his first sound night's sleep in a long time, Ronald felt his abdominal pain lessen in intensity. For the first time since his illness began, he didn't awaken with a fever. Throughout the course of the next several days, his diarrhea slowed in frequency and intensity. After several days, his stools began to firm up. After one week, his appetite began to return and he had his first normal bowel movement in almost a year.

Over the next several weeks, as he continued to swallow the capsules of beneficial dirt, Ronald's appetite and bowel movements continued to improve and normalize. His joint health, skin, mouth sores, energy level, and attitude all improved, as well. After six months, his weight was back up to 180 pounds, he was back in school, and he was completely well.

Eating dirt flies in the face of conventional medicine, which often views nature as the enemy and the cause of most diseases. When we work with our healing systems, however, natural solutions often work best. For Ronald, using beneficial organisms that are normally found in healthy, hygienic soil was the secret ingredient that ultimately cured his disease. Beneficial bacteria help in digestion, and they produce many valuable substances, such as vitamin K, thus restoring balance to the intestines; consequently, they are

one of the most important ways to cooperate with your body's natural healing system.

Rani's Story of Extraordinary Healing

Rani was an elderly woman who lived in a community I regularly visited in India. She had suffered from asthma since she was a little child, and she took medicines regularly to control it. Whenever she caught a cold, breathed dusty air, or was under heavy stress, her asthma would flare up. At these times, sometimes even her medicines would fail her, and she would have to go to the hospital, where intravenous medications and special breathing treatments were administered.

Having been away for a long time, I returned to India one year to find Rani in a very precipitous condition. Not only was her asthma flaring up, but her feet, ankles, and abdomen were swollen. She had not eaten for days, she could not get out of bed without help, and she appeared to be on death's doorstep.

When I examined Rani, I discovered shallow respirations, a feeble, irregular heart rate and abnormal heart sounds, fluid in her lungs and belly, and an enlarged liver. She told me she hadn't urinated in several days. These were all ominous signs. I suggested she be hospitalized, even though her family couldn't afford it.

In the hospital, after many examinations and investigations, the doctors found that Rani was in congestive heart failure, her liver was failing, and her kidneys were shutting down. She was told that nothing could be done for her. Rani was discharged from the hospital with little hope of living more than a week or two. Her family prepared for her imminent death.

As a last-ditch effort to help Rani, I attempted to administer several very strong medicines I had brought with me from my hospital back home in the U.S. for patients with serious, life-threatening conditions. One of these was *lanoxin*, a derivative of *digitalis*, used for congestive heart failure. Another was *lasix*, a strong *diuretic* (water pill) used to remove fluid from the lungs, feet, and abdomen. I also hoped the lasix might flush her kidneys and restore their function. In addition, I brought the latest, strongest *bronchodilator* and *corticosteroid* inhalers to open up her airways in an attempt to treat her

asthma. But several days on these medications only saw her condition worsen. She was going downhill fast.

One morning, when I was doing my usual rounds, I saw an Indian gentleman sitting down and talking with Rani as I approached her home. The family told me he was Dr. Vinod, a renowned doctor who practiced *Ayurveda*, India's ancient folk medicine. Ayurveda uses primarily natural medicines to help restore health to the body. Rani's family had called Dr. Vinod to see whether there was anything he could do to help her.

Dr. Vinod did something that I had never seen before, and which went completely against my medical training. He stopped all her medicines, went out back behind Rani's home, plucked a leaf from a particular tree, and placed it on her abdomen. He restricted her diet to three glasses a day of pure goat's milk. Every day a fresh leaf was applied. This treatment seemed primitive to me, and I was extremely skeptical that anything good would come of it.

However, within several days, Rani began sitting up in bed under her own power and eating full meals. Her breathing slowly returned to normal, the swelling in her feet and abdomen were gone, and, within a week, she was walking around the grounds outside of her home. Within three weeks, her breathing became normal, and she regained almost all of her previous strength. If I hadn't seen her recovery with my own eyes, I wouldn't have believed it.

Rani's case was more than a lesson in humility for me, a U.S.-trained physician who supposedly possessed the latest, most up-to-date education and high-tech medicines.

More importantly, it showed me how instituting the right treatment, even a ridiculously simple one, and even in the face of an apparently hopeless situation, can work with the healing system to help restore the body's natural state of health and vigor.

Pierre's Story of Extraordinary Healing

Pierre was an adventurous Frenchman I met during my earlier travels in India. The son of a royal French family, he had rebelled and run away from his homeland. Pierre had hitchhiked through Greece, Turkey, Iraq, Iran, and Afghanistan before he reached India.

Eventually, he built a hut on the beach in Goa, along the central western coast of India, and settled into a carefree life of an expatriate, international beach bum. His daily activities consisted of fishing, taking siestas, learning about the Indian culture, and panhandling for food. But the fun was soon to end.

One day Pierre awoke with a sharp pain on the right side of his abdomen, just beneath his rib cage. It was difficult for him to breathe. He noticed his urine was dark brown, almost tea-colored, while his stools were light yellow colored. He had a fever, no appetite, and was extremely nauseous. Food and water would not stay down—he frequently threw up. Several days later, while he was looking in a mirror in a public restroom, Pierre saw that his skin and the whites of his eyes had turned yellow. He was jaundiced. That's when he knew he had hepatitis. Being sick in your own country is scary enough, but when you are in a poor, developing country, far from home and without money, it can be even scarier.

Pierre went from hospital to hospital, hoping for a cure. He was told that there was no cure for his form of hepatitis, and that nothing could be done. Because he had a hard time keeping fluids down, and an even harder time keeping food down, he grew weaker and weaker and lost a lot of weight. Out of desperation, he was directed to the hospital and yoga research institute where I was studying and conducting research, about 400 miles northwest of Goa. In this hospital, all-natural treatments from the world of yoga are prescribed and administered to patients with diseases for which modern medicine has not been able to find a cure.

Pierre was prescribed things that made absolutely no sense to me whatsoever. For example, he was prescribed regular breathing practices, known as *pranayama*, that were supposed to calm his nervous system and improve oxygenation of the blood. He was also prescribed *kriyas*, specific intestinal water cleanses that flushed his intestines and were supposed to cleanse and purify his liver. Pierre was also prescribed certain *asanas*, or yoga poses, along with other gentle abdominal exercises to help massage his internal organs and promote blood flow to the liver. He also was instructed to drink lots of water and juices, and he was fed *kichari*, a traditional yogic food made up of cooked, split mung beans (dal) and basmati rice. I was told kichari was gentle and soothing, easy to digest, an excellent

source of protein, and that it contained numerous vitamins, minerals, and trace elements that help restore liver health. Other foods, such as papaya, along with natural medicines that helped nourish and strengthen the liver, were also prescribed.

Following treatment with these unconventional methods, Pierre regained his health and in several months completely cured his hepatitis. His case demonstrates that even in the absence of modern medicines, healing can occur when treatment is aimed at cooperating with your body's healing system. In yoga, all attempts at restoration of health are designed to work with your healing system, not against it. For this reason, yoga remains one of the most promising areas of investigation if you're interested in working with your healing system to achieve optimal health and well-being.

Ned's Story of Extraordinary Healing

Ned Peterson was a professor emeritus in psychology at the University of Hawaii. He was 59 years of age when he was first diagnosed with heart disease. Before his diagnosis, Ned had been suffering from vague chest pain for several months, but he dismissed these pains as only a muscle strain. When he finally visited his doctor, he was referred to a cardiologist, who ordered a stress test and an angiogram, a test that measures the blood flow in the arteries that feed the heart.

Ned's cardiologist told him that the stress test showed heart disease. Results of his angiogram were also not good. The main artery was 100 percent blocked and two others were 80 percent to 85 percent blocked. A *thallium test*, which measures blood flow to the heart muscle, confirmed severe blockages to important areas of the heart. Because of the locations of the blockages, Ned had only one option: immediate coronary-artery bypass surgery. He was told that if he didn't have this operation, he would be dead within several months.

Ned was reluctant to accept surgery as his only alternative. He was not fond of the idea of having his chest cracked open and his heart stopped while the surgeon stitched tiny veins to his coronary arteries, bypassing the blockages. The significant potential complications

associated with open-heart surgery caused him to seek another solution.

Ned told his cardiologist thanks, but no thanks; he would try another way. His cardiologist told him he was a fool and would probably be dead within the year.

By luck, Ned stumbled upon the work of Dr. Dean Ornish, the first person in the world to prove reversal of heart disease without drugs or surgery. Ned read Dr. Ornish's best-selling book, *Dr. Dean Ornish's Program for Reversing Heart Disease*, and he began a low-fat, plant-based diet. He also embarked on an exercise regimen of walking and bike riding three to six days a week, and daily gentle yoga stretching, relaxation, and meditation. And he learned how to get in touch with his feelings and express them.

After Ned had followed Dr. Ornish's program for two weeks, his chest pain diminished significantly. After one month, it had vanished completely. In three months, he could bike 12 miles while barely breaking a sweat. In one year, he went to another doctor who ordered a new angiogram and thallium test. Ned's repeat angiogram showed the blockages had dissolved significantly. The 100 percent-blocked vessel was now only 40 percent blocked, and the 80 percent to 85 percent blockages were reduced to 20 percent to 25 percent. The repeat thallium test showed 300 percent improvement of blood flow to the heart muscles. Ned was completely out of the danger zone.

Ned felt like a new man, and with laboratory proof to confirm his reversal of heart disease, he went back to the first cardiologist who had told him he'd be dead within a year if he didn't undergo open-heart surgery. Ned showed the doctor his angiogram and his thallium test results. The cardiologist stared at them in disbelief. He asked Ned how he had done it, how he had reversed his heart disease. Ned told him about the work of Dr. Ornish.

Today, Ned runs volunteer groups for newly diagnosed heart patients, and he receives regular referrals from the same cardiologist who originally told him he was a fool not to undergo open-heart surgery. He has written a best-selling book about caring for the heart, and he is completely free from heart disease. Because he was able to understand what contributed to the blockages in his heart, and he took corrective action that addressed the underlying causes of his problem, his healing system was able to repair the damages

and reverse his disease. Today, Ned enjoys radiant health because he has learned to listen to and cooperate with his healing system.

Norman Cousins' Story of Extraordinary Healing

Norman Cousins was the first person to tell me about the body's healing system. His own case is one of the most dramatic and vivid examples of the healing system in action.

A remarkable writer and international peacemaker, Cousins traveled to Hiroshima each year for 40 years to help heal people's wounds caused by the dropping of the atomic bomb on Japan in World War II. For many years, he also helped negotiate the release of important political and religious prisoners throughout the world. One day, after serving as a mediator during the famous SALT treaty talks between President John F. Kennedy and Nikita Krushchev, Cousins returned home from the Soviet Union completely exhausted, physically, mentally, and emotionally. He was extremely upset that the talks had not gone well and that the Soviets were defiantly moving forward on the buildup of nuclear weapons. It was a very stressful time for Cousins. Several days later, a mysterious fever surfaced.

In addition to his fever and exhaustion, Cousins' spine began to stiffen and become extremely painful. After many tests, he was diagnosed as having an advanced case of *ankylosing spondylitis*, a severe form of spinal arthritis that causes a progressive stiffening and fusion of all of the vertebrae of the spine. Cardiac involvement and death were a distinct possibility.

Cousins' family doctor checked him into one of the country's finest hospitals, and summoned and consulted the best specialists of the day. The expert medical opinions were unanimous: Nothing could be done; his was a hopelessly terminal case. Cousins was given six months to live.

The doctors monitored his *sedimentation rate*, which was a specific blood test that marked the severity of this disease. Already high, the rate continued to rise each day. Every day, the blood-drawing team would stick a needle in his arm to biochemically confirm his

progressive, deteriorating condition. In his rare lighter moments, because the blood-drawing team wasn't really helping him, Cousins jokingly referred to them as "the vampire squad." During this time, Cousins realized that, because he had only six months to live, he might as well enjoy his final days. In his state of despair and hopelessness, he accidentally stumbled onto the secret healing power of humor and laughter as antidotes to pain and misery.

Cousins was a friend to many celebrities, from U.S. presidents to Hollywood movie stars. One of these friends was Allen Funt, the producer of the hit TV comedy series *Candid Camera*. Funt supplied Cousins with films of the show's most memorable episodes. Cousins also watched other funny movies, including Marx brothers' films. As he lay in his hospital room, lost in the gaiety and laughter of the movies, he began to notice his pain lessening. Specifically, he discovered that for every 15 minutes of solid belly laughter, he could get two hours of pain-free sleep. At the same time, Linus Pauling, Nobel Laureate chemist and a close friend of Cousins, insisted that he take vitamin C every day.

As Cousins continued on this program, he slowly noticed his symptoms improving. The "vampire squad" also reported that his sedimentation rate started to drop, indicating that his internal biochemistry was changing for the good. Within several months, he could get out of bed and walk without a cane or crutches. Within a year, he was completely pain free, his sedimentation rate was back to normal, and he was declared "cured," not only by his doctor, but also by the top specialists of the day, who had previously declared his case hopeless.

After writing his best-selling book *Anatomy of an Illness*, which describes the details of his miraculous healing journey and triumph over ankylosing spondylitis, Cousins went on to spearhead pioneering research in a new field of medicine known as *psychoneuroimmunology*, which, as noted earlier, studies how the mind and nervous system can affect the immune system and influence the course of illness and health. Many AIDS and cancer patients have benefited from these studies. As with all the systems in the body, the immune system depends on the healing system to do its best work. A strong healing system is necessary for the immune system to function optimally—as it did in Norman Cousins' case. After 10 years of work in

this field, Cousins' next best-selling book was appropriately titled *Head First: The Biology of Hope and the Healing Power of the Human Spirit.*

Arthur's Story of Extraordinary Healing

Dr. Bernie Siegel is a well-known cancer surgeon, internationally acclaimed speaker, and best-selling author of numerous books, including the immensely inspirational, timeless classic, *Love, Medicine, and Miracles.* One of the earlier cases that helped inspire him involved a man named Arthur. Arthur was a patient of Dr. Siegel's who had been diagnosed with an advanced cancer. His condition was described as terminal, and he was given six months to live. Dr. Siegel did not expect to see or hear from him again.

One day five years later, however, Dr. Siegel ran into Arthur in the local grocery store, and he was astonished. He thought he'd seen a ghost. He told Arthur that he was supposed to be dead—what was he doing still alive?

Arthur replied, "Dr. Siegel, you probably don't remember what you told me, but you said I had only six months to live, and that it was important for me to make it the best six months of my life." Arthur went on, "I took your advice. I quit my job, which I never really liked. I went on a cruise, which was something I had always wanted to do, and I began taking piano lessons, which was something else I'd always wanted to do. After six months, I felt so good, I decided I didn't have to die. I've not been sick in the past five years, and I have never felt better in my whole life."

Dr. Siegel stood there scratching his head and thought, "I wonder how many more of my patients who I sent home to die are still alive, like Arthur."

The next morning, he had his medical-office staff call the families of hundreds of his patients who were assumed dead. To his surprise, he discovered that about 20 percent of these terminal cases were still living and were completely healthy.

He thought again and wondered why they hadn't come back to see him. Then it hit him: If you were a patient, your doctor said you'd be dead in six months, and after six months you felt better

than you ever had in your whole life, the last place you'd go is your doctor's office.

Dr. Siegel then personally called all of these patients and asked them if they'd be willing to attend weekly group meetings. Over the course of the next 12 years, these patients, who were all survivors of cancer, met as a group. Dr. Siegel called them Exceptional Cancer Patients, and they served as his teachers. Their stories, and the many things they did to activate their healing systems while overcoming terminal cases of cancer, are described in *Love, Medicine, and Miracles*.

The beauty of Dr. Siegel's work is that it has given hope to millions afflicted with terminal, life-threatening illnesses. In his words: "There are no such things as incurable illnesses, only incurable people." He backs up these words by pointing to the scientific literature, which contains case reports of people from all walks of life beating every so-called incurable illness known to man. It is Dr. Siegel's opinion that if one person can beat an incurable disease, by definition, the disease can no longer be called incurable. Dr. Siegel's Exceptional Cancer Patients provide strong evidence that our healing systems can be accessed and activated through a variety of means and ways, and that, once activated, they can overcome even the most severe of life's afflictions.

Louise Hay's Story of Extraordinary Healing

Louise Hay was a young woman who barely finished high school. At a young age, she developed cervical cancer, and she was told that if she didn't undergo immediate surgery and chemotherapy, she would die.

Louise was reluctant to have an operation and put strange chemicals with potentially toxic side effects into her body. Instead, she decided to pursue alternative methods of healing. She researched the impact of nutritious foods on her health, and she changed her diet. She also explored the mind-body connection and discovered how her thoughts, emotions, and attitudes could be powerful influences on her physical health.

During this journey of self-exploration, Louise discovered that she had been sexually abused, and that, as a consequence, she had

harbored shame and resentment for the part of her body where the cancer eventually developed. After she had discovered certain inner truths about herself, she realized that it was quite logical that cancer would show up there.

Slowly, as Louise's diet, lifestyle, and attitudes improved, and she learned how to care more for herself in thought, word, and action, her cancer went away, never again to return. She has since gone on to enjoy radiant health, and she has become an extraordinary teacher and healer.

In her healing work, Louise discovered that, in many instances, how we treat our bodies is a reflection of how we treat ourselves. This interaction has a powerful influence on our healing systems, and on our health. For example, when we think kind and loving thoughts about our selves and our bodies, we tend to treat them with love and kindness. This encourages us to eat right, and to exercise, rest, and sleep well, among other things. These behaviors help strengthen and fortify our healing systems and ensure our good health. When we are angry at life and resentful of ourselves and others, we tend to participate in self-destructive activities that are harmful to our bodies. These behaviors make extra work for our healing system and can ultimately contribute to illness.

Louise went on to write several international best-selling classics. Her first, and perhaps most famous, is *You Can Heal Your Life*, based on her own self-healing journey. She also has produced many other wonderful books and tapes to help others who are interested in healing. She even started her own successful publishing company, Hay House, which has grown rapidly since its inception.

Steve's Story of Extraordinary Healing

Steve was a carpenter doing framing work on a custom home. One day, while he was climbing a ladder and carrying his electric saw, he slipped and fell. In the commotion, somehow he accidentally hit the switch that turned the saw on. The powerful saw cut a clean track through his arm, completely severing it. He looked down and saw that his hand and wrist were no longer attached to his body. Blood was everywhere. He screamed for help, and his coworkers came running.

They called the ambulance, and someone had the presence of mind to apply a tourniquet to Steve's arm to help stop the bleeding. Another person grabbed his severed wrist and hand and put it in a bag.

The paramedics arrived on the scene within 20 minutes, and they took Steve and his severed hand to the UCLA Medical Center. He was immediately rushed to the operating room, where two teams of surgeons and nurses were already waiting to work on him. One team worked on the hand, dissecting the blood vessels, bones, tendons, muscles, and nerves, while the other team worked on his arm, preparing the severed end for reattachment. They were going to try to connect Steve's hand to his arm. This was in 1975, when these kinds of operations were not so common.

I was employed at the UCLA Medical Center as an operating-room assistant at the time. My shift started at 7:00 AM and ended at 3:30 PM. When I came back the next morning at 7:00 AM, the operation was still going on, and it continued for several more hours.

After the operation, Steve's arm was put in an immobilizing splint. After two months, the splint was removed, and he began physical therapy, during which he learned exercises to help stretch and strengthen his arm and hand. Thanks to Steve's healing system, the healing process was well under way by the time he reached physical therapy.

Within six months, Steve was able to gain full use of his arm, including his wrist, hand, and fingers. Within one year, most of the sensation had returned to his fingertips. Additionally, even though Steve had lost an enormous amount of blood from the accident (he had almost gone into shock), surprisingly, he didn't need any blood transfusions after the operation. By drinking lots of fluids and eating iron-rich fruits and vegetables, he was able to assist his healing system in making more blood for his body.

Because of Steve's healing system, circulation to his hand and fingers was restored. His severed bones knitted back together and were stronger than ever. The severed muscles and tendons were rejoined, mended, and healed. His nerves regenerated and registered almost fully intact sensation. Within one year, Steve was back on the job, healthy and strong, and cutting wood with his favorite saw. This time, however, whenever he moved around with it, he made sure the safety switch was on.

Rose's Story of Extraordinary Healing

Rose was an elderly woman who had been suffering from a rash on her arms and legs for several months. She went to see my good friend Dr. Elpern, who specializes in dermatology. Dr. Elpern had tried various remedies, and he had Rose come back several times for checkups. Each time, there was no improvement in her skin condition.

Becoming a little frustrated, Dr. Elpern decided to stop her medications and probe deeper into the possible causes of Rose's rash. He asked if she had been facing any unusual difficulties at home or had been under any kind of stress. Rose told Dr. Elpern that her husband had recently become very sick and that she was worried about his health. She went on to tell him that her husband's doctors had not been successful at making her husband better. Dr. Elpern discovered that her rash had first appeared about the time of the onset of her husband's illness.

Dr. Elpern asked to see Rose's husband. She brought him to Dr. Elpern on her next visit. He questioned her husband thoroughly, examined him, made a presumptive diagnosis, and treated him accordingly. In a week's time, Rose's husband was feeling much better. Oddly enough, Rose's rash also began to improve.

On Rose's next visit with Dr. Elpern two weeks later, her rash was completely gone. Dr. Elpern hadn't done anything other than treat her husband for an unrelated condition. Dr. Elpern knew that stress can affect a person's healing system, and he was wise enough to treat the source of Rose's rash, which was her husband's health. Once he regained his health, she regained hers, as well.

Sam's Story of Extraordinary Healing

Sam was an obese Hawaiian man who led a sedentary life and ate typical modern-day foods such as canned meats and high-fat Hawaiian foods such as pork lau lau. In addition to his obesity, Sam also suffered from several other chronic diseases, including insulin-dependent diabetes, which was poorly controlled. Sam's doctor wanted to send him to Dr. Shintani, a progressive young doctor who had a strong background in nutrition and preventive medicine. Dr.

Shintani had just launched a new preventive nutritional program for Hawaiians known as the Hawaiian Diet.

After taking his medical history and conducting a physical exam, Dr. Shintani recommended that Sam go on the Hawaiian Diet, which was formulated from a combination of modern science and traditional Hawaiian wisdom. According to historical accounts, the original Hawaiian people (before the arrival of the European explorers and missionaries) were quite healthy, athletic, and lean. Many diseases common among Western cultures were nonexistent among Hawaiian peoples when Captain James Cook first discovered them in the 1600s. The original Hawaiians ate mainly simple, wholesome, healthy foods such as fruits; complex carbohydrates, such as sweet potatoes and taro; vegetables; whole grains; nuts; seeds; and fish. This diet was in stark contrast to such high-fat foods as fried chicken, roasted pig, and fast foods, popular among present-day Hawaiians such as Sam. According to Dr. Shintani's research, it is because of their modern, perverted diet and unnatural lifestyles that Hawaiians suffer from high rates of obesity, diabetes, heart disease, high blood pressure, and stroke.

When he first met Dr. Shintani, Sam was more than 150 pounds overweight and required 100 units of insulin each day to control his diabetes. After one and one-half years on the Hawaiian Diet, Sam had lost 150 pounds. His blood-sugar levels had dropped to normal, and he was able to completely get off his insulin. He maintains normal blood sugar levels to this day by staying on the Hawaiian Diet.

The areas of nutrition and preventive medicine are sadly lacking in the practice of conventional modern medicine, and they are virtually absent from the curriculum of most medical schools in the West. But these two related fields of study, which most physicians rarely discuss with their patients, provide some of the most practical and important strategies to summon the support of the body's healing system in the healing and prevention of even the most devastating modern-day illnesses. This emphasis has been the main thrust of pioneering physicians such as Dr. Shintani. Sam's story provides a clear example of how cooperating with your body's natural healing system by applying these ideas about nutrition and prevention can reverse a deadly disease such as diabetes and effect true and permanent healing.

Jim's Story of Extraordinary Healing

Jim was a plumber in his early fifties. He led an active life, except when he became incapacitated with flare-ups of his psoriasis, a condition he had been suffering with for 30 years. Jim's psoriasis would flare up at the most inconvenient times. It caused him to cancel important scheduled events, such as family outings or fishing trips with his buddies.

Psoriasis can occur in patches on the skin, the knees, the feet and ankles, the elbows, the scalp, behind the ears, or just about any other place you can imagine. Although it is considered a skin disease, in severe cases psoriasis can also involve the joints, becoming a debilitating form of arthritis. Modern medicine does not understand what causes psoriasis. Unable to cure it, doctors treat it mainly with suppressive medications, which give temporary relief, at best. This approach is often referred to as *palliation,* or the process of easing discomfort without curing. Corticosteroid and immune-suppressing creams are usually administered daily to reduce the severity of the symptoms. These treatments are applied more frequently during flare-ups. Strong pills are often prescribed for more severe cases.

Jim had a drawer full of creams and pills that he had collected over the years during his many visits to doctors. However, as much as he used his medications religiously, his flare-ups were becoming more frequent and more severe. Each time his psoriasis erupted, his old patches grew larger and more angry, staying inflamed for longer periods. Additionally, new patches of inflamed skin were surfacing in areas that were previously normal. His condition was worsening, and, in addition to being painful and irritating, there seemed to be no rhyme or reason to the flare-ups or why his disease was spreading. His psoriasis was starting to drive him crazy. It was then that he began to understand the phrase "the heartbreak of psoriasis."

By luck, Jim came across the work of Dr. John Pagano, a chiropractor who had worked with many psoriasis patients over the years, and who had written an award-winning book entitled *Healing Psoriasis: The Natural Alternative.* This book contains many case descriptions and full-color plates of psoriasis patients (before and after) who have successfully cured their psoriasis by following Dr. Pagano's recommendations.

Dr. Pagano's approach to healing psoriasis is based on a broader understanding of the human body, the reality of a healing system, how all the other systems are interconnected, and how once balance is restored among these systems, healing can occur. In particular, Dr. Pagano's approach takes into consideration the unique relationship between the skin and the intestines. His work focuses on the eliminative properties of the skin, and how digestive disturbances such as constipation can lead to a buildup of toxins in the skin that contribute to psoriasis. His research has demonstrated that once intestinal health and hygiene are restored through proper diet, psoriasis is greatly improved or even completely eliminated.

When Dr. Pagano met Jim, he questioned him at length about his diet, something that no other doctor had done before. He then told Jim he had to give up his coffee habit, which was initially quite difficult for him to do, and to incorporate more fruits, vegetables, water, and fiber into his diet. He also told him to give up sodas and other junk foods that he had become habituated to over the years.

At first, Jim didn't think that all these sacrifices were worth it, especially when his condition didn't seem to change for the first six weeks. He asked Dr. Pagano if he really thought that the changes in his diet could heal his psoriasis. Dr. Pagano reaffirmed that Jim needed to stick with the program, that soon he'd start to see improvement.

After three months, Jim began to notice a reduction in the severity and frequency of his flare-ups, even during times of stress, which usually made his psoriasis worse. His patches looked less red and were more itchy than painful. After six months, his patches started to fade and look more like the color of his normal surrounding skin. After one year, his patches had receded and could only be discovered by persistent and deliberate probing. After two years, not a lesion could be found, and his psoriasis was gone. Five years have passed, and Jim has not had a recurrence. The "heartbreak of psoriasis" is now a distant memory. Jim hasn't missed a fishing trip or family outing in five years, and, instead of a drawer full of creams and medications, he now has a drawer full of shorts, which he never used to wear because of the embarrassment of his psoriasis patches.

Once again, the healing system went into action when Jim took measures to strengthen it through diet; and his psoriasis, which had been a major problem for years, was cured.

Hal's Story of Extraordinary Healing

Hal, a former athlete and now a medical student, had suffered chronic eczema on both of his hands for six years. When his eczema flared up, Hal couldn't even hold a football because of the cracking and bleeding on his hands, and, in particular, on the thumb on his throwing arm. This condition was especially debilitating and humiliating because Hal had been a star quarterback on his college football team.

Hal's eczema began when he was working as an orderly in a busy medical-center emergency room. During this period, he routinely used industrial-strength germicidal soaps, which seemed to irritate his hands, to clean the doctor's labs. The gloves he was supposed to use to protect his hands ripped and tore, and were more of a hindrance than a help. So Hal just did his scrubbing and cleaning without them. Other factors, such as stress, could have contributed to Hal's eczema, as well. After six months, his hands became extremely itchy, and they started to crack and bleed.

Doctor after doctor saw Hal's hands and prescribed treatments, but there was no improvement. He took a truckload of various creams and pills, and he was eventually referred to an allergist, who did some skin tests on Hal. The skin tests indicated positive for more than 20 allergens. Based on these tests, Hal underwent a series of allergy injections, all to no avail. After several years, he gave up all hope that his condition would ever be healed.

Six years to the day after he began, Hal had just finished the academic and clinical work for his senior year in medical school. He had a few weeks off before beginning his internship, usually the most difficult year in a young doctor's training. He was awaiting the results of the national match program, to find out which hospital he would be assigned to for his postgraduate residency training.

Every day for four years, on his way to medical school in Philadelphia, Hal had passed a pottery studio that offered beginning classes in making pottery. He had remarked to himself that someday, when he had a little extra time, he would like to take one of those beginning classes. Now was his chance.

Hal walked into the pottery studio and signed up for a beginning class that lasted six weeks. He informed the teacher that his goal was

to make a complete dinnerware setting for six, including plates, soup bowls, and coffee mugs, before the six-week class was finished. The teacher thought this was a bit too much, not realizing that she was dealing with a typical type A-personality medical student.

Hal came to class the first day and was given a lump of wet clay to mold and form between his hands. He was told how to care for the clay, how to add more moisture when it became too dry, how to dry it if it became too wet, and how to roll and knead it, just like bread dough. That first day, Hal thoroughly immersed his hands in the clay. He followed the teacher's instructions earnestly and sincerely.

After several classes, the students were introduced to the potter's wheel, on which pots are "thrown" or spun into shape by the skillful hands of the potter. Hal absolutely loved the potter's wheel, and he came in during his free time after class, working long hours with the clay. Even though he was only a beginner, Hal again reminded the teacher of his goal to create a complete dinner setting for six.

Six weeks later, at the end of the last class, Hal had completed his dinnerware set for six, which he removed with joy from the kiln and proudly displayed in front of the other students in the class. After he did this, he happened to glance down at his hands. They were no longer cracked or bleeding, and they had no signs of eczema.

Now, 20 years later, the eczema has never returned. We don't know exactly how Hal was cured. Perhaps doing something relaxing that he loved was enough to stimulate his healing system into action. Perhaps working with the clay itself had a healing effect on Hal's hands. Perhaps the cure involved a combination of the two; we'll never really know. What we do know for sure is that Hal's healing system was ready to do its work, and all it needed was the right catalyst for it to spring into action.

Sister Esther's Story of Extraordinary Healing

Sister Esther was senior nun at the Good Counsel Hill convent in Minnesota, the site of a groundbreaking 15-year study of Alzheimer's disease. The study was conducted by Dr. David Snowden, a researcher at the University of Minnesota, and it was important enough to appear on the cover of *Time* magazine. Sister Esther, who was 106

years of age, and many of her fellow nuns, who were in their eighties and nineties, showed no signs of Alzheimer's disease, despite significantly advanced ages. This fact was in sharp contrast to what conventional science would have predicted.

Dr. Snowden was particularly interested in Esther's life story, as well as those of her sister nuns who were free from Alzheimer's disease. Because Esther was fully functional and mentally sharp as a whip despite her advanced age, Dr. Snowden decided to look deeper and try to discover other causes than merely age or genetics that might explain the riddle of Alzheimer's disease, which annually affects about 4 million Americans.

Dr. Snowden's research revealed a completely different scenario for Alzheimer's disease than is currently theorized by most researchers. Because of the length and thoroughness of his study, Dr. Snowden's findings are not only credible, but they also offer tremendous hope and insights about how the healing system works and how we can stay healthy as we age. In Dr. Snowden's scientific opinion, Alzheimer's disease is strongly linked to lifestyle, environment, and social and emotional factors, all of which can affect the anatomy and physiology of the brain.

Likening the brain to a muscle, and applying the familiar axiom "Use it or lose it," Dr. Snowden found that the nuns who kept mentally stimulated and socially connected showed the fewest symptoms and were able to avoid the disease altogether. Age didn't seem to be a critical factor. The older nuns who continued to exercise their brains by thoughtful writing and speaking while remaining engaged in other meaningful work and activities continued free of the symptoms of Alzheimer's disease, while younger nuns who were socially withdrawn and not mentally stimulated developed symptoms of the disease.

Sister Esther enjoys working on various craft projects, and she rides a stationary exercise bike for 10 minutes every day. She stays actively involved with other nuns and with the affairs of her convent. In our attempts to understand how the mind affects the body, and vice versa, Sister Esther's example and Dr. Snowden's research remind us of how important it is to keep using our brains, remain socially connected with our friends and family, and find ways to keep ourselves stimulated and actively involved in life. A well-rounded, healthy lifestyle that involves mental challenges as well as

strong emotional and social connections helps support our healing systems, which can keep us healthy, even when we reach ages approaching Sister Esther's.

Gerry's Story of Extraordinary Healing

Gerry was an elderly patient of a doctor whose practice I was covering while he was away. Gerry had a long-standing history of diabetes, and she had suffered from hip pain for many years, pain that caused her to walk with a cane. Her medical chart was thicker than a phone book, and every time she came in to complain about her hip pain, she was told it was from her diabetes, which is known to cause nerve problems that can result in pain in the legs and lower extremities.

One day while I was examining her, Gerry asked me if I thought a visit to a chiropractor might help her hip pain. Not wanting to discourage her, but not wanting to build up false hopes either, I told her it might be worth a try and probably wouldn't hurt her. Because her regular doctor was adamantly opposed to chiropractors, he never approved of her doing this. She had never seen a chiropractor before, and she was somewhat apprehensive. She seemed relieved that I wasn't so against them, and perhaps my reaction helped her get up the courage to visit one.

Two weeks later, on her next visit with me, Gerry walked into the exam room smiling. I saw that she didn't have her cane.

"Gerry, you forgot your cane. What's up with you? " I asked.

"Doctor, I don't need my cane anymore," she replied. She added, "Last night, I went dancing for the first time in 30 years! My hip pain is completely gone!"

She then burst into tears and thanked me for healing her hip pain. All I did was give her permission to go to the chiropractor, who, after one simple adjustment, was able to relieve 30 years of pain and misery.

Even though Gerry's is a rather straightforward case, I learned something important from her. Sometimes, an open mind, a new way of thinking, and a simple adjustment are all that are necessary to assist your healing system in restoring health to your body.

Merry's Story of Extraordinary Healing

Merry was a young nurse I worked with who used to be a dancer. As Merry began to attend to her patients and concentrate more on her professional career, however, her time for dancing became less and less. Trying to maintain an active lifestyle, instead of dancing she took to a program of regular exercise, including jogging. Soon, however, Merry began to notice pains in her hips. At first the pain occurred only when she tried to exercise. Then, she experienced pain when she was getting in and out of her car, walking up stairs, and performing other simple movements. Over a several-year period, the hip pain became worse and worse, and although she was not yet 30 years old, she began to exhibit a noticeable limp. Merry had to curtail all exercises other than slow walking, and even that caused her considerable discomfort.

Merry eventually could ignore the problem no longer, and she had to go to see several doctors. The doctors did X-rays and blood tests, and after extensive investigations made the diagnosis of severe, progressive osteoarthritis. They placed Merry on strong anti-inflammatory medications, including corticosteroids, but they told her that eventually she would need a double hip replacement.

Because I was working with Merry, I had only a professional relationship with her and was not familiar with her medical history. When I went for a walk with her one day after work, however, I noticed her limp. I asked her why she was limping. It was then that I found out about her diagnosis of osteoarthritis. She shared her pain with me, and told me that she was not looking forward to having her hips replaced at such a young age.

As an alternative to surgery, even though there weren't a lot of scientific studies to support my work, I had had some previous clinical successes with yoga and gentle physical therapy for my patients with various types of arthritis and joint deformities. By having an open mind, self-discipline, and a genuine will to improve, many of these patients were able to avoid surgery and improve the health of their joints.

I spoke of this work with Merry and suggested several specific yoga stretches and other gentle therapeutic activities that might help open up the joint spaces in her hips and reverse her arthritis. She was

looking for a more permanent solution to her problem and wanted to avoid surgery, and so she was very open to this more conservative approach. She applied the stretching and other activities diligently and persistently.

Soon, however, my military duty and clinical training took me far away from Merry's world. It wasn't until nine years later that our paths crossed again, when we met at a medical conference. We walked as we talked, catching up on old times. It was then that I noticed that her limp was gone, which reminded me to ask her about the arthritis in her hips.

Merry told me that her hips were now disease free. She was dancing again, and it felt wonderful. She told me that she had followed my regimen faithfully during the first several months, and, after feeling great improvement, decided to stick with it. She has stuck with it to this day and continues to enjoy excellent health in both her hips. Merry's healing system was willing and able to go into action, but it needed her cooperation. By working with her healing system using natural, noninvasive techniques, Merry was able to reverse her arthritis and live her life to the fullest once again without resorting to the extreme solution of surgery, which also might not have been a long-term solution.

Clyde's Story of Extraordinary Healing

Clyde was a physics professor who had suffered from back pain for many years. One day, while he was lifting luggage from the trunk of his car, his back locked up on him and dropped him to his knees. The pain in his back was excruciating, and it shot down his right leg like a bolt of lightning. He couldn't move, not even with his wife's help. Luckily, she had their cell phone and called 911. The ambulance crew arrived shortly after.

In the emergency room, Clyde was given strong narcotic injections to relieve his pain, relax his muscles, and help break the intense muscle spasms. His spine was X-rayed, and the orthopedic surgeon was called in. Clyde was admitted to the hospital and underwent an MRI the next day. The MRI showed a severely herniated disc in the lower lumbar spine and a synovial cyst in the joint space between

the adjacent vertebrae. Other specialists were called in, including the neurosurgeon, and it was determined that spine surgery to repair the disc and remove the cyst would be necessary.

Clyde, however, was not ready to undergo spine surgery, and he asked if there was any urgency to the surgery. Clyde was hesitating because one of his friends had had a poor outcome with a recent spine operation. His friend had ended up with an infection that almost killed him, and that had kept him hospitalized for than six months after his surgery. Clyde was told that if he wanted to go home and rest, the surgery could be scheduled within the next couple of weeks.

When Clyde went home, he decided to find out whether there were other options that didn't involve surgery to correct his spine problem. He researched on the Internet and found a book about a doctor's own journey through back pain and an ultimate cure that involved holistic methods, including nutrition, exercise, stretching, and stress-management techniques, such as relaxation, meditation, and guided imagery.

Clyde thought he would give this alternative approach a three-month trial, and if it didn't work, he would then consent to the surgery. He contacted the doctor who wrote the book, and the doctor concurred that this might be a wise approach.

After three months of diligently applying this doctor's program, Clyde's back pain and the pain down his leg were completely gone. His herniated disc had shrunk significantly, and there was no evidence of his synovial cyst.

More than 300,000 people undergo back surgery each year in the U.S. Many of these people will undergo a second operation. It is not uncommon to meet people who have had 20 or more operations, and many of these people end up with chronic pain.

Fortunately for Clyde, he is not one of these people. Nor is he ever likely to be. Because he learned to work with his healing system, Clyde was able to heal his back pain naturally and restore health to his spine through the regular practice of simple, effective methods that work with his healing system.

The people you have just met are only a handful of the thousands I've either known myself or heard about who have learned to cooperate with their healing systems to eliminate a variety of health

problems. From serious, life-threatening illnesses such as cancer or heart disease to more benign conditions that, while not necessarily life-threatening, significantly compromise the quality of your life, your healing system can perform remarkable feats if you just learn how to work with it. You have the power to strengthen and fortify your healing system, just as Rani, Steve, Rose, and the other people in this section did, and, with extraordinary healing, overcome any health challenges you face.

PART TWO

Activating Your Healing System When You're Sick

Before You Begin

Now that you understand how your body's healing system works and how you can strengthen and fortify it, you can apply this knowledge to the treatment of specific health problems. Before you begin, however, there are seven key points to keep in mind while you are working with your healing system:

1. Remember that you are not a machine.

 Keep in mind that you are not a machine, but a complete human being with a body, mind, and spirit, and that all are interconnected. You need to take all three aspects into consideration if any physical disease is to be truly eradicated from your body. This is particularly true for chronic problems.

 When serious illness strikes, it is easy to become overwhelmed, not just physically, but mentally, emotionally, and spiritually, as well. You can become depressed and give up any hope that you will ever live a normal life again. At times like these, when you are in a weakened physical and emotional state, the task of getting better may seem daunting. Because your mind is connected to your body, when you are in this hopeless state of mind, it is difficult for your health to improve. As you recall, your mind is connected to your healing system and exerts

a tremendous influence over your internal mechanisms of repair and recovery. To enlist the services of your mind while you are working with your healing system, refer to the strategies, methods, and techniques given specifically for this purpose in Chapter 6.

2. Focus on your healing system, not on your illness.

Be careful not to pay more attention to your disease and the external agents that may be causing it than to your own healing system and the steps you need to take to bring it up to speed. The most common strategic mistake most people make when illness strikes is that they invest more time, energy, and fear into what has invaded their bodies, or what is wrong with their bodies, than they do focusing on their natural internal healing resources. This emphasis sabotages the healing process. When your are sick, you can easily lose sight of your body's intrinsic state of health and instead erroneously succumb to the belief that the illness is more powerful. When you do this, you waste precious energy that could be used for healing.

Focus your attention on your healing system and not on your disease, pain, and discomfort. When you do this, your mind will join forces with your body to more effectively overcome your illness. This powerful healing partnership can maximize the flow of your healing energies, mobilize the forces of healing that exist within you, and produce a more rapid, effective, and thorough healing response.

If you are motivated to get better, you can even use your illness as an opportunity to learn more about the factors that contributed to your loss of health in the first place. Your illness can show you not only the way to remedy your current situation, but how to stay healthy and remain balanced in all areas of your life, so you can avoid getting sick again in the future. In this respect, illness can be a blessing in disguise, a valuable learning experience, and a time of transformation, renewal, and healing.

3. Practice prevention.

We all remember the saying "An ounce of prevention is worth a pound of cure." Anything, including your body, is easier to fix

when problems first begin and damage is minor, than it is if you wait until the problem has escalated to the point at which extensive damage has occurred. More time, energy, and expense is required to repair the damage when you wait to address a problem than if you can prevent it from happening in the first place. Investing in your health by supporting your healing system when you are well, so that you can avoid illness, is more cost effective, in both time and money. Additionally, when you have the momentum of good health on your side, any illness or disease has far more difficulty invading your body.

If you can't prevent a health problem, at least intervene early to nip it in the bud. Institute corrective measures as soon as possible. Illnesses and diseases that are caught in their early stages are much more easily treated than those that have been allowed to progress, spread, and establish themselves in your body.

4. Pay attention to your body.

Remember to listen to your body whether you're sick or well because it can provide valuable information concerning your health. Although there are a few exceptions, do your best to avoid any activity or treatment that drains your energy, makes you irritable, interferes with sleep or other vital functions, increases your symptoms, or makes you feel worse. With a few exceptions, continue and pursue any activity or treatment that makes your mind and body feel stronger, clearer, lighter, more energetic, and more at ease. It is important to use common sense here, and to avoid artificial substances, such as anabolic steroids, opiates, stimulants, or other drugs that may provide temporary, short-term relief, but that in the long run often prove harmful. To help you access invaluable support for your healing during times of illness, review and regularly practice the exercise for listening to your body described in Chapter 4.

Remember that distinguishing between a symptom of disease and a healthy physiological response from your healing system is vitally important. For example, as discussed in Chapter 2, many symptoms of illness, such as coughing, sneezing, or fever, are commonly attributed to the actual disease process when, in fact, they more accurately reflect activation of

your body's healing system. Recognize these symptoms for what they really are, learn to cooperate and work with them, and don't panic when they occur.

5. Use natural medicines and treatments responsibly.

Natural medicines and treatments, when used responsibly, can be highly effective. They are particularly effective when they are used early on in the course of an illness, or for an illness that is chronic. And even though many natural medicines and treatments are safe, it is important that someone knowledgeable administers them, their use doesn't cause you to delay conventional treatment that may be more effective, they don't interact with conventional medicine you may be currently taking, and they don't cause any untoward reaction in your body. Natural medicine or treatment is best administered by a trained health professional who also has worked and trained in conventional medicine and is open-minded enough to understand the practical contribution and benefits of a variety of treatments that can support your healing system.

6. Use conventional medicines and treatments when necessary.

There are times when it is appropriate, particularly in acute situations, to use conventional treatments such as modern pharmaceutical agents and surgical procedures, even those that may be extremely invasive. These treatments can often be life saving, particularly in emergencies. When you are in a car accident and have sustained critical injuries is not the time to eat brown rice, meditate, and do acupuncture. You need to go by ambulance with the help of trained paramedics to the finest hospital emergency room. There, skilled surgeons and critical-care nurses will give you the treatment you need. In addition, conventional diagnostic methods, such as laboratory and imaging techniques, can provide key detailed information about your illness and serve as invaluable aids in monitoring your healing progress. While the least invasive methods usually should be attempted first, conventional medicine used appropriately has much to offer for supporting your healing system and facilitating the healing process.

7. Understand your pain, and learn how to work with it.

Pain is one of the most potent messages your healing system sends to you. Pain gets your attention and is an urgent wake-up call from your healing system's communication center that something is out of balance and wrong with your body. Pain tells you that, if you don't take immediate action, things could get worse. (There are exceptions to this, such as the pain of childbirth.) Don't be frightened or intimidated by your pain; rather, try to understand it. Pain is a valuable message from your healing system and in the long run is intended for your benefit.

The purpose of pain is to help you direct your healing energies to a particular area of your body where the normal flow of energy has become blocked. Pain conveys a sense of urgency, and, if you don't respond, its intensity increases. When pain escalates but is ignored or suppressed, it evolves into numbness. When this lack of feeling or sensation sets in, it is accompanied by a loss of function. Numbness is an ominous sign: It is difficult to heal that which you cannot feel.

Always remember that where there is pain, there is life. Your pain tells you that your nerves and your body's tissues are alive and well and are trying to communicate with you. It is telling you to take corrective action to restore normal function to your body. Where there is pain, there is always the opportunity for healing. Pain is not negative or punitive, but rather a positive, instructive, helpful message from your body's healing system. Pain is a consummate teacher, and you should consider it your friend, not your enemy.

Pain is always temporary and needs to be understood, not ignored or suppressed. When you suppress pain through artificial means, you are turning a deaf ear to valuable information your body is trying to share with you. A smoke alarm is installed for your protection, and if you were to snip its wires because you didn't like the irritating sound it made every time it was activated, your house might burn down. Snipping the wires to your internal alarm system is what you do when you suppress your pain. Unfortunately, through the widespread use of pain-suppressing medications, people in our society are learning how to successfully ignore their bodies. Doing this is often very

harmful because most conditions get worse when the underlying causes have not been addressed.

Sometimes, chronic pain doesn't have a physical cause but has its roots in deeper emotional pain. This emotional pain seeks bodily expression, which can come in the form of unbearable physical pain. This type of pain is often described as functional, which means that nothing structural can be found as the source, as opposed to organic, which means that there is a definite physical cause for the pain. You must address functional pain just as seriously as you do organic pain, and you must listen to these important messages from your body to activate your healing system and begin the healing process.

Learning to Work with Your Pain

Pain is a potent message from your healing system that something is out of order. Underlying causes always need to be addressed, but if no serious or life-threatening cause has been found, and your pain still persists, you can take the following steps to work with your pain, no matter how long it has been with you:

■ *Listen to your body.* Regularly practice the "How to Listen to Your Body" exercise according to the instructions given in Chapter 4. If your pain is severe and longstanding, you initially might need to practice this exercise up to four times a day, for a minimum of 30 to 45 minutes for each session. Allow several months for improvement if your pain has lasted for six months to a year. Allow more time if your pain has been present longer.

If you are taking strong pain suppressants, practicing this exercise and gaining full benefits may be difficult. To gain full benefits and for maximum healing, reduce or defer taking these medications while you are practicing the exercise of learning to listen to your body. As the pain eventually begins to lessen in intensity and your body heals, you will come to appreciate this discipline and see that it was well worth the effort.

■ *Dialogue with your pain.* Through the guided-imagery and visualization techniques presented in Part One, you can learn to have a conversation with your pain and gain valuable insights about its specific purpose and function. You can gain much healing information in this way. Your healing

system is intelligent and knows more about your illness than you do, and by practicing these techniques you can access information that may be completely unavailable through other means. This information can guide and direct your healing efforts and help you decide what other treatments may be of benefit. It is critical, however, that you make a commitment to implement into your life whatever insights you gain from these techniques. (For more information about these valuable techniques, consult the "Resources" section in the back of this book.)

▪ *Breathe with your pain.* In yoga, breath and energy are nearly equivalent. By working with your breathing, you can increase your energy and gain tremendous control over your pain. When you learn to slowly and gently lengthen your breathing, not only do you bring more oxygen and healing energy into your body, but you also help relax your nervous system, the master system in your body.

Your nerves control all of your muscle tissues, which contain the largest number of pain receptors in your body. So when your nerves are calm and relaxed because of your breathing, your muscles relax. When your muscles relax, tension and pain automatically diminish throughout your entire body. Breathing is one of the most powerful modalities known to help diminish pain and strengthen your healing system. Breathing is simple, easy to practice, and always available to you. (For more information on breathing, please refer to the breathing exercises in the stress-management section in Chapter 6.)

▪ *Stretch with your pain.* Stretching lengthens muscles in your body, decompresses nerves, helps to restore vital movement of important structures and fluids, improves lymphatic circulation (which aids immune function), and creates space within which more blood flow and healing energy can enter problem areas of your body. Stretching, when done gently and correctly, and when combined with slow, gentle, deep breathing, is a powerful modality for eliminating pain. When you are stretching, keep these basic tips in mind:

1. Follow the guidelines for stretching described earlier, and remember not to stretch too far.

2. Remember to avoid any movement that increases your pain.

3. Remember never to force or strain while stretching. (For a guide to

specific stretches that may apply directly to your condition, an excellent book to start with is *Yoga for Dummies* by Drs. Larry Payne and Georg Feurstein. Other books are listed in the "Resources" section at the back of this book.)

■ *Grow from your pain.* Most machines, when they exceed their capacities and shut down, have reset buttons that you can push to resume their normal functioning. Pain serves a similar function for us. Because our own poor personal health habits, attitudes, and thoughts create much of our pain and disease, pain forces us to take a deeper look at ourselves, reevaluate our lives, and change. Without pain, we cannot grow. In the words of well-known cancer surgeon and author Dr. Bernie Siegel, "Pain is nature's reset button."

Pain, particularly of a chronic nature, often carries with it deeper messages than merely indicating that something is wrong in your body. Although pain can be a living hell, it can also be a great teacher and a blessing in disguise. Pain opens us up, broadens our horizons, enlarges our perspectives, expands our minds, makes us more tolerant, teaches us patience and endurance, and toughens our spirit and moral fiber. Pain teaches us compassion and understanding, and helps us to become better people. After you've been through pain and you've survived the sheer brutality of its force and power, you'll never take anything in life for granted again. As gold is purified by superheating, so too the hell fires of pain can purify your soul and make you a better, stronger, more caring person.

No matter how long it has lasted, pain is always temporary. Once you have learned its deeper lesson, the pain will be released from your body and you will be free from its tyranny.

There's No Such Thing as an Incurable Disease

Diseases that are difficult to treat have always been with us, and they are challenging for both doctors and patients alike. But because you have a powerful healing system, there is another way to understand what the word *incurable* really means.

A number of years ago, Dr. Bernie Siegel spoke the following words that forever changed the way I viewed the word *incurable*: "There are no such things as incurable diseases, only incurable people."

The reasoning behind this statement is that, if you search the medical literature, you will find individual cases of people who have beaten every single supposedly incurable disease in the world. In Dr. Siegel's opinion, if only one person has found a way to cure himself or herself of a supposedly incurable disease, then, by definition, the disease is no longer incurable.

Just as human flight was once considered impossible in the days before the Wright Brothers, and it is now a routine experience, the incurable diseases of today will most likely be declared curable tomorrow. In the fields of health and healing, in which sorrow and suffering are our greatest enemies, it is important to think optimistically, as the Wright Brothers did when they ventured into previously uncharted territory on only a wing and a prayer, with no prior studies documenting that human flight was possible!

New cures are being discovered every day. One by one, diseases we previously thought of as incurable are being contained and overcome. The more we understand how our bodies work, the more we can acknowledge the incredible service our healing systems perform. The more we know about our healing systems, the better we will be able to understand the factors that contribute to disease, and the more effectively we can demystify, defuse, and defeat these afflictions.

The list of illnesses for which we have proven cures and preventions has grown considerably, and it continues to grow. Leprosy, the historical scourge of all societies and once thought to be incurable, is now easily treated and quite rare. The deadly plague that wiped out millions in the Middle Ages is now extremely rare, and if someone contracts it, he or she can be cured in fewer than 10 days with modern antibiotics. Cholera can now be easily cured in less than 72 hours. Smallpox, once a deadly killer, has been eradicated. Scurvy and rickets are almost unheard of. Gangrene is rare. Ptomaine poisoning and botulism almost never occur. Tuberculosis is also disappearing rapidly on a global level. Syphilis, comparable to HIV and AIDS, is now easily treated with penicillin, entirely preventable, and quite rare. Heart disease, once thought to be incurable, has been shown by Dr. Dean Ornish and others to not only be reversible even

in its severe forms, but completely preventable. The same is proving true for arthritis, diabetes, asthma, and other chronic conditions. Many forms of cancer are also being defeated, and the number of cancer survivors in the U.S. alone has reached more than 8 million. The more we are able to focus on preventive efforts and our healing systems, the sooner this condition also will become rare, as will many other afflictions that we currently fear.

When we go to a doctor and are told we have an inoperable brain tumor, terminal heart disease, multiple sclerosis, HIV, or some other horrible affliction, most of us have a tendency to go into a state of shock, followed by depression, because we assume that nothing can be done for us. Most of us have an unhealthy tendency to give all our power over to our fears, abandon all hope, and give up in the face of such a difficult challenge. But studies have shown that this response only accelerates our early demise.

Many people, however, have healed themselves of afflictions labeled as *terminal conditions* by their doctors. Even though doing so may not have been easy, most of these individuals reported a refusal to give up and an unwillingness to give in to a spirit of hopelessness. With this commitment and resolute attitude, a shift in their pre-conditioned beliefs and a subsequent improvement in the physiology of their body's internal environment occurred, which activated their healing system and reversed the tide of disease and debility. This process allowed the pendulum to swing back in the direction of a more positive state of health. A clear example of this is evident with HIV and AIDS. When HIV and AIDS first went public, there was mass fear and hysteria. People lost all hope, gave up, and succumbed quickly when a doctor rendered the diagnosis official. A positive HIV test was tantamount to a death sentence. Now, however, people with HIV are living 15 years, some longer, after the original diagnosis, and many of them are symptom free. Cases also are now being reported in which people who had HIV-positive blood tests are now being tested as HIV-negative. Those who take the time to tune into the wisdom and energy of their bodies, and learn to work with their healing systems, discover the body's ability to heal and recover its natural health, even from HIV and AIDS.

It is important to understand that these optimistic ideas are not

based on theoretical conjecture. An increasing number of studies in the medical literature have demonstrated that positive attitudes and beliefs contribute in large measure to your health, and that, once mobilized, they can help activate internal healing forces and reverse serious, life-threatening situations. As I continue to repeat, your mind and body are connected, and hope and the "will to live" have been recognized to produce biological consequences that can improve your state of health, strengthen your defenses, and stimulate your body's intrinsic healing mechanisms.

In her courageous book *Who Said So? A Woman's Fascinating Journey of Self Discovery and Triumph over Multiple Sclerosis*, Rachelle Breslow documented her successful 12-year struggle and epic victory over multiple sclerosis, and she came to similar conclusions as Dr. Siegel regarding the label of "incurable disease." In Ms. Breslow's words, "I learned that there is no such thing as incurable, that when a doctor says something is incurable, he really (and more accurately) is saying that the medical community has not yet found a cure. Who can accurately predict anything? The facts are never in. Saying that a disease is incurable and saying that a cure has not been found are two entirely different statements."

When you are confronted with the challenge of a serious disease, don't focus on the dynamics of the disease process and give your power over to the fear that is generated and reinforced by the disease. Try to understand the circumstances that might have led to the affliction in the first place. Try to recall that, before the affliction, your natural state was health. Do all you can to cooperate with your healing system so it can do its job properly for you. Remember that, as long as you are alive, you have a healing system with the capability to restore your body to its natural state of health.

Obstacles to Healing
Factors That Interfere with Your Healing System

I frequently meet people who tell me that they have tried every conceivable form of treatment and method for healing, and they still are not getting better. Upon further questioning, I often find that these people have not given these methods sufficient time to work. For

this reason, I strongly recommend that you give each healing method you select at least a six- to eight-week minimum trial period to notice improvement before you dismiss it as ineffective for you.

It is also important to remember that although external agents of healing can be important, your greatest resource for healing is the activation and stimulation of your body's own healing system. This is an internal job that requires commitment, courage, persistence, patience, and a willingness to acknowledge that, together with your body, you also have a powerful mind and a spirit. Solutions to difficult physical problems usually require that you utilize all aspects of who you are for healing.

If you are currently afflicted with a disease or illness, and you have been trying hard but still are not getting better, consider the physical, mental, emotional, and spiritual obstacles that could be keeping you from achieving your goal. Some of the physical obstacles to healing are

- An unhealthy, unwholesome physical environment, including poor air, poor water, irritating noise, overcrowded surroundings, and pollution, such as chemical pollution, microwave ovens, X-rays, and toxic waste
- A poor diet
- Not enough water in your diet
- Poor hygiene
- Not enough exercise and movement, including stretching
- A lack of space, privacy, or solitude
- Inadequate relaxation or rest
- Poor breathing
- Not enough contact with nature
- An absence of touching in a loving way (no hugging, physical intimacy, or warmth)

There are many potential mental obstacles to your healing, as well. Some of the more significant are

- Chronic mental tension, anxiety, fear, or worry

- Lack of focus
- No time spent in reflection, contemplation, or meditation
- Lack of gratitude for one's life and good fortune, whether big or small
- Poor mental attitude, including harboring a grudge ("chip on the shoulder"), being cynical, and having a pessimistic outlook
- Unresolved anger, hostility, or resentment
- No sense of humor
- Excess attachment to people or things
- Too much focus on goals and not enough focus on the process of getting there
- Worrying about the future, lamenting the past, or not being in the present

The potential emotional and spiritual obstacles to your healing are numerous. They include

- Self-punishment, self-blame, guilt, shame
- Self-destructive thoughts
- No love or joy in your life
- No sense of freedom in your life
- No support system, including family, friends, confidants, community
- No sense of purpose
- Lack of spirituality, universal wisdom, and prayer
- Lack of meaning and fulfillment in life
- A broken spirit

You can see that many elements in life can either contribute to your healing or interfere with your healing, in addition to the specific treatment you're undergoing. The first step in overcoming any obstacle is recognizing it. If you recognize any of these obstacles as ones that might be standing in your way, use this knowledge and the condition-specific guidelines that follow in this section of the book

as an opportunity to activate your healing system and regain your natural state of health.

A Word About Hereditary Conditions, Familial Diseases, Genetic Disorders, and Congenital Problems

Many diseases and conditions appear over and over again in families and therefore are thought to be genetic in origin. However, there is a difference between *familial* and *genetic* conditions. Although defective genes and inherited disorders do exist, it is important not to lump all diseases that turn up again and again in families into these genetic categories.

Identifying genetic disorders can help prevent the possibility of their occurrence, but to over-generalize and label all serious diseases that run in families as genetic is dangerous. This label causes people unnecessary helplessness and hopelessness. Many diseases that run in families are not the result of genetic factors but rather are based on deep-seated, maladaptive behaviors, attitudes, and emotions, and on psychological coping mechanisms that express themselves in poor personal health habits and self-destructive tendencies. Family members and subsequent generations can avoid and overcome these conditions. Do not feel bound to inherit your parents' or families' disease-oriented, maladaptive legacies; rather, realize the full potential of your body's natural state of health and the incredible healing system that you have to help you.

Congenital conditions, such as cerebral palsy, often can be traced back to unfortunate events or trauma sustained at birth or while a child was still in the womb. And even though the management of these difficult conditions can often be trying, many such problems can be prevented with proper prenatal education, care, and preparation for childbirth.

Getting Started

A Daily Program for
Enhancing Your Healing System

It is said that a journey of a thousand miles begins with one step. Even though the first step and each subsequent step along the way may seem small and insignificant, when they are added together, they eventually take you to your final destination. In the same way, the following daily program to strengthen and fortify your healing system provides a starting point on your journey toward improved health. At first, the activities that make up this program may seem quite ordinary and not very significant or life-changing. When combined and continued over time, however, they can make a huge difference in your health. In short, they can create extraordinary healing. After just 10 days of following this program, you will notice a marked improvement in your health, and you should experience a much greater sense of well-being.

A word before you start: Because your healing system is vast and complex, you should not consider this program all-inclusive. As you apply the activities in this program to the rhythms of your own life, you will want to use the methods, techniques, and information described in earlier chapters to suit your own particular health needs. Be flexible and practical when you use this program. You need to arrange the order of daily activities, and the types of activities, to fit into your daily schedule. For example, with breathing,

relaxation, guided imagery, meditation, or prayer, you might be starting out with 5 to 15 minutes a day that you can do in the morning before work. But you can gradually build up to at least 30 minutes, once or twice a day; when you do that, you might then have to do these activities in the evening. If you are suffering from a serious illness, it will be most beneficial for you to do these activities whenever you have the time to do them for at least 30 minutes.

In terms of the dietary suggestions, experience has shown me that each person has his or her own specific nutritional needs. For this reason, I don't advocate only one type of diet for all people. I honor the ancient axiom, "One man's meat is another man's poison." Although I do make some general dietary suggestions, do not adhere to them so strictly that you ignore common sense. For instance, if you have a fever, you need to drink lots of fluids and abstain from eating solid foods until the fever passes. If you suffer from a specific digestive disorder, follow the dietary guidelines in the sections in the earlier chapters that describe in more detail what and how you should be eating. When it comes to diet and nutrition, listen to the voice of your body's inner intelligence; that voice is closely connected to your healing system.

If you have a question about any activity in the daily program, refer to the earlier chapters in the book. They describe in more detail how each activity benefits your healing system.

Strengthening and Fortifying Your Healing System in 10 Days

In the Morning

Personal Hygiene for Your Healing System

Personal hygiene consists of the daily cleansing that strengthens and fortifies your healing system. Over a lifetime, your personal hygiene accumulates to wield a powerful influence on your health. In addition to brushing your teeth and other related activities, take a bath or shower each morning. Bathing supports your healing system by cleansing and protecting your body; keeping your skin healthy and

free from dirt, germs, and other potentially harmful microorganisms; and aiding in the elimination of toxins.

Elimination (Moving Your Bowels) for Your Healing System

In addition to urinating, it is important to move your bowels each morning. Doing this prevents unwanted waste and toxins from building up and helps keep your internal environment clean and healthy. Regular daily bowel movements reduce the burden on your healing system and make it easier for it to perform its duties of repair, reconstruction, and regeneration more efficiently for you. Here are a few tips to aid the process of elimination:

- Drink a cup of warm liquid (water, tea, decaffeinated coffee) to help move your bowels. You may need to drink several cups until you get a result. Warm beverages are better than cold because heat relaxes the smooth muscles in your intestines, enabling them to expand and dilate. As the warm fluids help flush the fecal material through the more relaxed and expanded bowels, unwanted waste products can be eliminated faster and more easily. Cold liquids, in contrast, constrict the muscles in the intestines, which narrows the opening of the bowels, and so they are usually not as effective in aiding the processes of elimination.

- If you are frequently constipated or suffer from irregularity, and you need more than several cups of warm liquids each morning to move your bowels, stir one or two heaping teaspoons of psyllium seed husks, or any other gentle natural fiber supplement, into a glass of warm water and drink it each night before you retire.

- If you want to prevent constipation, eat a healthy diet with lots of fluids and fiber, which you can find in fruits, vegetables, and whole grains and legumes. Soups at lunch or in the evening, along with herbal teas, are also ideal for this purpose.

- Although it is sometimes unpopular, okra, eaten either at lunch or dinner, is one of the best vegetables to help ensure healthy elimination in the morning. Lightly steamed or cooked, okra is one of the gentlest and most effective of all natural food fibers in the world.

Gentle Stretching for Your Healing System

Stretching helps to loosen up and tone your muscles and joints, and to improve circulation. By increasing flexibility in your joints and limbs, stretching can also improve lymphatic drainage in your body and stimulate your glands. When your muscles are lengthened and their flexibility is increased, space for the passage of nerves increases. Gentle, regular, systematic stretching often relieves pinched nerves. Stretching can keep your body lithe, young, and free from disease, and it is one of the best methods I know for strengthening and fortifying your healing system.

- Stretch for 5 to 15 minutes each morning, following the guidelines provided in the section on stretching in this book. You may also find it beneficial to stretch in the evenings. Stretch on an empty or light stomach, not right after eating.

- You can start stretching with the help of a yoga book or video for beginners, or you may want to sign up for a beginner's yoga class. If you've never done yoga before, or you have specific health issues, make sure you tell the instructor so he or she can accommodate your needs. (If you have back problems or are stiff, try my comprehensive yet gentle stretching routine called the Back to Life Stretching Program, which you will find in my previous book, *Healing Back Pain Naturally.*)

Breathing, Relaxation, Guided Imagery, Meditation, Quiet Reflection, or Prayer

All of these activities help to relax your body, calm your mind and nervous system, relieve stress, and strengthen and fortify your healing system. They can also help you discover a higher power that organizes and directs the flow of energy in the universe and in your body. Attuning your awareness to this force can be extremely empowering for your healing system. A great time to do these activities is right after stretching, when your body and mind are already in a naturally relaxed condition.

- Take 5 to 15 minutes each day to sit in a quiet place, relax your shoulders and entire body, and close your eyes. Begin by watching

your breath flow in and out of your nose. You can practice one or more of the breathing techniques described in the section on breathing. These techniques will help to calm and focus your mind and nervous system, bringing them into harmony with your healing system.

■ Once you feel calm and relaxed, try one of the guided imagery/visualization techniques described in this book. Allow your awareness to go into the interior of your body. As you focus your mental energies on your body's internal structures, imagine your healing system springing into action to help repair any damaged tissues as it restores your health and vitality.

Exercise for Your Healing System

Exercise helps your healing system by toning the heart, strengthening circulation, and improving mental health. Morning exercise is a great way to start the day. If you are not already doing so, try to find a way to fit morning exercise into your schedule.

■ Each day, do 15 minutes of simple walking, swimming, bicycling, jogging, aerobics, calisthenics, or any other exercise. If you feel like doing more, or are used to doing more, do so. However, if you are new to exercise, or you haven't exercised lately, it is better to start out gradually. Do not to force or strain when you exercise. Observe your breathing to see whether you are overdoing it. When you exercise, you should be comfortable with your breathing. Remember, slow and steady wins the race. For maximum benefit to your healing system, gradually build up to 30 to 60 minutes a day, three to six days a week.

Breakfast for Your Healing System

Eat a light, healthy breakfast each day. If your job requires a lot of physical activity and greater caloric intake, use your common sense and eat more. If you have a sedentary job, such as a computer operator or office worker, eat a lighter breakfast. If you are overweight or normally eat a larger lunch, you may want to skip breakfast and just drink water or juices. Here are other suggestions for breakfast:

- If you are on a carbohydrate or starch-restricted diet, eat lean protein and vegetables, and drink warm fluids such as herbal teas, decaffeinated beverages, and soups.

- If you are not a diabetic or not on a carbohydrate-restricted diet, eat fresh fruits, whole grains, and organic cereals, which can help reduce sugar cravings later in the day. These foods also provide key caloric energy and contain a host of vitamins, minerals, and trace elements, as well as essential fiber and fluids to aid your healing system. If you're allowed to have natural sugars in your diet, try dried fruits, including raisins, figs, dates, and apricots, and organic, naturally sweetened jams and jellies in limited quantities. These foods can be nourishing and healthful.

- You can also add small quantities of nut butters, such as peanut, cashew, almond, or sesame tahini, or other protein sources for breakfast.

- You can also eat dairy products, such as yogurt and low-fat cottage cheese, in limited quantities if you are not lactose intolerant or do not have other dietary restrictions.

- If you are diabetic, eat more protein and whole grains for breakfast, and avoid sweets of all kinds. Breakfast proteins and grains could include a whole-wheat bagel, or rice crackers with cottage cheese. You can also eat other proteins, such as nut butters. These foods will provide long-lasting fuel throughout the day without drastic increases in blood sugar. Natural sweeteners, such as *stevia,* also are available that can satisfy your sweet cravings while not increasing your blood-sugar levels.

- Avoid sweet, starchy, oily breakfast items such as donuts or pastries.

- Taking a natural supplement or daily vitamins may be appropriate, especially if you're not getting all the nutrients you need from your regular diet. (Review the section on vitamins and natural supplements earlier in this book for more information.)

Remainder of Morning and Afternoon

If your work takes you away from home, you can still find simple, easy ways to strengthen and fortify your healing system, even

though your schedule may be hectic. Even if you stay at home, try to incorporate the following activities into your morning routine.

Breathing, Relaxation, Guided Imagery, Meditation, Quiet Reflection, or Prayer

Throughout the day, because of your mind's influence on your healing system, which operates best in a calm, quiet, and relaxed internal environment, it is important to keep your mind calm, cool, and collected. Breathing, relaxation, guided imagery, meditation, quiet reflection, and prayer are ideal methods for helping to keep your mind tranquil. The more you practice these methods, the easier it will be for you to retain your composure and keep your healing system strong and vibrant.

- Take short, 30-second to one-minute breaks at least once an hour to calm your mind by practicing one or more of the methods for breathing, relaxation, guided imagery, meditation, quiet reflection, or prayer that are described in this book. In the beginning, you may need to experiment with several of these options to find out what works best for you. After you have found one that works for you, learn one or more of the other techniques, as well. I usually recommend giving each technique at least a one-week trial, until you are comfortable with it and have noted its positive benefits.

- During stressful times, or when you feel yourself becoming upset or losing your composure (especially in the presence of another person), momentarily excuse yourself and retreat to a safe, peaceful place. Once you are out of harm's way, practice one or more of these peaceful, calming techniques. After you have calmed down, you will be in a much better position to deal with your situation.

 One of the tricks to this strategy is learning how to recognize when you are first beginning to lose your composure. When you lose your composure, in addition to your mental agitation, you will most likely experience one or more of the following symptoms:

 - Rapid, fearful, or angry thoughts

+ Shallow, rapid breathing
+ Rapid heartbeat
+ Increased perspiration
+ Queasy stomach ("butterflies in your stomach")
+ Weak knees

From your earlier reading, you might recognize these symptoms as part of the fight-or-flight response, which, if allowed to continue or escalate, can interfere with your healing system and cause harm to your body, especially if they are sustained over a long period of time.

In my work as a doctor, these strategies are particularly helpful. For example, I sometimes meet new patients who have a lot of anger and are quite upset at "the medical system" in general and doctors in particular. They may be upset for other reasons, too, of which I may not be aware. In these situations, I am a prime target for their anger. Sometimes, the slightest thing I say can trigger a huge explosion of angry emotions. Naturally, this reaction from a patient will cause a wave of fear and anger to well up inside of me, too. In this state, I could easily retaliate with fear and anger of my own, but I try to stay composed. When I notice my heart rate speeding up, my breathing getting shallower and rapid, and my mind becoming agitated, I excuse myself and quickly retreat to the safety of another room. There, I close my eyes and do one or more of the following: breathing, meditation, relaxation, imagery, or prayer. I do this until I feel my breathing and heart rate slow down, and I am able to regain my composure. Usually, a maximum of five minutes is all that I need. Afterward, when I go back to see the patient who has provoked me, I am more relaxed and comfortable, and better able to help the patient.

Water for Your Healing System

Your body is 70 percent water, and because water constantly circulates throughout every cell, tissue, and organ in your body, the more water you introduce into your system, the faster it can distribute nutrients and eliminate toxins. Drinking water and fluids is one of the best ways to strengthen and fortify your healing system.

- Throughout the day, sip water or other fluids, such as juices or herbal teas.

- Drink six to eight glasses of water, or the equivalent, over the course of each day.

A Mid-Morning Snack for Your Healing System

You might need a light, mid-morning snack if your work requires you to take a late lunch, or if you have a fast metabolism and are prone to blood-sugar swings. It is important to listen to your body when it comes to getting the nutrition you need to function at your best. Here's some advice about mid morning snacks:

- Don't eat if you're not hungry.

- You can eat fresh fruits, carrots, wholesome crackers, or an herbal tea or other beverage if you feel you need to eat something before lunch.

Lunch for Your Healing System

For most people, eating a healthful, wholesome lunch is important. In many cultures around the world, lunch is the main meal of the day. To ensure a steady flow of nutrients and optimum fuel for your healing system, take the time out of your busy schedule each day to eat lunch. Skipping lunch is generally not recommended. And just as proper food is essential fuel for your healing system, eating that food in a way that optimizes its digestion is equally important. The following suggestions should be helpful:

- Avoid fats and oils, as well as processed snack foods, which are heavy and often difficult to digest.

- Try a cup or bowl of soup.

- Try a hearty salad, but avoid rich, oily dressings or toppings.

- If you eat carbohydrates, a healthful sandwich with fresh lettuce, tomatoes, sprouts, cheese, tofu, tempeh, or any other lean protein can often be a complete meal in itself. Eat breads made from whole grains, such as wheat, barley, rye, and oats.

- If you are not diabetic or on a sugar-restricted diet, a fruit

dessert will provide an adequate balance of essential nutrients, including vitamins, minerals, trace elements, fluids, and fiber.

- You can take water or another liquid with or immediately following your meal.

Here are a few more tips for eating lunch:

- If you are at the workplace or at home, take a break and focus solely on eating and digesting your food. Turn off your computer, TV, or radio, and make sure you aren't talking on the phone or reading a magazine or newspaper when you eat.

- When you are eating, your body needs to concentrate on the process of digestion. It should be a time of rest and relaxation, and you should devote all your attention to the process of eating. If you continue to talk on the phone, drive, or work on the computer while you are eating, you won't be able to feel your body's response to the food you are consuming. When your mind is in more than one place at a time, it is hard to fully taste your food. It also is easy to overeat and experience indigestion under these circumstances.

- If you eat with coworkers, family, or friends, lunch can be a pleasant social occasion. Avoid arguments, conflicts, or talk of business or finances. The mood and atmosphere should be pleasant and uplifting. Your emotional state at the time of your eating affects your digestion.

Consider an Afternoon Nap for Your Healing System

Studies show that most Americans are sleep deprived. Sleep deprivation has been linked to numerous chronic diseases, including heart disease. It has also been linked to accident-prone behaviors. Your healing system performs most efficiently when you are sleeping or resting, and an afternoon nap can be an effective way to help strengthen and fortify it. Most cultures around the world eat their largest meal at lunch time, followed by a nap, or siesta. This is a time-tested method to help optimize digestion. If you can, take a light nap after lunch.

In the Afternoon

Play, Fun, and Hobbies for Your Healing System

Not enough can be said about the health-promoting effects of a playful attitude, a sense of humor, and the ability to have fun. Bob Hope and George Burns, both famous comedians, each lived for 100 years by cultivating light-hearted attitudes. They pursued lives of fun and laughter while they tried to make others laugh. And as we discussed earlier, well-known doctor and author Norman Cousins cured himself of a painful, life-threatening disease with laughter and a little vitamin C. Humor and a light-hearted attitude can add years to your life, and they are powerful stimulants for your healing system.

Keeping your spirits light throughout the day is important. If you are working long, hard hours or are having an extremely difficult time in your life, you don't have to be serious all the time. Seriousness creates tension, which can drain vital energies away from your healing system and lead not only to disease, but also to pain. Keeping your spirits light will have a powerful strengthening and fortifying effect on your healing system. Here are a few tips for keeping your spirits high:

- Do at least one fun activity each day, for at least 30 minutes, preferably longer. Here are some suggestions:

 - Find something funny to laugh at. Share a joke with your family or coworkers.

- Watch a comedy movie, or engross yourself in a favorite personal hobby, such as painting, sewing, quilting, jewelry, or model-airplane building.

 - Play or listen to uplifting music.
 - Dance to your favorite music.
 - Play with children.
 - Go to a musical production, a movie, a play, or a sporting event.
 - Participate in your favorite sport.
 - Read a favorite book.
 - Write in a journal.

Social Activities for Your Healing System

Man is a social creature, and for this reason, it is important to stay connected to other people. Conversely, social isolation creates stress, which can lead to disease, both mental and physical. For example, heart disease, the number-one killer in the Western world, has been linked to feelings of social isolation. Studies have shown that heart patients who live alone fare much worse than heart patients who have connections with family, friends, or pets. To further illustrate this point, consider that, even among hardened criminals, solitary confinement, which is nothing more than social isolation, is one of the most dreaded of all forms of punishment.

Social support is important to help strengthen and fortify your healing system. Plan to spend time each day in an activity that supports your feelings of being connected to others. Try one or more of the following:

- Make a special effort to call or write a close, trusted friend or family member.

- Tell a loved one or a family member that you love them, even if doing so at first feels awkward or phony. The more you do it, the more real it will feel, and you will soon become comfortable saying it. What you give comes back to you, so you are really only telling yourself that you love yourself. The same principle applies to any other loving act of kindness.

- Give hugs to your family members, friends, and coworkers. Don't do it for their benefit, even though they will like it, but for yours. Nothing heals like love, and nothing stimulates your healing system more powerfully than love. Love starts with you.

- If you have the time, you can volunteer at least once a week at a senior citizens' center, hospital, library, school, local day-care center, or one of hundreds of other charitable and community organizations. You could also lend your special talents and energies to any of a number of state, national, and international organizations. Make a commitment to take the time to get involved in one or more of these types of activities. Your healing system will benefit from these activities, so do them first for yourself, knowing also that others will later benefit from your generosity.

Rest and Alone Time for Your Healing System

In sharp contrast to what I recommend for social connectedness, I also feel it is important to learn how to socially withdraw, to rest and be alone. Many people spend practically every waking moment taking care of others, or they are involved in too many activities that leave them emotionally, mentally, and physically drained. This pattern can result in chronic fatigue, "burnout," and even serious illness. If you are one of these people, it is imperative to learn how to say "No" to others and carve out a chunk of daily time for yourself. To rejuvenate your health, recharge your batteries, and strengthen and fortify your healing system, doing this is a basic necessity of life. Here are a few tips:

- Each day, take 10 to 15 minutes to be alone, shutting yourself off from the world and the constant onslaught of others. Make arrangements to have trusted family or friends perform your duties and take on your responsibilities during this period. Find a safe, quiet, uplifting place, either outdoors in nature, or in a room in your house or apartment.

- You may wish to use this time to meditate, breathe, pray, paint, listen to music, or do absolutely nothing.

- Honoring your special time alone, which your healing system requires to maintain its strength and vigor, is important. If you don't insist on the right to be alone to rest and rejuvenate, your healing system will have difficulty functioning optimally.

In the Evening

Dinner for Your Healing System

Try not to eat too heavy, or too late. Eating heavy or late will cause indigestion and disturb sleep, causing you to wake up tired and low on energy in the morning. In addition, eat peacefully, without the TV or stereo blaring, and without discussing business or other potentially stressful topics. Keep the family dinnertime conversations light and harmonious, which will improve digestion while it strengthens and fortifies your healing system.

Here are a few suggestions for dinnertime meals:

- Try a vegetable soup, such as squash, split pea, or carrot, which can be hearty, nourishing, and soothing.

- Try a dinner salad, with leafy greens such as lettuce, spinach, and one or more vegetables, including tomatoes, cucumbers, olives, mushrooms, artichoke hearts, or garbanzo beans (chickpeas).

- You can eat cooked whole grains, such as fluffy brown rice or barley, or organic pasta, separately or mixed together with a vegetable or protein side dish.

- A vegetable casserole or mixed-vegetable stir fry can be tasty and nourishing. You can add tofu, a touch of light cheese, or another lean protein. Minimize the use of heavy oils and butter when you cook these dishes.

- You may also have a light dessert such as yogurt, sherbet, or fresh fruit. (If you are diabetic, you can have a light dessert with a sugar substitute.)

- Drink water either before or after dessert.

Emotional Well-Being for Your Healing System

As we discussed earlier, emotions are powerful sensations of energy felt in the body. For healthy living, most emotions need to be released and expressed in your life. If they are suppressed and allowed to remain in your body longer than is necessary, or dragged around as energy-draining emotional baggage, emotions can severely hinder the work of your healing system and can contribute to illness. To know how you are feeling at any given moment, and then have the courage to share these feelings with others, is one of the most powerful ways to strengthen and fortify your healing system. Here are some suggestions for expressing your emotions in a beneficial way:

- To learn to express your emotions in a healthy way, it is often helpful to join a group and learn to participate in group activities. Join a group that meets at least once a week, or, if you have the time, more often. The group could be a support group or a therapeutic group. It should be a group that you feel comfortable and safe with, a group that you feel will not sit in judgment

of you should you choose to air your "dirty laundry" in public. Many non-alcoholics join AA (Alcoholics Anonymous), which has groups in nearly every major U.S. city, just for the sake of being in a group and learning to share their feelings. Take the time to find out about groups in your area, and make a commitment to participate in one.

- If you are not comfortable in a group, or you cannot find one in your area, professional counseling is available and might be offered through your house of worship, local YMCA or YWCA, or other community organizations. One-on-one counseling, especially with an effective counselor, is also a valuable way to express your feelings. Find out about counselors in your area, and make a determined effort to participate in this activity.

- Get a small notebook and pen, and start writing about your feelings. Writing in a journal, expressing all that is inside of you and all that you are feeling, can often be an effective way to release your emotions, your thoughts, and deepest feelings, even if you write for only 5 to 10 minutes each day.

- Each day, in a conversation with your family, friends, or loved ones, speak from your heart and share your deepest feelings. If you are not comfortable doing this, write a letter to someone with whom you wish to share your deepest feelings.

Spiritual Well-Being for Your Healing System

Your healing system functions best when you are spiritually healthy. Many physical diseases have their origins in the spiritual realm. For example, when your spirits are continually down, you can become depressed, which is a form of mental disease. As noted earlier, depression has been shown to contribute to heart disease, diabetes, cancer, and many other serious ailments.

If you are an atheist, you can still enjoy spiritual health and well-being. Try to connect to a higher cause, purpose, or force other than yourself. Ponder the fact that some intelligent, powerful, creative energy has put you on this planet. Doing this will take a huge burden of stress off your shoulders and allow your healing system to work more effectively. Thinking that everything in the world and your life depends solely on your constant mental vigilance and sur-

veillance creates tension and stress, drains vital energies, and can be emotionally and physically exhausting. These factors conspire against your healing system and can eventually lead to physical illness.

If you believe in God or a higher power, your plight is not much different from that of the atheist. Doubts about God and the Divine still might bombard you when you encounter rough waters or come up against a brick wall, and so it is necessary to continually renew your faith many times throughout each day, and ponder the meaning and purpose of your existence.

- This week, take a brief respite from your work and hectic schedule, and think about your life and its significance. Think about a higher power, a divine, creative, intelligent energy at work in the universe and your life. Do this for at least 5 to 10 minutes each day.
- If you are comfortable doing so, pray for 5 to 10 minutes each day.
- Before going to bed, take 5 to 10 minutes each night to read scriptures or other related books that can uplift your spirits.

Sleep for Your Healing System

Sleep is fundamental to all living things and is an intrinsic part of the natural rhythms and cycles of life. Sleep is a required physiological activity in all living species, a basic biological principle of life. Some animals hibernate and go into a cave to sleep for months at a time to restore their bodies' health and energies; humans generally require between 8 and 10 hours of sleep each day.

Your body requires regular sleep to restore vital energies and to heal. As you may recall, your healing system does its best work when your body is resting. Regular, restful sleep is one the most potent things you can do to strengthen and fortify your healing system. When sleep is disrupted, healing system function is compromised, and ill health can develop. It is not surprising that as sleep deprivation and insomnia increase in epidemic proportions in America, the number of chronic, stress-related diseases, including heart disease, high blood pressure, cancer, and autoimmune disorders, is also increasing.

To ensure proper sleep, try the following:

- Get up early each morning.

 Sleeping late disturbs the natural rhythms of your body and will cause you to go to bed late. This pattern will perpetuate an unnatural cycle that can be harmful to your healing system.

 Getting up early improves your chances of having an active, full day. Having a long, full day will improve your chances of going to sleep at night at a decent hour. A restful, good night's sleep will allow you to awaken early each day feeling refreshed and renewed, with abundant energy.

- Don't engage in agitating or disturbing activities before you go to sleep. (Such activities include watching the news or violent movies.)
- Avoid late-night arguments or conflicts with your partner or family members.
- Make sure your bed is comfortable.
- Make sure your bedroom or the place where you sleep is clean, neat, and peaceful. A clean, orderly environment reduces confused, chaotic mental stimuli and allows the brain, mind, and nervous system to relax more effectively. All this brings about a much deeper, more restful quality of sleep.
- If you live in a noisy place, where traffic or other noise is likely, consider using comfortable ear plugs to ensure a good night's sleep.

 Whenever I travel to large, congested, bustling cities, and I'm disturbed by the constant noise of the city at night, I use a simple pair of earplugs while I sleep. Instead of waking up fatigued, foggy-headed, grumpy, irritable, and low on energy, thanks to the earplugs, I can wake up feeling refreshed, renewed, and ready to greet the new day with enthusiasm.

- Make sure the air you breathe when you sleep is fresh and clean. Avoid dusty, foul-smelling, stale air. A good, fresh breeze can do wonders to improve the quality of your sleep.
- Don't eat a late dinner just before you go to sleep. A full stomach and heavily laden digestive system will put pressure on the

diaphragm and lungs and interfere with normal, natural breathing. Many people with sleep disturbances and other illnesses are overweight and have poor, late-night eating habits that cause indigestion and interfere with the quality of their sleep.

- Try a warm beverage before you go to sleep. A warm beverage can be soothing and relaxing, improving digestion, and helping to settle down the nerves. Herbal teas, such as chamomile or peppermint, can be particularly comforting.

- Relaxation, gentle breathing, meditation, imagery, or prayer can help calm and relax the mind and nervous system. When they are performed before bedtime, these methods can be a gentle and soothing way to induce deep, restful sleep.

- Listen to soft, soothing music. Doing this can be relaxing and restful, and can help induce gentle, effective sleep.

- Before bed, read an inspirational novel, book, or scripture, or some other uplifting material. This activity can be comforting and reassuring, and a pleasant way to wind down and relax before sleep. Some people I know read the *Yellow Pages* or *Webster's Dictionary* to help them get to sleep. This method works, I am told, because these books are so boring!

The suggestions included in this "Getting Started" section may seem simple and insignificant, but, when taken together, they will make an enormous difference in your life and the functioning of your healing system. Just five minutes a day of meditation, an uplifting phone conversation with a friend, a cup of delicious soup for lunch, and a good night's sleep can have a great impact on your healing system and your physical, mental, and emotional health.

Conquering Common
Health Conditions

In this section, you'll find strategies and approaches for tapping into, enhancing, and strengthening your healing system to heal a variety of specific health problems. Keep in mind, however, that these recommendations are only guidelines and are not intended to replace responsible, intelligent, personalized professional healthcare. Additionally, because every person is unique, not every one of these recommendations may be effective for you. When I recommend herbal remedies, I often suggest the dosages that are most commonly cited by research findings and my own experience to be both safe and effective, and commonly employed by responsible alternative practitioners whenever possible. I've cited studies that show the benefits of these therapies. Where no study is cited, the recommendations are based on my experience and practice. When you are working with individual healing systems, no simple formula or recipe will work equally well for everybody. In the art and science of medicine and healing, every treatment and therapy needs to be adjusted to meet the unique needs of each person. However, by following the recommendations that follow and incorporating those presented in previous chapters, your chances for success will be greatly increased. Remember that with each malady listed, what is recommended is

not intended to be all-inclusive; additional options might be available for your problem.

For your convenience, the following list of health problems is organized in the simplest way I know—according to the various systems and anatomical regions in the body. This list, while not all-inclusive, represents the most common maladies presented to me as a primary-care physician. If I have omitted a health problem that you may be currently suffering with or are interested in, just follow the general recommendations given throughout the book, and see the "Resources" section at the end. If you learn to work with your healing system to overcome your health problems, you will achieve success in your quest for greater health.

The herbs and supplements listed in this section can be obtained in most health food stores. However, these products are unregulated, and studies reveal that more than 40 percent do not contain the ingredients listed on the label. Ask for information from the manufacturer and buy only those products that have been independently tested. The companies that test such products can be found on the Internet (see the Resources). Be even more careful when purchasing Chinese herbals since many are adulterated and contain contaminants, and have not been tested. You should consult with a practitioner qualified in Chinese herbal medicine. You can obtain most of these products, including Chinese herbal formulas, at www.BalancedHealing.com.

Please remember, herbal and natural remedies can have powerful effects on your body, and some can interact with prescription and over the counter medicines. Some people can experience side effects when taking these remedies. Always consult with your doctor before adding new remedies to your treatment program—even if the therapy is described as "natural."

Skin Problems

Your skin is a reflection of your general state of health. People who are generally healthy exhibit healthy skin tone and color. Conversely, in diseased or weakened states, the skin is often pale or mottled and lacks a healthy sheen. When you have liver disease, for

example, your skin becomes jaundiced and takes on a yellowish appearance. Skin rashes are also often signs of deeper problems. For this reason, doctors have traditionally relied upon the skin for diagnostic clues to deeper internal problems.

Abrasions, Contusions, Lacerations, and Punctures

These four types of injuries are among the most common that the skin sustains, and they are usually present whenever physical trauma of any kind occurs.

Abrasions occur where the skin is scraped, revealing the raw under-surfaces of the skin. Abrasions most commonly occur from falls on pavement or asphalt, and although painful, they usually heal uneventfully if they are kept clean and dry. Several natural herbs applied topically may be helpful prevent infection and speed the work of your healing system with abrasions. A study by Klein and Penneys in 1988 showed that topical aloe vera can reduce pain, itching, and inflammation, and has antibacterial properties. Use the 0.5% cream or gel applied three times daily. Turmeric, a common spice, helps decrease inflammation when used topically. No specific dosage has been determined but it can be found in lotions, salves, and creams. Calendula is a potent anti-inflammatory and can be used in several ways, according to *Herbal Drugs and Pharmaceuticals:* The tea can be poured over an absorbent cloth and applied as a poultice to abrasions, or use 2–4 milliliters of the tincture diluted into 0.25–0.5 liters of water; ointments typically contain 2–5 grams of the herb in 100 grams ointment. Arnica is an anti-inflammatory that also has antibacterial properties, according to *Tyler's Honest Herbal,* 4th edition. It can be applied several ways, based on *Herbal Drugs and Pharmaceuticals*: As a poultice, the tincture of arnica is diluted three to ten times with water; ointments commonly contain a maximum of 20–25 percent of the tincture or 15 percent of the oil; the tincture is usually 1:10, and the oil is usually 1:5 in vegetable fixed oil. All of these topical agents can cause allergic skin reactions, so apply them on an area of normal skin before using on the abrasion.

Contusions are bruises that appear in the form of "black and blue" marks on the skin, which reflect broken blood vessels underneath the surface. Contusions may be accompanied by swelling and

pain, but they usually do not result in a break of the skin. Unless there is damage to underlying tissues, your healing system can repair the damages caused by contusions in a relatively short time. Ice applied for the first 24 hours to minimize swelling, followed by warm saltwater soaks or compresses, can assist your healing system in this work. To possibly accelerate healing of contusions, you can apply a topical Chinese herbal formula called *Qi Li San*; apply with a cotton ball 1 to 3 times daily. According to a study by Barceloux in 1999, taking 50 milligrams of zinc sulfate orally three times per day may double the rate of healing.

Lacerations are full, linear-shaped breaks in the skin where bleeding occurs. Stitches may be required if a laceration is extensive and the bleeding is profuse. Once the edges of the wound are brought together, your healing system takes over and heals the wound, in many cases with barely a scar. Even large lacerations that are not stitched will still heal with the help of your healing system, but they will generally take longer and may cause a scar. To accelerate healing of lacerations, you may apply *Qi Li San* as recommended for contusions above. According to a study by Barceloux in 1999, taking 50 milligrams of zinc sulfate orally three times per day may also double the rate of healing of lacerations. You can also apply unprocessed honey to the wound, 5–10 milliliters twice daily, which works as an antibacterial as well as accelerates wound healing, based on a study by Efem in 1988.

Puncture wounds are stab-type wounds that pierce the skin. If they are not too deep, and with proper care, your healing system can usually mend puncture wounds quite easily. To accelerate healing of puncture wounds, you can apply *Qi Li San* as recommended above.

Abscesses

Abscesses are swellings in the skin, most often caused by a bacterial infection. Many surgeons will lance an abscess with a scalpel, or drain it with a needle. But if you begin treatment in the earlier stages and work with your healing system by applying warm salt soaks (surgeons generally recommend Hawaiian, Epsom, or rock salts, but table salt can also work, in the ratio of one part of salt to three parts of water for 30 minutes, 3 to 4 times a day: see the earlier sections of the book on use of saltwater soaks) and pharmaceutical-grade clay (bentonite)

packs, many abscesses will disappear on their own. Natural sunlight, saltwater compresses, and a non-oily diet can also be helpful in assisting your healing system in healing abscesses. A study by Klein and Penneys in 1988 showed that aloe vera three times daily using a 0.5% cream or gel can also aid the body in healing abscesses.

Acne

Acne occurs in both males and females, most commonly during the onset of puberty, but it may linger for many years. Acne is caused by minute infections that occur in the oily buildup of the hair follicles. If scratched or picked, acne can cause permanent scarring and be disfiguring. Acne occurs most commonly on the face, which can have tragic consequences if scarring and disfigurement result.

The same natural treatments for abscesses can also be effective for acne. Drying agents, including alcohol, can also be helpful. Oily, fatty, rich diets, along with stress, can make acne worse. People with naturally oily skin need to pay particular attention to their diets. A *macrobiotic* diet (a very low fat, plant-based diet that originated in Japan) can often clear up stubborn cases of acne in a short time. In many cases, conventional medicines may also be necessary. These medicines include topical drying agents, such as those that contain *benzoyl peroxide*, or internal preparations such as *accutane*, a vitamin A derivative, which, when prescribed under the care of a knowledgeable dermatologist, can be highly effective. A study done by May, et al in 2000 demonstrated that tea tree oil is a natural topical which kills acne bacteria and can be used with the above. Start with a 5% solution for mild acne, up to a 15% solution for severe acne, used once daily. If not helpful, use a solution twice a day containing 20% azelaic acid, which is also a topical antiseptic. These topicals may take 1 to 2 months to be effective. Several nutrients can also decrease acne: 200 micrograms daily of selenium and 400 IU daily of vitamin E inhibit acne inflammation, and 45–60 milligrams of zinc daily, using the effervescent sulfate or gluconate forms, improves skin health.

Boils, Carbuncles, and Furuncles

These are infectious swellings in the skin similar to abscesses. Many start with just a simple ingrown hair, but they may become irritated, painful, and often quite large, especially if they are squeezed or

picked. They can also become unsightly, especially if they are on the face or shoulder.

Natural treatments that work best with your healing system include soaking in or compressing with in warm, concentrated salt solutions applying clay packs, exposing to sunlight, treating with alcohol and other drying agents, and keeping all dirt, oil, and bacteria away from the affected area. If boils, carbuncles, or furuncles are severe and are allowed to progress, antibiotics and/or lancing may be necessary to help your healing system repair these conditions.

Burns

Burns to the skin are relatively common, but if they are severe and extensive enough, they can cause much harm, even death. First-degree burns cause redness, pain, and swelling, but no blistering. When blistering occurs, second-degree burns have been sustained. Third-degree burns, the most serious type of burn, result when nerve endings are burned and the sensation of pain is lost. If you sustain a burn and it hurts, consider yourself lucky because it means that you don't have a third-degree burn.

Burns can be extremely painful, but if they are not extensive, your healing system can handle them with little intervention. Burns should be kept clean, dry, and free from excessive moisture and dirt. Topical agents that are cooling, including ice in the initial stages, generally reduce swelling and pain. Antibiotic creams, such as Silvadene cream, or a natural agent such as zinc oxide, can keep the skin from drying out and cracking and prevent infection. If the burn is first or second degree, you can apply 0.5% cream or gel aloe vera three times daily as noted in a study by Klein and Penneys in 1988, or you can splash apple cider vinegar directly on the burn several times a day or soak it in towel and apply for 30 minutes several times daily. A study by Efem in 1988 showed that you can also spread 5–10 milliliters of unprocessed honey twice daily, which promotes the growth of new cells by providing a barrier to moisture, which helps keep the wound hydrated. Enzymes and hydrogen peroxide in honey can aid in removing dead tissue. You can also use a 3% ointment of bee propolis three times a day to improve healing rates. Another study, done by Magro-Filho in 1990, showed that bee propolis helps repair damaged tissue and is antibacterial. A solution

containing aloe vera, tea tree oil, and vitamin E is available that is excellent for instantly relieving pain from burns. (See the Appendix for source information.)

If the burn is extensive, covering it with light gauze dressings and nonstick bandages, and then leaving it undisturbed for at least 24 to 48 hours, possibly longer, might be necessary. Any dressing that gets wet, however, needs to be changed because wet dressings suffocate healing tissues and can promote infection. Pain medications may also be appropriate for 1 to 2 days or more. For second-degree burns with blisters, it is best not to pop the blisters because they serve as a natural protective barrier that your healing system employs to protect the new skin that is forming underneath.

In the later stages of healing burns, you can assist your healing system with natural topical applications such as 0.5% cream or gel aloe vera three times daily, a 10% solution of vitamin E cream, and/or turmeric, the latter which helps decrease inflammation when used topically. There is no specific dosage determined for turmeric but it can be found in lotions, salves, and creams. For another beneficial natural treatment for burns, place comfrey roots or leaves in a blender with enough calendula tincture to make the blades function. Blend into a wet mass. Place the comfrey directly against the skin or spread onto a muslin pad, thin cheesecloth, or gauze bandage. Apply for 20 minutes several times a day.

Cysts

Cysts look very similar to abscesses, but they are often more chronic and have a tendency toward periodic swelling. Conservative treatment is similar to treatment for abscesses and boils, including soaking, sunlight, and using drying agents. Cysts may need to be lanced and drained if they become excessively large or intrusive. Once they have been lanced or drained, your healing system can take over and complete the healing process.

Folliculitis

This common condition represents inflammation and infection of the hair follicles, hence the name, *folliculitis*. Folliculitis looks like acne, but it may show up in areas of the skin away from the face, such as in the groin area or under the armpits. It can be very painful

and itchy and is best treated with salt soaks, clay packs, and natural sunlight. A study done by May, et al in 2000 demonstrated that applying a 10–15% solution of tea tree oil several times a day may accelerate the healing due to its antibacterial effects. If folliculitis is severe and is allowed to progress, antibiotics may also be required.

Impetigo

Impetigo, caused by bacteria and poor skin hygiene, is a rapidly spreading infection with a brownish-colored, crusty rash. Impetigo is common in children and may be spread at day care centers. Bathing and good hygiene help to eliminate the organisms that cause this infection. Once impetigo has been contracted, antibiotics may be necessary to eliminate it. Salt soaks, clay packs, and sunlight can also be effective if it is caught early on. Also helpful is a 0.5% cream or gel aloe vera applied three times daily, based on a study by Klein and Penneys in 1988, or as noted in another study by May, et al in 2000, using 10–15% solution of tea tree oil three times daily. You can easily prevent impetigo by observing good skin hygiene.

Skin Rashes

In certain generalized infections, characteristic rashes appear on the skin as toxins make their way out of the body's deeper structures. We commonly see these rashes in childhood illnesses such as *measles*, *chicken pox*, *rubella (German measles)*, and other viral diseases. If contracted at an early age, these conditions, although uncomfortable, are usually self-limiting and do little harm in Western populations. Certain food allergies and immune-system disorders such as *lupus*, may also show up on the skin in the form of a rash. Even nutritional deficiencies such as *pellagra* can show up as a rash on the skin.

While you are treating any skin rash, it is important to work with your healing system by addressing the underlying causes of the rash. Drinking plenty of fluids, (at least eight glasses a day, will support your healing system in eliminating toxins if an underlying disease is present. There are many other methods to work with your healing system in these cases, such as getting plenty of rest, eating lightly, and taking certain herbs and plant remedies. Natural salves, ointments, and clay plasters applied topically to the skin may also be

helpful. However, it is important to remember that a rash may have deeper origins than just the skin.

Because of its rich nerve supply, your skin is highly sensitive to pain and itching. When a rash itches, you will invariably scratch it, which will only make matters worse. An important part of the treatment of any rash is to stop the itch so the problem doesn't escalate while you are working to discover and treat the underlying causes. You can apply herbal topical creams, such as aloe in a 0.5% cream or gel applied three times daily, as noted in a study by Klein and Penneys in 1988. According to *Herbal Drugs and Pharmaceuticals*, you can also use calendula by pouring the tea over an absorbent cloth and applying as a poultice to abrasions, or take 2–4 milliliters of the tincture and dilute into 0.25–0.5 liters of water or use an ointment containing 2–5 grams of the herb in 100 grams ointment. In 2005, a study by Wand elucidated benefits of a 3–10% solution of chamomile as a poultice. You can also utilize turmeric, which has no specific dosage but can be found in lotions, salves, and creams. You can also apply conventional creams and ointments that contain *hydrocortisone*, and other over-the-counter conventional medicines, such as *antihistamines* or *analgesics*, which can also effectively eliminate itching and prevent the rash from escalating. You can sometimes combine herbal topicals with conventional topicals for better results.

Allergic Rashes

Rashes can appear in response to skin irritants and chemicals such as those found in various sunscreen agents, soaps, and solvents. Rashes can even appear in response to naturally occurring substances found in plants, such as in mangoes, poison ivy, and poison oak. Skin allergies can also result as complications from insect bites, including bee stings, spider bites, and jellyfish stings.

Once again, while you are treating these rashes and controlling the itch and spread of the rash, the key to eliminating them permanently is to identify the offending agent and avoid all further contact with it. (See above paragraph.) Many remedies, both conventional and natural, can be helpful in these cases. If you remove the offending agent and control the itching and scratching, your healing system can usually heal the rash and restore your skin to its natural state of health.

Infectious Rashes

Many rashes are the result of skin infections, most commonly fungal infections such as *athlete's foot* and *ringworm*. Bacterial infections, parasites (including *scabies*), and viruses such as *herpes simplex* (which causes cold sores) also can cause rashes. In each case, prevention is the key to avoiding infection in the first place. For example, fungi and most bacteria prefer wet, warm, dark places to breed and flourish. The feet, groin, buttocks, abdomen, and underarms are common sites of infection from these organisms. Environmental factors also play a role. For example, infectious rashes from fungi and bacteria are more common in the tropics, or during summer, when the weather is often more humid.

Once a skin infection is accurately diagnosed, natural remedies, including a 5–15% solution of tea tree oil, (based on a study done by May, et al in 2000), bentonite clay, ,and other drying agents, in addition to a wide range of medicated creams and ointments, such as a triple antibiotic creams (Bacitracin, Neosporin), are readily available to treat it. Of course, in difficult cases, additional conventional medicines may be required. This is particularly true for scabies. Keeping the skin clean and free from excess moisture, and allowing it to breathe and be exposed to fresh air and adequate sunlight are the best approaches for working with your healing system to prevent and eliminate skin infections.

Nerve-Related Rashes

Because the skin is intimately connected to the nervous system, many chronic rashes that don't easily go away have their origins in such conditions as chronic anxiety, stress, tension, or other emotional and nervous-system disorders. These are often classified as nerve-related rashes, and they include the following:

Eczema

Eczema is a chronic skin condition characterized by intense itching and a scaly, spreading rash that at times can be disfiguring. To aid your healing system, you can best treat this condition by applying topical soothing creams, taking pain medications if needed, and eliminating caffeine and nicotine from your system. You can also use herbs that calm the nervous system, such as Kava kava,

100 milligrams (70 milligrams kava-lactones) three times daily standardized to 70% kava-lactone content* (based on the Cochrane database, 2003), or an excellent Chinese herbal formula called *Ding Xin Wan*. The Chinese herbal has immediate effects but Kava may take 1 to 8 weeks to obtain benefits. Emollient creams and various oily preparations applied continuously to the eczema can help prevent the constant drying out and loss of natural body oils that occur with eczema. Because this skin condition flares up during times of stress and anxiety, stress-management techniques such as meditation, guided imagery, and QiGong/Tai Chi can also be very effective in controlling it. Eating a wholesome diet and drinking lots of fluids can also be helpful with this condition. You can also obtain benefit by taking zinc, especially if your zinc levels are low in blood tests. Start with 45–60 milligrams daily, then decrease to 30 milligrams daily when your skin clears. Omega-3 fatty acids, such as 500–1,500 milligrams Krill oil or 1 teaspoon flaxseed oil daily, can help since omega-3 fatty acid deficiencies can cause or contribute to eczema and because omega-3s also benefit the immune system, according to a study by Meydoni, et al in 1993. Other herbs that may be helpful include two 380-milligram chewable tablets of the DGL form of licorice before meals, grapeseed extract containing 50–100 milligrams of 95% procyanolic oligomeres content three times daily, or 400–500 milligrams of quercetin three times daily, all based on *The American Pharmaceutical Association Practical Guide to Natural Medicines*. These herbs may take several months to have an effect.

Psoriasis

Psoriasis is a chronic skin condition that is common around the knees, elbows, scalp, feet, and back. Psoriasis flares up during times of anxiety and tension. Foods that stimulate the nervous system, such as caffeine and nicotine, can also aggravate this condition. Sunlight is often prescribed for psoriasis, as are suppressive medications and various corticosteroid creams. Addressing the underlying causes through such methods as diet (avoid animal meats and a diet

*Kava root can cause liver injury in some people. Check with your doctor before adding it to your treatment program.

high in protein, and increase your fiber) and stress-management training (such as meditation, guided imagery, or QiGong/Tai Chi), while gently relieving the symptoms of itching and scratching, can often reverse even long-standing cases of psoriasis. Certain herbs and supplements may be helpful in reducing psoriatic lesions. Start with omega-3 fatty acids, which benefit the immune system, according to a study by Meydoni, et al in 1993, using either 500–1,500 milligrams Krill oil or 1 teaspoon flaxseed oil daily, and a high-potency daily multivitamin containing vitamin A (10,0000 units), zinc (30 milligrams), selenium (200 micrograms), vitamin D (400 IU), and vitamin E (400 IU). A study by Syed in 1996 showed that aloe vera extract, 0.5% cream applied three times daily can reduce psoriatic lesions. There are also several natural topicals that can be of benefit, including coal tar shampoos and solutions, calcipritol (related to vitamin D), capsaicin cream (0.025 %), gotu kola (1% solution), or glycerrhetinic acid, which is a derivative of licorice. Other than the coal tar, these topicals must be mixed by a compounding pharmacist. It may take 1 to 2 months to obtain benefits using these supplements.

Shingles

Shingles is caused by the *H. Zoster* virus, which stays in your body in a dormant stage but can flare up during times of stress and/or immune dysfunction. To aid your healing system, you can best treat this condition by applying topical soothing creams and taking pain medications if needed. Try using herbs or medicines that calm the nervous system such as Kava kava (100 milligrams, or 70 milligrams kava-lactones) three times daily (based on the Cochrane database, 2003), or an excellent Chinese herbal formula called *Ding Xin Wan*. The Chinese herbal has immediate effects but the Kava may take 1 to 8 weeks to obtain benefits. Also try eliminating caffeine and nicotine from your system, drinking lots of fluids to flush toxins from your body, and practicing stress-management techniques such as meditation, guided imagery, or QiGong/Tai Chi (*based on the American Herbal Pharmacopoeia*, 1999). Chinese herbal formulas containing astragalus and isatis herbs can accelerate healing due to their antiviral and immune-enhancing properties.

Problems of the Head

Disorders and symptoms in the head are very common. Because the head contains the brain, which is sensitive to subtle changes in your body's internal environment, these problems may reflect imbalances in other parts of the body. For example, with *anemia*, not enough red blood cells and oxygen reach the brain, and headaches may occur. In addition, if you have anemia, you might be unable to think clearly. Weakness, along with dizziness and fainting, especially when you are standing up or making sudden movements with your head, may also occur.

Proper treatment of problems in the head requires understanding the underlying causes and working with your healing system to correct these problems.

Dizziness and Vertigo

Dizziness and vertigo are two common symptoms that, like headaches, may have simple causes or may represent more serious conditions such as brain tumors, impending stroke, heart problems, dehydration, anemia, or infection. They may also signal a metabolic problem such as low blood sugar, as in diabetes.

The most common underlying causes of dizziness and vertigo include dietary imbalance, including excess caffeine or nicotine; problems with sugar metabolism; stress; lack of sleep; muscle tension in the face, neck, and upper back; motion sickness; middle- and inner-ear problems (including a persistent viral infection); and dehydration. When symptoms are severe, nausea and vomiting can result.

Treatment should be directed toward the underlying causes. If a proper medical evaluation determines nothing serious, try working with your healing system by taking a week away from your hectic schedule and focusing on a healthy, wholesome diet with plenty of fiber, less caffeine, and plenty of water. In addition, receive a massage of the upper back, neck, and face, and make sure you get enough sleep. Acupuncture and other natural treatments can also be effective when no serious underlying problem exists or when the cause is inner ear dysfunction. Several Chinese herbal formulas can be helpful; *Wen Dan Tang* or *Wu Ling San* can decrease fluid in the

inner ear that causes a feeling of fullness in the head or ears. *Tian Ma Gou Teng Yin* is helpful for the dizziness. *Ba Zhen Tang* can rebuild your blood stores if anemia is causing your problems. You should see some benefits within 10 days to 3 weeks when taking these Chinese herbs.

Headaches

Headaches are one of the most common reasons people go to see a doctor. And even though most are easily corrected and have simple causes, headaches can be caused by more serious illnesses and problems. The head is a sensitive barometer for physiological imbalances that may be occurring in other parts of your body. For this reason, you should not ignore headaches or merely suppress them with pain medication, particularly if they are persistent.

Headaches might occur as the result of fatigue, dehydration, anemia, indigestion, sinus infections, ear infections, overdoing certain foods or substances such as alcohol and caffeine, and as a result of other conditions, including stress. Headaches also commonly occur during regular monthly cycles of ovulation and menstruation. More serious causes of headaches include meningitis, encephalitis, stroke, and brain tumor. Headaches can also be the result of head trauma that causes increased pressure and swelling in the brain caused by fluid.

Your healing system can heal most headaches once the underlying problems are corrected. However, if a headache is severe, persistent, keeps you awake at night, or interferes with your ability to work or function, it is time to go and see your doctor to be properly evaluated.

Cluster headaches appear predominantly in males and are similar to migraines in their cause and treatment. Cluster headaches commonly appear around the eye on one side of the face, and they come and go in waves of pain. They are also influenced by stress and dietary imbalances, and they often respond well to dietary moderation, including decreased caffeine and nicotine and increased fluids. Massage, particularly of the upper back, neck, and facial muscles, along with acupuncture, chiropractic treatment, and gentle yoga stretching can often help your healing system eliminate cluster headaches.

Migraine headaches can be severe and disabling. Migraines were previously thought to be caused by swelling in the blood vessels of the head, but recent research has shown that they are similar in origin to tension headaches, only more prolonged and severe. Diet and lifestyle, in addition to hormonal fluctuations, may also be contributing factors. In their worst presentation, migraines, with their symptoms of nausea, vomiting, visual disturbances, and loss of balance, might force you to be incapacitated for hours and sometimes days at a time. You might temporarily require strong pain medications. Natural migraine treatment methods that support your healing system include eating a wholesome diet (especially fruits and vegetables), drinking plenty of fluids, and practicing stress-management techniques, such as meditation and guided imagery. Massage, particularly of the upper back, neck, and facial muscles, acupuncture, chiropractic treatment, and gentle yoga stretching are also often effective. Migraine headaches can often be relieved by getting rid of negative "emotional baggage, through psychotherapy or interactive imagery techniques," taking soothing herbs that calm the nerves and relax the muscles, and applying topical heat balms. Several herbs and supplements can prevent or help control migraines. These include 400 milligrams daily of riboflavin (vitamin B_2), based on a study by Schoenen in the journal *Neurology*; 120 milligrams daily of CoQ_{10}, based on research by Sandor and also published in *Neurology* in 2005; a pyrrolizidine alkaloid-free butterbur rhizome extract standardized to 15% petasin and isopetasin in doses of 50–100 milligrams twice daily with meals, again reported in *Neurology* by Lipton in 2004; or 50–125 milligrams of feverfew containing 0.2% parthenolide, as reported in a study by Pfaffenrath in 2002. The butterbur can be taken by children at half the dosage and can be used three times a day if the twice daily doesn't help. It may take several weeks before benefits are obtained.

Tension headaches are caused by stress and tension; they also can be related to dietary imbalances, including excesses of caffeine or nicotine, and other factors. Conventional medicines may temporarily help relieve a tension headache, but most just suppress the pain. Implementing diet and lifestyle changes that reduce tension and stress, practicing daily stress-management techniques (such as med-

itation, guided imagery, or QiGong/Tai Chi), and increasing fluids to eliminate toxins can all assist your healing system in relieving tension headaches. Massage, particularly of the upper back, neck, and facial muscles, in addition to acupuncture, chiropractic treatment, and gentle yoga stretching, can also be effective. Tension headaches are often relieved by soothing herbs such as 50–125 milligrams of feverfew containing 0.2% parthenolide, and 1 milliliter of chamomile three times daily, which calm the nerves and relax the muscles, and by topically applied heat balms. Beneficial Chinese herbal formulas include *Ding Xin Wan* for stress and anxiety and *Chai Hu Mu Li Long Gu Tang* for stress-related headaches. These Chinese herbs work very quickly and can be used as needed or on a continual basis.

Head Injury

Because the brain is so important, head injuries can have serious consequences. With a severe head injury, prompt and responsible action can mean the difference between life and death. When a concussion occurs as a result of head trauma, and there is associated loss of consciousness, the possibility of damage to internal structures always exists, and immediate evaluation and medical attention are required. If no nausea, vomiting, lethargy, loss of memory, undue sleepiness, or other neurological symptoms develop during a 24- to 48-hour period following a head injury, then there is a high degree of probability that nothing serious has occurred internally. If no loss of consciousness occurred during the head trauma, it is also highly unlikely that something serious has occurred. Anyone who has suffered a concussion, with reported loss of consciousness, should go immediately to the nearest emergency room to rule out the possibility of brain hemorrhage or other serious injury.

Amazingly, in spite of the potentially serious consequences, the majority of head injuries are not serious and respond favorably to your healing system's internal repair and restoration mechanisms. As with any other injury, however, your healing system works best when you cooperate with it by getting plenty of rest and making sure you are drinking enough fluids and eating wholesome, nutritious food.

Eye Disorders

Our eyes are the most dominant and important sense organs in our bodies. Additionally, because our eyes are so sensitive, problems in other parts of the body often affect them. In this regard, our eyes are a reflection of our overall general health. For instance, high blood pressure can erode and rupture the fragile blood vessels in the retina, a condition that a doctor can diagnose with a simple eye exam. Diabetes, which also causes changes in the appearance of the blood vessels in the back of the eye, can similarly be detected from a simple eye exam. Because our eyes are so important, a specialty in medicine known as *ophthalmology* exists just to tend to their needs.

Many chronic eye conditions are related to underlying problems elsewhere in the body, so these conditions are often preventable. Many of these disorders often reflect poor overall health, and so working with your healing system to improve your overall health can often improve such eye conditions. For example, when I was a flight surgeon in the U.S. Air Force, it was common knowledge that even among young, healthy fighter pilots, those who smoked had poorer night vision. They were considered a combat risk when they were flying night missions because the increased carbon monoxide and decreased oxygen in their blood as a result of smoking negatively affected their vision.

Good nutrition is very important to the health of your eyes. Vitamin A, which comes from beta carotene and is found in most yellow and orange fruits and vegetables, participates in the chemistry of vision. Eating a diet rich in beta carotene, and taking herbal medicines can help promote the health of your eyes. These herbals include 120 milligrams of bilberry extract twice a day, based on a study by Perossini in 1987; 25,000 IU of mixed carotenoids twice daily and 45–80 milligrams of zinc oxide daily, both based on the *Age-related Eye Disease Study Research Group* in 2001; 6 milligrams of lutein daily, as reported by Richer in the 2004 *Lutein Antioxidant Supplement Trial*; and 50 milligrams of grapeseed extract twice daily, as noted in a study by Bombardelli in 1995. You can take these herbs singly but they are more effective if combined. In addition, regular exercise, which improves blood flow and oxygenation of the

eyes, and specific eye exercises also work with your healing system to promote eye health.

Conjunctivitis

Known as *pink eye*, *conjunctivitis* is a common condition in children that can sweep through schools in epidemic fashion. Conjunctivitis is often caused by viruses or bacterial agents, and it can occur when air quality is poor or adverse environmental conditions are present. It can also be associated with respiratory infections. Conjunctivitis appears as a reddish or pinkish color in the whites of the eyes. Usually only one eye is affected, but about 40 percent of the time it can occur in both eyes.

Conjunctivitis can be itchy and sometimes even painful. In the morning, the crusted secretions that have hardened during the night may cause the eyes to be glued shut. Warm compresses can be helpful to free the glued eyelids.

If you can avoid itching and scratching, your body's healing system can often eradicate this condition on its own in 3 to 5 days. Saltwater eye drops and natural sunlight can be very helpful. A gentle herbal eyewash such as *hyssop* or *chamomile* may also be helpful. Based on *The Review of Natural Products by Facts and Comparisons* (1999), these substances have some antiviral and anti-inflammatory properties. You can place 5–10 drops in water and use two to three times daily or soak a compress and apply against closed eyes. Conventional treatments with anti-itch oral medications, including mild, over-the-counter anti-inflammatory medicines, analgesics, antihistamines, and antibiotic drops can be helpful in preventing complications and controlling the itch as your healing system does its job.

Corneal Abrasions

Corneal abrasions occur when the surface of the eye has been scratched. This can be a very painful condition, as most contact lens wearers know. However, because your eyes are so important, your healing system can initiate a rapid response to these injuries and usually repair them within 24 to 48 hours. If you have a corneal abrasion, an eye patch and antibiotic drops are customarily administered to rest and protect your eye, and to prevent it from

becoming infected while your healing system does its important repair work.

Styes

Styes are small, inflamed swellings that occur as minute infections in the follicles of the hairs that line the edges of your eyelids, commonly known as your eyelashes. Styes are common when dust, oil, or foreign particles clog the pores of the skin near the eye. They are common with carpenters and construction laborers who often work around dusty construction sites. They may also occur when you inadvertently and repeatedly wipe your eyes with oily, dusty, or dirty hands.

Warm saltwater compresses and natural sunlight usually cure styes in 1 to 3 days. Occasionally, in more difficult cases, topical antibiotic drops or ointments may be required. Natural eyewashes may also be helpful. You can place 5–10 drops of *hyssop* or *chamomile* in water and use it as an eyewash two to three times daily, or soak a compress and apply against closed eyes. Based on *The Review of Natural Products by Facts and Comparisons* (1999), these substances have some antiviral and anti-inflammatory properties. Even though they are close to the eyes and can be unsettling, styes are more inconvenient than dangerous, and, thanks to your healing system, they usually heal on their own without any further complications.

Ear Problems

Your ear consists of three distinct parts: your external ear, your middle ear, and your inner ear. Each part carries with it its own special set of problems and, because those problems are treated differently, we will consider each ear part separately.

Impacted Earwax

Impacted earwax is a common cause of hearing problems, discomfort, and outer-ear infections because the wax blocks the ear canal, can trap water, and can prevent sound waves from reaching your ear drum. Earwax serves a beneficial function as both a lubricant to the ear canal and a natural antibiotic. However, to prevent excessive earwax buildup, you can help your healing system by gently flushing

your ear canal with warm water and hydrogen peroxide in a 6:1 ratio, using a bulb syringe readily available from your nearest pharmacy. This flushing should take a maximum of 30 minutes. Ear candling is also becoming popular for this purpose. Most of us have been told never to stick anything in our ears smaller than our elbows, but I must confess that, after a hot shower, if the need presents itself, I will occasionally use a cotton-tipped swab to gently and carefully remove any excess wax that may have formed in my ear canal.

Meniere's Disease

Also known as *labyrinthitis*, this condition is marked by inflammation of the delicate inner-ear structures. Meniere's disease, which affects balance and hearing, is thought to be caused by a virus, which may follow on the heels of a respiratory infection. Meniere's disease often occurs only once, but it may recur from time to time. Natural approaches to inner-ear problems that support the work of your healing system include acupuncture, nutritional support (especially decreasing your salt intake), cranial-sacral therapy (osteopathic manipulation of the sacrum and skull), yoga, acupuncture, chiropractic care, and physical therapy. Based on a study by Cesarani in 1998, the use of 120–240 milligrams of *gingko biloba* daily can help dizziness and equilibrium. Several Chinese herbal formulas can be helpful: *Wen Dan Tang* or *Wu Ling San* can decrease fluid in the inner ear that causes a feeling of fullness in the ears, and *Tian Ma Gou Teng Yin* is helpful for the dizziness. Benefits may be seen within 1 to 3 weeks using these Chinese herbs.

Middle-Ear Infections

Middle-ear infections are quite common in infancy and early childhood, and they can be serious. They often cause fever and pain, and they can be accompanied by loss of hearing, loss of balance, vertigo, nausea, and vomiting. In children, under extreme conditions, a middle-ear infection runs the risk of spreading to the brain and causing *meningitis*. Because the passage that leads to the middle ear, the *eustachian tube*, is directly connected to the back of the nose, middle-ear infections occur as extensions of respiratory infections that may start as a cold, runny nose, sore throat, sinus infection, or chest congestion.

The key to treatment of middle-ear infections involves understanding the relationship between the middle ear and the respiratory system. You must cooperate with your healing system by focusing on prevention, and by treating respiratory infections in their early stages to preclude the possibility that they may spread to the middle ear. Diet can also play a role in preventing middle-ear infections. For example, by reducing intake of fats and oils and drinking plenty of fluids, you can help thin out the mucus, phlegm, and congestion in the respiratory system, which helps the body to eliminate toxins more readily. Good posture, gentle chiropractic adjustments, and deep breathing also appear to improve lymphatic drainage of the middle ear and can help prevent ear infections. Herbal remedies such as *Echinacea* (doses and forms of echinacea differ widely), or 4–7 grams daily of *astragalus* and *wasabe* (Japanese horseradish) may also be helpful. Astragalus has immune function benefits, as detailed in the *American Herbal Pharmacopoeia* (1999) and *Echinacea* has both antiviral and immune benefits, as reported by Barrett in the journal *Phytomedicine* in 2003.When middle-ear infections are in their full-blown stages, antibiotics are usually required, especially to prevent the possibility of meningitis. But avoid the continuous use of antibiotics to treat this common problem.

Noise-Induced Hearing Loss

Hearing loss caused by noise damages the sensitive hair cells in the inner ear that conduct sound to the brain. Such loss is common in people who have worked around heavy equipment and loud machinery, and it is now showing up in ex–rock musicians, who have blasted their ears for years with screeching guitars and loud amplified music. Noise-induced hearing loss is particularly common in people who work around airplanes and man the flight lines at airports. These people are now required by law to wear ear protection to prevent this unnecessary condition.

Hearing aids are common in the elderly and can be effective to help people compensate for inner-ear hearing loss. Delicate surgical techniques involving the implantation of electronic sound-amplification devices are usually reserved for severe cases. Natural approaches to inner-ear problems that support the work of your healing system include acupuncture, nutritional support, cranial-sacral therapy,

yoga, acupuncture, chiropractic care, and physical therapy. The use of specific herbs such as 240 milligrams daily of *gingko biloba* was shown by Burschka in 2001 to improve hearing loss in some cases. Other methods may also prove helpful in certain cases of inner-ear problems, particularly if they are initiated in the early stages of these disorders. Because your ability to hear is a precious gift, and these conditions are often difficult to treat, prevention of noise-induced hearing loss is critical.

Outer-Ear Infections

Often known as *swimmer's ear* infections, outer-ear infections can be extremely painful and are common where people spend a lot of time in the water or where humidity is high. If you develop an outer-ear infection, antibiotic drops and keeping your ear dry to discourage bacterial growth allow your healing system to restore health to your ear, usually in less than 7 days. Several natural eardrops, such as 2–4 drops twice daily of *mullein oil*, are also available and can be effective treatments, as noted by Turker in a study done in 2002. Gentian violet can also be used, mixing 16 drops of 1% solution with 4 tablespoons of boric acid in 16 ounces of isopropyl alcohol or witch hazel and using several drops twice daily. You can prevent or heal outer-ear infections by keeping your ears clean and dry. If you spend a lot of time in the water, you can help your healing system prevent outer-ear infections by applying alcohol and vinegar ear drops, or using a blow dryer after swimming. These can help keep your ears dry, which inhibits bacterial growth and minimizes the possibility of an outer-ear infection.

Perforated Ear Drum

This condition occurs as a result of increased pressure in the middle ear, which causes the eardrum to rupture. Perforated ear drums are common in divers, people who fly when they have respiratory infections, and people who are hit on the side of the head and the ear is traumatized. Symptoms may include pain, hearing loss, a bloody ear canal, and vertigo. Thanks to your body's healing system, if the tear is not too large, a ruptured eardrum will usually heal on its own in a month's time. During this healing period, it is important to sup-

port the work of your healing system by not getting water into your ears, which might cause a serious infection. If the rupture is very large, surgical grafting of a new eardrum may be required; but thanks to your healing system, this is not common because your ear usually can heal on its own.

Surfer's Ear

Known as *exostosis*, surfer's ear occurs when the bones in the ear canal grow together, obstructing the ear canal and causing water to be trapped. This condition can lead to chronic outer-ear infections. Surfer's ear is common not only in surfers who frequent cold waters, but also in skiers, hunters, farmers, and other outdoor-oriented people who live in cold climates.

An operation to scrape away the extra bone growth is conventionally offered; however, if you return to the cold environment after surgery without sufficient ear protection, the bone growth will also return. The recurring bone growth is actually a compensatory protective mechanism of your healing system in an attempt to keep the sensitive and delicate ear drum warm enough to efficiently conduct sound waves so that hearing is not impaired. Ear plugs or other ear protection keeps the ears warm and helps your healing system to prevent this condition from developing.

Tinnitus

Also known as ringing in the ears, *tinnitus* is a problem of the inner ear, and may or may not accompany hearing loss. Tinnitus is a troubling condition not often responsive to conventional medical treatment.

Natural approaches to inner-ear problems such as tinnitus that support the work of your healing system include acupuncture, nutritional support, cranial-sacral therapy, yoga, acupuncture, chiropractic care, and physical therapy. Morgenstern showed in a study done in 2002 that 240 milligrams daily of *gingko biloba* may help some patients with tinnitus. Other methods may also prove helpful in certain cases of inner-ear problems, particularly if they are initiated in the early stages of these disorders. Because your ability to hear is a precious gift, and these conditions are often difficult to treat, prevention is very important.

Respiratory System Disorders

Asthma

This chronic respiratory condition is characterized by congestion, coughing, wheezing, and constricted airways. During flare-ups, these symptoms can be severe and even life-threatening. Throughout the world, asthma appears to be on the rise, a fact that many experts attribute to increasing urbanization and air pollution. Other possible causes and triggers for asthma include respiratory infections, respiratory allergens, aerosol pollutants (including the inhalation of toxic fumes or vapors), climatic changes, dehydration, poor diets, and stress and emotional upheaval, among others. Conventional Western medicine has developed many effective medications for airway management to lessen the strain of breathing for persons who have asthma. Although many of these medications are invaluable, even life-saving, particularly in urgent and emergency situations, most do not address the underlying causes of asthma.

Treatment of asthma includes drinking plenty of fluids to help lubricate the lungs and decrease mucus and phlegm. You can also aid your healing system by breathing good, clean, wholesome air; avoiding dust, irritating aerosol chemicals, and other triggers; and keeping warm to avoid catching a cold. Also, stay away from fats and oils during flare-ups, practice stress-management and relaxation methods, release unhealthy emotions, and practice breathing exercises. All of these steps can be extremely effective in treating asthma. In addition to the medications your doctor may prescribe, natural, alternative medicines and treatments such as acupuncture that work with your healing system also can successfully treat asthma. Supplements that can improve breathing include 200–400 milligrams of *magnesium* three times a day, which acts as a bronchodilator, according to a study done by Ciarallo in 2000. Also in 2002, Bernstein reported that *grapeseed extract*, 50–100 milligrams of 95% PCO content three times per day, can inhibit allergic reactions. In another study by Howell in 1997, 200–300 milligrams of 50% polyphenol content *green tea extract* three times per day was noted to decrease airway resistance and stimulate respiration. Gupta reported in 1998 that *boswellia* (Indian frankincense), 300 milligrams three times daily, improves lung volume, reduces the

number of asthma attacks, and decreases shortness of breath. A Chinese herbal formula that can improve breathing is *Ren Shen Ge Jie San*. You should see some benefits within 3 to 6 weeks when taking these Chinese herbs.

Bronchitis

Bronchitis, one of the most common respiratory infections of the lungs, is most often caused by viruses or bacteria that have slipped past the body's primary defenses and entered into the airways. Bronchitis is characterized by inflammation and infection in the bronchi and bronchial tubes, which are the breathing passages in the lungs. Coughing and congestion are persistent, and fever may also be present. Conventional doctors usually prescribe antibiotics and cough medicines for this condition. (See the section on pneumonia for additional suggestions.) In addition to the restriction of dietary fats and oils, (which produce excess mucus) and increased fluid intake, heat and postural drainage twice a day helps get rid of excessive mucus. Apply a hot towel or wet heating pad to your chest for 20 minutes, then lie facedown on a bed with the top half of your body off the bed. Keep this position for 15 minutes and cough mucus into a basin. Chinese herbal formulas, such as *Ding Chuan Tang*, can also reduce symptoms in acute cases. For recurrent bronchitis, use 400–1,200 milligrams daily of *N-acetylcysteine*, an amino acid derivative that breaks up mucus. This was supported by a study in 2000 by Grandjean published in the journal *Clinical Therapeutics*. For persistent cough, another Chinese herbal formula, *Wen Dan Tang*, is beneficial. It may take several weeks to obtain benefits using these supplements and herbs.

Colds

Common colds are invariably associated with runny noses. When you catch a cold, usually the nose is the first organ affected because the thousands of bacteria, viruses, and other microorganisms in the air first come in contact with your body through the nose. Nasal congestion and inflammation can often be relieved by working with your healing system in several ways. These include breathing good air; avoiding dust, smoke, or polluted environments; keeping warm; eating lightly (focusing on soups and hot teas); and drinking plenty of fluids. Steam inhalation, saline nose drops, and other natural

remedies, including horseradish, onion, garlic, habanero juice, Chinese mustard, and wasabe (Japanese horseradish), can also be effective to help keep your nose and respiratory system healthy. Again, prevention is the key to avoiding the common cold; if this is not possible, your goal should be to initiate treatment in the earliest stages. There are many herbs that can both prevent and treat colds and flu. *Yin Chao Jin* is a Chinese herbal formula that can stop the development of a cold if used when you first get a scratchy throat and drainage. You can use it along with elderberry, 700 milligrams standardized to contain 28% anthrocyanins, 1–2 capsules three times a day. If you have a cold, elderberry can decrease the duration by half, as noted in a study by Zakay-Rones in 2004. Echinacea (no standard dose determined) can reduce symptoms for 1 to 2 days, based on a report by Yale in 2004. Similar effects have been shown by Hemila in 1996 utilizing 1,000 milligrams daily of vitamin C, and by Eby in 1984 using 9–24 milligrams of elemental zinc. All of these herbs must be started within 48 hours of onset to be beneficial. Chinese herbal formulas containing isatis, lonicera, or astragalus can also decrease the severity and duration of both colds and the flu through their immune system enhancement and antiviral properties, based on the *American Herbal Pharmacopoeia* (1999). To reduce mucus, you can use 50–200 milliliters of anise essential oil three times daily, or 80–320 milligrams of bromelain three times a day, as reported in *Herbal Medicine: A Guide for Healthcare Professionals*. For flu, 600 milligrams of N-acetylcysteine twice daily will break up mucus, as supported by a study in 2000 by Grandjean published in the journal *Clinical Therapeutics*. In a study by Josling in 2001, 4 grams of garlic daily helps keep viruses from invading and damaging your tissues, thus shortening the recovery period.

Emphysema and COPD (Chronic Obstructive Pulmonary Disease)

These two respiratory system disorders are usually related to long-term cigarette smoking, but they may also be linked to repeated exposure to asbestos or other chemicals that are harmful to the lungs, especially over a substantial time period. The best way to assist your healing system in the treatment of these conditions includes breathing good air, doing breathing exercises, and drinking

plenty of fluids. Certain natural remedies, including 1,000 milligrams of vitamin C daily and herbs that stimulate repair of damaged tissues, such as *aloe vera*, 100 milliliters in a 50% solution taken orally twice daily (gel form only, not latex), may also be helpful. *Comfrey* has commonly been used in lung diseases because it acts as an expectorant as well as a demulcent, or soothing agent. Dosages have not been established for comfrey, which is usually found in liquid extracts to be taken two to three times per day. Find a product that uses primarily the root rather than the leaves. Several Chinese herbal formulas are beneficial, including *Ren Shen Ge Jie San*, which primarily treats cough and wheezing, and *Si Jun Zi Tang*, used for weak lungs. You should see some benefits within 1–3 weeks when taking these Chinese herbs.

Again, prevention is much more effective and easier than attempting to cure either of these conditions once the disease has established itself. Because of the body's healing system, however, even people with long-term smoking habits can improve their breathing and the health of their lungs if they quit smoking before irreparable damage has occurred.

Pharyngitis

Pharyngitis is an inflammation of the pharynx that frequently results in a sore throat. Pharyngitis often begins when the body is chilled, and bacteria have entered past your body's primary defenses. Often, you will need a prescription for an antibiotic. Other, more natural methods that support your healing system to overcome pharyngitis include eating fewer fats and oils, drinking plenty of fluids, keeping warm, managing stress, and getting adequate sleep and rest. Ginger-root tea can also be very effective in treating pharyngitis. To make ginger-root tea, grate fresh ginger root, put it in boiling water, and steep for 5–10 minutes; then add lemon and honey before you drink the tea. You can also take a Chinese herbal formula called *Yin Chao Jin*, which can significantly decrease the duration of the illness and can prevent its progression if taken at the early stages. To control your sore throat, you can use slippery elm in an alcohol extract (1:1 in 60% alcohol), 5 milliliters three times daily, based on *The American Pharmaceutical Association Practical Guide to Natural Medicines*.

Pneumonia

Pneumonia is an extension of bronchitis and an invasion of the infection into the air sacs and deeper recesses of the lungs. Fever and night sweats are often present with pneumonia, and because oxygen is unable to enter the bloodstream as a result of the infection, overall weakness is common. Before the advent of antibiotics, pneumonia was one of the leading causes of death. As with all respiratory infections, pneumonia is usually a reflection of decreased immune function as the result of certain stresses on the body, such as an unhealthy diet and lifestyle. In addition to whatever medications you might require, including antibiotics, and the use of other natural remedies, such as the Chinese herbal formula *Ding Chuan Tang*, which opens up the airways and decreases sputum and cough, it is important to assist your healing system by following these recommendations:

1. **Drink plenty of fluids.**

 Your body is 70 percent fluid, and so the more fluid you bring into your system, the faster your body can eliminate the toxins from the infection. Additionally, it is important to avoid fats and oils until you are better because they tend to create more phlegm and mucus, which increase congestion and clog your airways.

2. **Keep warm.**

 Your body likes to stay warm, around 98.6 degrees. When you become chilled, your immune system is impaired as a result of the stress of your body attempting to restore proper temperature. You can keep warm by wearing a sweater or windbreaker, drinking plenty of warm liquids such as soups and herbal teas, and avoiding air conditioning, fans, or exposure to cold weather.

3. **Rest.**

 When you are sleep deprived or chronically fatigued, your immune system and healing system bog down and you become more susceptible to illness. It is difficult to get better and heal if you are not getting adequate rest because your healing system does most of its best work when you are resting or sleeping.

Respiratory Allergies

Respiratory allergies come in various forms and commonly afflict the nose and sinuses. A few of the more common varieties include *rhinitis*, *hay fever*, and *allergic sinusitis*. Many people report the source of their allergy to be specific plant materials, such as pollens, grasses, or fungal spores, but many others tend to have worse symptoms while they are indoors. This suggests that chemicals, dust, dust mites, mold, and other potentially allergic material in the ventilation systems at work or in the home may be responsible for most allergies. Additionally, the way people breathe can affect their susceptibility to a respiratory allergy. For example, people who breathe exclusively through their mouths have higher rates of respiratory allergies. This is probably because the air they are breathing does not have the opportunity for the nose to filter and clean it.

Following are six simple tips for helping your healing system eliminate a respiratory allergy:

1. Pay attention to the quality of the air you breathe.

2. Learn to switch to nasal breathing.

3. Eliminate or minimize fats and oils in your diet, including heavy, rich, fried foods, which tend to increase mucus and phlegm in the respiratory system.

4. Try natural plant medicines, such as an extract of butterbur standardized to 8–16 milligrams of petasin used three to four times daily, 50 milligrams of whole butterbur root extract twice daily (as published in the *British Medical Journal* in 2002), or 300 milligrams of stinging nettle leaf extract three times daily, as reported in a study by Mittman in 1990.

5. Reserve suppressive medications, including steroids, antihistamines, and decongestants, for urgent situations only, and don't rely on them for long-term treatment.

6. Try sunbaths, exercise, yoga, acupuncture, chiropractic care, and other natural methods that work with your healing system and that can play a supporting role in managing and overcoming respiratory allergies.

Sinus Infections

Sinus infections are some of the most common of all respiratory infections and one of the most common reasons people visit the doctor's office. Sinus infections occur when respiratory infections, which begin in the nose and throat area, spread to the sinuses. The sinuses are small, cavernous air pockets that play an important role in defense, balance, and buoyancy of the head.

Antibiotics are often prescribed and are effective in acute cases of sinus infection, but chronic conditions respond better to more natural methods that support your healing system. These methods include drinking more fluids; breathing steam; applying saltwater cleanses, sprays, or irrigation; and breathing good air. Natural sun-baths, acupuncture, yoga, gentle massage, and cranial-sacral bodywork may also be helpful to your healing system. In addition, reducing fats and oils in your diet can help. Natural plant remedies such as wasabe, horseradish, Chinese mustard, Echinacea (no standardized dosage determined), and 1–30 grams of astragalus powder daily may also be helpful. Astragalus has immune function benefits, as detailed in the *American Herbal Pharmacopoeia* (1999), and Echinacea has both antiviral and immune benefits, as reported by Barrett in the journal *Phytomedicine* in 2003. (An excellent book about sinus infections is *Sinus Survival* by Dr. Rob Ivker, past president of the American Holistic Medical Association and former chronic sinusitis sufferer.)

Strep Throat

Strep throat is caused by various types of *streptococcal* bacteria and is more common when the weather turns colder, often coinciding with the beginning of flu season. We used to consider strep throat highly contagious, but recent evidence points more toward changes in weather, stress, and compromised host-resistance factors, which lowers immune function.

Under most conditions, strep throat does not affect other organs and systems of the body; however, because of the rare complicating factors that can affect the kidneys and heart, doctors routinely treat it with antibiotic therapy. Again, the key to treating this condition lies in prevention. You can assist your healing system by keeping your body warm, drinking plenty of fluids, avoiding stress, and getting

sufficient rest, sleep, and adequate exercise. Ginger, in addition to other herbs, and saltwater gargles, can also be helpful. For a sore throat, you can use slippery elm in an alcohol extract (1:1 in 60% alcohol), 5 milliliters three times daily, based on *The American Pharmaceutical Association Practical Guide to Natural Medicines*.

Tonsillitis

Until recently, the tonsils were routinely removed if they were continually swollen. We now know, however, that the tonsils perform an important immune function and, if possible, are better left in.

Although antibiotics may be required to effectively treat tonsillitis, dietary management involving decreased dairy, fats, and oils, and drinking plenty of fluids, helps thin the mucus and aids your healing system in eliminating toxins. Keeping warm, getting plenty of sleep and rest, and managing stress all appear to be helpful in aiding your healing system in the treatment and prevention of tonsillitis. Ginger-root tea can also be very effective in treating tonsillitis. To make ginger-root tea, grate fresh ginger root, place it in boiling water, and steep for 5 to 10 minutes; then add lemon and honey before you drink the tea.

Tuberculosis

Tuberculosis (TB) is common where adverse environmental conditions such as poor air quality, lack of sunlight, and inadequate ventilation exist in conjunction with inadequate nutrition, poor sanitation, and lowered immunity. This illness more commonly occurs in developing countries or in populations that are destitute and despairing, such as alcoholics and people who are chronically malnourished.

Treatments exist to cure this illness, but if the underlying causes are not addressed, curative medications may last only temporarily. The problem may come right back after treatment has been completed because re-infection is likely. Conversely, once you cooperate with your healing system by addressing the underlying causes, symptoms of TB will often improve on their own. TB sanitariums, which still exist in many parts of the world, emphasize the importance of daily sunbathing and proper diets, factors that support the body's healing system. You should avoid taking Echinacea, which can make tuberculosis worsen.

Digestive System Disorders

Problems in the digestive system are common and are often the result of a faulty diet, in combination with stress. These problems can range from such common conditions as heartburn, acid indigestion, *esophageal reflux*, minor upset stomach, and *gastritis* to more serious conditions.

You can often prevent and treat these conditions by working with your healing system. This means paying closer attention to the foods you eat, drinking more water, practicing stress-management techniques, and avoiding irritating or harmful substances such as coffee and alcohol. The digestive system is very susceptible to stress because of the sensitive lining of the intestines and the rich nerve supply that connects these structures to the brain and nervous system. Increasing water intake; decreasing irritating and toxic substances such as coffee and alcohol; avoiding or minimizing acidic foods, such as vinegar, orange juice, and citrus juices; avoiding too many fried foods, fats, and oils; and going long periods without any food or liquid intake whatsoever are a few of the specific ways that you can work with your healing system to overcome most digestive system problems. Natural remedies such as peppermint and chamomile tea, *slippery elm*, *deglycyrrhizinated licorice*, aloe vera, and Chinese herbal formulas can also be helpful. Maintaining adequate fluid and fiber intake is important to ensure timely elimination of toxins and waste products while preserving the health of your intestinal tract.

Appendicitis

In this country, *appendicitis* has traditionally been regarded as a surgical emergency because people who fail to receive timely treatment can rupture their appendix and suffer serious and sometimes fatal consequences. In fact, during abdominal surgery for other reasons, a surgeon will often remove the appendix as a preventive measure at no extra charge. Low-residue foods and foods that are highly processed, along with excess fat in the diet, can be contributing factors to appendicitis.

Appendicitis, strangely enough, is not routinely operated on in China, as it is here; rather, if the inflammation is caught in its ear-

lier stages, it is often successfully treated with fluids and certain herbs. Even in this country, if caught early, many cases of appendicitis will respond well to clear-liquid diets. Diets high in fiber and low in fat can often help prevent this problem. Because little research has been done on the dietary influences on appendicitis, however, there is still a tendency to regard surgery as the only solution to the condition. Prevention, including the regular ingestion of adequate fiber and fluids, will help your healing system maintain the health of your appendix.

Colon Cancer

A leading cause of death in the United States, *colon cancer* is remarkably absent in most developing countries where little meat and refined food products are consumed. The now-famous study by Dennis Burkitt, M.D., reported that there were no cases of colon cancer in African villages where people subsisted largely on vegetarian diets. Similarly, in Seventh-Day Adventists, who are known vegetarians, colon cancer rates are very low compared to the mainstream U.S. population.

In addition to diet, apparent contributors to colon cancer are dehydration, chronic constipation, stress, and emotional factors. Learning how to relax, practicing stress management, following the dietary suggestions given above, and instituting measures aimed at good bowel hygiene will aid your healing system and prevent colon cancer from occurring, even if it has a high rate of occurrence in your family. Also to help prevent colon cancer, a colon cleansing every year removes toxins and wastes that accumulate in the colon. There are many products on the market, most containing some or all of the following herbs: apple pectin, slippery elm bark, marshmallow root, licorice root (DGL form), fennel seed, activated willow charcoal, and montmorillonite clay.

Constipation

Constipation is the most common condition of the colon, or large intestines, and is most often caused by poor diet, lack of fiber, not enough fluids, stress and anxiety, and a sedentary lifestyle. The problem with constipation is that it causes toxins to back up in your system, which can contribute to other disease processes. If it is

allowed to progress, constipation can result in *bowel obstruction*, which is a surgical emergency.

Increased fluid and fiber, relaxation and stress management, and increased exercise, which increases blood flow to the colon, are usually quite helpful to your healing system in preventing constipation. Yoga can also be very helpful, especially using the Cobra and Knee-to-Chest poses. You can also occasionally use gentle conventional and natural laxatives for acute episodes of constipation. The best is a combination of psyllium and flaxseed oil. Use 1–2 teaspoons of psyllium in cold water or juice, taken with an equal amount of flaxseed oil. These laxatives work by pulling water into the colon, making it easier to eliminate waste. A study done by McRorie in 1998 showed that psyllium was more beneficial than common conventional laxatives. You can also use herbs that "activate" the colon, meaning that they increase peristalsis, the normal muscle contractions that move wastes through the colon. There are several products available, most of which contain a combination of cape aloe, cascara sagrada, barberry root, senna, ginger root, african bird pepper, and fennel. In addition to these herbs, probiotics may help. These contain beneficial bacteria that help break down food in the stomach, thus making waste removal more efficient. A good probiotic should contain bifidobacteria and acidophilus.

Gastritis

Gastritis results most commonly from a combination of faulty diet and stress. Causes include improper food combinations, eating in a hurry, ingesting certain toxic substances such as strong coffee and alcohol, and certain carbonated sodas, acidic foods, or excessive fried or fatty substances. These substances serve to increase acid production in the stomach, which irritates the lining.

Removing these factors while drinking plenty of water and nonacidic, soothing liquids will aid your healing system in eliminating this condition. Eating more bland and soothing foods, especially during flare-ups, can be beneficial. Cabbage or cabbage juice, along with vitamin A (5,000 IU daily), vitamin E (100 IU three times a day), and zinc (20–30 milligrams daily) increase mucin, which protects the stomach from inflammation according to

Herbal Drugs and Phytopharmaceuticals. Managing stress and using natural soothing compounds can also be quite helpful. These include 100–200 milligrams of *aloe vera* juice or 50 milligrams of aloe extract taken daily (gel only, not latex), or peppermint, chamomile, and slippery elm teas. Based on a study by Madisch and another study by Melzer in 2004, you can also take 2 to 4 chewable tablets (380 milligrams each) of *deglycyrrhizinated licorice* 20 minutes before meals. (Take it for at least 6 to 18 weeks, and take it before meals because it needs saliva to be effective.) Taking probiotics, which contain beneficial gut bacteria, can decrease stomach inflammation by digesting food more thoroughly; bifidobacteria and acidophilus are the most important. Two Chinese herbal formulas, *Ping Wei San* and *Sai Mei An*, are also very effective at reducing stomach irritation. You should see some benefits within 1–3 weeks when taking these Chinese herbs.

Gastroenteritis

Gastroenteritis is a general term that refers to irritation and inflammation of the entire gastrointestinal tract, which includes the stomach and the small and large intestines. Mild cases of food poisoning represent the ingestion of contaminated foods and are among the more common causes of gastroenteritis. Some of these cases can be severe, but most last no more than a few days. Symptoms often include nausea and vomiting, abdominal pain with cramping, and diarrhea. Fever may or may not be present.

Treatment is directed toward supporting the body's healing system, which can flush out the intestinal contaminants with the vomiting and diarrhea, especially if no solid foods are eaten. Take clear liquids in abundance for the first 48 hours, without any solid foods. It is important not to introduce solid food that can feed the offending organisms and slow down your body's healing processes. If fever is present, antibiotics may be necessary for a few days, particularly if you are traveling overseas or are in an exotic tropical locale where your body may not be used to the local flora and contaminants in that part of the world.

The Chinese herbal formula *Bo He Wan* can be taken during the illness and can decrease the symptoms, protect the stomach, and decrease the duration of the illness.

Hepatitis

Inflammation of the liver is called *hepatitis*, and there are many causes for the different types of hepatitis. Cases of hepatitis can be acute and isolated, or chronic and debilitating. *Viral hepatitis* is contracted through various infectious sources. Viral hepatitis now appears in multiple forms, including hepatitis A, B, C, non-A, non-B, and many more. Hepatitis A is usually contracted by eating or drinking contaminated food or water, or through sharing contaminated eating utensils. Most other forms of hepatitis, such as B, C, and others, are most commonly contracted through unsafe sexual practices, contaminated needles, or blood transfusions. *Alcoholic hepatitis* is due to the chronic irritation and consumption of alcohol and can lead to *cirrhosis* of the liver, which causes scarring, abnormal growth, and other complications, including *liver cancer*.

Conventional Western medicine has little to offer in the way of medications to improve the health of the liver. Most treatments for hepatitis, as in chemotherapy for cancer, are aimed at attacking the supposed agents of disease, and they may be even more damaging to the liver than the agents themselves. One such medication is interferon, given for chronic, progressive hepatitis. If you are prescribed this medication, adding 15–25 milligrams daily of phosphatidylcholine can enhance its effectiveness, as shown in a study in 1998 by Niederau.

Diet is extremely important in supporting your healing system when you have hepatitis. Nutritional elements that help support the health of your liver include foods high in beta carotene, including turmeric and all yellow and orange vegetables and fruit. Consuming plenty of fiber and fluids is also important. High-fat diets and low-residue foods seem to aggravate liver conditions. The herb milk thistle, 240 milligrams containing 70–80% silymarin daily can be helpful for chronic active hepatitis, with higher doses (420 milligrams daily) used for cirrhosis, as noted in a study by Ferenci in the journal *Hepatology*. Traditional medicines from India and China also appear to be promising, especially using the herbs schizandra, which lowers liver enzyme levels, and astragalus, which improves the immune response, as noted in *American Herbal Pharmacopoeia*. One or two 380-milligram chewable tablets of *deglycyrrhizinated licorice* before meals, as reported by Abe in 1994 or 800 milligrams daily of vitamin

E and 600 milligrams of N-acetylcysteine twice daily can protect against toxin-induced liver injury through their antioxidant properties. Stress management, visualization and guided imagery, and emotional release of anger can also be very helpful for liver conditions. Because the liver is so important and so difficult to treat, practicing preventive medicine is essential to avoid these liver conditions.

Inflammatory Bowel Disease

Inflammatory bowel disease includes a large category of intestinal conditions such as *colitis, irritable bowel syndrome, spastic colon, Crohn's disease,* and *ulcerative colitis.* Diarrhea, abdominal pain, and cramping are common during flare-ups in patients with inflammatory bowel disorders, which behave similarly to autoimmune diseases. Like other chronic intestinal diseases, these conditions are influenced by dietary factors and stress. During times of stress, the nerves in the intestines can become hyperstimulated and irritate the delicate intestinal lining. For these reasons, these conditions have a higher occurrence in people who are under long-term stress, those who are high achievers, and those with perfectionist tendencies.

Conventional treatments, including drugs and surgery; a combination of stress-management techniques, including guided imagery and visualization; and special dietary practices are most helpful to the healing system in managing these conditions. An effective diet for these disorders is one that is bland, gentle, and soothing, and that consists of adequate fiber. Okra is ideal for people with inflammatory bowel problems because it contains adequate fiber and is also gentle and soothing, a rare dietary combination. Other natural substances that can assist your healing system in helping to soothe and heal inflamed intestinal surfaces in general are water, slippery elm and chamomile teas, 100–200 milligrams of *aloe vera* juice or 50 milligrams of *aloe extract* taken daily (gel only, not latex), and one or two 380-milligram chewable tablets of *deglycyrrhizinated licorice* before meals, the latter as reported in a study by Madisch and another study by Melzer in 2004.

For irritable bowel syndrome specifically, there are several beneficial herbs, including peppermint oil (0.2–0.4 milliliters twice a day), as reported by Liu in the journal *Gastroenterolgy* in 1997 or

flaxseed oil (1 tablespoon daily), reported in a study by Cunnane in 1994, both of which can help bulk up your stool and reduce diarrhea. Or you can take a five-herb formula consisting of chamomile flower, peppermint leaf, caraway fruit, licorice root, and lemon balm leaves, as described in a study by Melzer in 2004. (This formula is a modification of Iberogast, an herbal preparation now available in health food stores.) You should notice improvement within 1–3 months of using these herbs. Other herbs that may also help include fennel seed, buckthorn, rosemary, and chamomile. These herbs are usually found in combination products for IBS. *Magnesium* (400 milligrams daily) is useful for treating abdominal cramps, as well as constipation, as noted by Anderson in the *Handbook of Clinical Drug Data*, 8th edition.

For Crohn's disease and ulcerative colitis, *probiotics*, beneficial bacteria found in the gastrointestinal tract, can be very helpful. Of the probiotics, a study by Plein published in *Gastroenterology* in 1993 showed that saccharomyces boulardi has been proven beneficial for Crohn's disease, and another study done by Ishikawa in 2003 showed the benefits of bifidobacteria for ulcerative colitis. In addition, *omega-3 fatty acids*, found in fish oil and flaxseed oil, can decrease inflammation and also have a beneficial effect on the immune system, as reported in a study by Lorenz-Meyer in 1996. The best omega-3 is Krill oil, 500–1,500 milligrams daily. Other beneficial supplements include *boswellia* (Indian frankincense), 350 milligrams three times daily, as researched by Gupta in 1997, and *wheatgrass juice* (100 milliliters daily), as noted in a study by Ben-Arye in 2002, both of which help reduce bleeding and abdominal pain. Other supplements that can help are antioxidants *glutathione* and *N-acetylcysteine* (one of the components of glutathione). Doses are 250 milligrams daily for glutathione and 600 milligrams two to three times daily for N-acetylcysteine. You can take all of these supplements together, and you should notice improvement in 1–3 months.

Alternative approaches, including Ayurvedic medicine, Chinese herbal medicines, acupuncture, and yoga, can also assist your healing system to help reverse these conditions. *Bo He Wan* is a very effective Chinese herbal formula to control irritable bowel symptoms. *Chien Chi Tai Wan* has been used successfully in all inflammatory bowel syndromes. Addressing problems related to

these disorders early on is important because these conditions can contribute to problems elsewhere in the body. Those problems include anemia, vitamin deficiencies, and syndromes related to poor absorption of essential nutrients; if not brought under control, those conditions can worsen.

Stomach Ulcers and Duodenal Ulcers

Commonly referred to as *peptic ulcers*, *stomach ulcers*, and *duodenal ulcers*, these are areas of the stomach that become deteriorated by stomach acid. Indigestion and abdominal pain in the upper abdomen and lower chest often accompany stomach ulcers, and, sometimes, the ulcers can bleed. Stomach ulcers often have similar causes to inflammatory bowel disease, but they represent a more persistent and chronic imbalance in the digestive system. In recent years, a bacterium known as *H. pylori* has been implicated in the cause of certain ulcers, but stress also is known to be a big factor in these conditions.

In the acute stages of an ulcer, treatment depends on stopping the bleeding if it has already begun. A more long-term approach includes learning how to manage stress and changing your eating habits to support your healing system. Drinking more water and eating a blander, more neutral, gentle, soothing, less acidic, less flesh-oriented diet that consists of non-irritating foods are most helpful. Raw cabbage or cabbage juice is very effective for both preventing and treating stomach inflammation. Eliminate caffeine, nicotine, and alcohol from your diet if you have ulcers. Acting early to institute these measures will help prevent ulcers from developing in the first place. Stress-management techniques and learning how to relax are extremely helpful for the treatment and prevention of ulcers. Many gentle, soothing natural supplements, such as peppermint and chamomile tea, can be beneficial. A study by Terpie published in the journal *Gut* showed that one or two 380-milligram chewable tablets of *deglycyrrhizinated licorice* before meals can help heal ulcers. Slippery elm in an alcohol extract (1:1 in 60% alcohol), 5 millilters three times daily, increases mucus production and protection of the stomach lining, as noted in *Herbal Medicine: A Guide for Healthcare Professionals*. These herbs, in addition to the more traditional antacids and acid-blocking drugs, are often effective to help

your healing system in the short- and long-term management of ulcers. Other natural remedies include honey, which protects your stomach against *H. pylori*, as reported in a study published in *Lancet* in 1993. Taking probiotics, which contain beneficial gut bacteria, can decrease stomach inflammation by digesting food more thoroughly; bifidobacteria and acidophilus are the most important. Yogurt, which contains probiotics, can also he helpful. Two Chinese herbal formulas, *Ping Wei San* and *Sai Mei An*, are also very effective at reducing stomach irritation. You should see some benefits within 1–3 weeks when taking these Chinese herbs.

Urinary System Disorders

The kidneys are the main filters and organs of your body that eliminate liquid waste products. Your kidneys require adequate fluid intake and regular flushing, and they can become unhealthy if you don't drink enough fluids. Other factors that can be harmful to your kidneys include the regular ingestion of certain toxic substances, and long-standing high blood pressure and diabetes, conditions that, if treated early or prevented, will most often not harm your kidneys.

Kidney Stones

Kidney stones are another fairly common and very painful problem. Kidney stones are made of stonelike material that forms in the kidneys and then attempts to pass down from the ureters into the bladder, and from the bladder through the urethra. Kidney stones can be extremely painful, and they almost always cause a small amount of blood in the urine. If kidney stones are large, they can block the ureters and may require surgical removal.

Some stones can be blasted out by sound waves, a technique known as *lithotripsy*. Stress, dehydration, hormonal imbalance, faulty diet, and excess caffeine and nicotine can all contribute to the formation of kidney stones. Stress management, drinking plenty of fluids, and avoiding alcohol and caffeine all help to support your healing system to prevent and eliminate kidney stones.

If you pass a kidney stone, have it chemically analyzed. If it is an oxalate stone, the most common, you can help inhibit oxalate

formation by taking 25 milligrams of vitamin B$_6$, 2 milligrams of vitamin K, and 600 milligrams of magnesium daily. (A high-potency multivitamin should contain these amounts.) Taking 300–1,000 milligrams of calcium citrate daily is also effective. Cranberry juice increases oxalate concentration and should be avoided if you have kidney stones, according to a study published by Terris in the journal *Urology* in 2001. If your stone is made of uric acid, you can take 5 milligrams of folic acid daily to help prevent them.

Urinary Tract Infections

Urinary tract infections include *bladder infections*, which are more common in women than in men and can lead to serious kidney infections. Urinary tract infections can easily be prevented if good bladder and bowel hygiene are maintained. Once you have contracted a urinary tract infection, however, antibiotic therapy is mandatory to prevent further spread and damage to the kidneys. In adult women, the most common activity associated with urinary tract infections is sexual intercourse, and most women instinctively know to urinate after sex to prevent this from happening. Another, more prudent preventive measure is to take a bath or shower in the morning after you have moved your bowels. Doing this will eliminate the bacteria that are associated with these infections. A study done in Norway in 1996 showed that acupuncture can eliminate chronic urinary tract infections in most women. Along with lots of fluids, certain herbs such as *uva ursi*, juniper berries, and other natural substances such as cranberries, can help your healing system maintain the health of your kidneys, bladder, and urinary tract. With cranberries, drink 16–32 ounces of the unsweetened juice cocktail daily for acute infections, or 1–10 ounces daily to help prevent recurrent infections (the capsules are not effective). This is supported by a study published in the *Journal of the American Medical Association* by Haverkorn in 1994 and by another study by Jepson in 2004. Both *uva ursi* and juniper berries are used for acute urinary infections, not prevention. Based on a study by Larsson in 1993, *uva ursi* can be taken as a tea but the typical oral dose is 1.5–4 grams daily of the dried herb. Do not use *uva ursi* for more than 1 week at a time and more than five times per year. Based on *Tyler's Herbs of Choice: The Therapeutic Use of Phytomedicinals*, juniper is an antiseptic (kills bac-

teria) and an aquaretic (increases urine volume). With juniper, take 1–2 grams of the berry three times daily, but do not take it for more than 4 weeks at a time. Several Chinese herbal formulas are also very effective. *Ba Zheng San* is useful for acute kidney infections and *Qing Xin Lian Zi Yin* for long-term prevention.

Female Reproductive System Disorders

The female reproductive system is extremely sensitive and complex. It operates on a cycle, responding to nerve transmissions from the brain and hormonal messages from the pituitary gland. At the same time, it is producing its own hormones in the form of estrogen and progesterone that feed back to these other organs.

Problems in the reproductive system may reflect hormonal imbalances that originate in other parts of the body, and such problems often flare up during times of mental and emotional stress. An unhealthy diet, including excess caffeine, nicotine, and alcohol, and other harmful lifestyle factors may also contribute to problems of the female reproductive system. Sexually transmitted diseases can also damage the reproductive system. To help your healing system maintain the health of your reproductive system, follow the recommendations for overall health given in previous chapters, try appropriate natural herbs, and eat a wholesome, healthy diet. An excellent resource on how you can improve the health of your reproductive system is Dr. Christiane Northrup's best-selling book, *Women's Bodies, Women's Wisdom.*

Cancer of the Female Reproductive System

The female reproductive system is one of the most common sites for cancer to appear. There are two reasons for this. First, the female reproductive system is extremely sensitive and vulnerable, and it intimately interacts with other systems in your body. Second, the cells of this system are some of the most rapidly dividing, active, and volatile cell populations of any tissue in the body. *Cervical cancer, ovarian cancer, uterine cancer,* and *breast cancer* are the predominant types of cancer, male or female, on this earth. I address the subject of cancer and how to deal with it in more detail later in this chapter.

Menopause

It is during this time in a woman's life that ovulation and menstruation gradually end, resulting in diminishing levels of estrogen in the blood. The question of estrogen (hormonal) replacement therapy to prevent osteoporosis and heart disease that can occur following menopause is an ongoing area of debate among experts. Although estrogen replacement may be appropriate in certain cases, it also has an associated risk of increased reproductive system cancer. Because of this risk, the use of natural, plant-derived estrogens and substances that work with the healing system are becoming more popular. These options are generally safer, gentler, and often just as effective as more conventional forms of estrogen. These natural substances include 20–40 milligrams of natural progesterone daily, which can be applied by a cream through the skin, and which can decrease menopausal symptoms and help build bone, as reported in a study by Leonetti in the journal *Obstetrics and Gynecology* in 1999. DHEA is a natural hormone precursor that increases energy, helps decrease menopausal symptoms, helps decrease menopausal weight gain around the midsection, and also improves brain function, based on another study by Genazzani in 1993. Start at 10 milligrams daily and increase until symptoms abate, but don't take over 50 milligrams daily. Another study done by Folsom in 2004 showed that omega-3 fatty acids help brain function and reduce the risk of heart disease. The preferred type is Krill oil, a very potent fish oil, taken 500–1,500 milligrams daily.

Also, new evidence from NASA astronauts who experienced osteoporosis while they were in prolonged zero-gravity conditions showed that their osteoporosis could be reversed by their resuming normal weight-bearing activities once they were back on earth. The late actor Christopher Reeve, a quadriplegic who also developed osteoporosis due to inactivity, was able to reverse this condition as well by resuming weight-bearing exercises. Clearly, there is more to osteoporosis than merely menopause and estrogen.

In generations past, menopause was accepted as a natural condition of life, with little evidence that it caused increased risk of heart disease or osteoporosis. While the lack of estrogen may play a role in these conditions, certainly, other more important risk factors also need to be considered. It is necessary for post-menopausal women to exercise (primarily weight-bearing or resistance exercise)

and to take 1,200–1,500 milligrams of calcium, 400 milligrams of magnesium, and 400 IU of vitamin D daily to prevent osteoporosis, as noted by McGarry in a study published in 2000. If you have osteoporosis, adding strontium, 750 milligrams twice daily, will strengthen bone as well as increase bone density, as reported in the *New England Journal of Medicine* by Meunier in 2004.

Premenstrual Syndrome (PMS)

Premenstrual syndrome, or *PMS*, is a common, painful disorder that occurs around the time of menstruation and involves cramping of the uterine muscles. It may also include headaches and other associated symptoms, sometimes so severe that they can be disabling.

Stress, tension, emotional upheaval, lack of exercise, poor diet, dehydration, and excessive caffeine and alcohol can make PMS symptoms worse. For women who are always on the go, it is important to ease back a little on normal activities and listen to their bodies during menstruation, a time of blood loss and sloughing of reproductive tissues. Drink plenty of fluids, decrease caffeine and alcohol intake, practice stress-management and visualization techniques, and rest to support your healing system at these times. Natural herbs, such as *cramp bark* (no typical dose has been determined), raspberry tea, and *dong quai* (usually combined with other herbs in various dosages), can help alleviate PMS symptoms. Other herbs that can be beneficial include *chasteberry* extract with 0.5% agnuside content, 175–225 milligrams daily for associated breast pain or infrequent periods (as noted by Schellenberg in a study published in 2001), and *deglycyrrhizinated licorice*, one or two 380-milligram chewable tablets before meals to reduce bloating and swelling, as noted in a study published in the journal *Menopause* in 2002. There are several Chinese herbal formulas that can be beneficial in PMS, such as *Dan Zhi Shao Yao San*. You should see some benefits within 1–3 weeks when taking Chinese herbs.

Acupuncture, gentle yoga stretching, breathing, and massage may also be helpful. Other disorders of the female reproductive system, such as *endometriosis, uterine fibroids, ovarian cysts,* and *fibrocystic breast disease* often reflect hormonal imbalances which, if caught early, can successfully respond to methods that work with

your healing system. Some of these methods are proper diet, stress management, increased fluid intake, and natural medications and treatments. Natural progesterone cream can be quite effective for all these disorders, as reported in a study by Leonetti in the journal *Obstetrics and Gynecology* in 1999. It can be applied topically at 20–40 milligrams daily or taken orally at 50–200 milligrams daily. *Black cohosh*, 20 milligrams containing 27-deoxyacteine twice daily, is beneficial in shrinking fibroids, as supported by a study by Pepping in 1999. It may take several months to obtain benefits using these natural substances.

Male Reproductive System Disorders

Male Menopause

Recent research shows that men may go through a male equivalent to female menopause, when, around the ages of approximately 45 to 65, their testosterone levels become diminished, and they can suffer from mood swings and depression. Standardized doses of testosterone are currently available to supplement low testosterone levels, and natural sources of testosterone that work more harmoniously with your healing system are also currently being researched. Besides natural testosterone, there are several herbal products available that can be beneficial, containing various combinations of ginseng, yohimbe, damiana, sarsaparilla, saw palmetto, wild oat, kola nut, ginger, puncture weed, muira puama, and/or grapeseed extract.

Prostate Cancer

Prostate cancer has now become one of the most common types of cancer in men. New research on prostate health and prostate cancer, being conducted by Dr. Dean Ornish, Dr. Ruth Marlin, and others at the University of California, San Francisco, and at the Sloan-Kettering Cancer Institute in New York, is showing that diet and emotional factors, including stress, play a significant role in prostate cancer and other disorders of the prostate. In addition to these studies, many case reports and books are beginning to demonstrate successful treatments for overcoming prostate cancer using methods

that naturally work with your body's healing system. *Prostate Health in 90 Days* is an excellent book by Larry Clapp, a lawyer who had prostate cancer and successfully overcame it with methods that work with the body's healing system.

Prostate Enlargement

Also known as *benign prostatic hypertrophy*, or *BPH*, this condition compresses and encroaches upon the urethra, which is the tube leading from the bladder through the penis. Prostate enlargement makes passing urine difficult. In advanced cases, a man may have to wake up 6 to 10 times or more a night to urinate because with BPH, the bladder never fully empties.

In addition to conventional medicines, *saw palmetto*, a natural herb that works with your healing system by shrinking and reducing swelling in the prostate, can often be very helpful for BPH, as reported by Boyle in a study published in the journal *Urology* in 2000. The dosage is 160 milligrams twice daily, standardized to contain 85–95% fatty acids and sterols. Other herbs that can shrink the prostate include pumpkin seed, 5 milligrams twice daily, and 100–200 milligrams of pygeum twice daily, using a standardized lipophilic extract containing 0.5% docosanol and 14% triterpenes, as reported in a study by Carbin in 1990; or cernilton, a flower pollen extract used in Europe for more than 35 years, at 60–120 milligrams two to three times daily, and elucidated in a study by Dutkiewicz in 1996. In addition, 45–60 milligrams of zinc, 1 tablespoon of flaxseed oil, and several amino acids (a daily combination of 200 milligrams each of glycine, glutamic acid, and alanine) can increase urine flow and decrease enlargement and symptoms of BPH. A low-fat diet, increased fluids and fiber, and reducing overall body tension by learning how to relax can also support your healing system in preventing and minimizing symptoms of BPH. BPH is not related to prostate cancer.

Testicular Cancer

This form of cancer frequently afflicts younger males. If testicular cancer is caught in its early stages and given appropriate medical treatment, accompanied by lifestyle changes that help support the body's healing system, it is often curable. The subject of cancer is discussed more thoroughly later in this chapter.

Lymphatic System Disorders

Your lymphatic vessels, channels, and lymph nodes make up your lymph system, which shares an important relationship with your body's immune and healing systems. The white blood cells of your immune system, which help fight infection and keep your blood clean, circulate in the lymph fluid. Lymph node enlargement, which represents white blood cell proliferation and activation, occurs in response to infections.

Serious disorders of the lymphatic system include *Hodgkin's disease*, *lymphoma*, and other *lymphatic cancers*, which represent generalized, weakened conditions of the body. Conventional treatments such as radiation can often be helpful for these conditions, but it is also important to use natural methods that work with your healing system, such as stress management, eating a healthy, wholesome diet, increasing fluid intake, and using other natural medicines and herbs. If caught early, these conditions of the lymphatic system are easier to eradicate. A famous success story of a person who overcame lymphatic cancer is Lance Armstrong, legendary Tour de France champion and author of *It's Not About the Bike*.

Nervous-System Disorders

Disorders of the nerves are some of the more complex and difficult of all conditions to treat. These challenges are because of the intricate interactions between your brain, your nervous system, your mind, and your emotions.

Central Nervous System Disorders

Central nervous system disorders often involve the brain and are usually serious. They include such conditions as the following:

- *Alzheimer's disease*, characterized by a loss of short-term memory.
- *Cerebral palsy*, which appears early in life and is a debilitating condition related to birth trauma or other congenital problems; cerebral palsy results in speech and movement disturbances.

- *Epilepsy*, which includes a wide range of conditions that cause seizures.

- *Multiple sclerosis*, thought to be an autoimmune disease, with symptoms including progressive weakness, loss of balance, lack of coordination, and speech and visual disturbances.

- *Parkinson's disease*, characterized by tremors, a shuffling walk, and rigidity.

- *Spinal-cord disorders*, which are usually trauma related and result in life-altering paralysis of one degree or another.

Because of the seriousness of central nervous system disorders and the difficulties in treating them once they are established, the focus should be on working with your healing system to prevent them. Conventional medicines may be necessary to help manage these problems once they are established, supported by good nutrition and natural medicines. A study done by Oken in 1998 showed that *gingko biloba*, 240 milligrams daily, increases blood flow to the brain and may be helpful in selected cases of Alzheimer's and Parkinson's diseases. For multiple sclerosis, vitamin E, 800 milligrams, and 200–400 micrograms of selenium daily detoxify free radicals that are thought to play a role in MS. Krill oil, 500–1,500 milligrams daily, increases omega-3 fatty acids, which are often deficient in MS. Stress management, including relaxation training and breathing techniques, have a natural calming effect on the mind and brain, and they help manage these conditions by stabilizing the electrical activity of the nervous system. Stress-management techniques are also effective in relieving pain and tension resulting from these conditions. Gentle yoga techniques can also support the healing system by improving balance and coordination. Acupuncture, music therapy, and massage can also be helpful.

The most important thing you can do is pay attention to the underlying causes of these conditions and start treatment in the earliest stages when symptoms are less severe. Exciting new research in the field of nerve regeneration is investigating procedures that support the healing system's ability to mend damaged nerves and create new pathways for victims of spinal cord injury and other diseases of the central nervous system.

Peripheral Neuropathies

Peripheral neuropathies are nerve disorders that usually involve the extremities. These disorders include *diabetic neuropathy, sciatica* and *"pinched nerves,"* and *nutritional neuropathies* such as those caused by vitamin B12 deficiency (*pernicious anemia*), or thiamin deficiency (*beriberi*). Because these conditions are often associated with other health problems that are both correctable and preventable, addressing those underlying factors is the key to working with your healing system to improve and reverse the nerve disorders. Paying attention to good nutrition and incorporating stress management and other natural methods that work with your healing system can go a long way toward improving these conditions. Three herbs can be helpful as well: acetyl-L carnitine, 250 milligrams, two to four times daily, as reported in a study by Sima in the journal *Diabetes Care* in 2005; borage oil, 1,000 milligrams, 1–4 capsules daily, based on *Herbal Medicine: A Guide for Healthcare Professionals*; and alpha lipoic acid, 400–800 milligrams daily as detailed in a study by Ziegler in the journal *Diabetic Medicine* in 2004. All these herbs may take at least 2 months to provide benefits.

Musculoskeletal Disorders

Problems in the muscles and bones are common and range from bruises and contusions to fractures and other conditions.

Fractures

Fractures heal best with adequate calcium and vitamin D, rest, immobilization, plenty of fluids, natural sunlight, proper nutrition, and natural medicines that support your healing system. Because of your healing system's amazing ability to mend and remodel bone, most fractures heal uneventfully once the bones are held in place by either a cast or splint. The largest bone in the body, the femur, takes just 6 weeks to heal from a simple fracture.

Some complex fractures might require assistance with methods such as bone setting and open surgical reduction using plates, rods, screws, and pins as well as electrical bone stimulation, but most fractures may not even require casting. This was demonstrated in a

well-known study involving Nigerian bone doctors who never went to medical school; the study showed that the fractures they treated using only sticks healed in the same amount of time as those treated with modern methods in a large hospital in America.

To accelerate the healing of fractures, you can use a Chinese herbal formula, *Qi Li San*. Proteolytic enzymes, including bromelain, papain, trypsin, chymotrypsin, and rutin, decrease the inflammatory response as well as break down substances that interfere with the healing process, based on a study by Masson in 1995.

Muscular Injuries

Injuries of the muscles are common. If muscles are strong and overdeveloped, but not flexible or relaxed, the likelihood of injuries increases because of their stiffness and rigidity. Additionally, because your muscles are connected to your nerves, mental tension and stress can also cause muscular tension and stiffness. These conditions contribute to muscle pain, and they are often contributing factors to many muscular and neuromuscular disorders, including back pain and *fibromyalgia*. Dietary factors and other lifestyle and personal health habits also play a major role in these conditions.

A healthy muscle is one that is strong, flexible, and relaxed; so regularly stretching and relaxing all the muscles in your body, in addition to exercising, are important. Yoga is a gentle, systematic approach to ensuring proper health of your muscles through exercises that lengthen, stretch, and relax the muscles while building tone and strength. Anyone with a muscular condition would do well to investigate the possibility of adding yoga to his or her overall healing program.

If you've injured a muscle, a Chinese herbal formula, *Qi Li San*, is helpful in accelerating repair and can even help the body heal faster from surgery. Proteolytic enzymes, including bromelain, papain, trypsin, chymotrypsin, and rutin, decrease the inflammatory response as well as break down substances that interfere with the healing process, based on a study by Masson in 1995.

Osteoporosis

Common in postmenopausal women, *osteoporosis* represents a loss of bone density and strength. Many experts believe this condition is

caused by a lack of estrogen; however, newer research on astronauts shows that a lack of weight-bearing exercise may play a larger role. There is evidence that stress, which affects the endocrine system and influences calcium metabolism, and high-protein diets, which can leech calcium from bone, may also contribute to the condition.

Osteoporosis can be prevented and often reversed by regular weight-bearing exercise and stretching, stress management, and a healthy, wholesome diet that supports your healing system. Supplements including 1,200–1,500 milligrams of calcium, 400 milligrams of magnesium, and 400 IU of vitamin D should be taken daily to prevent osteoporosis, as noted by McGarry in a study published in 2000. If you have osteoporosis, adding strontium, 750 milligrams twice daily, will strengthen bone as well as increase bone density, as reported in the *New England Journal of Medicine* by Meunier in 2004. Natural progesterone can also increase bone density by making new bone. Use 20–40 milligrams topically or 50–200 milligrams orally once daily.

Joint Disorders

Because you are constantly moving, your joints are subject to wear and tear, and they are a common site for painful problems and disturbances. Joint diseases are particularly common in the Western developed world. Ironically, these conditions are relatively rare in most developing countries where activities and lifestyles are less sedentary.

Gout

Known as the "rich man's disease," *gout* is caused by excess uric acid production, often the result of rich foods such as meat and flesh products. Gout is virtually absent among poor populations, which subsist predominantly on vegetables and grains. Gout is entirely curable and preventable, and it responds well to reducing or abstaining from all meats, fowl, and seafood. In addition, increasing fluid intake and avoiding coffee and alcohol can prevent flare-ups of this condition. Folic acid, 10–40 milligrams daily, can decrease the production of uric acid, and flaxseed oil, 1 tablespoon daily, can prevent tissue damage from too much uric acid.

Osteoarthritis

Most doctors believe that *osteoarthritis* is caused by the steady wear and tear of joints. This condition can be prevented and reversed by following methods that work with your healing system. These include gentle stretching of the muscles that surround the affected joints, and increased consumption of fluids, including fruit and vegetable juices. Movement therapies such as yoga, tai chi, and swimming; acupuncture; and visualization and guided imagery can also be very helpful for this condition. Certain foods and natural supplements such as *glucosamine*, 1,500 milligrams daily, may also be helpful, as noted in a study done by Pavelka, et al in 2002. (Use the sulfate form, not the chloride form.) Avoid using this supplement if you are allergic to shellfish. Another beneficial supplement is SAMe, which is taken 200 milligrams three times daily. (Use the butanedisulfonate salt form, which is five times stronger than any other form.) The benefit of SAMe was reported in the *Journal of Rheumatology* in 1994 by Bradley, et al. Two Chinese herbal formulas are beneficial for osteoarthritis: *Shu Jing Huo Xue Tang* and *Huo Luo Xiao Ling*. You should see some benefits within 3–6 weeks when taking Chinese herbs.

Several other herbs and supplements have been found to be effective for arthritis, including the following: cetyl myristoleate, 400 milligrams, 1–3 capsules daily (more effective when used with glucosamine), based on a study published in the *Journal of Rheumatology* in 2002 by Hesslink; sea cucumber, 500 milligrams, 2–4 capsules daily; lyprinol, derived from a New Zealand mussel, 100 milligrams extract, 2 capsules twice daily for 3–6 weeks, then 1–2 capsules daily, proteolytic enzymes: rutin, 100 milligrams; trypsin, 48 milligrams; and/or bromelain, 90 milligrams, 2 tablets of each, three times daily, as repoted in a study by Klein in 1995; *boswellia* (Indian frankincense), 333 milligrams, three times daily, as revealed in a study by Kimmatkar published in *Phytomedicine* in 2001; curcumin, 500 milligrams, four times daily; ginger, 170–400 milligrams, three times daily or 255 milligrams, twice daily, according to a study by Bliddal published in 2000; *cat's claw*, standardized extract containing a minimum of 1.3% pentacylic oxindole alkaloids (POAs) and free of tetracylic oxindole alkaloids (TOAs); take 1 capsule or 15–30 drops of liquid extract twice daily, as reported in a study by Piscoya in

2001; stinging nettle, 9 grams daily, as discussed in *Principles and Practice of Phytotherapy* (1999); or *devil's claw*: daily dose of 2.5 grams should contain 57 milligrams of harpagoside and 87 milligrams of total iridoid, based on a study by Chantre in 2000. All of these herbs may take 6–12 weeks to show benefits.

Rheumatoid Arthritis

Now considered an autoimmune problem, *rheumatoid arthritis* is caused by dysfunction in the lines of communication among the immune system, the endocrine system, and your brain. Emotional upheaval often precedes painful flare-ups of rheumatoid arthritis. Dr. George Freeman Solomon, at UCLA, who is one of the world's foremost authorities on rheumatoid arthritis, has identified several psychological factors, such as repressed anger, that can alter the chemistry of your internal environment and trigger destructive autoimmune responses that affect joint surfaces. Other factors may also be present in this condition. If caught in its early stages, rheumatoid arthritis often responds well to physical therapy, stretching, diet, and stress-management practices, including breathing and imagery, all strategies that help support your heal-ing system. Numerous herbs and supplements may also assist your body to improve your condition. Cetyl myristoleate, 400 mil-ligrams twice daily for 2 weeks, then 1–3 times daily, modulates the immune system as well as providing anti-inflammatory prop-erties, based on a study published in the *Journal of Rheumatology* in 2002 by Hesslink. Other beneficial substances include sea cucumber, 500 milligrams, 2–4 capsules daily; Krill oil, 500–1,500 milligrams, daily for 1 month, then 1 capsule, 500 mil-ligrams, daily, as reported by Forin in 1995 and from another study by Kjeldsen-Kragh in the *Journal of Rheumatology* in 1992; lyprinol, derived from a New Zealand mussel, 100 milligrams extract, 2 capsules twice daily for 3–6 weeks, then 1–2 capsules daily; borage oil, 1.1 or 1.4 grams of borage seed oil daily, as reported in a study by Leventhal in the *Annals of Internal Medicine* in 1993; *boswellia* (Indian frankincense), 333 milligrams, three times daily, as based on research by Sander published in 1998; cur-cumin, 500 milligrams, four times daily, based on a study published in 1980 by Deodhar; or *proteolytic enzymes*: rutin,

100 milligrams; trypsin, 48 milligrams; and bromelain, 90 milligrams, 2 tablets of each, three times daily. (Combination products containing all three are available.) All of these herbs may take 6–12 weeks to show benefits. Several Chinese herbal formulas can also help: For pain and swelling, *Shu Jing Huo Xue Tang* treats the inflammation, *Chuan Yin Lian Kang Yang Pian* is for red and hot joints, and *Huo Luo Xiao Ling Dan* is taken for unrelenting pain. You should see some benefits within 3–6 weeks when taking Chinese herbs.

Disorders of the Hands, Feet, and Extremities

Hand Problems

The hands are subject to overuse and abuse, and consequently they are a common site for the occurrence of arthritis, particularly in later years. This arthritis is often due to chronic tension in the fingers, which eventually causes the muscles to fix the joints in a particular position, which subsequently leads to irritation, swelling, inflammation, and joint pain.

Working with your healing system by addressing the underlying causes of these problems, along with regular gentle extension of the muscles and tendons that control the movement of the fingers, can help reverse and prevent this problem. Arthritis of the hands is easier to manage or cure if you catch it early and if you incorporate into your daily life methods that work with your healing system.

Carpal Tunnel Syndrome

Carpal tunnel syndrome is a chronic condition of the wrists related to overuse of the wrist joints. Surgery is often performed in more severe cases. However, this condition responds well to methods that work with your healing system, such as acupuncture, low-level energy laser therapy, physical therapy and gentle, persistent stretching like that found in yoga therapy. In fact, the effectiveness of yoga therapy for carpal tunnel syndrome was documented in a study that appeared in the *Journal of the American Medical Association*.

Foot Problems

Your feet bear the entire weight of your body, and if you do not properly care for them, they can cause endless misery—so much so, that an entire specialty, known as *podiatry*, exists just to tend to the feet alone.

Corns, Heel Spurs, Plantar Fasciitis, and Plantar Warts

Corns, heel spurs, plantar fasciitis, and plantar warts are all common conditions of the feet. They are often caused by improperly fitted shoes or imbalances created by improper movement while walking, standing, jogging, or participating in sports and other strenuous activities. Although these conditions are so painful at times that they can be incapacitating, they can usually be reversed quite readily once the underlying causes are addressed. Stretching the muscles of the feet, toes, and legs; taking warm foot baths; going barefoot whenever possible; and applying gentle, soothing natural creams such as turmeric or calendula that soften the skin and support healing processes all serve as valuable aids to your healing system as it works to alleviate these conditions. Additionally, wearing roomy, comfortable shoes and getting regular foot massages can often help your healing system correct these problems. *Reflexology* is a type of massage that involves nerve meridians that connect areas of the feet to other parts of the body; it can be very effective for problems involving the nerves and muscles of the feet. Acupuncture also is beneficial in helping the body resolve many foot problems, especially heel spurs and plantar fasciitis.

Disorders of the Spine

Spine disorders represent a special and more complex aspect of musculoskeletal joint diseases. There are 24 joints in the human spine, and each one is subject to a potential problem if it is not properly cared for.

Back Pain

Back pain is the single most common cause of work disability in the United States. Approximately 100 billion dollars are spent annually

on this problem. Back pain comes in various forms and severity and is associated with common diagnostic names such as *spinal arthritis*, *spondylosis*, *spondylolisthesis*, *degenerative disc disease*, *ankylosing spondylitis*, *scoliosis*, *herniated* and *ruptured discs*, *spinal stenosis*, and *sciatica*. Long-standing histories of poor posture, stress, physical abuse, repetitive injuries, and inadequate diet often contribute to these conditions.

Even long-standing, stubborn cases of back pain can be reversed if you address the underlying causes and use methods that work with your healing system, such as developing proper spine mechanics, gentle stretching, eating a healthy, wholesome diet, and managing stress. In my previous book, *Healing Back Pain Naturally*, I address the underlying causes, treatment, and ways to prevent this common, debilitating group of maladies in a simple, organized manner that will allow you to work with your healing system to overcome these problems.

Circulatory System Disorders

Heart Disease

Heart disease is the number one killer in the Western world, and it comes in several forms. The most common type of heart disease, known as *coronary artery disease*, is caused by *atherosclerosis*, or clogging of the arteries of the heart. Coronary artery disease can lead to sudden death from heart attack and claims more lives than all other diseases combined, including cancer, diabetes, accidents, or infections.

High-fat diets, stress, lack of exercise, repression of anger and inhibition of emotions, social isolation, and a lack of intimacy all have been shown to be significant contributing factors to heart disease. Dr. Dean Ornish's groundbreaking work on the reversal of heart disease without drugs or surgery is based on a program that incorporates simple yet powerful natural methods that work with your healing system. These include eating a low-fat diet, performing moderate but regular exercise, practicing stress management and relaxation, and learning how to express emotions and share feelings in a supportive group environment. When you learn to work with

your healing system, even the worst and most dangerous disease in the world can be healed naturally. To help prevent heart disease, fish oil (containing omega-3 fatty acids) has been found to decrease the risk of heart attack by 50 percent, as reported in a study by Bucher, et al in 2002 and in another study by von Schacky published in the *Annals of Internal Medicine* in 1999. The best source of fish oil is Krill oil, 500–1,500 milligrams daily. If you already have heart disease, several herbs and supplements are beneficial. These include CoQ10, 1 milligram for each pound of body weight, as noted in a study by Watson in 1999, and another study by Soja in 1997; hawthorne extract, 100–250 milligrams containing 10% procyanidin content three times a day, as reported in a study by Tauchert in 2002 and from another study published in the *American Journal of Medicine* in 2003 by Pittler; or L-carnitine, 300 milligrams three times daily, as noted in a study by Rizos in 2000 published in the *American Heart Journal.*

High Blood Pressure

Also known as *hypertension, high blood pressure* is referred to as "the silent killer." It is a serious circulatory disease that, if not treated properly, can cause heart disease and stroke. This common disease is caused by constriction and narrowing of the arteries and smaller blood vessels, which increases the pressure of the blood flow inside them. The effect is similar to what happens when you place your thumb or finger over the end of a garden hose to spray the water out further and faster.

Because the smooth muscles that control the diameter of your blood vessels are, in turn, controlled by nerves that are connected to your brain, your blood pressure can become elevated when you are under stress. This can occur when you are upset, excited, frightened, or worried. Conversely, when you are calm and relaxed, your blood pressure tends to automatically become lower.

Medicines are available to artificially control high blood pressure, but many of them have side effects that can interfere with the quality of your life. Whether or not you are currently taking medications, it is critical for you to work with your healing system by learning how to relax and manage your stress to help bring your blood pressure down. Lowering your blood pressure this way will

lower your risk of stroke and heart disease and reduce your dependence on medications. Losing weight has also been shown to reduce blood pressure, as has exercise. In addition to cutting out caffeine and nicotine, which are both known to elevate blood pressure, some natural medicines can aid your healing system by supporting circulation and keeping your blood vessels calm and relaxed. These include CoQ_{10}, 60 milligrams for mild, 120–150 milligrams daily for moderate hypertension, based on research by Burke published in 2001; lycopene, derived from tomatoes, 15 milligrams daily, as reported in a study by Rao in 2002; Krill oil, 500–1,500 milligrams daily; garlic, containing at least 4,000 milligrams allicin daily as researched in a study by Yosefi in 1999; olive leaf extract, containing 20% oluerpein twice daily, as discussed in a study by Ferrara in 2000; and calcium, 800 milligrams daily and magnesium, 800 milligrams daily, reported in a study by Reid in 2005 and another study by Jee published in the *American Journal of Hypertension* in 2002. These supplements can be taken separately or together, and may take 1–3 months to obtain benefit.

Stroke

Stroke is a well-known circulatory disorder most often caused by underlying complications from long-standing high blood pressure. The prolonged, increased pressure in the blood vessels that go to the brain eventually causes the vessels to burst, rupture, and bleed. A second mechanism that causes stroke occurs when small blood clots, usually generated from an irregularly beating heart, become lodged in the brain's circulatory paths and clog the blood vessels that nourish the brain.

Stroke, which can be severely incapacitating and even fatal, most commonly results in paralysis of one side of the body, typically an arm and a leg. Other structures on the face may also be affected, such as the tongue, mouth, lips, and cheeks. Speech and swallowing are often affected. Memory loss and loss of other mental faculties can also occur.

For those who can keep their spirits up during the hard work of the stroke rehabilitation phase, the body's healing system can often restore the body to practically normal functioning, although this process might take months or even years. The body can do this by

accessing duplicate information on the undamaged side of the brain and transferring it to the affected side, and connecting new nerve pathways to compensate for the damaged portion that previously controlled these functions. Once the brain learns to make the necessary new connections, seemingly dead, paralyzed limbs and muscles miraculously can come back to life. Because of the body's healing system, even under circumstances where all hope appears lost, many people have been able to resume normal lives once again after they have suffered a stroke. Acupuncture has been supported by the National Institutes of Health as an adjunct to accelerate stroke rehabilitation. To help prevent strokes and improve brain function, you can take *gingko biloba*, 240 milligrams daily, which increases blood flow to the brain and prevents damage to the brain caused by hypoxia (decreased oxygen to brain tissue), as reported in a study by Logani in 2000. In a study by Iso in 2001, published in the *Journal of the American Medical Association*, Krill oil (potent fish oil), 500–1,500 milligrams daily, provides omega-3 fatty acids that are necessary for proper brain function and can help prevent atherosclerosis as well as reduce the risk of stroke by 27 percent.

Endocrine System Disorders

The endocrine system consists of important organs and glands that produce powerful hormones that are involved in a wide range of functions. Because of its extensive connections, the endocrine system may become imbalanced and dysfunctional as the result of underlying problems elsewhere in the body. For example, nutritional and metabolic problems can affect the endocrine system, and vice versa. The most common endocrine disorder is *diabetes*, which is a derangement of sugar or glucose metabolism, usually caused by insulin deficiency.

Chronic Fatigue Syndrome

Chronic fatigue syndrome is a relatively new disorder that is more common in women and also is somewhat difficult to treat by conventional medical practices. Experts who specialize in the treatment of the disorder believe exhaustion of the adrenal glands may be an

important factor. Prolonged stress and a lack of rest appear to be major factors in chronic fatigue syndrome. Many patients with this syndrome report extreme fatigue after living hectic, fast-paced lives, in which the pressures that surround them are enormous and they haven't rested or relaxed for many years. When the body is under considerable stress and lacks quality sleep and rest, it is only natural that it will suffer from a lack of energy and eventually become fatigued.

With chronic fatigue syndrome, there may be other concomitant problems such as yeast infections and fibromyalgia, in addition to the accompanying depression and other psychological factors that further deplete physical energy and prevent the condition from healing sooner. Psychological factors might include the fear of getting well and becoming overwhelmed again by the demands of work and other responsibilities. These factors may serve as impediments to the healing system's ability to do its job in a timely and efficient manner. To prevent this from happening, and to work with your healing system to restore natural health and energy, it is imperative to incorporate adequate sleep and rest into your lifestyle; focus on a healthy, wholesome diet; drink plenty of fluids; practice stress management; and participate in a regular physical exercise and movement program. Acupuncture can assist the body in healing and increasing energy. Several medicinal mushrooms, including ganoderma, poria, polyporus, and tremella, can increase energy and also support the immune system. A study by Zhu in 1998 showed that another Chinese herb, cordyceps, has beneficial effects on all systems of the body. An ancient Chinese herbal formula, *Zuo Gui Wan/You Gui Yin* is also very beneficial for combating fatigue. You should see some benefits within 3–6 weeks when taking these natural substances.

Diabetes

There are several ways to classify *diabetes* and the stages of this illness. The two main types of diabetes have traditionally been broken down into *Type I, juvenile onset, insulin-dependent diabetes* and *Type II, maturity onset,* or *adult diabetes*, which often starts out as non–insulin dependent, but may become insulin dependent over time. *Insulin dependent* refers to the need to inject insulin

from a syringe into your body to help bring your blood sugar under control.

The danger of high blood sugar, which is the common denominator of all types of diabetes, is that it can damage blood vessels in the eyes, causing blindness. It can also damage the kidneys, causing kidney failure, and contribute to other problems, such as nerve damage, and chronic skin ulcers on the feet and ankles as well. There also is a strong associated risk of heart disease in people who suffer from diabetes.

Adult, or maturity onset, Type II diabetes has been traditionally linked to obesity, a diet high in sugar, and a lack of exercise. It also appears to be related to stress, depression, emotional upheaval, and unresolved grief, conditions that influence personal health habits and diet, which in turn significantly influence the course of this disease. Although some researchers have tried to link this form of diabetes to genetic causes, the evidence clearly points more toward lifestyle factors, including stress and diet, since this type of diabetes is rare in developing countries, but on the rise in Western countries. The good news is that this type of diabetes can be reversed when you catch it early and apply methods that work with your healing system.

The juvenile form of diabetes, Type I, occurs at a much younger age and can often be severe. In the past, many experts believed that juvenile diabetes was an autoimmune illness triggered by a virus or another infection, but newer research points toward stress and deranged mind-body interactions that occur during periods of intense emotional upheaval in the individual or family, or during gestation. This changed perspective is due in part to the discovery that insulin communicates directly with the brain and is now classified as a *neuropeptide* or *neurotransmitter*, rather than as a pure hormone. The current view is further based on the scientific observation that more insulin can be found at any one time in the brain than in any other organ or structure in the body.

Newer treatments for diabetes that address the underlying causes, rather than merely manage the symptoms, involve methods that work with your healing system. These treatments include eating a proper diet, getting adequate exercise, practicing stress-management techniques, drinking plenty of water, taking natural medications, and addressing the deeper emotional, mental, and spiritual factors that

may be driving this unhealthy condition. Natural herbs that can help decrease as well as stabilize blood sugar include cinnamon, 125 milligrams, as reported in a study by Khan published in the journal *Diabetes Care* in 2003. It appears to be more effective if combined with biotin, 8 milligrams twice daily. Another study by Sotaniemi published in the same journal in 1995 showed that ginseng can reduce blood sugar. Ginseng can be combined with queen crepe myrtle, 550 milligrams, one to six times daily for even better effectiveness. An herb from India, *gymnema sylvestre*, 400 milligrams twice daily has been used for centuries to reduce blood sugar and this has been supported in a study by Baskaran in 1990. It can be combined with other herbs for better results, including bitter melon, 400 milligrams, as reported by Ahmad in 1999, and 200 milligrams of fenugreek, studied by Gupta in 1998, both twice daily. It may take 2–3 months to obtain benefits. These strategies are obviously more effective if they are instituted in the early stages of the illness. Insulin may be required until these other methods are well established, but a large number of patients have successfully weaned themselves from insulin dependence in a relatively short period of time. During my tenure as a medical student more than 20 years ago, getting patients off insulin was considered an impossibility. If diabetes happens to run in your family, focus on incorporating preventive strategies before the illness has a chance to surface in your body.

Thyroid Dysfunction

Thyroid dysfunction is more common in women than in men, and it occurs fairly frequently. It occurs in several forms, most commonly *hypothyroidism*, or low production of the thyroid hormone, which usually requires supplementation. When low thyroid function is corrected with thyroid hormone replacement, there is an increase in metabolism, greater energy, improved mood, and loss of weight. These are desirable qualities for an overweight person who may suffer from fatigue and depression, but the long-term effects of supplementing with thyroid hormone when it may not be absolutely necessary are unknown.

Additionally, because the thyroid gland is under the domain of the pituitary gland, which is under the domain of the hypothalamus and the brain, thyroid dysfunction usually indicates problems

higher up the chain of command, which need to be addressed if one is to get to the root of the problem. Unfortunately, Western medicine usually ignores these underlying causes in the treatment of thyroid conditions.

In many cases, you can support your healing system by addressing the underlying factors that may be responsible for thyroid dysfunction, such as stress, dietary imbalances, lack of exercise, and an unhealthy lifestyle. In many people, thyroid function is decreased because of lack of iodine in the diet. This can easily be verified by a simple blood test, and if proven so, can be corrected with iodine supplements. Implementing the methods that strengthen and fortify your healing system, as shared in previous chapters, can be most helpful in most thyroid disorders.

Immune-System Disorders

Very little was known about the powerful and sophisticated intricacies of the immune system before the onset of the devastating AIDS epidemic. We still have a long way to go, but, because of AIDS and the HIV virus, today we know much more than ever before.

Allergies

Every person is created as a unique individual and as a result may have specific sensitivities to certain substances or environmental conditions. These sensitivities, if prolonged or pronounced, can develop into an allergy. The most common types of allergies affect the skin and respiratory system, and we have already discussed those under these separate headings.

Allergies are often system specific. This means that only one system at a time may be sensitive to a particular substance. For example, if dust is breathed into the lungs, the dust may cause coughing, wheezing, and a runny nose, but if it is placed on the skin, dust may not cause any reaction at all. A substance that causes an allergic rash may not cause any reaction whatsoever when it is placed on the skin, chewed, swallowed, and eaten.

To overcome allergies in general, focus on building up the health of the specific system that is affected by the allergy. Employ

the methods discussed in previous chapters that strengthen and fortify your healing system as it relates to the affected system. Acupuncture has been shown to be beneficial in helping the body reduce allergies and can even resolve them in the long term.

Chemical and Drug Allergies

Chemical and drug allergies are common with medications and in medical settings. These include allergies to medicines such as penicillin and other antibiotics; mineral dyes such as iodine; and other drugs or chemicals. These allergies may show up in the form of a skin rash, or they may even result in a serious, life-threatening situation.

Effective conventional medications are currently available to help manage and suppress the acute symptoms of allergies from whatever cause. For long-term treatment, however, it is better not to suppress your symptoms, but instead to work with your healing system to overcome the allergy. You can do this by carefully observing how your body interacts with each and every suspected allergen in your environment. Even though discovering the true source of any allergy may require a bit of tedious detective work, if you cooperate with your healing system in this manner, sooner or later you will be able to identify the offending agent, take precautions to avoid further exposure or contact with it, and eliminate its unhealthy influence on your body.

Food Allergies

Food allergies are less common than those of the skin and respiratory system. Food allergies include conditions that may not be true allergies, such as *lactose intolerance*, one of the most common of all suspected food allergies. With lactose intolerance, the body lacks a specific enzyme and is simply unable to digest foods that contain lactose, which is a simple sugar found in dairy products. This enzyme is lacking in the majority of people from the Orient and many other parts of the world. In fact, lactose intolerance is not a true allergy but merely a normal variant found in certain ethnic groups. Many other suspected allergies have similar stories.

Many synthetic chemicals used in industry are harmful and irritating to the human body. Because new synthetic chemicals are continuously being introduced into our food supply, it is not surprising

to find that food-related allergies are becoming more common. To minimize the risk of exposure to such allergens, it is important to know exactly what you are introducing into your body when you eat. Variety is the spice of life, but to avoid food allergies, avoid foods with chemical additives whenever possible.

Cooperate with your healing system by eating foods from organic and natural sources that are free from chemical pesticides, pollutants, and additives. You can also work with your healing system to keep your digestive system free from irritating and toxic substances by consuming plenty of fluids and fiber, and practicing good intestinal hygiene.

Acquired Immune Deficiency Syndrome (AIDS)

AIDS is an example of what can happen to your body when the immune system is impaired. When the immune system is compromised, your body can become afflicted by organisms that cause infections and disorders that, under normal circumstances, would not occur.

Where the HIV virus initially came from is still controversial, but it is clear that those whose immune systems are already impaired and worn down are at higher risk. This virus can be found among people with multiple sexual partners, repeated intravenous drug use, or poor personal health habits.

AIDS is entirely preventable by practicing safe sex, abstaining from illegal intravenous drug use, and avoiding blood transfusions from unknown sources. The additional good news is that many people currently afflicted with HIV are learning to work with their healing systems to improve their health. This approach includes concentrating on healthy diets, drinking plenty of fluids, exercising, practicing stress management (including visualization/imagery techniques), and relying on natural medicines and modalities that support the rebuilding and restoration of the immune system. Chinese herbal formulas containing isatis and astragalus herbs and ganoderma mushrooms can help fight the HIV virus due to their antiviral and immune regulatory benefits, based on the *American Herbal Pharmacopoeia* (1999). Another herbal formula called Enhance has been developed specifically for HIV infection and is comprised solely of Chinese herbs including the above. It has been researched and is used by the Quan

Yin Healing Arts Center in San Francisco. A study by Jordan in the *Journal of Medicine* in 1998 showed that polysaccharides such as beta-1,3/1,6 glucan have beneficial immune system effects in HIV/AIDS. Many people with HIV are now symptom-free, and, in selected cases, a complete conversion from HIV-positive back to HIV-negative has been reported.

In the beginning much shame was associated with HIV infection, but those with this condition who are able to love and accept themselves and to open up to the loving support that is available from their families, friends, and communities, seem to have the greatest success in dealing with this difficult problem. As infected individuals learn to strengthen, fortify, and cooperate with their bodies' healing systems, it is highly likely that this disease will one day be declared completely curable, as has happened with other dreadful diseases from the past.

Anaphylaxis

Anaphylaxis is a less common but more serious form of an allergic reaction that can occur with bee, wasp, and other insect stings; jellyfish stings; and bites by other venomous animals. Anaphylaxis also can occur as a reaction to other substances, including pharmaceuticals.

Keeping your mind calm and relaxed is critical in the early stages of severe allergic reactions that might possibly become anaphylactic reactions. Remaining calm is essential because psychological factors such as stress, anxiety, and tension can increase the symptoms. Stress management and breathing techniques can be helpful for anaphylaxis, but, as explained in an earlier chapter, it is best to learn these techniques before any medical emergency occurs. Two acupressure points can be used to prevent or lessen anaphylactic reactions. The first is located between the base of your nose and upper lip (called Governor 26). The second is found one-third of the distance from the base of your toes to the back of your heel on the bottom of your foot (called Kidney 1). You should massage these points rigorously for several minutes. To prevent anaphylaxis, be careful with new foods, especially when you are traveling, and exercise caution when you introduce new drugs or substances into your body.

Autoimmune Diseases

This rapidly growing category of illnesses describes conditions that occur as a result of a derangement in the immune system that causes it to attack normal body tissues. Illnesses in the autoimmune disease category include *rheumatoid arthritis, ankylosing spondylitis, lupus, Sjogren's syndrome, scleroderma,* and *multiple sclerosis,* among many others. Some researchers feel that viruses and certain bacteria can trigger the immune system to attack normal body tissues, but new research suggests that these conditions represent complex mind-body interactions because they almost always worsen during times of stress. Behavioral scientists also believe that autoimmune dysfunction may be a reflection of deep-seated hostility, self-hatred, or resentment that causes elements of the immune system, acting under orders from the brain, to inadvertently attack the body. These scientists believe that self-destructive thoughts, if persistent and prolonged, can lead to physical self-destruction through powerful neurochemicals released from the brain. As the eminent cardiologist Dr. Robert Eliot said, "The brain writes prescriptions for the body." It is becoming increasingly clearer over time that this is indeed true, so this current perspective is not an unreasonable explanation for the origin of many difficult-to-treat autoimmune illnesses.

There are several natural substances that can help the body modulate the immune system (make it work better). A study by Jordan in the *Journal of Medicine* in 1998 showed that polysaccharides such as beta-1,3/1,6 glucan have beneficial immune system effects. Medicinal mushrooms such as ganoderma (also contains polysaccharides), tremella, poria and polyporus, and colostrum all support and strengthen the immune system as well. Another study done by Chen in 1993 showed that the Chinese herb cordyceps has beneficial immune system effects for diseases such as lupus. Avoid herbals such as Echinacea, which stimulate the immune system, thus making the disease worse.

Ankylosing Spondylitis

Ankylosing spondylitis is a severe form of arthritis of the spine. Stress and emotional trauma appear to worsen this condition. Conventional treatment is largely focused on suppressing the symptoms, and it is not very effective. Working with methods that

support your healing system, such as stress management, gentle yoga stretching, and a wholesome, natural diet, can be extremely helpful for this condition. In his best-selling book *Anatomy of An Illness*, Norman Cousins described his journey of complete recovery from an advanced case of ankylosing spondylitis. He attributed his success to learning to use the powers of his mind and body while he incorporated other, simple, natural methods, including large doses of vitamin C and laughter, which activated his healing system to overcome this autoimmune disorder. There is an acupuncture point, Urinary Bladder 62, which is specific for ankylosing spondylitis.

Autoimmune Disorders and Your Healing System

In addition to the experiences of Rachelle Breslow and Norman Cousins, there is now growing evidence, from both clinical case reports and laboratory data collected from various research programs around the country, that immune function, operating under the direction of the brain and nervous system, is strongly influenced by your thoughts, attitudes, beliefs, and emotions. By learning to harness these forces in a constructive way, you may be able to activate your healing system and overcome any one of a number of diseases with suspected autoimmune origins.

Strategies that may be effective for autoimmune disorders include the following:

- Mind-body strategies, including visualization and guided imagery

- Stress-management techniques

- A wholesome, healthy diet

- Release of unhealthy emotional baggage

- Exercise

- Group support

- Strengthened social intimacy

- Love

By incorporating these strategies into your life, you can work with your healing system to significantly increase your chances of overcoming autoimmune disorders.

Multiple Sclerosis

In her groundbreaking book *Who Said So? A Woman's Fascinating Journey of Self Discovery and Triumph over Multiple Sclerosis*, Rachelle Breslow documented the mind-body factors that contributed to her own case of multiple sclerosis. She was told by her conventional doctors that her condition was incurable, but she proved them wrong. By learning to work with her healing system, eating a healthy, wholesome diet, incorporating stress-management strategies and positive mental programming, and initiating other beneficial lifestyle changes, she was eventually able to overcome this so-called incurable disease. These strategies are entirely consistent with a comprehensive program based on the principles of working with the body's healing system, and they demonstrate what is also possible for you.

There are several natural substances that can improve symptoms of MS. Fish oil has been found to suppress abnormal immune system mediators, many of which play a role in MS. Krill oil, 500 milligrams three times daily, is the most potent fish oil. Lecithin, 5–16 grams daily, can strengthen nerve sheaths. Bee venom therapy (BVT) is a process that involves allowing yourself to be stung by live bees. This therapy has anecdotally given relief to people with MS, but its mechanism of action is unknown.

Cancer

Before I discuss the strategies for healing cancer, I need to address four common myths about cancer. First, cancer does not come out of the blue to attack people randomly. It also is not caused by the demons of fate. As with any illness, there are definite causes, events, and circumstances that allow cancer to take root in the body, even though these factors may seem hidden, obscure, or elusive. Second, cancer is not just one disease, but rather an entire category of illnesses, each with its own specific contributing causes. Third, even though cancer may congregate in families, the overwhelming majority of cancer cases do not have a genetic basis. Fourth, and perhaps most important, by all measurements, standards, and definitions, cancer is an unnatural illness and disease that can be prevented, and in many cases overcome, particularly if it is caught early.

Cancer appears more commonly where nature's laws of health have been violated. As such, it is not surprising to see the highest

cancer rates among the more modern, industrialized nations of the world, where synthetic, artificial chemicals and substances are used in abundance, and where lifestyles are becoming increasingly hectic, stressful, and unhealthy. This scenario represents a distinct departure from the simpler, more wholesome ways of life that our forefathers and ancestors enjoyed, when cancer was almost nonexistent. In developing nations, where these simpler, healthier lifestyles are still somewhat more preserved today, cancer rates are, not surprisingly, significantly lower than those in modern industrialized nations.

To understand the origins of cancer a little better, it will be helpful to remember the following important universal scientific principle that operates in nature and the world of living organisms: "Any stimulus or force, when applied to a system, will generate a specific response in return." For example, when the wind blows against a tree, it causes the tree to bend. When the sun shines, a plant or flower will grow toward the direction of the sunlight. When the sex hormones emitted by females of most species are released in the air, they create a powerful stimulus that attracts male animals to their source.

Problems in nature develop when artificial or unnatural stimuli are superimposed on systems that have been programmed to react to specific, natural stimuli in predictable ways. For example, deer and frogs, two animals that become more active at night, become mesmerized and freeze in their tracks in response to automobile headlights. They do this because the headlights are artificial stimuli not part of their normal nighttime environment. This abnormal response to an unnatural stimulus is hazardous to the health of both deer and frogs, and it often causes them to be hit and run over by passing cars. Moths get into similar trouble because their nighttime navigational systems are naturally programmed for starlight and moonlight, but not for artificial lights or flames, which are nearer and of much brighter intensity. To the unsuspecting observer, a moth's propensity to fly straight into a bright light or flame appears to be nothing short of a suicide mission. In reality, the movement is caused by an unnatural response to an artificial, unnatural stimulus.

What occurs in the cells of normal tissues in humans and how these cells turn cancerous is not unlike the plight of deer, frogs, and moths when they are confronted with unnatural stimuli. The story of cancer begins here, for it is here, on the cellular level, that cancer

first starts to grow, undetected and invisible, until many years later when it may first be discovered as a blip on an X-ray or a lump underneath the skin.

Before we can continue our story, it is important for you to know more about normal cells, how they grow, and how they evolve. This information will help explain how your body naturally works, so you will understand the underlying causes of cancer more clearly.

Normal Cellular Evolution

From the moment of conception, your body's original two cells multiply, divide, grow, and evolve into three distinct, primitive germ-cell tissues known as *ectoderm*, *mesoderm*, and *endoderm*. This stage is completed after just 3 weeks of gestation. From this stage, according to precise division-of-labor requirements, your cells embark upon an orderly, supervised journey of further multiplication, differentiation, segregation, and migration. They are eventually assigned to a particular organ or tissue, where they are programmed to carry out a specific function. For example, a neuron in the brain is programmed to conduct electrical impulses and discharge information to nerve tracts located throughout your body. A cell in your skin is programmed to help grow hair, absorb sunlight, and regulate sweating and body temperature. Although these cells look completely different and participate in completely different tasks, in reality, they have come from the same identical, primitive germ-cell lines, which, in this particular example, is ectoderm tissue. As different as they appear and behave when they have reached full maturity, these cells continue to communicate with each other and remain functionally connected throughout your life, through the same organizing intelligence that created them.

Evolution of a Cancer Cell

Cancer represents a departure from the highly ordered, natural state of health that exists within the cells of all living systems. When any cell or tissue is subjected to repeated irritation and disturbance from an unnatural stimulus, the cell begins to respond to this stimulus by defending itself against further irritation and injury. In so doing, it changes its appearance and function. In contrast to the high degree of differentiation all normal cells exhibited, cancer cells, irrespective of

the organ or tissue from which they may have originated, represent a reversion to a more primitive state. In this regressed state, a cancer cell no longer functions in its previous, highly developed capacity.

As cancer cells regress from their highly differentiated structure and function, and take on more primitive roles, they relinquish their connection to the natural, orderly form and function they exhibited previously. It is as if these cells rebel against the cooperative organization and orderliness of the body that characterizes its natural state of health and instead break away to form their own aberrant colony.

These changes do not occur overnight, but slowly, sometimes over many years. These new, more primitive cells now react directly with the stimulus that caused them to change and adapt, and they become their own independent, self-assertive, abnormal mass of cells.

These abnormal cells multiply and reproduce at an accelerated speed to improve their chances of survival. At the cellular level, cancer is nothing more than a maladaptive response to an abnormal, unnatural, persistent, irritating, injurious stimulus.

Let's look at a common example of how the evolution of cancer might come about from smoking, where, in the lungs, cancer has been clearly linked to repeated exposure to cigarette smoke.

- Cigarette smoke, which is unnatural and unhealthy, introduces harsh particles and noxious chemical compounds into the lungs, where they cause irritation and injury to the cells of the lungs.

- The cells in the lungs attempt to mend the damage from the irritation and injury the smoke has caused. At the same time, the cells also attempt to defend themselves from further damage as more smoke continues to enter the lungs.

- As the cells work without any rest to try to repair the damage to the lungs and to prevent further damage, the continued input of smoke disrupts normal mechanisms of healing and repair.

- Over the days, weeks, months, and years that a person continues to smoke, damage to the cells in the lungs is never allowed to heal. On top of this, more damage is created as more smoke enters into the lungs.

- The continuous and persistent damage from the smoke causes the delicate cells that are in the lungs to react in a defensive,

protective manner. Because the cells are now in "survival mode," the smoke begins to change their basic characteristics. This process is called mutation. Mutation is an adaptation response of the cell to changes in the external environment. In this case, mutation is a way that the lung cells can adapt and survive in the face of the continuous irritation from the cigarette smoke.

■ A mushrooming growth, characteristic of a cancerous tumor, eventually appears after many years in response to the repeated unnatural, injurious stimulus of the smoke.

■ In many cases, if smoking ceases and continuous damage to the cells of the lungs stops, healing processes in the lungs can resume and continue undisturbed. Cessation of the unhealthy stimulus allows the healing system to repair and regenerate new, healthy tissues, replacing the mutating cells with normal, healthy, lung cells.

From this example, it is obvious that a cancer cell is nothing more than a good cell turned bad in an effort to heal from repeated abuse, irritation, and injury. This cell eventually turns the region into the monster called cancer that we all so dreadfully fear. Cancer can occur anywhere in your body that an irritating, disruptive, unnatural stimulus is repeatedly applied to the cells of otherwise normal, healthy tissues. Once the injurious stimulus is removed, however, your healing system always has the ability to repair damages and restore normal health and functioning to any organ or tissue in your body.

Unnatural stimuli that cause cancer can come in many forms. For example, excessive exposure to the sun's powerful ultraviolet rays can cause skin cancer. Excessive radiation exposure from atomic bomb or nuclear energy leakage, as witnessed at both Hiroshima and Chernobyl, causes cancers of the skin, immune system, and other internal organs. In most cases, however, cancer is a gradual process, requiring many years of repeated unnatural irritation and injury to tissues at the cellular level.

Cancer is also linked to toxic drugs or chemicals. Intestinal cancers can often occur with the repeated ingestion of certain foods,

substances, or chemicals that continually irritate the lining of the stomach or intestines. This commonly occurs in Japan, where high rates of stomach cancer have been linked to excessive amounts of smoked fish, which contain toxic, irritating substances. Too much alcohol can cause liver cancer. Certain medicines and drugs can also cause cancer, as occurred with the drug DES, which caused thyroid cancer in the children of mothers who took this medication.

Additionally, the irritating stimulus that precipitates cancer may be a natural substance produced by your own body, but in excess. An example of this might be hydrochloric acid, secreted in normal amounts by your stomach during digestion. During times of increased stress and mental agitation, however, hydrochloric acid can be produced in excess. Excess hydrochloric acid can cause irritation, inflammation, and ulcers in your stomach and intestines, which can evolve into cancer.

Neurotransmitters, chemical messengers, and other powerful hormones produced by your brain and endocrine system can also exert an irritating, injurious effect on specific organ tissues. When stress or unhealthy moods or emotions repeatedly generate excessive amounts of these chemicals over an extended period of time, they can become powerfully unhealthy, irritating, and abnormal stimuli to the cells of specific organs. This constant stimulation results in the disruption of normal tissue structure and function, and can eventually lead to cancer. The largest number of cancers now occurring fall into this category.

Cancer Prevention

The promise of finding a cure for cancer lies in understanding its origins and focusing more on prevention than on treatment. Many experts advocate early screening measures to detect cancer, but in many cases, by the time the cancer is detected, it may already be well established and difficult to eradicate. Although cancer is certainly easier to treat if it's caught in its early stages, it is still far better to prevent it before it has a chance to take hold in the body.

Studies conducted in places around the world where cancer is noticeably absent can provide important clues to the direction we need to take with cancer research and prevention. Some of the critical factors to consider include lifestyles, health habits, foods,

medicines, beliefs, and mental attitudes of the populations being studied. We can be hopeful about the possibility of a cancer-free future if we begin to learn from these cancer-free societies, and institute changes in our own lives that support and strengthen our healing systems, incorporate ideas and methods from those cultures that place a strong emphasis on prevention, and continue cancer research and our quest for a cure.

Working with Your Healing System to Heal Cancer

As our knowledge and understanding increase, more people today than ever before have gone into complete remission and have overcome cancer. Currently, 8 million Americans who have gone into remission after their medical treatments are now cancer-free. Many of these cures have come about using conventional treatments, such as surgery, drugs, and radiation, while others represent a combination of conventional and alternative therapies. These methods include the use of natural medicines, exercise, diet and lifestyle changes, and specific mind-body techniques that work to activate and stimulate the body's healing system. Guided imagery and visualization techniques successfully employed by cancer specialists Dr. O. Carl Simonton and Dr. Bernie Siegel, as well as others, have been extremely effective in helping motivated people overcome their cancers. Learning to express emotions in a healthy way and reaching out for loving support are also highly effective in helping the healing system overcome cancer. And although there are times when surgery, radiation, and chemotherapy may be necessary to shrink tumors and remove cancerous lesions from your body to aid the work of your healing system, it is important to remember that ultimately you must not view cancer as something that has invaded your body from the outside, but rather, as a disease primarily of internal origins and causes. External agents of healing may be helpful, but your internal resources for healing are far more vast and powerful, and you should not ignore or neglect them.

Remember that cancer represents a regression of form and function by a specific group of your body's cells as the result of an unhealthy stimulus that has caused them to lose their unique identity, design, and purpose. In addition, this unhealthy stimulus has broken the connection these cells have to the rest of your body. If

you can discover the unhealthy stimulus in your life and remove it, you will be well on your way to healing. Additionally, if you can focus your mental energies, awareness, and desire to cooperate with your healing system deep inside your body, you will be in a much better position to overcome your illness and reclaim your natural state of health.

Here are a number of effective measures you can take to heal cancer:

- Remove all toxic, offending stimuli and substances from your body, such as cigarette smoke, alcohol, and junk food, as well as all toxic environmental stimuli.

- Eat a wholesome diet, with lots of fresh fruits, vegetables, and natural fiber.

- Drink plenty of fluids.

- Exercise regularly but not strenuously for at least 30 minutes each day.

- Focus on your healing system and internal resources for healing.

- Remember that your thoughts and attitudes affect your physiology. Use the power of your mind to create healthier internal chemistry for your body.

- Release all tension, anger, hostility, resentment, and grudges from your mind and body.

- Release all self-destructive thoughts, all thoughts of worthlessness and self-condemnation, and all negative beliefs about yourself.

- Learn to relax your body and mind completely. Practice stress management and meditation to the point that you can access your natural state of peace and inner tranquility regularly.

- Practice forgiveness of yourself and others.

- Use guided imagery and visualization techniques that are appropriate for your condition. Make them deeply personal and detailed, according to your own specific needs. Use these techniques to dialogue with your body and establish a line of communication with your cancer cells. To boost your confidence in healing, focus on the elements of your body that are healthy and

functioning well. Talk to your healing system. Enlist its help. In your internal imaging dialogue, remind the cancer cells that, based on the precise division of labor for which they were originally created, you value and appreciate their role, and that, in the spirit of cooperation for the greater health of your body, you sincerely request their assistance in healing.

■ Use discretion and common sense in choosing your treatments, but be open-minded. Consider all available means at your disposal, including all conventional and natural methods that have proven track records. Continue to focus all your energies and intentions on reversing the disease process until your natural state of health has been restored. Several natural herbs have been found to have anti-tumor effects. Coriolus (called Turkey Tail) has been found by Japanese research and over 400 clinical studies to stimulate natural killer (NK) cells and thus increase survival rates, especially when given with conventional treatments. One such study was done by Nio in 1992 and another study was done by Morimot in 1996. Several medicinal mushrooms also have anti-tumor effects and can help prevent fatigue caused by conventional treatments. These include *ganoderma*, *tremella*, *polyporus* and *poria*. Ellagic acid, 2,000 milligrams daily, is derived from red raspberries and is a potent tumor fighter, as reported by Constantinou in a 1995 study. Green tea (and green tea extract, 100–400 milligrams daily) has been found to interrupt abnormal tumor growth in a manner that has not been able to be duplicated scientifically in 20 years of cancer research. This has been supported by a study published in the *European Journal of Cancer Prevention* in 2003 by Ahn. Astragalus with glossy privet (ligustrum) may improve survival rates in breast and lung cancer, as supported by Upton in the *American Herbal Pharmacopoeia* (1999). Matsuoka provided a study published in the journal *Anticancer Research* in 1997 that showed that a particular beta 1,3/1,6 glucan may also prolong survival in various cancers. In the journal *Biotherapy*, Yamaguchi in 1990 demonstrated that cordyceps, a Chinese herb, has anti-tumor properties. A study by Burns published in the journal *Cancer* in 2004 showed that fish oil could reduce cachexia (weight loss) from cancer. Krill oil, 1,500 milligrams

daily, is the most potent form of fish oil. In another study done by Rao in 2000, lycopene (derived from tomatoes) was found to inhibit the proliferation of breast cancer, lung cancer, and prostate cancer.

Chemotherapy and radiation therapy are the basic conventional treatments for destroying cancerous cells, but can cause damage to normal tissues as well. Although you can help your body recover faster by using the other recommendations listed, two Chinese herbal formulas can help prevent and reduce side effects of conventional treatment. *Zuo Gui Wan/You Gui Yin* strengthens the immune system and helps prevent fatigue, the major side effect of conventional cancer treatments. The Chinese herb *Ji Xue Teng* (milletia) helps prevent bone marrow suppression during treatment, another common side effect and one that often delays appropriate treatment. This herb can be found in a proprietary Chinese herbal formula called Marrow Plus.

Several herbs and supplements can help conventional treatments kill more tumor cells or prevent damage from chemotherapy. Ginkgo biloba, 240 milligrams daily, can protect the brain from damage, especially during treatment for breast cancer. CoQ10, 50 milligrams daily, and L-carnitine, 1–2 grams daily, can protect the heart from damage when using chemotherapy agents such as adriamycin. In another study by Lockwood in 1994, CoQ10 was shown to fight breast cancer when used with fish oil and conventional therapy. In the journal *Cancer Chemotherapy and Pharmacology* in 2001, Yam and cohorts showed that fish oil in combination with vitamins E and C, along with the chemotherapy drug cisplatin, could suppress tumor growth and metastases. A study done by Lissoni in 1999 showed that melatonin, 20–50 milligrams daily, can increase tumor kill rate in several types of tumors when used with several chemotherapeutic agents. Another study done by Starvic, published in the journal *Clinical Biochemistry* in 1994, revealed that quercetin, 400–500 milligrams three times daily, can increase tumor kill rate when used with hyperthermia treatment.

Acupuncture can significantly aid your body in healing itself. It is well documented for resolving and preventing nausea due

to chemotherapy, and can reverse many of the side effects of radiation damage, such as xerostomia (decreased or absent salivation due to head and neck irradiation), incontinence, and GI side effects from lower-body irradiation.

▪ Understand that reversing cancer may be a gradual process. For the cancer to develop, evolve, and grow in your body was a gradual process, and you must allow at least an equal amount of time for the cancer to disappear back into the matrix of your body's naturally healthy cells, organs, and tissues. Just as Rome was not built in one day, so, too, restoration of health may take time. Never act out of a sense of desperation or hurry, because true healing cannot take place under these circumstances. Remember that your healing system works best in a quiet, calm, relaxed internal and external environment.

▪ Make healing your number one priority in life. Remember that by focusing your awareness deep inside your body, you have the power to activate your healing system and positively influence the health of every single organ, tissue, and cell. Remember that your natural state is health.

Closing Thoughts on Conquering Health Conditions

Your healing system has been designed and built to keep you healthy through every conceivable challenge life could possibly throw your way. Even illnesses believed to be incurable can be overcome when you set into motion the chain of events necessary to stimulate the activity of your healing system. Naturally, the longer you have had a particular disease, the longer the period of time required for healing. In this respect, it is important to cultivate the fine art of patience as you set about the diligent work of incorporating all of the ideas and methods outlined in this and previous chapters. Patience and perseverance are required to support the work of your healing system so it can restore your body to its natural state of health in the shortest time period.

As long as you are alive, you have healing power. Even as you

age, there are ways to stay healthy and overcome illness by keeping your healing system in tip-top shape. Because you have a healing system, if your commitment and resolve are sufficient, there isn't a disease on the face of this earth that can stand in the way of reclaiming your natural state of health.

Additional Relaxation Methods, Breathing Techniques, and Guided-Imagery Techniques to Strengthen Your Healing System

In this section of the book, you'll learn additional techniques and methods for tapping into the extraordinary power of your healing system.

Relaxation Methods to Strengthen and Fortify Your Healing System

Like any artist who requires a quiet, peaceful, uplifting environment to concentrate and perform his or her best work, your healing system does its best work when you are relaxed. When you are relaxed, your mind, your nervous system, and your body's internal environment provide the ideal backdrop in which your healing system can optimally perform its reparation and restorative work for your body.

Nature, in her infinite wisdom, has created the natural sleep cycle because the relaxation you get from sleep is essential to your health and well-being. When you are sleeping, your body's physiological processes are minimized, your internal environment quiets down, and your healing system can work optimally to restore your health. After a good night's sleep, you should feel refreshed, renewed, and invigorated to begin the new day. When responding to their patients' health problems, many doctors will tell them,

"Take two aspirins and call me in the morning." They know that most problems are not as serious the next day, thanks to the magical, healing, and restorative powers of sleep.

When we have trouble getting to sleep, and when we fail to take advantage of the natural, restorative powers of sleep, insomnia can set in. Health suffers and illness can easily take hold when we don't get enough sleep.

During our waking hours, however, it is also important to be relaxed. In fact, one of the major causes of insomnia is the inability to relax during waking hours. Relaxation used to be a natural aspect built into our lifestyles, but today our lifestyles have become so fast-paced that we don't have time to relax. Further, even if we had the time, we wouldn't know how to do it.

When we are not relaxed, but are instead tense or excited, the fight-or-flight response can become activated. As you may recall from our earlier discussions (see Chapter 6), the fight-or-flight response occurs whenever we are frightened, tense, or feeling threatened in any way. This response results in the release of adrenaline, which causes the speeding up of our heartbeat and breathing, among other things. The fight-or-flight response is definitely helpful when our life is actually being threatened; however, when the response is elicited frequently and sustained over time, it drains vital energies, weakens host-resistance factors, lowers our bodies' defenses, and interferes with the work of our healing systems. For these reasons, when tension becomes chronic and long lasting, it is easy for illness to step in and invade our bodies. In fact, long-standing tension is one of the key underlying factors in the development and progression of many chronic degenerative diseases.

To neutralize the harmful effects of tension and reverse the damaging effects of the fight-or-flight response, it is important to learn how to relax. In so doing, you will be strengthening and fortifying your healing system in a most fundamental way.

I am continually amazed at how many people don't know or never learned how to relax. When I inquire, most people report to me that they need some kind of external prop or activity, such as reading or watching TV, a mind-altering substance such as alcohol or a tranquilizer, or a combination of these, to wind down from their busy days and help relieve their tensions. These methods and

activities often feel relaxing, but, in most instances, the mind is still actively engaged. Or, at the cost of achieving mental relaxation, consciousness, proper judgment, and the body's health (most commonly the liver's) are sacrificed. At best, these methods and devices are only temporary and achieve only a small fraction of the relaxation that the healing system requires to function optimally. Additionally, they usually have harmful side effects that neutralize whatever benefits they might contribute.

In our high-speed modern lifestyles, learning how to relax is, unfortunately, a lost art, and one reason why many stress- and tension-related disorders are on the increase in North America and Europe. These diseases are not in the minor leagues, either; rather, recent research has determined that they include some of the heaviest hitters in the annals of international public health. As mentioned earlier, among these diseases are heart disease (the world's number-one killer), high blood pressure, diabetes, asthma, and cancer. To overcome these diseases and improve our health, it is imperative that we relearn what once was a natural process, built into our simpler, more organic lifestyles: how to relax.

True relaxation involves the natural quieting down and calming of your mind to a point at which a feeling of deep peace and comfort permeates every part of your body. True relaxation improves your overall health by calming and soothing your body's internal environment so your healing system can function and perform at its best.

As we learn, practice, and experience regular relaxation, many illnesses and diseases can be totally eradicated, never to return again—including the heavy hitters previously mentioned. Many scientific studies can attest to the power and efficacy of relaxation, which is an essential ingredient for lifelong, natural health. I might add that beyond the immediate benefits of the actual relaxation practices and techniques, a spillover effect occurs in the rest of your waking hours. These benefits accrue over time to produce greater health, much like a high-interest-bearing account grows larger and stronger over time.

In preparation for practicing the relaxation techniques, it is important to secure a 20- to 30-minute time slot for yourself during which you can be quiet and alone. Make sure you won't be disturbed during this period, and that you have no responsibilities to attend to—no phone or pager to answer, no diapers to change, no stove or

oven to turn off, and so on. Find a room where you can close the door and be free from all distractions. (You may need to wear earplugs or headphones if it is noisy.) Make sure you are not cold. Whatever your position, you may need to place blankets or pillows under your knees, head, or back to ensure your comfort.

Normally, when you are performing relaxation techniques or breathing exercises, it is preferable to breathe through your nose. Before you proceed with any of the following techniques, you might find it helpful to get a small tape recorder and record your voice as you read the instructions out loud, slowly and calmly. After you have recorded your words, you will have your own voice recorded, to guide you any time you wish. Or, if you wish, you can just read through each technique once or twice before you attempt to practice it.

Progressive Relaxation for Your Healing System

This is a wonderful relaxation technique for people who are chronically tense or "high strung." It is especially useful for people who have never experienced what it feels like to be relaxed. For people who have trouble with the Deep Relaxation technique described earlier in Chapter 6, Progressive Relaxation offers another simple yet powerful way to learn how to relax.

The Technique

- Lie down in a comfortable position with your feet about shoulder width apart. Keep your hands along the side of your body, with your palms facing up. Adjust any part of your body to make sure you are comfortable before you proceed.

- Gently close your eyes, and bring your awareness inside of your body.

- Now, shift your awareness to your feet and toes. Take a long, deep breath as you tighten and tense all the muscles in your feet and toes. Squeeze as hard as you can, and hold all the muscles in your feet and toes in a tight, contracted state. Count to eight in your mind as you squeeze the muscles tight. Do not force or strain, but hold your breath as you are squeezing.

- After a good, long, strong squeeze, let go of your squeezing as you slowly let your breath out. Allow these muscles to let go of

their tension and relax as you slow and deepen your breathing, gently, without forcing or straining. Continue to relax your muscles, and gently slow your breathing. With each exhalation of your breath, allow whatever tension exists in these muscles to leave your body.

- Next, bring your awareness to your ankles, lower legs, knees, and thighs. Take a long, deep breath as you tighten and tense all the muscles in your ankles, lower legs, knees, and thighs. Squeeze as hard as you can, and hold these muscles in a tight, contracted state while you slowly count to eight in your mind. Hold your breath as you are squeezing. After a good, long, strong squeeze, let go of your squeezing and at the same time slowly let your breath out, allowing these muscles to relax on their own. Allow these muscles to relax as you slow and deepen your breathing, gently, without forcing or straining. Continue to let go of all muscular efforts of squeezing these muscles. Continue to relax your muscles while you gently slow your breathing. With each exhalation of your breath, allow whatever tension exists in these muscles to leave your body.

- Now, bring your awareness to your hips, pelvic area, buttocks, and lower spine. Take a long, deep breath as you tighten and tense all the muscles in your hips, pelvic area, buttocks, and lower spine. Squeeze as hard as you can, and hold these muscles in a tight, contracted state while you slowly count to eight in your mind. Hold your breath as you are squeezing. After a good, long, strong squeeze, let go of your squeezing while you slowly let your breath out, allowing these muscles to relax on their own. Allow these muscles to relax as you gently slow and deepen your breathing, without forcing or straining. Continue to let go of all efforts to squeeze these muscles. Continue to relax your muscles and your breathing. With each exhalation of your breath, allow whatever tension exists in these muscles to leave your body.

- Next, bring your awareness to your stomach, abdomen, and chest. Take a long, slow, deep breath as you tighten and tense all the muscles in your stomach, abdomen, and chest. Squeeze these muscles as hard as you can, and hold them in a tight, contracted state while you slowly count to eight in your mind. Hold

your breath as you are squeezing. After a good, long, strong squeeze, let go of your squeezing, and at the same time let your breath out, allowing these muscles to relax on their own. Allow these muscles to relax as you gently slow and deepen your breathing, without forcing or straining. Let go of all efforts to squeeze these muscles. Continue to relax your muscles and your breathing. With each exhalation of your breath, allow whatever tension exists in these muscles to leave your body.

- Now, bring your awareness to the muscles in your middle and upper back, including the area between your shoulder blades. Take a long, slow, deep breath as you squeeze these muscles as hard as you can, drawing your shoulders back slightly while you gently arch your spine. Hold these muscles in a tight, contracted state while you slowly count to eight in your mind. Hold your breath as you are squeezing. After a good, long, strong squeeze, let go of your squeezing, and at the same time let your breath out, allowing these muscles to relax on their own. Allow these muscles to relax as you slow and deepen your breathing, without forcing or straining. Let go of all efforts to squeeze these muscles. Continue to relax your muscles and your breathing. With each exhalation, allow whatever tension exists in these muscles to leave your body.

- Next, bring your awareness to your shoulders, arms, forearms, wrists, hands, and fingers. As you draw in a long, deep breath, squeeze the muscles in your shoulders, arms, forearms, and wrists as hard as you can, and hold them in a tight, contracted state. Make tight, clenched fists with both of your hands while you slowly count to eight in your mind. Hold your breath as you are squeezing. After a good, long, strong squeeze, let go of your squeezing, and at the same time let your breath out, allowing these muscles to relax on their own. Let go of all efforts to squeeze these muscles. Allow these muscles to relax as you slow and deepen your breathing, without forcing or straining. Continue to relax your muscles and your breathing. With each exhalation of your breath, allow whatever tension that exists in these muscles to leave your body.

- In a similar manner, systematically tense, squeeze, and then relax all the muscles in the back of your neck and head, as well as those on the top of your head.

- In a similar way, systematically tense, squeeze, and then relax your forehead, and all the muscles around your eyes, ears, and jaws, and all the muscles on your face.

- In a similar manner, systematically tense, squeeze, and then relax all the muscles in your body, until all your muscles have been tensed and relaxed in this fashion.

- Next, allow your entire body to lie limp and relaxed, with the only movement being the automatic, involuntary movement of your stomach and abdomen as they rise and fall rhythmically, in conjunction with the movement of your breath as it flows in and out of your body. Every time the breath leaves your body, feel all the muscles in your body releasing tension and becoming more relaxed.

- Now slowly bring your awareness to the tip of your nose, where your breath is flowing in and out of your body through your nostrils.

- Notice the gentle, flowing movement of your breath as it comes in and out of your body at this point, without trying to control the rate or depth of the movement.

- Observe your breath as if it were something different from yourself.

- As you continue to observe your breathing for at least 5 to 10 minutes, or longer if you desire, let your mind and body relax completely.

After you complete this exercise, gently open your eyes and stretch your entire body. Don't rush to your next activity. Take the time to savor the calm and relaxed state you have just experienced. Know that this is not an artificial or contrived state, but rather your natural state of being. Focus on remaining in this calm and relaxed, natural state throughout the day, until the next time you are able to do this exercise.

Regularly practicing Progressive Relaxation helps to strengthen and fortify your healing system in a powerful way. If you are currently battling a health disorder, practice twice a day for a minimum of six weeks, and you should see significant gains in your health. If you are currently healthy, practice Progressive Relaxation once a day for 20 to 30 minutes to prevent illness from invading your body.

Blue Sky Floating on Your Back Relaxation

This relaxation technique begins like the Deep Relaxation technique (see Chapter 6), but this method also incorporates the soothing natural imagery of water and sky. If you have an affinity for these elements, this technique can be extremely effective and powerful.

The Technique

- Make sure you are in a comfortable position on your back.

- Keep your hands along the side of your body, with your palms facing up, or fold your hands on top of your stomach and abdomen. Gently close your eyes, and bring your awareness inside of your body.

- Notice in the area of your stomach and abdomen the slight up and down movement that occurs in conjunction with the movement of your breath as it flows in and out of your body.

- Notice that when the breath flows into your body, your stomach and abdomen gently rise, gently expand.

- Notice that when the breath flows out of your body, your stomach and abdomen gently fall, gently contract.

- Without trying to control the rate or depth of this movement, allow your mind to be a passive observer to the rhythmical flow of your breath as it moves in and out of your body, causing your stomach and abdomen to rise and fall.

- Every time the breath leaves your body, feel all the muscles in your body releasing tension and becoming more relaxed. (Note: There is a natural relaxation phase in your body that occurs during each exhalation of the breath. When you pay close attention to your body and its breathing processes, you can feel this relaxation phase quite distinctly.)

- Now, bring your awareness down to your feet and toes. Use your breath and the natural relaxation phase that occurs during each exhalation to gently relax all the muscles in your feet and toes.

- Relax all the muscles in your ankles, lower legs, knees, thighs, hips, pelvic area, buttocks, and lower spine.

- Relax all the muscles in your stomach, abdomen, and chest, as well as the muscles in your middle and upper back, including the area between your shoulder blades.

- Relax all the muscles in your shoulders, arms, forearms, wrists, hands, fingers, and fingertips.

- Relax all the muscles in the back of your neck and head, and the top of your head.

- Relax your forehead, and all the muscles around your eyes, ears, and jaws, and on your face.

- Relax all the muscles in your body.

- Continue to observe your breathing, noticing the gentle up and down movement in your stomach and abdomen. Continue to feel more relaxed with each exhalation.

- Now, keeping your eyes closed, imagine that you are floating on the surface of a quiet, serene lake, and there is blue sky above and all around you. (If you are not comfortable being directly in the water, you can imagine yourself floating on a strong and secure rubber inner tube in the water. Above all else, it is important to feel completely safe and secure with this imagery and this technique.)

- As you continue to breathe in and out in a gentle and relaxed manner, notice how the water beneath you is soothing and refreshing to your body. Notice how the vast blue sky above you is peaceful and refreshing to gaze upon, as if your entire being is embracing infinity and merging into the heavens.

- Notice a feeling of lightness and peace in your mind that extends into every part of your body as you continue to float on the surface of the water, gazing up into the blue sky. Allow yourself to feel this peaceful sensation of lightness and relaxation from the top of your head to the tips of your fingers and toes.

- As you continue to float on the surface of the water, look up at the blue sky above you, and allow yourself to feel as if you are melting into the expansiveness of the sky and all of creation.

- Continue to breathe and relax, drinking in the peace and serenity of this experience.

After you complete this exercise, gently open your eyes, and stretch your entire body. Make sure you don't rush to your next activity. Take the time to savor the calm and relaxed state you have just experienced. Know that this is not an artificial or contrived state, but rather your natural state of being. Focus on remaining in this calm and relaxed natural state throughout the day, until the next time you are able to do this exercise. Practicing this exercise regularly brings the most effective benefits.

Breathing Techniques That Strengthen and Fortify Your Healing System

Breathing is an activity that you probably take for granted because your body can breathe on its own, automatically. It usually does so 24 hours a day, seven days a week, without your even being aware of it. But breathing is a powerful physiological activity that can be modified, either to your benefit or detriment, and it can aid or hinder the functioning of your healing system.

As we discussed in Chapter 6, breathing works on many different levels to influence your body's health and the performance of your healing system. And although there is no right or wrong way to breathe, many people have developed habits of breathing that do not optimize the performance of their healing systems.

On a mechanical level, breathing affects your posture. Because the muscles of respiration move your rib cage and chest, which connect to the vertebrae in your spine, every breath you take influences the alignment of your spinal column. For example, people with asthma and other chronic breathing problems are typically shallow breathers, and they tend to develop restrictive, hunched-forward positions in their spine, known as *kyphosis*. Kyphosis further restricts deep breathing and deprives the body of adequate oxygenation. An extreme example of kyphosis could be seen in the Hunchback of Notre Dame.

Breath is also the link between your body and mind, and it exerts a powerful influence on your nervous system. For example, when you are agitated or upset, your breathing becomes shallow and rapid. Conversely, when you are relaxed and peaceful, your breathing

becomes slower and deeper. The processes are interrelated. In fact, by practicing slow, relaxed, deep breathing, you can calm and relax your mind and nervous system, while you improve the oxygenation of your body's tissues.

By learning to practice these simple, easy breathing techniques, which are based on ancient yoga techniques from India, you can bring more *prana*, or energy, into your body, and strengthen and fortify your healing system.

Because breathing, for the most part, is such a natural, unconscious activity, many people have a strong aversion to learning how to breathe in a way that may initially feel different or unnatural. However, based on my 25 years of experience as a doctor who has studied breathing, and on new scientific studies of breathing, I can assure you that taking a closer look at your breathing, and committing yourself to just one or two of the following simple breathing techniques, will enable you to notice a tremendous improvement in your overall state of health.

Of all the physical activities you can do to improve your health and influence your healing system, breathing is one of the most powerful of all.

Breathing Techniques

Breathing techniques are traditionally done in a sitting position, but you can also do them while you're lying down. The important thing is to make sure you are in a comfortable position. If you are doing breathing techniques while you are sitting, keep your spine straight and your shoulders relaxed. If you are doing these while you are lying down, you can assume a similar position to that of the Deep Relaxation (see Chapter 6) or Progressive Relaxation (see the section in this chapter on relaxation methods) techniques. Whatever your position, you may need to place blankets or pillows under your knees, head, and back to ensure your comfort. Make sure you are not cold.

Normally, when you are performing breathing exercises, as with other relaxation techniques, breathing through your nose whenever possible is preferable.

The beauty of breathing exercises is that you can do them at numerous intervals throughout the day, from one minute's duration, up to 30 to 60 minutes, depending on your schedule. Obviously, the

longer you can do them, the more powerful their effect. But even if you have only a few brief moments at selected times throughout the day, breathing exercises can make a tremendous difference in your overall health because of their cumulative effects. Breathing exercises are ideally practiced with your eyes closed, but you also can practice them with your eyes open. Breathing exercises are quiet and gentle, and they require no external props. So you can perform them effortlessly without anyone else knowing what you are doing when you're on long airplane flights, a bus or train, stuck in rush hour commuter traffic, or in the midst of boring meetings. Again, although they are simple and easy, and they feel good, breathing exercises are powerful in their ability to strengthen and fortify your healing system.

Breathing practices have a relaxing effect, so, in the beginning, you should not perform them while you are driving or operating mechanical devices or equipment. In time, as you become more accomplished, you may find that you can do them while you are carrying on your normal activities. Even though breathing practices are initially calming and relaxing, they can be extremely energizing in the long run.

Before you proceed with any of the following techniques, you might find it helpful to get a small tape recorder and record your voice as you read the instructions out loud, slowly and calmly. After you have recorded your words, you will have your own voice recorded to guide you any time you wish. Or you might wish to just read through each technique once or twice before you attempt to practice it.

In and Out Breath

This is a very simple yet powerful breathing technique that helps to quiet down your mind, calm and purify your nervous system, and strengthen and fortify your healing system. You can do the In and Out Breath technique either lying down or in a seated position. It is preferable to do it while you're seated, so you can do it in your spare moments in the midst of your busy days; but, in the beginning, it may be more convenient to learn this technique while you're lying down.

The Technique

- Make sure you are in a comfortable position, lying down or seated. Use blankets, pillows, cushions, pads, or other necessary support to help you get comfortable.

- Once you are comfortable, close your eyes, and bring your awareness inside of your body.

- Relax all the muscles in your body as you focus on the gentle movement of your breath flowing in and out of your body.

- Notice the slight movement in your stomach and abdomen every time your breath flows in and out of your body.

- Notice that when your breath flows into your body, your stomach and abdomen gently rise and expand. Notice that when your breath flows out of your body, your stomach and abdomen gently fall and contract. Without trying to control the rate or depth of this movement, just allow your mind to be a passive observer of this automatic movement of your breath as it flows in and out of your body.

- Continue to watch your stomach and abdomen move up and down every time your breath flows in and out of your body.

- Every time the breath leaves your body, feel all the muscles in your body releasing tension and becoming more relaxed.

- After you feel somewhat relaxed, gently shift your awareness to the tip of your nose, where your breath is flowing in and out of your body through your nostrils.

- Visualize your breath as if it were something different from yourself.

- Continue to observe the rhythmical flow of your breath as it flows in and out of your body through your nose.

- As you continue to observe your breathing, allow your mind and body to relax more deeply.

- After you have observed your breathing for several minutes, notice that the air flowing out of your nose is slightly warmer than the air flowing into your nose. Or you can notice that the air flowing into your nose is slightly cooler than the air flowing out of your nose. At first, focus your awareness on whichever

sensation is easier for you to feel. Notice this temperature differ-ence between the air moving into your nose and the air moving out of your nose as you continue to breathe with this increased awareness. Continue to breathe this way for one or two minutes.

■ After one or two minutes, on your next exhalation, as you breathe out, follow the breath as it leaves your nose, and see how far you can feel it moving away from your body.

■ In the beginning, you can place a hand in front of your nose to help you feel the movement of your breath. As your breath strikes your hand, keep moving your hand further away from your nose. As you continue to breathe, keep moving your hand further and further away until you can no longer feel your breath striking your hand. (After you get good at this, you will no longer need to use your hand.) Now bring your hand back slightly until you can still just barely feel your breath. As you continue to breathe this way, be aware of how far your breath flows out of your body.

■ Continue to hold your awareness at the point at which you can just barely feel your breath. Continue to hold your awareness at this point, only now, see whether you can do it without using your hand. (Adjusting your awareness may take a few moments.)

■ At the furthest point away from your body at which you are still able to just barely detect your outgoing breath, start to focus your awareness on the incoming breath. See whether you can begin to feel the slightly cooler air coming into your body from this same point. Continue to focus at the point of origin of the cooler air as it begins to enter into your body.

■ As you breathe in, follow the cooler air entering into your body and notice the place at which it comes in contact with your nose. Feel the cooler air gently striking your nose as it enters into your body, and then continue to follow this air as it moves into your throat and lungs. Follow your breath further into your body as it causes your stomach and abdomen to rise and expand. Feel your breath spreading throughout your entire body with each inhalation that you take.

■ With each breath you take, continue to follow your incoming breath as it flows into your body, watching it cause your stom-ach and abdomen to rise and expand.

- Continue to observe the gentle movement of your stomach and abdomen as your breath flows in and out of your body.

- Now, gently shift your awareness back to the most distant point at which you could detect the movement of your breath.

- Simultaneously feel both of these points: 1) the point that is furthest away from your body at which you can detect your breath, and 2) the most interior point within your body at which you can still feel the presence of your breath.

- Hold your awareness between these two extreme points as you continue to observe the automatic, flowing movement of your breath as it flows in and out of your body.

- After 5 to 10 minutes, slowly open your eyes, stretch your body, and release yourself from your seated or lying-down position.

"The Pause That Refreshes" Breathing Exercise

This is a simple and easy breathing exercise that you can do anytime, anywhere, while you are sitting or lying down. The more you do it, the easier it gets, and the more natural it feels. When you perform this exercise correctly, it is extremely pleasurable. Even though it is simple and easy, and feels so good, don't underestimate its power and effectiveness in strengthening and fortifying your healing system.

The Technique

- Although it is preferable to sit, you may also lie down in a comfortable position for this breathing technique. Close your eyes, bringing your awareness into your body. Relax your shoulders and all the muscles in your body.

- Bring your attention to the area of your stomach and abdomen. Notice in the area of your stomach and abdomen the slight up and down movement that occurs in conjunction with the movement of your breath as it flows in and out of your body.

- Notice that when the breath flows into your body, your stomach and abdomen gently rise, and when it flows out of your body, your stomach and abdomen gently fall.

- Without trying to control the rate or depth of this movement, just allow yourself to be a passive observer to the natural flow of

your breath as it moves in and out of your body. Breathe like this for several minutes, until you begin to feel a sensation of relaxation sweeping over your entire body.

■ Next, as you notice yourself becoming relaxed, gently slow and deepen your breathing, so that the time of your inhalation and exhalation are slightly prolonged. Note, however, that it is extremely important to do this gradually, without forcing or straining. Above all else, make sure you are comfortable with your breathing.

■ Now, as you continue to gently lengthen, deepen, and slow your breathing, notice that right before your breath flows into your body, and right before it begins to flow out again, there is a slight pause between these separate phases of your breathing. These phases are known as inspiration and expiration, respectively. Notice that there are a total of two pauses built into your body's natural breathing cycle.

■ As you continue to breathe in and out slowly, notice these two distinct pauses between inspiration and expiration.

■ Now, during the next pause after inspiration, right before you exhale, gently lengthen the time of the natural pause before you commence exhaling. Do this in a gentle and soothing way, without forcing or straining. If you do it right, you should feel a slightly pleasurable sensation, especially when you exhale. As you hold this pause, you may want to gently press your tongue against the back of your teeth or the top of your palate to make sure no air escapes during this period.

■ Now, after a brief and slight breath pause of one or two seconds, when you have temporarily suspended movement in your normal breathing rhythms, gently release the pause and let your breath out slowly and smoothly, as you would during normal breathing.

■ When you are ready, after the next full inspiration, and right before expiration, at the time of the next natural pause or break in your breathing, once again gently prolong and lengthen this pause for one or two seconds before you let your breath out naturally, as you would during your normal breathing cycle.

- Continue to breathe this way, gently prolonging the natural pause that occurs with each cycle of breathing between inspiratory and expiratory phases.

- During this pause, take a brief inventory of how you feel in your body and mind. Make sure you are not forcing or straining, and that you are comfortable with your breathing.

- Make sure you are comfortable at all times while you are performing this powerful breathing exercise. If you try to prolong the pause longer than you can handle, you will experience breath deprivation, discomfort, and a sensation of forcing or straining. Additionally, the rhythm of your breathing will not be smooth and flowing, but rather jerky and interrupted. As you breathe out, and then again as you breathe in, and even during the pause, your breath should be smooth and flowing, and you should feel comfortable and pleasurable sensations.

- In the beginning, do this breathing exercise for no more than 3 to 5 minutes at a time, and not more than four times a day, no matter how pleasurable and relaxing you may find it. Even though it is gentle and soothing, this technique is also extremely powerful and subtle, and you can overdo it, especially in the beginning. In time, you can build up to 20 to 30 minutes at a time.

- Also, over time, you can gently prolong the pause between each inspiration and expiration for up to one minute, or even longer. Remember to focus your awareness within, and take a brief inventory of your body and mind during this pause. During the pause, which is a time of complete cessation of respiration, an accompanying slowing down of physiological processes and mental activities occurs. This slowing down can be calming and peaceful, and it is extremely beneficial to your healing system, which, as you'll recall, does its best work when your body's internal environment is quiet and calm.

Breathing exercises calm the mind and body, and they are extremely beneficial to your healing system. Incorporate these exercises into your daily routine, and before long you'll begin to see their remarkable effects.

Guided Imagery to Strengthen and Fortify Your Healing System

Your brain translates mental images into electrical and chemical signals that are transmitted to your body. Because of this deep connection between your brain and your body, the techniques of visualization or guided imagery can be a powerful way to activate, strengthen, and fortify your healing system. Many studies have shown the health-enhancing benefits of guided imagery and visualization techniques in helping motivated patients overcome serious illnesses, including cancer and heart disease. (For more information on guided imagery and visualization, see Chapter 6.)

"Meeting Your Healing System" Guided-Visualization Technique

Begin this technique as you would the relaxation techniques described earlier in the book, such as Deep Relaxation, Progressive Relaxation, or Blue Sky Floating on Your Back Relaxation. Read through the directions completely once or twice before you attempt to practice it. You may also want to get a tape recorder and record your own voice as you read through this exercise. Then you will be able to close your eyes and listen to your own voice guide you through the imagery.

Follow these simple steps to do this technique:

- Make sure you are in a comfortable position, lying on your back with your eyes closed.

- Focus on your breathing as you allow your mind and body to relax completely.

- As you begin to feel yourself becoming relaxed, take a deep, sighing breath. As you breathe out, let all the tension leave your body.

- Take a second, deep, sighing breath, and, as you breathe out, allow your mind and body to be completely relaxed. Make sure you feel completely relaxed before you proceed further with this exercise. It is important not to hurry or rush through this step.

- After you are somewhat relaxed, keep your eyes closed, and allow an image to form in your mind of any quiet, serene, uplifting

place. Your image could be a beautiful outdoor setting or inside in a favorite, cozy room of a house. It could be a place you have actually been to in real life, a place you saw in a picture, or a totally fresh image that you have never seen before. Whatever image begins to appear, do not force or strain with the imagery, and do not judge it in any way.

- As you continue to breathe and relax, be patient with the imagery. Allow it to keep forming in your mind until you have a fairly clear picture of the place.

- Once your special place begins to come into focus, and you have a fairly clear idea of where you are, continue to breathe deeply and relax.

- Allow the image to become clearer and more well defined.

- Notice all the senses, and answer these questions in your mind:◆

 - ◆ What are the sights? What are the sounds? What are the smells?

 - ◆ What kind of day is it? What does the sky look like? Where is the sun?

 - ◆ What does the countryside or surrounding environment look like?

 - ◆ What sensations are you feeling on your skin?

 - ◆ What is the air quality? Is it cool or warm? Is there humidity, or is it dry? Are there any breezes?

 - ◆ What are you wearing?

- Breathe deeply and relax as you allow your mind to absorb the images.

- Find a place to sit down (or, if you feel more comfortable, to lie down, or even stand) in your quiet, special place. In your image, make sure you are in a comfortable position.

- Once you are comfortable in your special place, allow your awareness and imagination to go inside your body.

- See yourself examining the inner workings of your body as you gently survey the landscape.

- As you move around within the various structures and tissues of your body, imagine yourself going on a journey of discovery.

- Find a quiet place, deep within the recesses of your body's internal environment, where you feel safe and protected.

- Stop and relax once you've found a place where you feel comfortable. Let your intuition guide you.

- Breathe deeply, and allow yourself to relax in this quiet place within your body.

- See yourself waiting with anticipation, as you prepare to meet your healing system.

- Wait for the first image to form as your healing system begins to come into view.

- As you begin to get the first glimpses of your healing system, allow whatever image is developing to form on its own. There is no right or wrong here, so there is no need to judge anything about the image. If an image forms that is totally unexpected, which is often the case, welcome it. Do your best not to reject or be afraid of the image of your healing system that your imagination presents to you.

- Allow the image of your healing system to come into clearer focus. Notice all you can about its shape, dimensions, color, texture, and whether it is moving or still.

- Your healing system may even appear in the form of a person, animal, or some other creature. It might even have a face or a name.

- When you have a fairly clear picture of your healing system in your mind, allow yourself to come close enough to it so you can have a conversation with it. Or it may be so powerful that you are more comfortable stepping back and creating distance. Find the distance that feels best for you, and adjust your position to the image so that you are comfortable.

- Just as you would upon meeting a new friend for the first time, introduce yourself to your healing system. Or you may feel as if you are meeting an old friend after a long time, and you are reintroducing yourself.

▪ You may want to tell your healing system how you feel. If you are in pain, you may want to share this, or you may be angry with it because you think it's not been doing such a good job of protecting your health. Tell it this. Or you may feel more comfortable asking your healing system more questions and getting to know it first, before you tell it how you feel.

▪ If you are in pain, you may ask your healing system how it can heal your pain. If you are sick or have an illness, you may want to ask it how to heal and get better.

▪ Ask your healing system whether you might be doing something that is interfering with its work. Ask whether there is something you are neglecting to do to keep your healing system strong and vibrant. Ask how you can improve your lifestyle and your daily personal health habits in support of its work.

▪ Ask your healing system how you can get to know it better, and what it needs to be healthy and strong.

▪ Continue to ask as many questions as you like.

▪ Remember to listen attentively to the answers that will be forthcoming. There may be a slight delay in receiving the information, so don't rush the responses, or be in a hurry.

▪ When you are done, remember to say "Thank you" to your healing system.

▪ Find out when you can meet again.

▪ Schedule an appointment for the next time you will meet. Doing this is very important to help you stay accountable for your role in this ongoing internal dialogue with your healing system. Because your healing system is punctual and always available to you, it will definitely show up at whatever time and date you specify, but you must be specific.

▪ When you are finished, say "Goodbye" to your healing system.

After you have completed this guided imagery/visualization exercise, take a few moments to reflect on the experience. Take a pen and notebook and write down as much information about the experience as you can remember. What new insights did you gain? Make

an action plan based on new ideas or information that your healing system has shared with you in your imagery dialogue.

Now it is up to you to implement these ideas in your daily life. So, what are you waiting for? Do it today! If you stay in touch with your healing system, you'll see that it will function better and work harder to keep you healthy and strong.

RESOURCES

Recommended Reading

General Healing

Batmanghelidj, F., M.D. *Your Body's Many Cries for Water*. Falls Church, VA: Global Health Solutions, Inc., 1998.

Bennet, Hal Zina. *The Doctor Within*. New York: Clarkson N. Potter, 1981.

Bennett, Cleaves, M.D. *Control Your High Blood Pressure Without Drugs*. Garden City, NY: Doubleday, 1986.

Benson, Herbert, M.D. *The Wellness Book*. New York: Birch Lane Press, 1992.

Borysenko, Joan. *Minding the Body, Mending the Mind*. New York: Bantam Books, 1988.

Breslow, Rachelle. *Who Said So?: A Women's Fascinating Journey of Self Discovery and Triumph over Multiple Scierosis*. Berkeley: Celestial Arts, 1991.

Brownstein, Arthur, M.D. *Healing Back Pain Naturally*. Gig Harbor, WA: Harbor Press, 1999.

Cawood, Frank W. *High Blood Pressure Lowered Naturally*. Peachtree City, GA: FC, & A Publishing, 1996.

Chopra, Deepak, M.D. *Ageless Body, Timeless Mind*. New York: Bantam Books, 1993.

Chopra, Deepak, M.D. *Quantum Healing*. New York: Bantam Books, 1990.

Cortis, Bruno, M.D. *Heart and Soul*. New York: Villard Books, 1995.

Cousins, Norman. *Anatomy of an Illness*. New York: Bantam Books, 1985.

Cousins, Norman. *Head First: The Biology of Hope*. New York: E.P. Dutton, 1989.

Dossey, Larry, M.D. *Healing Words*. San Francisco: Harper Collins, 1993.

Eliot, Robert, M.D. *Is It Worth Dying For?* New York: Bantam Books, 1989.

Golan, Ralph, M.D. *Optimal Wellness*. New York: Ballantine Books, 1995.

Goleman, Daniel and Joel Gurin. *Mind Body Medicine: How to Use Your Mind for Better Health*. Yonkers, NY: Consumer Reports Books, 1993.

Hay, Louise. *You Can Heal Your Life*. Carlsbad, CA: Hay House, 1997.

Hirshberg, Caryle and Marc Ian Barasch. *Remarkable Recovery*. New York: Riverhead Books, 1995.

Hirshberg, Caryle, et. al. *The Art of Healing*. Atlanta: Turner Publishing, 1993.

Ivker, Rob. *Thriving*. New York: Crown Publishers, 1997.

Jampolsky, Gerald, M.D. *Forgiveness*. Hillsboro, OR: Beyond Words Publishing, 1999.

Jampolsky, Gerald, M.D. *Love Is Letting Go of Fear*. Berkeley: Celestial Arts, 1988.

Laskow, Leonard, M.D. *Healing with Love*. San Francisco: Harper Collins, 1992.

Locke, Steven, M.D. *The Healer Within: The New Medicine of Mind and Body*. New York: E.P. Dutton, 1986.

Myss, Caroline. *Why People Don't Heal and How They Can*. New York: Three Rivers Press, 1997.

Northrup, Christiane, M.D. *Women's Bodies, Women's Wisdom*. New York: Bantam Books, 1998.

O'Regan, Brendan and Caryle Hirshberg. *Spontaneous Remissions*. Sausalito, CA: Institute of Noetic Sciences, 1993.

Ornish, Dean, M.D. *Dr. Dean Ornish's Program for Reversing Heart Disease*. New York: Random House, 1990.

Pagano, Jon. *Healing Psoriasis*. Englewood Cliffs, NJ: The Pagano Organization, 1991.

Pinckney, Neal. *Healthy Heart Handbook*. Deerfield Beach, CA: Health Communications, 1996.

Pleas, John. *Walking*. New York: Norton Books, 1987.

Roizen, Michael, M.D. *RealAge*. New York: Cliff Street Books, 1999.

Schatz Pullig, Mary, M.D. *Back Care Basics*. Berkeley: Rodmell Press, 1992.

Siegel, Bernie, M.D. *How to Live Between Office Visits*. New York: Harper Collins, 1995.

Siegel, Bernie, M.D. *Love, Medicine & Miracles*. New York: Harper and Row, 1986.

Siegel, Bernie, M.D. *Peace, Love & Healing*. New York: Harper and Row, 1989.

Siegel, Bernie, M.D. *Prescriptions for Living*. New York: Harper Collins, 1998.

Simon, David, M.D. *Vital Energy*. New York: John Wiley and Sons, 2000.

Simonton, O. Carl, M.D. *Getting Well Again*. New York: Bantam Books, 1988.

Simonton, O. Carl, M.D. *Healing Journey*. New York: Bantam Books, 1992.

Sinatra, Stephen, M.D. *Optimum Health*. New York: Lincoln-Bradley Publishing Group, 1996.

Teitelbaum, M.D. *From Fatigued to Fantastic*. New York: Avery Publishing Group, 1996.

Weil, Andrew, M.D. *Spontaneous Healing*. New York: Knopf, 1995.

Whitaker, Julian, M.D. *Reversing Diabetes*. New York: Warner Books, 1990.

Whitaker, Julian, M.D. *Reversing Heart Disease*. New York: Warner Books, 1988.

Yanker, Gary and Kathy Burton. *Walking Medicine*. New York: McGraw-Hill, 1990.

Stress Management, Relaxation, Meditation, Breathing, and Imagery

Benson, Herbert, M.D. *The Relaxation Response*. New York: Avon Books, 1976.

Carrington, Patricia. *Freedom in Meditation*. Garden City, NY: Anchor Books, 1978.

Monroe, Robin, R. Nagararhna, M.D., and H. R. Nagendra. *Yoga for Common Ailments*. New York: Fireside Books, 1990.

Nagendra, H.R., *Pranayama*. Bangalore, India: Vivekananda Yoga Institute Publications, 1999.

Payne, Larry and Georg Feurstein. *Yoga for Dummies*. Foster City, CA: IDG Books, 1999.

Payne, Larry. *Yoga Rx.* New York: Broadway Books, 2002.

Rossman, Marty, M.D. *Healing Yourself: A Step-by-Step Program for Better Health Through Imagery.* New York: Pocket Books, 1989.

Sedlacek, Keith, M.D. *Finding the Calm Within You.* New York: Signet Books, 1990.

Srikrishna, M.B.B.S. *Essence of Pranayama.* Bombay, India: Kaivalyadhama Press, 1996.

Zinn, Jon-Kabat. *Full Catastrophe Living.* New York: Delta Books, 1990.

Nutrition

Agatston, Arthur, M.D. *South Beach Diet.* Emmaus, PA: Rodale Press, 2003.

Balch, James F., M.D. and Phyllis A. Balch. *Prescription for Nutritional Healing.* Garden City Park, NY: Avery Publishing Group, 1990.

Ballantine, Rudolph, M.D. *Diet and Nutrition.* Honesdale, PA: Himalayan International Institute, 1978.

Barnard, Neal, M.D. *Food for Life.* New York: Crown Publishers, 1993.

Griffith, H. Winter, M.D. *Vitamins.* Tucson, AZ: Fisher Books, 1988.

Haas, Elson, M.D. *Staying Healthy with the Seasons.* Berkeley: Celestial Arts, 1981.

Lane, Theresa (Ed.). *Foods That Harm, Foods That Heal.* Pleasantville, NY: Reader's Digest Books, 1997.

Lappe, Francis Moore. *Diet for a Small Planet.* New York: Ballantine Books, 1982.

Melina, Vesanto, Brenda Davis, and Victoria Harrison. *Becoming Vegetarian.* Summertown, TN: Book Publishing Company, 1995.

Nedley, Neil, M.D. *Proof Positive: How to Reliably Combat Disease and Achieve Optimal Health Through Nutrition and Lifestyle.* Ardmore, OK: Nedley Publishing, 1998.

Null, Gary. *Complete Guide to Health and Healing.* New York: Delta Books,1984.

Ornish, Dean, M.D. *Eat More, Weigh Less.* New York: Harper Collins, 1993.

Robbins, John. *Diet For a New America.* Walpole, NH: Stillpoint Publishing, 1987.

Rubin, Jordan. *Patient Heal Thyself.* Topanga, CA: Freedom Press, 2003.

Sears, Barry. *The Zone.* New York: Harper Collins, 1995.

Shintani, Terri, M.D. *Eat More, Weigh Less Diet.* Honolulu, HI: Halpax Publishing, 1993.

U.S. Dept. of Agriculture. *Handbook of the Nutritional Contents of Foods.* New York: Dover Publications, 1975.

Weil, Andrew, M.D. *Eating Well for Optimum Health.* New York: Knopf, 2000.

Natural Healing

Chan, Luke. *101 Miracles of Natural Healing.* Cincinnati, OH: Benefactor Press, 1997.

Guinness, Alma E. (Ed.). *Family Guide to Natural Medicine.* Pleasantville, NY: Reader's Digest Books, 1993.

Page, Linda. *Healthy Healing.* Carmel Valley, CA: Traditional Wisdom, 2000.

Weil, Andrew, M.D. *Natural Health, Natural Medicine.* Boston: Houghton Mifflin, 1990.

Organizations for Healing

Academy For Guided Imagery
30765 Pacific Coast Highway #369

Malibu, CA 90265
800-726-2070
www.interactiveimagery.com

American Holistic Health Association
P.O. Box 17400
Anaheim, CA 92817-7400
714-779-6152
www.ahha.org

American Holistic Medical Association
12101 Menaul Blvd. NE, Suite C
Albuquerque, NM 87112
505-292-7788
www.holisticmedicine.org

Association for Applied Psychophysiology and Biofeedback
10200 West 44th Avenue, Suite 304
Wheat Ridge, CO 80033
www.aapb.org

Center for Attitudinal Healing
33 Buchanan Drive
Sausalito, CA 94965
415-331-6161
www.attitudinalhealing.org

Center for Mind-Body Medicine
5225 Connecticut Ave. NW, Suite 414
Washington, DC 20015
202-966-7338
www.cmbm.org

Commonweal Cancer Help Program
P.O. Box 316
451 Mesa Road
Bolinas, CA 94924
415-868-0970
www.commonweal.org

Hawaii State Consortium of Integrative Medicine
932 Ward Ave. Suite 600
Honolulu, HI 96814
808-535-5559
www.blendedmed.net

Institute of Noetic Sciences
101 San Antonio Road
Petaluma, CA 94952
707-775-3500
www.noetic.org

Integrative Medicine Alliance
180 Massachusetts Ave.
Arlington, MA 02474
617-648-9866
www.integrativemedalliance.org

Mind/Body Medical Institute
824 Boylston St.
Chestnut Hill, MA 02467
617-991-0102
Toll free: 866-509-0732
www.mbmi.org

National Center For Complementary and Alternative Medicine
National Institutes of Health
Bethesda, MD 20892
www.nccam.nih.gov
info@nccam.nih.gov

Preventive Medicine Research Institute
900 Bridgeway
Sausalito, CA 94965
415-332-2525
www.pmri.org

Program in Integrative Medicine
Dr. Andrew Weil
University of Arizona
www.drweil.com
www.integrativemedicine.arizona.edu

Scripps Center for Integrative Medicine
10820 North Torrey Pines Road
La Jolla, CA 92037
858-554-3971
www.scrippsfoundation.org

Simonton Cancer Center
P.O. Box 6607
Malibu, CA 90264
818-879-7904
Toll free: 800-459-3424
www.simontoncenter.com
simontoncancercenter@msn.com

Cousins Center for Psychoneuroimmunology
UCLA Neuropsychiatric Institute
300 UCLA Medical Plaza, Suite 3109
Box 957076
Los Angeles, CA 90095-7076
310-825-8281
www.npi.ucla.edu/center/cousins

BIBLIOGRAPHY

Ahmad, N., Hassan, M.R., Halder, H., and Bennoor, K.S. "Effect of Momordica charantia (Karolla) extracts on fasting and post-prandial serum glucose levels in NIDDM patients." *Bangladesh Medical Research Council Bulletin* 25, no. 1 (April 1999): 11–3.

Ahn, W.S., Yoo, J., Huh, S.W., Kim, C.K., Lee, J.M., Namkoong, S.E., Bae, S.M., and Lee, I.P. "Protective effects of green tea extracts (polypenon E and EGCG) on human cervical lesions." *European Journal of Cancer Prevention* 12, no. 5 (October 2003): 383–90.

Anderson, P.O., Knoben, J.E., and Troutman, W.G. *The Handbook of Clinical Drug Data*, 10th ed. (New York: McGraw-Hill, 2001).

Bardhan, K.D., Cumberland, D.C., Dixon, R.A., and Holdsworth, C.D. "Proceedings: Deglycyrrhizinated liquorice in gastric ulcer: a double blind controlled study." *Gut* 17, no. 5, (May 1976): 397.

Barnes, J., Anderson, L., Phillipson, D., and Barnes, J.A. *Herbal Medicine: A Guide for Healthcare Professionals* (Chicago: Pharmaceutical Press, 2002).

Barrett, B. "Medicinal properties fo Echinacea: a critical review." *Phytomedicine* 10, no. 1 (January 2003): 66–86.

Ben-Arye, E., Goldin, E., Wengrower, D., Stamper, A., Kohn, R., and Berry, E. "Wheat grass juice in the treatment of active distal ulcerative colitis: a randomized double-blind placebo-controlled trial." *Scandanavian Journal of Gastroenterology* 37, no. 4 (April 2002): 444–49.

Bernstein, D.I., Bernstein, C.K., Deng, C., Murphy, K.J., Bernstein, I.L., Bernstein, J.A., and Shukla, R. "Evaluation of the clinical efficacy and safety of grapeseed extract in the treatment of fall seasonal allergic rhinits: a pilot study." *Annals of Allergy, Asthma, and Immunology* 88, no. 3 (March 2002): 272–78.

Bombardelli, E. and Morazzoni, P. "Vitis vinifera L." *Fitoterapia* 66, no. 4 (1995): 291–317.

Bradley, J.D., Flusser, D., Katz, B.P., Schumacher Jr., H.R., Brandt, K.D., Chambers, M.A., and Zonay, L.J. "A randomized, double blind, placebo controlled trial of intravenous loading with S-adenosylmethionine (SAM) followed by oral SAM therapy in patients with knee osteoarthritis." *Journal of Rheumatology* 21, no. 5 (May 1994): 905–11.

Breslow, Rachelle. *Who Said So? A Woman's Fascinating Journey of Self Discovery and Triumph over Multiple Sclerosis* (Berkeley: Celestial Arts, 1991).

Brownstein, Art. *Healing Back Pain Naturally: The Mind-Body Program Proven to Work* (New York: Pocket, 2001).

Bucher, H.C., Hengster, P., Schindler, C., and Meier, G. "N-3 polyunsaturated fatty acids in coronary heart disease: a meta-analysis of randomized controlled trials." *American Journal of Medicine* 112, no. 4 (March 2002): 298–304.

Burke, B.E., Neuenschwande, R., and Olson, R.D. "Randomized, double-blind, placebo-controlled trial of coenzyme Q10 in isolated systolic hypertension." *Southern Medical Journal* 94, no. 11 (November 2001): 1112–17.

Burns, C.P., Halabi, S., Clamon, G., Kaplan, E., Hohl, R.J., Atkins, J.N., Schwartz, M.A., Wagner, B.A. and Paskett, E. "Phase II study of high-dose fish oil capsules for patients with cancer-related cachexia." *Cancer* 101, no. 2 (July 2004): 370–78.

Burschka, M.A., Hassan, H.A., Reineke, T., van Bebber, L., Caird, D.M., and Mosges, R. "Effect of treatment with Ginkgo biloba extract EGb 761 (oral) on unilateral idiopathic sudden hearing loss in a prospective randomized double-blind study of 106 outpatients." *European Archives of Oto-rhino-laryngology* 258, no. 5 (July 2001): 213–19.

Carbin, B.E., Larsson, B., and Lindahl, O. "Treatment of benign prostatic hyperplasia with phytosterols." *British Journal of Urology* 66, no. 6 (December 1990): 639–41.

Cesarani, A., Meloni, F., Alpini, D., Barozzi, S., Verderio, L., and Boscani, P.F. "Ginkgo biloba (EGb 761) in the treatment of equilibrium disorders." *Advances in Therapy* 15, no. 5 (September-October 1998): 291–304.

Chantre, P., Leblan, D., and Fournie, B. "Harpagophytum procumbens in the treatment of knee and hip osteoarthritis. Four-month results of a prospective, multicenter, double-blind trial versus diacerhein." *Joint Bone Spine* 67, no. 5 (2000): 462–67.

Chen, J.R., Yen, J.H., Lin, C.C., Tsai, W.J., Liu, W.J., Tsai, J.J., Lin, S.F., and Liu, H.W. "The effects of Chinese herbs on improving survival and inhibiting anti-ds DNA antibody production in lupus mice." *American Journal of Chinese Medicine* 21, no. 3–4 (1993): 257–62.

Ciarallo, L., Brousseau, D., and Reinert, S. "Higher-dose intravenous magnesium therapy for children with moderate to severe acute asthma." *Archives of Pediatric and Adolescent Medicine* 154, no. 10 (October 2000): 979–83.

Clapp, Larry. *Prostate Health in 90 Days* (Carlsbad: Hay House, 1998).

Constantinou, A., Stoner, G.D., Mehta, R., Rao, K., Runyan, C., and Moon, R. "The dietary anticancer agent ellagic acid is a potent inhibitor of DNA topoisomerases in vitro." *Nutrition and Cancer* 23, no. 2 (1995): 121–30.

Cousins, Norman. *Anatomy of an Illness as Perceived by the Patient* (New York: W. W. Norton and Company, 2005).

Deodhar, S.D., Sethi, R., and Srimal, R.C. "Preliminary study on antirheumatic activity of curcumin (diferuloyl methane)." *The Indian Journal of Medical Research* 71 (April 1980): 632–34.

Dutkiewicz, S. "Usefulness of Cernilton in the treatment of benign prostatic hyperlasia." *International Urology and Nephrology* 28, no. 1 (1996):49–53.

Efem, S.E. "Clinical observations on the wound healing properties of honey." *The British Journal of Surgery* 75, no. 7 (July 1988): 679–81.

Ferrara, L.A., Raimondi, A.S., d'Episocopo, L., Guida, L., Dello Russo, A., and Marotta, T. "Olive oil and reduced need to antihypertensive medications." *Archives of Internal Medicine* 160, no. 6 (March 2000):837–42.

Folsom, A.R. and Demissie, Z. "Fish intake, marine omega-3 fatty acids, and mortality in a cohort of postmenopausal women." *American Journal of Epidemiology* 160, no. 10 (November 15 2004): 1005–10.

Foster, S. and Tyler, V.E. *Tyler's Honest Herbal: A Sensible Guide to the Use of Herbs and Related Remedies* (Binghamton, NY: The Haworth Herbal Press, 1999).

Grandjean, E.M., Berthet, P., Ruffman, R., and Leuenberger, P. "Efficacy of oral long-term N-acetylcysteine in chronic bronchopulmonary disease: a meta-analysis of published double-blind, placebo-controlled clinical trials." *Clinical Therapeutics* 22, no. 2 (February 2000): 209–21.

Gupta, I., Gupta, V., Parihar, A., Gupta, S., Ludtke, R., Safayhi, H., and Ammon, H.P. "Effects of Boswellia serrata gum resin in patients with bronchial asthma: results of a double-blind, placebo-controlled, 6-week clinical study." *European Journal of Medical Research* 3, no. 11 (November 1998): 511–14.

Haverkorn, M.J. and Mandigers, J. "Reduction of bateriuria and pyuria using cranberry juice." *Journal of the American Medical Association* 272, no. 8 (August 1994): 590.

Hemila, H. "Vitamin C supplementation and common cold symptoms: problems with inaccurate reviews." *Nutrition* 12, no. 11–12 (November-December 1996): 804–9.

Hesslink Jr., R., Armstrong III, D., Nagendran, M.V., Sreevatsan, S., and Barathur, R. "Cetylated fatty acids improve knee function in patients with osteoarthritis." *Journal of Rheumatology* 29, no. 8 (August 2002): 1708–12.

Ishikawa, E., Araki, M., Ishikawa, M., Iigo, M., Koide, T., Itabashi, M., and Hoshi, A. "Relationship between development of diarrhea and the concentration of SN-38, an active metabolite of CPT-11, in the intestine and the blood plasma of athymic mice following intraperitoneal administration of CPT-11." *Japanese Journal of Cancer Research* 84, no. 6 (June 1993): 697–702.

Iso, H., Rexrode, K.M., Stampfer, M.J., Mason, J.E., Colditz, G.A., Speizer, F.E., Hennekens, C.H., and Willett, W.C. "Intake of fish and omega-3 fatty acids and risk of stroke in women." *Journal of the American Medical Association* 285, no. 3 (January 2001): 304–12.

Ivker, Robert S. *Sinus Survival: A Self-Help Guide* (New York: Penguin Putnam, Inc., 2000).

Jee, S.H., Miller III, E.R., Guallar, E., Singh, V.K., Appel, L.J., and Klag, M.J. "The effect of magnesium supplementation on blood pressure: a meta-analysis of randomized clinical trials." *American Journal of Hypertension* 15, no. 8 (August 2002):691–96.

Jeong, S.C., Yang, B.K., Kim, G.N., Jeong, H., Wilson, M.A., Cho, Y., Rao, K.S., and Song, C.H. "Macrophage-stimulating activity of polysaccharides extracted from fruiting bodies of Coriolus versicolor (Turkey Tail Mushroom)." *Journal of Medicinal Food* 9, no. 2 (Summer 2006): 175–81.

Jepson, R.G., Mihaljevic, L., and Craig, J. "Cranberries for preventing urinary tract infections." *Cochrane Database of Systematic Reviews (Online)* no. 2 (2004):CD001321.

Josling, P. "Preventing the common cold with a garlic supplement: a double-blind, placebo-controlled survey." *Advances in Therapy* 18, no. 4 (July-August 2001): 189–93.

Khan A., Safdar, M., Ali Khan, M.M., Khattak, K.N., and Anderson, R.A. "Cinnamon improves glucose and lipids of people with type 2 diabetes." *Diabetes Care* 26, no. 12 (December 2003): 3215–18.

Kimmatkar, N., Thawani, V., Hingorani, L., and Khiyani, R. "Efficacy and tolerability of Boswellia serrata extract in treatment of osteoarthritis of knee—a randomized double blind placebo controlled trial." *Phytomedicine: International journal of phytotherapy and phytopharmacology* 10, no. 1 (January 2003): 3–7.

Kjeldsen-Kragh, J., Lund, J.A., Riise, T., Finnanger, B., Haaland, K., Finstad, R., Mikkelsen, K., and Forre, O. "Dietary omega-3 fatty acid supplementation and naproxen treatmetn in patients with rheumatoid arthritis." *Journal of Rheumatology* 19, no. 10 (October 1992): 1531–36.

Klein, A.D. and Penneys, N.S. "Aloe vera." *Journal of the American Academy of Dermatology* 19, no. 1 (July 1988): 82.

Klein, J.P., McCarty, D.J., Harman, J.G., Grassanovich, J.L., and Quian, C. "Combination drug therapy of seropositive rheumatoid arthritis." *Journal of Rheumatology* 22, no. 9 (September 1995): 1636–45.

Kraft, G. and Harrast, M. "Yoga for carpal tunnel syndrome." *Journal of the American Medical Association* 281, no. 22 (June 1999): 2088.

Leonetti, H.B., Longo, S., and Anasti, J.N. "Transdermal progesterone cream for vasomotor symptoms and postmenopausal bone loss." *Obstetrics and Gynecology* 94, no. 2 (August 1999): 225–28.

Leventhal, L.J., Boyce, E.G., and Zurier, R.B. "Treatment of rheumatoid arthritis with gammalinolenic acid." *Annals of Internal Medicine* 199, no. 9 (November 1993): 867–73.

Lipton, R.B., Gobel, H., Einhaupl, M., Wilks, K., and Mauskop, A. "Petasites hybridus root (butterbur) is an effective preventative treatment for migraine." *Neurology* 63, no. 12 (December 2004): 2240–44

Lissoni, P., Barni, S., Mandala, M., Ardizzoia, A., Paolorossi, F., Vaghi, M., Longarini, R., Malugani, F., and Tancini, G. "Decreased toxicity and increased efficacy of cancer chemotherapy using the pineal hormone melatonin in metastatic solid tumour patients with poor clinical status." *European Journal of Cancer* 35, no. 12 (November 1999): 1688–92.

Liu, X., Liang, X., Lu, X., and Yang, M. "The causes of chylous ascites: a report of 22 cases." *Zhonghua Nei Ke Za Zhi* 38, no. 8 (August 1999): 530–32.

Lockwood, K., Moesgaard, S., Hanioka, T., and Folkers, K. "Apparent partial remission of breast cancer in 'high risk' patients supplemented with nutritional antioxidants, essential fatty acids and coenzyme Q_{10}." *Molecular Aspects of Medicine* 15 (1994): 231–40.

Logani, S., Chen, M.C., Tran, T., Le, T., and Raffa, R.B. "Actions of Ginkgo Biloba related to potential utility for the treatment of conditions involving cerebral hypoxia." *Life Sciences* 67, no. 12 (August 2000): 1389–96.

Lorenz-Meyer, H., Bauer, P., Nicolay, C., Schulz, B., Purrmann, J., Fleig, W.E., Scheurlen, C., Koop, I., Pudel, V., and Carr, L. "Omega-3 fatty acids and low carbohydrate diet for maintenance of remission in Crohn's disease. A randomized controlled multi-center trial. Study Group Members (German Crohn's Disease Study Group)." *Scandanavian Journal of Gastroenterology* 31, no. 8 (August 1996):778–85.

Madisch, A., Holtmann, G., Mayr, G., Vinson, B., and Hotz, J. "Treatment of functional dyspepsia with a herbal preparation. A double-blind, randomized, placebo-controlled, multicenter trial." *Digestion* 69, no. 1 (January 2004): 45–52.

Magrath, I.T. "African Burkitt's lymphoma. History, biology, clinical features, and treatment." *The American Journal of Hematology/Oncology* 13, no. 2 (Summer 1991): 222–46.

Magro-Filho, O. and de Carvalho, A.C. "Application of propolis to dental sockets and skin wounds." *The Journal of Nihon University School of Dentistry* 32, no. 1 (March 1990): 4–13.

Massno, M. "Bromelain in blunt injuries of the locomotor system. A study of observed applications in general practice." *Fortschritte der Medizin* 113, no. 19 (July 1995): 303–6.

Matsuoka, H., Seo, Y., Wakasugi, H., Saito, T., and Tomoda, H. "Lentinan potentiates immunity and prolongs the survival time of some patients." *Anticancer Research* 17, no. 4A (July-August 1997): 2751–55.

May, J., Chan, C.H., King, A., Williams, L., and French, G.L. "Time-kill studies of tea tree oils on clinical isolates." *The Journal of Antimicrobial Chemotherapy* 45, no. 5 (May 2000): 639–43.

Meunier, P.J., Roux, C., Seeman, E., Ortolani, S., Badurski, J.E., Spector, T.D., Cannata, J., Balogh, A., Lemmel, E.M., Pors-Nielsen, S., Rizzoli, R., Genant, H.K., and Reginster, J.Y. "The effects of strontium ranelate on the risk of vertebral fracture in women with postmenopausal osteoporisis." *New England Journal of Medicine* 350, no. 5 (January 2004): 459–68.

Meydani, S.N. "Vitamin/mineral supplementation, the aging immune response, and risk of infection." *Nutrition Reviews* 51, no. 4 (April 1993): 106–9.

McArthur, C.A. and Arnott, N. "Treating seasonal allergic rhinitis. Trial does not show that there is no difference between butterbur and cetirizine." *British Medical Journal* 324, no. 7348 (May 2002): 1277.

McGarry, K.A. and Kiel, D.P. "Postmenopausal osteoporosis. Strategies for preventing bone loss, avoiding fracture." *Postgraduate Medicine* 108, no. 3 (September 1 2000): 79–82, 85–88, 91.

McRorie, J.W., Daggy, B.P., Morel, J.G., Diersing, P.S., Miner, P.B., and Robinson, M. "Psyllium is superior to docusate sodium for treatment of chronic constipation." *Alimentary Pharmacology and Therapeutics* 12, no. 5 (May 1998): 491–97.

Mills, S. and Bone, K. *Principles and Practice of Phytotherapy* (New York: Churchill Livingstone, 1999).

Mittman, P. "Randomized, double-blind study of freeze-dried Urtica dioica in the treatment of allergic rhinitis." *Planta Medica* 56, no. 1 (February 1990): 44–47.

Morgenstern, C. and Biermann, E. "The efficacy of Ginkgo special extract EGb 761 in patients with tinnitus." *International Journal of Clinical Pharmacology and Therapeutics* 40, no. 5 (May 2002): 188–97.

Niederau, C., Strohmeyer, G., Heintges, T., Peter, K., and Gopfert, E. "Polyunsaturated phosphatidyl-choline and interferon alpha for treatment of chronic hepatitis B and C: a multi-center, randomized, double-blind, placebo-controlled trial. Leich Study Group." *Hepatogastroenterology* 45, no. 21 (May-June 1998): 797–804.

Northrup, Christiane. *Women's Bodies, Women's Wisdom* (New York: Bantam, 2002).

Oken, B.S., Storzbach, D.M., and Kaye, J.A. "The efficacy of Ginkgo biloba on cognitive function in Alzheimer disease." *Archives of Neurology* 55, no. 11 (November 1998): 1409–15.

Ornish, D., Scherwitz, L.W., Billings, J.H., Brown, S.E., Gould, K.L., Merritt, T.A., Sparler, S., Armstrong, W.T., Ports, T.A., Kirkeeide, R.L., Hogeboom, C., and Brand, R.J. "Intensive lifestyle changes for reversal of coronary heart disease." *Journal of the American Medical Association* 280, no. 23 (December 1998): 2001–7.

Pavelka, K., Gatterova, J., Olejarova, M., Manchacek, S., Giacovelli, G., and Rovati, L.C. "Glucosamine sulfate use and delay of progression of knee osteoarthritis: a 3-year, randomized, placebo-controlled, double-blind study." *Archives of Internal Medicine* 162, no. 18 (October 2002): 2113–23.

Peirce, A. *The American Pharmaceutical Association Practical Guide to Natural Medicines* (The Stonesong Press, Inc. New York, 1999).

Pepping, J. "Black cohosh: Cimicifuga racemosa." *American Journal of Health-System Pharmacy* 56, no. 14 (July 1999):1400–2.

Perossini, M., Guidi, G., Chiellini, S., and Siravo, D. "Diabetic and hypertensive retinopathy therapy with *Vaccinium myrtillus* anthocyanosides (Tegens®): Double-blind placebo-controlled clinical trial." *Annali di ottalmologia e clinica oculistica* 12 (1987): 1173–90.

Pfaffenrath, V., Diener, H.C., Fischer, M., Friede, M., Henneicke-von Zepelin, H.H., and Investigators. "The efficacy and safety of Tanacetum parthenium (feverfew) in migraine prophylaxis—a double-blind, multicentre, randomized placebo-controlled dose-response study." *Cephalalgia* 22, no. 7 (September 2002): 523–32.

Piscoya, J., Rodriguez, Z., Bustamante, S.A., Okuhama, N.N., Miller, M.J., and Sandoval, M. "Efficacy and safety of freeze-dried cat's claw in osteoarthritis of the knee: mechanisms of action of the species Uncaria guianensis." *Inflammatory Research: Official Journal of the European Histomine Research Society* 50, no. 9 (September 2001): 442–48.

Pittler, M.H., Schmidt, K., and Ernst, E. "Hawthorn extract for treating chronic heart failure: meta-analysis of randomized trials." *American Journal of Medicine* 114, no. 8 (June 2003): 665–74.

Postmes, T., van den Bogaard, A.E., and Hazen, M. "Honey for wounds, ulcers, and skin graft preservation." *Lancet* 341, no. 8847 (March 1993): 756–57.

Rao, A.V. "Lycopene, tomatoes, and the prevention of coronary heart disease." *Experimental Biology and Medicine (Maywood, NJ)* 227, no. 10 (November 2002): 908–13.

Rao, A.V. and Agarwal, S. "Role of antioxidant lycopene in cancer and heart disease." *Journal of the American College of Nutrition* 19, no. 5 (October 2000): 563–69.

Reid, I.R., Horne, A., Mason, B., Ames, R., Bava, U., and Gamble, G.D. "Effects of calcium supplementation on body weight and blood pressure in normal older women: a randomized controlled trial." *Journal of Clinical Endocrinology and Metabolism* 90, no. 7 (July 2005):3824–29.

Richer, S., Stiles, W., Statkute, L., Pulido, J., Frankowski, J., Rudy, D., Pei, K., Tsipursky, M., and Nyland, J. "Double-masked, placebo-controlled, randomized trial of lutein and antioxidant supplementation in the intervention of atrophic age-related macular degeneration: the Veterans LAST study (Lutein Antioxidant Supplementation Trial)." *Optometry* 75, no. 4 (April 2004): 216–30.

Rizos, I. "Three-year survival of patients with heart failure caused by dilated cardiomyopathy and L-carnitine administration." *American Heart Journal* 139, no. 2 (February 2000): S120–23.

Robbers, J. and Tyler, V. *Tyler's Herbs of Choice: The Therapeutic Use of Phytomedicinals* (New York: Haworth Press, 1999).

Sander, O., Herborn, G., and Rau, R. "Is H15 (resin extract of Boswellia serrata, "incense") a useful supplement to established drug therapy of chronic polyarthritis? Results of a double-blind pilot study." *Zeitschrift für Rheumatologie* 57, no. 1 (February 1998): 11–16.

Sandor, P.S., Di Clemente, L., Coppola, G., Saenger, U., Fumal, A., Magis, D., Seidel, L., Agosti, R.M., and Schoenen, J. "Efficacy of coenzyme Q_{10} in migraine prophylaxis: a randomized controlled trial." *Neurology* 64, no. 4 (February 2005): 713–15.

Schoenen, J., Jacquy, J., and Lenaerts, M. "Effectiveness of high-dose riboflavin in migraine prophylaxis. A randomized controlled trial." *Neurology* 50, no. 2 (February 1998): 466–70.

Sima, A.A., Calvani, M., Mehra, M., Amato, A. and the Acetyl-L-Carnitine Study Group. "Acetyl-L-carnitine improves pain, nerve regeneration, and vibratory perception in patients with chronic diabetic neuropathy: an analysis of two randomized placebo-controlled trials." *Diabetes Care* 28, no. 1 (January 2005): 89–94.

Soja, A.M. and Mortensen, S.A. "Treatment of chronic cardiac insufficientcy with coenzyme Q_{10}, results of meta-analysis in controlled clinical trials." *Ugeskrift for Laeger* 159, no. 49 (December 1997): 7302–8.

Solomon, G.F., Moos, R.H., and Lieberman, E. "Psychological orientations in the treatment of arthritis." *American Journal of Occupational Therapy* 19, (May-June 1965): 153.

Sotaniemi, E.A., Haapakoski, E., and Rautio, A. "Ginseng therapy in non-insulin-dependent diabetic patients." *Diabetes Care* 18, no. 10 (October 1995): 1373–75.

Stavric, B. "Quercetin in our diet: from potent mutagen to probable anticarcinogen." *Clinical Biochemistry* 27, no. 4 (August 1994): 245–48.

Tauchert, M. "Efficacy and safety of crataegus extract WS 1442 in comparison with placebo in patients with chronic stable New York Heart Association class-III heart failure." *American Heart Journal* 143, no. 5 (May 2002): 910–15.

Terris, M.K., Issa, M.M., and Tacker, J.R. "Dietary supplementation with cranberry concentrate tablets may increase the risk of nephrolithiasis." *Urology* 57, no. 1 (January 2001): 26–29.

Turker, A.U. and Camper, N.D. "Biological activity of common mullein, a medicinal plant." *Journal of Ethnopharmacology* 82, no. 2–3 (October 2002): 117–25.

Upton, R. "American Herbal Pharmacopoeia and Therapeutic Compendium—Astragalus Root" (Santa Cruz: *American Herbal Pharmacopoeia*, 1999).

Von Schacky, C., Angerer, P., Kothny, W., Theisen, K., and Mudra, H. "The effect of dietary omega-3 fatty acids on coronary atherosclerosis. A randomized, double-blind, placebo-controlled trial." *Annals of Internal Medicine* 130, no. 7 (April 1999): 554–62.

Watson, J.P., Jones, D.E., James, O.F., Cann, P.A., and Bramble, M.G. "Case report: oral antioxidant therapy for the treatment of primary biliary cirrhosis: a pilot study." *Journal of Gastroenterology and Hepatology* 14, no. 10 (October 1999): 1034–40.

Yale, S.H. and Liu, K. "Echinacea purpurea therapy for the treatment of the common cold: a randomized, double-blind, placebo-controlled clinical trial." *Archives of Internal Medicine* 164, no. 11 (June 2004): 1237–41.

Yam, D., Peled, A., and Shinitzky, M. "Suppression of tumor growth and metastasis by dietary fish oil combined with vitamins E and C and cisplatin." *Cancer Chemotherapy and Pharmacology* 47, no. 1 (2001): 34–40.

Yoshida, J., Takamura, S., Yamaguchi, N., Ren, L.J., Chen, H., and Koshimura, S. "Antitumor activity of an extract of Cordyceps sinensis (Berk.) Sacc. against murine tumor cell lines." *The Japanese Journal of Experimental Medicine* 59, no. 4 (August 1989): 157–61.

Zhu, J.S., Halpern, G.M., and Jones, K. "The scientific rediscovery of an ancient Chinese herbal medicine: Cordyceps sinensis: part I." *Journal of Alternative and Complementary Medicine* 4, no. 3 (Fall 1998):289–303.

Ziegler, D., Nowak, H., Kempler, P., Vargha, P., and Low, P.A. "Treatment of symptomatic diabetic polyneuropathy with the antioxidant alpha-lipoic acid: a meta-analysis." *Diabetic Medicine* 21, no. 2 (February 2004): 114–21.

ABOUT THE AUTHOR

ART BROWNSTEIN, M.D. has been talking with his patients about the body's extraordinary ability to heal itself for almost as long as he's been a doctor. In his long and distinguished career as an award-winning physician, educator, and speaker he has witnessed thousand of cases of extraordinary healing achieved by patients who were able to tap into their own healing powers. His own remarkable recovery from debilitating back pain, without the use of drugs or surgery, inspired his first, highly successful book, *Healing Back Pain Naturally*.

Dr. Brownstein is a Diplomate of the American Board of Preventive Medicine and a Founding Diplomate of the American Board of Holistic Medicine. He is also Assistant Clinical Professor of Medicine at the University of Hawaii, and for many years he was Director of the Princeville Medical Clinic in Princeville, Hawaii. Dr. Brownstein has worked with Dr. Dean Ornish in Dr. Ornish's very successful program for reversing heart disease, which relies heavily on the body's ability to heal itself.

Dr. Brownstein lives with his wife and son in Hawaii.